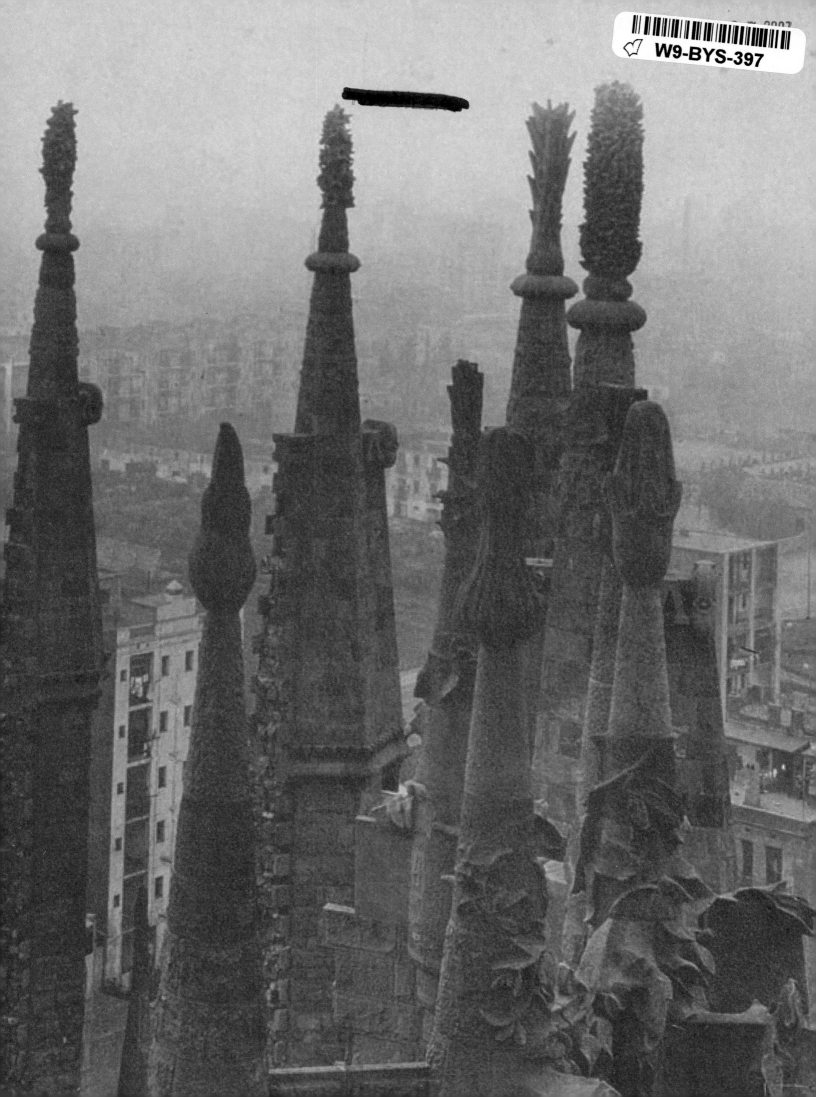

Barcelona and Modernity
Picasso, Gaudí, Miró, Dalí

The exhibition catalogue
was produced with the support of
the Institut Ramon Llull

# Barcelona and Modernity: Picasso, Gaudí, Miró, Dalí

William H. Robinson, Jordi Falgàs, and Carmen Belen Lord
Foreword by Robert Hughes

With contributions by Josefina Alix, Miriam M. Basilio,
Joan Bassegoda Nonell, Margaret Burgess, Sílvia Carbonell Basté,
Jordi Carreras, Narcís Comadira, Magdalena Dabrowski,
Mercè Doñate, Brad Epps, Mariàngels Fondevila,
Francesc Fontbona, Mireia Freixa, Daniel Giralt-Miracle,
Jared Goss, William Jeffett, Robert S. Lubar,
Jordana Mendelson, Cristina Mendoza, Jed Morse,
Dietrich Neumann, Maria Teresa Ocaña, Francesc M. Quílez i Corella,
Joan Ramon Resina, Judith Rohrer,
Josep M. Rovira, Alícia Suàrez, Eliseu Trenc,
Pilar Vélez, and Mercè Vidal

Published by the Cleveland Museum of Art in association with
Yale University Press, New Haven and London

The Cleveland Museum of Art
October 15, 2006–January 7, 2007

The Metropolitan Museum of Art
March 7–June 3, 2007

The exhibition was organized by The Cleveland Museum of Art
and The Metropolitan Museum of Art, New York,
in association with Museu Nacional d'Art de Catalunya,
Barcelona.

*Project Directors*

William H. Robinson, The Cleveland Museum of Art

Carmen Belen Lord, independent scholar

*Curators*

Magdalena Dabrowski, The Metropolitan Museum of Art

Jordi Falgàs, The Cleveland Museum of Art

Jared Goss, The Metropolitan Museum of Art

*Advisory Committee*

David Balsells, Museu Nacional d'Art de Catalunya

Miriam M. Basilio, New York University

Joan Bassegoda Nonell, Taller Gaudí–Reial Càtedra Gaudí

Jordi Bonet, Junta Constructora del Temple Expiatori de la Sagrada Família

Mercè Doñate, Museu Nacional d'Art de Catalunya

Mariàngels Fondevila, Museu Nacional d'Art de Catalunya

Francesc Fontbona, Biblioteca de Catalunya

Daniel Giralt-Miracle, independent scholar and curator

Robert S. Lubar, Institute of Fine Arts, New York University

Cristina Mendoza, Museu Nacional d'Art de Catalunya

Maria Teresa Ocaña, Museu Nacional d'Art de Catalunya

Francesc M. Quílez i Corella, Museu Nacional d'Art de Catalunya

Judith Rohrer, Emory University

Josep M. Rovira, School of Architecture, Universitat Politècnica de Catalunya

Gary Tinterow, The Metropolitan Museum of Art

Pilar Vélez, Museu Frederic Marès

The exhibition was developed with support from the National Endowment for the Arts and the Getty Research Institute.

The New York presentation is made possible by the Caixa Catalunya. Obra Social and the Generalitat de Catalunya. Additional support is provided by Jane and Robert Carroll and The Horace W. Goldsmith Foundation.

The Cleveland presentation is sponsored by Baker Hostetler. Funding provided in part by the generous support of the citizens of Cuyahoga County and the Board of County Commissioners. The Cleveland Museum of Art receives operating support from the Ohio Arts Council.

**Generalitat de Catalunya**

CAIXA CATALUNYA OBRA SOCIAL

institut ramon llull

# Contents

# Lenders to the Exhibition

## Private Collections

Bagués-Masriera, Barcelona

Lluís Bassat, Barcelona

Jordi Carulla, Barcelona

Josep Codina, Lleida

Yolanda Garcia-Lamolla, Lleida

Daniel Giralt-Miracle, Barcelona

Güell family, Barcelona

Joieria Sunyer, Barcelona

Jujol family, Els Pallaresos

Montserrat Mainar, Barcelona

Juan Pablo Marín, Barcelona

Marc Martí, Barcelona

Ricard Mas, Barcelona

Rosa Masó Bru, Girona

Jaume Mercadé Gallès, Barcelona

Renée Micoulaud, Barcelona

Alberto Oller y Garriga, Barcelona

Artur Ramon, Barcelona

Cristina Rebull Farré, Sant Cugat del Vallès

Inés de Rivera Marinel·lo, Barcelona

Gaspar Salinas Ramon, Barcelona

Rosa M. Subirana, Barcelona

Joan Tarrús and Josepa Castellà, Barcelona

Cecília de Torres, New York

Mercè Vidal, Esplugues de Llobregat

Several anonymous lenders

## Institutional Lenders

Ajuntament de Badalona

Arxiu Històric de la Ciutat de Barcelona, Institut de Cultura de Barcelona

Arxiu Històric del Col·legi d'Arquitectes de Catalunya, Barcelona and Girona

Arxiu Jujol, Els Pallaresos

Arxiu Municipal Administratiu, Ajuntament de Barcelona

Biblioteca, Ateneu Barcelonès

Biblioteca de Catalunya, Barcelona

Biblioteca de l'IVAM, Valencia

Biblioteca de Lletres, Universitat de Barcelona

Biblioteca-Museu Víctor Balaguer, Vilanova i la Geltrú

Biblioteca Nacional de España, Madrid

Biblioteca del Pavelló de la República, Universitat de Barcelona

Casa-Museu Domènech i Montaner, Canet de Mar

Casa-Museu Gaudí, Junta Constructora del Temple Expiatori de la Sagrada Família, Barcelona

Centre de Documentació i Museu Tèxtil, Terrassa

Cincinnati Art Museum

The Cleveland Museum of Art

Colección Masaveu, Oviedo

El Conventet, Barcelona

Daros Trading, S. L., Barcelona

The Detroit Institute of Arts

Diputació de Barcelona

Escola Tècnica Superior d'Arquitectura del Vallès, Universitat Politècnica de Catalunya, Sant Cugat del Vallès

Església del Sagrat Cor, Vistabella

Fondation Le Corbusier, Paris

Frances Loeb Library, Harvard University, Cambridge

Fundació Caixa Catalunya, Barcelona

Fundació Cultural Privada Manuel Rocamora, Barcelona

Fundació Joan Miró, Barcelona

Fundació Privada Centre d'Estudis d'Història Contemporània–Biblioteca Josep M. Figueras, Barcelona

Fundación Telefónica, Madrid

Galería Rafael Pérez Hernando, Madrid

Galerie Louise Leiris, Paris

Generalitat de Catalunya, Departament de Cultura

Gothsland Galeria d'Art, Barcelona

Grey Art Gallery, New York University Art Collection

Hirshhorn Museum and Sculpture Garden, Smithsonian Institution, Washington

Institut Amatller d'Art Hispànic, Barcelona

IVAM, Institut Valencià d'Art Modern, Generalitat, Valencia

Jake and Nancy Hamon Arts Library, Southern Methodist University, Dallas

Kent State University Libraries

Kunstbibliothek, Staatliche Museen zu Berlin

Manuscript, Archives and Rare Book Library, Emory University, Atlanta

The Metropolitan Museum of Art, New York

The Montreal Museum of Fine Arts

Musée National d'Art Moderne, Centre Pompidou, Paris

Musée Picasso, Paris

Museo Nacional Centro de Arte Reina Sofía, Madrid

Museo Pablo Gargallo–Ayuntamiento de Zaragoza

Museu d'Art i Història de Reus

Museu d'Art Jaume Morera, Lleida

Museu de les Arts Decoratives, Institut de Cultura de Barcelona

Museu Cau Ferrat–Consorci del Patrimoni de Sitges

Museu de Ceràmica, Institut de Cultura de Barcelona

Museu d'Història de la Ciutat de Barcelona, Institut de Cultura de Barcelona

Museu de Montserrat, Abadia de Montserrat

Museu Municipal Josep Aragay, Breda

Museu Nacional d'Art de Catalunya, Barcelona

Museu Picasso, Institut de Cultura de Barcelona

Museu de la Sagrada Família, Junta Constructora del Temple Expiatori de la Sagrada Família, Barcelona

Museum Berggruen, Berlin

The Museum of Fine Arts, Houston

The Museum of Modern Art, New York

National Gallery of Art, Washington

New Orleans Museum of Art

Northwestern University Library, Evanston, Illinois

Palau de la Música Catalana, Barcelona

Patio Herreriano, Museo de Arte Contemporáneo Español, Valladolid

Philadelphia Museum of Art

Reial Càtedra Gaudí–Taller Gaudí, Universitat de Barcelona and Universitat Politècnica de Catalunya

The Salvador Dalí Museum, St. Petersburg, Florida

Solomon R. Guggenheim Museum, New York

The State Hermitage Museum, St. Petersburg

Teatre Metropol, Ajuntament de Tarragona

Toledo Museum of Art

University of Illinois at Urbana-Champaign Library

# Directors' Preface

As the principal city of Catalonia and a major Mediterranean port, Barcelona has for centuries played a significant role as an economic, intellectual, and cultural center. A period of spectacular growth during the 19th century, due in large part to the opening of trade with the American colonies, gave the city a distinctive character that attracted and encouraged a thriving artistic community. For more than six decades, from the September Revolution of 1868 until the city's fall to the nationalist forces of Francisco Franco at the end of the Spanish civil war in 1939, Barcelona fostered a quest for modernism that not only provided an impulse for an assessment of traditional Catalan culture and values but also placed its participants firmly in the mainstream of the European avant-garde. Progressive thought in literature, music, architecture, and the visual arts manifested itself in numerous innovations, either following one from the other or coexisting in equanimity.

*Barcelona and Modernity: Picasso, Gaudí, Miró, Dalí* represents the first comprehensive attempt to introduce the American public to the vitality and complexity of Catalan modernism, a little-explored theme in the history of European art. For though the names Pablo Picasso, Antoni Gaudí, Joan Miró, and Salvador Dalí are familiar to many, few would associate them specifically with Barcelona and Catalonia. The exhibition features paintings, sculpture, drawings, prints, posters, decorative objects, furniture, architectural drawings, and designs, presenting the work of Picasso, Gaudí, Miró, and Dalí within the context of a broad spectrum of Catalan artists, designers, and architects whose range of achievement is largely unknown in this country, among them Ramon Casas, Isidre Nonell, Santiago Rusiñol, Lluís Domènech i Montaner, Josep Puig i Cadafalch, Gaspar Homar, and Josep M. Jujol. The installation will emphasize the unique sources of their inspiration as well as the special qualities of their visual expression.

The exhibition was conceived by William H. Robinson of the Cleveland Museum of Art, who was aided by Carmen Belen Lord and Jordi Falgàs. It was developed in collaboration with Gary Tinterow, Magdalena Dabrowski, and Jared Goss of the Metropolitan Museum of Art. The two museums benefited from the support and advice of the curatorial staff of the Museu Nacional d'Art de Catalunya in Barcelona, without whose commitment this ambitious project would never have been realized. We greatly appreciate the dedication and professionalism of all who helped ensure the success of the exhibition. Our heartfelt thanks go as well to the contributors to the exhibition catalogue.

Every exhibition of this scope depends on the cooperation of innumerable lenders. We owe a great debt of gratitude to the many institutions and individuals who so generously agreed to lend their treasured objects for such an extended period of time.

*Barcelona and Modernity* and its Cleveland presentation have been made possible through the generous financial commitments of a wonderfully diverse array of funders. The National Endowment for the Arts (NEA) and the Getty Research Institute provided vital, early support of the project and enabled it to evolve and grow into a comprehensive and engaging examination of enduring scholarship. The significant sponsorship of Baker Hostetler—which, like the museum, is celebrating its 90th anniversary this year—has yielded valuable underwriting support and a dynamic partner for the exhibition's Cleveland showing. We are indeed delighted that Baker Hostetler has chosen to commemorate its founding through this unique partnership. Funding for the exhibition's marketing and public relations campaign, provided in the form of an Arts and Culture as Economic Development Grant from the Cuyahoga County Board of Commissioners (The Honorable Jimmy Dimora, Tim Hagan, and Peter Lawson Jones), has been likewise essential. And, the important relationship between *Barcelona and*

*Modernity* and the exceptionally dedicated staff of the Institut Ramon Llull in Barcelona has formed a truly extraordinary resource for the exhibition's curators and the Cleveland Museum of Art's staff more broadly. The Institut Ramon's Llull's support of this publication and of the exhibition symposium are deeply valued and accepted with sincere appreciation.

The Metropolitan Museum of Art is profoundly grateful to those whose financial support has allowed us to bring this groundbreaking exhibition to New York. We wish to express our thanks to H. E. Pasqual Maragall i Mira, President, Generalitat de Catalunya, and The Honorable Narcís Serra i Serra, Chairman of the Board, Caixa Catalunya, for their critical contribution to this important project, which also would not have been realized without the generous support of Jane and Robert Carroll and the Horace W. Goldsmith Foundation. Finally, it is with great pleasure and gratitude that we acknowledge the special efforts on our behalf of Trustee Emeritus Plácido Arango and longtime friends of the Metropolitan H. E. Javier Solana, High Representative, Council of the European Union, and Leopoldo Rodés.

Timothy Rub
Director, The Cleveland Museum of Art

Philippe de Montebello
Director, The Metropolitan Museum of Art

Maria Teresa Ocaña
Director, Museu Nacional d'Art de Catalunya

# Acknowledgments

An exhibition of this size and complexity would never have been possible without the advice and support of many individuals and institutions. The exhibition organizers would like to thank, first and foremost, the specialists who so generously offered their time and assistance, especially the catalogue authors, our committee of scholarly advisors (listed in the previous pages), and many other colleagues at museums, universities, libraries, and archives in North America and Europe. This exhibition is the result of their continuous generosity over a period of years, during which they became not only collaborators, but also valued friends.

The exhibition was made possible through the efforts of three major institutions and their staffs. At the Cleveland Museum of Art, we are especially grateful to: Timothy Rub, Katharine Lee Reid, Charles Venable, Laurence Channing, Barbara J. Bradley, Jane Takac Panza, Tom Barnard, Charles Szabla, Carolyn K. Lewis, Kathleen Mills, Heidi Strean, Morena Carter, Ruth Weible, Mary Suzor, Bridget Weber, Jeanette Saunders, Jeffrey Strean, Andrew Gutierrez, JoAnn Dickey, Jeff Faslgraf, Bruce Christman, Marcia Steele, Moyna Stanton, Jim George, Joan Neubecker, Marta Oriola, Susan Jaros, Jack Stinedurf, Joan O'Brien, Donna Brock, Jill Mendenhall, Karen Carr, Eliza Parkin, Ann Koslow, Majorie Williams, Shannon Masterson, Leonard Steinbach, Holly Witchey, Jane Glaubinger, Heather Lemonedes, Elizabeth Lantz, Lou Adrean, and Christine Edmonson. Research assistance was provided by museum interns from the graduate art history program of Case Western Reserve University, including Patty Edmonson, Tami Gadbois, Amy Gilman, and Aimée Marcereau DeGalan. Special thanks to June de Phillips, Margaret Burgess, and Anthony Morris in the European Paintings and Sculpture department for their tireless efforts to bring this project to fruition.

At the Metropolitan Museum of Art, we would like to thank: Philippe de Montebello, Emily Rafferty, Mahrukh Tarapor, Martha Deese, Nina McNeely Diefenbach, Andrea Kann, Elyse Topalian, Linda Sylling, Michael Langley, Herb Moskowitz, John O'Neill, Ida Balboul, Kay Bearman, Christina Ripullone, Marc Barrio, Guillem d'Efak Fullana-Ferré, Colta Ives, Nancy Mandel, Holly Phillips, Samantha Rippner, and Ken Soehner.

At the Museu Nacional d'Art de Catalunya: Maria Teresa Ocaña, Eduard Carbonell, Gemma Ylla-Català, Eva Franquero, M. Teresa Guasch, Susana López, and Elena Llorens.

At the Institut Ramon Llull: Emilio Manzano, Xavier Folch, Mary Ann Newman, Carles Torner, Ita Roberts, and Elisabeth Linares.

Turning our ideas into reality required the assistance of many individuals who made an extra effort to open a door, find an address, make a phone call, or answer an e-mail—help that often proved crucial to completing research or obtaining a loan. We are also grateful to our colleagues who supported or approved loan requests. For their contributions, we wish to express our gratitude to: María José Abad, Joan Abelló Juanpere, Jordi Abelló, Santiago Alcolea, Núria Altarriba, Narcís Jordi Aragó, Francesc Arcas, Evaristo Arce, Sara Armengou, Philippe Ávila, Don Bacigalupi, Maria José Balcells, Anne Baldassari, David Balsells, Laura Baringo, Lluís Bassat, Joan Bassegoda i Nonell, Teresa Bastardes, Graham W. J. Beal, Agnès de la Beaumelle, Edwin Becker, Montserrat Beltran, Barry Bergdoll, Heinz Berggruen, Nathalie Bondil-Poupard, Maria Lluïsa Borràs, Eva Buch, Barbara C. Buenger, E. John Bullard, Ferran Burguillos, Manel Capdevila, Esteve Caramés, Sílvia Carbonell, Andreu Carrascal, Jordi Carulla, Victòria Casals, Josep Casamartina, Rossend Casanova, Maria Antònia Casanovas, Xavier Castanyer, Pere Català-Roca, Carles Cervera, Consuelo Císcar, Russ Clement, Francesc-Xavier Closas, Jaume Codina, Josep Codina, Guy Cogeval, Celestino Corbacho, Lluïsa Daniel, Mary Daniels, Lisa Dennison, Arnaud Dercelles, Dominique Dupis-Labbee, John Elderfield, Stephen Enniss, Bernd Evers, Jordi Faulí, Lluïsa Faxedas, Nicole Fenosa, Marc Ferran, David Ferrer, Josep M. Ferrer, Salvador Figueras, Virgínia

Figueras, Marcel Fleiss, Cristina Fontaneda, Carme Franch, Jaume Freixa, Francesc Gabarrell, Josep Miquel Garcia, Yolanda Garcia-Lamolla, Rosa Garicano, Josep M. Garrut, Beverly Gibbons, María Cristina Gil, Rosa M. Gil, Cara Gilgenbach, Carmen Giménez, Francesc Giol, Daniel Giralt-Miracle, Carmen Godia, Isabelle Godineau, Roger Griffith, Juan Güell, Lynn Gumpert, Anne d'Harnoncourt, Charles Henri Hine, Katherine Howe, Manuel Huerga, Àngels Jubert, Josep M. Jujol, Jordi Juncosa, Paula T. Kaufman, Joan Kropf, Manolo Laguillo, Juan José Lahuerta, Dolors Lamarca, Bernardo Laniado, Josep de C. Laplana, Christian Larsen, Brigitte Léal, Anna Lianes, Alison de Lima Green, Raimond Livasgani, Tomàs Llorens, Glenn D. Lowry, Teresa Macià, Laurence Madeline, Montserrat Mainar, Rosa Maria Malet, Marta Maragall, Juan Pablo Marín, Montserrat Marquès, Paz Marrodán, Marc Martí, Teresa Martí, Lourdes Martín, Ana Martínez de Aguilar, Mercè Martorell, Peter Marzio, Ricard Mas, Núria Masnou, Rosa Masó, Russell Maylone, Nancy McClelland, Marilyn McCully, Alexander McSpadden, Jaume Mercadé, Renée Micoulaud, Lola Mitjans de Vilarasau, Anna Molina, Isabelle Monod-Fontaine, Marta Montmany, Rosa Montserrat, Victòria Mora, Isabel Moreno, Santiago Muñoz Bastide, Juan Miguel Muñoz Corbalán, Jomi Murlans, Judit Nadal, Jesús Navarro, Naomi L. Nelson, Antoni Nicolau, Mercè Obón, Joan Oliveras Bagués, Jordi Oliveras Bagués, Oriol Oliveras Bagués, Alberto Oller y Garriga, Anna Omedes, Imma Parada, Pilar Parcerisas, Richard Peña,

Cris Pérez, Rafael Pérez Hernando, Gabriel Pinós, Mikhail Borisovich Piotrovsky, Carme Portolés, Lourdes Prades, Laura Pueyo, Jaume de Puig, Jordi Puig, Joan Puigdomènech, Raquel Quesada, Josep Radresa, Artur Ramon, Artur Ramon Jr., Glòria Ramoneda, Cristina Rebull, Rosa Regàs, Gérard Régnier, Rosa Reixats, Michel Richard, Rosa M. Ricomà, Ned Rifkin, Joan Rigol, Terence Riley, Joseph Rishel, Inés de Rivera, Josep M. Roca, Eduard Rocamora, Sebastià Roig, Robert Rosenblum, Mireia Rosich, Josep Manuel Rueda, Teresa M. Sala, Maria José Salazar, Gaspar Salinas, Cristòfor Salom, Josep Sampera, Trinidad Sánchez Pacheco, Anna de Sandoval Sarrias, Charo Sanjuán, Eloïsa Sendra, Katharine Slusher, Antoni Sobrepera, Roberto Sole Ribas, Mossèn Marià Sordé, Alan Stone, Claudia Stone, Jonas Storsve, Jordi Suàrez, Rosa M. Subirana, Àlex Susanna, Salvador Tarragó, Xavier Tarraubella, Joan Tarrús and Josepa Castellà, Michael Taylor, Jenny Tobias, Marta Torra, Cecília de Torres, Josep M. Turiel, Lina Ubero, Pedro and Kiki Uhart, Anne Umland, Teresa Velázquez, Sílvia Ventosa, Neus Verger, Cecília Vidal, Mercè Vidal, Sílvia Vilarroya, Laia Vinaixa, Montse Viu, Pere Vivas, Nancy Whyte, Betsy Wieseman, and Deborah Wye.

Above all, we wish to thank the institutions and private collectors (listed individually on the preceding pages) who lent works of art to the exhibition. We are infinitely grateful for their generosity, understanding, and unwavering support.

Magdalena Dabrowski

Jordi Falgàs

Jared Goss

William H. Robinson

# Foreword

*R O B E R T   H U G H E S*

Today, and especially when thinking about an exhibition like this one, it is natural (no, inevitable) to think of Barcelona as one of the chief centers of European visual culture at the end of the 19th century. One would have to make an effort—a perverse effort—to think otherwise.

But it was not always so. Forty years ago, when I was first prompted to go there, Barcelona was some way off the beaten track. Modernism was something that had been created mainly in Paris, with much input from other European centers and, somewhat later, from New York. But although Spain had produced some of the greatest artists of the 20th century—Picasso, Miró, Dalí, to name only a conspicuous three—and although almost all had some relationship, often very intense, with Catalonia, most non-Catalans (and even more, non-Spaniards) in the 1960s failed to appreciate what a seedbed of talent and invention the city had been. Nor did we grasp, at first, how its modernity was interwoven with its past. (Without a sense of the past, how do you know the modern is modern?) Ancient and traditional Catalan sources of imagery lay, half-hidden yet still fertile, within that apparent newness. You

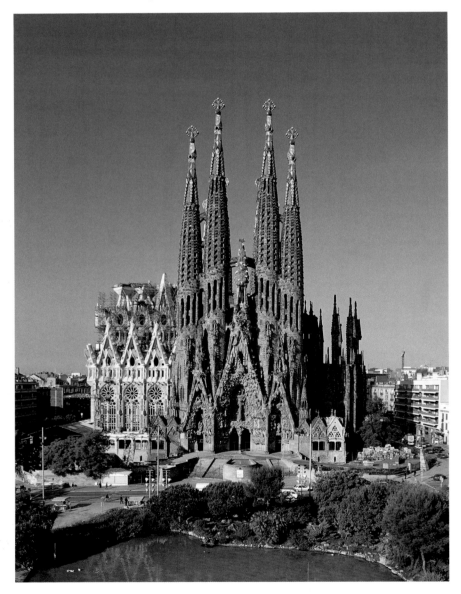

Fig. 1. Expiatory Temple of La Sagrada Família, designed by Antoni Gaudí, construction begun in 1882.

cannot, for instance, truly grasp the significance of Joan Miró's paintings of the 1920s and 1930s without some sense of the deep rural life from which he came: they are as new as Cubism, as fantasy-charged as Surrealism, but as old and real as the daytime chirping of grasshoppers or the hollow barking of a dog in the night on a Catalan farm.

When I first went to Barcelona, in the 1960s, I had no more idea of that city than I did of Atlantis. It took some time to realize how Barcelona had struggled to contradict what was then the prevalent image of a retrograde Spain, a failed empire. What I knew about the city was that some 30 years before, in the name of the republic, it had resisted Franco and paid a heavy price; that George Orwell (who knew very little about Catalan culture, but never mind) had written a book about it called *Homage to Catalonia;* and that it had once harbored a very peculiar architect named Gaudí, claimed by the French Surrealists, who had designed an enormous penitential church seemingly made of melted candle wax and chicken guts (fig. 1). And that was it. If my knowledge of Barcelona 40 years ago was unimpressive, I can only claim in my defense that it was no worse than that of most Europeans, let alone Australians. Not just slight: embarrassingly slight. So embarrassing that we weren't even embarrassed by it. Practically no foreigner, and certainly not I, was prepared for the magnificence of Catalan Romanesque fresco painting. The 1,500 years of the city's existence had produced only five names that came easily to mind. There was the cellist Pau Casals, the architect Antoni Gaudí, and the painters Joan Miró, Salvador Dalí, and Pablo Picasso, who had become a sort of honorary Catalan, having spent some of his youth there and having used the city as the springboard for his dive into Paris.

We had heard of Gaudí, but because we knew nothing about his deeply Catalan roots, his obsession with craft culture and his extreme right-wing piety, we got him completely wrong. We thought he was some kind of Surrealist, although everything in his beliefs repudiated the ideas of Surrealism. However, we wouldn't have recognized the name of an almost equally great architect, Lluís Domènech i Montaner, or even tried to pronounce that of Josep Puig i Cadafalch. We had no idea of how that singu-lar piece of utopian town planning, the Eixample (Expansion), came into existence, or who its designer Ildefons Cerdà was; yet, there it was, the first European grid city. The few guides to its architecture that were in print back in the 1960s were hopelessly unreliable, incomplete, and never in English. There was practically nothing on Catalan painting and sculpture from the Renaixença, as Catalans called the aggressive rebirth of their national consciousness in the late 19th century. No foreign visitor except a few specialists who knew the language could get acquainted with the great writers and poets of Catalan history, from Ramon Llull and Ausiàs March in the Middle Ages through to Jacint Verdaguer, Joan Maragall, and Josep Carner. Some of Barcelona's very best writers will almost certainly never be translated because their work is either too voluminous or too local, or both. The great Josep Pla, one of the European prose masters of the 20th century, was one of them. But how many people are likely to acquire Catalan for the sake of reading Pla? The artists, draftsmen, designers, architects, furniture makers, goldsmiths, and others who worked in Barcelona, however, are directly accessible to us. No single exhibition can do more than sample their achievements, which were so often magnificent. One of the purposes of this show is to stimulate an appetite for more.

As early as the 13th century, when Barcelona was the Gothic queen city of the Mediterranean and Madrid was hardly more than a few churches and a cluster of mud huts, the main governing body of the city was a group of 100 people who represented not only the nobility and the high merchants, but also, for the first time anywhere, artisans and laborers, who had more or less equal standing with landowners and bankers. The Consell de Cent was the oldest protodemocratic body in Europe. Its assembly room in the Ajuntament evokes a host of associations that bear upon the great issues of Catalan self-determination, in particular, and of cultural self-sufficiency, in general. From the moment I first arrived in Barcelona, there have been qualities of the city that I loved. The main one is that it has always been a citizens' town, more a city of capital negotiating with labor than of nobility lording it over commoners. Things were done by contract, not by divine right. The spirit was summed

up in the words "If not, not"—from the famous and unique oath of allegiance sworn by Catalans and Aragonese to the monarch. "We, who are as good as you, swear to you, who are no better than us, to accept you as our king and sovereign lord, provided you observe all our liberties and laws—but if not, not." Even today, these words have the sharp and thrilling ring of political truth: they evoke a people who have no doubt about themselves. Catalans had a knack for putting kingship in perspective. On the façade of Barcelona's town hall is a statue of a 15th-century merchant named Joan Fiveller. His likeness was put there in the 1850s instead of a figure of Hercules, as an emblem of civic strength. Why? Because in his role as councilor he had forced the retinue of the first Castilian king of Catalonia and Aragon to pay city taxes on the salt cod they ate. When 19th-century Catalans wanted titles they just went and bought them in Madrid: that is the

democratic way. Barcelona has never been too much impressed by the hidalgo mentality, the obsession with bloodlines and descent that affected so much of the rest of Spain. There is no church in the world that declares itself to be a citizen's church as plainly and vividly as Santa Maria del Mar, and whenever I go there, which is often, I look at the stone carvings on the base of its altar and the little bronze figures of the stevedores tacked to its oak doors, depicting the workers of the Ribera quarter carrying their loads—the church remembering the men who built it. I am filled with respect for the uncompromised, gritty reality that expresses itself in the city. At the time I first went to Barcelona, most people I knew in New York and London believed in the imperial model of culture, which is: at any time the world of painting, architecture, and so forth has a center, a place that monopolizes energy and invention and distributes it to the provinces outside. The center

Fig. 2. Palau de la Música Catalana, 1905–8, designed by Lluís Domènech i Montaner.

and the periphery. In the 17th century, the center had been Rome. By the 19th, it had shifted to Paris. To be unaware of Paris was impossible. To be indifferent to it was artistic illiteracy, a form of suicide. From 1800 to 1950 the supremacy of Paris as an incubator and judge of culture was taken for granted. Then, by the 1960s, the center seemed to have moved decisively to New York. And now, 40 years later, there is no center. Enhanced communications have done their work: one thinks of the art world as a web of linked points, not as a center surrounded by provinces.

The idea of an international style, created at the center but applicable anywhere, was everywhere. It was a benign cultural version of that idea of a transnational economy which excites such passionate debate and fierce criticism today. Imperialism creates provincialism. Provincialism arises when people begin to think that what they make, what images they find to describe themselves, are of unknown value until they are judged by people outside their own culture. The anguish of provincialism consists in always asking "is this novel/play/symphony/painting really good?"—while being condemned not to find a confident answer within one's own terms. The cure for this anguish lies in realizing and affirming that the cultures around us are not one but many, and that something that means little to one may signify a great deal to another. So much great art, at its root, is local. It comes from specific places, and its merits do not come from conformity to some imagined international standard.

But in the 1960s a generation of talented Catalans—writers, artists, architects, fledgling economists, incipient politicians—hoped to change perceptions of their city. They wanted to assert a *fet diferencial*, the belief that Barcelona was indeed different from the rest of Spain—closer to Europe, "the north of the South." They imagined Barcelona becoming, once again, a center of Mediterranean culture, as it had been in the Middle Ages and after the Industrial Revolution. They wanted to help Barcelona recapture some of the luster it had half a century before their birth, back in the 1880s: a moment forgotten by almost everyone, in 1966, except the Catalans themselves. They were committed to those ideas that eventually saved Barcelona as a city and as a culture: a firm belief in the social responsibility of government, combined with an equally

strong conviction that cultures are not made by ideology on command.

And Barcelona certainly needed saving. The city had decayed over the years that Franco was running Spain. During the *época* it was neglected and ignored. Once an enormous ashtray, it had earned the nickname "la Barcelona grisa." The buildings that should have made the city famous were suffocating and in decay. Things were done to the 19th-century architectural masterpieces of Barcelona that would never have been allowed to buildings from the medieval or Renaissance eras, because the earlier ones were rightly seen as precious and historical, whereas the later ones were wrongly thought of as old-fashioned or grotesque. And what drove all this was the unsupervised, opportunistic greed of developers. Was all this the result of some deliberate and thought-out policy? The answer has to be No: but. No, but decay is a most powerful force, and so is amnesia. Barcelona had resisted Franco; now the Caudillo would see that it got the wrong medicine. There would be money—there would always be money—for cement-works outside the city. But there was not going to be money for projects such as the restoration of that great emblem of the national Catalan spirit, the Palau de la Música Catalana, in which every brick and mosaic tile spoke of a romantic independence from Madrid and of an equally romantic relationship between northern Europe and the folk spirit of Catalonia (fig. 2).

Well, this time the good guys won. When those Americans to whom the word "liberal" is a term of abuse, signifying utopian fancies and failed hopes, used to ask me in a sneering way if the generation of 1968 ever achieved anything serious in the domain of large-scale social life, the reconstitution of Barcelona by the successive administrations of Narcís Serra, Pasqual Maragall, and Joan Clos is near the top of my list.

Culture, always critical of itself, always in debate with itself, is not just the butter on the bread of life: it is the bread itself. This has always been recognized for a fact in Barcelona, and that is another reason why I feel so devoted to the incomparable city. "La gran encisera," the great enchantress, Pasqual Maragall's grandfather the poet Joan called Barcelona; and he was right.

# Barcelona and Modernity

WILLIAM H. ROBINSON AND CARMEN BELEN LORD

But Barcelona is very different, isn't it? There one finds the Mediterranean, the spirit,
the adventure, the elevated dream of perfect love. There are palms, people from every country, surprising
advertisements, gothic towers and rich urban high tide created by typewriters. How I enjoy being there,
with that air and that passion! . . . Besides, I, who am a ferocious Catalanist, identified greatly
with those people, so fed up with Castile, and so creative.
—Federico García Lorca, 1926

This is the first exhibition in North America to examine a remarkable, 71-year period (1868–1939), when Barcelona ascended from a city of provincial culture into one of the most dynamic centers of modernist art and architecture in Europe. In the decades between the September Revolution of 1868 and the fall of the Second Spanish Republic in 1939, Barcelona experienced an astonishing transformation, finally arriving at full integration with the international avant-garde through the emergence of an innovative school of rationalist architecture and an array of surrealist artists led by Joan Miró and Salvador Dalí. The city's meteoric rise in the visual arts came to a crashing halt with General Francisco Franco's victory in the Spanish civil war in April 1939, an event that brought a right-wing dictatorship to power. Because Barcelona had served as a center of antifascist resistance and regional separatism, Franco imposed measures to erase the city's Catalan character and history as a leader of progressive political and artistic movements. Although democracy would return to Spain after Franco's death in 1975, 36 years of cultural repression, censorship, and revisionist histories have left the world with a fractured view of Iberian civilizations, a confusion reflected in the popular adage and advertising slogan: "Spain is different."

Perceptual ambiguity about Spain is not a recent invention. Since the birth in the 16th century of the Black Legend—a tradition of vilification by

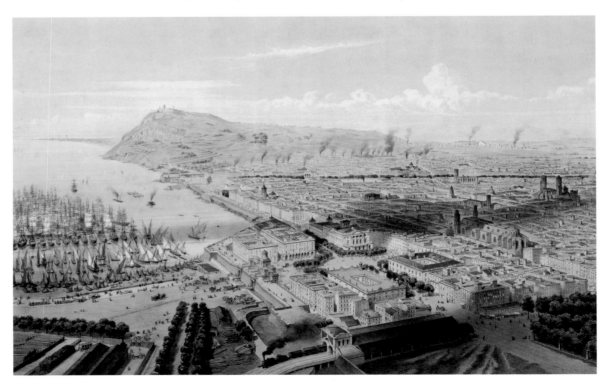

Fig. 1 (cat. 1:3). Alfred Guesdon, *Bird's Eye View of Spain, Barcelona*, 1860.

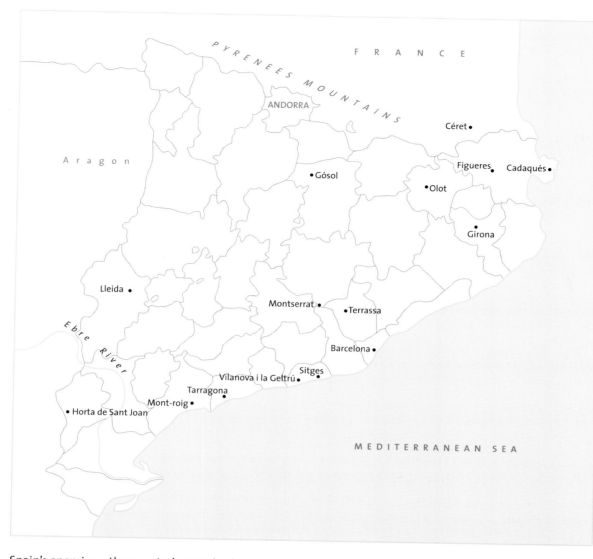

Spain's enemies—the country's complex history and character have been flattened by inaccurate stereotypes circulated in foreign newspapers and books. The modern tourist and film industries have promoted simplistic notions of Spain as an excessively conservative, homogeneous society populated by macho toreadors, flamenco dancers, religious zealots, corrupt aristocrats, ignorant peasants, and cruel despots.[1] This exhibition, focusing on Barcelona's modernist culture during a period when its artists became fully engaged with the international avant-garde, seeks to dispel any lingering perceptions of Spain as an exotic "other," a distant and insular country more oriental than European, a nation tethered to its medieval and Moorish past, a society untouched by the liberal reforms that swept the rest of Europe during the 18th and 19th centuries.

Certainly, any understanding of modernist culture in Spain must begin with Barcelona (fig. 1), a bustling Mediterranean seaport located in the northeast corner of the Iberian Peninsula. Situated barely 95 miles from the French border, Barcelona has historically served as the crucial point of interchange between Spain and northern Europe. By the end of the 19th century, Barcelona had become the most industrialized, populous, and culturally advanced city in Spain. Yet, as the capital and cultural heart of Catalonia (fig. 2), a region with its own language and artistic traditions, Barcelona also stood apart. During the 19th century Barcelona's cultural life became closely entwined with rising Catalan nationalism and aspirations for autonomy. The toppling of the Spanish monarchy in the September Revolution of 1868 ignited hopes for the passage of the liberal reforms so urgently desired in Catalonia, but which encountered stiff resistance from reactionary forces. The collapse of the First Republic (1873–74) and the restoration of the Spanish monarchy in 1874 con-

Fig. 2. Catalonia and the cities important to this catalogue.

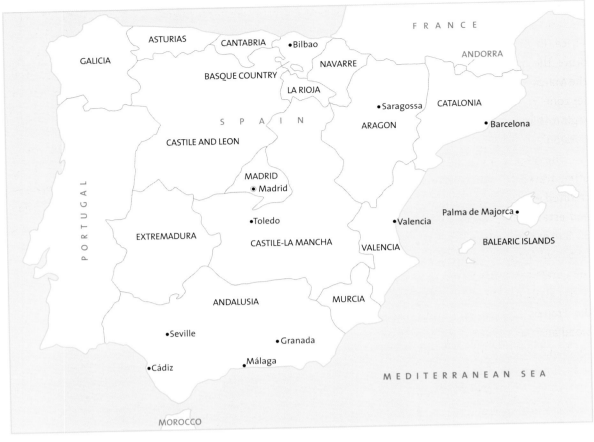

Fig. 3. The autonomous regions of Spain today.

vinced many Catalans that progress would only be achieved by redefining their relationship with the central government in Madrid. During this period Catalans of all social classes increasingly regarded themselves as different from the rest of Spain, a unique culture rooted in its own history, but constantly driven forward by an energetic striving for integration with the modern world. Many Catalans dreamed of transforming Barcelona into a world-class city rivaling Paris and London, an ambition they knew could only be achieved through an enduring commitment to modernization and progress.

### The City of Bombs: A Brief History

Today, Barcelona is Spain's leading seaport and second largest city.[2] It is the capital of Catalonia, a triangular-shaped region bordered by France to the north, the Mediterranean Sea to the east, the province of Aragon to the west, and Valencia to the south (fig. 3). Like Aragon, Catalonia is one of Spain's 17 "autonomous communities," each with its own parliament and president. The autonomous communities share various powers with the central government in Madrid, while other matters are reserved for the regional parliaments, creating a political structure roughly comparable to the federal-state relationship in the United States.[3] Catalonia's regional government consists of a parliament and the Generalitat, an executive branch directed by the president. The city of Barcelona is governed by the Ajuntament, a legislative council, and the Comissió de Govern, an executive arm led by the mayor.

Barcelona's exact origins remain shrouded in mystery. It is widely believed that the city dates to 230 BC, when Hamilcar Barca, the father of Hannibal, established the Carthaginian settlement of Barcino on a small plateau rising from the sea. The Romans invaded Iberia in 218 BC, landing first at the Greek colony of Emporiae (Empúries today) north of Barcino, then conquering and transforming the entire peninsula into a major province of the empire called Hispania. Under the Romans, Barcino developed into a city of modest size centered around a forum located at the site of the current plaça de Sant Jaume, the square where the offices of the Generalitat and the Ajuntament now face each other.[4] Remnants of the city's Roman temple and fortified walls survive today. Visigoths conquered Barcelona in AD 415 and

ruled until 717, when the Moors subjugated the city, six short years after crossing into Iberia from North Africa. In 801 Charlemagne's son, Louis the Pious, drove the Moors from the region and established the Marca Hispanica (Spanish March), a military buffer zone in the northeast corner of the peninsula, a region that formed the early footprint for modern Catalonia.

The origins of Catalonia as a political entity are often traced to Wilfred the Hairy (d. 897), who is credited with uniting various fiefdoms of the region and establishing the 500-year reign of the Counts of Barcelona, a hereditary line that lasted until 1410.[5] Wilfred is also associated with the origins of the Catalan flag. According to legend (several variations exist), as Wilfred lay wounded on a battlefield, the Frankish king dipped his hand into Wilfred's blood and wiped his fingers down the count's golden shield, creating an emblem of four red bars set against a yellow background.

The emergence of the Catalan language in the ninth century undoubtedly contributed more to the birth of a new national identity than the invention of a flag or a coat of arms. Contrary to popular perception, Catalan is not a dialect of Castilian Spanish, but a distinct Romance language that developed independently from vernacular Latin. Catalan most closely resembles Provençal and the ancient languages of southern France. Today, as many as 12 million people speak Catalan, more than Danish or Bulgarian, and fluency in the language remains the most defining feature of Catalan national identity.[6]

During the Middle Ages, Catalonia developed into a major Mediterranean sea power with illustrious political and cultural traditions. Barcelona's rise to power moved significantly forward when Catalonia was united by marriage with neighboring Aragon in 1137. Afterward, the Catalan-Aragonese federation embarked on a period of conquest and expansion, at times incorporating Roussillon, Provence, Montpellier, Majorca and the Balearic Islands, Valencia, Sicily, the duchy of Athens, Sardinia, and the kingdom of Naples. Major political strides were made with the establishment of the Catalan Corts in Barcelona in 1282, one of the oldest parliaments in Europe. Catalan literature, architecture, and painting flourished during this "golden age,"

when Barcelona reigned as the economic center of a vast Mediterranean empire, the rival of Genoa and Venice. Politicians, writers, and architects of the 19th century would invoke the memory of this golden age as the historical precedent for the rebirth of Catalan national identity and the restoration of an autonomous state.

After reaching the peak of its geographic expansion in 1443, the Catalan-Aragonese federation entered into a troubled period.[7] Barcelona's economy, already in decline, suffered a severe blow in the late 15th century when the Catholic monarchs, Ferdinand of Aragon-Catalonia and Isabella of Castile, united their kingdoms and awarded a monopoly on trade with the Americas to the cities of Seville and Cádiz.[8] In coming years, power would shift dramatically to Castile and its newly created capital of Madrid (est. 1619). Barcelona suffered yet another setback during the Reaper's War (1640–52), a struggle for independence ignited by Catalan peasants in response to Madrid's demands for money and troops to support its campaign in Flanders. After a prolonged siege, Barcelona surrendered to a Castilian army and Catalonia was forced to cede its territories north of the Pyrenees to France. Yet the struggle of Catalan peasants against a powerful invader was not forgotten, as their courageous resistance is still celebrated in the Catalan national anthem "Els Segadors" (The Reapers), and the resonance of their mythic defiance became embedded in Julio González's sculptures of Catalan peasants and Joan Miró's *The Reaper* (*Catalan Peasant in Revolt*), a large mural created for the Spanish pavilion of the Paris International Exhibition of 1937 (see fig. 3, p. 432).

Disaster again struck Barcelona when Catalonia sided with the Hapsburgs rather than the victorious Bourbons in the War of Spanish Succession (1705–14). After yet another prolonged siege (fig. 4), Barcelona surrendered to a Castilian-Bourbon army on 11 September 1714. Determined to eradicate all resistance to central authority, Philip V placed Barcelona under military law, disbanded the city and regional governments, eliminated Catalonia's historic rights and privileges, closed universities, and repressed the Catalan language. Henceforth, Catalonia would be ruled by a governor or a captain-general appointed in Madrid, usually a non-Catalan. Perhaps the king's

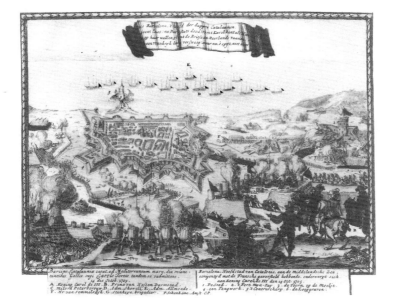

most hated act was constructing the Citadel (fig. 5, far left), a garrisoned fortress on the northern edge of Barcelona designed to insure Madrid's control over the city and its rebellious citizens. Just as determined to resist, Catalans later began celebrating September 11th as their national holiday.[9]

Despite the harsh measures imposed by Madrid, Catalonia's economy began to revive in the 18th century. After the ban on trade with the Americas was lifted in 1778, Barcelona's textile industry exploded, fueled by the importation of cheap cotton from the United States and expanding commerce with Cuba and the Philippines. In 1833 the Bonaplata firm began operating the first steam-powered textile mill in Spain, a significant step forward in Barcelona's

rise as the country's most industrialized city. The first railroad in Spain, a line linking Barcelona with Mataró, opened in 1848. Barcelona also became the first city in Spain connected by rail to Paris, again driving Catalonia's engagement with the modern world forward. Between 1840 and 1860 Catalonia's industrial production tripled, and the region came to control 80% of Spanish textile manufacturing.[10]

By the 1860s Barcelona had become one of the most rapidly growing and densely populated cities in Europe, partly due to waves of peasants migrating from the rural areas searching for work in the factories and mills. In 1863 alone, the rate of urban population growth reached over 27%—three times the national average. Congested slums and miserable,

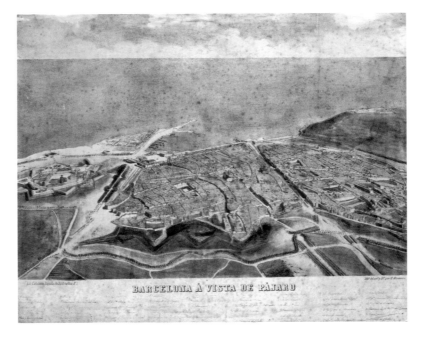

Fig. 4. *The Siege of Barcelona*, 1714, artist unknown.
Fig. 5 (cat. 1:2). Onofre Alsamora, *Bird's Eye View of Barcelona*, 1860, with the Citadel at the far left.

unregulated working conditions led to repeated epidemics and labor unrest. To relieve the overcrowding, in 1854 Madrid finally granted Barcelona permission to tear down the medieval walls that had stifled the city's growth for centuries. In 1860 Madrid approved Ildefons Cerdà's plan (see fig. 3, p. 24) for urban expansion beyond the medieval walls, a design linking the city (the dark roughly hexagonal shape in the lower center of the plan) with surrounding communities through an area of proposed new growth called the Eixample (Expansion) (fig. 6). Organized in a grid pattern bisected by broad boulevards, this vast district became the site for some of the most celebrated building projects of the modernista era, including Antoni Gaudí's Expiatory Temple of the Sagrada Família (begun 1882–83) and Casa Milà (1906–10). Since these structures, along with other art and events from the period covered by this exhibition, are examined more fully in subsequent essays in this catalogue, they will be mentioned only briefly here.

The destruction of Barcelona's medieval walls unleashed a torrent of new construction that transformed the city. In 1880 the Italian travel writer

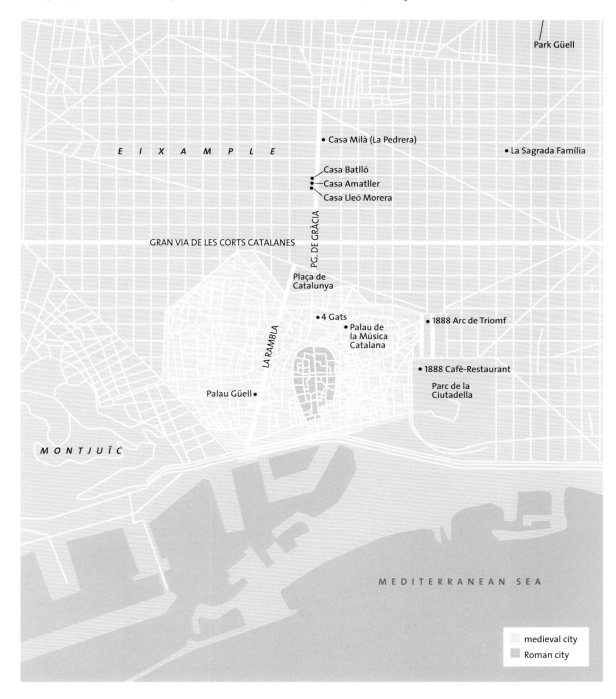

Fig. 6. Modern Barcelona with the Roman and medieval cities, and the 19th-century expansion.

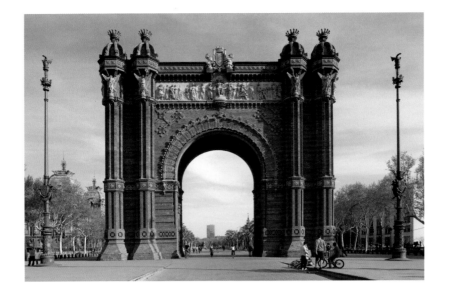

Edmondo de Amicis observed: "Barcelona is, in appearance, the least Spanish city of Spain. There are large buildings … long streets, regular squares … and a continuous coming and going of people. On every side there is manufacturing, transforming and renovating. The people work and prosper."[11] Yet, in stark contrast to the luxurious homes being constructed in the Eixample for the new middle and upper classes, laborers continued to live in appalling conditions. "I was shocked that human life could even develop in such detestable conditions," wrote Pedro García Faria in *La insalubridad de las viviendas de Barcelona* (1890).[12] García Faria took particular note of the tiny living spaces, fetid air, and frequently combined toilet and kitchen areas that contributed to recurring outbreaks of tuberculosis, anemia, scrofula, and rickets, a disease that prematurely enfeebled the children who worked in the factories that produced the city's wealth.

A renewed spirit of Catalan nationalism accompanied Barcelona's rising economic fortunes. This resurgence of Catalanisme was closely associated with the 19th-century Renaixença (Renaissance), initially a political and literary movement that eventually spread to all aspects of Catalan culture, including philosophy, theater, visual arts, and architecture. Elsewhere in this catalogue Francesc Fontbona observes that the birth of the Renaixença is often dated to the publication of Bonaventura Carles Aribau's poem *La Pàtria* (The Fatherland) of 1833. Other literary markers include the revival in 1859 of the Jocs Florals (medieval Catalan poetry contests), the po-

ems of Jacint Verdaguer and Víctor Balaguer, the founding of the magazine *La Renaixença* in 1871, and the establishment in 1879 of *Diari Català,* the first daily newspaper published in Catalan.[13]

The city of Barcelona celebrated its new prosperity by organizing the Universal Exposition of 1888, a world's fair of fine and industrial arts and the physical embodiment of Renaixença nationalistic fervor. This ambitious project reflected a growing confidence among Catalans that they had finally arrived as a European economic power. The exposition was the first of several international events staged in Barcelona to draw attention to the city's economic and cultural vitality (later examples include the International Exposition of 1929 and the Olympic Games of 1992). The fair of 1888 served another purpose as well: erected on the grounds of the recently demolished Citadel, a despised symbol of Madrid's domination over Catalonia, the exposition expressed Barcelona's aspirations for progress and autonomy through the concrete, physical reality of bricks, mortar, and stone (fig. 7).

The spirit of national revival, often expressed through references to Catalonia's glorious medieval past, became a leitmotif of Renaixença architecture. Overt medievalism appears in Elíes Rogent's University of Barcelona (1862–73), Josep Puig i Cadafalch's Casa Martí (1895–96), and Lluís Domènech i Montaner's Cafè-Restaurant (1887–88) of the Universal Exposition of 1888. Domènech, head of the Barcelona school of architecture, articulated a theoretical justification for expressing Catalan na-

Fig. 7. Triumphal arch for the Barcelona Universal Exposition, 1888, designed by Josep Vilaseca i Casanovas.

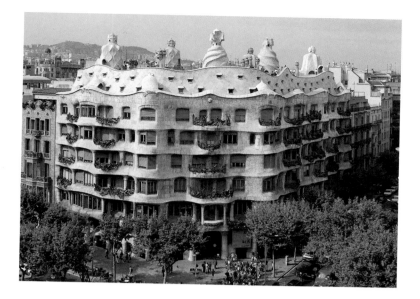

tionalism through the arts with his influential essay, "In Search of a National Architecture," published in *La Renaixença* in 1878.

As the century drew to a close, Barcelona architects increasingly abandoned historical revivalism in favor of original invention, often using the traditional Catalan building materials of brick, iron, ceramic, and stained glass in daring new ways. The leaders of this new tendency—Domènech, Gaudí, and Josep Jujol—are sometimes too closely associated with Art Nouveau, a style invented in northern Europe. This misguided interpretation of Catalan architecture may derive from a shared predilection with Art Nouveau for creating fantastic forms inspired by nature. But the comparison is largely superficial, as Domènech, Gaudí, and Jujol worked independently from their northern counterparts to create some of the most original works in the entire history of art, most notably Gaudí's Casa Milà (fig. 8), Parc Güell (1900–1914), Casa Batlló (1905–7), Colònia Güell chapel (1908–16), and the Expiatory Temple of the Sagrada Família (1883–1926). It should not go unnoticed that Gaudí's Casa Vicens (1883–85), with its remarkable ceramic surfaces and iron fence decorated with palmetto motifs, predates the invention of Art Nouveau in northern Europe.[14] Domènch also achieved a level of extreme originality independent of northern influences with his Palau de la Música Catalana (1905–8), perhaps the epitome of nationalistic expression in Catalan architecture.[15] While Catalan architecture developed largely along its own path, Art Nouveau did have a strong impact on

Catalan graphic arts and other disciplines, issues that are examined by other authors in this catalogue.

Catalan architecture of this period has become associated in critical and public discourse with Modernisme, a term referring not to "modernism" in general, but to a broad cultural movement that emerged in Catalonia in the 1880s and 1890s. Described as a "breath of fresh air" that swept away stagnant traditions, Modernisme found expression in literature, theater, music, painting, sculpture, decorative arts, and architecture.[16] The term first appeared in an article published in the journal *L'Avenç* in 1884 to describe a tendency to embrace radically new ideas and all things "modern," from the Naturalism of Émile Zola to anarchist politics. Modernisme originally implied a vehement denunciation of Renaixença revivalism and the conservative politics of the Catalan bourgeoisie. Countering Catalan nationalism with a new openness to foreign influences and radical ideas, the modernistes were especially attracted to the philosophy of Friedrich Nietzsche, the music of Richard Wagner, and the plays of Maurice Maeterlinck and Henrik Ibsen.

Catalan visual artists also came under a barrage of foreign influences during the final decades of the 19th century. Rather than Madrid or Rome, Paris and its private academies became the favored destination for foreign study. Ramon Casas, Santiago Rusiñol, Miquel Utrillo, and Enric Clarasó were among the artists who encountered the most recent currents in international modernism while studying in Paris during the 1880s. When Casas and Rusiñol began ex-

Fig. 8. Casa Milà, 1905–10, designed by Antoni Gaudí.

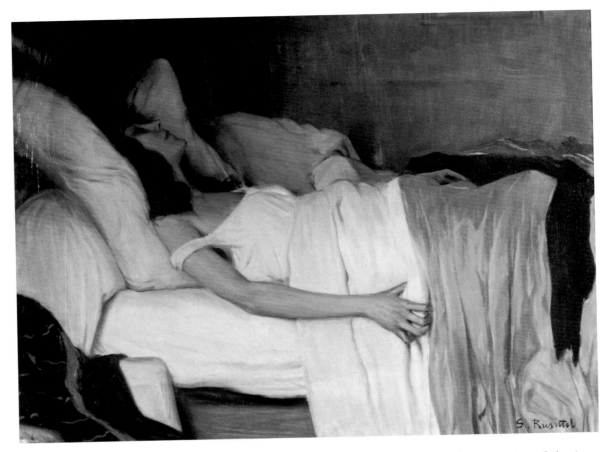

hibiting together at the Sala Parés in Barcelona in 1890, art critics identified them as the founders of a new movement of Modernisme in painting. They enhanced their reputation as the leaders of this new tendency by initiating a series of modernista festivals at nearby Sitges (1892–99) and cofounding the Barcelona artist's café Quatre Gats (Four Cats) in 1897. Picasso, at age 18, became a regular at Quatre Gats, the site of his first solo exhibition (February 1900). Bohemian artists and disaffected youth with anarchist leanings gathered at this legendary café for meetings, exhibitions, poetry readings, and puppet theater performances. They developed a morbid obsession with themes of death, suicide, and drugs, evident in Rusiñol's painting *Morphine*, 1894 (fig. 9), a poignant image by an artist who was addicted to the narcotic. The modernista penchant for flamboyant costumes, long hair, and late-night meetings—as portrayed in Picasso's *Decadent Poet (Sabartés)*, 1900 (fig. 10)—made the movement synonymous in the public mind with perverse affectations, excessive emotionalism, antisocial behavior, an unhealthy obsession with novelty, and bizarre distortions of form and color.

It is crucial to note that meaning of the term "Modernisme" has shifted since its origin in 19th-century literary discourse. Art historian Judith Rohrer observes that the designation was posthumously misapplied to Domènech, Puig, and Gaudí, even though these architects of the "new Catalan school" never entirely abandoned their nationalist ambitions of renewing Catalan civilization through associations with time-honored themes and medieval craft traditions.[17] Others argue that by moving away from historical revivalism toward more original styles based on personal invention and direct engagement with nature, these architects developed their own unique forms of Catalan Modernisme. Although they held vastly different political views from the bohemian painters of the Quatre Gats, they did share a common disdain for the stagnant academic traditions and neoclassical styles promoted by the Royal Academy in Madrid. Hence, many historians view Modernisme as a broad current that took a variety of disparate paths.

During the final decades of the 19th century, art became increasingly entwined with rising Catalan nationalism. The key political issue was centralism

Fig. 9 (cat. 2:8). Santiago Rusiñol, *Morphine*, 1894.

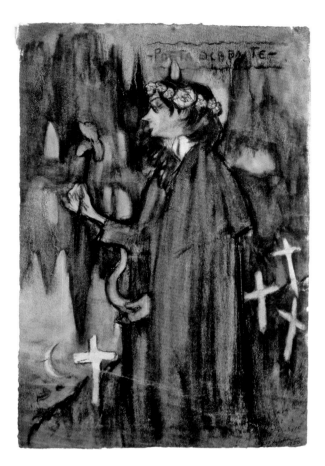

versus federalism. Since the September Revolution of 1868, the Catalan politician Valentí Almirall had advocated the creation of a federal republic in which Madrid would share power with autonomous regional governments, each exercising sovereign control over its internal affairs. In 1880 Almirall organized the First Catalan Congress to promote this idea, and his influential book, *Lo catalanisme* (1886), justified the creation of an autonomous Catalan state based on the idea that a nation, rather than being defined by mere geography, consists of a people sharing a unique language, culture, and heritage. He considered Spain, by contrast, an artificial political entity comprising many nations or nationalities who might voluntarily join together to form a confederation or republic, but not one under the absolute control of an unrestrained, centralized monarchy. Almirall buttressed this point by vehemently denouncing Madrid for treating Catalans like slaves and forcing them to speak a foreign language as a "constant reminder of our subjection."[18] Enric Prat de la Riba's equally influential book, *La Nacionalitat Catalana* (1906), also advanced this concept of Catalonia as a nation rather than a mere geographic region. To hasten the

movement toward autonomy and to defend the use of their language, Catalans formed a series of organizations and political parties, including the Lliga de Catalunya (est. 1887), Unió Catalanista (est. 1891), the Lliga Regionalista (est. 1901), Solidaritat Catalana (est. 1906), and Estat Català (est. 1922).

Nationalist political organizations and associated cultural institutions drew support not only from politicians, but also from prominent members of the art community. Domènech was elected president of the Lliga de Catalunya in 1888, president of the Unió Catalanista in 1891, and president of the Lliga Regionalista in 1901. Puig organized the restoration of Catalan Romanesque churches in the Pyrenees, transported paintings back to Barcelona for installation in the museum of Catalan art, and directed the archaeological excavations of the ancient Greek and Roman settlements at Empúries north of Barcelona. Puig also served as a member of the Lliga de Catalunya, cofounded the Lliga Regionalista in 1901, and directed the Institut d'Estudis Catalans (est. 1907).

In 1914 Madrid partly acceded to rising Catalan nationalism by approving the establishment of the

Fig. 10 (cat. 3:10). Pablo Picasso, *Decadent Poet (Sabartés)*, 1900.

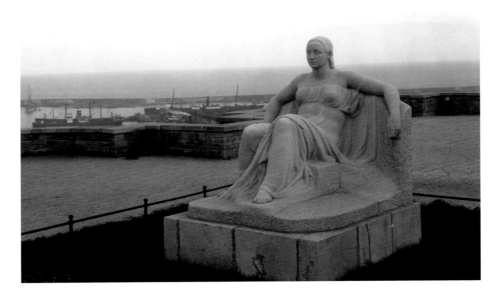

Mancomunitat, a regional government with limited autonomous powers. Under its first president, Prat de la Riba, the Mancomunitat opened the Biblioteca de Catalunya (Catalan national library) and sponsored a program for regularizing Catalan spelling and grammar. Architect Puig succeeded Prat de la Riba as president of the Mancomunitat in 1917. Other authors in this catalogue discuss more fully the Mancomunitat's ambitious programs for supporting the arts and establishing cultural institutions to promote Catalan national identity.

Leftist political parties and working-class labor organizations offered more radical solutions to Barcelona's economic and social problems than mainstream Catalanista institutions. In 1868 Giuseppi Fanelli, an Italian associate of Mikhail Bakunin, in-

troduced anarchism to Spain on visits to Barcelona and Madrid.[19] The PSOE (Spanish Socialist Workers Party) was formed in 1879, and the UGT (General Workers Union) at a Barcelona conference in 1888, but the center of socialist power remained in Madrid, Asturias, and the Basque region. Meanwhile, the anarchist movement continued to grow in Barcelona and reached fever pitch during the 1890s, when a wave of labor strikes, bombings, and police repressions shook the city. The bombing of the Liceu theater in 1893, killing 21 people, followed by the bombing of the annual Corpus Christi procession in 1896, inflicting 10 deaths, provoked drastic police reprisals, including the extraction of forced confessions under torture and public executions by medieval garroting. Sensational stories of the trials and executions of ac-

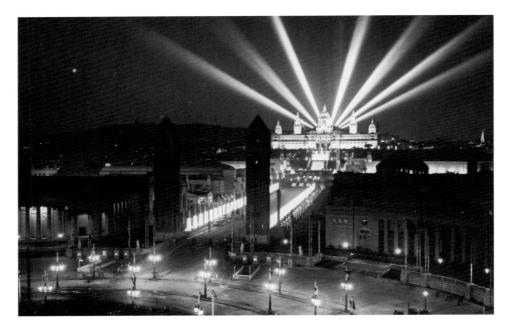

Fig. 11. *Serenity*, 1929, by Josep Clarà, in situ in the Parc de Montjuïc, Gardens of Miramar, Barcelona.
Fig. 12. The plaça d'Espanya, the esplanade, and the National Palace on Montjuïc, Barcelona International Exposition, 1929.

cused anarchists brought international attention to Barcelona, which became known worldwide as the "rose of fire" and the "city of bombs."

In concert with growing nationalism and political radicalism, new artistic tendencies emerged in Barcelona during the early 20th century. Noucentisme (1900s), the century's first new cultural movement, developed as a reaction against the emotional excesses of Modernisme. The philosopher and critic Eugeni d'Ors, who coined the term in 1906, advanced its ideology through his "Glosari" column published in *La Veu de Catalunya* (Voice of Catalonia). Although the term "1900-ism" would seem to embrace all artistic tendencies of the new century, in reality, artists associated with the movement focused largely on reconnecting with the roots of Catalan civilization by recovering its ancient classical past and folk traditions. Archaeological excavations of the ancient Greek settlement at Empúries (est. c. 600 BC) helped persuade many Catalans that Modernisme was a foreign aesthetic imported from the north and artificially grafted onto the region's natural spirit of logic, order, moderation, and *seny* (practicality). In 1913 Joaquín Torres-García painted *Eternal Catalonia*, one of a series of classicizing murals for the Palace of the Mancomunitat in Barcelona, a sign of the growing alignment between Noucentisme and Catalan nationalism. Although sharing certain characteristics with the classicizing "return to order" movement that developed in France and Italy as a reaction against the horrors of World War I, Noucentisme was not merely another classical revival;[20] it also embraced art with archaizing tendencies, nationalistic ambitions, and a concern for Catalan rural culture.

During its crowning years of about 1911–29, the ideology of Noucentisme became deeply ingrained in Catalan philosophy, politics, literature, and the visual arts. Torres-García, Joaquim Sunyer, Xavier Nogués, and Feliu Elias made significant contributions to noucentista painting. Enric Casanovas, Josep Clarà, Apel·les Fenosa, Pablo Gargallo, Manolo Hugué, and Joan Rebull produced sculptures that articulated the noucentista concern for eternal, timeless values (fig. 11). Josep Aragay, Francesc d'A. Galí, Rafael Masó, and Puig explored noucentista principles in architecture and design.[21] Although strictly speaking, Picasso and Dalí may not have been noucentista artists, they did contribute to the classical revival, and Ors claimed Picasso as a member of the movement. It is important to observe that Noucentisme was a concept, not an organization, so there was never an official roster of artists, and the movement's scope and nature remains open to interpretation.

Noucentisme reached the peak of its influence just prior to the 1929 International Exposition in Barcelona, which featured an open-air Greek theater (1914–29) erected on the slopes of Montjuïc. Planning for an industrial exposition on Montjuïc began as early as 1907, but the date was pushed back to 1917, and eventually to 1929.[22] Preparations were placed under the direction of Puig, who increasingly associated himself with Noucentisme as an instrument for advancing Catalan nationalism. He proposed a rigorously symmetrical design (see fig. 5, p. 389) for the entrance, which progresses from the circular plaça d'Espanya at the foot of Monjuïc, then up a rising esplanade before culminating at the National Palace on the summit (fig. 12). Before the exposition opened in 1929, Puig was dismissed and the project fell prey to a mélange of eclectic architectural styles. It must have come as a shock to many that the fair's most memorable achievement, the pavilion designed by German architect Ludwig Mies van der Rohe (see figs. 2–5, p. 392), refuted the confused and antiquated revival styles of its surroundings with a masterpiece of starkly minimal, rationalist design.

Nearly parallel with the unfolding trajectory of Noucentisme, a series of avant-garde movements emerged in Barcelona that brought the city's artists into the mainstream of the international art world. The cubist paintings Picasso produced on trips to Barcelona (May 1909), Horta de Sant Joan (summer 1909), and Cadaqués (1910), along with Pablo Gargallo's early cut-and-soldered metal sculptures of 1907–15, were among the earliest signs of avant-garde activity in Catalonia. However, these largely isolated developments had little immediate impact on artists in Barcelona. An avant-garde "movement" did not develop in the city until 1916–17, when numerous foreign artists arrived and a critical mass of resident artists engaged in radical experimentation. Torres-García's renunciation of Noucentisme, Rafael Barradas's invention of the cubo-futurist style of Vibracionismo, and the launching of a series

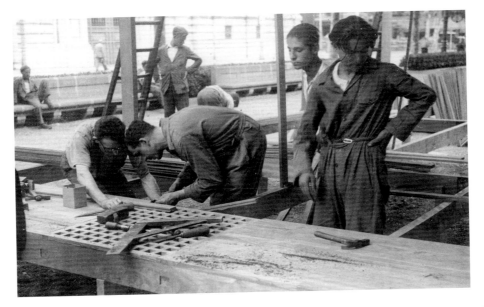

of avant-garde journals, including *Troços* (Pieces) and *Un enemic del Poble* (An Enemy of the People), are key markers of this new wave. Barradas, Torres-García, and the young Joan Miró led the new direction in painting, while Josep M. Junoy, Joan Salvat-Papasseit, Sebastià Gasch, and J. V. Foix distinguished themselves in criticism and poetry.

Avant-garde art in Barcelona reached a new stage of maturity during the 1920s and 1930s, when the city produced a distinguished group of surrealist artists and a significant school of rationalist architecture. Salvador Dalí burst onto the scene in the 1920s with remarkable contributions not only as a painter, but equally as a critical theorist, dramatist, filmmaker, lecturer, and public provocateur. During this period, Barcelona became the nerve center for

Catalan surrealist groups active from Cadaqués to Lleida. Artists and intellectuals also established numerous associations to promote avant-garde art, none more important than ADLAN (Friends of New Art), which in May 1936 sponsored the critically acclaimed Logicofobista (Fear of Logic) exhibition. The origins and development of avant-garde art in Barcelona are examined at length in sections six through nine of this catalogue.

In the late 1920s a collective of socially conscious architecture students from Barcelona, led by Josep Lluís Sert and Josep Torres Clavé, opened up yet another avant-garde front when they united to promote experimental forms of rationalist design (figs. 13 and 14). In 1930 they established GATCPAC (Association of Catalan Architects and Technicians

Fig. 13 (cat.8:20). GATCPAC, *Construction of a Dismountable House*, c. 1932, one of eight photographs.
Fig. 14 (cat. 9:20). François Kollar, *Pavilion of the Spanish Republic, Paris International Exposition, 1937, Stage,* 1937.

for Progress in Contemporary Architecture), a group of architects and engineers dedicated to producing inexpensive, mass-produced buildings and furnishings that would relieve social problems, from urban overcrowding to the elimination of epidemic diseases. Section eight of this catalogue is devoted to this phase of rationalist architecture and design.

In retrospect, it seems almost miraculous that avant-garde art developed in Barcelona at a time when cycles of violence repeatedly disrupted the city's economic and social life. One of the most searing outbreaks erupted during the Setmana Tràgica (Tragic Week) of July 1909, when Madrid's demand for conscripted troops to fight the colonial war in Spanish Morocco ignited widespread riots in

again. Inspired by the Bolshevik Revolution in Russia, Catalan leftists became increasingly radicalized. In 1917 the anarchist CNT and the socialist UGT labor unions united to organize a national general strike. The government reacted by imposing martial law and using the Civil Guard and army to suppress protests brutally. From 1917 to 1922 Barcelona was racked by waves of street violence, another general strike in 1919, and 809 terrorist assassinations.[24] Anarchists murdered politicians and government officials, and factory owners hired pistoleers to gun down labor leaders in the streets. Thousands were blacklisted, arrested, and sentenced to long prison terms by military tribunals. In 1921 three Catalan anarchists assassinated the prime minister of Spain, Eduardo Dato;

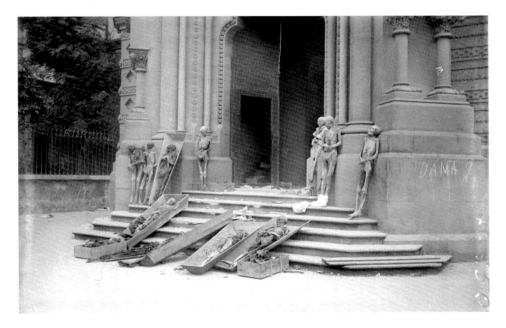

Barcelona. Incensed that the government permitted the affluent to avoid the draft by buying substitutes, rioters attacked trains and vented their wrath against the Catholic Church, widely despised among the working class as a repressive tool of the wealthy. In barely five days mobs burned as many as 56 churches, monasteries, and convents, at times desecrating graves and propping up the mummified corpses of nuns against public buildings (fig. 15). The military responded by shooting hundreds of people in the streets. Scores were arrested and five people executed, including some nonrioters guilty only of espousing radical views.[23] During the decade that followed labor strikes, factory lockouts, assassinations, and reprisal killings erupted time and

two years later the anarchist leader Salvador Seguí was murdered in Barcelona.

Reacting to the chaos, General Miguel Primo de Rivera, the captain-general of Catalonia, staged a coup d'état and installed a military dictatorship that ruled Spain from 1923 to 1930. The dictatorship outlawed the anarchist CNT labor union and censored the press. It cracked down on separatist movements by banning the Catalan flag, suppressing the Catalan language, and dissolving Catalonia's autonomous government (the Mancomunitat), along with its cultural institutions. Through a combination of political repression and a vast public works program, Primo de Rivera restored enough stability to mount the massive Barcelona International Exposition of 1929.

Fig. 15. Disinterred corpses during the Tragic Week, Barcelona, July 1909, photograph by Brangulí.

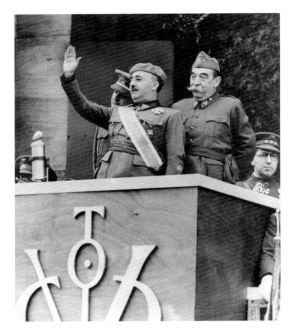

But only a year later he was forced to resign in the wake of an economic crisis precipitated by escalating federal deficits and the worldwide depression.

In 1930 Spain entered into another turbulent period of unrest and reaction, finally exploding into civil war. After socialists and center-left republicans triumphed in the elections of April 1931, Alfonso XIII, a constitutional monarch allied with the extreme right, tried to persuade army generals to initiate yet another coup d'état, but when they refused, he fled the country.[25] On 14 April the Cortes (national parliament) proclaimed the birth of the Second Spanish Republic, which soon approved a new constitution and controversial measures to redistribute land and reform the military. The new government also restored Catalonia's historic government, the Generalitat, and approved statutes of autonomy for Catalonia and the Basque region. Perhaps the most controversial measures concerned the establishment of strict church-state separation, and by extension, the secularization of education, the recognition of civil marriage, and the legalization of divorce.

The Second Republic's leftward drift set in motion a cycle of increasingly extreme reactions on both the right and left. In July 1936 right-wing military officers staged coordinated mutinies across the country aimed at overthrowing the republic. Led in part by Franco, the rebels, also known as the nationalists, plunged the country into a bloody civil war that ravaged Spain for three years. Throughout the conflict

Barcelona remained a center of ardent, antifascist resistance. Section nine of this catalogue examines how artists affiliated with the city responded to the crisis. By the spring of 1938, Franco and the nationalists had captured most of western Spain and the entire northern coast. In December, Franco launched an offensive against Catalonia, and in January 1939 Barcelona fell to the nationalists, sending half a million refugees across the French border. The heroic resistance in Madrid collapsed in late March, and Franco declared the war over on 1 April 1939.

It is estimated that 500,000 people died in the Spanish civil war, and as many as 300,000 people were driven into permanent exile.[26] After the war, Franco (fig. 16) instituted strict government control over the economy, banned strikes, replaced unions with state-controlled syndicates, prohibited divorce, and made church attendance mandatory. The nationalists censored the press and purged libraries of "incorrect" books. Programs were instituted for "re-Spanishizing" and "re-Christianizing" Catalonia (fig. 17) and the Basque region.[27] Neighbors could report anyone failing to attend Mass. Seeking to crush all separatist movements, Franco abolished the Generalitat and rescinded the Catalan and Basque statutes of autonomy. It became illegal to speak Catalan in public, perform La Sardana (the national dance of Catalonia), or give children Catalan first names. People of all professions, from teachers to priests, were examined and purged for their politi-

Fig. 16. General Franco at a victory parade in Madrid, May 1939.

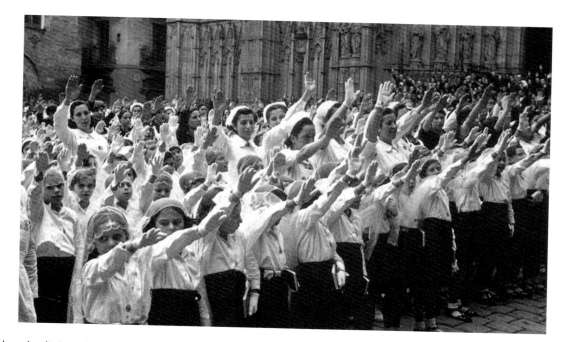

cal and religious beliefs. Under the Law of Political Responsibilities, enacted by the nationalists in February 1939, it became a crime to have supported the republic, or even to have failed with assisting the nationalists. By the end of 1939 the nationalists had imprisoned more than 270,000 people.[28] Thousands were sentenced by military tribunals and executed—a situation that forced many of Barcelona's most distinguished artists and intellectuals into exile. The height of the repression lasted into the early 1950s, but censorship and the arrest and torture of political dissidents never disappeared entirely during the "long night" of the Franco dictatorship.[29]

After a period of international condemnation and isolation, Spain began to re-engage with the outside world in the 1950s. In 1953 Franco signed a concordat with the Vatican and an agreement with the United States to provide military bases in exchange for economic aid. The Spanish economy began to revive and grew more rapidly than any other European nation, laying the foundation for the "Spanish miracle" of the 1960s, when industrial production and living standards soared dramatically. Student protests against the dictatorship also erupted, but Franco held tight to reins of power, even after naming the Bourbon heir Juan Carlos his eventual successor.

After Franco's death in 1975, Juan Carlos ascended the throne and guided the country's transition to democracy. In 1977 Spain held its first elections in 40 years, and on 11 September of that year Catalans in Barcelona mounted a massive demonstration for autonomy. A new constitution approved in 1978 recognized the historic rights of the Catalans and Basques, granted Catalonia limited autonomy, and restored the Generalitat. Spain joined the European Community (forerunner of the European Union) in 1986, and the EC recognized Catalan as an official language in 1990.

By the 1990s Barcelona had re-established itself as a thriving industrial and cultural center. Not only was the city's powerful economy attracting waves of immigrants from rural Spain, but increasingly from other areas of the world. Today, only about 74% of the population speaks and reads Catalan. To assimilate immigrants, the government supports a broad array of programs for teaching and promoting the Catalan language. It is fascinating to compare this solution to the problem of mass immigration with the response of other wealthy, industrialized societies. Yet even while Catalonia embraces immigrants, beneath the surface one senses that "fear of disappearing" prevalent among small nationalities facing an uncertain fate in the age of globalization. By 1996 historian Albert Balcells had already become pessimistic about the European Union's apparent indifference to the plight of "stateless nations," that is, nationalities living under the domination of larger, more powerful states. "The solution," Balcells concludes, "—though it may today appear Utopian— lies in the dissolution of the conventional nation-

Fig. 17. Fascist salute by children at first communion, Barcelona Cathedral, August 1939, photograph by Brangulí.

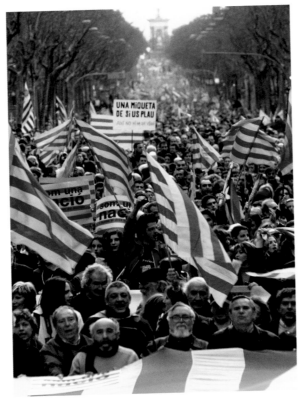

During the period covered by this exhibition (1868–1939), Barcelona reinvented itself, not merely as a reincarnation of its medieval past, but as a city of immense ambition energized by an insatiable desire for modernity and progress. Today, Barcelona is again that city—dynamic, energetic, open to the world, constantly redefining itself. At the same time, Barcelona remains a place of profound contradictions, where tensions are acutely felt between past and present, northern and Mediterranean attitudes, Catalan seny and utopian idealism. No one personified Barcelona's contradictory spirit more than Gaudí. He was a fervent Catholic and a reactionary Catalan nationalist who built the Expiatory Temple of the Sagrada Família (Holy Family) to atone for the sins of the modern age, yet he created revolutionary architecture of near savage modernity, merging suggestions of primordial nature with designs of indisputable originality that remain controversial to this day. Barcelona's dynamism seems to spring from this spirit of contradiction, as if the entire culture is imbued with an irresolvable identity crisis: is it a Catalan, Spanish, or European city? And we cannot help but ask, who exactly controls the city's destiny: the vast working class, the wealthy industrialists, or the intelligentsia?

As Barcelona moves toward a new European and global future, one wonders what will happen to its distinctive Catalan character and language. Will it remain the "elevated dream of perfect love" that García Lorca discovered in the 1920s, a city of "gothic towers and rich urban high tide created by typewriters," a city of adventuresome spirit and passionate creativity? To an outsider, it appears that the "city of bombs" and the "rose of fire" that was born in the 19th century, while no longer prone to violence, retains its profoundly revolutionary spirit. As Angel Ossorio, the city's governor during the Tragic Week of 1909, observed: "In Barcelona there is no need to prepare the revolution, simply because it is always ready. It leans out of the window on to the street every day."[33] Almirall's proclamation at the First Catalan Congress of 1880 could well be written at the city's entrance today: "Let our device be 'Catalonia and Progress'—today, tomorrow, and forever."[34]

states, nearly all of which are in fact plurinational, and the reconstruction of the historical territories of nations, based on their languages."[30]

The story of Barcelona's long, complex relationship with Madrid is far from complete (fig. 18). In 2005 the Catalan parliament approved a measure to revise the statute of autonomy, which, among other things, would increase regional control over taxation and immigration, and require all residents to learn Catalan. A majority in the Catalan parliament now advocate defining Catalonia as a "nation." Even so, the new legislation does not propose complete separation from Madrid, and the movement for absolute independence remains small and peaceful, bearing little resemblance to the campaign of assassinations and bombings associated with Basque separatism.[31] After heated debate, the statute was approved by the parliament in Madrid, despite fears expressed by some ministers that it will either lead to the dissolution of Spain or revive the old conflicts that gave rise to the civil war.[32] In June 2006 the new statute passed by referendum in Catalonia. Although approved by a margin of 74%, the low turnout of 49% of the electorate has left doubts about the future direction of such movements in Spain.

Fig. 18. Demonstration for revising the statute of autonomy, Barcelona, February 2006, photograph by Manu Fernàndez.

1. During the early decades of the 20th century Americans most commonly associated modern Spanish art with the paintings of Joaquín Sorolla and Ignacio de Zuloaga.

2. The current population of the city of Barcelona is 1.6 million people, the metropolitan area 4.7 million, and Catalonia 7 million.

3. The relationship between each regional government and Madrid varies according to individual agreements made with the central government. "Autonomous" does not mean that the regions are entirely independent of Madrid, only that certain powers are reserved to the regional government. Catalonia is further divided into comarques (roughly equivalent to a county in the U.S.) and municipalities.

4. Barcino never attained the importance of the Roman provincial capital of Tarraco (Tarragona), a seaport about 80 miles south of Barcelona.

5. The exact history of the Counts of Barcelona is a matter of dispute. Some sources cite Sunifred I (d. 848) as the first count of Barcelona and note that Wilfred the Hairy only united a portion of Catalonia. Count Borrell II is credited with breaking the vassalage relationship between the Counts of Barcelona and the Frankish king in 988.

6. Josep Miquel Sobrer observes that there are two ways of defining Catalonia: (1) a narrow definition confined strictly to current, geographical boundaries; and (2) the broader area of the Països Catalans (Catalan Countries), consisting of places historically linked to Catalonia and where a significant portion of the residents speak Catalan. The Catalan countries include: Catalonia itself, the Balearic Islands (Majorca, Minorca, Ibiza, Formentera), Valencia, an eastern zone in Aragon, the principality of Andorra, the French region of Languedoc-Rousillon, areas in the French Pyrenees, and part of Sardina. See Sobrer, *Catalonia: A Self-Portrait* (Bloomington: Indiana University Press, 1992), 4–5.

7. Historians observe that the city's economy had been in decline since the mid 14th century.

8. Ironically, the king and queen greeted Columbus upon his return from America in Barcelona, an event celebrated by the large Columbus monument near the harbor. Although Ferdinand II of Aragon-Catalonia and Isabella of Castile married in 1469 and united their kingdoms in 1479, the regions retained considerable independence. The real blow occurred when Philip V instituted a policy of centralization in 1716 that included abolishing Catalonia's government, along with its historic rights and privileges.

9. E. Allison Peers notes that the 11 September observance dates from 1901; see *Catalonia Infelix* (New York: Oxford University Press, 1938), 142.

10. Juan Díez Medrano, *Divided Nations: Class, Politics, and Nationalism in the Basque Country and Catalonia* (Ithaca: Cornell University Press, 1995), 46–47.

11. Edmondo de Amicis, *Spain and the Spaniards* (New York: G. P. Putnam's Sons, 1880), 12.

12. Pedro García Faria, *Insalubridad de las viviendas de Barcelona* (Barcelona: J. Balmes Planas, 1890); quoted in Cristina and Eduardo Mendoza's *Barcelona modernista* (Barcelona: Editorial Planeta, 1989), 127. All translations by the authors unless otherwise noted.

13. Catalan spelling had not yet been standardized, so variations appear for words such as "Renaixença/Renaixensa."

14. Casa Vicens is dated 1878–85 by Manuel Gausa in Gausa et al., *Barcelona: A Guide to Its Modern Architecture 1860–2002*, trans. Paul Hammon (Barcelona: Actar, 2002), D11; and 1883–88 by H. Kliczkowski in *Gaudí: Complete Works* (Barcelona: Paco Asensio, 2002), 31.

15. One could argue that the Sagrada Família, with its neo-Gothic overtones, is the epitome of Catalan nationalistic architecture.

16. Mercè Doñate and Cristina Mendoza, *Guide, Museu d'Art Modern* (Barcelona: Museu Nacional d'Art de Catalunya, 1999), 26. It might be argued that Modernisme in painting concluded with Nonell's death in 1911 and in architecture with Gaudí's death in 1926.

17. Judith Campbell Rohrer, "Artistic Regionalism and Architectural Politics in Barcelona, c. 1880–c. 1906" (Ph.D. diss., Columbia University, 1984).

18. Valentí Almirall, *Lo catalanisme: motius quel llegitiman, fonaments cientifichs y solucions practicas* (Barcelona: Llibr. De de Jaume Ballbé y Companyia, 1888), 97, online facsimile through the Biblioteca Virtual Miguel de Cervantes at www.cervantesvirtual.com.

19. Gerald Brenan, *The Spanish Labyrinth: The Social and Political Background of the Spanish Civil War* (Cambridge, U.K.: Cambridge University Press, 2000; first published 1943), 138.

20. The term, derived from Jean Cocteau's book *Le Rappel à l'ordre* of 1926, describes a classicizing tendency pervasive in French and Italian art of the 1920s that has been interpreted as a reaction of artistic moderation in response to the horrors of World War I.

21. The sculptor Aristides Maillol from Rousillon is often described as a Catalan and a significant precursor to Noucentisme. Around 1902 he began making classicizing sculptures embodying the spirit of ancient Mediterranean civilizations.

22. Gausa et al., *Barcelona: A Guide to Its Modern Architecture*, G:1–13.

23. Different historians record slightly varied statistics for the number of victims and churches burned. See Albert Balcells, *Catalan Nationalism: Past and Present* (New York: St. Martin's Press, 1996), 62–63; Brenan, 34–35.

24. Alejandro Sánchez Suarez, ed., *Barcelona, 1888–1929: Modernidad, ambición y conflictos de una ciudad soñada* (Madrid: Alianza Editorial, 2001), 250.

25. Temma Kaplan, *Red City, Blue Period: Social Movements in Picasso's Barcelona* (Berkeley: University of California Press, 1992), 166.

26. Hugh Thomas, *The Spanish Civil War* (New York: Modern Library, 2001; first published 1961), 900–901.

27. Kaplan, *Red City, Blue Period*, 189–92.

28. Stanley G. Payne, *The Franco Regime 1936–1975* (Madison: University of Wisconsin Press, 1987), 222.

29. According to Balcells, "The military tribunals in Catalonia had 3800 people shot between 1938 and 1953"; see *Catalan Nationalism*, 127. Payne argues that mass executions continued only until 1944; see *The Franco Regime 1936–1975*, 222–23.

30. Balcells, *Catalan Nationalism*, 198.

31. The Esquerra Republicana de Catalunya is the principal party advocating complete independence. Basque separatists of ETA (Basque Homeland and Freedom) launched a wave of political assassinations and terrorist violence in the 1960s. The Catalan separatist movement Terra Lliure (Free Land) was established in 1979 and engaged in terrorist tactics for a time, but disbanded in 1995.

32. No Spaniard needs to be reminded that military officers staged a failed coup attempt in 1981. For recent developments see Renwick McLean, "Spain Moves on Law to Give Broad Powers to Catalonia," *New York Times*, 31 March 2006, A: 3 (late edition).

33. Quoted in Manuel Vázquez Montalbán, *Barcelonas*, trans. Andy Robinson (London: Verso, 1992; first published 1990), 87.

34. Translated and quoted in Peers, *Catalonia Infelix*, 128.

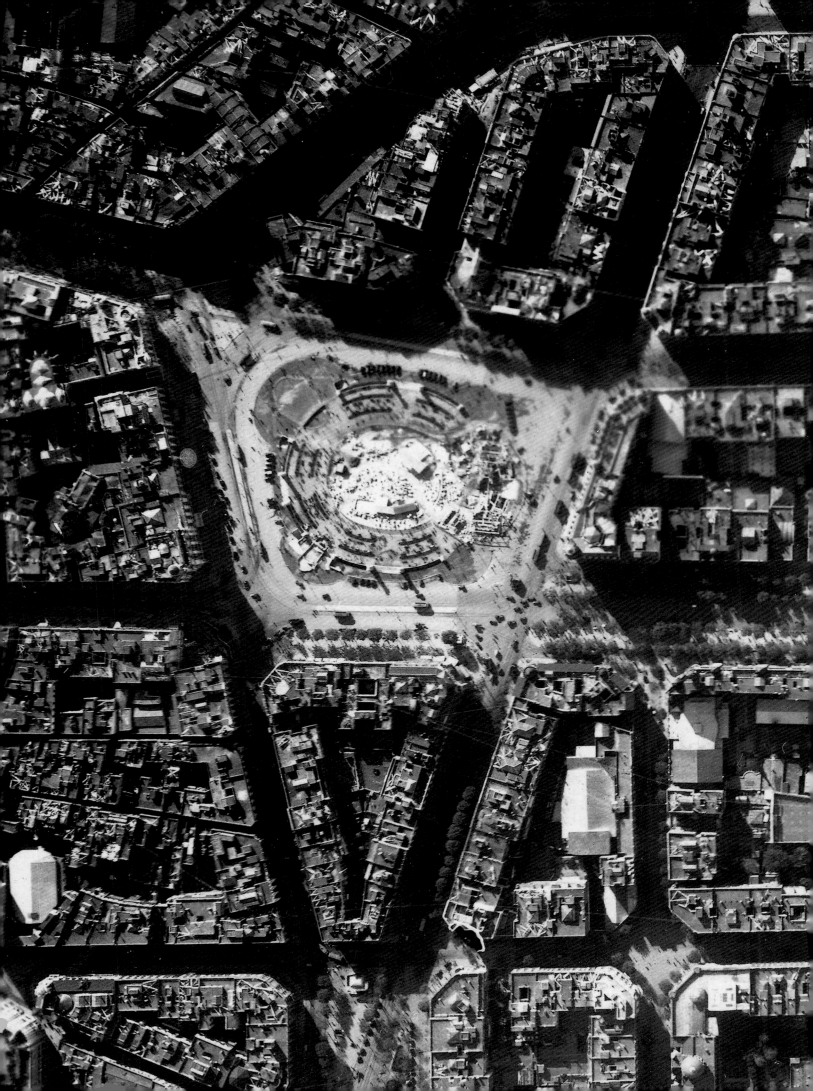

# 1
# Rebirth: The Catalan Renaixença

# The Renaixença in Art

*FRANCESC FONTBONA*

Thirty years ago, an American art historian closed his doctoral thesis by declaring that Pablo Picasso would forever be the finest exponent of Catalan Modernisme and the Renaixença.[1] I do not recall a Catalan historian ever having made such an assertion before, undoubtedly because it was so obvious that no one would have thought of stating it so plainly. Picasso, a highly creative artist who had a revolutionary impact on art around the world in the 20th century, first came to public attention in the opening years of that century in Barcelona—not only because of his skills but also because of the civic and cultural climate in the city during his youth. This period of Catalan art, known as Modernisme, developed out of the previous movement, the Renaixença.

The Renaixença emerged in Catalonia during the wave of national sentiment that Romanticism sent sweeping through the Western world. At that time, Catalonia's language, customs, and culture were under threat from two main forces. The first was the cultural uniformity that had been preached in the West ever since the time of the Enlightenment by the erudite, who imposed what they saw as "progress": the standardization of styles and the homogenization of distinctive regional or national characteristics. Second, and more particular to Catalonia, was the constant determination of Spain's political leaders to forge a single state, unified not only politically but culturally, by diluting the historical personalities of the different peoples that were then and are still today part of the Spanish crown. The Renaixença sought to counter these forces by reviving the national character of the Catalan people.

A complex and often diverse movement, the Renaixença initially sought to revive the knowledge of the Catalan language and restore it to its rightful place in the country. Yet the Renaixença came to encompass the entire national culture and history of Catalonia and of the other places that shared its language: the region of Valencia, the Balearic Islands, Andorra, the area of Aragon that borders on Catalonia known as the Franja, the city of Alghero in Sardinia, and Roussillon, the part of Catalonia that Spain ceded to France for political reasons.

While movements in art can rarely be accurately dated, the Renaixença is widely acknowledged as beginning with the publication of an ode entitled *La Pàtria* in 1833 by Bonaventura Carles Aribau. Aribau was an economist and an intellectual rather than a poet. He was very well connected and, though Catalan, lived in Madrid. Moved by a sense of yearning for the country of his birth, he wrote his stirring poem on Catalonia and its personality. *La Pàtria* was joined by similar works as other writers and men of letters gradually began to contribute to the revival

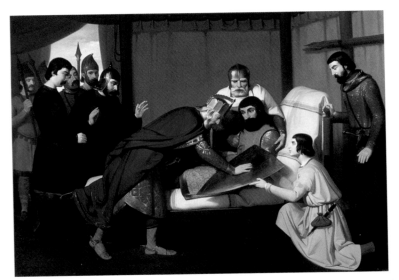

Fig. 1. *The Origin of the Coat of Arms of the House of Barcelona*, 1843–44, by Claudi Lorenzale i Sugrañes.

of the history, traditions, and language of Catalonia, which had suffered because of pressure from academics and others in Castilian Spain.

Though many regard the Renaixença as a purely literary phenomenon, this belief is in fact mistaken, as artists and other sectors of Catalan society adopted the philosophy of the movement in their own spheres. The statues sculpted in 1841 by Josep Bover that stand on either side of the main entrance of the neoclassical façade of Barcelona's city hall are excellent examples of the work of Renaixença artists. One of these statues represents Jaume I, whose reign was the most glorious of all in medieval times in Catalonia; the other is of Joan Fiveller, a councilor, again in the Middle Ages, who symbolized the staunch resistance of the citizens of Barcelona to the power of the crown.

Two years later, the painter Claudi Lorenzale i Sugrañes, who had studied in Rome and followed the precepts of the Nazarene school of painters there, began work on a vast composition charged with patriotic symbolism. *The Origin of the Coat of Arms of the House of Barcelona*, 1843–44 (fig. 1), shows the moment when, according to legend, Charles the Bald (Charles II of France) dipped his fingers into a bloody wound suffered by the Catalan count Wilfred the Hairy and drew them across the count's gold shield, thereby creating, so tradition has it, the national flag of Catalonia, which consists of four red bars on a yellow field. Lorenzale called on the help of numerous other artists and intellectuals while working on the painting, making the canvas a kind of artistic manifesto of the Renaixença.

In addition to these examples of Renaixença arts that hark back to Catalonia's past, there are others that reveal this generation of artists' rediscovery of their country as it was in their day. The defensive walls that had encircled many Catalan cities since medieval if not Roman times began to come down in the mid 19th century. The removal of this psychological and physical barrier encouraged people living in urban areas to venture out into the countryside and see the valleys, rivers, and mountains that made up their country. Artists who felt impelled to draw or paint the fatherland that had hitherto been unknown soon began to emerge. As a consequence, landscape painting is unquestionably the artistic genre that best represents Catalans' new encounter with their land.

The finest exponent of this new theme in Catalan art was Lluís Rigalt i Farriols, who not only painted a number of outstanding, technically accurate landscapes in oil in a polished and balanced Romantic style, but also produced numerous precise and evocative drawings done outdoors of many places in Catalonia and some in France. To give an idea of Rigalt's output, the collection of the Reial Acadèmia Catalana de Belles Arts de Sant Jordi in Barcelona alone holds around 700 of his drawings (fig. 2). Rigalt, the first in a long line of Catalan landscape painters, taught that subject at La Llotja, the official school of fine art in Barcelona. After him came his student Ramon Martí i Alsina, who was in turn followed by his own students, among them Joaquim Vayreda, the leading light of the Olot school. As a result of these painters' work, landscape became

Fig. 2. *The Castle, Perpignan*, 1850, by Lluís Rigalt i Farriols.

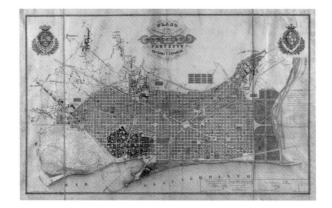

one of the foremost genres in Catalan art and soon proved extremely popular with the local public.

It was during the Renaixença, then, that Catalans began to learn about and appreciate their history, in particular the Middle Ages, the country's period of greatest splendor. This knowledge and a new awareness of the area's geography were essential in giving Catalans an understanding of and a love for their country. A further tangible consequence of the destruction of the old defensive walls was the redevelopment of cities, which took place during a period of economic growth and led to the dramatic rise of urban Catalonia in modern times. The Renaixença ran parallel to the industrialization of Catalonia. In 1833, the same year that Aribau wrote his ode, the first steampowered textile mill, owned by the industrialist Josep Bonaplata, began to operate. The textile industry, in particular the cotton sector, was the driving force behind the change in Catalonia's economy at the time and opened the way to a host of new industries—the wool

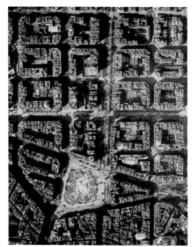

sector, winemaking, metallurgy, hydroelectricity, cement production, and so on. These industries shaped the new character of contemporary Catalonia and, without diminishing the continuing importance of merchants, landowners, doctors, lawyers, and the like, added their force to the cultural movement.

Sabadell, then growing into one of the chief cities of the textile industry, commissioned the architect and engineer Josep Oriol i Bernadet to draw up an urban expansion plan in 1847, though his plan was not actually implemented until 1871. In

1854, Tarragona, which had been a great capital in Roman times, used the opportunity provided by the demolition of part of its 16th-century walls (fortunately for the city's heritage, its Roman walls were left untouched and remain standing to this day) to construct the Rambla Nova, the broad promenade around which the city expanded in the 19th century, designed by the military engineer Josep Criviller.

Barcelona, Catalonia's capital, could no longer put off its own growth; beginning in the late 1830s various expansion plans had been proposed, some of them more ambitious than others. The architect Antoni Rovira i Trias (1816–1889) had been considering solutions for the future urban expansion since 1846, but nothing could be done until 1854, when Barcelona's walls were at last knocked down. Rovira submitted his plan, which he had worked on for years, to the public competition organized by the Barcelona city hall and was successful. Meanwhile, however, the highways engineer Ildefons Cerdà had gained the trust of central government. Despite the fact that city hall had already selected the winning plan, the government in Madrid imposed on the local council the plan that Cerdà rushed to produce (fig. 3).

There is little point in comparing the two plans—or indeed any of the other entries to the competition in Barcelona, which also had their merits—as Rovira's plan went no further than the paper on which it was drawn, whereas Cerdà's proposal began to shape the real face of Barcelona in 1860. It should be said, however, that Rovira's proposal,

Fig. 3 (cat. 1:1). Ildefons Cerdà, *Plan of the Outskirts of Barcelona and Proposal for Reform and Expansion of the City*, 1859.
Fig. 4. Aerial view of Barcelona's Eixample and the plaça de Catalunya, with the old city at the bottom, 1927.

which he had thought about far more than Cerdà had his, paid greater heed to the organic growth of the city. Cerdà's plan was based on the strict geometric application of a grid and gave little consideration to the city's old center, which has remained effectively separate from the urban expansion area ever since (fig. 4).

The fact remains, however, that Barcelona then featured a highly ambitious expansion that proved to be one of the most remarkable urban developments in Europe (fig. 5). It should be remembered that it was being planned and built at the same time that Paris and Vienna were also engaged in works that gave these cities their modern shape and structure. In 1859, Baron Haussman was in the throes of totally remodeling Paris—which had just annexed the municipalities that lay on its outskirts—leaving only the main monuments from medieval times still standing; that same year in Vienna, the famous circular Ringstrasse boulevard was built on the foundations of the medieval walls that had been demolished because they had been engulfed by the city's natural growth.

The international importance of Barcelona's Eixample—as the city's expansion area was known after the Catalan word *eixample* (enlargement)—was not widely recognized until many years later. Similarly, Catalan art from the time of the Renaixença remained largely ignored beyond the country's borders. Indeed, outsiders knew very little about Catalonia then and the same remains true, broadly speaking, today: people have heard of Spain but they remain unaware even of the existence of Catalonia.

The low international standing of Catalan art at that time came to a dramatic end with the rise of an exceptional figure, the painter Marià Fortuny i Marsal. One of Lorenzale's most noted students, he was direct heir to the older man's Nazarene Romanticism. In his early period, Fortuny drew and painted historical scenes from the Middle Ages in Catalonia in the soft style and sober colors characteristic of the Nazarenes. Examples of such works include his portrayals of Ramon Berenguer III, the Almogàvers (Catalan mercenaries in the Middle Ages), Roger de Llúria, and Jaume I. However, while continuing his studies in Rome, Fortuny was commissioned by the Diputació de Barcelona (Barcelona Provincial Council) to travel to Africa to serve as a war artist during the Moroccan War (1860). There he chronicled the events in a conflict that was of little historical importance but which was of burning interest in its day, as many Catalan soldiers were serving under General Joan Prim, who, like Fortuny, had been born in the Catalan city of Reus.

North Africa was a revelatory experience for Fortuny. There the young painter discovered intense color and light and his mastery of his technique developed to such an extent that he was acclaimed internationally when he returned to Rome and during his trips to Paris. Nevertheless, under the influence of his Parisian dealer Adolphe Goupil, Fortuny produced genre pieces and hence his name stood higher among circles that purchased such works

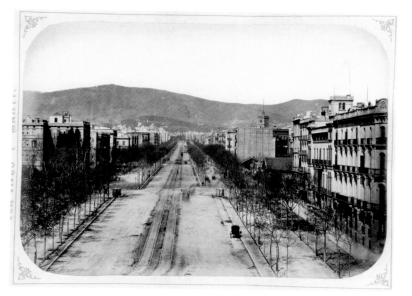

Fig. 5 (cat. 1:4). Joan Martí, *Paseo de Gracia*, photograph 12 from *Beautiful Sights in Barcelona*, 1874.

than among artists and art lovers interested in the new aesthetic approaches that were emerging at that time.

Fortuny triumphed in Europe and America,[2] returning only to Catalonia en route elsewhere. During the years of his international success before his death in Rome in 1874, he conveyed little of the Catalan sentiment seen in the Romanticism of his early works. Even so, he can be regarded as a product of the Renaixença because of the indelible mark left by his training as an artist.

Even though Fortuny was given more to orientalist subject matter and refined 18th-century genre pieces, his unquestionable international renown and the profound sense of loss and grief at his unexpected death at the age of 36 soon made him a legend in Catalonia. Because of his spectacular success, he was rightly seen as the first Catalan artist to rise to prominence in Europe in his day. Fortuny's life and work were given extensive coverage in the press, and he remained influential in Catalan artistic circles in the 1870s and 1880s. Despite his short life, he has been regarded ever since as one of Catalonia's most eminent figures and indisputably one of the most influential Catalan artists of his time.

After Fortuny's death, Josep Yxart, one of the critics who supported the then-nascent movement of Modernisme, wrote a best-selling biography about him, even though by this time the artist's style was deemed unfashionable and not "modern." No other recent Catalan artist had been the subject of a book such as this one. Nor was Yxart the only one to write about Fortuny, as Salvador Sanpere i Miquel had already published a book in 1880 and Francesc Miquel i Badia was to issue another in 1887. These writings give some idea of the high regard in which Fortuny was held barely a few years after his death.

Below the conventional surface of Fortuny's work, imposed on him by the demands of the market, lay hidden a fresh and innovative approach that in his late pieces clearly anticipated the arrival of French Impressionism, which had attracted much attention by the year the Catalan painter died. Nevertheless, Fortunyisme, as his style became known, did not mark the beginning of a new Catalan school of painting but was the glorious dying breath of what one might term 19th-century art in Catalonia (fig. 6).

Despite the high regard for Fortuny, his work was held to be out of keeping with the times. As a modern approach was then considered essential in the arts, the new Catalan school looked elsewhere for inspiration and particularly to the modern style then emerging in Paris and spreading to other art centers around the world. This was the start of Modernisme, the cultural and artistic movement that was to prove the most important in Catalonia in the 19th century.

1. Joseph Phillip Cervera, *Modernismo: The Catalan Renaissance of the Arts* (New York: Garland, 1976).

2. One of his principal collectors was the American railroad tycoon William H. Stewart.

Translated by Susan Brownbridge.

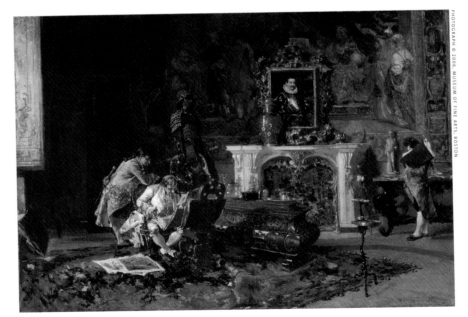

Fig. 6. *Antiquaries*, 1863, by Marià Fortuny i Marsal.

# Greeting the Dawn: The Impact of the Renaixença in Periodicals and Architecture

*JORDI FALGÀS*

The spirit of the Catalan Renaixença found early expression in newspapers, magazines, posters, and decorative arts. *La Renaixensa* (fig. 1) and *L'Avenç* (fig. 2), two of the leading periodicals published in Barcelona during the 19th century, represented the conservative and progressive sides, respectively, of the city's Catalanist "awakening." *La Renaixensa* began as a biweekly magazine in 1871 and turned into a daily newspaper with the New Year's Day edition of 1881. Initially spelled "Renaixensa" and later normalized as "Renaixença," it was named after the ambiguous term that defines the debated "recovery" or "rebirth" of Catalan language and literature during the second half of the 19th century.[1] Under the guidance of its two main editors, playwright and poet Àngel Guimerà and Pere Aldavert, an active journalist and politician, *La Renaixensa* became an influential newspaper. It was mainly devoted to all aspects of Catalan language and literature, and welcomed contributions from the best writers of the time, but also included historical research, serious criticism, and debates related to the arts.

Despite its initial apolitical position, from 1892 on *La Renaixensa* became closely associated with the Unió Catalanista whose leaders, Josep Puig i Cadafalch and Enric Prat de la Riba, among others, were regular contributors. Their opinions and claims, although conservative, cost the newspaper several suspensions. Eventually, *La Renaixensa* was displaced by *La Veu de Catalunya,* the newspaper of the Lliga Regionalista (Regionalist League), a conservative nationalist political organization. The last issue of *La Renaixensa* appeared on 9 May 1905.[2] Architect Lluís Domènech i Montaner designed the masthead and emblem combining the Catalan shield with the

phoenix in 1879. As Francesc Fontbona has noted, it is no coincidence that a prominent Catalanist chose such a aestheticizing image to provide the Renaixença—both the magazine and the movement—with a powerful symbol for the myth of a "reborn" national identity.[3]

*L'Avenç* (The Advance) was established in Barcelona by an 18-year-old enthusiast publisher and writer, Jaume Massó i Torrents. Initially called "L'Avens" and normalized as "L'Avenç" in 1891, the magazine had two periods of publication, appearing either biweekly or monthly from 1881 to 1884, and then monthly from 1889 to 1893. It consistently advanced an innovative and critical approach, a permanent claim to everything Catalan, and a devoted interest in the development of the language. In a promotional leaflet published in 1891, the magazine defined itself in these words: "This Catalan magazine, with contributions by the best writers and aspiring to be the speaker for our land's literature and regionalism."[4]

Permeated by 19th-century Positivism early on, *L'Avenç* soon evolved toward Naturalism, presenting articles by its most fervent defenders in Catalonia: Apel·les Mestres, Narcís Oller, Josep Ixart, and Joan Sardà. By the end of the second period, it was seen as a radical magazine, with equal doses of nationalism and demands that some linked to anarchism. In fact, the magazine lost the support of the bourgeoisie after the 1893 anarchist bomb attack at the Liceu theater and was soon forced to close.[5]

*L'Avenç* devoted many pages to current ideas and debates concerning European modernism, frequently printing translations of texts and references to northern European writers such as Baudelaire, Ibsen, Maeterlinck, Zola (fig. 2), and Nietzsche. It is no coincidence that the first appearance of the word "mod-

Fig. 1 (cat. 1:5). Lluís Domènech i Montaner, *La Renaixensa: Diari de Catalunya,* 9 May 1881, masthead designed in 1880.

ernista" in Catalan is to be found in the 15 January 1884 issue of *L'Avenç,* where Ramon D. Perés argued for "the growth in our homeland of a certain literature, a certain science, and a certain art essentially modernist."[6] From its early stages, though not profusely illustrated, the magazine showed care in its graphic design and featured drawings by such noted artists as Santiago Rusiñol, Modest Urgell, Francesc Masriera (uncle of Lluís Masriera), Dionís Baixeras, and Eliseu Meifrèn. Surprisingly, the radical political views of many of the magazine's editors and contributors do not match their less advanced positions on the art and the artists they promoted. Nonetheless, it was in *L'Avenç,* in 30 November 1891, that the art critic Raimon Casellas declared his open support to the new plein-air paintings of Ramon Casas and Santiago Rusiñol, recently brought from Paris and exhibited at the Sala Parés. While most other critics in Barcelona showed disapproval, Casellas declared that "the miseries of bohemia, the foolishness of vice, the bewilderment of pleasure, the violence of passion, the neuroses of genius, the convulsions of the *chahut* . . . all, all fits into this work so pregnant with character, so hot with emotion, that it even seems to stink with fever of that hysterically sick society."[7] Margarida Casacuberta rightly asserts that it was only with Casellas that, in its final stages, *L'Avenç* accepted the new subject matter and the role of the artist imported by the two painters.[8]

In addition to *La Renaixensa* and *L'Avenç,* the Barcelonese had a wide choice of periodicals to read during the last quarter of the 19th century, including the oldest newspaper in continental Europe, the powerful *Diario de Barcelona* (1792–1994). Others were *El Correo Catalán* (1876–1985), *La Publicidad* (1878–1939), *Gaceta de Cataluña* (1878–83), *Diari Català* (1879–81), *El Diluvio* (1879–1939), *El Liberal* (1879–1936), *La Vanguardia* (1881–in print), *Diario Mercantil* (1887–1933), *El Noticiero Universal* (1888–1985), *Diario del Comercio* (1889–1938), *Las Noticias* (1896–1939), and *La Veu de Catalunya* (1899–1937). Many of these were initially named and printed in

Spanish but switched to Catalan during the first decades of the 20th century.[9]

Thanks to halftone photoengraving, the new technology for printing images that revolutionized the press all over Europe and America in the 1880s, the number and circulation of illustrated magazines in Barcelona also grew increasingly during the same years. At the turn of the century, there were about 20 weekly, biweekly, or monthly illustrated publications. Besides *L'Avenç,* the most significant were *La Ilustració Catalana* (1880–94), *La Ilustración Artística* (1882–95), *Álbum Salón* (1897–1907), *Luz* (1897–98), *Hispania* (1899–1902), *Quatre Gats* (1899), *Pèl & Ploma* (1899–1903), and two very popular satirical magazines, *La Campana de Gràcia* (1870–1934) and *L'Esquella de la Torratxa* (1872–1939).[10]

The intangible sense of the city's awakening and renewal eventually materialized in the Universal Exposition of 1888. After a failed attempt by a private entrepreneur to organize a world's fair in 1885, the mayor of Barcelona, Francesc Rius i Taulet, picked up the project in 1887.[11] It was to be installed on the grounds of the Parc de la Ciutadella, the old Bourbon citadel, and scheduled to open in a year. Thus from a symbol of oppression the park would become a symbol of Catalan self-government. The old citadel's arsenal built by Próspero de Verboom after Felipe V defeated Catalonia in 1714, became the city's art museum in 1900, and the Catalan parliament building in 1932–39 and again since 1980.

It is no coincidence that the poster for the Universal Exposition (fig. 3) was commissioned by the Compañía de los Caminos de Hierro del Norte de España (Railroad Companies of Northern Spain). Railroad engineering was then one of the country's few booming industries and thus prominently displayed in the fair. During the 1880s more international exhibitions and fairs were celebrated around the world than any decade before or since. Five of them took place in 1888, in Melbourne, Glasgow, Brussels, Lisbon, and Barcelona. The new bourgeoisie was eager to wonder at the latest creations of

Fig. 2 (cat. 1:6). *L'Avenç: Literari, artistic, cientific,* no. 4 (30 April 1891).

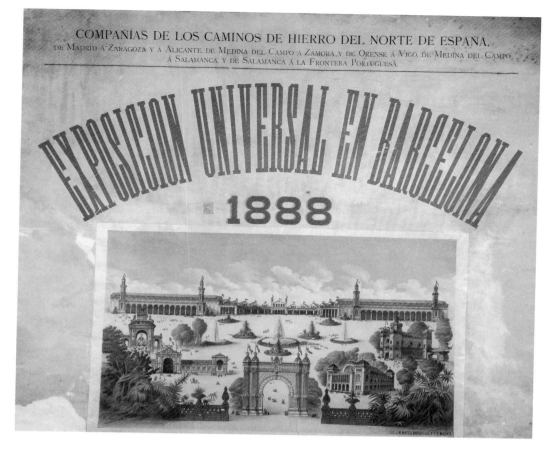

human invention from home and abroad. Although no longer a novelty—the first train track in Spain, 18 miles from Barcelona to Mataró, was then 40 years old—the railroad was still being spread very slowly throughout the peninsula, and had only reached the French border in 1878.

The poster, a color lithograph printed in Madrid by J. M. Mateu, depicts some of the fair's architectural highlights. Rather than a single bird's-eye view of the park drawn with a consistent perspective, it is a composite of different parts, each with its own vanishing point and little concern for scale or placement within the entire picture, thus forming an idealized aerial view of the fairgrounds. Though most of the fair's constructions would later be demolished, by a striking coincidence many of those depicted by the picture's designer—an unknown G. L. Ruiz—are still standing today.

In the foreground stands the Arc de Triomf, designed by Josep Vilaseca i Casanovas for the 1888 exposition though not entirely completed for the 20 May opening. Vilaseca's use of plain red brick, considered "of fundamental importance" by David Mackay, is seen as a departure point of Modernisme.[12] The triumphal arch is topped with large friezes and sculptures by Josep Reynés, Josep Llimona, Torquat Tasso, and Antoni Vilanova. Next to the Arc de Triomf the poster shows the Palau de Belles Arts, also built for the fair by August Font i Carreras. As Francesc Fontbona has stressed, it remained an active and essential center for art display until its "absurd demolishment" in 1942.[13] The Palau de Ciències, to the left of the arch, was also demolished.

Behind and above the Palau de Ciències appears the Cascade (1875–81), an enormous allegorical fountain conceived by Josep Fontserè i Mestres, who won the competition for the design of the new park in 1869. Though the Bourbon city walls had begun to be demolished in 1854 and Barcelona was finally able to expand, the Citadel had stayed and was a harsh reminder of the cruel Bourbon military rule. When the Catalan General Joan Prim ousted Queen Isabel II in 1868, one of the first things he offered Barcelona was to turn the Citadel over to civilian use to be transformed into a 150-acre public park. Despite Fontserè's assembling of some of the best Catalan sculpture of the period, and Feliu Elias's admonition that "this copious work has another kind

Fig. 3 (cat. 1:7). G. L. Ruiz, *Universal Exposition in Barcelona*, 1888.

of grace, which will only be grasped with the passing of years,"[14] I agree with Robert Hughes's evaluation of the fountain as "a work of almost unsurpassable ugliness, pomposity, and eclectic confusion."[15]

In the lithograph's background, the artist depicted the semicircular Palace of Industry, dismantled after the event closed in December. To the far right, Lluís Domènech i Montaner's Cafè-Restaurant stands out in this picture as it did in the fair—in Hughes's words, "as a suggestion of things to come."[16] Popularly known as the Castle of the Three Dragons in reference to a play that parodied medieval chivalry life, it is also made of red brick, with ceramic decorations in the outside and a partially uncovered metallic structure inside. Its striking features prefigure Domènech's accomplishments as well as some of Modernisme's main contributions.[17]

Even though Domènech was unable to finish the Cafè-Restaurant in time for the opening of the fair, the building was extensively used as a restaurant during the event. In 1891 Domènech was asked by the mayor to complete the building, but six months after he resumed working, the city council decided to change its function and use the structure to house the newly created Museu de la Història. Domènech then redesigned the building, relating many decorative elements to historical events. One fine example is the *Rooster Greeting the Dawn* (fig. 4), which was designed by Domènech together with Antoni M. Gallissà, the architect assisting him in the completion of the building who was also responsible for the different artisan workshops installed in the building.[18] The *Rooster* was therefore made on site, in June 1892, in a temporary workshop devoted to the metalwork led by the company Batalla i Cia. As Rossend Casanova discovered, two people in particular were responsible for making the sculpture, the Aragonese *repousseur* Valeri Tiestos and an unknown blacksmith nicknamed "Vulcanus" by his friends. The sculpture presented here is one of the four originals, all of the same size and materials, designed to stand near the top of the Torre de l'Homenatge (Homage Tower), at the bottom of the tower's lantern (fig. 5).[19] According to Casanova, their combs, beaks, wings, and feet were originally painted in gold. As he writes, "It is of interest to note the sinuous curves—one of the most representative forms of Catalan and European Art Nouveau—that were already used in the elaborate wrought-iron work that crowns the Torre de l'Homenatge. Owing to the laborious work involved in the ornamental elements of this topmost point of the building, it was not finished until December 1893, which was when Lluís Domènech left the project."[20]

The *Rooster* was not the only decorative element designed by Domènech to crown his building, but just like his phoenix for *La Renaixença* it stands as a strong symbol of the architect's message: combining the skilled craftsmanship of his workshop with his own refined draftsmanship, he transformed a common creature from the Catalan countryside into a beast of almost mythical proportions. The bird's feet have become powerful talons, firmly rooted, while an enormous head projects forward across the spread wings, ending in an almost menacing open beak and tongue. From the building's highest point, the four roosters faced the four cardinal directions, as if crowing to the new dawn of Catalan history.

Fig. 4 (cat. 1:8). Lluís Domènech i Montaner, *Rooster Greeting the Dawn*, 1892.

Fig. 5. *Rooster Greeting the Dawn*, one of the four sculptures in situ atop the Torre de l'Homenatge, photograph by Manolo Laguillo, 2006.

1. The Renaixença is still very much debated and bibliography is abundant. Some recent examples include *Actes del Col·loqui Internacional sobre la Renaixença*, 2 vols. (Barcelona: Curial, 1992); Jordi Galí i Herrera, *La Renaixença catalana: persones i institucions* (Barcelona: Barcelonesa d'Edicions, 1997); and Josep M. Domingo et al., *Bibliografía sobre literatura catalana del segle XIX, 1995–2000* (Barcelona: Xarxa Temàtica de la Renaixença, Universitat de Barcelona, 2003).

2. See Carola Duran i Tort, *"La Renaixensa," primera empresa editorial catalana* (Barcelona: Publicacions de l'Abadia de Montserrat, 2001), 86–89.

3. Francesc Fontbona, "L'Esteticisme," in *Aspectes generals,* ed. Fontbona, vol. 1 of *El Modernisme* (Barcelona: L'isard, 2003), 309. See also Lourdes Figueras, "Les arts gràfiques," in Lluís Domènech and Lourdes Figueras, *Lluís Domènech i Montaner i el director d'orquestra,* exh. cat. (Barcelona: Fundació Caixa de Barcelona, 1989), 89–110.

4. Folded printed sheet intended for free distribution to promote magazine subscriptions. Unitat Gràfica, Biblioteca de Catalunya, Barcelona. All translations from Catalan are by the author.

5. Josep M. Cadena, "Periòdics Modernistes a Catalunya," in *Aspectes generals,* 258–59. See also *L'Avenç* (April 1989): 10–61, which has several articles devoted to *L'Avenç* and Modernisme.

6. Joan Lluís Marfany, "Sobre el significant del terme 'Modernisme'," *Recerques* 2 (1972), 73–91. See also Juli Moll, "Els mots modernisme i modernista en català," in *Aspectes generals,* 39–56.

7. For reviews of the exhibition, see Isabel Coll, *Ramon Casas: Una vida dedicada a l'art. Catàleg raonat de l'obra pictòrica* (Barcelona: El Centaure Groc, 1999), 81 n. 99; Raimon Casellas, "Exposició de pintures. Rusiñol. Casas," *L'Avenç* 11 (30 November 1891), 334–43; and Raimon Casellas, quoted in Margarida Casacuberta, "La literatura en l'època del Modernisme," in *Aspectes generals,* 206.

8. *Aspectes generals,* 206.

9. See Josep Maria Huertas and Ramon Alberch, *200 anys de premsa diària a Catalunya,* exh. cat. (Barcelona: Fundació Caixa de Catalunya/ Arxiu Històric de la Ciutat/Col·legi de Periodistes de Catalunya, 1995).

10. Eliseu Trenc Ballester, *Les arts gràfiques de l'època modernista a Barcelona* (Barcelona: Gremi d'Indústries Gràfiques de Barcelona i Província, 1977), 115–40.

11. For accounts of the park's and the exhibition's history, see Ramon Grau and Marina López, eds., *Exposició Universal de Barcelona: llibre del centenari, 1888–1988* (Barcelona: Comissió Ciutadana per a la Commemoració del Centenari de l'Exposició Universal de Barcelona de l'Any 1888/L'Avenç, 1988); Xavier Fabré i Carreras et al., *Arquitectura i ciutat a l'Exposició Universal de Barcelona, 1888* (Barcelona: Universitat Politècnica de Catalunya, 1988), as well as *L'Avenç* (September 1988): 14–50. Specific chapters or essays devoted to the subject are found in Robert Hughes, "Going to the Fair," in his book *Barcelona* (New

York: Alfred A. Knopf, 1992), 307–73; Manuel Guardia and Albert García Espuche, "1888 y 1929: Dos exposiciones, una sola ambición," in *Barcelona, 1888–1929: Modernidad, ambición y conflictos de una ciudad soñada,* ed. Alejandro Sánchez (Madrid: Alianza Editorial, 1992), 25–43; Pere Anguera, "L'Exposició Universal de Barcelona del 1888," in *La consolidació del món burgès, 1860–1900,* vol. 7 of *Història, política, societat i cultura dels Països Catalans,* ed. Borja de Riquer (Barcelona: Enciclopèdia Catalana, 1995–2000), 190–91; Cristina and Eduardo Mendoza, " 'Ahora somos camaradas de armas.' La Exposición Universal de 1888," in *Barcelona modernista* (Barcelona: Seix Barral, 2003), 107–13. The best evocation, though, is to be found in a great novel by Eduardo Mendoza, *The City of Marvels,* trans. Bernard Molloy (San Diego: Harcourt Brace Jovanovich, 1988), 30–42.

12. David Mackay, *Modern Architecture in Barcelona 1854–1939* (Oxford: BSP Professional Books, 1989), 28. See also Fontbona, "Els nous palaus," in *Del Neoclassicisme a la Restauració: 1808–1888,* ed. Fontbona, vol. 6 of *Història de l'Art Català* (Barcelona: Edicions 62, 1997), 274–75.

13. Fontbona, "Mitjans de formació, difusió i valoració," in *Del Modernisme al Noucentisme: 1888–1817,* ed. Fontbona and Francesc Miralles, vol. 7 of *Història de l'Art Català* (Barcelona: Edicions 62, 1997), 159.

14. Elias Feliu, *L'escultura catalana moderna* (Barcelona: Barcino, 1926), 1:131.

15. Hughes, *Barcelona,* 357.

16. Ibid., 395.

17. See Rossend Casanova i Mandri, "El Cafè-Restaurant de Lluís Domènech i Montaner. Un estudi detallat del projecte i la construcció" (thesis, Universitat de Barcelona, 1998). For a study of Domènech i Montaner in English, see Lluís Domènech i Girbau, ed., *Domènech i Montaner: ano 2000 = year 2000,* exh. cat. (Barcelona: Col·legi d'Arquitectes de Catalunya/Centre de Documentació, 2000), in particular J. M. Martorell, "The Cafè-Restaurant of the International Exhibition," 64–73; Casanova, "Cafè-Restaurant," 130–49; and Manolo Laguillo, "Cafè Restaurant," 150–55. The building is highly praised by Oriol Bohigas, *Reseña y catálogo de la arquitectura modernista* (Barcelona: Lumen, 1973), 166.

18. I am gratefully indebted to Rossend Casanova, Anna Omedes, and Lourdes Figueras for providing me with information and details about the *Rooster.* See Rossend Casanova, "Antoni Maria Gallissà i el mite del 'Castell dels Tres Dragons'," in *A l'entorn de l'arquitectura,* ed. Fontbona, vol. 2 of *El Modernisme* (Barcelona: L'isard, 2003), 71–78.

19. According to Lourdes Figueras, during the remodeling and conservation of works made at the Cafè-Restaurant in 1988, one of the original sculptures was taken to the Domènech i Montaner house-museum in Canet de Mar and subsequently replaced by a replica in its original location.

20. Casanova, "Cafè-Restaurant," 136.

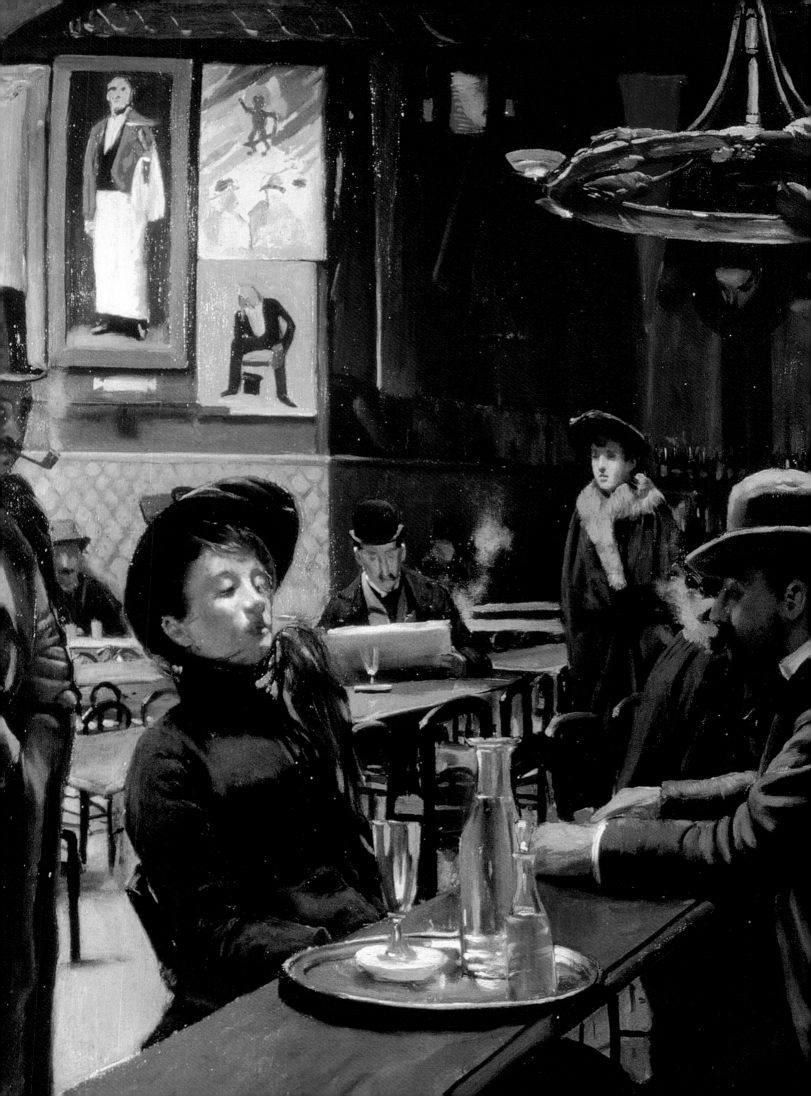

# Modernisme:
# Painting, Sculpture,
# Graphic Arts

# The New Art: Modernisme

*C A R M E N   B E L E N   L O R D*

Modernisme—the most important Catalan artistic movement of the 19th century—comprehensively transformed the arts of Barcelona, including painting, sculpture, graphic art, decorative art, and architecture. It was also the context for the revitalization of regional music, theater, and literature, as well as historic advances in the regularization of the modern Catalan language. Although it is sometimes misunderstood as a derivative of Art Nouveau, Modernisme's components are more complex. Arising from the charged context of the Renaixença—the most illustrious revival of Catalan political identity and culture since the Middle Ages—and supported by the region's concurrent prosperity, Modernisme nonetheless rejected the general conservatism of the Renaixença as well as its Romantic concentration upon the historic past. Instead, its proponents sought to establish a visual language uniquely expressive of Catalan modernity, of the dynamic of the new, within Spain, which at the same time acknowledged the region's ancient traditions. It is this concept of innovation that unifies the divergent forms assumed by Modernisme, rather than any defined style.[1] The architect Lluís Domènech i Montaner is thus representative of period values in creating architecture reflective of a contemporary Catalonia that drew on the best of the region's cultural and architectural heritage, and master craft traditions, yet demonstrated meticulous understanding of the latest international innovations, trends, and materials. At the same time, the fertile interrelationship between political, economic, and cultural life characteristic of the Renaixença persisted, as suggested by a colorful map, dating to approximately 1901 (fig. 1). Here, portraits of individuals associated with the Renaixença, Catalanisme, and Modernisme, among them politicians, architects, painters, poets, graphic designers, religious

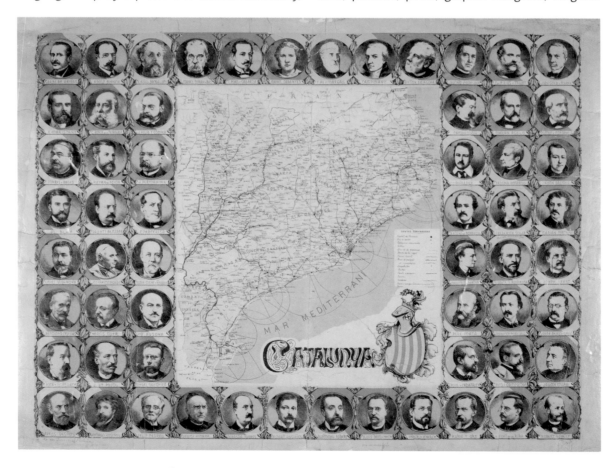

Fig. 1. Map of Catalonia with busts of prominent cultural and political figures of the day, c. 1901.

leaders, and critics, punctuate a lattice overlaid upon a Catalan flag, patriotically framing Catalonia's outline.

The beginning of Modernisme coincided with the Barcelona Universal Exposition of 1888, the city's first world's fair, which was triumphantly installed in what is today the Parc de la Ciutadella, once the seat of the much-hated occupying Bourbon army. Although not entirely successful as an international fair, the exposition offered Catalans a historic opportunity to evaluate their region in the context of vanguard European culture, technology, and industry; it also established a decisive formal precedent for a modern cosmopolitan outlook. Thus, from the beginning, Modernisme intentionally oriented its bearings toward Europe, rather than the Spanish capital of Madrid, in engaging important issues in the national politics of culture of the day. The movement signaled that Catalonia, shrugging off the limitations of provincial culture, intended to consider itself within the context of European culture. The modernista enthusiasm for the arts, architecture, and artistic freedom of other European capitals—particularly Paris—is in pointed contrast to the Madrid's alignment with the conservative Royal Academy and its investment in the older artistic traditions of Rome, where it continued to send its most gifted students.

Centered in Barcelona, which had the greatest concentration of artists, intellectuals, and patrons, Modernisme spread throughout Catalonia, developing active secondary hubs in smaller cities from Reus to Girona. Modernista painting peaked in the 1890s, waning by 1906 to be succeeded by the counterpoised ideals of Noucentisme, while modernista sculpture flowered through the first decade of the 20th century. Modernista architecture persisted longer. Class and economics circumscribed Modernisme's application to some extent. Although it eventually permeated popular culture, it received its strongest and most consistent support from among the middle class, which was most committed to the creation of an independent cultural identity for Catalonia with which Modernisme is closely associated.

As Joan Lluís Marfany explains in his foundational text *Aspectes del Modernisme*, the term "Modernisme" was first used in the 15 January 1884 issue of the vanguard magazine *L'Avenç*

(The Progressive), four years before the Universal Exposition.[2] Founded by adolescents in 1881 to foment Catalanisme and cultural awareness, *L'Avenç* became a leading, and increasingly radical, voice in the intellectual life of modernista Barcelona.[3] Intentionally countering the conservative stance of the Renaixença as well as the Restoration, the publication adopted the word "Modernisme" as a means of expressing reformist commitment to all that was modern and innovative. In response to the Renaixença aspiration of reinstating the glories of the past, the editors in ringing tones insisted that "the intellectual movement in Catalonia, should not, cannot be an exception in the midst of its century … and in as much should advance with it. 'L'Avens' defends—and always attempts to cultivate—the promotion in our country of an essentially *modernista* literature, science, and art."[4]

By 1892–93, with the consolidation of the movement, the word was in constant use in *L'Avenç*, which by then had modified the spelling of its name to reflect the reformation of Catalan orthography promoted by the magazine. The distinguished modernista poet Joan Maragall, painter Santiago Rusiñol, and Raimon Casellas, art critic for the newspaper *La Vanguardia*, similarly adopted the term in their influential writings. Although never explicitly defined, they employed it as shorthand for an amalgamation of all that was youthful, contemporary, new, and modern, in opposition to the entrenched, old-fashioned, and out-of-date. Such ideas were undoubtedly to a certain degree inspired by the enthusiasm for modernism expressed in contemporary critical French literature familiar to Catalans. However, a progressive, even revolutionary, advocacy of broad social and cultural reform on the part of many of its protagonists distinguishes Catalan Modernisme from such general period trends.[5] Among pressing issues facing the region at the end of the century that many Modernistes believed demanded innovative intervention were the urgent need for scientific parity with Europe, land reform, and a restructured political relationship between Catalonia and the central government in Madrid. At least in theory, to be Modernista was to be a radical, to oppose established societal precepts and strive for the transformation of Catalonia into an oasis of progressive

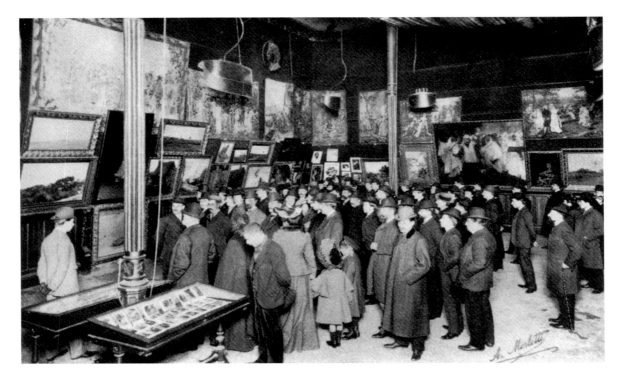

enlightened culture. This broader societal consciousness contributed to the modernista artists' active, dimensional conceptualization of their country and historic moment, and charged their work with tremendous purpose during a period of grave civil instability in Barcelona, of strikes, terrorist bombings, and police reprisal—conditions addressed more fully elsewhere in this catalogue.

Over the course of the 1890s, the term Modernisme became more narrowly associated with an artistic trend in Barcelona.[6] The earliest statement of a modernista artistic aesthetic occurred in painting, in the work of two rebellious young artists and close friends, Rusiñol and Ramon Casas, who quickly became iconic models for other restive artists discontented with conventional training and practice in Barcelona. After receiving their initial artistic instruction in Barcelona, Rusiñol and Casas spent a formative period painting in Montmartre, while living in an apartment in the Moulin de la Galette. There they avidly absorbed the immediate bohemian atmosphere, as well as the complete artistic freedom of the French capital, which contrasted so irresistibly with the constraints of middle-class life in Barcelona. Their close friend, the Catalan writer

and artist Miquel Utrillo, a correspondent in Paris for *La Vanguardia*, proved an important influence upon them. Companion to the French painter Suzanne Valadon and father of her son, the painter Maurice Utrillo, Miquel Utrillo was a sophisticated and restless intellectual who introduced the Catalan artists to less conventional dimensions of Parisian life. Like Rusiñol and Casas, Utrillo later returned to Barcelona, where he played a key role in historic projects, from the founding of the Quatre Gats café to the creation of the Poble Español for the 1929 International Exposition in Barcelona. Revealingly, all three men had middle-class backgrounds, Rusiñol and Casas originating from especially privileged families. Their decision to pursue artistic careers signaled a startling break from their conservative families, in keeping with the dissident character of Modernisme.[7]

A series of landmark exhibitions at the Sala Parés gallery in Barcelona by Casas and Rusiñol, along with their friend the sculptor Enric Clarasó, provided a decisive platform for the genesis of modernista painting (fig. 2). In the particularly bitter critical battles of between 1890 and 1896 that resulted, the two artists received the crucial support of Casellas, the principal

Fig. 2. Interior view of a Sala Parés exhibit, c. 1904.
Fig. 3. Raimon Casellas, undated, photograph by Napoleon.

apologist and theoretician for modernista painting, as well as a playwright, collector, and ardent Catalan patriot (fig. 3). The complementary impact of Casellas's didactic articles and Casas's and Rusiñol's artwork awakened public awareness in Barcelona concerning French modernism, thus providing an opening into 20th-century pictorial concerns in the region and paving the way for the next generation of modernista artists, including Pablo Picasso and Isidre Nonell. Casas's *Dance at the Moulin de la Galette*, c. 1890–91 (see fig. 6, p. 49), and *The Bohemian (Erik Satie in Montmartre)*, 1891 (see fig. 5, p. 48), as well as Rusiñol's *Café de Montmartre*, 1890 (see fig. 2, p. 44), and *Kitchen at the Moulin de la Galette*, 1890–91 (see fig. 8, p. 51), were all exhibited at the Sala Parés, where their characteristic plein-air technique, informality of composition, and unfinished paint application caused a sensation. Such paintings triggered vigorous public dialogue concerning the purpose and character of modern painting, in addition to providing a crucial model for other painters who rejected conventional anecdotal and academic painting. In keeping with the broad reformist scope of modernista precepts, however, rather than a defined style it was the overall engaging sincerity and fresh naturalness of such early modernista works that appealed to admirers. To close followers, such as Nonell, Joaquim Mir, Adrià Gual, Ricard Canals, and Ramon Pichot, together known as the Colla del Safrà (Saffron Group), active between 1893–96, Casas and Rusiñol provided a bridge to an investigative approach to painting hitherto unknown in Spain.

Both Casas and Rusiñol energetically pursued vigorous exhibition schedules in France and Spain. By 1895, they were widely thought to represent the best of Catalan painting in local exhibitions, as well as spearheading progressive regional representation in Paris and Madrid. By the end of the century, they were the most eminent and well-established painters in Barcelona, despite having by this time significantly diverged in their pictorial interests. Symbolist art and literature was an increasingly important influence upon Rusiñol after 1893–94 as a result of his absorbed study of Pre-Raphaelite painting, travel to Italy, and admiration for the theater of Henrik Ibsen and Maurice Maeterlinck. Casas, by contrast, remained fundamentally loyal to a natu-

ralist approach in his work throughout his career. Despite these differences, the early work of Casas and Rusiñol exerted a decisive and enduring influence upon their colleagues.

The diverse character of Modernisme was given greater cohesion thanks to five visionary Festes Modernistes (Modernista Festivals) celebrated in Sitges between 1892 and 1899 that Rusiñol was instrumental in organizing. Located on the Mediterranean coastline south of Barcelona, the small town of Sitges had since 1878 inspired luminist artists attracted to its brilliant light, whitewashed buildings, and picturesque setting.[8] The first modernista festival took place in 1892 with the exhibition of 100 paintings by contemporary artists that included works by Arcadi Mas i Fontdevila and Eliseu Meifrèn, whose lightened palette and intuitive brushwork revealed the influence of Rusiñol and Casas. In his review of the show for *La Vanguardia*, Casellas suggested that the artists were attracted to the little town because it permitted close observation of nature and light, "that obsession of contemporary painting," for which Sitges provided an ideal model: "First Mas y Fontdevila, Urgell and Roig y Soler, later Rusiñol, Casas, Meifrèn, etc., etc., flew to Sitges, the land of the golden rays, amazed by the splendid beach, the mother-of-pearl clouds, the bright patios, luminous countryside, so as to fix these visions, according to their personal and free manner, in harmonious notes, clear, transparent, drunk with the sun."[9]

The resultant exhibition was a landmark in Catalan and Spanish painting.

[O]ne is truly astonished ... before that ensemble of beautiful paintings ... of immense modernista feeling and of which I know of no example in the series of artistic exhibitions in our land.... Works by masters and tentative efforts by novices are equally distinguished by an eagerness to translate ... the sensations experienced before natural sights.... To create [light] in art ... modifying form and color according to the intensity and diffusion of illumination; to arrive by subtle visual sensation at the rigorous observation of values; to note the local tone, complementary reaction and incidental reflections; ... to arrive at a supreme synthesis of the characteristic of beings and things.... Here we

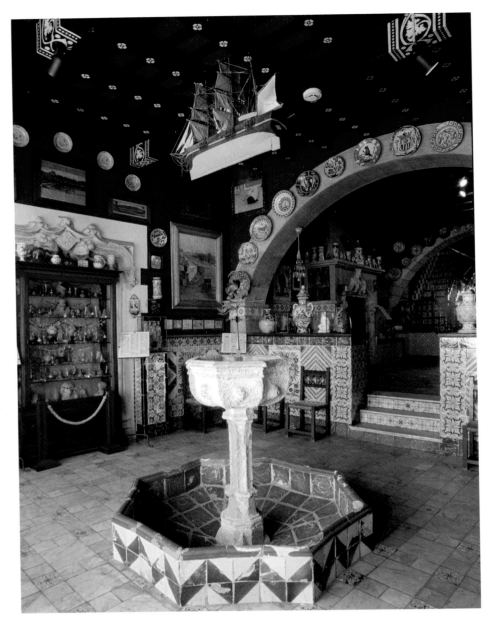

have a harsher and more difficult technical program *than that compelling history painting, which is within the reach of all intellectual gifts!*[10]

The youthful staff at *L'Avenç* enthusiastically organized the second Festa Modernista in 1893 to draw public attention to the rich diversity of contemporary Catalan literature. It proved "an authentic consecration of Modernisme."[11] The festivities featured a concert of the music of Enric Morera and Benjamin Godard, as well as the premiere of a composition by César Franck. It also included the national premiere of poet/playwright Maeterlinck's symbolist play *L'Intrusa (The Intruder)* (1890), translated into Catalan by Pompeu Fabra and starring the critic

Casellas as an octogenarian.[12] As the staff at *L'Avenç* intended, the event helped confirm the potential of the Catalan language and its ability to express subtle meaning, and promoted the regeneration of Catalan theater through the introduction of innovative international playwriting.[13] The following afternoon Rusiñol inaugurated his new home in Sitges, which he named Cau Ferrat (Den of Iron). Newly created from several fishermen's homes, it would house his extraordinary collection of antique ironwork, among the largest in the country (fig. 4).[14]

For the third Festa Modernista in the fall of 1894, distinguished artists, architects, politicians, writers, scientists, business people, and members of the press were brought by train to Sitges, which

Fig. 4. The living room of Cau Ferrat in Sitges.

was now referred to as the "Mecca Modernista." Two paintings by El Greco, which Rusiñol had purchased in Paris that spring upon the advice of the Basque painter Ignacio Zuloaga, were escorted from the station in a grand procession featuring decorative banners carried by Modernistes before being formally installed at the Cau Ferrat. Women and young girls tossed flower petals onto the paintings from balconies along the route. As Rusiñol explained to

tance to Rusiñol's painting, as well. The fourth Festa Modernista in Sitges occurred three years later, in February 1897, and simply featured a premiere of the opera *La Fada* (The fairy), by Catalan composer Enric Morera, with libretto by Jaume Massó i Torrents.[16] Shortly after this festival, the movement's center shifted to a new meeting place in Barcelona, the Quatre Gats café. However, the festivals had significantly advanced Modernisme in the public eye by

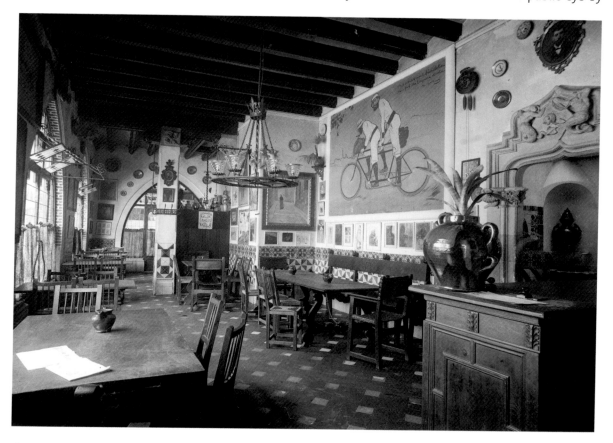

the public, El Greco provided an ideal role model for Modernistes because of his defiant individualism, unrestricted intellect, and cosmopolitanism. Still later, a literary conference featured a passionate defense of creative freedom and subjectivity by Rusiñol, who with Casellas was an increasingly prominent spokesperson for modernista ideals.[15] Readings by a representative sample of the most brilliant contemporary Catalan writers, including Casellas, Pompeu Gener, Narcís Oller, the poet Maragall, and the architect Josep Puig i Cadafalch, were later published in a single volume. The contributions of Casellas and Maragall at this third festival were especially significant as they signaled the introduction of symbolist elements in modernista literature, a trend of impor-

drawing attention to its ideas and representatives in the Catalan art world, as well as literature and music, and the interrelatedness of these creative mediums.

Thereafter, Casas and Rusiñol were in close contact with emerging artists and progressive intellectuals at the Quatre Gats café, on carrer Montsió, in Barcelona (fig. 5). Founded in 1897 by Rusiñol, Utrillo, Casas, and the athletic entrepreneur Pere Romeu, (the "four cats" referred to in the café's name), the colorful premises featured artwork by its patrons, including a self-portrait by Casas with Pere Romeu on a tandem bicycle (see fig. 6, p. 83). Like Rudolf Salis, owner of the Chat Noir in Paris who had inspired them, the Catalans hoped to stimulate the talent of writers and artists in their community.[17] The tavern

Fig. 5. The original interior of the Quatre Gats café, 1904.

promptly became the center of modernista activities in Barcelona—a meeting place, alternative exhibition gallery, shadow puppet theater, and music hall. The Chat Noir also inspired their publication of a modest *Quatre Gats* art journal in 1899, supplanted the same year by the more ambitious *Pèl & Ploma*, in which Utrillo and Casas collaborated (see figs. 8–10, p. 66). *Pèl & Ploma* was particularly effective in creating awareness of international artistic trends and exhibitions through its articles and editorials.

The Quatre Gats also influenced the flourishing graphic arts of Catalonia and their transition from a traditional to a modern vernacular, and inspired innovative exploration of the medium among its patrons, including Picasso, Utrillo, and Casas, who became one of Barcelona's most innovative poster designers. While throughout the 19th century the poster had typically been used in Spain as a means of announcing public events, by the end of the 1890s the medium was recognized as an effective advertising means and collectable modern art form, largely as a result of international poster expositions abroad and at home.[18] Official competitions added incentive to its development, leading in 1899 to the first show exclusively dedicated to Catalan poster design. Modernistes soon adopted the medium as an important means of expression.[19]

After the Quatre Gats closed in 1903, its premises at the Casa Martí were occupied by the Cercle Artístic de Sant Lluc, which represented a far more conservative trend in painting and sculpture. Founded in 1893 under the guidance of the conservative cleric Torres i Bages, the Cercle Artístic included among its numbers the Llimona brothers, Dionís Baixeras, Alexandre de Riquer, and Antoni Gaudí; it promoted conservative, Catholic religious art with symbolist overtones. Work by members of the Cercle Artístic often featured moralizing content, in contrast to the unconventionality and informality of modernista imagery. De Riquer was especially influential in the introduction of highly refined graphic artwork with symbolist elements, resulting from his firsthand contact with English Pre-Raphaelite artists (see fig. 7, p. 65; fig. 1, p. 69). Other members of the Cercle Artístic included some of the most gifted sculptors of the era, who contributed significantly to the revival of Catalan sculpture. Among them were Miguel Blay (see fig. 10, p. 77), Eusebi Arnau (see fig. 6, p. 74), and Josep Llimona (see fig. 3, p. 73), all of whom were profoundly influenced by the work of the French sculptor Auguste Rodin and Symbolism.

The short-lived Quatre Gats café represented the fruition of early Modernisme in Barcelona at the turn of the century. It also heralded the ascendancy of a second generation of modernista artists, including Hermen Anglada i Camarasa, Nonell, Mir, Pichot, Gual, Canals, and Picasso, who benefited significantly from the older artists' struggle with established tradition and the conservative critics of Barcelona. While this next generation was deeply influenced by Rusiñol and Casas early in their careers, the evolution of their concerns resulted in work that predictably superseded the confines of that older art, through the exploration of a freer range of subjects and techniques.

Over the course of the 1890s, satirists in the popular press often gleefully targeted the Modernistes, representing them as eccentric longhaired bohemians. However, by the turn of the century, some Catalan intellectuals joined in denouncing the modernista movement. There was particular uneasiness over what was perceived as Modernisme's drift toward decadence and enervated aestheticism, resulting from the introduction of symbolist influences and the retreat from naturalism among its representatives. Many of the most conspicuous original representatives of Modernisme, including the poet Maragall and *L'Avenç* editor Jaume Brossa, eventually chose to disengage themselves entirely from the movement. By 1906, such reactions had begun to coalesce into a new cultural and artistic movement in Barcelona known as *Noucentisme* (1900s). Rejecting what they regarded as the overburdened complexity and decadence of modernista principles and design, the Noucentistes proposed a return to restrained classical Mediterranean ideals and forms, and an expansive reaffirmation of Catalonia's common history with other Mediterranean cultures. While apparently opposing movements, Noucentisme adopted certain concepts associated with Modernisme and, like it, would seek to regenerate and modernize regional art and society, while being rooted in Catalan nationalism and preserving Catalonia's distinguishing traditions.[20]

1. Francesc Fontbona, ed., *Aspectes generals,* vol. 1 of *El Modernisme* (Barcelona: Edicions L'isard, 2003), 13.

2. Discussion of the term "Modernisme" here is based upon the scholarship of Joan Lluís Marfany, especially his *Aspectes del modernisme,* 8th ed. (Barcelona: Biblioteca Torrell-Jordana Curial, 1990), in which evolution of the word is mapped through *L'Avenç* magazine and the writings of Santiago Rusiñol and Raimon Casellas, among others.

3. On the magazine's history and significance in Catalan intellectual life, see Eduard Valentí Fiol, *El primer modernismo literario catalán y sus fundamentos ideológicos* (Barcelona: Ediciones Ariel, 1973).

4. Marfany, *Aspectes,* 36. All translations by the author.

5. Ibid., 40–41.

6. Judith Campbell Rohrer, "Artistic Regionalism and Architectural Politics in Barcelona" (Ph.D. diss., Columbia University, 1984), 4.

7. Joan-Lluís Marfany, "Burgesia, Modernització cultural, catalanisme," in *El Modernisme, 1890–1906,* ed. Pere Gabriel (Barcelona: Edicions 62, 1995), 17.

8. Casellas came to believe that Sitges, along with firsthand exposure to French art and direct observation of nature, contributed significantly to the palette of modernista artists. See Casellas, "Exposición General de Bellas Artes. IV. Los pintores de la naturaleza," *La Vanguardia,* 4 May 1894.

9. R. Casellas, "Bellas artes. La exposición de Sitjes," *La Vanguardia,* 27 August 1892.

10. Ibid.

11. Cristina and Eduardo Mendoza, *Barcelona modernista* (Barcelona: Planeta, 1989), 115.

12. Maeterlinck's *L'Intrusa* was published in *L'Avenç* (August 1893), translated into Catalan by Fabra. Ibsen's *Espectres* (*Ghosts*) (1881), jointly translated into Catalan by Fabra and Joaquim Casas-Carbó (the painter Ramon Casas's cousin), appeared in three issues of *L'Avenç* between October and December 1893.

13. See Jaume Brossa Roger, "La Festa Modernista de Sitges"; Jaume Massó Torrents, "An en Rossinyol"; Santiago Rossinyol, "Discurs Llegit a Sitges," in *L'Avenç,* 15 September 1893, 257–64.

14. [J. Roca y Roca], "La fiesta artística de Sitjes," *La Vanguardia,* 14 September 1893.

15. Marfany, *Aspectes,* 46.

16. "La fiesta artística de Sitges," *La Vanguardia,* 16 February 1897.

17. 'El caballero Micifuz,' "Els IV Gats," *La Vanguardia,* 1 July 1897, 4.

18. The first poster exhibit in Spain opened at the Sala Parés in November 1896. On the history of modernista graphic art, see Eliseo Trenc Ballester, *Las artes gráficas de la Epoca Modernista en Barcelona* (Barcelona: Gremio de Industrias Gráficas de Barcelona, 1977).

19. Marilyn McCully, ed. *Els Quatre Gats. Art in Barcelona around 1900,* exh. cat. (Princeton: Art Museum, Princeton University, 1978), 23.

20. Martí Peran et al., eds. *El noucentisme. Un projecte de modernitat,* exh. cat. (Barcelona: Centre de Cultura Contemporànea de Barcelona, 1994–95), 45.

# Casas and Rusiñol: The Allure of Montmartre

CRISTINA MENDOZA

Ramon Casas's portrait of fellow painter Santiago Rusiñol (fig. 1), executed in 1889, includes some suitcases alongside the image of his friend. They were not banal elements of the composition but the painter's wink at the subject, who was preparing for his first trip to Paris at the time. Although no one could have predicted it then, this decision would determine the immediate future of Catalan painting. Casas and Rusiñol, both born in Barcelona, had met in the early part of the 1880s, and they were predestined to get along.[1] Both men came from wealthy families in the Barcelona bourgeoisie, and neither had the slightest intention of following the plan determined for them by their social position. Instead, they wanted to rebel against the social conventions of the class to which they belonged and spend all their time painting. At this time, when they were just becoming good friends, Casas actually had a considerable advantage over Rusiñol. Contrary to what could be expected for the only son of a family that owned a prosperous textile factory, Casas encountered no obstacles from his family, even when he gave up his scholarly studies for an education in art. So when he was only 15 years old, he was allowed to go to Paris for approximately two years to complete his early education. A short time after his arrival in that city, he managed to gain admission to the prestigious workshop of the academic painter Charles-Emile-Auguste Carolus-Duran on his own merits. Among Carolus-Duran's students of an earlier time was John Singer Sargent, the very painter a Parisian newspaper critic would link to Casas based on the works the young Catalan exhibited at the 1883 Salon des Champs Elysées.[2] In short, when Casas and Rusiñol met, Casas had already had the opportunity to experience the ambience of the art world's capital.

Evidence of that exposure can be seen in the above-mentioned portrait of Rusiñol. Although it was painted in Barcelona several years after his stay in Paris, Casas had paid close attention to the artistic currents he had experienced in that city. The work, whose language was absolutely new in Barcelona, was not well received by the critics when it was shown there in 1889. Its representation of the figure was considered improper to the portrait genre, and the setting was deemed totally common. In fact, the painting steered completely clear of the contrivances of portraits being painted at that time by Catalan artists. In other words, this portrait had more in common with Édouard Manet's 1868 portrait of Émile Zola, which Casas—as a participant in the 1883 Paris Salon—would surely have had occasion to see. In this regard, it is noteworthy that the Catalan painter placed his friend in his natural environment, surrounded by the objects that were most related to Rusiñol at that time in his life. The suitcases were shown behind the figure, and the painter used the resource of a "painting within a painting," which Manet had also used. On the wall in the background, Casas placed a landscape painting that could have been a work by Rusiñol himself, under which we can just discern a copy of a fragment of the Velázquez painting *Las Meninas,* 1656 (Museo del Prado, Madrid).

Rusiñol had not had such good fortune as his friend; his art education was minimal. The lucky Casas had been able to flee the obligations placed on him by his family's situation and enjoy a solid formative period in Paris. But it took Rusiñol a long time to free himself of ties to his family's buoyant textile company, where he was obliged to spend most of his time working. Nevertheless, by the late 1880s, he had completed a number of paintings, most of which were landscapes along the lines of those in the French Barbizon school, the style that then dominated Catalan painting in this genre. Moreover, he had managed to assemble a respectable collection of antiques and old wrought iron, which would become one of the passions of his life.[3] Given the biographical circumstances described here, clearly Rusiñol's decision to head off to Paris and break the family and professional ties that linked him to Barcelona could have been neither easy nor well

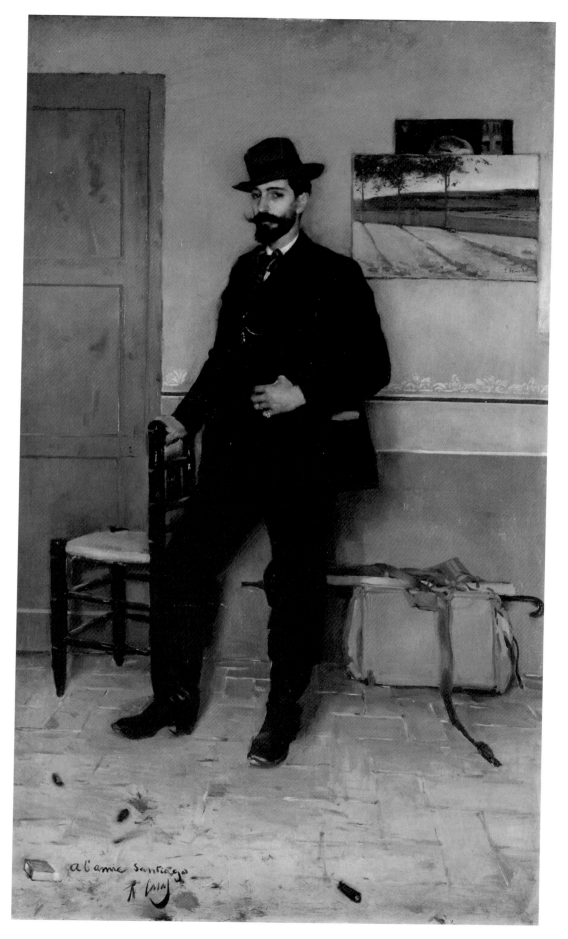

Fig. 1 (cat. 2:1). Ramon Casas, *Santiago Rusiñol*, 1889.

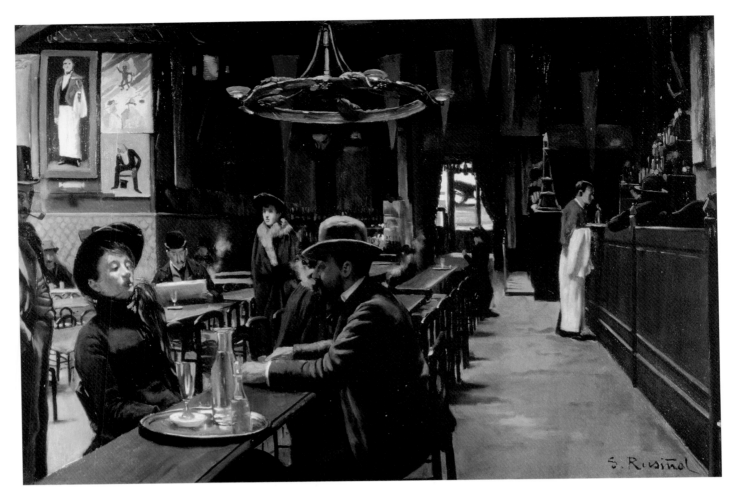

received. However, those ties were preventing him from carrying out his life plan: to be an artist.

During the years immediately before Rusiñol's departure for Paris, Barcelona was moving full speed ahead toward its first world's fair, which took place in 1888. The Universal Exhibition provided so much impetus for modernization of the city that, by the end of the century, it had become the most advanced capital in Spain. Paradoxically, the Catalan bourgeoisie—without whose total involvement the modernizing project could not have been accomplished—had very conservative taste in art. Thus the type of painting predominant in Barcelona at the time was completely conventional. It was very well made, with a rich chromatic palette, representing pleasant genre scenes, with leanings toward aristocratic taste—the sort of thing with which this emerging social class could identify. Consequently, these were the paintings the Catalan bourgeoisie chose to decorate the brand-new residences they were having built at the time. Such houses were going up along the main arteries of the area known as the Eixample, the urban center of the new, modern Barcelona. Against this backdrop erupted an innovative style of painting, led by Casas and Rusiñol, two young men who—as well as breaking artistic ground—were rebels against the local bourgeoisie. Consequently, that they were given a lukewarm reception, at times tinged with scorn and hostility, is understandable. We must bear in mind that while genre painting coexisted with innovative painting, the former was unquestionably predominant during the late 1880s and early 1890s. Only from that perspective is it possible to understand that the painting style led by Casas and Rusiñol represented a revolution to the art world in Barcelona.

Barcelona had only one important gallery at that time, the Sala Parés, and it became the city's best artistic thermometer. Thus it was inevitably the stage on which the battle would break out between those who would go down defending conservative painting and the supporters of Casas and Rusiñol's painting. The scornful name used for the new work by its detractors was "modernista" ("modern" in the

Fig. 2 (cat. 2:3). Santiago Rusiñol, *Café de Montmartre*, 1890.

pejorative sense). The first salvo in the conflict took place in the fall of 1890, when the Sala Parés opened its doors to the first of a series of three exhibitions in which Casas and Rusiñol showed their work together. The exhibition, which caused quite a brouhaha in the city's artistic circles and was given significant space in Barcelona's press, consisted of 99 works of art: 50 paintings by Rusiñol, 36 by Casas, and 13 sculptures by Enric Clarasó, a friend of the two painters. Among the paintings Rusiñol presented in this exhibition, the most innovative were the 25 works he had just completed in Paris in his recent, first stay in that city. Rusiñol had lived for only six months in a broken-down house on the rue d'Orient in Montmartre with the sculptor Clarasó, the engraver Ramon Canudas, and the critic Miquel Utrillo. Judging by the paintings from his Parisian work in this exhibition, that short period had broadened him to an extraordinary degree. During the time he spent in Paris, he attended classes at the Académie de La Palette, directed by the painter Henri Gervex, and contributed two paintings to the 1890 Salon du Champ de Mars.[4] All in all, the most significant determinant of the painter's artistic language was direct knowledge of Naturalism, which marked him profoundly, and Impressionism, from which he assimilated some formal elements. *Café de Montmartre*, 1890 (fig. 2), which was included in the exhibition in the Sala Parés, is the best example.[5] This work shows some characteristics that were present in Rusiñol's pictorial work before his stay in Paris, such as the strong linear perspective and the loneliness conveyed by the absence of communication among the figures. From a formal point of view, however, it is also evident that the artist incorporated some innovative elements. One is the choice of a motif related to a modern city and another is his subjective approach: capturing the immediateness of a scene. Moreover, the scene's plot extends beyond the limits of the canvas.

Among Casas's paintings shown in the same exhibition, portraits were the predominant genre. Unlike Rusiñol, most of whose works were rendered in Paris, Casas executed his paintings in Barcelona. Like those of his friend, however, Casas's works also showed traces of French naturalist painting. Even though Paris belonged to Casas's past by this time, he had absorbed the influence of the French

painters. The similarity in the artistic language of the two painters and the newness of this language to Barcelona's conventional art world led both the public and the critics to confound the two artists. Somehow, their collected works were judged as if they had been created by a single artist. So, although the exhibition was an important event in the city, with ample press coverage, the two painters were rejected as one, with few distinctions made between the two bodies of work. The unanimous reproach was aimed at both form and content. One comment by the defenders of conventional painting criticized Casas and Rusiñol for having dared to exhibit works that—based on their careless technique and predominantly cold palette—could only be regarded as simple studies. Such paintings, deemed unworthy of inclusion in an exhibition, were especially unjustifiable coming from two painters recognized by all for their excellent artistic gifts. Another criticism took them to task with equal severity for their choice of motifs, since they had chosen to represent a sad and sordid world as the setting for some scenes. In short, the numerous detractors considered it intolerable that the lives of common people predominated in these paintings as opposed to the artificial conventions of anecdotal painting that held favor among the bourgeoisie. All in all, the tandem eruption of the works of Casas and Rusiñol into the sleepy Barcelona art scene took everyone by surprise, which could explain why the reaction of the public and the conservative critics was less virulent than it would be the following year, when the two artists held a second exhibition at the same gallery.

In fact, as soon as their first, much talked-about exhibition in Barcelona was over, Casas and Rusiñol, impervious to the rejection they had provoked and the resulting commercial failure, returned to Paris. They stayed in that city, apart from the occasional interruption, until well into 1892. The close camaraderie of the two artists, together in Paris for the first time and actually living in the same place, was extraordinarily beneficial for the work of both and, therefore, for the immediate future of Catalan painting. Casas and Rusiñol set up house in an apartment in Moulin de la Galette, an old, out-of-use wooden mill, among the few that still remained in Montmartre at the end of the 19th century. In Rusiñol's words, "right in

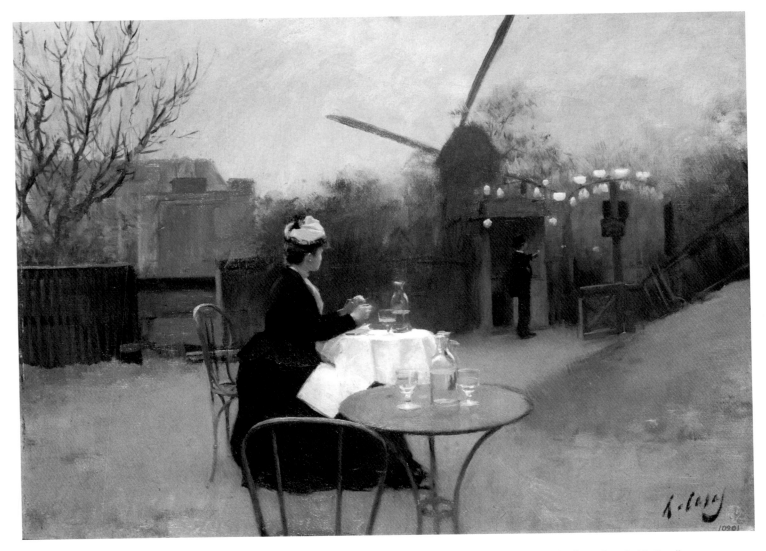

the center of a city so modern, proudly looms a hulk of a thing so useless."[6] As is well known, the Moulin de la Galette gave its name to a nearby amusement park and dance hall that would gain renown as the subject of paintings by Auguste Renoir, Henri de Toulouse-Lautrec, and later, Pablo Picasso. The park and the legendary dance hall also became the preferred settings for the artwork of both Casas and Rusiñol. Not only was this a prolific period for both artists, the paintings they created then may be considered the best of their respective careers (figs. 3 and 4). The quality of the work achieved by both was stimulated by the Parisian art scene and enriched by their close living arrangement. Thus Casas, who was more artistically gifted than his companion but had few intellectual preoccupations, was positively affected by the thought-provoking, erudite Rusiñol. Meanwhile, Rusiñol's lesser technical ability was offset by Casas's talent.

Under the eloquent title "Desde el Molino" (From the Moulin), the Barcelona newspaper *La Vanguardia* published several chronicles from Paris written by Rusiñol and illustrated by Casas. These articles helped spread the artistic spirit of Montmartre throughout Barcelona as well as cultivate the anti-conventional, bohemian image the two artists had forged from the beginning of their friendship. The articles and the letters both artists sent to Barcelona provided valuable information about the lives of the two Catalan painters during their stay in Paris. Also informative were the writings of Utrillo, another companion of the two painters as well as a decisive figure in the consolidation of Modernisme. All these writings also revealed the interest elicited in them by some artists, mainly French. Thus we know that the artists preferred by Rusiñol were Edmond François Aman-Jean, Émile Bernard, Eugène Carrière, and Jean-Charles Cazin as well as some aspects of the

Fig. 3. *Plein Air*, c. 1890–91, by Ramon Casas.

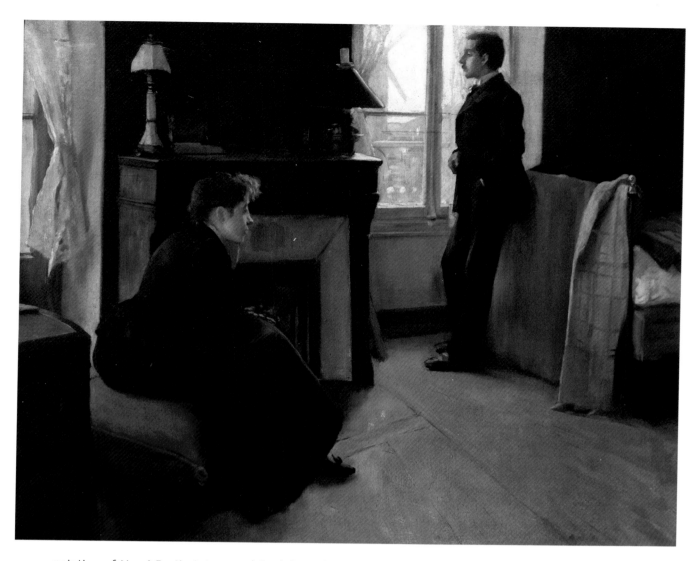

painting of Henri Fantin-Latour and Paul Gauguin. Among the Impressionists, he admired the works of Claude Monet, Manet, Camille Pissarro, Renoir, and Edgar Degas.[7] In an article about the importance of the truth as the only valid formula for expressing beauty, Rusiñol cited as examples the landscapes of Monet and the figures of Degas.[8] Among the non-French artists who lived in Paris at that time, he especially found interesting the English artists Sir Frank Brangwyn and Charles Robertson, the Italians Federico Zandomeneghi and Giovanni Boldini, the Scandinavians Albert Edelfelt and Anders Zorn, and the Americans William Dannat, Alexander Harrison, John Singer Sargent, and, above all, James McNeill Whistler.[9] There is no doubt that both Casas and Rusiñol also knew the work of Henri de Toulouse-Lautrec, a contemporary of the Catalan painters and a neighbor in Montmartre. They must have known the man himself as well, if only indirectly.[10] From

Casas, we also know that he had the opportunity to see Isaac de Camondo's highly important collection of Impressionist paintings (today in the Musée d'Orsay), and his enthusiasm about Monet. His disappointment about the use of color in the works of Degas suggests that, prior to his stay in Paris, he must have known this artist's painting only through black-and-white photographs.[11]

In any event, after two years in Paris, Casas and Rusiñol had consolidated an artistic language that assimilated the innovations learned in that city. In other words, they were influenced by naturalist painting while absorbing the purely formal aspects of Impressionism. Examples are their representation of the fleeting moment, their way of presenting the motif, and their solutions to composition, all of which were absolutely new at that time in the Barcelona art scene. The Casas paintings *The Bohemian (Erik Satie in Montmartre* or *Erik Satie)*, 1891 (fig. 5), *Dance*

Fig. 4. *A Summer Cloud*, 1891, Santiago Rusiñol.

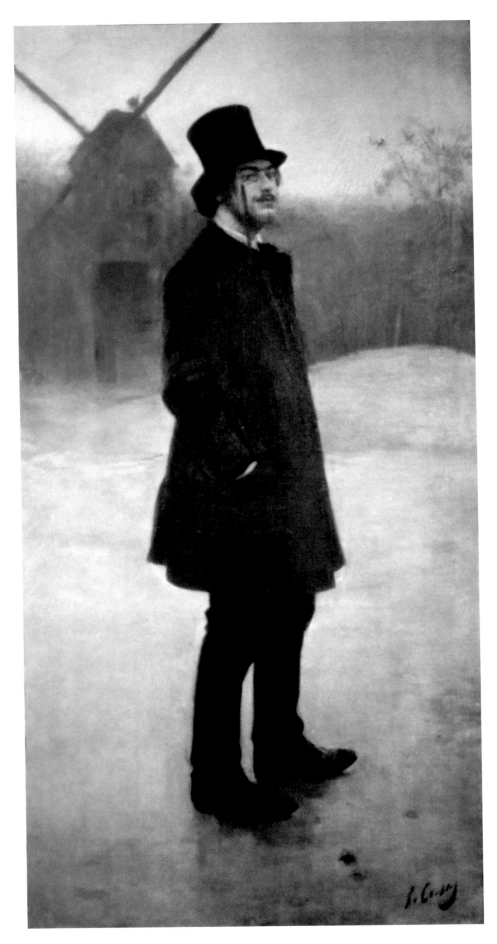

Fig. 5 (cat. 2:2). Ramon Casas, *The Bohemian (Eric Satie in Montmartre)*, 1891.

at the *Moulin de la Galette*, c. 1890–91 (fig. 6), and *At the Moulin de la Galette*, 1892, and Rusiñol's *An Aquarium (Interior of a Café)*, 1891 (fig. 7), and *Kitchen at the Moulin de la Galette*, c. 1890–91 (fig. 8), are highly illustrative. In *Dance at the Moulin de la Galette*, probably Casas's most important work, the painter represents from an aerial perspective the famous place already immortalized by Renoir and Toulouse-Lautrec. It is shown at a time when it is almost empty, in shadows, with a cold, mono-

Fig. 6 (cat. 2:4). Ramon Casas, *Dance at the Moulin de la Galette*, c. 1890–91.

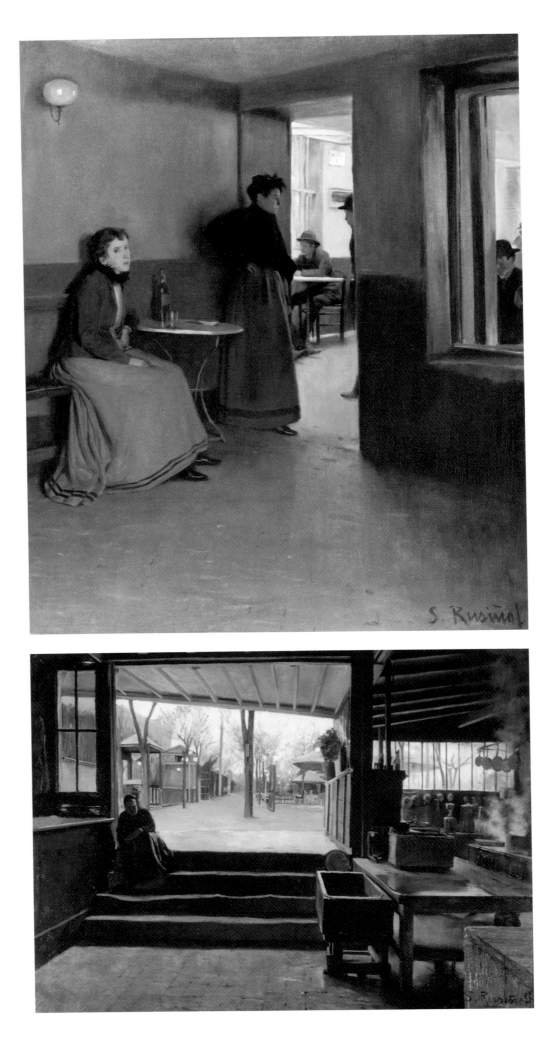

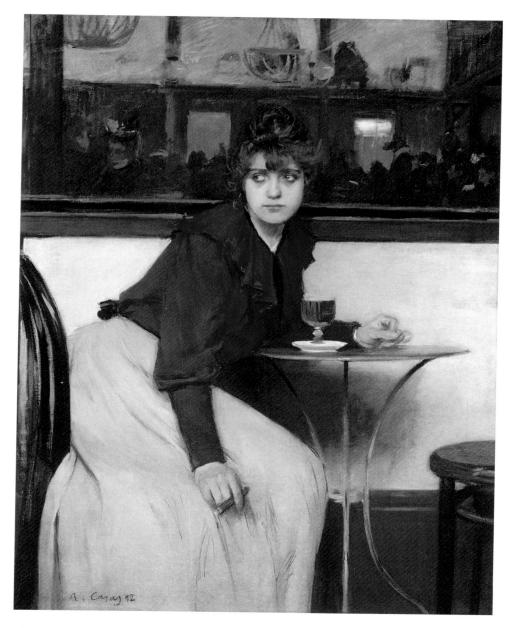

chrome palette and a highly developed treatment of the light filtering through the windows seen in the background of the composition. This is the same setting in which Casas would situate Madeleine de Boisguillaume, the model who also posed for Toulouse-Lautrec, capturing her in a fleeting and expectant pose, focused on something taking place beyond the composition (fig. 9). The fact that Casas placed a mirror behind her, reflecting the dance hall where the scene she is watching is supposedly taking place, indicates his knowledge of Manet's *A Bar at the Folies-Bergère*, 1881–82, in which that artist used the same device.

Also clear in the Casas work is his use of the same motif and composition, though not technique, found in Manet's *Plum Brandy*, c. 1877, Degas's *At the Café (L'Absinthe)*, 1876 (fig. 10), and some of Toulouse-Lautrec's paintings, also captured inside the Moulin de la Galette. Finally, like the aforementioned Casas paintings, Rusiñol's *Kitchen at the Moulin de la Galette* is also a paradigmatic example of his work from that period and one of the best pieces of his lengthy career. Once again, he used the Moulin de la Galette park as a setting. In contrast with the foreground, which is sordid and in shadows, the park appears in the light of day but

Fig. 7 (cat. 2:6). Santiago Rusiñol, *An Aquarium (Interior of a Café)*, 1891.
Fig. 8 (cat. 2:5). Santiago Rusiñol, *Kitchen at the Moulin de la Galette*, 1890–91.
Fig. 9 (cat. 2:7). Ramon Casas, *At the Moulin de la Galette (Madeleine* or *Absinth)*, 1892.
Fig. 10. *At the Café (L'Absinthe)*, 1876, by Edgar Degas.

at a moment of absolute inactivity. It is precisely this lack of activity that helps create a feeling of desolation and melancholy.

Many of the paintings rendered by Casas and Rusiñol in Paris were presented at official competitions that took place in both Paris and Barcelona. An abundant collection of their paintings was also exhibited at Barcelona's Sala Parés in 1891 and 1893, once again with some of Clarasó's sculptures. Again, the Barcelona public and critics reacted with hostility and repeated the same reproaches they had directed toward the artists at the time of their earlier exhibition.[12] This time, however, the artists had the enthusiastic support of the critic and writer Raimon Casellas, who took the opportunity to defend the innovative painting pedagogically, at a time when the two artists had firmed up their artistic language. Following the 1893 exhibition, the artistic paths taken by the two leaders of modernista painting diverged. Nevertheless, their biographies continued to be linked, and in the years immediately after that exhibition they would both make major contributions to the final consolidation of Modernisme. Rusiñol returned to Paris and set up house in an apartment on the Quai Bourbon. During this period, he cultivated decadent painting, with its roots in Symbolism. His protagonists were sickly women in sleepy surroundings, in which we can see the influence of Whistler. Soon Rusiñol began a garden series that also reflected his closeness to Symbolism. Casas made periodic trips to Paris, but he had already settled permanently in Barcelona and began exploring new genres of painting. His themes ranged from the portraits to interiors depicting sophisticated women, as well as other works representing special events in the life of Barcelona, with the multitude as the protagonist.

All in all, we could not conclude this article without mentioning an event closely linked to the events described above and centering on Rusiñol. In 1891, he was traveling on horseback between Paris and Barcelona. During a stay in Barcelona and in the course of an excursion, by chance he discovered Sitges, a town on the shores of the Mediterranean just a few kilometers from Barcelona. Fascinated by this place, Rusiñol acquired two adjacent fishermen's houses from whose windows only the ocean was visible. The following year he established his residence there, if there is any such thing for such a nomad, and installed his notable collection of wrought iron and antiques. Thus came into being, under the name of Cau Ferrat,[13] the mecca of modernista artists and intellectuals. Between 1892 and 1899, many would travel from Barcelona to Sitges to attend what were known as the Festes Modernistes inspired by Rusiñol.[14] These festivals, each of which was centered around an artistic, musical, or literary event, would culminate the process of modernization of Catalan art and culture, a course surely launched when Rusiñol decided to undertake the artistic life. In a symbolic way, Ramon Casas immortalized that moment when he made a portrait, in 1889, of his friend about to embark on his first trip to Paris.

1. The most recent and most exhaustive studies on these two artists are Mercè Doñate and Cristina Mendoza, eds. *Santiago Rusiñol 1861–1931*, exh. cat. (Barcelona/Madrid: Museu Nacional d'Art de Catalunya/Fundación Cultural Mapfre Vida, 1997); Doñate and Mendoza, eds. *Ramon Casas, el pintor del Modernisme*, exh. cat. (Barcelona/Madrid: Museu Nacional d'Art de Catalunya/Fundación Cultural Mapfre Vida, 2001); Isabel Coll, *Ramon Casas 1866–1932: una vida dedicada al arte. Catalogue Raisonné* (Murcia: De la Cierva, 2002); and Josep de C. Laplana and Mercedes Palau-Ribes, *La pintura de Santiago Rusiñol, obra completa* (Barcelona: Mediterrània, 2004).

2. Casas participated in a Parisian salon in 1883 with a portrait of himself dressed as a flamenco dancer (Museu Nacional d'Art de Catalunya, Barcelona), a notable exercise in chiaroscuro. This work showed the influence of Carolus-Duran, in whose workshop preference was given to the Spanish School of the Golden Age, especially to Velázquez. The review that pointed out the traces of Sargent and Manet in this painting appeared in a Parisian newspaper on 22 May 1883. See Coll, *Ramon Casas 1866–1932*, 490.

3. This collection was kept at a location, called Cau Ferrat, on carrer Muntaner in Barcelona that Rusiñol shared with the sculptor Clarasó; it was later moved to a site in Sitges, also called Cau Ferrat.

4. The works presented in the Salon du Champ de Mars were a portrait, *Miquel Utrillo* (Museu Nacional d'Art de Catalunya, Barcelona), painted on the patio of the house in Montmartre where they lived, and *Pawn Shop* (Cau Ferrat, Sitges).

5. Although this painting was included in the aforementioned exhibition under the name *Café of the Incoherent*, Rusiñol himself gave it the title *Café de Montmartre* on the back of the canvas, where he also noted that he used the faces of Casas (in the foreground), Utrillo (reading the newspaper), and Clarasó (in the background, on the left) to represent some of the figures. See Laplana and Palau-Ribes, *La pintura de Santiago Rusiñol*, 145.

6. Santiago Rusiñol, *Desde el Molino: impresiones de un viaje a Paris en 1894* (Barcelona: Parsifal, 1999), 5.

7. This information is provided by Miquel Utrillo in an article he wrote upon the death of Rusiñol. See Utrillo, "Santiago Rusiñol, pintor," *Butlletí dels Museus d'Art de Barcelona* (August 1932): 230–34.

8. Rusiñol, "Filosofías que como a tales no han de servir de gran cosa," *La Vanguardia*, 21 August 1892, 4.

9. See note 7.

10. In 1891, Miquel Utrillo acknowledged the child of Suzanne Valadon as his son (Maurice Utrillo, who would become a well-known painter) precisely when she renewed her interrupted relationship with Utrillo, after an especially tumultuous one with Toulouse-Lautrec.

11. This information comes from an undated card that Casas wrote to Miquel Utrillo kept in the archives of the Sala Parés, currently at Museu Nacional d'Art de Catalunya, Barcelona.

12. A review that appeared in the Barcelona daily newspaper *El Correo Catalán* on 17 February 1893, at the time of Rusiñol and Casas's third exhibition at the Sala Parés, illustrates the treatment their paintings received from conservative artists: "Serious painting is dead. This epitaph is present in its absence from the entrance to the Salón Parés, where a collection of Casas and Rusiñol's paintings are currently on exhibit. Casas freezes; in the white and grayish tones of this Impressionist school, we seem to feel the coldness of a cemetery. So much pallid canvas seems meant only to be made into a shroud for serious, painstaking art."

13. In Catalan *cau* means "den" and *ferrat* derives from the Catalan word *ferro*, which means "iron," in allusion to Rusiñol's collection of old wrought iron. Currently Cau Ferrat, which can be visited, is kept preserved as Rusiñol created it.

14. Five modernista festivals were held. The 1892 festival consisted of an exhibition of brilliant paintings done by the Sitges artists; in 1893, it centered around a staging of the Symbolist work *The Intruder* by the Belgian playwright Maurice Maeterlinck and a concert with pieces by César Franck and Enric Morera; in 1894, it was a procession through Sitges bearing to Cau Ferrat the two El Greco paintings Rusiñol had purchased in Paris as well as a literary competition; in 1897, a musical and theatrical evening was offered with a performance of *The Fairy*, written by the Catalan Jaume Massó i Torrents; in 1899, two works by the Catalan writer Ignasi Iglesias were presented as well as Rusiñol's own *Happiness that Passes* and a piano concert by Joaquim Nin, who played the works of Scarlatti, Grieg, Gay, and Morera.

Translated by Eileen Brockbank.

# The Second Generation of Modernista Painters

*FRANCESC FONTBONA*

The generation that revived 19th-century Catalan art was, of course, the modernista generation. They decided to do it, and they did it. This revival required being in tune with the modernist art in the rest of Europe—especially Paris—and producing high-quality paintings, sculptures, and illustrated books that struck a particular note in turn-of-the-century Western art. However, these artists—painters and sculptors only, the architects went much farther—adopted modern styles that had been consolidated elsewhere without thinking of making their own deep contributions: Alexandre de Riquer was a Symbolist, faithful to the British Pre-Raphaelites; Ramon Casas and Santiago Rusiñol were close to the gray Impressionism of Degas and Whistler; Josep Llimona produced a plastic sculpture clearly derived from the work of Rodin; and Joan Brull painted in a symbolist manner related to certain allegorical French painters. The first generation of Catalan modernista painters was born in the 1860s and had their finest hour in the 1890s. While their contribution was decisive in itself, it also opened the way for other younger, more creative artists—those whom for some years I have called "Postmodernistes."[1]

The Postmodernistes, born in the 1870s or even in the early 1880s, inherited from their predecessors a concern for modernizing Catalan culture, but they took it farther. Not content with copying new styles from abroad, they made evident personal innovations, which were nonetheless different from the ones appearing in European post-Impressionist painting and sculpture elsewhere.

Some of the Postmodernistes, or second generation of Catalan Modernistes, were independent, but most came from two sources: the Colla del Safrà

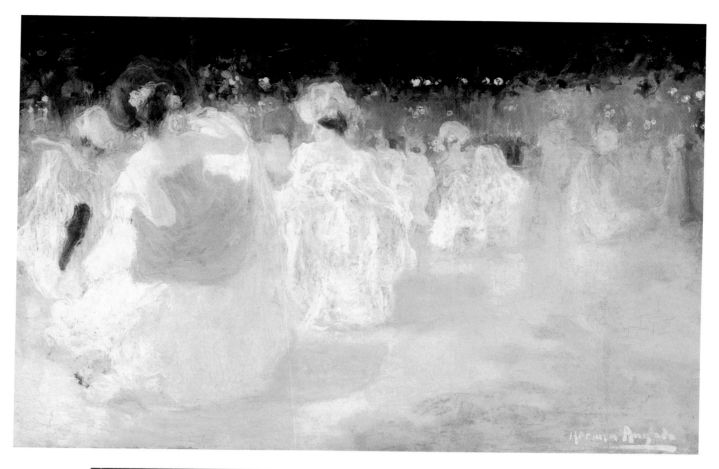

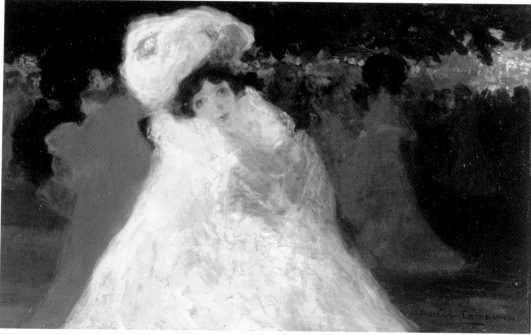

(the Saffron Group) and the Rovell de l'Ou (Egg Yolk) group, both informal associations of young artists who had met as students, the former in the classrooms of La Llotja (the official School of Fine Arts in Barcelona) and the latter at the academy of the old realist patriarch Pere Borrell del Caso. There is no doubt that the first Catalan postmodernista painter to become famous abroad was an independent, Hermen Anglada-Camarasa (figs. 1–4). He was a devoted disciple of Modest Urgell, but his links

Fig. 1 (cat. 2:12). Hermen Anglada-Camarasa, *Lady in Black, with Flowers*, c. 1899–1900.
Fig. 2 (cat. 2:13). Hermen Anglada-Camarasa, *The White Ball*, c. 1900.
Fig. 3 (cat. 2:14). Hermen Anglada-Camarasa, *Paris at Night*, c. 1900.

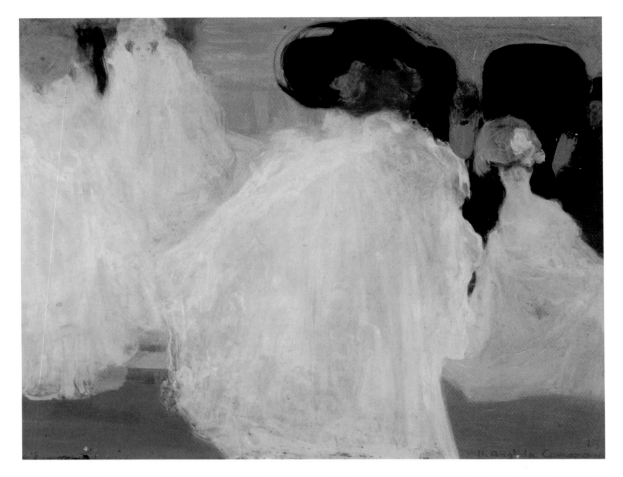

to the Barcelona art world were sporadic because, after a first period as a realist landscape painter in Catalonia, he went to Paris in 1894 and from then on his life unfolded in many places, Barcelona being just one stop along the way.

Anglada frequented the Académie Julian in Paris, where the members of the Nabí group also studied. There he formed a close relation with artists such as the Peruvian Carlos Baca-Flor, who introduced him to Paris nightlife, a milieu he used to create a deliquescent, luminous painting in which the drawing is diluted and everything is expressed through masses of color with sparse details—examples of the pure painting preached by another student of the Académie Julian, Maurice Denis. Anglada's early years in Paris were very difficult, but after 1898 he rose rapidly to the heights everywhere: between 1898 and 1904 he exhibited in Paris—frequently— and in Barcelona, Berlin, Brussels, Ghent, London, Venice, Munich, Düsseldorf, Dresden, and Vienna; his work was the talk of the press all over Europe.

From 1904 he included themes from Spanish folklore, especially from Valencia, though he treat-ed them as a source of dazzling colors, a style that connected him with many names from the Russian avant-garde, with whom he kept in close touch. Between 1905 and 1914 he took part in major exhibitions in Munich, Venice, Paris, Brussels, London, Buenos Aires, Moscow, and Rome—where at the 1911 International Exhibition he shared first prize with Gustav Klimt. By then the modernista period had ended, but his international career continued, especially in the United States and London, where the first major book about his work was published in 1929.[2]

Among the Postmodernistes from the Colla del Safrà, the group of young people who met in the classrooms of La Llotja in the early 1890s and start-ed out painting the suburbs of Barcelona, Joaquim Mir and Isidre Nonell stand out. Mir spent most of the first four years of the 20th century in Majorca, where he created a turbulent, often monumen-tal landscape style—as in the murals for the new Gran Hotel in Palma (1902–3)—which played with strange combinations of color that dissolved con-crete forms, placing his paintings at the gates of ab-

Fig. 4 (cat. 2:15). Hermen Anglada-Camarasa, *Sketch (Figures)*, c. 1900–1901.

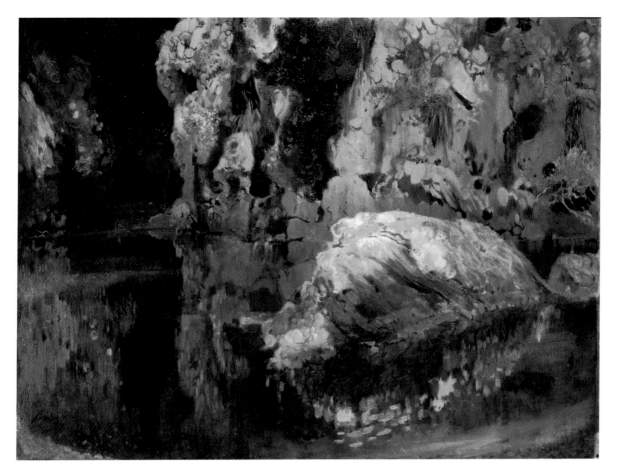

straction (fig. 5). Serious mental problems confined him to the psychiatric institute in Reus, where he fortunately recovered; after being released in 1906, he spent several years painting in the countryside near Tarragona. Many consider this his finest period, when he played with stains of color and made an extraordinary contribution to international Impressionism, with which he was nevertheless unfamiliar since he had never been to Paris, the mecca for the artists of his generation.[3]

Nonell, who had been a schoolmate of Mir's when they were children, visited Paris for the first time in 1897. He developed a special expressionism based on scenes of marginal society: gypsies, beggars, defeated soldiers returning from the war in Cuba. In Paris he exhibited frequently, but although showing at the Salon des Impressionistes et Symbolistes and individually at the gallery of Ambroise Vollard, he never achieved

the success of Anglada-Camarasa. Back in Barcelona in 1901, Nonell surprised everyone with his dark, harsh, and enormously expressive oils—serious and vigorous, stripped of all incidental elements—that took as their subjects figures of gypsy women. These paintings made him a controversial artist for the public, but highly respected by those with more advanced tastes, so much so that he became the unspoken leader of the Catalan painting of his day.[4]

Other former members of the Colla del Safrà were also exceptional. Ricard Canals, who went to Paris with Nonell in 1897, became the chronicler of the music halls. Canals's Impressionist style (fig. 6) caught the eye of Paul Durand-Ruel, who became his dealer and organized exhibitions of his work in Paris and also in New York.[5] Another former member of the group, Ramon Pichot, from Barcelona though an adopted resident of the Empordà, was also close-

Fig. 5 (cat. 2:17). Joaquim Mir, *The Rock in the Pond,* c. 1903.
Fig. 6 (cat. 2:11). Ricard Canals, *Interior of a Music Hall,* 1900.

ly linked to the milieu of early Modernisme and constantly seen in Paris. He is now the least remembered of the painters who showed their work in the famous *cage aux fauves* at the Salon d'Automne in 1905, which was the beginning of Fauvism.

Joaquim Sunyer, who was close to the Colla del Safrà, left for Paris in 1896 and won a certain renown with a style halfway between Théophile-Alexandre Steinlen and Pierre Bonnard, while Joaquín Torres-García (the Uruguayan of Catalan origin) declined working in the key of the other Postmodernistes and created a style that over the years made him an apostle of Noucentisme. Other notable painters of the same generation, such as Francesc Xavier Nogués and Feliu Elias, also took some time to achieve distinction and did not find a central place until the flowering of Noucentisme.

The other group of Postmodernistes included the students of the Borrell academy who met in the Barcelona café called El Rovell de l'Ou. During the time they were Pere Borrell's students, they remained true to their master's realist credo. After they discov-

ered Paris, however, they embraced Impressionism with the ardent faith of the convert. Such is the case of Marià Pidelaserra and Pere Ysern, who settled in that city in 1899 and stayed until 1901; Ysern would soon return to spend most of his life in the French capital.[6]

Pidelaserra evolved rapidly when he was back in Barcelona.[7] After his Impressionist period, he adopted one of the clearly individual styles of any Catalan artist or, indeed, of any artist from all of Spain. A solitary stay in the mountains of Montseny in 1903 pointed him toward a style marked by a growing primitivism with pointillist workmanship (fig. 7). Oddly enough, he gave up a very pleasant Impressionism—a style that would undoubtedly have been most profitable and that by then was gaining acceptance among those who had fought it—and embarked on an aesthetic adventure, creating expressionist and barbaric works that were very difficult for the public to digest and that bear witness to the painter's purity and authenticity at the moment of artistic creation.[8]

Fig. 7 (cat. 2:16). Marià Pidelaserra, *Mountains from the Montseny. Calm Day in the Morning*, 1903.

The most important painter of this generation was the youngest of all, Pablo Picasso, who had lived in Barcelona since age 13 and whose father taught at La Llojta. What transformed a young apprentice painter like Picasso from a conservative position into the great apostle of modernity was the very world of Catalan Modernisme in which he was steeped, especially at the Quatre Gats, the Barcelona café for artists and intellectuals that became the focus of the ferment of cultural modernity in Catalonia.[9] He had his first solo exhibition there in February 1900; it consisted mostly of a gallery of charcoal portraits with touches of color clearly inspired by those that Ramon Casas, the standard-bearer of Modernisme, had just presented in public.

In July of the same year, Picasso had another exhibition at the Quatre Gats at which he showed some distinctive, original bull-fighting scenes; the use of color was free and the effect totally modern. What had happened to bring about that change of direction in the young painter's style? His first exhibition had caught the eye of the regulars of the café: he met Rusiñol, Mir, Pichot, and Casas, whom he admired so much, and they welcomed him warmly. Also, in May at the Sala Parés in Barcelona, a solo exhibition by Anglada-Camarasa, who by now had been living in Paris for years, brought together the entirety of his new, innovative paintings for the first time. The exhibition had a tremendous impact in Barcelona and the critic Alfredo Opisso described it as the presentation of neo-Impressionism in the city, by which he meant not a specific tendency, but a style that went beyond Impressionism. Picasso, who on the occasion of Anglada's stay in Barcelona did three portraits of him in ink and watercolor (see fig. 19, p. 87), clearly showed the influence of the older artist's visual message, which pointed him definitively toward his own modern style.

From then on, Picasso embraced an explosive pre-fauvist color that he showed at the Vollard gallery in Paris in 1901, the starting point of his international career as the most innovative artist of the 20th century (figs. 8 and 9). He lived for a few more years in Barcelona, making excursions to Paris.

Fig. 8 (cat. 2:9). Pablo Picasso, *The Moulin de la Galette*, 1900.

This was the time of his anguished, symbolist Blue Period, which contrasts so strongly with the joyful outbursts of the previous one. But in 1904, stifled in a Barcelona that had abruptly lost the artistic thrust of the great moment of Modernisme, he settled in Paris for good.[10]

In general, fate did not smile on any of the postmodernista painters in Catalonia. Anglada-Camarasa not only stayed in Paris but took French citizenship, returning only when forced to do so by the First World War; he eventually ended up living in Majorca. Picasso left, Ysern settled in Paris, and Canals did not return until 1907. Sunyer stayed in Paris, returning only in 1911 to lead the new painting of Noucentisme. Mir went mad and his recovery kept him far from the din of Barcelona. Nonell did stay on in Barcelona, but he endured difficult years when his art was not valued. Pidelaserra, annoyed by the poor reception given to his new style, more or less withdrew to the family industry and did not return to painting actively until 20 years later.

1. Francesc Fontbona, "Concepto del postmodernismo catalán," in XXIII Congreso Internacional de Historia del Arte. Ponencias y Comunicaciones (Granada: Universidad de Granada, 1979), 387–92.

2. S. Hutchinson Harris, The Art of H. Anglada Camarasa. A Study in Modern Art (London: Leicester Galleries, 1929). The most complete monograph, with a catalogue raisonné of the paintings, is Fontbona and Francesc Miralles, Anglada-Camarasa (Barcelona: Polígrafa, 1981).

3. The most complete book about the painter is still Enric Jardí, Joaquim Mir (Barcelona: Polígrafa, 1989). New partial catalogues raisonnés have begun to appear, however, such as Miralles, Joaquim Mir al Camp de Tarragona (Tarragona/Barcelona: Diputació de Tarragona/Columna, 1998).

4. The most complete monograph on the artist is Jardí, Nonell (Barcelona: Polígrafa, 1984). More information about him is available in Cristina Mendoza and Mercè Doñate, eds., Isidre A. Nonell, 1872–1911, exh. cat. (Barcelona/Madrid: Museu Nacional d'Art de Catalunya/Fundación Cultural Mapfre Vida, 2000).

5. Jaume Socias Palau, Canals (Madrid: Espasa-Calpe, 1976).

6. Rafael Manzano, Pere Ysern Alié 1875–1946 (Barcelona: Edicions Catalanes, 1990).

7. Fontbona, "Marian Pidelaserra à Paris (1899–1901)," Gazette des Beaux-Arts, no. 1317 (October 1978): 141–46.

8. On the painter, see Josep Casamartina et al., Marian Pidelaserra 1877–1946, exh. cat. (Barcelona/Madrid: Museu Nacional d'Art de Catalunya/Fundación Cultural Mapfre Vida, 2002).

9. See Marilyn McCully, ed., Els Quatre Gats: Art in Barcelona around 1900, exh. cat. (Princeton: Art Museum, Princeton University, 1978).

10. The bibliography for Picasso is vast. On the Catalan Picasso, the classic work is Josep Palau i Fabre, Picasso, the Early Years, 1881–1907 (New York: Rizzoli, 1981).

Translated by Richard Jacques.

Fig. 9 (cat. 2:10). Pablo Picasso, The End of the Act, c. 1901.

# Modernista Illustrated Magazines

ELISEU TRENC

In the late 19th century a dramatic shift occurred in the graphic arts, which went from family business activities to commercial enterprises run on an industrial scale. This growth was due in part to the advent of the industrial era, in which new machinery along with technological and scientific advances revolutionized production processes. The other major factor was the change in the structure of Catalan society.[1] The population of Barcelona, for example, rose from 183,000 inhabitants in 1857 to 509,000 by 1899, giving rise to a new readership coming mostly from a petite bourgeoisie hungry for culture. These new readers, in the main women, prompted a remarkable increase in book publishing and made serialized novel publishers rich. Also affected by the same developments, newspapers became more mechanized in order to respond to rising readership: production times became shorter and print runs grew.

Illustrated and recreational magazines, as well as literary and artistic journals, flourished in the late 19th century thanks to the invention and industrial use of photomechanical reproduction processes. These publications reflected the philosophical and aesthetic concerns of a Catalan society that had, in the previous 50 years, undergone a change in its outlook: from a simple stirring of identity consciousness during the Renaixença, when the country had rediscovered its medieval splendor, Catalonia had joined the flow of European avant-garde culture to an extent unknown elsewhere in the Iberian Peninsula.

The widespread introduction of three-color printing in the 1890s led to the appearance of a vast number of illustrated journals in Europe and the United States. Barcelona too followed the trend. This new technique came into use at the same time as the emergence of the international artistic movement Art Nouveau, known in Catalonia as Modernisme. Unsurprisingly, this style was adopted by many publications produced in Barcelona to the extent that it became their hallmark of the period. A surprisingly high number of illustrated magazines (more than 20) was published in the city between 1893 and 1907. In order to analyze these magazines, distinguishing between general information magazines and literary or artistic journals is useful, even though the difference is not always immediately apparent. Moreover, some pseudoliterary and artistic periodicals, such as *Hispania*, were more recreational or commercial than purely artistic in purpose.

Several modernista magazines covering general information, such as *La Ilustració Catalana* and *La Ilustración Artística*, were first issued in the 1880s, making them among the oldest in the city. Published by Montaner y Simón, *La Ilustración Artística* preserved its traditional, classic appearance, a sign of good taste and seriousness that was essential for any publication that wished to retain a conservative, bourgeois readership. The exception to this rule were the special New Year's issues, the first of which was published in 1895, when Alexandre de Riquer drew allegorical covers and also decorated the inside pages with illustrations using richly colored floral motifs that bore no relation whatsoever to the content of the articles. In 1899, 1900, and 1903, Josep Triadó was commissioned to produce the New Year's issues. He decorated them in his characteristic Gothic Revival style and then later in his Japanese manner, which was also essentially ornamental. Even though Riquer's decorative illustrations in 1895, 1897, and 1898 were the first examples in Catalonia of a new concept and new technique in illustration, they were, as far as the publishers of *La Ilustración Artística* were concerned, a concession to fashion, a modernization of the magazine's appearance reserved for certain specific issues in which a classic text from Catalonia's Golden Age merged incongruously with the decorative plant motifs of Art Nouveau. The same could also be said of *Il·lustració Catalana* during its second period, 1903–17, which was a kind of modernization of the former magazine *La Ilustració Catalana* of 1880–94. Despite the lavish use of prints, the magazine remained relatively well balanced and retained its classical air. The illustra-

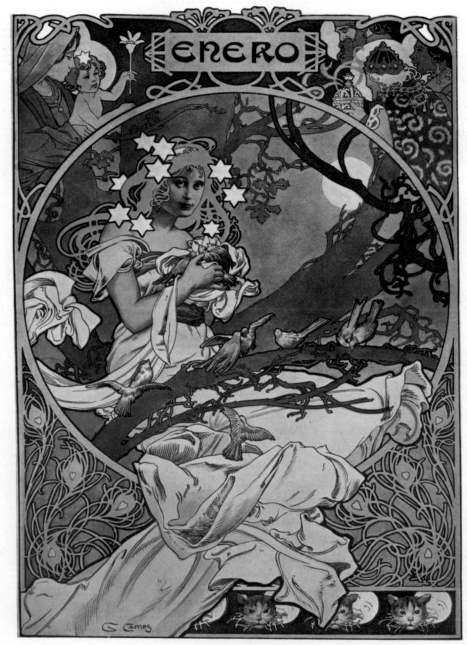

ALEGORIA DEL MES DE ENERO

Fig. 1 (cat. 2:24). Gaspar Camps, *Allegory of the Month of January,* illustration for *Album Salón* (January 1901).

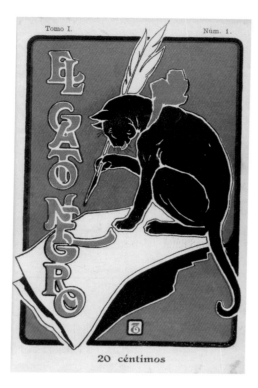

tions were perfectly framed and always appeared separate from the text itself, which was printed in a clean, well-formed typeface without ornamentation of any kind. An exception, the women's supplement to the magazine entitled *Feminal* (in which the latest trends in furnishings, jewelry, and clothing were an essential element demonstrating that Barcelona society was keeping up with the modern trends in Europe) was modernista in appearance.

In addition to these magazines, with their traditional, classic presentation, as indicated by titles incorporating the word "Il·lustració," others were more modern in appearance, a combination of part general information magazine and part literary artistic journal. These highly modernista publications include *Album Salón* of 1897–1907 (fig. 1) and *Pluma y Lápiz* of 1900–1905, both published by Miquel Seguí; *El Gato Negro* and *Hispania* of 1899–1902 (figs. 2, 3), published by the lithographer and bookbinder Ermenegild Miralles; and *Hojas Selectas* of 1902–21, published by the Salvat company. In all these magazines there was a kind of divorce between the literary and journalistic content (in the main anecdotal information rather than news), the illustrations for the short stories and articles (most of which by far were still realistic in style), and the very diverse range of reproductions of drawings, watercolors, and paintings. The illustrations were produced by a

wide variety of artists—from conventional painters, who produced works in a kind of saccharine pseudo-realism, to the Catalan artists who were the true innovators of Modernisme. Some magazines, such as *Album Salón, Pluma y Lápiz, El Gato Negro, Hispania, Hojas Selectas,* and *Feminal,* specialized in floral decorations and scrollwork borders done in the graphic aesthetic of Art Nouveau, not by illustrators but by decorators and designers, including J. Diéguez, Josep de Passos, Josep Pascó, Triadó, Josep Guardiola, Modest de Casademunt, and Gaspar Camps, who was known as the Catalan Mucha (a reference to the Czech artist Alphonse Mucha).

That *La Ilustración Artística* reserved its Art Nouveau decoration for its special New Year's issues and that *Il·lustració Catalana* had decorative elements of this nature only in its *Feminal* supplement leads to the conclusion that this phenomenon was related to fashion, with all the imitation and superficiality that such a connection entails. In other words, it is reasonable to say, in relation to these general information magazines published in Barcelona (as I have already remarked in my study on the appearance of the Madrid magazine *Blanco y Negro*),[2] that though these illustrations may look modern because of their ornamental Art Nouveau aesthetic, they nevertheless remain a superficial image of modernity.

The panorama of the truly artistic and literary

Fig. 2. *El Gato Negro* 1, no. 1 (15 January 1898), frontispiece by Josep Triadó.
Fig. 3. *Hispania*, no. 16 (15 October 1899), cover by Joan Llimona.

journals was somewhat different. Because these journals were published by writers and artists, they did not have the same commercial commitments as general information magazines. The essential difference between them, however, lies perhaps in the fact that literary and artistic journals were very similar, whereas general information magazines were diverse. In the artistic and literary journals, there is no divergence between classic articles or those dealing in

a realistic manner with local customs, on the one hand, and the modernista illustrations, on the other. These journals were founded on the principle of the present, a contemporary art synonymous with modernity, and hence their contributors consisted solely of men of letters and artists committed to the new movement of Modernisme. Identifying two large groups of magazines within the overall field is possible: first are the magazines in which Art Nouveau is obvious in the decorative details, such as *Joventut, La Ilustració Llevantina, Catalunya Artística, Garba,* and perhaps the most representative and the most symbolist of all, *Luz;* second are the two journals produced by Miquel Utrillo and Ramon Casas

working together, *Quatre Gats* and *Pèl & Ploma,* which brought to Barcelona a new breath of modernity in the form of the naturalistic and synthetic style created by Henri de Toulouse-Lautrec and Théophile-Alexandre Steinlen, and which spread through journals in Paris such as *Gil Blas.*

La Ilustració Llevantina of 1900–1901 and *Catalunya Artística* of 1900–1905 were similar to *Hispania* and *Pluma y Lápiz* in that they shared the same modernista decoration, the difference resting, as I mentioned earlier, in the unity between content and form, and in the modernity of the journals that carried only the work of contemporary and innovative artists.

At first sight, *Joventut* of 1900–1906 (fig. 4) might appear to closely resemble *La Ilustración*

*Artística* and *Il·lustració Catalana,* as they adopted the same formula: the classic appearance with text laid out in two columns and a limited number of illustrations, apart from the six New Year's issues and the *Suplements Artístichs.* The first distinction, though, is that *Joventut* was first and foremost a literary journal. As a result, there was no illustration in the "normal" issues apart from the symbolist masthead, the work of Riquer, and some of the vignettes and decorative capital letters, again by Riquer and Apel·les Mestres. Consequently, there was no realistic or academic illustration alongside modernista illustration or decorative elements. Further, in the New Year's issues the *Joventut* publishers unquestionably sought to achieve the same appeal as general information magazines, but the text and images are presented in a different way. The pages combining certain poems of the time by Joan Maragall, Àngel Guimerà, Josep Martí i Folgueras, and Joan Oliva Bridgman with illustrations by Riquer, Joan Brull, A. Solé i Pla, and the young Pablo Picasso offer good examples. In other words, these journals were not simply following a fashion by using Art Nouveau in an arbitrary manner. Instead, they aimed to create a total work of art by fusing the words and images. As their name suggests, the artistic supplements complemented the main section of the publication. Because *Joventut* aspired to the status of an artistic journal, as well as a literary and scientific magazine with a strong Catalan identity, it had to raise awareness of both international and Catalan art of the day. Its images have an intrinsic aesthetic value of their own and were not regarded as a commercial lure appealing to the unsophisticated reader. As Miralles, the editor of *Hispania,* wrote in a letter to Raimon Casellas, the journal's art director, "Have no color whatsoever on the inside pages, only on the front and back pages for the simpletons."[3]

Fig. 4 (cat. 2:23). Adrià Gual, cover for *Joventut* (1902).
Fig. 5 (cat. 2:25). Adrià Gual, illustration for a poem by Pompeu Crehuet in *Garba* 1, no. 6 (30 December 1905).

*Garba, Revista setmanal d'Art, Literatura y Actualitats* (fig. 5), a short-lived publication (November 1905–February 1906), was conventional in its overall appearance but extremely topical in its themes. The pages in which Adrià Gual decorated poems by contemporary authors by setting them in rectangular frames decorated with floral motifs in two or three inks are especially successful. Following Gual's example, Lluís Masriera and Dionís Baixeras also produced illustrations for poems in which they merged the words and the image.

Relatively small for a journal of its nature, *Garba* was almost square in shape (23.5 x 24 cm), while *Luz* of 1897–98 (figs. 6 and 7) adopted the longer format characteristic of modernista book publishing that was almost three times as high as it was wide (33.1 x 12.8 cm). As a magazine, *Luz* was the most homogeneous, free, and original of its time, at least from the formal point of view. In it there is an almost perfect partnership among the contents; an openly symbolist spirit; and decorative illustration done almost entirely by the editor, Josep M. Roviralta, and Riquer. By means of the enclosed look, the narrow vertical format, the two-dimensionality, and the large monochrome areas formed by inks in cold colors, often blue, mauve, or green, Riquer based his work on the antirealist and symbolist concept itself of the texts. *Luz*—an emblematic title since it referred to the mysterious light of the ideal—was a journal committed to modernity and in particular to Symbolism in Catalonia and Europe, as indicated by its subtitle *Arte Moderno*. The magazine carried illustrations by Santiago Rusiñol, Gual, and Riquer, and also raised the Catalan public's awareness of the work of Eugène Grasset, Pierre Puvis de Chavannes, and other foreign artists and writers. Nevertheless, the magazine was not solely symbolist in

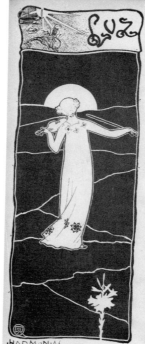

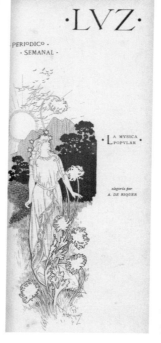

style. Even though it may seem odd to us—though it was common at the time, perhaps because of the Decadent style at the turn of the century and because the magazine was committed to modernity—we find an article entitled "Arte Nuevo" about Isidre Nonell and his "Miserabilism" along with "España negra" (Black Spain) by Émile Verhaeren, "tremendista" notes from his travels translated from the French with illustrations by Darío de Regoyos.[4]

Within the panorama of Catalan Modernisme, the journals *Quatre Gats* of 1899 and *Pèl & Ploma* of 1899–1903 represent the French realist and synthetic school of the art of Toulouse-Lautrec and Steinlen, embodied in Barcelona principally by Ramon Casas. It could even be said that these journals were *montmartraises*: just as the cabarets Le Chat Noir, Le Mirliton, Le Divan Japonais, and les Quatr'z'Arts published journals named after themselves,[5] so the Catalan café Quatre Gats published its own journal with its name as the title (see figs. 4–6, p. 95). *Quatre Gats* and *Pèl & Ploma* (figs. 8–10) were different from the other magazines because they were essentially artistic rather than literary journals and because, as far as the art content was concerned, they rejected what they considered the overly decorative nature of Art Nouveau and hence refused to follow commercial trends. Moreover, they were consistent in rejecting all past art and in condemning academic art, which they considered artificial and sclerotic. Their intention was to pursue the new and innovative; hence, the second period of *Pèl & Ploma*, which ran from June 1901 to December 1903, was notable for its richness of form: alongside the realist, synthetic drawings of Casas are the Vitalism of Josep Maria Xiró Taltabull, the frenzied Symbolism of Lluís Bonnín, and the evanescent Symbolism of Riquer—in other words,

Fig. 6 (cat. 2:18). Josep M. Roviralta, *Harmonies,* cover for *Luz* (2nd week of October 1898).
Fig. 7 (cat. 2:19). Alexandre de Riquer, *Allegory,* cover for *Luz* (3rd week of October 1898).

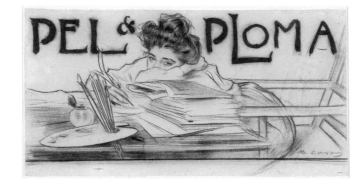

the entire spectrum of Modernisme in art, given that the journal also produced monographic issues on Joaquín Torres-García, Joaquim Mir, Eliseu Meifrèn, Rusiñol, and others.

Some of the finest exponents of Modernisme in Catalonia worked in the sphere of architecture, such as Lluís Domènech i Montaner, Josep Puig i Cadafalch, and the genius Antoni Gaudí, all of whose work has singular character. As a result, the other realms of modernista art have often been dismissed as they do not generally seem to be as original. Yet a distinction must be made between imitation and plagiarism, which are superficial and never of the quality of the copied original, and a much more authentic re-creation following the adoption of a model and its adaptation to the local cultural history.

Imitation arises from an urge to follow a particular fashion. In the case of magazines, editors and owners looked to international precedents when setting up their own publications. Miralles, for example, wanted *Hispania* to resemble the successful German magazine *Jugend*. Most of the magazines from the modernista era, whether of the general information or artistic literary variety, were a new genre, different from the earlier illustrated magazines. The sources on which these Catalan journals drew include *The Studio,* published in England from 1893, which proved very influential at the time; *Jugend* from Germany, which first appeared in 1896; and *Art et Décoration* and *Gil Blas* from France. These European journals shared a number of formal characteristics: they were smaller than illustrated maga-

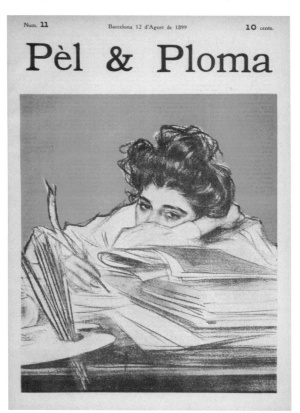

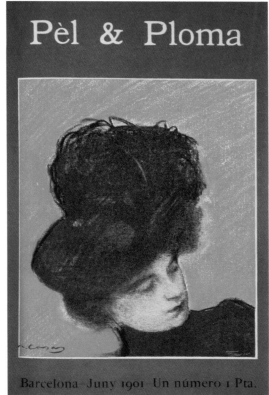

Fig. 8 (cat. 2:20). Ramon Casas, masthead design for *Pèl & Ploma*, 1899.
Fig. 9 (cat. 2:21). Ramon Casas, cover for *Pèl & Ploma* 1, no. 11 (12 August 1899).
Fig. 10 (cat. 2:22). Ramon Casas, cover for *Pèl & Ploma* 3, no. 16 (June 1901–May 1902).

zines; they included more illustrations in relation to the amount of text; they took a new approach to assembling the pages by combining images and text; and they established a purely decorative concept of the image in which Art Nouveau played an important part. In this formal aspect of the appearance of the magazines, the Barcelona journals were not truly original compared to European magazines, with the possible exception, perhaps, of *Luz,* with its unusual format and page layout. If there is a difference between imitation and re-creation, it lies in the Catalan artists commissioned to provide the decorative features of these modern magazines. First, there were the highly accomplished draftsmen, such as Triadó, Diéguez, Guardiola, Enric Moyà, and Argemí, on whom the editors could call for borders. Next were the Art Nouveau vignettes in a style very similar to those produced by Otto Eckmann and Hans Christiansen (who provided decorative motifs for *Jugend*). Finally came Camps and other decorative artists whose work featured mainly in general interest magazines but also in artistic and literary journals such as *La Ilustració Llevantina, Catalunya Artística,* and *Garba.* Very often artists from a previous generation, who trained during the period of Aestheticism in the 1870s and 1880s, are included in this group: de Passos, Mestres, and above all Pascó.[6] Pascó's idiosyncratic style resulted from his blend of Gothic Revival and the Japanese manner that was highly characteristic of Aestheticism. His iconography, based on animals and plants, was austere since his works tended to show a preference for cardoons and dragons, which he drew in a part medieval, part Oriental manner that was very different from the evanescence of Art Nouveau.

Artists such as Mestres remained faithful to Aestheticism while others, including Passos and Pascó, evolved toward a moderate Modernisme but continued to treat forms in a realistic manner.

They were not simple imitators of international Art Nouveau since they drew on a genuine protoform of Modernisme that developed in Catalonia itself. Nor were the great symbolist artists and poets of the period, Riquer and Gual, mere imitators. Though Riquer took his inspiration from the British Pre-Raphaelites, his aestheticist training alongside Mestres gave a local flavor to the plants and landscapes in his compositions, thereby resulting in his personal style (see fig. 7). With regard to Gual, the poetic nature of his ornamental floral pieces, which often accompanied works of poetry published in *Garba, Hojas Selectas,* and *Joventut,* reveals his elegant, evanescent personality and his highly individual sense and use of color (see fig. 4).

A number of other artists who also worked in the symbolist manner were less prolific but nevertheless had clearly identifiable personalities. They include Bonnín and Ramon Pichot, who illustrated *Catalònia,* a magazine that was effectively a continuation of *L'Avenç,*[7] and the very young Josep M. Roviralta, who worked with Riquer on the decoration of *Luz* (see fig. 6). Casas is highly regarded for his use of bright colors applied in such a way as to create uniform patches in the background and his new approach to drawing with a cursive, dynamic, synthetic quality, which he brought to Barcelona from Paris. These truly modern traits contrast with the detail, finish, and accurate outline of the forms of the Realism that went before. Yet are they original? A consideration of the style of drawing of Steinlen (the great illustrator of *Gil Blas*), of Toulouse-Lautrec, or Forain immediately reveals the influences on Casas's art. His innovation was in adapting the modern art of Paris to the climate in Barcelona and thereby modernizing the panorama of Catalan graphic art. To a large extent, the same could also be said of Nonell and the young modernista Picasso before his trips to Paris from 1900 onward.

1. Eliseu Trenc Ballester, *Les arts gràfiques de l'època modernista a Barcelona* (Barcelona: Gremi d'Indústries Gràfiques de Barcelona i Província, 1977).

2. Trenc, "La modernité de l'image ou une image de Modernité," in *Le projet national de Blanco y Negro (1891–1917),* ed. Danièle Bussy Genevoix (Saint-Denis: Université Paris 8, 2001), 99–111.

3. Jordi Castellanos, *Raimon Casellas i el Modernisme* (Barcelona: Curial i Publicacions de l'Abadia de Montserrat, 1983), 1:266.

4. "Tremendismo" is a characteristic of Spanish modern fiction, an extension of 19th-century Realism and Naturalism, with a stress on violence, misery, and terror.

5. See Mariel Oberthür, *Montmartre en liesse: 1880–1900* (Paris: Paris-Musées, 1994).

6. Aitor Quiney, *Hermenegildo Miralles, arts gràfiques i enquadernació,* exh. cat. (Barcelona: Biblioteca de Catalunya, 2005), 98.

7. For a discussion of *L'Avenç,* one of the leading periodicals published in Barcelona during the 19th century, see "Greeting the Dawn" by Jordi Falgàs, in section one of this catalogue.

Translated by Susan Brownbridge.

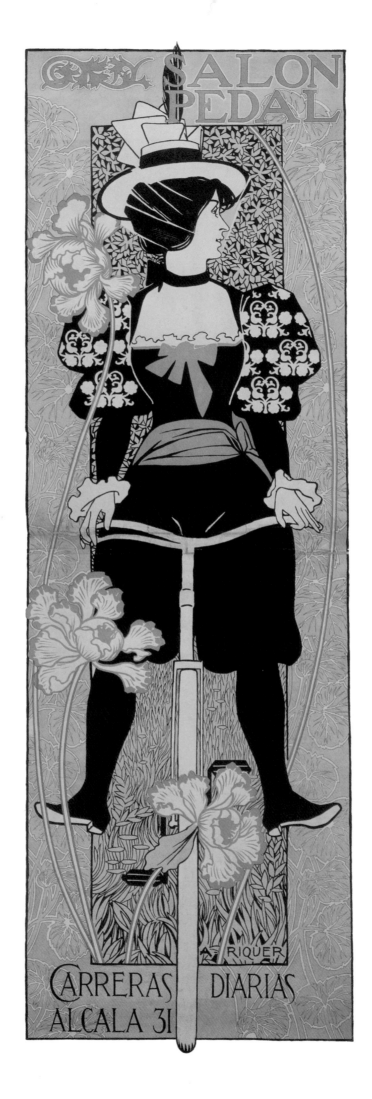

# The Art of the Poster

FRANCESC M. QUÍLEZ I CORELLA

Posters, a true sounding board for artistic developments in turn-of-the-century Barcelona, played a part in the renewal of Catalan figurative art. The artists' receptive attitude toward incorporating new styles showed their desire to go beyond the formulas and mannerisms of the archaic language that had ruled artistic expression before the appearance of Modernisme.[1] Some of the most authoritative voices in the Barcelona press of the time attributed to posters both artistic merit and a decisive role in the transformation of the visual arts. Yet what ultimately dazzled these writers were the expressive possibilities and the advertising function of a medium that was, paradoxically, ephemeral. That posters were functional did not harm their artistic value in the least, and by 1898 they had gained status within the artistic terrain of Barcelona. Among others, Francesc Miquel i Badia, the leading representative of official Barcelona art and critic for *Diario de Barcelona,* praised this innovative cultural development.[2]

On 3 December 1896 an exhibition opened in the Sala Parés that was enormously important in diffusing this new artistic sensibility. On view were a large number of examples from the most eminent contemporary practitioners of European poster making, including Jules Chéret, Eugène Grasset, Henri de Toulouse-Lautrec, Pierre Puvis de Chavannes, Jean-Louis Forain, Dudley Hardy, and John Hassall. Along with this notable collection of posters, many illustrated magazines could also be admired.[3] The exhibition thus helped awaken the interest of a wider public in the poster as an art form and enlivened the modes of Catalan artists of the time.

The artists dedicated to the art of the poster centered around the first generation of modernista artists, whose introspective and exotic subjects showed the influence of Symbolism; the naturalistic painting style of the Pre-Raphaelites was also significant. Scholars such as Rafael Cornudella and Eliseu Trenc have shown that Alexandre de Riquer, among others, took his inspiration from English graphic art, which had medieval origins and was devoted to the arabesque.[4] Riquer, one of the most representative figures of poster making at the end of the 19th century, is considered a precursor of the new Catalan graphic art; the neomedieval influence is striking in his ex libris (bookplates), created over a long career.[5]

Yet the approaches of the period's first poster artists cannot be reduced to a single influence or point of departure. Instead, currents, movements, and artistic models from England, Belgium, France, and Austria intermingled. There is little evidence of a specific Catalan style as far as posters are concerned, and, with a few notable exceptions, most artists produced a subordinate, scarcely original graphic art. Imported models using the organic imagery and flowing lines of what came to be known as Art Nouveau—or, its Viennese variant, Jugendstil—were used to satisfy the advertising demands of Catalan businesses. Further, some of the most important posters had a cultural dimension: many publicized public or private art exhibits, organized by Barcelona's city council to promote artistic and industrial products, that took place in the city throughout the 1890s.[6] Some of these posters confirm both the beneficial effects and the stimulus of avant-garde European models. The profound difference between two of the most prolific artists of this first phase may serve as an example.

Artist, draftsman, and illustrator Josep Lluís Pellicer—the creator, among others, of the poster projects for Barcelona's Universal Exposition of 1888 and Exposition of Fine and Industrial Arts of 1892—was firmly rooted in the formulations and inertia of 1890s tradition. His posters are highly circumspect and saturated with extremely outdated language. Alexandre de Riquer worked on the poster for the Third Exposition of Fine and Industrial Arts held in Barcelona in 1896. Riquer's work, more innovative than that of Pellicer, reveals his desire to rejuvenate the figurative repertoire of the reigning Catalan artists. Riquer incorporated elements from many diverse influences; this ability to assimilate a range

Fig. 1 (cat. 2:26). Alexandre de Riquer, *Salon Pedal,* 1897.

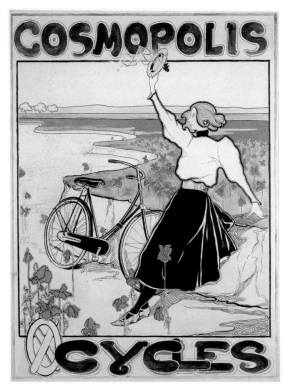

for ornament: the floral motifs here are similar to those he used in the original project, an 1895 poster design for Barcelona's Third Exposition of Fine and Industrial Arts. *The Guilty Woman*, 1899 (fig. 3), advertised a play that premiered on 18 December 1899, performed by Teatre Íntim, a company Gual had created earlier that year.[7] A model of self-sufficiency, Gual publicized his theatrical adaptations using posters he designed and then printed in his lithographic workshop. Yet elements such as the melancholy female figure in the foreground contrast vividly with the carefree figure in the *Cosmopolis* poster and indicate his interest in Symbolism.

These echoes of Symbolism are also obvious in Santiago Rusiñol's *Pages of Life*, 1898 (fig. 4), a work very close to the melancholy tone of painters

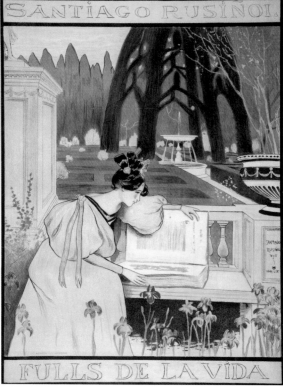

of styles helped him produce highly creative works and put an end to the banal, literary quality that had dominated poster aesthetics until then. As an example and as others have already noted, *Salon Pedal*, 1897 (fig. 1), evokes Japanese printmaking. Further, the theme of the work is a declaration of modernity and, as one of the most eloquent expressions of the new artistic sensibility, formed part of the collective imagination of the period.

Also illustrating this theme is *Cosmopolis Cycles*, 1898 (fig. 2). Created by the dramatist and stage manager Adrià Gual, the work uses highly synthetic formal language and borrowings from other European artists. The carefree and playful image of the female model depicted in a rural setting reflects fin-de-siècle taste. Gual also had a penchant

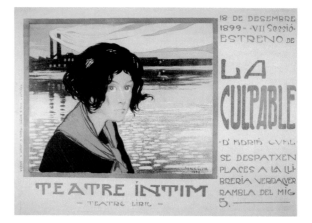

working in the decadent style. Completed in 1898 on the occasion of the publication of the literary work of the same title, the composition was made into a lithograph in the workshop of Rusiñol's friend Miquel Utrillo. The poster shows a sole female figure reading a book on a terrace overlooking an empty garden, thus offering a counterpoint between two manifestations of beauty: nature and human. The seated figure, reminiscent of the model Ramon Casas used in his popular 1899 drawing for a cover of

Fig. 2 (cat. 2:27). Adrià Gual, design for *Cosmopolis Cycles Poster*, 1898.
Fig. 3 (cat. 2:28). Adrià Gual, *The Guilty Woman*, 1899.
Fig. 4 (cat. 2:29). Santiago Rusiñol, with Miquel Utrillo, *Pages of Life*, 1898.

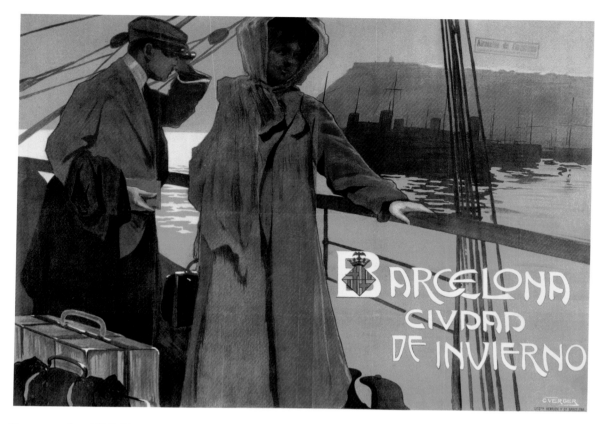

the magazine *Pèl & Ploma,* is enveloped in her own thoughts. Scenes of gardens are frequent in Rusiñol's art, and although the landscape does not correspond to a specific place, there are motifs and references drawn from his visits to Granada. For example, the fountain and the bower of arched cypresses are actual elements of the Generalife gardens and can also be found in Rusiñol's paintings made on trips to the city. The work that has the most components in common is *Fountains of the Generalife,* 1895–98 (private collection).[8]

Carlos Verger's poster *Barcelona, City of Winter,* 1909 (fig. 5), was made to promote tourism. In September 1908, the city government convened an international poster contest to promote Barcelona as a winter tourist center. Declaring the first prize unresolved, the jury convened another contest in March 1909; once again, it was impossible to name a winner. Finally, a decision was made to divide the 5,000 peseta prize equally among five artists: John Hassall, Josep Beltran, Josep Triadó, Julià Vals, and Carlos Verger. Verger, like the others, was awarded 1,000 pesetas, but the Commission for the Attraction of Foreigners and Tourists decided to print only those by Hassall and Verger.[9] Verger had selected Montjuïc, one of the icons of the city, and the mouth of the harbor as the setting for his elegant travelers; the scene conveys the sophistication and refinement of the Belle Epoque.

1. Eliseo Trenc Ballester, *Les arts gràfiques de l'època modernista a Barcelona* (Barcelona: Gremi d'Indústries Gràfiques, 1977); V. Salom Vidal, "El cartel modernista catalán," *D'Art* 5 (September 1979): 78–101; Jordi Carulla, ed., *Catalunya en 1000 cartells: des dels orígens fins a la Guerra Civil* (Barcelona: Postermil, 1994); S. Barjau, "La renovació del llibre i les arts gràfiques," in *Pintura i dibuix,* ed. Francesc Fontbona, vol. 3 of *El Modernisme* (Barcelona: L'isard, 2003), 149–62.

2. F. Miquel y Badía, "Los carteles y el arte popular," *Diario de Barcelona,* 13 April 1898, 4342–344.

3. *La Ilustración Artística,* no. 780 (7 December 1896): 826.

4. Rafael Cornudella, "Sobre els cartells d'Alexandre de Riquer i les seves fonts," *Locus Amoenus* 1 (1995): 227–47; Trenc, *Alexandre de Riquer* (Barcelona: Caixaterrassa/Lunwerg, 2000).

5. Pilar Vélez, *El llibre com a obra d'art a la Catalunya vuitcentista, 1850–1910* (Barcelona: Biblioteca de Catalunya, 1989); J. LL. de Yebra, "El gravat i l'exlibris," in *Pintura i dibuix,* 163–76.

6. Cecília Vidal and Carme Pujiula, eds., *Les arts industrials als cartells modernistes,* exh. cat. (Barcelona: Museu Nacional d'Art de Catalunya, 2002).

7. Carles Batlle i Jordà, *Adrià Gual (1891–1902): per un teatre simbolista* (Barcelona: Diputació de Barcelona/Institut del Teatre/Publicacions de l'Abadia de Montserrat, 2001).

8. Margarida Casacuberta, ed., *Els jardins de l'ànima de Santiago Rusiñol* (Girona: Fundació Caixa de Girona, 1999); Josep de C. Laplana and Mercedes Palau-Ribes, *La pintura de Santiago Rusiñol. Obra completa* (Barcelona: Mediterrània, 2004).

9. S. Barjau, "El desenvolupament de la promoció turística de Barcelona i el seu territori (1908–1936)," in ed. J. Roca i Albert, *Expansió urbana i planejament a Barcelona* (Barcelona: Institut Municipal d'Història, 1997), 207–17.

Translated by Vajra Kilgour.

Fig. 5 (cat. 2:30). Carlos Verger, *Barcelona, City of Winter,* 1909.

*MERCÈ DOÑATE*

Modernisme, a cultural movement closely linked to the city of Barcelona, represented a coming together of Catalan art and broader currents prevalent in late 19th-century European art. In due course, it helped modernize the aesthetic premises of the most outstanding Catalan artists of that epoch. This was a crucial period for Catalan sculpture, one of the most brilliant moments in its history. Previously, 19th-century sculptors educated at Barcelona's Escola de Belles Arts felt the need to study in Madrid, a city where their job prospects were much better. Starting with the Universal Exposition of 1888, the urban transformation of Barcelona included numerous monuments. At the same time, the economic and cultural flowering of the Catalan bourgeoisie set off a wave of construction that was extraordinarily beneficial to the sculptors. The production of the most outstanding modernista sculptors was not limited, then, merely to sculpture in the round, known at that time as salon sculpture or collectors' sculpture, but instead included a broad range of possibilities, including architectural decoration (fig. 1). While the works selected for this exhibition are outstanding, they represent only one segment of each sculptor's creative work, and this discussion of modernista sculpture will necessarily include works that cannot be included in a temporary exhibition.

Although the painters Ramon Casas and Santiago Rusiñol were the first to introduce new aesthetic qualities into Catalan art through their controversial joint exhibitions held in Barcelona in the early 1890s, architects played a decisive part in the cohesiveness of Modernisme. The contributions of Lluís Domènech i Montaner, Josep Puig i Cadafalch, and especially, Antoni Gaudí are exceptional. However, sculptors were also working on an extraordinary level, and they created some of their best works to decorate the façades or interiors of the new dwellings of the Catalan bourgeoisie. Purely decorative elements were of course executed in specialized workshops. However, fireplaces, capitals, and over-the-door panels—generally speaking, works of considerable size—were commissioned from the best sculptors of the period. Fortunately, a great many have been preserved in situ, but some significant works disappeared during the urban speculation of the 1960s. Most of the finest mod-

Fig. 1 (cat. 5:35). Eusebi Arnau, *Woman with a Camera* or *Nymph Photographer,* c. 1905.

ernista sculptures were preserved, as is evident in the city's emblematic buildings such as the Palau de la Música Catalana, the Casa Lleó Morera, and the Casa Amatller.[1] Monuments erected during this period have also survived. One of them, Josep Llimona's *Monument to Doctor Robert,* unveiled in 1910 (fig. 2), is not only the best exponent of monumental modernista sculpture but one of the greatest of Barcelona's monuments.[2]

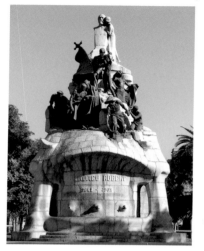

Decorative sculpture, as well as religious, funerary, and monumental works, offered a chance to carry out important commissions, which sculptors would alternate with their more personal work. To make people aware of that facet of their art, they often presented works at official exhibitions in Paris, Madrid, and Barcelona.[3] Some of the finest sculptures were presented at exhibitions in Barcelona, and the 1907 display was especially significant. This exhibition included not only a distinguished group of Impressionist paintings, but also numerous works by French sculptor Auguste Rodin and the Belgian Constantin Meunier. Alongside those works appeared sculptures by the two most paradigmatic leaders of Catalan Modernisme: Llimona's *Grief,* 1907 (fig. 3), and Enric

Clarasó's *Eve,* 1904 (fig. 4). Thus the 1907 exhibition concluded the innovative process initiated in the early 1890s; realistic sculpture turned toward the anecdotal, and conventional themes were much acclaimed by the Barcelona public and most of its art critics. Writing in the most progressive newspapers and magazines, some critics began to encourage a change that would move Catalan art closer to that of the rest of Europe. Outstanding among those critics was Raimon Casellas, who would be the most influential in creating a climate favorable to new artistic concepts. At that time, the art cultivated in the rest of Spain was firmly rooted in 19th-century principles, a far cry from any advanced aesthetics. So it should not come as a surprise that Catalan sculptors, like so many other European artists, found in Paris the referents for placing their own work on the road to modernity. In the creative power of Rodin, they found the inspiration to launch the artistic change that would allow them to be a part of European Symbolism.

Unlike what happened with modernista painting, whose new principles were imposed swiftly, change crystallized slowly in the sculptural sphere, and there were two distinct periods. The first phase

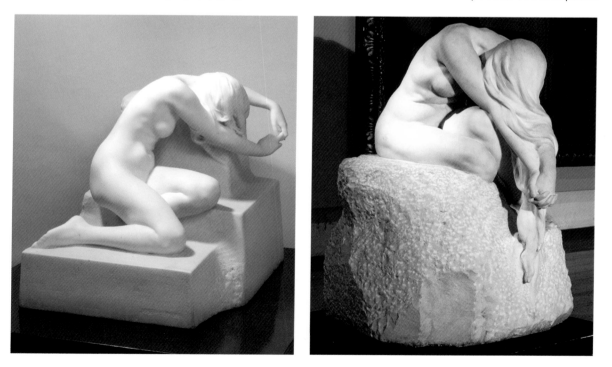

Fig. 2. *Monument to Doctor Robert,* conceived by Josep Llimona in 1903, completed 1910, dismantled 1940, rebuilt 1985.
Fig. 3 (cat. 2:33). Josep Llimona, *Grief,* 1907.
Fig. 4. *Eve,* 1904, by Enric Clarasó.

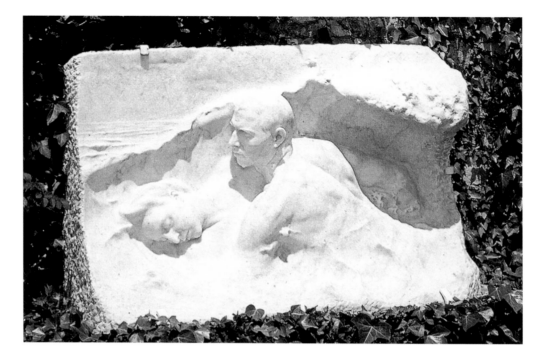

covers the years 1892–1900, during which Llimona, Miquel Blay, Clarasó, and Eusebi Arnau chose to idealize. During this time, they remained faithful to conventional motifs, but they modeled their sculptures with a blurriness that gave the works a novel appearance. After 1900, however, they adopted the symbolist language that gave more cohesion to their work (fig. 5). To understand this change, and more concretely, the earlier idealistic period, we must bear in mind the ardent Catholicism of these artists. They were all members of the Cercle Artístic de Sant Lluc, an artists association inspired by the Christian ideals of 14th-century Sienese painters and founded in 1893 to oversee morality in art.[4] A clause introduced into the bylaws of the Cercle Artístic specifically prohibited working from a nude female model and representing female nudes. A few years later, this provision was repealed upon request of the sculptors. They recognized that the clause constituted a burden on their artwork and placed them

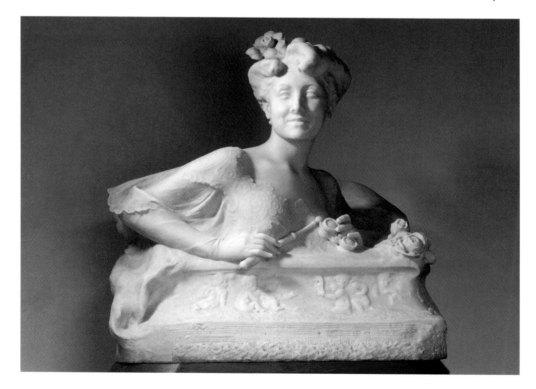

Fig. 5. *The Wave*, 1905, by Eusebi Arnau.
Fig. 6 (cat. 2:31). Eusebi Arnau, *At the Loge*, 1911.

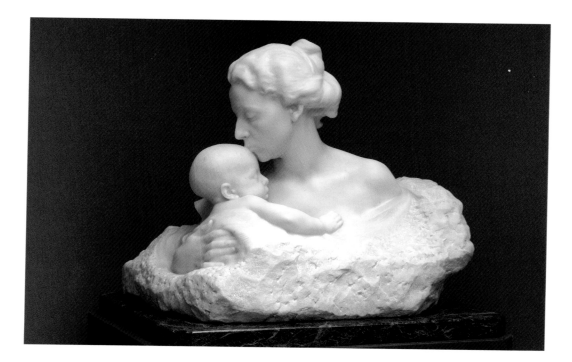

in a disadvantageous position in the art market. This situation became an important factor in their sculpture, fostering an idealism that was unequivocally rooted in Catholicism. They adopted idealism from the beginning and worked it into pieces made with impeccable technique (fig. 6). Although they set a high priority on transmitting intangible feelings, their sculptures suffered from a certain sentimentalism. Arnau's *Mother's Kiss,* 1896 (fig. 7), is one of the most representative sculptures of the time, for both its indisputable formal beauty and the idealization of the motif. Earlier treatments had been banal, with many superfluous details, while *Mother's Kiss* was designed to show a poetic, emotive view of human life. Here, as in some contemporary sculptures by Blay, Clarasó, and Llimona, we see a sublimation of the motif that transcends the human dimension and a certain moral lesson reflecting the Christian ideology of the Cercle Artístic de Sant Lluc.[5]

In the early 20th century, leading Catalan sculptors made a significant change in direction that eventually developed into a new sculptural movement emphasizing symbolist forms. Although European art had already begun to move beyond Symbolism, in Catalonia and to a greater extent throughout Spain, these works were innovative and represented a break with the past. Two factors were decisive in the sculptural evolution that crystallized in Symbolism: the rise of funerary sculpture and, noted above, the influence of Rodin. The specific characteristics of funerary sculpture, a genre that reached its greatest splendor during the modernista era, influenced the decision to adopt a female model that externalized spirituality through various forms and poses.[6] However, the predominant female figures were elongated, with round shoulders and long hair, and dressed in tunics flowing directly from their skin. The sculptors created suggestive figures of angels or virtues consoling women afflicted by great pain. Such allegorical figures were intended to evoke sublime thoughts and sentiments related to death, such as desperation, pain, or resignation. In short, these women were heartbroken, meditative, mysterious, and completely indifferent to their own beauty. Thus in turn-of-the-century Barcelona the most outstanding Catalan sculptors, especially Llimona, were giving shape to this model of the ethereal, evanescent woman, brimming with the most noble sentiments

Fig. 7. *Mother's Kiss,* 1896, by Eusebi Arnau.
Fig. 8 (cat. 5:20). Josep Llimona, *Exasperation,* 1900.

(fig. 8). Meanwhile, in Paris in 1900, a major sculptural exhibition took place, one that would directly or indirectly constitute a major influence. The event coincided with the Universal Exposition held that year in the French capital, where Rodin presented a great retrospective of his work. The pavilion was built in the Place del Alma and included 168 works, including sculptures and drawings. Rodin, the most outstanding sculptor of the 19th century, was already well known in the Catalan art world through numerous articles published in amply illustrated newspapers and magazines of the time. Moreover, most Catalan sculptors had become directly acquainted with his works during the time they spent in Paris, whether at the Salons or the Musée du Luxembourg. However, at the pavilion of the Place del Alma in 1900 Catalan sculptors, faced with the creative breadth of Rodin, took *Danaid*, 1886–1902 (fig. 9) as their undisputed model. The *Danaid* was a sculpture initially designed to be part of the monumental *Gates of Hell*, 1880–90 (Musée Rodin, Paris and Meudon).[7] They thus fused funerary sculpture—eliminating, of course, the aspect associated with the idea of death—with the expressionism of Rodin. Having already freed themselves of any moral commitment preventing representation of the female nude, Catalan sculptors finally adopted Symbolism, represented in the figure of a female nude, sculpted in marble, with sinuous forms, crouched down and withdrawn into herself.

At last, with the burden of the anecdote eliminated, Catalan sculptors gave absolute priority to the beauty of the human body. From this time forward, Llimona, Blay, Arnau, and Clarasó would promote the deliquescence of the human form, the effects of chiaroscuro, a *non finito* (unfinished) quality, and figures with long hair slipping over and hiding their faces. Blay's *Daydream*, c. 1905 (fig. 10), is a fragment of his work *Eclosion*, 1905 (Museu Comarcal de la Garrotxa, Olot), which represents a couple in an amorous pose, though in a lyrical style. The young woman's face, eyes half shut and expression innocent, makes her more spiritual than sensual. Llimona's *Grief*, undoubtedly the best known and most highly valued work of Modernisme and Catalan sculpture in general, shows a synthesis of the symbolist principles adopted by the Catalan sculptors. Beneath the sinuous pose of the woman's body, we can discern its perfect bone structure and musculature that is both delicate and powerful. Her despondent pose, the contrasting play of light and shadow, and the rough-hewn, bumpy appearance of the base are also infused with the symbolist aesthetic.[8] As opposed to the vitality, force, and sensuality of the women modeled by Rodin, Catalan sculptors including Llimona preferred to represent them in resigned, melancholic, and chaste poses. While undoubtedly their work reaches neither the breadth nor the resounding creative force of the French sculptor, its quality is indisputable. These artists gave Catalan sculpture an impetus that enriched Modernisme, and they simultaneously opened the way for a new generation that followed closely on their achievements. Younger

Fig. 9. *Danaid (The Source)*, conceived by Auguste Rodin in 1886, carved before 1902.

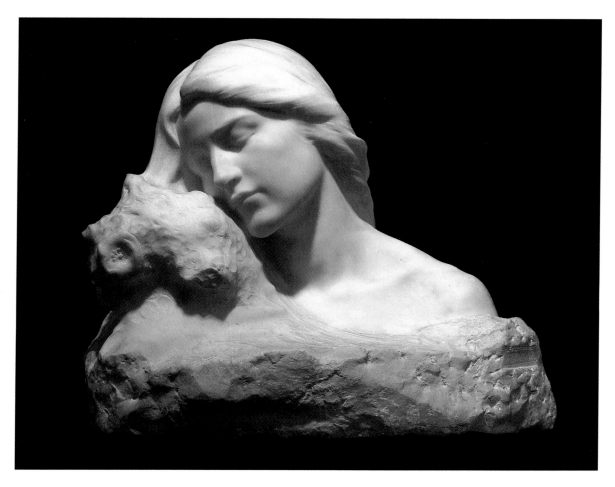

sculptors, such as Enric Casanovas, Josep Clarà, Manolo Hugué, Pablo Gargallo, and Julio González, among others, launched other movements. Most of them started their careers during Modernisme, although they had not been attracted to Symbolism. Instead, they preferred using motifs related to the marginal elements of society. These youthful pieces survive as a testament to the next generation's student period. Some of them would follow a neoclassical path, adopted around 1905 by the French sculptor Aristide Maillol, while others would venture toward new forms of avant-garde art.

1. At the Palau de la Música Catalana there are female figures by Arnau on the stage; Gargallo's *Procession of the Valkyries* on the proscenium; and Blay's group *Popular Song* on the façade. Also by Arnau are the over-the-door panels on the main floor of the Casa Lleó Morera and the magnificent fireplaces at the Fonda España and the Casa Amatller, among others.

2. Because of its political content, this monument exalting a Catalan patriot was dismantled during the Franco dictatorship but preserved in storage. It was erected again in 1985, though for technical reasons, it was given a new siting.

3. The city of Barcelona organized international exhibitions in 1891, 1894, 1896, 1898, 1907, and 1911 similar to those that took place in other European cities. The most distinguished exhibition, since it included significant European painters and sculptors, occurred in 1907.

4. Founded by a group of Catholic artists headed by the painter Joan Llimona, the membership of the Cercle Artístic de Sant Lluc included, in addition to the sculptors mentioned, the painters Alexandre de Riquer and Dionís Baixeras, and the architect Antoni Gaudí, among others.

5. In addition to Arnau's *Mother's Kiss* and *At the Loge*, the most outstanding sculptures of this period include Clarasó's *Broken Cocoon*, 1892 (location unknown), Blay's *The First Cold Spells*, 1893, and Llimona's *First Holy Communion*, 1897 (both Museu Nacional d'Art de Catalunya, Barcelona).

6. In a significant display of their economic power, the Catalan bourgeoisie commissioned their monuments from the same architects who designed their dwellings in the Barcelona Eixample. The Montjuïc cemetery, inaugurated in 1883, held the largest concentration of modernista monuments, among which the most distinguished are funerary figures modeled by the most renowned sculptors of the day.

7. Rodin presented a marble copy of the *Danaid* at the Paris Salon of 1890, where it was acquired by the French government. Two years later, it became part of the Musée du Luxembourg collection. Thus, Catalan sculptors could have seen this sculpture before 1900; however, its influence extends beyond that date.

8. The most paradigmatic sculptures of Catalan Modernisme and those that best reflect Rodin's influence are Llimona's *Grief* and Clarasó's *Eve*, 1904, which have similar formal characteristics. The two works are part of the collection of the Museu Nacional d'Art de Catalunya, although there are various copies of Llimona's work in private collections.

Translated by Susan Brockbank.

Fig. 10 (cat. 2:32). Miquel Blay, *Daydream*, c. 1905.

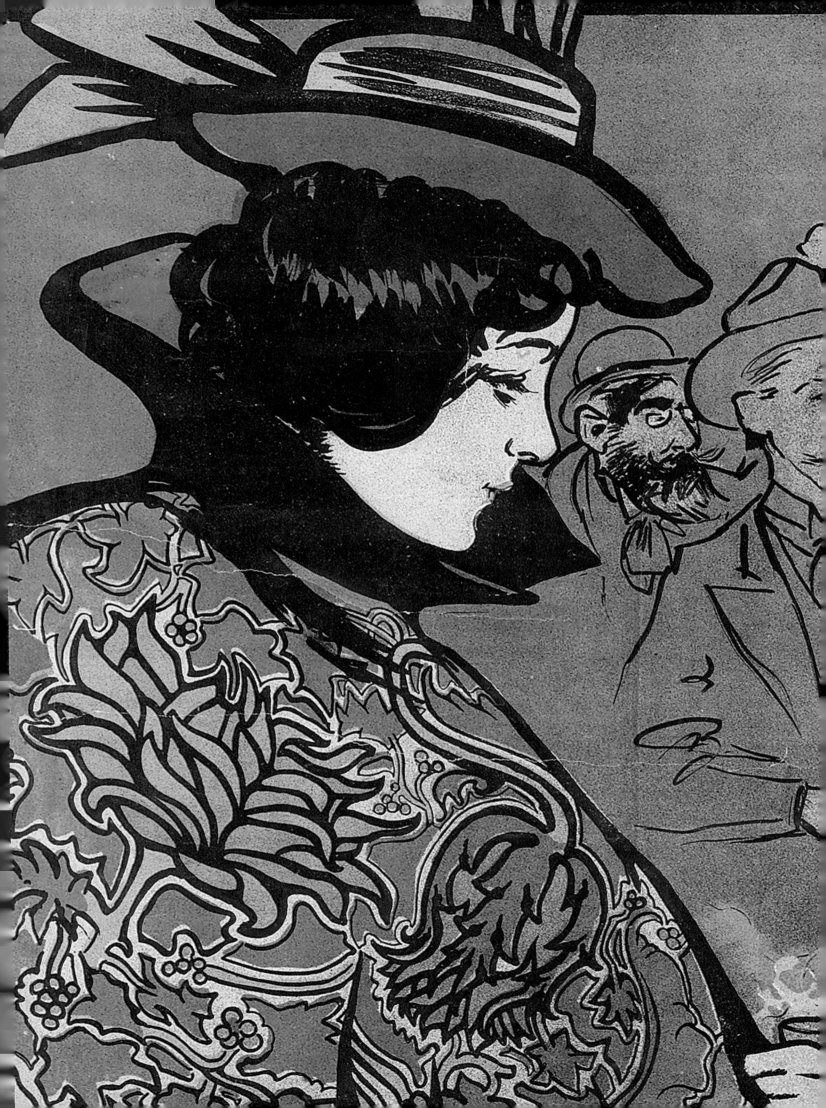

# Modernisme:
# The Quatre Gats

# Quatre Gats and the Origins of Picasso's Career

*CRISTINA MENDOZA*

In the first week of February 1900, the Barcelona press featured a few reviews on the exhibition being held by "a young man, practically a child," at Quatre Gats tavern.[1] Everyone recognized his unquestionable artistic gifts, although some criticized him for his adherence "to the most exaggerated Modernisme." Others commented that his works were "inexperienced and careless, forgivable given the artist's age, and mere detours on the road that must be taken by the artist." The subject of these comments was a young man then known as Pablo Ruiz Picasso. At only 18 years of age, he had attained an exhibition of his works at Quatre Gats. Although this establishment had been open only for three years, it nevertheless had become the most important center of cultural and artistic standards in modernista Barcelona. While it is true that the opportunity offered to Picasso by Quatre Gats was also offered to other young artists, it provided him with privileges not enjoyed by other artists of his generation.

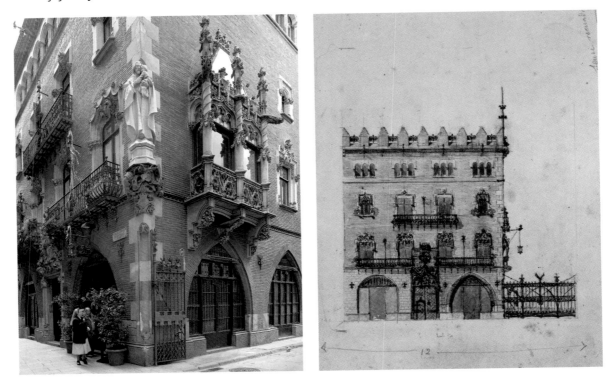

When the first individual exhibition of Picasso's work was held, he had been living in Barcelona for a year, after two years away from the city. Given that he would leave Barcelona again in the fall of 1900, Picasso's ongoing relationship with Quatre Gats could have unfolded only between February 1899 and September 1900 (fig. 1).[2] However brief it was, Picasso was young, receptive, and talented, and this was a highly stimulating time for Barcelona in general and Quatre Gats in particular. For these reasons, it was a formative period in the life of the person who would become one of the foremost artists of the 20th century.

Founded by Ramon Casas, Santiago Rusiñol, Miquel Utrillo, and Pere Romeu as a tavern and restaurant, Quatre Gats opened on 12 June 1897; active Modernisme was truly taking the reins in Barcelona. In the years just before this takeover, the domain of this movement had been in Cau Ferrat in Sitges. The name chosen for the Barcelona establishment was a play on words alluding to both

Fig. 1 (cat. 3:2). Attributed to Pablo Picasso, *Quatre Gats Mobile*, c. 1899.
Fig. 2. Quatre Gats tavern (Casa Martí), Barcelona, c. 1900, designed by Josep Puig i Cadafalch.
Fig. 3 (cat. 3:1). Josep Puig i Cadafalch, *Casa Martí (Quatre Gats)*, from *L'Oeuvre de Puig Cadafalch, Architecte: 1896–1904* (1904).

the number of founders and the idiom "to be four cats" (a number of people so small as to be considered insignificant). Moreover, the name "Quatre Gats" paid explicit homage to the famous Parisian locale Le Chat Noir, owned by Rodolph Salis, who had died a few months before the Barcelona tavern opened for business. So much so did the founders of Quatre Gats feel indebted to Le Chat Noir that a few days after their café opened, they wrote a letter to Salis that appeared in *La Vanguardia*. Signed with a pseudonym and undoubtedly written by Utrillo, the letter rendered homage to Salis and informed him of the "birth" of a "child of his line" in Barcelona.[3] In fact, Quatre Gats, located on carrer Montsió in the old section of the city, was a transposition of Le Chat Noir. The tavern was set up on the bottom floor of a neo-Gothic building (figs. 2 and 3), the first to be constructed in Barcelona by the young architect Josep Puig i Cadafalch. In the years immediately after, he would become one of the most outstanding figures of modernista architecture.

Quatre Gats, which looks almost exactly the same today (fig. 4), consisted of two rooms. In the first was the bar, with the proprietor Pere Romeu (fig. 5) standing near the tables around which centered the famous *tertúlies* (meetings) presided over by Casas, Rusiñol, and Utrillo. A second, larger room was used to house the literary and musical evenings,

and performances of *ombres chinoises* (shadow puppet plays) and string puppets, which were tremendously popular in the city.[4] Predominant in its interior decoration were elements of traditional Catalan architecture, such as ceramics, tiles, and wrought iron, and the walls were crammed with paintings and drawings. Still, the most outstanding work was the huge canvas painted by Casas specifically to decorate the tavern. For this painting, now a symbol of Barcelona's Modernisme, Casas created a self-portrait in profile with his characteristic cigar in a pipe, pedaling in tandem with Pere Romeu, who looks directly at the viewer (fig. 6). Behind the two figures dressed in sporting garb there is a hint of a factory chimney, a typical element of Barcelona's urban landscape in that day. To the right is the unequivocal outline of Montjuïc mountain, located in the southernmost part of the city.[5] Overall, based on both its formal and compositional simplicity and its flat background, as well as on the marked outlining of the figures, this work seems more poster than painting. At the outset of the 20th century, Casas replaced this painting with one that had the same formal and technical characteristics and the same figures, now driving a car (fig. 7)—probably because the automobile was considered more fitting for the century that had just gotten under way. When reproductions of the two paintings appeared in the pages

Fig. 4. Interior of Quatre Gats tavern, 1904.

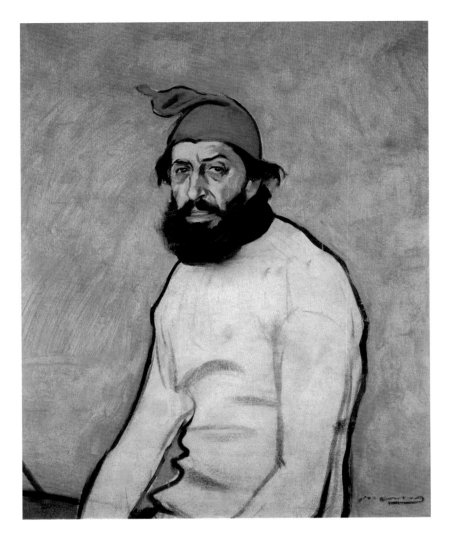

of the magazine *Pèl & Ploma*, they were entitled *The End of the 19th Century* and *The Beginning of the 20th Century*, respectively.[6]

While it is true that Quatre Gats was inspired by the Parisian Le Chat Noir, the Barcelona tavern turned out to play a much more decisive role than did its Parisian counterpart. Unlike Le Chat Noir, Quatre Gats was the only establishment of its kind in Barcelona at that time. While its apparent objective was to be a tavern and restaurant, it was actually no more than a pretext for having a place that would serve as the nerve center for progressive artists and intellectuals. It was a hub for those who sought to turn Barcelona into a modern city open to Europe. As well as a meeting place for active Modernistes, it was a mandatory stop for every prominent person in the world of arts and letters who was visiting the city. Moreover, its promoters always maintained a generous and supportive attitude toward the young artists who were trying to carve out a future in the art world of Barcelona, an especially laudable outlook given the resistance of that art world to accepting anything new.

In this regard, the group exhibition held in July 1898 to celebrate the tavern's first anniversary was illustrative. Alongside works by Casas, Rusiñol, and Utrillo—the three proprietors of Quatre Gats, all heavyweights of Modernisme—works by the young adherents of the tertúlies were displayed on an equal footing. Their number included Ricard Canals, Lluís Bonnin, Joaquim Mir, Isidre Nonell, and Ramon Pichot, then at the beginning of their careers.[7] Not a one-time gesture, this inclusiveness was based on a principle of ongoing support toward the younger generation. Promotion of such artists was also on the agenda of the magazine *Quatre Gats*, named after the establishment and issued weekly between February and May 1899.[8]

Although space does not allow discussing the content of the magazine here, in his editorials Pere

Fig. 5. *Pere Romeu*, 1897, by Ramon Casas.

Fig. 6 (cat. 3:3). Ramon Casas, *Ramon Casas and Pere Romeu on a Tandem*, 1897.
Fig. 7. *Ramon Casas and Pere Romeu in a Car*, 1901, by Ramon Casas.

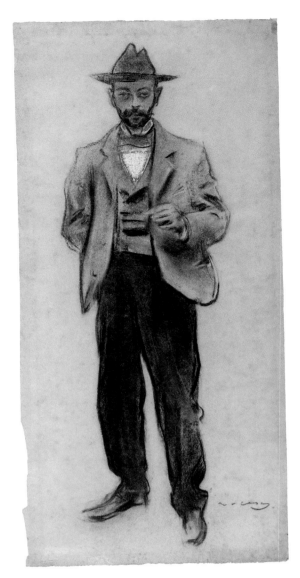

Romeu never missed an opportunity to let people know about the professional activities of the new artists. Another commendable aspect of such support was to call upon them often to draw the full-page cover illustration for each issue of *Quatre Gats*.[9] Even more important was the initiative of holding individual exhibitions. These installations were unquestionably modest: the works were often exhibited without frames, and accompanying catalogues were rarely published. Nevertheless, such exhibitions helped disseminate the work of these new artists. Given the artistic conservatism in the city's official and commercial circles, the young artists had few expectations of being able to exhibit their works publicly.[10] Having an exhibition at Quatre Gats meant that the artist had considerable support. What is more, that an exhibition was being held at a locale as symbolic and committed to modernity

as Quatre Gats usually led to some response on the part of the press.

While the focus here is Picasso's exhibition, which opened on 1 February 1900, other artists had preceded him with individual exhibitions: Nonell, Pichot, Xavier Gosé, Evelí Torent, and Josep Dalmau. After Picasso, artists who presented solo exhibitions included Carlos Vázquez and Carles Casagemas.

In October 1899, just before Picasso's February exhibition, an exhibition of Casas's drawings and paintings in Barcelona had left an impact on the younger artist. While Casas's reputation was already very strong at the time, this was his first individual exhibition at the Sala Parés and it brought together 223 works, all in the portrait genre. The most remarkable set consisted of 132 charcoal portraits, generally highlighted with pastel, of famous personages of the time. The group included both supporters and

Fig. 8 (cat. 3:5). Ramon Casas, *Manolo Hugué*, 1897–99.

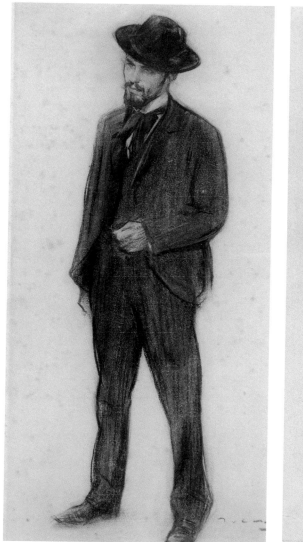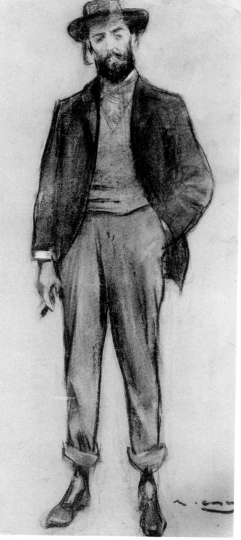

some who were hostile to modernista ideology as well as a sizable representation of young artists. In these works, the sitters usually appear standing against a neutral background, without any additional element that might help identify their profession (figs. 8–10). It seems that Casas would spend a couple of sessions with the model, concentrating on his face, which he would capture with the fidelity of a camera. Subsequently, working without the model, Casas would finish the portrait with thick, sure strokes. Making no effort to hide any corrections, he would trace the outline and shade the interior of the figure.[11] Without going into greater detail, what is important here is that the exhibition was an unprecedented success in Barcelona. The painter, overcoming the reluctant reception of his Parisian paintings just a few years earlier, was unanimously proclaimed the best painter of the Modernisme movement.

That Picasso visited the exhibition is a fair assumption. In any event, given his frequent presence at Quatre Gats, there is no question that he witnessed Casas's resounding triumph. Whatever actually happened, immediately after that exhibition closed, Picasso began working on his own portrait portfolio along the lines of those done by Casas. Within just over two months, he managed to execute a considerable number, which he showed at Quatre Gats. As is the case for most of the exhibitions held there, we do not know precisely what was included. Deducing from the comments of one of the critics who attended the exhibition, it seems that he exhibited three oil paintings along with the drawings. To judge from a description that appeared in another review of this exhibition, one of the paintings was *Last Moments*—a canvas along the lines of *Science and Charity*, rendered in 1897

Fig. 9 (cat. 3:6). Ramon Casas, *Joaquín Torres-García*, 1901.
Fig. 10 (cat. 3:8). Ramon Casas, *Pere Romeu*, 1897–99.

(Museu Picasso, Barcelona).[12] Picasso ended up obscuring *Last Moments* because he painted over it to create *La Vie* (see fig. 1, p. 134), his famous work from the Blue Period.[13] As for his drawings, the show's most notable feature, Picasso scholars agree that he exhibited around 100 portraits. It is clear, however, that no one knows precisely how many and which works were on view.

Picasso's portraits of the time belong to two different series, based on their technique, size, and intent. One set consisted of small-scale works (generally no larger than 12 cm), rendered in ink and watercolor and usually showing the figure's torso; the background is smooth, and the drawings have an element of caricature. The sitters include both Picasso's contemporaries such as Hermen Anglada-Camarasa, Pichot, and Mir, and others from the previous generation such as Casas, Rusiñol, and Romeu (figs. 11–21). These portraits may have been executed in the same year, 1900, but after the February exhibition. In any event, there is no question that some of them, such as those of Anglada-Camarasa and Rusiñol, must have been executed after the February exhibition.[14] The other set, a series of

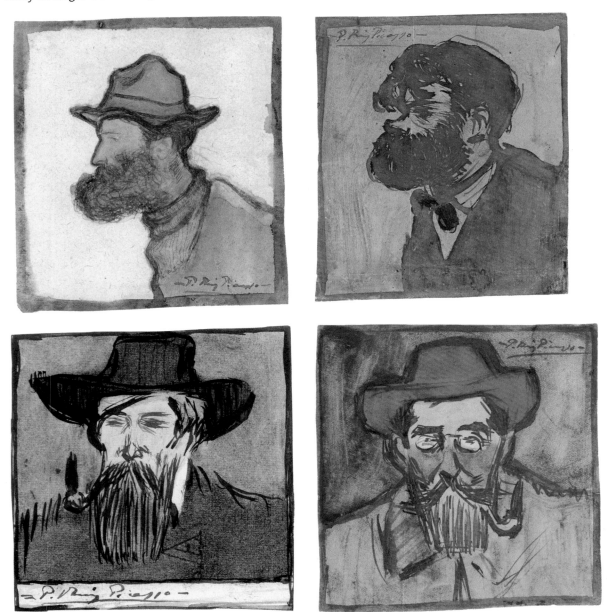

Fig. 11 (cat. 3:17). Pablo Picasso, *Pere Romeu Borràs*, 1900.
Fig. 12 (cat. 3:12). Pablo Picasso, *Ramon Pichot*, 1900.
Fig. 13 (cat. 3:15). Pablo Picasso, *Joaquim Mir*, 1900.
Fig. 14 (cat. 3:16). Pablo Picasso, *Santiago Rusiñol*, 1900.
Fig. 15 (cat. 3:14). Pablo Picasso, *Ramon Casas*, 1900.

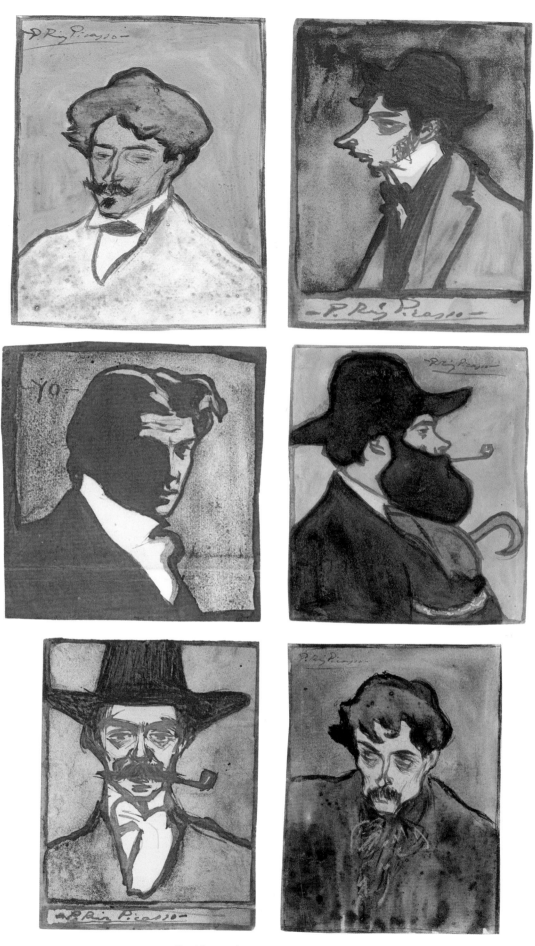

Fig. 16 (cat. 3:20). Pablo Picasso, *Benet Soler*, 1900.

Fig. 17 (cat. 3:18). Pablo Picasso, *Carles Casagemas*, 1900.

Fig. 18 (cat. 3:11). Pablo Picasso, *Self-Portrait*, 1900.

Fig. 19 (cat. 3:13). Pablo Picasso, *Hermen Anglada-Camarasa*, 1900.

Fig. 20 (cat. 3:19). Pablo Picasso, *Frederic Pujulà i Vallès*, 1900.

Fig. 21 (cat. 3:21). Pablo Picasso, *Juli Vallmitjana*, 1900.

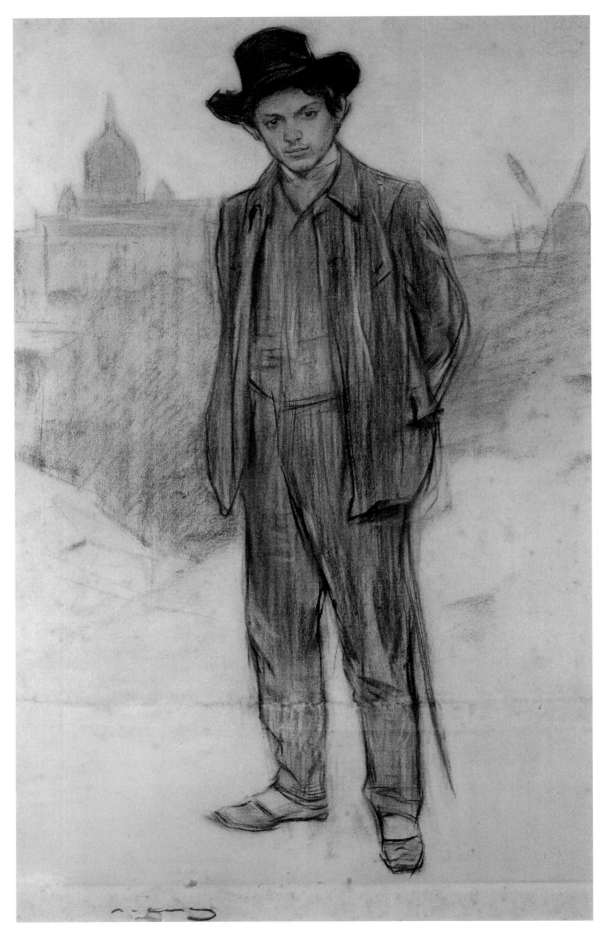

Fig. 22 (cat. 3:7). Ramon Casas, *Pablo Picasso*, 1900.

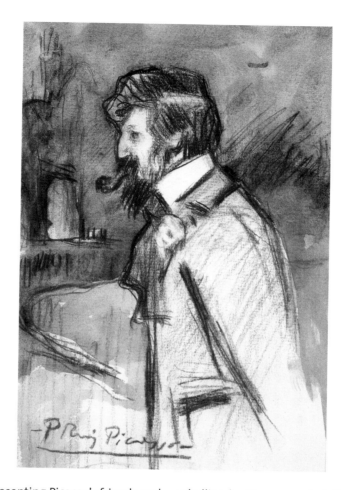

charcoal portraits representing Picasso's friends and associates of that time, was undoubtedly included in the Quatre Gats exhibition.[15] By their technique, format, and formal characteristics, they have many similarities to those that had garnered Casas such a resounding triumph just a few months earlier. In spite of the evident similarities between the portraits of the two artists, clearly they adhere to different artistic languages. As stated by Josep Palau i Fabre, Picasso's portraits are more dynamic than those rendered by Casas.[16] Moreover, unlike the Casas portraits, Picasso's usually include a background behind the subject. Two months after Picasso's exhibition, Casas encountered him in Paris and drew an image to add to his portrait collection. Perhaps by way of a wink at Picasso's portraits, Casas here represented Picasso with the silhouette of Sacré-Coeur and the arms of the windmill of Moulin de la Galette in the background (fig. 22).[17] In any event, in his memoirs Jaume Sabartés (see fig. 10, p. 11) states that the idea of creating portraits was not Picasso's; rather, he was encouraged to compete with Casas by Sabartés and their circle of friends.[18] Such a natural act of youthful

rebellion by Picasso against the established power represented by Casas cannot be ruled out. But if we take the perspective of that precise moment in Picasso's life, more than likely he decided to create the portraits in charcoal because he found Casas's work truly interesting. In any event, whether or not there was a touch of provocation in Picasso's attitude, his exhibition at Quatre Gats inevitably had an element of challenge to the supposed master. And the young painter emerged looking not bad at all. How else can we explain why the critics attending this exhibition avoided the mandatory comparison of portraits by a young man who was practically unknown with those of the most prominent artist of the time?

Picasso's February 1900 exhibition was neither the only one he held that year nor his only outstanding presentation at the tavern. In a return engagement in July 1900, he showed four paintings. The subject of these works was bullfighting, and they were highly praised by Pujolà i Vallès, who wrote the only review that appeared.[19] Although all that we know about these works was provided

Fig. 23 (cat. 3:9). Pablo Picasso, *Santiago Rusiñol*, 1900.

by Pujolà i Vallès, one of them could have been the excellent small-scale pastel Rusiñol owned that is preserved today at Cau Ferrat in Sitges. Regardless, Picasso definitely executed a portrait of Pujolà i Vallès that same year.[20] He also rendered nothing less than the menu of the Quatre Gats restaurant (see fig. 3, p. 94). This is truly surprising, bearing in mind that it was obviously an assignment of a certain importance and therefore naturally one to have been done by Casas himself. Before this menu, Casas had executed several posters related to Quatre Gats (see fig. 1, p. 92) and the various activities that took place there.[21] As opposed to the "anonymous" youth Picasso, Casas was not only one of the owners, but also the best known of the artists for his graphic work. Also that year one of Picasso's drawings (location unknown) was used to illustrate a postcard advertising the Barcelona tavern.[22] It shows a woman, her back turned and head toward the viewer, in front of a group of people about to enter Quatre Gats.

Given such incursions by Picasso onto terrain that was not only not his own but also forbidden to other colleagues of his generation, we have to ask who provided the young artist with the support that was as silent as it was decisive? Who would have had sufficient authority? We can rule out Casas, whose territory Picasso seemed to be invading, and Rusiñol, who was away from Quatre Gats for health reasons during the period when Picasso frequented the place. Thus, it is a reasonable assumption, as I have pointed out in an earlier work, that Picasso's supporter was Utrillo. Perhaps Utrillo, who always played a crucial role in the great undertakings of Modernisme, became aware of the artist's extraordinary gift and decided to provide tacit support. It would have been tacit in order to avoid stirring up conflict with Casas,

his great friend and companion in so many common ventures. Two events that took place just after Picasso had stopped coming to Quatre Gats could support this hypothesis. In January 1901, he moved to Madrid and undertook the venture of publishing the magazine *Arte Joven*. Utrillo did not miss the opportunity to praise both the initiative and the content of the weekly magazine. Yet he made no mention of the fact that it emulated *Pèl & Ploma* or even that Picasso was performing the same role in *Arte Joven* that Casas played in *Pèl & Ploma,* that is, drawing the magazine's illustrations.[23] Moreover, Utrillo's theoretical help for Picasso became much more explicit upon the occasion of Casas's third exhibition at Sala Parés, organized by Utrillo himself. This time, alongside Casas's drawings, Utrillo decided to exhibit some pastels created by Picasso. Predictably, the critics who reviewed this exhibition made no mention of the presence of works by Picasso. However, Utrillo used the occasion to write an article about him in *Pèl & Ploma,* the first article that would cover Picasso in depth. In this text, preceded by the charcoal drawing done by Casas of Picasso in Paris in 1900, Utrillo decidedly casts his lot with the young artist.[24] He predicts a brilliant future for him in his newly launched career in Paris. ("We know in our hearts that it will be for the best," he states.) At the time, Picasso was already exhibiting at the Vollard Gallery in Paris, and from then on he would no longer need tacit assistance from anyone. The brilliant career of the person who became the most important artist in the 20th century would bring worldwide renown to Quatre Gats—the Barcelona tavern that had so generously given a boost to Pablo Ruiz Picasso at a time when his only calling card was his talent.

On the relationship between Picasso and Quatre Gats, the catalogues of the exhibitions *Picasso and Els 4 Gats* and *Picasso i Barcelona, 1881–1981,* both held in Barcelona, are inescapable references. Writers who have specifically dealt with this subject are Josep Palau i Fabre, Francesc Fontbona, Marilyn McCully, and myself. This article inevitably owes much to my prior works on this subject. See Maria Teresa Ocaña, ed., *Picasso and Els 4 Gats: The Early Years in Turn-of-the-Century Barcelona,* exh. cat. (Boston: Little, Brown, 1995); Joan Ainaud de Lasarte, ed., *Picasso i Barcelona, 1881–1981,* exh. cat. (Barcelona: Ajuntament de Barcelona, 1981); and McCully, *Els Quatre Gats. Art in Barcelona around 1900,* exh. cat. (Princeton: Art Museum, Princeton University, 1978).

1. In response to Picasso's exhibition at Quatre Gats, the following reviews appeared, all anonymous: *La Renaixença,* 1 February 1900 (see Francesc Fontbona, "Picasso. Aspectes desconeguts de la seva joventut," *Serra d'Or,* no. 262/263 [July–August 1981]: 52; Fontbona first discovered this review, which he attributed to B. Bassegoda, a critic at the newspaper at that time); *La Vanguardia,* 3 February 1900 (the writer of this review must have been A. Opisso, a critic at the newspaper at that time); and *Diario de Barcelona,* 7 February 1900 (see Fontbona, *La crisi del modernisme artístic* [Barcelona: Curial, 1975], 175).

2. The Ruiz Picasso family arrived in Barcelona in September 1895. Picasso, after studying at the Escola de Belles Arts of Barcelona during the academic year 1895–96, took his next course at the Real Academia de Bellas Artes de San Fernando in Madrid. Upon completion of this course and after a brief visit in Barcelona, he began a long stay at Horta de Sant Joan with his friend Manuel Pallarès, which stretched out through February 1899.

3. El Caballero Micifuz [Miquel Utrillo?], "Els IV Gats. Al gentil hombre tabernero Rodolfo de Salis, Señor de Chatnoiville, Caballero de la Butte Sacrée, capitán de tercios bohemios, etc.," *La Vanguardia,* 1 July 1897.

4. About the performances and literary/musical evenings held at Quatre Gats, see Mercè Doñate, "Art Activity at Els Quatre Gats," in *Picasso and Els 4 Gats,* 223–36.

5. The previous owner of this work cut the canvas, removing the inscription written by Casas on the upper right, which said: "Per anar en bicicleta no es pot dur l'esquena dreta" (When you're riding a bicycle, you can't keep your back straight).

6. See *Pèl & Ploma* 3, no. 7–8 (July 1901): 62–63.

7. A succinct catalogue about this exhibition was published in which the participating artists appear in alphabetical order. The exhibition, which was open 11–18 July 1897, brought together a total of 64 works.

8. The magazine *Quatre Gats,* the precursor of the magazine *Pèl & Ploma,* was published weekly from the second week in February 1899 through May 25 of the same year.

9. Some of the young artists who had the privilege of providing illustrations for the cover of the magazine *Quatre Gats* were Mir, Nonell, Pichot, Gosé, and Ricard Opisso.

10. In this regard, Quatre Gats exhibited Joaquim Mir's large-scale painting dated to 1898, *The Cathedral of the Poor* (Carmen Thyssen-Bornemisza Collection, Museu Nacional d'Art de Catalunya, Barcelona), after it had been included in the Fourth Exposition of Fine and Industrial Arts of 1898, to give the painting more exposure. There, it was acquired by the tailor Benet Soler. Soler himself was immortalized some years later by Picasso, who created a portrait of Soler in the now-famous painting of the tailor with his family, *The Soler Family (Le déjeuner sur l'herbe)* in Barcelona during the summer of 1903 (Musée d'Art Moderne et d'Art Contemporain, Liège).

11. Most of the charcoal drawings by Casas are preserved in the Museu Nacional d'Art de Catalunya, Barcelona; see Cristina Mendoza, *Ramon Casas. Retrats al carbó,* exh. cat. (Barcelona: Ausa, Museu d'Art Modern del MNAC, 1995).

12. These two reviews appeared in the *Diario de Barcelona* (which stated that there were three paintings in the Picasso exhibition) and in *La Vanguardia* (where *Last Moments* is described). See note 1.

13. This fact was brought to light by Marilyn McCully and Robert McVaugh, "New Light on Picasso's *La Vie,*" *Bulletin of the Cleveland Museum of Art* 65 (1978): 66–71.

14. See Fontbona, "Picasso and Els 4 Gats," in *Picasso and Els 4 Gats,* 16. Given the outline drawn around the subjects by way of a frame, McCully points out the possibility that Picasso executed each of them for publication or as a personalized ex libris for the subject. See McCully, "Picasso's Portraits of His Barcelona Friends," in *Picasso and Els 4 Gats,* 175.

15. Among his subjects were Manuel Pallarès, Evelí Torent, Carles Casagemas, Àngel and Mateu Fernández de Soto, Benet Soler, Jacint Reventós, Francesc Bernareggi, and Jaume Sabartés; he drew portraits of some of them more than once. According to Palau i Fabre, the portrait of Pallarès was the first in the series. He also states that the two of Sabartés were executed in January 1900 because, according to the subject, they were created in the Riera de Sant Joan workshop Picasso and Casagemas rented that month. Palau i Fabre also states that of these two portraits, the one rendered first is *Decadent Poet;* see Palau i Fabre, *Picasso, the Early Years, 1881–1907* (New York: Rizzoli, 1981), 184.

16. Ibid., 185.

17. The charcoal portrait that Casas drew of Picasso probably dates from April 1900, when the two artists were both in Paris to visit the Universal Exhibition.

18. Jaime Sabartés, *Portraits et souvenirs* (Paris: L. Carré, 1946), 60–61.

19. Fontbona was the first to discover this review, which appeared in the newspaper *Las Noticias* on 23 July 1900; see Fontbona, "Picasso. Aspectes desconeguts," 52.

20. This is one of the small-scale caricature-type portraits executed by Picasso that same year, 1900. Perhaps he drew it in July 1900, the month when this review was published.

21. Casas had created various posters for Quatre Gats: one to announce its opening (1897) and two more designed to advertise performances. He created one for the *ombres chinoises,* which he must have done with Utrillo in late 1897 (cat. 3:24) and another to promote the puppet performances, in mid 1898 (see *Picasso and Els 4 Gats,* 269).

22. See Palau i Fabre, *Picasso, the Early Years, 1881–1907,* 528. Although the original drawing has not been preserved, there is a chromolithograph that measures 8.3 x 12.3 cm.

23. Only four issues of the magazine *Arte Joven,* which was obviously much more modest than *Pèl & Ploma,* were published. Francesc d'A. Soler, one of the creators of a prior magazine, *Luz,* took charge of the literary part and Picasso, its illustrations. Utrillo's brief write-up celebrating the appearance of *Arte Joven,* "New Magazines," appeared in *Pèl & Ploma* 2, no. 72 (15 March 1901): 7. The main objective of *Arte Joven* was to disseminate Modernisme in Madrid. This was why the second issue was dedicated exclusively to Rusiñol.

24. Pincell [Miquel Utrillo], "Pablo R. Picasso," *Pèl & Ploma* 3, no. 77 (June 1901): 14–17.

Translated by Susan Brownbridge.

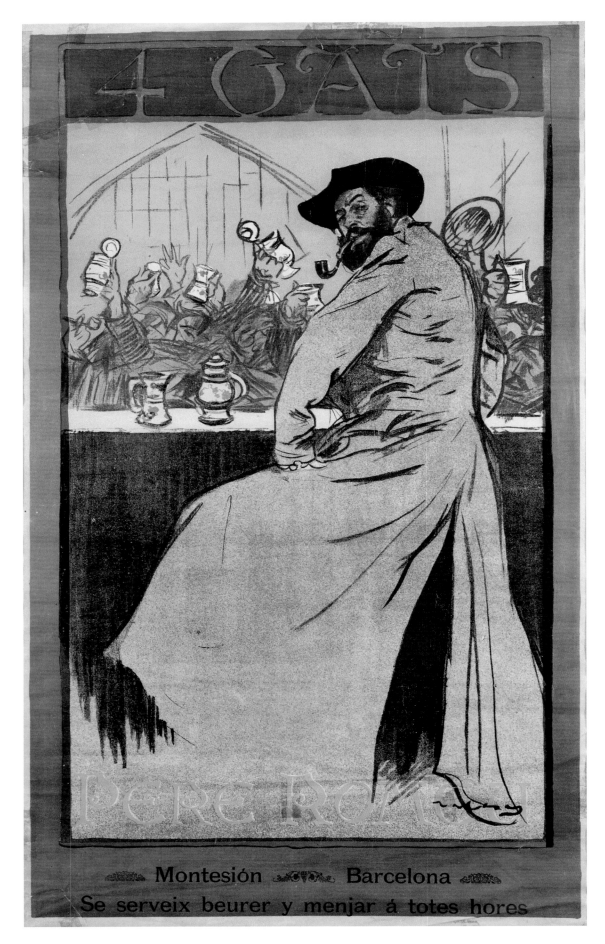

Fig. 1 (cat. 3:22). Ramon Casas, *Quatre Gats*, 1897.

# Graphic Art of the Quatre Gats

FRANCESC M. QUÍLEZ I CORELLA

Few artistic spaces have enjoyed the critical success achieved by the tavern Quatre Gats. Founded in 1897, it occupied the ground floor of Casa Martí on carrer Montsió in Barcelona. While critical literature on the subject is abundant, few authors have been able to separate themselves from the sentimental connotations that have always accompanied the image of the cabaret.[1] English-speaking scholars of Spanish culture have always been interested in Barcelona because of the city's convulsed, contradictory, and controversial history; Quatre Gats, with its folkloric image as one of the spaces most characteristic of turn-of-the-century artistic culture, has become a tourist attraction.

Quatre Gats is famous for the diverse activities that unfolded there (exhibitions, theatrical performances, literary readings) and the diverse artists who frequented its rooms (painters, sculptors, designers, poster artists, playwrights). The tavern's habitués came from different cultural sectors, and their ages ranged across generations. Yet neither medium nor age was a factor that separated the patrons into specific groups. They were united in that they neither openly declared principles or intentions, nor took positions regarding life or art. Even without concrete objectives, these proponents of Modernisme rebelled against the prevailing dominant art forms. Keeping in mind Le Chat Noir, the Parisian cabaret from which the Barcelona artists drew their inspiration, one might say that the Quatre Gats was the ideal place to exercise creative freedom.[2] Further, some of the artists had been influenced by the artistic scene in Paris, which they had come to know directly during one or another of their stays there, and they enthusiastically welcomed all the innovative modern practices proceeding from that dynamic creative center.

The Quatre Gats artists promoted an art form with highly eclectic content that was also ephemeral, and thus poster art, with its playful and mischievous elements, became one of the identifying characteristics of Modernisme. There can be no doubt that the artists were aware of the importance of this revolutionary mode of expression from the moment they first decided to use posters to advertise the activities that took place at the tavern. Very probably this decision came from a conception of art rooted in the workings of medieval artisan workshops, in which the principle of artistic authorship as the supreme affirmation of creative individuality was eclipsed by the spirit of collective participation. Perhaps the group's singular contribution was their ability to go beyond the halo of transcendence that accompanies the creation of a work of art—in its most deeply romantic sense—as a unique and unrepeatable experience of the power of transformation of creative genius. They must have found that the best way to express the fleeting, casual nature of the modern aesthetic experience was on a piece of paper.

In this context, the diffusion of the tavern's corporate image acquired great importance; activities there needed publicity, thus the demand for and abundant production of posters. In order of significance, it is doubtless fitting to confer status as a genuine iconographic emblem on the popular poster *Quatre Gats* by Ramon Casas (fig. 1). Produced in 1897, this work is one of the artist's finest achievements as a poster maker. It reflects the evolution of his graphic language and shows his knowledge of the work of Henri de Toulouse-Lautrec, from whom he seems to have derived some of the work's more daring figurative formulations. Lautrec's 1893 poster depicting Aristide Bruant in his cabaret shares many stylistic and compositional elements with *Quatre Gats;* the figure that Casas most obviously borrowed is that of Pere Romeu, one of the founders of the Quatre Gats tavern. In formal terms, the influence of Japonisme is apparent, from the flat colors to the absence of traditional European perspective and figure conventions.[3]

Much of the artistic expression of this period shares stylistic qualities. For example, a formal analysis of the poster *Shadows, Quatre Gats* 1897 (fig. 2), a collaboration by Casas and Miquel Utrillo, reveals

The poster announces the performance of a shadow-puppet play, a form of entertainment that enjoyed considerable prestige at this sanctuary for Barcelona's intelligentsia from 1897 to 1903. The fondness for this kind of diversion was another indication of how important such an amusement was among the Quatre Gats artists.[4] As expressions of popular culture, shadow-puppet shows, which drew large audiences, could not fail to make an appearance. The 1898 Casas poster *Quatre Gats Puppets* is a good example; here the leading role falls once again to Pere Romeu, who appropriated some of the distinguishing features of one of the characters in this puppet universe.[5] The charismatic Romeu, depicted in drawings, posters, and postcards, came to symbolize the Quatre Gats.

these artists' common visual language. Although attributing specific parts of the composition to one or the other artist may not be possible, some of the technical solutions can be credited to Casas. The composition has the graphic simplicity of his most brilliant compositions. Other elements are also readily recognizable: the strong black lines, the humorous, almost caricature-like quality, and the abrupt transition between the different figurative planes. Among the prominent features of the work are the outlined solid areas of color distributed over the paper, creating an effect similar to stained-glass windows, technically known by the French term "cloisonné."

The bohemian, informal nature of the creative activities carried out by the Quatre Gats group did not overshadow their brilliant functioning as a force of the avant-garde and catalyst of innovation in figurative art in turn-of-the-century Barcelona. The stimulus they provided and their efforts to promote a new generation of artists serve as an example. Among these young artists, Pablo Picasso stands out; he created the tavern's menu of c. 1899–1900 (fig. 3). An analysis of this work makes clear that, while he had his own genuine style, Picasso was indebted

Fig. 2 (cat. 3:27). Ramon Casas and Miquel Utrillo, *Shadows, Quatre Gats,* 1897.
Fig. 3 (cat. 3:23). Pablo Picasso and Ramon Casas, *Quatre Gats Menu, with Pere Romeu Caricatured as a Boer, and Other Sketches,* c. 1900.

to the first generation of modernistes and drew on their figurative culture. However, Picasso was able to transcend the formal determinants and the most conventional usages to make a work of art from something as prosaic as a restaurant menu. Such a practice was typical of the way most Quatre Gats artists worked: they broke traditions. Yet Picasso did not take this assignment lightly; the large number of drawings and preparatory sketches for the menu testifies to the importance he conferred on it.[6] The printed menu features a portrait of Pere Romeu on the back, borrowing the image from one of Casas's famous charcoal portraits.[7] The atmosphere of sophistication, elegance, and refinement of Picasso's menu recalls French posters of the time, revealing the taste for arabesque and decoration characteristic of what has come to be known as Art Nouveau.

Finally, the important popularizing work undertaken by the group that congregated around the cabaret needs mentioning. The creation of the magazine Quatre Gats undoubtedly represents a prominent landmark in the process of the consolidation of Modernisme. It goes without saying that one of the publication's prime functions was to publicize the tavern's activities, but, truth be told, the life of this weekly was very short: only 15 issues were published, and they appeared between February and May 1899.[8] In spite of its short life and the precariousness of its resources, this excellent publication in some ways cleared the way for and facilitated the appearance of other such magazines, including Pèl & Ploma, its direct descendant, as well as Forma and

Joventut. The covers of Quatre Gats boasted graphic works, mostly drawings, made by the most eminent practitioners of modernista art of the day. Among them were Casas (fig. 4), Santiago Rusiñol (fig. 5), Joaquim Mir, Isidre Nonell, Xavier Gosé (fig. 6), and Ricard Opisso. The first issue came out on an undetermined date during the second week of February 1899; Pere Romeu designated the graphic program and aesthetic ideals of the new magazine. In reality, the graphic program does not seem to follow a strategic plan; on the contrary, the miscellaneous, heterogeneous nature of graphics corresponds to the content.

1. Enric Jardí, Història de Els Quatre Gats (Barcelona: Aedos, 1972); Marilyn McCully, Els Quatre Gats: Art in Barcelona around 1900, exh. cat. (Princeton: Art Museum, Princeton University, 1978); Josep Bracons i Clapés, "Els Quatre Gats i la Barcelona modernista," in Quatre Gats: de Casas a Picasso, ed. Charo Sanjuán, exh. cat. (Barcelona: Museu Diocesà, 2005), 21–35.

2. Temma Kaplan, Ciudad roja, periodo azul. Los movimientos sociales en la Barcelona de Picasso (Barcelona: Península, 2003), 72–104; and Cristina Mendoza, "Le Chat Noir i els Quatre Gats," in Paris–Barcelona 1888–1937, exh. cat. (Paris: Réunion des Musées Nationaux, 2001), 198–214.

3. Eliseo Trenc Ballester, "Ramon Casas grafista modernista," in Ramon Casas, exh. cat. (Madrid: Banco de Bilbao, 1983), 81–89; Francesc M. Quílez i Corella, "La contribució de Ramon Casas al desenvolupament de l'art publicitari," in Ramon Casas i el cartell, ed. Daniel Giralt-Miracle, exh. cat. (Valencia: Museu Valencià de la Il·lustració i de la Modernitat/Diputació de València/Caja de Ahorros del Mediterráneo, 2005), 106–33.

4. Mercè Doñate, "Art Activity at Els Quatre Gats," in Picasso and Els 4 Gats: The Early Years in Turn-of-the-Century Barcelona, ed. Maria Teresa Ocaña, exh. cat. (Boston: Little, Brown, 1995), 223–36.

5. See cat. 204 in Picasso and Els 4 Gats, 269.

6. Museu Picasso, Picasso: Catàleg de pintura i dibuix (Barcelona: Ajuntament de Barcelona, 1984), 549–54.

7. See Els Quatre Gats Menu, fig. 4 in Mendoza, "Casas and Picasso," in Picasso and Els 4 Gats, 23.

8. Ramon Pinyol i Torrents, "Els Quatre Gats, un centre literari modernista," in Quatre Gats: de Casas a Picasso, 81–87.

Translated by Vajra Kilgour.

Fig. 4 (cat. 3:24). Ramon Casas, cover for Quatre Gats, no. 1 (second week of February, 1899).
Fig. 5 (cat. 3:25). Santiago Rusiñol, cover for Quatre Gats, no. 5 (9 March 1899).
Fig. 6 (cat. 3:26). Xavier Gosé, Throwing the Tackle, cover for Quatre Gats, no. 6 (16 March 1899).

# Picasso's Fellows at the Tavern: Beyond Modernisme?

*JORDI FALGÀS*

The similarities between Pablo Picasso's *The Artist's Sister, Lola,* c. 1899 (fig. 1), and Ramon Pichot's *Granadina,* 1898 (fig. 2), demonstrate not only how close these young artists were at the time, but also how they drew inspiration from the established artists they met at the Quatre Gats tavern/gallery on carrer Montsió, especially the modernista leaders Santiago Rusiñol and Ramon Casas. Both paintings also reveal how Picasso and Pichot, attracted by the work of the popular French illustrator Théophile-Alexandre Steinlen, were already searching beyond Catalan Modernisme.

In his early 20s, Pichot (see his caricature by Picasso, fig. 12, p. 86) was the oldest of the group of open-air painters known as La colla del safrà (Saffron Gang), which included Isidre Nonell, Ricard Canals, Joaquim Mir, Juli Vallmitjana, and Adrià Gual. At the same time, Pichot was one of the youngest among the Catalan Modernistes. In early 1898 he traveled with Rusiñol, who was ten years older, to Granada. During their stay in the Andalusian city,

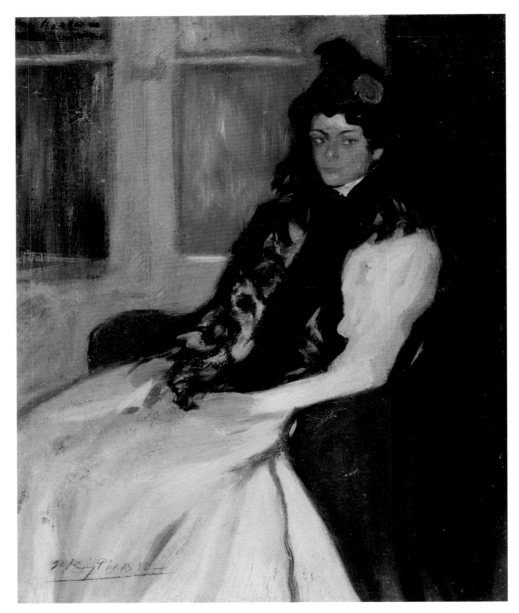

Fig. 1 (cat. 3:28). Pablo Picasso, *The Artist's Sister, Lola (Lola in a Spanish Dress),* c. 1899.

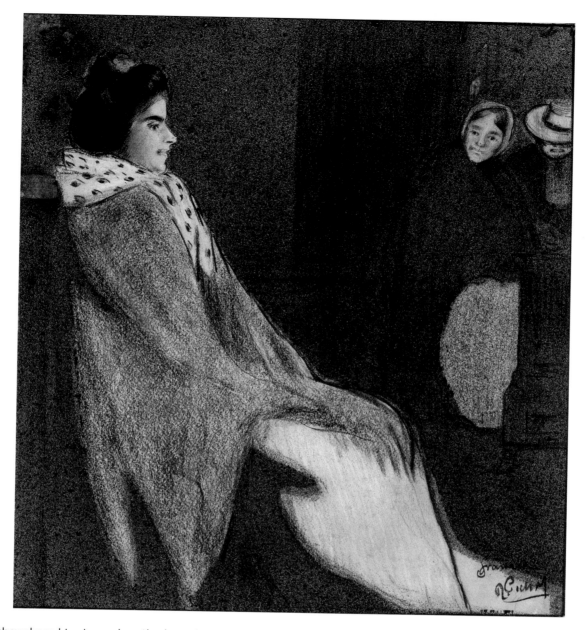

they shared topics and methods, and enjoyed painting the same subjects: young *granadinas, manolas, chulas,* and gypsy girls from the Albaicín district.[1] Pichot exhibited these paintings and drawings at Quatre Gats—as well as in Madrid under the title *España vieja* (Old Spain)—in February 1899, just as Picasso was returning to the city from Horta de Sant Joan.[2] Soon after, Picasso would share Pichot's studio and live with him for some weeks.[3] They remained close friends for years, sharing a room and exhibiting together in Paris in 1902. Pichot later married Germaine Gargallo, the woman over whom Carles

Casagemas committed suicide, and it is believed that the violence of Picasso's painting *The Three Dancers,* 1925 (Tate Modern, London), was influenced by his receiving the news of Pichot's death.[4]

Steinlen's influence on the youthful Picasso was noted by Gustave Coquiot as early as 1914 and has since been traced to several of his drawings and paintings, even to his copying Steinlen's signature. According to John Richardson, in the summer of 1899 Picasso "saw himself becoming another Steinlen" and showed a sudden interest in producing illustrations for newspapers and maga-

Fig. 2 (cat. 3:29). Ramon Pichot, *Granadina,* 1898.
Fig. 3. *Aux aguets,* c. 1891, by Ramon Casas.

zines.[5] Pichot's intentions must have been quite the same. In 1898 he illustrated Rusiñol's *Fulls de la vida* (Pages of Life); when his exhibition opened at Quatre Gats, another work from the same series, *De l'Albaicín* (collection unknown) was chosen for the cover of *Quatre Gats* magazine, followed by an article by Miquel Utrillo devoted to Pichot. Utrillo described him as Casas's "favourite disciple" and Rusiñol as his "second guide."[6] A flamenco dance by Steinlen had been featured on the front page of the 15 May 1896 edition of *Gil Blas illustré*.[7] It is a characteristic Steinlen drawing, roughly outlined but captivating and powerful nonetheless. Picasso and Pichot discovered Steinlen in such Parisian illustrated magazines, which were available in Barcelona, and they not only tried to emulate his sketchy style and medium, but also came to realize that Spanish topics dealing with low-class folklore were popular in Paris.

Cristina Mendoza, Marilyn McCully, and others have already described how the young Picasso crossed paths with Ramon Casas and how the Casas exhibition of 130 portraits at the Sala Parés in October 1899 challenged Picasso to produce and exhibit more than 100 of his own portraits at Quatre Gats in February 1900.[8] McCully suggests that one of the paintings exhibited there was very likely a portrait of the artist's sister, though possibly the larger version (*Portrait of Lola/Lola by a Window*, 1899, Marina Picasso Collection). The Lola portraits are different not only in size, but also in how the figure is presented. Whereas in the larger canvas Lola appears somewhat introspective and distant, almost unrecognizable—"less of a portrait than a study of light and mood," according to McCully—in the Cleveland portrait she stares at the viewer with the same powerful gaze that characterized her brother. If the former was meant to be exhibited, several traits indicate the latter was possibly meant to stay at home. She is certainly more easily identifiable and formally dressed, as indicated by the mantilla, the flower in her hair, and the fan she holds.[9] It was also executed in a rush. X-radiographs reveal that Picasso reused

Fig. 4 (cat. 3:30). Carles Casagemas, *A Couple*, c. 1899.

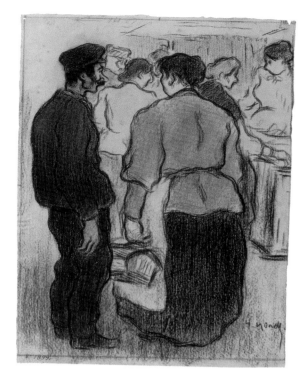

an old study of a nude seen from the back, which he turned upside down and covered with a dark layer. Once finished he signed it in the upper left corner while the paint was still wet, and signed it again when the paint was dry in the lower left.[10]

Despite their differences, these portraits of Lola strongly resemble Casas's portraits of seated models, such as *Choosing a Book, Between Two Lights,* 1894 (private collection), and, above all, *Aux aguets,* c. 1891 (fig. 3).[11] Casas exhibited these paintings as his second solo show at the Sala Parés in the spring of 1900, a few months before he, Picasso, Casagemas, Pichot, and others were to leave for Paris. By borrowing the mysterious orange and yellow light that haunts the figure through the glass in the Cleveland portrait, and its contrast with the cold interior, Picasso echoes the symbolist mood and intimacy Casas had imported from Paris—soon to be further explored by Picasso and Pichot in the French capital. As if making a statement about it, Picasso sketched his self-portrait holding hands with Pichot and Casas after their visit to the Paris Universal Exposition in 1900 (*Leaving the Universal Exposition, Picasso Surrounded by His Friends,* 1900, Arxiu Històric de la Ciutat, Barcelona).

These works on paper by Xavier Gosé, Casagemas, Pablo Gargallo, and Nonell exemplify the interest that a group of young Barcelona art-

ists developed at the turn of the century to present working-class topics and characters.[12] Together with Ricard Opisso, Vallmitjana, Pichot, Canals, Picasso, and those known as Els Negres (because of their use of charcoal to depict dark urban motifs)—Manuel Ainaud, Joaquim Biosca, Martí Gimeno, and the sculptor Enric Casanovas, among others—they frequented and exhibited at Quatre Gats while they pushed Modernisme toward new directions. Francesc Fontbona calls them the "Postmodernistes," and many would flee Barcelona to reunite in Paris.[13]

Casagemas (see caricature by Picasso, fig. 17, p. 87) has entered the lingua franca of art history because he was Picasso's closest friend from the moment they met in Barcelona in the spring of 1899 until Casagemas's suicide in Paris in February 1901.[14] It is also a recurrent claim that he deserves attention by himself as an artist of notable interest regardless of his relationship with Picasso. Casagemas presented a large series of drawings at Quatre Gats from 26 March to 10 April 1900, and *A Couple,* c. 1899 (fig. 4), was possibly part of that display.[15] It appears to be a good example of his production, which, just as with his friends, was filled at this time with working-class street scenes, outcasts, urban decay, and sinister landscapes. From today's perspective, Casagemas's paintings may seem strongly influenced by Picasso, who was already emerging as a powerful voice, although it may have been an exchange of ideas or a shared territory of experiments, not only between the two of them but with their friends at the Quatre Gats as well. A good example is Isidre Nonell's sketch *At the Boqueria's Meat Stands,* 1894 (fig. 5). Casagemas seems to have taken Nonell's "Tipos populares" and, further detached from the subjects, caricatured them. This approach, half-sketch half-caricature, is also seen in other drawings by Casagemas of this period, such as his *Singing Musician,* c. 1898 (Fundación Francisco Godia, Barcelona). From Picasso, who sketched many caricatures at this moment, he borrows a tendency to draw thick black outlines and enclose them also within a thick black frame.[16]

Gosé is possibly the best example of his generation's withdrawal from social engagement, despite an early start that seemed to indicate otherwise. In 1895 his work was already featured in the satirical

Fig. 5. *At the Boqueria's Meat Stands,* 1894, by Isidre Nonell.

*L'Esquella de la Torratxa,* followed by illustrations in *Barcelona Cómica* in 1897, and *La Saeta, El Gato Negro,* and *Madrid Cómico* in 1898.[17] The following year he illustrated the covers of issues 6 and 9 of the magazine *Quatre Gats.* The first, published on 16 March, was a drawing closely related to *Man on the Beach (Meditation),* c. 1899 (fig. 6). It was titled *Tirant l'art (Throwing the Tackle)* (see fig. 6, p. 75) and part of a series devoted to the urban working class, farmers, fishermen, and fishing activity at the beach. The second cover, *Nuvulosa (Cloudy)* (collection unknown), was an illustration for Frederic Pujulà i Vallès's short story of the same title published in the same issue. In 1899 he presented a solo exhibition at Quatre Gats (25 April–10 May), and before it closed Pere Romeu was already celebrating its success in sales and critical applause.[18] All these works show Gosé's talented draftsmanship and powerful realism, characterized by a confident line and a slight distortion of volumes that would soon be featured in French and German magazines such as *Le Rire, Simplicissimus, Jugend,* and *L'Assiette au Beurre.* Nevertheless, he would soon forget that subject matter; upon his arrival in Paris in 1900 he devoted himself almost exclusively to portraying and enjoying the belle époque until he returned to Barcelona when World War I broke out.

Rafael Nogueras is usually associated with a group from El Rovell de l'Ou, a tavern in old town Barcelona on carrer Hospital, where a different circle of artists and intellectuals met during the same years as the carrer Montsió group.[19] Nogueras was then an aspiring writer who contributed to *La Talaia Catalana, La Catalunya Artística,* and *Joventut.* He must have also been a regular at the Quatre Gats *tertúlies* because he appears in a Picasso painting depicting the tavern's interior (fig. 7), in at least two other drawings by Picasso, and is the subject of a portrait by Gargallo (fig. 8).[20] Even though he never formally exhibited his works at the Quatre Gats, Gargallo is believed to have frequented Pere Romeu's place. As Fontbona qualifies it, this is indeed a "very intense" portrait, a large work on paper almost entirely covered by charcoal shadows out which emerges a captivating gaze.[21] The young sculptor apprentice shows a fine technique as a sketcher and accomplishes the same penetrating effect as his friend Picasso did in the charcoal self-portrait of the same year (fig. 9).

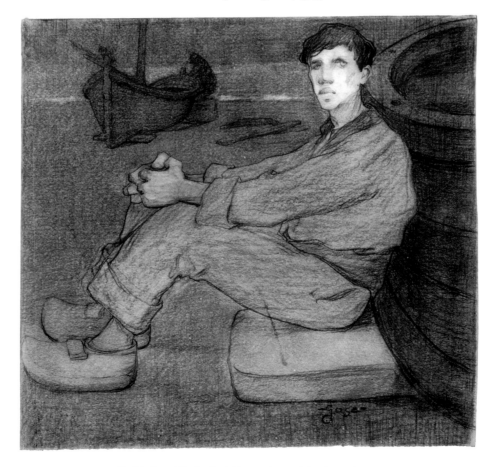

Fig. 6 (cat. 3:31). Xavier Gosé, *Man on the Beach (Meditation),* c. 1899.

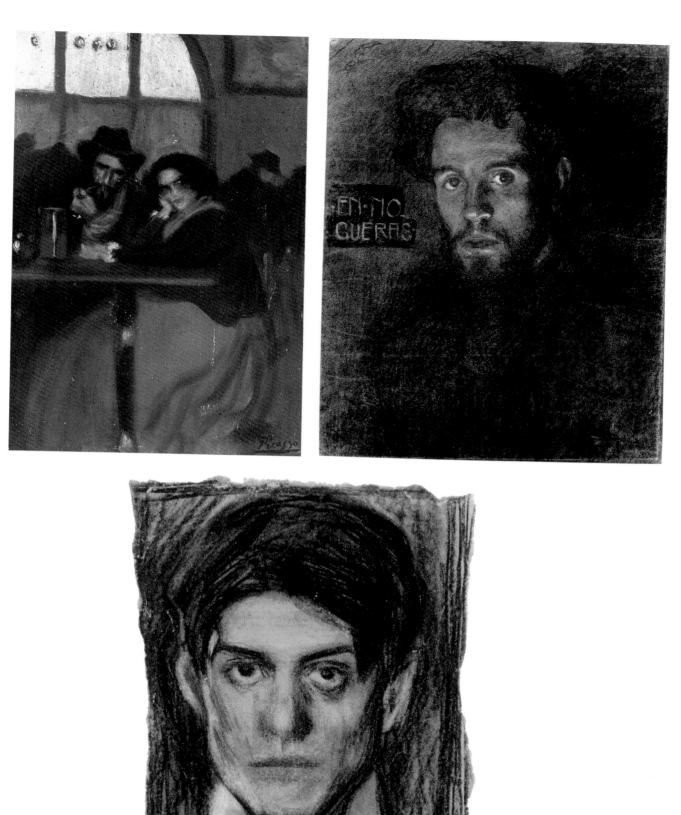

Fig. 7 (cat. 3:4). Pablo Picasso, *Interior of the Quatre Gats*, 1899.
Fig. 8 (cat. 3:33). Pablo Gargallo, *En Nogueras*, 1900.
Fig. 9 (cat. 3:32). Pablo Picasso, *Self-Portrait*, 1900.

When Picasso and Casagemas went to Paris in October 1900, they settled in Montmartre, at 49 rue Gabrielle, in the studio vacated by Nonell. As Cristina Mendoza points out, upon his return to Barcelona, Nonell's career made "a radical turn."[22] *Two Gypsies,* 1902 (fig. 10), exemplifies the transformation his work had undergone the year before, which he presented in an exhibition at the Sala Parés in January, and forecasts his great paintings of gypsy women of 1903–5 as well as the drawings of 1906 (see fig. 5, p. 131; fig. 5, p. 139; fig. 3, p. 129). The sketch reveals Nonell's initial glance at the subject: the bended figures turning their back on us, the rough strokes, the bold contour lines, the play of dark and light, the large and almost flat areas of color, and even his reduced palette. All the unique and highly expressive features that became his own are already present here. This drawing bears a striking similarity to Picasso's *Two Women at a Bar,* 1902 (fig. 11), which he did in Barcelona at the same time, upon his return to the city in January, when Nonell's show at the Sala Parés was still open. The confluence of the two artists is no surprise since they had now been friends for years, had both returned disillusioned from Paris, were now working not far from each other, and spending many leisure hours at Quatre Gats, El Rovell de l'Ou, and El Guayaba. Unaware of Nonell's earliest work, many scholars have repeatedly argued in favor of Picasso's influence on Nonell, even though the latter was nine years older and was developing his personal depiction of the dispossessed as early as 1894.[23]

Whereas a wide range of peasantry anecdotes and scenes of the urban low class had already been accepted for some time in academic circles as subjects worthy of attention (that is, certain works by the Sitges school, the Olot school, Casas's *The Garroting* [see fig. 1, p. 121], and Mir's *La catedral dels pobres,* 1898), this group of younger artists not only tried to make political statements in terms of subject matter, but also attempted to experiment with their work's formal qualities. Unlike their elders, they were no longer supported by bourgeois patrons and found work only as magazine illustrators, most often for the political and satirical press, where larger thematical and formal freedom was allowed compared to the academic training they received. Yet even if the artists' attention shifted toward social marginalization, their statements were often ambiguous, and—as Robert Lubar has noted—this generation's "failure to articulate a clear social message" ultimately turned either into generalized symbolic representations or a "mixture of condescension and revulsion."[24] Most of them had not yet attained self-dependence and their bourgeois and Catholic backgrounds still acted as a tenacious grip upon any truly groundbreaking group initiative, so the Quatre Gats was a springboard for a few and nothing but a playground for many.[25]

Fig. 10 (cat. 3:34). Isidre Nonell, *Two Gypsies,* 1902.
Fig. 11. *Two Women at a Bar,* 1902, by Pablo Picasso.

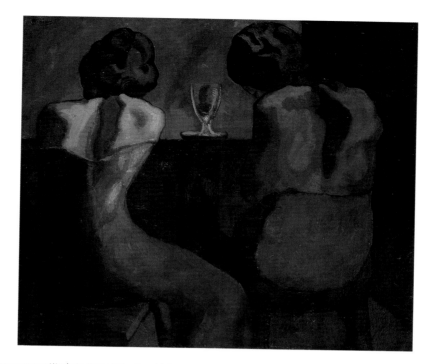

1. I would like to express my gratitude to Antoni Pitxot and Artur Ramon for providing and confirming information about Pichot's work. According to Francesc Fontbona, it is actually Pichot's influence that momentarily appears in Rusiñol's gypsies. See Fontbona, "La crisi del Modernisme," in *Del Modernisme al Noucentisme: 1888–1917,* ed. Fontbona and Francesc Miralles, vol. 7 of *Història de l'Art Català* (Barcelona: Edicions 62, 1997), 124.

2. See entry by Mireia Freixa, "Ramon Pichot i Gironès," in *La col·lecció Raimon Casellas,* exh. cat. (Barcelona: Museu Nacional d'Art de Catalunya, 1992), 223–24.

3. See John Richardson, *A Life of Picasso* (New York: Random House, 1991), 1:139, and Marilyn McCully, "Chronology," in *Picasso: The Early Years, 1892–1906,* ed. McCully, exh. cat. (Washington: National Gallery of Art, 1997), 28.

4. See Richardson, *Life of Picasso,* 1:139.

5. See Robert J. Boardingham, "Gustave Coquiot and the Critical Origins of Picasso's 'Blue' and 'Rose' Periods," in *Picasso: The Early Years* (exh. cat.), 146; Richardson, *Life of Picasso,* 1:126; and Brigitte Léal, "Steinlen et Picasso," in *Steinlen et l'époque 1900,* ed. Claire Stoullig, exh. cat. (Geneva: Musées d'Art et d'Histoire, 1999), 125–30.

6. M[iquel] Utrillo, "En Ramon Pichot," *Quatre Gats,* no. 3 (23 February 1899): 3. Two weeks later, the cover would feature a very similar drawing by Rusiñol (fig. 5, p. 95) likely made in Granada as well, and issues 6 and 10 include short stories by Rusiñol illustrated by Pichot, one of them being Rusiñol's portrait. *Granadina* was later reproduced in another Barcelona magazine, *Hispania,* no. 13 (13 August 1899): 146; in fact, *Hispania* published several of Pichot's and Rusiñol's drawings from the Granada series, see *Hispania,* no. 5 (30 April 1899): 19; no. 11 (30 July 1899): 119; and no. 12 (15 August 1899): 130.

7. See Gabriele Teuteberg and Gabriele Uelsberg, *Théophile-Alexandre Steinlen. Zeicher für das Pariser Volk,* exh. cat. (Mülheim an der Ruhr: Kunstmuseum in der Alten Post, 2000), 110.

8. See Cristina Mendoza's essay in section three of this catalogue. See also Mendoza, "Casas and Picasso," in *Picasso and Els 4 Gats: The Early Years in Turn-of-the-Century Barcelona,* ed. Maria Teresa Ocaña, exh. cat. (Boston: Little, Brown, 1996), 21–32; McCully, "Picasso's Portraits of His Barcelona Friends," in *Picasso and Els 4 Gats,* 177–78; and Richardson, *Life of Picasso,* 1:113–15.

9. The drawing *"Manola" Inspired by Lola Ruiz Picasso,* 1900 (Ms. Barbara Thurston Collection, New York) and the pastel *Portrait of the Artist's Sister,* 1898 (private collection, Germany), may be preliminary studies or related to Lola's portrait wearing the mantilla. See a later photograph of Lola with mantilla in Richardson, *Life of Picasso,* 1:435.

10. Examinations conducted by the Conservation department at the Cleveland Museum of Art in 1989 and 2003. The covered image is a life study of a naked man seen from the back, either from Picasso's years as a student at La Llotja (School of Fine Arts of Barcelona), from 1895 to 1897, or from those he painted during his first stay in Horta de Sant Joan, in 1898–99.

11. My thanks to William Robinson for pointing out this resemblance. See Isabel Coll, *Ramon Casas 1866–1932: Catálogo Razonado* (Murcia: De la Cierva Editores, 2002), 201, 203, 248; McCully, *Els Quatre Gats: Art in Barcelona around 1900,* exh. cat. (Princeton: Art Museum, Princeton University, 1978), 62–63; and McCully, "To Fall 'Like a Fly into the Trap of Picasso's Stare': Portraiture in the Early Work," in *Picasso and Portraiture: Representation and Transformation,* ed. William Rubin, exh. cat. (New York: Museum of Modern Art, 1996), 228.

12. I would like to thank Francesc Gabarrell, curator at the Museu d'Art Jaume Morera; Maria Teresa Ocaña, director of the Museu Nacional d'Art de Catalunya; and Mercè Obon, curator at the Fundación Francisco Godia, for their assistance with information about these works.

13. Fontbona, "La crisi del Modernisme," 124.

14. See Richardson, *Life of Picasso,* 1:118–121, 180–81.

15. See Alfred Opisso, "Exposición Casagemas en los IV Gats," *La Vanguardia,* 18 April 1900, 5; and Richardson, *Life of Picasso,* 1:151.

16. See, for example, the works *La Chata,* 1899, and *Mother & Daughter,* 1899–1900 (both Museu Picasso, Barcelona), and others, in *Picasso and Els 4 Gats,* 36–96, 164–65; and *Picasso: The Development of a Genius, 1890–1904,* ed. Maria Teresa Ocaña, exh. cat. (Barcelona: Lunwerg, 1997), 172–73, 256.

17. See Fontbona, "Xavier Gosé, París aparte," in *Xavier Gosé (1876–1915). El París de la belle époque,* exh. cat. (Madrid: Fundación Cultural Mapfre Vida, 1999), 25–27.

18. Pere Romeu, "Sobre la taula," *Quatre Gats,* no. 12 (4 May 1899): 3. See also Mercè Doñate, "Art Activity at Els Quatre Gats," in *Picasso and Els 4 Gats,* 231; and Fontbona, "Xavier Gosé, París aparte," 28.

19. See Fontbona, "Entorn del grup El Rovell de l'Ou," in *El Modernisme. Pintura i dibuix,* ed. Fontbona (Barcelona: L'isard, 2002), 229–40.

20. A *tertúlia,* also known as a *penya,* is a regular meeting of a circle of friends, often at a bar or tavern, for informal discussion of issues of common interest. During a tertúlia, people may come and go at any time, and topics may usually range from the arts to sports to politics. *Rafael Nogueras Oller,* 1900 (private collection) and *Nogueras with a Prominent Citizen at the 4 Gats,* 1900 (Dr. Martinez Sardà Collection, Barcelona).

21. Fontbona, "Gargallo y Cataluña," in *Pablo Gargallo,* exh. cat. (Valencia/Biarritz: Institut Valencià d'Art Modern/Ville de Biarritz, 2004), 66. See also Rafael Ordóñez Fernández, *Museo Pablo Gargallo* (Zaragoza: Ayuntamiento de Zaragoza, 2004), 374.

22. Mendoza and Doñate, eds., *Isidre A. Nonell, 1872–1911,* exh. cat. (Barcelona/Madrid: Museu Nacional d'Art de Catalunya/Fundación Cultural Mapfre Vida, 2000), 25. See also Mendoza's essay in section four of this volume.

23. See Pierre Daix, *Dictionaire Picasso* (Paris: Robert Laffont, 1995), 629; and Richardson, *Life of Picasso,* 1:235.

24. Robert Lubar, "'Barcelona Blues'," in *Picasso: The Early Years* (exh. cat.), 98–99.

25. Despite his obviously biased views, Ricard Opisso offers some insightful comments in his unpublished memoirs. See Jordi À. Carbonell, "Opisso i la memòria anecdòtica d'Els Quatre Gats," in *Quatre Gats: de Casas a Picasso,* ed. Charo Sanjuán, exh. cat. (Barcelona: Bancaja/Museu Diocesà de Barcelona, 2005), 65–71.

# Modernisme:
# Art and Society

# Art and Anarchism in the City of Bombs

*ROBERT S. LUBAR*

In the 1904 almanac of the widely circulated satirical magazine *¡Cu-Cut!* the art critic Raimon Casellas published a short story whose title, "En Ravachol Petit" (Little Ravachol), invoked for his readers a decade of social turmoil in Barcelona.[1] In European political circles and in the popular imagination, the name Ravachol had become synonymous with "propaganda by the deed"—violent and very public attacks by anarchists against individuals and private property that shook the foundations of bourgeois society in Belgium, France, and, with particular intensity, Spain. In March 1892 the young French anarchist François-Claudius Ravachol, exalted by writers such as Paul Adam as a hero in the fight for social equality and vilified by the French justice system as a terrorist, bombed the homes of two judges who had presided over the trial of suspected terrorists a year earlier. Condemned to the guillotine, Ravachol immediately became a martyr to the anarchist cause, defining in the process the terms of a new and heightened level of conflict in the European social and political arenas.[2]

Casellas's text, however, was neither a celebration nor a denunciation of Ravachol's actions and is, in fact, only tangentially related to the life of its title character. Rather, it is an apocryphal story of the changing fortunes of the anarchist movement in Barcelona, the so-called city of bombs, and the complex relation the movement had to the development of Catalan national political consolidation. The text—an ironic tale of economic opportunism, political betrayal, and shattered dreams—was published in the Catalan language and illustrated by the young graphic artist Ricard Opisso (fig. 1), a member of Picasso's circle at the Quatre Gats café, whose father presided over the influential daily newspaper *El Liberal*. In Casellas's dark account, a formerly idealistic young anarchist, a leader of the movement who is sent into exile from his native Barcelona in the wake of political repression, finds himself in a situation of abject misery in a strange new land. Unemployed and starving, he collapses on the streets of his host country, desperate and alone. When some passing workers discover his jaundiced and mangled body, marked by the ordeal he had endured at the hands of police in Barcelona, they revive him and bring him to a bar, where he is given food and drink. Unable to communicate in the language of his peers, the wretched creature grabs a piece of coal and scribbles the word "Montjuich" on the wall, which the stunned and sympathetic workers recognize as the infamous prison where the anarchist and his comrades had suffered unspeakable tortures. As the workers, at once fascinated and horrified by the creature's physical deformities, dig into their pockets to offer him alms, a bourgeois gentleman approaches Ravachol Petit with a tempting offer: he proposes that the young man join his organization and publicly exhibit his wounds, for a fee. And thus, Casellas concludes with sardonic wit, the former apostle of social justice and P. T. Barnum enters into a lucrative business arrangement in which torture and social repression are transformed into a sideshow by willing accomplices on both ends of the economic and political spectrum. "A Victim of Montjuïc: Smash Hit Across Europe!" the entrance to their exhibit at the 1900 Universal Exposition in Paris announces.

Casellas's moralizing tale hinges on two interrelated positions: his belief in the corrupt and decidedly destructive nature of anarchist direct action, and his commitment to defining a new public sphere that would unify the Catalan people across class lines, however much that ultimately played into the hands of bourgeois political hegemony. As both issues weighed heavily on the minds of artists, intellectuals, and writers of different political persuasions, even members of Picasso's circle at the Quatre Gats, many of whom had flirted with anarchist ideas, increasingly rallied behind the cause of an integral Catalan nationalism. The relation between intellectuals and anarchism, however, was never straightforward, as a review of the complex ideological roots of the movement and the assimilation of anarchist ideas within advanced artistic circles demonstrates.

106

At the outset, it is important to distinguish among different directions within the working-class movement in Spain as a whole, with specific consideration of the situation in Catalonia and its capital city. The declaration of the First Spanish Republic in 1868 brought great momentum to the reformist initiatives of the Catalan statesmen Francesc Pi i Margall and Valentí Almirall, who sought to reorganize the Spanish state along federalist lines. Although the restoration of the monarchy in 1874 issued in a new wave of political repression, the rapid pace of industrial development in the north empowered the Catalan upper classes to seek greater control over their markets and thus economic self-determination, a process that ran parallel to and ultimately superseded the development of Catalan romantic nationalism in the cultural sphere—the so-called Renaixença in the world of arts and letters that had begun in the 1850s. In the early years of the Renaixença, aspects of the federalist program shared common ground with the nascent anarchist ideology in their mutual opposition to the highly centralized and authoritarian Spanish state. But this opportunistic alliance, which was more a question of shared philosophical roots than real ideological compatibility, would be broken as Catalan political nationalism increasingly aligned itself with the interests of the industrial class and the Roman Catholic Church, taking on a decidedly conservative, politically repressive cast by the turn of the century.

Meanwhile, the parallel rise of the socialist movement in Spain, under the leadership of Pablo Iglesias, failed to take root in Barcelona. With its headquarters in Madrid, along with the transfer of its trade union—the Unión General de Trabajadores (UGT)—from Barcelona to the Spanish capital in 1899, the Partido Socialista Obrero Espanol (PSOE) found its greatest support in cities such as Bilbao

Fig. 1 (cat. 4:5). Ricard Opisso, *Little Ravachol (Montjuïc)*, 1904.

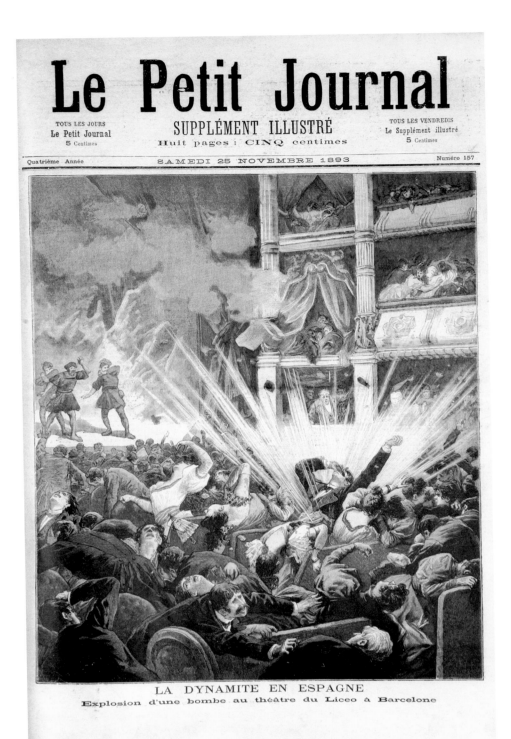

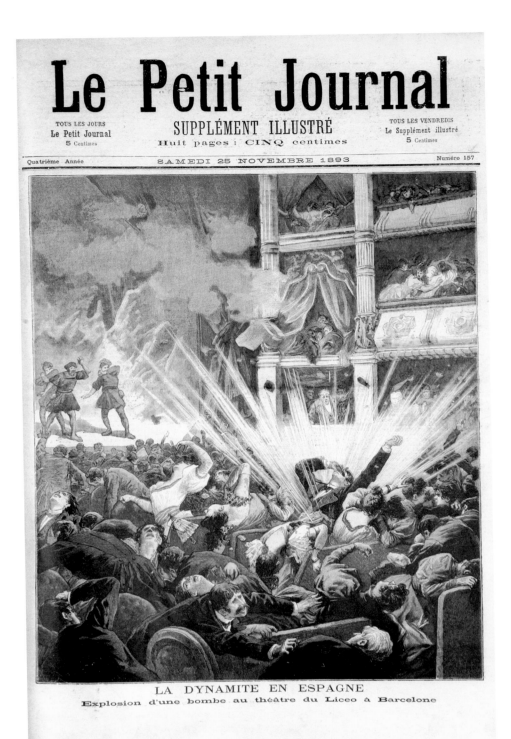

# Le Petit Journal

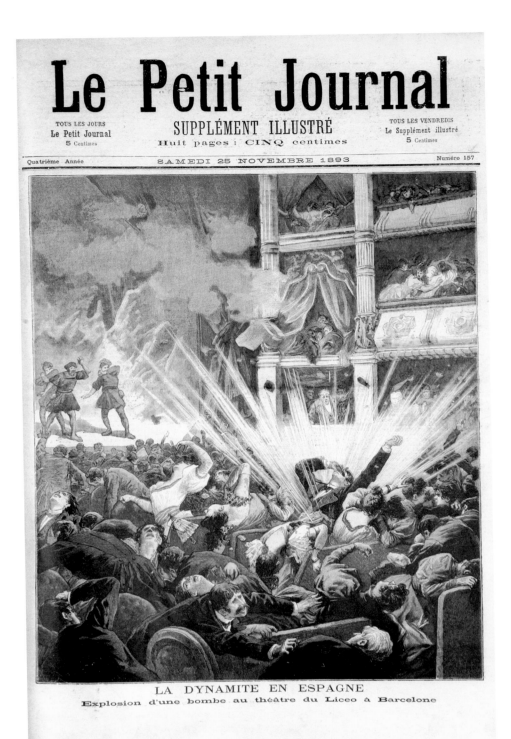

TOUS LES JOURS
Le Petit Journal
5 Centimes

SUPPLÉMENT ILLUSTRÉ
Huit pages : CINQ centimes

TOUS LES VENDREDIS
Le Supplément illustré
5 Centimes

Quatrième Année — SAMEDI 25 NOVEMBRE 1893 — Numéro 157

LA DYNAMITE EN ESPAGNE
Explosion d'une bombe au théâtre du Liceo à Barcelone

and among the steelworkers of Asturias and the miners of Linares; in Barcelona its membership was small. What is more, Spanish socialism, characterized by a strong centralist organization, a certain moral puritanism, and a refusal to embrace the cause of Catalan nationalism, alienated important sectors of the working and artisan classes in Barcelona, who were drawn to the anarchist movement and its emphasis on natural, organic communities.[3]

Spanish anarchism, however, existed in a fundamentally asymmetrical relationship to the rising tide of Catalan political nationalism. Its origins in the late 1860s in the split between Karl Marx and the Russian aristocrat Mikhail Bakunin over control of the International had a decisive impact in Spain, where Bakunin's collectivist model of a natural society based on sovereign groups working for the common good garnered support among the land-

Fig. 2 (cat. 4:18). *Dynamite in Spain,* cover of the illustrated supplement to *Le Petit Journal,* 25 November 1893.

less peasants of Andalusia and the factory workers of Barcelona, who had learned to distrust the political process and its ability to effect significant social change. Nevertheless, it would be wrong to consider Catalan anarchism a majority initiative or a mass social movement in the strict sense. Until the birth of anarcho-syndicalism in 1910, which was destined to have a profound impact on Spanish politics over the course of the next three decades, the anarchist contingent remained a relatively small, albeit dynamic force in the Spanish and Catalan social landscapes. With the adoption of "propaganda by the deed" in the 1880s as a strategy of social disruption, and in the absence of a centralized authority, anarchist *atemptats* (attacks) were generally carried out by isolated cells hoping to capitalize on the effects of terror. And this they did, with particularly spectacular results in Barcelona that ultimately drove a wedge between anarchists and Catalan leftist intellectuals.

The relationship of Catalan intellectuals to the anarchist movement is complex.[5] Beginning in the 1880s, artists and men of letters throughout Spain were drawn to the anarchist credo, although "intellectual anarchism" as a posture for social reform remained at a significant distance from the cause of direct action. As an extension of the liberal project initiated with the French Revolution, Pierre-Joseph Proudhon's emphasis on the need to substitute the political structures of civil society for a new economic organization based on mutual support among federations of workers was reconciled with Max Stirner's exaltation of individualism and Friedrich Nietzsche's exhortation to modern man to overcome his alienated nature through the exercise of free will. At the same time, aspects of Charles Darwin's theory of evolution were interpreted in a more materialist light in Spain via the writings of the German biologist Ernst Haeckel and the British social philosopher and biologist Herbert Spencer, providing new intellectual models for the victory of reason over instinct, and offering scientific justification for evolution as a socially progressive process.[6]

Catalan artists and writers drew inspiration from these sources in their multilayered responses to the anarchist movement. In the world of letters, Émile Zola and Henrik Ibsen were hailed as the spokesmen for a new genre of socially engaged literature, while French painter Camille Pissarro, a known anarchist sympathizer, helped define the role of the intellectual in society for an entire generation of artists. If these individuals served as moral exemplars in a general sense, in Barcelona intellectual anarchism was aligned with the project of Catalan national and cultural regeneration in very specific ways. In 1881 the journal *L'Avens* began publication as a review of Catalan letters, art, and science. When it reappeared in 1889 after a five-year suspension, its editors embarked on a far-reaching campaign to normalize the Catalan language and, under the leadership of the philologist Pompeu Fabra, to establish the foundations of a modern Catalan grammar. Over the next two years *L'Avenç*, spelled to reflect the adoption of new orthographic norms, became increasingly radicalized, as its most active contributors, the writers Pere Coromines and Jaume Brossa, called for the cultural and political "catalanization" of the working class and the formation of an integral and popular Catalan nationalism.[7] It was, in fact, Coromines and Brossa who presided over the transfer of anarchist ideas to the cause of Catalan national regeneration. Their vocal rejection of the status quo of Renaixença politics, their contempt for the mass bourgeois society under industrial capitalism, and their self-identified position as organic intellectuals who acted in opposition to the parochialism of their class inspired them to reconcile artistic individualism with social responsibility and to align Catalan nationalism with progressive trends in European culture and politics.

*L'Avenç* ceased publication in December 1893 in the wake of an anarchist bombing that polarized opinion among its subscribers, but significant elements of the journal's ideological and social program were absorbed by the Catalan republican Left and the artists and writers of Picasso's circle at the Quatre Gats at the end of the century. The terms

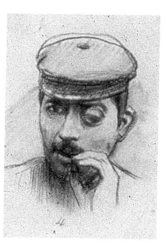

Fig. 3. *Heads of Anarchists*, 1894 (detail), by Santiago Rusiñol.

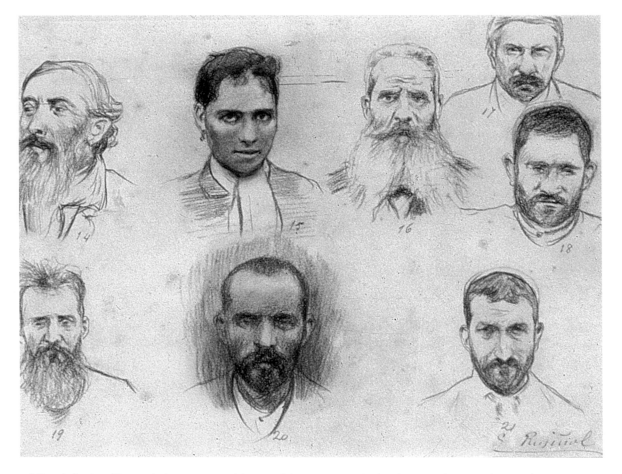

of the delicate alliance between anarchists and intellectuals were, however, decisively altered in the process. The event in question was the bombing of the Gran Teatre del Liceu on 7 November 1893 (fig. 2). Although a similar anarchist atemptat had rocked Catalan civil society a year earlier, when the Foment del Treball, the Catalan employers association, was bombed during a strike, it was the Liceu attack that elevated the threat of terror to a level of national consciousness throughout Spain. Located in the heart of the old city, the Liceu opera house was the symbolic and geographical center of high culture for the Catalan upper classes. On that terrible day in November, a young anarchist named Santiago Salvador Franch threw two Orsini bombs into the audience during the season's premiere of *William Tell*. Although only one bomb detonated, the human toll was considerable: it is estimated that 22 people were killed and some 35 were wounded, although the reported numbers are inconsistent. The Madrid government responded by suspending constitutional guarantees and granting the police free rein to pursue suspects.

Typical of Spanish anarchism, the Liceu attack was planned and executed as an act of reprisal—in this case, to avenge the public execution on 6 October 1893 of another young anarchist named Pauli Pallàs, who had been condemned to death for a failed attempt two weeks earlier on the life of the civil governor of Catalonia, General Arsenio Martínez Campos, during a military procession. It is likely that Salvador acted in partnership with a small fringe group, if not alone, although scores of innocent men and women were prosecuted. In a series of sketches by the wealthy Catalan artist Santiago Rusiñol (figs. 3–5), who appears to have attended the highly sensationalized trials, the accused are represented as criminal types—nameless specimens who are deprived of agency, assigned numbers within a taxonomical structure, and treated as the blind objects of juridical surveillance.[8]

Rusiñol's response may appear surprising, since he was a vocal and persistent critic of the provincial tastes of his class and an advocate of Catalan integration within mainstream European cultural affairs. But he was not a political radical. Just as the

Fig. 4. *Heads of Anarchists,* 1894 (detail), by Santiago Rusiñol.

Liceu bombing caused a rift among the supporters of *L'Avenç*, so too did it threaten to disrupt the fragile unity of political Catalanism. In 1887, a year before the Universal Exposition in Barcelona, conservatives founded the Lliga de Catalunya (League of Catalonia) to oversee their economic interests. Four years later the Lliga joined forces with other Catalanist organizations to form the Unió Catalanista (Catalan Union), with the expressed aim of drafting a proposal for Catalan legislative and juridical autonomy within the Spanish state. It is hardly coincidental that the first anarchist bombings in Barcelona coincided with the adoption of that plan in 1892, the so-called Bases de Manresa (Manresa Points), as the Catalan industrial class aligned itself with the Roman Catholic Church in its struggle to maintain social order and economic hegemony. Indeed, sometime after the Liceu attack, Antoni Gaudí installed a sculpture in the Chapel of the Rosary of the Sagrada Família in Barcelona, depicting a demon tempting a worker with an Orsini bomb (see fig. 6, p. 214). The Sagrada Família had been conceived in the late 1870s as an expiatory temple to atone for the "sins" of republican liberalism, which left no room to doubt the Church's position as the religious patron of the industrial class.

This is not to say that the cause of republican Catalanism did not find favor among progressive artists and intellectuals, but it did not play a significant political role until after 1900, and even then it failed to win wide support among the working class. In the meantime, two events signaled the transformation of Catalan nationalism into a major force within Spanish politics: another spectacular atemptat in Barcelona, this time on the occasion of a religious procession in 1896; and the grave economic consequences of the Spanish-American War of 1898 and the ensuing "national disaster," as it was called.

On 7 June 1896, a bomb was thrown into a crowd of observers during the annual Corpus Christi procession in the old city of Barcelona, wounding 35 bystanders and killing 12. As one of the dead was a soldier, the captain general of Catalonia (an appointee from Madrid and a symbol of oppressive state control over Catalan affairs) gave the military broad license to pursue the perpetrators. In the process, hundreds of anarchists, suspected anarchists, and anarchist sympathizers (including Pere Coromines)

were arrested and brought to the Montjuïc prison to await trial. When word got out that confessions had been obtained under torture, the international press reacted strongly and the central government was discredited. Various sectors of the Catalanist movement, including republicans, socialists, and liberals, used the occasion to condemn the regime, expressing their outrage in phrases like "tota Espanya és Montjuïc" ("Montjuïc is all of Spain").

Two years later, following the disastrous Spanish-American War of 1898, political events again played into the hands of Catalan nationalists. The final breakup of Spain's once-powerful colonial empire crippled the Spanish economy. Catalan industry was hit particularly hard with the loss of its primary foreign markets in Cuba, Puerto Rico, and the Philippines, leading to a consensus among the Catalan middle and upper classes that an economic solution to the crisis could not be negotiated within the prevailing political organization of the state.[9] When the Madrid government tried to levy a new profit tax to finance economic recovery a year later, the Catalan middle classes revolted and businesses were temporarily closed in protest. Madrid responded by declaring martial law, but the government's harsh tactics only served to intensify Catalan political initiatives. By 1901, a new coalition of Catalan conservatives and industrialists joined forces to found the Lliga Regionalista (Regionalist League), the first Catalanist political party in the strict sense, which won four of seven seats for Barcelona in elections that year.

As demands for new social legislation on issues ranging from workers compensation to restrictions on child labor increased in the wake of the economic crisis, writers throughout Spain called for the wholesale regeneration of the nation. In Catalonia the Left was split between the Radicals, a deeply anticlerical and anti-Catalan republican party under the leadership of Alejandro Lerroux, and more moderate republican Catalanists, who appealed to the Catalan libertarian tradition in response to the "social question."[10] Lerroux's Radical party gained considerable support among the working class and won five of the seats for Barcelona in the national elections of 1903 and 1905, but its authority was constantly tested by the conservative Lliga, which won a ma-

jority in municipal elections. Meanwhile, republican Catalanism held wide appeal for progressive artists and intellectuals, including members of Picasso's circle, whose opinions were expressed in the journal *Joventut* (Youth). Nowhere is this more moderate position expressed with greater economy than in Picasso's cover sketch for the 5 October 1902 edition of *El Liberal* (fig. 6) commemorating the annual celebration of Our Lady of La Mercè Day in Barcelona. In the wake of a devastating general strike that had crippled Barcelona eight months earlier, Picasso appealed to a shared ideal of Catalan national solidarity across class lines, as workers and bourgeois citizens join in the traditional procession of *gegants* (giant effigies) in the streets of Barcelona. The title of the accompanying editorial, "Barcelona Triunfante" (Triumphant Barcelona), leaves little room to misinterpret the political message: under the watchful eyes of the Spanish authorities, whose presence is symbolized by the silhouette of the Montjuïc prison in the distance, the people of Barcelona are united.[11]

In retrospect it may appear that Picasso's appeal to a shared ideal of Catalan political and economic solidarity is of a piece with Raimon Casellas's tale of "Little Ravachol." However much the approach to the question of Catalan national interests varied among conservatives and republicans—and the differences were considerable—for a time the rise of an integral, political Catalanism replaced ideological politics as a motor force for change in Spain. As the contest among conservatives, radicals, and republicans gained momentum in the early years of the 20th century, one final event was to have a decisive impact on the transformation of the Catalan political arena. On 23 November 1905 a cartoon critical of the military appeared in *¡Cu-Cut!* (the same journal in which Casellas had published his satire of the anarchist cause a year earlier). Two days later members of the Barcelona garrison attacked the offices of that magazine and the newspaper *La Veu de Catalunya*, both of which were aligned with the Lliga Regionalista, hoping to clamp down on what was perceived to be Catalan separatism. In response to a Law of Jurisdictions that was passed in 1906 giving military courts sweeping authority to prosecute crimes against the state and the army, a new coalition of Catalanist parties was established across political lines: Solidaritat Catalana (Catalan Solidarity). A year later Solidaritat swept both the municipal elections in Barcelona and the national elections for Catalonia's seats in parliament, decidedly altering the course of Catalan and Spanish politics in the process. For the next 15 years the Lliga maintained its grip on power in Catalonia and instituted a far-reaching plan for the urban transformation of Barcelona and the institutional restructuring of Catalan civil society. Although its hegemony was periodically challenged by labor unrest and outbreaks of violence, a new era in Catalan political life had begun.

1. Raimon Casellas, "En Ravachol Petit," *Calendari del ¡Cu-cut!* (1904): 124–29.

2. For responses by artists and intellectuals to the anarchist movement in fin-de-siècle France and Belgium, see Eugenia W. Herbert's classic study, *The Artist and Social Reform: France and Belgium, 1885–1898* (New Haven: Yale University Press, 1961). On Spain, see Lily Litvak, *Musa Libertaria: Arte, literatura y vida cultural del anarquismo español (1880–1913)* (Barcelona: Antoni Bosch, 1981).

3. For a discussion of politics and mass social movements in Spain and Catalonia, see Gerald Brenan, *The Spanish Labyrinth: An Account of the Social and Political Background of the Civil War* (Cambridge: Cambridge University Press, 1943); and Temma Kaplan, *Red City, Blue Period: Social Movements in Picasso's Barcelona* (Berkeley: University of California Press, 1992).

4. Jordi Castellanos, "Aspectes de les relacions entre intel·lectuals i anarquistes a Catalunya al segle XIX. (A propòsit de Pere Coromines)," *Els Marges*, no. 6 (February 1976): 7–28. See also Joan Lluís Marfany, *Aspectes del Modernisme* (Barcelona: Curial, 1975).

5. Alvaro Girón Sierra, *Evolucionismo y anarquismo en España, 1882–1914* (Madrid: Consejo Superior de Investigaciones Científicas/Centro de Estudios Históricos, 1996).

6. On the history of the magazine, see Joan Torrent and Rafael Tasis, *Història de la premsa catalana* (Barcelona: Bruguera, 1966), 199–209.

7. For an illuminating discussion of Rusiñol's drawings and a consideration of the disputed number of victims of the Liceu attack, see Brad Epps, "Seeing the Dead: Manual and Mechanical Specters in Modern Spain (1893–1939)," in *Visualizing Spanish Modernity*, ed. Susan Larson and Eva Woods (Oxford: Berg, 2005), 112–41.

8. A somewhat polemical reading of the events of 1898 can be found in *La resposta catalana a la crisi i la pèrdua colonial de 1898* (Barcelona: Generalitat de Catalunya, 1998).

9. Marfany, *La Cultura del catalanisme: El Nacionalisme català en els seus inicis* (Barcelona: Empúries, 1995).

10. For a full discussion of the context for Picasso's drawing, see my essay, "Picasso's Barcelona Blues," in *Picasso: The Early Years, 1892–1902*, ed. Marilyn McCully, exh. cat. (Washington: National Gallery of Art, 1997), 87–101.

Fig. 5. *Heads of Anarchists*, 1894 (detail), by Santiago Rusiñol.

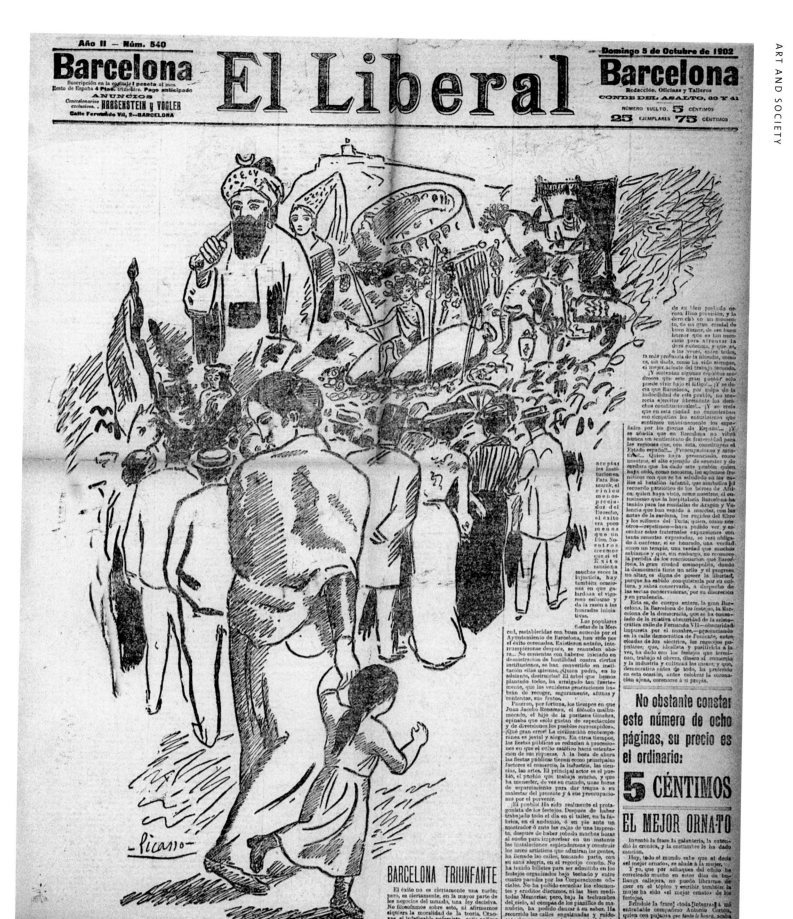

Fig. 6. Front page of Barcelona's *El Liberal,* 5 October 1902, with illustration by Pablo Picasso for the holiday celebrating Our Lady of La Mercè.

# Bourgeois Life and the Representation of Women

*CARMEN BELEN LORD*

Among the most decisive cultural, social, and economic developments in 19th-century Catalonia was the emergence of a powerful, independent middle class open to new ideas.[1] As Catalonia was transformed into "the factory of Spain," migration from the countryside to the capital of Barcelona increased exponentially, and the city grew from 100,639 inhabitants in 1826 to 533,000 by the end of the century, transforming it physically and socially.[2] For Barcelona, the transition from an agrarian to an industrial economy resulted in unprecedented affluence for those who controlled the factories that generated the wealth of the region. At the same time, the challenge to traditional culture resulting from such rapid social change formed the context for a profound reconsideration of the identity of women and their role at home and in society.

The middle class contributed substantially to the subsidization of the emergent modernista artistic movement at the turn of the century by relying upon artists and architects for the creation of their homes and a fashionable aesthetic environment. Consequently, the images created by contemporary artists often align with the taste, lifestyle, and ideals of their intended patrons. Romà Ribera's undated painting *Leaving the Ball* (fig. 1) and Ramon Casas's *Elisa Casas*, c. 1894–1900 (fig. 2), suggest keen interest by both artists in marketing their work to the fashionable well-to-do. Yet, while they respond to a prevailing enthusiasm for decorative representations of women and the lifestyle of the Barcelona bourgeoisie, the works also illustrate a significant transition in painting at the time they were created.

Ribera, Casas's senior by 17 years, belonged to an earlier accomplished generation of realist painters in Barcelona. As a young man, under the prevailing influence of Spanish academicism, Ribera worked in Rome, where he specialized in beguiling and picturesque street scenes. He was later successful at the Paris International Exposition of 1877 with paintings of fashionable society dances and Pierrots in a continuation of the same manner. He remained in the French capital for 12 years. As can be seen in the charming *Leaving the Ball,* a classic example of his work, Ribera pursued his delicate representational style, perfectly suited to conservative collectors, after he returned to Barcelona. Firsthand experience of French art had a more dynamic formative influence upon Casas. As a precocious adolescent, he studied in the Paris studio of the successful Salon painter Emile Auguste Carolus-Duran, with whom John Singer Sargent had worked a few years earlier. Under the guidance of his French teacher, Casas was exposed to a range of the French avant-garde and also made close study of the tonal painting technique of Velázquez.[3] When Casas returned to Paris as an independent artist in his early 20s, he lived over the dance hall of the Moulin de la Galette with his friend Santiago Rusiñol. Together they explored a sensitive, atmospheric responsiveness to modern subject matter that in turn became identified with emergent Modernisme through their exhibitions of 1889–95 at the Sala Parés gallery in Barcelona.[4]

Ribera's *Leaving the Ball* and Casas's *Elisa Casas* depict affluent Barcelona society women dressed in fashionable and elegant evening attire. Ribera's painting attractively entrenches other references to a prosperous lifestyle using a mosaic of social cues. The distinguished-looking male escort protectively flanking the tentative and seemingly vulnerable female figure, liveried servant, and crowd of fashionable people are painted in an anecdotal manner of particular appeal to conservative collectors. By contrast, few clues to the circumstances or station of Casas's subject are provided by her casual background—a much criticized aspect of modernista portraiture at the time. The setting for *Elisa Casas,* the artist's younger sister and model for the painting, is almost certainly the family's lavish new home, designed by architect Antoni Rovira i Rabassa, on passeig de Gracia in the new modernista Eixample district. Yet little effort is made to reference the fashionable address. Instead, the monumentally self-possessed and poised Elisa dominates her un-

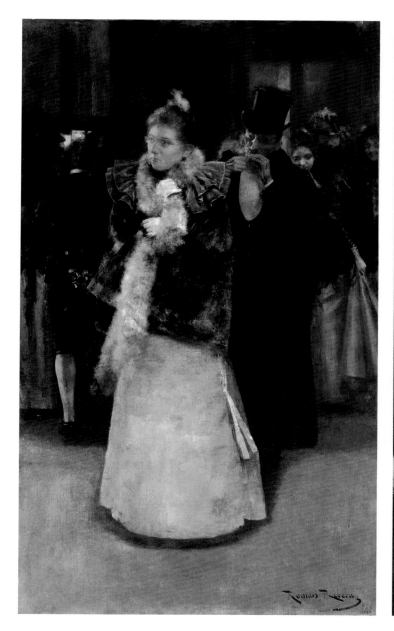

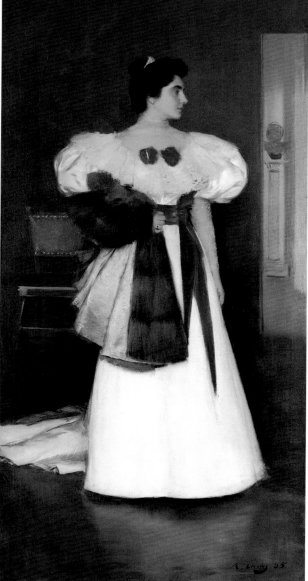

pretentious setting. The angular chair against the wall behind her and the view at right into a second room featuring a bust on a pedestal offset rather than compete with the warm humanity of the young woman. Her lustrous gown, with its immense iridescent sleeves, highlights Casas's absorption of the tonal painting of Carolus-Duran. Casas was fighting a battle for critical acceptance of his pictorial innovations in Barcelona at the time he began this work around 1894, but the composition anticipates the technically accomplished portrait style that would make him sought after by fashionable patrons of his own class a few years later.

Because of the growth of the middle class in Catalonia, as represented in paintings by Ribera and Casas, the reconsideration of the role of women became important to the discourse of social change during the approximately 70-year period between the 1870s and the beginning of the Franco dictatorship in 1939. In fact, in the decades immediately before and after the turn of the century, the condition of Spanish women was the subject of growing national debate. The very arenas that traditionally defined the boundary lines of women's lives—the home, marriage, motherhood—were subjects of concerned commentary. Editorials, conferences, sermons, articles, scholarly books, and many analytical publications addressed the legal, political, and social condition of Spanish women. By the 1870s, the improvement of women's education was a significant

Fig. 1 (cat. 4:3). Romà Ribera, *Leaving the Ball*, c. 1894.
Fig. 2 (cat. 4:2). Ramon Casas, *Elisa Casas*, 1895.

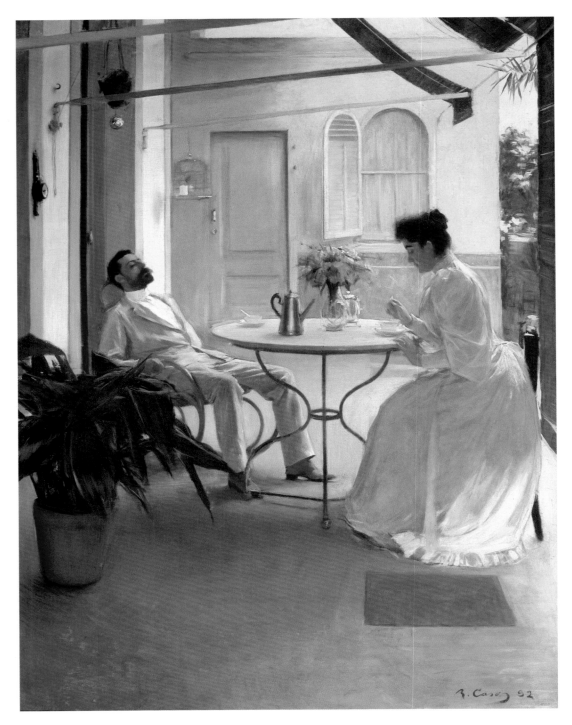

public concern and heatedly debated in women's magazines.[5] Momentous social change was also reflected in the intensification of women's public, and often political, engagement in Spain at this time.

Popular visual culture and fine art of the period reveal enormous public appetite for images of the national domestic experience and, more specifically, the private life of women. Representations of women engaged in prayer, housework, teaching children, and caring for the sick were lavishly recorded in paintings, prints, and illustrations. Traditional ideals concerning women's roles were similarly reflected in the many didactic books published especially for or about women at this time. Many instructional manuals geared to the female reader were published in Barcelona and Madrid, including books on hygiene, household arts, etiquette, and religious guidance. Representations of women in paintings of domestic life and instructional books intended to regulate female behavior often informed one another, each

Fig. 3 (cat. 4:1). Ramon Casas, *Interior in the Open Air,* 1892.

prescribing and at the same time recording social custom, as illustrated in Ribera's *Leaving the Ball*. As suggested in many guidebooks, even such wealthy women as these had grave moral responsibilities toward society, despite their freedom from mundane domestic chores. "It is understood that a rich woman is released from certain manual occupations in the house," observed Viscountess Bestard de la Torre in her classic *La elegancia en el trato social* (Elegance in Social Intercourse) of 1906:

*[B]ut on the other hand, a brilliant position demands an extraordinary vigilance. . . . She must direct the servants, she must guard their morality, worry herself over the most humble details, to the end that the wheels of that great machine that constitutes the comfort and regulation of the house never falters.*[6]

Such texts were intended to promote the development of good wives and mothers by providing templates for education, morality, comportment, social intercourse, housekeeping, and motherhood. Both paintings suggest a great concern for the pivotal role of women in sustaining and elevating the fabric of national life at a private level; together they map the imagined private realm of the Spanish woman as she entered the 20th century.

The model for women in 19th-century Spain was a conservative one, linking women's cultural identity to marriage, motherhood, domesticity, and the overarching principle of selflessness and service to others in private life. Julián López Catalán expressed deeply entrenched beliefs in 1877 when he stated in a public lecture in Barcelona that the ideal Spanish woman was "an angel of love, consolation for our afflictions, defender of our merits, patient sufferer of our faults, faithful guardian of our secrets, and jealous depository of our honor."[7] In a contemporary article written for a women's magazine, Faustina Saez de Melgar similarly idealized the beneficent impact of women on society, articulating the widespread belief that women's perceived virtues were deter-

mined by natural law.[8] Should a woman be unfortunate enough to be trapped in an unhappy marriage, she was advised to "resign yourself and give yourself completely to your children and to your Mother the Church, fount of all consolation."[9]

A second painting by Casas provides insight into daily life in a representative upper-class family circle at this time. *Interior in the Open Air*, 1892 (fig. 3), portrays Casas's eldest sister, Montserrat, and her husband, the Marquis de Villamizar, sharing afternoon coffee on a terrace adjacent to a garden. Dressed in elegant summer linen, the marquis closely observes his wife from beneath lowered lids as he leans back in a rocking chair. By contrast, his wife appears lost in thought as she stirs the coffee in her cup, quite unaware of him. At the rear, the bird suspended in a golden cage radiantly dissolved into a haze emphasizes the unspoken thoughts separating the couple. A rich variety of formal surfaces support the psychological subtlety of the work. Golden light drenches the sheltered garden enclosure, reflecting from many textures, including a mercury ball containing a miniature key to the colors in the painting and a vase and coffee service described in translucent light. The quiet intimacy of the mundane contemporary setting and the transitory, accidental quality of the moment described enhance our insight into the psychological life of both male and female figure, as well as the implied complexity of their marital relationship. While the tender hesitancy of Ribera's fashionable woman in *Leaving the Ball* suggests dependency upon her authoritative male escort, Casas represents both Montserrat and her sister in the 1894 portrait as strikingly self-possessed, modern young women.

In contrast to the elegance of Casas's and Ribera's subjects, Joan Planella Rodríguez's *The Child Laborer*, 1882 (fig. 4), directly confronts the disparity between the wealthy and the poor in the metropolis as well as the uneasy political and social tension of the era. Like Ribera, Planella received classical academic training in painting and in 1876 succeeded

Fig. 4. *The Child Laborer*, 1882, by Joan Planella Rodríguez.

in winning a coveted scholarship pension from the Diputación Provincial de Barcelona permitting him to study in Rome. *The Child Laborer,* which won a third-class medal in the National Exposition of 1884, is presented with somber exactitude, the figure rendered with touching dignity. The pleasant airiness of the home and terrace depicted by Casas and the decorative and opulent costumes typical of Ribera's compositions are here supplanted by the grim reality of daily life for many children in and around Barcelona.[10] In a grimy interior filled with shadows and heavy industrial machinery, a solitary young girl dressed in worn and wrinkled clothing maneuvers the shuttle of a large loom. Harsh cogs, straps, and wires contrast with her pale, childish form as she tiredly leans against the machine, her eyes following the shuttle as the fabric ceaselessly descends.

In contrast to the bleak lives of the working poor, not surprisingly, texts and images marketed to the upper classes were dominated by the ideals of motherhood and the education of children. According to the eminent Barcelona writer Pompeu Gener, in an article published in the widely read newspaper *La Vanguardia* in 1889, "in herself, a woman, unlike a man, is not a complete being; she is only the instrument of reproduction, destined to perpetuate the species; while man is charged with making progress, he is the generator of intelligence, at the same time creator . . . of the social world."[11] The idea that a woman's identity was fused with her reproductive capacity was common in late 19th- and early 20th-century Spain, as attested by its repetition in popular culture.

Many period texts and images address the education of children. *Regles morals y de bona criança* (Moral laws and laws of good breeding), a much-lauded guidebook with an ecclesiastical commendation by popular Catalan playwright Josep Pin y Soler, was first published in 1892 and reissued in 1915, suggesting continued interest in the author's ideas.[12] Well-

behaved children, according to the text, were the consequence of stringent regulation and vigilance. They arose at daybreak after sleeping a maximum of eight hours and immediately said their prayers. The child then affectionately greeted her parents, cleaned and dressed herself, ate breakfast, reviewed the previous day's school lessons, and helped dress and entertain younger siblings before facing her next round of duties—at school. Since children were unlikely to read such texts voluntarily, and a father's primary role was in the public realm, mothers were critical to the communication and enforcement of

this system of habits saturating the child's existence—an expectation for both working- and middle-class mothers.

As suggested by Planella's painting, however, daily life was brutally different for many children, particularly in the industrialized northeastern province of Catalonia. Almost 20% of women over the age of 14 in and around Barcelona worked in textile-related industries, suggesting a direct link between evolution in the needs of industry and women's roles. The pressing class differences between the leisured upper class and working poor raised public awareness to some degree and resulted in efforts to provide new protective legislation. By 1900, there were calls for the protection of women and children in the country's factories,[13] while community women in Barcelona organized an important demonstration protesting the sexual abuse of children in 1910.[14] Nonetheless, child labor was an accepted reality in both city and countryside. At the model Colònia Güell factory town, on which Antoni Gaudí collaborated, one great-grandmother recalled:

*At eleven years old I began working at the factory, spinning, barefoot, covered with oil, not even going out for lunch because while the spinners went out to eat, we were supposed to clean the machines. . . . I worked a good twelve hours.*

Fig. 5 (cat. 9:27). François Kollar or Daniel Henri, *Militia Woman Speaking from the Top of a Car or Truck,* c. 1937.

*Were there children at the factory? Why some even came from Sant Boi, others that came from Sant Vicenç, on foot, when it rained and the roads were full of mud, arrived covered with mud up to here, oh . . . !! . . . That wasn't living. Now no one would be able to stand what we withstood. . . . Sometimes an inspector would arrive and they would hide us. It wasn't allowed, but. . . . Later [we had] the labor unions and it was a whole other story.*[15]

The most fortunate Spanish little girls were taught to read, write, and do simple arithmetic at the local grammar school, but the inevitable focus of their education was preparation for the future management of a home. Accordingly, in 1872 Leopoldo Augusto de Cueto observed that the only books available to young girls in the Basque province of Guipúzcoa were the Bible, a few catechisms, and a small selection of storybooks. Sufficient, he felt, to "sustain in their breast the ideal of country and fear of God, the foundation of all human wisdom. It is more important for them to be good than knowledgeable. And in truth to be pure, patient, and hard-working in their homes, that natural sphere of woman, is to know all."[16]

While conventional images and texts of this time share a common desired culture and suggest a monolithic national consensus regarding the accepted boundaries of feminine behavior, female culture in Spain was considerably more complex and unstable than this implies. Thus many didactic texts and comfortably conventional images marketed to the middle class, including Ribera's painting, were created in a time when women's roles in Spain were, in fact, changing, and to some degree may have functioned as reassuring counterbalance to these developments. Paintings such as Casas's portraits of his sisters emphasize a new sensibility toward female autonomy and potential aside from reproductive capacity.

By the 1910s and 1920s, a new model of the modern Spanish woman had emerged, particularly in Catalonia because of the crucial role played by women in industry. The reconsideration of their roles undoubtedly played an important part in the national agenda by the 1930s and conspicuously informed the official policies of the Second Spanish Republic. It is not surprising that under Francisco Franco's dictatorship (1939–75) the Spanish government vigorously pursued an emphatic reversal of this trend. Thus from 1940 on, gains in women's legal rights were revoked and the traditional ideal of femininity, so common in fin-de-siglo Spain, was once again glorified. As contemporary Spanish culture proves, those ideals, represented in powerful new words and images, were ultimately just as impotent in stemming the tide of change.

1. Raymond Carr, *Spain, 1808–1975* (Oxford: Clarendon Press, 1982), 435.

2. Jaume Vicens i Vives and Montserrat Llorens, *Industrials i politics del segle XIX.*, 3rd ed. (Barcelona: Vicens Vives, 1980), 18–19.

3. As is well established, the study of Velázquez by French artists was a crucial component in the evolution of French modernism. See *Manet/Velázquez: The French Taste for Spanish Painting* (New York: Metropolitan Museum of Art, 2003).

4. See Carmen B. Lord, "Point and Counterpoint: Ramon Casas in Paris and Barcelona, 1866–1908" (Ph.D. diss., University of Michigan, 1995), which documents the artist's career on a year-by-year basis, along with critical response to his work, based upon primary documents of the period and more than 150 private collections.

5. Geraldine M. Scanlon, *La polemica feminista en la España contemporanea, 1868–1974* (Madrid: Ediciones Akal, 1986), 21–23.

6. Vizcondesa Bestard de la Torre, *La elegancia en el trato social. Reglas de etiqueta y cortesía en todos los actos de la vida* (Madrid: Librería de Fernando Fé, 1906), 44. All translations by the author.

7. Julián López Catalán, *Breves reflexiones sobre la educación doméstica: Discurso leído el día 1 de mayo de 1877 en la sesión pública que celebró la Sociedad Barcelonesa de Amigos de la Instrucción* (Barcelona: Librería de Juan y Antonio Bastinos, 1877), 10–11.

8. Faustina Saez de Melgar, "La Abnegación," *La Moda Elegante Ilustrada* 40 (1872), 327, quoted in Adolfo Perinat and Maria Isabel Marrades, *Mujer, prensa y sociedad en España, 1800–1939* (Madrid: Centro de Investigaciones Sociologicas, 1980), 170.

9. Bestard de la Torre, *La elegancia en el trato social*, 43.

10. A number of modernista painters, including Santiago Rusiñol, also painted the factory environment, providing further precedent for images of the disenfranchised by Pablo Picasso and Isidre Nonell.

11. Pompeu Gener, "De la mujer y sus derechos en las sociedades modernas," *La Vanguardia*, 26 February 1889.

12. J. Pin y Soler, *Regles morals y de bona criança* (Barcelona: Editorial Ibèrica, 1915).

13. Temma Kaplan, *Red City, Blue Period: Social Movements in Picasso's Barcelona* (Berkeley: University of California Press, 1993), 110.

14. Ibid., 108–9.

15. Oral history, quoted in Cristina Borderías, ed., *Les dones i la història al Baix Llobregat* (Barcelona: Centre d'Estudis Comarcals del Baix Llobregat/Publicacions de l'Abadia de Montserrat, 2002), 1:476.

16. Leopoldo Augusto de Cueto, "La mujer de Guipúzcoa," *Las mujeres españolas* (Madrid, 1872–73), 1:423, quoted in Geraldine M. Scanlon, *La polemica feminista en la España contemporanea (1868–1974)* (Madrid: Ediciones Akal, 1986), 20.

# Casas and the Chronicle of Social Life

*CARMEN BELEN LORD*

History painting in late 19th-century Spain offers singular insight into the national response to the momentous changes of the period, including unprecedented civil disturbances and the loss of the country's last colonies.[1] Traditional history painting was supported by official artistic circles, including the Academia de San Fernando, the Exposiciónes Nacionales de Bellas Artes, and the Academia Española de Bellas Artes en Roma,[2] which together formed a self-supporting system that discouraged innovation. By promoting the representation of heroic scenes from the national past, episodes from the antique or the history of the Catholic kings, for example, in painting and sculpture, the Academy joined its voice to that of the central government. Deliberately distancing itself from spiraling challenges to Spain's self-image as a unified world power, official history painting of the era visually embodied the Spanish government's stance that the present difficulties were passing ones. By calling for public unity, courage, and patriotism, such paintings sought to reinforce the values that fortified preceding generations and more heroic eras.

A combination of circumstances made Barcelona's situation unique within this national equation. Social structures in Barcelona were severely taxed by the rapid industrialization of the region and its subsequent explosive population growth. Matters culminated in the unstable atmosphere generated by waves of political terrorism in the Catalan capital in the 1890s. At the same time, a Catalaniste movement gained ascendancy, which in turn found expression in the modernista aesthetic. Modernista history painting, as addressed by the Catalan critic Raimon Casellas, promoted a dynamic combination of contemporaneous subjects and immediacy of composition and technique. These conditions inspired a search for innovative approaches to history painting that were virtually new to the conservative Spanish art world, as perhaps most compellingly represented in the work of Casellas's close friend, the painter Ramon Casas.

On 12 July 1893, jostled by a restless crowd gathered in the shabby Pati dels Corders next to the walls of the old prison near the Ronda de Sant Pau in Barcelona, Casas witnessed the public execution by garroting of 19-year-old Aniceto Peinador. Casas immediately recorded his disquieted reaction in several sketches and later returned to paint an oil study of the yard emptied of people. In *The Garroting* (fig. 1), the history painting that Casas created from this experience, the viewer is distanced from the suffering of the condemned man, who sits on the scaffold at the middle left, his throat bound by the garrote being tightened by the executioner.[3] Peinador's small, still figure is almost lost among canyon-like buildings, leafless trees, and the crush of people. Instead, Casas draws our attention to the collective experience of public execution at this time, framing the discomfiting subject in its historic and social context as a dispassionate observer. The contour of the lethal collar around the prisoner's neck is echoed in a succession of semi-circles that include the clergy, members of the religious association the Archicofradía de la Purísima Sangre clothed in their distinctive black robes and pointed headdresses, and disciplined ranks of military hemming in the condemned man. Together these three groups reference the ritual protocol that circumscribed the occasion of capital punishment. In contrast, a throng of gaping citizens crowd the foreground, roofs, and balconies strung along the two colored buildings at rear. A gray haze of mist and industrial smoke, characteristic of the neighborhood at this time, envelops the bleak setting. The inclusion of the small chapel above the prison wall at left, as well as the narrow doorway through which prisoners were led to the execution platform, underscores Casas's attentive fidelity, as revealed by comparison with a documentary photograph of other executions at the Pati dels Corders.

In March 1894, *The Garroting* was exhibited in dramatic solitude at the Sala Parés, Barcelona's most prestigious gallery, located on narrow carrer Petrixol in the medieval quarter of the city, where it was

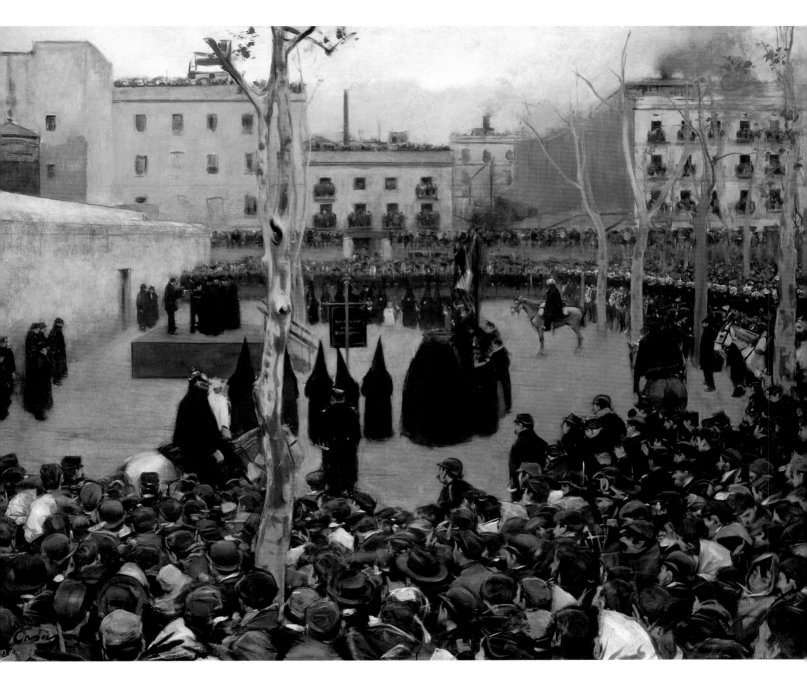

viewed by "all Barcelona."[4] As one observer remarked, the morbid crowds who came to scrutinize "that sinister spectacle" at times resembled extensions of the painted spectators in Casas's painting. One affected female viewer fainted before the canvas. Although Aniceto Peinador had been condemned for the murder of two people, and was unconnected to terrorism, Casas sharply heightened the sensationalism of

his first history painting by linking it to recent events in the public mind.

The topicality of *The Garroting* was reinforced by its evocation of the violence symptomatic of Barcelona in the 1890s. Escalating anarchist activity and recurrent cycles of labor unrest and harsh official retribution generated a destabilizing uncertainty in the community and divided public opinion and

Fig. 1 (cat. 4:4). Ramon Casas, *The Garroting*, 1894.

sympathies. Casas's work also referenced recent re-instatement of public execution after a hiatus of 17 years in the midst of this tense public atmosphere.[5] In 1892, Isidre Mompart was garroted for robbery and homicide before a rambunctious, shoving crowd. After a failed assassination attempt against Captain General Martínez Campos, Pauli Pallàs faced a firing squad on 24 September 1893, a mere six months before Casas exhibited *The Garroting* at the Sala Parés.[6] A month later, another anarchist killed 21 people and wounded 80 in revenge for Pallàs's death. Anarchist Santiago Salvador released two Orsini bombs during a performance of Rossini's opera *William Tell* at the Liceu theater the night of 7 November 1893, resulting in the death of 20 people.[7] In November 1894, he too faced garroting in the Pati dels Corders.

As suggested by Casas's haunting *The Garroting*, modern history painting was reinvigorated with new purpose specifically within the perimeters of the modernista movement. As one of Modernisme's chief apologists, Raimon Casellas—poet, novelist, collector, and close friend of Casas—was the foremost critic and theorist associated with its ascendancy. In essays published in the widely read Barcelona newspaper *La Vanguardia*, he argued compellingly on behalf of the need for a revitalized approach to national history painting, as when, in response to the conventional history-painting–filled halls of the 1892 National Exposition in Madrid, Casellas observed:

*The palpitations of contemporary existence, the ideals of the century, the customs of the era, the storms of social struggle, the intimate dreams, the movement of the street, everything in fact that reveals an aspect of agitation in the universe . . . is interrupted as if by enchantment on passing over the threshold of this region of dead paintings, where life outside is prohibited entrance. . . .*

*The summum of art consists, it seems, in demonstrating oneself old in everything; in significance and subject, in technique and procedure. Nothing could be farther from real life than the motive of these paintings.*[8]

In opposition to the exhausted conventions of official art as it was promoted from Madrid, Casellas advocated powerful immediate emotion over pedantic reconstruction of an idealized national past—painting that reflected the realities, complications, and uncertainties of the contemporary world. Almost certainly in part in response to Casellas's theories, *The Garroting* documents a disturbing and unconventional contemporary subject that was squarely emblematic of the period in which it was created. At the same time, by subtly emphasizing in his work not the executed but the executioners and their confederate witnesses, Casas implicated the clergy, military, general public, as well as himself and, by extension, viewers of his painting, as collaborators in a dubious social process. As Casellas trenchantly observed, "What *The Garroting* really contains is the picture of a heterogeneous civilization in one of its most disconcerting and indefinable moments," a moment, he believed, "at the same time terrible and ridiculous, cruel and grotesque, containing all antagonisms and contradictions: justice and ferocity, work and public holiday."[9] Casellas's aesthetic theories regarding history painting were informed by profound sympathy with Catalanisme as well as the regional labor movement, concerns reflected in the splendid and eclectic personal collection of artwork he assembled.

The struggles of the working class of Barcelona form the subject of Casas's most ambitious and monumental history painting, *The Charge*, 1899 (fig. 2). Measuring 304.8 x 472.4 centimeters, the painting depicts a unit of mounted Guardia Civil, in winter uniform and brandishing swords, charging at a throng of laborers. In a bold compositional stroke, Casas left the bottom half of the painting almost empty, while in the lower right corner an impassive Guardia Civil bears down on a fallen man. Casas dated the work 1903 in the lower left-hand corner immediately after his signature, suggesting that this contemporary history painting referred to the general strike by 80,000 workers that paralyzed Barcelona in 1902. A number of factors contradict this completion date, however, although perhaps not the historic association intended by the artist.[10]

The Guardia Civil represented in *The Charge* was a branch of the Spanish military established following the First Carlist War.[11] Responsible for maintaining public order and protecting individuals and their

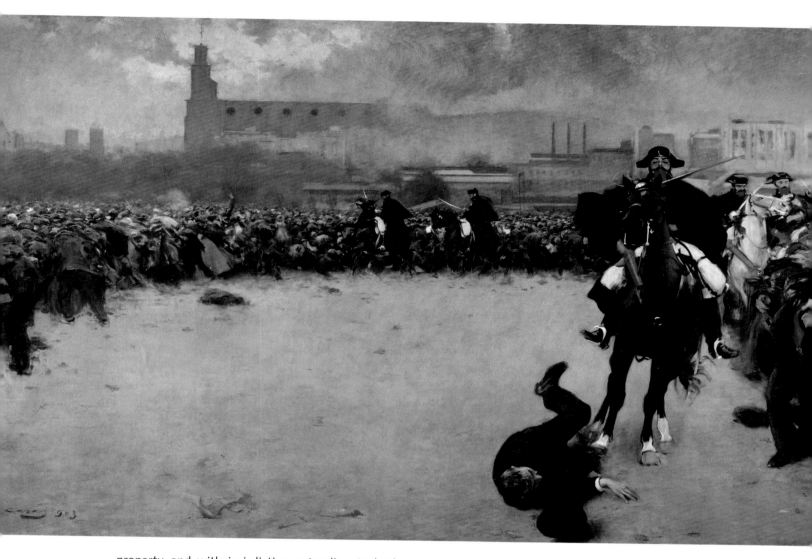

property, and with jurisdiction extending to both rural and urban areas, the Guardia Civil was also frequently deployed in instances of civil disorder, including the strikes common during this period. A sketch depicting the artist painting a mounted Guardia Civil preparatory to *The Charge* has been dated to 1900, suggesting that Casas actually completed the work at that time and postdated it later to imply a connection with the 1902 general strike.[12]

While wages and harsh living conditions in Catalan factories were at the crossroads of repeated encounters between factory owners and laborers in the late 19th and early 20th centuries, a defining crisis was reached by 1902. The overproduction of textile goods, exacerbated by the recent loss of the Cuban colonies, led to drastic cost reduction measures by management, including dismissal of male employees in favor of lower cost female and child labor as well as lengthened work days. Mounting

tensions between 1899 and 1901, expressed in waves of strikes and organized protests, finally erupted in the first general strike to occur in Barcelona. The strike brought the city to a virtual halt between 17 and 25 February 1902 and involved between 80,000 and 100,000 workers—an extraordinary percentage of Barcelona's population of around half a million. Before the crisis was resolved, the captain general of the city declared a state of war and placed the city under martial law. Guardia Civil on horseback patrolled the major streets and squares as well as the arteries of poorer neighborhoods, and pitched battles resulted in between 60 and 100 dead.

When Casas exhibited his monumental chef-d'oeuvre *The Charge* at the 1903 National Exposition in Paris with the title *Barcelona, 1902!!*, the international audience was sharply alert to recent history in Spain. Although the source of his original subject in 1899–1900 (almost certainly the date of the work's

Fig. 2. *The Charge*, 1899, by Ramon Casas.

completion) is unknown, the new title deliberately referenced the 1902 general strike in the Catalan capital. The topic remained so explosive that distribution of framed prints of the painting by a local newspaper in the city of Tarragona shortly after the original's Parisian exhibition in 1903 nearly caused a riot and was discontinued on the command of the military governor. The newspaper's hapless representative was jailed. While the composition emphasizes Casas's sympathetic bond with laborers through an antiheroic representation of military strength, his redating and retitling of *The Charge* suggests he was not above manipulating public sentiment for the sake of notoriety.[13]

Contemporary events in Spain offered artists a potentially wide range of subjects arguably as demanding as anything from the antique. In the face of the historic challenges facing Spain, there were Catalan artists who continued to create traditional history paintings according to academic principles and standards.[14] However, perhaps in part because of especially intense economic and social stresses in Catalonia, a small number of native artists strove to come to terms with disturbing events in their immediate aftermath. Among these artists, Casas created paintings that resonate with contemporary reality and perhaps most effectively represent the effort in Catalonia to transform history painting into a meaningful modern format. At the heart of history painting in Spain in the late 19th and early 20th centuries was a painful search for self-identity in a time of crisis and change. While official art asserted a commitment to tradition and affirmed civic values through the language of the national past, in Barcelona the search for a new kind of history painting, as embodied in the work of Ramon Casas, resulted in paintings that expressed the complex contradictions of the era. By addressing the dark side of Barcelona, these paintings provided a cathartic response to a succession of traumatic experiences with no foreseeable ending. In presenting open-ended questions about the events depicted rather than reassuring answers, the new history painting more authentically reflected the experience of citizens confronting an uncertain future.

1. Some of the ideas in this essay were presented in a lecture at the Institute of Fine Arts, New York University, in November 2000.

2. Revealingly, the Academia Española en Roma was formally established only in 1873, despite the international shift to Paris as the center of European art.

3. A means of execution originating in Spain, the *garrot vil* strangled, then broke the spine of the victim by the progressive tightening of a metal collar (the garrote).

4. J. Roca y Roca, "La Semana en Barcelona," *La Vanguardia*, 25 March 1894, 1. All translations by the author.

5. Tomás Caballé Clos, *La criminalidad en Barcelona. 21 procesos célebres de 1885 a 1908* (Barcelona: Ediciones Ariel, 1945), 65.

6. Ibid., 68. An eyewitness for *La Publicidad* at the public executions of this period, Caballé Clos mistakenly assumed Casas recorded the death of Mompart, not Peinador, in *The Garroting*. Casas planned to attend the execution of Pallàs in the company of other reporters but was frustrated by an official decision to restrict attendance.

7. See Gaudí's sculptural representation of an Orsini bomb on the Nativity façade of La Sagrada Família (fig. XX, p. XX, 5:10).

8. R. Casellas, "La Exposición de Bellas Artes de Madrid. Ranciedades," *La Vanguardia*, 10 November 1892, 4.

9. Casellas, "Bellas artes. 'Garrote vil.' Cuadro de Ramón Casas destinado al Salón de Paris–Champ de Mars," *La Vanguardia*, 24 March 1894, 4.

10. Casas painted a scaled-down version of the subject for an American friend and patron, Charles Deering, in 1910. Set in the Mercadal of the city of Vic, the Guardia Civil are depicted on foot, armed with guns, and running with the crowd of laborers toward the plaza's distinctive exits. Casas's continued meditation on the theme of striking workers and brutal military reprisals suggests the ongoing relevance of the subject to both the artist and the public.

11. The First Carlist War (1833–40) erupted when Don Carlos, brother of Ferdinand VII, refused to recognize the succession of Ferdinand's daughter Isabella II and claimed the throne for himself. Most Basques and many Catalans supported the revolt, hoping it would led to autonomy for their region. Other insurrections ensued and were brutally put down.

12. Francesc Fontbona suggests a completion date of 1900 for the painting based on this sketch because it was created on stationery discontinued by *Pèl & Ploma* in April of that year. Furthermore, in 1903 Casas's close friend Miquel Utrillo remarked that three years earlier a Spanish committee had rejected the painting for inclusion in the 1900 Universal Exposition in Paris. See "Noves & velles," *Pèl & Ploma* 94 (June 1903): 192.

13. In "Es pot parlar de pintura social en el cas de Ramon Casas?" *Actes del Col·loqui Internacional Sobre el Modernisme* (Barcelona: Publicacions de l'Abadia de Montserrat, 1982), 79–92, Fontbona suggests that Casas was not a genuine "social painter" as he expressed no clear political or social agenda.

14. For example, between 1885 and 1902 Ramon Tusquets completed a six-part series depicting national heroes from the past for a private collector.

# Nonell and Mani: Two Artists against the Current

CRISTINA MENDOZA AND FRANCESC M. QUÍLEZ I CORELLA

If there is a Catalan artist who deserves to be considered marginalized, it is Isidre Nonell.[1] Yet while it is true that most of his themes were oriented toward the social order, with a strong representation of figures from the poor outskirts of the city, that does not mean he used true-life situations to take a social or ideological stance or that he was taking up the cause of the oppressed. Therefore, despite the fact that most of his artwork was based on this subject, his work cannot be interpreted exclusively as social commentary. Neither can this type of representation be labeled as a mimetic reflection of the prevailing social circumstances, which could lead to the serious error of considering him a realist. It is evident that Nonell was influenced by the times in which he lived. More concretely, he shared with other Catalan artists a special sensitivity for capturing the uprootedness and social contradictions created by Barcelona's economic development in the late 19th century. This clear thematic interest neither implies a moral stance rejecting conduct typical of capitalist societies nor suggests emotional empathy with the marginalized. Nonell neither proclaims the moral superiority of the dispossessed nor justifies their situation. His vision has no emotional charge, and he maintained a prudent distance from the motif represented. The austere poetics of consciously eschewing moral judgments and fixed value systems—even his declining to put on intellectual airs—was clearly stated in one of his favorite expressions: "Jo pinto i prou" ("I paint and that's all"). This phrase summarizes his way of conceiving the creative process, setting aside fashions and dominant artistic theories, even if ignoring them meant social and commercial failure.

Like so many other contemporary Catalan artists, Nonell shared the collective enthusiasm for the new art trends found in Paris, and he lived there on two occasions. His first stay was from February 1897 to July 1898; the second was more prolonged, from January 1899 to late October 1900.[2] Contact with the Parisian scene and its stimulating art concepts con- tributed to revitalizing his style, which, while evolving, still showed some traces of his early creative dabbling in Barcelona. One highly important influence for him was a group known as La Colla del Safrà (The Saffron Group), formed around 1894 by the second generation of modernista followers of Ramon Casas and Santiago Rusiñol.[3] These artists sought to break with the archaic, run-of-the-mill models of the Catalan academic pictorial tradition. But different sensibilities coexisted within the group, which eventually crystallized into divergent aesthetic concepts. In spite of the varied directions of the members, some, such as Joaquim Mir, Ricard Canals, Joaquim Sunyer, Ramon Pichot, Juli Vallmitjana, and Nonell himself, aspired to a shared poetics, which translated into their antinaturalistic and arbitrary use of a chromatic range dominated by the colors yellow and green. The common denominator among members of La Colla del Safrà was the search for new art horizons, far from the hidebound referents of academic painting. So their works featured direct contact with and depiction of scenes in poor neighborhoods on the city's periphery. Nonell completed a significant number of landscapes between 1894 and 1896, compositions that generally replicate the atmosphere at a precise time of day, or in a certain season of the year.

Following the traditional model of his time, Nonell developed his ideas by making drawings.[4] A large portion of his abundant corpus of drawings consists of compositions designed to illustrate various periodicals, the first of which dates back to 1894. These early expressive compositions show the influence of the Swiss draftsman and illustrator Théophile-Alexandre Steinlen.[5] Nonell must have known Steinlen's popular types and figure models through illustrations or journals. This phase of Nonell's work in Barcelona has been overshadowed by his summer stay in 1896 in Caldes de Boí, which was significant in consolidating his identity as an artist. Caldes de Boí is a small, isolated town in the Pyrenées, the natural border that separates

Catalonia from France. Canals and Pichot accompanied Nonell, and his stay there would not have been so important had he not discovered some individuals affected with cretinism who lived in Boí. These deformed people became the subjects of a major series of drawings in which his unique, potent personality was manifest for the first time.

As his biographers confirm, Nonell made pencil sketches in Boí, executing the final versions later.[6] As evidence of that working method are the two practically identical versions of each drawing: one a pencil sketch, which must be interpreted as the one drawn from life, and the other a more finished ink drawing. Some writers maintain that these final drawings were done later, both in Barcelona and in Paris. The majority must have been rendered before he headed for Paris in February 1897 because, one month before his trip, some of the best-known drawings in the series were published in the magazine *Barcelona Cómica*.[7] In any event, the most interesting feature of the final version of these works, particularly evident in the work entitled *Cretin of Boí*, 1896–97 (fig. 1), is

Fig. 1 (cat. 4:6). Isidre Nonell, *Cretin of Boí*, 1896–97.

the influence of Japanese illustrations. This drawing includes figurative and compositional elements reflecting this new stylistic language: for example, the thick stroke that delimits the figure's outline, generating a solid color effect; the diagonal composition; the two-dimensional space; and the absence of traditional chiaroscuro. In this set of compositions, the artist tends to use a very schematic language, synthetic forms, and formal economy without any concession whatsoever to anecdotal art, which could be a distraction for the viewer. The attraction to things oriental that marked European art in this period also influenced the Catalan art world.[8] Once set up in Paris, Nonell proclaimed his profound admiration for Japanese art, but his contact with the culture probably took place before his trip to Paris, since it was already evident in his Barcelona work. In any event, some of his compositions have great poetic lyricism: the cretins, the protagonists of these drawings, are forever trapped in a fantasy space in which time seems to stand still, and this illusion seems to have been reinforced by some mysterious technical procedure.

Even during the artist's lifetime, some believed that the look of some of these drawings was created by submerging them in boiling oil.[9] It goes without saying that such a supposition is completely untenable because the paper on which the drawings were done is not marked by any degradation, which would have occurred had such a picturesque theory been true.[10] While the technique Nonell used remains an enigma, the research and analysis done during preparations for the 2000 exhibition of his work at the Museu Nacional d'Art de Catalunya allows us to specify some of the components. The yellowish or amber aspect of some of these works was produced by the general application of a varnish. The top layer is a resin—not an oil—with which the artist covered the drawing once it was finished. The use of this procedure gave the appearance of aging that it had in its own time, as was pointed out by contemporary critics and Nonell's colleagues.[11] In fact, this treatment, more typical of painters than draftsmen, was done both to help preserve the work and to reinforce its aesthetic nature.

The only reaction to the presentation of these drawings in Barcelona was a review in the Barcelona newspaper *La Vanguardia,* in which the reviewer correctly identified a change in the direction of the artist, who had moved away from Steinlen's influence in favor of "the malignant shadow of Goya and hints of Japanese art." This linking of Nonell with Goya was also the common denominator of the reviews that appeared somewhat later in the French press.

In addition to Nonell's first stay in Paris, several factors contributed to forging his sensibility and constructing his visual culture. In this regard, the correspondence he established during that time with the critic and writer Raimon Casellas is valuable evidence about his aesthetic preferences. Within less than a month of his arrival in Paris, his tastes underwent a radical change.[12] To begin, Nonell was disillusioned with the work of Millet, Corot, Monet, Degas, Pissarro, Manet, and Renoir. Yet he was enthusiastic about the vision in the works of Puvis de Chavannes, Whistler, Sargent, and Carrière. Among draftsmen, he was interested in Forain, Ibels, and Steinlen. However, within a short time he had already declared his enthusiasm for Monet and Degas, and he was elated because six of his drawings of cretins were going to be included in the Champ de Mars exhibition. In any event, the most important exhibition for Nonell in Paris was held in January 1898 at the Galerie Le Barc de Boutteville, an exhibition in which Nonell and Canals presented their drawings. Thus, less than a year after their arrival in Paris, Nonell and Canals had achieved what other colleagues never managed to do in a lifetime. The exhibition elicited a modicum of interest in the Parisian press, and these reviews were, of course, not widely read. One review was included in the notes on current exhibitions in the city. Generally, everyone agreed and commented on the talent shown by the two artists and usually described Canals's work with the expression "foreign, on the Spanish side." The comparison with Goya reappeared in the descriptions of Nonell, who was dubbed a "modernized Goya."[13] On 26 February 1898, Nonell sent a second letter to Casellas in which we can see a change of direction in matters of aesthetic taste. On the one hand, the artist again emphasized his very positive assessment of Impressionist painting; on the other, he was forthright about his lack of interest in artists who had attracted him before, such as Forain and Steinlen. His negative judgment

was particularly severe about Mucha, whom he even called cloying.

Back in Barcelona in late July 1898, Nonell became part of the artists circle at the Quatre Gats café. There in December he held his second individual exhibition, which in spite of slight public acclaim, garnered considerable reaction in the press. The exhibition included a set of drawings that captured scenes of Paris and Barcelona and figures of repatriates after the Cuban war. The loss of Cuba and the Philippines, the last Spanish colonies, caused a great uproar in Spanish public opinion. It also gave rise to the Generation of '98, an intellectual and literary movement characterized by great metaphysical pessimism, accompanied by a desire for social and political regeneration. The focus was different in Catalonia, where social concern was aroused by the conscription of young soldiers drafted to defend the last bastion of Spanish colonialism. On 26 November 1898, the Barcelona newspaper *La Publicidad* published a story about the arrival in the port of Barcelona of a steamboat carrying repatriates from the Cuban war. Nonell illustrated their precarious state of health with four sketches drawn from life.

Fig. 2 (cat. 4:7). Isidre Nonell, *Repatriate from Cuba on the Wharf*, 1898.

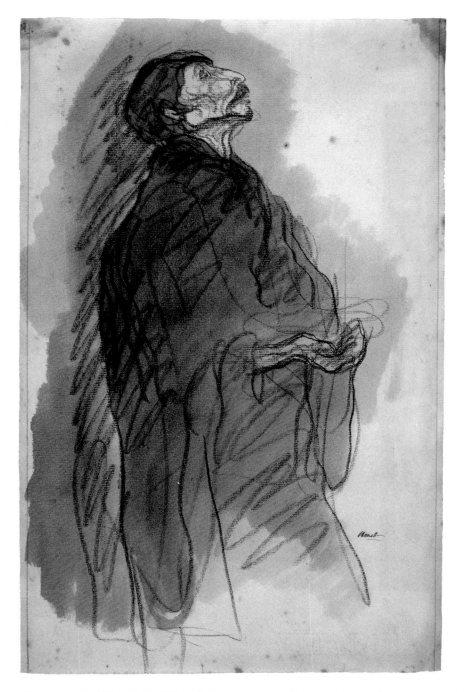

*Repatriate from Cuba on the Wharf,* 1898 (fig. 2), is from that series. What is most notable here is the original, elaborate technique. On the linen jacket of the figure, who stands on the right side of the composition, are a series of lines whose strokes recall the stenciling process, which suggests that Nonell used this technique. The drawing that rounds out the artist's work as a draftsman in this exhibition is *Blind Beggar,* 1906 (fig. 3). In formal terms, this drawing, which is very freely and spontaneously drawn, is a superb example of formal economy. With just a few disjointed strokes, the drawing achieved is techni-

cally sound, expressive in its gestures, and of great visual brilliance. Once again, the anecdote is reduced to a minimal expression, turning the image of the isolated figure into the sole subject of the composition. This treatment accentuates the feelings of uprootedness and neglect into which the figure seems to have been submerged.

During Nonell's second stay in Paris starting in January 1899, he applied himself more diligently to painting, and, while his work in that medium became stronger, he did not give up drawing. One of the most important of his works executed in this period

Fig. 3 (cat. 4:9). Isidre Nonell, *Blind Beggar,* 1906.

was *Poor People Waiting for Soup*, 1899 (fig. 4), which shows a clear break with his earlier paintings. For the first time, Nonell abandoned the landscape genre, which had dominated his work up to this time, and the human figure emerged as the exclusive protagonist of the canvases. To this more formal aspect, we may add other elements, such as his determination to express squalor unflinchingly. The line used is not unlike that of Daumier—an artist for whom Nonell felt great admiration—and the chromatic palette is warmer and more intense than before. The figurative types represented here have a fragile yet surly appearance. Abandoned to an adverse fate that they accept with resigned indifference, they do not communicate with one another at all. In the foreground of the right-hand corner of the canvas is a still-life motif formed by a basket, a ladle for serving soup, and three pieces of fruit. This motif prefigures the last stage of his active life as a painter.

When Nonell returned to Barcelona to stay, his artistic career underwent a radical change. Until this time, his personality as an innovative artist had only been evident in his work as a draftsman, especially in the series on the cretins. As a painter, he had been a gifted landscapist, although more imitative than personal. The exceptions were the two paintings he executed in Paris, one of which was discussed above (fig. 4). On his return to Barcelona in late 1900, he reduced his involvement with drawing in order to devote himself fully to painting. In January 1902, more than a year after his return to Barcelona, Nonell held his first individual exhibition in the Sala Parés, followed by three more: in June 1902, January 1903, and November 1903. All were received with such hostility by the public and the critics that he escaped to the solitude of his studio, where he continued working tenaciously and obsessively on his art.

The works presented in these four exhibitions had nothing to do with his previous efforts in terms of either content or technique. A highly singular painter had emerged to launch one of the most brilliant careers in modern Catalan painting. The motif

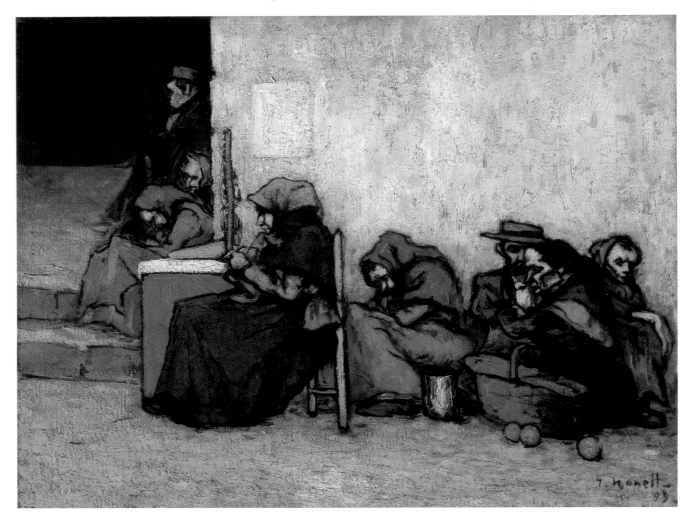

Fig. 4 (cat. 4:8). Isidre Nonell, *Poor People Waiting for Soup*, 1899.

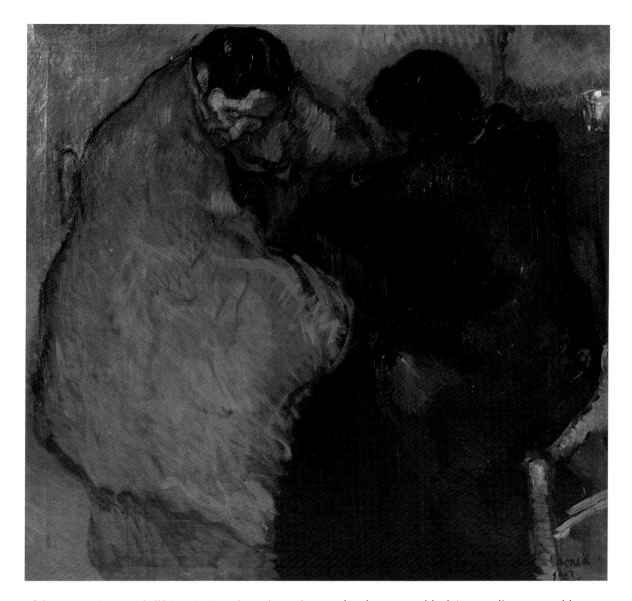

of these paintings, and all his paintings done through 1910, is tantamount to a monograph: the human figure presented isolated, unaccompanied by any element or background whatsoever. In the period from 1901 to 1902, the subjects are primarily male and female gypsies; from 1902 to 1908, female gypsies prevail. In fact, during this time, only slight variations in the formal type are obvious. As a rule, any differences are small variations in shade that have little effect on content. Most of Nonell's work during this period presents the figure half-length, and often observed in profile, captured from a certain height and therefore foreshortened. Perhaps the greatest difference from his earlier work is the palette. While between 1901 and 1902 the painter predominantly used whites and yellows, starting in 1903 his palette took on a darker chromatic range. Typically, the col-

ors he chose were black tones, olive greens, blues, or earth tones. To this period belongs a representative composition, *Two Gypsies*, 1903 (fig. 5), which reveals some of the paradigmatic aspects of Nonell's new poetics. First, he seemed to slough off the literary or narrative support present in earlier compositions. The motif of two female figures is merely a pretext for building an aesthetic based on the interaction between form and color. Considering his works from the period before 1903, there are other differences, less significant in our judgment. One is the execution of the work in a larger format, although after 1907 he returned to smaller formats. Another is the feeling of profound depression that overwhelms the figures in composition, emphasizing the loneliness and isolation that was already present in earlier pictorial work. This painting was included in the most

Fig. 5 (cat. 4:10). Isidre Nonell, *Two Gypsies*, 1903.

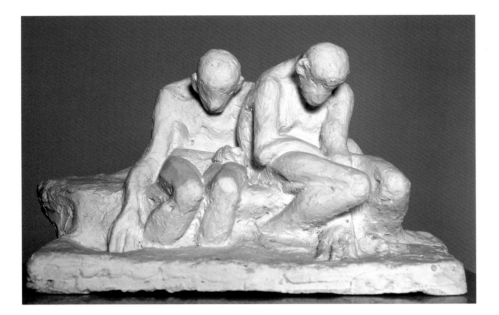

important solo exhibition of the artist's life, held at Faianç Català in Barcelona in 1910. At this exhibition, he was finally accorded the public and critical recognition that had been denied him until then. His death at the age of 38 cut short one of the most individual careers in modern Catalan painting.

Finally, the hypothetical mutual influence between Nonell and Picasso merits discussion. Yet reliable data about this subject no longer exist. Certainly there are similarities among the themes and chromatic range of Nonell's paintings from 1902–4 and those created by Picasso during what is known as his Blue Period. The other connection seems to be that both painters were living in Barcelona one year, and the following year both were in Paris. In fact, the two artists were together in Paris for one month, and at that time Nonell was getting ready to leave the city forever, just as Picasso was settling down there more or less permanently. It is no coincidence that when Nonell went back to Barcelona in late 1900 he left his studio in the rue Gabrielle in Paris to Picasso and Casagemas. From that day forward, their respective careers took different directions and adopted completely different referents. While the two artists were good friends, Nonell, who was nine years older than Picasso, was undoubtedly a role model for the younger artist during the time when the two were habitués of Quatre Gats. In February 1899, Picasso became an assiduous participant in the ongoing conversations at the Barcelona café. Only two months earlier, Nonell had presented an individual

exhibition there made up of 80 of his groundbreaking drawings of cretins, repatriates, and scenes of Paris. This exhibition had earned him a place of honor among young Catalan artists. As a logical consequence of their common history, their well-documented friendly relations could surely have included an exchange of aesthetic principles, tremendously fertile for both artists.

The work of Carles Mani, generationally part of the group of modernista sculptors, is difficult to categorize in any specific artistic movement. The vicissitudes of his biography have been factors in the critical judgment of his work. The course of his career was atypical, marked by misery and continual failure. Undoubtedly, such anomalous circumstances have helped to turn Mani into the prototype of the wretched artist.[14]

He began to be recognized based on an article written by Santiago Rusiñol that appeared in the newspaper *La Vanguardia* in 1895, when both artists were living in Paris. Mani's work, much of which has been destroyed, is evidence of his complex and tormented personality. *Degenerates,* c. 1901–7, a work known in his time by the title *Stultification,* is one of his most paradigmatic sculptures. Judging from its long execution process, it was also the one that presented the most difficulties for its creator. Started at the beginning of a 12-year stretch during which the sculptor lived in Madrid, it was reworked on numerous occasions. The writer Pío Baroja, one of the most illustrious members of the literary Generation

Fig. 6 (cat. 4:11). Carles Mani, *Plaster Study for "The Degenerates,"* c. 1891–1904.

of '98, came to know Mani. Baroja's work *Mala hierba* (1904) included a description of the sculptor in which he noted the strong expressionist component in Mani's work. The piece consists of two colossal human figures without faces, outlandish and simian, with disproportionate limbs. According to the writer, as a metaphor of the degeneration of the human condition, these figures came to symbolize and personify base instincts.[15] In 1907, the Fifth International Fine Arts Exhibition of Barcelona included the best known modernista sculptures along with a notable representation of French Impressionist painters. The presentation of *Degenerates* at this exhibition provoked scorn on the part of the critics and the public. The sculpture was mostly criticized for its departure from conventions and its appearance of being a study, which many people found disconcerting.[16] This monumental piece rendered in clay has, unfortunately, vanished; however, two plaster studies remain. One of these, owned by the Casa-Museu Gaudí, was signed and dated 1907. The other (fig. 6), signed but not dated, is part of the collection of the Museu Nacional d'Art de Catalunya. Given its sketchier characteristics, it would appear to correspond to an earlier stage; therefore, it must be placed in a prior period.

The torrent of opinion that was so negative about Mani's work provoked a reaction from the architect Antoni Gaudí. To silence the cacophony, Gaudí decided to turn Mani into one of his most trusted collaborators, inviting him to take an active part in the work of decorating the church of the Sagrada Familia.[17] Before that, Gaudí had opted for a type of sculptural decoration based on the use of casting from nature, which could subsequently be improved with varnish. He commissioned Mani to execute most of the sculptural work for several doors of this famous church of atonement, although which parts Mani rendered is not definitely known.[18] Around 1906, under the direction and influence of Gaudí, Mani executed the crucifix that presides over the chapel of the Casa Batlló owned by the Barcelona resident Passeig de Gràcia. Unfortunately, documents have not survived that would allow us to clarify the professional relationship between these two singular personalities. Neither do we have sufficient documentation to be able to reconstruct Mani's working methodology.

A portion of this text maintains the structure, with some new contributions, of Cristina Mendoza's article, "Isidre Nonell," in *Isidre A. Nonell, 1872–1911*, ed. Cristina Mendoza and Mercè Doñate, exh. cat. (Barcelona/Madrid: Museu Nacional d'Art de Catalunya/Fundación Cultural Mapfre Vida, 2000), 17–32.

1. On the artist and his work, see Alexandre Plana et al., *L'obra d'Isidre Nonell* (Barcelona: Publicacions de La Revista, 1917); Rafael Benet, *Isidro Nonell y su época* (Barcelona: Iberia, 1947); Enric Jardí, *Nonell* (Barcelona: Polígrafa, 1969); Francesc Fontbona, *Nonell* (Barcelona: Edicions de Nou Art Thor, 1987); and Cristina Mendoza and Mercè Doñate, eds., *Isidre A. Nonell, 1872–1911*, exh. cat. (Barcelona/Madrid: Museu Nacional d'Art de Catalunya/Fundación Cultural Mapfre Vida, 2000), 33–42.

2. On Nonell's presence in Paris, see Mendoza, "Isidre Nonell," in *Isidre A. Nonell, 1872–1911*. The author includes new information that allows more precision in establishing the duration of the second trip.

3. Xavier Solé Ávila, "La Colla del Safrà i les seves derivacions," in *Pintura i dibuix*, ed. Fontbona, vol. 3 of *El Modernisme* (Barcelona: L'isard, 2002), 191–210.

4. On this drawing, see Cecília Vidal, "Els dibuixos de Nonell (Aproximació a la seva tècnica i els seus procediments)," in *Isidre A. Nonell, 1872–1911*, 43–51; and Fontbona, "Nonell," in *Pintura i dibuix*, 219–28.

5. Francesc Fontbona and Victòria Durá, "Catalans en el Món de Steinlen," in *Steinlen i l'època del 1900*, exh. cat. (Barcelona: City Hall, Institut de Cultura, 2000).

6. See Plana, *L'obra d'Isidre Nonell, 1872–1911*, 37; and Benet, *Isidro Nonell y su época*, 43.

7. L. Ruiz de Velasco, "Los cretinos de los Pirineos," *Barcelona Cómica* (16 January 1897).

8. Letter from Nonell to Casellas, Paris, 26 February 1898, published in Ll. E. Bou i Gibert, "Les anades de Nonell a París," *D'Art*, no. 2 (1973): 3–19; Isabel Coll, "L'art orientalitzant, particularment el d'arrels japoneses, a Europa, i els seus reflexos a la Barcelona del vuitcents," *D'Art*, no. 11 (March 1985): 162; and J. Masriera, *Influencias del estilo japonés en las artes europeas* (Barcelona, 1885).

9. Vidal, "Els dibuixos de Nonell," 46–49.

10. The authors would like to thank Carme Ramells, paper restorer at the Museu Nacional d'Art de Catalunya, for her notable contributions on these technical aspects.

11. *Diario de Barcelona*, 21 December 1898, 13; A. L. de Barán [Miquel Utrillo], "Arte Nuevo. Isidro Nonell," *Luz*, no. 9 (second week of December 1898): 98–99.

12. Published in Bou i Gibert, "Les anades de Nonell a París," 3–19.

13. The exhibition catalogue, with an introduction by D. Fabrice, includes 57 drawings by Nonell and 31 by Canals; the motif of the Canals work is primarily Spanish, and the Nonell work belongs to the series on cretins, or represents scenes of gypsies or individuals in the streets of Paris.

14. Fontbona, *Carles Mani: L'escultor maleït* (Barcelona/Tarragona: Viena Edicions, Diputació de Tarragona/Museu d'Art Modern, 2004).

15. Doñate, "L'escultura de col·leccionisme," in *Les arts tridimensionals, la crítica del modernisme*, ed. Fontbona, vol 4. of *El Modernisme* (Barcelona: L'isard, 2003), 26; and Doñate, "La escultura modernista," in *El Modernismo catalán, un entusiasmo*, ed. Javier Tusell, exh. cat. (Madrid: Fundación Santander Central Hispano, 2000), 77.

16. In this regard, see the reviews collected by Fontbona, *Carles Mani: L'escultor maleït*, 50–52.

17. Fontbona, "La relació amb Gaudí," in ibid., 53–59.

18. Doñate, "L'escultura de col·leccionisme," 26.

Translated by Eileen Brockbank.

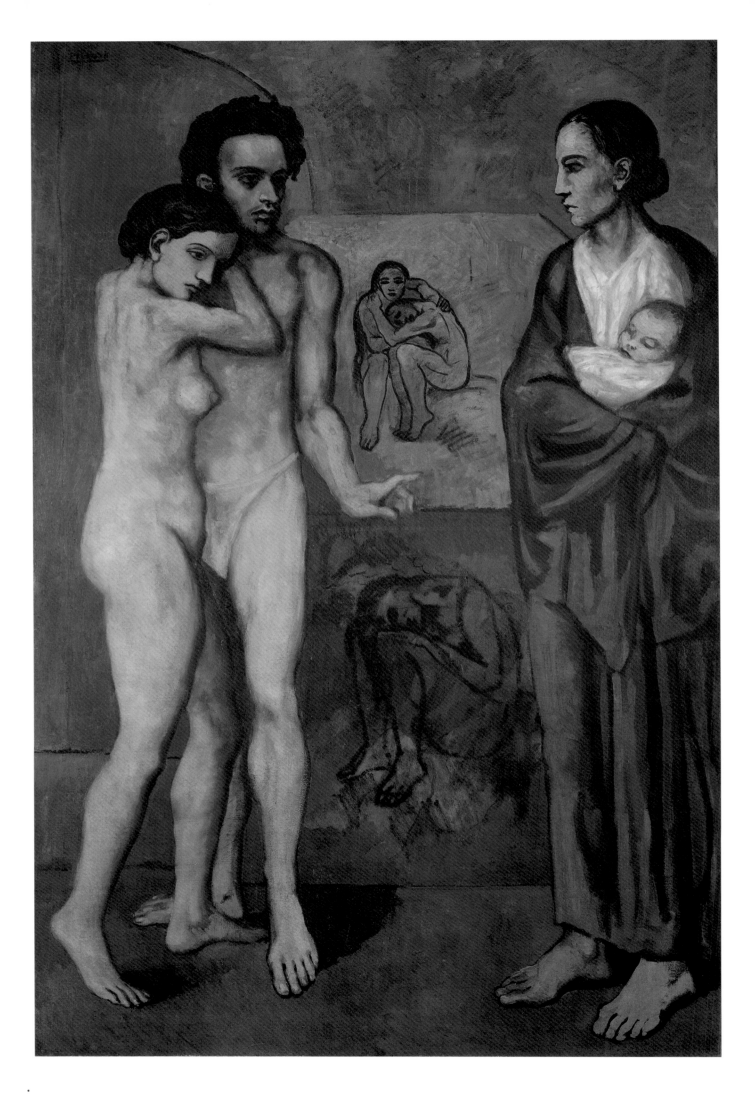

# Picasso's Blue Period

MARIA TERESA OCAÑA

Picasso's career was determined by his father, with strict discipline right from the start. So it should come as no surprise that some of the paintings created in his early years were stepping stones for the emerging artist. During his years in Barcelona, his father directed the execution of important works, such as *First Communion,* 1896, and *Science and Charity,* 1897 (both Museu Picasso, Barcelona), that allowed him to enter national exhibitions. But starting in 1900, Picasso became the one who drew his own parameters. In his exhibition of February 1900 at the Quatre Gats café he showed *Last Moments,* a painting conceptually very close to several works rendered in Barcelona at the time. He later presented this painting in Paris at the Universal Exposition of 1900, along with a series of drawings and the small oil painting *Poor Geniuses!* (Museu Picasso, Barcelona). His participation in the Paris exhibition was a step forward and provided him with exposure to the art flooding into Paris at the time.

According to documentation developed by art scholar and collector Douglas Cooper, a sketch reproducing the composition of *Last Moments* still exists although the painting has disappeared. The sketch matches a drawing at the Museu Picasso in which the male figure at the feet of the dying woman can be identified as the sculptor Mateu Fernández de Soto, one of the Picasso's friends. An X-radiograph of Picasso's *La Vie,* 1903 (fig. 1), shows an underlying composition identical to that of *Last Moments,* leading scholars to believe that *La Vie* was painted over the canvas exhibited in Paris.

Correspondence preserved from this period, especially letters between Picasso, Carles Casagemas, and the brothers Ramon and Cinto Reventós, provides more information. For example, the principal ideas in *Last Moments* were also prevalent in the circles in which the artist moved during his months in Paris. After Casagemas's suicide in February 1901, Picasso repeatedly evoked the theme of death as he moved into his Blue Period. The composition and motifs of *Last Moments* reappear in *The Dead Man (The Mourners)* (private collection) and in the lower scene of *The Burial of Casagemas (Evocation)* (Musée d'Art Moderne de la Ville de Paris). However, the symbolism in those paintings bears no relationship to the naturalism of the works rendered in Barcelona. Toward the end of 1901, the bohemian world of Barcelona was replaced in Picasso's art by metaphorical allusions to classical antiquity, as interpreted in the paintings of Puvis de Chavannes. At the same time, Picasso's art began to reflect the religious ideology found in the paintings of several late 19th-century artists.

Between 1901 and 1904, Paris and Barcelona emerged as the twin locales of Picasso's artistic career. The galleries of Ambroise Vollard and Berthe Weil bolstered his initial conquest of Paris, a predictably arduous struggle marked by the reality of his unmistakably Spanish origins. In his first seasons in the French capital, Picasso was immersed in a primarily Catalan world, and his paintings were often categorized within the idiosyncrasies of Spanish art. Upon arriving in Paris, immigrant artists often resorted to painting clichéd scenes of Spain that would almost certainly find a commercial outlet. This phenomenon is reflected in an article by the art critic Félicien Fagus in *La Revue Blanche* on the occasion of Picasso's Vollard exhibition. Under the title "The Spanish Invasion: Picasso," Fagus was highly complimentary of the chromatic and thematic variety of his compositions, including several bullfighting scenes. But based on the artist's origins and pictorial methods, Fagus placed him squarely with the other Spanish painters who flock "to Paris in search of a fevered existence."[1]

Crucial to Picasso's artistic orientation was his encounter through the Vollard exhibition with Max Jacob, a great aficionado of the symbolist poet Paul Verlaine. In Madrid in 1901 Picasso and colleagues associated with the magazine *Arte Joven* had first become aware of Verlaine through the extravagant Frenchman Henry Cornuty. The Spanish writer Azorín (José Martínez Ruiz), who admired the great bohe-

Fig. 1 (cat. 4:17). Pablo Picasso, *La Vie,* 1903.

mian Cornuty, recalls that "no one has visited the Latin quarter more, or has been a more impassioned friend of Paul Verlaine."[2] Many years later, Picasso retained very specific memories of Cornuty: that he was "a Frenchman from Beziers who spoke Spanish very badly. But he was the one who taught all those people in Madrid what they needed to know about French poetry and many other things."[3] But it was the unknown French poet Jacob who opened the door to French culture for Picasso and thoroughly initiated him into a knowledge of the French language. In doing so, Jacob reintroduced him to the poems of the French Symbolists, especially Verlaine.

Max Jacob found a direction for the artist's Parisian experiments and guided Picasso toward strengthening the ideas and knowledge that would underlie the renewal he sought during those years. Seduced by Jacob's knowledge and strong, auda-

cious intellect, the artist from Málaga still had few other ties to the Parisian art scene, and he continued to be friends with the Catalan artists established there temporarily, like himself: Jaume Sabartés, Emili Fontbona, Manolo Hugué, and Pere Manyac.

In early 1902, when polychromy had disappeared from his canvases, giving way to monochromatic paintings that were essentially blue, Picasso returned to Barcelona with plans to stay there until October. Only one letter to Jacob has survived from these early months in Barcelona, a letter in which Picasso spoke for the first time of a feeling of distance from Catalan circles and the people who had been his colleagues until that time:

*I'm showing what I'm doing to the artists here, but they think there is too much soul and no form. It's very funny. You know how to talk to people like that;*

Fig. 2 (cat. 4:12). Pablo Picasso, *Seated Woman*, 1902.

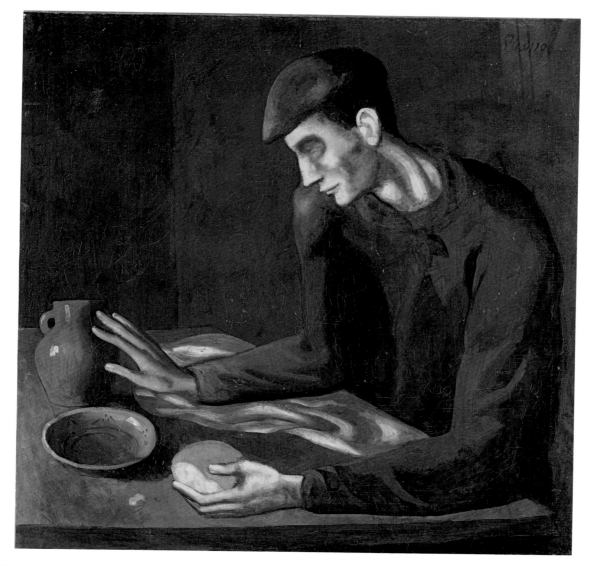

but they write very bad books and they paint idiotic pictures. That's life. That's how it is.

Fontbona is working very hard, but he's getting nowhere.

I want to do a picture of this drawing I'm sending you [Two Sisters, 1902, Musée Picasso, Paris]. It's a picture I'm doing of a St. Lazare whore and a nun.

Send me something you've written for Pèl & Ploma.[4]

It was precisely in Barcelona in 1902 that Picasso, working in the studio of the sculptor Fontbona, produced his first sculpture, Seated Woman (fig. 2). The work is considered an isolated achievement that does not predict his later involvement with sculpture. The figure's face, in particular, shows the hieratic nature and simplification of features characteristic of his Blue Period.

Thus it is not unreasonable to imagine that the young artist, worried and ambitious, would find solace in Verlaine's poems. Perhaps Picasso found in Verlaine the support that would allow him to share his concerns with his parents in a letter dated 20 December 1902:

That's why it's so sad for me not to be able to paint anything I had planned for the exhibition. Sure, I could keep on marching there, but what would be the point? You've already seen that I can talk to you like a good bourgeoisie, so I truly do not know what to do. My doubts are mostly behind me, and I am more sure of myself and what is around me. I believe I have the serenity to render a work, but if I make something for sale (a dubious idea), my lack of faith in it right from the start, the insincerity, would keep me from liking it. It is this artificial basis itself, also found in other

Fig. 3 (cat. 4:16). Pablo Picasso, Blindman's Meal, 1903.

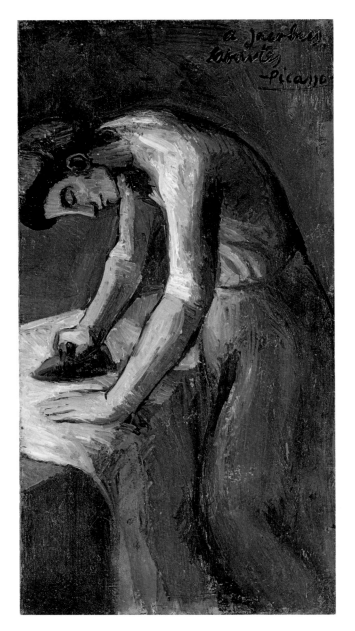

less intelligent or more valuable works, that I could resolve in a satisfactory way in my own work. But this would lead to the opposite result, since the fact that I have no love for that kind of success would make the work unpleasant to the buyers.[5]

The plans he referred to would not crystallize into any composition, but rather remain a set of drawings that for the most part recapitulated archetypes from his iconography of the period.

Realism and Symbolism tinged with a bent for purification brought him closer to religious references, as we can see in the painting *Two Sisters*, 1902 (Hermitage Museum, St. Petersburg), and again in *La Vie* of 1903. This painting and all its preparatory

elements contain a compendium of his iconography from these years, in form and subject matter. Once again he focused on Casagemas, and in the drawing process set down a variety of male figures who were then united in the composition into a single archetype. At a given moment, the figure that appeared in several of the allegorical compositions referred to above—a sturdy, bearded man—was transformed into Picasso himself. Gradually, the artist turned the figure of Casagemas into a symbol of the cycle of love, its metamorphoses through the various stages of life and its inexorable deterioration.

The road leading up to *La Vie* was long. Of the minor compositions and the few paintings (now lost) from isolated groups that make up the painting's

Fig. 4 (cat. 4:13). Pablo Picasso, *Woman Ironing*, 1901.

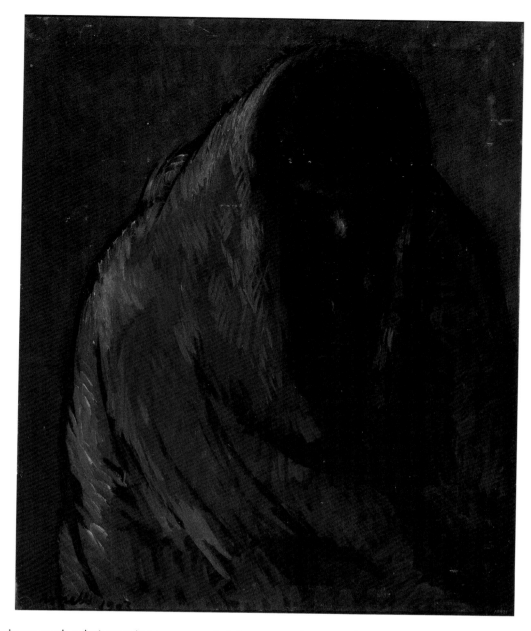

preliminary work, what remains are mere sketches or paintings later rejected and painted over. Along with the bearded man that appears in the first efforts, there is in the final version a young woman with long hair who is a constant presence in drawings rendered in late 1902 and 1903. Through her, the artist drew a framework in which allegorical scenes alternate with scenes that are probably biographical. In the final version of *La Vie*, he turned one of the surviving figures into the woman embracing the defeated man in the background of the composition. Along with the figure below the pair, this man represents the decrepitude of existence.

Picasso's Barcelona work of 1903 included various paintings based on themes of misery and hu-

man impoverishment. Isolation and old age served as the subjects for a series of compositions—such as *Blindman's Meal* (fig. 3), *Woman Ironing* (fig. 4), *The Ascetic* (Barnes Foundation, Merion, Pa.), and *The Old Guitarist* (The Art Institute of Chicago)—in which the world of the socially marginalized surfaces in an incisive way.

We tend to link the preference for this set of motifs to the paintings of the Catalan Isidre Nonell, an artist greatly admired by Picasso, whose work was also affected by the most marginalized social groups. Whether there was a real link between the series of gypsies painted by Nonell, exhibited at the Sala Parés in Barcelona in 1902 and 1903 (fig. 5), and the protagonists of Picasso's canvases at that time is

Fig. 5 (cat. 4:15). Isidre Nonell, *Young Gypsy*, 1903.

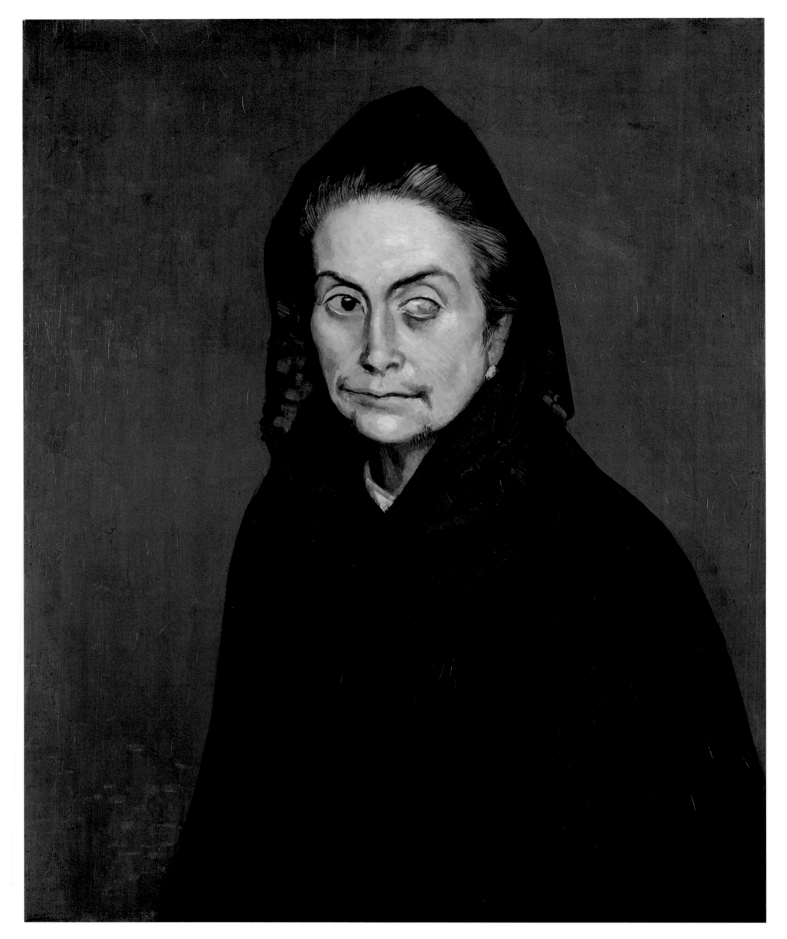

Fig. 6 (cat. 4:14). Pablo Picasso, *Carlota Valdivia* (later called *La Celestina*), 1903.

unknown. The coincidence may be more a reflection of the art world at that time than the result of the painters' influence on each other. The symbolic and even sacred charge that emanates from the works of the painter from Málaga give them a depth that distances them from the more descriptive works done by the Catalan painter. Stylistically, the artists based their work on different parameters. Picasso's set relies on a monochromatic palette and mannerism of the type found among Spanish painters of the 16th century, especially El Greco—to whom Picasso often turned for inspiration. Yet, Nonell's paintings present a greater variety of chromatic schemes, and his brushstrokes refer more to French painting.

During his stay in Barcelona in 1903–4, Picasso produced a series of scenes featuring the figure of the Celestina, a female character who procured women for men in Fernando de Rojas's *La Tragicomedia de Calisto y Melibea* of 1499. Particularly noteworthy is the magnificent portrait he executed in 1903, *La Celestina* (fig. 6), modeled in this painting by Carlota Valdivia, who lived in the same building as the Eden Concert, a music hall in the old section of Barcelona. The solemnity accorded to this portrait makes it an extraordinary representation of one of the most important characters in Spanish literature.

Thus just as he was consolidating and affirming his own artistic language, a certain gravity, accompanied by a profound meditation on society and an exaltation of the most intimate and sad feelings, came to permeate Picasso's creations. The common denominator in these works was the family, with the central recurring motif of the mother and her children representing solitude and human isolation. During this period Picasso sought to unite everything into a great work that would portray all the uneasiness of the time. Such a work would not appear until 1905, when he painted *Family of Saltimbanques* (National Gallery of Art, Washington). Since the time of his preliminary studies for *Last Moments*, passing through *Evocation* and *The Dead Man*, one thread has been identified by scholar Theodore Reff. He contends that the life cycle developed in *La Vie* is related to the traditional allegory contrasting sacred and profane love.[6] *La Vie* was not only Picasso's key work of the Blue Period, but also his first painting to feature the theme of the artist and his model, a subject he would explore in depth in his subsequent work.

1. Félicien Fagus [Georges Faillet], "L'invasion espagnole," *La Revue Blanche* (15 July 1901). Extracts from this article have been translated in Josep Palau i Fabre, *Picasso, the Early Years, 1881–1907* (New York: Rizzoli, 1981), 514–15; and John Richardson, *A Life of Picasso* (New York: Random House, 1991), 1:199.

2. Azorín, *Madrid* (Madrid: Biblioteca Nueva, 1995), 152–53.

3. Roberto Otero, *Lejos de España: Encuentros y conversaciones con Picasso* (Barcelona: Dopesa, 1975), 125.

4. Pablo Picasso, "Letter from Barcelona (13 July 1902) to Max Jacob," in *A Picasso Anthology: Documents, Criticism, Reminiscences*, ed. Marilyn McCully (London: Arts Council of Great Britain, 1981), 38.

5. Jaime Sabartés, *Picasso: Documents iconographiques* (Geneva: Pierre Cailleur Editeur, 1954), ill. no. 70.

6. Theodore Reff, "Themes of Love and Death in Picasso's Early Work," in *Picasso in Retrospect*, ed. Roland Penrose and John Golding (New York: Praeger, 1973), 11–47.

Translated by Eileen Brockbank.

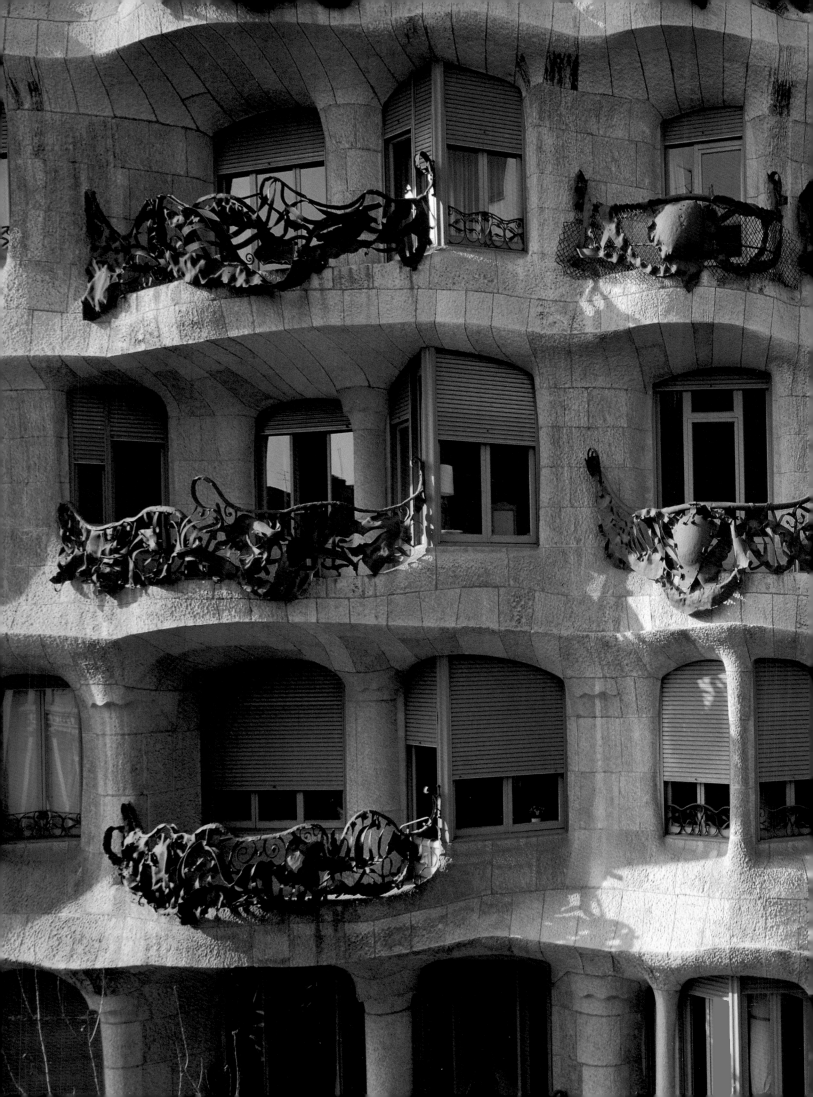

# Modernisme:
# Architecture and Design

# Architecture and Design of the Modernista Era

*MIREIA FREIXA*

Catalan Modernisme should be understood in a broader sense than Art Nouveau, as it represented the desire for modernization in Catalan culture as a whole, a project in which the plastic arts, music, and especially literature and the Catalan language played decisive roles. Whereas Art Nouveau was animated by a desire to create a new architectural and international style reflecting cosmopolitan culture at the turn of the century, the Catalan movement was caught in a contradictory attempt to safeguard the country's revered cultural roots and traditions while extolling modernity. As a consequence, in Catalonia the cosmopolitan spirit of Art Nouveau took the form of a general idea of "modernity," but a modernity intended to thrust the country into the future through celebrating its roots.

This ambivalent identity is at the core of Catalan Modernisme, simultaneously international and local, and fundamental to all its cultural manifestations. The Barcelona Universal Exposition of 1888 is regarded as the date that Modernisme began in Catalan culture (fig. 1); it would actually outlive its successor, the cultural movement called Noucentisme.

Modernisme was made possible in Catalonia by the growth of construction and related industries such as tile manufacturing, ornamental plaster moldings, tapestry, and furniture, impelled by the urban development project of the Eixample (expansion) in Barcelona.[1] Under martial law since its defeat by a Bourbon army on 11 September 1714, and still contained within its medieval walls, in the mid 19th century the city was allowed by the new liberal political climate to expand into the neighboring plain, following a plan by Ildefons Cerdà. The old walls were demolished in 1854, and a new city sprang up, resulting in a fivefold increase in buildable land (fig. 2).

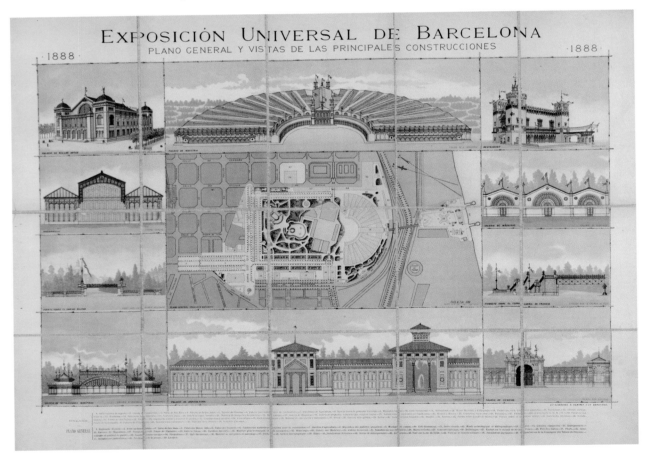

Fig. 1. General plan of the 1888 Universal Exhibition in Barcelona.

The dramatic growth of construction-related industries was further spurred by the return of capital from Cuba and by the economic growth of the period known as "gold fever" in Catalonia.[2] Increased demand called for new professionals; the architects who trained at the new Escola d'Arquitectura de Barcelona, which opened its doors to students in 1871, earned such social prestige that many went on to play leading roles in the emerging politics of Catalanism, and in the world of culture.[3]

Large numbers of decorative items were produced industrially, and no distinction was drawn between them and traditionally crafted works. In some instances both industrial and artisanal manufacturing methods were used. Industrial methods were not rejected, as they were by the English designers of the Aesthetic movement and William Morris's company, collectively known as the Arts and Crafts movement. The designs that triumphed in Catalonia were those promoted by Henry Cole and Gottfried Semper, who had encouraged British industry to adopt new designs ever since the Great Exhibition of 1851 in London, resulting in the founding of schools and museums—such as the Victoria and Albert Museum in South Kensington, which opened in 1862—in order to improve industrial design.

The term Modernisme, as defined by Joan Lluís Marfany in a book published in 1982 and as it is understood today, should be interpreted on three levels: as a movement of individuals and groups who supported it, as an attitude of widespread optimism about everything modern, and as a period of history.[4] However, its meaning has changed since the time when the only individuals who described themselves as modernists were the circle of intellectuals associated with the magazine *L'Avenç* in the 1880s and 1890s, or those who, led by Santiago Rusiñol, held the Modernista Festivals in Sitges during the same era. Moreover, according to Marfany, in the opening years of the 20th century the concept of Modernisme was reviled, as it was solely associated with decadence, and was the subject of all kinds of harsh interpretations.[5] The architects who were members of *bien pensant* society would never have joined a movement they regarded as decadent or of suspect moral standards. In fact, this group of professionals considered themselves to be simply followers of the "new architecture," and most of them,

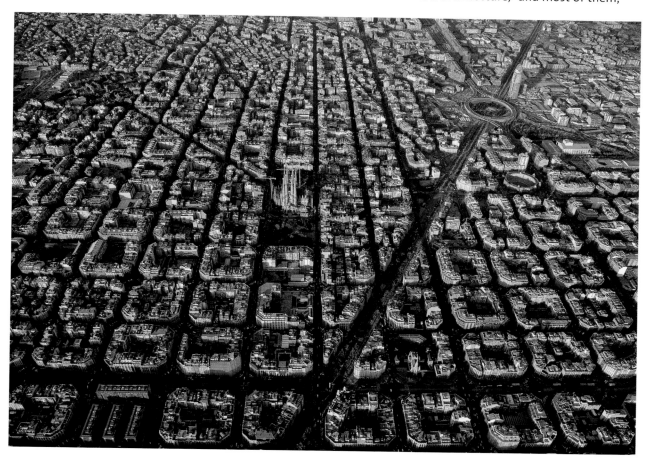

Fig. 2. Aerial view of Barcelona's Eixample, with La Sagrada Família at center.

as Judith Rohrer points out, were closely involved in regionalist politics.[6]

No one wanted to be a modernista, yet the forms of Art Nouveau were there to be seen on the streets and inside homes in the shape of consumer items intended for every social class and identified as symbols of all things modern. By the 1920s, however, as Noucentisme began to establish itself, Modernisme entered a period of decline. The sinuous lines and ornamental excess were anathema to the prevailing classical taste. Nevertheless, even though this period proved disastrous for the conservation of the modernista heritage, Antoni Gaudí's personal standing remained high and work continued on the Sagrada Família, despite the prevailing taste of the time. The reason for this can be found in Gaudí's ideological background, as he was a supporter of the philosophy advocated by one of the most eminent figures of the

time in Catalonia, the Bishop of Vic, Josep Torras i Bages. Torras believed staunchly in a firm, conservative Catalanism imbued with a profoundly religious spirit, a concept first formulated politically by Enric Prat de la Riba that became one of the fundamental theories of Noucentisme. Gaudí's death in 1926, while he was still working on the Sagrada Família, occurred at the threshold of the Western modern movement.

The early days of Catalan modernista architecture must be viewed in light of the cultural and political climate that gave rise to the movement. At this time, Catalan culture was in the throes of the modernization that began after the 1888 Universal Exposition and intensified during the 1890s. The Catalan language was championed by poets and the journal *L'Avenç*, and Impressionism and Symbolism in the visual arts were introduced to the Catalan public. The determination of Catalans

Fig. 3. The Cafè-Restaurant, currently the Museu de Ciències Naturals, designed by Lluís Domènech i Montaner.

Fig. 4. Postcard of Casa Amatller, c. 1920–30, photograph by Lucien Roisin.

to embrace their roots and modernity at the same time ensured that the romantic mindset of the Renaixença, in particular the taste for medievalism, remained strong for many years. The sublimation of the country's medieval past provided the perfect point of reference for a society whose prime goal was to restore its language and culture. Between the 1888 fair and 1900, when Victor Horta was building the Hôtel Tassel (1893) in Brussels and Charles Rennie Mackintosh was working on the Glasgow School of Art (1897–99), the first in keeping with the precepts of Art Nouveau and the second in line with those of the Glasgow school, Catalan architects and designers were liberally reviving the Gothic in a free interpretation that embraced many elements of other historical languages and cultures, provided that they supported a taste for the archaic.[7] Beyond revisiting ancient conceptual models, efforts were made to revive traditional crafts and old building methods, such as constructing vaults from unglazed tiles, in the spirit of the British Arts and Crafts movement. Despite the new appreciation of the past, there was no hesitation about adopting modern construction techniques and industrial manufacturing methods.

For the Barcelona Universal Exposition, Lluís Domènech i Montaner designed a pavilion to serve as the Cafè-Restaurant, also known as the Castell dels Tres Dragons, which now houses the Museum of Natural History (fig. 3). In appearance, this building is an idealized medieval castle. It was the first step toward defining an architecture intended to be different, though indisputably eclectic. The building remained unfinished at the close of the fair and Domènech was commissioned in 1891 to undertake its conversion to a history museum.[8] With the architect Antoni Maria Gallissà as his assistant, he organized a series of workshops—on metalworking, blacksmithing, repoussé work, and modeling—in the building for the purpose of completing the Torre de l'Homentage (the Keep) and the decorative features. Working together with his assistants and friends, Domènech turned the workshops into veritable studios where they experimented with integrating old traditions and modern production systems, and new functions of ornamentation. Among the artisans were sculptor Eusebi Arnau, later responsible for the main ceramic appliqué work, the stained glass

maker Antoni Rigalt i Blanch, and the ceramist Paul Pujol i Vilà. The workshops became a magnet, drawing everyone interested in reviving the applied arts, among them architect Josep Puig i Cadafalch, who had finished his studies in 1891 and who was heavily influenced by Domènech during the early part of his career.

Domènech's Cafè-Restaurant was merely the first step, as other architects soon followed in his footsteps. Puig is perhaps the finest exponent of the architecture of this period, as can be seen in his Casa

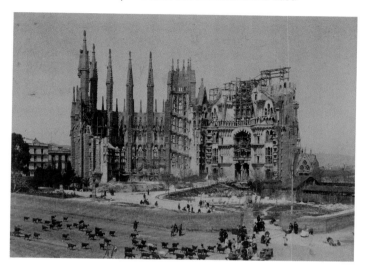

Martí (1895–96) and Casa Amatller (1898–1900, fig. 4). Gaudí too followed the same path in his Palau Güell (1886–89), the townhouse built for his patron, Count Güell, on carrer Nou de la Rambla. Focusing on construction research for Palau Güell, he took Gothic methods as his starting point. Arches originally conceived as pointed took on parabolic forms, revealing his evolution from the Gothic, as the parabola is a more robust supporting element. Gaudí was already at work on his most emblematic project, the Sagrada Família, which exhibits obvious references to the medieval past in the crypt and apse (fig. 5). Nevertheless, he began to strike out on his own, spurning not only references to the architecture of the past but also that of his contemporaries.

Efforts to promote the arts and crafts increased. In 1892, the Barcelona City Hall organized the first exhibition of industrial design, the National Exhibition of Industrial Arts and the International Exhibition of Reproductions, which marked a turning point in the way these arts were regarded.[9] Shortly afterward, in 1894, the Centro de Artes Decorativas was

Fig. 5. La Sagrada Família in 1906.

characteristic of the Japanese manner, so popular in Europe since the second half of the 19th century.[11]

Designers and industrialists also adapted these models. The Hijo de José Pujol y Baucis factory in Esplugues de Llobregat produced ceramic tiles inspired by Catalan Gothic, and Eudald Canibell created the Gòtic Tortis (1891) and Gòtic Incunable Canibell (1904) typefaces.[12] The revival of ancient crafts and motifs coincided with the first studies of the country's artistic heritage and a peak in interest in collecting artifacts, as demonstrated by Santiago Rusiñol's creation of the Cau Ferrat, a collection of ironwork, and the collection of Catalan tiles assembled by Gallissà. Albums of design models also began to appear, such as *Materiales y Documentos de Arte Español* (Materials and Documents in Spanish Art), edited by Mira Leroy and published by the Librería Parera bookshop in Barcelona.

It was the workshop run by Francesc Vidal i Jevellí, however, that guided the tastes of the Catalan bourgeoisie. Its output was founded on the principles of high technical quality—with a fair element of design logic—and eclecticism in the designs offered.[13] Though Vidal specialized in selling decorative objects, the workshops also presented themselves as publishers of plates and photographs of artworks and as experts in case and box making, one of the specialties of the workshop of Francesc's father, Lluís Vidal i Sobrevia. Francesc Vidal's workshop was especially renowned for luxury furniture. Around 1881, he set up a company with Frederic Masriera i Manovens, the brother of the painters Josep and Francesc. The Masriera family recruited refined, cultured artists who were held in high regard in Barcelona. In the early 1880s, Vidal's workshop had moved to a large building designed by Josep Vilaseca on the corner of carrer Bailén and carrer Diputació. Centered around Vilaseca, Vidal, and the Masriera brothers, the influence of this workshop on Catalan bourgeois décor of the late 19th century depended on the baroque quality of its designs, a taste for luxury, and unusual focus on architecture, which enabled the first attempt to bring architecture and the decorative arts together in Catalonia and create unified works of art.

The masters who were to lead the advance of applied and decorative arts associated with Catalan Modernisme all trained at Vidal's workshops: Frederic

established. This center published the journal *El Arte Decorativo* between October 1894 and May 1896, featuring contributions from all kinds of industrial designers, furniture makers, ceramicists, mosaic makers, smiths, gilders, lace manufacturers, wallpaper makers, engravers, artists, carvers, and other artisans. These endeavors to promote the applied arts culminated in the Third Exhibition of the Fine Arts and Industrial Arts of 1896, the first time that the fine and applied arts were exhibited on an equal footing.

Alexandre de Riquer played an important role in fostering the new taste for decorative arts in Catalonia when he introduced English Aestheticism into the country, following a trip to Great Britain in 1894 (fig. 6). Riquer subscribed to the magazine *The Studio* and his library contained the most significant books on Aestheticism.[10] Apel·les Mestres, a versatile artist, also made a key contribution to the new aesthetic by introducing the stylized plant motifs

Fig. 6. *Mosaicos Escofet-Tejera i Ca.*, c. 1902, by Alexandre de Riquer.

Masriera, who became a specialist in casting; Rigalt, who worked in the stained-glass workshop; Gaspar Homar, the noted furniture maker; Enric Gómez, the brother of the painter Simó Gómez, who worked in the prints section; and Riquer and the painter Joan Gonzàlez i Pellicer, the brother of Juli Gonzàlez, in the projects and plans department.

The opening years of the 20th century brought two important milestones. The Paris Universal Exposition of 1900, providing an international showcase for Art Nouveau, had a tremendous impact in Catalonia, where the style became the fashionable language for the cosmopolitan bourgeoisie.[14] Two years later, an exhibition of decorative arts in Turin attracted public attention to techniques that had until then been little regarded.[15]

Many architects, notably Enric Sagnier, the most prestigious architect in Barcelona at the time, and Jeroni Granell i Manresa allowed themselves to be influenced by the style, but as an additional element of their eclecticism. The most important modernista architects, Domènech, Gaudí and his followers, and numerous others, arrived at a highly individual interpretation of Art Nouveau, resulting in the paradox mentioned earlier, tradition as a passport to modernism. Domènech, for many years director of the Architectural School of Barcelona, produced many of the works most representative of Catalan society of the period, including the Palau de la Música Catalana (1905–8) and the Hospital de la Santa Creu i Sant Pau (1903–30), on which he worked until his death. Domènech was expert in the modern construction techniques of his day and used steel and cast iron in a highly original, daring manner, on occasions employing traditional techniques as well. His principal goal was to integrate architecture and ornamentation, linking form and function. As a result, he placed an abundance of elaborate decorative features on extremely clean architectural structures (fig. 7). Domènech also played a part in organizing entire teams of craftsmen and industrial designers who made a tremendous contribution to popularizing the new style.[16] Other architects, such as Manuel Raspall i Mayol and Eduard M. Balcells, who worked in the main on villas and summer residences, also embraced the taste for rich ornamentation established by Domènech.

Puig, by contrast, is the most representative architect of the new language of the "call to order" that gradually began to assert itself in the second decade of the 20th century, which led in Catalonia to Noucentisme. His political role within the Lliga Regionalista (Regionalists League), a Catalanist political party, was such that he came to occupy public positions of considerable responsibility and as a result gradually abandoned private constructions. Gaudí, for his part, continued to pursue his own increasingly individual, even hermeneutic, path, which culminated in his vision of architecture as a symbolic object, a concept that runs against the grain of modern Western architecture.

Gaudí's forceful personality profoundly influenced contemporary architects.[17] First, there were the architects who worked directly with him, including Joan Rubió i Bellver, who became one of the theorists of Gaudí's construction systems, and Josep M. Jujol, Francesc Berenguer, Domènech Sugrañes, and Cèsar Martinell. In addition, other architects without direct contact with Gaudí were influenced by his concept of architecture, such as Lluís Muncunill, Salvador Valeri, and Manuel Sayrach.[18]

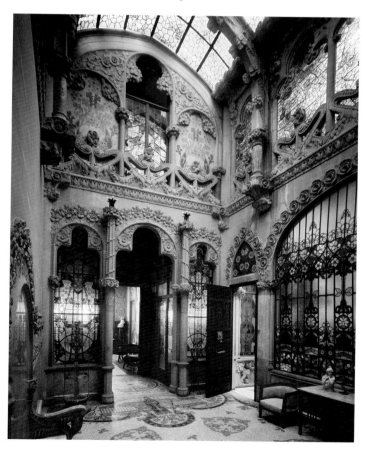

Fig. 7. Interior of Casa Navàs, Reus, designed by Lluís Domènech i Montaner.

Companies that made items of applied art for architecture, such as decorative ceramics, stained glass, tiles, plaster moldings, artificial stone, and metal objects, experienced extraordinary growth during this period. Traditional craft techniques were maintained, but modern forms of production and marketing began to prevail in response to demand, and many items, such as pressed paving stones, stained glass windows, furniture, and tiles of high artistic quality were industrially manufactured.

Like Art Nouveau internationally, modernista design in Catalonia sprang from a holistic concept of architecture: the integration of interior and exterior, and unified interior spaces. This prompted an increase in those artists known today as interior decorators or designers, such as Josep Pascó and Salvador Alarma. Furniture designers and makers, notably Joan Busquets and Gaspar Homar, and specialist workshops such as Casas i Bardés were key to establishing the new taste.[19] They also designed interiors in collaboration with draftsmen such as Josep Pey and Sebastià Junyent, who developed pictorial motifs for decoration, and with artists such as de Riquer. Aleix Clapés, for example, was among those who contributed to the decoration of the Palau Güell.[20]

The most significant artisanal manufacturers were the decorative tile manufacturers Hijo de José Pujol y Baucis in Esplugues de Llobregat, mentioned earlier; the mosaic workshop of Lluís Bru and Butsems y Cia., which specialized in artificial stone; the stained-glass makers Rigalt, Granell y Cia.; the pressed paving stone manufacturers Orsolà Solà; and above all Casa de Pavimiento Artístico Escofet, Tejera i Cia.[21] The leading companies in wrought-ironwork and blacksmithing included Manuel Ballarín and Andorrà, while the best-known foundries were Masriera i Campins in Barcelona and Barberí in Olot.[22]

Special mention must be made of the craftsmen and companies that made objets d'art, the beautiful, finely crafted curios or figurines that were so popular at the time. These included the workshop of Marià Burgués in Sabadell and the artistic ceramic and porcelain workshop of Antoni Serra i Fiter, who introduced techniques used by Sèvres and commissioned renowned artists to produce designs for him, such as Enric Casanovas, Ismael Smith, and Pablo Gargallo. Other remarkable enterprises flourished: the polychrome terracottas produced by Lambert Escaler, more strictly ornamental that those of Serra,[23] and the complex world of textile design that thrived in Barcelona and Catalonia.[24] Finally, it is important to comment on the extraordinary jewelry produced by the company Masriera Brothers, particularly those produced by Lluís Masriera, who developed the translucent material known as Barcelona enamel.[25]

In 1903, a new body called Foment de les Arts Decoratives (FAD, the Decorative Arts Promotion board) was established to promote the industrial arts and maintain the bonds between art and industry.[26] FAD was so successful in both fields that it can be credited with the tremendous growth of the decorative arts and, subsequently, design.

The final chapter in the history of architecture and design during the modernista era was written by a number of architects who rejected the French fashion for Art Nouveau after discovering the more regular and logical forms of the Vienna Secession. Secession-style designs were popularized through illustrated magazines and as a result of the Eighth International Congress of Architects, held in Vienna in 1908, which had a tremendous impact on architects. As an alternative to modernista architecture the new aesthetic was embraced by Noucentisme, the new social and cultural outlook then on the rise in Catalonia. This is why Secession-style works are usually included in the discourse on Noucentisme. Surprisingly, the finest exponents of this movement, Rafel Masó and Josep Maria Pericas, were profoundly influenced during the early years of their careers by Gaudí, with whom they shared a Catalanist spirit and deep Catholic convictions.[27] This would be the final contradiction of Catalan Modernisme: at a time when art and architecture had clearly moved away from the style, Gaudí continued to work on the Sagrada Família, paying no heed to the trends in contemporary architecture, yet sharing with leaders of the Noucentista movement the same understanding of Catalan culture.

This essay is part of the GRACMON project (Grup de Recerca en Història de l'Art i el Disseny Contemporanis), which is attached to the Departament d'Història de l'Art of the Universitat de Barcelona. The GRACMON is financed by the Spanish Ministerio de Ciencia y Tecnología (BHA 2003 03215) and the Direcció General de Recerca of the Generalitat de Catalunya (2005 SGR).

1. Joan Francesc Ràfols rescued Modernisme from oblivion in the early years after the civil war with his pioneering book *El arte modernista en Barcelona* (Barcelona: Librería Dalmau, 1943), in which he described the artistic and literary climate in modernista Barcelona, though without the architects. Ràfols had personally known some of the leading figures of the movement and so was very aware of these professionals'

suspicions of the cultural movement of Modernisme. Years later, however, in 1949 in a new edition, *Modernismo y modernistas* (Barcelona: Ediciones Destino), he devoted two chapters to architecture. Shortly after, Alexandre Cirici, in *El arte modernista catalán* (Barcelona: Aymà, 1951), produced the first unified vision that encompassed the plastic arts and architecture, looking in depth at the decorative arts. In 1968, Oriol Bohigas initiated a new line of research with *Arquitectura modernista*, with photographs by Leopold Pomés (Barcelona: Editorial Lumen, 1968), an expanded version of which was published in 1973 under the title *Reseña y catálogo de arquitectura modernista,* which included a list of works and architects' biographies edited by Antoni González i Raquel Lacuesta. At the same time, the director of the art museums in Barcelona, Joan Ainaud de Lasarte, organized an exhibition entitled *El Modernismo en España* (Madrid/Barcelona: Comisaría General de Exposiciones, 1969), which presented an extensive selection of works representing every aspect of the movement. The number of general and research studies on Modernisme increased in the 1980s, culminating in the exhibition held as part of the Cultural Olympiad, *El Modernisme* (Barcelona: Olimpíada Cultural/Lunwerg, 1991), and the five-volume compilation *El modernisme* (Barcelona: L'isard, 2003–4). Specific books and chapters on the applied and decorative arts include: *FAD: Del Bells Oficis al disseny actual, Una història de les Arts Decoratives a Catalunya al segle XX* (Barcelona: Caixa de Barcelona/Saló del Tinell, 1981); *Arts Decoratives a Barcelona: Col·leccions per a un museu* (Barcelona: Ajuntament de Barcelona/Palau de la Virreina, 1994); Pilar Vélez, "De les arts decoratives a les arts industrials," in *Arts decoratives, industrials i aplicades: Art de Catalunya, Ars Cataloniae 11,* ed. Xavier Barral (Barcelona: L'isard, 2000).

2. Xavier Tafunell, "Construcció i conjuntura econòmica," in Txatxo Sabater Andreu et al., *La formació de l'Eixample de Barcelona: Aproximacions a un fenomen urbà* (Barcelona: Fundació Caixa de Catalunya/Col·legi d'Arquitectes de Catalunya, 1990), 175–88.

3. Antoni Ramon and Carmen Rodríguez, "1871–1962: Reseña histórica," in *Escola d'Arquitectura de Barcelona: Documentos y Archivo,* ed. Ramon and Rodríguez (Barcelona: Edicions UPC i ETSAB, 1996), 16. Domènech i Montaner, for example, chaired the meeting known as the Bases de Manresa, held in the city of Manresa on 25 and 27 March 1892, which laid the foundations for political Catalanism. Josep Puig i Cadafalch became president of the Mancomunitat de Catalunya, a federation of the four provincial councils of Catalonia and the origin of political autonomy between 1917 and 1923. See Isidre Molas, *Lliga Catalana: Un estudi d'estasiologia* (Barcelona: Edicions 62, 1972).

4. Joan Lluís Marfany, "Modernisme i Noucentisme amb algunes consideracions sobre el concepte de moviment cultural," *Els Marges,* no. 26 (September 1982): 31–42.

5. See "Problemes del modernisme" and "Sobre el significat del terme 'modernisme'," in Marfany, *Aspectes del modernisme* (Barcelona: Curial, 1975), 15–60.

6. The architect Jeroni Martorell, one of Gaudí's most fervent admirers, said in 1903: "Catalonia begins a new architecture today." See Martorell, "La arquitectura moderna. I, La estètica. II, Las obras," *Catalunya,* no. 14 (1903): 426. Judith Campbell Rohrer, *Artistic Regionalism and Architectural Politics in Barcelona, c. 1880–c. 1906* (Ann Arbor, Mich.: University Microfilms International, 1987).

7. Joan Bergós had already defined the architecture of this period as "evolved Gothic," in *L'Art català,* ed. Frederic-Pau Verrié (Barcelona: Aymà, 1958), 341.

8. See Rossend Cassanova, "Cafè-Restaurant," in *Domènech i Montaner: año 2000 = year 2000,* ed. Lluís Domènech i Girbau (Barcelona: Col·legi d'Arquitectes de Catalunya/Centre de Documentació, 2000), 130–49. This summary of the author's doctoral thesis restores this workshop, which historians had regarded as parallel to the workshops of William Morris and the Arts and Crafts movement, to its rightful place.

9. Cristina Mendoza, "L'Exposició Nacional d'Indústries Artístiques de 1892 i les arts industrials a les exposicions generals de Belles Arts de Barcelona," in *Gaspar Homar: Moblista i dissenyador del modernisme,* exh. cat. (Barcelona: Museu Nacional d'Art de Catalunya/Fundació "la Caixa," 1998), 167–81.

10. Riquer's library is now held in the Biblioteca dels Museus d'Art de Barcelona. See Eliseu Trenc and Alan Yates, *Alexandre de Riquer (1856–1920): The British Connection in Catalan Modernism* (Sheffield, U.K.: Anglo-Catalan Society Occasional Publications, 1988); and Trenc, *Alexandre de Riquer* (Barcelona: Caixa Terrassa/Lunwerg, 2000).

11. *Apel·les Mestres (1854–1936)* (Barcelona: Fundació Jaume I, 1985).

12. Ma. Pia Subias Pujadas, "La Rajoleta, La gènesi de la ceràmica modernista a Catalunya," in *Patrimoni i ciutat: Esplugues i el modernisme,* ed. Mercè Vidal (Esplugues de Llobregat: Ajuntament d'Esplugues de Llobregat/Grup d'Estudis d'Esplugues, 2000). Trenc, *Les arts gràfiques a l'època modernista a Barcelona* (Barcelona: Gremi d'Indústries Gràfiques, 1977); and Pilar Vélez, *El llibre com a obra d'art a la Barcelona vuitcentista (1850–1910)* (Barcelona: Biblioteca de Catalunya, 1989).

13. A monographic study on the contribution of the Vidal workshops to the history of the decorative and applied arts in Catalonia is yet to be written. The first reference of any great length is by Josep Mainar, *El moble català* (Barcelona: Destino, 1976), 276–86, whose information seems based on a considerable amount of information provided orally by Santiago Marco. Other references include: Vicente Maestre Abad, "L'època de la industrialització c. 1845–c. 1888: Anotacions a l'ebenisteria catalana del segle XIX," in *Moble català,* ed. Eulàlia Jardí, exh. cat. (Barcelona: Generalitat de Catalunya i Electa, 1994), 106–9 and 310–13; Santi Barjau, "Francesc Vidal, decorador i col·laborador d'arquitectes," in *III Jornades Internacionals d'Estudis Gaudinistes* (Barcelona: Centre d'Estudis Gaudinistes, 1995). The most complete information on the Vidal workshops can be found in Marcy Rudo, *Lluïsa Vidal, filla del modernisme* (Barcelona: La Campana, 1996), which is a biography of one of Francesc Vidal's daughters, who was a painter.

14. Mireia Freixa, "Art nouveau et 'Modernisme': L'introduction de l'Art nouveau français dans les arts décoratifs en Catalogne," in *L'école de Nancy et les arts décoratifs en Europe* (Nancy: Serpenoise, 2000), 114–24.

15. Copies of the French edition of the catalogue *L'Exposition internationale d'arts décoratifs modernes à Turin* (Darmstadt: Librairie des Arts Décoratifs, n.d.) have been found in the libraries of numerous designers and architects.

16. Lluís Domènech and Lourdes Figueras, eds., *Lluís Domènech i Montaner i el director d'orquestra,* exh. cat. (Barcelona: Fundació Caixa de Catalunya, 1989).

17. See David Ferrer and Josep Gómez Serrano, eds., *Els arquitectes de Gaudí* (Barcelona: Col·legi Oficial d'Arquitectes/Àrea de Cultura/Formació i Publicacions, 2002).

18. See Joan Rubió i Bellver's definitive essay, "Dificultats per arribar a la síntesi arquitectònica," in *Anuario de la Asociación de Arquitectos* (1913), reprinted in Ignasi de Solà-Morales, *Joan Rubió i Bellver o la fortuna del gaudinismo* (Barcelona: Colegio Oficial de Arquitectos de Cataluña y Baleares, 1975), 120–36.

19. Teresa-M. Sala, "La Casa Busquets (1840–1929)" (Ph.D. diss., Universitat de Barcelona, 1993); Sala, *J. Busquets* (Barcelona: Nou Art Thor, 1989); *Gaspar Homar, moblista i dissenyador del modernisme,* exh. cat. (Barcelona: MNAC/Fundació "la Caixa," 1998); and A. González Simó, "Arquitectura interior en los talleres de la época de los Masriera," in *Los Masriera,* ed. Ma. Teresa Serraclara Pla, exh. cat. (Salamanca: Caja Duero, 1999), 35–41.

20. M. Pey, "Josep Pey, anònim col·laborador de moblistes i decoradors," in *Gaspar Homar,* 155–63. Sala, *Junyent* (Barcelona: Nou Art Thor, 1988).

21. Marta Saliné is now working on a doctoral dissertation on Lluís Bru. See also *Lluís Bru, fragments d'un creador* (Esplugues de Llobregat: Diputació de Barcelona/Ajuntament d'Esplugues de Llobregat/Nestlé, 2005); *El vitrall modernista* (Barcelona: Fundació Miró, 1984); *Els vitralls cloisonné de Barcelona* (Barcelona: Ajuntament de Barcelona/Museu d'Art Modern, 1985); Joan Vila-Grau and Francesc Rodón, *Els vitrallers de l'època modernista* (Barcelona: Polígrafa, 1982); Núria Gil, "L'arquitecte Jeroni F. Granell i Manresa (1868–1931)" (B.A. thesis, Universitat de Barcelona, 1998); *El paviment hidràulic* (Barcelona: Col·legi d'Aparelladors/Arquitectes Tècnics de Catalunya, 1985); and T. Navas, "El mosaic hidràulic. Un art aplicat al segle XX," *Butlletí informatiu de ceràmica,* no. 37 (1988): 24–27.

22. Mercè Doñate, "La foneria artística Masriera i Campins," in *Els Masriera,* exh. cat. (Barcelona: MNAC/Generalitat de Catalunya/Proa, 1996), 214–27; also Casanova, "Cafè-Restaurant."

23. See Josep Casamartina, *Marian Burgués, un terrisser que va fer història* (Sabadell: Fundació Caixa de Sabadell, 1993); Francesc X. Puig Rovira, *Antoni Serra i Fiter (1869–1932), Ceràmica Serra (1927–1977)* (Cornellà de Llobregat: Ajuntament de Cornellà de Llobregat/Ceràmica Serra, 1985); Joan M. Minguet Batllori, ed., *Serra: El arte de la cerámica,* exh. cat. (Madrid/Cornellà de Llobregat: Subdirección General de Museos Estatales/Ajuntament de Cornellà de Llobregat, 2005); J. C. Bejarano, *Lambert Escaler* (Barcelona: Infiesta Editor, 2005).

24. Sílvia Carbonell Basté and Josep Casamartina, *Les fàbriques i els somnis. Modernisme tèxtil a Catalunya,* exh. cat. (Terrassa: Centre de Documentació/Museu Tèxtil, 2002).

25. Pilar Vélez, *Masriera Jewellery: 200 Hundred Years of History* (Barcelona: Àmbit, 1999).

26. *FAD: Dels bells oficis al disseny actual, La història de les arts decoratives a Catalunya al segle XX,* exh. cat. (Barcelona: Caixa de Barcelona, 1981).

27. On Rafael Masó as part of the noucentista movement, see Joan Tarrús and Narcís Comadira, *Rafael Masó: Arquitecte noucentista* (Barcelona: Lunwerg, 1996).

Translated by Susan Brownbridge.

# Puig i Cadafalch, a Versatile Architect

MIREIA FREIXA

In 1881, Josep Puig i Cadafalch submitted his degree project at the Escola Superior d'Arquitectura, then located on the fourth floor of what was called the Universitat Literària de Barcelona. Antoni Gaudí had submitted his final project in 1878, and Lluís Domènech i Montaner, a key influence on Puig in the early years of his career, had presented his in 1873. Sixteen years younger than Domènech and 15 years younger than Gaudí, Puig was, like Lluís Muncunill, Pau Salvat i Espasa, and Joan Rubió i Bellver, one of the second generation of modernista architects who completed their studies when the courses at the school of architecture were fully established, able to impart solid training. Moreover, in addition to the construction of the Eixample in Barcelona, a law required Catalan towns and cities of a certain size to establish positions for municipal architects, creating an advantageous situation for aspiring students.

Puig i Cadafalch was a complex man. As a politician, he came to play a decisive role in the Lliga Regionalista and even served in the most important post in Catalan politics, president of the Mancomunitat de Catalunya. As an art historian, he laid the foundations for the historiography of Romanesque art. His most important publication is *Arquitectura romànica a Catalunya* (Romanesque Architecture in Catalonia), but he was also interested in painting and one of the organizers of the splendid collection of Romanesque painting at the Museu Nacional d'Art de Catalunya. Equally interested in sculpture, during the last years of his life he published *Escultura romànica a Catalunya* (Romanesque Sculpture in Catalonia).[1] His work as an archaeologist and an urban planner was also of fundamental importance.[2]

Puig produced his first work of architecture in the 1890s, the period I have defined as early Modernisme. As indicated in this section's introduction, the nationalist sentiments of Catalan society were expressed through a late revision of medieval styles at a time when eclecticism was in decline in other Western countries. Puig played an important role in medieval revivalism in Catalonia. A detailed discussion of his most significant works, published in French in 1904, provides insights into the architect's intentions. He explained in this book that his work was the result of a collective stance that gave the appearance of a movement (fig. 1). Phrases such as "This work is the result of a collective undertaking by a collaborative group of unwitting visionaries," and "this art that we have created between us," explain the collegial spirit that Puig described, while foreseeing that his peers in other countries would find it difficult to grasp.[3]

Puig's works from the 1890s demonstrate his profound knowledge of history, his tremendous capacity for composition, and his painstaking attention to ornamental elements that are perfectly attuned to the dynamics of his architectural structures. In addition to Casa Martí and Casa Amatller, his Casa Coll i Regàs (1897–98) in Mataró and Casa Garí, also known as El Cros (1898–1900), in Argentona, and even later works such as Casa Terrades, known as the Casa de les Punxes (1903–5), and the Palau del Baró de Quadras (1902–6), are in accord with this style.

Casa Martí was Puig's first mature work, the first in which he defined the "nationalist" style of the early years of his career (figs. 2 and 3). The property, a residential building with commercial premises on the first floor, was commissioned by the brothers Pere and Francesc Martí i Puig.[4] In 1897 the commercial premises on the ground floor were rented to the Quatre Gats tavern, run by Pere Romeu, which proved extraordinarily popular. As Judith Rohrer remarks, the popularity of the Quatre Gats

Fig. 1 (cat. 5:1). Josep Puig i Cadafalch, title page of *L'Oeuvre de Puig Cadafalch, Architecte: 1896–1904* (1904).

contributed to raising public awareness of the building and of the young architect's ideas.[5] In July 1897, only a month after the tavern opened, a report by Bonaventura Bassegoda published in *La Renaixença* remarked on its artistic links and pointed out the connections with Catalanist ideals and "seeing our artistic ideals written in stone."[6] To give only a few examples, Pablo Picasso's chromolithograph advertising the Quatre Gats menu (see fig. 3, p. 94) and Ramon Casas's promotional poster (see fig. 1, p. 92) identify the establishment with the arches designed by Puig.

The property is situated in the heart of Barcelona's old quarter on the carrer de Montsió, at a corner bisected by a narrow alley. The entire building is constructed of exposed brickwork, a clear allusion to traditional Catalan construction methods, and the top is crowned with small battlements. Unusual pointed arches, one on either side of the entrance door and five more on the side façade, are the most representative features of the entire building. Elsewhere in the building, Puig experimented with features that were to become characteristic of his oeuvre: a gallery on the second floor, the *piano nobile,* with decorative elements reminiscent of the Baroque, and ornamental sculpture, in this case a statue of St. Joseph on the corner of Montsió and the alley where the building's façades meet.[7] The only surviving reference to the interior is a small drawing published by Rohrer, but from this we can deduce that it anticipated the interior of Casa Amatller.[8]

The first floor is the most notable part of Casa Martí. It is divided into two spaces, the first intended

for use as a dining room and the second as a room for multiple functions. The complex décor of the second room blended the avant-garde with traditional styles, old Catalan tiles, dark wooden furnishings, and paintings by the artists that gathered at the tavern. The most prominent object in the room was the large painting *Ramon Casas and Pere Romeu on a Tandem* by Casas himself (see fig. 6, p. 83), which was later replaced by *Ramon Casas and Pere Romeu in a Car,* also by Casas (see fig. 7, p. 83). When Quatre Gats closed, the premises were temporarily occupied by the Cercle Artístic de Sant Lluc and later used as a fabric warehouse. In recent years, the ground-floor rooms have been restored to their original layout and are now occupied by a restaurant.

Casa Amatller, on passeig de Gràcia, is Puig's most important building from this period (fig. 4). He was not commissioned to construct a new building, but to refurbish an existing one, as Gaudí was later with the neighboring Casa Batlló, reflecting a common practice of the time. Scholars who have studied the construction of the Eixample, Barcelona's urban expansion area, have remarked on the significant change in the type of buildings produced after the introduction of the municipal bylaws of 1891. These new rules, allowing taller and deeper buildings, were introduced just as the commercial center was beginning to shift toward the new part of the city. Owners took advantage of the changed bylaws to make their properties more profitable by replacing single-family homes with apartment blocks, or by refurbishing buildings and adding extra stories.[9]

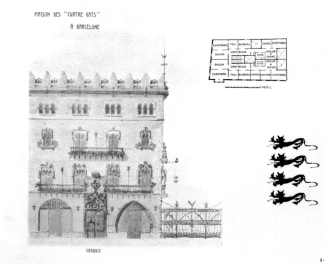

Fig. 2 (cat. 5:2). Josep Puig i Cadafalch, *Façade of Casa Martí (Quatre Gats), Barcelona,* 1896.
Fig. 3. *Façade of Casa Martí,* 1898, by Josep Puig i Cadafalch, from *L'Oeuvre de Puig Cadafalch, Architecte: 1896–1904* (1904).

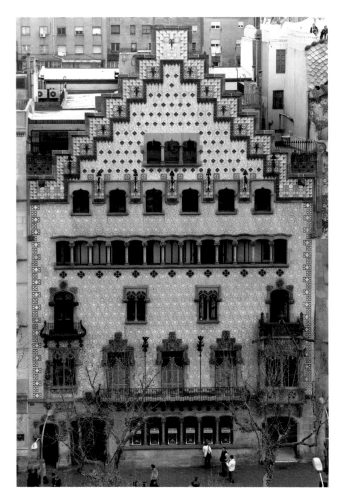

Originally a four-story building based on a plan dated 1875, Casa Amatller was owned by Maria Martorell i Peña and designed by the master builder Antoni Robert Morera.[10] Each floor was divided into two apartments, and the façade was designed in accordance with the precepts of academic art and architecture. Toward the end of the 1890s, the plot was purchased by the chocolate manufacturer Antoni Amatller i Costa, who commissioned Puig to refurbish the building throughout.[11]

The plans, elevation, and floor plans presented to city hall are dated 9 October 1898 (fig. 5). In his design, Puig added an extra story and constructed an attic below the roof, a part of the building hidden by a stepped gable intended to house a photographic studio, as Amatller was a keen amateur photographer.[12] The façade's appearance was also altered according to the design of medieval Catalan mansions and consisted of a first floor, the piano nobile with large windows, a third floor, and an attic with a gallery accented by a row of small windows. To this initial composition was added the gable inspired by central European art. The façade's base is made of stone, the central section is stuccoed, and the entire gable is decorated with colored tiles (fig. 6).

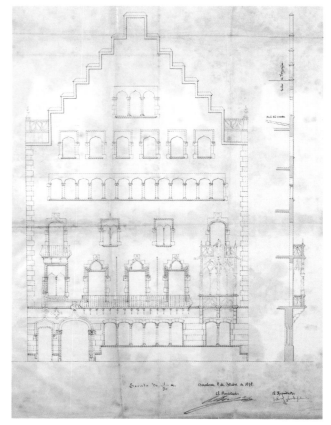

Fig. 4. The façade of Casa Amatller, designed by Josep Puig i Cadafalch.
Fig. 5 (cat. 5:3). Josep Puig i Cadafalch, *Façade of Casa Amatller*, 1898.
Fig. 6. *Design for the Façade of Casa Amatller*, 1898–1900, by Josep Puig i Cadafalch.

As was common in constructions of this type, the ground floor was set aside for functional use and contained the kitchen, the servants' quarters, and entrances to the garden and the second floor. The owner lived on the second floor, considered the most desirable part of the building, and the other apartments were rented. For this reason, the property has two very different entrances: a main staircase that winds around the inside of the interior courtyard, in keeping with the design of medieval townhouses and palaces in Catalonia, and leads up to the

entrance of the main apartment on the second floor (fig. 7), while a door of lesser grandeur serves as the entrance to the other apartments.

The main apartment occupies the entire second story of the building. The rooms are configured to meet the needs of the owner Amatller, who lived with his only daughter, and had to accommodate his large collection of glass and other artistic objects. On the side of the property overlooking the street there was a large room that housed his collection. The display room led to two bedrooms. At the rear of the building, overlooking the garden, was a large dining room, the drawing room, and the music room. In this building all the arts united with architecture

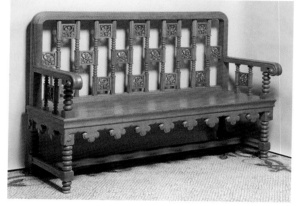

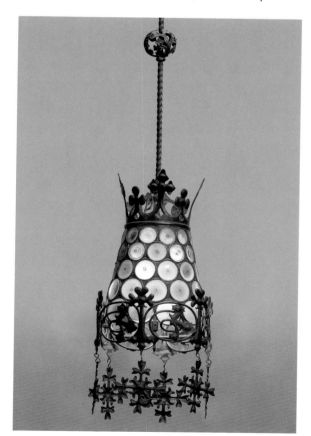

in accordance with the ideals of John Ruskin. An article of 1901 published in the magazine *Arquitectura y Construcción* reviewed all the craftsmen and industrialists who had played a part in its refurbishment.[13] The magnificent mosaic in the most important part of the main apartment was produced by the Maragliano company, and the pressed floor tiles were made by Escofet, Tejera i Cia. Two of the renowned smiths of the time, Esteve Andorrà and Manuel Ballarín, produced the ironwork. Joan Paradís made the delicate stucco on the main façade and the interior, and the decorative painting was by Gelabert, the wallpaper by Salvador Salvia, the tiles by Hijos de Jaime Pujol y Bausis, the bronzework by Masriera i Campins, the stained glass by Espinagosa, and the furniture by Gaspar Homar (figs. 8 and 9). Eusebi Arnau made the ornamental sculpture, Joan Coll the plasterwork, and the Juyol brothers cut the stone.[14]

The refurbished property did not go unnoticed. The magazine *Arquitectura y Construcción* published a report on the building illustrated with photographs.

Fig. 7 (cat. 5:4). Josep Puig i Cadafalch, *Project for the Main Stairway of Casa Amatller*, 1898–1900.
Fig. 8 (cat. 5:5). Josep Puig i Cadafalch, *Ceiling Lamp from Casa Amatller*, 1898–1900.
Fig. 9 (cat. 5:6). Josep Puig i Cadafalch (designer), Taller Homar (probable manufacturer), *Bench from the Entrance Hall of Casa Amatller*, 1900.

buildings: walls of exposed brick, Catalan roof vaulting, and a bare minimum of decorative elements. The Casaramona factory was built between 1909 and 1911 for a company that specialized in making cotton fabric.[18] The building stands at the foot of Montjuïc, an area at that time isolated from the city center. The premises are divided into separate pavilions of different heights, connected by "streets" running between the various parts of the complex. This industrial facility has a striking artistic appearance, consisting as it does of a series of compact blocks of one, two, or three stories watched over by the clock tower and water tower. The entire complex is constructed of exposed brickwork that contrasts with the colored mosaic of the signs and the powerful wrought ironwork. Slender buttresses situated between the large windows support arches that protect the windows against rain. The buttresses are

These images and others that complemented the report were also reproduced in the British journal *Academy Architecture and Architectural Review,* thus spreading the property's fame beyond Catalonia and Spain.[15] In 1902, the magazine *Hispania* published a monographic issue on Puig i Cadafalch in which Casa Amatller figured prominently.[16] Today, in accordance with the wishes of Antoni Amatller and his daughter Teresa, the main floor is home to the Institut Amatller d'Art Hispànic, which is responsible not only for raising awareness of the history of Spanish art, but also for the conservation of the building and its collections.

The Casaramona textile factory (fig. 10) is one of the landmark buildings in the history of modernista industrial architecture, along with the factories built by Lluís Muncunill in the city of Terrassa. Casaramona, which Puig worked on between 1903 and 1911, was not the architect's only contribution to commercial architecture, as he had already designed the Granja Terrades farm in Seva, the Celler de Can Codorníu winery in Sant Sadurní d'Anoia, the Fàbrica Carbonell i Susana (a knitwear factory) in Canet de Mar, and the Marconi telegraph exchange in El Prat de Llobregat.[17] In such buildings, Puig usually employed a construction system frequently seen in his

also crowned by delicate pinnacles, giving the entire complex a medieval look. Although an industrial building, Casaramona was praised in its own time, with the city council awarding Puig its annual prize for architecture. Despite the building's success, it did not operate for long as a textile mill and closed in 1920. After the civil war, Casaramona was turned into a station of the Policia Nacional and the Policia Armada police forces. Even though it was declared a monument of national historical and artistic interest in 1976, it gradually fell into a state of disrepair. Fortunately, it has recently been restored and transformed into an exhibition space and a cultural center run by a major savings bank. The refurbishment strengthened the building, which retains all of its original form.

Fig. 10. Aerial view of the Casaramona factory, designed by Josep Puig i Cadafalch.

Fig. 11 (cat. 5:7). Josep Puig i Cadafalch, *Casaramona Factory,* c. 1910, model made in 1989 by Juan Pablo Marín.

1. Josep Puig i Cadafalch et al., *L'arquitectura romànica a Catalunya* (Barcelona: Institut d'Estudis Catalans, 1909–18). A facsimile edition has a prologue by Xavier Barral i Altet (Barcelona: Institut d'Estudis Catalans, 2001). Josep Puig i Cadafalch, *L'escultura romànica a Catalunya* (Barcelona: Alpha, 1949–54). See also Milagros Guardia et al., *La descoberta de la pintura mural romànica catalana: La col·lecció de reproduccions del MNAC*, exh. cat. (Barcelona/Madrid: Museu Nacional d'Art de Catalunya/Electa, 1993); and Jordi Camps i Sòriaet et al., *Puig i Cadafalch i la col·lecció de pintura romànica de MNAC*, exh. cat. (Barcelona: Museu Nacional d'Art de Catalunya, 2001). Ramon Grau and Marina López provide a fascinating reading of Puig i Cadafalch's historiographical work in "La teoria històrica de l'arquitectura de Puig i Cadafalch," *Artilugi*, no. 12 (January 1981). See also Joaquim Graupera i Graupera, *Josep Puig i Cadafalch i l'Associació Artístich Arqueològica Mataronesa* (Mataró: Grup d'Història del Casal, 2001).

2. Barral devotes a considerable section to Puig in *L'arqueologia a Catalunya* (Barcelona: Destino, 1989). It was Oriol Bohigas who, with his habitual wisdom, wrote an initial article about him, "José Puig i Cadafalch, arquitecto octogenario: La obra no realizada," *Destino*, no. 556 (1948). In 1956, the year Puig i Cadafalch died, J. F. Ràfols, a careful follower of the careers of the architects who had gone before him, paid a small tribute to him in "Puig i Cadafalch," *Cuadernos de arquitectura*, no. 28 (4th quarter 1956): 1–17. However, Puig was finally brought to public attention as a result of one of the events that mobilized Catalan intellectuals against Franco and the dictator's policies. This event was the "lock-in" of some 500 students at the Capuchin convent, 9–11 March 1966, who were surrounded by police for 48 hours. On 10 March, the Col·legi d'Arquitectes opened in its Sala Picasso an exhibition of photographs taken by Català-Roca of Puig i Cadafalch's house in Argentona. The opening ceremony was to have included a speech by Alexandre Cirici. The dean of the Col·legi, Antoni de Moragas, was at that time at the convent and therefore unable to attend, and when Cirici and others attending the opening began to applaud spontaneously as a sign of support, the talk was suspended by the police. Cirici's speech was included in *Cuadernos de arquitectura*, no. 63 (1st term 1966): 49–54. It was later reprinted in 2001 as part of the events organized to celebrate the "Puig i Cadafalch Year." In the mid 1970s, rising interest in Modernisme prompted the publication of a number of monographic works on the subject. In 1975, Enric Jardí produced the first biography that analyzed every aspect of the architect's life, *Puig i Cadafalch, arquitecte, polític i historiador de l'art* (Barcelona: Ariel, 1975), which remains an essential source of reference. However, the main impetus for historical studies on the architect was the exhibition held in Casa Macaya in Barcelona in 1990. See Judith Rohrer et al., *Josep Puig i Cadafalch: la arquitectura entre la casa y la ciudad*, exh. cat. (Barcelona: Fundació Caixa de Pensions/Col·legi d'Arquitectes de Catalunya, 1990). This study also brought to light the architect's own richly stocked archives, now in the hands of his heirs, which contain a vast quantity of previously unknown details and his fascinating notes and sketches that provide insights into his working methods. The Puig i Cadafalch Year in 2001 also gave rise to various studies that cannot be enumerated here because there is no space. Finally, the publication of Puig, *Escrits d'arquitectura, art i política*, ed. Barral (Barcelona: Institut d'Estudis Catalans, 2003), a meticulous edition of the architect's own writings, has contributed significantly to our understanding of his life and work.

3. Puig, *L'Oeuvre de Puig Cadafalch, Architecte: 1896–1904* (Barcelona: M. Parera, 1904), 7.

4. The original plans are published in the *Catàleg del patrimoni arquitectònic i històrico-artístic de la ciutat de Barcelona*, issued by the Servei de Protecció del Patrimoni Monumental (Barcelona: Ajuntament de Barcelona/Àrea d'Urbanisme i Obres, 1985), 301. A modern version can be found online at http://www.urbanismedebarcelona.net/patrimoni/home.htm

5. Rohrer, *Josep Puig i Cadafalch*, 25. A report on the house was published in *Arquitectura y Construcción* (1901): 69–98.

6. Bonaventura Bassegoda, "Notas artísticas," *La Renaixença*, 1 (27 June 1897): 131; quoted by Rohrer, *Josep Puig i Cadafalch*, 25.

7. The original sculpture by Joan Llimona disappeared and has since been replaced by a copy at the initiative of the Institut Municipal del Paisatge Urbà.

8. Rohrer, *Josep Puig i Cadafalch*, 156.

9. See Joan Molet, "Barcelona entre l'enderroc de les muralles i l'Exposició Universal: arquitectura domèstica de l'Eixample" (Ph.D. diss., Universitat de Barcelona, 1996); Santi Barjau, "Arquitectura, paisatge urbà i ordenances. L'aspecte dels edificis a l'Eixample clàssic," in Barjau et al., *La formació de l'Eixample de Barcelona: Aproximacions a un fenomen urbà* (Barcelona: Olimpíada Cultural, 1990), 223–34; and Barjau, "El paisatge arquitectònic del Quadrat d'Or," in *The "Quadrat d'Or" (Golden Square): 150 houses in the centre of modernista Barcelona: Guidebook* (Barcelona: l'Ajuntament/Olimpiada Cultural, 1990), 17–24.

10. Morera was one of the best known master builders of the second half of the 19th century. See Juan Bassegoda, *Los maestros de obras de Barcelona* (Barcelona: Real Academia de Bellas Artes de San Jorge, 1972), 97.

11. See Santiago Alcolea Blanch, "Antoni Amatller Costa (1851–1910)," in *El Museu Domèstic. Un recorregut per les fotografies d'Antoni Amatller*, exh. cat. (Barcelona: Fundació "la Caixa," 2002), 31–39, and also at http://www.infonegocio.com/cebbcn/casa_amatller_texto_alcolea.htm. The plans were first reproduced by Adolf Florensa i Ferrer, "Puig i Cadafalch, arquitecto, historiador y arqueólogo," *Cuadernos de Arquitectura*, no. 68–69 (2nd–3rd quarters 1967): 75–78, and later in *Catàleg de patrimoni*, 210–11.

12. Amatller was a photography enthusiast. His collections are held by the Institut Amatller d'Art Hispànic. The project shows the space marked specifically as a photography studio. See *El Museu Domèstic*.

13. *Arquitectura y construcción: revista técnica quincenal* 5 (1901): 303–6.

14. See also Maria Isabel Marín, "Eusebi Arnau Mascort 1863–1933" (Ph.D. diss., Universitat de Barcelona, 1993), 750–813.

15. *Academy Architecture and Architectural Revue* (1901): 60, 128–30.

16. *Hispania*, no. 73 (29 February 1902).

17. The premises of the telegraphic exchange have recently been identified. See Alícia Suàrez, "El Prat de Llobregat," in *El modernisme al Baix Llobregat* (Barcelona: Mediterrània, 2003), 108–9.

18. *Catàleg del Patrimoni*, 278–79. See Jordi Romeu, "Josep Puig i Cadafalch. Obres i projectes des del 1911" (Ph.D. diss., Universitat Politècnica de Catalunya, 1989).

Translated by Susan Brownbridge.

# Domènech i Montaner and Architectural Synthesis

*MIREIA FREIXA*

Until the late 20th century, Lluís Domènech i Montaner was the most misunderstood of the modernista architects and his concert hall, the Palau de la Música Catalana (fig. 1), the building most reviled as an example of the poor taste of Art Nouveau. Following his death, a number of articles recalled primarily his personality as a teacher and his career as director of the Escola d'Arquitectura, but it was not until the early 1960s that he may be said to have been "discovered" as an architect.[1] The events held in Catalonia in the year 2000 to mark the Domènech i Montaner Year contributed to a reappraisal of the architect's work and his public persona. That same year, his heirs estab-lished an archive of his private papers at the Col·legi Oficial d'Arquitectes de Catalunya, and a number of published studies reveal him to be a key figure of this era of Catalan culture, examining his activities as an architect and a force behind the revival of the applied arts, as well as his work as a politician and a hardy scholar of art history, whose research took him to remote areas, often on foot. In this essay, I will focus on his professional activities, in particular through an analysis of one of his most important works, the Palau de la Música Catalana, commissioned by the Orfeó Català choral society in 1904.

Other essays in this catalogue comment on the importance of the Barcelona Universal Exposition

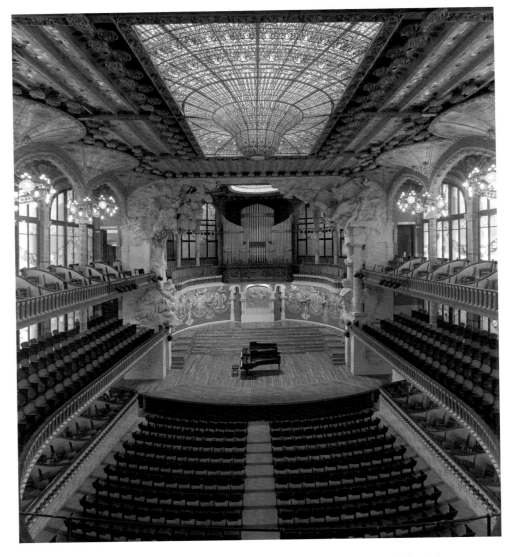

Fig. 1. The auditorium of the Palau de la Música Catalana, designed by Lluis Domènech de Montaner.

of 1888 and its influence on the awareness of modernity. Domènech i Montaner was given two important commissions for the exposition, the Hotel Internacional, which was demolished after the event, and the pavilion for the Cafè-Restaurant, subsequently turned into the Museu d'Història and finally the Museu de Ciències Naturals. This building was the first step toward the definition of a language which, while indisputably eclectic, nevertheless sought to be different. As mentioned in my introductory essay to this section, this was the context in which Domènech assembled his first team of collaborators, among them the sculptor Eusebi Arnau, the master stained glass maker Antoni Rigalt, and the expert ceramicist Pau Pujol i Vilà.

In 1888, Domènech's professional career was still young but filled with activity. He had completed his studies in architecture in 1873 and had designed a number of notable works in collaboration with Josep Vilaseca.[2] This formative early period affords insight into his understanding of architecture. In 1902, Josep Puig i Cadafalch published an article in the magazine *Hispania* evaluating Domènech's work within the context of Catalan architecture of the day.[3] Puig contrasted Domènech's modernity with Elies Rogent—a follower of Viollet-le-Duc—and Joan Martorell, whose Romantic medievalism was not far removed from the Victorian spirit in Britain.[4] As Puig saw it, Domènech epitomized the modernization of Catalan architecture by fusing the concepts of structure, form, and function; he defined a new eclecticism that transcended the appropriation of stylistic models by encompassing container and content, form, and function, structure and ornamentation. Expressing all these values was a vast project never constructed, intended for the Institucions Provincials d'Instrucció Pública of the Diputació de Barcelona.[5] Domènech and Vilaseca worked on this commission from 1875 to 1884. The surviving planimetric materials produced during this long period, as well as other technical and theoretical documents, provide numerous clues that help us to understand their architectural thinking. Broadly speaking, their intention was to transform eclecticism by rethinking the movement's own concepts, surpassing a simple relationship between models and forms through new methods of design.

The discovery of German eclectic architecture lay at the root of these reflections. In a brief treatise they published in 1889, the architects recalled the impact of the great eclectic architecture of Central Europe on their training.[6] They described their travels for research through Germany and Switzerland, and their fascination with the architects whose work they encountered there. Vilaseca also visited Vienna, returning full of enthusiasm for the city's architecture, and on the cornice of a house built in Plaça Urquinaona (1874–78) he inscribed the names of Semper, Schinkel, and von Klenze alongside those of Ictinus, Villanueva, Juanelo, Mendivil, Michelangelo, Mansart, and Wren.[7]

The work of Andreas and Friedrich von Gärtner and Leo von Klenze in Munich, Karl Friedrich Schinkel in Berlin, and above all Gottfried Semper were distinguished by a synthesis of technique and form, and the choice of historical models appropriate to the urban fabric. Stylistic alternatives should be understood as a "cultivated" component, as a compilation of history. This led to a judicious use of ornamentation as a basic complement to architecture, always in rhythm with the building's structure. In parallel with these ideas Domènech published in *La Renaixença* a manifesto entitled "In Search of a National Architecture," which reviews historicism from the modern standpoint, according to which technique and style depend on a close relationship with ornamental elements.[8] Domènech played a decisive part in the definition of the new aesthetic of the early modernista period. The preference for the forms of the past, as well as the revival of old techniques, gave the buildings of this period a distinctly medieval appearance clearly influenced by Romanticism, which, paradoxically, was intended to convey a modern, cosmopolitan image.

In the opening years of the 20th century, Domènech was an eminent architect, teacher, and director of the Escola Superior d'Arquitectura. His commissions were among the most representative of Catalan society in his day. After a number of years of intense political activity—during which he served as president of the Lliga de Catalunya and the Unió Nacionalista, as well as a member of parliament for the Lliga Regionalista—he resigned from the Lliga Regionalista in protest over political machinations.

number of important residential projects, such as Casa Navàs (1901–7) and Casa Lleó Morera (1903–5, fig. 2). He remained loyal throughout to the functional and "rigorist" principles of his training. In his more mature works, he held to his vision of the unity of technique, form, and ornamentation, to the extent that this principle became the key to understanding his entire oeuvre. Though always founded on eclecticism, his work gradually embraced new sources of stylistic inspiration, from a review of historical styles to a free interpretation of natural forms. In addition, he was extremely familiar with modern construction techniques and employed steel and cast iron in an original and daring manner, often combined with traditional methods.

The Palau de la Música Catalana is the "home" of the Orfeó Català and very closely linked with this choral society, which has a special significance in the history of culture of Catalonia (figs. 3–5). Music, and in particular choral singing, was key to the rise of cultural Catalanism during the Renaixença era. In February 1850, Josep Anselm Clavé created a choir for male voices with the clearly utopian aim of improving the living conditions of the working classes.[9] One of Clavé's great innovations was the revival of a basic repertoire of popular music consisting of familiar works with simple harmony that could be sung

A productive period now began in which he concentrated on his architectural practice and his historical research. He supervised the two emblematic public projects of the day, the Palau de la Música Catalana (1905–8) and the Hospital de la Santa Creu i Sant Pau, begun in 1901, on which he continued to work until his death. In addition, he worked on a

Fig. 2 (cat. 5:8). Lluís Domènech i Montaner, *Project to Reform the Façade of Casa Lleó Morera, Barcelona,* 1903.
Fig. 3 (cat. 5:9). Adrià Gual, *Orfeó Català,* 1904.

by choirs without musical training. Clavé's choirs were the most popular voice of the Renaixença, as various authors have recognized, and were an important element in the recovery of popular music. Joan Llongueras, one of the most important musicians of the modernista and noucentista years, acknowledged the role of these choirs, commenting, "The early popular choir endowed by Clavé with an essentially social component has at all times taken pains to arouse noble sentiments in the people and to patiently rebuild the Catalan soul."[10]

The Orfeó Català represented progress. It was intended to be a quality choir with sections for women and children, to provide musical training to singers, and preserve the Catalan spirit.[11] Its social base was different from that of Clavé's choirs, as it drew on the middle class and the petite bourgeoisie and craftsmen, rather than the working class. Founded in September 1891 by two young musicians, Fèlix Millet and Amadeu Vives, the Orfeó Català performed its first public concert in April 1892. As its importance increased the Orfeó came to need its own premises, and when the jeweler Joaquim Cabot was president of the choir Domènech was formally commissioned to design a building for it in October 1904. Work began in April 1905, and the building complex officially opened on 9 February 1908.[12] The Palau de la Música Catalana is still used as a concert hall. The painstaking refurbishment and extension work in recent years by the architects Òscar Tusquets, Lluís Clotet, and Carles Díaz, with the aid of Ignacio Paricio, is daring yet respectful of the original structure.

The site of the concert hall, built amid the narrow streets of the old part of Barcelona to be near the working-class singers' homes, was the determining factor in Domènech's design. Since the location did not offer visual perspectives, Domènech devised a number of ingenious solutions, such as an entrance for coaches and horses on the ground floor of the building and, above all, the impressive design of the meeting point of the two façades (figs. 6 and 7), a corner dominated by architectural sculpture by

Fig. 4 (cat. 5:10). *Orfeó Català*, 1916, cover.
Fig. 5 (cat. 5:11). *Orfeó Català*, 1916, two-page spread.
Fig. 6 (cat. 5:12). Lluís Domènech i Montaner, *Original Project for the Façades of Palau de la Música Catalana*, c. 1908.

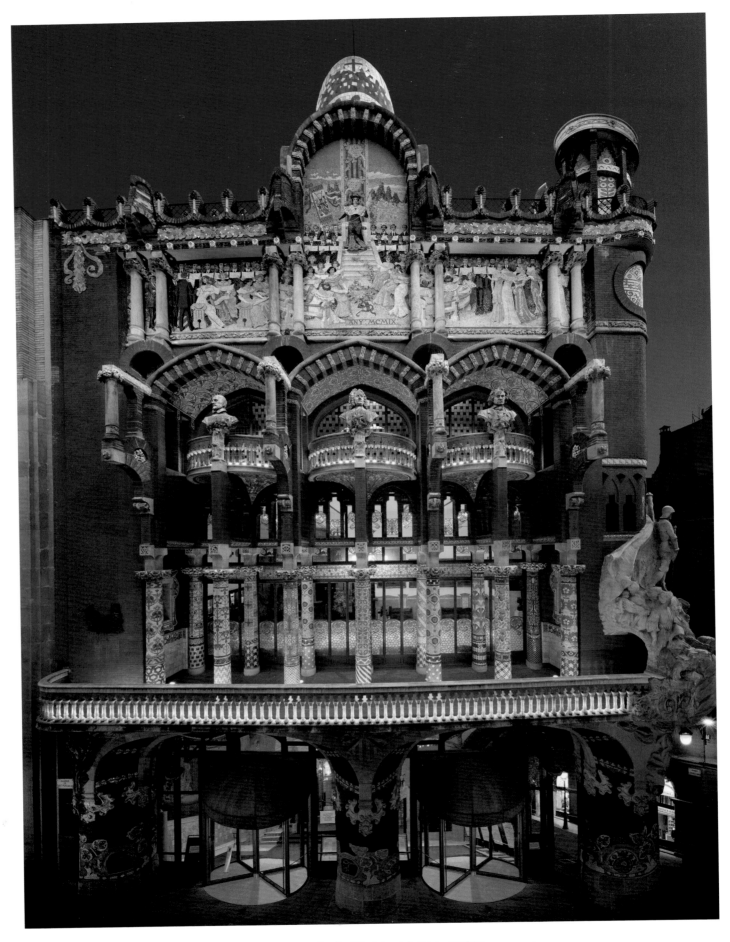

Fig. 7. The main façade of the Palau de la Música Catalana.

Josep Blay. As Domènech Girbau points out, the architect studied the construction of other contemporary concert halls and was familiar with a number of studies on acoustics.[13] The construction itself is extremely modern, as the entire structure is made of metal, with brickwork used to unify the complex.[14] The concert hall itself is on the second floor of the building, while the ground floor is occupied by offices and the rehearsal room. Both the exterior and the interior clearly reveal its structure, with a surface of only exposed brick and ornamental ceramics and tiles, in keeping with Domènech's principle of seeking the maximum integration between architecture and ornamentation.

Highly important is the architect's attention to the applied and decorative arts (figs. 9–11). The ornamental decoration of the palace of music is related in its entirety to themes from the musical culture of his day, especially the popular music of Richard Wagner, the paradigm of modernity.[15] García-Martín's study, mentioned earlier, provides considerable information on the decorative approach Domènech employed with his usual group of collaborators:[16] the mosaic work is by Lluís Bru; the splendid ceramics by Josep Orriols, Modest

Sunyol, and others whose names are unknown; the stained glass, especially the skylight that hangs like an inverted dome in the center of the auditorium, is by the Rigalt i Granell company; the pressed floor tiles are by the Escofet company.[17] The ornamental sculptures were produced by several artists: Eusebi Arnau, who often collaborated with Domènech, made the busts of female musicians at the back of the stage and the heads of the musicians on the façade; the large sculptures on the proscenium arch of the *Ride of the Valkyries* and *May Flowers* (referring to a famous musical composition by Clavé) are by Pablo Gargallo and Dídac Masana Majó, an unknown artist.[18] Finally, the vast composition that occupies the corner of the two exterior façades, *Popular Song*, was commissioned from Miquel Blay, the most prestigious Catalan sculptor of the day.[19]

The prolific and elaborate decoration on Domènech's buildings is deployed across an extremely clean architectural structure. His mature work magnificently achieves the principal goal of his entire production since the beginnings of his architectural career: the integration of structure and ornamentation, prompted by a desire to link architectural form and function.

Fig. 8 (cat. 5:14). Lluís Domènech i Montaner, *Transparent Yellow Glass Balusters from the Palau de la Música Catalana*, c. 1905.
Fig. 9. View of the transparent yellow glass balusters on the staircase of the Palau de la Música Catalana.
Fig. 10 (cat. 5:15). Lluís Domènech i Montaner, *Ceramic Architectural Ornament with Musical Notes*, c. 1906.

1. A monograph on Domènech i Montaner was published in the journal *Cuadernos de Arquitectura*, no. 52–53 (2nd and 3rd quarter 1963). The articles were reprinted in Lluís Domènech i Girbau, ed. *Domènech i Montaner: año 2000 = year 2000* (Barcelona: Col·legi d'Arquitectes de Catalunya/Centre de Documentació, 2000), together with a number of complementary pieces. This publication included a study by Oriol Bohigas on Domènech's architectural life, "Vida y obra de un arquitecto modernista," in which he demonstrates Domènech's understanding of modern construction techniques and his ability to employ them alongside traditional systems. A summary of this study was printed in *Architectural Revue* 142 (December 1967): 428–36, which proved influential in raising awareness of Domènech's work beyond the local sphere. Among many valuable contributions to this rehabilitation was an extensive exhibition that emphasized the role of the architect in the revival and renewal of the applied and decorative arts, while also considering his personality as a politician, an expert in heraldry, and a scholar of art and archeology. See Lluís Domènech and Lourdes Figueras, eds., *Lluís Domènech i Montaner i el director d'orquestra*, exh. cat. (Barcelona: Fundació Caixa de Barcelona, 1989). The holding of Domènech Year in 2000 was a final landmark in the restoration of the architect to his rightful place in history. In addition, the Museu Nacional d'Art de Catalunya is now preparing an exhibition on the studies on Romanesque art by Domènech and his son Pere Domènech Roura.

2. Rosemarie Bletter, *El arquitecto Josep Vilaseca i Casanovas. Sus obras y dibujos* (Barcelona: La Gaya Ciencia, 1977).

3. "Don Luís Domènech i Montaner," *Hispania*, no. 93 (30 December 1902): 544.

4. In writing these words, Puig took as his sole reference Rogent, the restorer of Ripoll. The analysis of Pere Hereu, *Vers una arquitectura nacional* (Barcelona: Universitat Politècnica de Catalunya, 1987), reveals that Rogent was extremely knowledgeable in the new structural methods of his day.

5. I have discussed this project in "The Design of the Provincial Teaching Institutions Building. The Early Years of Lluís Domènech i Montaner and Josep Vilaseca i Casanovas," in *Domènech i Montaner: año 2000 = year 2000*, 109–29.

6. *Antecedentes del pleito contencioso-administrativo que contra la Diputación de Barcelona siguen los arquitectos D. José Vilaseca i D. Luis Domenech en reclamación de perjuicios por los acuerdos de venta de los terrenos del Instituto* (Barcelona: Impremta "La Renaixensa," 1889), 17.

7. See the tribute to Vilaseca given by Joaquim Bassegoda, 15 May 1910, at the opening of the exhibition in *Anuario de la Asociación de Arquitectos* (1911): 248–49.

8. Domènech i Montaner, "En busca de una arquitectura nacional," *La Renaixensa*, February 1878, 149–60, reproduced in facsimile in *Lluís Domènech i Montaner i el director d'orquestra*, 277–88.

9. See Jaume Carbonell i Guberna, *Josep Anselm Clavé i el naixement del cant coral a Catalunya: 1850–1874* (Cabrera de Mar: Galerada, 2000).

10. "Estat, importància i significació artística dels orfeons," *Revista Musical Catalana* 15 (1918): 286.

11. On the history of the Orfeó Català, see Pere Artís i Benach and Lluís Millet i Loras, *Orfeó Català Barcelona: llibre del centenari (1891–1991)* (Barcelona: Fundació Orfeó Català-Palau de la Música Catalana/Barcino, 1991); and Josep M. Roig i Rosich, *Història de l'Orfeó Català: Moments cabdals del seu passat* (Barcelona: Orfeó Català/Publicacions de l'Abadia de Montserrat, 1993).

12. There is a considerable body of literature on the palace of music. See David Mackay's article in the monographic issue of *Cuadernos de Arquitectura* cited in note 1. See also Manuel García-Martín, *Benvolgut Palau de la Música Catalana* (Barcelona: Catalana de Gas, 1987), who has produced much unpublished documentation. On the construction process, see Pere Artís, *Pedres vives* (Barcelona: Barcino, 1998); and Lluís Domènech i Girbau, ed. *El Palau de la Música Catalana de Lluís Domènech i Montaner* (Barcelona: Fundació Orfeó Català–Palau de la Música Catalana/Lunwerg/Universitat Politècnica de Catalunya, 2000) with contributions from Domènech i Girbau, Artur Ramon, Francesc Fontbona, Teresa Rovira, Pere Artís, and Ignacio Paricio.

13. Domènech i Girbau, "L'arquitectura del Palau," in *El Palace of Catalan Music de Lluís Domènech i Montaner*, 42–45.

14. Paricio, "La construcció del Palau," in ibid., 183–90.

15. Anna Muntada and Teresa-M. Sala, "Apunts d'iconografia musical en les arts decoratives del modernisme," in *El modernisme* (Barcelona: Olimpíada Cultural/Lunwerg, 1990–91), 1:135–46.

16. I would also like to mention an unpublished study by a doctoral student in the Departament d'Història de l'Art of the Universitat de Barcelona, Mar Pal, "Les arts aplicades al Palace of Catalan Music" (2004), which reviews the material presented by García-Martín.

17. We must await Núria Gil's dissertation to learn in depth about the production of the Rigalt i Granell company. The Lluís Bru Archives, held by the Ajuntament d'Esplugues de Llobregat, contain material such as designs done in watercolors, drawings, and stencils related to the Palau de la Música. See Marta Saliné, ed., *Lluís Bru, fragments d'un creador. Els mosaics modernistes*, exh. cat. (Esplugues de Llobregat: Museu Can Tinturé, 2005). Marta Saliné is currently working on a thesis that will shed light on many aspects of the mosaic work at the Palau.

18. See Maria Isabel Marín, "Eusebi Arnau Mascort 1863–1933" (Ph.D. diss., Universitat de Barcelona, 1993), 1223–249.

19. Pilar Ferrés i Lahoz, "Miquel Blay i Fàbrega. 1886–1936" (Ph.D. diss., Universitat de Barcelona, 1993) 4: cat. M8.

Translated by Susan Brownbridge.

# The Decorative Arts of the Modernista Era:
# European Art Nouveau Plus the Local Tradition

*PILAR VÉLEZ*

Barcelona, an industrial, bourgeois city keen to embrace modern times, experienced several influences at the turn of the century that fostered its enthusiasm for modernity. This period, rightly termed modernista, was defined by the desire to be modern, to join the flow of contemporary Europe, and to make the leap into the 20th century—socially, politically, economically, and culturally.

This explains why Modernisme leaned toward European Art Nouveau. We should not forget, however, that the Modernistes also revived and celebrated local traditions. Tradition and modernity, the old and the new, fused in symbiotic relationship, established a new period and began one of the most glorious moments in the artistic and cultural history of Barcelona, and by extension, the whole of Catalonia.[1]

The new approaches incorporated aspects of Art Nouveau by embracing the influences from northern Europe, especially trends in Symbolism, but also the English Pre-Raphaelite movement and Aestheticism. By contrast, the roots of the Catalan tradition, reaching all the way back to the Middle Ages, had been revived some decades earlier during the Romantic movement. Catalonia's search for its roots, which nourished the country's history and was responsible for its specific cultural character, was not consummated until the opening years of the 20th century—the time of Modernisme.

There is, however, another way to approach Modernisme, and that is to begin with the most significant modernista works of art. Catalan Modernisme is most vivid in the decorative arts, synonymous with Modernisme because of the useful and decorative objects that filled so many bourgeois homes and public buildings at the turn of the century. It is precisely in the decorative arts that it is easiest to identify the two sides of Modernisme: Art Nouveau on the one hand and the revival of the past—Gothic Revival in particular—on the other. Indeed, it is possible to find the new and the old in a single work: the form may be Art Nouveau and the technique medieval, though adapted to the modern era. A single artist could draw on both trends simultaneously.

In addition, the decorative arts provide the clearest evidence of one of the most characteristic traits of Modernisme and international Art Nouveau: the merging of diverse art forms. Many artists collaborated in Barcelona around 1900, especially the architects, who surrounded themselves with numerous craftsmen and members of the building trades, and those who supervised groups of artisans and artists who contributed to the decoration of buildings, inside and out.

At the time, Barcelona and Catalonia were enjoying a period of growth reflected in an explosion of construction and architecture, when the architect became a leading figure. Antoni Gaudí, Lluís Domènech i Montaner, and Josep Puig i Cadafalch are the three greatest names, and their works alone give us an idea of the vast number of craftsmen and designers who worked to realize their projects. In this essay, I will focus on Domènech, who in recent years has been rightly described as an "orchestra conductor."[2] In addition to his work as an architect, Domènech also played a key role in Catalan politics, at that time closely entwined with the arts. He was influential in reviving the old artistic crafts and trades, especially between 1891 and 1892, when he established his workshop in the Cafè-Restaurant of the Barcelona Universal Exposition of 1888, a building popularly known as the Castle of the Three Dragons, which today houses the city's Museum of Natural Sciences.[3]

Domènech not only designed the architectural structures for his projects, but also supervised the finishing of both exteriors and interiors, including what we today would call "interior design," because

he viewed each of his buildings as a unified whole. Consequently, he had to recruit an array of designers, craftsmen, and artists to produce all the elements required for an interior, from the floor tiles—such as the one exhibited here, which he designed and which was made in 1900 by the Escofet company (fig. 1)—to the windows, stained and leaded glass, doors and shutters, coffered ceilings, and other furnishings such as lamps, rugs, and even various accessories for parts of the home that were new features of the time, such as elevators and bathrooms. Whether in the bourgeois residences of Barcelona's Eixample or in his large public buildings (the Palau de la Música Catalana, the Hospital de Santa Creu i Sant Pau, and the Institut Pere Mata in Reus), Domènech worked with numerous specialists in the in-

dustrial and decorative arts. These included some of the most important of the time, such as Gaspar Homar, the great furniture designer, maker, and *ensemblier* (to use the French expression then current), who in turn coordinated a considerable number of collaborators. Today Homar is considered, along with Joan Busquets, one of Catalonia's leading producers of modernista furniture.[4] The Museu Nacional d'Art de Catalunya holds a fine selection of his work, including the works that decorated the interior of the main apartment of Domènech's Casa Lleó Morera.

Homar's many assistants included Antoni Serra i Fiter,[5] who founded the Manufactura de Porcellanes i Gres d'Art (Porcelain and Artistic Tile Manufactory) in 1904. Serra remained one of the leading representatives of Catalan Art Nouveau in his media, although financial reasons forced him to close his factory after four years. Homar commissioned him to produce numerous low reliefs in white porcelain for tile panels—many of them designed by Josep Pey—such as those found in Casa Lleó Morera, which Serra made using molds created by the sculptor Joan Carreras. Casa Lleó Morera is a fine example of a project by a team of artists working under the coordination of an architect and an ensemblier.

Serra's noteworthy decorative objects include his large and small porcelain vases, which are very finely crafted, often in a Japanese manner—another characteristic trait of Modernisme and Art Nouveau (fig. 2). The highly skilled Serra received several prizes at Spanish and international exhibitions. He also worked at his factory with leading artists, such as Ismael Smith and Pablo Gargallo, on porcelain and earthenware objects and figurines of every kind. Gargallo also worked with Domènech on various projects, including the Palau de la Música Catalana and the Hospital de la Santa Creu i Sant Pau.

Another ceramicist, Lambert Escaler, produced pottery that became extremely popular in Barcelona, in step with the widespread distribution of similar objects throughout Europe, such as those—to give but one example—produced by the Bing Company in Paris.[6] Escaler's mass-produced painted terracottas were priced affordably, and appeared in a catalogue he published in 1903 entitled *Artistic Reproductions in Polychromed Ceramic*. The

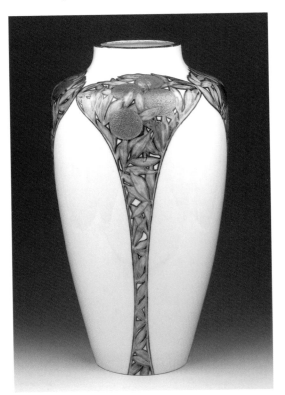

Fig. 1 (cat. 5:16). Lluís Domènech i Montaner, *Floor Tile No. 1019*, 1900.
Fig. 2 (cat. 5:19). Antoni Serra, *Large Vase*, 1907.
Fig. 3 (cat. 5:18). Lambert Escaler, *Jardinière*, c. 1903.
Fig. 4 (cat. 5:17). Alexandre de Riquer, *Screen from Palau Güell*, 1900.

magazine *Pèl & Ploma* also carried images of his works, which already sold widely, even before Escaler issued his catalogue.[7]

Escaler trained in the 19th-century tradition of small realist sculpture. He began producing the decorative terracottas for which he is famous shortly before 1900. These works, with the sinuous lines of Art Nouveau, always feature a female figure in a Symbolist manner, as well as Symbolist-inspired floral elements and titles, such as *Jardinière* (fig. 3). Small decorative sculpture was also produced by Dionís Renart and by the great sculptor Gargallo, but Escaler's is considered the finest.

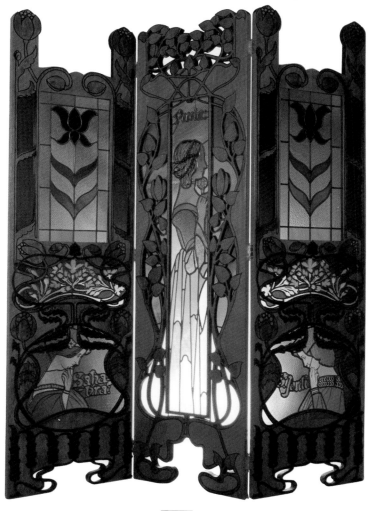

In addition to the great architects, ensembliers, and craftmen, Catalan Modernisme introduced a new figure into the decorative arts, the versatile forerunner of the modern designer. This project draftsman and creative artist could design everything from furniture and ceramics to fabrics and posters. One of the most prominent of these artists, Alexandre de Riquer, led this new métier. His career summarizes the innovation in the decorative arts—or, as they were also known at the time, the artistic industries—at the turn of the century. Riquer, along with more renowned architects, must be regarded as one of the great creators of Catalan Modernisme because he represented better than anyone else the integration of the arts, and at the same time, the decorative spirit of Art Nouveau.[8] He trained in the Tallers de les Indústries Artístiques run by Francesc Vidal Jevellí, the only major workshop operating in Barcelona during the years leading up to Modernisme, where many of the great artists and craftsmen met, including Homar and the stained glass maker Antoni Rigalt. Acclaimed as a draftsman and designer, painter and printmaker, Riquer was also a skilled etcher, book illustrator, graphic designer, poster designer, and, beyond the visual arts, a poet. His life and art testify to the birth of a new totality, the combination of many different art forms exemplified by the work of Richard Wagner.

Riquer and Domènech were close contemporaries and played similar leading roles in Catalan Modernisme. Though his work is imbued with Art Nouveau, on a trip to London in 1894 Riquer was deeply impressed by the work of the Pre-Raphaelites, whose influence may be seen, together with some reminiscences of Symbolism, in his decorative work,

and especially in the painting on which he concentrated after 1911 (fig. 4). The décor of the scriptorium of the Cercle del Gran Teatre del Liceu (1900), one of his most representative projects, features true artistic integration: his furnishings, marquetry, floor tiles, lights, etched glass, wall fabrics, and decorated ceiling may all be seen today, just as he left them.

As a young man, Riquer worked for many years as a draftsman at the Masriera jewelry firm. The business was run by the three Masriera Manovens brothers: Josep and Francesc, who were goldsmiths and painters, and Frederic, who managed the company. Years later Frederic left to establish the Foneria Masriera i Campins foundry, which became very famous.[9] Josep's son Lluís Masriera also proved to be a versatile artist—jeweler, enameler, goldsmith, painter, playwright, and set designer. He also had a gift for managing cultural events.[10]

Besides Picasso, Lluís Masriera is among the Catalan modernista artists best known internationally, together with the great architects Gaudí and Domènech i Montaner. Lluís Masriera trained in the family workshop, one of the most renowned in Barcelona in the last quarter of the 19th century, alongside his father and uncle, and also with Riquer, who was 16 years his elder. His apprenticeship in the finest enameling workshops in Geneva, his travels and visits to the international expositions in Paris, together with innate sensibility and skill, combined to make his work of outstanding artistic and technical quality.

Lluís Masriera's taste for Art Nouveau, which he introduced and popularized through the family jewelry business in Barcelona, also influenced modernista art. Beginning in 1910, he developed his classic themes of flowers, insects, women with dragonfly wings, women wearing skullcaps that hark back to the Gothic and the Renaissance (for which he is especially famous), and his dragons, as featured in his depiction of *St. George and the Dragon*. It should be noted that as the patron saint of Catalonia, St.

George was portrayed frequently by modernista artists (figs. 5–12).

Besides his influential imagery, Lluís Masriera's major contributions to modernista art were technical. He united art and industry so that his creations—whether jewelry or functional objects of silver, such as coffee and cutlery sets, and trays—could be mass-produced without any loss of the aesthetic quality demanded by luxury objects of this nature and expense. Above all, however, Masriera was successful at reviving traditional enameling techniques, such as plique-à-jour, and invented others that were yet more sophisticated, such as Barcelona Enamel, a name that has come to be applied to his entire oeuvre. These methods, together with his casting and production techniques for jewelry, has enabled the company to survive; not only is it one of the few businesses in Europe with more than 200 years of history behind it, but its designs continue to please customers. For these reasons, Lluís Masriera, who counted the Bing family itself among his clients, is today regarded as one of the most outstanding creators of international Art Nouveau jewelry, alongside Georges Fouquet, Henri Vever, and René Lalique.

The work of the artists in this exhibition, while representing only a fraction of their output, highlights how Catalan Modernisme combined the urge for modernity and newness with the recovery of the country's history. The applied arts in architecture and the decorative arts, which ornamented the interiors, and the crafts of jewelry and metalwork contributed to the creation of this new artistic and cultural climate, which was a harbinger of the future: henceforth, all these arts would be regarded as equals of the traditional fine arts. For this reason, one often comes across such terms as "artistic ceramics" and "artistic jewelry," which demonstrate the triumph of the decorative arts and the symbiosis between beauty and utility that established the foundation for modern industrial design.[11]

Fig. 5 (cat. 5:28). Lluís Masriera, *Pendeloques*, no. 12 from *Album of Jewelry Designs*, c. 1905.
Fig. 6 (cat. 5:21). Lluís Masriera, *Pendant with St. George and the Dragon*, c. 1901–2.
Fig. 7 (cat. 5:22). Lluís Masriera, *Isolde Pendant*, c. 1910.
Fig. 8 (cat. 5:23). Lluís Masriera, *Pendant with the Bust of a Renaissance Woman*, 1900–1910.

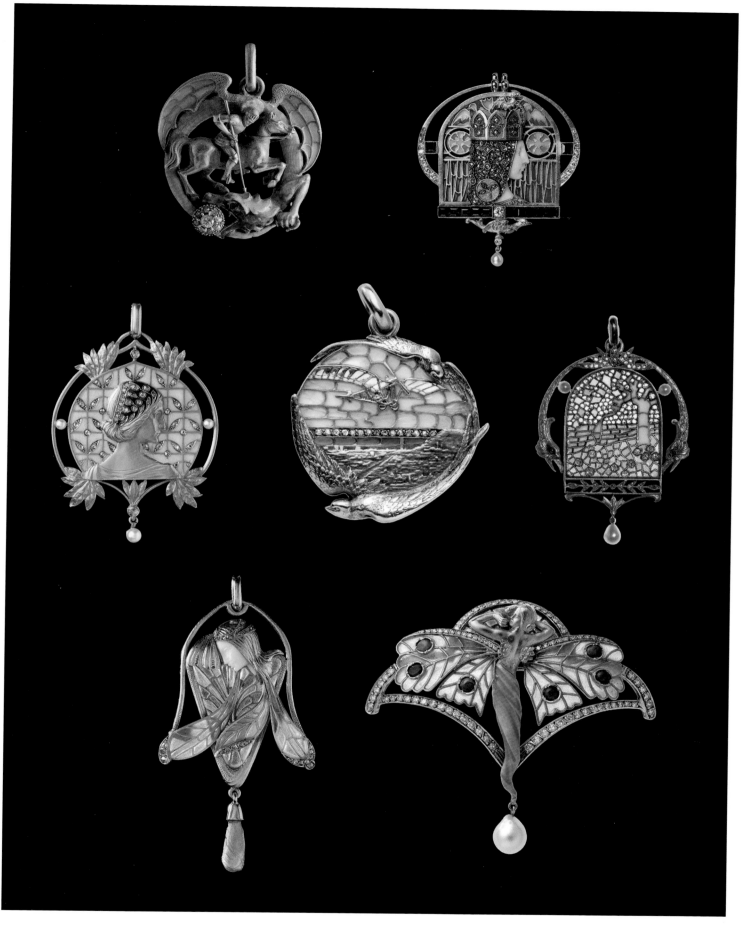

Fig. 9 (cat. 5:24). Lluís Masriera, *Pendant with Airplane over Barcelona*, 1905.
Fig. 10 (cat. 5:25). Lluís Masriera, *Pendant with Landscape*, c. 1912.
Fig. 11 (cat. 5:26). Lluís Masriera, *Pendant of a Woman-Fairy*, 1903–6.
Fig. 12 (cat. 5:27). Lluís Masriera, *Pin with the Insect Woman*, c. 1916.

1. A more detailed consideration of this subject is found in Pilar Vélez, "La influència de l'*Art Nouveau* en la pintura del tombant de segle," in *Pintura i dibuix,* ed. Francesc Fontbona, vol. 3 of *El Modernisme* (Barcelona: L'isard, 2002), 291–300.

2. See Lluís Domènech and Lourdes Figueras, eds. *Lluís Domènech i Montaner i el director d'orquestra,* exh. cat. (Barcelona: Fundació Caixa de Barcelona, 1989).

3. For insights into the true purpose of this workshop, see Rossend Casanova, "Antoni Maria Gallissà i el mite del 'Castell dels Tres Dragons'," in *A l'entorn de l'arquitectura,* ed. Fontbona, vol. 4 of *El Modernisme* (Barcelona: L'isard, 2002), 71–78.

4. The most recent monograph on this artist is Mariàngels Fondevila, ed., *Gaspar Homar. Moblista i dissenyador del modernisme,* exh. cat. (Barcelona: Museu Nacional d'Art de Catalunya, 1998).

5. The key study on the Serra family of ceramists is Francesc X. Puig Rovira, *Els Serra i la ceràmica d'art a Catalunya* (Barcelona: Selecta, 1978).

6. A detailed biography of the artist has recently been published by Juan Carlos Bejarano, *Lambert Escaler* (Barcelona: Infiesta Editors, 2005).

7. *Pèl & Ploma* 3, no. 95 (July 1903): 197, 200, 201, 203, and 204.

8. See Eliseu Trenc, *Alexandre de Riquer* (Barcelona: Caixa de Terrassa/ Lunwerg, 2000).

9. On the history of the Masriera family of jewelers, see *Els Masriera,* exh. cat. (Barcelona: Museu d'Art Modern/Museu Nacional d'Art de Catalunya, 1996); Pilar Vélez, *Joies Masriera. 200 anys d'història* (Barcelona: Àmbit 1999), a study done following the discovery of the archives in the house where many of the workshop accounts, sales, inventories, and other accounting books were kept; and Vélez, *Els Masriera. Un segle de joieria i orfebreria,* exh. cat. (Girona: Fundació Caixa de Girona, 2004).

10. On Lluís Masriera, in addition to the works cited in note 9, see Pilar Vélez, *Lluís Masriera* (Barcelona: Infiesta, 2002); and Vélez, "Lluís Masriera: la singularitat de la joieria catalana dins l'Art Nouveau internacional," in *Joieria modernista a les col·leccions europees. El jardí fantàstic,* exh. cat. (Palma de Mallorca/Lleida: Fundació "la Caixa," 2004), 40–52.

11. For an overview of modernista design, see Vélez, "De les arts decoratives a les arts industrials," in *Arts decoratives, industrials i aplicades,* vol. 11 of *Art de Catalunya, Ars Cataloniae,* ed. Xavier Barral (Barcelona: L'isard, 2000).

Translated by Susan Brownbridge.

# Fabrics and Fashion at the Turn of the Century

SÍLVIA CARBONELL BASTÉ

Although for years Modernisme has been studied in depth, textiles have remained largely unrecognized, perhaps due to a dearth of specialists. It was thought that the aesthetics of Modernisme had scarcely penetrated Catalan textile production, though this was evidently not true of fashion. It is important to remember that fabrics were not traditionally regarded as works of art for exhibition, but rather for use, to be worn, torn, and discolored, even recycled in other items. Consequently, we often find fabrics have been manipulated, no longer in their original state. For these reasons, in comparison with other arts, few fabric works have survived. For example, household linens are rare, even though complete household furnishings still exist. With regard to clothing, more publications devoted to the subject have appeared, and today clothes are more frequently included in exhibitions, perhaps because fashion is more glamorous, but above all because appreciating it requires less technical knowledge. Sadly, lack of understanding has suppressed attention to the fabric from which the clothes were made.

At long last, however, Catalan modernista fabric is no longer an enigma. It is no surprise that fabrics with modernista decorative details should have been made in Catalonia, the preeminent center of textile production in Spain and a place where Modernisme spread into every field. Despite the loss of the colonies in the Americas in the late 19th century, which led to a crisis in export trade and competition with fabrics from other countries, a slow process of recovery began in the year 1900, in particular in wool and cotton. Catalonia quickly embraced evolving technological advancements, and led the process of industrialization in Spain. The Jacquard loom, with improvements made by Vincenzi and Verdol, was soon installed in factories, becoming an important factor in textile production at the turn of the century. This was a time of ferment in the industry, when skilled employees began moving from one company to another. It was a time of inventions and new patents, and of mechanical improvements that helped forge an organized Catalan textile industry capable of producing fabrics of every kind, to supply the whole of Spain.

The most important sectors of the textile industry were cotton, with mills situated along the Llobregat, Ter, and Cardoner rivers, and wool in Sabadell, Terrassa, and their outlying areas, followed by silk in Barcelona, Reus, and Manresa. Less important sectors include artificial silk, worsted, hemp, linen, and other cotton fabrics.

Most of the great patrons of Modernisme were the owners of textile businesses. Their houses, mansions, and even factories were built by renowned architects such as Antoni Gaudí, Lluís Domènech i Montaner, Josep Puig i Cadafalch, and Lluís Muncunill, and decorated by the finest designers, such as Gaspar Homar, Joan Busquets, and Alexandre de Riquer. Examples of their work are found in the homes of the Güell, Milà, Muntadas, Quadras, Batlló, Casaramona, Coll i Regàs, Burés, Navàs, Aymerich, Amat, and Jover families. Some of these buildings have survived intact; in other cases all that is left are a few architectural elements. Even though it may seem strange that interior décors—especially upholstery—should have been preserved, for several years considerable effort has been made to research and recover these materials for posterity.

For more than five years, the Centre de Documentació i Museu Tèxtil de Terrassa (CDMT)—which is featured on the European Art Nouveau route—has made the recovery of the city's modernista textile heritage a priority.[1] The museum now has more than 300 textiles representing diverse materials and functions, including household linen, clothing, accessories, flags, and various collections of company swatches, as well as almost 2,000 original designs and point cards for Jacquard machines. Modernista ornamentation first made its appearance in these items in the mid 1890s. Yet, not all the textile output from this period was modernista in design, as plain and checked pieces, as well as others

with floral motifs, continued to be produced in styles far more conventional and less daring.

The aesthetic of the British Arts and Crafts movement was unquestionably one of the early influences on Catalan modernista fabrics, followed by Art Nouveau, which particularly served as a source of inspiration for women's fashions and in certain sectors of the décor industry.[2] Central European movements were somewhat less influential, but may be recognized in the geometrical motifs found in tapestries. Many fabrics from other countries were available to the public in Catalonia through suppliers and small retailers, and also had an impact on Catalan textile companies, which used them as models on which to base their own offerings for the local market.[3]

Similarly, Catalan and foreign art journals and fashion magazines also played a key role in spreading Modernisme, and not just among industrial designers, artists, and architects, but also into people's homes. Women spent much of their time making and decorating textiles for the home, painting and embroidering handkerchiefs, cushions, sheets, cloths, and aprons, or making lace for decorating these items.

The period between 1850 and 1910 saw the opening of industrial schools in Sabadell, Manresa, and Barcelona, of textile engineering schools in Terrassa and Barcelona, and of schools of arts and crafts in Barcelona, Badalona, Vilanova i la Geltrú, and Terrassa, which provided training for skilled staff such as engineers, theorists, company directors, and draftsmen. Equipped with their new skills, these people were able to make improvements to machinery, fabrics, and designs, helping existing companies to grow and new ones to begin. In addition to the more technical subjects, applied design for textiles was a compulsory subject in all the schools. The tradition of teaching textile design in Catalonia had begun in the 18th century at La Llotja, the school of fine arts in Barcelona, in response to the Catalan industry's need to produce printed calico, then in demand throughout Europe. The production of this fabric picked up dramatically once again at the start of the 20th century. Camil Cots, Gràcia i Ferrater, Agustí Esclasans, and Miquel Travaglia all began to make names for themselves as some of the finest Catalan textile designers of the century. One of the outstanding contributions of this period was diagrammatic design, a geometrical formula devised by Travaglia that facilitated the design of ornamental motifs that repeated without forming a pattern.

Designers usually came from the textile sector itself, but in addition to the remarkable legacy of Josep Palau i Oller, consisting of more than 1,400 designs, other talented designers such as Mateu Culell Aznar, Jaume Llongueras, Antoni Saló, and Josep Pascó can be included in the new generation of artists and draftsmen who designed textiles.[4] Their original drawings were the first step toward weaving, printing, or embroidery.

Counterpanes, bedspreads, handkerchiefs, ticking, matching tablecloths and napkins, towels, Jacquard textiles, and printed fabrics, decorated with all kinds of motifs, were made of cotton. Colònia Güell, a model industrial village where corduroy and velvet were made, was one of the most renowned cotton mill complexes, famous as much for its fabrics as for its techniques. Ferran Alsina improved the looms invented by Jacint Barrau to make velvet, and made extremely high-quality manufacture possible. Pau Rodon worked at Colònia Güell as a technician. Other notable cotton manufacturers included Estabanell i Pahisa, Vda. Tolrà, Mitjans i Cia., and Algodonera Canals.

Jacquard-woven towels, sheets, matching tablecloths and napkins, and underwear testify to the quality of linens made in Catalonia. The pieces that have been studied are generally white, with small decorative or geometrical motifs and an occasional touch of color. Linen manufacturers were concentrated mostly in the Maresme region, as were makers of the lace that adds a delightful finishing touch. The Castells family from Arenys de Mar, the most famous family of lace makers in Spain, excelled with the designs of Marià Castells. The family also commissioned designs from artists as celebrated as Alexandre de Riquer and Aurora Gutiérrez.[5] The Museu de la Punta in Arenys de Mar holds the collection of the Castells family, which includes drawings, templates, punchcards, runners, sheets, towels, mantillas, and fans. White lace was also made in the Maresme region, using the technique of winding fine threads around a pattern of pins in a lace-making cushion. The workshops in the Baix Llobregat

Fig. 1 (cat. 5:32). *Carpet,* 1900–1914, made by Sert i Germans.

and L'Arboç, however, specialized in black lace. Some companies had long traditions in lace making, such as Josep Fiter and Casimir Volart, but gradually moved away from handmade lace by introducing mechanical looms. Not only did this cut manufacturing time and costs, but also made a broader range of products possible.

The firms of Ignasi Balcells, Fills de Malvehy, Francesc Vilumara, Salvador Bernades, and Pich i Aguilera are only a few of the silk manufacturers that have left us with swatchbooks of remarkable technical and artistic quality. These fabrics, intended for women's clothing, ties, handkerchiefs, and upholstery, were decorated in a variety of ways, many inspired by Art Nouveau, and a few by the geometry of the Vienna Secession. An analysis of these samples reveals that Catalan textile manufacturers and designers kept abreast of the trends throughout Europe, which they knew through style books they subscribed to, from their trips to leading textile cities in Europe such as Lyon, from the imported fabrics sold at large stores and specialist retailers, and from increasing numbers of periodicals. Artists, theorists, and draftsmen arrived at their own interpretations of these sources, giving rise to truly Catalan modernista fabrics. Swatches are indispensable to the provenance and chronology of the works, which we would otherwise be unable to attribute with any degree of certainty.

Other companies such as Sert and La España Industrial opted for diversity in their materials and products. Sert specialized in rugs, some marvelous examples of which have survived, while La España Industrial was renowned from its inception for its printed fabrics and later for its velvet.

Catalan artists, architects, and interior decorators were probably responsible for the height of the splendor of modernista textiles, but because most of their fabrics, prints, or embroideries were designed for unique items such as banners, flags, liturgical items, or decorative fabrics, a close collaborative relationship never developed between them and Catalan industry, despite their alert response to European trends. Apart from a few original designs by Riquer for the Sedera Franco-Española and Ponsa Hermanos companies, which we cannot be certain were ever manufactured, collaboration between industry and the arts was rare.[6]

The unique and sumptuous pieces by these artists and designers also left their mark, if only lightly, on the local textile industry, which took this bolder Modernisme as a source of inspiration. Artists and decorators were keenly interested in new treatments of architectural interiors. They gathered furniture, objects, and fabrics in new complementary combinations of textures and colors to give every room individuality and elegance. Some of the leading designers with interest in fabrics include: Gaudí, Domènech i Montaner, Puig i Cadafalch, Aleix Clapés, Josep Jujol, Pericas, and Rafael Masó, as well as Gaspar Homar, Joan Busquets, and Homar's assistants, Sebastià Junyent, Josep Pey, and Pau Roig.

Modernista homes were filled with fabrics from the floor up, creating an ambience of seclusion and harmony by means of portières, curtains, blinds, screens, counterpanes, ticking, table cloths, and carpet runners, with matching table sets, rugs, and towels (figs. 1–3). To a large extent, curtains were the most important textiles in a home, often with a matching blind, table cloth, and rug. Interiors

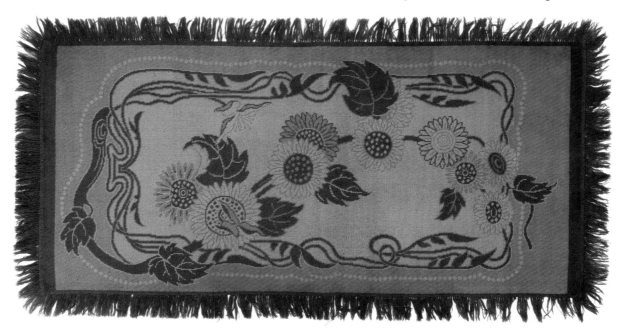

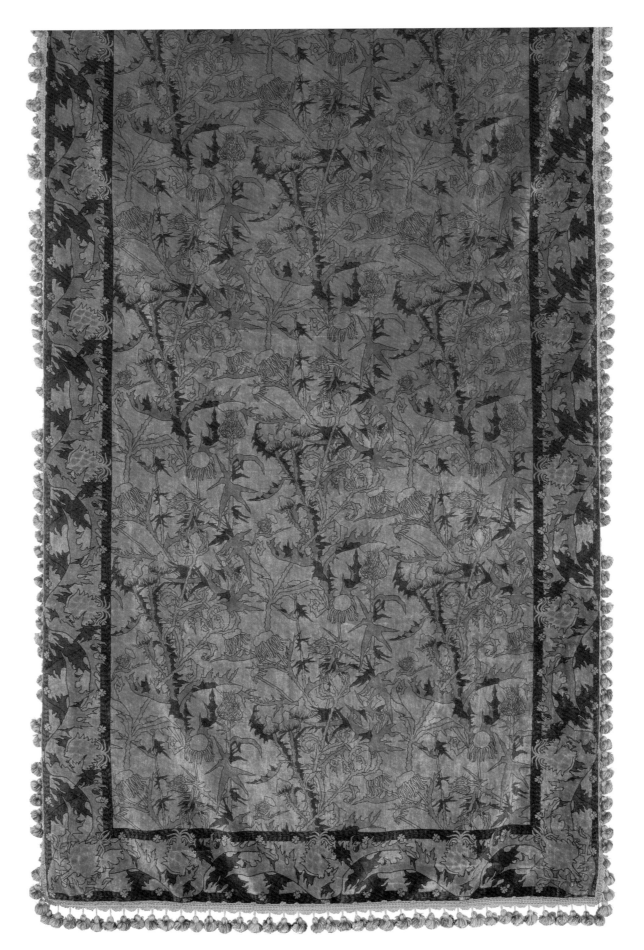

Fig. 2 (cat. 5:29). *Curtain from the Dining Room of Casa Molins*, 1900, made by J. Pons Hijo workshop.

designed by Gaspar Homar, such as the Casa Navàs in Reus—virtually intact—or the Casa Lleó Morera, contain some of the finest examples of modernista Catalan textiles (see figs. 1–8, pp. 178–82). The joint effort of artists using all kinds of materials is reflected in these spaces.

Alexandre de Riquer, one of the artists who introduced the Arts and Crafts movement to Catalonia, was, like Homar, a key figure in the development of modernista textile design. He produced various designs probably intended to be printed on fabric, including a handkerchief for the Casa Castells company in Arenys de Mar and the decorated silk end-papers of a gift album for the marriage of Alfonso XIII in 1906.

Leading artists of the day not only designed textiles for domestic and liturgical interiors, but also standards, flags, and banners for organizations and individuals. Such items were made in large stores of the time, such as Jorba in Manresa and Oller and

Casa Medina in Barcelona, which employed women capable of doing artistic embroidery of very high quality. In many instances, these pieces were paid for by public subscription and embroidered by local women. Gaudí, Domènech, Puig, Joan Rubió i Bellver, Antoni Maria Gallissà i Soqué, Jujol, Bonaventura Bassegoda i Amigó, and others all received commissions of this nature, in the main to help Catalan choirs and choral societies to publicize themselves. The silk company founded by Benet Malvehy provided the finest fabrics for embroidering upon, as can be seen in the damasks designed by Domènech in the Saló de Cent in Barcelona's city hall, the standard of the Unió Catalanista designed by Riquer (Museu de Montserrat), and the standard of the Cercle Artístic de Sant Lluc. Some militia flags were also designed by architects, such as the Ripoll flag, designed by Rubió, and the Girona flag, designed by Masó.[7]

The female form at the turn of the century was enveloped in soft, sinuous, asymmetrical lines, hint-

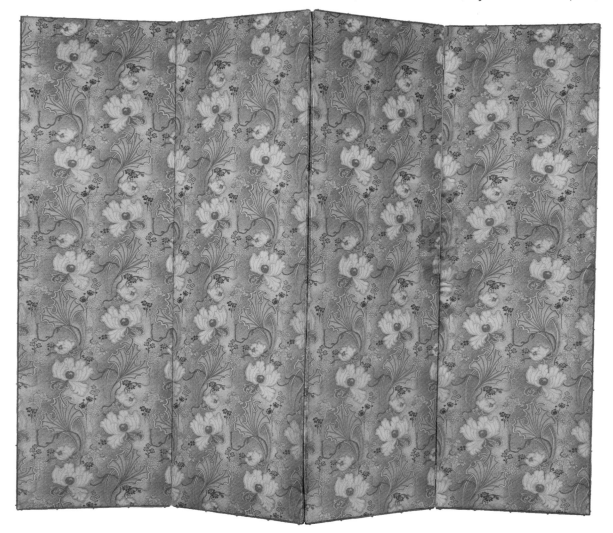

Fig. 3 (cat. 5:30). *Screen*, 1900–1910, probably made at La España Industrial or Batlló i Cia.

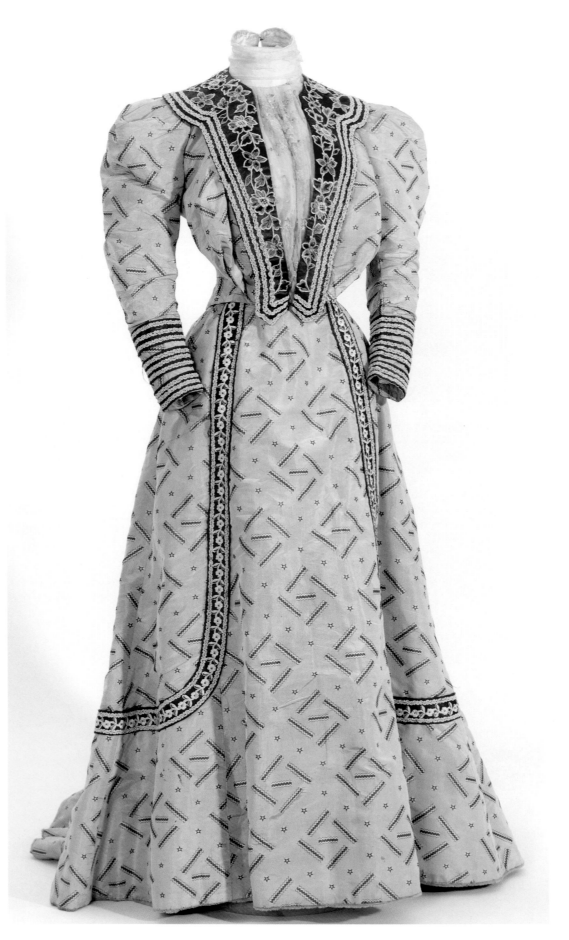

Fig. 4 (cat. 5:31). *Mauve Silk Dress*, early 1900s.

ing at sensuality. Women did not wear corsets, but still wore stays that gave the body a certain firmness and an hourglass shape (fig. 4). Collars were reinforced to keep them upright and sleeves initially billowed before gradually becoming more tight-fitting. Skirts spread toward the bottom in a bell shape, with a slight train that was even found in day dresses. Decorative elements were usually inspired by natural forms, often plants. This was the dress of the Belle Époque, clearly influenced by Art Nouveau.

As leading fashion designers such as Carolina Montagne and Maria Molist became celebrated, they signed their work with labels sewn into the clothing. These designers, organized in couture studios, worked with very high quality fabrics delicately decorated by appliqués, layered effects, and translu-

cent areas. Such fabrics, made locally or imported, began to be sold in the large department stores in major cities. The dress displayed in the modernista section of the exhibition is typically Catalan in design, made using the diagrammatic design method devised by Travaglia.

The dress reform movement advocating unboned women's apparel hanging like a tunic from the shoulders and allowing freedom of movement, though popularized by the Pre-Raphaelites and endorsed by the Arts and Crafts aesthetic, never took root in Catalonia. Thus the beautifully decorated dresses worn by the women in Riquer's posters do not always accord with the fashions of the day, even when they agree with its aesthetic ideals (see fig. 6, p. 148).

1. Since 2001, the Centre de Documentació i Museu Tèxtil (CDMT) in Terrassa has organized a number of exhibitions accompanied by catalogues that have identified and raised awareness of modernista textiles, including *Les fàbriques i els somnis* (2001); *L'interior del 1900: Adolf Mas, fotògraf* (2002); *Josep Palau i Oller, del Modernisme a l'Art Decó* (2003); *Miralls d'Orient* (2004); *Moderníssims!!!* (2005); *Pau Rodon, un modernista d'avantguarda* (2006); and *L'Herbari Modernista* (2006).

2. The CDMT holds in its collections a number of textiles produced in Europe, some of them attributed to the Silver Studio, as well as drapes displayed at the Museu Nacional d'Art de Catalunya that once decorated Catalan homes.

3. Almacenes El Siglo, Blanco y Bosch (later called Blanco y Bañeras), Santaeulalia, Antigua Casa Franch, Almacenes Jorba, and Casa Navàs also sold textiles from Britain, France, Vienna, Belgium, and Catalonia.

4. These were presented as a gift by Palau i Oller's son to the CDMT, where they are now stored. The Museu de l'Estampació in Premià also has a number of loose designs and others that were part of a collection of samples. The Museu Tèxtil i de la Indumentària de Barcelona has a number of swatches from the Ponsa Hermanos company, including prints on silk designed by Josep Palau.

5. Alexandre de Riquer designed the handkerchief given to Victoria Eugenia of Battenburg on her marriage to Alfonso XIII (Museu de la Punta, Arenys de Mar).

6. The Museu de l'Estampació de Premià de Mar has 13 of Riquer's designs in its collection.

7. Nine such militia flags are held in the collection of the CDMT.

Translated by Susan Brownbridge.

# Homar and Busquets:
# Modernista Furniture Makers and Ensembliers

*MARIÀNGELS FONDEVILA*

Decorative arts are among the most authentic expressions of Modernisme, a movement with a wide range of aesthetic manifestations. An item of jewelry, a bibelot, and especially a piece of furniture reflect the tastes, customs, and spirit of a particular period. The works by the furniture makers and *ensembliers* (interior decorators) Gaspar Homar and Joan Busquets recall the exquisite ambience of interior spaces at the turn of the century: enveloping, sensual, yet used everyday.

The work of these designers should be considered in the context of Barcelona at the time: the site of the Universal Exposition in 1888, and the explosive growth of the Eixample district. There the ascendant bourgeoisie, grown rich from the textile industry, sought ways to demonstrate its ascendancy. The heady pace of construction benefited architects, who surrounded themselves with bands of highly skilled specialists, including furniture makers and decorators who took charge of the furnishings and other complementary items in homes, which they made to their own designs.[1]

This was the city where craftsmen and designers such as Busquets and Homar found employment. Homar left his native Majorca at the age of only 13, and was taken in by Francesc Vidal's workshops around 1883. Vidal was the preferred decorator of the leading authorities, institutions, and eminent residents of Barcelona in the 19th century, and he constructed a vast industrial complex in the heart of the Eixample. His workshops, known as the Indústries d'Art, included sections specializing in stained glass, metalworking, a foundry, and furniture, where Homar and other leading figures of the

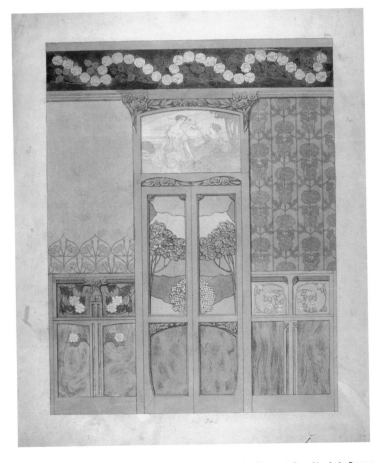

Fig. 1 (cat. 5:36). Gaspar Homar, *Decorative Design for the Drawing Room at Casa Navàs in Reus,* c. 1905.

modernista decorative arts learned their craft. Vidal became a pioneer in a new professional role that was in considerable demand during the period of Modernisme and Art Deco: the ensemblier, a trades-man capable of supplying all the functional accessories required for home interiors, who took particular pains to create comfortable environments.

In terms of style, Vidal was still caught up in eclecticism at its apogee. His interiors featured enormous candelabras, braziers, cornucopias, and tapestries, and his furniture was decorated with a profusion of moldings and carvings, with details from a diverse range of sources—the Middle Ages, the East, and classicism—as well as mechanical elements like cogs, which gave his objects individuality.[2]

For Homar, the comprehensive training he received at Vidal's workshops was as important as the fruitful professional relationship he established with Lluís Domènech i Montaner, a modernista architect described as an "orchestra conductor," who commissioned the young Homar to furnish various private residences he built.[3]

Particularly noteworthy are the home of Dr. Lleó Morera on the passeig de Gràcia in Barcelona, and the home of the fabric dealer Joaquim Navàs in Reus, where Homar was responsible for the interior décor and the various elements required to equip these properties with all the latest technological advances: electrical light fittings, textiles such as curtains, tapestries, and rugs, carpentry from the furniture to the floors, stained glass, fireplaces, and mosaics.[4]

In these interiors, Homar rejected the eclectic formulae he had learned in Vidal's workshops and turned instead to a floral, poetic, and symbolist Modernisme, which he alternated with sober, restrained forms. This is evident in his watercolor sketches for Casa Navàs (figs. 1 and 2). Like Emile Gallé of Lorraine, France, who had sculpted decorative motifs from his homeland, Homar's furniture features citrus fruit and olive leaves, linked to his Majorcan and Mediterranean origins. Homar most commonly used Spanish walnut, olive, and cherry, though he also employed American oak and ash. Moreover, Homar kept a watchful eye on the decorative projects emerging at the various international exhibitions and world's fairs organized in major cities around Europe. Paris and, above all, Vienna fascinated him, which explains why Homar recreated,

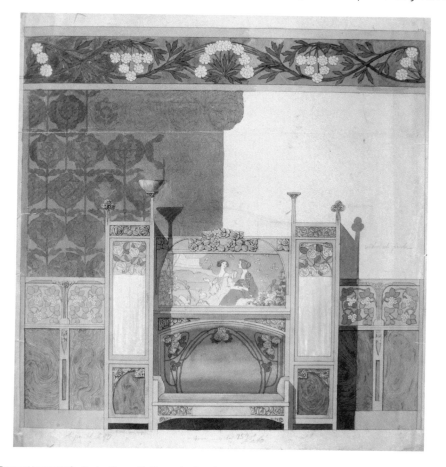

Fig. 2 (cat. 5:37). Gaspar Homar, *Sofa-display Case with Marquetry Panels, Decorative Design for the Drawing Room at Casa Navàs in Reus*, c. 1905.

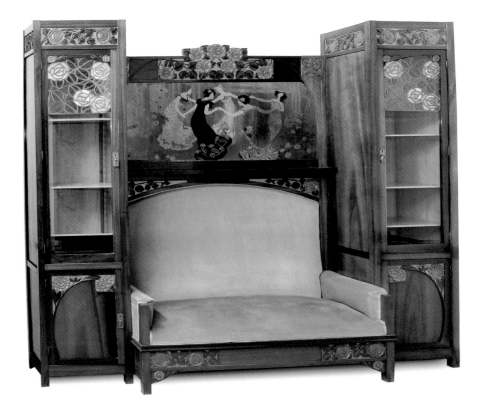

albeit in his own individual manner, devices employed by the Vienna Secession in some of his designs.

Against all odds, virtually all the furniture he designed for Casa Navàs has remained in place, whereas his original furnishings for Casa Lleó Morera are now on view at the Museu Nacional d'Art de Catalunya in Barcelona. These pieces decorated one of the emblematic spaces in this bourgeois home in the Eixample, the drawing room in the main apartment on the second floor, the *piano nobile,* which contained the most impressive furniture in the property. This is a sophisticated, luxurious suite of furniture in which Homar updated typologies and designs from the past, such as seats of honor from Roman times and medieval benches, as well as traditional techniques (marquetry and carving, in which Homer excelled).[5] All these traditional elements were disguised by lavish decoration, which attracted contemporary bourgeoisie.

One of the distinctive hallmarks of Homar's firm, the key to his success and his posthumous acclaim, is

the marquetry that decorated the panels of his furniture and room paneling. There can be no doubt that, with Emile Gallé of Nancy and Charles Spindler of Alsace, Gaspar Homar of Catalonia was one of the three masters of this revived technique. A good example is his large sofa/display case from the home of the industrialist Vicenç Bosch in Badalona (fig. 3). Bosch, the manufacturer of the extremely popular anise liqueur Anís del Mono, commissioned the decoration of his offices. The sofa in question is of a type that Homar repeated on numerous occasions with slight variations. The emphatic marquetry panel in the center, depicting symbolist nymphs dancing in a forest,[6] was designed by Josep Pey, one of Homar's loyal collaborators. He entitled it "La Sardana," after the popular Catalan dance. The composition of the decorative panel is in keeping with the advertising poster designed by Leonardo Bistolfi in 1902 for the First International Exhibition of the Modern Decorative Arts in Turin, and is made in a wide range of different types of wood (sycamore, jacaranda, ash

Fig. 3 (cat. 5:33). Gaspar Homar, *Sofa-display Case with "La Sardana" Marquetry Panel,* c. 1903.
Fig. 4. *Marquetry Panel with a Lady in a Garden,* c. 1905, designed by Gaspar Homar.

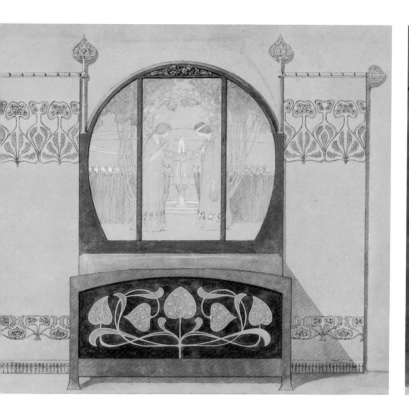

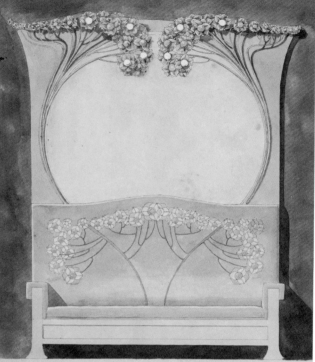

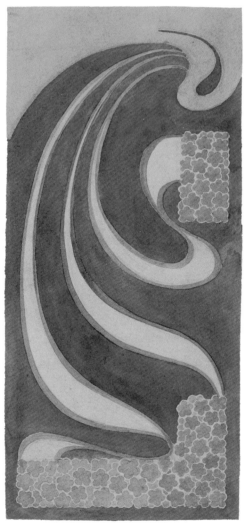

from Hungary, aloe wood, box, cherry, and *limoncillo,* among others), which, together with the leaded glass, give the piece of furniture a rich coloration.[7]

Not only did Homar incorporate marquetry in furniture, but he also used it to create independent works of art. These two-dimensional compositions, which may employ as many as eight wood veneers in a format reminiscent of *kakemono* (scroll painting) were commercially very successful.[8] (Homar appreciated Japanese art, which had been rediscovered by Sigfrid Bing.) *Marquetry Panel with a Lady in a Garden* (fig. 4), also designed by Pey, features a figure that evokes Cléo de Mérode, a wasp-waisted French dancer of the Belle Époque acknowledged as the model of beauty of her day, who decorated her hair with ribbons and flowers.

The watercolor designs in the exhibition also document Homar's exquisite approach to textile design: upholstery in delicate mauve or apple green colors with sinuous floral motifs, most of which have not survived wear and tear; and curtains, hand-woven wool rugs, and painted drapes that decorated the bedrooms and contributed to their harmonious unity (figs. 5–7).

Homar used Pey's designs not only in his marquetry panels, but also in the ceramic mosaic panels that decorated the interior of his clients' homes.

Fig. 5 (cat. 5:38). Gaspar Homar, *Project for Headboard with a Representation of the Annunciation,* c. 1905.
Fig. 6 (cat. 5:39). Gaspar Homar, *Project for Sofa with Mirror in the Back, Including the Upholstery Design,* 1905.
Fig. 7 (cat. 5:40). Gaspar Homar, *Design for a Damask,* c. 1900.

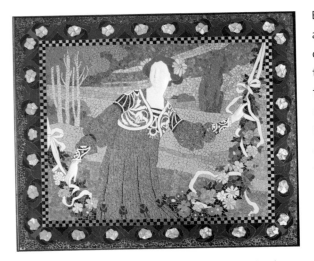

Stand-alone pieces, such as the one on display here, were also made from Pey's designs (fig. 8). The ceramist Antoni Serra i Filter, who ran the leading manufacturer Porcellanes i Gres d'Art, reproduced in low-relief porcelain the heads and hands molded by the versatile sculptor Joan Carreras, who was also responsible for carving the furniture. The finest tile panels were produced between 1904 and 1906, when Homar was working on the interiors of Casa Lleó Morera in Barcelona and Casa Navàs in Reus. Many of the tile panels (enhanced with metal and mother-of-pearl appliqués) and marquetry panels share the same designs.

Another ensemblier who devoted himself to the comfort and beauty of home interiors, Joan

Busquets i Jané was the son of the furniture maker and upholsterer Joan Busquets i Cornet. From 1840 on, the father produced furniture for numerous distinguished clients in Barcelona, and also supplied the aristocracy in Madrid, Cuba, Puerto Rico, and the republics of Central and South America. The younger Busquets trained at first in his family's workshop on carrer Ciutat de Barcelona, but then went on to study further at the Escola Oficial de Belles Arts i Oficis (School of Fine Arts and Crafts), where he specialized in furniture design. Busquets also made extensive trips around Spain and Europe. His watercolor designs, still imbued with a certain eclecticism, were awarded prizes at exhibitions of the fine arts and crafts organized by the Barcelona city council.[9]

In 1900, Busquets took over the family business and traveled to Paris for the world's fair, where he shared a stand with the Sobrinos de Juan Batlló. During his time in Paris, Busquets viewed first hand the French creations that he knew through décor and architecture journals (*Art et Décoration, L'Art Décoratif, L'Illustration, Innen Dekoration*) that published the designs of Victor Horta, Henry van de Velde, Eugène Gaillard, Louis Majorelle, Charles Plumet, and Antoine-Paul Selmersheim.

Broadly speaking, Busquets followed Art Nouveau in France and Belgium: he adopted the whiplash and the gigantic arborescent forms em-

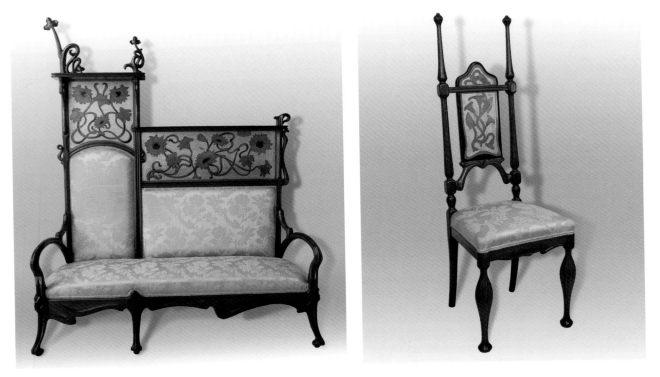

Fig. 8 (cat. 5:34). Gaspar Homar, *Decorative Panel with Figure and Garland of Ribbons and Flowers*, c. 1905.

Fig. 9 (cat. 5:41). Joan Busquets, *Sofa*, 1899.

Fig. 10 (cat. 5:46). Joan Busquets, *High-back Chair*, 1899.

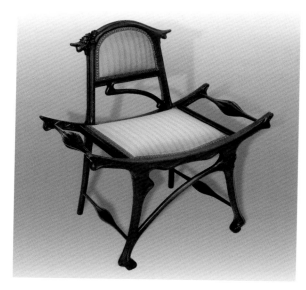

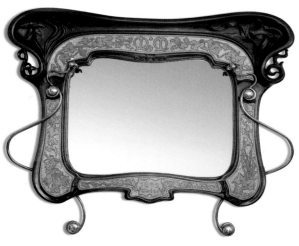

ployed by Majorelle and Gallé of the Nancy School. He reveled in the exuberant curves of Hector Guimard. Among the hallmarks of his furniture are bifurcated legs and bone-like forms, always softened by his personal interpretation. The modernista output of Busquets's workshops included chairs, side tables, screens, double sofas, and dressing tables with graceful, slender lines. He typically used fine woods, especially mahogany, with oblique crosspieces and legs that finish in sinuous folds influenced by Louis XV style. The works in this exhibition are exemplary (figs. 9–14); they come from a private collection, and many were published in leading periodicals of the time.[10] Particularly noteworthy are the chairs and the furniture in the anteroom, whose slender, bone-like structures reveal the influence of Horta, and are prefigured by the watercolor designs produced by Busquets in 1898.

While a geometrical rose reminiscent of Aubrey Beardsley, carved or in marquetry, became a recurrent motif for Homar's workshops, the leitmotiv of Busquets's firm was the golden sunflower with sinuous stem (to which must be added other motifs based on flora and fauna, such as lilies, orchids, and snails), evident in the furniture on display.[11] Even though Busquets also decorated his furniture with

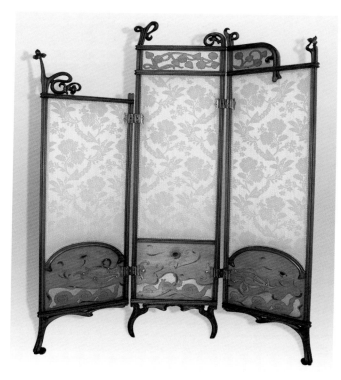

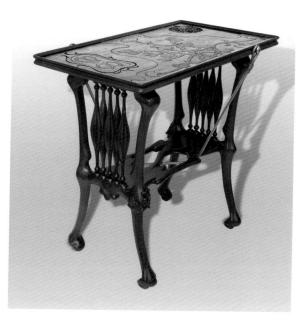

Fig. 11 (cat. 5:44). Joan Busquets, *Low Chair*, 1899.
Fig. 12 (cat. 5:42). Joan Busquets, *Mirror*, 1899.
Fig. 13 (cat. 5:43). Joan Busquets, *Folding Screen*, 1899.
Fig. 14 (cat. 5:45). Joan Busquets, *End Table*, 1899.

marquetry, he turned far more frequently to pyrography, in which designs are burned into the wood with heated tools; he often signed his furniture this way, with a characteristic flourish. Homar, by contrast, signed the keys of his furniture.

In the furniture suite exhibited, Busquets left the decorative traditions of the past behind, even though at the same time he, like Homar, would produce furniture in other styles occasionally demanded by clients: perhaps an Empire drawing room, a Louis XV alcove, or a Henry II office. Homar and Busquets's modern creations appealed to an elite with considerable spending power (bankers, manufacturers, politicians, and traders) with a sense of style formed in the capital cities of Europe.

The taste for Modernisme was short-lived, spanning the decade of the 1890s; it became virtually exhausted by 1910.[12] The First World War had a tremendous impact, transforming tastes and habits. The cataclysm turned everything upside down, as the decorator Santiago Marco remarked: "Art cannot stand still when everything changes face."[13]

Henceforth, artists rejected Modernisme—among decorators, it was known as the "onion" style due to the whiplash form of an onion shoot—while some began, however hesitantly, to adopt the new fashion for Art Deco, made popular by the International Exhibition of Modern Decorative and Industrial Arts in Paris in 1925.[14] On his contribution to this exhibition, Joan Busquets himself declared that he had recovered from what he called the "measles" pandemic of Modernisme.[15] Homar, by contrast, survived the crisis of Modernisme by devoting himself to the market for antiquities.[16] Works from his and other collections can be viewed today at the Cloisters in New York.

1. They also produced works from designs supplied by architects and artists. The Casas i Bardés furniture workshops made the furnishings designed by architects such as Antoni Gaudí, while Homar's workshops were responsible for the furniture in Casa Amatller, designed by Josep Puig i Cadafalch. Contrary to some suggestions, there is no evidence that Busquets's workshops produced furniture from designs by Gaudí.

2. Vidal, good decorator that he was, was familiar with all the most usual repertoires of his time and passed on to the young Homar his knowledge of the aesthetic content of Owen Jones's *The Grammar of Ornament* (London: B. Quaritch, 1868) and Auguste Racinet's *L'Ornement Polychrome* (Paris: Firmin Didot Frères, Fils & Cie., 1869–73).

3. In 1893, after ten years of apprenticeship in Francesc Vidal's workshops, Homar set up his own business with his father. He opened a shop at 129 Rambla de Catalunya, then a few years later at 4 carrer de la Canuda with his brother-in-law and partner, Joaquim Gassó. One of their first important commissions, passed on by the architect Lluís Domènech i Montaner, was for the furnishings for the boardroom of the Col·legi d'Advocats in their former premises in Casa de l'Ardiaca. Domènech also provided the commission for the Palau Montaner on carrer Provença in Barcelona around 1894. See Lluís Domènech and Lourdes Figueras, eds., *Lluís Domènech i Montaner i el director d'orquestra*, exh. cat. (Barcelona: Fundació Caixa de Barcelona, 1989).

4. In 1900, Reus was the second most important city in Catalonia in terms of population. The financial might of its wealthy residents manifested itself in new architectural constructions and in the early adoption of the latest inventions in domestic technology. Casa Navàs is a good example of the new concept in architecture and housing.

5. Catalonia was experiencing a period of tremendous cultural effervescence, which went hand in hand with the definition of political Catalanism and the literary and historiographical revival of one of the most splendid periods of Catalonia's past, the Middle Ages. There was a veritable fascination with the Gothic.

6. Similar works are found in Casa Lleó Morera and Casa Navàs, among other ensembles. Responding to demand, furniture makers and decorators would use design templates, making slight changes to each piece. Other artists connected with Homar's workshops should be mentioned, such as Sebastià Junyent and Alexandre de Riquer, who were responsible for some of the marquetry designs.

7. There is some dispute over the different types of wood used. The marqueters Sagarra, the grandchildren of Homar's assistant, helped identify many varieties that can no longer be found and are hence difficult to recognize. The Tayà family, who imported wood, traveled around the world with their fleet of vessels. One of the granddaughters provided us with testimony, nostalgically recording the details passed on to her by her forebears. She spoke of the forests of Canada, with trees that give naturally blue wood, and of the grain, with a texture similar to alabaster, typical of ash from Hungary.

8. Japanese prints still hang on the walls of Homar's home. Vidal had already displayed products from China and Japan in his shop on carrer de la Pau in Barcelona. Homar was himself a notable collector of glass, fabric, ceramics, and medieval objects, and for a while he shared a business with the sculptor Julio González, who had opened a shop dealing in jewelry and objets d'art in Paris. See the documentation held in the archives of the González Estate, IVAM, Valencia.

9. At the Third Exposition of Fine and Industrial Arts in 1896, he presented a design for a bookshop cupboard in the Gothic style, a decorated cabinet in the style of the Spanish Renaissance, and a walnut umbrella stand in the Gothic style; in 1898, a small chest-cum-cabinet in a modernized Renaissance style was acquired for the Museus de Barcelona.

10. See Mira Leroy, ed., *Materiales y Documentos de Arte Español, Siglo XIX–Arte Contemporáneo* (Barcelona: Parera, 1905). The furniture of the Casa Busquets is published in the *Dietari* of the Busquets's workshops, which includes photographs by P. Audouard and which can be consulted at the Casa-Museu Gaudí, Barcelona.

11. The "Rose Boudoir" was popularized by Margaret McDonald at the Scottish pavilion of Charles Rennie Mackintosh in the Turin exhibition of 1902.

12. The other forms of Modernisme, such as the Vienna Secession and the School of Glasgow, enjoyed greater opportunities for continuity. Both Homar and Busquets eventually turned to the rectilinear and geometrical solutions associated with Art Deco.

13. "El Foment de les Arts Decoratives de Barcelona a l'Exposició Internacional d'Arts Decoratives a París," *Gaseta de les Arts*, no. 16 (January 1925): 6–7.

14. The critic Rafael Benet termed it the "Moroccan Style" or the "solitary worm style," repeating the expression used by René Chapoullié, *Exposition des Rénovateurs de l'Art Appliqué de 1890 à 1910* (Paris: Musée Galliera, 1925).

15. "I have recovered from the measles which, like everyone else, I suffered from around 1900; at that time, I thought it was possible to create a new style by agreement between a few like-minded individuals. That was a dream. Anything that is not the outcome of a slow, historical evolution has no guarantee of success." See "El moblista Busquets," *D'Ací d'Allà*, no. 93 (September 1925): 291.

16. In the closing years of his life, when he lived alone and forgotten, Homar looked back on the period of Modernisme with a sense of nostalgia. In his work, he had never followed foreign dictates or fashions, as Busquets had, but instead identified fully with the spirit of the times.

Translated by Susan Brownbridge.

# Gaudí: The Art of Architecture

*DANIEL GIRALT-MIRACLE*

Eighty years after his death Antoni Gaudí has achieved a level of international recognition that he would never have imagined possible. This success is not due to the number of his works, which barely amount to 20, nor to their geographical location (most of them are to be found in the Barcelona area), nor to the fact that he was determined to go down in history. His solitary, impulsive, unworldly temperament meant that his life was devoted to his work, his family, and spiritual contemplation. Apart from the few artists, intellectuals, and politicians who recognized the exceptional nature of his art, his contemporaries—the erudite and the masses alike—were relatively hostile to his creations, perhaps, as the philosopher Francesc Pujols remarked, because his style asserted itself without ingratiating.

Whatever the reasons for this neglect, the slow but steady recognition of his work flows from its intrinsic strength. Although Ernst Neufert and Paul Linder in Germany and Kenji Imai in Japan visited Gaudí's buildings and wrote articles on them in 1907 and 1926 respectively, it was America that fostered Gaudí's international reputation: in 1936 the first director of the Museum of Modern Art (MoMA) in New York, Alfred H. Barr Jr., included examples of Catalan Modernisme and several objects by Gaudí among the works in the exhibition *Fantastic Art, Dada, Surrealism*; more important, in 1957 Henry-Russell Hitchcock organized an exhibition on Gaudí for MoMA, probably at the urging of the Barcelona architect Josep Lluís Sert, at that time dean of the Graduate School of Design at Harvard and head of studies of the Department of Architecture at the school. The MoMA exhibition offered a wide-ranging view of the architect's work illustrated by 85 large-format photographs. It also included furniture, decorative arts, and liturgical objects that were a veritable revelation for the American public.

Hitchcock understood Gaudí's work, and in his catalogue essay interpreted it clearly. He went beyond the spectacular outer form and color of Gaudí's work, which most critics praise, to remark: "The art of Gaudí is so rich, so varied, so impossible to reduce to a single formula . . . that in the total picture of the modern architecture of the 20th century Gaudí stands apart; his uniqueness is of an order no others approach." He added, "Not since the Baroque has there been architecture so rich in all its aspects."[1] These remarks were especially prescient, because people had begun to look at Gaudí with new eyes and it seemed that Sert's prophecy of 1955 might at last come true: "It is likely that in the continuing evolution of modern architecture, Gaudí's final experiments will acquire greater value and will be fully appreciated. At that time, the greatness of his role as a pioneer and as a precursor will be recognized."[2] Sert, a rationalist disciple of Le Corbusier, also wrote *Antoni Gaudí* with James Johnson Sweeney, which treats Gaudí's life as well as his work, and substantially raised international awareness of the architect's achievements. Published in English, German, and Spanish, the book was distributed widely around the world.[3]

These initiatives gradually brought Gaudí to public attention, while experts were also coming to value him at his true worth. Le Corbusier wrote in 1957: "What I saw in Barcelona—Gaudí—was the work of a man of an extraordinary force, faith, and technical capacity, which he demonstrated throughout his life."[4] Later, other great architects and historians of architecture also came to subscribe to this view, including Siegfried Giedion, Nikolaus Pevsner, Bruno Zevi, Roberto Pane, Leonardo Benevolo, Manfredo Tafuri, and Francesco Dal Co, and most especially George R. Collins. While a professor of art history at Columbia University, Collins produced numerous studies on Gaudí, including a noteworthy monograph, an impressive bibliography that places the architect within the context of Modernisme, and a catalogue of Gaudí's drawings with Joan Bassegoda Nonell.[5] These studies, combined with other works by eminent Catalan and Spanish historians, unquestionably cultivated the architect's

reputation and contributed to UNESCO's decision to declare Palau Güell, Park Güell, and La Pedrera (Casa Milà) World Heritage Sites in 1984; in 2005 Casa Vicens, the Nativity façade and crypt of the Sagrada Família, Casa Batlló, and the crypt of the church at Colònia Güell were added.[6]

Gaudí was born in 1852 during a monarchy (the reign of Isabel II), lived through the first Spanish Republic (1873–74), the reign of Alfonso XII, the regency of Maria Cristina, and the reign of Alfonso XIII, dying during the dictatorship of General Manuel Primo de Rivera (1923–30). He lived in Barcelona during a period of high euphoria, that is to say, between the two world's fairs of 1888 and 1929, when the Eixample began to take shape. This crucial moment in history, the turn of the 19th into the 20th century, was marked by a striving for modernity. Gaudí was a contemporary of Karl Marx, Bismarck, the Eiffel Tower, the invention of cinema, the Glasgow School, the skyscrapers of Louis Sullivan, Frank Lloyd Wright, the Bauhaus under Walter Gropius, Hannes Meyer, Mies van der Rohe, Le Corbusier's Maison Domino, and the Russian Revolution. He lived through Post-Impressionism, Fauvism, Expressionism, Cubism, and Surrealism, though he was not directly influenced by any of them. Nor can he be regarded as the archetypal modernista, though in his early days he used some of the movement's formal and aesthetic devices, and supported national renewal in Catalonia.

Born in Reus, a city in the Camp de Tarragona region, a stony, arid area of vines and olive, almond, and carob trees, Gaudí spent his childhood there, closely observing plants and animals, and learning craft secrets in his father's workshop, where pots, cauldrons, pitchers, and stills for alcohol were made from beaten sheets of copper. It was here, he said, that he learned the geometry of space, and the warped forms and continuous surfaces that would later appear in his architecture. His primary education completed, Gaudí moved to study architecture in Barcelona, a city then in the throes of expansion and modernization.[7] Though he could not be described as a good student of architecture (1873–78), he excelled in draftsmanship and calculus, and was very interested in the theory and history of art. He avoided other subjects in favor of the ideas of Eugène Emmanuel Viollet-le-Duc, the Arts and Crafts principles of John Ruskin and William Morris, and classes

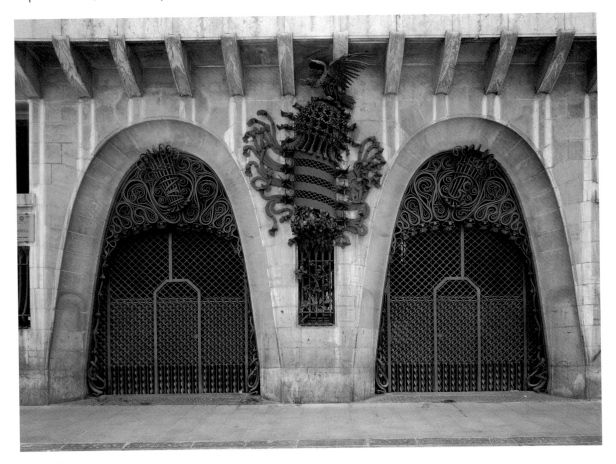

Fig. 1. Façade of Palau Güell, designed by Antoni Gaudí.

in classical literature and aesthetics. When he gradu-ated, the director of the school, Elies Rogent, won-dered if he had granted a degree to "a madman or a genius."

The young Gaudí worked his way through school as a draftsman in the studio of Josep Fontserè, on the projects for Parc de la Ciutadella and the Mercat del Born in Barcelona. He also worked in the workshops of renowned metal craftsmen and carpenters in the city, but once he qualified as an architect in 1878 he devoted himself solely to his profession. Early in his career he supported movements to improve society and worked for workers cooperatives, such as the one in Mataró. After this period, however, Gaudí's clients were mostly members of the emerging bour-geoisie (the Güell, Milà, Batlló, Calvet, and other families), a natural partnership, since his spectacular architecture perfectly matched their character and aspirations for social prominence and recognition. His other main client was the Catholic Church, for which he undertook numerous projects.

Even though his best-known works are churches, mansions, urban buildings, schools, and parks, Gaudí was involved in every sphere of architecture: he re-stored buildings, such as the Barcelona Cathedral, designed the water pipes at Caldes de Montbui, refurbished the interior of Palma de Mallorca Cathedral, designed a winery for the Güell family in Garraf, and planned the Can Artigas gardens at La Pobla de Lillet. He even drew ambitious plans for a building for the Franciscan monks in Tangiers and a 985-foot-high skyscraper in New York. Neither of these projects came to fruition, and a few sketches are all that survive.

Gaudí's first project in Barcelona as a qualified architect was Casa Vicens (1883–88), a four-story summer residence set among gardens. Despite its evident Moorish influence, Casa Vicens is an early demonstration of two characteristics of Gaudí's ma-ture work: simplicity of construction and the use of decorative ceramic tilework.

The industrialist Eusebi Güell commissioned Gaudí to construct the Palau Güell (1886–89) as a home for his family. This six-story building, located in what was then the old center of Barcelona, in-corporates Moorish and Gothic influences, though Gaudí introduced a number of new ideas in its con-

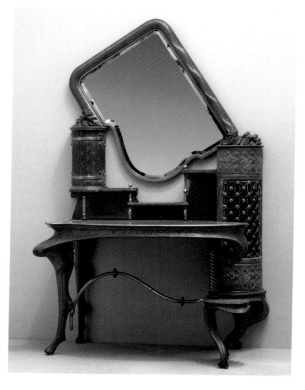

struction. The sobriety of the façade contrasts with the interior décor and furnishings (figs. 1 and 2). The most outstanding parts of the building are the spa-cious drawing room on the ground floor illuminated by natural light, and the rooftop with its central spire and varied chimneys and ventilation shafts with cowls, decorated with *trencadís* (fragments of tile and other materials often used by Gaudí to face curved surfaces).

The Col·legi de les Teresianes (1888–89), a school run by Teresian nuns, was built in what is now the neighborhood of Sant Gervasi in the northern part of Barcelona. The rectangular floor plan of this de-tached four-story building is arranged around three parallel corridors; the central corridor, which con-nects the various parts of the building, is lit from directly overhead. Constructed largely of stone and brick, the building is accented by striking wrought-iron features and symbolic motifs in the façade ex-ecuted in ceramic tiles. The building is still used as a school and as a convent for a community of nuns.

In 1898, Eusebi Güell gave Gaudí the job of con-structing a church for his model industrial settle-ment in Santa Coloma de Cervelló, just over 12 miles southwest of Barcelona. The architect developed a creative method of engineering for the support for the crypt, deriving structural forms from the cat-

Fig. 2 (cat. 5:47). Antoni Gaudí, *Palau Güell, Dressing Table*, c. 1889.

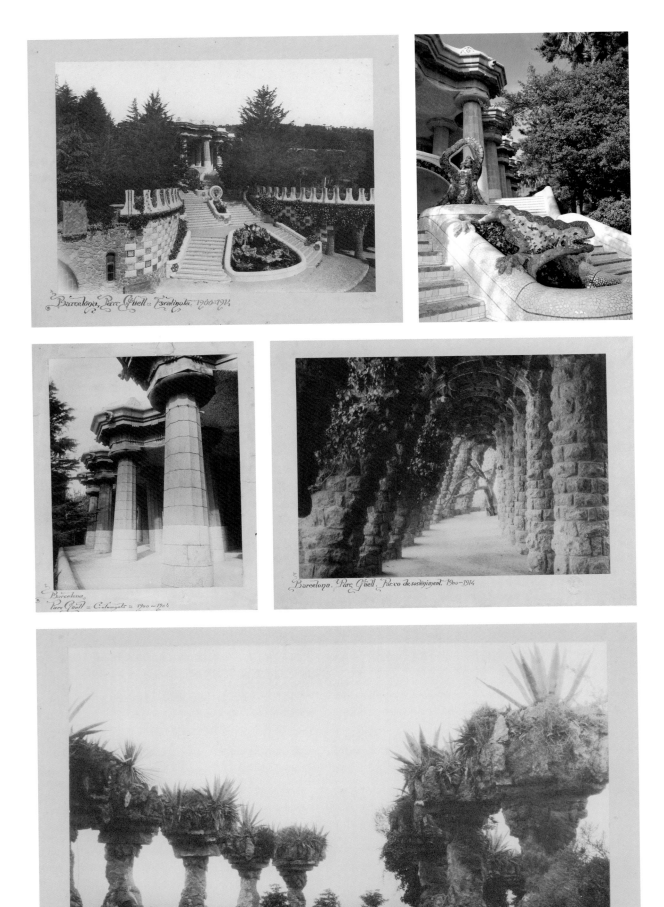

Barcelona, Parc Güell = Escalinata. 1900=1914

Barcelona, Parc Güell = Columnata = 1900=1904

Barcelona, Parc Güell. Pòrxo de sosteniment. 1900=1914

Barcelona = Parc Güell = Viaducte = 1900=1914

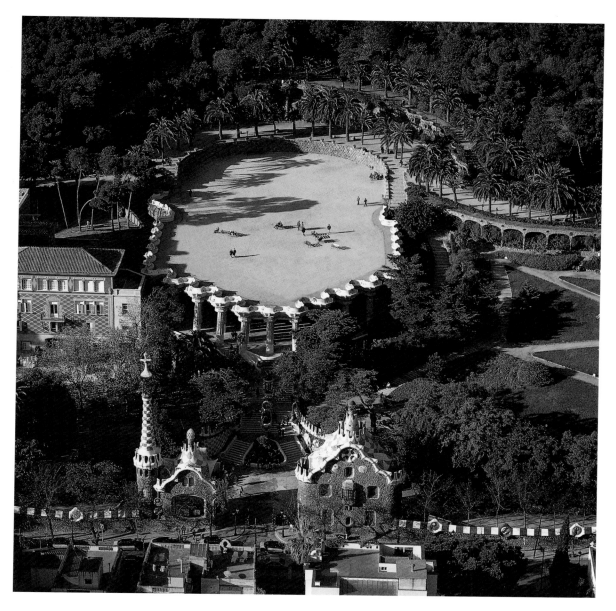

enary curves of cords loaded with weights. This difficult process and a lack of money hobbled the work, which finally came to a halt in 1917. Only the polygonal star-shaped crypt, the base of the church, had been built at that point, as had the exterior porch that so successfully blends into the site. The sloping basalt pillars and the interior brickwork combine to create a space that invites meditation, and it is still used today for religious services.

In 1883, Gaudí was commissioned to take over the design of a church dedicated to the Holy Family, to be built by public subscription on land purchased for the purpose by a religious foundation. Known as the Expiatory Temple of the Sagrada Família, this monumental project, characterized by innovative geometry, exuberant ornamentation, and emphatic

symbolism, occupied Gaudí for the rest of his life. Work continues today, based on scholarly reconstruction of Gaudí's models, many of which were destroyed in the Spanish civil war. Judith Rohrer discusses the Sagrada Família in detail in her essay in this section of the catalogue.

Park Güell (figs. 3–7) occupies a 37-acre site in the north of Barcelona. This real estate development project for the industrial magnate Eusebi Güell was to include, in addition to 60 building plots, two entrance pavilions, a grand flight of steps, a covered market, and a theater in the form of a large open-air square. It was perfectly adapted to the topography of the mountain site and its vegetation (fig. 8). Work continued on the project from 1900 to 1914, when the recession caused by the First World War brought

Fig. 3 (cat. 5:54). Adolf Mas (photography, 1910) and Francesc de Paula Quintana (calligraphy, 1927), *Park Güell, Stairway*.
Fig. 4. Detail of the dragon stairway at Park Güell, designed by Antoni Gaudí.
Fig. 5 (cat. 5:55). Adolf Mas (photography, 1910) and Francesc de Paula Quintana (calligraphy, 1927), *Park Güell, Colonnade*.
Fig. 6 (cat. 5:53). Adolf Mas (photography, 1910) and Francesc de Paula Quintana (calligraphy, 1927), *Park Güell, Portico*.
Fig. 7 (cat. 5:52). Adolf Mas (photography, 1910) and Francesc de Paula Quintana (calligraphy, 1927), *Park Güell, Viaduct*.
Fig. 8. Aerial view of Park Güell.

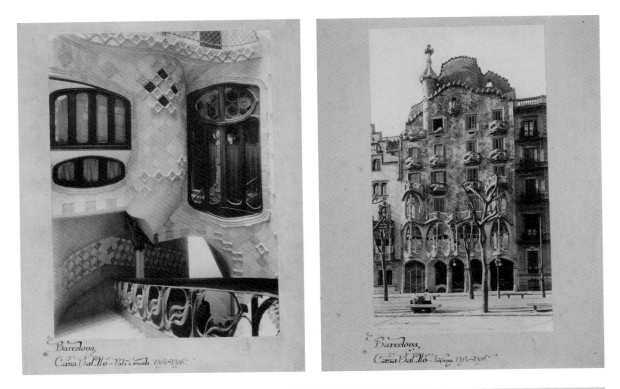

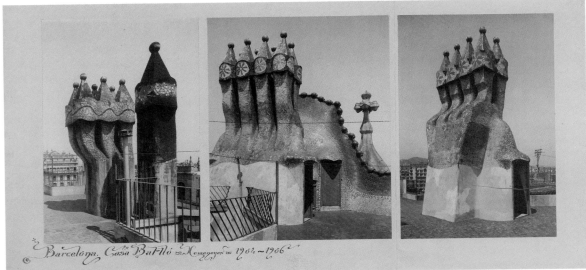

Fig. 9 (cat. 5:58). Adolf Mas (photography, 1910) and Francesc de Paula Quintana (calligraphy, 1927), *Casa Batlló, Staircase and Landing.*
Fig. 10 (cat. 5:56). Adolf Mas (photography, 1910) and Francesc de Paula Quintana (calligraphy, 1927), *Casa Batlló, Façade.*
Fig. 11 (cat. 5:59). Adolf Mas (photography, 1910) and Francesc de Paula Quintana (calligraphy, 1927), *Casa Batlló, Chimneys.*
Fig. 12 (cat. 5:57). Antoni Gaudí, *Casa Batlló, Plans for the Façade,* 1904.

the entire enterprise to a halt. In constructing the complex, Gaudí was aided by a number of craftsmen and other architects, notably Josep Maria Jujol, who was responsible for the fine trencadís work. In 1923, ownership of the site passed to the city of Barcelona, which opened it to the public as a park.

In the heart of the Eixample, Gaudí undertook projects for three residential buildings: Casa Calvet (1898–99); Casa Batlló (1904–6), the refurbishment of an existing building that involved structure as well as décor (figs. 9–12); and Casa Milà, also known as La Pedrera ("the stone quarry," an allusion to its exterior appearance). La Pedrera, which proved to be Gaudí's last secular building project, stands on passeig de Gràcia and is organized around two inner courtyards. Its structure of stone and thin brick pillars requires no support from the façade, which permits the large openings that flood the apartments with natural light. La Pedrera was also renowned for its basement automobile garage, one of the first in existence. But the rooftop is its most remarkable feature, scattered with chimneys and stairwell entrances and supported by a series of parabolic arches of different heights and breadths, built of thin bricks in the attic beneath.[8]

Although these are perhaps Gaudí's most emblematic works, a number of others are worthy of mention: El Capricho in Comillas (1883–85); the pavilions, the Fount of Hercules, and the gates at Finca Güell (1884–87), an estate belonging to Eusebi Güell; the Episcopal Palace in Astorga (1887–93); Casa de los Botines in León (1891–92); the spire and entrance porch of Torre de Bellesguard (1900–1909); the gateway to Finca Miralles (1902); and the Temporary

Schools at the Sagrada Família (1909) in Barcelona, which so interested Le Corbusier.

Gaudí approached every project, from a small piece of furniture to a major building, in the same way: he aimed for a total work of art whose unity resulted from the harmony of its various elements. The fundamental concept, what he called the "idea," comprised functionality, form, symbolism, structure, and especially construction. In his mind, there were no higher or lesser arts, nor did he differentiate among architecture, sculpture, painting, or crafts.

Because he began his career with small-scale projects—his work desk, lamp posts for Plaça Reial in the city of Barcelona, liturgical furnishings—and because he believed "for an object to be attractive, its first quality must be that it fulfills the purpose for which it is intended," he is regarded as a precursor of modern industrial design.[9] He produced an extremely wide range of furnishings for the home, including cupboards, tables, seats of every kind, priedieus, screens, mirrors, windows, doors, door knobs and handles, grilles, and spyholes for identifying a visitor before opening the door.

It is possible to identify two periods in both these smaller projects and his architectural work: the first is eclectic and indebted to the styles of the past, and can be seen in the furnishings he designed for Palau Güell (see fig. 2) and the drawing room of Casa Calvet; in the second period, he sought clarity of structure and cleanliness of construction. Inspired by the idea of *commodité*, design as the intersection of structure and purpose, which he learned from the manuals of Viollet-le-Duc, he reconsidered the concept of furniture, adapting everything to anthropo-

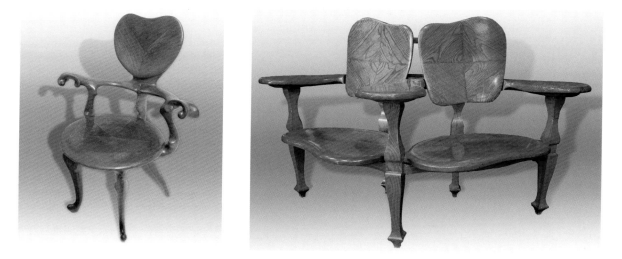

Fig. 13 (cat. 5:48). Antoni Gaudí, *Casa Calvet, Armchair,* c. 1900–1901.
Fig. 14 (cat. 5:61). Antoni Gaudí, *Casa Batllo, Two-seat Sofa,* c. 1907.

morphic forms that are close to organic. The table, chairs, and bench in the shop at Casa Calvet (fig. 13) date from this second period, as do the furnishings for Casa Batlló, some of which are worthy of special mention, such as the sofas with two and four seats in concave shapes (fig. 14), and the quintessential ash chair, the perfect synthesis of Gaudí's furniture with its exquisite proportions, carefully calculated structure, and ergonomic forms.

This same spirit is found in his accessories, as decorative as they are practical. I refer here to the handles, knobs, and spyholes in seemingly whimsical forms, but indisputably beautiful and functional. Like all Gaudí's oeuvre, they were not designed on paper, but modeled directly in clay or plaster by the hand pursuing the object's function (in the case of a door handle, opening, closing, and turning). The spyholes and door handles to the apartments in Casa Calvet, and all the door handles Gaudí made for La Pedrera, are paradigmatic examples of this approach (figs. 15–18).

Gaudí would use any material or technique necessary for new formal or aesthetic solutions—ceramic, iron, wood, glass and stained glass, stone, and paint—and draw from these materials qualities and virtues that, though inherent, no one had been able to extract before. He used ceramic tiles creatively, following popular Moorish traditions, and making the most of the impetus given to ceramics by the Arts and Crafts movement and Modernisme.

Tiles form an ornamental element on the façade of Casa Vicens, insulate and waterproof the façade of Casa Batlló, and cover the floors in his apartments. Sometimes he used tiles already on the market, and sometimes he had them made—such as the hexagonal tiles he designed for Casa Batlló, but which were eventually laid at La Pedrera and which are found today as paving on the sidewalks of passeig de Gràcia (fig. 19). Gaudí further expanded the architectural range of ceramics with his invention of trencadís, irregularly shaped pieces of ceramic tiles—either recycled or rejected by the manufacturers—to cover façades, chimneys, benches, and rooftops. Examples of trencadís can be seen in Casa Batlló, La Pedrera, Park Güell (fig. 20), the crypt at Colònia Güell, and the pinnacles of the towers of the Sagrada Família.

Ironwork features in all Gaudí's buildings, probably because metalworking was the first skill he learned alongside his father, whether functional, decorative (fig. 21), or structural. Examples of his functional and aesthetic use of iron include the knobs and handles mentioned earlier, the gate in the form of a dragon at Finca Güell, the meshed and coiling ironwork of the entrances to Palau Güell and of the elevator in Casa Calvet, and the railings of Casa Batlló and La Pedrera (fig. 22), a building in which iron was also used as a structural element. He also designed various liturgical objects for the cathedral in Palma de Mallorca and the Sagrada Família, among them the Sagrada Família's impressive Easter candelabrum.

Fig. 15 (cat. 5:70). Antoni Gaudí, *Casa Milà, Knob*, c. 1910.
Fig. 16 (cat. 5:71). Antoni Gaudí, *Casa Milà, Spyhole Bolt*, c. 1910.
Fig. 17 (cat. 5:72). Antoni Gaudí, *Casa Milà, Knob*, c. 1910.
Fig. 18 (cat. 5:73). Antoni Gaudí, *Casa Milà, Two-piece Door Handle*, c. 1910.

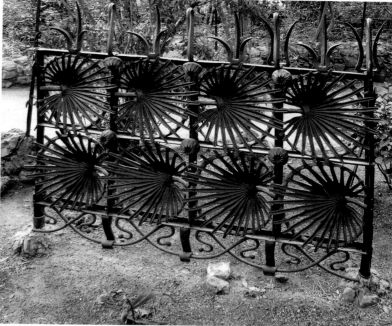

Attracted to the warmth and malleability of wood, Gaudí used it for banisters, blinds, windows, porticoes, doors, moldings, and overdoor panels (fig. 23). The architect sought to exploit the sinuous nature of wood and its knots and grain in construction and ornament, as can be seen in his designs for furniture, which, though they can seem capriciously sculptural, always abide by his functional criteria. He used glass principally for maximum natural illumination indoors. He designed very few solid doors—the upper part or one of the panels is generally translucent—and allowed even deeply interior spaces to

Fig. 19 (cat. 5:50). Antoni Gaudí, *Casa Milà, Hexagonal Paving Tiles*, 1909 (designed for Casa Batlló in 1904).
Fig. 20 (cat. 5:51). Antoni Gaudí, *Park Güell, Trencadís*, c. 1903.
Fig. 21 (cat. 5:49). Antoni Gaudí, *Casa Vicens*c, *Fence Fragment*, c. 1883–85.
Fig. 22 (cat. 5:69). Antoni Gaudí, *Casa Milà Façade, Window Railing*, c. 1910.

be reached by sunlight through frosted, etched, or colored glass. Gaudí's most spectacular use of colored glass, however, is the façade of Casa Batlló and the pinnacles on the Sagrada Família, where he used ceramic and Murano glass to provide maximum protection against weather and to protect the color. In Palma de Mallorca Cathedral, Gaudí also attempted "plating," a technique invented by Louis Comfort Tiffany in which colored glass is layered to achieve a three-color effect, in a number of stained-glass windows. While clearly innovative, the result was not entirely successful.

Of course the essential materials in Gaudí's architecture are stone and terracotta, and while stone is a Roman tradition common in all Mediterranean countries, Gaudí used it in innovative ways. He used rough-hewn, bush-hammered, and polished stone in all possible forms—as ashlar or construction blocks, as columns, or for walls and floors—depending on their strength, color, and texture. He used limestone, sandstone, and igneous rocks such as basalt, as in the columns in the crypt at Colònia Güell. Terracotta also appears in his work in the form of full-sized bricks, thin bricks, tiles, and the like, and it is used in walls, vaults, columns, and catenary arches in

attic spaces (La Pedrera, the Col·legi de les Teresianes, Casa Batlló, and Torre de Bellesguard). He also made the bases of his chimneys of terracotta decorated with marble, glass, or ceramic.

Gaudí's interest in color prompted him to use paint to emphasize or enhance the expressiveness of his forms and surfaces. He also graduated the color of the paint to increase the effect of natural light, as can be seen in the interiors of Casa Vicens, the columns in Casa Batlló, and the entrance vestibule and inner courtyards of La Pedrera.

Clearly, Gaudí could use any technique or material with artistic originality, which has led many to regard him as a forerunner of modern art, and makes his identification with a particular movement or trend problematic.[10] As we have seen, he went beyond Modernisme, concurred with the avant-garde movements, and at times was a proto-rationalist. In reality, however, he was too independent to identify with any fashion or style. He created his own style, which, though not imitated, unquestionably changed the direction of art and architecture. Consequently, to use the words of his disciple Cèsar Martinell, I think the best we can do is define him as the creator of Gaudinianism.

1. Henry-Russell Hitchcock, "Gaudi," in *Antoni Gaudi,* exh. cat. (New York: Museum of Modern Art, 1957).

2. Josep Lluís Sert, quoted by Robert Descharnes, in Descharnes and Clovis Prévost, *La visió artística i religiosa de Gaudí* (Barcelona: Aymà, 1969).

3. Sert and James Johnson Sweeney, *Antoni Gaudí* (New York: Praeger 1960).

4. Le Corbusier, *Gaudí* (Barcelona: Polígrafa, 1967).

5. Siegfried Giedion, *Space, Time, and Architecture* (Cambridge: Harvard University Press, 1967); Nikolaus Pevsner, *Pioneros del diseño moderno De William Morris a Walter Gropius* (Buenos Aires: Ediciones Infinito, 1963); Bruno Zevi, "Un genio catalano: Antonio Gaudi," *Metron* (September–October 1950); Roberto Pane, *Antoni Gaudí* (Milan: Edizioni di Comunità, 1964); Leonardo Benevolo, *Storia dell'Architettura Moderna* (Rome: Editorial Laterza, 1973); and Manfredo Tafuri and Francesco Dalco, *Architettura Contemporanea* (Milan: Electa, 1977). George R. Collins, *Antonio Gaudí* (New York: George Braziller, 1960);

Collins, *Antonio Gaudi and the Catalan Movement, 1870–1930* (Charlottesville: American Association of Architectural Bibliographers/ University Press of Virginia, 1973); Joan Bassegoda Nonell and Collins, *The Designs and Drawings of Antonio Gaudi* (Princeton: Princeton University Press, 1983).

6. Cèsar Martinell, Joan Bergós, Bassegoda, Carlos Flores, Salvador Tarrgó, Ignasi de Solà-Morales, Juan José Lahuerta, etc.

7. A process described by the author Eduardo Mendoza in his novel *The City of Marvels,* trans. Bernard Molloy (San Diego: Harcourt Brace Jovanovich, 1988).

8. For additional information on La Pedrera, see Bassegoda's essay in this section of the catalogue.

9. Martinell, *Gaudí: Su vida, su teoria, su obra* (Barcelona: Colegio Oficial de Arquitectos de Cataluña y Baleares, 1967), 133.

10. Juan Eduardo Cirlot, *El arte de Gaudí* (Barcelona: Omega, 1965), 37.

Translated by Susan Brownbridge.

Fig. 23 (cat. 5:62). Antoni Gaudí with Josep M. Jujol, *Casa Batlló, Door,* c. 1905.

# Casa Milà, a Legendary Monument

*JOAN BASSEGODA NONELL*

ere Milà i Camps, who commissioned the Casa Milà (fig. 1) on the corner of passeig de Gràcia and carrer Provença, was the last of the Barcelona magnates to act as a patron of Antoni Gaudí. The building would be the last great project Gaudí completed. Afterward, the architect's time and affection were lavished solely on the church of the Sagrada Família. Josep Bayó, the builder of Casa Milà—popularly known as La Pedrera (the Quarry)—has related the history of its construction step by step, so that all the details of what can unhesitatingly be called an "architectonic gesture" are known.[1]

Pere Milà and his wife acquired an enormous piece of land in the Eixample district, on which stood a chalet belonging to Josep Anton Ferrer-Vidal, in June 1905. The lot, in the best, most central location in Barcelona, was more than a thousand square meters. Gaudí conceived an astonishing project, the execution of which required the use of a large plas-

ter model, since it was totally impossible to draw La Pedrera in plans and perspectives. He conceived an apartment house around two large curvilinear courtyards, and devised a structure of stone, cast iron, and cylindrical brick pillars in a framework of iron girders and joists. Thus there are no weight-bearing walls, but rather a structure of simple pillars and girders of an entirely modern type. The difference between Gaudí's structure and that of any other rationalist architect lies in the organic nature of the skeleton he constructed. The pillars are placed according to a geological or sculptural concept, and do not conform to a rigid, preconceived plan.

The principal façade was composed of large stone blocks from Vilafranca, delivered to the site on board a locomotive or engine that moved along the highway—a kind of slow, hobbling steamroller whose arrival was always a spectacle.[2] The huge stones made up a series of porticos superimposed

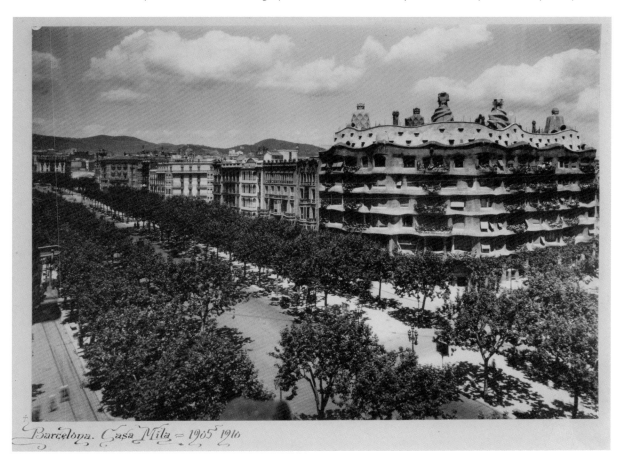

Fig. 1 (cat. 5:63). Adolf Mas (photography, 1910) and Francesc de Paula Quintana (calligraphy, 1927), *Casa Milà*, 1910.

ARCHITECTURE AND DESIGN

195

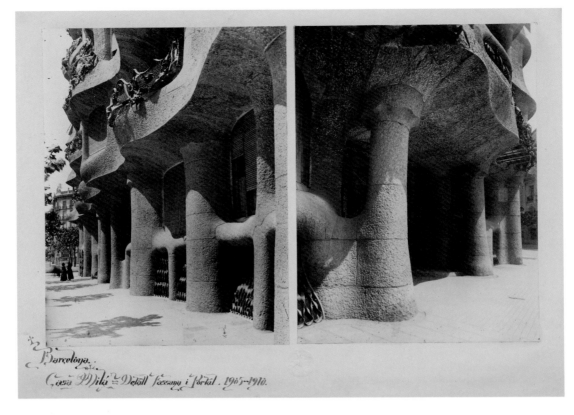

on the inclined columns and the lintel, which was in the form of a colossal arch. The façade is like a large cliff pierced with openings (fig. 2). To make it stable, an undulating running girder at the height of the floor-ceiling framework on each floor was joined by projecting joists to the structural girders. There is no discontinuity between the structure and the façade, which seems to climb up the internal skeleton like living skin or clinging ivy. The solution for the roofs is the most original and well executed in all of Catalan architecture. Above the last floor-ceiling framework, Gaudí ordered the construction of a series of thin partition walls in catenary form, going from façade to façade. The reduced pressure of these arches was absorbed by the framework holding them up. Since the façade was developed in a curvilinear form with successive recesses and salients, and the façade of the courtyard is also curved, the successive catenary arches have different widths and are consequently of different heights. On these, the support for the roof terrace was constructed (fig. 3); being seated on arches with different crown heights, it had necessarily to be staggered in a graceful set of steps, which also made expansion joints unnecessary and rendered the roof absolutely watertight.

To gain access to this staggered roof, there are exits from spiral staircases (fig. 4), which on the inside take the form of truncated cones with a parti-

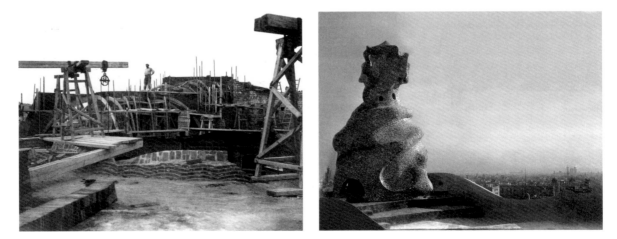

Fig. 2 (cat. 5:65). Adolf Mas (photography, 1910) and Francesc de Paula Quintana (calligraphy, 1927),
*Casa Milà, Detail of Façade* (left) *and Main Entrance* (right).
Fig. 3. Wooden trusses arrangd for constructing the attic catenary arches of Casa Milà, c. 1909, photograph by the contractor, Josep Bayó.
Fig. 4. The ventilation tower on the roof of Casa Milà, taken just as the work was being completed, c. 1910, photograph by Josep Bayó.

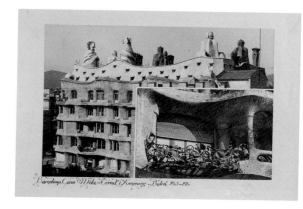

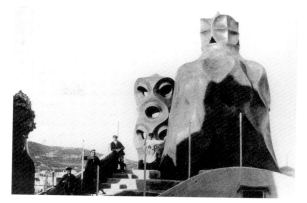

tioned dome; on the outside, they become delirious sculptural themes of great beauty (fig. 5). By means of the spiral movement of different forms, such as crosses and rectangles, a few odd small castle-like structures were formed and covered with small fragments of cut marble or ceramic, which confer on them the magical sheen of reflected light. These strange colossal giants are accompanied by a sensational suite of chimneys in unusual forms (fig. 6). Based on the concept that smoke spirals as it rises, the chimneys take spiral forms and are topped off with cowls, which are perfectly adequate to their function, while, at the same time, presenting opportunities for Gaudí's inexhaustible imagination. Some of them are finished with fragments of bottle glass; the majority have a simple mortar covering over their capricious brick forms.

This entire exercise, always resolved with geometric forms, confers a unique personality on the terraced roof of Casa Milà (fig. 7). It was supposed to have been completed with an image of the Virgin Mary in one of the chamfered cornices, since Gaudí wanted to render homage to the Most Holy Mary of the Rosary, the celestial patron of the building's

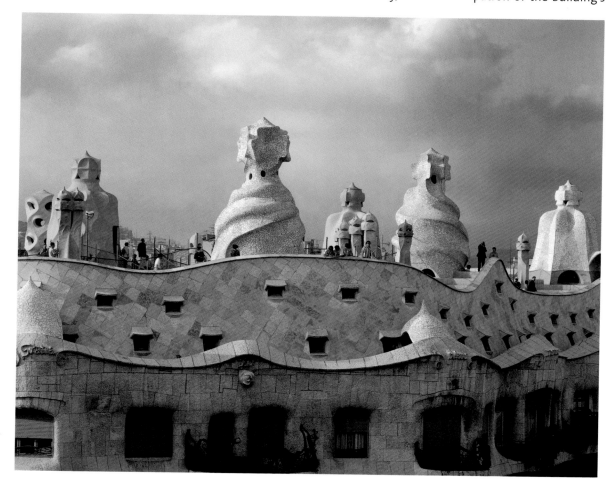

Fig. 5 (cat. 5:64). Adolf Mas (photography, 1910) and Francesc de Paula Quintana (calligraphy, 1927), *Casa Milà, Roof and Chimneys, Balcony* (inset).
Fig. 6 The roof of Casa Milà during construction, 1911, photograph by Josep Bayó.
Fig. 7. The ventilation towers and stairway exits on the roof of Casa Milà.

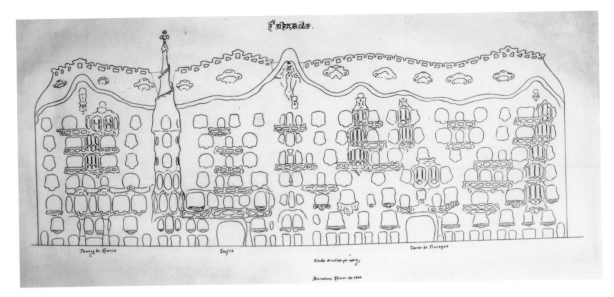

owner, Roser Segimon i Artells de Milà, whom everyone called "Doña Rosario." Gaudí entrusted the studies for this Virgin Mary, flanked by the Archangels Michael and Raphael, to the Tarragona sculptor Carles Mani (see fig. 6, p. 132), who worked with him on the Sagrada Família. The studies, however, were not to the liking of Pere Milà, and the project was never completed.

Some have speculated that the project was abandoned for fear of the mobs that burned a large number of religious houses and churches in Barcelona during the infamous Setmana Tràgica (Tragic Week) in July 1909, while the building was being constructed.[3] It has also been said that Gaudí abandoned the direction of the entire project for this reason—something that Bayó denied.[4] Gaudí left the work in 1911 because of a disagreement with the Milàs about the pictorial decoration, which had been entrusted to Aleix Clapés against the architect's wishes. The immediate collaborators with Gaudí on La Pedrera were the architects Domènec Sugrañes and Josep Canaleta, along with Jaume Bayó, brother of the builder and a great planner. The architect Josep Jujol collaborated on the interior decoration, and the painters Ivo Pascual, Teresa Lostau, and Xavier Nogués made paintings for the ground-floor hall and the main floor, under the direction of Aleix Clapés. The balcony railings, a poem in wrought iron, were created under the personal direction of Gaudí, who, according to Bayó, spent entire afternoons in

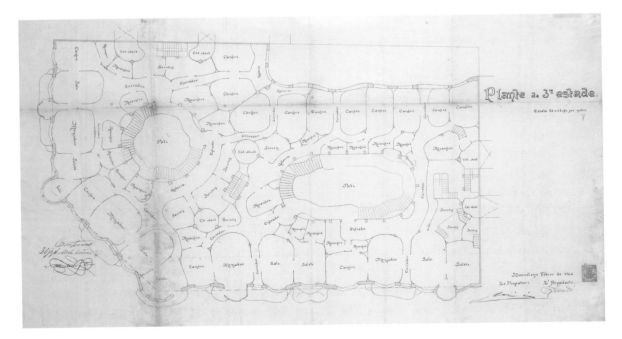

Fig. 8 (cat. 5:66). Antoni Gaudí, *Elevation of the Façade of Casa Milà*, 1906.
Fig. 9 (cat. 5:67). Antoni Gaudí, *Plan for the Third Floor of Casa Milà*, 1906.

the Badia workshop in carrer Nàpols, overseeing the ironworkers' labors.

The rear façade of La Pedrera is simpler than the outer façade and is made of stuccoed brick, but it follows the undulating system of the façade that faces the street. La Pedrera is a continuous sculpture that begins with the ground-floor ironwork and pillars on the corner of passeig de Gràcia and carrer Provença, rises to the roof, continues across it, and descends along the façades on the courtyards with an admirable unity, without the slightest fissure or discontinuity. In the interior, many of the stone pillars are sculptured and contain several inscriptions. Gaudí personally directed the formation of the mold for the floor mosaic that depicts a starfish, seaweed, and an octopus in a delicate and extraordinary hexagonal bas-relief. Other rooms were floored with wood parquet, combining two colors into the simple form of triangles drawn within squares. In the work space for Casa Milà, set up in the building's basements, was the model on a scale of 1:25, which the plaster sculptor Beltran retouched according to the architect's direct instructions.[5] The models for the chimneys, on a scale of 1:10, were made in the same way; these are now kept in the Museu d'Arquitectura de la Reial Càtedra Gaudí.

La Pedrera was begun in 1906 and officially finished in 1912, although Gaudí had left the project the year before. In-depth study of the building is a passionate pursuit that surprises and enthuses engineers.[6] The solution for the façade's drainage, which is made of lead and crosses the façade in curves, the supporting structure for the circular courtyard, which is an iron ring to which a series of girders is joined, and the metal corbel that holds up the courtyard stairway are all simultaneously displays of both imagination and wisdom with regard to construction.

La Pedrera was declared a national historic and artistic monument in 1969—together with another 16 works by Gaudí—and a World Heritage Site in 1984, but as we shall see, its monumentality was recognized much earlier, including officially.

La Pedrera belonged to Roser Segimon, who had been married to Josep Guardiola i Grau and widowed in 1901. She was married again in 1903 to Pere Milà, the signatory on all the administrative documents related to Casa Milà who was closely linked to Gaudí.

In the course of 1906, the plans for the new building as projected by Gaudí, dated 2 February, were submitted in duplicate to the city government (figs. 8 and 9).[7] The document requesting the permit, signed by Pere Milà, is dated 20 February. On 27 February, Milà requested permission for the demolition of the Ferrer-Vidal house on the lot, which had been used as a work space.

On 27 December 1907, a municipal inspector reported the construction of a pillar that intruded on the public thoroughfare.[8] This pillar, called "the elephant's foot," does effectively take up a bit of the sidewalk on passeig de Gracía, and Josep Bayó tells how the report was communicated to him and transmitted from him to Gaudí. Gaudí simply replied, "Tell them that if they want us to, we'll cut the pillar as if it were a piece of cheese, and on the polished surface that's left, we'll carve an inscription that says: 'Cut by order of the city government as agreed by the plenary session of thus-and-such a date.' " Bayó passed this on to the inspectors, and there the matter rested.

The year of greatest activity around the construction of La Pedrera was 1909. On 15 June, the favorable technical report on Gaudí's project was released; on 18 June, the Special Commission for the Eixample issued its report; and on 24 June, work permits were granted, when the building had already risen five stories. On 28 September 1909, a municipal inspector reported that, besides the ground floor and five floors above it, Milà was constructing various projections on the roof that exceeded the permitted heights. The chief of the Seventh Division declared on 8 October that the reported works could not be allowed, and passed the matter along to the special commission, which in turn ordered, on 11 October, that a technical report on the matter be made. On 21 October, an order suspending the work was issued. The fact that this occurred during an election period made it impossible to ignore the decision, and the municipal police were ordered to assist in carrying out the decree.

Meanwhile, Gaudí, oblivious to municipal ordinances, stubbornly kept on building. On 13 December 1909, the technical report based on a visual inspection of the work was signed. In this report, it was noted that owing to the greater height than projected

of the floors, the apartment house rose 4.4 meters above the permitted height, and on top of this, a service attic with a variable height—from 3 to 5 meters—was being built. Even higher up, there were six large towers, each of which was 6 meters high. The municipal engineer who saw all this must have felt as if his head were spinning—especially when he calculated that the amount by which all these structures exceeded the permitted volume was 4,000 cubic meters, and that if it was desired to make that work legal, the extraordinary sum of 100,000 pesetas ought to be paid. He ended by recommending that this entire enormous upper platform be torn down.[9]

The special commission displayed more common sense at its 20 December 1909 meeting when it agreed that, although the municipal engineer's estimate was certainly correct, "it is obvious that the building in question, whatever its purpose may be, has an artistic quality that sets it apart from other private buildings, giving it a special physiognomy, to which the work carried out in a departure from the approved plans makes the principal contribution." For all these reasons, the commission recommended that the building be considered in light of Article 184 of the municipal ordinances, which said that such types of construction were not subject to any dimensions other than those derived from the necessities of art—and that the artistic nature of the building was undeniable.

It is clear that in 1910 duties were paid for a building permit and for permits for the temporary fence and the sewer system—all on the same day, 5 July—for a grand total of 27,790.78 pesetas. The apartment house was so far along that on 21 December, Doña Rosario—with the consent and written authorization of Pere Milà—sought permission to rent out the second floor of La Pedrera.[10] Gaudí signed the certificates of completion of work for the main floor in 1910, and for the rest of the building in 1912.

This entire bureaucratic history approached its end with a document from Gaudí's attorney, dated 19 November 1914, requesting certification that Casa Milà was authorized as a monumental construction. This document is followed by a report from the chief of the Second Division affirming that the plans, signed by proxy by Pere Milà for Roser Segimon, were submitted by Gaudí in February 1906. On 22 December 1914, the city government issued a certificate according to which Casa Milà was authorized as a building of a monumental type. Thus the proclamation in Decree 1792 of 1969, which declares it a national historical and artistic monument, only

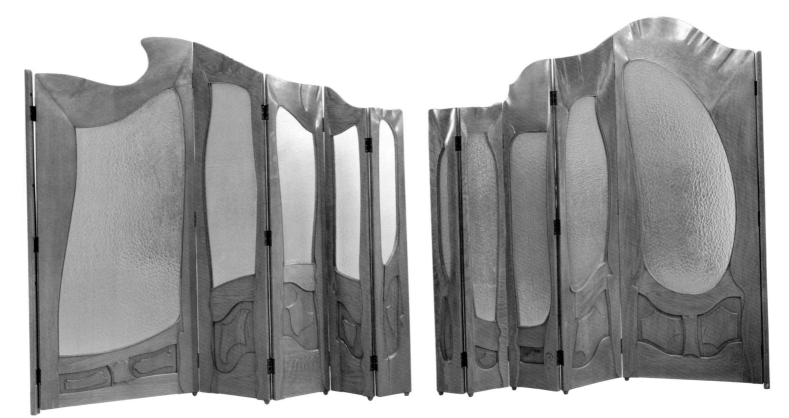

Fig. 10 (cat. 5:60). Antoni Gaudí, *Double Folding Screen from Casa Milà*, 1909.

confirms—55 years later—what the government of Barcelona had already been able to recognize.

False interpretations and legends about the building are another matter. An architect has suggested that the chimneys, ventilation towers, and staircase exits on the roof represent the Flight into Egypt. The chimneys that appear to be warriors would be Herod's soldiers, one of the ventilation towers Joseph, and one of the staircase exits—which had a spiral chimney next to it—the Virgin Mary and Baby Jesus. As it happens, however, the chimney that would represent the Baby Jesus was built by the architect Barba Corsini in the 1950s, when he installed some apartments in the attics. Another "researcher" found inscribed on another staircase exit "M. Rebled. 1910," and deduced that "M" must be the name of Mary, "rebled" a medieval Latin word with an arcane meaning, and "1910" the date of the inscription. When the meaning of "Rebled" could be worked out, the subliminal message left by Gaudí on the roof of La Pedrera for the pleasure and enjoyment of whoever might try to comprehend his mysterious thinking would be revealed. In fact, it turns out that Miguel Rebled was Pere Milà's administrator, who lived on the lower levels of La Pedrera, and the inscription was the work of a mason on the job who wanted to play a joke on him. Gaudí's subliminal message became a simple act of mischief—a precursor of the graffiti that is now so abundant.

Unfortunately, in 1927 Doña Rosario put Josep Bayó, the same contractor who had built La Pedrera, in charge of completely demolishing the interior of the main floor, where the Milà family lived, and redoing it under the direction of a decorator. With this, one of Gaudí's most splendid pieces of work was lost.[11] With respect to the furnishings, the only pieces that have been preserved are the lobby's oak cupboards, kept in the Casa-Museu Gaudí in Park Güell, and a spectacular wood-and-glass folding screen, which was sold and is now in an American collection (fig. 10).

1. Joan Bassegoda Nonell, *Josep Bayó i Font, contractista de Gaudí* (Barcelona: Escola Tècnica Superior d'Arquitectura i Edicions UPC, 2003).

2. Bassegoda, *Gaudí. La arquitectura del espíritu* (Barcelona: Salvat Editores, 2001), 160.

3. Bassegoda, *L'estudi de Gaudí. Selecció d'articles publicats a la revista Temple entre 1971 i 1994* (Barcelona: Temple Expiatori de la Sagrada Família, 1996), 159–62.

4. Bassegoda, *El Senyor Gaudí. Recull d'assigs i articles* (Barcelona: Claret, 2001), 172–79.

5. Bassegoda, *El Gran Gaudí* (Sabadell: Ausa, 1989), 513.

6. Francisco Javier Asarta et al., *La Pedrera. Gaudí and His Work* (Barcelona: Fundació Caixa Catalunya, 1998).

7. Ana María Férrin, *Gaudí. De piedra y fuego* (Barcelona: Jaraquemada, 2001), 285–97.

8. Bassegoda, *Josep Bayó i Font, contractista de Gaudí*, 38.

9. Bassegoda, *Gaudí o espacio, luz y equilibrio* (Madrid: Criterio Libros, 2002), 193–206.

10. Bassegoda, "El grup escultòric," *Nexus* 8 (July 1992): 24–35.

11. Bassegoda, "Derribo de la Pedrera," *La Vanguardia*, 21 December 2001, 49.

Translated by Vajra Kilgour.

# The Extravagant Jujol

*MARIÀNGELS FONDEVILA*

The architect and historian Josep Francesc Ràfols rightly described the architect Josep Maria Jujol as the most famous, pure, and extravagant of all Antoni Gaudí's disciples.[1] As one of Gaudí's team of assistants, which included many colleagues from his youth, Jujol's reputation was eclipsed by the genius of his master. Nevertheless Jujol produced an indisputably remarkable and highly individual oeuvre of his own, as his works in this exhibition testify.

In recent years, the numerous exhibitions mounted and monographs published have raised awareness of Jujol's creative accomplishments.[2] This exhibition does not mark the first time that his work has crossed the Atlantic; in 1989, a small photographic display of his output was shown at the New York Public Library, the Spanish Institute in New York, and the Graham Foundation in Chicago, and a representative selection of his work was shown as part of *Gaudí in Context: Building in Barcelona, 1873–1926*,

an exhibition at the Cooper-Hewitt National Design Museum in New York.[3] Jujol proved to be a revelation for an entire generation of architects, poets, and artists, who have granted his work recognition far beyond traditional historiography.[4]

Paradoxically, the environment in which this cosmopolitan figure actually moved was predominantly rural and agricultural, and he achieved little recognition during his lifetime. Like Gaudí, he lived the life of a recluse and paid little heed to discussions and developments in the artistic and intellectual circles of his day. He spent his entire life in Catalonia, apart from one trip to Italy that came about as a result of his marriage to his cousin. Thus, in order to view his creative legacy one has to travel around the varied geography of Catalonia, from Barcelona, where Jujol studied and pursued his career alongside Gaudí, to the small town of Sant Joan Despí, where he was employed for more than 20 years as the municipal architect and the site of his most original works,

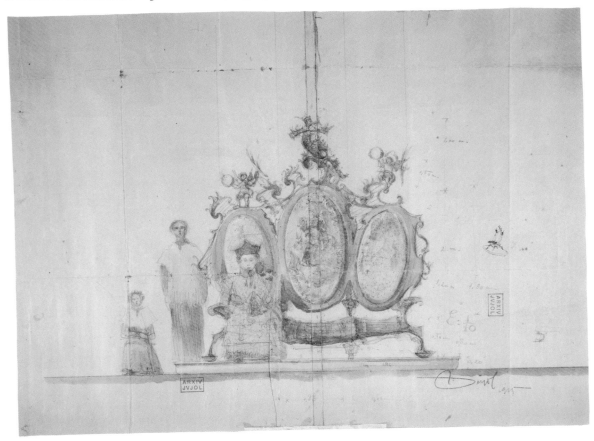

Fig. 1 (cat. 5:80). Josep M. Jujol, *Seat of Honor in the Church of Sant Feliu Màrtir in Constantí*, 1915.

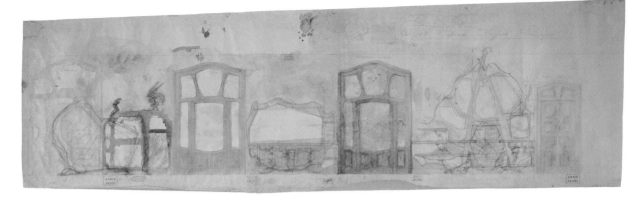

Casa Negre and the Torre de la Creu. Above all, one must visit the numerous villages scattered around the region of Tarragona—Vistabella, Constantí, Els Pallaresos, Roda de Barà, Creixell, Bràfim, Montferri—where he worked during the final years of his life, focusing especially on liturgical art (fig. 1). These itineraries are linked to the land of his birth and his world, the Mediterranean. The works shown in this exhibition reflect the different creative periods of his career and the places where he worked.

Any evaluation of his art—uneven but sometimes touched with genius—should be complemented by oral testimony from the people who knew him: friends, family, elderly parish rectors, and, above all, his disciples. Jujol's pupils at the Escola Tècnica d'Arquitectura de Barcelona recall his skill at producing a form from stains, a bit of paper, or a trickle of paint, and the architect Oriol Bohigas remembers that he was one of the finest and most accurate draftsmen he had ever known.[5] Nor should we ignore the documentary sources, most especially the Arxiu Jujol (Jujol Archives), kept by his son, that can partly complete our knowledge of his work.

These sources describe an artist who defies classification in the realm of 20th-century art, not only an architect but also a smith, a calligrapher, and a designer of furniture and other objects, which, in his hands, were transformed into unusual and disconcerting creations. Conventional in private life, Jujol invested his art with a free-ranging imagination that crossed boundaries and subverted norms. In fact, as his son says, there were two sides to Jujol, a characteristic duality common to much of Catalan culture and society of his time: conservative, backward-looking, and Catholic on the one hand, yet imaginative, free, and irrational on the other.

There can be no doubt that Gaudí gave Jujol (who was 27 years his junior) the opportunity to make the most of his creative personality. At the same time, Jujol injected new energy into the work of the master, who at that point was moving in a distinctly new direction, away from references to the past. Various sources recount that Gaudí was fascinated by the young architect's gift for drawing and his mastery of color. Casa Milà (fig. 2, known as La Pedrera), in Barcelona (1909), was the site of one of Jujol's most significant undertakings: he was responsible for the plasterwork of the ceilings, the wrought-iron balcony sculptures, and the railings on the main façade (fig. 3). A well-known anecdote records how Jujol, with Gaudí's acquiescence, directed the twisting and interlacing of the wrought ironwork. According to oral reports, Jujol personally painted the interior of the dining room in La Pedrera with a cloth soaked in paint and a small wooden stick from which he fashioned a catapult, which he used to launch the cloth against the wall. The dripping paint took on an irregular form, which Jujol then traced with a brush dipped in purpurin, metallic powder suspended in a painting medium.[6]

Recently some have suggested that the two men were in competition, and the extent of Jujol's contribution to Gaudí's work has been the subject of heated debate. In fact their relationship was highly productive and creative, and they admired each other.[7] During the restoration of the cathedral in Palma de Mallorca, undertaken by Jujol and Gaudí, Jujol worked on the tiling and the expressionist paintings in the choir, which scandalized some members of the cathedral chapter because of the artist's daring manner. A witness recalled, "I had the opportunity to watch part of a painting session. Jujol was ap-

Fig. 2 (cat. 5:68). Josep M. Jujol, *Elevation of the Interior of the Main Dining Room of Casa Milà*, c. 1909.

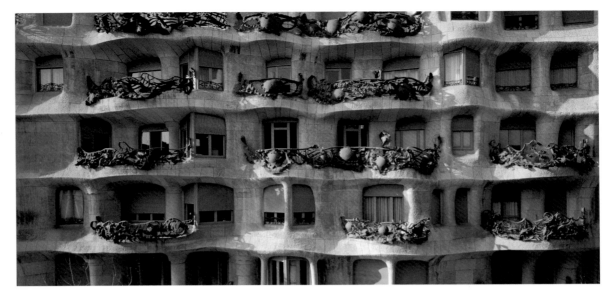

plying paint, not with a pot but with a large decorator's brush that sometimes dripped. Jujol would ask, 'What do you think, Senyor Antoni?' 'Good, Jujol, outstanding.'"[8]

Between 1911 and 1913, Gaudí entrusted Jujol with the production of the circular medallions in the ceiling of the Hypostyle Hall in Park Güell and the ceramic facing on the bench in the park (fig. 4). The medallions are veritable objets trouvés made from *trencadís,* mosaic created in this instance from

shards of mirror, cups, and a porcelain doll. The monumental bench, which is often featured in tourist guidebooks, is decorated with a mosaic made of fragments of ceramic. Occasionally considered a precursor of collage, this mosaic also contains a veiled tribute to the Virgin Mary. It is important to bear in mind that Barcelona had just experienced one of the most turbulent episodes in its history, Setmana Tràgica (Tragic Week), when rioters deliberately burned many churches, monasteries, and convents.

As the early Christians had done, Jujol inscribed signs and phrases in the mosaic, making it a vast calligram based on the name Mary. At the same time, he left his own signature in the form of a cross, by adding a horizontal stroke to the letter J.

Jujol shared Gaudí's mystical and religious feeling for artistic creation and concurred with him on the full integration of the arts. He made no distinction between the so-called high or fine arts and the lesser or applied arts, and his creations can rightly

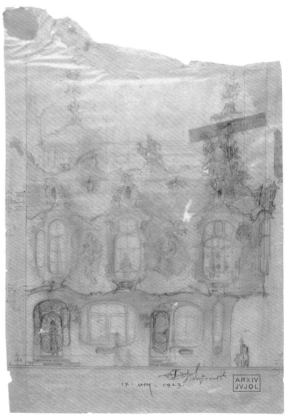

Fig. 3. The wrought-iron balcony railings designed by Jujol, on the main façade of Gaudí's Casa Milà.

Fig. 4. Detail of Jujol's trencadís on Gaudí's meandering bench in Park Güell square.

Fig. 5 (cat. 5:79). Josep M. Jujol, *Casa Planells, Sketch of the Façade,* 1923.

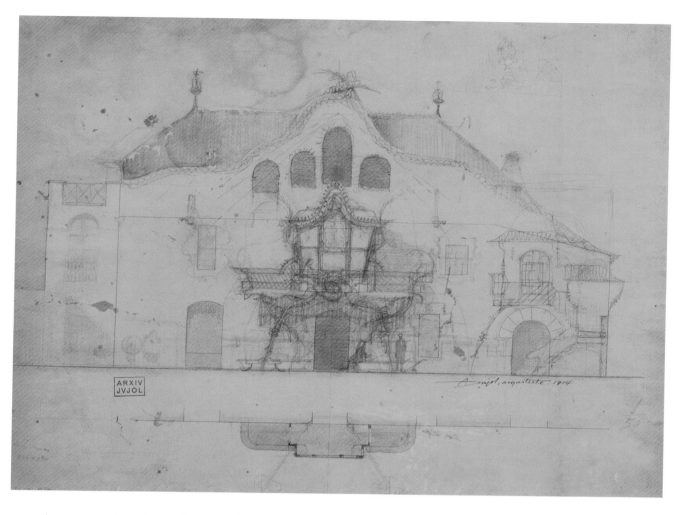

be described as Gesamtkunstwerkes, total works of art. Jujol learned from Gaudí the opportunities inherent in rejected materials and the language of undulating forms, as exemplified by Casa Planells in Barcelona (fig. 5), which recalls the design of Casa Milà. It is often said that Jujol's clients were not the aristocracy or the haute bourgeoisie, but small businessmen, the rectors of numerous churches in the Camp de Tarragona area, and the wealthy farmers of Sant Joan Despí. It is true that he never received any ambitious commissions, and his works were often designed to cut costs, and sometimes to make use of existing buildings. Good examples of this are Casa Bofarull in Els Pallaresos and Casa Negre in Sant Joan Despí (fig. 6), where Jujol worked on an existing farmhouse with features borrowed from the Catalan Baroque and the Rococo.[9]

Casa Negre is one of the most noteworthy achievements of his independent career, as are the works commissioned by Pere Mañach, many of which are shown in this exhibition. Before analyzing these objects, it is worth recalling that Mañach was a businessman who had been Picasso's art dealer during his youth and had shared a studio with Picasso on Boulevard Clichy in 1900. It was Mañach who introduced Picasso to the art galleries in Paris.[10] In the opening years of the 20th century, Mañach's adventure in Paris came to an end, and he returned to Barcelona to take over running the family business of making locks, safes, and other metal objects.[11] Yet he retained his interest in modern art, and in 1911 commissioned the young Jujol, who was just beginning to make a name for himself for his work at Casa Milà, to undertake the decoration of his shop, Botiga Mañach (fig. 7).

The shop, which sadly no longer exists (our information comes from black-and-white photographs), attracted the attention of passersby on carrer de Ferran in Barcelona, a street known for its luxury stores (fig. 8). Jujol covered the entire surface of the ceiling with patches in various colors, allowing himself to be carried away by the freedom of the

Fig. 6 (cat. 5:78). Josep M. Jujol, *Façade Sketch of Casa Negre*, 1914.

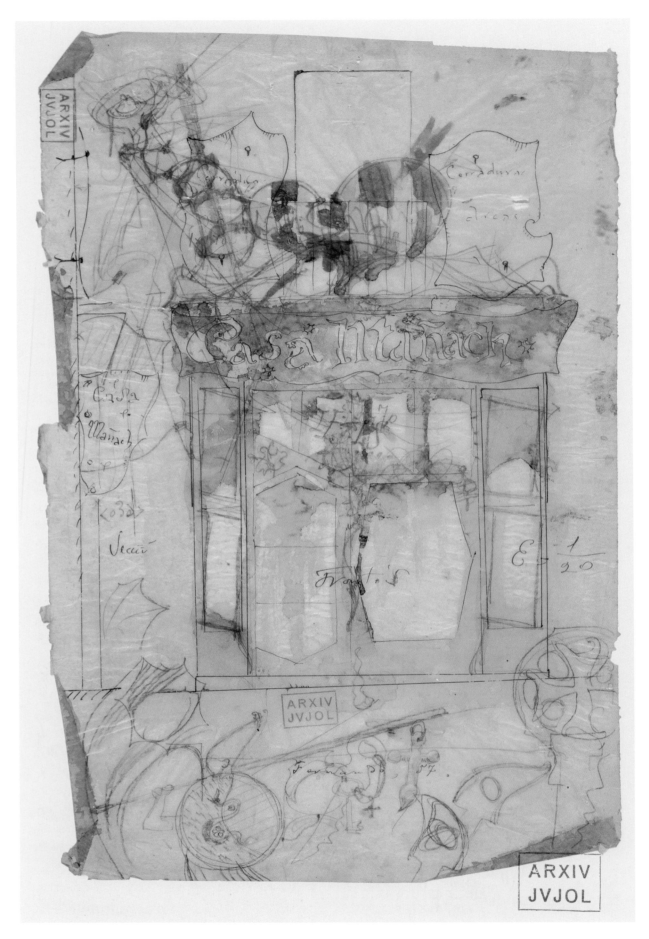

Fig. 7 (cat. 5:74). Josep M. Jujol, *Botiga Mañach with Drawings in the Margins*, 1910.

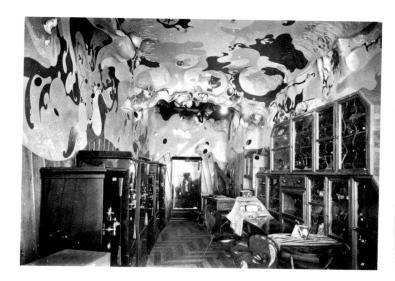

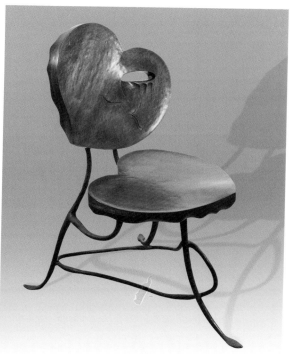

brushstroke and employing solutions close to those of Surrealism. He created a disturbing ambience, and some people find similarities between the shop décor and Joan Miró's paintings of the 1930s, as well as the expressionist aura of the film *The Cabinet of Dr. Caligari*.[12] Alfonso Buñuel, who moved in Surrealist circles in Paris, said that in the burst of polychromy in the interior, Jujol had sought to achieve "sauces that mix and firework rockets that explode."[13]

Again, Jujol created an artistic universe based on religion: the leitmotiv of the décor is a masked tribute to the rosary and the Virgin Mary. Ambroise Vollard noted that, like Jujol, Pere Mañach was a deeply pious man.[14] Religious devotion is evident in

a suite of furniture from the Botiga Mañach, as can be seen in the chair, one of a pair, exhibited here (fig. 9).[15] From the formal and structural viewpoint (Jujol combined iron and wood), these pieces are very similar to the chaise longue in Palau Güell and in particular to the pews in Gaudí's church at Colònia Güell (fig. 10). Jujol designed furniture of an expressionist character that can described as "living" or "eloquent." Unlike other artists of his time—such as Louis Majorelle, Emile Gallé, and Gaspar Homar, who used natural forms decoratively—Jujol gave the back of this chair the form of a heart with a large, bleeding wound, connected to the pure tradition of Spanish mysticism. More particularly, its form

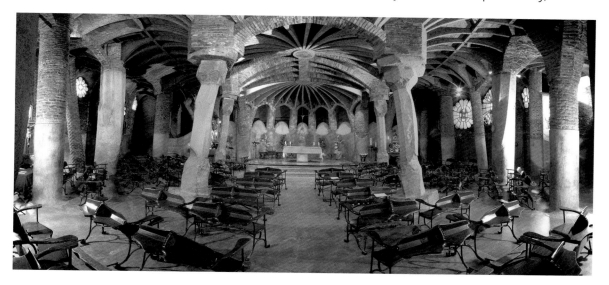

Fig. 8. The interior of Jujol's Botiga Mañach at 57, carrer de Ferran in 1911.
Fig. 9 (cat. 5:75). Josep M. Jujol, *Chair in the Form of a Bleeding Heart, for Botiga Mañach*, 1911.
Fig. 10. The crypt of Colònia Güell, showing the pews designed by Gaudí c. 1914.

is linked to Jujol's profound devotion to the cult of the Sacred Heart of Jesus, which, in 1911, the year Mañach's shop opened, drew many new devotees to the 23rd International Eucharistic Congress. The Congress consecrated Spain to the Sacred Heart of Jesus and declared Mount Tibidabo on the western edge of Barcelona as its National Expiatory Church.

In 1916, Pere Mañach commissioned Jujol to design a new building for his workshops, now used as an educational center, in the Gràcia district of Barcelona. The heavy lamp fashioned from iron and colored glass in the form of three monstrous heads (fig. 11), possibly an allusion of the forces of evil, was made at the Mañach workshops. Jujol used artisanal resources to design prototypes that could then be mass produced. A good example of this is the bronze inkwell displayed in this exhibition, which recalls the futurist art of Umberto Boccioni. This work comes from Jujol's studio on Rambla de Catalunya (fig. 12).[16]

After Pere Mañach's marriage, Jujol also furnished his home. Noteworthy works include the desk in lavish polychromy (fig. 13). Jujol moved away from the colors typical of the turn of the century (peacock blue, apple green, opaline grays, mauves, and acidic tones) and in their place began to employ a bright, daring palette based on patches of red, turquoise, and the golden hues characteristic of his work. It is not surprising that Jujol's followers somewhat wryly termed purpurin "jujolin."

The furniture and objects Jujol "designed" are mostly small pieces with organic forms, usually combining materials rare in traditional furniture making. The freedom of his approach allowed him to plan, imagine, and personally manipulate the objects, many of which were the result of direct communication with craftsmen, rather than working drawings—when he did not make the piece with his own hands. Jujol's method was very different from that of Gaudí, who was assisted by a talented group of collaborators such as the Badia wrought-iron-workers and the Casa i Bardés carpentry workshops, who made his pieces for him.

Jujol had no preference for any particular form or material, and one of the defining features of his art is his use of recycled elements, such as old packaging that could be turned into an item of furniture. His son describes how Jujol would arrive home loaded with the things he had collected along the way: cans, nails, bits of cardboard, glass, etc., all waste that

Fig. 11 (cat. 5:77). Josep M. Jujol, *Lamp from Mañach Workshop*, c. 1916.
Fig. 12 (cat. 5:76). Josep M. Jujol, *Inkwell*, c. 1920–27.

208

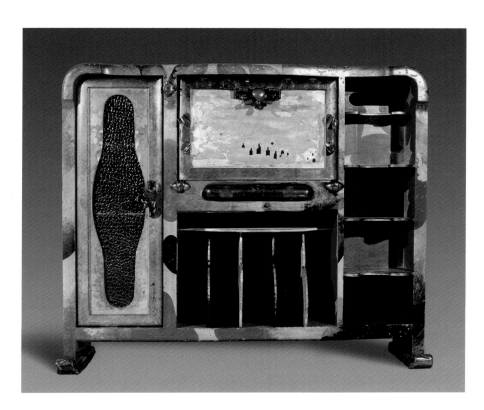

Jujol would personally transform into objects with new life and purpose. A good example of this is the lamp in the Church of the Sagrat Cor in Vistabella, made out of wooden laths, a nail, wire, and cans (fig. 14).[17] The candelabra in the church are made from wooden skittles recycled from everyday children's games and condensed milk cans. Hidden from sight are some incisions that call to mind Jesus' wounds during the Passion. Even the tabernacles (such as the one at Bonastre) call to mind knapsack sprayers like those used by local farmers. The fountain of Our Lady of Loreto (in Bràfim) is welded from old pipes, while the sculpture of the Agnus Dei in the church in Constantí is made of scrap metal.

Fig. 13. The desk and filing unit for scores for the home of Pere Mañach, designed c. 1919 by Jujol, made by the Tallers Comas workshops.

Fig. 14 (cat. 5:81). Josep M. Jujol, *Hanging Lamp from the Church of the Sagrat Cor in Vistabella*, 1918–23.

In one of the most perceptive interpretations of Jujol's use of lowly materials the contemporary artist Perejaume compares the light in the Vistabella church with Picasso's cardboard guitar, recognizing that Picasso's sculpture signals a break with an existing language of art, whereas Jujol's work is the result of a close reading of the Gospels: the transubstantiation of materials, the Franciscan redemption of the humble, and the gathering together of all the community's tools.[18]

Jujol's humble art, founded upon waste and everyday objects, made him a pioneer of modernity. An artist gifted with a very special sensibility, his vision foresaw many creative features later reaffirmed in the work of leading 20th-century artists who never met Jujol. His creations are, therefore, milestones of tremendous importance in contemporary Catalan art, works that offer insights into the imaginative, ingenuous, rudimentary, and extravagant art of Jujol.

1. Josep Francesc Ràfols, "Gaudí i Jujol," *La Veu de Catalunya*, 3 December 1925, 5; and "Els deixebles d'en Gaudí," *La Revista* (1 June 1918): 187–88. Ràfols's contribution is based on primary sources. He studied under Jujol at the Escola d'Arquitectura in 1908 and worked with Gaudí in his studio at the Sagrada Família. Ràfols wrote an important essay in which he revealed the keys to understanding Jujol's artistic personality, published in *Cuadernos de Arquitectura*, no. 13 (September 1950): 61–82.

2. Notable among the various exhibitions on Jujol are *Exposició Commemorativa del Centenari de l'arquitecte Josep M. Jujol* (Barcelona, 1979–80); *Josep M. Jujol, arquitecte* (Barcelona/Palma de Mallorca/Madrid/Girona/Paris, 1989–91); and *L'Univers de Jujol* (Barcelona, 1998). In 1999, a number of events were organized in the city of Tarragona to commemorate the 50th anniversary of his death. One of the most recent exhibitions was organized by the Museu Nacional d'Art de Catalunya, *Jujol dissenyador* (Barcelona, 2002), and focused above all on one of the most unusual and as yet unexplored aspects of his career: objets d'art and designs. Among the monographs published on Jujol are studies by Ignasi de Solà Morales, Carlos Flores, Josep Llinàs, Dennis Dollens, Vincent Ligtelijn, Joan Bassegoda, and Montserrat Duran. See Carme Arnau, "Exposicions i bibliografia," in *Jujol dissenyador*, ed. Mariàngels Fondevila, exh. cat. (Barcelona: Museu Nacional d'Art de Catalunya, Fundació "la Caixa," 2002), 154–59.

3. Exhibition curated by Judith Rohrer in 1987, though sadly no accompanying catalogue was published.

4. See "Sextina a l'arquitecte Josep M. Jujol" by the poet Joan Brossa, published in *Josep Maria Jujol Architecte 1879–1949*, exh. cat. (Paris: Centre de Création Industrielle/Centre Georges Pompidou, 1991); and the essay by the Catalan contemporary artist Perejaume, *Ludwig–Jujol: què és el collage, sinó acostar soledats?* (Barcelona: La Magrana, 1987). One of his keenest admirers is the actor John Malkovich, who had a replica of a bench by Jujol built at his home.

5. Oriol Bohigas, "Fragment d'un diari de memòries," *Quaderns d'Arquitectura i Urbanisme* (October–December 1988/January–February 1989): 30.

6. M. Periel, "Jujol como profesor (entrevista a Federico Correa)," in ibid., 35.

7. The debate intensified following studies published by Carlos Flores and Josep M. Jujol Jr. in the 1970s, which a number of Gaudí scholars regarded as giving exaggerated prominence to Jujol's role in Gaudí's projects. For essential reading on relations between Jujol and Gaudí see A. Pabón Charneco, "The Architectural Collaborators of Antoni Gaudí" (Ph.D. diss., Northwestern University, Evanston, Ill., 1983).

8. See Emilio Sagristá, *Gaudí en la catedral de Mallorca: anécdotas y recuerdos* (Castellón de la Plana: Sociedad Castellonense de Cultura, 1962).

9. This building of 1936 prompted Ràfols to consider Jujol a modern follower of the style of Bernini, Borromini, and Fischer von Erlach. See Ràfols, *Entorn del nostre barroc (1936)*, ed. Joan Bassegoda i Nonell (Barcelona: Labor, 1992).

10. In 1901 Picasso painted a portrait of Mañach, now in the collection of the National Gallery of Art, Washington.

11. Half of Barcelona had locks made by the Mañach company, and its invulnerable safes proved capable of withstanding bombs during the Spanish civil war.

12. Even though it is tempting to believe that Jujol and Joan Miró knew each other, the two men never met. (Pere Mañach did have professional contact with Miró, who lived just a few yards from Botiga Mañach on the same street.)

13. Alfonso, the brother of the filmmaker Luis Buñuel, studied under Jujol at the Escola Tècnica Superior d'Arquitectura and wrote an unpublished monograph on his teacher, *Ensayo sobre Jujol. Trabajo de 5° Curso de carrera* (Barcelona, 1945).

14. Vollard said of his visit to the Mañach workshops: "At the entrance to the workshops was a lamp burning in front of a statue of a saint." See *Recollections of a Picture Dealer*, trans. Violet M. Macdonald (Boston: Little, Brown, 1936). According to Mañach's descendants, he had his workers say the rosary every day.

15. Made by the Calonge furniture makers' workshops in Barcelona and not at the Bardés workshops, as is sometimes said. Reproductions of some of the furnishings in Mañach's shop—three countertops and six chairs—have recently been made.

16. Another copy of the same piece was owned by Pere Mañach's estate, which has donated it to the Museu Nacional d'Art de Catalunya, Barcelona.

17. The village of Vistabella did not have a church, and Jujol was commissioned to construct one in 1917. Paid for by a family and by public subscription, it was built by Jujol using simple materials (local stone, wood, brick, and iron).

18. Perejaume, "Homenatge," *Quaderns d'Arquitectura i Urbanisme* (October–December 1988/January–March 1989): 25–26.

Translated by Susan Brownbridge.

# La Sagrada Família

*JUDITH ROHRER*

When the 31-year-old Antoni Gaudí took over as architect of La Sagrada Família (Expiatory Temple of the Holy Family) late in 1882 (fulfilling its founder's prophetic dream that the work would be directed by a man with blue eyes), construction had already begun on the crypt. Disagreement between Francisco de Paula del Villar, the diocesan architect who had drawn up the plans for the church, and Joan Martorell, the architect assessor to the construction board, led to the resignation of the former and the recommendation by the latter that the relatively unknown Gaudí be given the responsibility of continuing the work. The remainder of his life would be occupied by this project, and his last 12 years were devoted to it exclusively (fig. 1).[1]

Josep Maria Bocabella, the religious publisher and bookseller, conceived the idea for the construction of an expiatory temple dedicated to Jesus's family, the "Earthly Trinity." The temple would serve as the mother church for his Spiritual Association of Devout Followers of Saint Joseph, founded in 1866. The association was ideologically conservative and "integrista," or fundamentalist, in character, populist in its appeal, and intended to reach especially the humble classes, who might identify with the chaste and pious Joseph as the ideal working-class father. Bocabella published a regular monthly bulletin, *El propagador de la devoción a San José,* which sought to promote Christian family values and to counter the radical, anti-clerical thinking that had taken hold among the laboring sectors of the population.

It was in the pages of the *Propagador,* in April 1874, that the idea of a temple first appeared.[2] Initially it was to have been a replica, in Barcelona, of the Baroque church at Loreto, Italy, along with a replica of the House of the Holy Family of Nazareth contained in this Italian basilica. Following the mod-

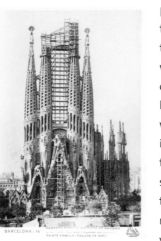

el of the Sacré-Coeur in Paris, its construction would serve as a beacon of faith, proclaiming the revived piety of the Spanish people, while atoning for the sacrileges of enemies of the faith who had militated against the church in the name of federal republicanism. In a more general way, the temple would be called upon to expiate the sins, both public and private, of a modernist, materialist age.

Land in the Barcelona Eixample had become expensive. After several failed attempts to raise money for a site near the center, in November 1881 an entire block was acquired in the still-affordable outskirts, a sparsely developed neighborhood of working-class families with streets unpaved and livestock in evidence. This unpretentious location, while not ideal, was nevertheless seen as providential: the presence of the temple among the working poor might exhort to piety those most vulnerable to the forces of "Satanic warfare"—the forces of anarchism and syndicalism, which were vying with increasing success for their allegiance.[3] Because of both its neighboring population and the humble donations that sustained the work, the Expiatory Temple of the Sagrada Família came to be known as "la catedral dels pobres," the cathedral of the poor.[4]

Leaving behind the baroque of Loreto, del Villar had drawn up plans for a moderately sized neo-Gothic church in keeping with modern places of worship in the Eixample. Once the first stone was ceremoniously laid on St. Joseph's day, 19 March 1882, work proceeded slowly. When Gaudí took over direction of the work, the apse crypt had been excavated and built up to about shoulder height.

It is said that in the early years of his career he was something of a dandy, but Gaudí's work on the Sagrada Família project took hold of him over the years, intensifying his faith to a point of near fanaticism, and he in turn transformed the temple, expand-

Fig. 1. Postcard of Gaudí's Expiatory Temple of La Sagrada Família, c. 1927.

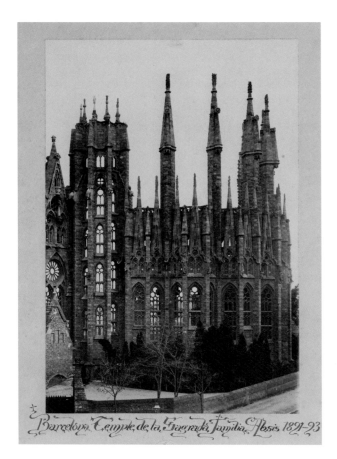

ing its scope with a continually evolving vision of a dramatically new symbolic structure and form—a synthesis that he honed to perfection in his desire to bring the Catholic liturgy alive in the very body of the church itself. This temple-body concurrently grew in size to become grand enough to contain the entire population of Barcelona at the time.[5] His work on other projects over the years would serve as testing ground for ideas for the growing temple, particularly in times of lean funding.

After a slow start in the 1880s, the 1890s produced a devout and anonymous benefactress who donated a magnificent sum, sufficient to accelerate construction over the entire decade.[6] During these years which he would later wistfully refer to as the "time of the fat cows," Gaudí completed work on the crypt, devoting special care to the design and execution of exquisite furniture of woodwork and wrought iron, as well as artistically inventive liturgical instruments and objects for ritual use.[7] He also was able to complete the exterior of the Gothic apse (figs. 2 and 3), with its shell-form gargoyles, and the first bays of an internal cloister that was meant eventually to surround the entire temple, isolating it

from external street noises and creating a space for ritual procession.

To this point Gaudí had been constrained by the previous design, but now, emboldened by the extraordinary funding, his vision for the temple turned toward the gigantic scale it exhibits today. Plans for an adjacent religious theme park were abandoned and the church grew to fill the entire block, based on a basilica plan of five nave aisles and a transept of three. More importantly, at this juncture the architect decided that the ambitious project should proceed "vertically" rather than "horizontally." In other words, he determined that it would be advantageous to build it façade by façade, beginning with that of the northeastern transept, dedicated to the Nativity (fig. 4), and thus to create in his lifetime not the outline of a sacred precinct, but rather a lofty monument, something of a billboard of layered symbolic message. Aware that he could not possibly see the entire building completed, his idea was to leave behind something that would demonstrate the scope of his vision to the generations that would be called upon to finish the work. By beginning, as with a living organism, in birth, with the three por-

Fig. 2 (cat. 5:85). Adolf Mas (photograph, 1910) and Francesc de Paula Quintana (calligraphy, 1927), *La Sagrada Família, Apse.*

tals of Faith, Hope, and Charity, dedicated to the nativity and early family life of Christ, he felt he could more gently and directly reach the working-class neighbors than through the tortured imagery of the Passion, with which he intended to imbue the southwestern portal. Gaudí spoke often of architecture as seduction, and the idea of a gigantic manger scene, beckoning the humble with the joys of Christmas, seemed fitting in this regard.[8]

By the turn of the century, this Nativity façade had grown to the considerable height of the central archivolt, to the level where the four bell towers, their square bases set diagonally, were just beginning to separate themselves from the stony mass to begin their circular, spiraling, parabolic rise. The beginnings of the sculptural program, the popular imagery of the vast manger scene, were being gradually set in place. The chief sculptor was Llorenç Matamala; his son Joan completed the sculptures of the Nativity façade after his father's death. To reinforce the didactic effect of this program, Gaudí included figures that would be immediately legible and relevant to

Fig. 3 (cat. 5:84). Adolf Mas (photograph, 1910) and Francesc de Paula Quintana (calligraphy, 1927), *La Sagrada Família, Apse Spires.*
Fig. 4 (cat. 5:82). Adolf Zerkowitz (photograph) and Francesc de Paula Quintana (calligraphy), *La Sagrada Família, Nativity Façade,* c. 1927.

the Catholic worker. One of the first of these, anchoring the right-hand portal of Faith, was the image of a young Jesus, working in his father's carpentry shop (fig. 5). Similarly, to depict the Temptation of Man inside the Rosary portal to the cloister, he modeled a man of the working classes turning away from a monstrous presence that prof-

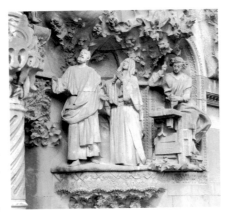

fers an Orsini bomb—the weapon of choice in those years for anarchist terrorism in Barcelona (fig. 6). St. Joseph, the chaste and pious working father, was, of course, present throughout the façade, not only in those tableaux that represented his scarce appearance in biblical reference (the Flight into Egypt, the finding of Jesus among the elders, the marriage to the Virgin Mary, the Nativity itself), but also in scenes of fatherly tenderness. As the captain of the ship of the Church, alluding to his status as Patron of the Universal Catholic Church as proclaimed by Pious IX, he navigates a rugged and cavernous landscape evocative of Montserrat, the mountain sacred to the

Catalans where Bocabella was inspired to found the Josephite association (fig. 7).[9]

More than the figurative sculpture for which Gaudí often used neighborhood inhabitants as models, the exuberant "flowering" of the stone in this "architectural poetry," as Gaudí's friend Joan Maragall would characterize it in 1900, was in its relentless plasticity the most dramatic element of the work, bringing together in "still chaotic" juxtaposition evocations of incense, foliage, frost and snow, rosary beads, constellations, stalactites, birds emerging into flight, the geology of cave and cliff, and religious emblems.[10] In keeping with his explorations elsewhere that were moving toward a sort of architectural Modernisme, here the architect took delight in the rich variety of texture and fluidity that seemed to enliven every inch of the transformed stone.

In 1900, Maragall spoke of the enchantment of indefinite formation in a temple that grew "without

Fig. 5. Jesus in his father's carpentry shop, part of the sculptural group on the Nativity façade, designed c. 1882.
Fig. 6. The Temptation of Man, part of the sculptural group in the narthex of the Rosary portal of Nativity façade, designed c. 1882.

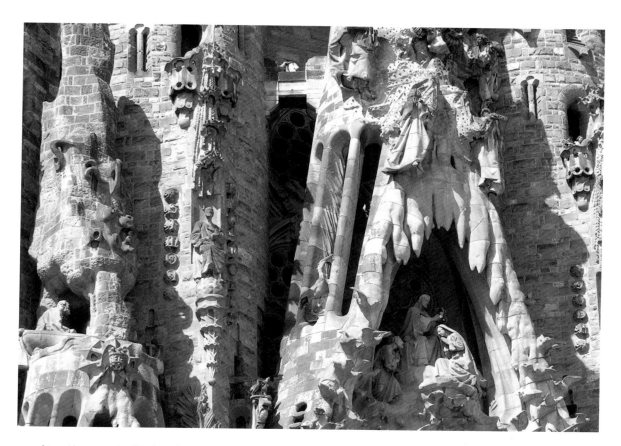

speaking the secret of its height nor its proportions," but five years later the secret was out.[11] In January 1906, a full-blown image of what the temple might one day become was published in the Barcelona press (fig. 8). It was not in *El Propagador,* but rather as the center of a full-page spread in the *Veu de Catalunya,* the organ for the Lliga Regionalista, the conserva-tive Catalanista party. The illustration, bearing the caption "El somni realisat" (The dream realized), re-vealed publicly for the first time the true magnitude of the project wherein the Nativity façade, which had been built to only about a third of its height, was dwarfed by the grandiose central dome.[12] The verti-cal mass was accentuated by the multiple towers and sacristy domes that would climb to the central cross, from which would shine cruciform beams of light to

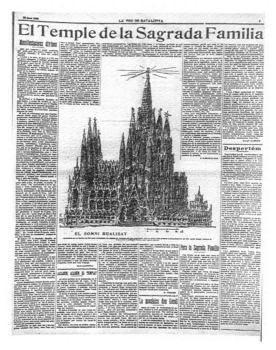

illuminate the night sky, making the Sagrada Família visible from all parts of the city, centering its spiri-tual ideality.

By publishing this first complete image of the future temple in a specific political context and by glossing it with surrounding commentary by leaders from the political and cultural ranks of the party, the Lliga Regionalista clearly meant to adopt this monu-ment as its own—to iden-tify the rising profile with the rising Catalan nation, to transform the "cathedral of the poor" into the "catedral nova," the new cathedral of the new Catalonia as envisioned by conservative, confessional Catalanism. The articles that accompa-nied this visionary temple reinforced such an identifi-cation, as had several other articles published over the preceding months. Aimed at cultivating sponsorship

Fig. 7. Joseph guiding the ship of the Church (lower left), part of the sculptural group on the Nativity façade, designed c. 1882.
Fig. 8. "El somni realisat," illustrating Gaudí's vision of the finished Sagrada Familia, *La Veu de Catalunya,* 20 January 1906, 3.

for the construction among the Catalan bourgeoisie, the respect for the church "among our popular masses" was adduced as another reason to back it in a time of revolutionary concern.[13] As Joan Rubió, the draftsman of the visionary drawing, had written just two days after his election to the city council on the Lliga ticket the previous November: "If we wish to consolidate our Pàtria [and] to feel ourselves swept up in the spirit of brotherhood around the same center and following the same ideal . . . let us raise up to the heavens something that will

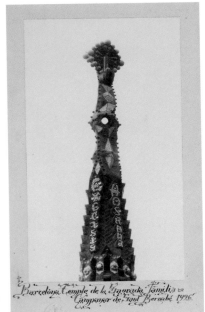

endure. . . . As that triumphal moment of our faith approaches, let us build the house that will hold us all in that day of victory."[14] Rubió was seconding in his promotion of the temple (and in his plea that the Catalanistes give to its construction) another article by Maragall in the *Diario de Barcelona,* "Una gràcia de caritat!," which referred to the Sagrada Família as "our Parthenon," "the monument of Catalan ideality in Barcelona, symbol of ascending piety . . . the image of the popular soul," suggesting that, if Barcelona failed him, Gaudí might have to go into the streets, hat in hand, to beg for alms.[15]

Gaudí, who had given his assistant permission to go through his portfolios and create the composite sketch, was clearly a willing participant in this political appropriation of the work. An ardent sympathizer with the cause, the architect had turned down suggestions that he run for office, saying, "Everyone must use the gifts that God has given them. . . . I am working for Catalonia in my own field, raising

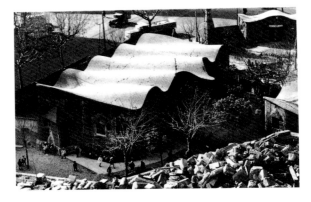

its Temple, since a temple is a people's worthiest representation."[16] Activist architects such as Puig i Cadafalch and Domènech i Montaner had, in the previous decades, established a relationship between architecture, both past and present, and Catalan national identity. By 1906 political meaning was easily read into monumental structures.[17] That a specifically religious monument should come to represent the Lliga's Catalonia reinforced a turn toward the right in a divided Barcelona where the strongest opposition came from the radical republican left. It also represented the success of a number of Catalan clerics who had organized, during the 1890s, among the Catholic forces of the Lliga, founding associations and magazines meant to ensure that "Catalonia would be Christian or she would not be at all," a phrase often attributed to the Bishop Torras i Bages. Gaudí was on close terms with many of these clerics and found a good part of his clientele among those who followed them.[18] At a time when the Sagrada Família had come almost to a standstill for lack of funds, the Lliga support infused new money and new meaning useful for both political and spiritual camps. As the city grew to embrace it and the temple spires rose skyward (fig. 9), it was the more general imagery of "growth," of massive and vertiginous ascent, that would carry the symbolic weight desired by the Lliga over the following years, indexing the ascendancy of the party within the Catalan political panorama.

Juan José Lahuerta has studied the noucentista responses to Gaudí's work in the 1910s in Lliga publications and elsewhere.[19] Despite Eugeni d'Ors' characterization of the temple as "sublime abnormality," these responses seek to find in Gaudí's projects, and particularly in this most troublingly effusive of his works, an underlying order, a harmony that would assimilate it into the symbolic economy of the Catalan conservative cause. It is not without significance that this improbable Gaudí of "law and order" emerged in the wake of the Tragic Week events of

Fig. 9 (cat. 5:85). Adolf Mas (photograph, 1910) and Francesc de Paula Quintana (calligraphy, 1927), *La Sagrada Família, St. Bernabé Bell Tower.*
Fig. 10. Gaudí's parish school at La Sagrada Família, c. 1925.

July 1909 and found its epitome in the façade of a temple that stands incomplete, its double image of ruin and rebirth particularly poignant at a time when many of the city's churches lay in real ruin, torched by the truly chaotic forces of spontaneous mob violence. Nevertheless, this Noucentista embrace was something of a stretch. Far more comprehensible was the enthusiasm for Gaudí and his temple on the part of the Surrealists, who visited Barcelona in the 1930s at Dalí's behest to see and photograph the architect's "soft and hairy" architecture of "terrifying and edible beauty."[20]

It was in the wake of the revolt of 1909 that Gaudí built the provisional school building adjacent to the Sagrada Família (fig. 10), belatedly realizing Bocabella's original desire to educate the street urchins of the neighborhood into the ways of Christian citizenship. This simple, rational structure of Catalan flat brick masonry, combining hyperbolic paraboloids of conic (roof) and sinusoid (walls) profiles, would earn the admiration of Le Corbusier when he visited the site with Josep Lluís Sert in 1928.[21]

With regard to the evolving design for the visionary temple, Gaudí's working methods centered on the making of plaster scale models. He cited a "Hellenic" or Mediterranean sense of plasticity as well as a genealogy of coppersmiths to explain his preference for spatial modeling over linear drawing. After 1915, when a guide service was established at

the Sagrada Família and tourism was encouraged as a way of funding the enterprise, these partial models served to explain those parts of the temple not yet built or fully realized. In 1910 he prepared a particularly remarkable model of the Nativity façade to send to Paris for an exhibition of his work at the Societé Nationale des Beaux-Arts—remarkable because it was partially painted, in bright greens, blues, yellows, and reds especially for the occasion by Josep Maria Jujol. Gaudí always insisted that the temple would be painted (just as the Greeks had painted their temples), but this was the first time that the idea had been visually represented.[22]

In studying the structure for the interior, perhaps the most important model was one which was not specifically meant for the Sagrada Família. Gaudí later told Cèsar Martinell that without first trying out his structural ideas at the Colònia Güell he would never have dared to adopt them for the temple.[23] For the chapel at Güell's factory town south of Barcelona Gaudí had created an original funicular model of hanging cords, catenaries weighted with bags of buckshot according to the loads and thrusts the building parts might bear (fig. 11). The resulting arcs described the skeleton of a building of inclined supports, parabolic towers, and undulating hyperbolic paraboloid surfaces—a chapel whose form would contain within its equilibrated structure all of the loads and thrusts incumbent upon it,

Fig. 11. Scale model of Gaudí's Colònia Güell chapel, made in 1982 by Rainer Graefe, Frei Otto, Jos Tomlow, Arnold Walz, and thier team.

without resorting to any form of buttressing.[24] The model was subsequently photographed both inside and out, and these photographs became the basis for drawings in color depicting the exterior and interior perspectives of the church (figs. 12 and 13). Only the crypt of the Colònia Güell chapel had been built by 1914 when Gaudí turned his attention exclusively to the Sagrada Família. In the end, the models that he constructed in order to clarify the structure of the temple were somewhat less daring, if at the same time more organic in their arborescent imagery.

By 1915, the temple was 30,000 pesetas in debt and continuation of the work was in doubt. It was then that Gaudí and Bocabella's grandson took up the suggestion that Maragall had set forth in 1905, visiting the homes of wealthy patrons of commerce and industry and asking directly for funds. It was at this point, too, that the guide service was established and an album of photographs with a history and explanation of the religious symbolism of the temple in five languages was published by the Devout Followers of St. Joseph, along with a series of postcards. One fund-raising idea, that of offering burial in the temple to those who might leave considerable sums to the work, was eventually rejected by the authorities after several months of pitched battle between the Lliga forces and the radical left in the press, the committee rooms, and even the Spanish parliament. As something of a consolation, in an extraordinary budget of 1917, the municipal government did grant a one-time subvention of 100,000 pesetas for the construction of a definitive model of the Sagrada Família at a scale of 1:10. Jaume Bofill i Mates, the councilor who proposed the subvention, argued that "building this model will assure that the criteria that its Architect has determined will be definitively established and that its conception will endure, so that when he is gone from the world of the living, his ideas can serve as the standard for future Architects."[25]

As the towers slowly neared their pinnacles, it was to this large model that Gaudí devoted much of his attention in the later years. Unlike the Colònia Güell model, this one was more traditionally calculated on paper and then realized in plaster, accommodating its dramatic scale by a movable ceiling in the workshop located on the building site.[26] Rather than a diagram of mechanical forces at work, the image here was one of a forest of branching rotational columns rising up to the skylights opened in the hyperbolic paraboloids that formed the folded vaulting. Each of the inclined "trees" with its extended, twisting, polygonally evolving branches was made to support the segment of vault above it, creating a self-sustaining framework that left the nave walls relatively free of load-bearing functions. Instead

Fig. 12 (cat. 5:92). Antoni Gaudí, *Colònia Güell Chapel, Sketch of the Interior Nave on an Inverted Photograph of Its Polyfunicular Model*, c. 1910.

they were pierced with lacy windows formed with multiple ruled surfaces (curved surfaces generated by straight lines) that admitted a raking light deep into the body of the temple.[27]

There is a certain angularity to the forms that emerge in this model, less fluid in its continuity than Gaudí's earlier work. While not abandoning the ruled surfaces of double curvature that were so much a part of his structural thinking, he nevertheless turned in the last phase of his work toward intersecting and interlocking polyhedral geometries that yield an angular, prismatic, crystalline, almost cubist effect. This can best be seen in the finials that he designed to cap the twelve apostle towers, combining complex polyhedrons with spheres and hyperbolic paraboloids to create the abstracted symbols of episcopal office: the ring, the crosier, and the miter (fig. 14).[28]

Gaudí only lived to see one of the towers complete. Several months thereafter, on 7 June 1926, he was struck down by a trolley on his way to evening Mass and died two days later. By special dispensation he was allowed to be buried in the crypt of the Expiatory Temple of the Sagrada Família, to which he had dedicated so much of his working life.

With Gaudí's death there was debate regarding whether and how the Sagrada Família should be continued.[29] Some thought it should be left as he had left it, a monument to the architect's vision. Others felt it should be continued according

Fig. 13 (cat. 5:93). Antoni Gaudí, *Colònia Güell Chapel, Sketch of the Elevation of the Main Façade on an Inverted Photograph of Its Polyfunicular Model,* c. 1910.

Fig. 14. The bell towers of Gaudí's La Sagrada Família.

to the models and drawings that he had left behind. (fig. 15) Still others hoped for another visionary to come along and take up the challenge (Jujol?). Once again work came to a near standstill as those who had worked closely with the master completed over the next decade the three remaining finials of the Nativity façade and continued to work on the sculptural figures that were planned but not completed in his lifetime. In 1936, at the outbreak of the civil war, Gaudí's workshop and studio were burned and the models smashed to pieces.

As anyone who has recently visited Barcelona knows, this was not the end of the story. Followers of Gaudí took on the postwar task of reconstructing the models from the thousands of shards collected in the crypt (figs. 16–18), and in 1954, with two small sketches to go on, work commenced on the Passion façade, the towers of which were completed in 1976, just as the Franco dictatorship came to a close.[30] In 1986, the sculptor Josep Maria Subirachs was given carte blanche to create a controversial sculptural program for this façade, centered on the last days and Crucifixion of Christ. Simultaneously a devoted team of architects, sculptors, and engineers has been

working to build the body of the temple according to meticulous research into Gaudí's working methods.[31] Searching and re-searching the plaster artifacts, using computerized projections to uncover the geometric "laws" that generated the architect's final structural solutions, and introducing modern materials such as reinforced concrete, they have now set in place most of the interior columns, their branching crowns, and the starburst vaults that cover the vast space of the temple (fig. 19).

In the year 2003, the Vatican opened the formal process for the beatification of Antoni Gaudí, responding to an initiative by people close to the Sagrada Família. The tomb of Gaudí is being promoted as a cult site, while the temple itself, despite continuing controversy related to its politico-religious and architectural significance, has become the one building most closely associated with the city of Barcelona and its principal tourist attraction. As hordes of tourists throng to its precinct, supporting the work with their entrance fees, more than a few have seen in the spectacular temple, still growing in a time that may have outgrown its message, the requisite "miracle" needed to situate the architect among the "Blessed."

Fig. 15. Gaudí's 1:10 model of La Sagrada Familia nave in his studio, 1926.

Fig. 16 (cat. 5:86). Antoni Gaudí, *Model of Finial for Spires from the Temple of La Sagrada Família*, c. 1920.

Fig. 17 (cat. 5:87). Antoni Gaudí, *Model of Spires from the Temple of La Sagrada Família*, c. 1910.

Fig. 18 (cat. 5:88a–b). Antoni Gaudí, *Model of a Column and Capital from the Temple of La Sagrada Família*, c. 1920.

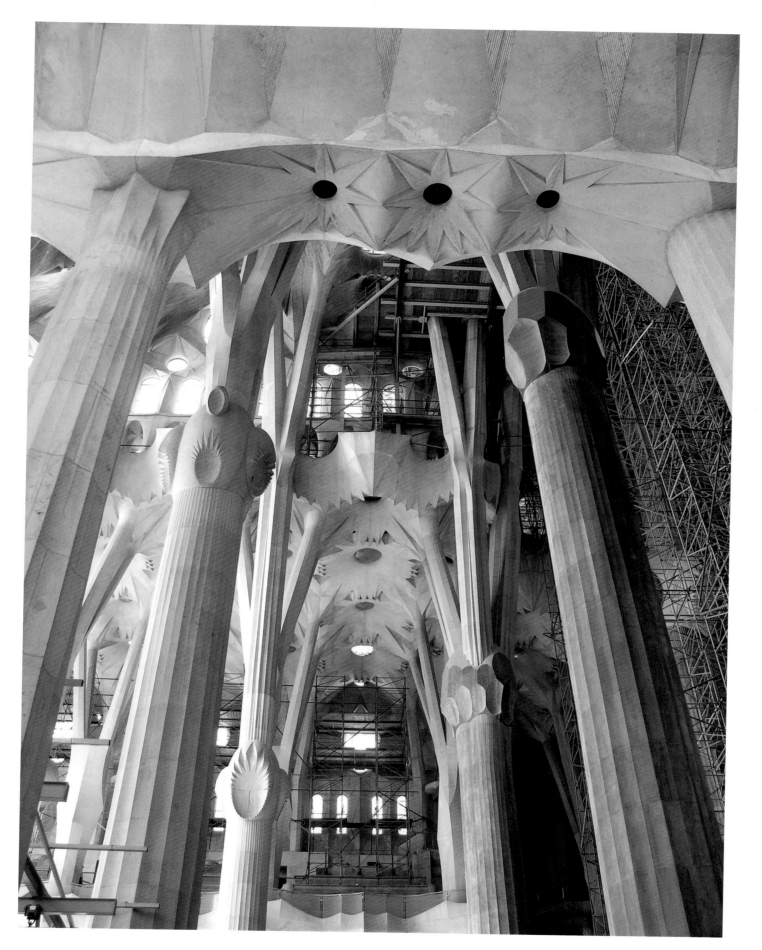

Fig. 19. Current construction on nave of La Sagrada Família, 2005.

1. The primary sources for Gaudí's work on the Sagrada Família are the several accounts written by the younger men, some of them assistants on the project, who had firsthand contact with the "mestre." These include Isidre Puig Boada, *El Temple de la Sagrada Família* (Barcelona: Barcino, 1929); José F. Ráfols, *Antonio Gaudí* (Barcelona: Canosa, 1929), which contains Francisco Folguera's, "La Arquitectura Gaudiniana"; Cèsar Martinell, *Gaudí i La Sagrada Família comentada per ell mateix* (Barcelona: Aymá, 1951); and Joan Bergós, *Gaudí, The Man and His Work,* trans. Gerardo Denis (Boston/New York/London: Little, Brown, 2002). More recent sources for this material include Joan Bassegoda Nonell, *El gran Gaudí* (Sabadell: Ausa, 1989), especially for the chronology and extensive bibliography, and, in English, Cèsar Martinell, *Gaudí: His Life, His Theory, His Work,* trans. Judith Rohrer (Cambridge: MIT Press, 1975); Juan José Lahuerta, *Antoni Gaudí: Architecture, Ideology and Politics,* trans. Graham Thompson (Milan: Electa, 1992); Mark Burry, *Expiatory Church of the Sagrada Família* (London: Phaidon Press, 1993); and Jordi Bonet, *The Essential Gaudí,* trans. Mark Burry (Barcelona: Pòrtic, 2000).

2. The temple idea and its relation to Montmartre was first published in April 1874 in the letter sent from Rome by the spiritual director of the association, José Maria Rodríguez, a regular feature of the *Propagador,* making it clear that the concept was Bocabella's. It was not until February 1875, however, that specifics of the project were developed, including its replication of the Loreto. "Un templo dedicado á la sagrada Família," *El propagador de la devoción a San José* (February 1875): 84–87. From this point on the refinement of the concept, the collection of funds, the search for land, and the expiatory mission of the temple can be followed in the pages of the monthly bulletin. Beginning in 1883, the *Propagador* commenced twice-monthly publication: the first issue was a "bulletin of piety," with prayers and reports on donations and progress at the building site, and the second a "bulletin of struggle," meant to directly confront those who "whether because of indifference or incredulity, neither pray nor meditate and, in fact, make fun of these activities." By July 1878 the association had more than 500,000 members and the *Propagador* 11,000 subscribers.

3. "Te Deum Laudamus!!!," *El propagador de la devoción a San José* (November 1881): 366–68.

4. The painter Joaquim Mir exhibited his large painting *The Cathedral of the Poor* (Carmen Thyssen-Bornemisza Collection, Museu Nacional d'Art de Catalunya, Barcelona) in 1898, which fixed the epithet in the public mind. The painting depicted a poor, ragged family huddled in the foreground with the church construction rising in the background. The son of the joyless family holds out his hand to the viewer, begging pathetically for money clearly not intended for the building project. It seems possible that Mir intended this as an ironic commentary on the title (and, by extension, on the project). For a standard interpretation of the picture as sympathetic to the project and its social aims see B. Bassegoda, "La navidad en piedra," *Diario de Barcelona,* 20 December 1905. Clearly assuming a positive association, the Generalitat de Catalunya chose this image for the poster it issued in 1982 to commemorate the centennial of the laying of the first stone.

5. On Gaudí's growing religiosity see especially Martinell, *Gaudí: His Life, His Theory, His Work,* 50–51, 70–75.

6. "Una Limosna," *El propagador de la devoción a San José* (1 June 1898): 285–88 reported on the end of the donation, which had added sums alternating between 2,500 and 5,000 pesetas monthly to the construction coffers from August 1891 to May 1896; from June 1896 to February 1898, 15,000 pesetas were donated each month with a final donation in March of 10,000 more, bringing the total over the years to 577,500 pesetas. The article was intended to rally the faithful to send money to stave off the drought that was bound to follow once the "limosna grande" dried up. Martinell, *Gaudí i la Sagrada Família,* 103–4, records that Gaudí indicated that Bocabella, before he died in April 1892, urged his architect to spend the money as rapidly as possible, concerned that the new Bishop of Barcelona might take interest in the still-private enterprise and seek to divert funding to things diocesan.

7. Martinell, *Gaudí i la Sagrada Família,* 45, reports that Gaudí indicated that he would not spend the money thus if given the chance again, but that he wasn't sorry to have done so then.

8. Gaudí's decision is reported widely in the literature on the temple. See, for example, Puig Boada, *El Temple de la Sagrada Família,* 14, who quotes Gaudí as saying: "It is not possible for one single generation to build all of the Temple; so let us leave behind such vigorous signs of our passing that the generations to come will feel stimulated to do their part. At the same time, let's not tie them down regarding the rest of the work." He explained the choice of the Nativity façade as the ideal "vigorous sign" because "facing the workers [it would] make the new construction call to the people in evoking Christmas." In a later version of his book (Barcelona: Nou Art Thor, 1986) Puig Boada emphasizes Gaudí's concern for the seductive aspect, attributing to him a further comment: "If instead of building this façade, decorated, ornamented, soft, I had begun with the Passion, hard, barren, as if made of bones, people would have been repelled."

9. Lahuerta, *Antoni Gaudí,* 258–73, develops a rich case for an identification of the Sagrada Família itself, the temple-mountain, with Montserrat, based especially on an equally rich analysis of the poetics of Joan Maragall in the first decade of the 20th century. For an especially complete explanation of the elaborate symbolism and iconography of the temple as Gaudí envisioned it, see Bergós, *Gaudí, The Man and His Work,* 71–79.

10. Maragall, "El Templo Que Nace," *Diario de Barcelona,* 20 December 1900, 10593–594.

11. Ibid.

12. "El Temple de la Sagrada Família," *La Veu de Catalunya,* 20 January 1906, 3. Under this banner were included the following articles: Joan Llimona, "Manifestacions divines"; Josep Pijoan, "Acabèm, acabèm el temple"; Fèlix Cardellach, "La mecànica den Gaudí"; Josep Carner, "Per la Sagrada Família"; and "Despertèm!" Previous articles setting the stage for this revelation in *La Veu,* included Josep Pijoan, "La Sagrada Família: la catedral nova," 27 September 1905, 1; Joan Rubió i Bellver, "En Joan Maragall té rahó," 14 November 1905, 1; and Josep Pin i Soler, "El temple de la Sagrada Família: l'arquitecte Gaudí," 15 November 1905, 1.

13. Pijoan, "La Sagrada Família," 1. For a more detailed account of this "Catalanization" of the Sagrada Família see Judith Rohrer, "Una visió apropiada: el Temple de la Sagrada Família de Gaudí i la política arquitectònica de la Lliga Regionalista" in *Gaudí i el seu temps,* ed. Lahuerta (Barcelona: Barcanova, 1990), 191–212.

14. Rubió, "En Joan Maragall té rahó," 1.

15. Joan Maragall, "Una gràcia de caritat!," *Diario de Barcelona,* 7 November 1905, 12127–128. This article was also published in *El propagador* and reprinted often over the years to rally donations to the construction.

16. Bergós, *Gaudí, The Man and His Work,* 32.

17. For this cultural-political work on the part of the Catalanista architects who referred to themselves and their project as "la nova escola catalana" or the new school of Catalan architecture, see Judith Rohrer, "Puig i Cadafalch: The Early Work," in *J. Puig i Cadafalch: l'arquitectura entre la casa i la ciutat,* ed. Judith Rohrer and Ignasi de Solà-Morales, exh. cat. (Barcelona: Fundació Caixa de Pensions, 1989), 14–32.

18. See Jordi Castellanos, "Torras i Bages i Gaudí," in *Gaudí i el seu temps,* 143–89, for the influence of the bishop and the Vic circle of prelates on Gaudí's aesthetic-religious thinking as well as on that of his clientele, especially those in the Lliga Espiritual de Nostra Senyora de Montserrat.

19. Lahuerta, *Antoni Gaudí,* 296–300. It seems possible also to read similar appeals to order and reason already in the 1906 articles in

*La Veu* cited above (note 12), especially that by Félix Cardellach who explains the rational, geometric basis of Gaudí's design, fending off criticisms of it as irrational or capricious.

20. For the surrealist reception of Gaudí, see *Dalí i Gaudí: la revolució del sentiment d'originalitat,* exh. cat. (Barcelona: Fundació Caixa Catalunya, 2004), and Lahuerta, "Gaudí, Dalí: les afinnitats electives," in *Dalí: Arquitectura* (Barcelona: Fundació Caixa de Catalunya, 1996), 50–59.

21. The best discussion of Gaudí's structure, particularly that related to traditional Catalan building methods, is still George R. Collins, "Antonio Gaudí: Structure and Form," *Perspecta* 8 (1968): 63–90. On the school, see Jordi Boneti Armengol, *The Escoles Provisionals of the Sagrada Família* (Barcelona: Escudo de Oro, 2002).

22. On polychromy, see Martinell, *Gaudí i La Sagrada Família,* 33–34, 59–60. As Martinell tended to correct anything in his notes from the 1915–16 period that he knew subsequently to have changed in Gaudí's mind, we can assume that he intended to paint the façade—in those parts of the building especially which were not touched by the sun—right up until the end. On the Gaudí exhibition in Paris, which was sponsored by Gaudí's mecenas Eusebi Güell, see Judith Urbano, ed., *Gaudí a París l'any 1910,* exh. cat. (Barcelona: ESARQ, Universitat Internacional de Catalunya, 2002), which reprints the significant reviews from the Barcelona and French press.

23. Martinell, *Gaudí i La Sagrada Família,* 87.

24. The most complete study of the Colònia Güell model is Jos Tomlow, "The Model: Antoni Gaudí's Hanging Model and Its Reconstruction: New Light on the Design of the Church of Colònia Güell," in *IL 34* (Stuttgart: Institute for Lightwork Structures, 1989).

25. The debate over this subvention can be found in the city council minutes, vol. 220, 18 May 1917, 197v–216v, during which it is attested that the city had already subvened models of the Sagrada Família in two previous allocations of 6,000 pesetas each. For the political battles over the burial request see Judith Rohrer, "Filled with Meaning: Polemic and Politics Surrounding the Sagrada Família," in *Gaudí 2002: Miscellany,* ed. Daniel Giralt-Miracle (Barcelona: Planeta, 2002), 278–93, especially 286–88.

26. On Gaudí's workshop, see Josep Gómez-Serrano, *L'obrador de Gaudí /Gaudí's Workshop* (Barcelona: Edicions de la UPC, 1996).

27. An early account of the interior structure as set forth in the model can be found in Folguera, "La Arquitectura Gaudiniana," 256–63. More recent, highly technical accounts can be found in Burry, *Expiatory Church of the Sagrada Família,* and Bonet, *The Essential Gaudí.* Jordi Bonet i Armengol is the current directing architect and coordinator of work on the Sagrada Família, and Mark Burry is a structural consultant on the work; both write from close association with the ongoing work to reproduce Gaudí's structural methods (in both plaster and computer modeling) as a guide to the construction of the temple. Related information regarding Gaudí's complex geometries can be found in J. Gómez-Serrano, *Gaudí: la recerca de la forma* (Barcelona: Lunwerg/ Ajuntament de Barcelona, 2002).

28. For Gaudí's thoughts on the completion of the first tower, see Martinell (reporting on a conversation with Gaudí of 22 January 1926), *Gaudí i La Sagrada Família,* 137–44.

29. *La Veu de Catalunya,* 6 July 1926, opened an inquiry that summarized the range of opinion at that time, asking the questions: 1. What do you think is the worth of the Sagrada Família? 2. Work is going very slowly—how do you think it might be accelerated? 3. Don't you think that now, given Gaudí's death, that we must, all of us, come together to see to it that his masterpiece is completed? Answers from well-known figures in the Catalan cultural world were published over the next two months and included some responses that questioned the continuation, despite the partisan assumptions of the survey. In 1965, in response to accelerated work on the Passion façade, a major controversy centered on a letter to the editor of *La Vanguardia Española,* initiated by the architect Oriol Bohigas and signed by illustrious architects, artists, and other cultural representatives from Europe and Catalonia, urging a stop to the construction on social, urbanistic, pastoral, and artistic grounds. See "Cartas a *La Vanguardia*: La obra del templo de la Sagrada Família," 9 January 1965. Defenses of the project were published in *La Vanguardia* and other periodicals through 14 February of that year.

30. Bonet, *The Essential Gaudí,* 46–53, relates the story of the destruction, salvaging, and eventual reconstruction of the model, as well as the cataloging of the many non-reconstructed pieces for possible future use.

31. Burry and Bonet are the primary sources for continuing work on the temple.

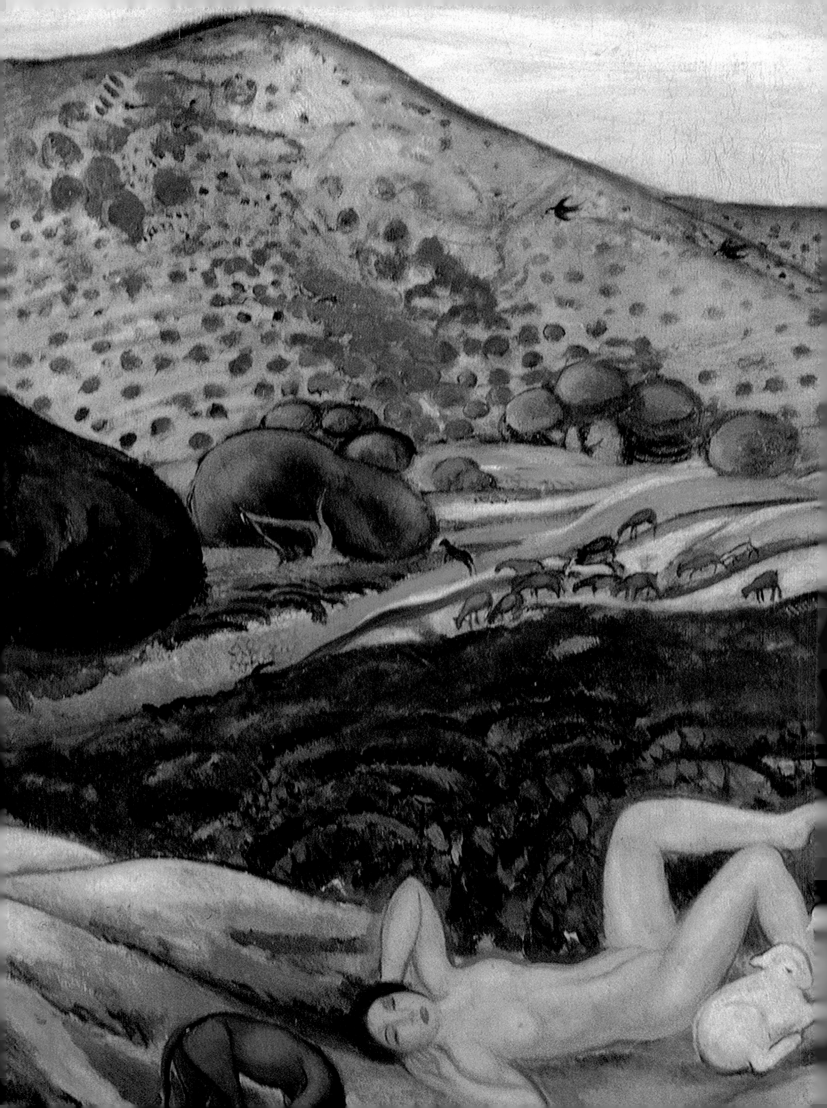

# Noucentisme and the
# Classical Revival

# Catalan Noucentisme, the Mediterranean, and Tradition

*ALÍCIA SUÀREZ AND MERCÈ VIDAL*

Since the 1980s, new thinking about the avant-garde has raised the question of whether it progressed in a single direction. This reconsideration of the cultural map of art movements has allowed phenomena such as Catalan Noucentisme to be studied in much greater detail than before, with entire sections of international exhibitions devoted to it.[1] Today, Noucentisme is no longer seen as separate from the other developments that took shape in Europe, from the turn-of-the-century classicist reaction against Symbolism to the demand for a "return to order" after the First World War. As a European phenomenon, the roots of Noucentisme lie in the Latin world of the Mediterranean. It is also true, however, that the political and cultural climate of Catalonia was crucial in determining some of the specific elements that Noucentisme adopted.

The first systematic coordination of politics and culture and the pursuit of common goals can be found in the programmatic and constructive character of Noucentisme. As has been said before, Noucentisme was "the first attempt at an orientation, not imposed but guided and channeled; the first governmental intervention in the history of our culture."[2] Barcelona lost its own Corts (parliament) in the 16th century and has suffered under the yoke of a state hostile to it since the 18th century. However, the positive results achieved by the Regionalist League in the 1901 general elections, when a number of its members were elected, followed by its widespread success in the municipal elections shortly after, made the party an important political alternative under its charismatic leader, Enric Prat de la Riba.[3] The key points of its manifesto were Catalanism, building a modern country, and reforming society along interclass lines. The goal was to attain the "normality" in Catalonia that Prat "saw in more 'civilized' countries," an objective reflected today in the widespread urge to see Catalonia as one of the countries "at the forefront of Europe."

Prat de la Riba's vision, published in 1906 in his book *La nacionalitat catalana*, refers continually to the organic nature of the nation, and it is imbued with Hippolyte Taine's theory of race, milieu, and moment as it "seeks in these qualities, as Taine describes them, the foundations and roots of regionalism."[4] Similarly, when Prat discusses art, he points directly to the convergence of a series of sociological causes resulting from race, climate, and culture: "That nationality that has been able to create an original art has produced one of the finest demonstrations of life that a people can make."[5] From the moment it appeared, *La nacionalitat catalana* provided clear guidance, even to philosopher and writer Eugeni d'Ors, who often mentioned it, describing it as "the pivotal book of Catalonia," and to Joaquim Folch i Torres, who said it was the missing element that "gave everyone a program of tasks to perform."

As the philosophy and program of Noucentisme began taking shape, so manifestations of the break with the 19th-century tradition of Modernisme became more marked. The nub of the issue was how to endow Noucentisme with a new and distinctive character that would emphasize its modern dimension. Gradually, eyes began to turn to those aspects deemed inappropriate, such as foreign influences introduced under Modernisme. Alexandre Plana, for example, commented that Modernisme "led us to a foolish and irrational admiration for the foreigner," but "we now have a school of sculptors who seek models in the bodies of our own race" and "we now have a school of painting that has been born into the light of the Mediterranean."[6] Joaquín Torres-García too remarked on Modernisme, dubbing it a phenomenon typical of "the people of the north."[7] Whereas Modernisme had sought modernization through an openness to European culture, Noucentisme hoped to discover in nationalism the values that would disseminate a modern ideology of timeless values, such as the Mediterranean tradition, the Latin world, classicism, clarity, and craft, that would be useful in satisfying the aspiration for modernity. Noucentisme was, therefore, inclined toward idealism and opposed to modernista naturalism.

When contemplating Torres-García's work, Ors described the artist as "our idealistic painter: idealism is far from naturalism, but nor does it signify abstraction. . . . We Mediterraneans remain, in accordance with our purest tradition, idealists, which is not to say that we deny or scorn the material world, but that we order it according to type and size."[8] This was, in effect, the aesthetic approach of Noucentisme—founded on concepts such as structure, rhythm, harmony, and order, and presented as an exercise in organization, as opposed to the emotionalism and spontaneity of modernista art. As the Noucentistes set about reworking (in other words, idealizing) nature, they acted on reality from the outside, drawing closer to it from the distance imposed by their intelligence, and hence requiring models that drew on popular and classical tradition.

In this dichotomy between Modernisme and Noucentisme, it is important to point out that in contrast to the autonomous concept of art proclaimed by Modernisme (allied with the notions of art for art's sake and individualism, of which Josep Pijoan remarked, "individualism is what is popularly known as Modernisme"[9]), Noucentisme directed its hopes toward a social art capable of regeneration through the artistic crafts and the attainment of public beauty. Much of the doctrine surrounding the noucentista aesthetic ideal of a national and civil art was a reaction against Vuitcentisme (1800s), and it followed the general direction being taken in France by emerging Mediterraneanist trends: first, through the École Romane and its political counterpart, Action Française, and continued later by Maurice Denis and Cézannism; and, second, by cubist classicism, as formulated by Jean Metzinger and Maurice Reynal and the classical rhetoric of l'Esprit Nouveau. There are, then, certainly similarities to be found between noucentista artistic production and this framework in the international context.

Another event that influenced the emergent concept of Noucentisme occurred in 1906, when Ors[10] began his "Glosari" (see fig. 1, p. 235), a series of brief reflections published daily in the newspaper La Veu de Catalunya, 1906–20. In this column Ors gradually fashioned an approach and an aesthetic system in which art played a key role because it was capable of shaping the civilizing ideals of Noucentisme, a project that embraced modernity. Even though the term "Noucentisme" literally meant "1900s," in other words the 20th century, it soon began to acquire another meaning and helped to shape the new program. As Ors remarked, "Let us all be happy for now with calling ourselves noucentistes, a chronological adjective, for though it may have no specific meaning as yet, perchance it may be the most meaningful of all adjectives tomorrow."[11] In this respect, it should be noted that art was expected to respond to collective interests, and the artist—as occurred at the height of splendor of humanism—was expected to serve as the mouthpiece for the aspirations and the national condition on which the noucentista program was established.

If Ors's editorials proved extremely influential among young people, then the "Pàgina Artística" section, edited at first by Raimon Casellas[12] and shortly after by Joaquim Folch i Torres,[13] was an important reference for the artistic community. It is possible to identify in Folch, an art critic with a social concept of art, ideas derived from theorists such as Taine and Jean-Marie Guyau. Folch's view was that artists should look at the rural world and popular art because sources capable of nurturing the new artistic creations survived there in a pure and uncontaminated state.

This was not, however, the popular regionalist trend that served as a source of artistic inspiration for several decades during the wave of nationalist sentiment in 19th-century Europe. Underpinned by nationalism, Noucentisme looked to the rural world for constant and essential values: "It is not a problem of copying forms but of studying the whys and wherefores of these forms. . . . There is a need for artists who can pour their personal force into the glass of these immutable, unvarying principles."[14] Very simply, Noucentisme sought in the countryside fundamental values that, in its view, would guide the project to which everyone aspired.

When this noucentista discourse was first being formulated, there was no noucentista art; that phenomenon only emerged with the blossoming of works by Josep Clarà, Joaquim Sunyer, Enric Casanovas, and Torres-García, for as Folch said, "painting needs years to develop before resolving itself, hence it is behind our intellectual move-

ment."[15] The group Les Arts i els Artistes, founded in 1910, gradually gathered and shaped the most representative exponents of noucentista art, though the approach taken by art criticism often contributed to a specific reading of it.[16] Folch considered the sculptor Clarà one of the instigators of the new aesthetic ideal, followed by Torres-García, Sunyer, and Casanovas. In 1911, Clarà's works were described as the "reconstruction of an ancient beauty," and two years later, Clarà's Latin heritage supplied Folch with a simile: "the art of those houses with white walls and a large tiled roof, those round portals and broad windows, those sheltered sunny spots with galleries with arches."[17] As we can see, nothing could be closer to that image than the one offered by popular architecture. Torres-García's paintings gave Folch "the feeling of patriarchal, austere dignity" and Sunyer "the feeling of the primitives" but expressed in the language of today, above all in the simplicity that permeated the elements of his paintings, the "figures, trees, mountains reduced to the *summum* of their structural form." Folch noted, in an early exhibition of Casanovas's sculptures with roughly finished heads, that "crumb of archaeological weakness" (meaning that the sculptures were highly indebted to classical sculpture just as bread crumbs are small pieces of something much larger) and a sense, not of the ability to see, but of "something" related to the geography of Catalonia, with its rolling hills "that face toward the blue sea."[18]

There were some artworks, however, that anticipated the movement. Examples include Torres-García's paintings of 1901–5, which are imbued with a classical reaction against Symbolism similar to that found in the work of Pierre Puvis de Chavannes in France; the unusual drawings of Pere Torné Esquius, which appeared from 1904 onward in *Forma* magazine and which, in 1910, gave rise to *Els dolços indrets de Catalunya;* and finally, Ors's early if fruitless initiative in 1909 to form a group of architects, men of letters, and musicians as a nucleus of creators. This attempt eventually proved successful when the group Les Arts i els Artistes was established in 1910 and became better known upon the publication of its journal *Almanach dels Noucentistes* in 1911.

When the *Almanach* appeared, a short article, meaningfully entitled "Upon Commencing the History of the Noucentistes," signed by Flama, declared that thenceforth the word "Ciutat" (city) would be written with a capital C.[19] The *Almanach* regarded members of many sections of society—sculptors, painters, architects, men of letters, economists, politicians, teachers, and students—as jointly responsible for the venture to build the nation of Catalonia. If the members of Les Arts i els Artistes were this categorical, however, it was because a bolder statement had already been made. Above and beyond the artistic eclecticism of the *Almanach,* which is always remarked on, the artist was considered a member of a group and accorded the role of its collective mouthpiece. Thus, art and society were reconciled. The cover of the journal is illustrated with a woodcut by Josep Aragay, reviving a technique that was common during the Baroque period, especially in the popular arts, and uses a bird-like tailpiece to indicate the months of the year.[20] The half-title page features a reproduction of a small head of Venus discovered in 1909 in Empúries, and through this identification with a mythical Latin origin they hoped to make their ideals legitimate.

Noucentisme was predominantly urban in character, as it adopted the city as an emblem of modernity. The word "Ciutat" appears frequently in noucentista texts, where it became a metaphor identified with the overall goal of building a nation, starting with the capital of Barcelona and spreading out through the concept called "Catalonia-city."[21] Moreover, the Noucentistes identified with everything associated with being part of a community and surrounding oneself in one's own habitat, identifying the values of urban life with libraries, museums, schools, monuments, etc. "As fragmentarily and as confusedly as you want," wrote Xènius in 1906, "it must be recognized that the noucentistes have, in their Catalan idealism, coined two new words: *Imperialism* [and] *Arbitrarism*. —These two words are encompassed in a single word: Civility. —The work of the noucentistes in Catalonia is—or rather, will be—*civilizing work*."[22]

Noucentisme saw culture as a cohesive force that required the commitment of the intellectual as mediator, otherwise it would never be built, so much so that the active presence of a ruling elite consisting of specialists, professionals in culture if you will,

became one of the movement's goals. This elite was considered jointly responsible for the fundamental mechanisms required to construct a modern culture. Examples of this approach are provided by Josep Pijoan, the first secretary of the Institut d'Estudis Catalans and the driving force behind the Junta de Museus and the Biblioteca de Catalunya; Ors, director of Public Instruction for the Mancomunitat and secretary of the Institut d'Estudis Catalans; Folch i Torres, director general of Museus d'Art de Barcelona; Francesc d'Assís Galí, principal of the Escola Superior dels Bells Oficis; and Jeroni Martorell, director of the Servei de Catalogació i Conservació del Patrimoni. The Noucentistes encouraged or put in place a range of services and policies capable of generating a "normalized" cultural dynamic, including standardizing the rules of the Catalan language and fostering its use in every sphere of social activity; primary and secondary schools, and scientific education centers; libraries built throughout the country; museums; exhibitions; and publishing companies that would issue small monographs on artists, thereby creating a history of this art (fig. 1).[23]

After the proclamation and establishment of a new body of self-government—the Mancomunitat de Catalunya, a federation of the four provinces in the country with Prat de la Riba as its president—political circumstances in Catalonia created a climate of optimism that intensified the noucentista cultural and institutional dynamic.[24] The high point of Noucentisme occurred during the years 1906–23,

after which a series of events disrupted the unity of purpose that the Noucentistes had managed to sustain until then. The establishment of the dictatorship of Primo de la Rivera in 1923 marked a turning point from which there was no political recovery until the era of the Second Republic (1931–36), although in the arts fields events such as the publication of the *Manifest groc* (*Yellow Manifesto*, 1928) and the establishment of GATCPAC (Association of Catalan Architects and Technicians for Progress in Contemporary Architecture, 1930) and ADLAN (Friends of New Art, 1932) show the possibility of projects of modernity far more radical in their proposals.

While the noucentista philosophy of building a modern culture was founded on national and civic ideals, classical Mediterranean and popular traditions informed and underpinned the movement. Numerous artists discovered the Mediterranean in the late 19th and early 20th centuries. The notion prevalent during the Impressionist era that painting was the private reserve of northern countries began to change when Vincent van Gogh discovered the Midi and when artists such as Pierre Auguste Renoir, Claude Monet, and Pierre Bonnard were drawn to the south by the master of Aix-en-Provence, Paul Cézanne, who turned "le motif" into the crux of his research. Many artists began making sorties from Paris to capture the coastal landscape from Bordhigera to L'Estaque, Saint-Tropez, and Collioure. More artists became aware of the south and some of them, such

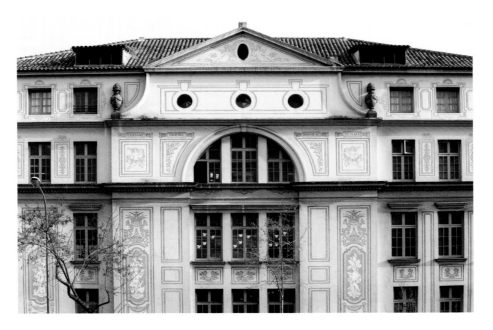

Fig. 1. The school complex Grup Escolar Ramon Llull, designed by Josep Goday in 1919, with sgraffito decoration by Francesc Canyellas.

as Henri Matisse and André Derain, created small arcadias, a paradise recovered.[25] Maurice Denis's critical commentaries on Cézanne and Aristide Maillol, who had taken up residence in Banyuls-sur-mer, where he was born, did not go unnoticed by Catalan critics or artists.[26] The Mediterranean played a precise role in the history of modern painting from the closing quarter of the 19th century to the 1920s.[27] Catalan journals such as *Vell i Nou, Revista Nova* (see figs. 5 and 6, p. 276), *La Nova Revista,* and *La Ciutat i la Casa,* as well as the art pages in newspapers such as *La Veu de Catalunya, La Publicidad,* and *El Correo de las Artes y las Letras,*[28] revealed an understanding of this Mediterraneanist output, which fashioned from the landscape and light a new call to order in the form of the exaltation of color and the classical spirit. In one of his first "Glosari" editorials, significantly entitled "Emporium," Ors wrote: "Sometimes I think that the entire ideal sense of a redeeming gesture for Catalonia could today be reduced to *discovering the Mediterranean.* Discovering the Mediterranean in ourselves and affirming it, in imperial work, among men."[29] Ors did lament, however, that in 1906 Catalan artists might not be capable of collaborating in the venture.

In addition to comments and reviews in the media, contemporary noucentista art affirmed the movement's search for a mythical origin that would make it legitimate. Far from academicism, this art would identify the formal and thematic models suited to its creative work (fig. 2). The realization of these goals was aided by trips to Paris by artists and critics alike (Domènec Carles, d'Ors, Xavier Nogués, Josep de Togores, Francesc Vayreda, Folch, Feliu Elias, and Rafael Benet), and to Céret by artists (Sunyer, Manolo Hugué, Casanovas—who had soon established contact with the composer Déodat de Séverac[30]—and Picasso), making it, in the words of André Salmon, the "Mecca of Cubism." Artists were also assisted by travels to Italy, beginning in 1912 with Torres-García, who went to learn the technique of mural painting at first hand and was followed by a series of other artists, including Sunyer, E. C. Ricart, Rafael Sala, Aragay, and Josep Obiols.

The other basis of Noucentisme, popular tradition, included architecture and crafts. This tradition, imbued with a new professionalism thanks to the Escola Superior dels Bells Oficis, was used by Noucentisme—just as avant-garde art used primitivism—as a veritable guide on its path of discovery toward essential values. The still lifes in noucentista paintings are a showcase of old and simple objects. Regarding sculpture, figures of country girls were common, whether they were from Céret, Roussillon, Mallorca, or any other part of the historic "Catalan lands." Such works picked up on and reaffirmed the new female type, now marked by a solid archetype, ultimately of the Latin woman, as established by Aristide Maillol with his sculpture *The Mediterranean* (1909), also known as *Latin Thought* (fig. 3).

Fig. 2. *Rain,* 1919, by Rafael Benet.

Fig. 3. *The Mediterranean* (also known as *Reclining Bather, Statue for a Shady Garden, The Thought,* and *Latin Thought*), 1909, by Aristide Maillol.

Fig. 4. *Three Arches with a Pair of Lovers, a Boy Flying a Kite, and a Man Lying Down* (fragment of the murals for the cellar of the Galeries Laietanes), 1915, by Xavier Nogués.

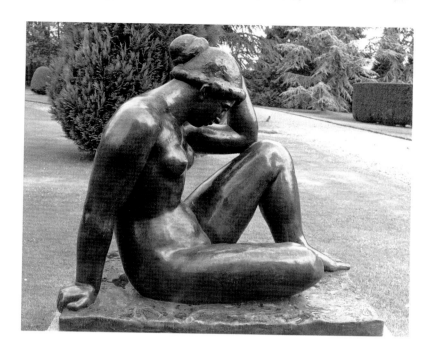

The special value conferred on tradition is evident in many areas, but perhaps particularly in those arts that revived artistic crafts. In contrast to the modernist period, approved training in the crafts was now provided by the Escola Superior dels Bells Oficis and higher standards of craftsmanship were demanded. Moreover, finished works were expected to bear the unmistakable hallmark of the country's identity. The same care and attention to detail in the crafts associated with interior décor or applied to architecture, such as murals and sgraffito, is also evident in popular furnishings, tapestries, ceramics, glasswork. In all the crafts, there was a demand for quality but also for authenticity through the revival of stylistic elements from the past. In some instances, forms, compositions, and colors hark back to the 1700s, and to the Barcelona blue colors characteristic of 17th-century pottery. In other cases, decorated glass revived the prestige such works acquired in the 16th century as a feature of Catalan workshops.

The murals Nogués made for the cellar of the Galeries Laietanes are fine examples of tempera painting on plaster. His tenderly illustrated landscapes are imbued with humanism, as seen in scenes of lovers out for a stroll, a boy flying a kite (fig. 4), hunting scenes, or simple arches of a farmhouse framing a gentle urban landscape in Catalonia (see fig. 12, p. 258). HIs repertoire of friezes and geometric motifs are reminiscent of ancient Roman art and the culture that flourished along the shores of the Mediterranean during the Cretan period. His baskets of flowers and horns of plenty recall those of the 17th and 18th centuries; the niches with shells evoke the second period of the Renaissance; the different kinds of glass and arcades framing some of his characteristic figures remind us of the world of Roman murals. Nogués's mural decorations contributed to the beautifying of a public space. Painted with blue and reddish and ocher hues, they once again place us in the Latin world of the Mediterranean.

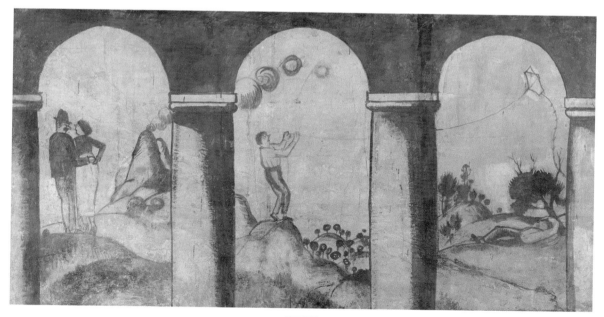

1. See *Les Realismes 1919–1939*, exh. cat. (Paris: Centre Georges Pompidou, 1980); *Homage to Barcelona: The City and Its Art 1888–1936*, exh. cat. (London: Arts Council of Great Britain, 1985); Elizabeth Cowling and Jennifer Mundy, eds., *On Classic Ground, Picasso, Léger, de Chirico and the New Classicism 1910–1930*, exh. cat. (London: Tate Gallery, 1990); Martí Perán et al., eds., *El Noucentisme, un projecte de modernitat*, exh. cat. (Barcelona: Generalitat de Catalunya, Departament de Cultura/Centre de Cultura Contemporània de Barcelona/Enciclopèdia Catalana 1994); and Brigitte Léal and Maria Teresa Ocaña, eds., *Paris–Barcelone, de Gaudí à Miró*, exh. cat. (Paris: Réunion des Musées Nationaux, 2001).

2. Maurici Serrahima, "Sobre el Noucentisme," *Serra d'Or*, no. 8 (August 1964): 7.

3. Enric Prat de la Riba studied law. From a very early age he formed connections with and was given positions in Catalanist organizations such as the Centre Escolar Catalanista, Unió Catalanista, and Centre Nacional Català. In 1901 he founded the Lliga Regionalista; he was elected president of the Diputació de Barcelona in 1907 and of the Mancomunitat de Catalunya in 1914.

4. Enric Prat de la Riba, *La nacionalitat catalana* (Barcelona: Edicions 62/Caixa de Pensions, 1978), 53. First published by the Tipografia L'Anuari de la Exportació in 1906, in 1910 a new edition was paid for by public subscription as a tribute (Barcelona: La Cataluña); in 1930 another edition was published, with modern spelling (Barcelona: Les Ales Esteses); a fourth edition was published in 1934 (Barcelona: Editorial Barcino). See the studies by Jordi Solé-Tura, *Catalanisme i revolució burgesa. La síntesi de Prat de la Riba* (Barcelona: Edicions 62, 1967); and Josep M. Ainaud de Lasarte and Enric Jardí, *Prat de la Riba, home de govern* (Esplugues de Llobregat: Ariel, 1973). The French historian Hippolyte Adolphe Taine was one of the principal theoreticians of French naturalism, a major proponent of sociological positivism, and one of the first practitioners of historicist criticism. Taine is particularly remembered for his three-pronged approach to the contextual study of a work of art based on the aspects of race, milieu, and moment.

5. Prat de la Riba, *La nacionalitat catalana*, 84.

6. Alexandre Plana, "El Llibre de La Ben Plantada," *El Poble Català*, 5 February 1912.

7. Joaquín Torres-García, "La nostra ordinació i el nostre camí," *Empori* (April 1907).

8. Eugeni d'Ors, "A la porta de l'exposició Torres-García," *La Veu de Catalunya*, 19 January 1912.

9. Josep Pijoan, "L'individualisme artístic," *La Renaixença*, 7 December 1898.

10. See the studies by Enric Jardí, *Eugeni d'Ors, vida i obra* (Barcelona: Aymà, 1967); Norbert Bilbeny, *Eugeni d'Ors i la ideologia del Noucentisme* (Barcelona: Edicions de La Magrana, 1988); and *Eugenio d'Ors, del arte a la letra* (Madrid: Museo Nacional Centro de Arte Reina Sofía, 1997).

11. Ors, "Els noucentistes espanyols," in Ors, *Glosari 1906–1907*, ed. Xavier Pla (Barcelona: Quaderns Crema, 1996), 564.

12. Raimon Casellas, journalist and writer, was one of the most influential art critics during Modernisme; see the study by Jordi Castellanos, *Raimon Casellas i el Modernisme* (Barcelona: Curial/Publicacions de l'Abadia de Montserrat, 1983).

13. Joaquim Folch i Torres was an art critic, historian, and museographer; see the study by Mercè Vidal i Jansà, *Teoria i crítica en el Noucentisme: Joaquim Folch i Torres* (Barcelona: Institut d'Estudis Catalans/Publicacions de l'Abadia de Montserrat, 1991). The "Pàgina Artística" appeared in *La Veu de Catalunya* once a week and covered exhibitions, cultural activities, issues to do with monuments and sites, and architecture. The contributors to this page included Josep Puig i Cadafalch, Josep Pijoan, Father Josep Gudiol, Eugeni d'Ors, Jeroni Martorell, Joaquín Torres-García, and other eminent figures. In the mid 1920s, when Joaquim Folch i Torres was occupied with his work as director of the art museums in the city of Barcelona, the painter and art critic Rafael Benet took over as editor of the "Pàgina Artística." See Alícia Suàrez, *Un estudi sobre Rafael Benet* (Barcelona: Fundació Rafael Benet, 1991).

14. Joaquim Folch y Torres, "L'Obra de l'Art Popular," *La Veu de Catalunya*, 11 September 1913.

15. Folch y Torres, "El Saló de Les Arts i els Artistes," *La Veu de Catalunya*, 16 January 1913.

16. The first exhibition by the group, consisting of Ricard Canals, Xavier Nogués, Joan Colom, Feliu Elias, Isidre Nonell, Josep Aragay, Josep Clarà, Enric Casanovas, Pablo Gargallo, Miquel and Llucià Oslé, and Ismael Smith, was held in 1910 at the initiative of Ors, Francesc Pujols, and Iu Pascual; see Francesc Pujols, "La significació de 'Les Arts i els Artistes'," *Vell i Nou* (20 March 1915); and Alexandre Cuéllar i Bassols, *El pintor Ivo Pascual, biografia íntima* (Olot: Dalmau Carles Pla, 1983).

17. Folch y Torres, "El sepulcre Lluís XVI," *La Veu de Catalunya*, 13 February 1913.

18. Folch y Torres, "Les pintures den Torres-García," *La Veu de Catalunya*, 18 January 1912; Folch y Torres, "Les pintures den Sunyer," *La Veu de Catalunya*, 14 April 1911; and Folch y Torres, "L'exposició Casanovas," *La Veu de Catalunya*, 2 November 1911.

19. Flama was Folch i Torres's nom de plume. Flama, "Al començar l'Història dels noucentistes. A pròposit de l'Almanach," *La Veu de Catalunya*, 23 February 1911.

20. Baroque decorative arts were especially important in Catalonia and widely adapted; noucentista graphic programs clearly echo them.

21. See Martí Peran et al., eds., *Noucentisme i Ciutat* (Madrid: Electa, 1994); and *El Noucentisme* (Barcelona: Publicacions de l'Abadia de Montserrat, 1987).

22. Xènius (Ors's nom de plume), " 'La Nacionalitat Catalana' i la generació noucentista," in Ors, *Glosari 1906–1907*, 169. Editors' note: Ors advocated what he called Mediterranisme, emphasizing the racial, cultural, and historical roots of Catalonia in the Greco-Roman tradition and its solidarity with other Mediterranean nations. Ors also promoted Imperialisme, Catalan political and cultural expansionism; Arbitrarietat, an aesthetic for the imperial culture based on the subjection of will to ideal laws and the domination of reason over emotion; and Civilitat, a civilizing role centered on the city.

23. This initiative first appeared in 1917 in the pages of *La Revista*, which published a monograph on Nonell, followed by a monograph by Feliu Elias (who wrote under the name of Joan Sacs), *La pintura francesa moderna fins el cubisme* (Barcelona: Publicacions de la Revista, 1917), by Martí Casanovas's *L'escultura catalana* (Barcelona: Publicacions de la Revista, 1917), and by Alexandre Plana's study on Joaquim Sunyer (Barcelona: Publicacions d'Art de la Revista, 1920). This initiative continued in 1920 with publications by the Junta Municipal d'Exposicions, Minerva Press, and the first publications of the Escola Superior dels Bells Oficis. These initiatives were interrupted in 1923 and did not start up again until 1925 with the *Monografies d'art*, published by Edicions Quatre Coses, and later the editions promoted by Joan Merli in the *Els Artistes Catalans* collection; see Vidal i Jansà, *Teoria i crítica en el Noucentisme*, 190–210.

24. See volume three of Albert Balcells, ed., *Història dels Països Catalans* (Barcelona: Edhasa, 1980–81).

25. Joséphine Matamoros and Dominique Szmusiak, eds., *Matisse–Derain, Collioure 1905, un été fauve* (Céret: Musée d'Art Moderne, 2005).

26. In 1905 Maurice Denis wrote a critical commentary, one of the first linking him to the new classicism, for *L'Occident*, followed by another review in the same journal on the occasion of Cézanne's 1907 retrospective. Denis reprinted both texts in his book, *Théories 1890–1910, du Symbolisme et Gauguin vers un nouvel ordre classique* (Paris: L. Rouart and J. Watelin Éditeurs, 1913).

27. See Françoise Cachin and Monique Nonne, eds., *Méditerranée, de Courbet à Matisse*, exh. cat. (Paris: Réunion des Musées Nationaux, 2000).

28. See Jaume Vallcorba-Plana, *Josep M. Junoy: Obra poètica* (Barcelona: Quaderns Crema, 1984); and Vallcorba-Plana, *Noucentisme, Mediterranisme i Classicisme* (Barcelona: Quaderns Crema, 1994), 75–86.

29. Ors, "Emporium," in Ors, *Glosari 1906–1907*, 31–32.

30. Déodat de Séverac did research in Roussillon on popular music of the past and praised the sound of the tenora (a Catalan wind instrument similar to an oboe), a characteristic sound of the Catalan orchestra known as a cobla when playing sardana country dance music. His work on early music was in keeping with the research being done by artists at that time; see *Centenaire Déodat de Séverac* (Céret: Musée d'Art Moderne, 1972); and Matamoros, ed., *Picasso: Dessins et papiers collés, Céret 1911–1913* (Céret: Musée d'Art Moderne, 1997).

Translated by Susan Brownbridge.

# The Almanach dels Noucentistes: A Hybrid Manifesto

*JORDI FALGÀS*

Possibly no other physical object in the history of modern Catalan culture has become as symbolic of one of its movements as the *Almanach dels Noucentistes* (fig. 1). It is distinctive also because it is not a group manifesto proclaiming its intentions or listing an agenda, not a work of art by one of its distinguished artists, and not a theoretical or philosophical treatise by one of its literary representatives. It has something of all of the above, yet it is something else. As for its diverse contributors, not all were Noucentistes, nor were all the Noucentistes included. Although a shared aesthetic appears to be their common nexus, which Eugeni d'Ors defined as "a new proof of a generation's spiritual unity," the *Almanach* published works by a wide range of writers and artists who did not necessarily subscribe to one another's postulates.[1] It was meant to appear annually, yet only one issue was published, and its print run was only 150 numbered copies.

Almanacs were popular publications in the Catalan press of the 1890s and the early decades of the 20th century. The most famous examples were published by the satirical newspapers *La Campana de Gràcia, L'Esquella de la Torratxa,* and *¡Cu-cut!* Each published its almanac or calendar around the new year for use during that year. As Eliseu Trenc has explained, their pages gradually featured not only illustrations influenced or made by some Modernistes, but also the Noucentistes, among a heterogeneous group of illustrators, cartoonists, and painters.[2]

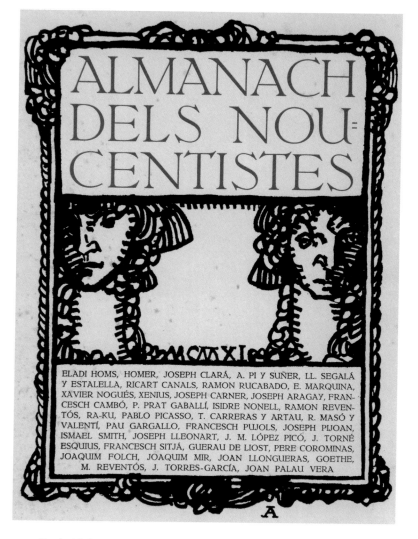

Fig. 1 (cat 6:2). Josep Aragay, title page design for *Almanach dels Noucentistes* (1911).

The *Almanach* was fundamentally the idea of Eugeni d'Ors (fig. 2), who may be considered its noncredited editor or director, in close collaboration with Josep Aragay, who was responsible for the design.[3] Then writing under the pseudonym Xènius, Ors chose the celebrated publisher Joaquim Horta, selected and commissioned the contributions, wrote about the *Almanach* for 1911 in *La Veu de Catalunya*, and hosted a dinner to honor the publisher's workshop once the volume appeared. It was scheduled to appear in January, but as Horta explains in the preface, it did not appear until 16 February because the Giralda font used in the texts was late arriving from Germany.[4]

The contributing artists are a diverse group, and in some cases Xènius appears to have made improper and contradictory choices. What did Pablo Picasso, Isidre Nonell, and Joaquim Mir have to do with Josep Clarà, Joaquín Torres-García, and Pere Torné Esquius? By using Picasso's drypoint *The Bath*, 1905, Xènius appointed Picasso a forerunner of Noucentisme and forced Nonell and Mir into contexts that hardly fit them.[5] Ors's selection of the other works was also purposeful. While presenting a wide assortment of

names from different generations, as well as works in various techniques—prints, paintings, and drawings—he made sure the artists covered the same topics as the writers, expressing the noucentista ideal he had been sketching in his "Glosari" (short opinion columns) since 1906 (fig. 3).[6] Ors even went as far as to retitle the works he selected, and it is no surprise to find four of them devoted to female nudes (Clarà, Pablo Gargallo, Ismael Smith, and Torres-García [see fig. 3, p. 251]), three to the themes of maternity and the family (Ricard Canals, Xavier Nogués, and Picasso), and others to the home, city, and nation (Aragay, Torné Esquius, and Smith [the project for a monument to Milà i Fontanals]).

While his choices may seem subjective Ors was trying to be inclusive by bringing together disparate poles and creating a common ground for those willing to accept his invitation to "a permanent cure of perfection, a quiet and free of excess magnificence, a secure elegance, as that of a race."[7] Some shared his view momentarily, others discreetly moved away. In the meantime, as Francesc Fontbona has noted, Ors was able to "make his readers believe that everything being created, more or less anarchically by

Fig. 2. *Eugeni d'Ors*, c. 1906–7, by Ramon Casas.

this disparate group of the country's more dynamic painters, draftsmen, and sculptors, responded to a common idea."[8]

The same could be said for the *Almanach*'s larger assortment of writers, a remarkable accomplishment by Ors that stands today as a who's who of Catalan politics and humanities in the 1910s and 1920s. A survey of the names reveals the elite of Catalan society during those years in a variety of disciplines: pedagogy (Eladi Homs, Joan Palau i Vera), journalism (Ramon Rucabado), politics (Pere Coromines), literature (Josep Carner, Guerau de Liost, Josep Lleonart, Josep M. López Picó, Eduard Marquina, Francesc Pujols, Ramon Reventós, Francesc Sitjà), history (Joaquim Folch i Torres, Josep Pijoan, Lluís Segalà), economics (Manuel Reventós), music (Joan Llongueras), and architecture (Rafael Masó). Many were prominent in more than one field: politician and lawyer Francesc Cambó also collected art, and Tomàs Carreras was a philosopher, lawyer, and ethnologist. This group's eclecticism also shows Ors's intention of broadening Noucentisme beyond aesthetics to engage all sides of civic life in a project of collective renovation. Not surprisingly, at the end of the *Almanach* he included a section devoted to "Els petits Noucentistes," with poems and drawings by a group of eight- and nine-year-old children. As Fontbona states, "The *Almanach* is a conjunction of diverse expressions of good will—without a specific mention of a political program with names and last names—that inscribe themselves into a moment of enthusiasm for an auspicious future."[9]

The *Almanach*'s somewhat unclear nature and purpose was noted from the very beginning. Francesc Miralles recalls that, not even two weeks after its publication, the critic Romà Jordi entered into a debate with Joaquim Horta in the pages of *La Publicitat* discussing whether the *Almanach* was a promotional or a "spiritual" endeavor.[10] So while conceived as a presentation of the movement, the publication had a hybrid quality that ultimately best defined the nature of Noucentisme and gave the *Almanach* the status of a "point of reference."[11] Although exclusive at first glance, Noucentisme turned out to be very permeable. I subscribe to Narcís Comadira's exclamation: "Splendid mixture: Noucentisme!"[12]

1. Xènius (Eugeni d'Ors's nom de plume), "L'Almanach dels Noucentistes," *La Veu de Catalunya*, 15 February 1911, evening edition, 2. All translations in this article are by the author.

2. Eliseo Trenc Ballester, *Les arts gràfiques de l'època modernista a Barcelona* (Barcelona: Gremi d'Indústries Gràfiques de Barcelona, 1977), 129–30.

3. For additional information, see the preface by Francesc Fontbona to the facsimile edition, *Almanach dels Noucentistes* (Barcelona: José J. de Olañeta, 1980), 1–7; and Marta Torregrosa, *Filosofía y vida de Eugenio d'Ors. Etapa catalana: 1881–1921* (Pamplona: EUNSA, 2003), 120–21.

4. See Francesc Miralles, "L'Almanach dels Noucentistes," in *Del Modernisme al Noucentisme: 1888–1917*, volume 7 of *Història de l'Art Català*, ed. Fontbona and Miralles (Barcelona: Edicions 62, 1997), 227.

5. *The Bath* is an etching with drypoint. After the plate was steel-faced in 1913, it was published by Vollard as plate XII from *La suite des Saltimbanques*, which means that in 1910 Ors must have had access to one of the original engravings. See Georges Bloch, *Pablo Picasso. Catalogue de l'oeuvre gravé et lithographié 1904–1967* (Bern: Kornfeld et Klipstein), 1:21–22.

6. Ors published his first *glosa* in *La Veu de Catalunya* on 1 January 1906. The series went on almost without interruption until 1921 and was compiled in the different volumes of his *Glosari*. These columns were also the basis for several novels and essays. When he moved to Madrid, Ors continued to write *glosa* in Spanish. See the 11 volumes of the collection *Obra Catalana d'Eugeni d'Ors*, in particular Xavier Pla, "Presentació," in Eugeni d'Ors, *Glosari 1906–1907*, ed. Pla (Barcelona Quaderns Crema, 1996), xiii–xxvii.

7. Xènius, "L'Almanach dels Noucentistes," 2.

8. Fontbona, "El primer Noucentisme en l'art," in *Noucentisme i Ciutat*, ed. Martí Peran et al. (Barcelona: Centre de Cultura Contemporània/Electa, 1994), 75.

9. Fontbona, "Almanach dels Noucentistes," 4.

10. Miralles, "L'Almanach dels Noucentistes," 228.

11. Peran et al., "El noucentisme, un projecte de modernitat," in *El Noucentisme, un projecte de modernitat*, ed. Peran et al., exh. cat. (Barcelona: Generalitat de Catalunya, Departament de Cultura/Centre de Cultura Contemporània de Barcelona/Enciclopèdia Catalana, 1994), 27.

12. Narcís Comadira, "L'Almanach dels Noucentistes," in Comadira, *Forma i prejudici: Papers sobre el Noucentisme* (Barcelona: Empúries, 2006), 36.

Fig. 3 (cat. 6:1). Eugeni d'Ors, *Glosari* (1907), with illustration by Apa (Feliu Elias).

# Picasso in Gósol:
# Savoring the Secrets of the Mysterious Land

*JORDI FALGÀS*

> The Picassos were in Spain and Fernande wrote long letters describing Spain and the spaniards and earthquakes.—Gertrude Stein, *The Autobiography of Alice B. Toklas*

Fernande Olivier had been living with Picasso in his studio at the Bateau Lavoir for only six months when, in the spring of 1906, he decided they would spend the summer in Catalonia. Ambroise Vollard, Picasso's dealer during those years, bought almost all the artist's recent work, and with 2,000 gold francs in his pocket—more than he had ever made in a single sale—the 24-year-old artist suddenly felt rich. The occasion was ideal to make a triumphal return home after a two-year absence. He planned to introduce Fernande to his family in Barcelona and then go to work in some isolated village in the country with one of his Catalan friends, trying to revive the good memories of his stay in Horta de Sant Joan with his friend Manuel Pallarès in 1898–99. The events leading up to the couple's departure from Paris on May 20 and what took place subsequently have been carefully reconstructed by Picasso's biographers, thanks to the availability of his own and several other firsthand accounts and written testimonies.[1] With a few exceptions, these scholars have traditionally emphasized how, for Picasso, this trip meant a return to his Iberian roots and his Spanish milieu and culture. Nonetheless, as we shall see, the cultural and political environment of Barcelona at the time and the works he produced owe much more to a distinctly Catalan spirit. Catalonia was then living a process of national emancipation on which Picasso found the perfect ground for his own.

This was Fernande's "first long journey" outside of Paris; it was also her release after six months of almost complete seclusion in Picasso's tiny cold studio. He had forced her to give up her career as a model for other artists. Her lover was "so jealous he won't allow me to go out alone" and kept her locked in, "and although he's never gone for too long this is not pleasant."[2] Certainly not for a young woman who had done as she pleased with her life for some time. But her memories of a childhood and a marriage marked by constant abuse, suffering, rape, a miscarriage, and a complete absence of love must have been so strong that Picasso's devotion compensated for her lack of freedom, the cold, and the frequent hunger they suffered that winter at the Bateau Lavoir. There was no better proof of his affection than seeing how she engaged his complete attention and that she was becoming the center of his new creations: the acrobats, harlequins, and saltimbanques of 1905 were being rapidly replaced—soon almost exclusively—by "la belle Fernande."

Despite Fernande's main role in Picasso's work, she was also the first to note that "during this period the atmosphere of his own country was essential to him and gave him a quite special inspiration."[3] It was a very special atmosphere indeed: 100 years later, 1906 is still being defined as "a key, crucial year in the development of contemporary Catalan culture," when republican Catalanism emerged and exerted the strongest political and cultural influence.[4] And by a striking coincidence the event that became the turning point took place on Sunday, 20 May, the day before the couple arrived in Barcelona. The Festa de l'Homenatge (Homage Celebration), organized by Solidaritat Catalana in Barcelona in support of the 30 Catalan and several non-Catalan members of the Spanish parliament who had opposed the Law of Jurisdictions turned into the largest demonstration ever seen in the city (fig. 1).[5] More than 200,000 people gathered at the passeig de Sant Joan and marched peacefully behind political leaders representing almost the entire political spectrum. Not surprisingly, Fernande's first impression on Monday, off the train, was that they "were surrounded by crowds of noisy Catalans."[6]

The couple stayed with Picasso's parents for several intense days and nights, and Fernande remembered spending "much of our time with our friends" throughout the city, a group that included several artists: Ricard Canals, Miquel Utrillo, Pablo Gargallo, Mateu de Soto, and, in particular, Enric Casanovas, who was then also living most of the time in Paris and with whom Picasso planned to spend the rest of the summer working together. The impact of the events of 20 May was very much in the air during the week they spent in Barcelona, and the special atmosphere impregnated not only the political life, but that of the artist and his friends as well.[7] On 18 May, the conservative Lliga Regionalista, a major force behind Solidaritat, opened a large exhibition of contemporary Catalan art at its headquarters. The show was highly praised not only by its own newspaper, *La Veu de Catalunya,* but also by Josep M. Roviralta in the pages of *El Poble Català.* It was organized by Utrillo, and the list of painters, sculptors, and illustrators he gathered included many luminaries in Catalan art of the period. So Picasso must have certainly visited, read about, debated, and felt driven by what was defined by Roviralta as "an exhibition

that opens a road to be traveled, it marks an end to attain."[8]

For the time being, the road Picasso and Fernande took was the one to Gósol, a small remote village in northern Catalonia that had been recommended by the son of a Greek political leader.[9] In the end, Casanovas was not able to join them, but he was certainly influential in deciding where to go and planning the trip and then kept in touch by mail. It makes perfect sense that Picasso and Casanovas would listen to a Greek because they were preoccupied with the Greek and Mediterranean roots of Catalan culture, as were many young artists, writers, and intellectuals both in France and Catalonia at the time. In Barcelona, this penchant was soon known as Noucentisme; its main theorist, Eugeni d'Ors, had been writing his "Glosari" editorials in *La Veu de Catalunya* from Paris since early May. A few years later, in 1912, Utrillo devoted an article to Casanovas and the art of his generation, comparing "what is happening to my 'primitivists' with the fable of Anteus: art recovers new strengths when it rests on mother earth's ground," which according to Teresa Camps was a call to the affirmation of a

Fig. 1. The Solidaritat Catalana demonstration, 20 May 1906, photograph taken from the top of the Arc de Triomf.

national Catalan art.[10] As Marilyn McCully explained, in 1906 "Picasso felt the need to return to his roots . . . in order to break new ground. Moreover, in line with ideas about ancient cultures—which would no doubt have appealed to Casanovas—the remote village of Gósol represented a relatively untouched, primitive society: the kind of model from which modern Catalonia, its land and its people, derived their strength."[11]

Mountain hiking and climbing in Catalonia is known as "excursionisme"; becoming increasingly popular beginning in the late 1800s, it went beyond mere sport and embraced folklore, literature, archaeology, science, and nationalism. During the first decade of the 20th century many Centres Excursionistes were established in Barcelona and every major Catalan town, and for the first time the Catalan Pyrenees were fully explored by outsiders, always in search of a lost Romanesque church or a higher summit and creating along the way an entire national mythology filled with many iconic names, such as the resorts Ulldeter and la Molina, and the peaks Matagalls, Núria, Canigó, and Pedraforca, which became one of the symbols of excursionisme.[12] Gósol—which is neither in Andorra nor near it—lies at the bottom of the majestic Pedraforca (2,497 m.),

on the southern slope of the Serralada del Cadí, and was indeed a perfect spot for Picasso.

The week in Barcelona had stimulated Picasso, where he felt at the crossroads between Modernisme and the rising Noucentisme, the new classicism, the signs of which he had already witnessed at the 1905 Salon d'Automne in Paris before Maillol's plaster female nude *The Mediterranean* (see fig. 3, p. 231). In Barcelona, two books had been published during the spring that Ors declared were "of the highest importance . . . for the noucentista generation."[13] According to Ors, Enric Prat de la Riba's *La nacionalitat catalana* embodied and defined the political ideals of Noucentisme, and Joan Maragall's book of poems *Enllà* was the last example of the Romanticism that Noucentisme had to overcome. Ors, who may or may not have been aware of Picasso's work in 1905, later considered it entirely noucentista, and Picasso, who almost certainly knew about Ors's ideas, must have been intrigued by the debate and took a copy of *Enllà* with him to Gósol.[14]

Picasso's entire output from Gósol is seen by different authors as resulting from his personal struggle with, in Robert Rosenblum's words, the "reawakened awareness of his national roots . . . [and] an inventory of guises culled from antiquity through

Fig. 2 (cat. 6:3). Pablo Picasso, *Catalan Landscape (Gósol Landscape)*, 1906.

the nineteenth century," but if proof is needed, it lies in the first pages of one of Picasso's Gósol sketchbooks.[15] On page 5 of the tiny *Carnet Catalan,* he copied several verses of Maragall's poem "Vistes al mar" (Views to the sea) from *Enllà* next to, on page 4, a sketch for a sculpture based on the classical theme the Three Graces.[16] The next poem in *Enllà* is "Les muntanyes" (The mountains), in which Picasso must also have found deeply inspiring verses: "A l'hora que el sol se pon,/bevent al raig de la font,/he assaborit els secrets/de la terra misteriosa" (At the time when the sun sets,/drinking at the fountain's jet,/I have savored the secrets/of the mysterious land).

Even though by "national roots" Rosenblum meant "Spanish origins," a clear distinction must be made here between Picasso's lineage and what was in fact the awakening of his Catalan identity.[17] Born in Málaga, living in Corunna, and finally growing up in Barcelona, Picasso had been exposed to three different cultures and languages in a migration process that certainly affected his notion of selfhood and search of a self-identity.[18] On top of the nationalist fervor he witnessed in Barcelona—which would increase during the summer—and the poems and newspapers in Catalan he read, he signed his letters to Casanovas as "Pau" (in Catalan); he spoke all day in Catalan and wrote down Catalan words that even Fernande used in her letters; he integrated the typically Catalan glass drinking vessel the *porró* in several paintings; and both he and Fernande were enormously curious about the local festivities, legends, traditions, and folklore of Gósol.[19] Writing about Picasso's work in Horta de Sant Joan in 1909, Christopher Green asserted that "before 1914 if nationalism in Spain touched his life it was much more the anti-Castilian nationalism of Catalonia than anything else."[20] Picasso "savored the secrets." Indeed, he fully embraced a land and a culture that must have appeared as the perfect cradle upon which to create his art afresh—an art that had nothing to do with Spanish traditions, that, if anything, was opposed to such.

The seven paintings presented here allow us to trace Picasso's approach and process during his two and a half months in Gósol. Even if not produced in the order given here, they are fine examples of how Picasso went from appropriating his most im-

mediate surroundings in several landscapes to portraits of local men, women, and children. Then, he placed Fernande at the center of this newly created realm and proceeded to integrate all within his own iconology, his stream of dislocated borrowings from Catalan, Spanish, French, and ancient Greek and Iberian art, and his own deep fixations and self-imposed challenges.

The views from today's paved road up to Gósol, while not the same path Picasso and Fernande took by mule, convey the same powerful impression they must have made upon a visitor 100 years ago. The omnipresent mountain vies for attention with the landscape elements—the yellow, red, brown, and ocher of the clayish land and buildings, and the patches of green in pastures and forests (the variety and richness of the flora there is unparalleled in Catalonia); on a clear day the sky is pristine blue. It is no surprise then, that Picasso was prompted not only to capture such views in paintings and drawings but also felt perfectly at ease with the earthy colors he had used recently in Paris. *Catalan Landscape,* also known as *Gósol Landscape,* 1906 (fig. 2), was painted at noon from the part of town known as la Clota, looking south toward the church and the part of town known as l'Obac (Shady). The walls facing the viewer are in shadow created by juxtaposed brown and reddish brown shapes, in contrast with both green and blue. Claustre Rafart, Brigitte Léal, and Rosenblum are all correct that, in retrospect, both Cézanne and Cubism are only one step away, with the "interlocking networks of intensely sunned and shadowed monochrome planes"[21] and the fusion the artist creates with the background and foreground planes, "the saturation effect on the space."[22]

The portraits of a boy, a woman carrying loaves of bread, and the old innkeeper Josep Fondevila show different sides of Picasso's search for what Léal calls "a new concept of the human body"[23] and, in particular, the expressive potential of the human face as the artist's mirror as well as the sitter's mask. Picasso treats these figures as three-dimensional objects, sculptures made of clay. The colors he used are of clay, but that substance is also present in the many vessels, jugs, and other ceramic pots he depicted in his Gósol paintings. Even the touch of his brushstroke, whether he is using oil or gouache, has the quality of liquid clay.

*Head of a Boy,* c. 1906 (fig. 3), resembles and may even be a study for the oldest figure in a larger canvas painted in Gósol, *The Two Brothers* (Kunstmuseum, Basel).[24] Perhaps an idealized portrait of youth, it also hints at a rejuvenated self-portrait. In Gósol, after shaving his head, Picasso discovered that he looked younger and possibly realized that he, too, acquired what Kirk Varnedoe described as "the kind of generic 'personality' one finds in archaic Greek *kouroi.*" Varnedoe also correctly pointed out that "by diminishing the chin and lower face and proportionally enlarging the ear, nose, and eyes, Picasso simultaneously pushes his physiognomy back toward that of

his youth."[25] After all, being in Gósol must have felt like living in a memory since he was suddenly free of all the social constraints of the city he despised, as was Fernande, who wrote that she loved "the simplicity of living here, . . . Pablo is in high spirits."[26]

*Head of a Catalan Peasant (Josep Fondevila),* 1906 (fig. 4), is the boy's counterbalance.[27] Taken from the same angle, and with his head also shaved, this is Picasso's confrontation with old age, with his own fear of death, to the point that John Richardson also talked of a self-portrait.[28] Further, just as in his self-portraits, as William Rubin noted, "Picasso was so fascinated with this old man's personality and ap-

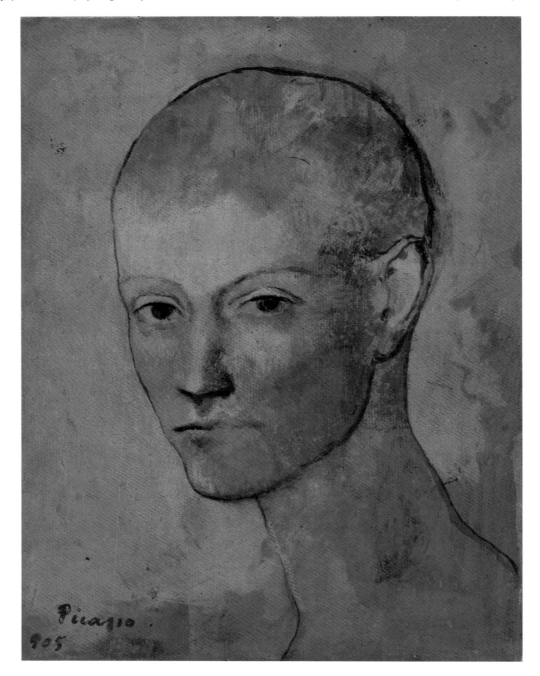

Fig. 3 (cat. 6:6). Pablo Picasso, *Head of a Boy,* c. 1906.

pearance that he was led to imagine both forward and backward in time," and in a drawing of the same man (Musée Picasso, Paris), Picasso imagined a much younger Fondevila.[29] Old Josep, though, no longer stares at the viewer or anywhere else; his is an introspective glance. Picasso's rough brushstrokes are particularly poignant on Fondevila's face, showing skin that has been carved by age and the elements. It is not surprising that as soon as he returned to Paris, Picasso modeled a powerful *Bust of Josep Fondevila* in clay, later cast in bronze.[30]

The volume and weight of sculpture is an ever-present element in Picasso's work from Gósol, and the references to ancient Iberian and Greek sculpture permeate his paintings and drawings as well as his sculptures. Correspondence with Casanovas reveals that Picasso was eager to do some carving and requested tools, although they did not arrive before his sudden departure in mid August. Nevertheless, he managed to produce a woodblock and a few small sculptures.[31] If any sculpture truly captured his imagination, though, it was the only one in town, *The Gósol Madonna*, 1300s (fig. 5), an exceptionally fine example of Romanesque polychrome sculpture from the region. Pierre Daix finds traces of the Madonna in a portrait of Fernande, and Richardson and Josep

Fig. 4 (cat. 6:5). Pablo Picasso, *Head of a Catalan Peasant (Josep Fondevila)*, 1906.

Palau i Fabre see them in many other works as well, one of the finest being *Woman with Loaves*, 1906 (fig. 6).[32] In discussing this painting, Rosenblum observed not only the Madonna's "immobile grandeur" but also her link to, once again, "the classical world."[33] There are several fine studies drawn from life in the *Carnet Catalan* and the larger *Carnet no. 6*, as well as other drawings showing women carrying bundles of sticks, water jugs on their heads and buckets on a yoke, and large loaves of bread.[34] The painting pushes her up close, and unlike the others, she confronts the viewer; her timeless, stoic face and loaves of bread are the central motifs. In an almost unreal setting, transported to an atmosphere of delicate gold that transforms her into a pagan goddess, her face is surrounded by pristine white.[35] Rather than a symbol of the sacred body, bread becomes the attribute of her fertile realm, an archetype of eternal fecundity. Just like the Egyptian goddess Isis, Picasso's *Woman with Loaves* is also "The One Who Is All," lady of bread, lady of love, lady of rebirth. In her, he achieved the incarnation of Joan Maragall's virgins of the Mediterranean and reached a "note higher than any in the score" of art he had seen so far in Barcelona and Paris.[36]

In his enlightening study on semiotics and Cubism, Francis Frascina explains Picasso's crucial role in the development of modern pictorial language by presenting two works painted in Gósol, *The Harem*, 1906 (fig. 7), and *Reclining Nude (Fernande)*,

Fig. 5. *The Gósol Madonna*, 12th century.

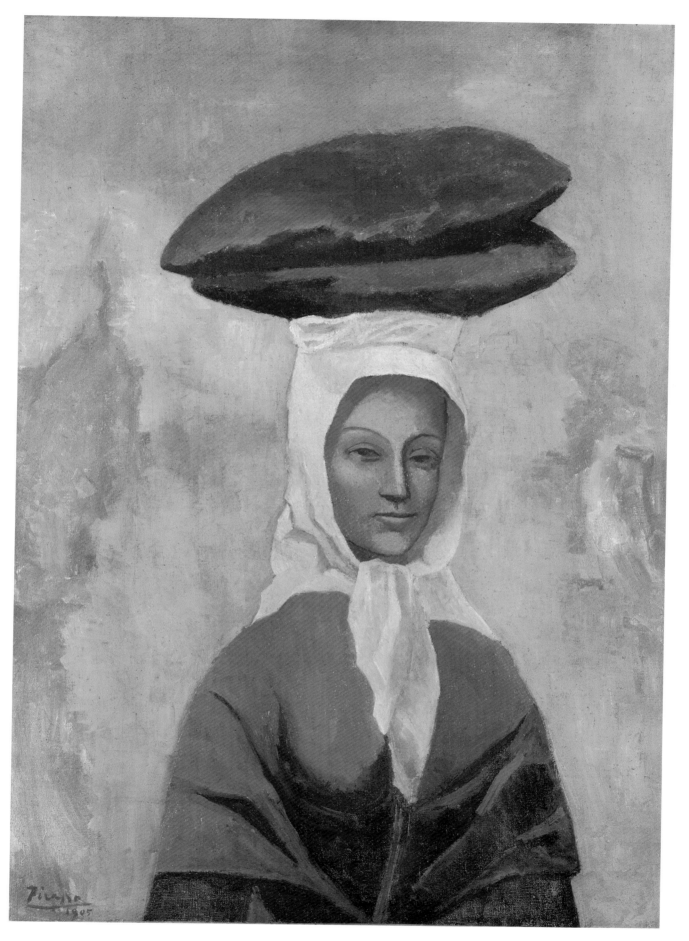

Fig. 6 (cat. 6:4). Pablo Picasso, *Woman with Loaves*, 1906.

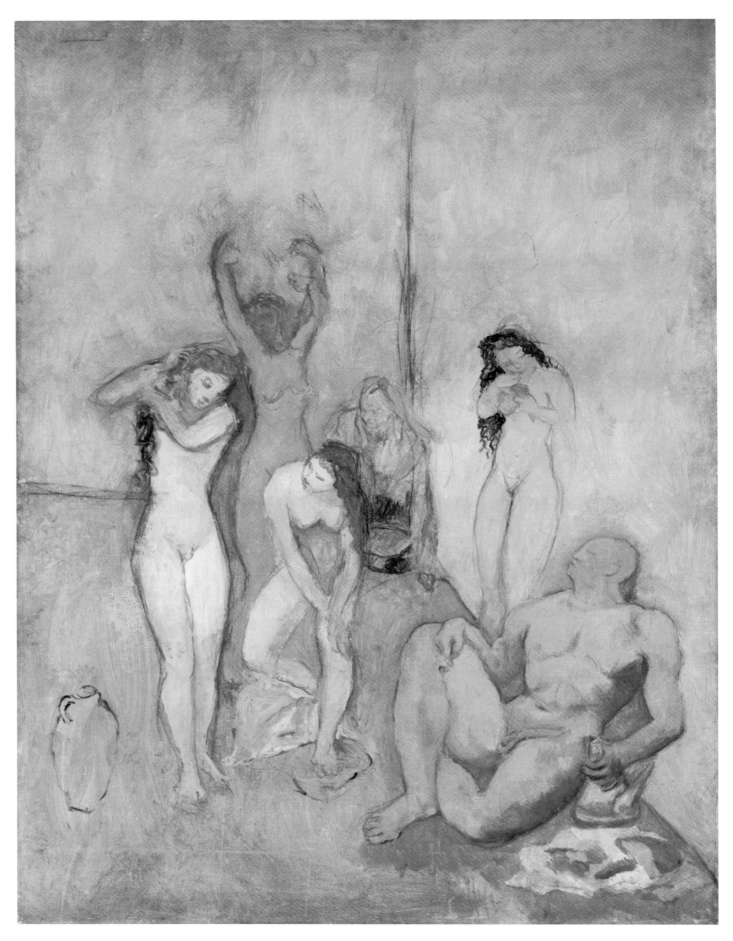

Fig. 7 (cat. 6:8). Pablo Picasso, *The Harem*, 1906.

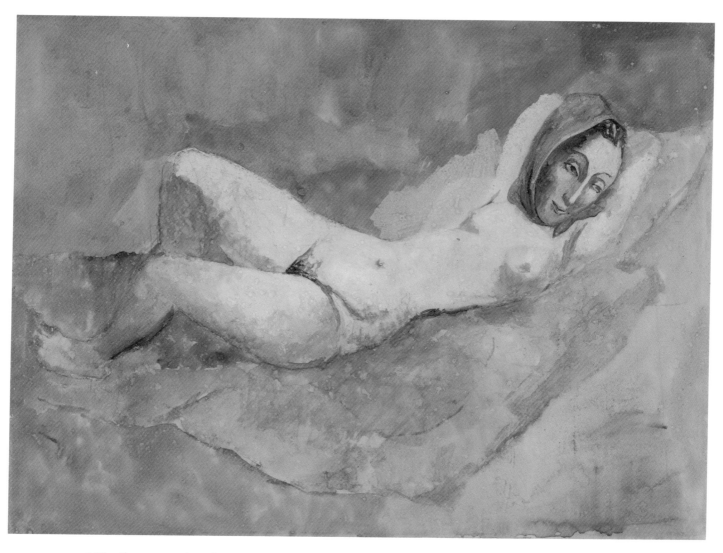

1906 (fig. 8), as examples of, respectively, the "Venus anadyomène" and "odalisque" poses. These postures "can be considered as elements of the 'language' system known as 'the body': each has particular meanings within the language. Or they may be versions of 'the body' which is itself a sign in other systems such as 'woman,' 'the feminine' or 'Classical myth' or 'history painting.'"[37] Thus Picasso scholars have plunged deeply into each of these works and their associated categories to unearth a considerable number of interpretations that, above all, reinforce the radicality of his accomplishments in Gósol. As much as they are finished pictures, these two paintings were also works in progress. Both have multiple pentimenti and are closely related to other works done in Gósol, including specific studies for various figures, such as *Nude (Pink)*, 1906 (fig. 9).

Many authors have stressed how *The Harem* and *Reclining Nude (Fernande)* reveal Picasso's re-

Fig. 8 (cat. 6:9). Pablo Picasso, *Reclining Nude (Fernande)*, 1906.
Fig. 9 (cat. 6:7). Pablo Picasso, *Nude (Pink)* or *Woman Washing Herself (Study for "The Harem")*, 1906.

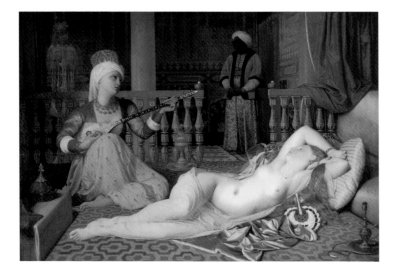

sponse to multiple art-historical sources, including the supine women in Goya's *Nude Maja*, 1800 (Museo del Prado, Madrid), Manet's *Olympia*, 1863 (Musée d'Orsay, Paris), Ingres's *Turkish Bath*, 1863 (Musée du Louvre, Paris), and Matisse's *Bonheur de Vivre*, 1905–6 (Barnes Foundation, Merion, Pa.).[38] The Ingres retrospective at the Salon d'Automne of 1905 had a strong and lasting influence on Picasso.[39] Even more so than the *Turkish Bath*, another work by Ingres, *Odalisque with a Slave*, 1839–40 (fig. 10), seems to have been a direct source of inspiration.[40] Picasso incorporates the pose of all three figures into *The Harem* and *Reclining Nude (Fernande)*: the odalisque in her pose of sexual availability, arms raised behind her head, becomes Fernande; the slave sitting with legs crossed and staring upward is flopped and turns into the male figure; and the eunuch in the background is transformed into the painting's *palanganera* (old servant) in the same spot, where the three presumably perpendicular planes meet.[41] Here, too, Ingres provided Picasso not only with a rich palette of flesh, pink, orange, and red, but as Rosenblum notes about the *Turkish Bath*, a denial of the logic of one-point perspective that enthralled Picasso and led to the radical spatial constructions of the coming year.[42]

The vibrant pink-toned *Nude (Pink)* seems to have posed a particular challenge for Picasso. The fig-

ure adopts the most unconventional if not awkward pose of the assembled harem. This nude stands on her left leg, but strangely seems to rest on the right knee, while leaning forward and resting her arms on the weight-bearing leg. Picasso may have derived this pose from a familiar place, as it recalls the imposing central figure in Sebastiano del Piombo's *Christ's Descent into Limbo*, 1516 (fig. 11), a work he certainly saw at the Prado Museum in Madrid.[43]

*The Harem* and *Reclining Nude (Fernande)* were harbingers in a process that culminated less than a year later in *Les Demoiselles d'Avignon* (Museum of Modern Art, New York).[44] Picasso discovered many of the ingredients that fueled this painting with "the destructive force of an earthquake," as Rosenblum so aptly remarked, in Gósol. The Catalan village and its people enabled Picasso to bring together, materialize, and experience firsthand varied and disparate mental visions that troubled and excited him. His Gósol paintings express a rich set of multilayered concerns, including his relationship with Fernande, his role as lover and fascination with the female body, his ability to emulate and disrupt the art of living and past masters, his language as an artist in a period of cultural redefinition, and his identity as both emigrant and immigrant in a context of collective self-determination.

Fig. 10. *Odalisque with a Slave*, 1839–40, by Jean-Auguste-Dominique Ingres.
Fig. 11. *Christ's Descent into Limbo*, 1516, by Sebastiano Luciani, known as Sebastiano del Piombo.

A version of this essay was presented at the Picasso BCN 2006 event hosted by the Tourist Office of Spain in Chicago on 9 March 2006. My thanks to Julio López Astor and Patricia Wood for providing this opportunity.

1. See Josep Palau i Fabre, *Picasso, The Early Years, 1881–1907*, trans. Kenneth Lyons (New York: Rizzoli, 1981), 438–65; John Richardson, *A Life of Picasso* (New York: Random House, 1991), 1:433–53; Palau i Fabre, "The Gold of Gósol," in *Picasso 1905–1906*, ed. M. Teresa Ocaña and Hans Christoph von Tavel, trans. Richard Rees, exh. cat. (Barcelona: Electa/ Ajuntament de Barcelona, 1992), 75–88; Claustre Rafart, "Towards Cubism," in *Picasso Landscapes, 1890–1912: From the Academy to the Avant-garde*, ed. Ocaña, trans. Caroline Clancy, exh. cat. (Boston: Bulfinch Press, 1994), 259–69; Marilyn McCully, "Chronology," in *Picasso: The Early Years, 1892–1906*, ed. McCully, exh. cat. (Washington: National Gallery of Art, 1997), 49–51; Pablo Picasso and Guillaume Apollinaire, *Picasso/Apollinaire: Correspondance*, ed. Pierre Caizergues and Hélène Seckel (Paris: Gallimard/Réunion des Musées Nationaux, 1992), 36–56; Seckel, ed. *Max Jacob et Picasso*, exh. cat. (Paris: Réunion des Musées Nationaux, 1994), 46–53; and Fernande Olivier, *Loving Picasso: The Private Journal of Fernande Olivier*, trans. Christine Baker and Michael Raeburn (New York: Harry N. Abrams, 2001), 161–87.

2. Olivier, *Loving Picasso*, 180, 175, 177.

3. Olivier, *Picasso and His Friends*, trans. Jane Miller (New York: Appleton-Century, 1965), 93.

4. "Editorial: La cruïlla de l'any 2006," *L'Avenç*, no. 309 (January 2006): 3; in the same issue, see also "Dossier: La cruïlla de 1906," with articles by Jordi Castellanos and others, 21–40. See also Jordi Casassas, "Batallas y ambigüedades del catalanismo," in *Barcelona, 1888–1929: Modernidad, ambición y conflictos de una ciudad soñada*, ed. Alejandro Sánchez (Madrid: Alianza Editorial, 1992), 133–38; and Borja de Riquer and Jordi Casassas, eds., *L'època dels nous moviments socials, 1900–1930. Història, política, societat i cultura dels Països Catalans 8* (Barcelona: Enciclopèdia Catalana, 1995–2000), 29–35.

5. Solidaritat Catalana was a broad coalition of Catalan political parties, from left to right, established in January 1906 in response to the assault and sacking by more than 300 soldiers of the offices of the weekly satirical *¡Cu-Cut!*, the daily *La Veu de Catalunya*, and a bookstore in Barcelona the night of 25 November 1905, as well as the suspension of constitutional laws in Catalonia that followed. A political cartoon published in *¡Cu-Cut!* had ignited the anti-Catalanism of the entire Spanish army, and events led to the formation of a new cabinet in Madrid, which soon passed the Ley de Jurisdicciones, which established military jurisdiction over expressions of political opinions deemed an offense to the armed forces and the symbols of Spain. For a concise account, see Josep Termes, "La formació de Solidaritat Catalana," in *De la Revolució de Setembre a la fi de la Guerra Civil (1868–1939)*, ed. Josep Termes, vol. 6 of *Història de Catalunya* (Barcelona: Edicions 62, 1987), 202–7.

6. Olivier, *Loving Picasso*, 181. Thousands of people from other Catalan towns, as well as Valencia and Mallorca, who attended the Sunday demonstration went in and out of Barcelona between Saturday and Monday, thus the chaotic train station noted by Fernande. See, for example, the long list of short announcements made by dozens of varied cultural, religious, and political organizations whose members planned to attend the event in *La Veu de Catalunya*, 19 May 1906, 4.

7. Even though Fernande's memories were of "several weeks in Barcelona," their first letter from Gósol, to Guillaume Apollinaire, is dated 29 May 1906, so they only stayed one week. See Picasso and Apollinaire, *Picasso/Apollinaire: Correspondance*, 39–40.

8. Josep M. Roviralta, "L'Art Català: Exposició a la Lliga Regionalista," *El Poble Català* (23 May 1906): 1. This remarkable artistic event seems to have escaped the scrupulous accounts of Picasso's biographers. Since he had sold almost all his works in Paris before the trip to Barcelona, it is not surprising that Picasso did not exhibit any works at the Lliga, despite the fact that many of his old friends from the Quatre Gats days did and that Utrillo was an early champion of his work. It was at this time that Utrillo published a short book on El Greco, the master whose influence soon reappeared in Picasso's art.

9. See Palau i Fabre, "Gold of Gósol," 76, and Palau i Fabre, *Picasso: The Early Years*, 439. According to Palau, Picasso believed "it may have been [Eleftherios] Venizelos's son," although that can hardly be true. First, Venizelos did not go to Paris until 1919; second, in 1905 his oldest son, Kyriakos, was only 13; and finally, there is no record that father or son had ever been to Spain, Barcelona, or Gósol. So, if Picasso met with the son of a Greek politician in 1905, it must have been someone else. I am grateful to Argyro Vatsaki, from the Eleftherios Venizelos Foundation, for his help in clarifying this issue.

10. Miguel Utrillo, "El primitivismo," *Museum* 2, no. 1 (1912); quoted by Teresa Camps Miró in "El nostre primitivisme," in *L'avantguarda de l'escultura catalana*, exh. cat. (Barcelona: Departament de Cultura, Generalitat de Catalunya, 1989), 20.

11. McCully, "Mediterranean Classicism and Sculpture in the Early Twentieth Century," in *On Classic Ground: Picasso, Léger, de Chirico and the New Classicism 1910–1930*, ed. Elizabeth Cowling and Jennifer Mundy, exh. cat. (London: Tate Gallery, 1990), 330. For additional insightful analysis of noucentista art in that publication, see Teresa Camps, "Models for the Female Figure in Catalan Art, 1906–1911," and Alícia Suárez, "Critical Theories of Noucentisme, Classicism and the Avant-garde in Catalonia, 1906–1930," 338–44.

12. See Christopher Green, *Picasso: Architecture and Vertigo* (New Haven/London: Yale University Press), 136–50. Although Green's analysis of excursionisme and Noucentisme is related to the 1909 cubist landscapes from Horta de Sant Joan, I believe both were already present in the Gósol period. The bibliography of hiking in Catalonia is extensive. See, for example, Francesc Roma, *Història social de l'excursionisme català: dels orígens a 1936* (Vilassar de Mar/Barcelona: Oikos-Tau, 1996).

13. Eugeni d'Ors devoted three of his "Glosari" to these books. See Ors, "Dos llibres," "'La Nacionalitat Catalana' i la generació noucentista," and "'Enllà' i la generació noucentista," in Ors, *Glosari 1906–1907*, ed. Xavier Pla (Barcelona: Quaderns Crema, 1996).

14. See my essay on the *Almanach dels Noucentistes* in this section.

15. Robert Rosenblum, "Picasso in Gósol: The Calm before the Storm," in *Picasso: The Early Years* (exh. cat.), 264, 266.

16. "Una a una, com verges a la dansa,/entren lliscant les barques en el mar;/s'obre la vela com una ala al sol,/i per camins que només ells veuen/s'allunyen mar endintre . . ./Oh cel blau! Oh mar blau, platja deserta,/groga de sol! De prop el mar te canta,/mentres tu esperes el retorn magnífic,/a sol ponent, de la primera barca,/que sortirà el mar tota olorosa." In the sketchbook Picasso also wrote down his own French translation of these verses for Fernande. See Joan Maragall, *Enllà*, ed. Glòria Casals (Barcelona: Edicions 62, 1989). For a study and a facsimile of the sketchbook, see Douglas Cooper, ed., *Carnet Catalan* (Paris: Breggruen, 1958).

17. See Rosenblum, "Picasso in Gósol," 268, and Rosenblum, "The Spanishness of Picasso's Still Lifes," in *Picasso and the Spanish Tradition*, ed. Jonathan Brown (New Haven/London: Yale University Press, 1996), 73–75. Elsewhere in that essay (n. 19, p. 174) Rosenblum also mistakenly identifies the Catalan flag as "the more regional counterpart of the Spanish flag," when in fact it is at least four centuries older than the Spanish.

18. On Picasso's Catalan identity, see Richardson, *Life of Picasso*, 1:13–14, and Palau i Fabre, "Gold of Gósol," 78–82.

19. See Richardson, *Life of Picasso*, 1:441; Cooper, *Carnet Catalan*, 7–8; Palau i Fabre, *Picasso, The Early Years*, 441; and Picasso and Apollinaire, *Picasso/Apollinaire: Correspondance*, 51. In her long letter to Apollinaire dated 21 or 22 June that included other interesting aspects of life in Gósol, Fernande used several Catalan words to explain that they eat nothing but the typically Catalan soup "escudella i carn d'olla," with "troumfousses" that are in fact "trumfus" (potatoes, as they are called in Gósol), "pilota" (seasoned ground meat) and "cols" (cabbage); her "counill" is "conill" (rabbit). See Colman Andrews, *Catalan Cuisine* (New York: Collier Books, 1992), 231–33. For a study of Gósol's history and traditions, see Antoni Díaz i Arnau and Ricard Gonzàlez i Arnau, eds., *Gósol: Quaderns de divulgació del futur Museu de Gósol*, issues 1 (1988), 2 (1989), and Annex (1989), and by the same authors, *Etnografia: Butlletí del Museu Municipal de Gósol*, issues 1 (2000) and 2 (2001). I am grateful to Josep Coromines and Laura Pueyo, from the Gósol city council, for providing me with copies of these publications.

20. Green, *Picasso: Architecture and Vertigo*, 137.

21. Rosenblum, "Picasso in Gósol," 268.

22. Brigitte Léal, "Landscapes During the Pink Period," 256. See also Claustre Rafart, "Towards Cubism," in *Picasso Landscapes, 1890–1912*, 265–67.

23. Léal, in *Picasso Landscapes, 1890–1912*, 243.

24. *Head of a Boy* was dated incorrectly "905" on the lower left corner by the artist at a later date. See William H. Robinson's entry for *Head of a Boy* in *Master Drawings from the Cleveland Museum of Art*, ed. Diane De Grazia and Carter E. Foster, exh. cat. (Cleveland/New York: Cleveland Museum of Art/Rizzoli International, 2000), 228–29.

25. Kirk Varnedoe, "Picasso's Self-Portraits," in *Picasso and Portraiture: Representation and Transformation*, ed. William Rubin, exh. cat. (New York: Museum of Modern Art, 1996), 132–35. According to Brigitte Léal, "the [Gósol] boys have become Greek kouroi"; see Léal, Christine Piot, and Marie-Laure Bernadac, *The Ultimate Picasso*, trans. Molly Stevens and Marjolijn de Jager (New York: Harry N. Abrams, 2000), 91.

26. Olivier, *Loving Picasso*, 183.

27. The last name of the old Cal Tampanada's innkeeper is often spelled as "Fontdevila;" in fact, his granddaughter, Dolors Fondevila, pointed out in an interview that the correct spelling is "without t." Magda Ballester, "Picasso permanence vivo en Gósol," *La Vanguardia*, 1970s; quoted by Antoni Díaz, "Gósol i la seva gent," in *Gósol: Quaderns de divulgació del futur Museu de Gósol*, no. 1 (March 1988): 63.

28. Richardson, *Life of Picasso*, 1:438.

29. Rubin, "Reflections on Picasso and Portraiture," in *Picasso and Portraiture*, 28.

30. See Werner Spies, *Picasso, the sculptures* (Ostfildern-Ruit: Hatje Cantz, 2000), 34.

31. See ibid., 31–37, and *Picasso: The Early Years* (exh. cat.), 50.

32. See Pierre Daix, "Portraiture in Primitivism and Cubism," in *Picasso and Portraiture*, 266; and Richardson, *Life of Picasso*, 1:451–52. The painting was wrongly dated "1905" on the lower left corner by the artist at a later date.

33. Rosenblum, "Picasso in Gósol," 269.

34. For the *Carnet Catalan*, see Cooper, *Carnet Catalan*, 29, 31, 46, 48, 50, 69; for the *Carnet no. 6*, see Brigitte Léal, *Musée Picasso: Carnets, catalogue des dessins* (Paris: Réunion des musées nationaux, 1996), 1:106; Palau i Fabre, *Picasso, The Early Years*, 440–41; and *Picasso 1905–1906*, 324–25, 350–51. Cooper, *Carnet Catalan*, 24, notes that some of these are sketches for a sculpture Picasso never executed.

35. My thanks to Michael Taylor and Suzanne Penn at the Philadelphia Museum of Art for their information about the painting's background.

36. On p. 40 of the *Carnet Catalan*, Picasso described himself as "a tenor who reaches a note higher than any in the score. Me!"; see Cooper, *Carnet Catalan*, 27; and Richardson, *Life of Picasso*, 1:451.

37. Charles Harrison et al., *Primitivism, Cubism, Abstraction: The Early Twentieth Century* (New Haven/London: Yale University Press/Open University, 1994), 120.

38. See William H. Robinson's entry for *Reclining Nude (Fernande)* in *Master Drawings from the Cleveland Museum of Art*, 230–31.

39. See Richardson, *Life of Picasso*, 1:421–23.

40. Even though neither of the two versions of *Odalisque with a Slave* (the second is at the Walters Art Museum, Baltimore) seem to have been exhibited at the 1905 Ingres exhibition at the Salon d'automne, I agree with Gary Tinterow that "Picasso was undoubtedly familiar with reproductions, . . . there were engravings and probably photos of all of Ingres's works floating around Paris"; email message to the author from Tinterow, New York, 28 February 2006.

41. Regarding the crouched woman in the corner, the palanganera, see Claustre Rafart, "A l'entorn de 'L'harem' de Pablo Picasso," *Revista de Catalunya*, no. 189 (November 2003): 51–64.

42. See Rosenblum, "Picasso in Gósol," 263–64.

43. Unaware of this reference in Picasso's work, André Malraux had already used Cézanne's version of Piombo's work to illustrate Picasso's dialogue with the old masters, where he states that Picasso was also familiar with Cézanne's version. See André Malraux, *La tête d'obsidienne* (Paris: Gallimard, 1974), 56, and figs. 14 and 15 in the appendix.

44. See the arguments made by Rubin, "La genèse des Demoiselles d'Avignon," in Hélène Seckel-Klein et al., *Les Demoiselles d'Avignon*, exh. cat. (Paris: Editions de la Réunion des Musées Nationaux, 1988), 396–400; Robinson, *Reclining Nude (Fernande)*, 230; Rosenblum, "Picasso in Gósol," 263; and Margaret Werth, "Representing the Body in 1906," in *Picasso: The Early Years* (exh. cat.), 277–78.

# The Forms of Paradise:
# Noucentista Painting and Sculpture

*NARCÍS COMADIRA*

The political and cultural movement known as Noucentisme set out to civilize and modernize Catalonia in the early 20th century, as well as to lay the foundations for putting Catalonia on an equal footing with the cultured countries of Europe. In terms of the arts, however, Noucentisme was not stylistically univocal. Eugeni d'Ors, the spokesman for Noucentisme and one of its leading theoreticians, invented the name, which merely refers to a chronological period ( the 1900s); the name indicates that the sole link among the people associated with it was that they worked in the century that had just dawned. In fact, as the *Almanach dels Noucentistes* shows, no single aesthetic current became dominant, even by 1911.

Ors began publishing his daily editorial, "Glosari," in *La Veu de Catalunya* early in 1906. That year is regarded by most historians as the first year of Noucentisme because, in addition to the launch of Ors's opinion column it was in 1906 that Josep Carner, who was to be the great Catalan poet of the century, published *Els fruits saborosos* (The Tasty Fruits), a kind of Arcadian idyll with classical sounding names. That year also saw the foundation of Solidaritat Catalana, the first unified nationalist movement, and Barcelona hosted the first International Conference of the Catalan Language. All these events showed that the ferment of Modernisme (the Catalan form of Art Nouveau) and the Renaixença (the older, national revivalist movement) required a change and an organization that would introduce some degree of political autonomy, however frail, that could guarantee the creation of the basic cultural infrastructures necessary to transform Catalonia into a modern, civilized, and cultured country. The Catalan language needed reforming and regulating after centuries of neglect, and libraries, museums, and laboratories were too few in number. A desire for order was enormously important in aesthetics and the arts, and thus noucentista painting, sculpture, and architecture must be understood as part of a movement to build a country that wanted to be and be able.

Several years had passed since Josep Torras i Bages, the future bishop of Vic, began instructing a group of Catholic artists working more or less within the aesthetic of Modernisme. The brothers Josep and Joan Llimona (sculptor and painter, respectively), Antoni Gaudí, Dionís Baixeres, Iu Pascual, and others founded the Cercle Artístic de Sant Lluc, a kind of brotherhood that defended the possibility of a modern art not in conflict with their Catholic faith and that would even serve to spread their beliefs. Both the great architect and the future bishop preached removal from the mists of the north and a return to the Mediterranean, to the balanced light and order of Greco-Roman classicism. In a lecture at the Cercle Artístic de Sant Lluc in 1894, Torras i Bages said:

*What a difference, dear friends, between the purpose discovered by Art in many modernistes and what is expressed by the artistic tradition handed down from beautiful Greece and discrete Rome, enlivened by Christian inspiration, which has delighted so many civilized societies! In this Art, which they try to adorn by baptizing with the vulgar epithet modernista, which has come mostly from the icy fogs of the North, which sends shudders running down the spines of those who gaze at it, can you not feel the breath of barbarity? Could it be that Orpheus has vanished from the world? Is it progress in the artistic order to replace the lyre that tamed the wild beasts with the dark suggestion that arouses the aversion of the social body, the spirit of revenge and insatiable lust, that throws down human society and grinds it to dust? Is it progress toward social perfection to turn Art, which had always been an agglutinant, into a solvent?*[1]

And Gaudí, who worked with Joaquín Torres-García in 1903 and 1904 on the stained-glass windows of Majorca cathedral, said:

*Virtue is to be found at the mid point: Mediterranean means in the middle of the earth. The shores of middle light and at 45 degrees, which is the kind that best defines things and shows us their form, are where the great artistic cultures have flourished because of that balance of light: neither too much nor too little, because both provoke blindness; the Mediterranean is ruled by the specific vision of things on which true art has to rest. Our plastic strength is the balance between feeling and logic: the Northern races intoxi-*

*cate, smother all feeling, and, with their lack of light, neglect rationality and engender monsters. . . . The Mediterranean arts will always hold a marked superiority over the Northern ones.*[2]

However, ideas are not formalized so quickly; they need time and dedication to struggle against the inertia of acquired forms, which is not usually given to artists who are already masters of their own language. But in the Cercle Artístic de Sant Lluc, there was also a section of young artists to which Torres-García belonged, who were ductile enough to seek an artistic language suitable for these guidelines for renewal (fig. 1).

This Mediterraneanist direction of aesthetics was not peculiar to Catalonia. In France, Jean Moréas, Maurice Barrès, and Charles Maurras also preached a return to classicism, and several leading artists, such as Henri Matisse, André Derain, and Aristide Maillol, looked to the south. And let us recall that in that very year, 1906, Picasso spent his sojourn in Gósol and his contact with the primitive nature of that remote region brought about a crucial change in him. Paris was the capital of art at the time and many Catalan artists traveled there to learn, work, and make their fortune. Joaquim Sunyer and Enric Casanovas were

among them. So was Manolo Hugué. There, in 1907, the great Cézanne exhibition was held and everyone could see the works of Gauguin, the Nabis, as well as the works Matisse and Derain painted at Collioure. Maillol, who had been a painter in the orbit of the Nabis, surprised everyone with the power of his sculpture *The Mediterranean,* 1905 (see fig. 3, p. 231). This French Mediterraneanist ferment would be where Sunyer and Casanovas did their training, and later on, from the time they both exhibited in Barcelona in 1911, it became a powerful current that swept into Catalonia and flowed with the local noucentista movement.

Mediterraneanism, then, is a major component of noucentista aesthetics, but not the only one. Since Noucentisme was also and especially a national reconstruction movement, we can understand that Catalonia's glorious medieval past was regarded as one of the factors to be taken into account, and so mainly Romanesque art, but also the austere Catalan Gothic style, was included and contributed to some of the attempts at formalization. For example, the architects Rafael Masó and Josep Maria Pericas, along with the sculptor Fidel Aguilar, were touched in some way by the Romanesque. But as they wanted to make Catalonia a modern country within the

Fig. 1 (cat. 6:16). Joaquín Torres-García, *Architectural Composition with Figures,* 1925–26.
Fig. 2. *Philosophy Presented by Pallas on Parnassus,* 1911, by Joaquín Torres-García.

orbit of Europe, they came under the influence of German, Viennese, and English attempts at seceding from conventional academic and literary art. Thus the first noucentista formalizations had a certain northern weight, even though such ran counter to the dictates of Gaudí and Torras i Bages. Further, the secessionists had their own interpretations of classicism, though they were far more filtered. There was another component in the first noucentista formalizations, one that sprang from the people. After the popular arts, the uncontaminated crafts, the authenticity of tradition, and all that would be part of the noucentista aesthetic began to wane, then realism, decorativism, and archaeologism burst onto the scene. Although they had always been present in noucentista forms, they became dominant when the strongest creativity of the movement was swept away by the whirlwind of the First World War.

Both Mediterranean classicists and popularists tried to view Catalonia through an Arcadian glass. It is strange that while Barcelona was the fiery rose of anarchism, and while the city burned during la

Setmana Tràgica (the Tragic Week) of July 1909, those who became its most important artists seemed determined to look only at what remained of the Eden-like authenticity of the coasts and the mountain villages. They searched for modern forms in Catalonia that could return society to that paradise, which even if fading away in the capital was still alive near the sea, in the country, and among the ancient crafts.

Thus Torres-García saw goddesses and classical temples on a local Parnassus, as in the two friezes *Philosophy Presented by Pallas on Parnassus:* one conserved at the Reina Sofía in Madrid, which comes from Ors's collection, a painting still deeply indebted to Pierre Puvis de Chavannes, indeed straight out of *The Sacred Wood Cherished by the Arts and the Muses* (The Art Institute of Chicago); and the other, which looks far more like a mural painting, the property of the Institut d'Estudis Catalans (fig. 2). Or he surprises a nymph going down to a cove, as in the painting *Bather,* 1911 (fig. 3), a variation or sketch of what was published in the *Almanach dels Noucentistes* and baptized *On the Shores* by Ors to help to dignify

Fig. 3 (cat. 6:14). Joaquín Torres-García, *Bather,* 1911.

those Catalan beaches with the presence of characters from mythology. Indeed, Torres-García found his first classicist model in Puvis de Chavannes; the Cercle Artístic de Sant Lluc bought the monograph *Puvis de Chavannes* (1895) by M. Vachon, and the painter was held up as a model of order by Torras i Bages in a lecture in 1897. Torres-García's first classicist formalization, reproduced on the cover of the magazine *Pèl & Ploma* in 1901, came directly from Puvis de Chavannes. His influence is obvious in the two friezes mentioned and the *Bather*, which resembles the figure with its back turned in *Young Women at the Sea Shore*, c. 1879 (fig. 4). His work also played an important part in the frescoes in the Sant Jordi room of the Palau de la Generalitat in Barcelona, especially in the first painting.

Because of that commission, which may have been inspired as a whole by the decoration of the Paris city hall, with ceilings ringed by a decorative border, Torres-García took a trip to Italy, where he discovered the required tonalities for mural painting.

*Definitely, Orcagna, Giotto, and Gozzoli are the true decorators, despite the flaws that might be found in the drawing and the enormous errors in proportion between the objects and the perspective. The decorative, flat character of their paintings, which never recede into the wall, is an achievement we should learn from. And the sobriety of the color, within a general tonality, dominant to give unity to the whole.*[3]

When financial security allowed, Torres-García built a family house in Terrassa, which he called Mon Repòs (My Rest); the four murals he painted inside the lantern room are considered the high water mark of his Mediterraneanism. With only himself to please, he painted without the pressures of political correctness and gave himself up to a decorative style with no constraints, employing a figurative style derived directly from Puvis de Chavannes and linked, in terms of drawing, to Maillol's woodcut illustrations for Virgil.[4]

In the first of the frescoes at the Palau de la Generalitat in Barcelona, a sketch for which is included in this exhibition (fig. 5), we can clearly see how the iconic program weighs heavily on the form. The painter clearly separated the theme on the lunette from the one on the wall, and resolved the latter with a frieze over the door and a group of figures on each side. On the lunette, the tree of the motherland, from which the heraldic coat of arms of Catalonia hangs, shelters a Vestal Virgin who watches over the altar of the language; her parchment and pen indicate that this language is also literary. Beside her Athena, who had introduced Philosophy to Parnassus as the tenth muse on the 1911 frieze, reigns over eternal Catalonia, crowned with the royal Catalan helmet. In other words Catalonia, like Athens, was founded by the goddess. The frieze below comes directly from the version at the Institut d'Estudis Catalans. The nine muses, now ten following the incorporation of Philosophy, accompany the image of Catalonia, seated like a Roman matron with Abundance standing next to her, a basket of fruit at her feet. Below the frieze on either side are manual labor on the left and intellectual work on the right, which symbolize the human Catalonia. The entire composition resonates with symmetry, plasticity, and great planes of opaque colors, flat paint that does not recede into the wall, applied according to the artist's prescription for decorative painting, and all in a tone as archaic as the scene it set out to depict.

Joaquim Sunyer's paintings at a Barcelona exhibition of 1911 caused a great commotion in cultural circles in the city. Ors, who had not included Sunyer in the *Almanach dels Noucentistes,* hastened to sing his praises. At the time Sunyer was seen as a "French" painter and a critic compared him to Matisse.

*His art is genuinely French, the son or at least the spiritual brother of Matisse. . . . To no one as much as Sunyer can the label "Frenchified" be attached, and indeed, it is for Sunyer that the definition of the Mediterranean School of Painting appeared. The fact is that perhaps no one else has been able to capture the spirit of French art and interpret it with a temperament of such pure Catalan roots.*[5]

Fig. 4. *Young Women at the Sea Shore,* c. 1879, by Pierre Puvis de Chavannes.

Fig. 5 (cat. 6:15). Joaquín Torres-García, *Project for the Fresco "The Eternal Catalonia,"* 1912.

Sunyer trained in Paris, although his classicism also has a Germanic element, that is, a realist component, perhaps resulting from his exhibitions in Liège and Munich, and later in Prague, where public tastes must have affected his figural style. Indeed, before his triumphant return in 1911, he spent some time in Sitges, his hometown beside the sea, a few miles south of Barcelona. There, in 1909 and 1910, he painted the local landscape he knew so well, seen through the eyes of Gauguin and the Nabis, and after 1913 increasingly through Cézanne's. *Pastoral*, 1910–11 (fig. 6), is one of Sunyer's finest paintings of the period and a synthesis of many things. The Arcadian theme links him to Matisse's *Joy of Life*, 1906 (Barnes Foundation, Merion, Pa.), while the treatment of the distant hills recalls *Luxury I*, 1907 (Musée National d'Art Moderne, Paris). At the same time, Sunyer was strongly influenced by the Nabis, by Maurice Denis most of all, and by Gauguin, as reflected in the kidney-shaped trees, the decorative quality, and, above all, the symbolic air that comes from that realist point

of intention, which when applied to classicist painting inevitably leads to Symbolism. In an earlier text, I compared *Pastoral* to Gauguin's *The Awakening of Spring (The Loss of Virginity)*, 1891 (Chrysler Museum of Art, Norfolk), although the "narrative" in Sunyer's painting goes beyond the other. If the reclining girl in Gauguin's painting fears for her virginity, spring in Sunyer's composition is a clear summer expression of erotic satisfaction.[6] In October 1906, after the death of Cézanne, Ors reproached the French master for painting landscapes lacking mythology.

*Instead of making the landscape a state of the soul, Cézanne made the soul a state of the landscape. That absence of lyricism is of great value. But it should be completed with . . . mythology. Seeing things independent of the onlooker's personality is fine. Provided they are always seen as gods, those things.*[7]

Sunyer's landscape is a mythological one, which is certainly why Ors praised him. The poet Joan

Fig. 6 (cat. 6:10). Joaquim Sunyer, *Pastoral*, 1910–11.

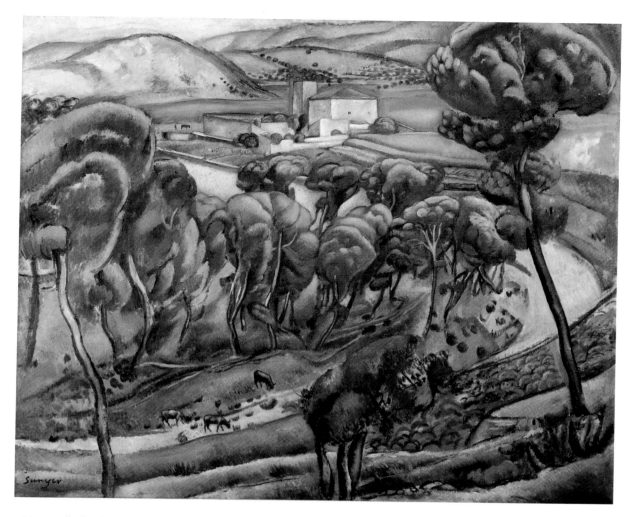

Maragall also knew how to see Sunyer's mythification of the landscape when he wrote:

[T]he woman in *Pastoral* is the flesh of the landscape: it is the landscape that has made itself flesh by becoming animated. There is nothing arbitrary about that woman there, she is fate: it is the whole history of creation . . . woman and landscape are degrees of the same thing; and the artist, fascinated by the lines of the landscape, will see how the lines of the woman's body bloom unintentionally from his brush.[8]

For Sunyer, perhaps because of his French training, everything is intellectually mediated, and one of his strengths is that rational clarity always presides over and tempers his extraordinary sensitivity to color.

Less programmatic, and apparently more spontaneous, is Sunyer's *The Valley of the Friars*, 1913 (fig. 7), a painting in which Cézanne's presence is felt in the shapes of the pine trees and the structure of the masses marking fields, roads, and hills. This is a landscape without added mythology, but which, because of its intimate relation with another from the same year, *Three Nudes in the Wood* (fig. 8)—in which three naked women appear in the same place between the tree trunks, a clear quotation from Cézanne's bathers, but with a formalization of the

bodies that comes from Luca Signorelli—can be read as a mythical vision of the landscape of Catalonia. The light bucolic touches, the animals grazing and the peasant plowing in the distance, provide it for us. Sunyer took this picture, painted in Sitges, to Paris

Fig. 7 (cat. 6:17). Joaquim Sunyer, *The Valley of the Friars*, 1913.
Fig. 8. *Three Nudes in the Wood*, 1913, by Joaquim Sunyer.

for exhibition. The exhibition was never held, no doubt because of the First World War, and the picture remained in the hands of Sunyer's art dealer Barbazanges. The painter recovered it 30 years later, exchanging it with Barbazanges's son for another. It was shown in Barcelona and then in Madrid in 1955, shortly after his death. Ernest Flender of the U.S. embassy bought it and took it to the United States; in the early 1980s it returned to Barcelona via an antiquarian and remains there in a private collection.

Enric Casanovas received his first sculpture lessons in the studio of Josep Llimona, the great modernista sculptor. It seems that, at the age of 14, he chose this teacher himself, and Llimona encouraged him to pursue sculpture. Casanovas then studied in the official program of the Llotja art school, in other words, in an academic program, even though his aim was to obtain a grant that would allow him to settle in Paris, which he eventually did in 1904. He became a friend of Sunyer, Manolo Hugué, and Picasso, among others, and felt the same impulses for change and Mediterraneanism as his contemporaries. From the nervous realism of his first works he went on to create sculptures with more compact mass, though still with a certain formal Symbolist veil, which in the 1920s reappeared tenuously and which I believe to have come from Llimona. In 1906 he stayed with Picasso in Gósol, where the rugged landscape appears to have taken him toward more archaic forms. Indeed, until the 1920s he used such shapes, beginning with *Woman from Gósol,* 1925

(Casanovas Family Collection, Barcelona), and those works may be set thematically within what we might call mythological territory. Obvious examples include *Juno,* 1910 (M. Brullet Collection, Barcelona); *Bathing,* c. 1911 (private collection) (a relief guided by the taste for such themes in France and whose composition again recalls Puvis de Chavannes); *Flora,* 1917 (Museu Nacional d'Art de Catalunya, Barcelona); and *Nausica,* 1920 (private collection). The two sculptures in this exhibition, *Persuasion,* c. 1913 (fig. 9), and *Youth and Love,* c. 1914 (fig. 10), are very much a part of this phase of Mediterraneanist mythological figuration. The Arcadian view is imposed upon the forms of reality, and Casanovas (who in his view, like Sunyer, acted with a strong intellectual accuracy) seemed to still need these mythological prejudices to face it positively, that is, to be able to derive from reality what he already may have had in his head as the ideal of sculpture.

In 1916 Casanovas spent some time with Sunyer in Fornalutx in Majorca, and there, as in Gósol, the harsh character of the landscape may have impressed him. *Majorcan Peasant Woman,* c. 1916 (Museu Municipal, Tossa de Mar), and *Woman from Fornalutx,* 1916 (fig. 11), two sculptures carved directly in stone, seem to have no mythological references. The Arcadian vision was already coming to an end; the horrors of the First World War had cut short the possibility of such dreams, and classicists like Casanovas had to learn to read the real world without embellishments. Indeed, from the 1920s on

Fig. 9 (cat. 6:13). Enric Casanovas, *Persuasion,* c. 1913.

Casanovas abandoned mythological subjects and concentrated on the reality of the female figure. But he transfigured that reality with a veiled nostalgia that emerges in the mythical smile of his subjects. Josep Pla, the greatest prose writer of the century and the author of a portrait of the sculptor, says:

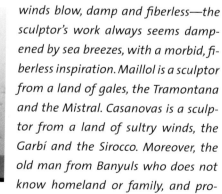

*Casanovas' work has the same meaning as Maillol's, but—objectivity obliges me to say—it is more languid, though that does not mean that he ever lapses into literaturism [literalism], the plague of this art. I have always explained this feature of languor in the hands sculpted by Casanovas as resulting from a physical cause that it seems to me cannot be ignored. Maillol*

*was formed and worked in a country where the north winds blow, the atmosphere is limpid, the inspiration is bracing and stinging. Casanovas lives almost permanently in that part of Catalonia where the south winds blow, damp and fiberless—the sculptor's work always seems dampened by sea breezes, with a morbid, fiberless inspiration. Maillol is a sculptor from a land of gales, the Tramontana and the Mistral. Casanovas is a sculptor from a land of sultry winds, the Garbí and the Sirocco. Moreover, the old man from Banyuls who does not know homeland or family, and professes the religion of physical or figured beauty, runs from sentimentalism like a singed cat from embers. Casanovas was a far more tender, sentimental man.*[9]

Fig. 10 (cat. 6:12). Enric Casanovas, *Youth and Love*, c. 1914.
Fig. 11. *Woman from Fornalutx*, 1916, by Enric Casanovas.

Pla's meteorological reasons do not explain the nature of Casanovas's sculpture of the 1920s satisfactorily; rather, the veil of nostalgia and the formal softening he took from Llimona are precisely the fruits of disillusionment from the noucentista project, of which Casanovas, after his exhibition in Barcelona in 1911, so highly praised by Ors, was one of the leading artists. These sculptures of the 1920s by Casanovas are formalizations of goddesses with no names and no paradises.

*Coastal Landscape*, 1915 (fig. 12), by Xavier Nogués, has to be considered in the context of its provenance. Indeed, it was part of a mural decorating the cellar of the Galeries Laietanes, where a dinner in honor of Picasso was held in 1917. This environment explains the relaxed tone, spontaneity of conception, and speed of execution. It was a cheap decoration, one might say, tempera applied directly to the wall, far from the artisan-like effort of fresco painting. Nogués embodied the popular component of Noucentisme that acted as a counterweight to a sometimes obsessive mythological classicism inclined toward pedantry. Nogués was the artist who sang Papageno in the noucentista opera, if I may be allowed the image, a popular chord of Noucentisme that found a major poetic consecration in the book

*Auques i ventalls* (1914) by Josep Carner, and later in *Sàtires* (1927) by Guerau de Liost, which Nogués illustrated. Nogués took part in the *Almanach dels Noucentistes* and, even when flirting with a more or less Arcadian theme, could not avoid humor. The defining work of his art of this period is the engraving *La Ben Plantada* (*The Shapely Woman*), 1912 (fig. 13), symbol of the ideal Catalan woman, whom he saw almost as a giantess surrounded by tiny frightened figures at her feet, rebuking her, stoning her, terrified by her presence.

More than anything Nogués was an extraordinary draftsman and engraver. His paintings seem less important, and his serious works as a painter came late in his career and belong to a slightly vacuous decorative realism—with some affinity with the Italian Novecento—toward which a large part of noucentista painting was moving. An artist who looked at reality with a sense of humor, Nogués could caricature it with a sense of critical irony that is never offensive. His line in both drawings and engravings, always impeccably executed with subdued expressionism, gave shape to a whole gallery of country types, and his exactly calculated compositions constitute a repertoire of stage settings where the human comedy of his time unfolds.

Fig. 12 (cat. 6:18). Xavier Nogués, *Coastal Landscape* (fragment of the murals for the cellar of the Galeries Laietanes), 1915.

1. Josep Torras i Bages, "De la fruïció estètica," in *Obres Completes* (Barcelona: Abadia de Montserrat, 1986), 2:252.

2. Joan Bergós, *Gaudí. L'home i l'obra* (Barcelona: Ariel, 1954).

3. Joaquim Torres-García, "Notes de viatge," in *Notes sobre art* (Girona: Masó, 1913); reprinted in *Escrits sobre art,* ed. Francesc Fontbona (Barcelona: Edicions 62, 1980), 85.

4. For more information on this issue, see my essay "Torres-García i el Mediterranisme," in *Torres-García. Pintures de Mon Repòs,* ed. Cristina Mendoza, exh. cat. (Barcelona: Caixa de Terrassa, Museu Nacional d'Art de Catalunya, 1995), 27–33.

5. "Saló de les Arts i els Artistes. Joaquim Sunyer," *Vell i Nou,* no. 25 (15 May 1916), 22.

6. See Narcís Comadira, "Sunyer, 1908–1918: Una dècada prodigiosa," in *Joaquim Sunyer. La construcció d'una mirada,* ed. Cristina Mendoza and Mercè Doñate, exh. cat. (Barcelona: Museu d'Art Modern, 1999), 63.

7. Eugeni d'Ors, "Paul Cézanne," in Ors, *Glosari 1906–1907,* ed. Xavier Pla (Barcelona: Quaderns Crema, 1996), 297.

8. Joan Maragall, "Impresión de la Exposición Sunyer. A un amigo," *Museum,* no. 7 (July 1911), 259.

9. Josep Pla, *Obra Completa* (Barcelona: Destino, 1972), 21:423.

Translated by Richard Jacques.

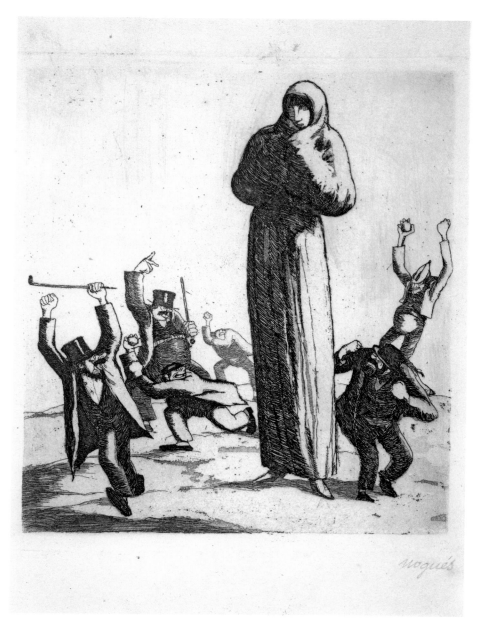

Fig. 13. *La Ben Plantada* (*The Shapely Woman*), 1912, by Xavier Nogués.

# Noucentisme and the Revival of Classicism

## ALÍCIA SUÀREZ AND MERCÈ VIDAL

Strictly speaking, none of the works of art in this section keep to the precepts of Noucentisme, which is characterized by its classicism, craftsmanship, and defense of traditional values. Neither Salvador Dalí nor Pablo Picasso joined the movement, and only the painters Josep de Togores and Feliu Elias were linked to it, though in a somewhat distant manner. Even so, these works can be regarded as part of the international movement that emerged following the First World War that art historians have called the "retour à l'ordre."[1]

Picasso is unquestionably one of the movement's most significant figures because, as one of the leading lights of Cubism, his shift to classicism was especially noteworthy. Picasso painted *Olga Kokhlova with Mantilla* (fig. 1) in Barcelona in the summer of 1917. Earlier that year, in February, he had traveled to Italy with Jean Cocteau—they worked together on the ballet *Parade* for Sergei Diaghilev—and met the Russian ballerina Olga Kokhlova, whom Picasso was to marry the following year. In June 1917, he followed Diaghilev's company to Madrid and Barcelona. Back

in the Catalan capital, he moved into his mother's house and familiarized himself with the Barcelona of his early days when he was training to be a painter, meeting up once again with his Catalan friends, who organized a supper as a tribute to him.

This was not the first time that Picasso painted a woman wearing a mantilla, a traditional item of women's clothing in Andalusia. Two earlier works have the same theme: the portrait of his sister, Lola, dating from 1898–99 (see fig. 1, p. 96) and the portrait of Señora Canals of 1905. He must have painted the portrait of Kokhlova to please his mother, with whom he was staying, since the portrait remained in her home. Alfred H. Barr regarded this painting as one of Picasso's first in a new classical or realist style.[2] According to Josep Palau i Fabre, Picasso's intention was to transform Kokhlova into a Spanish woman, but in the painting's poignant realism the critic saw a portrait of a Slavonic peasant girl with a certain primitive brutality.[3]

Picasso showed a number of paintings, among them his portrait of Kokhlova, at the Barcelona

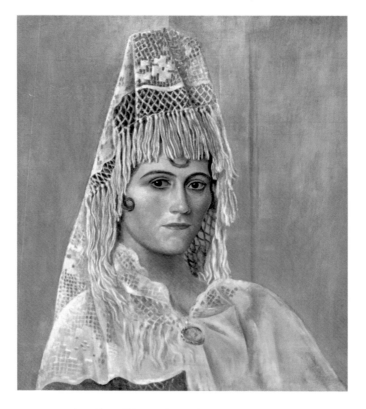

Fig. 1. *Olga Kokhlova with Mantilla*, 1917, by Pablo Picasso.

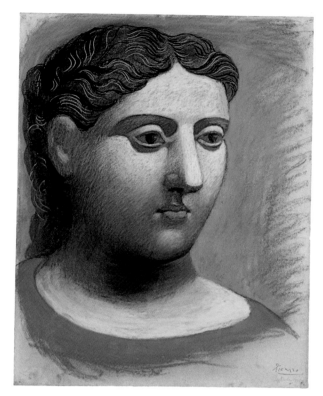

Municipal Art Exhibition of 1919, an initiative organized by the Noucentistes. In addition, Picasso donated works to the Museu d'Art, another initiative of the Noucentistes. Moreover, noucentista critics acclaimed Picasso's paintings in the classical manner (fig. 2). In 1917, even Eugeni d'Ors proposed a ballet for Diaghilev with a libretto written by himself and set designs by Picasso, though it never came to fruition. Picasso also played a leading role in Barcelona art circles during this period because he was much admired by Dalí, Togores, and Elias, the other painters represented here.

Dalí executed his magnificent portrait of Luis Buñuel, 1924 (fig. 3), when he and Buñuel were stay-

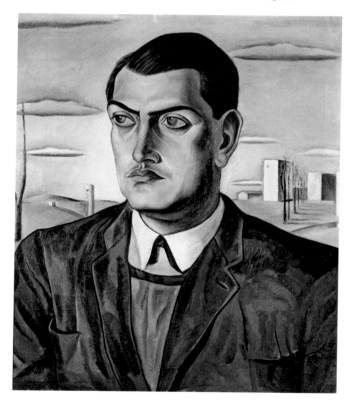

Fig. 2 (cat. 6:21). Pablo Picasso, *Head of a Woman*, 1921.
Fig. 3 (cat. 6:24). Salvador Dalí, *Luis Buñuel*, 1924.

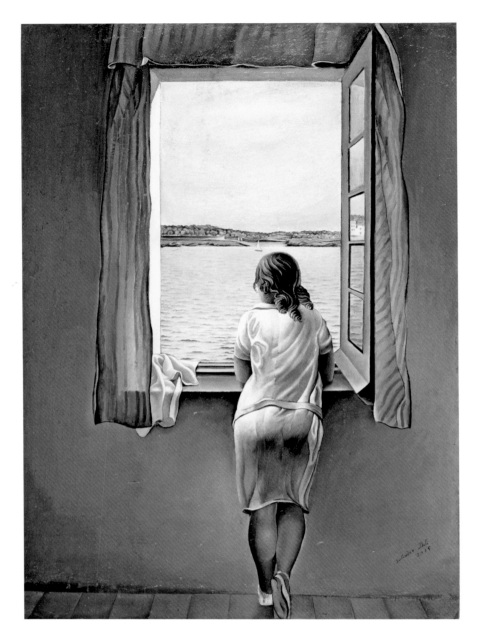

ing in the Residencia de Estudiantes in Madrid during their years as students. The two went on to work together on one of the finest works of Surrealism, the film *Un Chien Andalou* (1929). Dalí had adopted Impressionism during his early years, but later became interested in Cubism and Futurism. Through the French journal *L'Esprit Nouveau,* he followed Picasso through his classical phase and the Italians of Valori Plastici, their version of the new order. A great admirer of Ingres, Raphael, and Vermeer, Dalí found it easy to embrace the precise realism of his works in this section.[4] Two details in the background of the portrait of Buñuel are worthy of attention: the perspective on the right calls to mind the paintings of Giorgio de Chirico, and the long clouds are remi-

niscent of the opening shots of *Un Chien Andalou,* in which a cloud passes in front of the moon.

Dalí's *Figure at a Window (Girl at a Window),* 1925 (fig. 4), belongs to a series of works depicting his sister Anna Maria, here looking out at the sea. When it was shown in 1925 at Dalí's first solo exhibition at the Galeries Dalmau in Barcelona, the painting was acclaimed for its light crispness and even its air of mystery. The noucentista critics praised Dalí's work, and Joaquim Folch i Torres even went so far as to say that he saw in Dalí "the future of our young painting."[5] The critic Rafael Benet saw him as a verist of the Valori Plastici school.[6] For the catalogue, Dalí chose a number of Ingres's aphorisms. The Dalí who became a leading light of Surrealism a few years

Fig. 4 (cat. 6:25). Salvador Dalí, *Figure at a Window (Girl at a Window),* 1925.

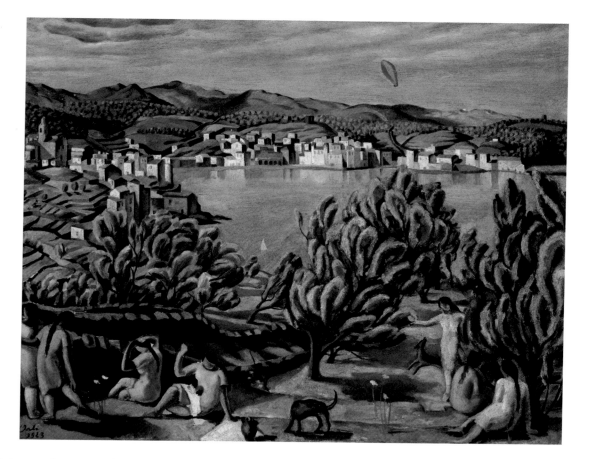

later was here a good representative of the return to order (figs. 5 and 6).

Josep de Togores, who as he stated was attracted to "Cézannism and Cubism," made his home in Paris in 1919.[7] There he visited the much-admired Picasso and shortly after began his highly successful period of painting with realistic precision and rigor. The art dealer Daniel-Henry Kahnweiler took Togores under contract and brought his paintings to international attention. His works were shown in exhibitions and magazines in Germany, where he fit in so well with the New Objectivity movement that Franz Roh in-

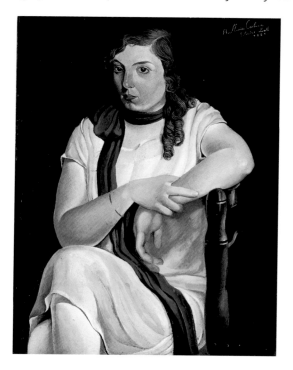

Fig. 5 (cat. 6:23). Salvador Dalí, *Cadaqués*, 1923.
Fig. 6 (cat. 6:26). Salvador Dalí, *Maria Carbona*, 1925.

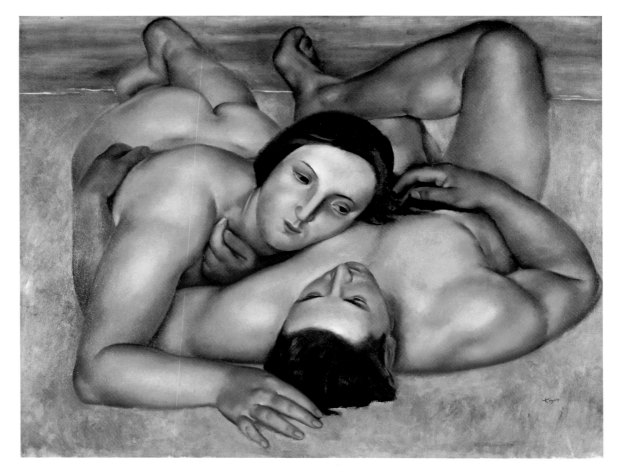

cluded him in his 1925 article entitled "Magic Realism: Post-Expressionism."[8] *Nudes on the Beach,* 1922 (fig. 7), was produced during this phase of the artist's career,[9] painted in Bandol on the Mediterranean coast near Marseilles. Significantly, Togores had spent the previous summer in Banyuls-sur-mer (in French Catalonia), where he had struck up a close friendship with Aristide Maillol, whose sculpture he admired. Maillol's rounded volumes are evident in *Nudes on the Beach,* a painting that seems to exemplify the artist's idea that "a Mediterranean, a Catalan, is a man sensitive to curves."[10] Hence, the tanned couple on the sand, with the blue of the sea in the background, are depicted in curvilinear rhythms and shown from a point of view that is surprising because it is unusual, as if they were on a dune and the painter was also relaxing on the sand. Togores was highly regarded by the noucentista critic Eugeni d'Ors (fig. 8), who always praised him, to such an extent that when Ors wrote an essay in 1925 reviewing the state of Catalan painting, he

commented that after Sunyer there was nothing of masterly quality until Togores.[11]

Feliu Elias was an unusual figure in Catalan painting of this period. He signed his drawings and caricatures as Apa, but his nom de plume as an art critic was Joan Sacs.[12] Scorned for his staunch defense of realism and his political differences with the Noucentistes, he was not a central figure of the movement. Paradoxically, however, Ors described him as early as 1906 as a noucentista draftsman because of the discipline of his work, and the cover of Ors's *Glosari* is illustrated with Elias's drawing of David and Goliath. In addition, a drawing of St. George featured prominently in a series of profoundly noucentista publications: *Les pintures murals catalanes* (Catalan Mural Paintings), issued from 1908 to 1911 by the Institut d'Estudis Catalans.

Elias was also involved with the Escola Superior dels Bells Oficis (School of Fine Crafts), where he taught art history, and the Les Arts i els Artistes, an

Fig. 7 (cat. 6:20). Josep de Togores, *Nudes on the Beach,* 1922.
Fig. 8. *Eugeni d'Ors,* 1928, by Josep de Togores.

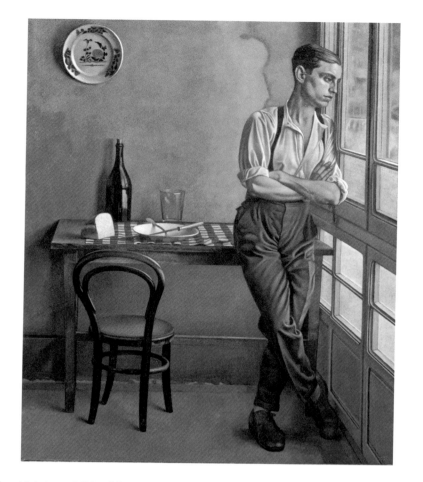

association with which he exhibited from its founding in 1910; both were essential to the noucentista movement. His painting *The Gallery,* 1928 (fig. 9), is a good example of his meticulous, precise technique. It also has a disturbing appearance, making it very close to work of the New Objectivity movement in Germany. The ceramic plate hanging on the wall is significant, first, because Elias was an expert collector of ceramics, and, second, because together with his colleague Francesc Quer, who was in charge of Arts de la Terra at the Escola Superior dels Bells Oficis, he contributed to the revival and spread of the Catalan tradition of ceramic art. Ceramics also appear in other Elias paintings, such as the portrait of his daughter of 1929–32 (private collection, Barcelona), which features a vase by Quer on the table. Elias was a great admirer of Picasso's classical phase and shared Dalí's fascination with Vermeer. Throughout his career, Elias remained faithful to realism because he regarded it as "an optimistic revelation of the Universe," and he declared, "I have struggled to translate onto canvas that Reality that fills us with joyous wonder from the moment we arrive in the world."[13]

1. This "return to order" was known in Italy as Valori Plastici (Plastic Values) and in Germany as Neue Sachlichkeit (New Objectivity).

2. Alfred H. Barr Jr., *Picasso, Fifty Years of His Art* (New York: Museum of Modern Art/Arno Press, 1966), 100.

3. Josep Palau i Fabre, *Picasso: Dels ballets al drama. 1917–1926* (Barcelona: Polígrafa, 1999), 69.

4. See Michael Raeburn, ed., *Salvador Dalí: The Early Years,* exh. cat. (London: South Bank Centre, 1994); and Fèlix Fanés, *Salvador Dalí: La construcción de la imagen. 1925–1930* (Madrid: Electa, 1999).

5. Joaquim Folch y Torres, "El pintor Salvador Dalí," *Gaseta de les Arts,* no. 60 (November 1926), 2.

6. Rafael Benet, "Salvador Dalí," *La Veu de Catalunya,* 27 November 1925.

7. Josep de Togores, *Monòlegs amb Esteve Fàbregas i Barri i altres escrits* (Barcelona: Selecta, 1988), 49.

8. Franz Roh, "Magic Realism: Post-Expressionism," in *Magical Realism: Theory, History, Community,* ed. P. Zamora and W. B. Faris (Durham, N.C.: Duke University Press, 1995).

9. Josep Casamartina, ed., *Togores: Classicisme i renovació (obra de 1914 a 1931)* (Barcelona: Museu Nacional d'Art de Catalunya, 1997).

10. Togores, *Monòlegs amb Esteve Fàbregas i Barri,* 44.

11. Eugeni d'Ors, *Cincuenta años de pintura catalana,* ed. Laura Mercader (Barcelona: Quaderns Crema, 2002), 248.

12. As an art critic, he wrote two notable works: Joan Sacs, *La pintura francesa moderna fins el cubisme* (Barcelona: Publicacions de La Revista, 1917); and Feliu Elias, *L'escultura catalana moderna* (Barcelona: Barcino, 1926).

13. Apa, "Prefaci a l'espectador," *Catàleg de l'exposició de pintura de Feliu Elias (Apa),* exh. cat. (Barcelona: Galeries Laietanes, 1916).

Translated by Susan Brownbridge.

Fig. 9 (cat. 6:27). Feliu Elias, *The Gallery,* 1928.

# The Mediterranean Roots of Noucentista Sculpture

*MERCÈ DOÑATE*

> Rodin brought us his keen sense of feeling, his love of dynamic beauty, character and expression,
> and especially his style: his own passionate and complex style.... Yet, here a new Master [Aristide Maillol]
> unveils another ideal, another beauty, naïve sensuality, simplicity, a modest nobility that stems from
> classicism, all of which resembles water that is both crisp and very pure.
> —Maurice Denis, 1905

These words by the painter Maurice Denis, published in his book *Théories*, illustrate the transformation that took place in European sculpture in the early 20th century. In the changing of the guard between two great French sculptors, Auguste Rodin, who had dominated the last quarter of the 19th century, gave way to Aristide Maillol, who would open up a new artistic path, that of the classical ideal, which would develop along with the avant-garde for several decades.[1] The very title of the sculpture *The Mediterranean* (see fig. 3, p. 231), shown by Maillol at the 1905 Salon de Paris, represents an authentic manifesto of a new direction in art. Only a few months after Denis's article appeared, Catalan art theorist and critic Eugeni d'Ors published an article in a Barcelona newspaper espousing the new ori-

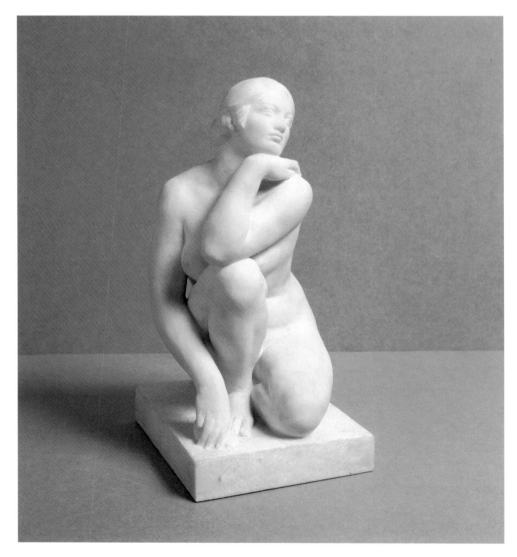

Fig. 1 (cat. 6:31). Josep Clarà, *The Goddess*, 1928.

entation. He stated: "Our position as Mediterraneans not only gives us rights, but also imposes duties. Right now, one of our most important duties is to work together on this *Mediterranization* of all contemporary art."[2] For the new path sketched out by Maillol, Ors would be the Catalan standard-bearer, spreading the message well beyond the strictly artistic sphere. Several young Catalan sculptors proved to be Maillol's most faithful followers on this path.

Although Ors was the one who promoted the artistic movement known as Noucentisme in Catalonia, it was Maillol who set the guidelines followed by other Catalan sculptors, the artists with whom he had strong ties of friendship. Maillol was French, but he spoke Catalan, which is not surprising considering that he had been born in Banyuls, a Mediterranean coast town just a few kilometers from the Spanish border. That area of modern France had been part of Catalonia until the seventh century.[3] After an early period as a painter and member of the Nabis group, Maillol began a lengthy, productive career as a sculptor. Before long, his work became the new archetype for the medium in Catalonia. Enric Casanovas and Josep Clarà adopted Maillol's classical ideal with the most fidelity. Their goal was to synthesize natural forms, specifically the forms of the human body, in order to reach the essence of beauty. To this end, they subordinated details to the harmony of the whole and adopted a canon that placed the architecture of the human body in relief. Their female figures, like those of Maillol, display the physical characteristics of Mediterranean women: round backs, wide hips, robust breasts, and thick ankles—a woman Ors called "La ben plantada" (the shapely woman).[4]

Noucentisme came of age in 1911, when several Barcelona exhibitions placed a number of works recently made by the most distinguished noucentista artists within the reach of critics and the general public. Among those represented were Clarà and Casanovas, the indisputable leaders of the new sculptural classicism in Catalonia. If the works shown by both artists in 1911 demonstrated their fidelity to ancient Greece, then the pieces each sculptor subsequently created evolved in more personal directions.

The two works by Casanovas included in this exhibition are magnificent examples of noucentista sculpture of the first decade (see fig. 10, p. 257; fig. 6, p. 308). Yet, Clarà's *The Goddess,* 1928 (fig. 1), represents the model adopted in the following decade. By then, Casanovas had eliminated all traces of archaism and Clarà had begun a slow process of formal refinement. Although the date given for *The Goddess* is 1928, the sculptor had already executed several earlier versions between 1908 and 1910. Like most of the sculptors who had set up workshops in Paris in the early 20th century, Clarà in his early years felt profound admiration for Rodin, whom he knew through Maillol. However, his friendship with Maillol allowed him to witness the creation of *The Mediterranean* in Maillol's workshop in Marly-le-Roi, outside Paris. In 1906, Clarà made trips to London, where he was able to admire the Parthenon marbles, and to Italy, where he absorbed the wonder of Michelangelo's sculpture. It must have been these trips, following his exposure to Maillol, that guided him in a new artistic orientation, allowing him to discover his absolute affinity for the values of classical art. Around 1910, his artistic direction emerged when he was modeling female figures, nude or half-draped, on a smaller scale and filled with the serenity and harmony of ancient Greek goddesses. His work from this period also includes busts of gods and heroes with classic features. Along with these works, he also executed a series of large-scale female nudes in which we can see lessons learned from the Renaissance and especially from Michelangelo. Clarà's nudes are robust, muscular goddesses, presented at rest. Conceived by the sculptor as closed structures, they were modeled with great formal rigor and perfect articulation of the parts of the body.

In the late 1920s, Clarà developed new versions of several of these figures, including *The Goddess,* in which he removed all superfluous details and softened the passionate exaltation of the forms beneath androgynous musculature. The second version of *The Goddess* displays a similar female body, but more settled and serene, with more synthetic forms, executed to achieve greater formal perfection. This later version was installed at Barcelona's Plaça de Catalunya in 1928 for the city's International Exhibition of 1929, and from that time on, this second *Goddess* became one of the sculptural subjects most closely identified with the city.[5] The version

included in this exhibition, the small-scale model Clarà kept in his workshop, perfectly embodies the most important period in the artist's career. Later, he abandoned the theme of goddesses and focused on women who are closer to the figure of the Catalan ideal defined by Ors. Only in Clarà's later phase did excessive formal refinement dehumanize a great deal of his work.

Many Catalan sculptors of the same generation followed the path opened by Maillol.[6] Others, such as Pablo Gargallo and Manolo Hugué, while remaining in the sphere of the new classicism, distanced themselves from too strict an interpretation of the classical ideal, and preferred instead to present a much more personal vision.

In his early work, Gargallo adhered to the standards of modernista sculpture. But his mature work was rendered in two distinct languages. His figurative language was applied to sculpture in the round, modeled with traditional materials such as marble, bronze, fired clay, alabaster, and stone (fig. 2). His other, experimental, language emerged from his work in iron, copper, and lead. While his more academic works stayed close to the classical premises of Noucentisme, the experimental nature of his metal sculptures adhered to the innovative hypotheses of the European avant-garde. The duality in his work related to Barcelona and Paris, the two cities where Gargallo lived, each with its distinct artistic environment. *Young Woman's Torso*, 1933 (fig. 3), a work shown for the first time in 1934 in Barcelona, shows his contribution to Noucentisme. At the same time, his interpretation of classicism and his more innovative work, the iron sculptures shown in another section (see fig. 7, p. 309; fig. 5, p. 379), can be compared. During the years when Gargallo was most intensively involved with this new approach, he occasionally rendered female figures in copper or lead, producing sculptures that are not conventional representations of this motif. It was not until after making two excellent male nudes in 1924 that the sculptor returned to the motif of the female nude, representing the body, modeled in clay or sculpted in

marble, as a closed mass, with rounded forms, strong and sensual, and strikingly expressive. Gargallo used a canon less stylized than the goddess figures of Clarà and Casanovas, somewhat closer to the peasant-woman type represented in his works. Examples include the harvester sleeping and the water carrier holding jars of water on her head. At the same time, Gargallo avoided purely realistic interpretation that sought simplicity within a synthetic concept, as was done by other noucentista sculptors. Unwilling to defer to any particular canon, he never stopped portraying his subject's expression. Thus Gargallo did not limit himself to creating purely visual images, but rather instilled an internal force in his female figures, a reflection of what was unmistakably a human breath.

Another sculptor who, like Gargallo, occupies a specific place in Catalan art of the noucentista period is Manuel Martínez i Hugué, better known as Manolo. His personality was overwhelming to the point that it was legendary, almost eclipsing the undeniable quality of his art. Around 1910, when Manolo signed a contract with the prestigious art dealer Daniel-Henry Kahnweiler and set himself up in the town of Céret, he was already almost 40 years old.[7] Under the auspices of the dealer, he began a new and productive stage that extended to the end of his life.[8] Earlier, Manolo had lived a bohemian life in Barcelona, where he assiduously participated in the ongoing *tertúlia* (regular informal discussions) at the café Quatre Gats. Later, he frequented the circle of Picasso and the Cubists in Paris, as well as that of the Greek-born poet Jean Moréas, whom he admired greatly. Because so little of his youthful work done in Barcelona and Paris has been preserved, it is assumed that he produced very little during this period. Through his connection with Kahnweiler, he finally found the stability that allowed him to launch an international art career.[9] In spite of witnessing the birth of Cubism, Manolo was not drawn to this movement. He preferred to create work closer to the spirit of Moréas and therefore based on principles

Fig. 2. *Nude Young Man*, 1917, by Pablo Gargallo.

Fig. 3 (cat. 6:32). Pablo Gargallo, *Young Woman's Torso*, 1933.

similar to those of the Noucentistes, although he did not adopt the same canon as that of his friend Maillol. During his years in Céret, Manolo produced small-scale sculptures with themes related to the rural environment, and his portrayals of village women are especially significant. These figures are treated with the same quietude and fullness as the effigies of ancient Egypt or remote Chaldea and are thus transformed into timeless beings. His female nudes are based on a female prototype that is not especially stylized or graceful, but vigorous, with full forms transmitting a great serenity. At the same time, he used blocks of stone to sculpt figures formally close to André Derain's sculpture *Woman Crouching*, 1907, which belonged to Kahnweiler at the time. A certain geometric tendency is obvious in these works, possi-

Fig. 4 (cat. 6:29). Manolo (Manuel Martínez i Hugué), *Woman's Torso*, 1922.
Fig. 5. *La Baccante*, 1934, by Manolo (Manuel Martínez i Hugué).

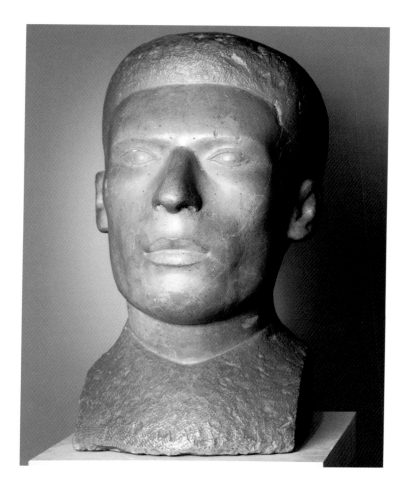

bly unconsciously introduced through Manolo's contact with the Cubists. In his bas-relief *Woman's Torso,* 1922 (fig. 4), the artist united his formal discoveries, which are clearly reminiscent of ancient art, with technical discoveries. The result is a marked contrast between the flat polished surfaces—whose outline is worked with striations, producing a shadowing that enhances the figure's volume—and the voids. The apparent simplicity of this figure, which occupies practically the entire space of the block, is the outcome of the sculptor's synthesis of forms. But while the majority of contemporary Noucentistes used formal simplification to represent beauty, Manolo's objective was greater expressiveness. Rather than adhering precisely to the classicist principles of the Noucentistes, Manolo opted for a more personal artistic language in which he mixed popular elements with innovations. The full creative freedom Manolo

enjoyed in Céret allowed him to represent the daily world that surrounded him and to transform it into mythology (fig. 5).

This generation of sculptors born in the 1870s reached artistic maturity with their reputations absolutely established. Even so, they brought youthful values to bear and were identified as the Generation of '17 because their early works date from that time. Some belonged to the Evolucionistes, a group of artists determined to modernize Catalan art without abandoning figuration. In fact, the majority of them were soon involved in Noucentisme, although after the Spanish civil war, they adopted different artistic principles. Outstanding among these sculptors were Joan Rebull and Apel·les Fenosa, each with his own, unmistakably distinctive artistic language. Rebull (fig. 6) opted for a return to ancient Mediterranean culture with excellent works inspired by Egyptian

Fig. 6 (cat. 6:28). Joan Rebull, *Self-Portrait,* 1919.

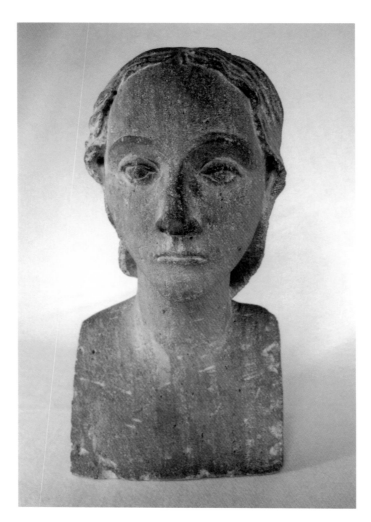

art. Meanwhile Fenosa, after executing a number of portraits in stone (fig. 7), followed Picasso's lead in modeling small-scale figures.[10] Both belonged to a generation interrupted by the Spanish civil war and forced into exile. Starting in the 1940s, when the Franco dictatorship assumed full control, only Clarà remained active in Barcelona. His work, distanced from the artistic values of Noucentisme, served as a model for the sculpture of the new regime.

1. The new classicism prominent in Europe during the period 1910–30 was the subject of an exhibition organized by the Tate Gallery in 1990 that included works of the most outstanding artists of Catalan Noucentisme. See Elizabeth Cowling and Jennifer Mundy, eds., *On Classic Ground: Picasso, Léger, de Chirico and the New Classicism, 1910–1930,* exh. cat. (London: Tate Gallery, 1990).

2. Eugeni d'Ors, "Artístiques raons," *La Veu de Catalunya,* 10 April 1906; reprinted in Ors, *Glosari 1906–1907,* ed. Xavier Pla (Barcelona: Quaderns Crema, 1996), 79.

3. Banyuls is the town near Colliure where the Fauve painters Henri Matisse and André Derain lived for some time. It is also near Céret, a town that André Salmon rightly dubbed the mecca of Cubism.

4. Ors, *La ben plantada; de Xenius* (Barcelona: Joaquim Horta, 1912); see also Ors, *La ben plantada,* ed. Xavier Pla (Barcelona: Quaderns Crema, 2004).

5. The copy of *The Goddess* that is currently located in the Plaça de Catalunya in Barcelona was made in 1981. The original statue, somewhat worn down by time, is located in the vestibule of Barcelona's city hall.

6. Among the sculptors who followed in Maillol's path were Joaquim Claret and Ricard Guinó, artists who worked as Maillol's assistants during their youth. In addition to creating his own work, Guinó executed sculptures designed by the Impressionist painter Pierre Auguste Renoir, and is thus considered their co-creator.

7. Once a nucleus of important artists had gathered there, the town of Céret became an active center for European avant-garde art. Especially significant was the stay of the Cubists Pablo Picasso, Georges Braque, and Juan Gris.

8. Manolo was linked to Kahnweiler until 1932, the year when he returned to Catalonia to stay. For a number of years, he was the only sculptor in the famous dealer's circle, and his works were customarily exhibited in Paris at the Galerie Simon, which was owned by Kahnweiler.

9. Manolo was the only Spanish sculptor who participated in the Armory Show held in New York in 1913.

10. Picasso acquired more than 100 sculptures done by Fenosa in different periods, which he kept all his life.

Translated by Eileen Brockbank.

Fig. 7 (cat. 6:30). Apel·les Fenosa, *Head of Marthe Morère,* 1927.

# Noucentista Graphic Arts and Journals

## FRANCESC M. QUÍLEZ I CORELLA

**M**any elements of Noucentisme were important and representative, but the development of graphic art was essential to the movement. While that fact merits emphasis in and of itself, this growth would not have been possible without the many magazines that provided outlets for a significant portion of the artistic activity of the period.[1] The proliferation of graphic art led to increased demand on the part of clients, but artists did not sacrifice quality to increase quantity. In fact, most of the artists who contributed to these publications also created other works and showed no contempt for their graphic work.[2]

Favored by a propitious environment, many graphic schemes emerged during those years that attempted to marry popular appeal with artistic rigor, while at the same time not relying on pre-existing formal language. The problem lay with finding an aesthetic ideal that would go beyond the grandiloquent lavishness and pomposity of the modernista movement but not put faith in myopic provincialism. The distillation of the elaborate, intricate rhetoric of modernista artistic forms gave way in Noucentisme to a language that recovered a sense of order, simplicity, and balance, the same elements as those of the classical repertoire.[3]

Some scholars, probably trying to find a rationale in the amalgam of tendencies that distinguish this movement, have coined a new term: Mediterranisme.[4] Broadly speaking, this concept would define a new sensibility based on two complementary components: on the one hand, a solid base rooted in the classical tradition, crystallized in a kind of Renaissance Neoclassicism; on the other, an ethereal ideology informed by elements from Mediterranean popular tradition, derived from the most emblematic and stereotypical iconographic characteristics of Catalan culture. Rather than presenting a cohesive voice, this combination gave rise to aesthetic proposals that were different in function from their models or the sources of inspiration used by the various artists, making it impossible for a single historic and artistic entity to emerge.[5]

Almost all noucentista artists were attracted to xylography, the technical term for images printed from woodblocks, and some displayed a special affinity for it.[6] Examples of the cultivation of this printing technique can be found in the work of Francesc Canyellas and Josep Obiols. They created a significant body of xylographic images that awakened the interest of an artist who was to become one of its most distinguished practitioners, Enric Cristòfol Ricart.[7] These artists were both versatile and productive, qualities that allowed them to participate in many projects during this phase of the history of Catalan art. While the work of Canyellas and Obiols is stylistically different, the two used popular imagery but were receptive to artistic developments elsewhere. Canyellas's relationship with the French art of the period can be seen in his cover for the June 1921 issue of *D'Ací d'Allà* (fig. 1). The elegance and

Fig. 1 (cat. 6:37). Francesc Canyellas, cover for *D'Ací d'Allà*, no. 6 (June 1921).

aristocratic bearing of the figures recall Art Deco. Actually, similar figures appear in the advertising images Canyellas created for the hat business of the artistic promoter Joan Prats during the 1920s.[8] First emerging in 1918 under the initiatives promoted by Editorial Catalana, which was directed by Josep Carner, *D'Ací d'Allà* evolved from its initial noucentista aesthetic toward a professed avant-gardism—beginning with the emblematic 1934 issue, which was dedicated to 20th-century art. The publication lacked a defined graphic identity because of the different artistic sensibilities of illustrators such as Lluís Labarta, Pere Torné Esquius, and Joan Junceda.

Obiols was best known for his painting, but like his contemporaries he made incursions into the field of illustration and created engravings, posters, and drawings.[9] Although he did not devote a lot of time to the graphic arts, he did produce some of the most representative and outstanding posters of the period. His c. 1920 poster for the Associació Protectora de l'Ensenyança Catalana (Association to Protect Catalan Education) is a good example (fig. 2). Created by Francesc Flos in 1899, this association was the first school to offer instruction in Catalan and was recognized for its pedagogical work; the poster underlines the artist's social and cultural ac-

tivism. Distilling the most stereotypical elements of a style whose fundamental quality is simple artistic forms, he avoided ornamental flourishes, which could have reduced the credibility and centrality of the composition's real protagonist: the student who looks directly out at the viewer. Obiols made a preparatory drawing (private collection) in 1921 almost identical to the poster but that, curiously, is larger. The poster and drawing have elements in common with another of his most emblematic works, the 1927 poster *Jordi,* an advertisement for the children's weekly of the same name.[10]

Earlier Obiols had designed a cover for another periodical of the time, *La Revista,* 1916 (fig. 3). In contrast to the poster of c. 1920, which is deeply rooted in noucentista iconography and popular aesthetics, this illustration reveals his debt to the classicist style of Joaquín Torres-García. The female figure, dressed in classical attire, could be a personification of one of the seasons of the year, probably autumn since she appears to be gathering grapes; several of Torres-García's murals evoke that season as well. Other elements that both artists used are the flat colors and outlining to describe shapes and figures. The image seems to proclaim the excellence and virtues of living in the country, an ideal of society consonant with

Fig. 2 (cat. 6:38). Josep Obiols, *Have You Joined the Association to Protect Catalan Education?,* c. 1920.

LA REVISTA

BARCELONA
MCMXVI

Núm. IX · · · · ANY II

the ideology that informed the noucentista movement. Indeed, the compositional simplicity has a precedent in Obiols's 1914 illustration for the cover of the *Revista de la Escola de Decoració*.[11]

The message of harmony and placidity that underlies much of the thematic material of the period is also present in a series of drawings by Pere Torné Esquius that were published in 1910, with a prologue by the poet Joan Maragall, under the suggestive title *The Sweet Places of Catalonia* (fig. 4). Although it may seem surprising, or even contradictory to the

title, the series has nothing to do with picturesque imagery or the romantic genre of 19th-century travel books. Torné's compositions recreate the cartography of the human landscape, of its sentimental universe, and several depict interior or exterior spaces in which the presence of human beings is evident only in the most insignificant details.[12] The image thus projects the principles of an austere aesthetic in which such subjective values as order, visual harmony, and emotional equilibrium predominate. Nevertheless, these qualities are not spontaneous

Fig. 3 (cat. 6:35). Josep Obiols, cover for *La Revista*, no. 9 (1916).
Fig. 4 (cat. 6:33). Pere Torné Esquius, illustration in *Els dolços indrets de Catalunya*, 1910.

expressions that manifest the reproductive sense of nature. On the contrary, they owe their existence to human activity: they are the result of the projection of a value system underlying the moral vision of the noucentista subject. In this sense, the taste for decoration, interior design, and the furnishing of pictorial spaces are elements that form part of the period's philosophy of life. The works by Esquius also rouse feelings of melancholy before a universe of simple, humble objects devoid of a human presence. To paraphrase Marcel Proust, these drawings make visual the metaphysical poetics of memory, which is recovered through the sensations and sentimental relationships that human beings establish with their domestic surroundings.

Francesc d'Assís Galí contributed much to the archetype of the noucentista artist. A greatly prolific artist also known for his work as the head of the Escola d'Arts i Oficis (School of Arts and Crafts), Galí was a gifted graphic designer.[13] Although visual cli-

chés and outdated compositional formulas appear in his later works, his early works, especially his posters, are notable efforts to renew the language and revitalize the formal repertoire of the preceding modernista phase. Some of his images include two types of extremely dissimilar compositions. In the first category of posters, Galí adopted a more complex structure that ultimately weighed down the final result. These compositions compromise the message being transmitted, resulting in visual confusion. The second type is illustrated by the cover of the first issue of *Vell i Nou* (fig. 5), which was published from 1915 to 1921 by Santiago Segura. By contrast, this illustration is perfectly adapted to the canonic models and strict orthodoxy of noucentista aesthetics. The ship is an icon of noucentista culture, and the artist himself returned to this image for a 1920 poster advertising the Spring Exposition organized that year by the city of Barcelona. The ship can be interpreted as a reference to Mediterraneanism, which informed

Fig. 5 (cat. 6:34). Francesc d'Assís Galí, cover for *Vell i Nou* 1, no. 1 (15 May 1915).
Fig. 6 (cat. 6:36). Pablo Gargallo, front page for *Revista Nova*, no. 45 (31 December 1916).

# REVISTA NOVA

Butlletí de l'Agrupació "Les Arts i els Artistes"
Any II - Segona Epoca - N.º 45          BARCELONA          31 de Desembre de 1916

DIBUIX, PER PAU GARGALLO

Noucentisme. The foremost noucentista writers and artists contributed to *Vell i Nou,* which fulfilled the crucial task of popularizing the movement. Galí also took on the assignment to make the magazine's advertising poster.

The catalogue of graphic works by Pablo Gargallo is sparse. Although his forays into this creative field can best be described as intermittent, by 1909 he had worked on various magazines, one of which was *Papitu.* Later, his illustrations appeared in the *Almanach dels Noucentistes* and poet Joan Salvat-Papasseit's magazine *Un enemic del Poble.*[14] His 1916 drawing for the cover of issue 45 of *Revista Nova* (fig. 6) indicates his knowledge of the typical components of avant-garde language, especially the physiognomy of the female model in which ritual and totemic African masks are recognizable. The artist's sculpture of this period also shows his interest in this type of representation.[15] Other elements include formal synthesis, abstraction, and the elimination of any anecdotal reference, albeit without entirely relinquishing a certain fascination with decorative effects.

1. See Francesc Fontbona, "La imatge del noucentisme," in *El Noucentisme: Un projecte de modernitat,* ed. Martí Peran et al., exh. cat. (Barcelona: Generalitat de Catalunya/Centre de Cultura Contemporània de Barcelona/Enciclopèdia Catalana, 1994), 73–83.

2. See Santiago Estrany i Castany, *L'Art gràfic al Noucentisme* (Argentona: La Comarcal, 2002).

3. See Joan Lluís Marfany, "Reflexions sobre modernisme i noucentisme," *Els Marges* 1 (1974): 49–71.

4. See Antoni Marí, "El espíritu clásico y el retorno al Mediterráneo," *Saber* 2 (March–April 1983): 34–39; and Jaume Vallcorba Plana, *Noucentisme, mediterranisme i classicisme. Apunts per a la història d'una estètica* (Barcelona: Quaderns Crema, 1994).

5. See *El Noucentisme: Un projecte de modernitat* and Enric Jardí, *El Noucentisme* (Barcelona: Aymà, 1980).

6. See Fontbona, *La xilografia a Catalunya entre 1800 i 1923* (Barcelona: Biblioteca de Catalunya, 1992); Estrany i Castany, *L'Art gràfic al Noucentisme.*

7. See Maria Rosa Planas i Banús, *Enric-Cristòfol Ricart. Gravador del Noucentisme* (Barcelona: Biblioteca de Catalunya, 1988).

8. See Estrany i Castany, *L'Art gràfic al Noucentisme,* 196–216.

9. See Pilar Vélez, "Josep Obiols, la imatge gràfica noucentista," in *Josep Obiols,* exh. cat. (Barcelona: Ajuntament de Barcelona, 1990); Montserrat Castillo, *Grans il·lustradors catalans del llibre per a infants (1905–1939)* (Barcelona: Barcanova, 1997).

10. See cat. 105 in *El Noucentisme: Un projecte de modernitat,* 163.

11. See cat. 167 in ibid., 177.

12. See Alexandre Cirici i Pellicer, "Torné-Esquius o el formalisme primitivista," *Serra d'Or,* no. 211 (15 July 1977): 253–60.

13. See Jardi, "Francesc Galí, figura clave del Noucentisme," *Artes Plásticas* 11 (September–October 1976): 58–61.

14. See Maria Lluïsa Borràs, ed., *Gargallo, 1881–1981. Exposició del Centenari,* exh. cat. (Barcelona: Ajuntament, CEGE Creacions Gràfiques, 1981).

15. See Pierrette Gargallo-Anguera, *Pablo Gargallo. Catalogue raisonné* (París: Éditions de l'Amateur, 1998).

Translated by Vajra Kilgour.

# Textiles and Fashion in the 1910s

SÍLVIA CARBONELL BASTÉ

In Catalonia, the impetus generated at every level of endeavor—industry, architecture, literature, painting, and the like—in the closing years of the 19th century lasted well into the 20th. Concerning textiles, there was no clear end to Modernisme, since its specific stylistic features remained ambiguous and at certain times blended with those of Noucentisme. Even so, in decoration and clothing alike, a shift away from the sinuous line of the French *coup de fouet* (the whiplash) that for several years seems to have taken over everywhere came about slowly, with the geometric forms preva-

lent in Viennese art, and in central and northern Europe as a whole, taking its place. This new design incorporating rational elements drawn from the Vienna Secession gradually became more accessible to general Catalan tastes (fig 1).

Noucentisme, an essentially conservative movement, never managed to leave its mark in the sphere of textiles. The decorative style in fabrics began to embrace Art Deco, which tended toward greater functionality and eventually influenced design and fashion of the future. Even though the legacy of Modernisme was obvious for many years in fabric

Fig. 1 (cat. 6:39). *Curtain*, c. 1900–1910, possibly made at La Indústria Llinera or Bassols.

swatches, after 1908 abstraction and simplification of form was evident.[1]

Representations of the female figure became increasingly slender and youthful, and line came to predominate over form. Fabrics tended toward a more stylized, geometric, and zigzag decoration, and there was greater contrast between colors. In 1910, the exotic look that had invaded Europe arrived in Catalonia. Women's apparel resembled the robes of odalisques, and they dressed in luxurious, richly embroidered, soft, and ethereal clothing, wrapping themselves up in more than one fabric at a time and creating plays of brilliancy and transparency. Turbans and hats with feathers came into fashion. The French couturier Paul Poiret set the style. He did away with corsets, thereby giving women greater freedom of movement, and made straight dresses with high

waistlines in the Directoire style. This liberation was countered, however, by his later design of the hobble skirt, which made walking difficult. The dresses dating from 1910 to 1912 that once belonged to Mme. Renaud, who ran the A. R. Renaud et Cie. studio in Barcelona, clearly reflect the fashion in Paris and even Vienna, which gradually spread among Catalan women in high society (fig. 2).[2]

There was little change in fabrics except in their decorative style. Apart from the introduction of rayon in 1915—the first year the cloth is found in swatch books—companies continued to use natural materials, as they had in previous years, and, of course, they continued to introduce new machinery and technology.

The range offered by Josep Palau i Oller is in line with this chronology.[3] Palau spent the years 1910 to

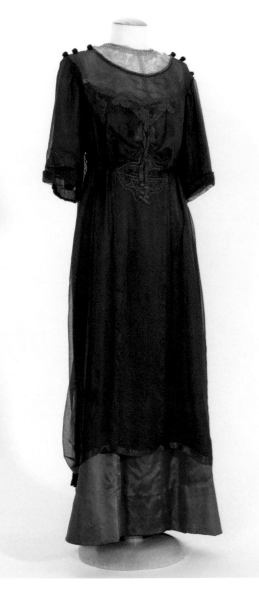

Fig. 2 (cat. 6:40). *Blue Silk Dress*, 1910–12.

1923 designing household linens, shirts, and head-scarves, most of them with tiny geometrical details clearly inspired by Viennese design, and he sold these items to the Sedera Franco-Española, Ponsa Hermanos, and Samaranch companies.[4]

The architects Josep M. Pericas and Rafael Masó produced a number of projects influenced by central European architecture and design, sources of inspiration they had used during the modernista era. Pericas's noteworthy pieces include his flag for the Orfeó Cirvianium choral society, made in 1916, and the canopy for Església de Sant Cugat in Barcelona, made in 1910. Masó was heavily influenced by the Glasgow School and the Vienna Secession, although he would eventually become engrossed in Noucentisme. Even though information concerning his involvement in a specific project for a fabric in the noucentista style is nonexistent, he did pay particular attention to textiles from 1900 on. He designed a number of flags, including the standards for the Somatent de Girona militia (1903, possibly destroyed), the Orfeó Lleidatà choral society (1903, possibly never made), the Congregació Mariana in Girona (1904, Seminari, Girona), Arts i Pàtria in Figueres (1907, location unknown), and a tapestry for the Confraria de Sant Jordi brotherhood in Girona (1907, Pla-Solà-Morales Collection, Girona). Among his designs are the impressive chasuble for Father Joan Roquet (1906, destroyed during the civil war), done in collaboration with Gaudí, and another for Father Ricard Aragó (1908, location unknown).[5] Masó's designs for two cushions of 1909 and 1910, embroidered by his wife Esperança, show an architect immersed in the stylistic tendencies of Austria and Germany, which were later superseded by Art Deco, as evident in the photographs Adolf Mas took of Casa Masó (1911–12) and Casa Masó-Bru (1912–16) in Girona.[6]

The designer Mateu Culell i Aznar submitted a triptych (Museu d'Arts Decoratives, Barcelona) to the International Exhibition of the Decorative Arts at Monza in 1911, but his designs for rugs reveal a more classical style, in keeping with conventional Noucentisme, than his other designs.[7] The flag for the Cambra de Directors, Majordoms i Encarregats de l'Art Tèxtil in Barcelona (Chamber of Directors, Butlers, and Managers of Textile Arts), designed by the sculptor Josep Llimona and now in the collection of the Centre de Documentació i Museu Tèxtil in Terrassa, is one of the few textiles that can be clearly identified as noucentista, mainly because of the figuration in the embroidery.[8] The backing fabric is made of wool, and it is just barely possible to discern the four bars of the national flag of Catalonia. The embroidery, done by the wives of the founders of the Cambra, depicts two men wrestling.

Apart from the occasional surviving textile, the majority of the known fabrics that can be dated to the era of Noucentisme are not representative of the movement. Consequently, at the present time it is not possible to say that many noucentista fabrics were manufactured in Catalonia, or that Noucentisme set a trend in Catalan fashions.

1. Until well into the 1930s swatch books from the Estabanell y Pahisa cotton manufacturing company and from the Felipe Iglesis silk manufacturer contained samples that were still fully modernista in design. These swatches were lifted from turn-of-the-century swatch books and evidently remained commercially successful.

2. These dresses are found in the Centre de Documentació i Museu Tèxtil in Terrassa and in the Museu Tèxtil i de la Indumentària in Barcelona.

3. See Josep Palau Oller, Josep Palau Oller, del Modernisme a l'Art Déco, exh. cat. (Terrassa: Centre de Documentació i Museu Tèxtil, 2003).

4. The designs held in the Museu de l'Estampació in Premià come from a catalogue issued by the Sedera Franco-Española. The Museu Tèxtil i de la Indumentària in Barcelona has silk swatch books from the Ponsa Hermanos company containing designs by Palau. The Centre de Documentació i Museu Tèxtil has more than 1,400 original designs sold by Palau, according to his son, to the Samaranch company.

5. Most of these objects, destroyed or location unknown, are known through photographs and Masó's original designs. For further information, see Joan Tarrús and Narcís Comadira, Rafael Masó: Arquitecte Noucentista (Barcelona: Lunwerg/Col·legi d'Arquitectes de Catalunya, 1996), 363–66.

6. See Josep Casamartina, ed. L'interior del 1900: Adolf Mas, fotògraf, exh. cat. (Terrassa: Centre de Documentació i Museu Tèxtil, 2002), 122–23.

7. Culell i Aznar is best known for his ceramic paneling designs. He advertised himself at his studio as an "industrial designer."

8. All that has survived is a fragment of the embroidery, recovered thanks to Antoni Bargalló. It was probably made before 1915.

Translated by Susan Brownbridge.

# Noucentisme between Architecture
# and the Art of the Object

*JORDI CARRERAS*

During the second decade of the 20th century, Modernisme gradually became diluted, superimposing itself on the new and rising aesthetic and philosophy of Noucentisme. The noucentista artists, particularly in architecture and the decorative arts, began with a more participatory and often more committed approach, although they did not take a single aesthetic direction. Their creative eclecticism was considerable, and their inclination toward a classicist and Mediterranean orientation was distinctly generalized, stemming from a broad foundation of Catalan traditions and identity consciousness, which they wished to promote. In contrast to the sinuous lines, medievalism, and tendency to look toward France, England, and the Germanic countries associated with Modernisme, Noucentisme leaned more in the direction of Italy and Greece as ideal representatives of measure, classical order, and serene clarity. In architecture, this classicist orientation produced buildings reminiscent of 14th-century Florence. Yet a revision of folk culture also existed during this period, with Baroque elements (Jeroni Martorell, for example) and a preference for the more conservative, academic, and monumental. To these architectonic orientations must also be added the refined positions of Josef Hoffmann and Charles Rennie Mackintosh (Rafael Masó in Girona, for ex-

ample), the presence of Art Deco, and the hesitant introduction of avant-garde rationalism.

The artists who were sensitive to and involved in the new process advanced urbanism and architecture, simultaneously promoting the civic virtues and the improvement of personal surroundings championed by Noucentisme. Barcelona's status as a provincial capital, serving as both model and field of practical implementation, stimulated many projects aimed at modernizing all of Catalonia. Martorell, scholar and architect, was active in both the execution of new projects and the conservation of Catalan architectural heritage.[1] His texts on the subject were extremely diverse; his knowledge of local art of the past helped advance the new art.[2] His architectural work is highly representative of the moment: he designed almost no private residences, working instead mostly on buildings or urban areas intended for collective use, such as town halls, markets, public parks, and promenades. What stands out in his career are his buildings associated with the ambitious educational program of the Mancomunitat, a plan made possible by the union of the four Catalan provincial councils. Under this system, Martorell designed a large number of schools for towns throughout Catalonia. Using the most advanced pedagogical criteria of the time, his plan for a unified school

Fig. 1 (cat. 6:45). Jeroni Martorell, *Project for Unitary Schools, Granollers*, 1918.

in Granollers (fig. 1), gives a good sense of his buildings, their plain folk character, combinations of simple volumes, and evocations of rural structures of earlier times. As distinct from the more painterly nature of his earlier works, with their contrasting polychromes, the schools created by Martorell invariably feature traditional tiled roofs, smooth cornered walls, dressed blocks of stone, and decorative openings. His project for Calella (fig. 2) is a good example of the popular libraries built to encourage cultural improvement, another initiative of the Mancomunitat.[3] The reading room, with its rational distribution of space, has classical elements (the door with a pediment and pilasters) combined with elements from the Baroque tradition (tables with sloping feet and iron fastenings). The mitered and undulating lines of windows recall the arches that separated living rooms and bedrooms in many 18th-century houses.

Thanks to Rafael Masó, Girona became an important artistic center during the first third of the 20th century, with particular interesting creations. Masó was one of the most inclusive and active of the Catalan artists with a background in Modernisme, but he quickly advocated the philosophy of Noucentisme. He combined a deep reflection on traditional Catalan architecture and Greek classicism with an analysis of the most advanced European architecture of the early 20th century, including both the Glasgow School and the Vienna Secession, to create an extremely

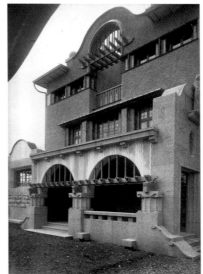

refined formal language of simple lines, planar compositions, and unadorned surfaces in exquisite harmony. His architectural ornament, for both interior and exterior, gave form to a decorative concept that coordinated the most varied materials with walls and spatial designs in a unified way.

One of the most remarkable examples of Masó's work is the Casa Masramon in Olot, of 1913–14 (fig. 3), conceived as a single-family residence in a suburban development.[4] On the outside, the play of volumes is distinctive, with highly studied articulation between the walls and openings. The finishes of all the surfaces were also very carefully considered, providing vivid contrasts in texture between heavy blocks of stone, roughcast, sgraffito work in waves, and ceramics in gray, blue, and green tones. The four sides offer a clear and suggestive composition in which the overwhelming presence of orthogonal lines is combined with a few curves that soften the visual effect. All these elements are clear in the rough drawing with a perspective and watercolor sketch of the principal façade (fig. 4), which are very close to the final result. In the upper part of the drawing, we can also see one of the innumerable notes on solutions for details that Masó generally made for each building. In this case, the detail is a fragment with a flattened column (part of his archaizing reading of classicism), which he transformed in the final work into a stylized Ionic column with an equally short but fluted shaft.

Fig. 2 (cat. 6:44). Jeroni Martorell, *Interior of a Public Library, Calella*, c. 1931.
Fig. 3. Masramon House, Olot, 1913–14, designed by Rafael Masó, photograph taken in 1916 by Adolf Mas.
Fig. 4 (cat. 6:43). Rafael Masó, *Masramon House, Design for the Principal Façade and Perspective*, 1913.
Fig. 5 (cat. 6:42). Rafael Masó, *Design for a Bedroom*, 1910.

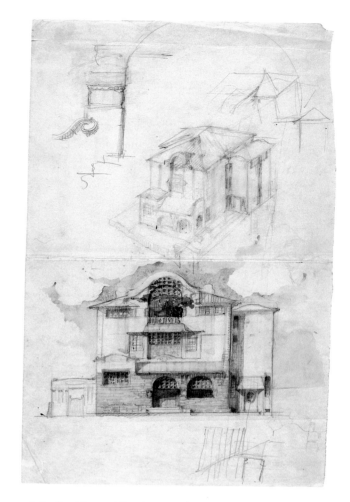

Masó's activity was not limited to architecture. From his earliest works, he was concerned with the design of every type of object, and his highest aspiration was coordinating both exterior and interior decoration.[5] At the same time, it is worth noting that he was unable to find furniture, ceramics, lamps, or other complementary objects corresponding to his idea of beauty and his approach to composition. He admired the English concept of comfort and increasingly occupied himself with a series of decorative projects using geometric volumes, lines, and an unadorned clarity (in a Catalonia that still had distinctively modernista tastes). The design of his master bedroom (fig. 5) is a perfect example of his refined conciseness and strongly held notion of simplicity; it epitomizes his skill in uniting the surfaces and volumes of a space. Along with the furniture—freestanding or built-in—the drawing makes plain the prominent role Masó conferred on textiles. Several recognized Catalan intellectuals of the time

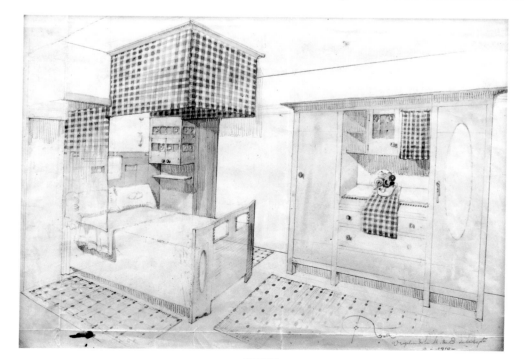

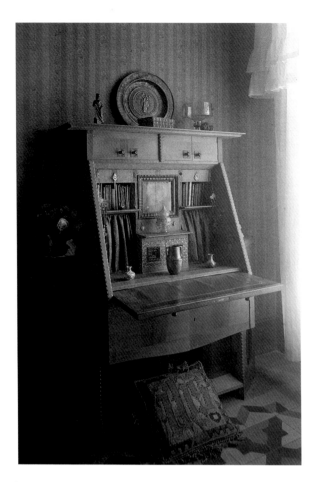

understood the new aesthetic option this design represented and praised it as a proposal that illustrated the simple line of beauty and practicality that noucentista interior decoration would take.[6]

For his wife, and for the master bedroom, Masó designed a desk (fig. 6) that is one of the most modern and original pieces of furniture made in Catalonia in the first decades of the 20th century.[7] The use of walnut and the inclined cover are characteristic of Catalan tradition, but the geometric originality, the articulation of trapezoidal volumes, and the stripped-down ornamentation are Masó's contributions, with echoes of advanced English and Austrian designs (the oval forms on the sides, the collapsible cover, and the simple molding, clearly of Viennese origin). Beyond its practical use, this piece of furniture is not free of some symbolic and evocative references, survivals in the artist of the modernista generation and his own religious convictions. These allusions are apparent in the interior panel depiction of the Virgin of Hope (for the name of his wife, Esperança), the monogram of Jesus Christ on the cushion for the footrest,[8] and, especially, the dried flowers enclosed

in the central oval. Masó had gathered them in Paris for his fiancée, a permanent memento of an engagement filled with difficulties.[9]

The debate over the training of artists in the discipline of decorative arts, and the effort to unite these arts with manufacturing, which had begun with Modernisme, were of singular importance in Noucentisme. Although the ideas of intellectuals and artists in this regard were advanced and strongly held, the initiatives begun by institutions and private entities were often narrowly focused and of short duration. Economic difficulties and political stumbling blocks often slowed down the desired development, but there can be no doubt that the seeds that were sown produced many outstanding, interesting results. As to the teaching of decorative arts, the main initiative was the creation of the Escola Superior dels Bells Oficis (School of Fine Crafts) in Barcelona in 1914. Promoted by the Mancomunitat, this institution was intended to elevate the level of creative work, following the plan of comprehensive improvement in Catalonia and supporting the taste for *obra ben feta* (well-made work)

Fig. 6 (cat. 6:41). Rafael Masó, *Desk*, 1911, in use in 1916.

and for the symbiosis between beauty and utility. The school was designed to infuse artists and directors with an organizing and creative capacity in different specialties. The Escola Tècnica dels Oficis d'Art (Technical School of Fine Crafts) was also established to train artisans who would understand noucentista projects and be able to produce the various manufactured articles.[10] At the same time, Masó wanted to begin teaching traditional artistic occupations in Girona, but could not obtain the required institutional support. Nevertheless, through his guidance a constant stream of artists, artisans, and enterprises provided, among other things, ceramic pieces and furniture appropriate to his buildings.

The Galeries Laietanes and Faianç Català, created in Barcelona by the art promoter Santiago Segura, were essential centers for the exhibition, diffusion, and sale of objects created in the orbit of Noucentisme. Nevertheless, the private association with the greatest impact in relation to the decorative arts was the Foment de les Arts Decoratives (FAD), which is still in existence. Founded in 1903, it promoted the creation and production of decorative objects through exhibitions, contests, publications, and other initiatives. Its participation at the International Exposition of Furniture and Interior Decoration, held in Barcelona in 1923, with a publication and projects for the competition in furniture and interior decoration for low-income housing, clearly indicated the noucentista philosophy of conferring dignity on this kind of work.[11]

Among the noucentista decorative arts, ceramics—on which special attention was lavished by the School of Fine Crafts—may have attained the greatest development and degree of representation. As opposed to Modernisme's sophistication and sinuous lines, with a predominance of motifs that were floral, gothic, or reflecting international taste, Noucentisme ceramics demonstrate a more austere repertoire of colors, forms, and design types, inspired by the local ceramic repertoires of the 16th to 18th centuries, as well as by folk pottery traditions.[12] The simple forms, intense green glazes, and hot yellows, ochers, cobalt blues, and dark greens applied on tin-white bases all hark back to these origins. Ornamentally, the taste for lavish borders and folk scenes, deftly resolved, are also reminders of this interest (fig. 7). Nevertheless, earlier ceramics were decorated by artisans without artistic training, but with an intuitive mode of expression. Noucentista creators aspired to conserve the freshness of this earlier work, albeit with their own intentions, style, and compositions. At the same time, potters explored techniques for which there was no local tradition, such as stoneware, which promoted the use of this material and brought noucentista work closer to Asian ceramics.

The creation of glass objects, also a Catalan tradition, was particularly notable in the Renaissance and Baroque periods, but its importance gradually diminished to the point where, faced with the unstoppable drive toward industrialization, it became diluted in the 19th century.[13] While Modernisme was an outstanding period for the decorative arts, with spectacular glass windows made in Catalonia, no other interesting glass objects were produced at that time. During Noucentisme the creation of pieces with enamel decoration was re-evaluated.

Fig. 7. Two ceramic plates and a pharmacy bottle, 17th century, Barcelona.

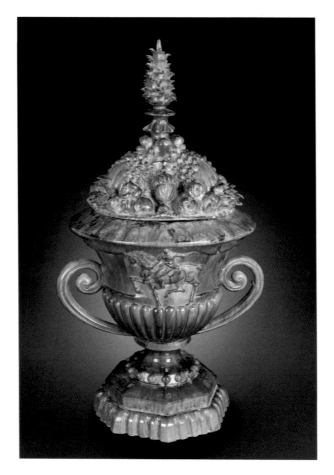

Although the forms of noucentista vases, plates, and jars were often of an elemental simplicity, artists involved in various areas of ornamentation revitalized a technique that was maintained until the middle of the 20th century. Glass with polychrome decoration revived a traditional Catalan technique and, at the same time, aligned contemporary production with the modern taste that was triumphing in Europe. The 1914 exhibition of enameled glass by the French artisan Maurice Marinot in Barcelona was a milestone for future Catalan workers in enamel because that show acquainted them with an innovative artistic language while demonstrating possibilities for this traditional technique.[14] The exhibition of various pieces of Catalan ceramics and glass in the 1925 International Exposition of Modern Decorative Arts and Industries in Paris, organized by FAD, was an event of international magnitude.[15]

Josep Aragay was an essential figure both in his opposition to the aesthetic of Art Nouveau and in his unwavering commitment to Noucentisme's new theoretical and artistic proposals.[16] A versatile artist, he quickly began working in ceramics, revealing his deep respect for traditional Catalan ceramic work as well as his Mediterraneanist and popular taste. To fulfill an assignment given him by the city government of Barcelona in 1916, he created the ceramic decoration for the fountain of Santa Anna (figs. 8 and 9) as an emblem of his interest in the anti-elitist purposes and public use of art.[17] Aragay's work centered on the creation of five tiled panels and the large ornamental urns that complete the composition. The reduced polychromy, profusely decorated borders around the central figures, and the general air of willful ingenuity of the tile panels are reminiscent of a local ceramic tradition. The

Fig. 8 (cat. 6:46). Josep Aragay, *Vase*, Fountain of Santa Anna, 1918.
Fig. 9. Aragay's panels and vases in situ, Fountain of Santa Anna, 1918 (the vases are replicas from 2002).

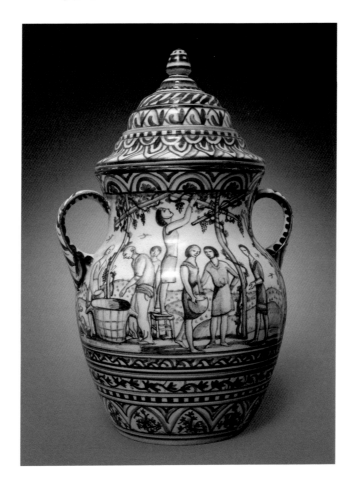

vases atop the cornice evoke the finishing touches of Catalan churches and civil structures of the 17th and 18th centuries. Aragay expressed his classicist taste in these works by using an amphora with egg-and-leaf ornamentation, but the brimming composition of fruit and the pinnacles transform the Greco-Latin origins into opulent Baroque-like forms. In addition, however, the stylized synthesizing quality and some of the impressively geometric decorative forms—precociously Art Deco—also demonstrate that Aragay shared the artistic inclinations of his time. A young horseman on the front—a customary image in local celebrations—adds a popular flavor. The green glaze has been employed in Catalonia since the medieval period, used abundantly in folk pottery, which made the urns almost familiar to the ordinary citizenry. These crowning elements, along with those of terracotta atop the cornices of Josep Goday's school buildings, pioneered a style that, in the ensuing decades, lined the rooftops of apartment buildings throughout Barcelona with towering pinnacles and jars laden with fruit.[18] Unveiled in 1918, Aragay's fountain came to represent a new artistic alterna-

tive: simple, direct, and with roots in folk traditions.[19] With its happy union of artistic ceramics arranged on a fountain of Gothic origin and its discreet but impressive presence in the city's fabric, the composition is an emblem of urban noucentista art.

While the works associated with this fountain are excellent examples of applied ceramics, Aragay's lidded grape harvest jar (fig. 10) offers a view of his achievements as a creator of independent pieces. Once again, the object is reminiscent of a local ceramic tradition, both in the simple pot-bellied form with two handles and, especially, in the intensity of decoration. The monochrome cobalt blue over white and the bands with different friezes call to mind 15th- to 19th-century Catalan tableware and pharmacy vessels (fig. 7). Paralleling the central motifs enclosed in decorative borders in older examples, the friezes on Aragay's vase enclose a continuous scene depicting different aspects of the grape harvest. Once again, the subject has folk and Mediterranean connotations—except that, in accord with the noucentista spirit of being up to date, the figures have a contemporary appearance.[20]

Fig. 10 (cat. 6:47). Josep Aragay, *Wine*, c. 1930.

Although Xavier Nogués—who also worked at painting, drawing, and engraving—could not be considered in the strictest sense a glass artist or ceramist, he did work as a decorator in both techniques, demonstrating an extraordinary adaptation and sensitivity to the materials. In 1923, he created a set of tile panels for the restaurant Can Culleretes (figs. 11 and 12). The compositions represent a rich inheritance in the Spanish (and Mediterranean in general) tradition of creating grand ceramic wall coverings. Modernisme had already distinguished itself for creating "sample" tiles in series with endless repeating surface patterns. Nogués opted for another type of single panel, treating a set number of tiles as a pictorial surface that he decorated with enamels to form part of a greater ornamental composition (following the Catalan Baroque tradition, which also featured matching tiles in series).[21]

The scenes and decorative borders in Nogué's panels produce a visual effect similar to that of easel paintings hung in frames. The artist applied the colors in broad and energetic brushstrokes, which mark the volumes and shadows, playing artistically with tints that are achieved with transparency against the white ground. The contours appear to be edged with fine manganese lines that decisively mark their

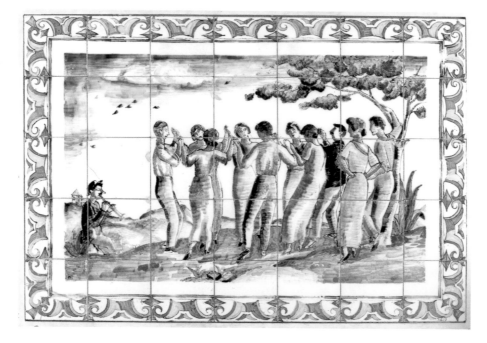

Fig. 11 (cat. 6:48). Xavier Nogués, *Ceramic Panel for Can Culleretes (Picnic)*, 1923.
Fig. 12 (cat. 6:49). Xavier Nogués, *Ceramic Panel for Can Culleretes (La Sardana)*, 1923.

es and jars to create landscapes and scenes, offering multiple points of view between foreground and background according to the way the viewer moves around the piece. The themes are typical of Nogués's art: fontades, everyday scenes, young women, and drunkards. The nature of the images varies according to the subject matter, shifting from placid rural themes to humorous drunkards. The dignified and stylish look of the female figures and the grimacing, caricature-like quality of the male types are characteristic of Nogués's work. The comic stylization can be especially appreciated in the drinking glass titled *Flirt* (fig. 13), in which a young woman hesitates between two young men who are courting her.[23] The narrative exposition is direct and the aesthetic solution simple and effective: the figures are arranged as three equidistant vertical motifs on the surface,

limits—a resource that, together with the limited polychromy, is reminiscent of traditional Catalan Moorish tiling. While the volute borders offer a reading of these older repertoires, the figurative motifs correspond fully to the visual world of Nogués. In this decorative work, vertical panels representing female figures alternate with horizontal views of *fontades* (picnics in the countryside), from which a joyful sensation of placid calm is distilled—not without a certain irony. In the two panels on display, the typical circular dance (*sardana*) and the seated man who is drinking with his arms upraised (from a *bóta*, or wineskin) reveal the artist's interest in incorporating characteristically indigenous elements. These themes perfectly expressed the noucentista spirit and idealized a way of life that is the antithesis of the nightlife and bohemian passions characteristic of Modernisme.

For his glass pieces, Nogués collaborated with Ricard Crespo, who made the objects, created the enamels, and, by means of transparencies, copied the drawings the artist supplied (often in association with Crespo's wife, Conxa Domènech).[22] The themes are similar to those of the ceramic panels but adapted to the characteristics of the glass, with outlines in black and enamels of graduated impasto. The colors used offer delicate nacreous and translucent effects, as well as intense contrasts of vivid tones. Nogués skillfully learned how to take advantage of the transparency of glass and the tubular form of glass-

with the two men addressing their attention to the young woman and turning their backs on each other. The same ordering of three groups rules the exemplary *Circus Scenes* (fig. 14), although on this occasion Nogués opted for isolated and dynamic images. More fluid in their visual solution and united by a continuous landscape-like effect are the glasses *Hunting* (figs. 15 and 17) and *Fishing* (fig. 16), with an interesting play of planes suggested by the figures, trees, and birds.[24] The creation of matching plates for each glass heightened their artistic significance as objects for collection and contemplation, and has resulted in interesting unitary groupings. The borders of the *Flirt* and *Circus* sets, with their distinctly geo-

Fig. 13 (cat. 6:50). Xavier Nogués and Ricard Crespo, *Flirt* (glass and plate), 1924.
Fig. 14 (cat. 6:51). Xavier Nogués and Ricard Crespo, *Circus Scenes* (glass and plate), 1924.

 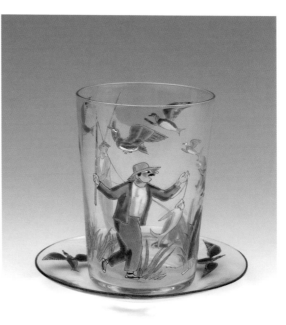

metric character, reveal a gradual introduction of Art Deco motifs.

Francesc Elias is another multifaceted artist, but his work in glass and ceramics was especially distinguished. Together with Francesc Quer, an instructor at the Escola Superior de Bells Oficis, and Josep Maria Gol, he was a pioneer in the field of reviving enameled glass in Catalonia, creating pieces of distinctly folk-like freshness and schematic design. His glass work fit perfectly with noucentista philosophy, which was also true of his early ceramics. Later, his apprenticeship with Quer, his formative stay in France, his contact with Josep Llorens i Artigas, and his passion for Japanese production methods led him to create a body of work in which stoneware was the preferred medium. His covered jar of 1932 (fig. 18) reflects his artistic inclinations and offers a rereading of the decorated stoneware vases

Fig. 15 (cat. 6:52). Xavier Nogués and Ricard Crespo, *Hunting* (glass and plate),1924.
Fig. 16 (cat. 6:53). Xavier Nogués and Ricard Crespo, *Fishing* (glass and plate), 1924.
Fig. 17. *Preparatory Drawing for the Glass "Hunting,"* c. 1924, by Xavier Nogués.

from the Far East. The jar's cover, with a ground of a sandy tone and whitish glaze drippings that create delicate shadings through transparency, reveals his experimentation with chromatics and texture in enamels.[25] Both Francesc and his brother Feliu, who wrote art criticism under the name Joan Sacs, were active supporters of the revitalization of the Catalan school of ceramics of their time. They published texts in its defense, along with others introducing contemporary foreign artists and Asian ceramics to their readers.[26]

Josep Llorens i Artigas, a friend and collaborator with Elias early in his career, is undoubtedly the most distinguished Catalan artist in the field of decorative arts and among the few who have gained international recognition. Unlike others of his generation, he did not have a wide-ranging career, but instead dedicated his efforts and creativity exclusively to the refinement of ceramics. He was one of the first students at the Escola Superior de Bells Oficis, where he quickly went on to become a staff member. His early ceramics reflect the general tendencies prevalent among artists of the time, applying decoration over white covers, although his avant-garde motifs approaching Cubism are surprising.[27] Nevertheless, these early signs of innovative tendencies did not

fulfill his expectations sufficiently, and painted ornamentation in enamel pleased him less and less. A scholarship enabled him to go to Paris, where he deepened his knowledge of stoneware and began working with avant-garde painters such as Raoul Dufy. The adaptation of his creativity to the techniques of stoneware—which is harder, more compact, and more precise than earthenware—grew apace, and this medium henceforth became his principal vehicle of expression. With it, he sought a pure and unadorned art, the beauty of which was rooted primarily in the loveliness of the turned forms and the attractiveness of the surfaces, which were colored, but without any painted figural decoration.

In his always unique ceramics, Llorens i Artigas carried the philosophy of well-made work much farther than any other artist of noucentista background. Moreover, he set himself apart from the majority of his generation by concentrating on concise forms and reflections on the philosophy and techniques of Chinese and Japanese ceramics.[28] He always exercised complete control over the creative process, from beginning to end, including the selection of raw materials, finishes, and firing, and was as demanding of his experiments as he was of the final results. Directly manipulating the material on

Fig. 18 (cat. 6:57). Francesc Elias, *Covered Jar*, 1932.
Fig. 19 (cat. 6:54). Josep Llorens i Artigas, *Clair de Lune Vase*, 1927.

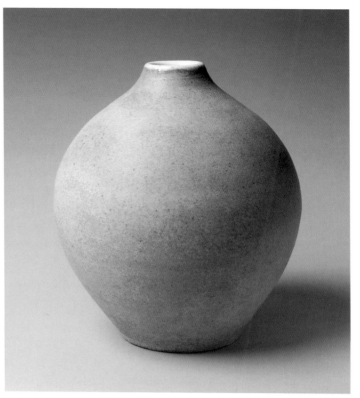

the potter's wheel was of overriding importance to him. In manually raising the forms of his works, he sought the infinite possibilities of their profiles through subtle curved inflections. Their unadorned refinement, possessing neither extravagance nor stridence, was accompanied by a thoughtful exploration of finishes—matte or glossy colored textures—that harmonized and highlighted the forms.[29]

Llorens i Artigas exhibited one of his first stoneware masterpieces, the *Clair de Lune Vase* (fig. 19), in the Paris autumn salon of 1928 and the Barcelona spring salon of 1932.[30] It is one of the few pieces titled by the artist, but its name does not refer to any imitative or figurative aspect, evoking instead a poetic nature related to the expressive shadings of its tonalities. The harmony between the roundness of the form and the patchy effect of iridescent and satiny

turnings makes this vase an excellent example of the degree of expression he had already achieved at that time. The vase he exhibited in the Barcelona spring salon of 1934 (fig. 20) reflects the taste for a continuous curve in the profiles that became so characteristic of his work, offering a balanced but strong contrast between the ample pot-bellied form and the narrowness of the upper part. The glossy dark green tonality of the enameled covering creates an effective visual clash with the pink enamel of the interior, subtly visible in the flared mouth. One measure of the international stature Llorens i Artigas attained by the 1930s was that the Metropolitan Museum of Art bought one of the works (fig. 21) from his 1932 exhibition at the Brummer Gallery in New York—the first piece of contemporary ceramics acquired by that encyclopedic museum.[31]

Fig. 20 (cat. 6:55). Josep Llorens i Artigas, *Vase*, 1931.
Fig. 21 (cat. 6:56). Josep Llorens i Artigas, *Vase*, 1931.

1. *Jeroni Martorell Terrats. Una mirada d'arquitecte,* exh. cat. (Girona: Col·legi d'Arquitectes de Catalunya, Demarcació de Girona/Fundació Caixa de Sabadell, 2000).

2. Jeroni Martorell, "L'art cívic en l'antiga Catalunya," *D'ací d'allà* 15 (1925): 376–79.

3. Josep M. Ainaud de Lasarte, "Educació i civisme," in *El Noucentisme: Un projecte de modernitat,* ed. Martí Peran et al., exh. cat. (Barcelona: Generalitat de Catalunya/Centre de Cultura Contemporània de Barcelona/Enciclopèdia Catalana, 1994), 152–55, 167.

4. Joan Tarrús and Narcís Comadira, *Rafael Masó. Arquitecte Noucentista* (Barcelona: Lunwerg/Col·legi d'Arquitectes de Catalunya, 1996), 171–72, 241–507, 377–78.

5. With an interior design expressly created for the family with young children that was going to live in it.

6. Tarrús and Comadira, *Rafael Masó. Arquitecte Noucentista,* 72, 373–75.

7. Francesc Miralles, "Escriptori," in *Moble Català,* ed. Eulàlia Jardí, exh. cat. (Barcelona: Electa/Generalitat de Cataluña, 1994). A frontal and profile watercolor drawing is preserved in a private collection; see Tarrús and Comadira, *Rafael Masó. Arquitecte Noucentista,* 69.

8. A cushion that Masó's wife embroidered is still in the possession of his heirs.

9. The marriage was postponed because of his father-in-law's opposition to it. Masó's mystical veneration for his wife appears constantly in drawings and compositions, with the inclusion of his slogan: "Déu i ton nom" ("God and Your Name"; Esperança means "hope" in Catalan).

10. Both schools closed precipitously in 1924, for political reasons. See Miralles, ed., *L'època de les avantguardes: 1917–1970,* vol. 8 of *Història de l'Art Català* (Barcelona: Edicions 62, 1983), 44–46; and Pilar Vélez, *Arts decoratives, industrials i aplicades,* vol. 11 of *Art de Catalunya–Ars Cataloniae,* ed. Xavier Barral (Barcelona: L'isard, 2000), 228–35.

11. *Per la bellesa de la llar humil, recull d'orientacions* (Barcelona: Foment de les Arts Decoratives, 1923).

12. See Albert Telese, *La ceràmica blava catalana de 1570 a 1670* (Barcelona: A. Telese, 1991); *El descobriment de la ceràmica catalana,* exh. cat. (Barcelona: Fundación Francisco Godia, 2005); Sergio Savini, "Alfarería española: época medieval a contemporánea," in *Cerámica española,* vol. 42 of *Summa Artis* (Madrid: Espasa Calpe, 1998), 585–628.

13. Ignasi Domènech, "El vidrio," in *Artes Decorativas I,* vol. 45 of *Summa Artis* (Madrid: Espasa Calpe, 1999), and Domènech, "Spanish Façon de Venise Glass," in *Beyond Venice: Glass in Venetian Style, 1500–1750* (Corning, N.Y.: Corning Museum of Glass, 2004), 85–113.

14. J[oan] S[acs], "Els vidres den Maurici Marinot," *Revista Nova* 14 (11 July 1914): front page and 8–11.

15. *Exposition Internationale des Arts Décoratifs. Catalogue Géneral* (Paris: Imp. De Vaugirard, 1925), 562–66; Santiago Marco, "L'Exposició de París," in *Anuari del Foment de les Arts Decoratives 1924–1925* (Barcelona: Foment de les Arts Decoratives, 1926), 19–43.

16. Pía Subías, "La cerámica decorada en la época del *Noucentisme,*" in *Cerámica española,* vol. 42 of *Summa Artis* (Madrid: Espasa Calpe, 1998), 538–41.

17. Alexandre Cirici, *La ceràmica catalana* (Barcelona: Destino, 1977), 428–32; Subías, "La cerámica decorada en la época del *Noucentisme,*" 539–40; *El Noucentisme: Un projecte de modernitat,* 141.

18. *El Noucentisme: Un projecte de modernitat,* 158–59.

19. Quite distinct from the symbolist ostentatiousness characteristic of Modernisme, evident in the monument-fountain to Dr. Robert by Josep Llimona, unveiled in 1910 (see fig. 2, p. 73). Miralles, "L'època del Noucentisme," in *Del Modernisme al Noucentisme: 1888–1917,* vol. 7 of *Història de l'Art Català,* ed. Francesc Fontbona and Francesc Miralles (Barcelona: Edicions 62, 1985), 207.

20. Aragay expressed similar thematic and decorative intentions in the two versions of the jar *Bread,* published in *La ceràmica moderna a Catalunya,* exh. cat. (Barcelona: Dau al Set, 1983), 1; Subías, "La cerámica decorada en la época del *Noucentisme,*" 540.

21. The restaurant is still in existence, but the most emblematic panels decorated by Nogués entered the Museu de Ceràmica de Barcelona.

22. Cecília Vidal, *Xavier Nogués* (Barcelona: Sala d'Art Artur Ramon, 1994), 53–55. The glass pieces are usually signed "Nogués p[inxit] y Crespo f[ecit]." Preparatory drawings by Nogués were published in *La mà trencada,* no. 3 (11 December 1924).

23. The pieces were shown in the first Nogués–Crespo glass exhibition, with the catalogue numbers 59, 65, 62, and 61, and the indication "Unique pieces." *Exposició d'esmalts sobre vidre de Ricard Crespo originals de Xavier Nogués,* exh. cat. (Barcelona: Galeries Laietanes, 1924).

24. Jordi Carreras, "Got i plat de la caça," in *Arts Decoratives a Barcelona. Col·leccions per a un Museu* (Barcelona: Palau de la Virreina, Ajuntament de Barcelona, 1995), 165–66.

25. Joan Sacs, "Los ceramistas españoles modernos," *Cerámica industrial y artística* 5 (1932); "Francesc Elias Bracons," *Revista Internacional Cerámica* 45 (1992): 86–87.

26. Francesc Elias, "Por una escuela de Cerámica," *Cerámica industrial y artística* 2 (1931): 40–41; Joan Sacs, "La cerámica de arte," *Cerámica industrial y artística* 1 (1931): 3–5; Joan Sacs, "La cerámica japonesa," *Cerámica industrial y artística* 35 (1934): 191–94.

27. *Josep Llorens Artigas,* exh. cat. (Barcelona, Artur Ramon Col·leccionisme, 2005), 6; *El Noucentisme, un projecte de modernitat,* 180, no. 177.

28. María Antonia Casanovas, "Llorens Artigas y la ceràmica de estudio," in *Josep Llorens Artigas,* 4–5.

29. The artist himself explained his predilection for stoneware and for experimentation with enamels in Josep Llorens Artigas, "Técnicas diferentes," *Cerámica industrial y artística* 5 (1932): 143–46.

30. In his personal journal of the results of his work, he made the note "masterpiece" above this jar. Miralles, *A l'entorn de Llorens Artigas* (Barcelona: Nou Art Thor, 1981), 21–22. It was acquired in Paris by Catalonia's Junta de Museus, and subsequently dispatched to the Museu de Ceràmica in Barcelona.

31. Miralles, *A l'entorn de Llorens Artigas,* 22.

Translated by Vajra Kilgour.

# Noucentisme and the Influence of French Art Deco

*JARED GOSS*

In considering the architecture and design that came from Barcelona during the first decades of the 20th century, at most two names will likely come to mind to the nonspecialist: Antoni Gaudí and Josep Lluís Sert. Through Gaudí, generations have been made aware of the riches of the Modernisme movement, and in great part thanks to his renown the movement has become one of the best-known in Catalan design history. Sert, an important figure of the rationalist movement of the 1930s, burnished his international reputation through his second career in the United States, teaching at Yale and Harvard universities. But what of the period between Modernisme and rationalism? While much attention has been paid to Catalan fine arts of the 1910s and 1920s, the period remains one of the least explored in the evolution of Catalan design.

The catchall label of Noucentisme, or "1900s style," is frequently applied to Catalan culture of this period.[1] While much studied in Catalonia, this complex movement is little known or understood outside the region. Akin to the concurrent French "return-to-order," Noucentisme attempted to codify a classically based language as the foundation for a new nationalistic culture that would not only link Catalonia with its Mediterranean—even its vernacular—past, but also be adapted to the needs and requirements of the modern world (figs. 1–4).[2]

To suggest that the foundation for the movement was exclusively Mediterranean, however, would be to overlook many international influences that also helped form it. Barcelona, as a major industrial and trade center, was very much engaged with the world. Improved ease of travel, the abundance of readily available foreign newspapers and magazines, even movies and radio all allowed increased awareness of ideas, trends, and fashions that were developing elsewhere. Despite any purportedly nationalist tendencies visible in noucentista culture, one of Barcelona's principal aims throughout this period was to assert its position as a major modern European city, and indeed it is the particular combination of traditional with up-to-date, local with foreign that gives Noucentisme its cultural relevance.

Although the movement ultimately proved to be more a literary and intellectual one than one with a distinct physical presence, the architecture and decorative arts of the period embody its complexity. Accepting that Noucentisme existed as a mindset rather than a particular stylistic idiom, it is not surprising that the movement had a variety of physical expressions: not all noucentista design was literal in its interpretation and use of the Mediterranean-classical and or vernacular vocabulary. Perhaps its most important unifying theme, however, was a renewed interest in traditional craftsmanship, which became

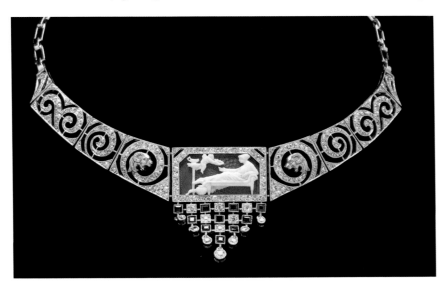

Fig. 1 (cat. 6:58). Lluís Masriera, *Necklace*, c. 1909–16.

a sort of rallying cry for the movement. The concept of the *obra ben feta* (well-made work) became an essential part of the noucentista design philosophy, one that evolved out of a perception that designs of the preceding modernista period lacked quality, having been conceived by designers who were more artists than artisans.[3] Designer and fabricator were

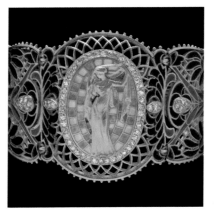

rarely one and the same. An emphasis, therefore, on a practical (even apprentice-based) design education that gave firsthand experience in specialized crafts was considered a crucial step for the future development of the Catalan design industry.

Perhaps the most significant manifestation of this approach was the formation of the Foment de les Arts Decoratives in Barcelona in 1903. This organization (which exists today and is known as FAD) became the dominant force shaping Catalan design until the advent of civil war in 1936; its mission was to stimulate, encourage, and promote the growth, development, and spread of Catalan design. According to its official history:

*FAD aimed to attract the greatest possible number of members and to promote itself by organizing events, supporting better education, organizing competitions, and participating in exhibitions. Its underlying objective was to raise the status of arts and crafts and to end, once and for all, the sterile hierarchy that had traditionally existed between the greater arts, which included painting, sculpture, and architecture, and what were considered the lesser, or decorative, arts. FAD's founders believed that the decorative arts should not be considered to be inferior forms of expression, but rather the opposite.[4]*

For the benefit and education of its members, the organization formed a research library and museum whose goal was to "bring together all types of

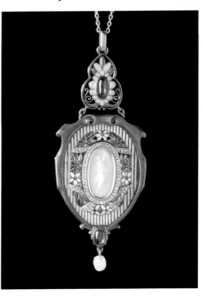

artworks resulting from arts and crafts techniques." Between 1919 and 1931, FAD published an annual yearbook that illustrated not only new works by members but also included essays on historic subjects and important local collections, as well as summaries of activities related to FAD.[5]

Related organizations soon followed. The Escola Superior dels Bells Oficis (School of Fine Crafts) was founded in 1914; many of its teaching faculty were members of FAD. Courses were taught in a variety of crafts, both traditional to Catalonia (ceramics, metalworking, and leatherworking) and new (most notably the art of lacquering, imported from Asia via France). When the school was closed in 1923, FAD offered classes in its place. In 1929, the Escola Massana opened; this school for arts and crafts was funded by the bequest of a Barcelona collector and FAD member Agustí Massana.

FAD's participation in international exhibitions gave the organization its widest public exposure, both abroad and locally. Exhibitions of Catalan art in Lisbon in 1921 and Amsterdam in 1922 included works by FAD members; in 1925 FAD took part in the great International Exposition of Modern Decorative and Industrial Arts in Paris (winning a number of prizes for excellence); and in 1936, FAD exhibited at the 6th Milan Triennale. In Barcelona in 1923, FAD presented an installation devoted to decorating the low-income home at the International Exhibition of Furniture and Interior Design, and although FAD did not officially contribute to the Barcelona International Exhibition of 1929, some of its members took part individually.

FAD took an active interest in design trends abroad, particularly those of Paris.[6] Paris was considered perhaps the most important cultural capital of the day, and while it is widely known that many Catalan fine artists had close ties to that city—Pablo

Fig. 2 (cat. 6:59). Lluís Masriera, *Bracelet*, c. 1909–16.
Fig. 3 (cat. 6:60). Lluís Masriera, *Pendant with Figure in Motion*, c. 1909–16.

Picasso, Joan Miró, Salvador Dalí, Ramon Casas, and Pablo Gargallo all spent time there—it must be noted that the same can be said for some designers. But even if many Catalan designers did not spend time living in Paris, they nonetheless were aware of new design being created there: an aggressive campaign was under way to revitalize French design industries. It was the era of Art Deco.

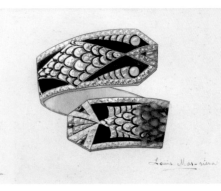

Disillusioned by the failure of Art Nouveau and competitively concerned by advances in design and manufacturing in Austria and Germany in the early years of the century, French designers felt the need to re-establish their traditional role as leaders in the luxury trade. Associations such as the Société des Artistes Décorateurs were founded to encourage new standards for French design and production, and in 1912 the French government voted to sponsor an international exhibition of decorative arts in 1915 promoting French pre-eminence in the field. The exhibition, postponed on account of World War I, did not take place until 1925. It was this fair, the International Exposition of Modern Decorative and Industrial Arts, that later gave its name to Art Deco.[7]

Although ultimately an international idiom, the roots of Art Deco were decidedly French. During the 1910s, many French designers looked to traditional models from the late 18th and early 19th centuries for both technical and stylistic inspiration. These historic periods would provide many of the formal and ornamental sources for much Art Deco design—a style that often proves as much backward as forward-looking.[8] The return to the past was not only aesthetic, however, but also philosophical, parallel to Catalan Noucentisme.[9]

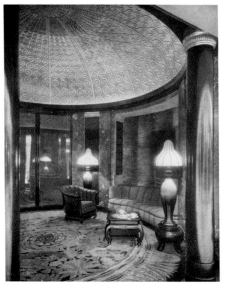

One Catalan designer with particularly close ties with Paris during the 1920s was Santiago Marco Urrutia, a decorator, design reformer, educator, and director of FAD from 1921 to 1932 and again from 1934 to 1949; he can be credited as being the principal conduit through whom French Art Deco arrived in Barcelona.[10] Trained in the Barcelona workshops of the glassmaker Rigalt and the furniture maker Vidal (educated also in sculpture, painting, and color theory at the Llotja art school in Barcelona), Marco had a thorough understanding of both craftsmanship and composition. But perhaps more important, he also was keenly aware of—and held in high esteem—work by his French contemporaries, particularly Émile-Jacques Ruhlmann.[11]

Ruhlmann's work was quite well known in Barcelona. Examples were included in the grouping of French Art Deco furniture and objects shown there at the 1923 International Exposition of Furniture and Interior Decoration, and again at the 1929 International Exposition. It was widely published in design periodicals readily available to Catalan designers. And while Marco himself traveled frequently to Paris to visit workshops of leading French designers (Ruhlmann included), in 1933 a larger delegation of FAD officials made a visit specifically to the Ruhlmann showroom and atelier.[12] Indeed, Ruhlmann was held in such high esteem in Barcelona that one local furniture maker, F. Giménez, appropriated an image of a cabinet by Ruhlmann for his own advertising campaign.[13]

Marco's work reflects lessons learned from Paris. Although his earliest commissions (mainly interiors for private residences) were exercises in historicism that give little indication of his subsequent originality, by the 1923 International Exposition of Furniture and Interior Deocration in Barcelona his taste had evolved. The majority of the Catalan exhibits at the fair were pastiche interiors offering lessons in historical styles from the 12th to the 19th centuries; there was very little

Fig. 4 (cat. 6:61). Lluís Masriera, *Design for Snake Bracelet*, 1925.

Fig. 5. Tea room by Santiago Marco Urrutia at the International Exposition of Furniture and Interior Decoration, Barcelona, 1923.

"modern" design at the fair apart from a large grouping of contemporary French design—including a number of important pieces by Ruhlmann—which served to introduce French high-style taste to Barcelona.[14]

A tearoom presented by Marco was the notable exception (fig. 5). A theatrical tour-de-force, the circular domed space was decorated in the most up-to-date style. Clearly influenced by the orientalist exoticism of the fashionable Ballets Russes, the room had tapestry panels and a carpet by Tomàs Aymat, lacquered columns by Lluís Bracons, and was furnished with an upholstered divan, armchairs, and low Chinese-style tea tables by Marco.[15] The dominating feature, however, was a set of four lamps of meiping form (a tall, narrow-necked, broad-shouldered vase used to hold a flowering branch), expertly lacquered with eggshell by Bracons (Museu de les Arts Decoratives, Barcelona). The room was awarded a grand prize. Marco clearly thought highly of the design: he presented a maquette for a similar room at the 1925 Paris exposition.

Marco's displays at the Paris exhibition were part of a much larger Catalan contribution.[16] Even so, as president of FAD he had a notably strong influence on the region's presence at the fair:

*Having failed to secure the support of the Barcelona City Council, FAD contacted the committee responsible for Spain's contribution directly, to ensure that it would be represented at this great, multi-disciplinary event in Paris. As a result, FAD's executive board, under the presidency of Santiago Marco, was commissioned to coordinate a section by Catalan artists, who exhibited their works in the Galeries de Saint Dominique and in the dome of the Grand Palais. FAD was responsible for the entire process, from the selection of Catalan works and artists to appear in Paris, to their travel arrangements and the design of a single exhibition unit "in order to ensure harmony in the totality of objects on display."[17]*

In all, more than 40 Catalan artists and designers showed their works at the fair and their efforts were met with a number of awards. One notable absence, however, was the architect Antoni Gaudí, whom Marco had unsuccessfully attempted to persuade to act as head of the section.[18]

In addition to individual works of art, complete room settings were shown in the Galeries Saint Dominique. Among them, Marco's *Amethyst Boudoir* was awarded a gold medal (fig. 6).[19] A more intimate version of his earlier tearoom, Marco anchored the room with a cushioned divan set into an alcove with tapestry panels by Aymat. A textile designed by Marco with a motif of does prancing among abstracted flowers was used both as upholstery and vertically pleated as a window or wall treatment, again demonstrating his familiarity with similar French contemporary interiors.[20]

Particularly noteworthy, however, was Marco's drop-front desk (fig. 7), part of a suite including a dressing table and chairs that was awarded a gold medal. Inspired by the sophisticated marquetry traditionally used on French furniture, the surfaces

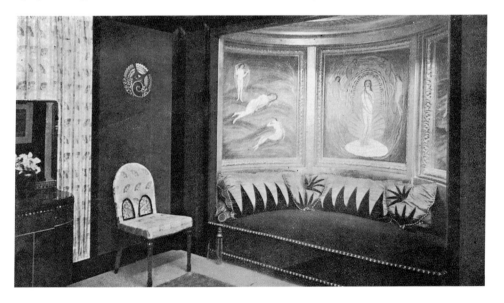

Fig. 6. *Amethyst Boudoir* by Santiago Marco Urrutia at the International Exposition of Modern Decorative and Industrial Arts, Paris, 1925.

sunburst at the center of the drop front; from its oval giltwood center, triangular rays of inlaid aluminum and brass radiate out, ending with discs of mother-of-pearl. Each drawer has a triangular cubist motif of inlaid brass and aluminum functioning as a decorative keyhole escutcheon, as well as a pair of silver scroll-shaped pulls. The overall flatness and sobriety of the piece, relieved by the luxuriousness of its materials and perfection of its finish, are characteristic of French Art Deco, and provide a marked and purposeful contrast with modernista designs.

Also notable was a lacquer panel, the collaborative effort of the artist Jaume Busquets, who devised the decorative composition, and Lluís Bracons, who executed it in lacquer (fig. 8).[21] Presented as part of a dining room setting by the decorator Joan Busquets i Jané, the screen depicts a contemporary, stylized view of Barcelona seen from the air.[22] Though it easily could be mistaken as French Art Deco in origin, uniquely noucentista considerations informed its conception:

of the desk are completely veneered in unbroken sheets of burled thuya wood. Metallic beaded molding delineates each of the major functional components of the piece: the drop-front writing surface at the top and three drawers below. The top of the desk (enriched with a frieze inlaid with small ovals of mother-of-pearl) and stylized cabriole legs are both ebonized. The principal decorative motif is a

*The panel Barcelona Harbor brought a complementary note to the Mediterranean atmosphere of the dining room presented in 1925 by Joan Busquets, at the same time giving it a certain modernity. The decorative motif that unified the atmosphere of the en-*

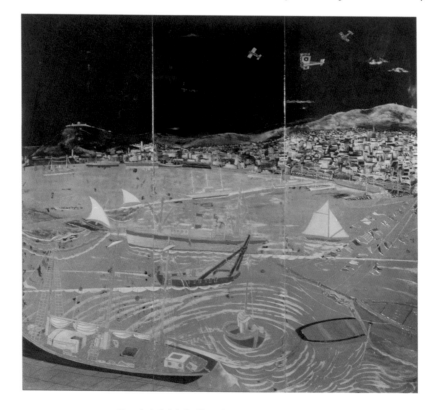

Fig. 7 (cat. 6:62). Santiago Marco, *Writing Desk*, 1925.
Fig. 8 (cat. 6:63). Lluís Bracons and Jaume Busquets, *Port of Barcelona*, 1925.

semble was the pinecone, visible at the bottom of the stained glass window which depicts pine trees and the water of the sea, at the supports of the central light, on the woodwork of the door friezes, on the metal sabots of the furniture, and the capitals of the marble pedestals. Also, the upholstery tapestries made by Tomàs Aymat—with their butterfly motif—complete this Mediterranean landscape.[23]

By the time of the 1929 Barcelona International Exhibition, Marco's work had matured significantly, and there he presented the most ambitious project of his career, in great part based on lessons learned

at the 1925 exhibition. Like a number of the pavilions in Paris (most notably the Ruhlmann pavilion, the so-called Townhouse for a Rich Collector), the Pavelló dels Artistes Reunits presented a complete mock residence furnished in the most up-to-date taste (figs. 9 and 10) "with all the refinements of luxury, comfort and hygiene,"[24] and was considered one of the highlights of the Barcelona fair. Though FAD did not officially sponsor the pavilion, more than half of the designers, artists, and craftsmen who worked to create the pavilion were members.[25]

The elegant, classically inspired building itself was designed by the architect Jaume Mestres Fossas

Fig. 9 (cat. 6:64). Jaume Mercadé, *Coffee Service*, c. 1925.
Fig. 10 (cat. 6:65). Ramon Sunyer, *Cocktail Shaker Service*, 1928.

and arranged around a large central octagonal hall-music room, off of which opened a salon-library on one side, a bedroom with dressing room and bath on the other, and, in the rear, a low kitchen and pantry with a mezzanine exhibition gallery above.[26] The interior was coordinated and furnished by Marco with the intent of showing how, through a judicious blend of contemporary fine and decorative arts, harmonious and pleasing modern rooms could be created. A contemporary critic noted:

*The interior of the pavilion is a real success, not only the arrangement of the floor plan (cleverly resolved, maintaining the appearance of a private home while combining it with the requirements of an exhibition space where even the smallest objects have to be carefully examined) but also the tonalities of the rooms, which, although each has its own particular and characteristic accents, end up having a surprising harmony because the metallic gray tone of the hall both centers and unifies them. . . . The endeavor to restore painting and sculpture to their right place in serving architecture and decoration . . . has been successfully undertaken. . . . The furniture, reduced to its proper proportion and function, is free of most of the decorative excesses of the immoderate and overbearing attempts . . . that we are used to seeing by our ébénistes, and indeed it can be presented as a veritable model, if for no other reason than for the laudable tendencies that it generally displays.[27]*

Marco's stringent aesthetic standards were applied even to the most mundane elements, and nothing was overlooked:

*The octagonal hall, where marbles are combined with gold and bronze, and iron with nickel in an admirable way, is dominated by a great organ; it looks like a music chamber. . . . At the center [of the room] on a pedestal made from a radiator there is a figure by Pablo Gargallo, one of the genius works of the type we have been accustomed to seeing in recent years by this master sculptor. . . . Having mentioned radiators, we note in passing that it has been a great success to leave them exposed, without trying to hide them or disguise them in vain. Here we have conclusive proof that beauty comes automatically from the nature of a thing itself.[28]*

The 1929 exhibition marked the high point of Art Deco in Barcelona. Indeed, the fairgrounds—with a theatrical allée of illuminated obelisks and rows of fountains brightly lit in color (designed by Carles Buïgas) leading from the Plaça d'Espanya to the Palau Nacional, surmounted with a crown of searchlights, at the top of Montjuïc—might easily have been mistaken for Paris in 1925. But the decorative and luxurious qualities of Art Deco, soon seen as increasingly irrelevant, particularly in light of the worldwide economic downturn of the 1930s, were replaced by the more vigorous and rational approach espoused by young design reformers who believed that beauty need not depend on ornament but could be achieved through the manipulation of form and the judicious use of color and texture. The simplicity and economy of rationalism would become preferable aesthetically—even morally—to the elaboration and extravagance that had typified Art Deco.

While the grouping of works selected for this exhibition clearly draws inspiration from modern, urban, and foreign sources, it also can be seen clearly to have strong roots in the revival of tradition that was so important to the Noucentistes. It was through works such as these, in the words of Santiago Marco, that Catalan designers:

[H]*ave made a small contribution to the aesthetic evolution of the time. . . . We acknowledge that it is a small contribution, but despite its small size we see with joy that it is truly Catalan, that it is firmly stamped with our personality. In a time of art without borders, when tastes and developments have a universal character as soon as they emerge, that is the time one emphasizes the fading traits that make up ethnic character. Paradoxically, everyone wants to be universal but with his own character; everybody yields, but nobody resigns. . . . We, small as we are weighed against a universal process, contribute to this movement . . . preserving the nobility and dignity of the arts and crafts while at the same time asserting once again the personality of our beloved land.[29]*

1. "Nou" also suggests the concept of newness.

2. Little on the subject has been written in English. For a thorough summary of Noucentisme and its relationship to the decorative arts and architecture, see Daniel Giralt-Miracle, "The Decorative Arts in Everyday Life," in *Homage to Barcelona: The City and Its Art, 1888–1936*, ed. Michael Raeburn, exh. cat. (London: Arts Council of Great Britain, 1985), 226–39.

3. "A quest for technical perfection . . . a taste for true civilization . . . [has been] somewhat lost since the arrival of the *modernista* movement and the intervention of unskilled artists in the technical aspects of the arts and crafts." Joaquim Folch i Torres, *Santiago Marco: 31 realitzacions* (Barcelona: Joan Merli, 1926), 11. All translations from this book by Guillem d'Efak Fullana-Ferre.

4. Mariàngels Fondevila, "1903–1936, FAD. An Historical Perspective," in *Improving Our Lives: FAD. Over a Century of Architecture, Design and Creativity* (Barcelona: FAD, 2005), 27. This article provides a thorough English-language overview of the FAD and its accomplishments during the period being discussed.

5. Ibid., 31.

6. "In 1922, the FAD executive board organized a trip to Paris for its members, which included, among other things, visits to the Museum of Decorative Arts and to the Gobelins factories 'given its importance to anyone involved in the applied arts, the importance of experiencing the French capital is generally acknowledged, so there is no need for discussion.'" Ibid., 65.

7. Held in Paris between April and October 1925, the exposition drew more than six million visitors. The primary requirement for inclusion (more than 20 foreign countries were invited to participate) was that all works had to be thoroughly modern; no copying of historical styles of the past would be permitted. Nonetheless, much of what was exhibited was firmly rooted in the traditions of the past. The stylistic unity of the displays indicates that Art Deco was already an internationally mature style by 1925—one that had flourished in the years following World War I and peaked at the time of the fair. The enormous commercial success of Art Deco insured that designers and manufacturers throughout Europe continued to promote this style until well into the 1930s.

8. This would prove a useful marketing tool for French designers as well. French Art Deco creations were invariably beautiful, luxurious, and costly—aimed at the very rich. Therefore, when a French designer such as Émile-Jacques Ruhlmann referred to the huge amounts of money paid by the nobility of the ancien régime for furniture by masters such as Boulle and Riesener, he not only compared and associated himself with the greatest *ébénistes* of the past but also linked his patrons with royalty, a compliment they were not likely to overlook.

9. Even so, developments in other areas of the arts—such as the advent of Cubism in 1907, or the exoticism of Diaghilev's Ballets Russes, which arrived in Paris in 1908—influenced the look of Art Deco; there was a fairly wide acceptance of ideas of the artistic avant-garde by the consumer public during the period. With time, increasingly stylized and abstracted decorative motifs replaced overtly historicist ones, and unusual materials (often imported from colonies in Africa and Asia) replaced conventional ones. Ultimately, while Art Deco did not provide any substantive break with the past, it provided a newly stylized decorative vocabulary that could be manipulated for dazzling surface effects, sometimes without any real content or innovation.

10. See Folch i Torres, *Santiago Marco*. One of the few sources on Marco, this book was published within his lifetime and therefore addresses only a portion of his professional career; nonetheless it gives a good synopsis of the events of his early life.

11. Perhaps the most renowned designer of his day, Ruhlmann is considered the primary exponent of high-style French taste following World War I. Though best known as a furniture designer, he was also able to provide any element needed for an interior, from architecture to lighting fixtures, ceramics, carpets, and textiles. Aesthetic refinement, sumptuous materials, and impeccable construction techniques place his work—which epitomizes the glamour of Art Deco—on a par with the finest furniture and decorative arts of any era.

12. After a visit to the designer's Paris workshop, Marco remarked that Ruhlmann was "quite possibly the cabinetmaker who places the most importance on quality. One could inspect his pieces close up, microscopically, and declare: Perfect!" Fondevila, "1903–1936, FAD," 35.

13. *Anuari del Foment de les Arts Decoratives, 1924–1925* (Barcelona: Foment/Oliva de Vilanova, 1926), 82.

14. In fact, as early as 1917 a selection of contemporary French decorative arts had been included in an exhibition of French art held at the Palau de Belles Arts.

15. The famous ballet company had performed in Barcelona in 1917. Aymat and Bracons had both been trained in their crafts in France: Aymat learned tapestry making at the Gobelins factory in Paris;

Bracons was taught to work in lacquer by the Swiss-born Jean Dunand, whose workshops were also in Paris. Though designed by Marco, the pieces were probably made in the workshops of the Barcelona furniture maker Frederic Orri, who used an image of them to advertise his firm. See *Anuari del Foment de les Arts Decoratives*, 92.

16. Two separate displays presented works from other parts of Spain: an official Spanish pavilion and a presentation of works on the ground floor of the Grand Palais.

17. Fondevila, "1903–1936, FAD," 44.

18. "We undisputedly wanted this section to be presided over by a unique figure, the master Gaudí, but because his opposition was so firm, we were not able to take him to the artistic capital of the world at this most propitious moment for his triumph. Years ago, a complete overview of Gaudí's architecture was shown in Paris, but due to his too-advanced genius and the daring of his conceptions that linked aesthetics and science, the cultural environment was not yet then ready." It is possible that Gaudí rejected the offer to head the Catalan section because of the painfully bad earlier reception of his work in Paris. See Santiago Marco, "L'exposició de París," in *Anuari del Foment de les Arts Decoratives*, 28–29. Translation by Guillem d'Efak Fullana-Ferre. It seems that architectural fragments or possibly even models by Gaudí were presented in the Catalan display at the Grand Palais. The *Catalogue Général Officiel* of the exhibition (Paris: Imprimerie de Vaugirard, 1925), 365, lists the inclusion of "Éléments d'architecture moderne" by Antoni Gaudí, and in a special section devoted to Catalonia in a review of the Spanish contributions to the fair a critic wrote: "Those who seek a new art will find what they need in front of the modern architectural elements by Antonio Gandi [sic] (first floor, Grand Palais). They will also want to undertake the trip to Barcelona to see the Sagrada Família, the modern cathedral that was begun before one was able to speak of a modern art as a counterpoint to the arts of yesterday." Adolphe Falgairolle, "L'Espagne Décorative et Livresque à l'Exposition," in *L'Exposition des Arts Décoratifs Paris 1925* (Paris: Les Éditions G. Crès et Cie, 1925), 121. Translation by the author.

19. In contemporary publications, the room was also referred to as the "Boudoir of Venus." Folch i Torres, *Santiago Marco*, 45.

20. Ruhlmann, for example, frequently used vertically pleated fabric panels as architectonic decoration in his interiors.

21. Bracons was the first of a small number of Catalan craftsmen who came to specialize in the technique of traditional lacquer work.

22. Made in three pieces, the panel could be used flat or folded as a screen. The work was shown again at the 1929 Barcelona Exposicion Internacional. Teresa Sala i Garcia et al., "Plafó Decoratiu," in *Moble Català*, ed. Eulàlia Jardí, exh. cat. (Barcelona: Generalitat de Catalunya, 1994), 339. The modernity of its pictorial stylization is matched by the artist's vantage point: aviation was still considered a new and exciting pastime.

23. Ibid., 338–39. Translation by Marc Barrio Gázquez.

24. *Improving Our Lives*, 50.

25. "The Pavelló dels Artistes Reunits was a reaction against the eclectic and academic spirit of the official Decorative Arts pavilion by Manuel Cases Lamolla . . . the contents of the official section failed by a long way to achieve the degree of modernity expected of it. As a result, following a series of statements from both sides distancing themselves from one another's points of view, FAD refused to take part in this section." Ibid., 47, 50.

26. The pavilion (number 67 on the official map for the exhibition) was located in the Avinguda dels Montanyans, just above the Poble Español and next to the Palau de la Química. It was torn down following the close of the exhibition. Mestre's floor plan recalls that of the Ruhlmann pavilion (designed by the French architect Pierre Patout): centered on an oval drawing room, it had a dining room and library on one side, a bedroom, boudoir, and bathroom on the other side, with an entrance hall at the front.

27. Dòric, "L'Obra dels Artistes Reunits," from "Les Arts Decoratives a l'Exposició Internacional de Barcelona" in *Arts i Bells Oficis* (Barcelona: Foment de les Arts Decoratives, 1929), 220–22. All translations from this article by Guillem d'Efak Fullana-Ferre.

28. "Radiators, and in general all the other modern heating appliances, have generally been one of most troublesome things for decorators. Always considered an intrusion; they have never known what to do with them and have usually swept them into the corners; the easiest thing would be to accept them as they are, to study their nature, and if possible embellish their lines and determine their right and just placement." Ibid., 222. It is difficult to say where or when the idea of adapting radiators as freestanding pedestals for metal sculpture originated, but it is interesting to note that Ruhlmann also treated them as such at the same time.

29. Marco, "L'exposició de París," 31–32.

# Avant-Gardes for a New Century

WILLIAM H. ROBINSON

WE DENOUNCE the lethargy of the putrefied atmosphere of the circles and egos having to do with art.
—Salvador Dalí, 1929

The only thing that's clear to me is that I intend to destroy, destroy everything that exists in painting.
—Joan Miró, 1938

The spirit of destruction is also the spirit of construction.
—Mikhail Bakunin, quoted by Emma Goldman, 1936

By any measure Barcelona was the leading center of avant-garde art in Spain prior to the fall of the Second Republic in 1939.[1] Perhaps there was something in the history or character of the city that made it so receptive to the growth of subversive, revolutionary art. The poet Joan Maragall may have discovered the wellspring of this spirit with his observation that "within every Catalan there is an anarchist."[2] During this period, Barcelona served as the nerve center for avant-garde groups active throughout Catalonia, from Cadaqués to Sitges, from Vilafranca del Penedès to Lleida. Barcelona modernists also maintained close ties with colleagues in Europe and the Americas, and they established particularly strong affiliations with Paris, home to a close-knit community of Catalan and Spanish artists. Scores of artists drifted back and forth between Paris and Barcelona, often behaving like dual nationals who remained actively engaged in the art world on both sides of the border despite the appearance of residency in one city or the other.[3] Yet it would be a mistake to imagine that these artists limited themselves to a cultural dialogue exclusively with Paris. Barcelona artists had direct experience of Dada in New York and Futurism in Italy, and they participated in major exhibitions of surrealist and abstract art in cities as distant as London, Tenerife, and Montevideo. The rationalist architects of GATCPAC (Association of Catalan Architects and Technicians for Progress in Contemporary Architecture) centered in Barcelona played an important role in CIAM (International Congress for Modern Architecture) and CIRPAC (International Congress for Contemporary Architecture); through these organizations they maintained close ties with colleagues in France, Germany, Belgium, and the Soviet Union.

Despite steady interchange with other art centers, avant-garde art in Barcelona developed along its own trajectory and under the inevitable influence of regional political and historical events.[4] The ramifications of Spain's defeat in the Spanish-American War of 1898 and Catalonia's struggle for national self-definition were among the events that set Barcelona's history apart from the more familiar narrative of its counterparts elsewhere. Other distinctive aspects of Barcelona's history include the emergence of anarchism as a powerful political force, the rise of Noucentisme, Spain's neutrality during World War I, the repressive dictatorship of General Miguel Primo de Rivera (1923–30), social turmoil under the Second Republic (1931–39), and the Spanish civil war (1936–39).

While these events certainly affected cultural developments, they alone did not determine the character or the evolution of avant-garde art in Barcelona. Ultimately, individual artists—often working together in organized groups—were largely responsible for creating and shaping this unique

Fig. 1. Frontispiece of *L'Amour et la mémoire* (1931), photograph of Salvador Dalí taken by Luis Buñuel.

avant-garde in the history of European modernism. The seminal figures were not merely the more familiar artists on the international stage—Pablo Picasso, Joan Miró, and Salvador Dalí (fig. 1)—but an array of painters, sculptors, graphic artists, architects, designers, poets, and critics. Although many of these figures have yet to receive the same level of international recognition as their more celebrated colleagues, together they created a collective avant-garde whose historical development may be divided into three phases, each lasting about ten years: emergence (1906–15), the flowering of a new European avant-garde (1916–25), and the dominance of Surrealism and GATCPAC (1926–36). Artistic production during the civil war, when the focus of attention was directed toward other concerns, is discussed in section nine of this catalogue.

### Emergence: 1906–15

Avant-garde art developed more slowly in Barcelona than in Paris, partly because the community of progressive artists in Catalonia was smaller and less organized, and partly because many artists remained committed to Noucentisme, an ideology associated with conservative Catalan nationalism. Experimental artists in Barcelona also suffered from a lack of patrons and exhibition venues. The closing of the Quatre Gats café in 1903 temporarily deprived the city's most progressive artists of their principal venue for staging their own exhibitions and cultural events. The Sala Parés, a private gallery that promoted the modernista paintings of Santiago Rusiñol and Ramon Casas in 1890s, had served as the city's leading outlet for progressive art.[5] However, after organizing Picasso's second solo exhibition in the city in June 1901, Sala Parés turned increasingly conservative and did not resume significant support of innovative young artists until the mid 1920s.[6]

It was occasionally possible to encounter modernist art at the semi-annual municipal exhibitions launched by the Ajuntament de Barcelona (city council) in 1891. The city initially planned to hold these shows every two years but could not sustain the effort, and during the period 1891–1918 the exhibitions only appeared on an irregular basis.[7] Still, the municipal exhibitions played an important role in the city's growing artistic life. The 1907 exhibition was especially noteworthy because it was expanded to include a large selection of works by foreign artists, including Claude Monet, Maurice Denis, Auguste Rodin, Fernand Khnopff, and Giacomo Balla. But since this sporadic and unwieldy venue was far from the ideal instrument for promoting new artistic tendencies, Barcelona artists formed associations for presenting their own exhibitions. Les Arts i els Artistes (1910–36), perhaps the most important of these organizations, sponsored regular exhibitions for its members at Faianç Català, a gallery founded in 1909 and renamed the Galeries Laietanes in 1915.[8] Before 1915, however, Les Arts i els Artistes tended to promote an eclectic mixture of classicizing Noucentisme and tepid Post-Impressionism.

The art dealer Josep Dalmau is widely credited with introducing avant-garde art to Barcelona.[9] Adamantly opposed to academic art and provincial attitudes, Dalmau insisted on forging connections between Catalan artists and the international art world. His seminal role in promoting radically new art might be compared with that of Ambroise Vollard in Paris, but even more so with Alfred Stieglitz in New York, considering Dalmau's dedication to importing avant-garde art from abroad as a means of stimulating innovation in his own country. As a young man, Dalmau had studied painting and received his first solo exhibition at the Quatre Gats in 1899. He came into contact with advanced forms of modernist art while living in Paris and Brussels from 1900 to 1906. In 1906 he established a gallery in Barcelona, at first dealing in conventional art and antiquities, then expanding to include contemporary art with exhibitions devoted to Josep Mompou in 1908 and Isidre Nonell in 1909. Turning his attention to the avant-garde in 1912, Dalmau organized one of the first exhibitions of cubist art outside Paris. His groundbreaking show opened in April 1912 and featured paintings by Albert Gleizes, Jean Metzinger, Juan Gris, and for the first time at any public setting, Marcel Duchamp's *Nude Descending a Staircase No. 2*, 1912 (Philadelphia Museum of Art).[10] Although Picasso did not participate, the local press identified him as the creator of Cubism.[11] Dalmau's exhibition received extensive media coverage, and numerous articles about Cubism appeared in Barcelona newspapers and magazines. Dalmau's exhibition

moved Cubism into the arena of public discourse in Barcelona, and afterward the Catalan press continued to cover unfolding developments in the international avant-garde. Jordi Falgàs discusses Dalmau and the foreign avant-garde in Barcelona in greater depth in the next essay in this catalogue.

Despite Dalmau's efforts, a sustained "movement" of locally produced avant-garde art did not materialize immediately. Prior to 1916, avant-garde activity in Catalonia was largely uncoordinated and sporadic, carried out mostly by a few individuals working in isolation or in small groups. The most notable developments were Picasso's early forays into Cubism and Pablo Gargallo's sculptures of cut-and-soldered metal. Although Picasso had taken up residence in Paris in 1904, he often returned to Catalonia during the spring and summer, for instance, visiting Barcelona and Gósol in 1906. Returning to Catalonia again for five months in May 1909, he painted one of his earliest cubist portraits (fig. 2) while shar-

ing a studio in Barcelona with the painter Manuel Pallarès, a close friend since their teenage years at the Llotja art academy. At this point, Picasso's principal focus was eliminating narrative or anecdotal elements and concentrating on the analysis of form. He reduced the figure in this portrait to large, planar shapes and used color to enhance the volume of forms, rather than as an independent expressive element. Perhaps out of respect for his friend, Picasso treated the head in a fairly conventional manner, while rendering the body with more aggressively flattened, abstract shapes.

After leaving Barcelona in June 1909, Picasso spent the rest of the summer painting landscapes in the small village of Horta de Sant Joan (also known as Horta d'Ebre), located in a high, mountainous region about 40 miles southwest of Tarragona.[12] There he produced some of his first fully cubist paintings, achieving breakthroughs in compositional integration through the techniques of *passage* (merging

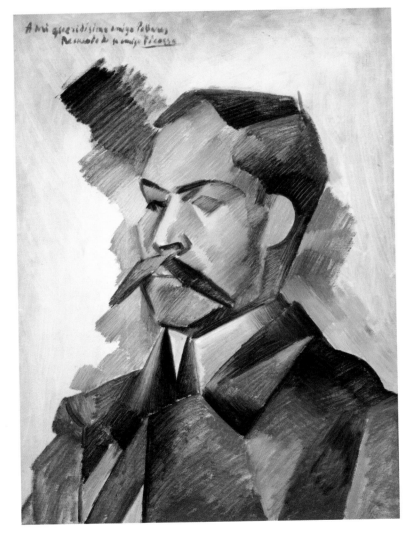

Fig. 2 (cat. 7:1). Pablo Picasso, *Manuel Pallarès*, 1909.

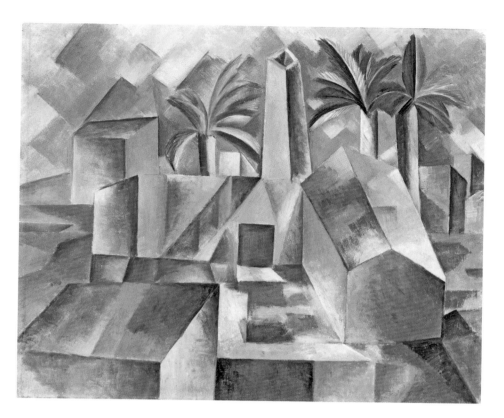

forms by leaving contours open) and reverse per-
spective. Rather than becoming smaller as they re-
cede into the distance, the blocky houses along the
bottom and center of *The Factory* and *Houses on the
Hill, Horta d'Ebre* (figs. 3 and 4) defy the rules of tra-
ditional perspective and grow larger as they prog-
ress up the canvas surface.[13] Similarly, the geometric
shapes of the roofs and hills continue into the sky,

reverberating like an echo chamber and contribut-
ing to the integration of forms throughout a shal-
low, compressed picture space that obeys only the
logic of compositional necessity. Photographs taken
by Picasso of the unadorned, blocky houses at Horta
suggest that his cubist paintings were at least par-
tially inspired by the austere, planar quality of the
Catalan town and surrounding landscape.[14]

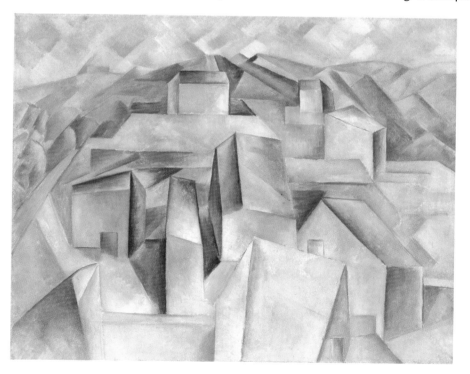

Fig. 3 (cat. 7:3). Pablo Picasso, *The Factory (The Brick Factory at Tortosa)*, 1909.
Fig. 4 (cat. 7:2). Pablo Picasso, *Houses on the Hill, Horta d'Ebre*, 1909.

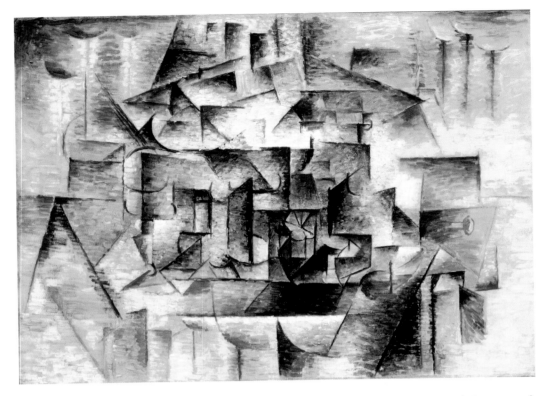

Returning to Catalonia in the summer of 1910, Picasso stayed at Ramon Pichot's hometown of Cadaqués, a fishing village north of Barcelona. There Picasso pushed Cubism toward an ever more abstract style of transparent, fragmentary planes floating in a compressed yet luminous space (fig. 5). Principles of geometrization, *passage,* color neutralization, transparency, and the integration of forms with surrounding space have advanced remarkably since his previous summer in Horta.

During the summers of 1911 through 1913, Picasso joined Manolo Hugué and other artists working in Céret, a small town in the French Pyrenees, formerly part of Catalonia and barely four miles from the modern Spanish border.[15] For a time Céret became home to an international community of artists and writers, including Picasso, Manolo, Pichot, Josep M. Junoy, Joaquim Sunyer, Max Jacob, and Georges Braque. Picasso apparently preferred the remote locations of Gósol, Céret, Cadaqués, and Horta because they offered fewer work distractions and social obligations than Barcelona. Nevertheless, while staying at these small villages he made short trips into Barcelona, and so remained in contact with ar-

Fig. 5 (cat. 7:4). Pablo Picasso, *Still Life with Glass and Lemon,* 1910.
Fig. 6 (cat. 6:11). Manolo Hugué, *Seated Nude,* 1912 (carved 1913).

tistic circles in the city during the formative years of Cubism.

The importance of Picasso's summer trips to Catalonia should not be dismissed lightly. His companion, Fernande Olivier, observed that "the atmosphere of his own country was essential to him and gave him a quite special inspiration. The sketches he made in Spain suggested the working of stronger emotion and sensibility.... The Picasso I saw in Spain was completely different from the Paris Picasso; he was gay, less wild, more brilliant and lively and able to interest himself in things in a calmer, more balanced fashion."[16] Many historians interpret Picasso's depiction of the distinctive drinking vessel known as a *porrón* or *porró* (Catalan) in several paintings of

1906 as a sign of his emotional bond with his homeland. John Richardson has observed that the musical instruments often mistaken for clarinets in Picasso's cubist paintings of 1910–13 are actually *tenores*, traditional Catalan wind instruments used to accompany the sardana, the national folk dance of Catalonia.[17] The appearance of these instruments in Picasso's early cubist paintings seems to indicate a sense of self-identification with Catalan life and culture. Eva Gouel remarked that while traveling through a village in the Pyrenees with Picasso and Max Jacob in 1913, they stopped to participate in the dance, whose importance Picasso later explained to Brassaï while demonstrating its intricate steps: "It's a very serious thing, the *sardane*! . . . This dance is a communion of souls.... It abolishes all distinction of class. Rich and poor, young and old, dance it together: the postman with the bank manager, and the servants hand-in-hand with their masters."[18]

Although aware of developments in the international avant-garde, artists in Barcelona were slow to formulate a coherent, sustained response to Cubism or Fauvism. Instead, late Post-

Impressionism and the classicizing tendencies of Noucentisme remained the ascendant modes of artistic expression until at least 1915. Even Picasso's close friend Manolo, although inspired to reduce forms to rudimentary geometric shapes (fig. 6), never embraced the more radical implications of Cubism, and despite his association with Picasso in Céret, art historians generally place Manolo's sculpture within the sphere of Noucentisme.

Gargallo was perhaps the first Catalan artist to truly embrace the radical implications of Picasso's discoveries. Trained in the Barcelona workshop of Eusebi Arnau, Gargallo assisted with the modernista sculptural decoration of Lluís Domènech i Montaner's Hospital de la Santa Creu i Sant Pau (1906–11) and Palau de la Música Catalana (1908–11). Yet as early as 1907, at the very time he was working on modernista projects, Gargallo began experimenting with archaic, geometric forms in small sculptural masks (fig. 7), works suggesting the early influence of African art and Cubism. The relationship is not accidental. Fernande Olivier observed that whenever Picasso was in Barcelona he would visit Gargallo, who was working from a studio in a basement.[19] With *Woman's Torso,* 1915 (fig. 8), made of sheets of cut-and-soldered copper, Gargallo discovered a path for merging Catalan metalworking traditions with the geometric forms and intersecting solids and voids of Cubism. He first exhibited these metal sculptures at the Galerías Valentí (1915–16) and the Galeries Laietanes (1916) in Barcelona, but they had little immediate impact on his colleagues.

Another largely solitary development in the early history of avant-garde art in Barcelona was Celso Lagar's invention of the cubo-futurist style called Planisme. Born in Ciudad Rodrigo (Salamanca), Lagar studied at the Llotja art academy in Barcelona,

Fig. 7 (cat. 7:5). Pablo Gargallo, *Mask with Lock of Hair,* c. 1911 (enlargement of 1907 version).
Fig. 8 (cat. 7:7). Pablo Gargallo, *Woman's Torso,* 1915.

worked in Paris from 1911 to 1914, and returned to Catalonia in 1915.[20] The exhibition of his planist works at the Galeries Dalmau in 1915 prompted art historian Eliseu Trenc to identify him as the creator of the first avant-garde on the Iberian Peninsula.[21] Whether accurate or not, Planisme remained a mostly singular achievement with little lasting impact, except perhaps for establishing a precedent for Rafael Barradas's invention of Vibracionismo.

### The Flowering of a New European Avant-Garde: 1916–25

A new and remarkably vital avant-garde emerged in Barcelona during the years 1916–17. This momentous turn in the city's cultural history was ignited in part by an influx of foreign artists who came to neutral Spain during World War I to escape the oppressive conditions of life in the belligerent countries. Serge Charchoune, Robert and Sonia Delaunay, Albert Gleizes, and Fr ancis Picabia were among the artists to arrive by 1916. The Galeries Dalmau became the focal point of their activities, and Dalmau organized a series of exhibitions devoted to their art, including a display of Charchoune's "ornamental Cubism" in April–May 1916. Picabia played an especially important role in stimulating avant-garde activity in Barcelona. After participating in a proto-Dadaist movement in New York, he moved to Barcelona in the summer of 1916. Picabia's relentless attack against the stagnant social order and all forms of traditional culture deeply impressed progressive artists in Barcelona, including the young Miró, who recalled meeting Picabia in Barcelona in 1917.[22] Also enhancing awareness of developments abroad was the vast display of modern French art sponsored by the Barcelona city council in April 1917, an exhibition featuring works assembled from three major shows, including the Salon d'Automne, canceled in Paris because of the war.[23] Picasso also returned to Barcelona in June 1917 and spent six months in the city, lending publicity and prestige to the city's growing avant-garde movement. He stayed until November, long enough to

preside over a large celebration thrown in his honor by the city's artists at the Galeries Laietanes (fig. 9) and to see his sets and costumes displayed in a performance of Serge Diaghilev's ballet *Parade* at the Liceu theater.[24]

It was at this point, during the years 1916–17, that a critical mass of artists in Barcelona began embracing avant-garde art with an enthusiasm previously unseen in the city. The painter Rafael Barradas, born in Uruguay, settled in Barcelona in early 1916 and began associating with other members of the city's nascent avant-garde.[25] Influenced by his encounters with Futurism on a trip to Italy and France in 1913–14, Barradas began painting the modern city with fragmented forms and intense colors conveying the kinetic qualities of speed and sound associated with machines, cars, trams, electric lights, and "rushing ideas." This new aesthetic, named Vibracionismo, and discussed in greater depth by Jed Morse in this catalogue, exerted a profound influence on his colleagues Joaquín Torres-García, Joan Salvat-Papasseit, and Miró.[26] In early 1917 Torres-García renounced Noucentisme and joined the avant-garde by declaring himself "an enemy of all forms of tradition."[27] Rejecting universal and timeless values, he now aligned himself through his manifesto *Art Evolució*, published in *Un enemic del Poble*, with individualism, the present, internationalism, and an art of constant change expressing the "plasticity of the times."[28]

Perhaps the new spirit of revolt and defiance expressed itself most directly in the birth of new avant-garde journals. These short-lived reviews offered visual artists, poets, and critical theorists opportunities to collaborate on the merging of experimental texts and images. The poet and art critic Junoy directed the review *Troços* (est. March 1917), which reappeared as *Trossos* in 1918; the final two issues were published under the direction of poet J. V. Foix.[29] The journal *Un enemic del Poble* (An Enemy of the People), subtitled *Fulla de subversió espiritual* (Leaflet of Spiritual Subversion), appeared in 1917 under the direction of Salvat-Papasseit, a pet. Barradas, Gleizes, Lagar,

Fig. 9. Barcelona artists gather to honor Picasso at the Galeries Laietanes, 1917.

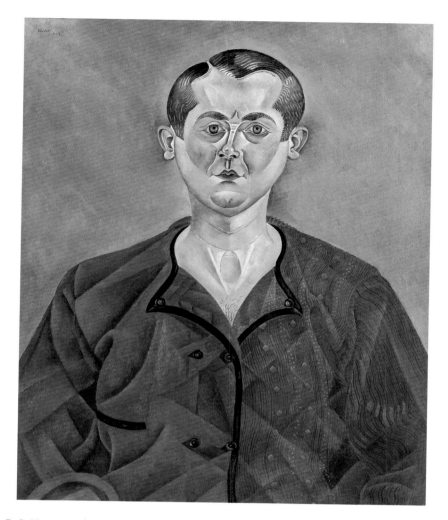

Torres-García, E. C. Ricart, and Miró contributed illustrations to these avant-garde publications. The cover of the first and only issue of *Arc-Voltaic*, published in 1918 under the direction of Salvat-Papasseit, carried an illustration by Miró above the inscription: "Plasticity of the vortex/Forms in emotion and evolution—Vibrationism of ideas—Poems in Hertzian waves." Torres-García and Barradas provided the illustrations for Salvat-Papasseit's first book of poetry, *Poemes en ondes hertzianes* (Poems in Hertzian Waves) of 1919. Brad Epps examines Catalan avant-garde journals and calligrams more fully elsewhere in this catalogue.

The most important and original painter to emerge from this phase of avant-garde activity in Barcelona was Miró (fig. 10). During his early years, Miró came to admire Catalan Romanesque paintings and learned to draw objects by mere touch. He was deeply impressed by the municipal exhibition of 1917 and the fauve and cubist paintings he saw at the Galeries Dalmau. From Picabia and Duchamp,

Miró acquired an iconoclastic desire to destroy the past and "step over all the rotting bodies and fossils."[30] His admiration for Antoni Gaudí reinforced his intuitive rather than theoretical approach to the creative process, as well as his love of primordial nature and Catalan folk art. In 1917 Miró, by then intimately involved with avant-garde activities in the Dalmau circle, expressed a desire to achieve a "vibration of the spirit" and to "emancipate the artist's emotion and give him absolute freedom."[31] In 1918 he joined forces with Ricart, Torres-García, and Josep Llorens i Artigas to form the Agrupació Courbet, a short-lived association of avant-garde artists (1918–19) who exhibited together at the Galeries Laietanes and the Cercle Artístic de Sant Lluc.[32] Josep Dalmau organized Miró's first solo exhibition in February 1918 and helped arrange the artist's first exhibition in Paris in 1921. When Miró made his first trip to Paris in 1920, he stayed in Gargallo's studio and began a lifelong friendship with Picasso. For the next 16 years, Miró divided his time between Paris, Barcelona, and the

Fig. 10 (cat. 7:24). Joan Miró, *Self-Portrait*, 1920.

family farm in Montroig near Tarragona, often beginning paintings in Catalonia and completing them in France. He described his landmark painting *The Farm* (see fig. 6, p. 343), begun in Montroig in 1921 and completed in Paris the following year, as an attempt to rid himself of foreign influences by getting in touch with Catalonia. Although acknowledging that he learned disciplined structure from Cubism, Miró was quick to observe: "Everything I've ever done in Paris was conceived in Montroig."[33] With his breakthrough paintings *The Tilled Field* (Solomon R. Guggenheim Museum, New York) and *The Hunter (Catalan Landscape)* of 1923–24 (see fig. 7, p. 343), Miró entered into a new period of more intuitive, internalized creation expressed through ideographic signs. "I have already managed to break absolutely free of nature," he wrote in September 1923, "and the landscapes have nothing whatever to do with outer reality."[34] Robert S. Lubar's essay on Miró and Dalí in this catalogue looks more closely at these artists during the seminal years of their early engagement with Surrealism.

Unfortunately for the new generation of avant-garde artists, economic and political conditions in Barcelona were not favorable for sustaining the momentum of 1916–17. The re-opening of international markets after World War I sent Barcelona's economy into a downward spiral, and the city entered into a period of social turmoil marked by cycles of labor strikes, lockouts, riots, assassinations, and military repression. Although deeply attached to his homeland, Miró was disappointed by public hostility to his art and his inability to attract significant patrons. The same conditions that had plagued Picasso years

before now prompted others to leave Barcelona, including Picabia in 1917, Barradas in 1918, and Torres-García in 1920. Barradas did return briefly to attend two of his exhibitions, once in the summer of 1920, and again for a more extended stay during 1926–28, when he formed a modernist circle at nearby L'Hospitalet de Llobregat. Picabia also returned temporarily to attend the opening of his solo exhibition at the Galeries Dalmau in November 1922 (fig. 11). André Breton, who wrote the catalogue introduction for the exhibition, arrived the day before to deliver a lecture at the Ateneu Barcelonès.

During these difficult years, avant-garde artists still found exhibition opportunities in Barcelona. In 1918 the city launched its first annual "spring exhibition," and the Associació d'Amics de les Arts (Association of Friends of the Arts) mounted its first annual Saló de Tardor (Autumn Salon) at the Galeries Laietanes. Both venues mixed conservative with avant-garde art, at times featuring works by Barradas, Torres-García, Gargallo, and Picasso. Conditions for the production of avant-garde art became even more unfavorable after General Primo de Rivera overthrew the government by coup d'état in 1923 and installed a military dictatorship that ruled Spain until 1930. The dictatorship not only imposed press censorship, but repressed the use of the Catalan language, abolished the Catalan government (the Mancomunitat), and dissolved its cultural organizations and programs, including the city's annual spring exhibition.[35] In 1924 Gargallo left Barcelona for Paris after signing a petition denouncing the dictatorship, which closed the art school where he taught.[36]

Fig. 11. The opening of the Picabia exhibition at the Galeries Dalmau, 18 November 1922.

Since private galleries remained outside government control, the Galeries Dalmau continued to present an ever-changing program of exhibitions, repeatedly showing works by Miró, Barradas, Torres-García, and Ricart, with occasional appearances by Picabia and Gargallo. Dalmau also continued showing foreign avant-garde art and in 1920 mounted a large exhibition featuring works by Braque, Picasso, Miró, Henri Matisse, Fernand Léger, Jacques Lipchitz, and Gino Severini, among others. In November 1925 Dalmau introduced Barcelona to another emerging artist by opening Salvador Dalí's first solo exhibition, a display featuring the artist's early neo-cubist and classicizing paintings.

### The Dominance of Surrealism and GATCPAC: 1926–36

In 1926, the year a passing street tram struck and killed Antoni Gaudí, a new art form began taking root in Barcelona. Surrealism soon emerged as the leading avant-garde movement in Catalonia, with groups active in Barcelona, Sitges, Cadaqués, Vilafranca del Penedès, and Lleida. The art critic Sebastià Gasch also identified 1926 as a turning point in Catalan art because it marked the founding of *L'Amic de les Arts* (1926–29), a review published in the coastal town of Sitges.[37] For three years *L'Amic de les Arts* served as the most influential Catalan forum for critical discussion of avant-garde art, with a particular focus on Surrealism. *L'Amic de les Arts* published Gasch's article on Max Ernst and Surrealism in 1926, and Lluís Montanyà's article on Surrealism in 1927. Dalí became a regular contributor and presented many of his most important early texts and images in this review, including "Saint Sebastian" (July 1927), *Honey Is Much Sweeter Than Blood* (October 1927), and an appreciative article about Joan Miró (June 1928).[38] *Hèlix* (1929–30), another seminal avant-garde review and advocate for Surrealism, published part of Breton's automatic text "Soluble Fish" in 1929 and Dalí's article "The Moral Position of Surrealism" in 1930. Located in Vilafranca del Penedès, *Hèlix* also featured texts by Luis Buñuel, Foix, Gasch, Ramón Gómez de la Serna, and James Joyce, as well as discussions of music and cinema, including Dalí and Buñuel's film *Un Chien andalou* (*An Andalusian Dog*).

It could be argued that Spain produced the three greatest surrealist painters: Picasso, Miró, and Dalí.[39] Picasso and Miró became involved with the movement nearly from its inception by participating in La Peinture Surréaliste at the Galerie Pierre Colle in Paris (November 1925), the first group exhibition of Surrealist art.[40] Although never a formal member of the movement, Picasso created paintings, collage-constructions, and automatic texts that are often more authentically surrealistic than the pedestrian work of some of the movement's lesser yet "official" artists. Picasso and Miró's early involvement with Surrealism attracted the attention of influential publications and galleries in Barcelona, inspiring a new generation of Catalan artists to embrace its ambition of exploring unconscious thought through dream imagery and the technique of psychic automatism. William Jeffett and Jordana Mendelson discuss Surrealism and related topics in greater depth elsewhere in this catalogue.

During the years 1926–29, Dalí evolved from an obscure painter of neo-cubist and classicizing works into one of the world's leading Surrealists. In 1929, after passing through a phase of experimentation with biomorphic abstraction influenced by Picasso and Miró, Dalí abandoned the "painterly touch" often associated with modernist art for a more impersonal, hyper-realist style of Surrealism inspired by "paranoiac-critical" activity. He also played a crucial role in the Catalan avant-garde as a writer and theorist. His *Manifest groc: Manifest anti-artístic català* (*Yellow Manifesto: Catalan Anti-artistic Manifesto*) of 1928, written with Gasch and Montanyà, violently attacked Noucentisme and the complacency of Catalan society, advocating its replacement by a "revolutionary modernist spirit."[41] Dalí shouted his radical ideas at the public through the megaphone of lectures often filled with insulting and obscene language, including a lecture on Surrealism delivered at the Ateneu Barcelonès in 1930. In 1929 he officially joined the surrealist movement in Paris and collaborated with Buñuel to produce the groundbreaking film *Un Chien andalou*, shown privately that year in Barcelona and Paris, and publicly in both cities in 1930.[42] Dalí's impact was immense, and his presence in Catalonia during the late 1920s and 1930s attracted a steady stream of international Surrealists to Barcelona and Cadaqués.

The Galeries Dalmau promoted Surrealism during this period through a series of exhibitions featuring emerging artists, including Dalí's second and third solo exhibitions in 1926 and 1928, respectively, along with exhibitions devoted to Joan Massanet, Artur Carbonell, and Àngel Planells. Dalmau did not limit himself, however, to promoting any single tendency. In 1926 he organized a large exhibition divided into two sections, one featuring avant-garde works by foreigners, the other works by Catalans, in effect bringing together artists such as Gleizes and Delaunay with Barradas, Torres-García, Dalí, and Miró.[43] In 1929 Dalmau and Torres-García, who was then living in Paris, arranged a large exhibition of abstract art that united works by Catalan artists, such as Carbonell and Planells, with works by prominent foreigners, including Hans (Jean) Arp, Piet Mondrian, Jean Hélion, and Theo van Doesburg.[44] Dalmau also collaborated with Van Doesburg on a plan to publish a new art journal and circulate a series of exchange exhibitions, but both projects collapsed when the Galeries Dalmau closed in 1930. After being appointed director of the art gallery of the Lliberia Catalònia in 1933, Dalmau returned to organizing exhibitions, including displays devoted to Dalí and Man Ray (1933), Dalí and Planells (1934), and a large group exhibition of Catalan modernists (1936). In 1936 Dalmau formed the Associació d'Artistes Independents, which provided annual, jury-free exhibitions for its members.[45]

By the 1920s, Barcelona was increasingly exerting a cultural influence beyond Catalonia. Gargallo, Picasso, and Julio González made significant advances in sculpture while living in Paris, at times actively collaborating and sharing techniques. Gargallo's role in the trio has been overshadowed by the contributions of his colleagues. Trained in Barcelona, Gargallo was familiar with Catalan metalworking traditions and the expressive ironwork visible throughout the city, from the iron tower and roosters on Domènech i Montaner's Cafè-Restaurant, to the remarkable iron balconies of Gaudí's Casa Milà (see fig. 3, p. 204).[46] As previously mentioned, Gargallo produced his first mask from sheets of cut-and-soldered copper in 1907, a work reflecting his early awareness of African art and Picasso's proto-cubist paintings. Gargallo produced experimental sculptures in other metals

as well, including iron masks by 1914 and figures in lead by 1920.

The relationship among González, Gargallo and Picasso dates back to their earlier years. González knew Picasso in Barcelona and apparently met Gargallo in Paris in 1902. When Gargallo returned to Barcelona the following year, González began using Gargallo's Paris studio. González made return visits to Barcelona in 1902, 1909, 1910, and 1911, and the creation of his first mask in 1910 from repoussé copper, a technique shared by Gargallo, suggests a continuing relationship between the artists. When Gargallo returned to Paris in 1924, he resumed his relationship with González and Picasso. It is hardly surprising that González's early iron sculptures— small heads in low relief of 1929 (fig. 12)—are closely related in subject, style, and technique to the masks Gargallo had been producing in various metals since 1907.

The story of González's discovery of oxyacetylene welding at an automobile factory in 1918, and his subsequent teaching of the technique to Picasso, leading to a series of collaborative sculptures during 1928–32, is so well known it need not be discussed in detail here.[47] Still, it bears repeating that these constructions revolutionized sculpture by dematerializing static form and replacing it with open, dynamic volumes in space. Moreover, their experimental iron sculptures are linked to Catalan metalworking traditions, including Gargallo's early figural works, Gaudí and Jujol's architectural ironwork, and even the decorative Catalan ironwork Rusiñol displayed at his home, the Cau Ferrat (Den of Iron) in Sitges, site of the Festes Modernistes of the 1890s. Undoubtedly aware of this collection, Picasso visited the Cau Ferrat during one of his three trips to Barcelona in 1933–34.[48]

While Surrealism emerged as the leading avant-garde tendency in Catalan painting and sculpture of the late 1920s, it was not the only one. By this time, Torres-García had developed a style of geometric abstraction that was well known in Barcelona. Even after moving to New York in 1920 and to Paris in 1926, Torres-García remained an important presence in Barcelona and continued exhibiting there until at least 1934. He also returned briefly in 1926 to attend the opening of his exhibition at the Galeries

Dalmau. Meanwhile, he developed a close relationship with Van Doesberg and Mondrian in Paris, and cofounded Cercle et Carré, an association of leading European abstractionists. As previously mentioned, Torres-García was instrumental in organizing the large 1929 exhibition of "foreign and national" art at the Galeries Dalmau. In 1933 he exhibited a large selection of works at the Cercle Artístic in Barcelona, but his style of geometric abstraction failed to attract many followers, and the following year he left Spain permanently for Uruguay, where he established an avant-garde group centered in Montevideo but connected to others throughout the Americas. His theory of Constructive Universalism influenced a broad spectrum of artists, including several of the future Abstract Expressionists in New York.

During this period Barcelona was the center but not the exclusive site of avant-garde activity in Catalonia. In the early 1930s a colony of foreign and domestic artists began working in the village of Tossa de Mar on the Mediterranean coast north of Barcelona. The foreigners included the painters André Masson and Marc Chagall, the French writer Georges Bataille, and the English printmaker Stanley William Hayter. The Catalans who frequented Tossa,

by contrast, were mostly noucentista artists, including the painter Feliu Elias and the sculptors Josep Clarà, Enric Casanovas, and Apel·les Fenosa. Although most of the foreign artists active in Tossa did not establish strong ties with their counterparts in Barcelona, Masson did enjoy a close relationship with Miró, and Gargallo paid homage to Chagall with a portrait bust exhibited at the Sala Parés in 1934.

In the late 1920s, at a time when Surrealism dominated avant-garde painting and sculpture in Barcelona, a new school of rationalist architecture emerged that made a significant mark in the history of 20th-century design. It is perhaps ironic that the disciplined logic of rationalism came to dominate Catalan architecture at a time when the antirationalism of Surrealism reigned in painting and sculpture. The leaders of this rationalist trend, Josep Lluís Sert and Josep Torres Clavé, were disciples of the Swiss architect Le Corbusier and profoundly influenced by his theories published in the journal *L'Espirit Nouveau*. Sert worked briefly as Le Corbusier's assistant and arranged for him to deliver a lecture in Barcelona in the spring of 1928. In April 1929, Sert and Torres-Clavé joined other students in organizing an exhibition at

Fig. 12 (cat. 7:6). Julio González, *Pensive Face*, 1929.

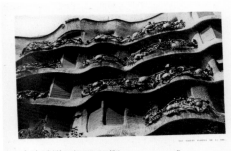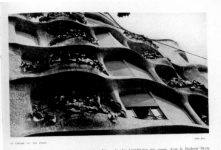

the Galeries Dalmau displaying plans and models of their new, rationalist architecture. In 1930 they formally united by establishing GATCPAC, a collective of architects and engineers that promoted rational, functional design as a means of alleviating social problems through the construction of inexpensive buildings and furnishings for the masses. During its short life, GATCPAC (1930–36) produced designs for apartments to relieve urban overcrowding, hospitals to eliminate epidemic diseases, schools to expand education, a portable house, and vacation facilities for the working class. The organization hoped to liberate society by using standardization to create more efficient and economical structures.[49] In 1932 GATCPAC held an international conference of CIRPAC in Barcelona attended by Le Corbusier and Walter Gropius, among others. Through such activities it established direct ties with the world's leading architects in France, Germany, and the Soviet Union. GATCPAC and rationalist design are examined more fully in section eight of this catalogue.

In 1932 GATCPAC architects joined together with artists, intellectuals, and businessmen to establish ADLAN (Friends of New Art), an organization dedicated to promoting avant-garde art. ADLAN sponsored lectures and exhibitions featuring works by both Catalan and foreign artists, including Arp, Man Ray, and Alexander Calder. The organization's importance to the diffusion of Catalan avant-garde art cannot be understated, and in 1935–36 it established affiliate groups in Madrid, Valencia, Bilbao, and Tenerife.

In January 1936 the association organized a large Picasso exhibition in Barcelona and broadcast the opening ceremonies live over radio, including remarks by Dalí, Miró, and González. Four days later, Paul Eluard delivered a lecture on Picasso at the gallery, followed four days later by a lecture on Surrealism at the Ateneu Enciclopèdic Popular.[50] In May 1936 ADLAN sponsored an event that has been described as the most important Surrealist exhibition in Spain, the Exposició Logicofobista in Barcelona.[51] William Jeffett and Jordana Mendelson examine ADLAN and the Logicofobista (Fear of Logic) exhibition in other essays in this section of the catalogue.

The Exposició Logicofobista was but one indication of Surrealism's ascendant position in the Catalan avant-garde. By the 1930s surrealist satellite groups were active from the Empordà region north of Barcelona, to Sitges south of the city, to Lleida in the western interior.[52] Cristòfol and Lamolla led the Lleida group, which published their own review, Art (1933–34).[53] Catalonia's leading photographers of the period, Pere Català-Pic and Josep Masana, along with Emili Godes and Josep Sala, were strongly influenced by Surrealism, although not strictly members of the movement. More significantly, surrealist activities in Catalonia attracted a steady stream of artists and intellectuals to Barcelona, transforming the region into a breeding ground for new ideas and a place where Catalan Surrealists interacted with a host of artists and writers of the international avant-garde, including Breton, Eluard, Ernst, Man Ray, Duchamp,

Fig. 13 (cat. 7:37). Salvador Dalí (text), Man Ray (photography), detail from "On the Terrifying and Edible Beauty of Architecture in the 'Modern' Style," *Minotaure*, no. 3–4 (12 December 1933).

and René Magritte. Such exchanges led to Man Ray photographing sites in Barcelona, and Dalí using the photographs to illustrate his article concerning the "terrifying and edible beauty" of the city's modernista architecture (fig. 13), published in a 1933 issue of the French journal *Minotaure*.[54]

By 1936 Barcelona had developed into a significant contributor to the international avant-garde. After a delayed start, Catalan artists were making major contributions to Surrealism and rationalist architecture. "For three or four years," Breton remarked, "Dalí will incarnate the Surrealist spirit and make it shine."[55] Breton probably did not realize how profoundly Dalí and Miró, whose styles seemed so antithetical by the 1930s, were equally grounded in the iconoclastic spirit of the Catalan avant-garde, a culture deeply informed by an anarchist spirit of destroying traditional culture and erasing the boundaries between literature and the visual arts.

The outbreak of the Spanish civil war in July 1936 redirected the Catalan avant-garde toward the more immediate concern of defending Catalonia and the freedoms granted under the Second Republic.[56] With a military coup d'état now threatening democracy and fascists assaulting progressive culture, everything was at risk. GATCPAC completed its final projects, the Casa Bloc (1932–36) and the Dispensari Central Antituberculós (1934–38), then merged with the Sindicat d'Arquitectes de Catalunya, and finally dissolved, many of its leaders killed or forced into exile by the war's end. Josep Dalmau organized only a few more exhibitions before his death in September 1937. The Catalan government continued to sponsor annual exhibitions through 1938, but their character became increasingly polemic and devoted to war propaganda. Barcelona's surrender to Franco's nationalist army in January 1939 signaled an end to three decades of intensifying avant-garde activity in Catalonia, a premature death that would go largely unnoticed to outsiders distracted by the gathering world conflict and subsequent Cold War.

1. Avant-garde art emphasizes a violent reputation of the past, radical experimentation, and groundbreaking discoveries. Jaime Brihuega Sierra argues that during the period 1918–25 the center of the avant-garde art activity in Spain shifted from Barcelona to Madrid, a development signaled by the emergence of Ultraism, the School of Vallecas, and the Society of Iberian Artists. Other centers of early avant-garde activity include Bilbao, Valencia, Zaragoza, and Tenerife. See Brihuega in Xavier Barral i Altet, *Art and Architecture of Spain* (Boston: Bulfinch Press, 1998), 448–50.

2. Joan Maragall, *Por el Alma de Cataluña*, vol. 7 of *Obres Completes* (Barcelona: Sala Parés Llibreria, 1930), 144. All translations by the author unless otherwise noted.

3. The relationship between the two cities during this period is examined in *Paris–Barcelone, de Gaudí à Miró*, exh. cat. (Paris: Réunion des Musées Nationaux, 2002). Other major studies of avant-garde art in Barcelona include Marilyn McCully et al., *Homage to Barcelona*, exh. cat. (London: Haywood Gallery, 1986), and Daniel Giralt-Miracle, ed., *Avantguardes a Catalunya: 1906–1939*, exh. cat. (Barcelona: Olimpiada Cultural/Fundació Caixa de Catalunya, 1992).

4. In *Visualizing Spanish Modernity* (Oxford, U.K.: Berg, 2005), Susan Larson and Eva Woods comment, "Contributors to this volume seek to avoid the commonly held assumption that Spain's modernity was radically different from that of the rest of Europe." The present essay does not disagree with this point and proposes only that there are unique features to avant-garde art in Spain, rather than radical differences. See Larson and Woods, *Visualizing Spanish Modernity*, 4.

5. Sala Parés was established in 1840 as an artist's supply store and became an art gallery in 1877.

6. The importance of this gallery—a meeting place for artists that also sponsored lectures and concerts—has been overshadowed by the greater attention given to the Galeries Dalmau. See Juan Antonio Maragall, *Historia de la Sala Parés* (Barcelona: Selecta, 1975). The gallery remains active today and posts a brief history of its activities on its website at www.salapares.com.

7. The city launched these exhibitions, held at the Palau de Belles Arts, in an effort to sustain the momentum of the Universal Exposition of 1888. The original plan was to alternate between the fine and the industrial arts, so that fine art exhibitions would appear every four years. Beginning in 1896, the city combined the fine and industrial arts in a single exhibition.

8. McCully notes that this gallery sponsored the first and second Saló de Tardor (Autumn Salon), held in 1918 and 1920, respectively. See McCully, *Homage to Barcelona*, 52. More conservative artists also formed associations, including the Cercle Artístic de Sant Lluc (est. 1893) and Els Evolucionistes (est. 1918; among its members were Josep Mompou, Joan Rebull, Apel·les Fenosa, and Francesc Domingo).

9. Jaume Vidal i Oliveras examines the history of the Galeries Dalmau in *Josep Dalmau: L'aventura per l'art modern* (Manresa: Fundació Caixa de Manresa, 1988).

10. Duchamp submitted the painting to the Salon des Indépendants in Paris that spring, but it created such controversy that he withdrew it before the opening and sent it instead to Dalmau's L'Exposició d'Art Cubista. In June 1912 the Círculo Artístico in Barcelona opened an exhibition surveying recent trends in modern art that included post-Impressionist and fauvist paintings, but mostly by minor artists: see Joan M. Minguet Batllori and Jaume Vidal i Oliveras, "Critical Chronology (1906–1939)," in *Avantguardes a Catalunya*, 655.

11. Robert S. Lubar examines press coverage and critical reaction to the exhibition in "Cubism, Classicism, and Ideology: The 1912 *Exposició d'Art Cubista* in Barcelona and French Cubist Criticism," in Elizabeth Cowling and Jennifer Mundy, eds., *On Classic Ground: Picasso, Léger, de Chirico, and the New Classicism, 1910–1930*, exh. cat. (London: Tate Gallery, expanded version 1990), 310–23.

12. Horta is not located on the Ebre River, but merely in the vicinity. Picasso called it "Horta de Ebro" (Horta d'Ebre in Catalan) to distinguish it from another town of the same name near Barcelona. Traditionally known simply as Horta or Orta, the town acquired the name Horta de Sant Joan in 1910. Information about the town's history and Picasso's activities there can be found on the internet at www.hortanet.org and www.centrepicasso.cat.

13. Picasso probably painted *The Factory*, known also as *The Factory at Horta de Ebro* and *The Brick Factory at Tortosa*, in the vicinity of Horta rather than Tortosa. He stayed only a few days in Tortosa, a city on the Ebre River, while traveling from Barcelona to Horta, a village where he had lived with Manuel Pallarès during his student years (1898).

14. Anne Baldassari examines the relationship between Picasso's cubist paintings and photographs during the Horta period in *Picasso: Photographe, 1901–1916*, exh. cat. (Paris: Réunion des Musées Nationaux, 1994), 164–95.

15. Picasso stayed in Céret for only a month in 1912, leaving abruptly for Sorgues with Eva Gouel in an effort to avoid the expected arrival of his former mistress Fernande Olivier.

16. Fernande Olivier, *Picasso and His Friends*, trans. Jane Miller (New York: Appleton-Century, 1965; first published in 1933), 93.

17. John Richardson, *A Life of Picasso: 1907–1917* (New York: Random House, 1996), 2:163, 273.

18. These observations are all made in Richardson's biography; ibid., 2:164, 280. Also see Brassaï, *Picasso and Company*, trans. Francis Price (New York: Doubleday & Company, 1966), 238.

19. Olivier, *Picasso and His Friends*, 167.

20. Conflicting accounts are given for Lagar's place of residency during this period. It is known that he exhibited twice in Barcelona in 1915 and stayed at various times in the French Pyrenees (1914), Girona (1915), Blanes (1916), and Barcelona (1915–18), before returning to France in 1918.

21. It could be argued that Planisme was not a truly original style since it largely borrowed elements from Cubism and Futurism; however, the same argument could be applied to many other avant-garde styles. See Elisée Trenc, *Les Avant-Gardes en Catalogne* (Paris: Presses de la Sorbonne Nouvelle, 1995), 97.

22. "Interview with Deny Chevalier" (1962), in *Miró: Selected Writings*, 263.

23. The exhibition featured 1,458 objects from the canceled Salon des Artistes Français, Salon de la Société Nationale des Beaux-Arts, and Salon d'Automne, and included works by Claude Monet, Paul Cézanne, Paul Gauguin, Georges Rouault, and Henri Matisse.

24. Many galleries and institutions identified themselves by both Spanish and Catalan names during this period. For consistency, this catalogue employs only the Catalan version, for instance, Galeries Laietanes rather than Galerías Layetanas, Galeries Dalmau rather than Galerías Dalmau.

25. Barradas left Montevideo for Europe in 1913. After visiting Milan and Paris, he came to Barcelona in 1914, then worked in Zaragoza before returning to Barcelona in February or March of 1916. See Jaime Brihuega et al., *Barradas: Exposició Antològia 1890–1929* (Barcelona: Generalitat de Catalunya, 1993), 305.

26. Barradas exhibited works explicitly called "Vibrationist" at a joint exhibition with Torres-García at the Galeries Dalmau in December 1917.

27. Torres-García, "Conferència a Can Dalmau," in Joaquim Torres-García, *Escrits sobre art*, ed. Francesc Fontbona (Barcelona: Edicions 62, 1980), 182; quoted in Giralt-Miracle, "Paths in the Avant-Garde: A Tour of the Exhibition," in *Avantguardes a Catalunya: 1906–1939*, 71, 628.

28. Joaquín Torres-García, "Art Evolució," *Un enemic del Poble*, no. 8 (November 1917): 1.

29. The first, unnumbered issue of *Troços* is dated 1916. Minguet and Vidal believe this date is false and should be March 1917; see Minguet and Vidal, "Critical Chronology (1906–1939)," 661.

30. Miró also said he met Duchamp in Barcelona in 1917, but there is no record of Duchamp visiting the city that year. See Miró to E. C. Ricart, 11 May 1917, in *Miró: Selected Writings*, 53, 263.

31. Miró to E. C. Ricart, August 1917, in ibid., 51.

32. Francesc Domingo, Rafael Sala, and Josep de Togores also belonged to Agrupació Courbet; their group exhibitions also included works by Picasso, Barradas, Manolo, Sunyer, and Nogués.

33. *Miró: Selected Writings*, 93; see also 207.

34. Ibid., 82.

35. The municipal spring exhibitions were held annually from 1918 to 1923, suspended from 1924 to 1931, and resumed in 1932 under the Second Republic at two separate venues, the conservative Saló de Barcelona and the more progressive Saló de Montjuïc.

36. *Miró: Selected Writings*, 100.

37. Sebastià Gasch, *D'Ací d'Allà*, no. 179 (Winter 1934), unpaginated.

38. Other important contributors to *L'Amic de les Arts* include J. V. Foix, M. A. Cassanyes, Lluís Montanyà, and Sebastià Gasch. The review also featured articles critical of Surrealism and a heated debate in 1927 on whether Dalí was or was not a Surrealist. Dalí also published important early texts in the Madrid review *La Gaceta Literaria*.

39. José Pierre compares French and Spanish contributions to surrealist art and literature in "La contribución española a la revolución surrealista," in *El Surrealismo en España*, exh. cat. (Madrid: Museo Nacional de Reina Sofía, 1995), 45–49.

40. The birth of Surrealism is commonly dated to André Breton's *First Surrealist Manifesto* (1924). It could be argued that Miró independently produced surrealist paintings, such as *The Tilled Field*, as early as 1923–24; however, a surrealist "movement" did not begin to coalesce in France until 1925, and not until at least 1926 in Catalonia.

41. For a translation of the complete *Manifest groc*, see *Collected Writings of Salvador Dalí*, ed. and trans. Haim Finkelstein (Cambridge, U.K.: Cambridge University Press, 1998), 59–63. Dalí met Picasso on his first trip to Paris in 1926, and his first solo exhibition in Paris opened at the Camille Goemans Gallery in November 1929.

42. Jaume Fàbrega reports that Planells attended a private screening of *Un Chien andalou* in Barcelona in 1929; see *Surrealismo en Catalunya, 1924–1936* (Barcelona: Ediciones Polígrafa, 1988), 44. The film premiered to the public at Studio 28 in Paris on 1 October and at Sessions Mirador in Barcelona on 24 October: see Minguet and Vidal, "Critical Chronology (1906–1939)," 685.

43. Minguet and Vidal, "Critical Chronology (1906–1939)," 677. The Sala Parés, now under new ownership, also became more active in promoting new artistic tendencies by launching its first annual Saló de Tardor (Autumn Salon) in 1926, effectively replacing the municipal Saló de Tardor canceled in 1924 under the Primo de Rivera dictatorship. Although Dalí participated in the Sala Parés exhibitions, they were dominated by conservative noucentista artists and often served as a counterpoint to Dalmau's avant-garde exhibitions.

44. Exposición de Arte Moderno Nacional y Extranjero (October–November 1929).

45. During the 1930s the Galeries Syra in Barcelona also sponsored important avant-garde exhibitions featuring works by Carbonell, Planells, Miró, and other Catalan Surrealists. Other avant-garde exhibition venues included the Galeries Laietanes and the Galeria d'Art Catalònia. In 1931 the Sala Parés established an annual Saló d'Independents, featuring large sections devoted to Carbonell and Gargallo.

46. Tomàs Llorens cautions against exaggerating the influence of González's Catalan heritage and early training, since his family was originally from Galicia and produced mostly ornamental objects and jewelry. Still, Catalan metalwork in Barcelona could not have escaped González's attention. See Llorens, "Paris, Barcelona et l'Essor de le sculpture moderne en fer," in *Paris–Barcelone*, 541.

47. See Carmen Giménez, *Picasso and the Age of Iron*, exh. cat. (New York: Guggenheim Museum/Rizzoli, 1993); Margit Rowell, *Julio González: A Retrospective*, exh. cat. (New York: Solomon R. Guggenheim Museum, 1983), and Elizabeth Cowling, *Picasso: Sculptor/Painter*, exh. cat. (London: Tate Gallery, 1994).

48. Picasso visited the Cau Ferrat in August 1933. See Minguet and Vidal, "Critical Chronology (1906–1939)," 701–3.

49. See Josep M. Rovira, ed., *Sert: Complete Work, 1928–1979: Half a Century of Architecture* (Barcelona: Fundació Joan Miró, 2005).

50. Minguet and Vidal, "Critical Chronology (1906–1939)," 705.

51. Lucía García de Carpi, *La pintura surrealista española (1924–1936)* (Madrid: Ediciones ISTMO, 1986), 78.

52. Jaume Fàbrega discusses the Empordà artists in *Surrealismo en Catalunya, 1924–1936* (Barcelona: Ediciones Polígrafa, 1988), 43–46.

53. Not all of the members of the Lleida group were Surrealists. They first organized as the group Studi Art in 1932 and exhibited together that year in Lleida and at the Galeries Laietanes in Barcelona.

54. Dalí's family home was in Cadaqués, but when Gala Éluard became his mistress in 1929 and Dalí's father expelled him from the family home, the couple acquired a house at the nearby fishing village of Portlligat. Salvador Dalí, "De la beauté terrifiante et comestible de l'architecture 'modern' style," *Minotaure*, no. 3–4 (1933), 69–76.

55. André Breton, *Entretiens: 1913–1952* (Paris: Gallimard, 1969), 159 ; taken from a series of radio interviews with Breton from the years 1941–52.

56. Dalí, a notable exception, maintained an ambiguous and contradictory attitude toward the war. Breton accused him of fascist sympathies, and their increasingly strained relationship led to a complete rupture in 1939, with Breton famously dubbing his former colleague "Avida Dollars."

# Gleizes and Picabia at Galeries Dalmau:
# Too Green for Our Teeth

*JORDI FALGÀS*

In 2006 the rent for a small retail business on Portaferrissa is the most expensive of any street in Barcelona.[1] When 95 years ago the antiques dealer Josep Dalmau moved his gallery to 18, carrer de la Portaferrissa, his intention was to occupy a large space at the center of Barcelona's commercial and business district. As Jaume Vidal has explained, after only five years in the business the activities at Galeries Dalmau were quite varied: Dalmau had shown that his was not just another gallery like the others in the neighborhood.[2] He needed a large space where he could exhibit, restore, and sell antiques (his main source of income); have room to show the work of modern Catalan artists; and have enough storage space for the exhibitions he imported from foreign markets. He stayed there until 1923, when he moved the gallery to 62, passeig de Gràcia, in what turned out to be his decline and final years. From 1911 to 1923, though, his activity did nothing but increase, and he became particularly engaged with the latest isms and names of the European avant-garde. In addition to holding many shows of the work of established and upcoming local artists, as well as several foreign avant-garde painters then living in Barcelona, he published avant-garde journals, wrote several articles on modern art, and attempted to promote the Catalan avant-garde on the international scene.[3]

Dalmau may not have been aware of the historical significance and critical response he acquired with his international breakthrough, the 1912 Exposition of Cubist Art. Robert Lubar has shown that "despite mixed reviews, the Barcelona art world immediately recognized the singular importance of the exhibition."[4] It was not only the first group exhibition of Cubism in Spain, but also the second show of Cubism ever to be held outside Paris. So by the time Albert Gleizes and Juliette Roche Gleizes sailed on the *Alfonso XIII* from New York to Barcelona at the end of May 1916, his cubist works had already been exhibited at Dalmau's—and reproduced in the Barcelona press—together with more than 50 paintings, drawings, and sculptures by August Agero, Marcel Duchamp, Juan Gris, Marie Laurencin, Henri Le Fauconnier, Fernand Léger, and Jean Metzinger.[5]

The Gleizes remained in Barcelona eight months, their stay ending with the artist's solo exhibition at Galeries Dalmau, 29 November–12 December, the first cubist show in the city since 1912. In Barcelona they joined a notable colony of exiled artists, scientists, and writers who had fled Paris and other European cities menaced by the Great War—a series of couples and friends including Arthur Cravan and his wife, Renée, who arrived with his brother Otho Lloyd and Olga Sacharoff; Dagmar Mouat; Chana Orloff; Kees van Dongen; Marie Laurencin and her husband, Otto von Wätjen; Hélène Grunhoff and Serge Charchoune; the architect and landscapist Jean-Claude Nicolas Forestier; Riciotto Canudo and Valentine de Saint-Point; Otto Weber; Sonia Delaunay-Terk; and Francis Picabia with his wife, Gabrielle Buffet. Some were close friends, and some avoided the others, but most of them were frequent visitors to and exhibited their works at Galeries Dalmau, which in Pascal Rousseau's words, turned into "the headquarters of this avant-garde swarm in Barcelona."[6]

They all arrived within a period of less than six months, between the end of 1915 and the spring of 1916. In neutral Barcelona they not only found dozens of other émigrés, but a city that was making the most out of its strategic location. During the war years, Barcelona experienced a sudden flow of money and uneven growth that created the perfect environment for both foreign and local nouveaux riches to spend money quickly, enjoy themselves, and forget the horrors of war. The Paral·lel became one of Europe's most lively boulevards, flourishing with theaters, restaurants, music halls, and gambling houses in an unprecedented environment;

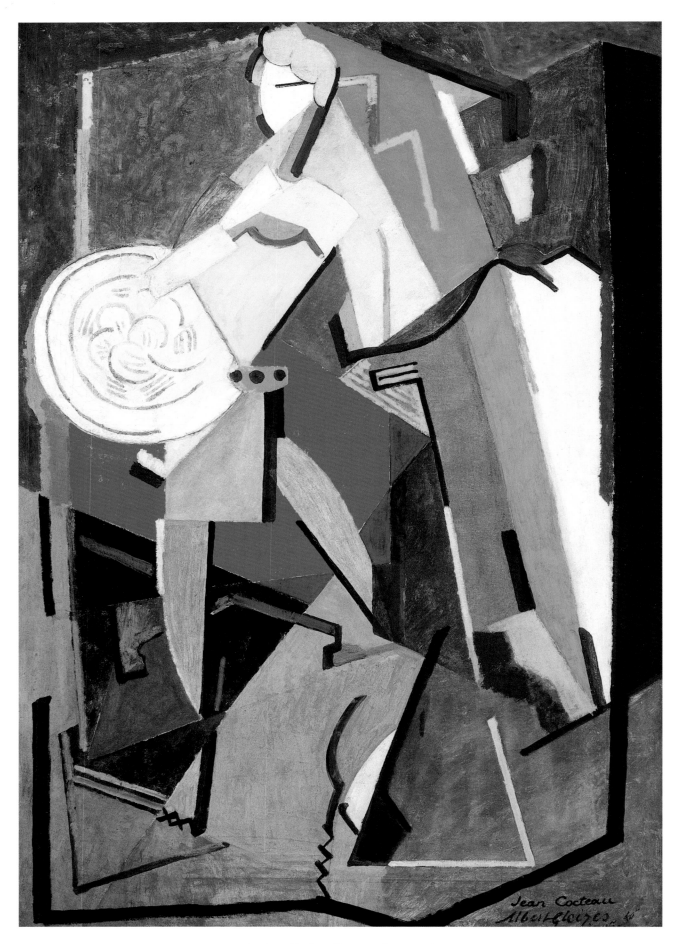

Fig. 1 (cat. 7:8). Albert Gleizes, *Jean Cocteau*, 1916.

the city's red light district—known as the Barri Xino or Chino (Chinatown) though there was no Asian population—attracted large numbers of performers, prostitutes, gamblers, spies, and all sorts of new types either stranded or perfectly afloat.[7] However, as Romero Salvadó has pointed out, "this sudden prosperity only emphasized the weaknesses of the Spanish economy and widened the gap between rich and poor areas."[8] Therefore, conflict was always present, particularly in urban areas, and as the war and inflation progressed so did the labor movement's distress, which often turned into strikes and violence. In 1916, anarchist and socialist unions grew strong all over Spain and especially in Catalonia. For instance, on 18 December 1916 a successful 24-hour nationwide work stoppage took place just two days after the Gleizes left Barcelona. So even if the foreign artists colony in Barcelona seemed to ignore what was taking place around them, daily life was not peaceful.

Gleizes's portrait of Jean Cocteau (fig. 1), number 15 in the Dalmau catalogue, was exhibited along with 30 oils, watercolors, and etchings, including a *Study for Jean Cocteau* (location unknown). One of several for this portrait, the study was the first of a series that goes back to the initial meeting between the painter and the writer during the Easter holidays of 1914.[9] In fact, the meeting involved another portrait of Cocteau, the one that Juliette Roche was working on in her studio when Gleizes paid her an unexpected visit. Gleizes and Cocteau biographers recount how, although the latter had been despising the Cubists and Roche was afraid of what might happen, the two became friends on the spot and Cocteau was soon enlisting Gleizes in different projects.[10] Even though Cocteau was seen as "a man of the right" at the time, the outbreak of the First World War produced a radicalization of aesthetic positions in France, and, according to Jaume Vallcorba Plana, the new atmosphere compelled Cocteau's shift toward the avant-garde ranks, and he decided to make a move "that would take him from being a 'Salon-type' poet to a recognized and important contemporary poet."[11] One of Cocteau's commissions for Gleizes was to design the sets and costumes for a production of *A Midsummer Night's Dream,* which Gleizes gladly accepted and worked on after he was conscripted and sent to the garrison town at Toul, although the production never materialized. According to the painter, some of the characters "were dressed with picturesque evocations of the allied army's military uniforms," and Cocteau loved them.[12] So it is no surprise that one of these figures evolved into a portrait of Cocteau, who, as Vallcorba explains, after being declared unfit for combat and eager to show his patriotism, "liked to stroll around dressed in various military uniforms, as pure fantasy and product of his prolific imagination."[13] Over more than a year, Gleizes produced at least six sketches and studies for this portrait. In the meantime he was discharged, married Juliette, and moved with her to New York in September 1915; after an eight-month stay there the couple moved to Barcelona, where he was finally able to complete Cocteau's portrait in oils.[14]

Just as four years earlier, the response to Gleizes's Cubism from the Barcelona critics was striking. Although the artist was viewed with great respect and efforts were made to interpret his contributions, the dominant conservative taste and ideology among critics prevented them from fully endorsing his art.[15] Despite Gleizes's and Cocteau's efforts to present Cubism—elsewhere and specifically in his portrait—as a symbol of the alliance between French patriotism and avant-garde modernism, Barcelona critics such as Joan Sacs (nom de plume of the painter Feliu Elias, who was an outspoken Francophile) and Joaquim Folch i Torres took the same approach as many in France, where in the context of the war Cubism had become synonymous with, in Vallcorba's words, "the tip of the German iceberg . . . an invasion that had to be rejected with the same energy as on the battleground."[16] In 1912, as Lubar has shown, Catalan critics had interpreted Salon cubist works "through the veil of the Noucentista political and aesthetic ideology," and they were seen "as a necessary classicist reaction in accord with 'the pulse of the times.'" In 1916—in the context of war and confronted with more abstract works—they saw Gleizes's Cubism in opposition to the classicism and "eternal and immutable things" they favored.[17] Another critic, Huisch, also recognized the dichotomy between the northern taste for Cubism and his meridional taste, concluding his review in the pages of *El Poble Català* with these

words: "The works of the Cubists are overly green fruits, [born] of a bitterness too disagreeable for our teeth accustomed to oranges gilded by the sun."[18] In 1916 French and Catalan critics no longer saw, or were afraid to defend, the relationship between Cubism and the French classical tradition. Gleizes could no longer be defined, as Metzinger had done earlier, as the "logical, sensual, human, and Latin, Gleizes."[19] The only exception was Josep M. Junoy, who showed enthusiastic support and published a text called "El Jéan Cocteau d'Albert Gleizes," in which he seems to be fully aware of Gleizes's and Cocteau's intentions: "Here is the poet Jéan Cocteau who wears a dalmatic in French military horizon blue."[20] Dalmau himself

had to come out in defense of Cubism in general and his artist in particular in two articles published in *La Veu de Catalunya* in December.[21] Finally, a short reference to Cocteau's portrait also appeared in the first issue of the magazine *391*, published by Dalmau on 25 January 1917, where Cocteau's friend Picabia quotes an admirer of Gleizes who presumably wanted to know whether the painting "represents an old lady or a vase of flowers."[22] Noting Gleizes's recent departure for New York, Picabia is clearly exposing the lack of comprehension for Cubism among Barcelona's collectors.

Barcelona has entered into the history of Dada, albeit as a "proto-Dadaist" city, thanks to Picabia, who

Fig. 2 (cat. 7:9). Francis Picabia, *Marie Laurencin. Four in Hand*, c. 1916–17.

Fig. 3. Double-page advertisement for the Splitdorf-Apelco Single Unit System, published in *Motor Age* (1 July 1915).

arrived in August 1916 from New York via Algeciras and San Sebastián accompanied by his wife, Buffet.[23] Just like the Gleizeses, their stay was short but productive and deeply involved with Josep Dalmau. Soon after their arrival, Buffet left for Gstaad to look after their children and did not return to Barcelona until November, and then only for another brief period. As Maria Lluïsa Borràs has explained, Picabia's *Marie Laurencin. Four in Hand* (fig. 2) originated in the affair that developed between Picabia and Laurencin in Barcelona during the absences of Picabia's wife and the crisis in both marriages, and thus the painting depicts a love triangle.[24] The portrait is one from a series Picabia had begun a year earlier, on his arrival in New York, and devoted to his group of friends from Alfred Stieglitz's *291* magazine, all done in a new mechanomorphic style, or in Picabia's words, "mechanical symbolism."[25]

Thanks to Gerald Silk and Mariea Caudill Dennison, we know Picabia used a photograph from a 1915 advertisement of a Splitdorf-Apelco electric starter lighting system (fig. 3) as the basis for his portrait of Laurencin.[26] The ad was published in several American magazines related to the car industry, so either the portrait had already been sketched in New York, or Picabia took the ad with him to Barcelona as a possible source for one of his works. The structure

is similar to other engines and mechanical devices that Picabia—like his friend Marcel Duchamp in his *Large Glass*, 1915–23 (Philadelphia Museum of Art)—often employed as an analogy for sexual intercourse. On this occasion, the ventilator has been identified as the volatile and lively Laurencin (who used to carry a fan), connected to the male element below (emphasized by Picabia with the addition of a phallic shaft), which in turn is chained to another wheel, a possible reference to Picabia's wife, to whom the author declares to be "faithful" as Laurencin's dog Coco by inscribing "Le fidèle Coco" on it.[27]

Picabia's extensive use of words and phrases in this portrait and elsewhere have also been deciphered and interpreted.[28] All quotes in this painting come from the central pink pages of *Petit Larousse* devoted to "Locutions Latines and Étrangeres" (Latin and Foreign Locutions).[29] "Four in hand" (meaning a team of horses under harness) is extrapolated to a car's stick shift, a phallic symbol, and is believed to be a reference to Laurencin's multiple relationships during this period. "A l'ombre d'un boche" (in the shadow of a *boche* [slang for German]) comes from the Roman poet Virgil's phrase "sub tegmine fagi" (in the shade of a beech tree) and implies Laurencin's German husband; "Le fidèle Coco" (the faithful Coco), which suggests Laurencin's dog but possibly the art-

Fig. 4 (cat. 7:10). Francis Picabia, *Bride*, cover for *391*, no. 1 (25 January 1917).

ist himself, is also from Virgil, "fidus Achates (the faithful Achates [Aeneas's companion])." Finally, "Il n'est pas donné à tout le monde d'aller à Barcelone" (not everyone can go to Barcelona) is based on a Latin translation of the Greek proverb "Non licet omnibus adire Corinthum" (not everyone can go to Corinth), meaning not everyone can afford the ex-

pensive pleasures to be found in Corinth or in any given place or situation. According to Juan José Lahuerta, the proverb was a specific reference to Corinth's "mythic prostitutes . . . the most expensive ones in the world. . . . Although I don't think Barcelona's prostitutes were the most expensive, they were, in fact, legendary ones, or at least her district was legendary, the Barrio Chino, and that's what Picabia's picture is all about."[30] On the lower right, Picabia wrote "A mi-voix" (in a low voice), probably indicating, as Dennison has noted, an effort to keep the affair quiet and Laurencin's preference for discretion.[31]

Picabia's main effort during his stay in Barcelona was the publication of a new magazine, *391*, with a title and format inspired by Stieglitz's *291*, but this time the concept was solely the result of Picabia and his most purely Dada spirit.[32] Even though in a letter to Stieglitz he claims that the magazine is "better than nothing, because here really, there is nothing, nothing, nothing," in truth Picabia found the perfect publisher in Josep Dalmau, who offered full support, paid the bills, let artists do as they pleased, and asked no questions.[33] Four issues were published in three months (figs. 4–7), between January and March 1917, a frequency Picabia did not maintain when he later published the magazine in

Fig. 5 (cat. 7:11). Francis Picabia, *Comb*, cover for *391*, no. 2 (10 February 1917).
Fig. 6 (cat. 7:12). Francis Picabia, *Flamenco Dancer*, cover for *391*, no. 3 (1 March 1917).
Fig. 7 (cat. 7:13). Francis Picabia, *Wheel*, cover for *391*, no. 4 (25 March 1917).

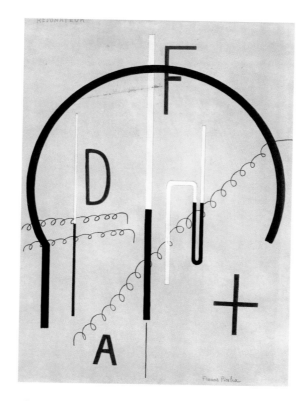

New York, Zurich, and Paris. Galeries Dalmau is listed as the editorial office and Oliva de Vilanova as the printer, the best one in town. Among the foreign artists then living Barcelona, Picabia found a number of contributors to the magazine. Marie Laurencin, Max Goth, Gabrielle Buffett, Olga Sacharoff, and Otho Lloyd provided illustrations and poems, and Max Jacob, Georges Ribemont-Dessaignes, and Guillaume Apollinaire sent contributions from Paris. The magazine was written exclusively in French and conceived entirely for an international audience. As he expressed in his remark to Stieglitz, except for Dalmau, Picabia did not seem to care much for what Catalan writers or artists had to offer.[34] The painter reserved the magazine covers for himself and filled many pages with texts and illustrations. Picabia's drawings and collages are all further examples of his symbolic machinist style incorporating designs for automobile parts and accessories borrowed from magazines and handbooks. Following the pattern of the Laurencin portrait, he also used words and sentences in these works.[35]

*Resonator* (fig. 8) was number 16 in the catalogue of the 47 paintings Picabia exhibited in a solo show at Galeries Dalmau when he returned to Barcelona in 1922. He first visited the dealer in April to discuss the project, and then returned on 8 November for the opening, which took place on 18 November.[36] Along with Picabia came André Breton, who had written the preface for the catalogue and who, on 17 November, offered a lecture at the Ateneu Barcelonès entitled "Caractères de l'evolution moderne et ce qui en participe."[37] *Resonator* is a good example of what Arnauld Pierre has classified as "the last machinist style of Francis Picabia."[38] Pierre has identified Picabia's iconographical sources for many works exhibited in Barcelona, which were mostly derived from illustrations in the French magazine *La Science et la Vie*. For *Resonator* Picabia used details of a cross-section design for a "Résonateur-inflammateur" published in June 1919. Sales and critical response to the 1922 Dalamau exhibition were even worse for Picabia than what Gleizes had experienced six years earlier. The only positive response came in a review by an emergent critic, Magí A. Cassanyes in *La Publicitat*.[39]

So even if the impact of the foreign avant-garde artists who passed through Barcelona during the years of the Great War was neither immediately obvious nor received with great enthusiasm, Barcelona's role—and Dalmau's in particular—was crucial to art and artists he supported. His life and persona were certainly remarkable, and his efforts to promote Catalan and foreign avant-garde art during those

Fig. 8 (cat. 7:14). Francis Picabia, *Resonator*, 1922.

years had no parallel in the city for many decades to come. The great Catalan writer Josep Pla was probably right when he asserted that even though Galeries Dalmau saw "truly sensational types ... the most strange of all in the house is Mr. Dalmau himself."[40] Unfortunately, despite the undeniable function he played and the recognition he has received posthumously, Dalmau always had to swim against the elements (clients, critics, audience, economy, and politics) and bankruptcy forced him to close the gallery in 1930. Luckily, and thanks in part to his unconditional support, some of those sensational types have entered into the history of modern art.

1. Lluís Pellicer, "Los alquileres de las tiendas se disparan en Portaferrissa y la Rambla de Catalunya," *El País*, http://www.elpais.es/diario/autonomias/catalunya.html?d_date=20060215, 15 February 2006.

2. See Jaume Vidal i Oliveras, *Josep Dalmau: l'aventura per l'art modern* (Manresa: Angle/Fundació Caixa de Manresa, 1993); later enlarged in Vidal, "Josep Dalmau i Rafel: Pintor, restaurador i promotor d'art" (Ph.D. diss., Universitat de Barcelona, 1998).

3. Besides Vidal's exhaustive research (see previous note); see also Christopher Green, "The Foreign Avant Garde in Barcelona, 1912–1922," and Alícia Suàrez, "Avant-garde painting in Barcelona, 1912–1930," in *Homage to Barcelona: The City and Its Art, 1888–1936*, ed. Michael Raeburn, exh. cat. (London: Arts Council of Great Britain, 1985), 183–209; as well as *Avantguardes a Catalunya 1906–1939*, ed. Daniel Giralt-Miracle, exh. cat. (Barcelona: Olímpiada Cultural/Fundació Caixa de Catalunya, 1992), 150–99, 653–70; Pascal Rousseau, "La Galería Dalmau," and Maria Lluïsa Borràs, "Crónica de un exilio," in *Paris Barcelona, 1888–1937*, ed. Brigitte Léal and Maria Teresa Ocaña, exh. cat. (Paris/Barcelona: Réunion des Musées Nationaux/Museu Picasso, 2002), 327–63.

4. Robert S. Lubar, "Cubism, Classicism, and Ideology: The 1912 Exposició d'Art Cubista in Barcelona and French Cubist Criticism," in *On Classic Ground: Picasso, Léger, de Chirico and the New Classicism 1910–1930*, ed. Elizabeth Cowling and Jennifer Mundy, exh. cat. (London: Tate Gallery, 1990), 309–23.

5. See Mercè Vidal, *1912: L'exposició d'art cubista a les Galeries Dalmau* (Barcelona: Universitat de Barcelona, 1996). Vidal's book not only includes a thorough analysis of the exhibition, its catalogue, and its protagonists, it also includes a compilation of all the articles and reviews published in the Barcelona press relevant to the exhibition.

6. Pascal Rousseau, "'L'âge des synthèses': L'oeuvre d'Albert Gleizes à Barcelone (1912–1916)," in *Albert Gleizes: Le cubisme en majesté*, ed. Maria Teresa Ocaña and Vincent Pomarède, exh. cat. (Paris: Réunion des Musées Nationaux, 2001), 166. All translations in this essay are by the author, unless noted otherwise. See also Michel Sanouillet, "'391' à Barcelone," in Sanouillet, *391* (Paris: Éric Losfeld, 1966), 2:41–45; Borràs, *Picabia*, trans. Kenneth Lyons (New York: Rizzoli, 1985), 172–74; and also her "Crónica de un exilio," in *Paris Barcelona, 1888–1937*, 350–54. For the Delaunays, in particular, see Rousseau, "'El arte nuevo nos sonríe': Robert y Sonia Delaunay en Iberia (1914–1921)," in *Robert y Sonia Delaunay*, exh. cat. (Barcelona: Carroggio/Institut de Cultura/Museu Picasso, 2000), 51–57.

7. See Lluïsa Suàrez, "El Paral·lel al començament del segle XX," *L'Avenç*, no. 269 (May 2002): 54–58; and Jordi Pujol Baulenas, *Jazz en Barcelona, 1920–1965* (Barcelona: Almendra Music, 2005), 13–17.

8. Francisco J. Romero Salvadó, *Twentieth-Century Spain: Politics and Society in Spain, 1898–1998* (New York: St. Martin's Press, 1999), 31.

9. See cats. 595–600 in Anne Varichon, ed., *Albert Gleizes: catalogue raisonné* (Paris: Somogy/Fondation Albert Gleizes, 1998), 1:208–9.

10. See Peter Brooke, *Albert Gleizes: For and Against the Twentieth Century* (New Haven/London: Yale University Press, 2001), 43–44.

11. Cocteau's description is by Misia Godebska-Sert, from Juliette Roche Gleizes's *Mémoires*, quoted by Pierre Alibert, *Gleizes: Biographie* (Paris: Galerie Michèle Heyraud, 1990), 64. Jaume Vallcorba Plana, "Albert Gleizes: *Portrait de Jean Cocteau*, 1916," in Eugenio Carmona et al., *El Cubismo y sus entornos en las colecciones de Telefónica* (Madrid: Fundación Telefónica, 2004), 318. For a further study on the role played by Cocteau in the artistic development of this period, see Kenneth E. Silver, *Esprit de corps: The Art of the Parisian Avant-Garde and the First World War, 1914–1925* (Princeton: Princeton University Press, 1989), 43–58.

12. Gleizes, *Souvenirs*, quoted by Varichon, *Albert Gleizes: catalogue raisonné*, 1:182.

13. Vallcorba, "Albert Gleizes: *Portrait de Jean Cocteau*, 1916," 318. The now-lost *Study for Jean Cocteau* is also known as *Jean Cocteau (Model for "A Midsummer Night's Dream")*, see Varichon, *Albert Gleizes: catalogue raisonné*, 208.

14. The canvas is titled, signed, and dated, lower right: "Jean Cocteau/Albert Gleizes 16/Barcelone."

15. For an insightful overview of art criticism in the Barcelona periodicals during World War I, see Pascal Rousseau, "Les revues d'art catalanes pendant la première guerre mondiale," *La Revue des revues*, no. 20 (1995): 19–41.

16. Vallcorba, "Albert Gleizes: *Portrait de Jean Cocteau*, 1916," 318. The same conclusion is found in Vidal, *Josep Dalmau*, 151–52, 270.

17. Lubar, "Cubism, Classicism, and Ideology," 318; and Folch i Torres, quoted by Vidal, *Josep Dalmau*, 270.

18. Huisch, "A Can Dalmau," *El Poble Català*, 7 December 1916, 2.

19. Metzinger's text is published in full in Guillaume Apollinaire, *Les peintres cubistes: Méditations esthétiques*, ed. Leroy C. Breunig and Claude Chevalier (Paris: Hermann, 1980), 194–97; quoted by Lubar, "Cubism, Classicism, and Ideology," 313.

20. Quoted by Vallcorba, "Albert Gleizes: *Portrait de Jean Cocteau*, 1916," 319. Junoy first published "Visites-Indicacions. El Jean Cocteau d'Albert Gleizes. En l'exposició d'aquest artista a les Galeries Dalmau," in *La Veu de Catalunya*, 4 December 1916, and later reprinted it in issue no. 0 of his magazine *Troços*, dated 1916 but in fact published in March 1917. In return, Junoy received one of the studies for the portrait, dedicated by the painter, which he reproduced in *Troços*, no. 2 (1 October 1917): 5.

21. See Vidal, *Josep Dalmau*, 148–51, 168–70.

22. Francis Picabia, "Odeurs de partout," *391*, no. 1 (25 January 1917): 4; reprinted in Picabia, *Écrits*, ed. Olivier Revault d'Allonnes (Paris: Pierre Belfond, 1975), 1:30.

23. Julie Béret, "Barcelone," in *Dada*, ed. Laurent Le Bon, exh. cat. (Paris: Éditions du Centre Pompidou, 2005), 142. See also, Véronique Richard de la Fuente, *Dada à Barcelone, 1914–1918: chronique de l'avant-garde artistique parisienne en exil en Catalogne pendant la grande guerre: Francis Picabia, Manolo Hugué, Serge Charchoune, Marie Laurencin, Olga Sacharoff, Franck Burty, Chana Orloff, Albert Gleizes, Kees Van Dongen, Arthur Cravan, Otto Lloyd, Pau Gargallo, S. et R. Delaunay* (Céret: Albères, 2001).

24. Borràs, *Picabia*, 173–75.

25. "French Artists Spur on an American Art," *New York Tribune*, 24 October 1915, IV:2; quoted by William A. Camfield, "Diseños maquinomórficos y Dadá, 1915–1921," in *Francis Picabia, Máquinas y españolas*, exh. cat. (Valencia/Barcelona: IVAM Centre Julio González/ Fundació Antoni Tàpies, 1995), 24. See also Camfield, "The Machinist Style of Francis Picabia," *Art Bulletin* 48 (1966): 309–22; and Didier Ottinger, "D'une mariée à l'autre: Duchamp et Picabia en foottit et chocolat," in *Francis Picabia: Singulier idéal*, exh. cat. (Paris: Musée d'Art Moderne de la Ville de Paris, 2002), 101–3.

26. Gerald Douglas Silk, "The Image of the Automobile in Modern Art" (Ph.D. diss., University of Virginia, 1976), 98, 280; quoted by Mariea Caudill Dennison, "Automobile Parts and Accessories in Picabia's Machinist Works of 1915–17," *Burlington Magazine* 143 (2001): 279, and Ottinger, "Portrait de Marie Laurencin, Four in Hand," in *Francis Picabia dans les collections du Centre Pompidou, Musée national d'art moderne*, ed. Ottinger (Paris: Centre Pompidou, 2003), 41.

27. Different interpretations exist, see Camfield, "Diseños maquinomórficos y Dadá," 26; and Dennison, "Automobile Parts and Accessories," 279. For Picabia's use of mechanical devices as symbols of human eroticism and sexuality, see also Arnauld Pierre, *Francis Picabia: La peinture sans aura* (Paris: Gallimard, 2002), 125–61; and William Rozaitis, "The Joke at the Heart of Things: Francis Picabia's Machine Drawings and the Little Magazine 291," *American Art* 8, no. 3–4 (1994): 42–59.

28. See "Locutions latines et étrangeres extraites du Petit Larousse," in *Francis Picabia*, ed. Jean-Hubert Martin and Hélène Seckel, exh. cat. (Paris: Centre National d'Art et de Culture Georges Pompidou/Musée National d'Art Moderne, 1976), 47–49; Borràs, *Picabia*, 180; Dennison, "Automobile Parts and Accessories," 279; and Ottinger, "Portrait de Marie Laurencin," 42.

29. Claude Augé, ed., *Petit Larousse Illustré* (Paris: Librairie Larousse, 1908), 1067–698.

30. Juan José Lahuerta, *Destrucción de Barcelona* (Barcelona: Mudito & Co., 2004), 5.

31. Dennison, "Automobile Parts and Accessories," 280, interprets the "silent" leather-link belt as an indication of discretion.

32. All monographs devoted to Picabia deal with *391*, but the most complete study, which includes a facsimile of the magazine, is by Michel Sanouillet, *391* (Paris: Le Terrain vague, 1960). A second volume with commentary and other critical material was published in 1966, see note 6.

33. Letter from Picabia to Stieglitz, Alfred Stieglitz/Georgia O'Keeffe Archive, Yale Collection of American Literature, Beinecke Rare Book and Manuscript Library, Yale University; quoted by Sanouillet, *391*, 2:46. Issues 1–4 of *391* were published in Barcelona through the Galeries Dalmau, issues 5–7 in New York, number 8 in Zurich, and numbers 9–19 in Paris.

34. See Rafael Santos Torroella, "Francis Picabia i Barcelona," in *Francis Picabia (1879–1953): Exposició Antològica*, exh. cat. (Barcelona: Ministerio de Cultura, Fundació Caixa de Pensions, 1985), 54–55.

35. For a detailed study of each page see Sanouillet, *391*, 2:48–64; and further iconographical sources for Picabia's images are provided by Dennison, "Automobile Parts and Accessories," 280–83.

36. The 1922 exhibition was the subject of a commemorative exhibition in 1995–96, presented at the Fundació Tàpies, Barcelona, and the IVAM Centre Julio González, Valencia, as part of the exhibition *Francis Picabia: Máquinas y españolas;* and at the Galerie d'Art Graphique du Musée National d'Art Moderne–Centre de Creation Industrielle, Paris. See *Francis Picabia: galerie Dalmau, 1922*, exh. cat. (Paris: Éditions du Centre Pompidou, 1996). The Dalmau catalogue listed 47 works, but Jean-Jacques Lebel believes Picabia possibly added a few more before the opening. See Lebel, "Picabia, 1922, *ready-made empêché*," in *Francis Picabia: galerie Dalmau, 1922*, 26–27 n. 12.

37. André Breton, *Oeuvres completes*, ed. Margueritte Bonnet (Paris: Gallimard, 1988), 1:290–308.

38. Arnauld Pierre, "Le dernier style machiniste de Francis Picabia: nouvelles sources," in *Francis Picabia: galerie Dalmau, 1922*, 34–41.

39. Breton later published a French translation in *Littérature*, no. 9 (February–March 1923): 22.

40. Josep Pla, *Obra completa* (Barcelona: Destino, 1982), 1:657.

# The Avant-Garde Visual Poetry of Junoy
# and Salvat-Papasseit

Josep Maria Junoy and Joan Salvat-Papasseit, along with Joaquim Folguera and J. V. Foix, introduced avant-garde visual poetry to Catalonia at a time when the modern Mediterraneanism championed by philosophical critic Eugeni d'Ors under the name of Noucentisme dominated the cultural and political landscape. Junoy and Salvat drew on the spatial acrobatics of Cubism and the mechanistic dynamism of Futurism (Junoy more on Cubism, Salvat more on Futurism), but they did so within a preponderantly noucentista framework that, bound as it was to a Catalan project of linguistic and cultural normalization, tended to curb the more daring attitudes and acts of the avant-garde in Italy, France, and elsewhere. (Junoy detested the nihilism of Dada.) Then again, many members of the Catalan bourgeoisie had already curbed what they saw as the bohemian excess, extravagance, and anarchy of Modernisme, channeling its initial contestatory energy into something more decorative than revolutionary and enlisting it in the service of a loose project of national regeneration under their direction. If the Noucentistes took up, tightened, and institutionalized this regenerative project, Junoy, Salvat, and other experimenters largely accommodated themselves to it; both Junoy and Salvat had productive relations not only with Ors but also with Joaquim Sunyer, a devoted noucentista artist on whose painting Junoy wrote an essay (1925) and to whom Salvat dedicated his second book of poetry, *L'irradiador del port i les gavines* (The Port Light and the Seagulls) (1921). Although such avant-garde artists as Francis Picabia went to Barcelona during World War I, and although Josep Dalmau established a vibrant gallery for the new art, the Catalan capital could not replicate the inventive climate of Paris.

The relative timidity of the Catalan avant-garde was not a matter of individual talent or personal politics alone. As many have noted, it was one thing to impugn the culture of an established nation-state, but it was another thing entirely to impugn a stateless culture whose very claims to national legitimacy were, and continue to be, in dispute. Indeed, it would not be until 1928, with the publication of the *Manifest groc* (Yellow Manifesto) by Salvador Dalí, Sebastià Gasch, and Lluís Montanyà, that Catalan culture would be most memorably denounced from within. By that time, however, Noucentisme had long been in crisis, probably beginning as early as 1918 and certainly since 1923, when the coup d'état by Miguel Primo de Rivera attempted to suppress all modes of Catalanism—modernista, noucentista, avant-garde, or otherwise—and when Ors moved to Madrid and all but abandoned Catalan and Catalonia. However partial Junoy's and Salvat's relationship to the avant-garde might have been, neither man simply supported the status quo. Jaume Vallcorba, Junoy's most important critic, maintains that Junoy struggled against the current of "good society," and virtually all critics see Salvat's poetry as an affirmation of life, love, and freedom in the face of misery, injustice, disease, and death.

Despite their common interest in visual poetry, the origins and ends of Salvat and Junoy were quite different. Junoy was a man of wealth and privilege who drew satirical caricatures before moving to contemporary art criticism and his own poetic production; Salvat-Papasseit was a man of the working class who held several jobs, including night watchman at the port of Barcelona, before managing the book department of the Galeries Laietanes in 1919. The position, which Salvat obtained in part thanks to Ors, brought him into contact with many Catalan intellectuals as well as with the latest literary innovations from France and Italy. Death from tuberculosis truncated Salvat's career, while aesthetic and political changes—including the Spanish civil war—brought an end to Junoy's. In the plays of Catalan literary history, Salvat's life looms large, while neither Junoy's life nor work has commanded much

sustained attention—his brilliant calligrammatic homage to Georges Guynemer, a young French pilot killed in World War I, notwithstanding.

Yet, Junoy played a fundamental role in the reception, interpretation, and promotion of modern art in Catalonia, publishing a study, *Arte & artistas,* in 1912. His turn to poetry was more intellectual than sensual or sentimental and limited to a short-lived review titled *Troços* (Pieces) (1917) (Foix directed the last two numbers under the name of *Trossos,* in keeping with the new linguistic norms); the books *Poemes i cal·ligrames* (Poems and Calligrams) (1920), *Amour et paysage* (Love and Landscape) (1920), and *Fi de paisatge* (End of Landscape) (1935); a variety of haikus, and other miscellaneous pieces. Junoy was an avid rewriter and published various versions of many of his poems, often moving between Catalan, French, and Spanish. A fervent admirer of Guillaume Apollinaire, who revived the calligrammatic form at a time when advances in audiovisual technology threw the very status of the book into question (and who praised the "poetic plasticity" of a French version of Junoy's ode to Guynemer), Junoy sounded out the ties and tensions between verbal and visual signs. If Cubism shattered the one-point perspective that had been essential to illusionistic representation and incorporated printed material (newspaper clippings, letters) into the space of the canvas, avant-garde visual poetry broke the syntactical linearity—left to right and top to bottom—that had undergirded conventional linguistic signification. The breakage of syntax; elimination of punctuation; variations in typography, margins, and spacing; incorporation of music and advertising; juxtaposition of fragments; and other verbal-visual games in which Junoy engaged did not spell chaos but, rather, as the poet contended, a new, multifaceted manifestation of harmony and rationality.

The composition dominated by the word "Deltoïdes" is a case in point (fig. 1). Dedicated to the Russian dancer Nijinsky, who performed in Barcelona

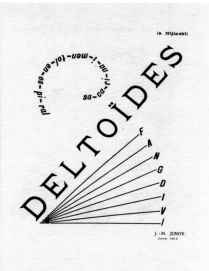

in 1917, the poem, which appeared in *Troços,* consists of eight words in three geometric shapes—a spiral, a triangle or fan, and a diagonal—that suggest, as Willard Bohn has argued, a pirouette, a muscular arching, and a great leap. The pirouette is formed by the words "sacarina i mentol en espiral" (saccharine and menthol in spiral) and refers to the futurist passion for spirals and other figures of energy as well as to the artificial intensification of sugar and mint (the modernization of the natural). The fan of the dancer's back, the muscles that allow for graceful flights that seem to defy gravity, is formed by the words "fang diví" (divine mud), in capitals like "deltoïdes," and suggests a celestial radiation from earthly matter that harks back to the story of Genesis. The fan thus reinforces the central, most typographically imposing of the words: the boldfaced diagonal "deltoïdes," whose upward thrust reinforces, in turn, the sense of transcendence implicit in "divine mud." The distribution of the words does not follow established syntactical logic (the poem may be "entered" in a number of ways), but the distribution of the letters is also intriguing: only "deltoïdes" is presented without a break, while the letters of "fang diví" are marked by a line from the middle of each letter to the triangular base and the letters of "sacarina i mentol en espiral" are at once separated and connected by a series of hyphens. The hyphens bring to the fore the syllabic rhythm of the words and the corporeal rhythm of the dancer, but they are also a symbol that Filippo Tommaso Marinetti, the principal theoretician of Futurism, celebrated as fitting the hurried condensation of modern meaning and that Joaquín Torres-García, a noucentista painter who turned to the avant-garde, incorporated into his very name—a gesture that apparently prompted Salvat-Papasseit to do the same.

If Junoy took an aestheticizing path distanced from progressive politics, Salvat was, at least in his first works, more openly political and more consciously avant-garde. Although today Salvat is re-

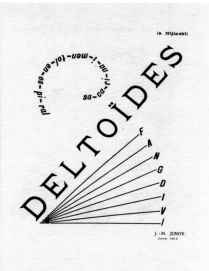

Fig. 1 (cat. 7:15). Josep M. Junoy, *Deltoïdes (a Nijinski),* poem-illustration in *Troços,* no. 1 (September 1917).

quired reading in Catalonian schools, for many years he was a marginal figure. As the critic Enric Bou has remarked, Salvat's restive marginality acquired mythic proportions under Franco, in keeping with his romantically colored status as a consumptive, working-class Catalan poet with anarchist leanings. Baptized during a time of bloody conflict between anarchists and the bourgeoisie, Salvat construed himself as an "arson of adolescent words." For a short time he was affiliated with the Socialist Youth movement and wrote for a review called *Los Miserables* before his first lengthy publication, *Humo de fábrica* (Factory Smoke) (1918), which was written in Spanish under the pseudonym "El Gorkiano" in recognition of Maxim Gorky. Aware of the power of the press, he founded three short-lived reviews, the most important being *Un enemic del Poble* (An Enemy of the People), subtitled *Fulla de subversió espiritual* (Leaflet of Spiritual Subversion), which ran from 1917—the year of the Russian revolution, as Salvat remarked—to 1919. The title of the review derived from Henrik Ibsen's play and conveyed a contrariness that was nonetheless belied by Salvat's interest in popular song and poetry. Salvat was also indebted to modernist poet Joan Maragall's vitalist sense of spontaneity and sincerity and to Marinetti's aggressively programmatic call to liberate words and abolish adjectives, adverbs, punctuation, and the "I" itself.

The mixture of regenerationism and radicalism, the natural and the mechanical, has led critics to stress Salvat's duality. Joaquim Molas, for instance, presents Salvat's work as "sure and stammering," grounded in tradition yet aspiring to something new. Said aspiration generated a series of manifestos—a genre that became an avant-garde tradition—in which the poet's I, in contradistinction to Marinetti's dictum, held sway: "Sóc jo, que parlo als joves" (It is I, Who Speaks to the Young, 1919), "Concepte del poeta" (Concept of the Poet, 1919), and "Contra els poetes amb minúscula: Primer manifest futurista català"

(Against Lower Case Poets: First Catalan Futurist Manifesto, 1920). Salvat may have written the first Catalan futurist manifesto, but he was not the first to articulate Futurism in Catalan. That honor goes to the Majorcan Gabriel Alomar, whose speech "El futurisme" at the Ateneu Barcelonès in 1904 expressed a progressive modernity that has been overshadowed by Marinetti's later, fascistic rendition. Salvat's first poem is itself a veritable manifesto. Titled "Columna vertebral: sageta de foc" (Backbone: Arrow of Fire), it appeared in *Un enemic del Poble* in December 1917 (fig. 2) and, as Molas notes, may have drawn on Thomas Carlyle's depiction of the poet as a pillar of fire and/or on Alomar's *La columna de foc* (The Column of Fire). The arrow is bolstered by the disposition of the words "victoria" and "joventut" (youth), whose uppercase form connects them to "lluita" (struggle) and "voluntat" (will). Nietzschean in tone, the poem presents experience, morality, systems of governance, philosophy, and religion as sophisms, and ends with the exclamation: "always ahead!!"

Salvat included "Columna vertebral" in his first book of poetry, *Poemes en ondes hertzianes* (Poems in Hertzian Waves, 1919), with drawings by Torres-García and Rafael Barradas. The title alludes to the vibrations (Vibracionismo was an avant-garde modality espoused by Barradas) of the radio or electromagnetic waves named after their discoverer, H. R. Hertz, but perhaps also to Apollinaire's *Calligrammes* (1918), whose first section is called "Ondes." Salvat called his "calligrams of the social life of our city," a claim given appreciable form in "Plànol" (Map) and in a welter of references to trams, electric lights, and other urban objects. The autobiographically resonant "Drama en el port" informs his following book, *L'irradiador del port i les gavines*, which makes its avant-garde intentions explicit in its subtitle, but which tempers the avant-garde artificiality of the light with the romantic naturalness of the gull. The cover (fig. 3) resembles a collage, with the great inventor's name

Fig. 2 (cat. 7:17). Joan Salvat-Papasseit, *Columna vertebral: sageta de foc,* poem on front page of *Un enemic del Poble: fulla de subversió espiritual,* no. 9 (December 1917).

at the bottom, misspelled as "Edisson" in white dots or light bulbs against a black gramophone; the act of sexual communion at right, "connubi," with the "o" crossed or penetrated by the remaining letters (erected, as Jaume Aulet contends, at 12 o'clock high); and a star with an open triangular tail. All three elements refer to poems inside: the star to "Els tres reis de l'orient" (The Three Kings of Orient) and "Edisson" and "connubi" to "Marxa Nupcial" (Marriage March), arguably Salvat's most intricate calligram. Although Salvat gradually distanced himself from the avant-garde, he did scatter a few calligrams in his later books, *Les Conspiracions* (Conspiracies, 1922), *La gesta dels estels* (The Epic of the Stars, 1922), *El poema de la rosa als llavis* (The Poem of the Rose at the Lips, 1923),

with a composition in red and another in blue, and *Óssa menor* (Ursa Minor, published posthumously in 1925), the last poem of which is a calligram containing a string of "o"s tied to "the terror of letting go": testimony, in extremis, to Salvat's appreciation of writing and reading as a visual act and art.[1]

1. For further information on this subject, see Willard Bohn, *The Aesthetics of Visual Poetry: 1914–1928* (New York/Cambridge, U.K.: Cambridge University Press, 1986); Josep Maria Junoy, *Obra poètica,* ed. Jaume Vallcorba Plana (Barcelona: Quaderns Crema, 1984); Joan Salvat-Papasseit, *Antologia de poemes,* ed. Enric Bou (Barcelona: Ariel, 1992); Salvat-Papasseit, *L'irradiador del port i les gavines,* ed. Jaume Aulet (Barcelona: Edicions 62, 2005); Salvat-Papasseit, *Poesies,* ed. Joaquim Molas (Barcelona: Ariel, 1978).

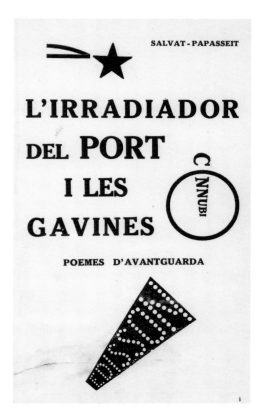

Fig. 3 (cat. 7:18). Joan Salvat-Papasseit, *L'irradiador del port i les gavines (The Port Light and the Seagulls)* (1921).

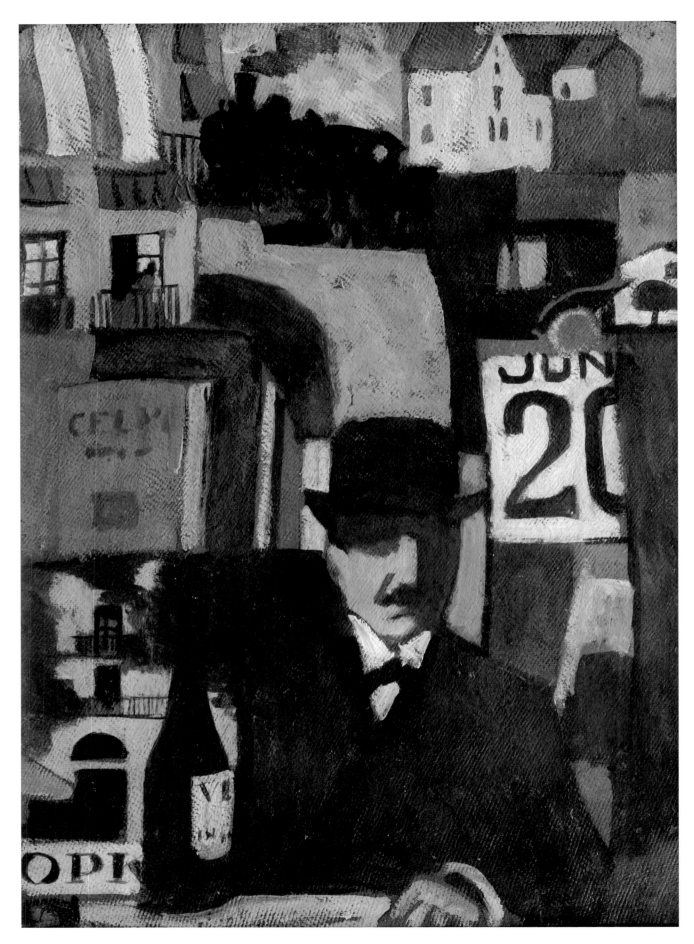

Fig. 1 (cat. 7:18). Joaquín Torres-García, *Figure with Landscape of the City*, 1917.

# Art-Evolució and Vibracionismo: Torres-García,
# Barradas, and an Art of Higher Consciousness

*J E D   M O R S E*

The 22nd day of February of the year 1917. Twentieth century. Two steps from here, a street.
A swarm of people cross one another in opposite directions and will lose themselves in a thousand streets
that connect with another thousand and a thousand more. And on each street, thousands of houses,
thousands of holes, housing those thousands of individuals. Our city. Our city with its moon and its sun.
With its trees, and its avenues, and its fountains, and its monuments. With its port. . . .
We are only beginning to discover it. How beautiful it is!
—Joaquín Torres-García, *Gènesi de l'obra artística*

By exhorting the untapped inspiration of the city, Joaquín Torres-García began a speech at the Galeries Dalmau that would signal a break from his past as one of the most prominent purveyors of Noucentisme, the conservative cultural project of the Catalan Nationalist movement (see fig. 1, p. 250).[1] At the time, Barcelona was a burgeoning center of avant-garde art and temporary home to many expatriate artists seeking refuge from World War I. The Galeries Dalmau, the epicenter of this vibrant artistic community, hosted exhibitions of several members of the Parisian avant-garde, including Robert and Sonia Delaunay and Albert Gleizes, and helped Francis Picabia publish the first four issues of his avant-garde art and literature magazine, *391*. By 1916, when Torres-García's plans for the final fresco in the Saló de Sant Jordi met resistance from his patrons in the government, he already had begun to re-evaluate his theoretical and aesthetic bases. In 1917, in articles, lectures, and particularly in his book *El descubrimiento de sí mismo,* Torres-García began to advocate a process of self-discovery that stressed artistic freedom, intuition, and experience in the present.[2] It was during this period of re-examination that he met Rafael Barradas.[3] The young Uruguayan had recently arrived in Barcelona brimming with the new ideas he had absorbed through his travels to Milan and Paris in 1913–14. Barradas's work reflected his excitement about his recent contact with Futurism and Cubism; Torres-García, originally from Montevideo, was interested in its radical emphasis on form and color, or, as he called it, "Plasticisme." Taken

with the dynamism of the modern city and excited by the innovations of the avant-garde, Barradas and Torres-García sought to find a formal language capable of expressing their visions of modern life.

In a December 1917 exhibition at the Galeries Dalmau, the two artists introduced two movements that marked a crucial new phase in the Spanish avant-garde: Torres-García's Art-Evolució and Barradas's Vibracionismo. Paintings that exemplified their new ideas featured train stations, trolley cars, storefront signs, cafés, streetlights, and the hustle and bustle of city streets. For Torres-García, the subject of the city offered a clean break from the classicism of Noucentisme and a focus well suited for his experiments in cubist form. For Barradas, the city was a futurist-inspired whorl of simultaneous experiences, ideal for his vibrant explorations of color.[4] Although stylistically distinct, these movements were the first in Spain to integrate the formal innovations and theories prevalent in the broader European avant-garde.[5] Like many of their cubist and futurist contemporaries, both Torres-García and Barradas emphasized the basic tools of form and color in an idealistic attempt to communicate deeper, intangible truths.

In a series of essays, beginning with "Art-Evolució (a manera de manifest)" in the November 1917 issue of Joan Salvat-Papasseit's avant-garde art and literature magazine *Un enemic del Poble,* and continuing with the five "Evolucionismo" essays published periodically from December 1917 to March 1918 in *La Publicidad,* Torres-García described a tran-

scendent art based on pure painting that seeks to express the unity and harmony of an eternal present. The artist postulated that by liberating one's thinking, following one's intuition, and delving into one's own consciousness, one discovers "unity within multiplicity ... the unity of our consciousness: The self is a complete universe. All of reality, cast within it, is brought into harmony, with us then living in a supreme moment, a complete world, reality in its totality."[6] Within this unity, Torres-García continued, objective reality, the here-and-now, becomes eternal and universal, "a supreme moment." To express this elusive condition, the artist advocated forgetting all artistic tradition and painting according to one's intuition, which for him meant painting in the style of the avant-garde.

In *Figure with Landscape of the City,* 1917 (fig. 1), Torres-García created a "unity within multiplicity." The tightly overlapping arrangement of disparate views suggests a tension and dynamism associated with the city. However, the subdued palette and balanced compositional structure generate a sense of harmony within the painting. Each element appears isolated, carefully counterpoised in an orderly, almost grid-like pattern. Torres-García had experimented with gridded compositions in drawings, such as the one published in the June 1917 issue of *Un enemic del*

*Poble* (fig. 2). In the painting, however, he eliminated the frames and extraneous details to emphasize the interplay of forms and colors and open the flow of the composition.

Torres-García recognized that this emphasis on structure and timelessness distinguished his work from that of Barradas:

*Ours! Something identical and very different at the same time.... His was a dynamic conception of painting, which as a whole departed from empirical facts ... and I tended toward something static like architecture, toward the idea of things, toward proportion as a foundation, toward constancy, laws, and generalities; and more than the modern outlook, to that human tradition of the centuries.*[7]

The ideas expressed here—painting like architecture, proportion, and constancy—closely reflect the ideals of Torres-García's previous noucentista paintings and also his later development of Constructive Universalism.

By contrast, in *Barcelona Street at 1 p.m.,* 1918 (fig. 3), Barradas rendered the city and its inhabitants as a riotous crescendo of overlapping planes of color. As in most of his vibrationist work, here Barradas reduced the details of the city to a series of

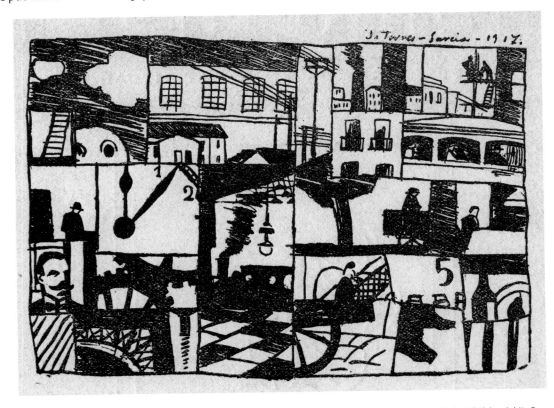

Fig. 2. Drawing published in *Un enemic del Poble,* no. 3 (June 1917), by Joaquín Torres-García, illustrating his text "D'altra òrbita."

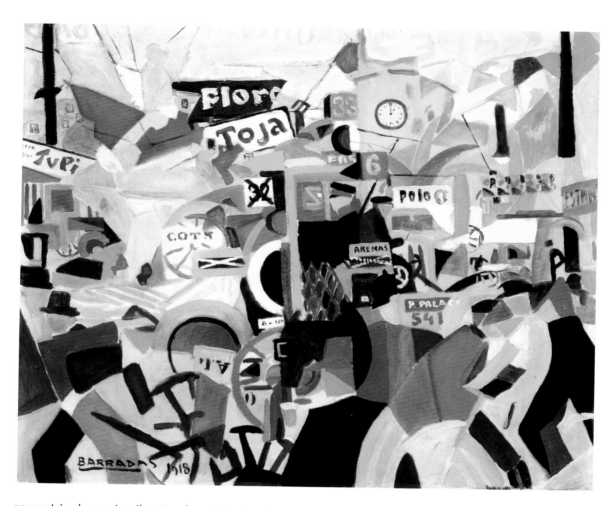

geometric shapes in vibrant colors. Wheels of cars, wagons, and trams are expressed as simple circles, some with rough lines for spokes. Pedestrians and drivers are deconstructed into closely juxtaposed planes of color, often overlapping, sometimes with multiple figures sharing the same shape. Within the drastically conflated space, one can just make out the tightly layered forms of cars, wagons, buildings, and a multitude of people. Here, the concrete gives way to the abstract. The objects of interest in Barradas's scene are not "car," "wagon," "building," or "urban throng," but "blue," "yellow," "red," and "triangle," "oval," "square." Although the dynamism of the modern city is his subject matter here, the dynamic juxtaposition of color serves as the focus of Vibracionismo.

In his 1944 book *Universalismo Constructivo* (Constructive Universalism), Torres-García recounted a conversation with Barradas in which the young Uruguayan encapsulated Vibracionismo in terms of color relations:

*A certain red, that has struck his sensitivity, will inevitably look for its complement in a green of the same intensity; a value that would represent a 3 (within the scale), will seek to equalize itself with another 3. The intervening objects will remain linked or subject to the first ones. Vibrationism is, therefore, a certain MOVEMENT that is determined inevitably by the passage of one sensation of color to another corresponding [color and sensation], being, each one of these in agreement, diverse notes of harmony, distinct, fused together by more, muffled harmonies, in gradation each time more obscure.*[8]

This account reveals in Barradas's art the ghosts of M. E. Chevreul and Ogden Rood, whose treatises on optics and color harmonies served as the basis for post-Impressionist movements from Divisionism and Fauvism to Futurism and Orphic Cubism. Moreover, it confirms the artist's intent to evoke a subtle sense of movement through his emphasis on form and color. As both Chevreul and Rood noted, colors vibrate with

Fig. 3 (cat. 7:19). Rafael Barradas, *Barcelona Street at 1 p.m.*, 1918.

335

their own particular intensity, and when juxtaposed, one color's vibratory frequency is altered, either weakened or intensified, by the vibratory frequency of the colors immediately surrounding it. In his formal emphasis on color relations, Barradas sought to employ and evoke the electromagnetic vibrations that are the basis of one's visual capacity.

By the time Barradas used the term to describe his art, "vibrations" had already taken on special significance. The widespread popularization of recent discoveries in the field of electromagnetic radiation made "vibrations" a general, layperson's term for a wide range of electromagnetic waves. Indeed, the overwhelming popular reception of Wilhelm Conrad Röntgen's 1895 discovery of X-rays and the use of the Eiffel Tower as a station for wireless telegraphy made vibrations an international phenomenon, particularly among European avant-garde artists, many of whom were in Barcelona at the time.[9]

The metaphor of "vibrations" provided a potent analogy for Barradas's art. Like many European avant-garde artists, he sought to make color vibrations communicate the invisible and ephemeral.[10] Barradas determined the arrangement of colors not according to what he actually saw, but by the "emotions or sensations" that corresponded to his initial impressions. These forms and colors then sought "to complement or rectify themselves IN THE VIEWER, and in so doing the artist achieves another manner of vibration, something alive, THAT OBJECTS NORMALLY OR COMPLETELY WOULD NOT GIVE."[11]

This system of communicating with the viewer through certain color combinations directly mirrors the transmission and reception of vibrations in radio communication. The painting functions as an oscillator, transmitting meaningful vibrations through specific juxtapositions of color. The viewer, then, is the receiver, absorbing the painting's vibratory transmissions. In this process of wireless communication, the concept of syntony is key. That is, in order that the receiver register the message of the transmitter, the two must be in tune with each other, sensitive to similar frequencies, or, as we say today, on the same wavelength. Similarly, the viewer must be extremely sensitive to, or hyperconscious of, the vibrations of the painting in order to receive them clearly.

As we have seen in his Evolucionismo essays, Torres-García also idealized this type of hyperconscious sensitivity. The elder Uruguayan often rhapsodized over "that other interior world . . . of superconsciousness," in which one "can embrace the most heterogeneous things, ad infinitum, giving to everything a precise character, as if it were the revelation of its intimate essence."[12] Not surprisingly, Torres-García further characterized this heightened sensitivity in terms of vibrations:

*This spirit does come to us without enthusiasm, and this is another characteristic. We are engulfed in flame, we vibrate; our spirit is vibratory, agile; it covers immense spaces in seconds; we feel in ourselves the conviction that we can achieve extraordinary things. Good things fall to us; we become altruistic, sincere, indulgent, cordial. The world is beautiful, exuberant with life, with heat, with light. Serenity, like a sovereign, reigns over everything. The world enjoys perpetual peace.*[13]

In describing a vibratory spirit that "covers immense spaces in seconds," Torres-García suggests a state of consciousness that recalls radio communication. He also echoes his friend Barradas, who situated his new aesthetic territory in the invisible realm of vibrations, or as Torres-García described it in 1936, in "algo sobrerreal o más real," in something beyond real.[14] The comments in his Evolucionismo essays reveal an idealism verging on the spiritual.[15] Barradas seems to have believed too that Vibracionismo transcended that realm of invisible matter confirmed by science. Torres-García recalled that Barradas would say to him at times: "I believe, Torres, that we are arriving at what the theosophists call the superior mind, or almost so, because there are moments in which one is no longer oneself."[16]

The work of Torres-García and Barradas represented a collaboration of kindred spirits. Both were captivated by the city, dedicated to pure painting, and stirred by the pursuit of more advanced, transcendent art forms. Their art and writings in 1917–18 served as catalysts for further development of avant-garde art in Barcelona, other parts of Spain, and abroad. The structured, cubist compositions and idealistic aspirations of Torres-García's Art-Evolució were a crucial step in his eventual development of Constructive Universalism, one of the most influential movements in modern Latin American art. The ultramodern, multidimensional, cosmic spirit of Vibracionismo would serve as one of the bases of Ultraism, the avant-garde art and literature movement that Barradas helped found in Madrid after World War I, which later became a catalyst for new developments in South America.

Much of this essay is based on my M.A. thesis at the University of Texas at Austin, "Rafael Barradas and 'Vibracionismo': Science and Spirituality in Spanish Avant-Garde Art" (2001). I would like to thank Jacqueline Barnitz and Linda Dalrymple Henderson for their assistance and advice, and Robert S. Lubar for his generosity with his research. Their help on that project informs this essay, too.

1. Joaquín Torres-García, *Gènesi de l'obra artística,* manuscript of a lecture delivered at a conference at the Galeries Dalmau, 22 February 1917, Biblioteca General d'Història de l'Art, Barcelona; reprinted in Spanish translation in Joan Sureda Pons, *Torres García: Pasión clásica* (Madrid: Akal, 1998), 293. All translations are by the author, unless otherwise noted.

2. Torres-García, *El descubrimiento de sí mismo: cartas a Julio que tratan de cosas muy importantes para los artistas* (Terrassa: Establ. Tip. La Industria, Morral & C., 1916; Girona: Tip. de Masó, 1917).

3. An entry in Torres-García's diary confirms that Joan Salvat-Papasseit introduced him to Barradas on 27 August 1917. The three would later collaborate on several influential avant-garde art and literature magazines including *Un enemic del Poble* and *Arc Voltaic.* The date they were introduced is cited in Robert S. Lubar, "Joaquín Torres-Garcia y la Formación Social de la Vanguardia en Barcelona," in *Barradas/Torres-García* (Madrid: Galería Guillermo de Osma, 1991), 26; and Pilar García-Sedas, *J. Torres-García y Rafael Barradas: Un diálogo escrito, 1918–1928* (Barcelona: Parsifal Montevideo/Libertad Libros, 2001), 61.

4. Most critics who saw the exhibition recognized each artist's affinity with particular avant-garde movements and categorized their work accordingly. Joan Sacs, in particular, refused to let Torres-García call his work anything but Cubist: see Sacs, "Exposiciones Torres-García y Barradas," *La Publicidad,* 15 December 1917, 1. Barradas's work was generally met with confusion, but most critics saw formal affinities with both Cubism and Futurism, and some even praised his ability as a colorist. See, in particular, Florian, "Gaseta d'art-Galeries Dalmau: Exposició Barradas," *El Poble Català,* 15 December 1917, 2; and Eduard M. Puig, "Exposicions: Barradas," *La Revista* 3, no. 54 (16 December 1917): 443–44.

5. Some scholars note Celso Lagar's Planism as the first Spanish avant-garde movement.

6. Torres-García, "Evolucionismo V," *La Publicidad,* 14 March 1918, 3.

7. Torres-García, *Universalismo Constructivo* (Buenos Aires: Poseidón, 1944), 553. Translation from the English manuscript in Lubar, "Joaquín Torres-Garcia," 28 (page 14 of manuscript). Thanks to Linda Dalrymple Henderson for providing the manuscript.

8. Torres-García, *Universalismo Constructivo,* 556.

9. For more complete examinations of the popular interest in science and technological advancements among the European avant-garde, see Stephen Kern, *The Culture of Time and Space 1880–1918* (Cambridge: Harvard University Press, 1983); Henderson, *The Fourth Dimension and Non-Euclidean Geometry in Modern Art* (Princeton: Princeton University Press, 1983); and Douglas Kahn and Gregory Whitehead, eds., *Wireless Imagination: Sound, Radio, and the Avant-Garde* (Cambridge/London: MIT Press, 1992). For the Cubists' interest in X-rays, see chapter 1 of Henderson, *Duchamp in Context: Science and Technology in "The Large Glass" and Related Works* (New Haven: Yale University Press, 1998); and Henderson, "Francis Picabia, Radiometers, and X-Rays in 1913," *Art Bulletin* 71 (March 1988): 114–23.

10. For example, it was the stated ambition of the Italian Futurists to depict "the simultaneousness of states of mind"; see Umberto Boccioni et al., "The Exhibitors to the Public," in *Exhibition of Works by the Italian Futurist Painters,* exh. cat. (London: Sackville Gallery, 1912), reprinted in Umberto Apollonio, ed., *Futurist Manifestos* (New York: Viking Press, 1970), 47. Also, Gino Severini talks about "forms and colors expressing sensations of noise, sound, smell, heat, speed, etc.," elements as intangible or invisible as states of mind; see Severini, "The Plastic Analogies of Dynamism—Futurist Manifesto" (September–October 1913), trans. J. C. Higgitt, in Apollonio, *Futurist Manifestos,* 121; Robert Delaunay later wrote about the color vibrations on canvas being "recreated in the eye of the beholder." Robert Delaunay, "Constructionism and Neoclassicism," trans. David Shapiro and Keith and Paula Cohen, *The New Art of Color: The Writings of Robert and Sonia Delaunay,* ed. Arthur A. Cohen (New York: Viking Press, 1978), 10–11.

11. All caps are Torres-García's, one presumes to express Barradas's own emphasis; Torres-García, *Universalismo Constructivo,* 556–57.

12. Torres-García, "Evolucionismo IV," *La Publicidad,* 19 February 1918, page unknown.

13. Torres-García, "Evolucionismo V," *La Publicidad,* 14 March 1918, 3.

14. Torres-García, *Universalismo Constructivo,* 557.

15. In "Rafael Barradas and 'Vibracionismo': Science and Spirituality in Spanish Avant-Garde Art" (M.A. thesis, University of Texas at Austin, 2001), I expand on the theme of spirituality in Vibrationism and the broader Spanish avant-garde at this time. In particular, I identify it with a general spiritualism that attends the popularization of various scientific and technological advancements, as well as a vulgate Bergsonism reinforced by the writings of José Ortega y Gasset.

16. Torres-García, *Universalismo Constructivo,* 559.

Del present **MANIFEST** hem eliminat tota cortesia en la nostra actitud. Inútil qualsevol discussió amb els representants de l'actual cultura catalana, negativa artisticament per bé que eficaç en d'altres ordres. La transigència o la correcció conduexen als deliqüescents i lamentables confusionismes de totes les valors, a les més irrespirables atmòsferes espirituals, a la més perniciosa de les influències. Exemple: *La Nova Revista*. La violenta hostilitat, per contra, situa netament les valors i les posicions i crea un estat d'esperit higiènic.

| | |
|---|---|
| **HEM ELIMINAT** | tota argumentació |
| **HEM ELIMINAT** | tota literatura |
| **HEM ELIMINAT** | tota lírica |
| **HEM ELIMINAT** | tota filosofia |
| | a favor de les nostres idees |

{ Existeix una enorme bibliografia i tot l'esforç dels artistes d'avui per a suplir tot això.

| | |
|---|---|
| **ENS LIMITEM** | a la més objectiva enumeració de fets |
| **ENS LIMITEM** | a assenyalar el grotesc i tristíssim espectacle de l'intel·lectualitat catalana d'avui, tancada en un ambient resclosit i putrefacte. |

| | |
|---|---|
| **PREVENIM** | de la infecció als encara no contagiats. Afer d'estricta asèpsia espiritual. |

| | |
|---|---|
| **SABEM** | que res de nou anem a dir. Ens consta, però, que es la base de tot el nou que avui hi ha i de tot el nou que tingui possibilitats de crear-se. |

| | |
|---|---|
| **VIVIM** | una època nova, d'una intensitat poètica imprevista. |

| | |
|---|---|
| **EL MAQUINISME** | ha revolucionat el món |
| **EL MAQUINISME** | —antítesi del circumstancialment indispensable futurisme—ha verificat el canvi més profund que ha conegut la humanitat. |

| | |
|---|---|
| **UNA MULTITUD** | anònima — anti-artística — col·labora amb el seu esforç quotidià a l'afirmació de la nova època, tot i vivint d'acord amb el seu temps. |

## UN ESTAT D'ESPERIT POST-MAQUINISTA HA ESTAT FORMAT

| | |
|---|---|
| **ELS ARTISTES** | d'avui han creat un art nou d'acord amb aquest estat d'esperit. D'acord amb llur època. |

## ACÍ, PERÒ, ES CONTINUA PASTURANT IDÍL·LICAMENT

| | |
|---|---|
| **LA CULTURA** | actual de Catalunya és inservible per a l'alegria de la nostra època. Res de més perillós, més fals i més adulterador. |

## PREGUNTEM ALS INTEL·LECTUALS CATALANS:

—De què us ha servit la Fundació Bernat Metge, si desprès haveu de confondre la Grècia antiga amb les ballarines pseudo-clàssiques?

| | |
|---|---|
| **AFIRMEM** | que els sportmen estan més aprop de l'esperit de Grècia que els nostres intel·lectuals |
| **AFEGIREM** | que un sportman verge de nocions artístiques i de tota erudició està més a la vora i és més apte per a sentir l'art d'avui i la poesia d'avui, que no els intel·lectuals, miops i carregats d'una preparació negativa. |
| **PER NOSALTRES** | Grècia es continua en l'acabat numèric d'un motor d'avió, en el teixit anti-artístic d'anònima manufactura anglesa destinat al golf, en el nu en el music-hall americà. |

| | |
|---|---|
| **ANOTEM** | que el teatre ha deixat d'existir per a uns quants i gairebé per a tothom |
| **ANOTEM** | que els concerts, conferències i espectacles corrents avui dia entre nosaltres, acostumen a ésser sinònims de llocs irrespirables i aburridíssims. |

| | |
|---|---|
| **PER CONTRA** | nous fets d'intensa alegria i jovialitat reclamen l'atenció dels joves d'avui. |
| **HI HA** | el cinema |
| **HI HA** | l'estadi, la boxa, el rugby, el tennis i els mil esports |
| **HI HA** | la música popular d'avui: el jazz i la dansa actual |
| **HI HA** | el saló de l'automòbil i de l'aeronàutica |
| **HI HA** | els jocs a les platges |
| **HI HA** | els concursos de bellesa a l'aire lliure |
| **HI HA** | la desfilada de maniquins |
| **HI HA** | el nu sota l'electricitat en el music-hall |
| **HI HA** | la música moderna |
| **HI HA** | l'autòdrom |
| **HI HA** | les exposicions d'art dels artistes moderns |
| **HI HA** | encara, una gran enginyeria i una magnífica trasatlàntics |
| **HI HA** | una arquitectura d'avui |
| **HI HA** | útils, objectes, mobles d'època actual |
| **HI HA** | la literatura moderna |
| **HI HA** | els poetes moderns |
| **HI HA** | el teatre modern |
| **HI HA** | el gramòfon, que és una petita màquina |
| **HI HA** | l'aparell de fotografiar, que és una altra petita màquina |
| **HI HA** | diaris de rapidíssima i vastíssima informació |
| **HI HA** | enciclopèdies d'una erudició extraordinària |
| **HI HA** | la ciència en una gran activitat |
| **HI HA** | la crítica, documentada i orientadora |
| **HI HA** | etc., etc., etc., |
| **HI HA** | finalment, una orella immòbil sobre un petit fum dret. |

| | |
|---|---|
| **DENUNCIEM** | la influència sentimental dels llocs comuns racials de Guimerà |
| **DENUNCIEM** | la sensibleria malaltiça servida per l'Orfeó Català, amb el seu repertori tronat de cançons populars adaptades i adulterades per la gent més absolutament negada per a la música, i àdhuc, de composicions originals. (Pensem amb l'optimisme del chor dels *Revellers* americans). |
| **DENUNCIEM** | la manca absoluta de joventut dels nostres joves |
| **DENUNCIEM** | la manca absoluta de decisió i d'audàcia |
| **DENUNCIEM** | la por als nous fets, a les paraules, al risc del ridícul |
| **DENUNCIEM** | el soporisme de l'ambient podrit de les penyes i els personalismes barrejats a l'art. |
| **DENUNCIEM** | l'absoluta indocumentació dels crítics respecte l'art d'avui i l'art d'ahir |
| **DENUNCIEM** | els joves que pretenen repetir l'antiga pintura |
| **DENUNCIEM** | els joves que pretenen imitar l'antiga literatura |
| **DENUNCIEM** | l'arquitectura d'estil |
| **DENUNCIEM** | l'art decoratiu que no sigui l'estandarditzat |
| **DENUNCIEM** | el pintors d'arbres torts |
| **DENUNCIEM** | la poesia catalana actual, feta dels més rebregats tòpics maragallians |
| **DENUNCIEM** | les metzines artístiques per a ús infantil, tipus: *Jordi*. (Per a l'alegria i comprensió dels nois, res de més adequat que Rousseau, Picasso, Chagall...) |
| **DENUNCIEM** | la psicologia de les noies que canten: *Rosó, Rosó...* |
| **DENUNCIEM** | la psicologia dels nois que canten: *Rosó, Rosó...* |

## FINALMENT ENS RECLAMEM DELS GRANS ARTISTES D'AVUI, dins les més diverses tendencies i categories:

PICASSO, GRIS, OZENFANT, CHIRICO, JOAN MIRÓ, LIPCHITZ, BRANCUSI, ARP, LE CORBUSIER, REVERDY, TRISTAN TZARA, PAUL ELUARD, LOUIS ARAGON, ROBERT DESNOS, JEAN COCTEAU, GARCÍA LORCA, STRAWINSKY, MARITAIN, RAYNAL, ZERVOS, ANDRÉ BRETON, ETC., ETC.

---

## SALVADOR DALÍ    LLUÍS MONTANYÀ
## SEBASTIÀ GASCH

Barcelona, març de 1928

IMP. FILLS DE F. SABATER

# Art and Anti-Art: Miró, Dalí, and the Catalan Avant-Garde

*ROBERT S. LUBAR*

In March 1928 Salvador Dalí, in collaboration with the writer Lluís Montanyà and the art critic Sebastià Gasch, issued the *Manifest groc (Yellow Manifesto,* fig. 1), a provocative broadsheet denouncing the provincial torpor of Catalan arts and letters. "In the present MANIFESTO," the cosignatories began, "we have eliminated all courtesy from our attitude. Any discussion with representatives of today's Catalan culture is pointless, as they are negative artistically though efficient in other orders." Rejecting a host of Catalan institutions ranging from the traditional dance "La Sardana" to the romantic poetry of Angel Guimerà, the authors called for Catalan artists and intellectuals to complete the project of modernity that had been inaugurated in the late 19th century. If representatives of Catalan politics had been successful in building the institutional infrastructure of a modern European nation, the persistence of local stereotypes and entrenched folkloric traditions threatened to derail that process in the cultural sphere.

The fact that the *Manifest groc* was issued in Catalan speaks to the participation of its authors in the hegemonic project of Catalan nationalism. Just as modernista artists such as Santiago Rusiñol and Ramon Casas had struggled against their own class to install a European culture of modernity in Barcelona, Dalí and his colleagues militated against the entrenched parochialism of the Catalan bourgeoisie throughout the 1920s. If, however, the paradigm of struggle and resistance remained the same, the experience of modern life had changed dramatically. Dalí's generation witnessed a vast expansion of media technologies, from the proliferation of advertising and mass print culture to new developments in the cinema, photography, and recorded music.[1] "Avant-gardism," as it was known, came to represent not only recent developments in the fine arts but also a new attitude toward modern life itself. In the *Manifest groc,* spectator sports such as boxing and rugby, aeronautic and motor shows, beauty pageants, and fashion parades share the page with the great names of advanced painting, literature, music: André Breton, Jean Cocteau, Igor Stravinsky, Tristan Tzara, Le Corbusier, Paul Eluard, Louis Aragon, Pablo Picasso, Juan Gris, Amadée Ozenfant, Giorgio di Chirico, and Joan Miró. Industrial standardization edges out historicism in architecture, and modern jazz trumps the traditional choral music of the Orfeó Català. However much the heterogeneous nature of the broadsheet reflected fundamental differences of opinion among its authors concerning the limits of their cultural critique, the *Manifest groc* pointed to momentous changes in Catalan social and cultural life of the mid to later 1920s as the population of Barcelona swelled, hydroelectric power became widely available, rail and metro lines were expanded, and new roads built.[2]

Miró's position among "the great artists of today," as the cosignatories of the manifesto described him, speaks to the historical maturation and transformation of the Catalan avant-garde. For Dalí and his contemporaries, Miró's work represented "the most original and important contribution since Picasso," as Gasch confidently asserted in 1925.[3] That same year Miró celebrated an important solo exhibition in Paris and participated in the first group exhibition of the Surrealists, identifying himself as a major player in the recently constituted movement. His success in Paris, like that of Picasso before him, in turn set an example for young artists back home.

As early as February 1918, the date of his first exhibition in Barcelona, Miró had demonstrated a keen interest in the visual languages of European avant-garde art, which he assimilated through reproductions and sporadic contact with foreign artists living in the Catalan capital during World War I. Between 1915 and 1918 Miró's dealer Josep Dalmau, who had participated in the activities of the Quatre Gats circle, hosted exhibitions of fauvist works by

Fig. 1 (cat. 7:30). Salvador Dalí, Sebastià Gasch, and Lluís Montanyà, *Manifest groc (Yellow Manifesto)* (1928).

Kees van Dongen and cubo-futurist works by Celso Lagar (1915), recent cubist and abstract paintings by Albert Gleizes (1916), and ornamental compositions by Sergei Charchoune and Helena Grunhoff (1916 and 1917), to cite but a few of Dalmau's commercial initiatives. Miró responded to these myriad stimuli formally, and as a profession of faith in the broader project of modernity. In a letter to his friend and studio-mate Enric C. Ricart dated 1 October 1917, Miró expressed the same dissatisfaction with contemporary Catalan art that Dalí, Gasch, and Montanyà would make their cause célèbre 11 years later. "Here,

in Barcelona," Miró insisted, "we lack courage. When the critics who are most interested in the modern and ultramodern movements find themselves in front of an outmoded academic, they melt and end up speaking well of him."[4] In contrast, Miró waxed lyrical over "the Futurist writings against outmoded Rome and its moonlight nights," the elevated trains of "ultramodern New York," and the "resonant vibration of the creative spirit."[5] His artistic practice and abiding belief that painting since the time of the Impressionists tended to "emancipate the artist's emotions and give him absolute freedom" was a call

Fig. 2 (cat. 7:20). Enric C. Ricart, *Joan Miró,* 1916.

Fig. 3 (cat. 7:21). Joan Miró, *E. C. Ricart,* 1917.

to the recalcitrant Catalan bourgeoisie to embrace the culture that was the legitimate expression of their economic and social interests.[6]

As Miró predicted, the work he exhibited at the Galeries Dalmau in February 1918 so outraged the public that his name became synonymous with the "eccentricities" and "abuses" of modern painting. Alongside landscapes executed in the Catalan countryside and Cézannist still lifes comprised of common household objects, Miró's figural compositions bore the brunt of public ridicule. If in his *Joan Miró,* 1916 (fig. 2), Ricart adopted the technique of

color modulation employed by Paul Cézanne, Paul Gauguin, and Henri Matisse, his portrayal of Miró as an infantryman during the period of his military service in Barcelona provided a firm social ground for his still-tentative exploration of advanced pictorial strategies. In contrast, Miró's *E. C. Ricart,* 1917 (fig. 3), offered no such concessions. Although the painting has a clear historical pedigree in Vincent van Gogh's portrait of his dealer Père Tanguy of 1887–88, Miró's willful distortion of form, Ricart's exotic costume, the incorporation of a Japanese print as a collage element, and the symbolic reference to the artist's

palette as a metonym for pure painting itself (the colors Miró employs throughout the composition are neatly arranged in a row), shocked the public. Miró received anonymous copies of the calligram the Catalan poet Josep M. Junoy had designed for the cover of the exhibition catalogue (fig. 4), describing the chromatic brilliance of the artist's palette—"impregnada d'una refractabilitat congestionant" (saturated with a congestive refractivity)—and his emphasis on formal values—"forta pictòrica matèria" (strong pictorial matter). Addressed to the Galeries Dalmau from an anonymous source, one calligram was altered to read, "Molt Indecent Resulta aixÓ" (Very Indecent This Result), and another "MERDA d'una pudó ALIMENTISIA" (SHIT of a NOURISHING smell).

Like so many artists of the preceding generation, Miró's response to public scorn and, even worse, to commercial indifference was to immigrate to Paris. As he confided to Ricart in September 1919, "I would a thousand times rather—and I say this in all sincerity—fail *utterly, totally* in Paris than go on suffering in these filthy, stinking waters of Barcelona."[7] Ten months later, upon his return from a three-month sojourn in the French capital, Miró again advised Ricart: "You have to be an *International Catalan;* a *homespun* Catalan is not, and never will be, worth anything in the world."[8] Despite his contempt for the conservative Barcelona art world of the time, Miró and his colleagues remained committed to the project of Catalan nationalism. The fact that Junoy had published his calligram in Catalan points to a shared belief among advanced writers and painters that the Catalan language itself was at the vanguard of national identity and expression, as the editorial team of the literary journal *L'Avenç* had insisted in the late 1880s and early 1890s.[9]

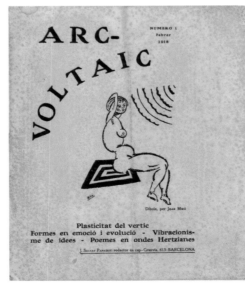

The linguistic question remained central to Miró's artistic practice throughout his long career. Locating his work at the boundary of painting and poetry ("peinture-poésie"), Miró developed a rich and multivalent vocabulary of visual signs through which he reconceived the traditional terms of painting as a new operation of writing and mark making.[10] Miró's friendship with Junoy and the poets J. V. Foix and Joan Salvat-Papasseit, and his contributions to short-lived Catalan literary journals such as *Arc-Voltaic* (Electric Arc, fig. 5), conditioned his participation in the surrealist movement and his interest in the relation between words and images. But his development of a new structural language was anything but "literary" in the traditional sense of anecdotal and narrative painting, and the surrealist movement confirmed, rather than determined, the direction of Miró's mature work after 1924.

As early as *The Farm,* 1921–22 (fig. 6), Miró had begun to define the terms of his new approach to the "language" of painting. "I was thoroughly convinced that I was working on something very important," he later told an interviewer. "[I was] attempting to summarize the world around me."[11] Miró conceived *The Farm* as a kind of visual index to rural Catalonia, an inventory of traditional peasant life that he organized according to the logic of an archive. Farm implements, a host of wild and barnyard animals, and a range of physical tasks, from washing and pressing grapes to planting, gardening, and watering, are described in vivid detail or are implied by the presence of specific objects in the landscape. Forms are distributed evenly across the picture plane along horizontal and vertical axes, and thematic and visual links are established among discrete objects of different classes and types through formal alliteration. With one eye on

Fig. 4 (cat. 7:23). Josep M. Junoy, acrostic (altered by an anonymous person), for *Catalogue of Joan Miró Exhibition*, Galeries Dalmau, 16 February–3 March 1918.

Fig. 5 (cat. 7:22). Joan Miró, cover for *Arc-Voltaic*, no. 1 (February 1918).

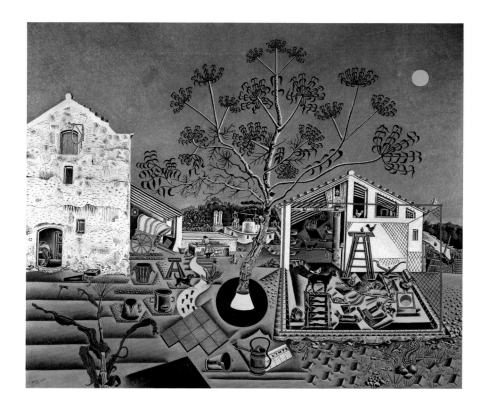

the specificities of the Catalan countryside, where Miró's parents maintained a summer residence, and another on an abstract pictorial structure that demonstrates his sophisticated assimilation of cubist and purist formal principles—the forward tilt of the picture plane, the grid-like structure, the rudimentary and often arbitrary use of chiaroscuro, and the simplification and strategic repetition of forms and colors—Miró adapted the language of advanced painting to a traditional, "homespun" theme. The presence of the Parisian newspaper *L'Intransigeant* in the center foreground restates this relationship in symbolic terms, establishing a spatial and temporal arc that spans the organic patterns of rural life and the anonymity of mass print culture, the Catalan countryside, and the Parisian art world.[12]

The process of formal consolidation that Miró embarked upon in *The Farm* had profound implications for his emerging conception of painting as a kind of writing. As Miró reduced objects to their essential characteristics in visual terms that call to mind the conventions used in a child's language primer, his calligraphic line assumed multiple significations. In *The Hunter*, 1923–24 (fig. 7), a groundbreaking can-

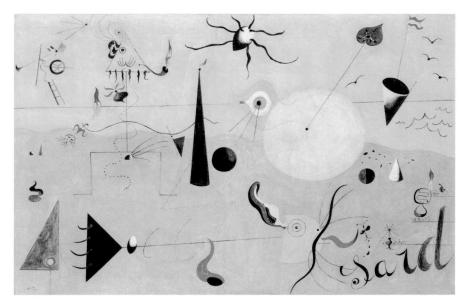

Fig. 6 (cat. 7:25). Joan Miró, *The Farm*, 1921–22.
Fig. 7 (cat. 7:26). Joan Miró, *The Hunter (Catalan Landscape)*, 1923–24.

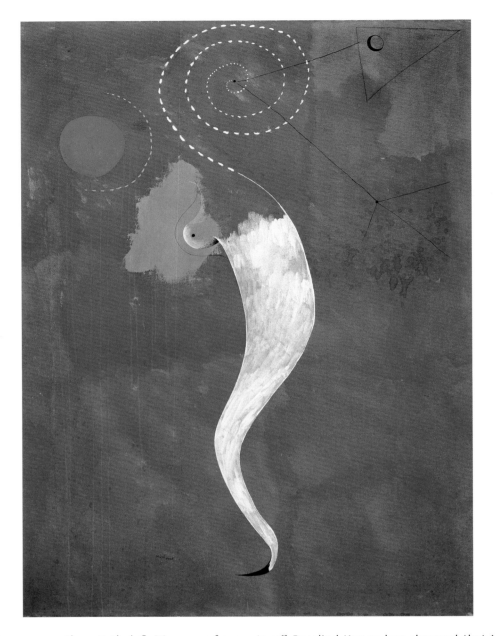

vas that announces the artist's definitive move from a descriptive toward a more conceptual realism, the markers of Renaissance space are all but abrogated: chiaroscuro is almost entirely abandoned; forms are radically flattened and tied to the frontal plane of the picture; and color achieves a heightened level of optical immediacy as Miró stretches broad fields of yellow and pink across the surface of the picture plane. As the objects of the Catalan landscape are schematically rendered—a bearded hunter smoking a pipe and holding a gun and knife, a boat in the distant sea sporting the emblem of the Spanish state, a fantastic "sard" (sardine) beached in the foreground—there is a corresponding transformation in the traditional role of line as bounded con-tour.[13] Rosalind Krauss has observed that in Miró's paintings of the mid 1920s line often fulfills several functions simultaneously: ideogram, spatial marker (a horizon or rudimentary orthogonal), lingual sign (in the sense of the artist's frequent incorporation of words and poetic phrases), and indexical imprint of the physical condition of the canvas support and its framing edges.[14] That Miró was involved in constructing a new, post-Renaissance spatial regime in *The Hunter* is in turn suggested by the fantastic eye that bisects the horizon, a symbolic mise en scène of the subject of vision itself. "This is hardly painting," Miró confessed to his friend Michel Leiris shortly after completing *The Hunter*, "but I don't give a damn."[15]

Fig. 8 (cat. 7:27). Joan Miró, *Woman Strolling on the Rambla of Barcelona*, 1925.

Over the next three years Miró refined his pictorial language and pushed his figuration to new limits. In *Woman Strolling on the Rambla in Barcelona,* 1925 (fig. 8), he plotted the coordinates of a woman promenading down Barcelona's central pedestrian thoroughfare, the serpentine sweep of her body mirroring the course of the rambla itself as it winds downtown from the Plaça de Catalunya to the port. The summary modeling of the right breast, an exhortation to the sense of touch, imparts a surprising degree of erotic agency to this latter-day *flâneuse,* while the broken, spiral line of the head symbolically maps the physical course of the lady's trajectory and her movement through space. But once again, it is a resolutely pictorial space that Miró defines. Extending from the figure's cyclopean eye are two lines, one terminating in a point from which three more lines extend—a schematic re-presentation of the visual field as it expands and spreads out before the viewer—and another terminating in the artist's sign for a palette. With a striking economy of means, Miró pries vision away from the gaze and relocates it to the autonomous space of painting—to the shadowy depths of the variegated brown wash, the self-contained luminosity of the red-orange disk, and the strangely ineffable materiality of the irregular blue patch. As Dalí immediately recognized, "Joan Miró brings the line, the point, the slight stretching out of shape, the figurative meaning, the colors, back to their purest elemental magical possibilities."[16]

Dalí's comment appeared in a short text he wrote for the Catalan literary journal *L'Amic de les Arts* (fig. 9). Published in the magazine's issue of 30 June 1928, just two months after the *Manifest groc* scandal, Dalí's text exists in a symmetrical relationship with his and Gasch's campaign to promote quintessentially modern (and in their words, "anti-artistic") tendencies such as documentary photography, wireless telegraphy, and the "poetry of mass-produced utility."[17] For if Dalí championed Miró's formal innovations, he also recognized the extent to which his colleague had systematically dismantled the terms of Western painting in a calculated act of cultural subterfuge. Miró the form-giver was also Miró the "anti-painter," the aesthetic outlaw who had made good on his promise to "assassinate" painting.

Miró's celebrated declaration to the French critic Maurice Raynal—"I want to assassinate painting"—was interpreted by his Catalan colleagues as a call to arms in the battle against cultural conservatism. "Miró . . . consoles us," Dalí asserted, "for the overwhelming local emptiness and the heavy burden of absurdities and commonplaces that populate our exhibition halls and our magazines."[18] Indeed, between the appearance of the *Manifest groc* and his article on Miró, Dalí had published the final two installments of a three-part essay titled "New Limits of Painting," in which he praised Hans (Jean) Arp, Max Ernst, Yves Tanguy, André Masson, and his own beloved Miró for moving beyond Cubism toward

Fig. 9 (cat. 7:29). Joan Miró, illustration for *L'Amic de les Arts,* no. 26 (30 June 1928), articles by Salvador Dalí, Sebastià Gasch, and Lluís Montanyà.

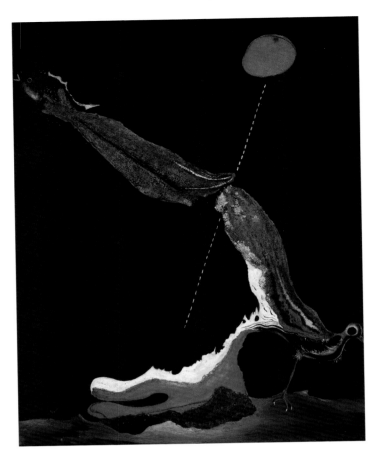

a more poetic and lyrical conception of painting. Although he maintained a cautious distance from the surrealist movement, which he did not "officially" join until the autumn of 1929, Dalí championed its spirit of risk and its rejection of cultural orthodoxies. "The assassination of art, what a beautiful tribute!!" Dalí declared.[19]

Over the course of 1927 and 1928 surrealist influences were increasingly pronounced in Dalí's work and informed his theoretical position. *Bird . . . Fish*, c. 1928 (fig. 10), for example, owes an obvious debt to Miró's "dream" paintings of the mid 1920s and the artist's articulation of space in terms of stark figure/ground oppositions. The broken line that bisects the fantastic creature in Dalí's painting in turn has clear affinities with such canonical works as Miró's *Person Throwing a Stone at a Bird*, 1926 (fig. 11), where it connotes suspended movement and metaphysical tension. But if Miró remained a constant point of reference for Dalí in his negotiation of surrealist

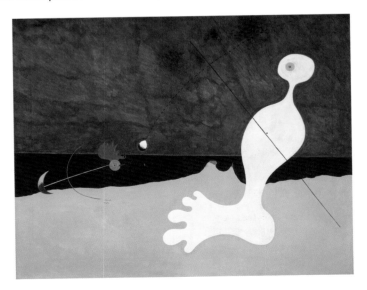

Fig. 10 (cat. 7:28). Salvador Dalí, *Bird . . . Fish*, c. 1928.
Fig. 11. *Person Throwing a Stone at a Bird*, 1926, by Joan Miró.

ideas and practices, it was Ernst who inspired the imagery of decomposition and putrefaction in *Bird . . . Fish*. Not only does the rotting bird recall Ernst's obsession with avian imagery, but the rough surface texture suggests that Dalí was also interested in the German artist's frottage technique.[20] Beyond the question of formal affinities, however, the theme of abjection, loss of identity, and base materialism that Dalí explored here and in related paintings of 1928 was a calculated assault on the Barcelona cultural establishment and the outmoded cult of romantic naturalism in Catalan landscape painting that it supported at the institutional level—what Dalí referred to as "the painting of twisted trees."[21] The broken, petrified body of *Bird . . . Fish,* a metaphor for the putrefaction and ossification of "official" Catalan culture, is set in a foreboding landscape that is illuminated by the mysterious light of a full moon. As in the opening sequence of Dalí and Luís Buñuel's pioneering film *Un Chien andalou* (1929), where a thin cloud cuts across the moon immediately before the notorious scene of a razor slicing a woman's eye, Dalí challenges the well-worn clichés of Romantic painting, putting the viewer and the public on notice.

"Putrefaction," "Assassination," "Anti-Art": These were the terms of cultural critique with which artists and writers came armed in the formation of an indigenous Catalan avant-garde front. In the ten-year period between Miró's first solo exhibition and the publication of the *Manifest groc,* modern Catalan painting and literature came of age. Miró had achieved considerable celebrity in Paris and was quickly consolidating his international reputation, while Dalí was about to transform the discourse and visual practices of French Surrealism.[22] For an entire generation of Catalan artists, Miró and Dalí represented the two essential reference points of a new cultural axis of modernity. However much they continued to meet with resistance back home, the hard-won battle they had fought insured that Catalan art would play a significant role on the international stage.

1. Jordana Mendelson, *Documenting Spain: Artists, Exhibition Culture, and the Modern Nation, 1929–1939* (University Park: Pennsylvania State University Press, 2005).

2. For a discussion of dissenting opinions among the authors of the manifesto, see Joan M. Minguet Batllori, *El Manifest Groc: Dalí, Gasch, Montanyà i l'antiart,* exh. cat. (Barcelona: Fundació Joan Miró, 2004).

3. Sebastià Gasch, "Els pintors d'avantguarda/Joan Miró," *Gaseta de les Arts,* no. 39 (15 December 1925); reprinted in Sebastià Gasch, *Escrits d'art i d'avantguarda (1925–1938),* ed. Minguet (Barcelona: Edicions del Mall, 1987), 52–57.

4. Joan Miró, letter to Enric Cristòfol Ricart, 1 October 1917, in Joan Miró, *Joan Miró: Selected Writings and Interviews,* ed. Margit Rowell (Boston: G. K. Hall, 1986), 52–53.

5. Ibid.

6. Miró to Josep Francesc Ràfols, 13 September 1917, in ibid., 50–51.

7. Miró to Enric Cristòfol Ricart, 14 September 1919, in ibid., 64–65.

8. Miró to Ricart, 18 July 1920, in ibid., 73. Miró arrived in Paris for the first time in late February–early March 1920 and returned to Barcelona in mid June. See Anne Umland's chronology in Carolyn Lanchner, *Joan Miró* (New York: Museum of Modern Art, 1993), 321.

9. For a consideration of the dual political and cultural position maintained by *L'Avenç,* see my essay, "Art and Anarchism in the City of Bombs," in section four of this volume.

10. For an extended discussion of Miró's response to advanced French poetry, particularly among the Surrealists and the writers of the Rue Blomet group, see Margit Rowell, "Magnetic Fields: The Poetics," in Rosalind Krauss and Margit Rowell, *Joan Miró: Magnetic Fields,* exh. cat. (New York: Solomon R. Guggenheim Museum, 1972), 39–66.

11. Lluís Permanyer, "Revelaciones de Joan Miró sobre su obra," *Gaceta Ilustrada* (12 April 1978): 45–56, in Miró, *Selected Writings,* 290.

12. The newspaper is also an autobiographical reference, as Miró's first solo exhibition in Paris, organized by Josep Dalmau for the Galerie La Licorne (29 April–14 May 1921), was reviewed in *L'Intransigeant* by the French critic Maurice Raynal.

13. On the occasion of his third retrospective at the Museum of Modern Art, Miró provided curator William Rubin with a detailed description of his iconography in *The Hunter (Catalan Landscape).* See Rubin, *Miró in the Collection of the Museum of Modern Art* (New York: Museum of Modern Art, 1974).

14. Krauss, "Magnetic Fields: The Structure," in Krauss and Rowell, *Joan Miró: Magnetic Fields,* 11–38.

15. Miró to Michel Leiris, 10 August 1924, in Miró, *Selected Writings,* 86–87.

16. Salvador Dalí, "Joan Miró," *L'Amic de les Arts* 3, no. 26 (30 June 1928): 202; reprinted in Dalí, *The Collected Writings of Salvador Dalí,* ed. and trans. Haim Finkelstein (New York/Cambridge, U.K.: Cambridge University Press, 1998): 94–95.

17. Dalí, "Review of Antiartistic Tendencies," *L'Amic de les Arts* 4, no. 31 (31 March 1929), 10; and "The Poetry of Mass-Produced Utility," *L'Amic de les Arts* 3, no. 23 (31 March 1928), 176–77; reprinted in *Collected Writings,* 57–59, 103–5.

18. On the origins and significance of Miró's statement to Raynal, see Umland, "Joan Miró and Collage in the 1920s: The Dialectic of Painting and Anti-Painting" (Ph.D. diss., New York University, Institute of Fine Arts, 1997), 191–98. Dalí, "Joan Miró," in *Collected Writings,* 59.

19. Dalí, "Nous límits de la pintura" (Part III), *L'Amic de les Arts* 3, no. 25 (31 May 1928): 195–96, in *Collected Writings,* 91–93. The full quotation reads: "The assassination of art, what a beautiful tribute!! The Surrealists are people who honestly devote themselves to this. My thought is quite far from identifying with theirs, but can you still doubt that only those who risk all for everything in this endeavor will know all the joy of the imminent intelligence."

20. "Frottage," a term with clear sexual connotations in French slang, refers here to Ernst's technique of making direct imprints of objects and textures through a process of rubbing, as in the common practice of transferring tomb inscriptions onto paper.

21. Dalí, "Joan Miró," in *Collected Writings,* 59. Dalí had already denounced "els pintors d'arbres torts"—a polemical reference to second-generation Catalan landscape painting in the tradition of the Escola d'Olot, a local interpretation of the French Barbizon School—in the *Manifest groc.*

22. In 1926 Miró participated in the International Exhibition of Modern Art, a group show assembled by Katherine Dreier's Société Anonyme at the Brooklyn Museum, New York. The show ran 19 November 1926–1 January 1927 and, along with the great Armory Show of 1913, is considered a hallmark in the introduction of advanced painting to the American public.

# Paranoiac Surrealism

*WILLIAM JEFFETT*

Salvador Dalí formulated his thinking regarding paranoia simultaneously through the exploration of double images in painting and writing. Double images first appeared in 1929 in paintings such *Accommodations of Desire* (fig. 1), where the head of a lion appears in many positive and negative images. In Freudian terms, the painting's iconography symbolizes impotence in the face of paternal power, but the lion's head could also be read as suggesting a woman's sex and Dalí's fear of intercourse.

This spectacular painting formed part of Dalí's first solo exhibition in Paris at the Galerie Goemans, by which time it had already been acquired by André Breton, the formidable leader of the Surrealists. Breton, too, wrote the preface to the 1929 exhibition catalogue accompanying the exhibition, praising Dalí's novelty and capacity for "voluntary hallucination." Breton specifically alluded to this work when he wrote: "We are literally caught . . . in the gaze of this lion's head, large like anger . . . not only in his paintings but moreover inside us, yes in a sort of interior vitrine."[1]

When the painting was originally exhibited in 1929, it was listed in the catalogue with the French title *Les accommodations des désires*, but at the time of Dalí's second solo exhibition (with Pierre Colle, 3–15 June 1931), it subtly had changed to *Les accommodations du désir*. In this way the desires were rendered grammatically singular and the current title established. In his statement, published in the exhibition handlist, Dalí wrote, "Ornamental Art Nouveau objects reveal to us in the most material way, the persistence of dream in reality, for these objects submit to a scrupulous examination giving us the most hallucinatory dream elements."[2]

The captivating power of the double images in *Accommodations of Desire* was first explained by Dalí in theoretical terms the following year in both Catalonia and Paris. In his March 1930 essay "The Moral Position of Surrealism," published in the review *Hèlix*, Dalí referred to another recent painting, *Paranoiac Woman-Horse* (Centre Pompidou, Paris), and told how this methodology grew out of painting: "Recently I have obtained, by a distinctly paranoiac process, an image of a woman, whose position,

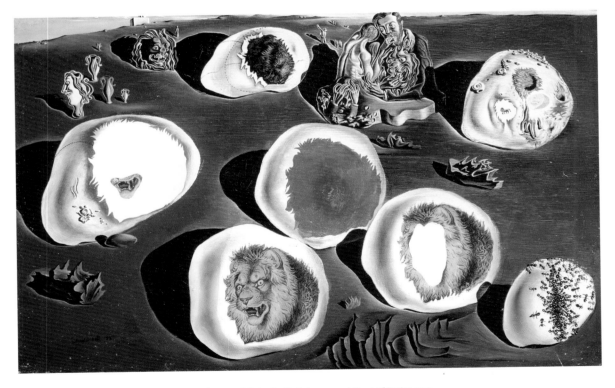

Fig. 1 (cat. 7:33). Salvador Dalí, *Accommodations of Desire*, 1929.

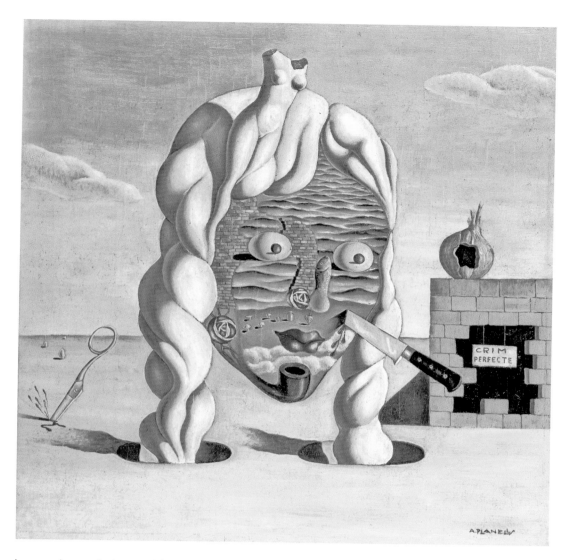

shadow, and morphology, without altering in the slightest its real appearance, help form at the same time the image of a horse."[3] Though this explanation remained theoretically ambiguous, his ideas were soon clarified in the short text, "The Rotting Donkey," published both in the movement's organ *Le Surréalisme au service de la Révolution* (1930) and in Dalí's book *La femme visible* (1930):

*The reality of the external world serves as an illustration and proof, and is placed thus at the service of the reality of our mind. . . . It is by a distinctly paranoiac process that it has been possible to obtain a double image: in other words, a representation of an object that is also, without the slightest pictorial or anatomical modification, the representation of another entirely different object.*[4]

For Dalí, the double image was proof of the paranoiac's domination over reality.

While it is commonplace to consider the other Catalan Surrealists from the Empordà, the coastal region north of Barcelona, as Dalí's followers, it must be noted that, though they knew him, they simultaneously achieved ends remarkably parallel to Dalí's painting, making them partners in a common surrealist project. This was especially true of Àngel Planells, whose *Perfect Crime,* 1929 (fig. 2), depicts a woman whose transparent face becomes the sea. The metamorphosis is set in a barren landscape that brings to mind Dalí's painting of the period, and it is similar to Dalí's *Accommodations of Desire* in that the basic element is a face. The knife stabbing the face recalls the violence at the beginning of Dalí and Luis Buñuel's film *Un Chien andalou* (1929). Joan Massanet's *Landscape,* 1929–30 (fig. 3), presents a similarly transformed woman's head, which doubles as a mask and is set at the edge of the sea. This head-mask is connected to bone-like phallic shapes from

Fig. 2 (cat. 7:32). Àngel Planells, *The Perfect Crime,* 1929.

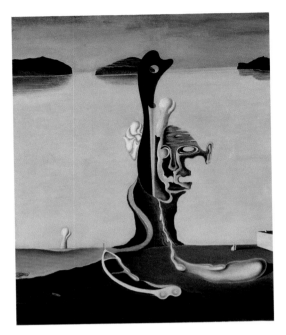

which flows a white liquid symbolic of desire, and two breasts protrude from the stern of the partially soft fisherman's boat in the foreground. In Esteban Francés's *Surrealist Composition*, 1932 (fig. 4), a stage-like platform is set in a barren landscape, a compositional device that evokes both psychoanalytic narrative and cinema, devices notably present in Dalí's *The First Days of Spring*, 1929 (Salvador Dalí Museum, St. Petersburg, Florida), another work included in the 1929 Paris exhibition. In the left foreground an eyeless, seated figure with one leg applies the needle of a sewing machine to its leg—a sexual metaphor. The figure's disembodied eyes are supported by a long-necked figure with a spoon attached to its leg. Beyond, another similar figure with spoons at the end of an arm and a leg wades through the sand in a ponderous dream landscape.

Massanet, born in the Empordà town of l'Armentera, was self-taught and scarcely active in the wider situations of Barcelona and Paris, apart from his participation in the 1936 Exposició Logicofobista, while Planells and Francés were more active participants in the avant-garde. Planells participated in the group exhibition of abstract art at Galeries Dalmau in 1929. In 1932, the Galeria Syra gave him a solo exhibition, and again in 1934 he exhibited at the Galeries Catalònia. In 1936 he participated in the Primer Saló de l'Associació d'Artistes Independents at the Galeries Catalònia and the important Exposició Logicofobista, whose title suggesting a phobia against logic. Massanet also contributed to the 1936 International Surrealist Exhibition at the New Burlington Galleries in London, along with Dalí and the other Spaniards Oscar Domínguez, Maruja

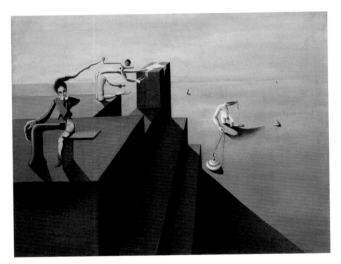

Fig. 3 (cat. 7:34). Joan Massanet, *Landscape*, 1929–30.
Fig. 4 (cat. 7:36). Esteban Francés, *Surrealist Composition*, 1932.

Mallo, Joan Miró, and Pablo Picasso, although the latter was never an official member of the group.

Esteban Francés was born in Portbou, also in the Empordà region, on the border with France, and like Dalí grew up in Figueres. He met the Surrealists in the early 1930s. After participating in the 1936 Exposició Logicofobista, he fought in the Spanish civil war and then moved to Paris, where he joined the surrealist movement. After the German occupation in 1940, he fled to Mexico, where he contributed his *The Atrocious Rites,* c. 1938 (location unknown), to the International Exposition of Surrealism at the Galería de Arte Mexicano, organized by Breton, Wolfgang Paalen, and Cesar Moro. Two years later Francés went to the United States, where he was again in touch with the Surrealists in exile and exhibited in the First Papers of Surrealism curated by Marcel Duchamp. Apart from Dalí, Francés was the only Surrealist from the Empordà to enter the movement formally, though his later work moved away from its origins and had more in common with that of artists such as Roberto Matta.

For Dalí, modernista and Art Nouveau architecture offered a concrete example of the contemporary psychological crisis that he wanted to propel to a breaking point. Such ideas contrasted with the then-fashionable tendency for sleek rationalism in architecture advanced in Paris by Le Corbusier and in Barcelona by architects such as Josep Lluís Sert and members of GATCPAC (Association of Catalan Architects and Technicians for Progress in Contemporary Architecture). Nothing was more out of fashion than the 1900s style associated with the previous generation. Dalí's interest in Art Nouveau was already present in *Accommodations of Desire,* where an Art Nouveau jug in the top left-hand corner seems to look out at the viewer. For Breton, who noted this detail in his catalogue preface, the gaze of this jug opened inside the viewer an "interior vitrine."[5] For Dalí, Art Nouveau perhaps best embodied the most disturbing aspects of the 1930s, precisely because it was not merely a "fantasy," but architecture that had actually been constructed, with many of the most spectacular examples located in Barcelona. Dalí's 1933 essay "Concerning the Terrifying and Edible Beauty of Art Nouveau Architecture" appeared in the French surrealist re-

view *Minotaure.* Dalí focused on the cannibalism implicit in such architecture and related ornamentation, and notably included photographs by Man Ray of the wave-like façade of Antoni Gaudí's Casa Milà and related examples of architecture and ornamentation:

*It is thus to my mind, precisely . . . the quite ideal Art Nouveau architecture that would embody the most intangible and delirious hyper-materialist aspiration. An illustration of this apparent paradox would be found in a wild comparison . . . that consists of likening an Art Nouveau house to a cake, to an exhibitionist, an ornamental "confectioner's" table. I am saying that this is a lucid and intelligent comparison, not only because it indicates the overwhelming materialist prosaism of the immediate and urgent needs on which rest ideal desires, but also because this comparison in reality alludes without euphemism to the nutritive and edible character of this kind of houses, that are none other than the first edible houses, the first and only eroticized buildings, whose existence gives proof of a "formation" that is urgent and needful for the amorous imagination: to be really and truly able to eat the object of desire.*[6]

As if the point was not stressed strongly enough in Dalí's vigorous prose, the text was immediately followed by another short text, "The Phenomenon of Ecstasy" (fig. 5), which was accompanied by a photocollage by Man Ray using images mostly of

Fig. 5 (cat. 7:38). Salvador Dalí (text) and Man Ray (photography), "The Phenomenon of Ecstasy," *Minotaure,* no. 3–4 (12 December 1933).

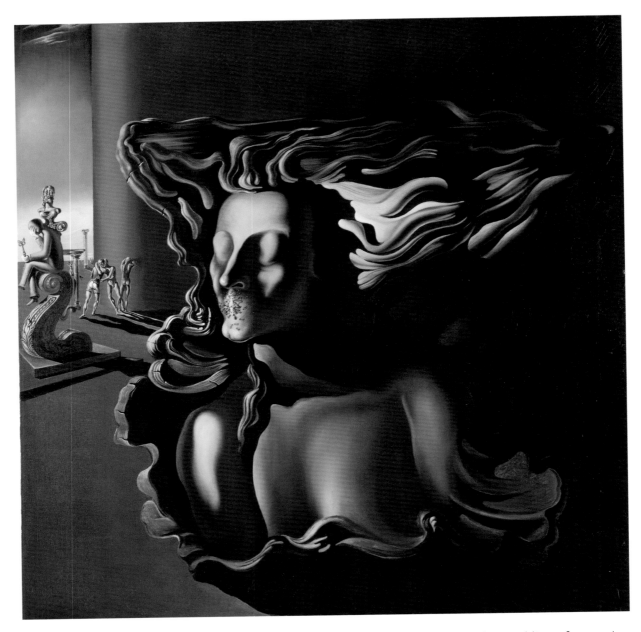

women's ears and faces in a spiral suggesting erotic abandon, the ear of course standing in for the vulva. In the text, Dalí wrote: "Ecstasy is the 'pure state' of the demanding and hyperaesthetic vital lucidity, the blind lucidity of desire."[7] He concluded by calling for a search for images likely to provoke such a state.

The central image of Dalí's *The Dream*, 1931 (fig. 6), is the bust of a woman, her flowing hair evoking the Art Nouveau ornamentation of female figures; it also recalls the article in *Minotaure*, which had the following captions: "sculptural ecstasy" and "invention of sculptural hysteria."[8] A similar female figure appears in *The Font*, 1931 (Salvador Dalí Museum, St. Petersburg, Florida), which includes a kind of desecrated Art Nouveau baptismal font. Here, though,

the figure is more sculptural, resembling a fragment ripped from an architectural façade. Michael Taylor suggests that her sculptural presence brings to mind the Medusa myth, which certainly would have been congruent with Dalí's terror of intimacy with women.[9] Her closed eyes suggest the realm of sleep. The area where her mouth should be is covered by ants, indicating that it represents a displacement of her sex, just as Dalí had similarly used the ear as a displacement of the object of desire in "The Phenomenon of Ecstasy." The male figures in the background hold their heads in shame; they could be the dream images of the female figure. Arguably, Dalí most successfully realizes the metaphorical convergence of Art Nouveau and erotic desire in *The Dream*.

Fig. 6 (cat. 7:35). Salvador Dalí, *The Dream*, 1931.

In an extraordinary issue of the magazine *D'Ací d'Allà* (see fig. 1, p. 370) guest edited by Josep Lluís Sert and Joan Prats as representatives of GATCPAC and ADLAN (Friends of New Art), Magí Cassanyes wrote of the "infinite silence" and "fatal resonance" of Dalí's paintings of the early 1930s.[10] Though he was referring to Dalí's *The Weaning of Furniture Nutrition,* 1934 (Salvador Dalí Museum, St. Petersburg), Cassanyes might just as well have been writing about *The Dream.* Another article in the same issue, "Vers la màgia" (Toward Magic), immediately followed, in which Cassanyes argued that, unlike Miró's expression of primitive magic, Dalí represented a "myth" in painting in order to create a "religion."[11] For Cassanyes, Dalí and Miró were the only two Catalan artists who had influence (and mattered) in "universal art."[12] In strict art historical terms this assertion has proved to be true. At the same time, while Dalí was the most universal of the Empordà surrealist painters, he was paradoxically also the most local.

1. André Breton, *Dalí,* exh. cat. (Paris: Galerie Goemans, 1929), unpaginated; text reprinted as "Première exposition Dalí," in Breton, *Œuvres complètes* (Paris: Gallimard, 1992), 2:308.

2. Salvador Dalí in *Exposition Salvador Dalí* (Paris: Galerie Pierre Colle, 1931), unpaginated. Translation by the author.

3. Dalí, "Posició moral del surrealisme," *Hèlix* (Vilafranca del Penedès, Spain) 10 (22 March 1930), 4–6; reprinted in *Collected Writings of Salvador Dalí,* ed. and trans. Haim Finkelstein (Cambridge, U.K.: Cambridge University Press, 1998), 221.

4. Dalí, "L'Âne pourri," in *La Femme visible* (Paris: Editions Surrealistes, 1930), 11–20, and *Le Surréalisme au service de la Révolution* (Paris), no. 1 (July 1930), 9–12; reprinted in Finkelstein, *Collected Writings of Salvador Dalí,* 223–24.

5. Breton, *Dalí.*

6. Dalí, "De la beauté terrifiante et comestible de l'architecture 'modern' style," *Minotaure,* no. 3–4 (12 December 1933), 69–76; reprinted in Finkelstein, *Collected Writings of Salvador Dalí,* 197–98.

7. Dalí, "Le Phénomène de l'extase," *Minotaure,* no. 3–4, 76–77; reprinted in Finkelstein, *Collected Writings of Salvador Dalí,* 201.

8. *Minotaure,* no. 3–4, 73.

9. Michael Taylor, in *Dalí,* ed. Dawn Ades and Michael Taylor, exh. cat. (Philadelphia: Rizzoli/Philadelphia Museum of Art, 2005), 122.

10. Magí A. Cassanyes, "Dalí," *D'Ací d'Allà,* no. 179 (December 1934), unpaginated.

11. Cassanyes, "Vers la màgia," ibid.

12. Ibid.

# Between Amateur and Avant-Garde: The Professional Photographer in Barcelona during the 1930s

*J O R D A N A   M E N D E L S O N*

Pere Català-Pic was arguably not an avant-garde photographer.[1] To write this is to understand something of the complexity of 20th-century Catalan photography. Looking at photomontages such as Català-Pic's *Desire to Fly*, 1931 (fig. 1), or *Billy*, 1935–36 (fig. 2), one can sense the novelty, speed, and excitement of modernity. These are not simple images. Català-Pic used overlay, juxtaposition, and selective lighting to create otherwise impossible combinations. In *Desire to Fly*, the profile of a woman's head with flowing hair is joined to the body of an airplane as this visual monstrosity glides effortlessly over a semi-rural landscape of buildings and fields. The plane's propellers and engine have been replaced with the force of the woman's imagination. Her closed eyes and slightly open mouth, along with the clouds that border the bottom edge of the photograph, introduce the viewer to a dreamscape: the image of modernity flies high above the expansive pull of the land, yet the technique of montage presses her sharply against tradition.

As beautiful as *Desire to Fly* is in its ability to capture the triangulation of industry, tradition, and imagination, it is also an awkward image. The difference in scale between the woman, the plane, and the townscape make reconciling these figures nearly impossible. If, as Walter Benjamin wrote, the photographer is like a surgeon whose instruments cut through reality,[2] here Català-Pic shows us the sutures of that operation, literally. In this early montage, we see the fissures between contrasting sources in the white lines delineating the figure from ground. Whereas *Desire to Fly* shows Català-Pic to be an apprentice in the advanced techniques of both publicity and surrealist photography, in *Billy* he dominates our senses and has mastered montage and the application of surrealist juxtaposition for the purpose of mass advertising. *Billy* is an illusion made real, and the product being worn is not just a manufactured item, but modernity itself in the form of a well-built shoe and a seamlessly joined photomontage.

The rationalization of desire (and its relation to commerce) was one of the features to define Català-Pic's work during the 1930s; it was also the key to his standing as a polemicist, if not a rebel, within the context of Barcelona's photographic institutions.[3] The innovation that he brought to Barcelona was

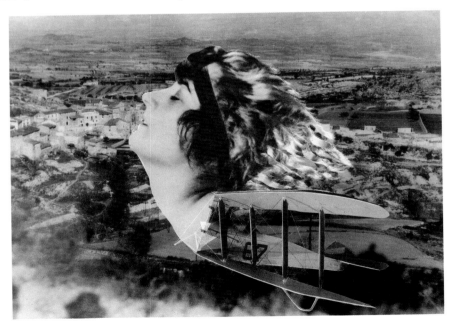

Fig. 1 (cat. 7:41). Pere Català-Pic, *Desire to Fly*, 1931 (printed by Pere Català Roca in 1969).

his embrace of avant-garde artistic techniques with a deep understanding of the revolutionary potential of advertising and the application of psychological insights to the field of commercial photography. Thus, at the same time that he praised French surrealist photographer Man Ray in the Barcelona press, Català-Pic also supported the Catalan government's Seminar on Publicity and used his skills as a writer, editor, and commercial photographer to contribute to magazines, including *Mirador* and *D'Ací d'Allà*.[4] During the civil war he became head of publications for the Generalitat's Comissariat de Propaganda and produced one of the war's most famous posters, *Let's Crush Fascism* (see fig. 7, p. 441).[5]

In bringing together antithetical modes of thinking and being (avant-garde and commercial), Català-Pic was positing a new kind of photographer, the "phototechnician." Neither portrait photographer nor pictorialist amateur, for Català-Pic the phototechnician would draw upon broad cultural knowledge, expert training, and the specific qualities of photography to guide the viewer's eye to respond to the public display of visual images. He launched his polemic from within one of the same institutional contexts he sought to renovate, the Agrupació Fotogràfica de Catalunya's *Art de la Llum: Revista Fotogràfica de Cataluña*, which had become the primary outlet for amateur pictorialist photographers in Barcelona and had established itself as the register against which the artistic value of a photograph (and its author) was measured.[6] Published in August 1933, Català-Pic used his editorial for *Art de la Llum* to mark not only a distance from his previous work as a portrait photographer in the town of Valls, but also to signal his position as a major voice within the capital's ongoing debates about photography.[7]

Photographic societies supported Pictorialism as a benchmark of excellence and artistic achievement by establishing regular competitions and publishing beautiful high-quality illustrated journals that created a selective system for approval. The amateur photographic society was an international phenomenon that made of Pictorialism a widely accepted style well into the 20th century. In Spain, the Agrupació Fotogràfica de Catalunya and the Real Sociedad de Fotografía in Madrid were among the two most active and long-standing associations. While scholars have recently recovered the diversity

Fig. 2 (cat. 7:40). Pere Català-Pic, *Billy,* 1935–36.

within Pictorialism and argued for a greater attention to those photographers who operated idiosyncratically within amateur photography societies, when Català-Pic published his complaint in 1933, Pictorialism was the default photographic style for an elite group who saw their national identity as Catalans intimately linked to their dedication to photography. For them, true photographic practice (as an art form) was necessarily separated from the world of commerce and the banalities of everyday life.[8] Dedication to time-intensive bromoil transfer and pigment processes insured that individual prints (sometimes made using Fresson paper) were valued highly as the products of quality craftsmanship: no two prints or two photographers were exactly alike. It is because of their close attention to older photographic techniques and a more conservative approach to subject matter and composition that pictorialist photographers were seen to be more traditional, both artistically and, at times, politically. Ironically, however, the same affluent members of the Agrupació who defended amateurism and Pictorialism in photography belonged to the class of industrialists and professionals who contributed to the city's economic prosperity and modernization. In this light, one might read Català-Pic's essay as a call to bring the photographer closer to the industrialist, to close the gap between what the Agrupació perceived to be photography's proper place within the artistic pantheon and Català-Pic's argument for photography to work hand-in-hand with industry to create new images that produced reality through the photographic lens instead of copying the past.

Català-Pic's editorial was no doubt directed at photographers such as Joaquim Pla Janini, who helped found the Agrupació in 1923. Like many of the members of the Agrupació, Pla Janini's exposure to photography began when he was young, in his case at the age of 14. While maintaining a successful career in medicine (he received his doctorate in 1903 from the Universidad Pontifícia de Santo Tomás in the Philippines), Pla Janini actively published and exhibited his photography, gaining national and international attention for his work. Along with Madrid-based José Ortiz-Echagüe, he was considered Spain's foremost representative of Pictorialism and an expert technician.[9] He was president of the Agrupació from 1927 to 1930 and when he retired from medicine in 1931 he turned all of his attention to photography. In 1934, *Art de la Llum* dedicated a monographic issue to his work, with Claudi Carbonell (one of the cofounders of the Agrupació) praising Pla Janini's technical skill and his role as a model for new generations of Catalan photographers.[10]

Although Català-Pic and Pla Janini shared a commitment to developing photography within a Catalan framework of civic culture and institutional support (whether it be the Generalitat or the Agrupació), they occupied opposite poles in terms of the kind of techniques they sought to develop and the model for photographic practice they encouraged. Pla Janini promoted his work within the competitions and journals sponsored by amateur photographic societies and took inspiration from the traditions of the Academy; he sought to bring to photography a painter's attention to pigment, process, and materials. Català-Pic was widely published in the commercial illustrated press and exploited the possibilities of new vantage points, experimental techniques, and modern advancements in cameras and printing. And yet, during the 1930s, both men grappled to define a mode of photographic artistry and production that at times intersected, as in their common appearance in *Art de la Llum*.

Pla Janini is most well known for his landscapes and costumbrista scenes, many of which are lush photographic prints made with exceptional attention to texture and detail that often shared compositional affinities with modernista painters such as Santiago Rusiñol.[11] *Guarro Factory Garden* (Museu Nacional d'Art de Catalunya, Barcelona), an undated early work by Pla Janini, is an example of his expert use of symmetrical composition and deep perspective to instill a sense of timelessness on a subject of modernity: the leisure spaces of industrialists and the working classes. From about 1915 to 1930, Pla Janini engaged in a series of mythological works, including the triptych *The Fates,* 1915–30 (fig. 3), in which draped figures populate a barren coastal landscape evoking a sense of loss and return through repetition and variance. Framed together as a single piece, Pla Janini imbued this work with atmospheric Romanticism and monumental importance. Perhaps influenced by Català-Pic's call for photographers

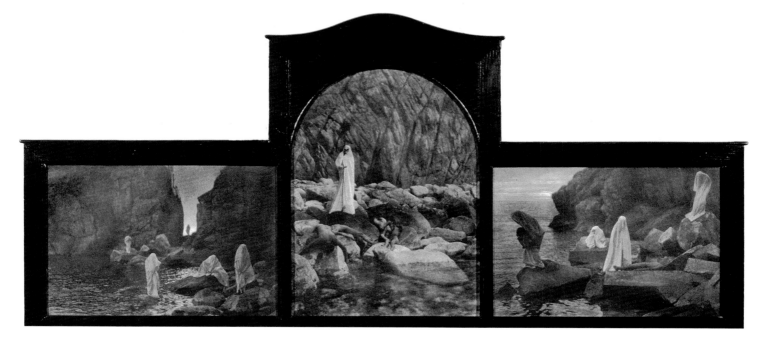

to experiment and use the camera to capture new subjects, in the years following *The Fates* Pla Janini continued to photograph landscapes, genre scenes, and still lifes, though with greater attention to the possibilities of abstract composition and the dynamic use of light and shadow. His undated *Still Life* (Museu Nacional d'Art de Catalunya, Barcelona), likely from the 1930s, contrasts the raking diagonal of a background shadow with the ultimate hybrid sign of German New Objectivity and Mediterranean modernity—the cactus—in a still life that fuses, if incompletely, the traditional bromoil process with references to contemporary culture.[12]

If both commercial photographers and select Pictorialists were willing to incorporate formal lessons from the avant-garde through the adoption of more dynamic camera angles, sharper cropping, and experimental techniques, the separation between the two practices, professional and amateur, was nonetheless firmly defended. As discussed earlier, for those who had the economic independence to dedicate themselves to photography as a leisure activity, albeit one that was organized and institutionalized, there was a stated desire to separate their activities from those who used the medium to earn a living. However, as Joan Fontcuberta has pointed out, there were cases of "schizophrenic" photographers, individuals who were able to straddle both sides of this photographic divide. In describing the possible reasons for such a crossover (mostly of professional

photographers participating in the Agrupació's activities), Fontcuberta proposed: "A possible interpretation is that numerous professionals believed that their reputation could be strengthened with the success and popularity of the competitions and publications controlled by the Pictorialists, and that this reputation might later prove to be useful as a form of publicity for future clients."[13]

Josep Masana was one of the most successful of these schizophrenic or crossover photographers, and his photographic style and practice embody the complexities and pitfalls of trying to relegate Catalan photographers to one category at the exclusion of others. Like Català-Pic, who was born in the southern Catalan town of Valls, Masana grew up just outside Barcelona, in Granollers. In Valls and Granollers, cafés, *tertúlias* (meeting places for informal discussion), film houses, and photography studios were among the signs of a growing middle class that benefited from Catalonia's industrialization. Both Català-Pic and Masana established themselves first as professional studio portrait photographers, and like many photographers of the period they were interested in film.[14] From about 1922–24, Masana was general director of the *Boletín de Información Cinematográfica*, which was housed in the same building as his portrait studio, and in 1935 he founded the Cine Savoy on Barcelona's passeig de Gràcia. For his part, Català-Pic had been one of the founders of Publi-Cinema, a movie theater also located on the passeig de Gràcia

Fig. 3 (cat. 7:39). Joaquim Pla Janini, *The Fates,* c. 1915–30.

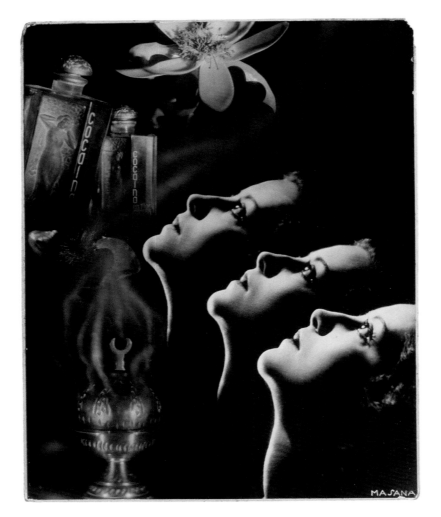

that began publishing a magazine of the same name in October 1934.[15] Thus, both photographers were active participants in developing the photography and cinematography industries in Barcelona, and they understood through their engagement with popular culture the complexity of designing images that could capture and hold a viewer's attention. Along with Català-Pic and Josep Sala, Masana was one of the city's most widely published publicity and commercial photographers.[16] All three made active use of photomontage, typography, and graphic design in their work.

By 1924, Masana had moved his photo studio and residency to 3, ronda de Sant Pere, just off the centrally located plaça de Catalunya, where he installed an advanced illumination system for taking indoor portraits (which became Masana's specialty). As Christina Zelich has pointed out, Masana was able to draw influences from both Pictorialism and the most advanced artistic and publishing practices in Barcelona, in large part through his extended

network of social and professional contacts.[17] While never a member of the Agrupació, Pla Janini was one of Masana's good friends. His home-studio was located in the same building as the Llibreria Catalònia, which housed the administrative offices for the popular magazine *D'Ací d'Allà*, whose artistic directors, Sala and later the team of Llovet and Frisco, made into one of the most stridently modern and prolifically illustrated photographic magazines in Spain.[18] The pages of *D'Ací d'Allà* featured advertisements designed by Català-Pic and Masana, among others. Josep Dalmau, Barcelona's most famous dealer and curator of avant-garde art, organized landmark exhibitions (including a show that paired Salvador Dalí's paintings with Man Ray's photographs of Gaudí's architecture) in the basement galleries of the Llibreria Catalònia.

Masana's undated publicity photograph for the perfume *Cocaine* (fig. 4) combined Català-Pic's call to create seamless montages for the creation of photographic illusions with a studied use of portraiture,

Fig. 4 (cat. 7:42). Josep Masana, *Cocaine,* undated.

still life, and expert manipulation of artificial light. The three repeated profiles of the woman looking up toward the doubled bottles of perfume and the blooming flower draw the viewer into a fantasy built less on the mechanics of modernity (like Català-Pic's *Desire to Fly*) than on a cinematic model of projection and fantasy. Perfume, textiles, automobiles, and *cava* (Catalan sparking wine) were some of the products to be advertised using montages by Català-Pic, Masana, and Sala. Each developed an identifiable style, but all three understood that the application of avant-garde photographic techniques, from the close-up straight style of new objectivity to the montage aesthetics of Surrealism and the promotion of commercial goods, allowed them to merge artistic and industrial modernity in a way that clearly appealed to the same members of the Catalan elite, who in their leisure time might, nevertheless, choose for themselves the more artistically conservative practice of Pictorialism.

Beyond Català-Pic, Pla Janini, and Masana there were numerous photographers whose practices exceeded the categories outlined in this essay. Each of them intersects with and complicates further our understanding of the various modes through which photographers in Barcelona were able to draw upon the city's rising modernity and growing social and political tensions. Many of these photographers took the city itself as their subject. Adolf Zerkowitz, who was born in Vienna, came to Barcelona in 1914 when he fled World War I. As Fontcuberta has noted, although Zerkowitz used the popular format of the postcard to distribute his work, he bypassed the typical tourist frame of the city, capturing instead concentrated meditations on the monuments and figures of the urban scene with insistence and sobriety.[19] His photographs of Antoni Gaudí's Park Güell, Casa Batlló, and Casa Milà (see fig. 4, p. 213) also serve as striking examples of early architectural photography, capturing both the wide expanses of structure and the rhythm of repeated forms. Austrian-born Margaret Michaelis also arrived in Barcelona as an exile, fleeing persecution from the Nazis around 1933. Like Zerkowitz, she made a reputation as an architectural photographer, and her work for the progressive architectural collective GATCPAC (Association of Catalan Architects and Technicians for Progress in Contemporary Architecture) spanned capturing the street life and tenement housing of the 5th District to the architects' showcase designs in the Eixample and Sitges.[20] Her photographs dominated the pages of the GATCPAC's journal *A.C.*, as well as other local and national publications (see figs. 14 and 15, p. 404).

With the outbreak of the Spanish civil war, many photographers contributed their work to the Comissariat de Propaganda, including Sala, Michaelis, and Emili Godes, who was most famous for his experiments in macrophotography during the 1930s.[21] Agustí Centelles was, like many of the aforementioned photographers, including Godes, a member of the Agrupació, yet he became neither a publicity photographer nor a committed Pictorialist. Instead, Centelles was a pioneer in modern photojournalism. After purchasing a Leica in 1934, Centelles worked as an independent photographer, publishing widely in newspapers that included *La Humanidad, Diario de Barcelona,* and *La Vanguardia*. His photographs of Barcelona's barricades during the popular defense of the city against the insurgent coup in July 1936 were published worldwide, including repeatedly in the comisarriat's serial magazine *Visions de Guerra i Reraguarda*.

The history of photography in Catalonia is full of stories of individuals who worked to develop a photographic practice that combined personal vision (their own understanding of a photographer's place in relation to society, the traditions of art, and the novelty of publicity and the illustrated press) and the aspirations of a city that sought to hold onto its unique national identity as the capital of Catalonia while embracing cosmopolitan modernity. In the work of Català-Pic and Masana we see two photographers who blended these influences into dynamic, luxurious photomontages that appeared widely in the magazines of the period and helped to shape an image of modernity as enticing, ephemeral, and available for purchase. At the same time, their own practice grew and was pressured by competing photographic institutions and styles, which included both Pictorialists such as Pla Janini and photojournalists such as Centelles.

1. In his exhibition and catalogue on Spanish avant-garde photography, Juan Naranjo brings together a diverse group of photographers, including Pere Català-Pic, Josep Renau, Emili Godes, and others. His essays provide an excellent overview of modern photography in Spain and are a major resource for those interested in the history of Catalan photography. In questioning Català-Pic's status as an avant-garde photographer, my intention is not to undermine the legitimate connections that existed between Català-Pic and members of the local and international avant-garde but to clarify his commitment to publicity photography as a fundamental partner to Barcelona's modernization, which necessarily depended upon a collaboration with industry and institutions such as the Generalitat. If the value of Naranjo's study was recuperative and inclusive, mine here is to figure the differences between photographers who might otherwise be seen together under the umbrella of "avant-garde" or "modern." See Juan Naranjo's introductory essay in *Les avantguardes fotogràfiques a Espanya 1925–1945*, exh. cat. (Barcelona: Fundació "la Caixa," 1997), 14–31. For an earlier study of modern Spanish photography, see Joan Fontcuberta, *Ideas & Chaos: Trends in Spanish Photography 1920–1945*, exh. cat. (Madrid: Ministerio de Cultura, 1985).

2. Walter Benjamin, "The Work of Art in the Age of Mechanical Reproduction (1936)," in *Illuminations: Essays and Reflections*, ed. Hannah Arendt (New York: Schocken Books, 1969), 233.

3. For a more extended analysis of Català-Pic and publicity, see my "Desire at the Kiosk: Publicity in Barcelona during the 1930s," *Catalan Review* 18, no. 1–2 (2004): 191–207.

4. Pere Català-Pic, "Man Ray," *Mirador* 8, no. 329 (6 June 1935): 7; and Català-Pic, "Man Ray. Un fotógrafo de nuestros días," *Revista Ford*, no. 36 (August 1935): unpaginated.

5. For more on Català-Pic's work for the comissariat and his poster *Let's Crush Fascism*, see Miriam Basilio's essay, "Catalans! Catalonia! Catalan Nationalism and Spanish Civil War Propaganda Posters," in section nine of this catalogue, and my "Advertising the Revolution," in *Traces, Flashes and Vision in Spanish and Latin American Photography*, ed. Andrea Noble and Antonio Sánchez (Oxford/New York: Berghahn Books, forthcoming).

6. *Art de la Llum* was founded and directed by photographer and critic Andreu Mir Escudé; see Fontcuberta, "La fotografía catalana de 1900 a 1940," in Naranjo et al., *Introducción a la Historia de la Fotografía en Cataluña* (Barcelona: Lunwerg, 2000), 82.

7. Català-Pic, "Un article per 'Art de la Llum,'" *Art de Llum: Revista Fotogràfica de Catalunya* 1, no. 3 (August 1933): 19–20. See also Català-Pic's "La fotografia: El seu valor psicopublicitari," *Butlletí Seminari Publicitat* 1, no. 1 (July 1933): 16–17; "La publicitat moderna," *Mirador* 5, no. 216 (23 March 1933): 7; and "La publicitat moderna," *Mirador* 5, no. 220 (20 April 1933): 2. The most complete documentation on Català-Pic and his publications is Pilar Parcerisas, *Fotografía y publicidad. Pere Català i Pic*, exh. cat. (Barcelona: Lunwerg/Fundació "la Caixa," 1998). I

thank Parcerisas for generously sharing with me her notes on the photographer and her many years of research.

8. Fontcuberta, "La fotografía catalana de 1900 a 1940," 82.

9. See Carl S. King, *The Photographic Impressionists in Spain: A History of the Aesthetics and Technique of Pictorial Photography* (Lewiston, N.Y.: Mellen Press, 1989); and *La fotografía pictorialista en España 1900–1936*, exh. cat. (Barcelona: Fundació "la Caixa," 1998).

10. Pere Formiguera, "Joaquim Pla Janini: La fotografía apasionada," in *Joaquim Pla Janini*, exh. cat. (Barcelona: Lunwerg/Fundació "la Caixa," 1995), 19.

11. Even more than Pla Janini, Pere Casas i Abarca and Joan Vilatobà i Figols created photographic compositions in relation to modernista painters. See Fontcuberta, "La fotografía catalana de 1900 a 1940," 79–80.

12. See Juan José Lahuerta, "Instantànies de viatge," in *J. LL. Sert i la Mediterrània*, ed. Antonio Pizza (Madrid/Barcelona: Ministerio de Fomento/Col·legi d'Arquitectes de Catalunya, 1997), 190–208; and Ángel González García, "Meditación de los cactus," in *El Resto. Una historia invisible del arte contemporáneo*, ed. Miguel Ángel García, exh. cat. (Bilbao/Madrid: Museo de Bellas Artes/Museo Nacional Centro de Arte Reina Sofía, 2000), 217–31.

13. Fontcuberta, "La fotografía catalana de 1900 a 1940," 82. Translation by the author.

14. Cristina Zelich, "Josep Masana. Del classicisme a l'avantguarda," in *Josep Masana 1892–1979*, exh. cat. (Barcelona: Generalitat de Catalunya, 1994), unpaginated. For an overview of Masana, see also *Masana Fotògraf, Granollers 1894–Barcelona 1979*, exh. cat. (Granollers: Cercle Cultural de la Caixa de Pensions, 1984).

15. "A manera de presentación," *Publi-Cinema* 1 (October 1934): 1.

16. For a more extensive comparison of Català-Pic and Sala, see *Visions útils: Pere Català Pic, Josep Sala. Fotopublicistes dels anys 30*, exh. cat. (Barcelona: Fundació "la Caixa," 1994).

17. Zelich, "Josep Masana."

18. Joan Tresserras, *D'Ací d'Allà. Aparador de la modernitat (1918–1936)* (Barcelona: Llibres de l'Índex, 1993), 83–96, 144–58.

19. Fontcuberta, "La fotografía catalana de 1900 a 1940," 86.

20. See my "Architecture, Photography and (Gendered) Modernities in 1930s Barcelona," *Modernism/Modernity* 10, no. 1 (January 2003): 141–64; and with Lahuerta, *Margaret Michaelis: Fotografía, vanguardia y política en la Barcelona de la República*, exh. cat. (Valencia/Barcelona: IVAM Centre Julio González/Centre de Cultura Contemporània de Barcelona, 1998).

21. For an overview of the Comissariat de Propaganda and its publications, see Maria Campillo, *Escriptors catalans i compromís antifeixista (1936–1939)* (Barcelona: Curial/Publicacions de l'Abadia de Montserrat, 1994).

# Against Logic: The Exposició Logicofobista in Catalonia

*JORDANA MENDELSON*

The history of modernism is rich with stories about the ways in which particular moments of display have created lasting imprints in the formation of the historical legacies of artists, movements, and their promoters.[1] In the case of Barcelona and the history of Surrealism in Catalonia that event was the Exposició Logicofobista, held 4–15 May 1936 at the Galeries d'Art Catalònia, located in the basement of the Llibreria Catalònia, a bookstore headquartered just off the Plaça de Catalunya.[2] The timing of the exhibition—a little more than two months before the outbreak of the Spanish civil war—has created an aura around Barcelona as a veritable last stand for Surrealism in 1930s Spain, or at the very least, as a sign of the city's enduring embrace of the latest artistic trends championed by the Catalan literary and cultural elite at a moment of increasing political violence. Of course, Surrealism was not a new invention at the time of the exhibition, nor was Barcelona the only city in Spain to hold a significant show of surrealist art: in 1935, an international exhibition of Surrealism was held in Santa Cruz de Tenerife, accompanied by the second issue of the *Bulletín International du Surréalisme* published in October.[3] For artists and historians working to recuperate an avant-garde tradition in Barcelona, however, the Exposició Logicofobista has been seen as a demonstration of the acceptance of avant-garde art in a capital where Surrealism had been received with mixed reviews since the mid 1920s.

Although the artists included in the exhibition, both mature and newly minted, produced work that firmly rested within ongoing trends in European modern art (collage, surrealist-inspired iconography, and abstract objects and assemblages), and which represented some of the most dynamic art being produced in Catalonia during the 1930s, the reason for the exhibition's lasting impact within art history might be attributed less to the selection of artists than to the group of experienced cultural entrepreneurs who organized the event and helped frame its reception as a capstone in a line of other Catalan vanguard events. Legendary dealer and avant-garde promoter Josep Dalmau oversaw the bookstore's gallery from 1933 until the end of 1934.[4] His inaugural show paired Salvador Dalí's latest paintings with Man Ray's photographs of Antoni Gaudí's modernista architecture. Although receiving uneven reviews in the press, the event marked a return of sorts for Dalmau, but even more it demonstrated the emerging role of a new organization with which he collaborated, ADLAN (Friends of New Art). The group's statutes made its objectives clear: "ADLAN calls on you to protect and to lend your zealous support to any risky manifestation that involves a desire to make things better."[5] As utopian and provocative as its goals may have been, ADLAN was able, perhaps more than any other group, to promote Surrealism (and a host of other artistic endeavors) as newsworthy items within the Catalan press, and thus inscribe itself (and Surrealism) into the historical record.

The primary motivators behind ADLAN were a dedicated group of businessmen, shopkeepers, critics, and artists who had already demonstrated their capacity to organize spectacles—from manifestos and concerts to exhibitions—and were thus primed to take full advantage of the public's mix of curiosity and hesitation before the challenges of Cubism, Futurism, and Surrealism.[6] Members included poet J. V. Foix and critics Sebastià Gasch and Magí A. Cassanyes, all of whom had contributed to the literary magazine *L'Amic de les Arts,* published in Sitges from 1926 to 1929. Although it was Cassanyes who had originally suggested calling the group El Club dels Esnobs (Club of Snobs), as Joan M. Minguet Batllori and Jaume Vidal i Oliveras have recounted in their chronology of the avant-gardes in Catalonia, it was the combined force of writer Carles Sindreu with that of industrialist Joaquim Gomis, architect Josep Lluís Sert, and hatmaker Joan Prats that provided the group's solid foundation.[7] Each was more than his described profession, and their connections to a national and international network of artists insured an ever-changing variety of activities: Gomis was

also a photographer and postcard collector; Prats was a promoter and collector of avant-garde art; Sert was instrumental in bringing the work of ADLAN into close collaboration with that of the progressive architectural collective GATCPAC (Association of Catalan Architects and Technicians for Progress in Contemporary Architecture). Prats and Sert co-edited a special issue of *D'Ací d'Allà* in December 1934 dedicated to explaining the most advanced artistic practices to the magazine's middle-class readership (see fig. 1, p. 370); since its publication, the issue has become a landmark souvenir of the early 20th-century avant-garde in Barcelona (especially for artists such as Antoni Tàpies who came into their own after the civil war).[8]

Within the context of the many events ADLAN organized, the Exposició Logicofobista turned out to be an eclectic show; intended as a major, collective exhibition of Surrealism, it ended up bringing together artists whose commitment to André Breton's tenets varied along with their choices of style and medium. The program for the exhibition itself, described in detail below, made this tension visible by including two texts that defined Logicofobisme

and its relation to Surrealism differently. Thus, instead of holding the exhibition up as the pinnacle of surrealist achievement, we might acknowledge that it worked better as a demonstration of heterodoxy within Catalan art and as the culmination of ADLAN's promotional activities than as any conclusive statement about the uniform acceptance of one artistic method over another. In the time running up to the Exposició Logicofobista, the group had sponsored exhibitions of Hans (Jean) Arp and Pablo Picasso, and a group show in March 1935 dedicated to sculptors Ramon Marinel·lo, Jaume Sans, and Eudald Serra, all three of whom would be included in the Logicofobista exhibition.

Of the shows held at the Galeries d'Art Catalònia, it was ADLAN's exhibition of Marinel.lo, Sans, and Serra (and to a lesser degree Dalmau's 1934 monographic exhibition of Àngel Planells) that prefigured the Exposició Logicofobista. The announcement, designed by Salvador Ortiga, featured cutout photographs of the sculptors' heads atop brightly colored paper costumes. As if stepping out of a carnival scene, Ortiga featured the artists as characters from a parade, each one occupying a different role:

Fig. 1 (cat. 7:48). Joan Miró, *Homage to Joan Prats*, 1934.

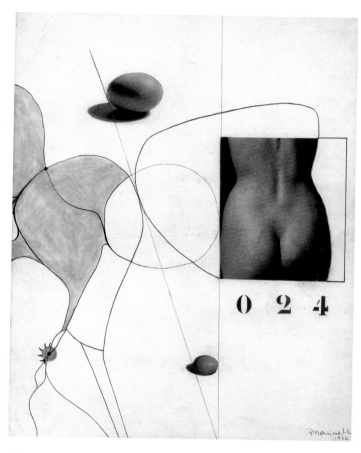

dancer, bullfighter, and horseman (accompanied by a miniature drawn horse). A paper doily surrounded the announcement and contrasted its references to domesticity and turn-of-the-century embellishments with the modern stenciled letters revealing in bright green "ADLAN," followed by the names of the artists and the date and location of the exhibition stenciled in black ink. Collage as a medium of choice was shared by all four artists (including Ortiga), and linked their experiments with the contemporaneous work of Joan Miró, who in 1933 had produced a series of collages contrasting hand-drawn lines with mass reproductions (postcards, anatomical engravings, publicity images, etc.).[9] Miró's *Homage to Joan Prats,* 1934 (fig. 1), is particularly playful, combining five cutout photographs of hats (taken from publicity material) thrown into an overlapping, twisted array of lines that loosely form an erotic sketch that brings together desire, friendship, commerce, and artistic innovation. Miró wrote in pencil "homenatge a," leaving the viewer to complete the sentence with the printed logo, "Prats is quality." Marinel·lo's *Venus 024,* 1936 (fig. 2), owes a great deal to Miró's collage. Not only did Marinel·lo include clear references to

the anthropomorphic oculi that populated Miró's drawings and paintings from the 1920s onward, he also played with the juxtaposition of freely drawn lines and photographic images that put into conversation not only forms of creativity, but also categories of the avant-garde: the shadowed egg might have reminded viewers of Herbert Bayer's Bauhaus publicity montages, while the photograph of the back of a nude female torso recalls both Man Ray's photographs and those from popular photography annuals and magazines from the period. The addition of the stenciled black numbers "024" below the photograph further brings to mind standardization, mass reproduction, and the aesthetic of the sales catalogue, which Miró too was exploring in these years.

Magí A. Cassanyes was a motivating force behind the Exposició Logicofobista. Along with Prats and other members of ADLAN, Cassanyes imagined an exhibition that would survey Surrealism in Spain and include Dalí and Miró as well as the younger generation of artists, such as Marinel·lo and Sans. However, in the end, neither Dalí nor Miró contributed to the show, though their influence was clearly

Fig. 2 (cat. 7:47). Ramon Marinel·lo, *Venus 024,* 1936.

present in the work of Marinel·lo, Planells, and Joan Massanet.[10] Artists just making their way into gallery exhibitions, such as Estaban Francés, his studio mate Remedios Varo, and Joan Ismael pushed critics to consider Surrealism as an energizing, not just imitative force. Varo's collage *Anatomy Lesson*, 1935 (fig. 3), though not included in the Exposició Logicofobista, punches holes in the viewer's expectations. A white biomorphic space in which float cutouts of eyes, two X-rays of torsos, and an anatomical cross section creates the platform for four truncated figures whose drawn torsos (complete with arrows pointing to specific features) are topped off with photographic portraits.

Varo's penetrating use of collage to explore the limits of biological integrity and the permeability of appearances is also visible in the work of Antoni García Lamolla. His *Diary of a Psychoanalyst*, 1935 (fig. 4), pairs anatomical references with a newspaper silhouette of a female figure containing painted shapes. The open space in the center of the figure is blocked by a grid behind which is the profile of a face with eye open. Drawn in a rudimentary style, Lamolla's figures and shapes take on enigmatic

Fig. 3 (cat. 7:44). Remedios Varo, *Anatomy Lesson*, 1935.
Fig. 4 (cat. 7:50). Antoni G. Lamolla, *Diary of a Psychoanalyst*, 1935.
Fig. 5 (cat. 7:49). Antoni G. Lamolla, *Untitled*, 1934.
Fig. 6 (cat. 7:45). Artur Carbonell, *Constellation*, 1933.

qualities that make of his compositions riddles to be solved (fig. 5). As Manuel Viola explained in a statement about Lamolla written on the occasion of his exhibition in Madrid in 1935: "Psychologists and poets, in a combined effort, have reached a spiritual introspection that reaches out in posterior derivations to the field of biology."[11] The anatomical and the interior life of the subject are joined together as illustrations in the collages of Varo and Lamolla, but in Lamolla's sculptural work, like Marinel·lo's, the influence of Arp is the strongest; both artists could have seen Arp's work at the Galeries d'Art Catalònia. Their

three-dimensional pieces were often shaped, then painted in white, creating open expanses of undulating forms that contrast with the referential complexity of their collages, connecting as much with fellow Logicofobista Artur Carbonell's painted abstract visionscapes (fig. 6) as with Arp's biomorphic sculpture. Lamolla had more works than any other artist included in the Exposició Logicofobista (six in total), and he was one of three artists from Lleida actively involved in ADLAN and the exhibition.

The presence of surrealist artists from Lleida was remarkable in the Exposició Logicofobista, in

large part because of the relative novelty of their involvement with the Barcelona art scene. Lamolla, Leandre Cristòfol, and Manuel Viola (pseudonym of José Viola Gamón, who signed his work at the time as J. V. Gamón, J. Viola, or J. Viola G.) represented a group of young artists, writers, and designers who were making Lleida into a significant center of avant-garde activity, even if their complaints reveal a need to connect not only with Barcelona as the "center" of progressive art in Catalonia, but also with an international community of artists who were challenging assumptions about the way art and design should function within the framework of local culture. One of the most visible contributions made by the Lleida group was the magazine *Art*, published from 1933 to 1934.[12] Joining a long line of "little magazines" that sought to revolutionize Catalonia's provincialism through the publication of searing manifestos and sharp-tongued attacks on the status quo, *Art* was a richly designed publication that featured poems, art criticism, and manifestos. Its editor, Enric Crous Vidal, made of typography itself a weapon (and liability) in the strategic placement of counterculture ambitions. As the presentation appearing in the first issue stated: "An international magazine. Against geographic closure. Not as a voluntary imperative, but as a vital necessity. Not Lleida-Barcelona or cosmos, but within the cosmos: Lleida-Barcelona."[13] The last line made perfectly clear what Crous Vidal, Viola, and their colleagues at arms were calling for: "A printing error has left off the prefix 'anti' before our masthead." Thus, what was absent from the banner of their first issue—Antiart— was what came closest to connecting this mid 1930s rebellion to earlier Catalan manifestos, which too had made the call to "antiart" a rallying cry for artistic and literary innovation.[14]

Published on the occasion of the Exposició Logicofobista, the manifesto-program (fig. 7) exposed a divide that existed between writers such as Cassanyes, who had been involved with the Catalan avant-garde since the 1920s, and the continued enthusiasm for Surrealism that was supported by Viola and the artists from Lleida. Whereas Cassanyes's text leaned toward the philological and philosophical in his description of what the term "Logicofobista" meant (explaining through Hegelian dialectics that a fear of logic would result in the embrace of metaphysics), Viola linked the exhibition to Surrealism by making Surrealism itself a kind of subset of Logicofobisme and making poetry the portal through which both would take artists to a new form of knowledge. Cristòfol was one of the artists who made the ideals of Logicofobisme most visible, as well as the artist closest to *Art*'s declaration: "We forget what 'sculpture' means. It is not in our dictionary." Cristòfol's *Moonlit Night*, 1935 (fig. 8), displays strong similarities to the experiments of another artist included in the Logicofobista exhibition, Àngel Ferrant, whose juxtapositions of found and natural objects became three-dimensional counterparts to the collage experiments of Lamolla, Marinel·lo, and others. For Viola, it was the purity of the forms in Cristòfol's work and the elimination of everything extraneous to the object that opened the door for these constructions to function as poetic objects.[15]

In interviews with Jordi Jou published in the press, Cassanyes publicized his ambitions for the exhibition: "Look, basing ourselves in Hegelian classifications, we believe that art should not lower itself to that which is below it, like politics, the economy, etc., but rather should force itself to serve that which is above it, which is to say, religion and philosophy."[16] At the time of the

# Exposició Logicofobista

ARTUR CARBONELL
1 Interior
2 Paisatge assassinat
3 Orbita

LEANDRE CRISTÒFOL
4 Peix damunt la platja
5 Nit de lluna
6 L'auréola axial i impassible esia a punt de sortir
7 Finestra

ANGEL FERRANT
8 Composició
9 Dibuix

ESTEVE FRANCES
10 Maria és casadora
11 De la mar sorgeix un mal son
12 Chipre-remei o el complex del dictador

A. GAMBOA-ROTHWOSS
14 Pensaments claustrals de Jo-salat Jokey
15 Records dels ocells sentimentals
16 Entertainment

A. G. LAMOLLA
16 L'espectre de les tres gràcies dins l'aura subtil
17 Madrèpora onirico-plàcida
18 Tubercul incubic tot esperant l'hora seca
19 Per la planicie implacable passa alguna cosa
20 Carícia oviforme
21 Abracada aeri-plàstica sense perifrasi

RAMON MARINEL·LO
22 Cap crepuscular
23 Els meus records d'adolescent
24 Noies que es besen
25 Les dues amigues (cristal·lització)

JOAN MASSANET
26 Rastre fatídic del simulacre sòlid

MARUJA MALLO
27 L'empremta
28 Granotes i excrements

ANGEL PLANELLS
29 Natura morta (el silenci s'ha fet concret)
30 La dona impúdica
31 L'arpa de Napoleó

JAUME SANS
32 Camagüey

NÀDIA SOKALOVA
33 La boira

REMEDIOS VARO
34 Llicons de costura
35 Accidentalitat de la dona-violència
36 La cama alliberadora 'de les amibes gegants

JOAN ISMAEL
37 L'arpista tot improvisant
38 En arribar Clotilde
39 Va arribar quan jo l'esperaba

Fig. 7 (cat. 7:43). Magí A. Cassanyes and J. Viola Gamon, *Catalogue of the Exposició Logicofobista*, May 1936.

interview with Jou at the Cafè Vienès in Barcelona, Marinel·lo, Francés, Varo, and Viola accompanied Cassanyes. His prediction for the exhibition was that it would "include all of the Surrealists of the Peninsula and some from elsewhere," and when Jou asked him about the long-range plans for Logicofobisme, Cassanyes responded: "We are thinking of organizing exhibitions in all of the major cities within and beyond the Peninsula. Publications and conferences, even by radio, will disseminate the group's ideas."[17] So, while historians consider Viola the most ardent Surrealist of the emerging group, Cassanyes clearly had in mind a model for expanding Logicofobisme built on Breton's strategies in Paris: use publicity and modes of public display and attraction to create an expanding artistic and cultural movement from a small group of artists.

Despite the enthusiasm of Cassanyes and Viola and the best-laid plans by members of ADLAN to found a new Logicofobisme movement, at least related to Surrealism in the minds of several of its promoters and participants, critics such as Gasch refused to view the Exposició Logicofobista as a successful demonstration of Surrealism's lasting impact in Catalonia. In his interview with Guillem-Jordi Graells on the 50th anniversary of the surrealist manifesto, Gasch declared: "There was never a surrealist group in Catalonia." Pushed to clarify, Gasch explained:

*Apart from isolated cases, from some individuals, [there was] little [penetration of Surrealism in Catalonia]. In fact, it had a resonance through Dalí, Foix, Planells. As a movement, it didn't reproduce anything here, not even a coherent group, only individuals. They would call us "Surrealists," but it was an inappropriate label. What happens is that beginning in the 1930s they called everything Surrealist, even*

Fig. 8 (cat. 7:46). Leandre Cristòfol, *Moonlit Night*, 1935.

*though it didn't have anything to do with orthodox Surrealism. The majority of us were more like rationalist avant-gardists. At least that's what I think, that I have always been anti-Surrealist because I have been dominated by logic.*[18]

As illogical as it appeared to Gasch, the Exposició Logicofobista was staged to become a major event in the history of modern art in Catalonia. Viola's writings demonstrate a rich dialogue with Surrealism, and many of the artists involved in the exhibition were able to take over a decade of surrealist-inspired experimenation into surprisingly new directions, even when their works showed the continued imprint of Miró and Dalí. Varo's collages, Cristòfol's object-sculptures, Carbonell's abstract paintings, and Lamolla's painting-collages and objects all demonstrate the willingness of a new generation of Catalan artists to innovate within (and against) a history of avant-garde art in Catalonia that by 1936 had become more of a tradition than the members of ADLAN could have imagined.

1. See Bruce Altshuler, *The Avant-Garde in Exhibition: New Art in the 20th Century* (Los Angeles: University of California Press, 1994).

2. For a more detailed history of each of the artists participating in the Exposicó Logicofobista, see Lucía García de Carpi, *La pintura surrealista española: 1924–1936* (Madrid: Istmo, 1986), 77–136.

3. *Gaceta de Arte y su época: 1932–1936,* exh. cat. (Las Palmas de Gran Canaria: Centro Atlántico de Arte Moderno, 1997).

4. Jaume Vidal i Oliveras has observed that following the closure of Dalmau's own gallery in 1930, his presence within the Catalan art scene began to recede even while he was coordinating the exhibitions at the Galeries d'Art Catalònia. Dalmau died in September 1937. See Vidal, *Josep Dalmau: L'aventura per l'art modern* (Manresa: Fundació Caixa de Manresa, 1988), 103–4, 232. For more on Dalmau and the exhibitions he organized at his own galleries, see Jordi Falgàs's essay, "Gleizes and Picabia at Galeries Dalmau: Too Green for Our Teeth," in this section of this catalogue.

5. See Joan Minguet Batllori and Jaume Vidal i Oliveras, "Critical Chronology (1906–1939)," in *Avantguardes a Catalunya 1906–1939,* ed. Daniel Giralt-Miracle, exh. cat. (Barcelona: Fundació Caixa de Catalunya/Olimpíada Cultural, 1992), 696.

6. On the most infamous of these events, see Minguet, *El Manifest Groc: Dalí, Gasch, Montanyà i l'antiart,* exh. cat. (Barcelona: Generalitat de Catalunya/Fundació Joan Miró/Círculo de Lectores, 2004).

7. Minget and Vidal, "Critical Chronology (1906–1939)," 696–97.

8. For more on ADLAN, see William Jeffett's essay, "Joan Miró and ADLAN," in this section of the catalogue.

9. For a fuller discussion of this series of collages, see my "Joan Miró's *Drawing-Collage,* 8 August 1933: 'Intellectual Obscenities' and the Collection of Mass Culture," *Art Journal* 63, no. 1 (Spring 2004): 24–29.

10. For more on the Empordà Surrealists, see Jeffett's essay, "Paranoiac Surrealism," in this section; *Joan Massanet o el espectro de las co-sas,* exh. cat. (Madrid: Aldeasa, 2005); and Lucía García de Carpi and Josefina Alix Trueba, eds., *El surrealismo en España,* exh. cat. (Madrid: Museo Nacional Centro de Arte Reina Sofía, 1994).

11. Manuel Viola, "Un artista leridano. El espectro Lamolla," in Viola, *Escritos surrealistas (1933–1944),* ed. Emmanuel Guigon (Teruel: Museo de Teruel, 1996).

12. Valeri Mallol Agulló, *La Revista "Art" de Lleida* (Lleida: Institut d'Estudis Ilerdencs, 1995). Also see Minguet, "Art i les revistes catalanes d'avantguarda," *URC.Revista literària,* no. 20 [special issue: "Revistes literàries a la Lleida d'entreguerres 1919–1939"] (December 2005): 68–74.

13. "Presentació," *Art,* no. 1 (1933): 1. All translations from the Catalan by the author, unless otherwise noted. For more on Vidal, see Patricia Molins, *Enric Crous-Vidal de la publicidad a la tipografía* (Valencia: IVAM, 2000).

14. For more on "anti-art" in Barcelona, see Minguet, "Anti (1930): una revista d'avantguarda," in *Miscel·lània Joan Fuster* (Barcelona: PAM, 1990), 171–82; and Juan José Lahuerta, *Decir anti es decir pro. Escenas de la vanguardia en España* (Teruel: Museo de Teruel, 1999).

15. For Viola's writings on Cristòfol and others, see Viola, *Escritos surrealistas.*

16. Jordi Jou, "Una conversa amb Magí A. Cassanyes. El Logicofobisme," *La Humanitat,* 29 April 1936, 4. My thanks to John Wilcox for locating several articles on the Exposició Logicofobista in Barcelona, all of which were originally cited in the bibliographies of Lucía García de Carpi's *La pintura surrealista española: 1924–1936* and Josep Bota-Gibert's "Bibliogafía," in *Joan Massanet o el espectro de las cosas.*

17. Ibid.

18. Guillem-Jordi Graells, "Gasch: No ha existido ningún grupo surrealista en Cataluña," *El Noticiero Universal,* 10 December 1974, 37.

# Joan Miró and ADLAN

*WILLIAM JEFFETT*

By the time the association ADLAN (Friends of the New Art) was founded (officially on 9 November 1932), Joan Miró was already established as the most important Catalan artist of his generation. The main instigators of ADLAN were close friends: Joan Prats, Joaquim Gomis, and Josep Lluís Sert. Its membership included Salvador Dalí, Josep Vicenç Foix, Sebastià Gasch, Joan Miró, Lluís Montanyà, Carles Sindreu—that is, most of Barcelona's literary, artistic, and architectural avant-garde—as well as their supporters: the silversmiths Ramon Sunyer and Rogeli Roca; Monserrat and Núria Isern of the Galeria Syra; and Antoni and Miquel Albareda, owners of the Hotel Bristol, where the inaugural meeting of the group took place on 23 October 1932.

The new association was announced in November 1932 by art critic Gasch in the newspaper *La Publicitat,* which noted: "Several sympathizers of art that try to say something new have gathered together under the name of ADLAN (Friends of New Art). Books that can not find an editor, exhibitions that can not find a gallery, all that only counts with the adhesion of a select minority, will be welcomed complacency by the ADLAN."[1] The group's manifesto, distributed in 1932, proclaimed its vague ambition to support all things free and new in the arts, with emphasis on the latest manifestations and a call to support a "totalitarian" art, meaning an art with universalist aspirations rather than one with a political agenda:

ADLAN
a group of friends open to all new forms of spiritual disquiet.
ADLAN will interest you:
1) if you are temperamentally disposed to follow the trajectory of the arts of today.
2) if you respectfully protect (selecting with passion) all efforts towards the unknown.
3) if you maintain an open mind in the face of dogma and accepted values.

4) if you wish to march to the rhythm of the discoveries of the spirit of today (alongside the discoveries of genius).
5) if you wish to be receptive to the latest manifestations in all of the arts.
6) if you wish to fight for a totalitarian art in accord with the universal aspirations of the moment.
7) if you wish to save what is **living** within **the new** and what is **sincere** within the **extravagant**.
ADLAN calls you
to protect and to encourage **all enterprises of risk accompanied by a desire to excel**.[2]

ADLAN was ecumenical, even missionary, and above all open-minded. Yet it was apolitical and promoted art rather than politics, though it sought to defend the contemporary against tradition. This was an exceptional position in a divided period, which essentially corresponded with the Second Republic (1931–39), especially given that most of the members' sympathies lay with the republic, a fact that would become ever more obvious after the Spanish civil war began in 1936. At this point the ambitious activities of the group were necessarily truncated, though a number of members, such as Miró and Sert, were major instigators of the republic's Spanish Pavilion at the Paris Universal Exposition of 1937.

ADLAN carried on the activities of the group around the review *L'Amic de les Arts,* which had ceased publication in 1930. Indeed, many of the members of both groups were the same. During the 1910s and 1920s, the art dealer Josep Dalmau had almost single-handedly invented the "avant-garde" scene in Barcelona. Though he closed his gallery in 1930, from 1933 forward he supported the many cultural activities of the association in his role as artistic director at the Galeria d'Art Catalònia.

In the beginning, ADLAN's activities were varied and ambitious but targeted at a small and select group. In November 1932, Alexander Calder performed his circus and late that same year Federico García Lorca read from *Poet in New York.* The as-

sociation also sponsored exhibitions devoted to Objects of Bad Taste (1934), Primitive Art (1935), and Children's Drawings (May 1935), as well as performances Black Music and Theatre (23 December 1932) and Comparative Dancing (24 March 1935), not to mention the exotic Perfumes Essences Retrospective to 1900 (15 June 1934), along with diverse poetry and literature readings of a more conventional nature. Though initially such events and exhibitions reached a small audience, and often lasted only for a day, the art exhibitions had the greatest impact. In 1933, the Galeries Syra presented exhibitions by Alexander Calder and Àngel Ferrant (privately in January), and Dalí showed at the Galeria d'Art Catalònia (8–21 December) in an exhibition that also included photographs of Dalí's paintings by Man Ray, as well as a number of independent works by the American photographer. In 1934, ADLAN expanded its activities to Madrid. In Barcelona, the Cordobés painter Antonio Rodríguez Luna exhibited at the Galeria d'Art Catalònia (April), as did Dalí later in the year (2–4 October), although Dalí's lecture scheduled for 5 October was cancelled and he hastily returned to France because of the political crisis (see below). ADLAN presented Jean Arp at the Roca Jewelry shop

(9–14 March 1935), which was designed by Sert in the rationalist mode and located on the fashionable passeig de Gràcia. At the end of the month, the Galeria d'Art Catalònia presented a three-person exhibition of sculptors Ramon Marinel·lo, Jaume Sans, and Eudald Serra (27–30 March 1935). Later that spring, the group also presented Man Ray in a solo exhibition at the Roca Jewelry shop (29 May–30 June 1935).

The culmination of exhibition activity was the organization of a major Picasso show at the newly opened Sala Esteve (13–18 January 1936) and the large group Exposició Logicofobista (4–15 May 1936) at the Galeria d'Art Catalònia. The former presented 25 recent works by Picasso and attracted several thousand visitors. All in all, the Picasso exhibition was a huge success, though a controversial and scandalous one that provoked a critical backlash from the mainstream press, which was less predisposed to the group than *La Publicitat,* whose main critic was the far from neutral Gasch.[3] The group's final exhibition, the Exposició Logicofobista (the title implies a phobia against rationality), demonstrated the rippling effect of Surrealism through the contemporary Catalan avant-garde: apart from

Fig. 1 (cat. 7:51). Joan Miró, cover for *D'Ací d'Allà,* no. 179 (December 1934).

Miró, Dalí, and Oscar Domínguez, it included every Catalan artist of any importance engaged with such progressive ideas.[4]

Throughout its existence, however, ADLAN was most consistently focused on Miró. On 18 November 1932, it sponsored a private view of Miró's most recent works at the Galeries Syra that included paintings on wood and object assemblages from the previous summer. However, Gasch's account of the elegant party—where the guests wore dinner jackets and evening dresses, and which commenced at 11 p.m.—only mentions the paintings, though his comments are deliberately vague, as if Miró's work transcended language: "Forms never seen, colors never imagined, expressive force never dreamt, true creations of a pure poet, Miró's works are a formidable human fact, on which the stereotyped phraseology of a critic cannot comment."[5] Guillem Díaz-Plaja's review in *Mirador* is more explicit about the objects: "THE OBJECTS—of the objects—wood, nails, bones, jars of marmalade, cages and mirrors—one can't even speak of them; they are not even funny."

His comments on the paintings are informed by the objects: they take on an organic quality as if they are straining against the confines of their frames, "and well; one has all the impression that these canvases of Joan Miró are not surrendered to the frame. That the figures—which they have found, without permission of the author, are liquid or intestine forms—they can become larger or smaller, wider or narrower, without losing their own quality of the organic thing."[6] This event established a pattern of presenting the artist's work in Barcelona just before sending it for exhibition in Paris. Miró again exhibited new work, a series of 18 paintings based on collages, on 4 June 1933 under the auspices of ADLAN in another private event, this time at Sert's house. In May that year, the Liceu Theater on the Rambla had presented the Ballet Russes de Montecarlo's production of *Jeux d'enfants,* with sets designed by Miró, to an enthusiastic critical reception. Finally, on 16 February 1934 at the Galeria d'Art Catalònia, Miró again presented paintings after collages in a private viewing attended by Josep Cassanyes, Artur Carbonell, Josep

Fig. 2 (cat. 7:52). Joan Miró, *Figures in Front of the Sea,* 1934, pochoir published in *D'Ací d'Allà,* no. 179 (December 1934).

Dalmau, J. V. Foix, Lluís Montanyà, Joan Prats, Carles Sindreu, etc.

In December 1934 an "extraordinary" edition of the review *D'Ací d'Allà* appeared with a special *pochoir* (hand-colored) print and the cover designed by Miró (figs. 1 and 2). Miró was further featured in a number of the texts that offered a short history of the international avant-garde to date, from Cubism through Dada, including abstract art, architectural rationalism, and Surrealism.

For Carles Sindreu, Miró's painting embodied purity. Neither figurative nor representational, it was "Stenographic painting. Stenographic in the drawings, even stenographic in the colors."[7] By stenographic, Sindreu evoked automatism as if the line and color derived from biological pulses producing an involuntary form of calligraphic "sign writing." Cassanyes's "Vers la Màgia" (Toward Magic) argued that Miró's mark-making amounted to a "primitive

magic" and consisted of "spontaneous and automatic conjurations" revealing a "disturbing vitality."[8] The issue ended with Gasch's "L'Art d'avantguarda a Barcelona," a résumé not only of such activity in the city, but of ADLAN's contribution to the avant-garde. Fittingly, Miró's part in these activities was significant, leading Gasch to comment, "At the end of 1932, the Friends of New Art (ADLAN), were disposed to continue the task of their predecessors. Thanks to ADLAN, each season Miró's most recent works were shown in Barcelona before being sent abroad. Without ADLAN these works would never have been seen here."[9]

Miró's position during the republic extended his earlier anti-art position of the years 1927–30, when he had proclaimed the "murder of painting" and begun working with unorthodox, anti-pictorial materials.[10] The essential logic of his new position was rooted in collage. His 1933 *Painting* (fig. 3) is based

Fig. 3. *Painting*, 1933, by Joan Miró.

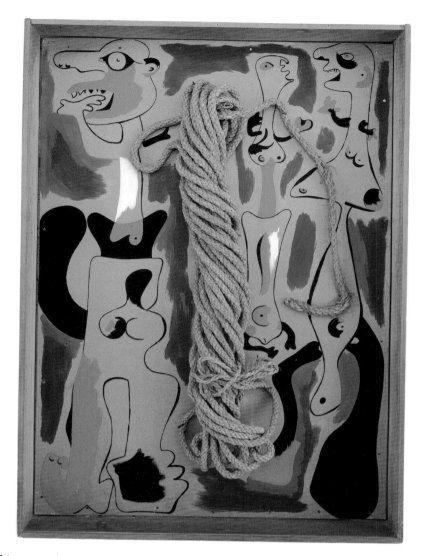

on a collage of images that he cut from technical catalogues and pasted on large sheets of paper. The shapes of the cutout forms, rather than the images represented, determined the forms in the painting, which more often than not suggested bone-like structures or the imagery of prehistoric cave paintings. The overall effect produced what resembled an abstract painting, though clearly rooted in figuration. At the same time, even these organic or "biomorphic" forms retained some trace of the original image. For example, the three curving forms in the upper right were derived from an image of three umbrellas, and the large white bone form at left taken from an illustration of industrial pipe, as can be seen in the preparatory collage from 28 January 1933 (Fundació Joan Miró, Barcelona), which replaced drawing as the model for the work. In this way collage, through its juxtapositions, sparked a productive creativity.

Miró challenged a transparent or decorative understanding of painting through both the inclusion of nonart materials and the creation of grotesquely distorted forms. His *Rope and People I,* 1935 (fig. 4), combines both strategies, and is notably less aesthetic than the 1933 *Painting.* Here grotesque male and female figures are depicted in brightly colored oil colors against a cardboard ground, the latter suggestive of the color of the earth and also decidedly not a precious material. The central protagonist of the painting, however, is a large twine of rope attached to the surface in a relief, perhaps establishing a link, or "bond," between the figures. Miró's turn toward the grotesque, which he and others have called his "savage paintings," has been described in terms of the worsening political situation and as a portent of civil war. Yet, they do not have to be read in terms of premonition, for the political situation by October 1934 was already sufficiently strained

Fig. 4. *Rope and People I,* 1935, by Joan Miró.

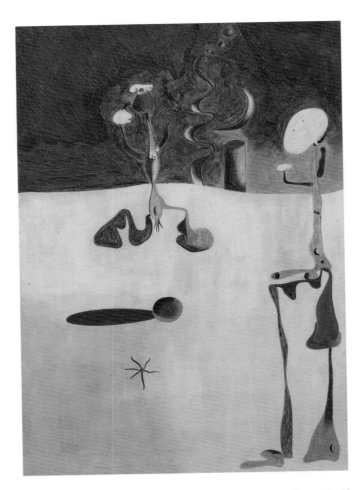

because of the revolution in Barcelona and Asturias that was brutally suppressed by the Moroccan army with significant loss of life, mainly civilians—a clear prelude to the coming conflict. Miró's small painting on copper, *Nocturne*, 1935 (fig. 5), is best understood against this backdrop. Its characters, stripped down to their essential sexuality, as in the male figure with erect sex in the foreground, and the more distant, also nude female figure in the middle ground, exist in a barren, isolated, and desert-like space. Though they are represented through their sexual attributes, their joining in such a hostile environment is by no means clear. Through such symbolism, *Nocturne* does not so much predict civil war as provide an ominous sense of the night already descending on Spain and Europe.

1. Sebastià Gasch, "Amics de l'art nou," *La Publicitat,* 30 November 1932; reprinted in *Sebastià Gasch: Escrits d'art i d'avantguarda (1925–1938),* ed. Joan M. Minguet i Batllori (Barcelona: Edicions del Mall, 1987), 203.

2. For the English translation see Rosa Maria Subirana, "ADLAN and the Artists of the Republic," in *Homage to Barcelona: The City and Its Art 1888–1936,* ed. Marilyn McCully, exh. cat. (London: Arts Council of Great Britain, 1986), 211. For the Catalan, see Jaime Brihuega, *La Vanguardia y la República* (Madrid: Cuadernos Arte Cátedra, 1982), 70; and *Las vanguardias artísticas en España: 1909–1936* (Madrid: Istmo, 1981), 332–33. See also Josep Corredor-Matheos, "ADLAN i el Surrealisme," in *Surrealisme a Catalunya 1924–1936: de l'Amic de les Arts al Locigofobisme,* exh. cat. (Barcelona: Generalitat de Catalunya, 1988), 49–51, 188; and *Las Vanguardias en Cataluña 1906–1939,* exh. cat. (Barcelona: Fundació Caixa de Catalunya/Olimpiada Cultural, 1992), 356.

3. For a more extensive discussion of the Picasso exhibition see Emmanuel Guigon, "ADLAN 1932–1936," in *Paris–Barcelone: de Gaudí à Miró,* ed. Brigitte Léal and Maria Teresa Ocaña, exh. cat. (Paris: Réunion des Musées Nationaux, 2001), 562–64.

4. See Jordana Mendelson's essay in this section of this catalogue, "Against Logic: The Exposició Logicofobista in Catalonia."

5. Gasch, "Amics de l'art nou," in *Sebastià Gasch,* 204.

6. Guillem Díaz-Plaja, "Notes a un catàleg inexistent: Joan Miró a les catacombes," *Mirador* 4, no. 199 (24 October 1932): 7.

7. Carles Sindreu, "Miró," *D'Ací d'Allà,* no. 179 (December 1934), unpaginated.

8. Magí A. Cassanyes, "Vers la màgia," ibid.

9. Sebastià Gasch, "L'Art d'avantguarda a Barcelona," ibid.

10. See William Jeffett, "Miró's Unhappy Consciousness: Sculptures and Objects, 1930–1932," in *Joan Miró,* ed. Agnès de la Baumelle, exh. cat. (Paris/London: Éditions du Centre Georges Pompidou/Paul Holberton Publishing, 2004), 81–93; *Dalí and Miró, ca. 1928,* exh. cat. (St. Petersburg, Fla.: Salvador Dalí Museum, 2003); and "A Constellation of Images: Poetry and Painting, Joan Miró 1929–1941," in *Joan Miró: Paintings and Drawings,* exh. cat. (London: Whitechapel Art Gallery, 1989).

Fig. 5 (cat. 7:53). Joan Miró, *Nocturne,* 1935.

# Two Sculptors Forged in Barcelona:
# Gargallo and González

## MERCÈ DOÑATE

Some Catalan artists hold an indisputable place among the avant-garde that developed during the years before World War II. Much of their work was developed outside Barcelona, mainly in Paris, where they moved in search of greater stimulation for their artistic creativity. For this reason, many people are unaware of their origins. An understanding of their artistic underpinnings and what it may have meant to have been born in Catalonia, thus having their own language and culture, is important because such background information may provide a key to interpreting their work. One especially significant example is the sculptor Julio González, whose work as an apprentice in his father's metal workshop was essential to his subsequent work with iron. His origins are also important to the symbolic nature of one his most outstanding works, *The Montserrat,* 1936–37 (see fig. 1, p. 468), which reflects his deep sense of his own Catalan soul.[1] González's international reputation was made during the 1930s and consolidated in the 1950s with the first rigorous studies on his work. And though it may seem paradoxical considering his strong ties to Catalonia, for many years he was practically unknown to the general public in his own city.[2] The fact is that while González maintained strong personal and professional ties with Barcelona, he lived apart from the Catalan art world during his most creative years. Perhaps he was aware that his innovative artistic language would not be well received during the 1930s, a decade when noucentista principles still prevailed and

Catalan institutions almost exclusively supported figurative art with classic roots. Pablo Gargallo, who was born in Aragon but moved to Barcelona when he was a child, is better known than González in the context of Catalan sculpture. One reason Gargallo is so well known in Barcelona is that he executed most of his sculpture there; another is that his work has a major presence in that city.[3] As well as having common objectives, the two artists had parallel journeys through life. Together, their work represents Catalonia's most important sculptural contribution to international art. The works included in this exhibition, drawn from several different periods in their careers, reflect the creative talent of both sculptors.

Gargallo and González began their careers in Barcelona in the late 19th century—the heyday of Catalan Modernisme. In spite of their different ages and the fact that they traveled in different circles, the two artists were acquainted during this period, though their friendship was cemented later in Paris. While their activities would converge in the future with their respective plans for injecting new life into sculpture with iron, their early training was very different. Gargallo was apprenticed to a sculptor, while González began as an artisan through family obligation, rounding out his training with drawing and painting. Painting was the discipline in which he envisioned his future (fig. 1). Along with his academic training at the Escola de Belles Arts in Barcelona, Gargallo worked as an apprentice in the workshop of the modernista sculptor Eusebi Arnau. At that time,

Fig. 1 (cat. 6:19). Julio González, *Woman Bathing Her Feet,* 1913.

the whirl of construction in Barcelona provided op-portunities for sculptors to collaborate on the archi-tectural decoration of the many modernista build-ings going up in the area of the city known as the Eixample (Expansion). The young sculptor quickly gained favor with the architect Lluís Domènech i Montaner, who gave him various commissions for sculptural projects for buildings such as the Palau de la Música Catalana and the Hospital de la Santa Creu i Sant Pau. Gargallo's academic training was impor-tant to his subsequent development in that, while conducting innovative formal experiments, he never gave up modeling sculpture in the round. His sculp-tural materials were diverse—stone, alabaster, mar-ble, and bronze. Added to his mastery of sculptural technique, he also had an exhaustive knowledge of forging, repoussé, joining, and welding,[4] allowing him to work with sheet metal several years later and produce sculptures of impeccable quality and con-struction from a technical point of view. Such skills were necessary during the modernista period, when architects such as Antoni Gaudí or even Domènech i Montaner promoted the revival of ancient trades deeply rooted in Catalonia. The architects sought to apply these ancient trades to the new architecture. A singular example of this revival is the wrought iron dragon on the gate of the Güell Pavilions in Barcelona designed by Gaudí in 1885, a fence that in reality is a sculpture Gargallo and González would have admired in their youth.

A possible collaboration with Gaudí is noted in a González biography. However, there is no documen-tation to confirm that the architect commissioned any artistic metalwork from Concordi González, the sculptor's father. If it existed, such a commission could have involved the son, who began working with metal decorative objects at an early age. In the family workshop, located on Barcelona's Rambla de Catalunya, he produced objects such as lamps, mirror frames, grilles, bouquets of flowers, furniture, vases, window boxes, candelabra, as well as jewelry and religious articles in gold and silver. González's expe-rience as an apprentice metalsmith allowed him to render repoussé and openwork with great technical precision. However his specialty—which he shared with his two brothers—was iron flower bouquets, some of which appeared in fine art exhibitions held

in Barcelona in the 1890s. Upon his father's death, the family business was carried on under the name Hijos de C. González, run by the oldest son. But be-cause the two brothers' aspiration to create art was inhibited by their craft work, they decided to close the business, and in 1900 the family moved to Paris.[5] During those years most young Catalan artists com-pleted their training by establishing themselves in Paris, which opened the door to a different world of art. Some quickly returned to Barcelona; others decided to stay in Paris, where their fortunes would be uneven. For more than 20 years, González exhib-ited at the Salon des Indépendants and the Salon d'Automne, including paintings, gold- and silverwork pieces, repoussé copper masks, and some small-scale bronze sculptures. He gained very little recognition apart from a few magazine reviews and the French government's purchase of a hammered bronze mask in 1912. Around 1922–23, his first individual exhibi-tions brought him a certain notice, although he did not make the decision to devote himself to sculp-ture until 1927. That was the year when he created his first iron sculptures, adding to his metalwork experience a competence in oxyacetylene welding acquired while working at La Soudure Autogène Française in 1918.[6]

It was precisely that year, 1927, that Gargallo first exhibited his iron sculptures in Paris, where he had lived from 1912 to 1915. After living in Barcelona from 1915 to 1924, where he first exhibited his iron sculptures, Gargallo returned to Paris to stay and found the new horizons that brought him closer to the innovative principles of avant-garde art. His cultural knowledge at that time consisted of a body of distinctive figurative work and some early metal-work experiments dating back to 1907, when he had rendered a mask from cut-and-joined sheet copper. Between 1913 and 1917, he attempted more complex works, in particular, repoussé or hammered reliefs of copper, brass and iron, with various ingenious technical solutions. *Woman's Torso,* 1915 (see fig. 3, p. 269), signaled a step forward in terms of its formal developments. Here Gargallo conceived a sculpture in the round in which he used a technique similar to that used for reliefs but gave the sheet copper rounded forms to obtain a modeled effect. After using beaten sheet lead to create a small series of

highly interesting but fragile pieces, he adopted a working method that consisted of cutting sheet metal from cardboard templates.[7] Once the different pieces were cut, he assembled them into innovative sculptures that retained the appearance of volume associated with sculpture in the round. Close observation of these objects allows us to confirm how his progressive mastery of these materials allowed him to advance in his formal treatment.[8] In his search for his own language with metal, Gargallo did not limit himself to the more technical aspects related to the construction of the work. Rather, he proposed new ways of treating volume. For example, he used concave forms instead of convex forms to obtain striking visual effects, and he added voids to enhance the impression of volume. The result was open or transparent structures in which voids increase the impact of volume while at the same time creating a highly attractive expressive effect. Three series with the titles "Mask of Harlequin," "Small Mask of Star," and "Mask of Picador," executed between 1926 and 1928, allowed him to perfect his working method. Other interesting works created with these techniques in-

cluded *Self-Portrait*, 1927 (Gargallo heirs, Paris), *Kiki of Montparnasse,* 1928 (Gargallo heirs, Paris), and the series "Mask of Greta Garbo" of 1928. Gargallo exhibited a version of *Homage to Chagall,* 1933 (fig. 2), at his first New York exhibition, and shortly thereafter in Barcelona and Reus, the latter exhibition opening just months before the artist's death in 1934.[9] Around 1929, he began to work with sheet iron, a thicker and more resistant material than copper, allowing him to construct works on a larger scale, including one of his most important sculptures, *Large Dancer III (Grand Ballerina),* 1929 (fig. 3).[10]

Against this background, in 1928 Picasso sketched out ideas for iron sculptures in a notebook, but his limited knowledge of metal techniques prevented him from executing these works himself. Undoubtedly he was familiar with the recent work of both Gargallo and González, two friends from his youth, through various articles published about their work. As suggested by Werner Spies in his meticulous study on Picasso's sculpture, that Picasso turned to González rather than Gargallo made sense, since Gargallo had already established his mature style,

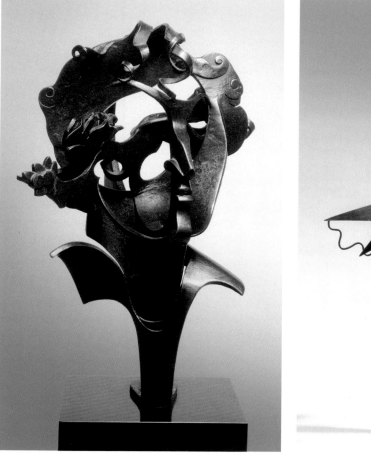

Fig. 2 (cat. 7:54). Pablo Gargallo, *Homage to Chagall,* 1933.

Fig. 3. *Large Dancer III (Grand Ballerina),* 1929, by Pablo Gargallo.

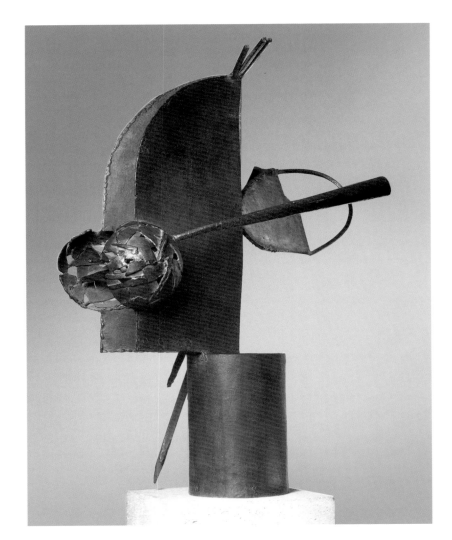

while González was still in an experimental phase.[11] The sculptures they created together, including several major works in Picasso's oeuvre, surely represented a positive experience for both artists. There can be doubt that sharing this creative endeavor with the painter was crucial in defining González's new artistic language and would be a rich resource for him in the coming years.[12] Certainly his sculptural work, primarily created after the artist was 50 years old, contributed to the essential characteristics of modern sculpture. Carrying out his creative process required absolute mastery of technique, but he also relied on drawing as an instrument to support his sculptural language. And to open up his work to new, experimental directions, González had to call upon great imaginative freedom. This freedom, along with the effective simplicity of construction that can be seen in all his works, allowed him to define an absolutely personal syntax and iconography in his maturity.

Starting in the early 1930s, González made several experimental sculptures that prepared him for executing a series of works linked to Cubism, such as the reliefs *Head with Hat, Still Life II, Dessert Dish,* and the figure *Head of a Woman I* (all Museu Nacional d'Art de Catalunya, Barcelona). A progression in the treatment of sheet iron is apparent in these works, each one cut to achieve greater depth for the figure than had been achieved with the previous work. At the same time, other formal problems led the artist to dissolve volumes and incorporate voids. Light/dark contrasts among the mass of forms and voids move these sculptures in the direction of abstraction. One work representative of these formal developments is *The Large Trumpet,* 1932–33 (fig. 4), a sculpture of great conceptual complexity suggesting the head of a woman, and which was included in the exhibition *Cubism and Abstract Art* (1936) at the Museum of Modern Art in New York. This sculpture is a wrought and welded

Fig. 4. *The Large Trumpet,* 1932–33, by Julio González.

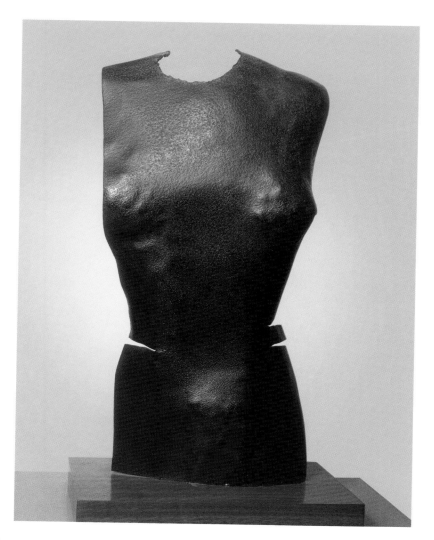

iron version of *The Small Trumpet* of c. 1932 (Museo Nacional Centro de Arte Reina Sofía, Madrid), a small-scale work in silver exploiting the same stylistic elements. The head is formed by two metal sheets joined to form a corner from which some eyes emerge in the form of half-spheres, as well as some hair. This sculpture allows different readings and interpretations, depending on the viewpoint from which it is seen.[13] Compared with the artist's abstract works, its closed and compact volumes are more in line with Brancusi's sculptures, such as *Hood,* c. 1935, and its molded sheet iron is used to suggest the volumes of the human body. González created one of his finest works, *Large Female Torso (Woman's Bust),* 1935–36 (fig. 5), using a deceptively simple technique. In this work, González demonstrated his capacity for synthesis, integrating solid material and space, while also exploiting the actual texture and appurtenance of iron, elements that enhance the sculpture's expressiveness.

*Large Female Torso* is but one in a series of sculptures created on González's other experimental path, closer to figuration. The first work in the series was *Little Peasant Woman,* rendered in silver between 1932 and 1933 (Museu Nacional d'Art de Catalunya, Barcelona), and the last was *The Montserrat.* During the same period, the artist developed a technique he defined as "drawing in space." His thread-like representations, in which the space occupied is shaped not only by physical material but also by air, are constructed with iron rods. These sculptures show the clarity of his technique—corners perfectly outlined, pieces perfectly welded—and even more important, the richness of his approach. Although their formal structure appears to be schematic, these works are highly complex, as we can see in *Woman Combing Her Hair,* c. 1934 (Moderna Museet, Stockholm), and *Large Figure Standing,* c. 1935 (Fondation Maeght, Saint-Paul-de-Vence). His late abstract sculptures, *Cactus Man,* 1939 (González Estate, Paris), and

Fig. 5 (cat. 7:55). Julio González, *Large Female Torso (Woman's Bust),* 1935–36.

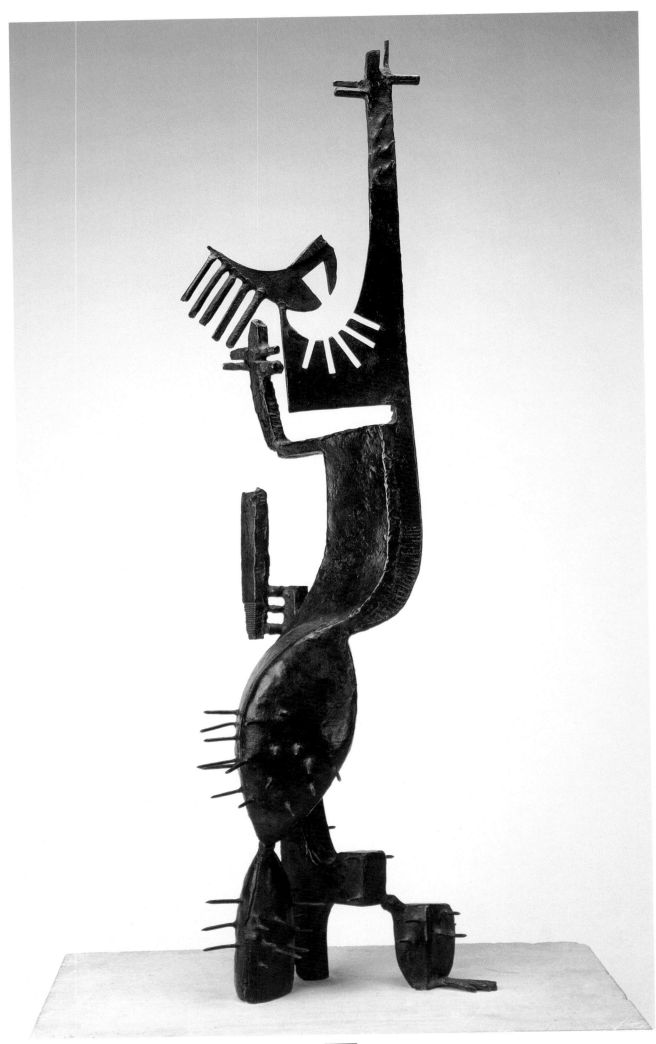

*Cactus Woman*, c. 1939–40 (fig. 6), also known as *Cactus Man II*, are actually anthropomorphic figures rendered with asymmetrical structure. In these sculptures, González dissected the structure of the human body, replacing some of its parts with schematic elements. A reading of the creative syntax of these works, alongside the artist's entire body of work, has given rise to a number of in-depth theoretical studies speculating on their significance. All in all, such writings have fostered the recognition of this Catalan artist as a major contributor to modern sculpture.[14]

Shortly before his death, Gargallo executed a series of works including *Large Bacchante* (Museu Nacional d'Art de Catalunya, Barcelona) and *Large Harlequin*, both from 1931, as well as the *Large Prophet*, 1933 (Hirshhorn Museum and Sculpture Garden, Washington), in which he combined his greatest technical and aesthetic discoveries. Here he eschewed all superfluous elements to finally achieve a synthesis of his sculptural language. González, for his part, reached artistic maturity with two works that brilliantly culminate his two parallel lines of experimentation, *The Montserrat* and *Woman with a Mirror* (IVAM, Centre Julio González, Valencia), both rendered in 1937. The decisive contributions of both artists set the parameters of sculpture in iron and, in short, enriched 20th-century art.

1. One bit of evidence of this is that for many years González signed his drawings with the Catalan name "Juli." After 1914, he began to sign González, J. González, or J.G., because of the confusion caused by his name being pronounced the same way as Julie, the female counterpart of his name in French.

2. The sculptural work of González was shown for the first time in Barcelona in 1960, except for the two masks he exhibited in the 1923 Exposició d'Art. His daughter made a major contribution of his work to the now defunct Museu d'Art Modern in Barcelona in 1972 (47 sculptures, 143 drawings, 12 pieces of gold- and silverwork, decorative art pieces, and enamel), which allowed Barcelona to preserve a portion of his work, currently included in the collection of the Museu Nacional d'Art de Catalunya.

3. In addition to his youthful work on modernista buildings, Gargallo's best known works in Barcelona are the equestrian groups he executed for the Montjuïc stadium of 1929, and which were restored for the Olympic games of 1992.

4. Gargallo was familiar with electric soldering and later, presumably through González, used autogenous or oxyacetylene welding.

5. The death of Joan González in 1908 profoundly affected his brother, with whom he was very close. Joan began his art career as a sculptor in Barcelona, although he had done artwork in Paris, focusing on drawing and painting while he was there. See *Joan González 1868–1908: Pintures, Escultures, Dibuixos* (Barcelona: Museu Nacional d'Art de Catalunya, 1998).

6. The biographical data on González appear in the extensive bibliography published on this artist. Two basic works about his career are Margit Rowell, *Julio González: A Retrospective*, exh. cat. (New York: Guggenheim Museum, 1983), and J. Merkert, *Julio González: Catalogue raisonné, Sculptures* (Milan: Electa, 1987).

7. These templates, preserved in the Museo Pablo Gargallo in Zaragoza, make it easy to understand the technical process adopted by this sculptor. Gargallo used the same templates to make several copies of the same work. See R. Ordóñez, *La nueva edad de los metales* (Madrid: Fundación Cultural Mapfre Vida, 1991).

8. See Pierrette Gargallo-Anguera, *Pablo Gargallo: Catalogue raisonné* (Paris: Les Éditions de l'Amateur, 1998).

9. Brummer Gallery, New York, 24 February–15 April 1934. Gargallo died in December that same year in the Catalan town of Reus, where he had gone to attend the opening of what would be his final exhibition.

10. One of these was included in the Pavilion of Reunited Artists at the International Exhibition in Barcelona in 1929 and the other was shown at the international sculpture exhibition organized by his art dealer, Georges Bernheim, in his Paris gallery late that same year.

11. See Werner Spies, *Picasso: The Sculptures* (Ostfildern-Ruit: Hatje Cantz, 2000).

12. Excellent studies have been published analyzing González's relationship with Picasso during the period 1928–32. See Rowell, *Julio González*, and Spies, *Picasso: The Sculptures*.

13. The catalogue raisonné not only reproduces two versions, but also the preparatory drawings. See Merkert, *Julio González: Catalogue raisonné*.

14. Various specialists such as J. Withers, T. Llorens, R. Kraus, P. Curtis, and V. Bozal, among others, have analyzed González's abstract sculpture.

Translated by Eileen Brockbank.

Fig. 6 (cat. 7:56). Julio González, *Cactus Woman (Cactus Man II)*, c. 1939–40.

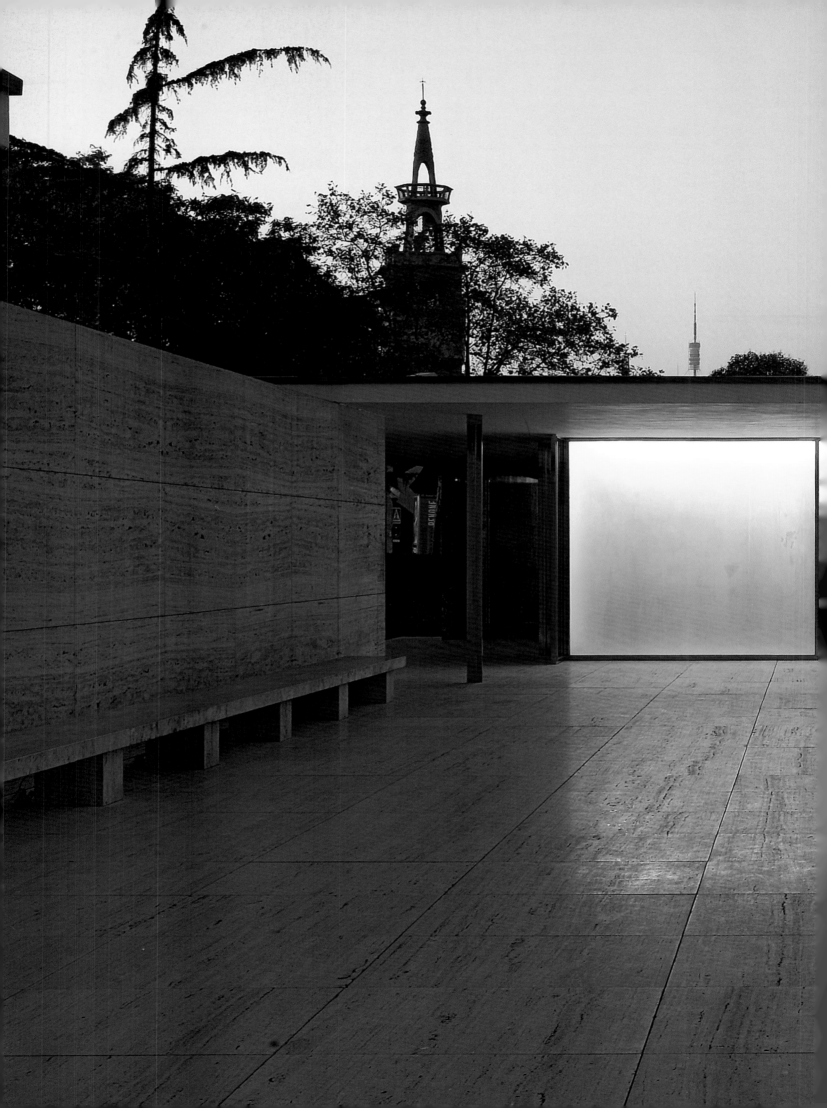

# 8
# Avant-Gardes:
# The Rational City

# Revivalism to Rationalism in Architecture and Planning

JOAN RAMON RESINA

Among planners it is an article of faith that Madrid's imposition of Ildefons Cerdà's project on a reluctant Barcelona was a blessing in disguise (see fig. 3, p. 24). If one suggests that the Eixample (Expansion) is insipid and unimaginative to the point of boredom, one is likely to be informed that Cerdà prudently anticipated 20th-century traffic problems. Underscoring this self-satisfied functionalism, the municipal patriot will probably add that the competing project by Antoni Rovira i Trias would have spelled disaster for the era of private locomotion (fig. 1). For this conventional view, the fanatic regularity of the latticework of streets crossing each other at right angles was the silver lining in the bureaucratic clouds that blew over mid century Barcelona, stamping a colonial rationalism on its most opulent tract.

In 1859, however, Cerdà's disregard for organic design disappointed the city's patricians, who longed for monumental public spaces and perspectives like those in other expanding European cities. Conscious of the multifaceted nature of a modern city, they demanded a plan that connected the old city with the outlying villages as well as provided for squares, gardens, fountains, markets, railway stations, and public buildings. The terms of the contest stipulated a central square in front of the old city gate. Ennobled with a monument and public buildings, this space would become the hub for the main avenues of the new city. Prominent in Rovira i Trias's plan, which also included a ring—an encircling boulevard—around the historical district, this space would at once facilitate the transition between the old and the new city and distribute traffic between the center and the outlying municipalities, which would soon become secondary centers of a multinuclear city. None of this was contemplated in Cerdà's plan, which ignored the city's millennial history and applied a checkerboard to the topography, including parts of the old city, totally disregarding existing conditions. It was noted at the time that the grid would help to stifle uprisings by allowing shrapnel to be fired down the barrel-like paths of its system of coordinates.

Only by keeping in mind that the grid was contemporaneous with Catalonia's cultural revival, the Renaixença, is it possible to grasp how alien Cerdà's

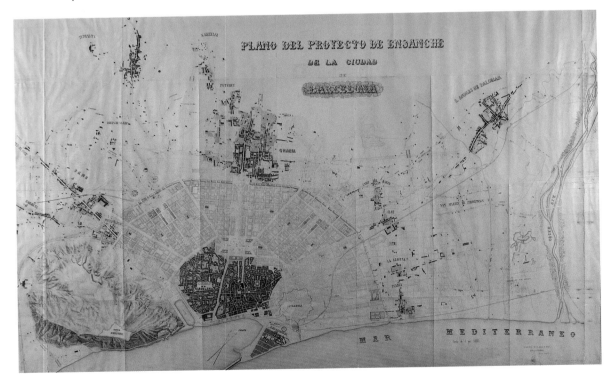

Fig. 1. *Plan for the Enlargement of the City of Barcelona,* 1859, by Antoni Rovira i Trias.

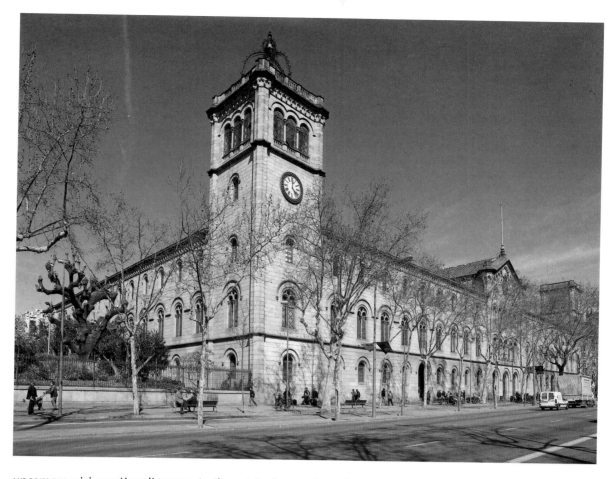

uncompromising rationalism was to the spirit of national resurgence. Forward looking, even futuristic in its vision of a global society based on universal access, Cerdà's project laid the groundwork for an atomized society of rootless individuals circulating in global networks. It is tempting to regard him as a prophet of the 21st century's worldwide diasporas and an unwitting mystic of the nonplace in his conception of the residential building as a way station on the circuits of universal traffic. The Renaixença, in contrast, was historicist, nostalgic for the organic society that was just coming apart in industrial Catalonia. It invoked temporal continuity and a marked sense of place. Thus, while Cerdà removed the Eixample from the city's historical referents, Barcelona's patriciate undertook the restoration of the medieval district, refurbishing the façade of the cathedral toward the end of the century and that of city hall in the 1920s. In fact, the restorative momentum continued almost until mid century, overlapping with the work of the rationalist architects of the 1930s.

The city's umbrage at the imposition of Cerdà's plan was acute. In 1862, the city government peti-tioned Madrid for a partial reversal of the project. It requested, and obtained, the conservation of passeig de Sant Joan, the construction of a ring on the perimeter of the old town, and a central square in the transitional area, precisely where Rovira's plan had situated it. The resulting urbanization was the hybrid of a partially implemented rationalistic scheme and haphazard piecemeal solutions, often adopted under pressure from property owners and always contingent on the whim of Madrid's bureaucracy.

By the turn of the century, the tension between the monotony of the new space and the intellectual penchant for antiquarian references to an inspiring history led to the re-enchantment of the Eixample. Pushing the historicist syncretism of Elies Rogent—illustrated in the building of Barcelona's university (fig. 2)—to new imaginative heights, younger architects such as Lluís Domènech i Montaner, Antoni Gaudí, and Josep Puig i Cadafalch deployed their dreams in masonry on the desolate geometry of the grid. It was with them and their imitators that Barcelona began to accumulate oneiric substance. The profusion of curves in the façades and interiors

Fig. 2. Universitat de Barcelona, 1863–67, designed by Elies Rogent.

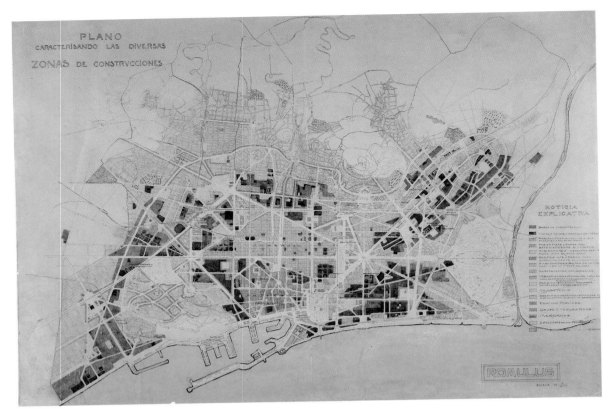

PLANO
CARACTERISANDO LAS DIVERSAS
ZONAS DE CONSTRVCCIONES

NOTICIA
EXPLICATIVA

ROMULUS

of the modernista buildings, in the ironwork, sculptures, furniture, sgraffiti, and motifs designed by countless auxiliary artists, conveyed a refusal of the abstraction made visible in Cerdà's fetishism of the straight line.

Treating the terrain as a mechanical problem to be solved by leveling and partitioning, the engineer in Cerdà was unconcerned about the way his plan might blend with the natural and built environments. The same distance that existed between his geometric blueprint and the actual city, shaped by centuries of habitation, kept the grid apart, and in some ways aloof, from the other townships and suburbs scattered throughout the Plain of Barcelona. Although Cerdà's plan could not be altered in its principal features, it could at least be sutured, like a prosthesis, to the living body of the city. On 20 April 1897 a royal decree had incorporated the surrounding municipalities to Barcelona, entitling the city to assimilate those incongruent bodies to its geometric spread. The challenge of merging Cerdà's straight lines with the uneven peripheries of formerly independent boroughs was met through a competition for a *Pla d'Enllaços*, a Connections Plan, won by the French architect Léon Jaussely in 1905 (fig. 3).

Jaussely's plan kindled an enthusiasm that Cerdà's had never aroused. If the engineer had been unmindful of architectural values, Jaussely gratified the bourgeoisie's desire for a visually ordered space. The significance attributed to the Pla d'Enllaços, in contrast to Cerdà's haziness about the social uses of space, demonstrates how Jaussely satisfied the yearning for something like an urban spirit that could inspire particular works.[1] With its attention to detail and its articulation of previously disconnected districts, Jaussely's plan seemed the blueprint for a structured society. It visualized Barcelona's capacity to overcome the crisis of growth by structuring the territory in a rational yet elegant way. It was chiefly the longing for representative space that defined Barcelona's cultural politics in the new century.

Jaussely pandered to this longing when he wrote in the 1907 appendix to the memorandum that accompanied his plan that a city required "diversity based on the real condition of the circumstances," and he criticized Cerdà's plan for lacking a structured sense of the whole. "In principle," he said, "the blueprint of a great city must express two ideas: one, the expansion that marks the sense of the development of the city and its influence beyond its perimeter, and the other, the concentration that makes it more

Fig. 3. *Plan Showing the Different Construction Zones*, c. 1903, by Léon Jaussely.

compact as one approaches the nuclear zone." This was music to the ears of Barcelonans. A Parisian architect with an international reputation had vindicated their choice of Rovira i Trias's plan, which foregrounded the two ideas that, according to Jaussely, denoted a great city. In addition, Jaussely promoted, through his dialectical defense of the square, the collective spirit that the new Catalanist generations considered their most important political asset vis-à-vis the centralist state: "Large, beautiful squares are centers for the multitude and factors in the arousal of enthusiasm. Despite modern inventions, multitudes feel at certain times the need to congregate, to demonstrate, to gather strength in the dignity of collective thought; and this is as much a need today as it was in former times."[2] It sounded as if the city could be tailored to the needs of the Catalan solidarity, the great civic movement of these years.

In an article about the ideal city, Josep Pijoan wrote ecstatically about the selection of Jaussely's plan, which he endowed with the power of inspiring a new democratic civilization.[3] The enthusiasm induced by a relatively modest intervention into Cerdà's grid contrasts with the disappointment caused by the grid's abstraction. Not to be overlooked is another magnifying factor: the Connections Plan was the choice of the citizens, not a tutelar government's imposition. And it came in the wake of the elections that had propelled Catalan nationalists to the city hall for the first time. By a quirk of fate, the plan acquired the symbolic value of the hour in which Catalonia's civic society acceded to the governance of its institutions. Two years later, in 1907, Eugeni d'Ors referred to Jaussely as the architect "with fiery eyes." Nothing short of a "seer," the planner had achieved the "hallucinated vision of the whole" of the future city, not through the vulgar generalization of one idea or principle but by means of scrupulous attention to the details.[4] In the end, Jaussely's plan went the way of many worthy projects in Barcelona. Filed for more than a decade, it was modified in 1917 by Ferran Romeu and Ezequiel Porcel, who eliminated the aesthetic aspects that had filled turn-of-the-century intellectuals with enthusiasm.

The main features of the Pla d'Enllaços had been outlined a few years earlier by Josep Puig i Cadafalch, who, as alderman between 1901 and 1905, promoted the selection of Jaussely's project. In an article published in January 1900, he opposed the notion of a living, organic city to the lifeless checkerboard, and the idea of holistic design to the mere drafting of basic infrastructures. Many years later he was still claiming precedence for the laws of organic development in planning: "The structure of cities follows certain laws, perhaps the most interesting in human geography."[5] In 1900, though, he advocated an overall plan of reform that would comprise the Eixample and the old city, blending both in a harmonious totality through a Connections Plan.

Puig's vision of an urban totality was consistent with his efforts to reconcile tradition and modernity by stressing the living connection between the art of the past and the need for a modern idiom. As politician, he strove for a correspondence between Barcelona and Catalonia, two complementary realities that had drifted apart—and would do so again during the Franco dictatorship—through the Industrial Revolution and a long period of political subjection. In 1923, summarizing his task as president of the Mancomunitat, Catalonia's regional administration, Puig wrote: "I ask myself what the Catalans would have been without the city of Barcelona. . . . But Barcelona committed an injustice against the rest of Catalonia. The Mancomunitat has repaired that injustice. . . . And our task was to reestablish the unity of the country."[6] Puig conceived his political work as a Connections Plan to integrate Barcelona's increasingly autonomous reality with the historical society from which it stemmed and to which it must inevitably relate. His political vision determined his historical and archaeological work, rather than the other way around, as is often asserted. In proposing and then directing the excavations of the ancient Greek and Roman colonies at Empúries, in restoring medieval buildings like the Catedral de Santa Maria in Seu d'Urgell and the apse of the church in Sant Joan de les Abadesses, and in compounding the seminal *L'arquitectura romànica a Catalunya* (1907), he was guided by a philosophical understanding of the enlivening force of the past. His was a nearly ecological—and for that reason very modern—grasp of the relation between a people's creativity and its ability to make use of accumulated experience. It would be tempting to consider him, in Levi-Strauss's

well-known intellectual typology, a *bricoleur* in opposition to an engineer, were it not that Puig subjected his cultural materials to exacting calculations and erudite reflection.

Ironically, his very significance in the cultural politics of the first half of the century undermined his public undertakings, which fell victim to political turmoil. Puig's project for the plaça de Catalunya, Barcelona's main square, was abandoned after he broke with the dictatorship, and a third-rate architect, Francesc de P. Nebot, was charged with the realization. This decision compounded the problem created by Cerdà, a problem that Puig had tried to solve in full awareness that the space available was not a formal square such as Rovira's plan envisaged, but a haphazard tract of land that only painstaking calculation could endow with a certain monumentality.[7]

A similar fate befell his project for the International Exposition in Montjuïc. In 1929, when General Miguel Primo de Rivera allowed the city to host the exposition as a way of propping up his sagging regime, the conservative mayor, Darius Romeu i Freixa, Baron of Viver, shelved Puig's scheme. Nevertheless, two palaces that were already built were preserved,

as well as the central flight of stairs leading up to the grounds where the National Palace would later be erected. Then again, the four columns placed by Puig at the entrance of the exposition were pulled down to extinguish their symbolism, and replaced with two Italianate towers that added to the stylistic confusion without conferring any meaningful reference.

Plaça d'Espanya, the first monumental space greeting the visitor on the southern side of the city, was thoroughly remodeled for the occasion. Three large hotels flanked the square and mitigated the discord of the Arenes bullfighting ring, considered alien to the classical spirit that contemporary artists sought to inject into Catalan culture. At the center of the square, which is really a traffic-distributing girdle, stands a neo-baroque fountain by Gaudí's collaborator, Josep Maria Jujol (fig. 4). But for many visitors the most enticing feature of the exposition was the Spanish Village, a theme park with samples of traditional architecture from every Spanish region. Although carried out by Miquel Utrillo, Xavier Nogués, and Ramon Reventós, the project harked back to an idea conceived by Puig in 1915

Fig. 4. Commemorative fountain at the plaça d'Espanya for the Barcelona International Exposition, 1928–29, designed by Josep M. Jujol.

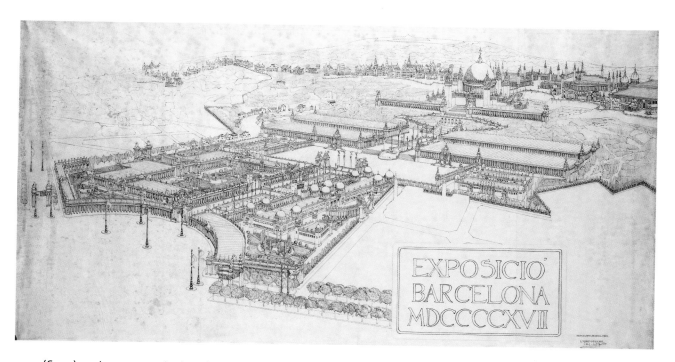

(fig. 5) and was reworked without reference to the original project. With Puig removed from office, the Mancomunitat dissolved, and Catalanism debarred from public expression, Primo de Rivera found the way to use his enemy's ideas for his own purpose. Whereas Puig's arrangement of rural architecture "represented a statement about regional autonomy and cultural differentiation,"[8] the new version of the Spanish Village emphasized a unifying national program at the heart of Barcelona's modern impulse.

If the simulacrum of "Spain inside a bottle" drew the masses into its ideological trompe l'oeil, the true revelation of the International Exposition was the German pavilion by Mies van der Rohe (see figs. 2–5, p. 392; fig. 8, p. 393). With this unassuming structure, the epoch of historicism was brought to a close and a new era of rational architecture inaugurated, one whose classical features stood seamlessly realized in all their ascetic elegance on a hillside of Barcelona.

1. Manuel Torres i Capell, "Un nou model urbà: global i sintètic, arquitectònic i artistic," in Martí Peran et al., eds., *El Noucentisme. Un projecte de modernitat*, exh. cat. (Barcelona: Generalitat de Catalunya/Centre de Cultura Contemporània de Barcelona/Enciclopèdia Catalana, 1994), 90.

2. Léon Jaussely, "Proyecto de enlaces de la zona de ensanche de Barcelona y de los pueblos agregados" (1907), Arxiu Municipal Administratiu de Barcelona, Pla Jaussely: Memòria, Caixa 4 bis, Signatura: C 2–A–21–1.

3. Josep Pijoan, *La lluita per la cultura*, ed. Enric Jardí (Barcelona: Edicions 62, 1968), 42.

4. Eugeni d'Ors, "Lleó Jaussely noucentista," in *Glosari 1906–1907*, ed. Xavier Pla (Barcelona: Quaderns Crema, 1996), 724.

5. Josep Puig i Cadafalch, "La Plaça de Catalunya," in *Escrits d'arquitectura, art i política*, ed. Xavier Barral i Altet (Barcelona: Institut d'Estudis Catalans, 2003), 260.

6. Torres, "Josep Puig i Cadafalch i l'urbanisme de Barcelona als inicis del segle XX," in *Puig i Cadafalch i la Catalunya contemporània*, ed. Albert Balcells (Barcelona: Institut d'Estudis Catalans, 2003), 136.

7. Puig, "La Plaça de Catalunya," 258–59.

8. Jordana Mendelson, *Documenting Spain: Artists, Exhibition Culture, and the Modern Nation, 1929–1939* (University Park: Pennsylvania State University Press, 2005), 11.

Fig. 5 (cat. 8:1). Josep Puig i Cadafalch, *Exposition 1917, Perspective Drawing for the 1917 Universal Exposition of Electrical Industries*, 1915.

# The Barcelona Pavilion

*DIETRICH NEUMANN*

King Alfonso XIII of Spain showed a subtle sense of humor when he delivered a brief speech at the opening of the German pavilion (fig. 1) at the Barcelona International Exposition on 27 May 1929, one week after the official opening of the exhibition on 19 May.[1] With the Spanish dictator Miguel Primo de Rivera in attendance, as well as several high-ranking German officials and the architect, Ludwig Mies van der Rohe, King Alfonso told his audience that he "had driven by the pavilion every day for the past week, waiting for it to be finished." He finally realized, he said, "that the Germans had delayed the opening of the pavilion on purpose, in order to show off their uncanny technical and improvisational abilities to a world audience."[2] The king's gentle mockery marked the final moment in the astonishingly complex story of the creation of what was soon to be-

come the exhibition's best-known building and one of the icons of 20th-century architecture.

Mies and his team had worked "continuous night shifts and on Sundays and holidays to the very last minute . . . in order to finish the building for the appointed hour,"[3] but the simple fact that the building existed at all was the achievement of one individual, Georg von Schnitzler, the German commissioner for the exhibition. Indeed, at the time of the opening ceremony he had poured so much of his private fortune into the pavilion that he was in fact its legal owner.

After the king had spoken, a telegram from the German president, Paul von Hindenburg, was read and greeted by an ovation on the part of the German visitors. But it was von Schnitzler's carefully chosen words at the ceremony that endowed the

Fig. 1. King Alfonso XIII of Spain leaving the opening ceremonies for the German pavilion, Barcelona International Exhibition, 1929.

pavilion's architecture with such rare political and social specificity that they were immediately adopted or paraphrased by most commentators in local and international newspapers, and began to shape the building's reputation.[4] He presented Mies as "one of the most outstanding and original architects of the new generation," and his pavilion as both an architectural compliment to the Spanish hosts and an expression of the spirit of the new Germany:

*The hard times that we have gone through have led us to consider simplicity as essential and to reject anything that is not precise as superfluous. To be able to show such simple forms under the blue sky of your Mediterranean country, amidst its natural beauty, has emboldened us.... We wanted to be able to demonstrate what we want, what we can do, who we are, what we feel and see today. We want nothing but clarity, decency, honesty.... Here is the spirit of the New Germany: simplicity and clarity of means and intentions—everything is open, nothing is concealed. It is a piece of work honestly done, without arrogance. This is the quiet home of a peaceful Germany.*[5]

Soon, a consensus emerged that Mies's pavilion was a "spiritual demonstration" that stood for the new Germany, its young democracy, its honest desire to be a peaceful member of the family of nations, but also its leading role in the world of art and architecture. The German critic Justus Bier, for instance, explained in the Werkbund journal *Die Form*:

*The task was quite unusual for today: a building without function, or at least without apparent, tangible, or obvious function—a building dedicated to representation, an empty space, and for this very reason Space-In-Itself, architecture as a free art, the expression of a spiritual commitment. That this commission has found its way into the hands of Mies van der Rohe, and that Germany is represented by a building of modern architecture, is to be welcomed.*[6]

Lilly von Schnitzler, who had accompanied her husband to the opening, found similar words in the literary monthly magazine *Europäische Revue*, praising the German pavilion:

*As if from a fairy tale, not of the Arabian Nights, but from an almost supernaturally inspired music of eternal space, not as a house, but as a drawing of lines in such a space by a hand that defines the human reach towards infinity. We Germans owe gratitude to Mies van der Rohe, for he has succeeded in casting our spiritual existence into form.*[7]

It was by no means the German critics alone who expressed their enthusiasm; the British magazine *The Spectator* considered the German pavilion "the outstanding feature of the Exhibition" and wrote:
*It is a gesture rather than a building, deriving its effects from a sense of severe, spacious and efficient simplicity which we rarely find except in an up-to-date hospital or a modern power house.... A visitor remarked that a colored handkerchief, dropped on its white floor, would be hastily swept up as an insult to its austerity. Essentially, this pavilion is the expression of a lonely, powerful and forward looking spirit. It is a gesture, incomplete in itself, the significance of which finds its fulfillment in the displays of German industry elsewhere in the Exhibition.*[8]

Two Spanish critics considered the "sunlight" in the pavilion:

*[O]ne of the foremost decorative motifs. Indeed, it may be the most important, in this labyrinth of large planes, straight lines and bare, plain walls. To have tamed light from above is a great achievement. If a people should adopt this architecture, they will be a people of clear horizons. Such is the German Pavilion: the architecture of reflections. Walls, paving stones and roofs form a prodigious blending of rays of lights which criss-cross freely. And this, precisely, is the soul of the new Germany.*[9]

Mies himself was hardly a good interpreter of his intentions. In his usual deadpan manner he later recalled the development of the pavilion in merely functionalist terms:

*When I had the idea for this building I had to look around. There was not much time, very little time, in fact. It was deep in winter, and you cannot move marble in from the quarry in winter because it is still wet inside and it would easily freeze to pieces. So we had to find dry material. I looked around in huge marble depots, and in one I found an onyx block. This block had a certain size and, since I had only the possibility of taking this block, I made the pavilion twice that height.*[10]

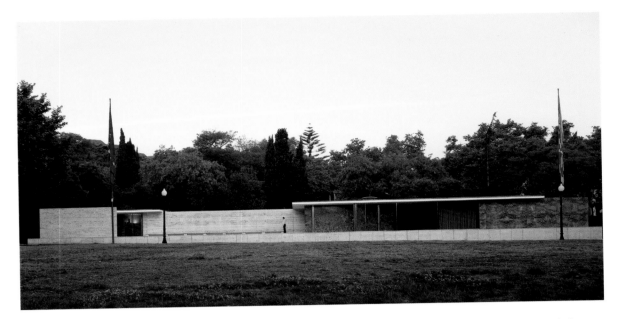

Despite the enthusiastic descriptions in the press, it is not unlikely that the encounter with the building (figs. 2–5) presented a somewhat puzzling experience to most visitors. Many may not even have realized that they had come across the German pavilion. Mies had insisted on keeping the building as uncontaminated by the mundane as possible. He had rejected a request by the German government to have a sculpted eagle applied to one of the marble walls inside, and he managed to delay the application of the word "Alemania" in black letters on the façade for several months, until all official photographs had been taken.[11] He even insisted on keeping the pieces of furniture inside the pavilion to a minimum.[12] While in the pavilions of other countries one could expect to find some travel brochures and information about the country's beauty, its industry, art, and heritage, Mies had moved the entire information section for Germany to the second floor of the Machinery Hall (fig. 6), where it was probably

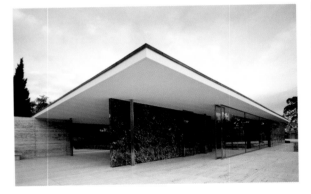

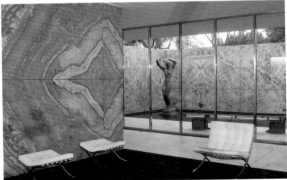

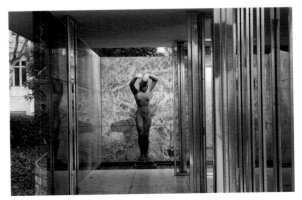

only seen by those who came upon it by accident.

Many visitors might have encountered the pavilion by chance on their way to or from the Spanish Village, a picturesque assemblage of sample buildings from different parts of Spain, west of the main exhibition area. One of the paths to the village led across the site, and the pavilion may have appeared as a peaceful transition from the present of movement, color, and the constant noise of the splashing water jets, to the imaginary past that the Spanish

Fig. 2. German pavilion of the Barcelona International Exhibition, 1929, designed by Ludwig Mies van der Rohe.

Fig. 3. German pavilion of the Barcelona International Exhibition, 1929.

Fig. 4. Interior view of the German pavilion.

Fig. 5. Interior view of the German pavilion.

Village tried to evoke. The pavilion's two shallow pools were probably the only bodies of water in the exhibition that serenely reflected the sky, whereas everywhere else water was flowing down cascades or gushing up in many fountains.

This purposeful contrast to the rest of the exhibition became particularly apparent at night. With the intention of turning the world's fair into a superb nocturnal spectacle (by then a tradition at large industrial fairs), the organizers had purchased a $250,000 apparatus from the American Westinghouse Corporation, custom made, to synchronize the changing colors of 850 floodlight projectors installed near Puig i Cadafalch's exhibition palaces, whose expansive windowless surfaces served as reflectors (fig. 7). The park's architectural

lighting was complemented by a well-coordinated sequence of 50 fountains and cascades, illuminated in color and designed by the Catalan "magician of light," Carles Buigas. The result was a lighting spectacle on "a scale several times larger than any similar display hitherto produced."[13] To this environment, Mies's pavilion presented a calm and self-assured counterpoint. A large double-glass opal screen with light bulbs inside had been placed at the center of the pavilion (fig. 8). Its steady white light was the only illumination at night—with the result that visitors repeatedly fell into the small pool when visiting at dusk.[14] At the same time, the building's raised platform, with a long stone bench in its open courtyard, served as a grandstand for observing the ever-changing play of color and light in front of it.

While the construction materials of all other exhibition pavilions anticipated their short life spans and usually consisted of stucco over a light frame of metal or wood, Mies had decided to use solid mate-

rials that signaled reliability, longevity, and wealth. The pavilion offered its visitors a sequence of spatial situations, openly connected and subtly different, framed by wall-high slabs of semi-precious stone, glass, and travertine and punctuated by eight chromium-covered cruciform columns. The depth of the roof overhang provided coolness and shade, and the luminous play on the ceiling echoed the ripples of the water of its two pools, a large pool on the outside terrace and a smaller pool on its western side that surrounded Georg Kolbe's statue *Dawn;* part of the pavilion was open to the sky. Brightness and temperature varied considerably between the blinding white outer terrace and the comparatively dark interior. Despite three different kinds of marble—onyx doré, timos, and vert antique—and white, green, and gray glass, as well as a black carpet and a red curtain, the overall impression was of a carefully calibrated, elegantly restrained composition.

The daring power of this concept cannot be overestimated. Instead of marketable commodities, national products, or recent inventions, here was a new approach to architecture and space that was not yet easily applicable, and its vague suggestions of a domestic setting implied patterns of a life altogether different (figs. 9–12).

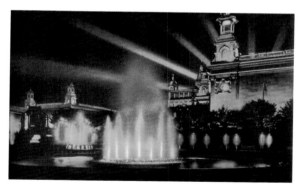

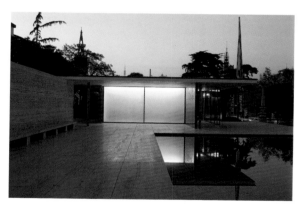

Fig. 6. German Information Center, Barcelona International Exposition, 1929.
Fig. 7. Barcelona International Exposition at night.
Fig. 8. German pavilion at dusk.

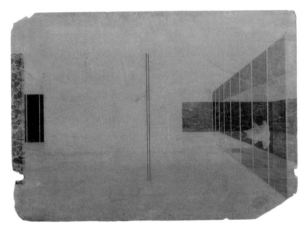

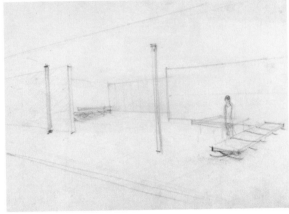

To a certain extent, the pavilion was a demonstration piece for the prowess of the German economy, beyond its obvious solidity and precious materials. Much of its aesthetic and technology stemmed from recent developments in the design of storefronts and display windows. The three wall-high glass panes at the front of the building, almost 12 feet wide, were so unusual that visitors repeatedly failed to see them and bumped into them.[15] The chromium electroplating that covered the eight cruciform columns and the frames of the Barcelona chairs and ottomans (fig. 13) had only recently become available, after its fundamental principles had been discovered in 1924. This "thoroughly modern metal" was just finding areas of application in designs for cars, bicycles, and storefront display cases.[16]

During its eight months of existence the pavilion housed few official functions. The day after the opening ceremony there was a tea reception for the members of the German colony in Barcelona, and occasional gatherings for high-ranking visitors followed. But for Georg von Schnitzler, the German commissioner, and his wife, Mies's pavilion was part and expression of a larger modern project, extending beyond architecture to art, dance, and music. They had planned to demonstrate the pavilion's "essential purpose" by making it the centerpiece of two performances during "German week," 19–25 October.[17] The pavilion should have served as the location for a concert by the Hindemith Quartet (the celebrated contemporary composer Paul Hindemith was a professor at the Berlin Music Academy) and

Fig. 9 (cat. 8:5). Ludwig Mies van der Rohe, *Pavilion for the Barcelona International Exposition, Perspective View of the Principal Façade,* 1929.

Fig. 10 (cat. 8:4). Ludwig Mies van der Rohe, *Pavilion for Barcelona International Exposition, Interior Perspective View,* 1929, sketch by Sergius Ruegenberg.

Fig. 11 (cat. 8:6). Ludwig Mies van der Rohe, *Pavilion for the Barcelona International Exposition, View of the Interior with Table and Stools,* 1929, sketch by Sergius Ruegenberg.

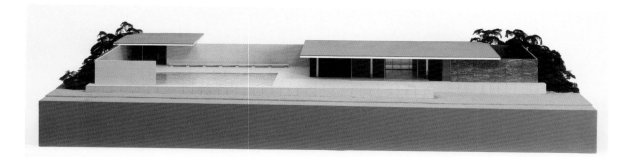

a dance performance of the Laban School.[18] Rudolf Laban was the head of the German Ausdruckstanz (Expression Dance) movement and, since his early training as an architect at the École des Beaux Art in Paris, deeply interested in human motion in response to built space.[19] Mies was a close friend of Laban's student, the dancer Mary Wigman. In the end, more conservative tastes prevailed: during the German week, Wagner's operas *Tannhäuser, Siegfried,* and *Götterdämmerung* were performed at the Gran Teatre del Liceu, and the battleship *Königsberg* and a German zeppelin visited the city.

The complex prehistory of the pavilion and its financing is worth telling in some detail, as it complicates the broadly accepted view of the pavilion's symbolic representation of the aims and spirit of the new Germany.[21] The German government had hesitated for an entire year before finally accepting, in February 1928, the Spanish invitation to take part in the International Exposition. The Spanish commissioner offered plenty of free exhibition space and urged Germany to build a "small representative pavilion" for receptions and festive events. A piece of land of up to 600 square meters would be provided free of charge, and such a pavilion, he claimed, need not cost more than 70,000 reichsmark (RM) (about $16,500 in 1928 U.S. dollars). After a representative

Many reviewers acknowledged the evident continuity between the clarity of the pavilion and the unified appearance of the ten different German sections in various exhibition palaces. In their contract with the exhibiting industries, von Schnitzler and Mies had reserved the right to approve or reject each individual exhibit, and Mies and Lilly Reich determined the appearance of each industry's section, its overall design, the furniture—all previously designed by Mies—as well as the lettering and signage by Mies's old friend Gerhard Severain.[20]

had visited Barcelona in February 1928, the Foreign Office confirmed Germany's participation, but stated categorically that a "pavilion was out of the question."[22] Immediately, a search for a German commissioner for the exposition was begun, someone with organizational skills and management experience, strong ties to different industries, diplomatic talent, and enough personal wealth to be able to do the job on a voluntary basis. In May 1928, Georg von Schnitzler, a 45-year-old top manager at IG Farben, was offered the position and, after a few weeks of negotiations, accepted on 28 May.[23] Trained as a banker and lawyer, in 1924 von Schnitzler had assumed a seat on the board of directors at Farbwerke Höchst, which soon became one of the key members of a cartel of German chemical companies, called IG Farben, in which he became a vice president responsible for color production.

Von Schnitzler immediately named Mies artistic director and architect of the German section, and Mies inspected the site one week later.[24] Probably von Schnitzler had already contacted Mies during the negotiations that preceded his appointment.

Fig. 12 (cat. 8:2). Ludwig Mies van der Rohe, *Model for the German Pavilion of the Barcelona International Exposition of 1929,* 1929.
Fig. 13 (cat. 8:7). Ludwig Mies van der Rohe, *Barcelona Chair,* 1929.

Despite only a few executed buildings and visionary designs to his credit, Mies had reached national prominence with the great success of the Weissenhof exhibition in Stuttgart in 1927, which he had coordinated together with Lilly Reich, and which combined architecture and exhibition design comparable to the task at hand in Barcelona.

As a high-ranking manager at IG Farben, von Schnitzler was used to a style of decision making somewhat at odds with the complicated processes of a parliamentary democracy (fig. 14). He seems to have had little regard for the directives of politicians, especially in the volatile political climate of the Weimar Republic, where 16 different governments had followed each other in a nine-year period. When he assumed his post, the government had committed a sum of 350,000 RM for the German participation in the Barcelona fair and had categorically ruled out a pavilion. Nevertheless, in July 1928, von Schnitzler assured the Spanish hosts that a German pavilion would be built.[25] When rumors of this reached Berlin, the minister of economics firmly reminded the Spanish ambassador in August 1928 that "the question of a German pavilion . . . had long been dismissed as impractical" as there were no financial means for it and, furthermore, "the remaining eight months would be in no way sufficient" to build "anything remotely comparable" to the other pavilions in the exhibition.[26] Entirely undeterred, in October von Schnitzler signed an official contract with the Spanish authorities, agreeing "to build a representative pavilion of his country in the exhibition, of a size of 200–300 square meters."[27] Von Schnitzler notified the potential participants in the exhibition of the signed contract and assured them that "luckily, the financial basis for the German participation in the exhibition can be considered secure."[28] This statement considerably simplified the actual situation. Von Schnitzler knew that the actual costs would be much higher than the 350,000 RM he had been granted. In fact, in his contract with Mies and Lilly Reich on 12 November 1928, he estimated building costs of 1,350,000 RM (100,000 for the pavilion and 1,250,000 for the different sections in the exhibition), hoping, however, that some of

this would be paid by the exhibiting industries. Mies was granted a generous honorarium of 125,000 RM plus all expenses paid for him and his team.[29]

After these contracts had been signed, von Schnitzler turned to the government and requested an additional 750,000 RM from the Economics Ministry, bringing the overall sum requested to 1,100,000 RM. At that point, the estimated cost of the pavilion had risen to 150,000 RM. Hesitant to support the request, Finance Minister Dr. Rudolf Hilferding of the Social Democrats (SPD) delayed his approval for several months and finally presented it to the parliamentary finance committee on 26 February 1929. The current government under Chancellor Hermann Müller (SPD), which lasted from 28 June 1928 to 27 March 1930, consisted of an uneasy coalition between the SPD as the strongest party, the Zëntrum (Center), the DVP (German People's Party), and the DDP (German Democratic Party). The two ministers most closely involved with the German participation in Barcelona were the foreign minister, Gustav Stresemann, and the economics minister, Julius Curtius. They were both members of the German People's Party, which stood right of center, had close ties to industry, and was openly hostile to the Social Democrats. All parties of the Reichstag were represented in the finance committee in proportion to their fraction in parliament. According to the surviving records, the finance committee deliberations on 1 and 2 March concerning the German participation at the Barcelona world's fair were a stormy affair: several committee members strongly criticized the nonchalance with which von Schnitzler had brazenly ignored earlier agreements and precise financial limits, in addition to the perceived lateness of the request for additional funds and its lack of proper documentation.[30]

Despite personal appearances and appeals of both Curtius and von Schnitzler, the two days of heated deliberations ended disastrously. While the Social Democrats and Communists argued strongly against any additional support, the representatives of the DVP pleaded for a fulfillment of the contracts von Schnitzler had signed. In the end, a compromise brought forward by the Bavarian People's Party and

Fig. 14. Georg von Schnitzler, c. 1929.

the DVP was accepted. It suggested granting von Schnitzler an additional 150,000 RM, raising the overall funds to 500,000 RM, far less than the 1,100,000 he had requested.[31] This shortfall meant a fatal blow to the program as von Schnitzler and Mies had conceived it. In a memorandum of 4 March 1929, von Schnitzler conceded defeat. He presented a much reduced version of Germany's participation, which included canceling the pavilion: "As difficult as it is for me personally to abandon the pavilion, it is the only possible way to honor the budget committee's decision and still secure Germany's participation."[32] Von Schnitzler's anger at the committee's affront was only thinly veiled when he pointed out that only the bare minimum of receptions and cultural programs would be possible, and that Germany's lack of funds would be fully obvious to the international public.

Work on the pavilion stopped immediately. For 16 days the building site lay idle in the midst of the hectic construction efforts at the exhibition grounds, until a telegram arrived from Berlin on the evening of 20 March: "Execution of pavilion secured. Spanish embassy notified."[33] The Foreign Office and the economics minister had provided a loan of more than 250,000 RM to secure the continuation of the work.[34] The German ambassador in Spain had made it clear that the Spanish prime minister, the dictator Miguel Primo de Rivera, would be personally offended by a German withdrawal so late in the game, and especially by the sight of an abandoned building in the middle of the exhibition grounds.[35] (Primo de Rivera had indeed considered the Barcelona exposition an important tool to resurrect his waning political fortunes, but to no avail, as he was forced to resign in January 1930.)

Work on the pavilion was immediately resumed, with continuous night and weekend shifts for the remaining nine weeks essential in order to finish by the scheduled opening date of 27 May. After only four weeks, however, the newly provided funds were exhausted and von Schnitzler desperately applied for a personal loan of 150,000 RM at the Reichskreditbank, using the pavilion itself as collateral. Because he had had to prefinance the erection of the pavilion out of his own pocket, he had become, together with the contractor, the pavilion's legal owner.[36] That it was von Schnitzler's pavilion, rather than the German government's, was not lost on official representatives who came to Barcelona for the festive opening: "Our role as representatives of the German government was not easy to play, as not we, but von Schnitzler commanded all the funds."[37] Throughout the summer and fall von Schnitzler had to continue his requests for money.[38] The final cost for German participation in the exhibition was 1,414,801 RM (338,422 RM for the pavilion alone),[39] of which von Schnitzler himself (probably with some help from IG Farben) had prepaid 740,000 RM to suppliers and builders.[40] Despite the obvious success of the pavilion, Schnitzler's appeals were repeatedly denied by the Reichstag's finance committee through the fall.[41] Internal correspondence between different government agencies reveals the minister of economics' unhappiness with "von Schnitzler's incompetence," the generosity of Mies's contract, and the extravagant and wasteful mode of operation of the "young architects" who had traveled on the Train Bleu and massively overcalculated the materials.[42] After von Schnitzler had heard about these misgivings, Mies's honorarium vanished from the list of overall costs, in all likelihood a sign that von Schnitzler paid for it out of his own account. Mies himself seems to have been of little help in Schnitzler's desperate appeals, refusing, for instance, to show up at a crucial meeting at the Economics Ministry in September, as he was vacationing on the island of Sylt.[43]

Finally, on 15 December, von Schnitzler threatened to close the exhibition prematurely and recommend that all suppliers sue the German government. Shortly after, a check of more than 550,000 RM from the minister of economics arrived.[44] The exhibition closed as planned on 15 January 1930; the pavilion was dismantled and its marble and travertine parts shipped to Hamburg in March to be sold.[45] As this proved impossible, they were taken into possession by the Finance and Economics ministries, who had given von Schnitzler a debt guarantee for this case. They ended up in the hands of the president of the State Finance Board in Hamburg, and were apparently reused in public building projects there.[46] All financial problems were not settled until July 1932,[47] and it is obvious that von Schnitzler invested much more of his own money in the exhibition and its pavilion than the 150,000 RM he had initially pledged.

The Barcelona pavilion never would have come into existence without Georg von Schnitzler, who hired Mies and decided to build the pavilion despite the directives of the Foreign Office and a complete lack of funds. Widely accepted as the representational pavilion of the German republic, it was the result of the vision, steadfastness, and considerable financial sacrifice of one individual. Von Schnitzler and his wife, Lilly, also played an important role in shaping the early public reception of the pavilion.

It is important to note that both von Schnitzlers were politically conservative. In all likelihood they had ties to the DVP, the party of the foreign minister, Gustav Stresemann, and the minister of economics, Julius Curtius, who had supported Georg von Schnitzler's efforts in Barcelona. Industrialists often aligned themselves with this right-of-center party, which had originally opposed the new political system of the Weimar Republic in favor of a return to the monarchy. Lilly von Schnitzler, a grand dame of Frankfurt's society and prominent collector of contemporary art (in particular Max Beckmann), had, in 1924, founded the conservative literary and political journal *Europäische Revue,* which promoted the vision of a pan-European leadership from an aristocracy of intellectuals. Thanks to her husband, it was partially financed by funds from IG Farben.[48] While through most of the 1920s modernist architecture in Germany had been associated with left-wing politics, the minimalist clarity of Mies's architecture had, at this point, become acceptable for conservative clients such as the von Schnitzlers, who considered it representative of the present and future German republic.

Although the pavilion was dismantled in 1930, it became one of the canonical works of 20th-century architecture. In 1981, Oriol Bohigas, the director of architecture and urban planning of Barcelona's city council, began a campaign to rebuild the pavilion. In 1986 the reconstruction was completed, and the pavilion stands again as a pure rendering of the essence of architecture. Its history, however, is also a reminder of the fluidity of architecture's role as a carrier of metaphorical meaning.

1. Beyond the general literature on Ludwig Mies van der Rohe, the Barcelona Pavilion is covered in greatest detail in the following publications: Wolf Tegethoff, *Mies, The Villas and Country Houses* (New York: Museum of Modern Art/MIT Press, 1985), 66–89; Yilmaz Dziewior, *Mies. Blick durch den Spiegel* (Cologne: Verlag Walter König, 2005); George Dodds, *Building Desire. On the Barcelona Pavilion* (London: Routledge, 2005); Terence Riley and Barry Bergdoll, eds., *Mies in Berlin* (New York: Museum of Modern Art, 2001); Josep Quetglas, *Fear of Glass: Mies's Pavilion in Barcelona* (Basel: Birkhäuser, 2001); Cristian Cirici et al., *Mies van der Rohe: Barcelona Pavilion* (Barcelona: Gustavo Gili, 1993).

2. Lilly von Schnitzler, "Weltausstellung Barcelona," *Der Querschnitt* 9, no. 8 (August 1929): 582–84.

3. Mies to Georg von Schnitzler, 28 September 1929, Bundesarchiv Berlin Lichterfelde, Ausstellung Barcelona, Auswärtiges Amt (hereafter BA/AB/AA ), Abteilung II, R 9.01, 40029, no. 119–211.

4. Ignasi de Solà-Morales has already discounted Juan Pablo Bonta's claim that "the pavilion passed unnoticed to all but a handful of the multitude of visitors who showed up during the year the exhibition was open," in Bonta, *Architecture and Its Interpretation* (London, 1979), 134, and pointed at the numerous contemporary articles praising the pavilion immediately after the opening. See Cirici, *Mies van der Rohe,* especially the extensive bibliography, 68–71. In addition, there were, among others: "Inauguración del pabellón alemán" in *La Época,* 28 May 1929; "Solemne inauguración de los pabellones de Alemania" in *ABC,* 28 May 1929; Francisco Marroquin, "El Pabellón de Alemania en la exposición de Barcelona," in *ABC,* 25 January 1930; the Argentine newspaper *La Razón* interviewed Schnitzler in early October and quoted him in its headline: "Alemania en la gran exposicion international de Barcelona: olvidando las horas trágicas de la guerra, el ex-imperio tiende a lograr 'El triunfo de un franqueza absoluta, mediante la claridad, la calidad y la sencillez'," *La Razón,* 5 October 1929. Also important is the Italian architect and film critic Carlo Enrico Rava's account in the Italian journal *Domus* (March 1931).

5. As the complete text of von Schnitzler's speech has not survived, we have to rely on excerpts in different contemporary publications. The three text passages quoted here are from the following three sources, in the same order: "Inauguración del pabellón alemán," *Epoca,* 28 May 1929; L.S.M. [Lilly von Schnitzler-Mallinckrodt], "Die Weltausstellung Barcelona 1929," *Querschnitt* 9, no. 8 (August 1929): 582–84; and Nicholas M. Rubió i Tuduri, "Le Pavillon de l'Allemagne à l'Exposition de Barcelone," *Cahiers d'Art,* no. 8–9 (1929).

6. Justus Bier, "Mies's Reichspavillon in Barcelona," *Die Form* 16, no. 4 (15 August 1929): 423–30. See also Guido Harbers, "Deutscher Reichspavillon in Barcelona auf der internationalen Ausstellung 1929," *Der Baumeister* (November 1929): 421–27; Walther Genzmer, "Der Deutsche Reichspavillon auf der Internationalen Ausstellung Barcelona," *Die Baugilde* (1929): 1654–657; Alfredo Baeschlin, "Barcelona und seine Weltausstellung," *Deutsche Bauzeitung,* no. 57 (17

July 1929): 497–503, and no. 77 (25 September 1929): 657–61. Baeschlin's article is a notable exception among the German essays: after expressing his admiration for the "Spanish Village," he wrote about the pavilion that, while "there are interesting effects, however, unfortunately, no idea has been expressed. The visitor stands perplexed and wonders if this building is still under construction."

7. L.S.M., "Weltausstellung Barcelona," *Europäische Revue* 5, no. 4 (July 1929): 286–88.

8. "A visit to the Barcelona Exhibition," *Spectator*, no. 5299 (18 January 1930): 84–85.

9. Ángel Marsà and Luis Marsillach, *La montaña iluminada. Itinerario espiritual de la Exposición de Barcelona 1929–1930* (Barcelona: Horizonte, 1930), quoted from Quetglas, *Fear of Glass*, 15.

10. Interview with Mies, issued as a record, *Conversations Regarding the Future of Architecture* (Kentucky: Reynolds Metals Company, 1956), quoted in Tegethoff, *Mies, The Villas and Country Houses*, 77 n. 41.

11. The previously unknown fact that the black-lettered inscription "Alemania" had adorned the building's façade from early October on is evident in two sources. The designer of the inscriptions, Gerhard Severain, reports in a letter to Mies that he applied the word "Alemania" (Severain to Mies, 11 October 1929, Museum of Modern Art, New York, Mies van der Rohe Papers, folder 8) and a British observer remarked: "Otherwise its only decorations are the black-lettered word "Alemania" upon its front, and the four German flags at the borders of its domain." ("A visit to the Barcelona Exhibition," 84–85).

12. Mies asked explicitly to not have more than two of his Barcelona chairs in the pavilion. Lilly Reich to Dr. von Kettler, 5 July 1929, Museum of Modern Art, Mies Papers, folder 9.

13. C. J. Stahl, "The Colored Floodlighting of the International Exposition at Barcelona, Spain," *Transactions of the Illuminating Engineering Society* 24, no. 9 (1929), 876–89. On the lighting of the Barcelona fair, see Dietrich Neumann, "Architecture of the Night" (Munich/New York: Prestel, 2002), 138–39.

14. Von Kettler to Reich, 5 July 1929, Museum of Modern Art, Mies Papers, folder 9.

15. Ibid.

16. Erik Jacobson, "Chromium: A thoroughly modern metal," *Dartmouth Toxic Metals Research Program,* Dartmouth University website, http://www.dartmouth.edu/~toxmetal/TXSHcr.shtml (accessed 4 February 2006).

17. Von Schnitzler, 23 June 1929, BA/AB/AA, Abteilung II, R 9.01, 40029, 169.

18. Memorandom, Foreign Office, 25 June 1929, ibid., 179.

19. Unfortunately, no traces of any work of Rudolf Laban for the Barcelona Pavilion have survived in the archives of the Laban Institute in London.

20. An article by the author about the collaboration between Mies and Severain is forthcoming in the *Zeitschrift für Kunstgeschichte*.

21. This previously untold part of the pavilion's history stems from the discovery of documents about the German participation at the Barcelona world's fair in the files of the Foreign Office in the Bundesarchiv in Berlin.

22. Report of visit at exhibition grounds, Dr. Mathies (Reichskommissar für Ausstellungen und Messen), 25 February 1928, BA/AB/AA, Abteilung II, R 9.01, 40027, no. 174, 175.

23. The runner-up had been Herr von Bülow, brother of the chancellor, of the Krupp Corporation in Essen, memorandum, 4 May 1928, ibid., no. 229.

24. A telegram of 30 May to the Spanish organizers named Mies as the responsible architect and announced his visit to Barcelona for 7 June. See Cirici, *Mies van der Rohe,* 8 n. 7. Lilly von Schnitzler, Georg von Schnitzler's wife, later claimed that it was her suggestion to hire Mies. This seems credible, as Lilly was much more involved in artistic affairs than her husband. See the transcription of Ludwig Glaeser's interview with Lilly von Schnitzler (Murnau), 6 September 1974, in Ludwig Glaeser Papers (1968–1980), Canadian Center for Architecture, Montreal, box 4, item 2, p. 2.

25. See opening remarks in the contract between von Schnitzler and Santiago Trias, chair of the executive committee of the exhibition in Barcelona, October 1928, BA/AB/AA, Abteilung II, R 9.01, 40028, 122.

26. Economics Minister Hans Posse to Foreign Office in response to an inquiry from the Spanish ambassador through his press attaché, Rodiño, 17 August 1928, ibid., 49, 50.

27. Contract between von Schnitzler and Santiago Trias, October 1928, ibid., 125.

28. Von Schnitzler to representatives of the German industry, 27 October 1928, ibid., 127–30.

29. Von Schnitzler to Mies, 12 November 1928, ibid., 40030, 101–3; von Schnitzler promised to pay up to 150,000 RM of his personal funds to cover all expenses in connection with his role as German commissioner of the exhibition, such as the offices in Berlin and Barcelona.

30. Report of the meeting of the parliamentary budget committee, 1 March 1929, ibid., 40028, 265–68, 275, 278–79.

31. Memorandum, Finance Ministry to Economics Ministry, 4 March 1929, ibid., 275. The entire discussion in the parliamentary budget committee is preserved in the Bundesarchiv Berlin (Lichterfelde).

32. Memorandum, von Schnitzler, 4 March 1929, ibid., 40029, 11.

33. Telegram, Foreign Office to German Consulate (Barcelona), 20 March 1929, ibid., 30.

34. Von Schnitzler to Ministerialdirektor Ritter at the Foreign Office, 25 July 1929, ibid., 204–7.

35. Telegram, German ambassador (Madrid), 6 March 1929, ibid., 14. Von Schnitzler to Curtius, 5 April 1929, ibid., 61.

36. "We understand, that the credit will be paid back by you out of the future proceeds of the sale of the pavilion in Barcelona's Park 'de Montjuic' (currently still under construction), of which you are the sole owner." Reichs Kredit Anstalt to von Schnitzler, 23 April 1929, ibid., 142–43. According to a questionnaire of 1946, von Schnitzler had earned 300,000 RM in 1930, slightly less in the following and preceding years, Meldebogen auf Grund des Gesetzes zur Befreiung von Nationalsozialismus und Militarismus vom 5.3.1946, Hessisches Hauptstaatsarchiv Wiesbaden.

37. Legationsrat Windel to Ministerial Council, 28 May 1929, BA/AB/AA, Abteilung II, R 9.01, 40029, 188.

38. See, for example, his requests in July, September, October, and November 1929: von Schnitzler to Ministerialdirektor Ritter at Foreign Office, 25 July 1929, ibid., 204–7; von Schnitzler to Stresemann and Curtius, 29 September 1929, ibid., 105–7; von Schnitzler, 10 October 1929, ibid., 175.

39. Lists with monies spent, attached to a report by Mies, 3 October 1929, ibid., 110–13.

40. Von Schnitzler, 10 October 1929, ibid., 175.

41. Memorandum about a meeting of 14 November 1929, between the chancellor and all party leaders, rejecting additional funds for Barcelona.

42. Memorandum, 25 September 1929, BA/AB/AA, Abteilung II, R 9.01, 40030, 11; von Kettler and Mies, 15 July 1929, and memorandum about a meeting regarding the financing of the exhibition on 22 August 1929; both Mies Papers, Museum of Modern Art, Barcelona Pavilion, folder 1.

43. Von Schnitzler to Mies, 19 September 1929, and Mies's answer on 21 September, ibid., folder 2.

44. Minister of Economics to von Schnitzler, 15 December 1929, ibid., folder 3.

45. G. Mainrath to Mies, 5 March 1930, ibid., folder 9.

46. Reichs Kredit Anstalt to Foreign Office, 24 May 1930, BA/AB/AA, Abteilung II, R 9.01, 40029, 134; von Schnitzler to Foreign Office, 15 February 1931, ibid., 113.

47. Economics Ministry to Foreign Office, 29 July 1932, ibid.

48. Guido Müller, "Von Hugo von Hofmannsthals, Traum des Reiches' zum Europa unter nationalsozialistischer Herrschaft—die 'Europäische Revue' 1925–1936/44," in Hans-Christof Kraus, ed., *Konservative Zeitschriften zwischen Kaiserreich und Diktatur* (Berlin: Duncker & Humblot, 2003), 15.

# GATCPAC (1930–36): Social Architecture and the Functional City for a New Society

JOSEP M. ROVIRA

On 25 October 1930, GATEPAC (Association of Spanish Architects and Technicians for Progress in Contemporary Architecture) was established at a meeting at the Gran Hotel in Zaragoza. Attending this gathering were various professionals interested in modern architecture who were working in Madrid, San Sebastián, and Barcelona, where there had been several architectural demonstrations linked with the most radical European trends. Those who traveled from Barcelona to the capital of Aragon were very young architects with newly minted degrees; some were still students: Cristòfor Alzamora (received degree in 1930), Pere Armengou (1931), Ricard Churruca (1926), Sixte Illescas (1928), Francesc Perales (1931), Germà Rodríguez Arias (1926), Josep Lluís Sert (1929), Manuel Subiño (1929), and Josep Torres i Clavé (1929). That the delegation from Barcelona was the biggest was no accident.

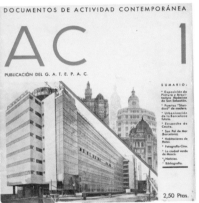

The desire to form a group had taken hold some time before, beginning in April 1929 with the opening of the exhibition *Arquitectura Nova* (New Architecture) at the Galeries Dalmau on the passeig de Gràcia in Barcelona.[1] This exhibition presented models based on design principles that ran counter to the buildings of the International Exposition, upon which construction was about to begin on Montjuïc at the southern edge of Barcelona. Consisting of forms belonging to 19th-century academic eclecticism, these structures were being built for the wrecking ball, useless for modern times. The young architects focused on modern plans (airports, factories, vacation hotels, etc.) offering pure volume— white buildings without ornamentation. At first, the Catalan group was known as GATEPAC GE (the eastern group of the national organization). Before long,

they decided they preferred the name GATCPAC (Association of Catalan Architects and Technicians for Progress in Contemporary Architecture). In this way, the members linked themselves by name with the land and the special political circumstances with which they identified during their active lives as architects. First, they formed a group to disseminate modern architecture; then they created a magazine, *A.C.: Documentos de Actividad Contemporánea*; finally, they opened a place of business to sell furniture and modern materials at 99, passeig de Gràcia in Barcelona. The first issue of *A.C.* (fig. 1) was published in April 1931, the same month they opened their studio. Sharpening their weapons and brandishing their equipment, they readied for battle. Next came the first salvo.

Armed with knowledge, they went forth. Back in their student days, they had wanted to know what the new architecture would encompass. The professors who taught architectural projects and history dismissed them, busy as those professionals were building academic palaces and pavilions on Montjuïc. So beginning in 1926, the young architects buckled down to work: they read books by Le Corbusier, traveled to the heart of the new language (Paris, Dessau, Berlin, Frankfurt), and invited the Swiss master Le Corbusier to lecture in Barcelona.[2] Sert worked in Le Corbusier's studio on rue de Sèvres and attended International Congress of Modern Architecture (CIAM) meetings in Frankfurt and Brussels, where he met Walter Gropius, Sigfried Giedion, Victor Bourgeois, Cor van Eesteren, and many other architects. The young Catalans subscribed to modern architecture magazines and began to construct their buildings in Barcelona, where Illescas and Sert first made their mark. Illescas led off with the Casa Vilaró, commissioned by an indus-

Fig. 1 (cat. 8:8). GATCPAC, *A.C.: Documentos de Actividad Contemporánea*, no. 1 (1931).

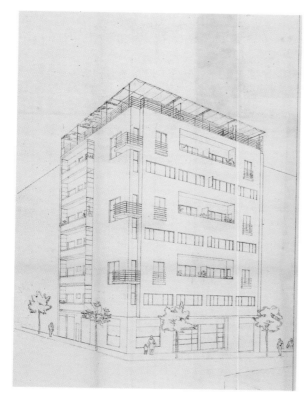

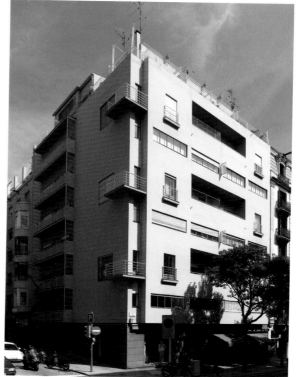

trialist who backed the group, and Sert built two apartment buildings with financial support from his mother (figs. 2 and 3).

In the 1930s, GATCPAC undertook another urgent task: to become vocal critics of the urban development being carried out by the city government of Barcelona.[3] By 14 May 1931, the day the Second Spanish Republic was proclaimed and King Alfonso XIII fled the country, the plan for urban development of the Diagonal, a broad avenue on the northwest side of Barcelona, was almost complete. Beginning in 1926, the municipal urban development authorities had intended to turn the Diagonal into a great luxurious city garden around the royal palace. In opposition, GATCPAC architects proposed a residential neighborhood consisting of tall buildings arranged in rows (fig. 4), just like what they had seen at the CIAM conference in Brussels. Such structures would also have been familiar to them: Sigfried Giedion's *Befreites Wohnen* (Liberated Living) was known to

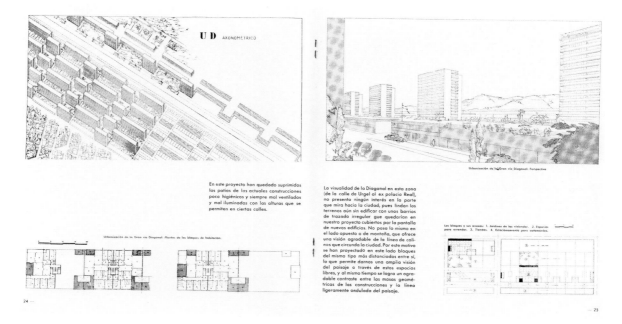

Fig. 2 (cat. 8:11). Josep Lluís Sert, *Genara López Apartment Building, Carrer Muntaner, Barcelona, Perspective Drawing*, 1929.
Fig. 3. Genara López Apartment Building, carrer Muntaner, Barcelona, designed in 1929 by Josep Lluís Sert with Sixte Illescas.
Fig. 4 (cat. 8:14). GATCPAC, *A.C.: Documentos de Actividad Contemporánea*, no. 4 (1931).

have been in Sert's library, and he was well aware of its ideology.[4] The blocks in Barcelona would be created by vertical, linear buildings and ventilated with air, sun, and light, and have green areas around them. The dwellings would be small—the architecture a social service for those unable to afford homes with lots of floor space. Because of this proposal, GATCPAC architects entered a living-space competition in Bilbao in early 1932.[5]

On 25 November 1931, Sert wrote to Giedion: "I would much appreciate your sending me all the information possible on the Moscow conference about the 'functional city' and sending me everything that has been published on this matter, or letting me know where I could obtain it."[6] Shortly after, on 21 January 1932, Sert wrote to Le Corbusier: "We have begun work on the urban development of the future Barcelona."[7] The young architects seem to have been very clear about this plan. They were working to establish the design for the Future Barcelona, which Le Corbusier named the Macià Plan after their supporter, Francesc Macià, then head of the Catalan government. From what we know, this plan aspired to transform Barcelona into a functional city. Sert's contacts at CIAM seemed to bear fruit very quickly. In late March 1932, when it became clear that a CIAM conference would not be held in Moscow, the members of GATCPAC organized a meeting of the CIRPAC (International Committee for the Solution of Problems in Contemporary Architecture) in Barcelona. In the end, it was held on the deck of

a ship, the *Patris II,* as it plied the waters between Marseilles and Athens in the summer of 1933.

So Le Corbusier went to Barcelona and with him elements of CIAM. The Swiss architect was enthusiastic about the opportunity to give material form to the "Ville Radieuse," a series of designs he made for the magazine *Plans* between January 1931 and March 1932. Sert began by traveling to Paris to prepare the first sketches of the Macià Plan. As soon as he returned to Barcelona, he discussed the plan with his colleagues while they were drawing up the final proposal, which took the form of a diorama eight meters long that showed a functional city (figs. 5–7). With zones designated for housing, leisure, transportation, and factories, it presented a city designed for industry, workers, and the capital.

Against Le Corbusier's wishes, the proposed CRV (City of Rest and Vacation) was located along the beaches and virgin pine forests south of Barcelona. It was an area "discovered" by GATCPAC members on a Sunday excursion in late 1931. Organizing "rest" for the masses at a time when they were starting to have 15 days of vacation plus weekends was another challenge for the functional city (fig. 8). This issue had already been addressed in Moscow, with its well-known "Green City," to which the members of GATCPAC had paid careful attention since the outset of their careers.[8]

From the minutes of the GATCPAC board meeting held on 1 December 1932: "City for rest. Commissioned to: Sert, Perales, Fàbregas, Churruca,

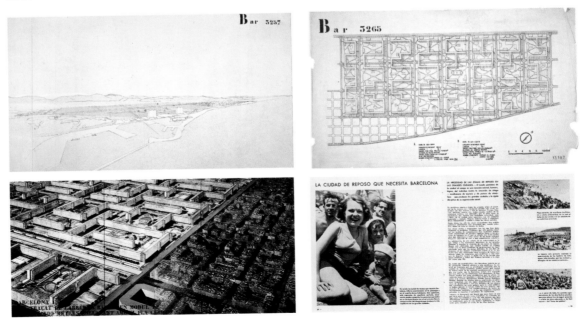

Fig. 5 (cat. 8:15). Le Corbusier, *Barcelona Macià Plan,* 1932.
Fig. 6 (cat. 8:16). Le Corbusier, *Barcelona Macià Plan,* 1932.
Fig. 7 (cat. 8:17). GATCPAC, *City of Rest and Vacation and Macià Plan,* c. 1935, one of four photomontages.
Fig. 8 (cat. 8:19). GATCPAC, *A.C.: Documentos de Actividad Contemporánea,* no. 7 (1932).

Rodríguez, Alzamora, Illescas, Torres Clavé, Subiño. Collective work," group collaboration. Far from conceiving a traditional plan such as those drawn up for the Italian or French rivieras, the GATCPAC group designed a "city" based on the needs of the Catalan working class, whether manual laborers or white-collar workers. Resorts by the sea, hotels, open-air

Vía de les Corts Catalanes, would allow rapid access to the beaches, now that the automobile had become the means of transport par excellence (as opposed to the railroad). They exhibited the plan in the plaça de Catalunya in March 1933 and February 1934. On a third occasion in the summer of 1934, they showed it at the Salón de Turismo, held on Montjuïc.

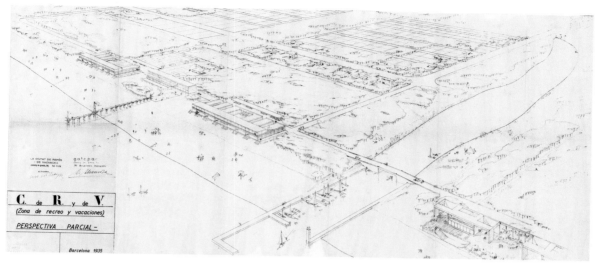

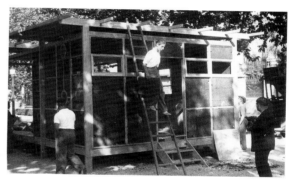

movies, bathhouses, small garden plots, movable houses, single-family housing, bus terminals, and the like were located in various areas amid the area's magnificent pines (figs. 9 and 10). The extension of one of the main arteries in the Macià Plan, the Gran

Promotion was essential in order to give potential users an idea of the architects' aspirations, and the exhibitions were very popular.

The GATCPAC architects shared ideas about their work. Sert, Torres Clavé, and Ricardo Ribas built their small, dismountable houses on the beach (figs. 11–13). Minutes of group meetings mention the houses frequently, and photographs of the owners with their houses are in the Ribas archives. Such a house would have to be assembled like an automobile, as a separate entity, and could be moved to different sites as the owner wishes—like a camping tent but more comfortable. Modern man did not need a fixed dwelling. Adolf Loos and Ludwig Hilberseimer upheld the idea of living in hotels, with all the resident's property in a suitcase.

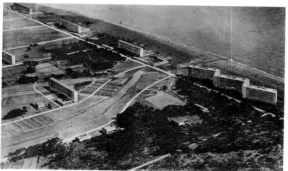
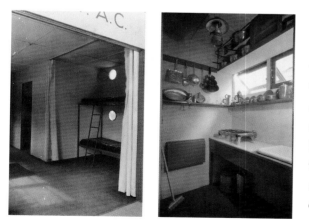

Fig. 9 (cat. 8:18). GATCPAC, *City of Rest and Vacation, Partial Perspective,* 1931–35.
Fig. 10 (cat. 8:17). GATCPAC, *City of Rest and Vacation and Macià Plan,* c. 1935, one of four photomontages.
Fig. 11 (cat. 8:20). GATCPAC, *Construction of a Dismountable House,* c. 1932, one of eight photographs.
Fig. 12 (cat. 8:21). GATCPAC, *Completed Interior of the Dismountable House,* c. 1932, one of four photographs.
Fig. 13 (cat. 8:21). GATCPAC, *Completed Interior of the Dismountable House,* c. 1932, one of four photographs

Living in the open air, in contact with nature, in low-cost structures was a way of claiming the right to leisure and hygienic dwellings that would assure the health of their inhabitants. Sert and Torres Clavé built three types of minimal weekend dwellings in 1934 within the limits of the CRV. Designed to be sold, the houses were a vehicle for advertising the architects' ideas, the plans based on an interpretation of the

Mediterraneanist ideology that had interested Sert and Torres Clavé for some time.[9] They proposed the idea that the new architecture would have to adapt to the characteristics of a specific climate rooted in the land. But that was not all. They came up with the idea that modern architecture originated in the ageless towns around the Mediterranean, where the buildings were white, standardized, cubic, unornamented, and flexible. They proposed that the birthplace of modern architecture was right here, on the Mediterranean coast, not in Germany. To understand such thinking, we must not forget that

many European intellectuals vacationed on the architects' favorite island, Ibiza. Walter Benjamin was there; Raoul Hausmann, the Dadaist who said that Barcelona was more modern than Berlin, also visited the island in the 1930s;[10] and there were many others. Thus the avant-garde "invented" Ibiza and constructed a myth for it.

For the GATCPAC group, the intellectual and ideological explanation for the Mediterraneanist ideology was obvious: it was a way to look out for themselves, to show their part in the origins of the

new architecture, to show they were modern and that the historical concept of center/periphery is not infallible and may occasionally be turned on its head. Thus, what were known as the Garraf "weekend" houses (figs. 14–16) were built on stone bases, covered with Catalan-style domes, equipped with straw furniture, and decorated with fishermen's baskets and ceramic amphorae. Furniture made of chrome tubing disappeared. Nevertheless, in his weekend house Sert hung a Fernand Léger painting from his studio and found a place for the small African idol he carried wherever he went. The avant-garde and primitivism were seamless.[11] The architect Josep Soteras, affiliated with GATCPAC, built his own minimal house on land identified for the CRV plans, located more than two hours by foot from the train station in Castelldefels. Looking like a grounded ship, the house itself was a manifesto, an example of the architect practicing what he preached.

The period between the proclamation of the republic in 1931 and October 1934 was the best of times for the party in power, the ERC (Republican Left of Catalonia), founded and led by Francesc Macià until his death on 25 December 1933. During this time, modernist architects were able to obtain commissions and fill in the content of the programs sketched out by the ERC. GATCPAC architects became the technocrats of a party that was governing without economic resources, a young and fragile party surrounded by enemies to the right and left. What it needed to provide credibility among both its supporters and enemies was urban development and architecture. Housing for workers, hospital buildings, and school buildings had an important role to play in this platform. ERC politicians and GATCPAC architects diligently undertook the financing, design, and construction of these buildings, according to modern standards.

A memorandum from the group written on 13 March 1932, which conveyed an interest in having the CIAM panels that had been exhibited in Brussels also shown at the CIRPAC meeting in Barcelona,

Fig. 14 (cat. 8:22). Margaret Michaelis, *Exterior View of Sert and Torres Clavé's Weekend House at Garraf,* 1934–35.
Fig. 15 (cat. 8:23). Margaret Michaelis, *Interior View of Sert and Torres Clavé's Weekend House at Garraf,* 1934–35.

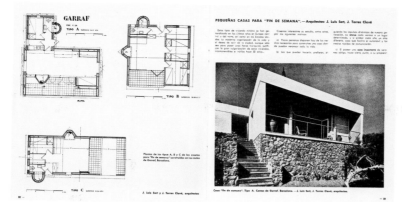

ple were housed in shacks, would have to be solved. There was good reason for journalists to call the city "Barracópolis," based on the Spanish word *barracas* (shacks).

The minutes of the GATCPAC board meeting of 21 April 1932 acknowledge a commission from Josep Dencàs, a member of the ERC executive committee, for a group of ten single-family houses to be built in the workers' neighborhood of Sant Andreu. They made sketches of a tall building block on an adjacent site, and then submitted them to President Macià. The meeting minutes of 10 November 1932 read: "Worker Housing Commission. Sert, Torres Clavé, and Alzamora are commissioned to develop a solution for a new apartment building as quickly as possible." Working together, the three developed a solution, the Casa Bloc (figs. 17 and 18). Macià laid the first stone in Casa Bloc and contemplated its model when they started work on the ten dwellings on 12 March 1933. It was housing for workers constructed along the lines of a *redent* (stepped formation), as was supposed to be applied in the housing zones

reads: "[P]reparatory meeting for one that will be held later in Moscow to determine the specific characteristics of modern urban development as it relates to the worker's functional unit."[12] Thus by 1932 they must have believed that a city and its workers' dwellings should be in harmony. On 14 February 1931, the mayor of Barcelona, Jaume Aiguader, had given a lecture entitled "The Worker Housing Problem in Barcelona," stating: "Block houses may be just as healthy as the houses in a garden city, and they may be the precise solution to the problem of housing for workers."[13] Politicians and modern architects thus shared a common ideology and recognition of the housing problems of Barcelona, where 50,000 peo-

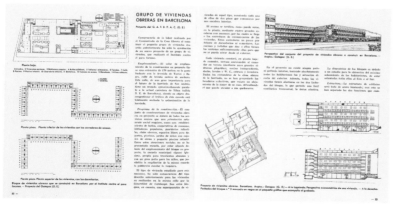

of the Macià Plan. The buildings were designed to be tall to save on infrastructure costs, with balcony walkways to save costs on stairways and elevators. Each apartment was 70 square meters, and they were arranged as duplexes, with communal services included. In addition, the buildings were close to a school and a factory, just

Fig. 16 (cat. 8:24). GATCPAC, *A.C.: Documentos de Actividad Contemporánea*, no. 19 (1935).

Fig. 17 (cat. 8:12). Josep Lluís Sert, Joan B. Subirana, and Josep Torres Clavé, *Casa Bloc*, 1933, model designed by Fernando Marzá, made in 1992 by Laura Baringo and Ángel García.

Fig. 18 (cat. 8:13). GATCPAC, *A.C.: Documentos de Actividad Contemporánea*, no. 11 (1933).

like the blocks the GATCPAC architects had seen on their many trips through Europe.

Barcelona's pressing housing problem of the 1920s and 1930s was caused mostly by the wave of immigrant laborers who came to work on the construction of the 1929 International Exposition. The health of the inhabitants and the scarcity of medical facilities was another chapter pending in the Catalan capital. Tuberculosis raged among those living in unhealthy dwellings (figs. 19 and 20), especially in the old part of the city known as the "Barri Xino" or "Chino" (Chinatown). In an article published in *La Publicitat* on 30 March 1933, Josep Dencàs, then the minister of sanitation and social services, announced the construction of a new tuberculosis clinic in the city center, which made use of

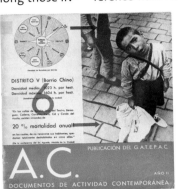

a building site expropriated from a religious order in the late 19th century. Sert and Torres Clavé were selected as architects, while Juan Baptista Subirana designed the structure and drew up other technical documents.[14] Months later, the magazine *El mall* (28 October 1933) reproduced a presentation, "Public Health Problems in Catalonia," given at the second ERC convention. It contains a strict public health plan designed to resolve the problem throughout Catalonia, evidence of the new republican order. Once again, the political sphere sought a solution to a social problem through the formal elements of

modern architecture. Construction of the Dispensari Central Antituberculós (figs. 21 and 22) began in mid August 1933 and progressed very slowly. The building was finally inaugurated at the height of the civil war, on 28 April 1937.

Not just a hospital, the clinic was designed to function as a center for medical research and almost constituted a small university, with a library and conference hall. The L shape adopted by the architects separated its functions and created a courtyard (fig. 23). The patients' block and its balconies face the sun to facilitate heliotherapy. The space designed for research has a more severe, monumental nature, justifying its role based on the scientific nature of the clinic's function. The porter's living quarters closes off the courtyard. The complex shuts the city out, turning its back on the sources of infection. Instead, it is open to the mountains, the sun and the air essential for a cure.

Sert, Torres Clavé, and Subirana had time for little more because the political handwriting was on the wall. Presented as a model, from the autonomy of its discipline and its new formal presence, modern architecture was solving urban planning problems. Working from pre-established plans, such architecture could find a place in any city in Catalonia. It was exemplary, universal, and modern, and proposals were forthcoming. Plans for a hospital by Sert and

Fig. 19 (cat. 8:9). *A.C.: Documentos de Actividad Contemporánea*, no. 6 (1932).

Fig. 20 (cat. 8:10). *A.C.: Documentos de Actividad Contemporánea*, no. 25 (1937).

Fig. 21. Dispensari Central Antituberculós, designed by Josep Lluís Sert, Joan B. Subirana, and Josep Torres Clavé .

Fig. 22. Dispensari Central Antituberculós, interior view.

Fig. 23 (cat. 8:25). Joan B. Subirana, *Dispensari Central Antituberculós, Façade Perspective*, 1934.

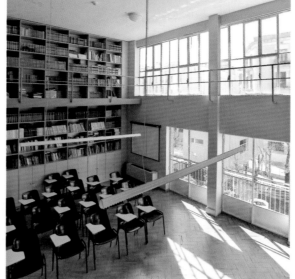

Torres Clavé at Vall d'Hebron in Barcelona, the 100-bed Hospital Comarcal (Sert, Subirana, and Torres Clavé), a hospital at Seu d'Urgell, and others provide some indication of how architects contributed to solving Catalonia's public health problem. But they would not succeed because the civil war frustrated their plans, along with their hard-won freedom.

Neither did the republic face better prospects in the renovation of schools. The condition of most Catalan schools of the period was deplorable. "In most towns . . . the school is set up in a foul shack without any consideration of hygiene, without light, air, or happiness. . . . These schools have a single room where 60, 70, or 80 children move around, breathing brick dust mixed with the stench of the nearby

toilet, without water. . . . Others are on low-lying sites so humid that puddles form on the floor."[15] Not only were the buildings provided for public education disaster areas, almost 40% of the population of Catalonia was illiterate. In the city of Barcelona, this figure was somewhat lower, at 25%.

Given the situation, the republican government planned to construct the maximum number of schools possible. Between 1931 and 1935, they provided education for 40,900 children in Catalonia, which solved 28% of the government's actual requirements. As was to be expected given their steady attention to politics, GATCPAC architects were aware of these building plans. They offered their services to the state and organized exhibitions about modern

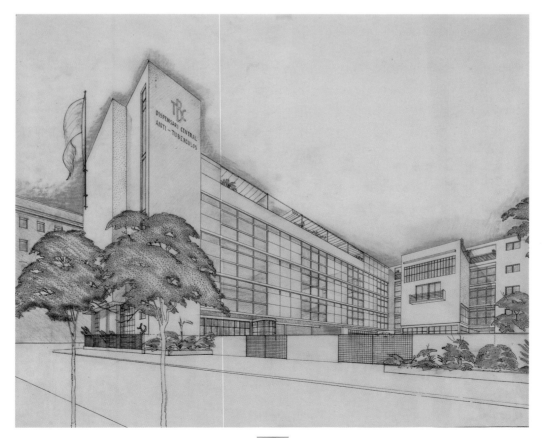

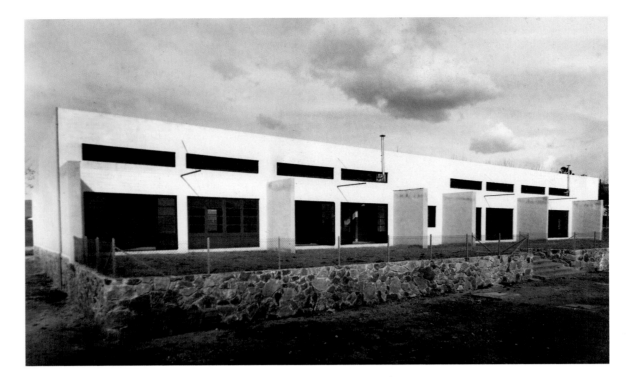

schools.[16] They also proclaimed—through their professional practice and in the pages of the magazine *A.C.*[17]—the need for schools to be modern throughout, including form, pedagogical ideas, and sanitary facilities.[18] They made contact with their European mentors, this time, Gropius, Giedion, and Werner Moser. They consulted German books on schools, from which they drew formal and organizational models. One of their important sources was Julius Vischer's book *Der Neue Schulbau* (1931).

With this background, they began. In 1932 Sert designed a school for Avinguda del Bogatell in Barcelona, but it never went beyond the project stage. Between 1933 and 1935 he designed and built an elementary school in Palau-solità (fig. 24), and in 1935–36 he designed and began construction on two projects in Martorell. I have discussed them elsewhere, and their photographs, sections, and floor plans are enough to understand their modernity.[19] Jaume Mestres Fossas designed and built the Blanquerna school in Barcelona, Raimon Duran i Reynals the schools in Pineda de Mar, Ramon

Puig Gairalt the Escola de Mar at l'Hospitalet,[20] and Pere Armengou the great school buildings of La Renaixença in Manresa.[21] Sert and Subirana also designed prefabricated nursery schools and libraries, as well as kindergartens.[22]

For obvious reasons, the war and General Francisco Franco's fascism put an end to the climate that protected the venture of modernist architecture in Catalonia. Torres Clavé died on the front. Sert went into voluntary exile in the United States, Rodríguez Arias in Chile, Ribas in Colombia, Fàbregas in Cuba. Illescas and Subirana were severely punished for working for the republic. GATCPAC was disbanded. Armengou, Churruca, Perales, Subiño, Alzamora, and others were drafted into the regime and not punished. About the professional careers of the GATCPAC members who remained in Barcelona during the Franco years, it is best to say nothing. Only a few buildings designed by Duran i Reynals were saved from the cultural grief of the postwar period. People would have to wait many years before modern architecture returned to Catalonia.

Fig. 24. Elementary school in Palau-solità i Plegamans, 1933, designed by Josep Lluís Sert.

1. Regarding the Catalan political and architectural background in 1930 and the plans presented by Sert and his fellow reformers at the exhibition at the Galeries Dalmau, see the English edition of Josep M. Rovira, *José Luis Sert: 1901–1983* (Milan/London: Electaarchitecture, distributed by Phaidon, 2003), 11–35.

2. On Le Corbusier's stay in Barcelona, see Le Corbusier, *Le Corbusier i Barcelona*, exh. cat. (Barcelona: Fundació Caixa de Catalunya, 1988); Juan José Lahuerta, ed., *Le Corbusier y España*, exh. cat. (Barcelona: Centre de Cultura Contemporània de Barcelona, 1997); and Le Corbusier, *'Espagne'. Carnets* (Milan: Electa, 2001).

3. To understand the scope of GATCPAC activities with respect to urban development, see Rovira, *José Luis Sert*, 47–79; and Rovira, "Sert and the GATCPAC," in Sert, Half a Century of Architecture: 1928–1979, Complete Work, ed. Rovira, exh. cat. (Barcelona: Fundació Joan Miró, 2005), 52–72.

4. Sigfried Giedion, *Befreites Wohnen: 85 Bilder* (Zurich: O. Füssli, 1929). An editorial in issue 3 of A.C. cites a portion of the Swiss historian's book and specifically mentions his name. Sert and Giedion were friends and fellow reformers throughout their lives. See Rovira, "Sert and Giedion," in *DC. Revista de crítica arquitectònica,* 13–14 (2005): 140–54.

5. In the minutes of a GATCPAC board meeting held on 9 January 1932 is an agreement to participate in said competition, for which plans had to be delivered on 28 February 1932. The project report reads: "The cheap house is the most important subject of architecture in our time. ... This may be the first time a city government in our country has initiated a construction plan of this kind, inspired by the social spirit of the times. Focusing its activities on the solution of functional problems, not focusing all its attention on superfluous monuments and unnecessary decoration." Col·legi d'Arquitectes de Catalunya, Arxiu Històric, fons GATCPAC.

6. Ibid., C-10/65.

7. Ibid.

8. "La ciudad verde de Moscú," *A.C.,* no. 1 (1931): 30–32.

9. Ibid., 24–25. Ideas about Mediterraneanism are discussed in *A.C.* issues 6, 18, 19, and 21. A recent edition of *A.C.* was produced in DVD format, with a facsimile of the first issue and essays by various writers presenting the phenomenon of GATEPAC: Ricardo Marco Fraile and Carlos Buil Guallar, eds., *El GATEPAC y la revista A.C.: catalizador de la vanguardia arquitectónica española 1931–1937* (Zaragoza: Demarcación de Zaragoza del Colegio Oficial de Arquitectos de Aragón, 2005).

10. For a book that brings together Raoul Haussman's experience in Ibiza, see Haussman, *Hyle: Ein Traumsein in Spanien* (Frankfurt am Main: Heinrich Heine Verlag, 1969). Benjamin's texts on Ibiza are the best known.

11. The progress of the Mediterranean ideology is examined in Rovira, *Urbanización en Punta Martinet, Ibiza, 1966–1971: E. Broner, S. Illescas, G. Rodríguez Arias, J. L. Sert* (Almería: Colegio de Arquitectos de Almería, 1996), and Antonio Pizza, ed., *J. LL. Sert y el Mediterráneo* (Barcelona: Col·legi d'Arquitectes de Catalunya, 1997).

12. Archive of the Diputació de Barcelona, file 38, Sig. 4162, GATEPAC.

13. Aiguader's lecture, published as a brochure, contains the plans designed by GATCPAC architects as solutions for a block on Cerdà's Eixample, with the new ideas of linear blocks surrounded by gardens. This proposal is the embryo of the future Casa Bloc, with some deficiencies that were corrected in the buildings at Sant Andreu.

14. Sert to Subirana, 18 October 1933, Col·legi d'Arquitectes de Catalunya, Arxiu Històric, fons GATCPAC.

15. Ramon Navarro, *L'educació a Catalunya durant la Generalitat, 1931–1939* (Barcelona: Edicions 62, 1979), 215–16, 278.

16. Col·legi d'Arquitectes de Catalunya, Arxiu Històric, fons GATCPAC, C17/97.

17. An exhibition about modern public schools opened in Madrid on 20 December 1932, which then traveled to Barcelona to open on 11 January 1933, where Macià, Ventura Gassol, and Aiguader participated in the opening.

18. In the minutes of a GATCPAC meeting held on 1 October 1931 we read: "It is agreed that Mr. Sert will take responsibility for all work for the *A.C.* issue on schools." Both issue 9 (1932) and 10 (1933) of the GATCPAC magazine focus on modern schools.

19. See Rovira, ed., *Sert, Half a Century of Architecture,* 34–35, 39–41, 79–83.

20. Antonio Pizza and Josep M. Rovira, eds., *La tradició renovada: Barcelona anys 30. La tradición renovada: Barcelona años 30,* exh. cat. (Barcelona: Col·legi d'Arquitectes de Catalunya, 1999), 121–38, 159–77.

21. See *A.C.,* no. 16 (1934): 24–27.

22. Rovira, ed., *Sert, Half a Century of Architecture,* 50–51.

Translated by Eileen Brockbank.

# Rational or Organic: Barcelona Furniture of the 1930s

*JARED GOSS*

The second quarter of the 20th century saw radical changes in design. The luxury of Art Deco seemed increasingly irrelevant, particularly in light of the exigencies of the worldwide economic depression of the 1930s, and it was replaced by a vigorous, reform-minded rational design. The simplicity and economy of rationalist design was preferable aesthetically—even morally—to the elaboration and extravagance that had typified Art Deco. Although completely different in approach, the two pieces of furniture discussed here embody this shift to rational design.

That Joan Baptista Subirana was familiar with the works of his European contemporaries is not surprising since he was a member of the GATCPAC (Association of Catalan Architects and Technicians for Progress in Contemporary Architecture). Indeed, his table (fig. 1) epitomizes Catalan efforts to design up-to-the-minute furniture of the sort that was coming out of the German Bauhaus, tubular-steel furniture in particular.[1] A truly modern material, tubular steel freed designers from the structural limitations and complicated joinery processes of conventional furniture construction. The German-born architect-designer Marcel Breuer had introduced tubular-steel furniture in 1925 with his Wassily armchair (model B3).[2] The armchair was followed by a design for nesting tables (model B9), originally conceived as a stool, and made of a continuous length of bent tubular steel supporting a top surface of laminated wood. Maintaining the uninterrupted frame required sled runners along two of the bottom edges, a feature that would appear in many tubular-steel designs by Breuer and his followers.[3]

Subirana designed his table on the same principles as the B9 table, but with additions. The table is made from a continuous length of chrome-plated tubular steel, bent to provide a horizontal support for the black lacquered wood top; a lower shelf (lac-

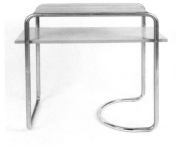

quered aqua green) is screwed into the four vertical legs; the tubing is bent to provide runners at the bottom—straight on one side, arcing inward on the other—giving the piece stability and visual interest. The table formed part of a suite used in the entrance hall of Subirana's house in Barcelona, completed in 1931.

The strict severity of rationalist tubular-steel furniture tended to please designers more than consumers, and by the late 1930s the aesthetic had yielded to a more fluid, organic approach to design. Characteristic of this new, softer approach is the BKF chair, often referred to as the "butterfly" chair (fig. 2), now one of the iconic designs of the 20th century. Although its origins are generally considered Barcelonian, its story is as much international as Catalan.

A native of Barcelona, architecture student Antoni Bonet spent time working as an apprentice during the mid 1930s both in the Barcelona studio of Josep Lluís Sert and Josep Torres Clavé and in the Paris atelier of Le Corbusier, where he met fellow apprentices the Argentines Juan Kurchan and Jorge Ferrari-Hardoy. Because of the increasing political turmoil in Spain, in 1938 Bonet decided to accompany his colleagues to Buenos Aires, where the three established the Grupo Austral, an architecture and design association founded on principles similar to those of GATCPAC. The BKF was one of the group's first designs, dating from around 1938; its name derives from the first letter of each designer's last name. After 1940, the chair was produced in limited numbers by Artek-Pascoe of New York; following World War II it was mass-produced by Knoll and other manufacturers.

The chair is made from welded metal rods with a detachable leather sling seat; the small rubber sleeves at its base prevent it from sliding. Its organic design blurs the relationship between the various

Fig. 1. *Table*, c. 1932, designed by Joan B. Subirana.

Fig. 2 (cat. 8:27). Grupo Austral (Antoni Bonet, Jorge Ferrari-Hardoy, Juan Kurchan), *BKF Chair Prototype*, 1938.

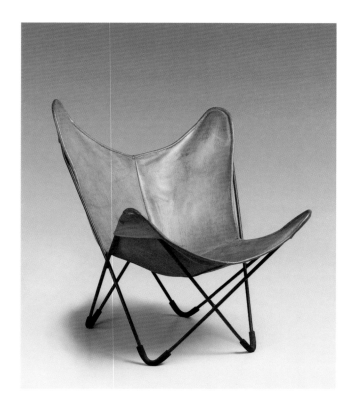

components: there is no discernible separation between seat, back, legs, and arms. While it functions well, the chair is a completely sculptural object, and surrealist art may have played a role in its conception.[4] The worldwide economic crisis of the 1930s had led to a new informality in domestic arrangements, and furniture of the period followed suit: it is impossible to sit upright in the BKF chair, there is no support for the body—it is entirely meant for relaxation. It is notable that Museum of Modern Art curator Edgar Kaufmann Jr. included the chair in *What Is Modern Design?* (under the heading "Chairs for Conversing and Relaxing, Metal Frames"), his landmark book illustrating his Twelve Precepts of Modern Design.[5]

But for all its innovation, the chair also has strong roots in the past. Apart from the obvious (its materials—iron and leather—are traditional to Spain), its form is clearly descended from wood or metal folding campaign chairs from the 19th century, particularly the so-called Tripolina chairs designed by the Englishman Joseph Beverly Fenby around 1855 and patented in 1877.[6]

1. The Bauhaus was founded in Weimar, Germany, in 1919 as a school of arts and crafts but soon became known as a center of avant-garde design. In 1925, it moved to the small industrial city of Dessau. The school's emphasis was on training designers who, beyond having a practical knowledge of the materials with which they worked, could design industrial objects suitable for mass production. The aim was to bring good design within the reach of the masses. In 1933 the Nazis closed down the Bauhaus, but in its brief 14 years it had become a magnet of modernist concepts, producing a generation of architects, artists, and designers who spread its teachings throughout the world. Among them were the architects Walter Gropius, Ludwig Mies van der Rohe, and Marcel Breuer; the industrial designers Marianne Brandt and Wilhelm Wagenfeld; and the artists Wassily Kandinsky, Paul Klee, Oskar Schlemmer, Laszlo Moholy-Nagy, and Josef Albers.

2. "The genesis of Breuer's first tubular-steel chair has achieved the status of modernist legend. It tells of how the designer was inspired by the strength, lightness, and utility of the bicycle he was riding; of how he approached the bicycle company with his idea of furniture made out of bicycle tubes and of the company's predictable rejection of the novel idea; of how at first he purchased lengths of tubular aluminum (an unsuccessful experiment) and then 'precision steel tube,' which he worked into a crudely constructed chair with the help of a plumber." Christopher Wilk, "Furnishing the Future: Bent Wood and Metal Furniture 1925–1946," in *Bent Wood and Metal Furniture 1850–1946* (New York: American Federation of Arts, 1987), 126.

3. "Although not a new concept, these floor runners came to be regarded as a leitmotif of the new designs executed in tubular steel. With them . . . chairs acquired a degree of mobility impossible to achieve with the traditional arrangement of four individual legs. It was hoped that many households, particularly those with limited means, would find this feature attractive, for it permitted a chair or stool to be moved around at will to serve a variety of needs." Derek Ostergard, *Bentwood and Metal Furniture 1850–1946* (New York: American Federation of Arts, 1987), 272.

4. "During his time in Paris, Bonet became interested in the paintings of Roberto Matta and worked with Le Corbusier on the Maison Jaoul . . . [and] to note here the influence of Gaudí would almost be redundant. Bonet always admitted his interest in surrealism and abstract expressionism. He was very well acquainted with the works of Picasso and Miró, in addition to having friendships with them." Isabel Campí i Valls, "Butaca 'BKF,'" in *Moble Català*, ed. Eulàlia Jardí, exh. cat. (Barcelona: Generalitat de Catalunya, 1994), 357. Translation by Marc Barrio Gázquez.

5. An example was added to the collection of the Museum of Modern Art at that time. For the principles, see Edgar Kaufmann Jr., *What Is Modern Design?* (New York: Museum of Modern Art, 1950), 7.

6. So named because the Italian army used them during maneuvers in Libya.

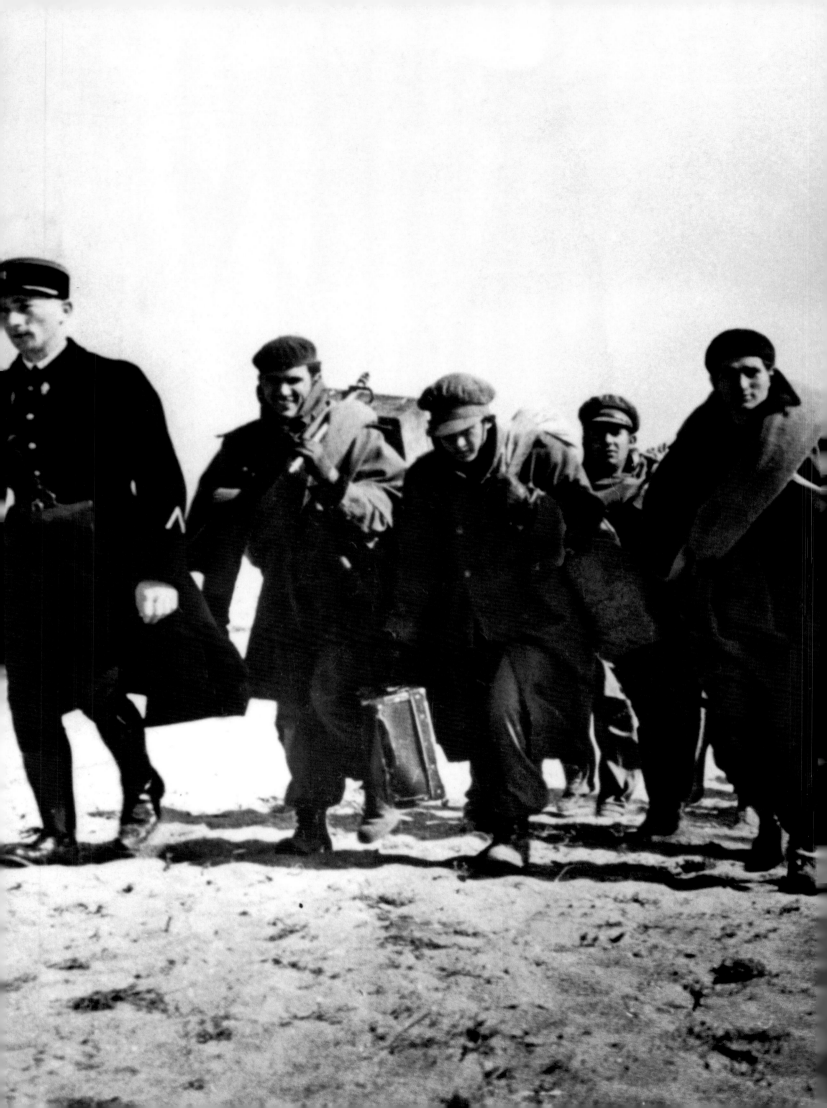

# 9

# Avant-Gardes and Civil War

# Barcelona in the Maelstrom

*W I L L I A M   H .   R O B I N S O N*

Yes, the dictatorships, they are like a frightful epidemic, they infest the whole world.
Now it is Spain. If it should succeed in spreading its poison, France will be next and so will be England.
—Emma Goldman, July 1936

Spain in the summer of 1936 was at once one of the most revolutionary and one of the most conservative societies in Europe. The recently elected leftist government enacted a series of controversial measures to redistribute property, reform the military, and enforce strict church-state separation. When parliament also approved statutes of autonomy for Catalonia and the Basque region, the extreme right reacted by accusing the government of allowing Spain to disintegrate into the chaos of regional separatism and class warfare. On 17–18 July right-wing military officers launched a series of coordinated revolts across the country aimed at overthrowing the Second Republic. The insurgents—also known as the rebels or nationalists—viewed their coup d'état as a last chance to rescue "eternal Spain" from atheistic socialism. They hoped to restore the Spanish empire and its traditional values of monarchy (or at least centralized, authoritarian government), ardent Catholicism, property rights, order, and national unity. They envisioned their uprising as a second *Reconquista* that would save Spain and ultimately Europe from the "reds" who were infect-ing the working class with foreign, heretical ideas.[1] Believing that armed mutiny was the only way to purge the nation of this alien contagion, the nationalists, led in part by General Francisco Franco, thought they could overwhelm the republic within days. Instead, they plunged Spain into a bloody civil war that devastated the country for three years. The war split not only Spain but the world into pro- and antifascist camps, with Nazi Germany and fascist Italy actively aiding the rebels, and the Soviet Union and the International Brigades supporting the loyalists of the Spanish republic.

The city of Barcelona, a stronghold of anarcho-syndicalism in Spain, would remain a pillar of support for the republic throughout the war (fig. 1). During the early days of the conflict anticlerical extremists burned Antoni Gaudí's studio at the church of the Sagrada Família (fig. 2). When a nationalist offense threatened Madrid, the republic moved the seat of government first to Valencia, then to Barcelona.[2] George Orwell, who joined a Marxist militia in the city and later fought on the Aragon front, observed that class conflict reached such a fever

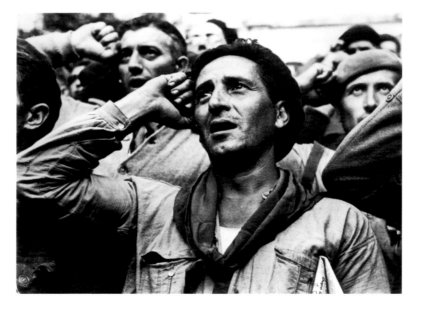

Fig. 1. *Montblanc, near Barcelona* (meeting of the International Brigades), 1938, by Robert Capa.

pitch in Barcelona that it became dangerous to wear a tie or tip a waiter; others reported that militiamen considered it a sign of slavery to salute an officer.[3] Orwell recalled feeling "startled and overwhelmed" upon arriving in Barcelona in December 1936:

*It was the first time I had ever been in a town where the working class was in the saddle. Practically every building of any size had been seized by the workers and was draped with red flags or with the red and black flag of the anarchists. . . . Every shop and café had an inscription saying that it had been collectivized; even the bootblacks had been collectivized and their boxes painted red and black. . . . Servile and even ceremonial forms of speech had temporarily disappeared. Nobody said "Señor" or "Don" or even "Usted" . . . revolutionary posters were everywhere . . . loudspeakers were bellowing revolutionary songs all day and far into the night. . . . I recognized it immediately as a state of affairs worth fighting for.[4]*

Artists in Barcelona responded to the war with a mixture of anguish, revulsion, and determined resistance. While some artists actively supported the republic by joining the military, others mobilized art as an essential weapon in the fight against fascism. They responded to the war's brutal savagery—to the mass executions and the bombing of cities— with paintings and sculptures, stage sets and films. Posters became vital for galvanizing the masses. To win the battle for world opinion, films and photographs were made for mass distribution to foreign audiences. References to the war appeared almost immediately in the paintings of Salvador Dalí and Joan Miró).[5] Thematic allusions to the war surfaced even in the jewelry of Manuel Capdevila (see fig. 1, p. 434). Pablo Picasso joined the fray with his stridently partisan etching *Dream and Lie of Franco* (see fig. 1, p. 459; fig. 2, p. 460) and his landmark painting *Guernica* (Museo Nacional Centro de Arte Reina Sofía, Madrid), commissioned by the

Spanish republic for its pavilion at the Paris world's fair of 1937. A remarkable assemblage of artists and architects—including Picasso, Miró, Julio González, Alexander Calder, and Josep Lluís Sert—collaborated on this pavilion (see fig. 3, p. 432; figs. 1–3, p. 451; fig. 7, p. 453) with the intention of attracting world support for the embattled republic.

Meanwhile, artists in Barcelona threw themselves energetically into organizing collectives and exhibitions in support of the republic. On 31 July 1936, architect Josep Torres Clavé established SAC (Syndicate of Catalan Architects) to contribute to the republican effort at social revolution.[6] The socialist UGT (General Workers Union) and the anarchist CNT (National Workers Confederation) also organized collectives of graphic artists and designers, including the SDP (Syndicate of Professional Designers, established July 1936 under Helios Gómez), to support the war effort. Trade union artists even painted automobiles and buildings with antifascist messages. The CNT–FAI (National Workers Confederation–Iberian Anarchist Federation) collectivized the film industry and produced films such as Antoni Sau's *Aurora de Esperanza* (Dawn of Hope, 1937) to broadcast their view of the conflict.[7] New magazines were established to support the republic, and photojournalists such as Agustí Centelles gave a human face to the war through powerful photographs published in *La Humanitat* and *La Vanguardia*.[8] Foreign artists and intellectuals also contributed. British surrealist Roland Penrose and French art historian Christian Zervos came to Barcelona to express their solidarity with the republic; Romanian poet Tristan Tzara and Russian novelist Ilya Ehrenburg arrived to assist with the distribution of war propaganda.[9]

The Catalan government was especially effective at mobilizing the arts to support the war effort. In October 1936 the Generalitat established the Comissariat de Propaganda under the direction of Jaume Miravitlles, a leftist writer for *L'Opinió* and *La Humanitat*. Close friends with Dalí, Miravitlles had

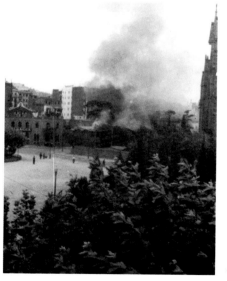

Fig. 2. The burning of Antoni Gaudí's studio, 1936.

appeared as an actor in the films *Un Chien andalou* (*An Andalusian Dog,* 1929) and *L'Age d'or* (*The Age of Gold,* 1930). Under his leadership, the Comissariat commissioned poems, photographs, posters, and films intended for worldwide distribution. Miravitlles also established his own film production and distribution companies, Laia and Catalonià Films, the former producing 135 documentaries during the war.[10] Throughout the conflict the Generalitat, the Ajuntament (city council), and independent organizations sponsored scores of exhibitions emphasizing ideological messages. The Concurs de Cartells Antifeixistes, an exhibition of antifascist posters, opened on 3 October 1936, and the Exposició de Cartells contra el Feixisme, another exhibition of antifascist posters sponsored by the Comitè de Milícies Antifeixistes (Committee of Antifascist Militias), opened on 6 October 1936 with a live radio broadcast by Miravitlles.[11] The government kept soldiers in the field aware of such developments by distributing cultural materials and books through its Serveis de Cultura al Front and the Serveis de Biblioteques al Front.[12]

From the beginning of the war, cultural activities suddenly shifted focus from a privileged, elitist position toward engaging mass audiences with popular imagery, often stressing Catalonia's commonality with other parts of Spain, rather than its differences or uniqueness. Visual messages frequently urged solidarity with Madrid, Asturias, and the Basque country. As Catalonia stepped into the center of a world stage where its very life hung in the balance, artists were forced to adjust their thinking to the urgent realities of a war from which they could not remain aloof.

A few Catalan painters and intellectuals did side with the nationalists. Pere Pruna, known for his classicizing paintings of the 1920s, spent much of his career working in Paris, but during the civil war produced propaganda works for the rebels. Josep Maria Sert, uncle of the architect Josep Lluís Sert and one of the most internationally celebrated painters of the 1930s, also supported the nationalists. Born and trained in Barcelona, Sert painted murals for the local Palau de Justícia (1909), city hall (1929), the Waldorf Astoria in New York (1930–31), and the League of Nations headquarters in Geneva (1936). He is per-

haps most infamously remembered for painting the murals (begun 1933) that replaced those of Diego Rivera at Rockefeller Center, a blasphemy in the eyes of many, which did not exactly enhance Sert's reputation in the international art world. His close relationship with the nationalists became all too apparent at the Paris International Exhibition of 1937. Countering the stridently pro-leftist messages at the pavilion of the Spanish republic, the archbishop of Toledo commissioned Sert to paint the altarpiece for the Vatican pavilion.[13] Depicting the crucified Christ receiving dead nationalists as martyrs of the civil war, Sert's altarpiece presented a devoutly religious, pro-monarchist rejoinder to Picasso's *Guernica* and Miró's *The Reaper,* both commissioned for the republic's pavilion.

The civil war was such a cataclysmic event that even artists living abroad could not escape its trajectory. The war drew them back to their homeland, if not physically, at least in their thoughts and creative life. The war became an insistent reminder of friends and families now living in deprivation and danger. Picasso, who last visited Barcelona in 1934, exchanged letters with his family and colleagues in the city. He avidly followed developments in the daily newspapers and likely received firsthand accounts through a nephew serving in the republican army. The republic acknowledged Picasso's support by appointing him director of the Museo del Prado, a position he accepted, even if as only an honorary title. Miró and Dalí also spent most of the war outside Spain, but like Picasso, they too remained in close contact with relatives and colleagues in Catalonia. The war remained a constant presence in Miró's violent, threatening imagery of the late 1930s, evolving into what the artist described as his "savage" period of 1936–39. González, a member of the close-knit community of expatriate Catalans in Paris, embarked on a series of paintings and sculptures of Catalan peasants that signaled his self-identification with his suffering homeland (see fig. 4, p. 470; figs. 5 and 6, p. 471). Artists from Barcelona, at home or abroad, internalized and reacted to the conflict through the most immediate and compelling means at their disposal—their art. They insured that the war left a legacy, not just in political and military affairs, but equally in the history of modern art.

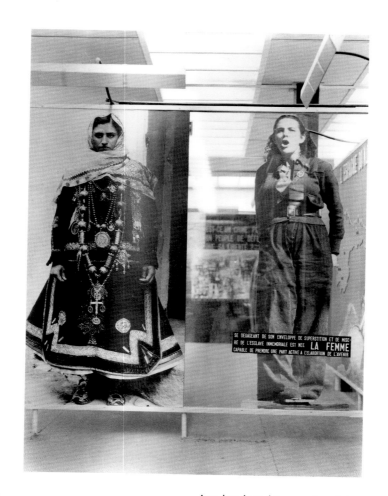

*Origins of the War*

Historians observe that the Spanish civil war was a class conflict, a religious and cultural war, and a struggle of revolutionary against counter-revolutionary forces (fig. 3). The war was also the opening salvo in a worldwide confrontation among the competing ideologies of fascism, liberal democracy, revolutionary socialism, and communism.[14] Yet, the seeds of the conflict were rooted deep in Spanish history and regional issues. Despite Madrid's efforts at forging a powerful centralized state, Spain remained a country deeply divided. The Catalans, the Basques, and the Galicians pressed for recognition of their historic rights, respect for their indigenous languages, and at least a degree of local autonomy. Monarchists and army generals of the far right, by contrast, considered these demands a mortal threat to traditional Spain, which they defined as a nation of one language (Castilian Spanish, the "language of the Empire"), one religion (Roman Catholicism), and one powerful, authoritarian government.

Perhaps the Second Republic's greatest failure was its inability, despite programs for redistribut-ing land and improving labor conditions, to relieve the gross economic disparities between different classes and regions. As late as the 1930s the industrial revolution had only reached a few areas in the north, concentrated in the textile factories of Barcelona, the steel mills of Bilbao, and the coal and ore mines of Asturias. Throughout the rest of the country, most of the population still made their living from the land, yet agricultural productivity remained the lowest in Europe. In the south and west migrant farm laborers called *braceros* worked under wretched conditions on enormous estates, often owned by absentee landlords who shamelessly left vast fields uncultivated. Historian Antony Beevor observes that in Andalusia and Extremadura, "most of the landless *braceros* had never tasted meat and lived in adobe huts with a hole for a window. On occasions these day-labourers would try to move into newly built pigsties because the accommodation for animals was so much better."[15] Sometimes unable to obtain more than 40 days of work during an entire year, millions of braceros wandered the countryside on the brink of starvation. Corrupt local bosses con-

Fig. 3. *Young Woman from Salamanca and a Militia Woman*, 1937, by Josep Renau, displayed at the Spanish pavilion, Paris International Exhibition.

trolled their votes through threats and intimidation, and when the braceros protested with strikes and rebellions, the Civil Guard suppressed them with extreme brutality.[16] Unable to escape the recurring cycles of violence and repression, rural peasants migrated to industrial Barcelona in mass waves. Tens of thousands came seeking a worker's utopia, only to discover miserably overcrowded slums and appalling labor conditions in the factories. By 1905 women and children—typically working long, unregulated hours—accounted for more than 67% of the workforce in Barcelona's vast textile industries.[17] By the 1930s, observes historian Albert Balcells, "over a third of the city's population had been born outside Catalonia."[18]

Faced with pervasive poverty and political repression, Spaniards became politically engaged. The perception of Spain as a country populated mostly by corrupt *hidalgos* (nobles), a degenerate monarchy, and servile peasants is due largely to national-racial stereotypes. In reality, millions of Spanish peasants belonged to radical political organizations, and a smaller percentage of the population attended Mass—less than 20% in the country as a whole and less than 5% in parts of the south—than in any other Christian nation.[19] Throughout Spain, the Catholic Church was widely detested for favoring the rich, supporting the repressive monarchy, resisting democratic reforms, manipulating education, and controlling more than a third of the national wealth. Consequently, from the 1860s to the 1930s Spain experience repeated waves of anticlerical riots, most severely in 1909, 1931, and 1936. Historian Raymond Carr observes: "Every tension in Spanish society was refracted through the prism of the religious issue. . . . The working-class mobs who burnt the churches in 1909 believed they were burning the temples of the rich—the '*gent de bé*'—inhabited by Jesuits who used the confessional to provide employers with information about their employees."[20]

Entrenched opposition to political reform pushed dissidents toward increasingly radical solutions. Spain was the only European country where anarchism became not only a mass movement, but a dominant force on the left. First introduced to the country in 1868 by Giuseppe Fanelli, anarchism spread like wildfire among the impoverished braceros of Andalusia and the factory workers of Barcelona.[21] At nearly the same time, socialism emerged as a significant political movement in Spain, with its center of strength in Madrid, Asturias, and the Basque country. Although both socialists and anarchists aimed at improving the lives of the working class, they held fundamentally opposing views on how to achieve their ends. While the socialists favored a gradual, parliamentary path to change, the anarchists dismissed bourgeois democracy as corrupt and ineffectual, and they dreamed of replacing the centralized state with a free, egalitarian society organized through a federation of local communes and trade union syndicates. Anarchists hoped to achieve their utopian society through direct, revolutionary action, especially a general strike that would paralyze the entire country and precipitate the conditions necessary for demolishing the oppressive social order.

Anarchism achieved a level of support in Spain unheard of in other European countries. By 1900 there were nearly 100,000 anarchists in Spain compared with only 15,000 socialists; by 1917 the number had risen to 800,000 anarchists, still significantly more than the country's 200,000 socialists.[22] Although anarchists and socialists occasionally formed alliances of convenience, they often clashed over irreconcilable differences. The anarchists disdained the Socialists as bourgeois parliamentarians whose support for a centralized state threatened individual liberty. For their part, the socialists considered the anarchists juvenile utopians. These fissures on the left came sharply into focus in the wake of the Russian Revolution of 1917. While the "ten days that shook the world" gave hope and inspiration to many on the left, the anarchists denounced Lenin for imposing yet another dictatorship on the workers. When Lenin and his followers established the Communist International or Comintern in 1919, the anarchists refused to join. Disagreeing with this decision, a splinter faction of the Spanish left broke way in 1920 and established the PCE (Spanish Communist Party) allied with the Comintern. Still, communism would remain a small, insignificant movement in Spain for years. When the Spanish civil war erupted in 1936, there were 30,000 to 50,000 communists in Spain, compared with more than 1,500,000 anarchists and nearly as many socialists.[23] Although still distinct mi-

norities within the overall electorate, the anarchists and socialists became powerful forces amid a political landscape fractured into innumerable competing parties.

The immediate spark that ignited the civil war can be traced to the controversial reforms introduced when the Second Republic came to power in 1931. The government reduced the army's bloated officer core, enacted a program of land redistribution, and passed laws to improve labor conditions, including the introduction of an eight-hour day for farm workers. A new constitution gave women the vote, legalized civil marriage, and permitted divorce for the first time in the country's history. Catalonia and the Basque region were granted statutes of autonomy that provided a limited amount of self-government and control over regional affairs. The most controversial measures involved the separation of church and state. The new constitution made free, secular education available to all, required the removal of crucifixes from classrooms, and banned the clergy from teaching at both public and private schools.

Alarmed by the country's leftward drift, conservatives united in 1933 to form a powerful alliance of the right called CEDA (Spanish Confederation of the Autonomous Right).[24] CEDA's answer to atheistic socialism was to "re-christia nize" Spain through a second reconquista. The movement's fiery leader José María Gil Robles declared: "We must give Spain a true unity, a new spirit, a totalitarian polity. . . . It is necessary to defeat socialism inexorably . . . either parliament submits or we will eliminate it."[25] In October 1933 José Antonio Primo de Rivera, son of the former dictator, established an even more extreme right-wing group, the fascist Falange Española. Inspired by Mussolini and Hitler, who had just seized power that February, Primo de Rivera agitated for an ardently nationalistic Spain ruled under absolute dictatorship. Like the Nazis, he denounced capitalism and advocated organizing the entire economy to support militaristic expansion, which meant nationalizing banks and other vital services, but respecting personal property. The Falange Española differed from German fascism, however, in its attitude toward religion. Although Primo de Rivera supported the separation of church and state, he remained an ardent Catholic who detested Nazi atheism and its attacks against the church.

CEDA candidates swept the elections of November 1933 and began reversing the reforms of the Second Republic, precipitating a series of insurrections in Barcelona, Madrid, Zaragoza, Andalusia, and Extremadura. The most serious revolt occurred in Asturias, where miners established a revolutionary commune, collectivized property, burned land deeds, and outlawed money. The government declared a state of emergency and sent in the Foreign Legion and Moroccan troops who crushed the rebellion with extreme cruelty directed even against women and children. Both sides accused the other of horrific atrocities, including rape, torture, and summary executions.[26] The new government reacted to the national crisis by declaring a state of emergency, suspending Catalonia's statute of autonomy, and imprisoning the ministers of the Generalitat, including its president, Lluís Companys. A tribunal condemned Companys to death, but the sentence was reduced to a long prison term.

In 1936 liberal democrats, socialists, communists, and even many anarchists joined together under the umbrella of a Popular Front coalition.[27] The Popular Front concept, formally proposed the previous summer at the seventh congress of the Comintern in Moscow, was designed to halt the spread of fascism by uniting all factions of the left and center throughout the world.[28] This strategy required compromise, including communist acceptance of parliamentary democracy, at least until Hitler and Mussolini were defeated. Temporarily united, the Spanish left won a narrow victory in the elections of February 1936. Yet, they failed to attract a majority of the electorate, which split into 34.3% for the Popular Front, 33.2% for the National Front (CEDA and its allies), and 5.4% for the center.[29] CEDA did not accept the results. Militias on both sides began arming and street battles between leftists and fascists erupted throughout the country. As assassinations and reprisal killings escalated, it became apparent that all sides had lost faith in parliamentary democracy. Popular Front leaders frightened moderates with May Day parades featuring photographs of Lenin and speeches demanding the collectivization of property. Decrying the chaos and citing fears that the "reds" were on the verge of

delivering Spain to the Soviet Comintern, Spanish military officers began plotting their coup d'état.

## The War

The "uprising" erupted on 17 July 1936 with a mutiny by right-wing army officers in Spanish Morocco, where insurgents expected and received strong support from their Foreign Legion and Moorish divisions. The following day, coordinated mutinies spread to army and naval units across the Spanish mainland. Wherever the mutineers succeeded, they summarily shot anyone who refused to join them. The rebellion did not succeed everywhere, however, because the military was deeply divided and many soldiers, perhaps a third of the army and most of the navy, remained loyal to the republic.

Rebel officers tried to take control of Barcelona by seizing the plaça de Catalunya in the center of the city. Early on the morning of 19 July the army garrison at the Pedralbes barracks on the northwest edge of the city began advancing down the Avigunda Diagonal and captured several buildings on the plaça, but militias of the anarchist CNT and Marxist POUM (Workers Party of Marxist Unification, an anti-Stalinist group formed in Barcelona in 1935 to oppose the Soviet-dominated Comintern), aided by policemen and citizen volunteers, soon began erecting barricades and assaulting army positions. As the battle raged into the afternoon, the Civil Guard, traditional defenders of law and order, assembled and advanced along the Rambla to join the fight. Uncertain about which side the guard would join, bystanders watched anxiously until the soldiers raised their arms and gave the leftist, clenched-fist salute, an amazing sight that elicited cheers from the crowd.[30] As the day wore on, army soldiers increasingly abandoned their lines to join the militias. The revolt collapsed entirely the next day following successful militia assaults against the Drassanes and Sant Andreu barracks. A month later General Manuel Goded, leader of the rebellion in Barcelona, was tried and shot for treason.

While republican loyalists defeated the insurrections in Madrid, Valencia, and Bilbao, the insurgents triumphed in Burgos, Valladolid, Segovia, Avila, Seville, Cadiz, Granada, and Teruel. In Zaragoza, capital of Aragon, the nationalists overwhelmed and slaughtered the anarchist CNT militias. Even before the outbreak of violence, republican leaders had suspected General Franco of treason and assigned him to a post in the Canary Islands as a precautionary measure. On 19 July he flew to Spanish Morocco to take command of the rebellion there. Since most of the navy remained loyal to the republic, there was no possibility of Franco transporting his rebel army from North Africa to the mainland by sea. The insurrection might have been broken at this crucial moment, except Hitler intervened by dispatching German planes that transported Franco's forces to the mainland on 27 July, achieving the first airlift of an entire army in military history.[31]

By late August the rebels controlled nearly half of Spain (fig. 4). Their territory formed an arch stretching from Navarre, Castile-León, and Galicia in the northwest, to the western edge of Andalusia in the south. The republic still controlled the largest cities: Barcelona, Madrid, Valencia, and Bilbao.[32] The republic also held the key industrial and mining centers, so there was every reason to believe it would eventually triumph. The loyalists suffered, however, from two fatal flaws: internal divisions and an inability to control the extremists in their own ranks. The nationalists, by contrast, were more united and disciplined. In October 1936 they selected Franco as their "Caudillo" (leader). In less than a year he forced all factions on the right, from monarchists to fascists, to join a single organization under his control, the Falange Española Tradicionalista (FET) y de las JONS.

Both sides fought the war with extreme ferocity and cruelty. After the republic distributed arms to the local militias, radicals unleashed what has been described as "the most profound European working-class revolution since 1917."[33] With the government unable to contain the violence, radicals seized land, "liberated" property, burned churches, slaughtered priests, and executed as many as 20,000 political opponents.[34] Victims were often dragged from their homes at night and murdered, their bodies dumped on the side of a road with a warning note pinned to their clothes. Collectivization of industry ranged from 70% in Catalonia to 50% in Valencia and 30% in Madrid.[35] The nationalists accused the republicans of torturing priests and raping nuns, among other horrors, although historians question the validity

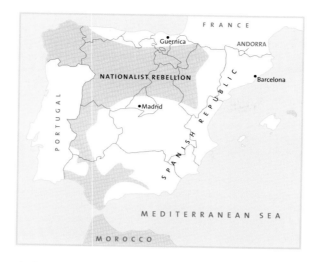

of many of these claims and observe that each side invented propaganda stories in the battle for world opinion.[36]

The nationalists employed their own terror tactics. Their Foreign Legion and Moroccan troops became notorious for brutally torturing and raping civilians. After the nationalists overran a sector, they typically declared martial law and began liquidating anyone suspected of republican sympathies (fig. 5). One report told of a victim forced to lie in the shape of a cross while his attackers hacked off his limbs shouting, "Long live Christ the King!"[37] Estimates of political murders and executions by the nationalists vary widely, but the number most likely falls within the range of 72,000 to 150,000 victims.[38]

Both the republic and the insurgents appealed for aid from the outside world, turning the conflict into a flash point in the worldwide struggle among competing political ideologies. Hitler and Mussolini

provided crucial support to the nationalists. Besides contributing the aircraft necessary for transporting Franco's army to the Spanish mainland, Hitler sent war supplies, tanks, artillery, and perhaps most decisively, Luftwaffe fighters and bombers, including the infamous Condor Legion. Mussolini dispatched more than 70,000 Italian soldiers to fight with the nationalists, along with tanks, artillery, fighter planes, and bombers. The Italian navy played a significant role in blockading Spanish ports and sinking ships transporting supplies to the republic. More than 70,000 Moorish troops from Spanish Morocco and smaller groups of fascist volunteers from Portugal, Ireland, France, and various Latin American countries fought with the rebels.

The republic appealed for assistance from the Western democracies, but the Soviet Union and Mexico were the only governments to provide consistent aid. Stalin sent tanks, artillery, combat air-

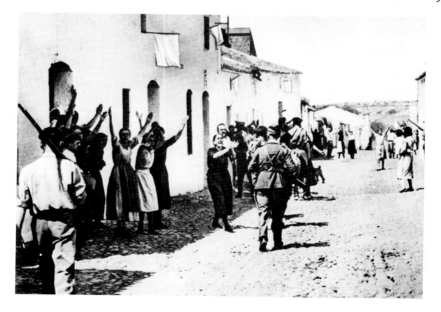

Fig. 4. Spain in August 1936.
Fig. 5. Nationalists capture a village near Córdoba, 1936.

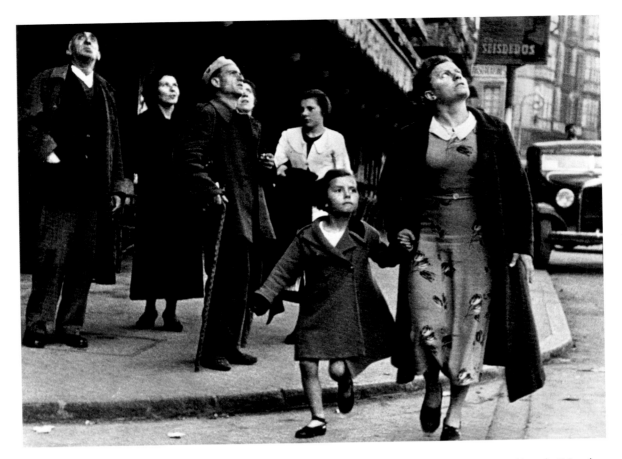

craft, 2,000 advisors, and delivered them on Soviet transport ships. During the early days of the war, France sent military aircraft and other forms of aid, but stopped all shipments upon adopting a nonin- terventionist policy on 8 August 1936, less than a month after the outbreak of hostilities.[39] The republic was bolstered by 35,000 troops of the International Brigades, comprised of volunteers from more than 50 countries around the world, including Britain, France, and the United States. Although illegal un- der U.S. law, nearly 3,000 Americans fought with the loyalists, some under the banner of the Abraham Lincoln Battalion of the International Brigades. Refugees of persecution from Nazi Germany and fascist Italy also served in the Brigades.

Despite the republic's repeated pleas for assis- tance, the Western democracies remained fearful of becoming entangled in a direct confrontation with Nazi Germany because it might ignite a world war. What would happen, the British wondered, if their navy was forced to protect its merchant ships from German bombers or Italian submarines? American and British politicians, even those sympathetic to the moderate left, found it difficult to support the

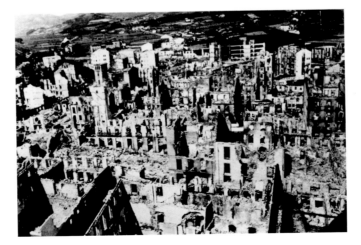

Fig. 6. *Bilbao* (citizens facing the alarm of sirens announcing possible bombing), 1937, by Robert Capa.

Fig. 7. Guernica (general view), 1937, attributed to Azqueta.

republic in light of its reputation for desecrating churches, killing priests, confiscating property, and kowtowing to the Comintern. In September 1936, barely two months after the outbreak of war, governments from around the world convened the Non-Intervention Committee (NIC) in London. The NIC managed to obtain pledges of strict neutrality from Germany, Italy, Great Britain, France, and the Soviet Union, then spent the rest of the war listening to these nations accuse each other of violating their agreements. Although the United States adopted a nonintervention policy, private citizens and firms found ways of skirting the law. Texaco, Standard Oil, General Motors, and other American companies, along with British and German bankers, provided oil and other vital supplies to Franco, often on credit.[40]

The nationalist army made significant gains in the south and west during the spring of 1937, but its offensive to capture Madrid failed. Blocked in the center, Franco turned his attention northward and opened an assault against the Basque region (fig. 6). On the afternoon of 26 April the German Condor Legion, flying in repeated waves and dropping incendiary bombs, destroyed 70% of the small Basque town of Guernica (fig. 7), historic seat of the Basque parliament, and a national symbol of regional liberties and democratic government. The killing of 1,600 civilians outraged world opinion and provided Picasso with the subject for his painting *Guernica*.[41] In June the nationalists entered Bilbao, the largest Basque city; by the fall they had captured Asturias and the entire northern coast of Spain.

The republic's fragile alliance of leftist parties began unraveling almost as soon as it formed. Communist influence, minuscule at the start of the war, grew steadily with the republic's growing reliance on Soviet aid. At the outbreak of the war in 1936 there were only 30,000 to 50,000 communists in Spain; by 1937 their ranks had grown to more than a million. The communists attracted increasing support from moderates by opposing collectivization of property and by expressing support for parliamentary democracy, however disingenuous. Believing the time was not yet ripe for revolution, communist strategy focused on winning the war first through strict discipline and authoritarian leadership, which meant disbanding the anarchist militias and folding them into a unified army under centralized command. Anarchists regarded this approach as a mortal threat to individual freedom and a betrayal of the revolution. Their view was shared by the POUM.[42] George Orwell, who served with the POUM militia, commented: "The Communist's emphasis is always on centralism and efficiency, the anarchist's on liberty and equality."[43] The conflict came to a head when communist assault forces entered Barcelona in May 1937 and smashed the anarchist CNT and POUM militias.[44] The show trials and executions of anarchist and POUM leaders that followed poisoned the republic with fatal internal dissent.

By the spring of 1938 the nationalists controlled the entire northern coast of Spain and vast portions of the west and southwest. In March they opened a new offensive that split the republic in two. Attacking first in Aragon, the rebels drove eastward toward the sea and reached the Mediterranean on 15 April, dangerously isolating Catalonia from Madrid and the center (fig. 8). When Britain and France signed the Munich accords with Nazi Germany in September 1938, the republic lost all hope of obtaining alliances

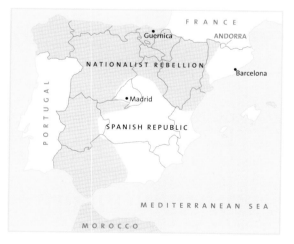

Fig. 8. Spain in May 1938.

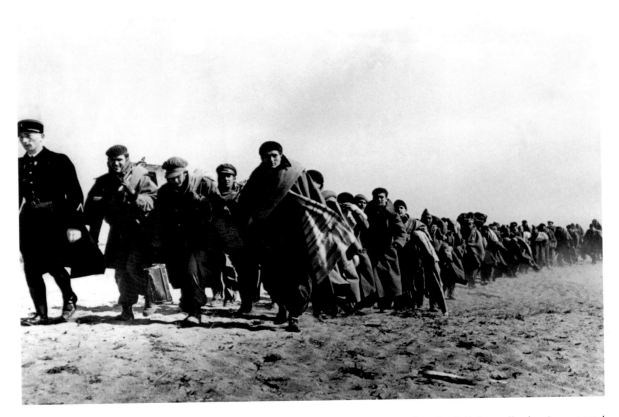

or significant aid from the Western democracies. The Munich agreement, hailed by British Prime Minister Neville Chamberlain as achieving "peace in our time," sealed the fate of the Second Republic, which announced the disbanding of the International Brigades in September and saluted them with an emotional send-off in Barcelona on 1 November. A month later, Franco launched an offensive against Catalonia and captured Barcelona on 26 January 1939. Nearly 500,000 refugees fled to France (fig. 9), where many were forced into internment camps. Renewing their offensive against the republicans in central Spain, the nationalists captured Madrid on 28 March 1939. Three days later Franco announced: "Today the Red army has been captured . . . the war is ended."[45] The following year the German Gestapo captured Lluís Companys in occupied France and turned him over to authorities in Barcelona, where he was executed at the Montjuïc prison.

Barcelona's cultural life suffered immensely after the fall of the republic. Picasso, an ardent anti-fascist and supporter of the republic, never returned to the city that had nurtured his artistic formation.

Antoni Clavé and Antoni G. Lamolla, having served in the Loyalist army, fled to France and were immediately tossed into internment camps. Writer Sebastià Gasch fled to France, painter Remedios Varo to Mexico. Architect Josep Lluís Sert and designer Antoni Bonet, along with film director Luis Buñuel, also became political refugees.[46] More tragically, a bomb killed Sert's colleague, architect Josep Torres Clavé, in early 1939. When sculptor Enric Casanovas returned home in 1942, authorities imprisoned him. The government welcomed back renowned architect Josep Puig i Cadafalch by prohibiting him from practicing his profession. Salvador Dalí did not return until 1948. Julio González never had the chance, as he died in Paris in 1942. Joan Miró slipped back into Spain after the Nazi invasion of France in 1940 and managed to live discreetly in Majorca and Barcelona, although he would not exhibit in his homeland again until 1949. For many artists, the "long night" of the Franco dictatorship that ruled Spain from 1939 to 1975 became a suffocating straitjacket, and Barcelona would struggle for decades to regain its place in the international art world.

Fig. 9. *Between Argelès-sur-Mer and Le Barcarès, France* (civil war refugees from Catalonia), 1939, by Robert Capa.

1. During the first *Reconquista* (722–1492), the Christian kingdoms of Hispania fought and conquered the Muslim states of the Iberian Peninsula, which had been overrun by the Moorish invasion of 711.

2. The government moved to Valencia in November 1936 and to Barcelona in October 1937.

3. Raymond Carr, *Modern Spain 1875–1980* (London: Oxford University Press, 2001; first published 1980), 138.

4. George Orwell, *Homage to Catalonia* (London: Harvest Books, 1980; first published 1952), 4–5, 47.

5. Dalí exhibited *Soft Construction with Boiled Beans* at the Alex Reid gallery in London in June 1936 and added the subtitle *Premonition of Civil War* a year later. He followed *Soft Construction* with *Autumn Cannibalism,* late 1936 (Tate Modern, London), another painting referring to the war.

6. Joan M. Minguet Batllori and Jaume Vidal i Oliveras, "Critical Chronology (1906–1939)" in *Avantguardes a Catalunya: 1906–1939,* ed. Daniel Giralt-Miracle, exh. cat. (Barcelona: Fundació Caixa de Catalunya, 1992), 706–7.

7. Josep Termes, *De la Revolució de Setembre a la Fi de la Guerra Civil (1868–1939),* volume 6 of *Història de Catalunya* (Barcelona: Edicions 62, 1987), 412.

8. Ibid., 411.

9. Minguet and Vidal, "Critical Chronology (1906–1939)," 706–7. Among the writers and intellectuals who came to Spain to support the republic were Ernest Hemingway, Lillian Hellman, and Dorothy Parker. André Malraux served as a military pilot and W. H. Auden as an ambulance driver.

10. Termes, *De la Revolució de Setembre a la Fi de la Guerra Civil,* 412.

11. Minguet and Vidal, "Critical Chronology (1906–1939)," 707.

12. Termes, *De la Revolució de Setembre a la Fi de la Guerra Civil,* 410.

13. See Marko David, "Spain: Culture at War," *Art and Power: Europe under the Dictators 1930–1945,* ed. Dawn Ades et al., exh. cat. (London: Hayward Gallery, 1996), 64.

14. Stanley Payne argues that the left has mythologized and romanticized the war into a conflict of fascism against democracy, when in fact it was more a revolutionary versus counter-revolutionary struggle, since the dominant forces within the republic were revolutionary rather than democratic. Payne disagrees with the view that the communists were a counter-revolutionary force, noting that the communists only advocated revolution at a slower pace than the CNT–FAI anarchists and the POUM. From a Spanish perspective, Paloma Aguilar examines how interpretations of war have shifted over time in Spain; see Aguilar, *Memoria y olvido de la Guerra Civil española* (Madrid: Alianza Editorial, 1996), published in English as *Memory and Amnesia: The Role of the Spanish Civil War in the Transition to Democracy,* trans. Mark Oakley (New York: Berghahn, 2002). Also see Payne, *The Spanish Civil War, the Soviet Union, and Communism* (New Haven: Yale University Press, 2004), 111, 313, 316.

15. Antony Beevor, *The Spanish Civil War* (London: Cassell, 2001; first published 1982), 42. See also Hugh Thomas, *The Spanish Civil War* (New York: Modern Library, 2001; first published 1961), 77.

16. Beevor, *Spanish Civil War,* 42. In 1931 nearly 30% of the Spanish population was illiterate. See Stanley G. Payne, *The Franco Regime 1936–1975* (Madison: University of Wisconsin Press, 1987), 35, and Thomas, *Spanish Civil War,* 54.

17. Temma Kaplan, *Red City, Blue Period: Social Movements in Picasso's Barcelona* (Berkeley: University of California Press, 1992), 2.

18. Alberto Balcells, *Crisis económica y agitación social en Cataluña de 1930 a 1936* (Barcelona: Ariel, 1971), 18, translated and quoted by Thomas, *Spanish Civil War,* 44.

19. Beevor, *Spanish Civil War,* 38. Thomas, *Spanish Civil War,* 47, notes that in the 1930s two-thirds of Spaniards "were not practising Catholics," and "in some villages in Andalusia, only 1 percent of men attended church."

20. Carr, *Modern Spain 1875–1980,* 40–41.

21. The Russian aristocrat Mikhail Bakunin and the German philosopher Karl Marx were founding members of the IWA (International Workingmen's Association), established in 1864 at the conference of the First International in London. Shortly after, Bakunin split with Marx over the issue of a centralized worker's state, which Bakunin feared would lead to another form of authoritarian oppression. Insisting on the necessity of absolute freedom, Bakunin and his anarchist followers proposed that all existing political states should be abolished and replaced with a decentralized, federal union of free, cooperative associations or syndicates. Bakunin also argued for the collectivization of all property, the abolition of religious cults, and complete economic and social equality for all races, classes, and sexes. Marx eventually forced Bakunin out of the IWA.

22. Beevor, *Spanish Civil War,* 27.

23. Ibid., 54. Gabriel Jackson gives the higher figure of 50,000 Spanish communists in 1936. Payne notes that in 1929 about 320,000 workers, or 15% of the labor force, belonged to Catholic labor unions. See Jackson, *A Concise History of the Spanish Civil War* (New York: John Day, 1974), 116, and Payne, *Franco Regime 1936–1975,* 27.

24. Payne argues that CEDA was not, as some claim, a fascist organization of the radical right, but rather a center-right coalition dominated by middle-class Catholics and small landowners. Payne notes that the fascist Falange always remained a minor party, receiving only 0.7% of the electorate or 44,000 votes in the elections of 1936. See Payne, *Franco Regime 1936–1975,* 41, 46, 65.

25. Paul Preston, *The Spanish Civil War, An Illustrated Chronicle 1936–39* (New York: Grove Press, 1986), 32.

26. Beevor, *Spanish Civil War,* 51. See also Jackson, *Concise History of the Spanish Civil War,* 24–25; Thomas, *Spanish Civil War,* 131–6.

27. The anarchists were divided over the issue of whether to join the Popular Front: some felt it betrayed their principle of local autonomy, others participated as a matter of practical necessity.

28. Vladimir Lenin established the Communist International, or Comintern, in 1919 to coordinate all revolutionary communist groups through the world. Stalin dissolved the Comintern in 1943.

29. The percentages are based on the total possible electorate; see Payne, *Franco Regime 1936–1975,* 44; Thomas, *Spanish Civil War,* 147.

30. Beevor, *Spanish Civil War,* 85; Thomas, *Spanish Civil War,* 221–25.

31. Beevor, *Spanish Civil War,* 90.

32. At the time, Barcelona had a population of slightly more than a million and was the largest city in Spain, followed closely by Madrid.

33. Carr, *Modern Spain 1875–1980,* 137.

34. Estimates of political executions and murders in the republican zone vary widely. Jackson believes there were about 20,000 murders, mostly during the first three months of the war. Thomas places the number of murders in the republican zone during the entire war at 55,000. Beevor notes that during the war the nationalists accused the republicans of executing 500,000 people, while the nationalists later reduced the number to "the still excessive figure of 55,000." Thomas estimates that leftists destroyed 150 churches completely and 1,850 partly. See Jackson, *Concise History of the Spanish Civil War,* 176; Thomas, *Spanish Civil War,* 900–901; Beevor, *Spanish Civil War,* 100.

35. Jackson, *Concise History of the Spanish Civil War,* 67–68.

36. Beevor notes that while priests were brutally murdered, some even burned or buried alive, there is no evidence to support the charge that nuns were raped. He also observes, "During the war the nationalists claimed that 20,000 priests had been slaughtered; afterwards they said that 7,937 religious persons were killed. . . . This figure would still appear to be high." Carr places the number of priests murdered during the early months of the war at 6,832. See Beevor, *Spanish Civil War,* 101; Carr, *Modern Spain 1875–1980,* 137.

37. Beevor, *Spanish Civil War,* 99.

38. Beevor estimates that nationalists executed 100,000–200,000 people during the war. Thomas puts the figure at 75,000, Payne at 42,000, and the Francoist historian Salas Larrazábal at 28,000–30,000. Payne disputes Jackson's claim of 300,000–400,000 executions by the nationalists during 1936–44 and places the number at 70,000–72,000 for the entire period of 1936–50. See Beevor, *Spanish Civil War,* 107; Thomas, *Spanish Civil War,* 900; Payne, *Franco Regime 1936–1975,* 216–17; Jackson, *Concise History of the Spanish Civil War,* 176.

39. France also barred the Soviet Union and others from shipping arms to the republic across its Spanish border. France briefly reopened the border from March to June 1937, then closed it again. In January 1939 France reopened the border, but it was too late to save the faltering republic.

40. Jackson, *Concise History of the Spanish Civil War,* 107; Thomas, *Spanish Civil War,* 107.

41. The nationalists claimed that retreating "reds" set Guernica on fire, and it remained a crime in Spain to assert that the city had been bombed until 1967. See Jackson, *Concise History of the Spanish Civil War,* 125.

42. The POUM was sympathetic with the anarchist CNT, but even more revolutionary, believing that workers must seize power immediately. The POUM was not affiliated with the Trotsky International in Paris, a charge the communists used to eliminate the POUM. See Carr, *Modern Spain 1875–1980,* xvii, 139.

43. Orwell, *Homage to Catalonia,* 61.

44. In July 1936 Catalan communists and socialists united to form the PSUC (Unified Socialist Party of Catalonia), a group controlled by the Comintern.

45. Aguilar, *Memoria y olvido de la Guerra Civil española,* 112.

46. Sert enjoyed a distinguished postwar career as the dean of Harvard University's architecture school.

# Painting in the Shadow of Death: Dalí, Miró, and the Spanish Civil War

ROBERT S. LUBAR

Among the iconic images that have come to represent the art-historical face of the Spanish civil war—Pablo Picasso's *Guernica*, 1937 (Museo Nacional Centro de Arte Reina Sofía, Madrid), Alexander Calder's *Mercury Fountain*, 1937 (Fundació Joan Miró, Barcelona), and Julio González's *Montserrat*, 1937 (Stedelijk Museum, Amsterdam)—two works stand out as intensely private and deeply anguished responses to a nation in crisis—Salvador Dalí's *Soft Construction with Boiled Beans (Premonition of Civil War)*, 1936 (fig. 1), and Joan Miró's *Still Life with Old Shoe*, 1937 (fig. 2).[1] Executed while both artists were living in Paris— Miró in self-imposed exile following the outbreak of hostilities in his homeland on 17 July 1936, and Dalí en route to New York and Hollywood— these two paintings also challenge fundamental assumptions about the very nature of avant-garde art and the public image of a conflict that transformed intellectuals into partisans and ordinary citizens into combatants.

It should be observed that both Miró and Dalí contest modernist notions of formal autonomy, enlisting the devices of illusionistic painting in the service of a harrowing and "tragic" realism.[2] Throughout the 1930s, Dalí repeatedly expressed his contempt for the doctrine of aestheticism, deriding abstract art as "one of the most truly sweet things from the point of view of the intellectual and 'modern' desolation of our era."[3] From the ironic incorporation of collage elements in his work to the most exacting use of trompe-l'oeil techniques, Dalí firmly established his reputation as modernism's "counter-muse," questioning the formal logic of the tradition he had inherited.[4] In contrast, by 1936 Miró was widely acclaimed in international avant-garde circles for inventing a new language of visual signs. However much he insisted on the representational character of his work as a "peintre-poète" (painter-poet), Miró's advanced formal syntax expanded the boundaries of so-called "pure" painting for subsequent generations of artists.[5]

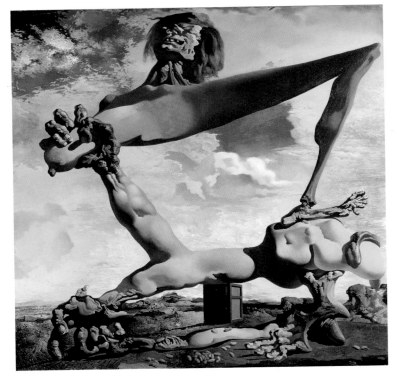

Fig. 1 (cat. 9:1). Salvador Dalí, *Soft Construction with Boiled Beans (Premonition of Civil War)*, 1936.

*Still Life with Old Shoe* is a singular work in Miró's oeuvre. Long relegated to a position of secondary status by critics who championed Miró's lyricism and his "decorative spirit," the artist's return to illusionism was interpreted as an existential response to his condition as an exile in Paris and his corresponding need to anchor his life and work in the objective reality of things.[6] As Miró informed his dealer Pierre Matisse on 12 January 1937: "We are living through a terrible drama, everything happening in Spain is terrifying in a way you could never imagine. I feel very uprooted here and am nostalgic for my country."[7] A month later, in his first reference to *Still Life with Old Shoe*, Miró indicated how this experience might be translated into aesthetic terms: "No sentimentalism. Realism that is far from being photographic, and also far from the realism exploited by some of the Surrealists. Profound and fascinating reality."[8] Unlike Dalí, who championed "illusionism of the most despicably go-getting and irresistible imitative art" in order to visualize "the new exactitudes of concrete irrationality," Miró's realism was provisional: an ethical as much as an aesthetic position that was called upon to express a specific historical experience.[9]

It is surprising that critics have been slow to recognize the conditional nature of Miró's realism, as *Still Life with Old Shoe* is in every sense an aesthetic battlefield, a mise-en-scène in which the status of representation itself is at stake. On a barren plane that is as much a landscape as it is a table top, Miró has assembled the protagonists of a sober yet terrifying drama: a bottle of gin wrapped in torn paper and twine; a crust of bread; a fork impaling an apple; and the worn old shoe itself, its form sculpted by years of human use. With a nod to Vincent van Gogh's famous *souliers* (shoes), Miró employs rural imagery to represent the land and people of his native country, a nation besieged by conflict and death. The space of the painting is tight and claustrophobic. Ominous black clouds hover in a sky that is illuminated by the eerie light of a nocturnal conflagration. And color is orchestrated in dissonant rhythms. The torn paper of the bottle symbolically presents the terms of this discord, as the clouds can also be read as tears in the visual field, empty pockets of space that engulf the central protagonists. For just as Miró tries to affirm the vitality and resilience of the Spanish people—their regenerative life force—the specter of death threatens everything with imminent collapse. The solidity of the objects, rendered by means of a rudimentary use of chiaroscuro and color modulation, is abrogated, as forms teetering along the edge of abstraction challenge their placement in the world. There is no room for the characteristic polyvalence of Miró's signs. Meaning is no longer produced as an open structure, and metaphor is denied. Under the ever-present

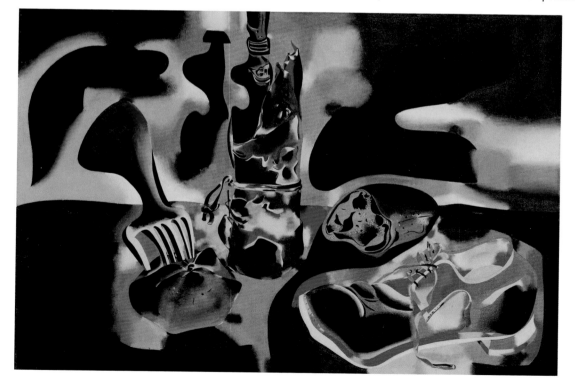

Fig. 2 (cat. 9:2). Joan Miró, *Still Life with Old Shoe*, 1937.

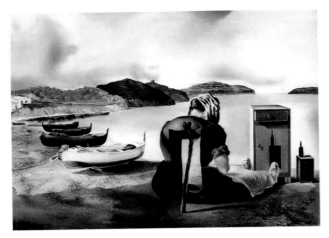

shadow of death, symbolically figured in the skull-like contours of the crust of bread, Miró's "realism" offers no hope of escape or spiritual transcendence. The humble protagonists of his still life are trapped in the space between affirmation and negation.

If Miró described the fragmentation and collapse of the social body through the language of an aesthetically besieged realism, Dalí interpreted the civil war as a dual experience of psychic and social shattering. In *The Secret Life,* Dalí's unorthodox autobiography of 1942, the artist expressed his views on the war in terms that challenge the political associations attending the familiar rearguard/avant-garde opposition as it relates to formal innovation, shedding light on both his and Miró's aesthetic choices. "The Civil War had broken out!" Dalí recounted. "I knew it, I was sure of it, I had foreseen it! And Spain, spared by the other war, was to be the first country in which all the ideological and insoluble dramas of Post-War Europe, all the moral and esthetic anxiety of the 'isms' polarized in those two words 'revolution' and 'tradition,' were now to be solved in the crude reality of violence and of blood."[10] Although Dalí's comment comes toward the end of his text, where the artist announces his return to the classical, Catholic, and apostolic tradition, his view that aesthetic and moral (political) positions had been significantly compromised during the civil war speaks to the ideological crisis that gripped artists and intellectuals in France and Spain at this time.[11]

Characteristically, Dalí interpreted this crisis in psychoanalytic terms as a cyclical process of destruction and regeneration, invoking Freud's concept of the death-drive to underscore the traumatic experience of civil war. Thus he described the imagery of

*Soft Construction with Boiled Beans (Premonition of Civil War)* as a "narcissistic and biological cataclysm. …In this picture," Dalí explained, "I showed a vast human body breaking out into monstrous excrescences of arms and legs tearing at one another in a delirium of autostrangulation. As a background to this architecture of frenzied flesh. . . . I painted a geological landscape that had been uselessly revolutionized for thousands of years, congealed in its 'normal course.' The soft structure of that great mass of flesh in civil war I embellished with a few boiled beans, for one could not imagine swallowing all that unconscious meat without the presence (however uninspiring) of some mealy and melancholy vegetable."[12]

For Dalí, to view the civil war in psychoanalytic terms as a regressive drive toward self-annihilation was to insist, with Freud, that aggression and the death instinct are ever-present in psychic life. Freud had long recognized the existence of a sadistic component in the formation of the drives, especially in what he termed "pre-genital organizations," such as the oral stage. In *Beyond the Pleasure Principle* (1920), he described Eros as a force that unifies, and Thanatos, or the death-drive, as a mechanism of unbinding, a disruption or "shattering," in David Lomas's words, "of the body, of thought, of self."[13] Related to Julia Kristeva's concept of the "abject"—that which incites disgust or repugnance as a symbolic defense against the death-drive—this "shattering" is located at the boundary of seduction and horror.[14]

To be sure, Dalí's interpretation of the civil war is structured along a symbolic axis of fascination and pleasure on one side, and revulsion and pain on the other. The grimacing face of the central figure, its body torn apart in a brutal act of self-desecration, is belied by the seductive force of Dalí's painterly technique, his talent as a miniaturist (though in this case the painting measures approximately 39 x 39 inches), and the dazzling mastery with which he describes a range of textures, from the soft, meaty flesh of the body, to the brilliant luminescence of the clouds and the stony consistency of the figure's extremities. Under the watchful presence of a tiny bearded figure that Dalí culled from a scientific magazine, the monstrous creature undergoes a metamorphosis, its body ossifying and merging with the barren landscape that surrounds it.[15]

Fig. 3. *Weaning of Furniture-Nutrition,* 1934, by Salvador Dalí.

Both the scientist and the small night table that partially supports the colossal figure provide additional clues to Dalí's complex iconography. Although he began the painting before civil war erupted in Spain, there is no question that Dalí considered the broader implications of Freud's account of the death-drive, which the Viennese doctor had defined as a disruptive, conservative force that seeks to restore organic life to a prior, inanimate state in order to release the subject from conflict and tension.[16] In Dalí's fertile imagination, this regressive force is understood to be both psychic and social, as the artist locates his harrowing scene of self-annihilation in the landscape of his youth, the Empordà plain. As Michael Taylor has persuasively argued, by means of an elaborate chain of coincidences Dalí associated the figure of the scientist with a great Catalan physicist and inventor named Narcís Monturiol (1819–1885), who in Dalí's mind came to represent the Catalan tradition of reason (*seny*) and intellectual advancement under siege by the forces of destruction.[17] There is no question that Dalí was both disturbed and fascinated by the specter of fascism abroad and in his home country. The night table had appeared two years earlier in *Weaning of Furniture-Nutrition,* 1934 (fig. 3), where it is "carved out of the supersoft and Hitlerian backs of atavistic and tender nannies," as Dalí described his imagery in a related text.[18] The association between the Hitlerian theme and regression to the pregenital stage (the young child suckling on the bosom of his wet nurse) underscores the idea of the death-drive as a movement backward in psychic and social history, as Spain, besieged by the forces of darkness, slipped into a devastating civil war.

1. For an in-depth analysis of Miró's great painting, from which portions of the discussion that follows are extrapolated, see Robert S. Lubar, "Painting and Politics: Miró's *Still Life with Old Shoe* and the Spanish Republic," in *Surrealism, Politics, and Culture,* ed. Raymond Spiteri and Donald LaCoss (London: Ashgate, 2003), 127–60.

2. I am borrowing this term from Jacques Dupin, *Miró* (Barcelona: Polígrafa, 1993), 207–21.

3. Dalí, "Conquest of the Irrational," in Salvador Dalí, *The Collected Writings of Salvador Dalí,* ed. and trans. Haim Finkelstein (New York/Cambridge, U.K.: Cambridge University Press, 1998), 262–72.

4. In his now classic essay on collage, the surrealist poet Louis Aragon wrote in 1930: "What defies interpretation best is probably the use of collage by Salvador Dalí. He paints with a magnifying glass; he knows so well how to imitate a chromo, that the result is inevitable: the pasted parts of the chromo are thought to be painted while the painted parts are thought to be pasted. Does he aim thus at confusing the eye and does he enjoy causing a mistake on purpose? This may be admitted but it does not explain a double game that cannot be ascribed either to the artist's despair before the inimitable, or to his laziness before a ready-made expression." Louis Aragon, "La Peinture au défi," preface to an exhibition of collages at Galerie Goemans, Paris, 1930, in *The Autobiography of Surrealism,* ed. Marcel Jean (New York: Viking Press, 1980), 210. On Dalí's relation to modernist painting, see my essay, "Salvador Dalí: Modernism's Counter-Muse," *Romance Quarterly* 46, no. 4 (Fall 1999): 230–38.

5. Carolyn Lanchner, "*Peinture-Poésie,* Its Logic and Logistics," in *Joan Miró,* exh. cat. (New York: Museum of Modern Art, 1993), 15–82.

6. Writing on the occasion of Miró's first retrospective exhibition (Museum of Modern Art, New York, 1941), curator James Johnson Sweeney asserted: "If [Miró's] conscience was in the effort, certainly his heart was not." Sweeney, *Joan Miró,* exh. cat. (New York: Museum of Modern Art, 1941), 68. Speaking of Miró's return to "realism" in response to the civil war, the critic and painter George L. K. Morris likewise dismissed *Still Life with Old Shoe* and related works as "confused episodes in a welter of unabsorbed sense-impressions." See George L. K. Morris, "Art Chronicle: Miró and the Spanish Civil War," *Partisan Review* 4, no. 3 (1938), 32–33. Before beginning work on the painting, Miró informed his dealer Pierre Matisse: "I don't deny that one day I will plunge in again and set out on the discovery of a *profound* and *objective* reality of things, a reality that is neither superficial nor Surrealistic, but a deep poetic reality, an extrapictorial reality, if you will, in spite of pictorial and realistic appearances. The moving poetry that exists in the humblest things and the radiant spiritual forces that emanate from them." Miró to Pierre Matisse, 28 September 1936; reprinted in Joan Miró, *Selected Writings and Interviews,* ed. Margit Rowell (Boston: G. K. Hall, 1986), 126.

7. Miró to Matisse, 12 January 1937, in *Selected Writings and Interviews,* 146.

8. Miró to Matisse, 12 February 1937, in ibid., 147.

9. Dalí, "Conquest of the Irrational," in *Collected Writings,* 265.

10. Dalí, *The Secret Life of Salvador Dalí* (New York: Dial Press, 1942), 358.

11. As Dalí somewhat disingenuously stated: "I believed neither in the communist revolution nor in the national-socialist revolution, nor in any other kind of revolution. I believed only in the supreme reality of tradition." Ibid., 360.

12. Ibid., 357.

13. David Lomas, *The Haunted Self: Surrealism, Psychoanalysis, Subjectivity* (New Haven/London: Yale University Press, 2000), 140. According to Lomas the first French translation of Freud's text appeared in 1927. See also Sigmund Freud, *Beyond the Pleasure Principle,* trans. and ed. James Strachey, introduction by Peter Gay (New York: W. W. Norton, 1990).

14. See Julia Kristeva, *Powers of Horror: An Essay on Abjection,* trans. Leon S. Roudiez (New York/Guildford: Columbia University Press, 1926); and Lomas, *Haunted Self,* 175–76.

15. Michael Taylor notes that the figure is based on an illustration of a doctor demonstrating a heart pumping machine. See Taylor's entry on the painting in Dawn Ades, ed., *Dalí,* exh. cat. (New York/Philadelphia: Rizzoli/Philadelphia Museum of Art, 2004), 262–64. In *Beyond the Pleasure Principle,* Freud spoke of the death-drive (*todestrieb*) as a rival to the sexual drives, the life force of the libido. Establishing a new structural theory of the mind, he defined the death-drive as a disruptive, conservative force that seeks to restore organic life to a prior, inanimate state in order to release the subject from conflict and tension. If the reality principle, Freud argued, demands the abandonment or postponement of satisfaction, the ultimate aim of the death-drive is the extinction of desire. See Freud, *Beyond the Pleasure Principle.*

16. On the exhibition history of the painting and related studies, see Taylor's entry in *Dalí,* 262–64.

17. Taylor, "The Chemist of the Ampurdàn [sic] in Search of Absolutely Nothing," in *Dalí,* 246.

18. Dalí, "Apparitions aérodynamiques des 'Etres-objets,'" *Minotaure* 6 (Winter 1935–36): 33–34; translated in *Collected Writings,* 207–11.

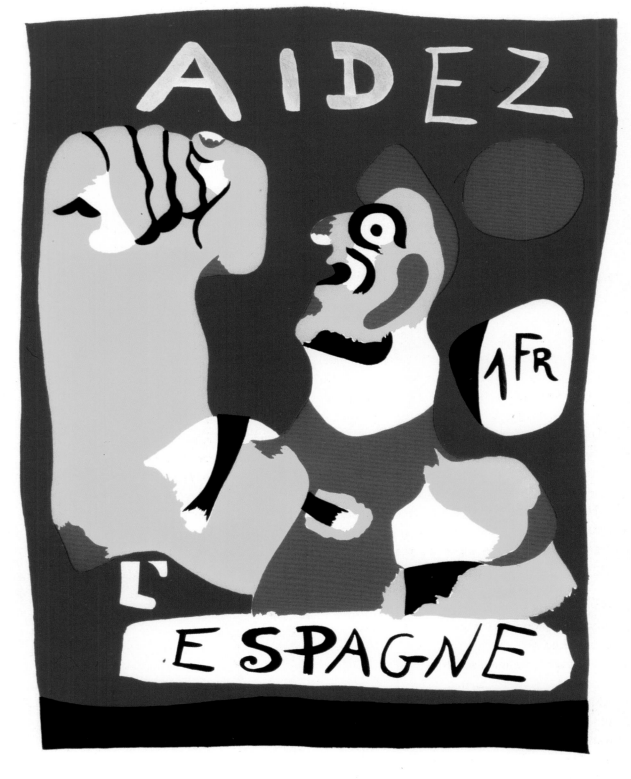

Dans la lutte actuelle, je vois du côté fasciste les forces
périmées, de l'autre côté le peuple dont les immenses ressources
créatrices donneront à l'Espagne un élan qui étonnera
le monde.                    Miró.

Fig. 1 (cat. 9:3). Joan Miró, *Aidez L'Espagne*, 1937.

# Miró's Aidez L'Espagne

## WILLIAM H. ROBINSON

For centuries academic artists portrayed war from the perspective of a dispassionate reporter, often envisioning events through the hazy lens of hindsight. The unfolding tragedy in Spain during the brutal civil war of 1936–39, by contrast, brought scores of artists to the immediate aid of the besieged Spanish republic. The war even turned avant-garde artists into fierce partisans in the struggle to preserve the republic's democratically elected government. Artists went beyond merely portraying the war to creating and selling works to raise money for the cause. Joan Miró's stencil print *Aidez L'Espagne* (*Help Spain*) (fig. 1) and Picasso's etching *Dream and Lie of Franco* (see fig. 1, p. 459; fig. 2, p. 460) are among the most remarkable examples of this development. Copies of both were sold at the Spanish republic's pavilion at the Paris International Exhibition of 1937, giving the public the opportunity to directly participate in the fight against fascism.[1]

Miró originally created *Aidez L'Espagne* as a design for a French postage stamp.[2] Art historian Christian Zervos initiated the idea in early 1937 by asking the artist if he would consider painting a design for this purpose. Costing only a franc, the stamp represented an ingenious mechanism for bringing the Spanish republic's threatened condition to the attention of a mass audience at a time when it was urgently seeking an alliance with the Western democracies. Although the stamp was never produced, Miró executed the design in the form of a gouache painting (Fondation Zervos, La Goulatte, France), which he then used to create this small, yet powerful poster. "I wanted it to have great visual impact," he remarked.[3] Sandwiched between the words "Aidez" and "Espagne," a boisterous Catalan peasant painted mostly yellow and red, colors associated with the Spanish and Catalan flags, appears in profile against a brilliant blue background, with an enormous arm raised in the leftist, clenched-fist salute and mouth agape. "I painted the figure of a Catalan peasant wearing a barretina," Miró commented, "because it's a human being I know very well and because he is a person who stems from the earth. This was more genuine than the figure of an intellectual would have been."[4] Miró's peasant offers a male counterpart to Julio Gonzalez's iron sculpture *Montserrat* (see fig. 1, p. 468), also exhibited at the Spanish pavilion, but depicting a Catalan woman holding a child and a sickle. The poster's simple and distinct forms represent a considerable shift from the abstract signs and obscure symbols Miró used to portray Catalan hunters and women strolling down the Rambla in the 1920s. This poster, by contrast, makes a direct appeal to the masses through a populist, almost cartoon-like character. Miró made the poster's message even more explicit by adding an inscription beneath the image: "In the current struggle, I see on one side the antiquated forces of fascism; on the other side, the people, whose vast creative resources will give Spain a spirit that will astonish the world."

Miró's gouache study for *Aidez L'Espagne* was published in a 1937 issue of *Cahiers d'Art* and in an issue of the GATEPAC (Association of Spanish Architects and Technicians for Progress in Contemporary Architecture) magazine *A.C.*[5] Miró based the composition on a drawing depicting not a man, but a bare-breasted woman wearing a hat and raising one arm in the leftist salute (fig. 2).[6] She is accompanied by a bird-like creature with outstretched limbs. The principal figure below flashes a long tongue through rows of clenched teeth, echoing the screaming heads recurrent in the civil war paintings and sculptures of Picasso and González. The woman in Miró's sketch also wears a stocking cap that rises from the back and

Fig. 2. *Preparatory Drawing for "Aidez l'Espagne,"* 1937, by Joan Miró.

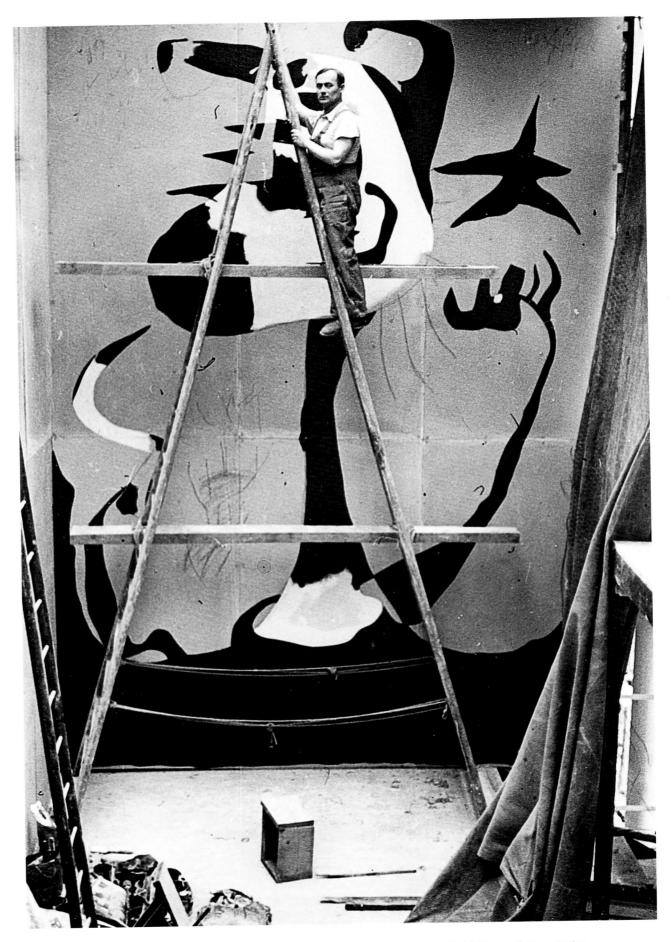

Fig. 3. Miró painting *The Reaper* at the pavilion of the Spanish republic, Paris International Exhibition, 1937, by Pierre Matisse.

folds toward the front, recalling the Phrygian bonnet worn by Marianne, the female personification of the French Revolution and democratic resistance against tyranny. Perhaps the most memorable Marianne in the history of art appears in the center of Eugène Délacroix's *Liberty Leading the People,* 1830 (Musée du Louvre, Paris). Bare-breasted and wearing the red bonnet of revolution, Délacroix's heroine strides over the barricades toward the viewer. Thrusting a French flag in the air with her raised right arm, she turns her head in right profile, echoing the peasant's profile in Miró's print.[7] The figure's female sexuality in the preparatory drawing is an indication of its origin in Marianne iconography. Rather than merely enlarging the design from the drawing, Miró adjusted the composition and transformed the figure into a man with bulging biceps and an arm enlarged to gigantic proportions, so it dominates the composition and infuses the image with tremendous power. Similarly, Miró surrounded the eye with a heavy black outline that opens, not on the profile side as expected, but along the bottom right, forcing the viewer to read the eye in frontal view and enhancing its hypnotic gaze.

*Aidez l'Espagne* established a model for Miró's enormous mural *The Reaper,* also known as *Catalan Peasant in Revolt* (fig. 3), commissioned by the Second Republic for its pavilion at the Paris International Exhibition of 1937.[8] More than 18 feet tall, the mural was painted on six sheets of Celotex, the material used for the pavilion's interior walls, and installed in a large stairway. Miró again focused on a single figure, a Catalan peasant wearing a *barettina,* who now seems to explode with uncontrolled fury. The figure raises both arms rather than just one and swings a sickle with its slender right extremity, suggesting a bolt of rippling energy more than a limb. Dark, spiky forms protrude from the mouth, while the tip of the bonnet coils up into a fist, ready to strike out, echoing the other shapes that protrude menacingly from the head. This is not the suffering victim of war—the wounded horse, the crying mother, the dead soldier portrayed in Picasso's *Guernica,* 1937 (Museo Nacional Centro de Arte Reina Sofía, Madrid)—but a fierce Catalan determined to defend his liberties.

Miró's mural disappeared after the pavilion was dismantled and, considering its fragile support, has probably not survived. Yet its lineage and role in the fight against fascism lives on in the artist's small poster, *Aidez l'Espagne.* The poster's potent denunciation of fascism made Miró fear for his life after the German invasion of France in 1940. After hiding in Perpignan, he managed to slip across the border and spent the rest of World War II living discreetly in Majorca and Barcelona.

1. Catherine Blanton Freedberg notes that Picasso donated editions of this etching so they could be sold to raise money for the republic, and postcards of the individual scenes were also sold at the desk for the same purpose. See Freedberg, "The Spanish Pavilion at the Paris World's Fair" (Ph.D. diss., Harvard University, Cambridge, 1986), 1:424.

2. See Margit Rowell, ed., *Joan Miró: Selected Writings and Interviews* (Boston: G. K. Hall, 1986), 292–93. Miró produced two editions of the poster, one with the inscription and one without.

3. Ibid.

4. Ibid.

5. The gouache is reproduced in *A.C.,* no. 25 (June 1937), back cover, and in color in *Joan Miró: Rétrospective de l'oeuvre peint* (Saint-Paul, France: Fondation Maeght, 1990), 113.

6. Pere Gimferrer, *The Roots of Miró* (New York: Rizzoli, 1993), 220–30.

7. Marianne iconography in modern art is discussed by Kenneth E. Silver in *Esprit de Corps: The Art of the Parisian Avant-Garde and the First World War, 1914–1925* (Princeton: Princeton University Press, 1989), 13–24, 93–99.

8. Jacques Dupin, *Joan Miró: Life and Work* (New York: Harry N. Abrams, 1962), 296–99.

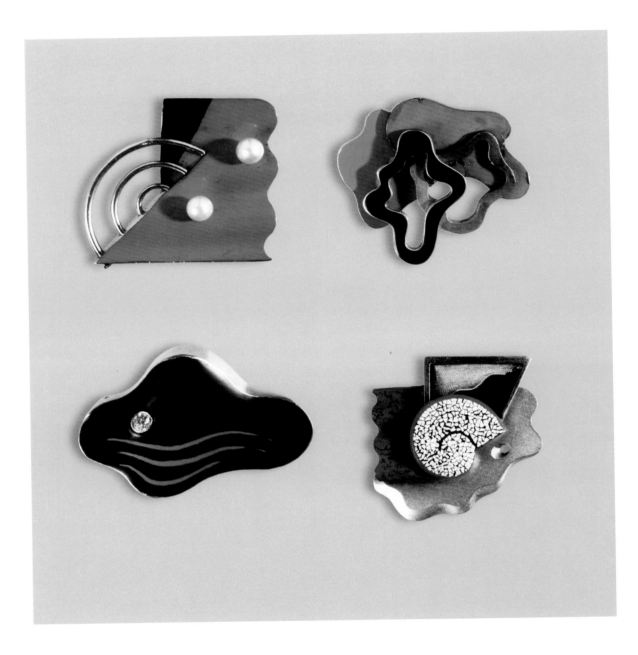

Fig. 1 (cat. 9:4a–d). Manuel Capdevila with Ramon Sarsanedas, *Iris* (top left), *Rhythms* (top right), *Cetacean* (bottom left), and *Spain Withdrawn* (bottom right), 1937.

# Artistic Jewelry

M A R I À N G E L S   F O N D E V I L A

M

anuel Capdevila, like other Catalan artists of the 20th century (Julio González, Pablo Gargallo, Manolo Hugué, Lluís Masriera, and Jaume Mercadé), worked equally well in two separate disciplines, in his case, precious metals and painting. He trained in the family workshop in Barcelona, run by his father, Joaquim Capdevila. As a young man, Manuel Capdevila produced utilitarian objects (plates, jugs, candelabra), as well as jewelry (brooches, earrings, bracelets, and pendants), which he fashioned from openwork structures that he set with diamonds, pearls, and stones in a style reminiscent of late Modernisme or early Art Deco.

Art Deco, more popularly known at the time in Catalonia as Cubist Style, was beginning to percolate into the creations of the artists in the Foment de les Arts Decoratives (FAD), a body that promoted the applied arts in Barcelona and whose members included decorators, furniture makers, ceramists, lacquerers, and jewelers. FAD sent a significant collective contribution to the 1925 International Exposition of Modern Decorative and Industrial Arts in Paris. Even though Capdevila was not among those who showed work at the exhibition, touches of the "1925 style" can be seen in some of his works. He did, however, play an active part in FAD during the 1930s, presenting objects in the monographic exhibition of the Taula Parada (1934), as well as the First Salon of Decorator Artists (1936), and in the FAD section of the Sixth Milan Triennial (1936).[1]

Capdevila went beyond the decorative nature of Art Deco, as can be seen in the series of pieces of jewelry (fig. 1) he made in 1937 while working in the Atelier Lacambre in Paris. In his studio on rue Raspail, Capdevila designed these brooches that clearly reveal the influence of the approaches of the avantgarde and are in keeping with the spirit of ADLAN (Friends of New Art). The principal materials are silver, eggshell, and Japanese lacquer, which produces a rich and contrasting range of colors. His collaborative work with the lacquerer Ramon Sarsanedas needs special mention. Sarsanedas learned the technique of applying lacquer at the Escola Polythecnicum under Lluís Bracons (see fig. 8, p. 298), who had studied with Jean Dunand in Paris and then introduced Japanese urushi lacquer into Barcelona.[2] That Capdevila had worked with Sarsanedas before is demonstrated by a commemorative silver and lacquered goblet that was produced to mark the occasion of the annual festival of FAD in 1932.[3]

The brooches in this exhibition combine organic forms with subtle hints at figuration, as exemplified by their titles.[4] Shown at the 1937 Salon d'Automne in Paris but largely unnoticed in their day, they should be regarded as some of the most advanced expressions of Catalan jewelry on the international scene. The brooch *Spain Withdrawn* alludes to the bitter experience of the Spanish civil war; the shape, derived from the Iberian Peninsula, is inlaid in the center with eggshell in the form of a spiral, a reference it would seem to the internal fragmentation caused by war.

1. The exhibition included the pectoral medal that he made in 1934 in collaboration with the sculptor Carles Collet, for the president of the Catalan Court of Cassation. A large replica was fabricated and hung in the Autonomous Community Court of Justice, where it watched over the court hearings.

2. The Escola Polythecnicum, sponsored by Francesc Cambó, filled the void left by the Escola Superior dels Bells Oficis de Barcelona, which closed in 1924 under the dictatorship of Miguel Primo de Rivera. Lluís Bracons taught lacquerware at the Escola Polythecnicum, which was founded in 1924 with Francesc d'Assís Galí as artistic director. Manuel Capdevila also studied there.

3. See *Arts decoratives a Barcelona: Col·leccions per a un museu*, exh. cat. (Barcelona: Ajuntament de Barcelona, 1994), 138.

4. This series of brooches was donated by Capdevila to the Museu Nacional d'Art de Catalunya in 1993. Capdevila has recently made a limited facsimile edition of these pieces.

Translated by Susan Brownbridge.

# Catalans! Catalonia! Catalan Nationalism and Spanish Civil War Propaganda Posters

MIRIAM M. BASILIO

Catalonia's long struggle for self-determination and efforts to preserve its unique culture and language were a reservoir from which diverse and sometimes competing factions drew in designing posters and propaganda campaigns intended to mobilize specific sectors of the population during the Spanish civil war (1936–39). Not only did a large number of posters address their audiences in Catalan, but many also referenced Catalan national symbols, historic events, and leaders, because it should not be forgotten that the struggle to defend the republic intersected with the efforts of Catalan leaders to preserve regional autonomy. At stake was not only the fate of the progressive workers republic but also that of Catalonia's government, culture, and way of life.

Catalonia, with large segments of the population immediately and heroically fighting against forces supporting the coup (17–18 July 1936), was regarded as one of the bulwarks of the republic. Its capital, Barcelona, was poised to develop a sophisticated multimedia propaganda effort at the advent of the civil war because it was recognized as having the best graphic arts and design infrastructure in the country. The Generalitat established its own propaganda division—the Comissariat de Propaganda, on 3 October 1936, before the creation of the republican Ministerio de Propaganda.[1] Jaume Miravitlles, chief of the comissariat, made a proposal to Lluís Companys, president of the Generalitat, arguing that Catalonia should have its own propaganda division, given that the rebels would surely emulate the propaganda strategies of their allies—the German Nazis and Italian fascists—while the Spanish communists would imitate that of their colleagues in the Soviet Union (fig. 1).[2] The comissariat's activities included disseminating propaganda posters and postcards, publishing pamphlets, graphic albums, and books, as well as organizing performances, rallies, lectures, and exhibitions.[3] It issued musical

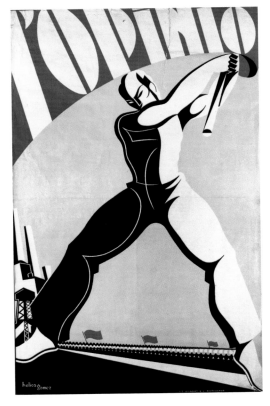

Fig. 1 (cat. 9:7). Helios Gómez, *L'Opinió*, c. 1934.

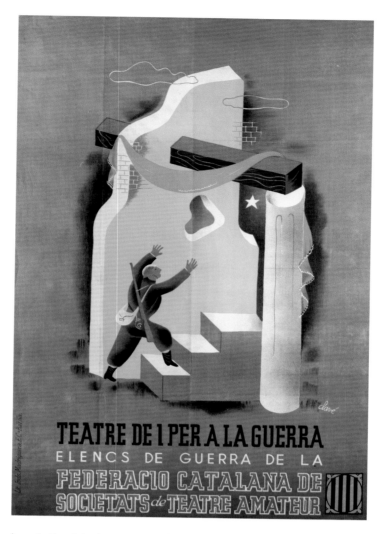

recordings and produced theatrical events, radio broadcasts, and films (fig. 2). Activities were aimed for audiences at the front and rear guard, as well as internationally. The comissariat published a bulletin in Catalan, Spanish, French, English, and Esperanto, as well as the magazine *Nova Iberia* in Catalan, Spanish, French, and English, and it established delegations located in Madrid, London, Brussels, Oslo, and Copenhagen.[4]

A number of political parties and unions were also mobilized; like the comissariat, they recognized the crucial role of visual imagery to broad propaganda campaigns that incorporated broadsheets, murals, newspapers, music, films, ephemeral monuments, radio broadcasts, rallies, and marches.[5] Posters were reproduced in newspapers and magazines, the postcards often sent to and from soldiers at the fronts.[6] *Consignas,* or slogans, were thus reinforced through various means with posters serving as a vital visual public nexus for the circulation of

such calls to action.

Poster production in the republican-controlled area was far greater in quantity and quality than that in rebel territories, and a strong graphic arts and publicity infrastructure existed in the major cities loyal to the republic: Barcelona, Madrid, and Valencia. The tolerance for pluralistic political expression that existed for at least part of the war (after May 1937 anarchist groups were persecuted by communist groups loyal to Stalin and by sectors within the republican government) also meant that groups were able to create their own propaganda.[7] The lack of paper supplies and the mobilization of artists to the fronts, however, led to a waning in poster production toward the end of the war.[8] Moreover, the posters had wide latitude in content and form, as evident in their stylistic diversity and their production by a broad spectrum of artists, photographers, and designers with commercial experience. The well-developed poster and graphic design infrastructure exist-

Fig. 2 (cat. 9:9). Antoni Clavé, *Theater from and for the War,* 1938.

ing before the war and the circulation of works from abroad, either because foreign designers were working in Barcelona or through publications, meant that many poster artists were aware of the latest trends in modern French and German design, particularly Art Deco and Bauhaus, and John Heartfield's photomontages.[9] Leftist publications disseminated constructivist-inspired design and Soviet propaganda as well. Pivotal to the production of posters in Barcelona was the SDP (Syndicate of Professional Designers), which had been founded in April 1936 as part of the socialist UGT (General Workers Union) and created posters for a variety of political, union, and Generalitat entities.[10] In fact, the majority of posters made in Barcelona were produced by members of the SDP. The utopian belief in the Popular Front coalition as empowering all Spaniards and in the transformative power of education, political participation, and art also contributed to the importance given to all kinds of propaganda.

In terms of content, propaganda produced in Catalonia, as distinct from that from other areas of republican Spain, was characterized by appeals to a specifically Catalan national identity. In the case of posters, first and foremost, many were published in Catalan. Second, the comissariat, at times in collaboration with other agencies of the Generalitat, had an ambitious program that included measures intended simultaneously to give continuity to prewar efforts to preserve and promote Catalonia's rich culture, boost morale at the rear, and educate the troops at the front. Among these activities were the annual celebration of the Fira del Llibre (Book Fair),[11] theater and musical performances, and the use of the *auca,* the traditional popular woodcut print (fig. 3), for wartime purposes.[12]

In addition, posters included references to Catalan monuments, sites of memory, dates of historic commemorations, allegorical symbols of Catalonia, and leaders of the Generalitat. Ricard

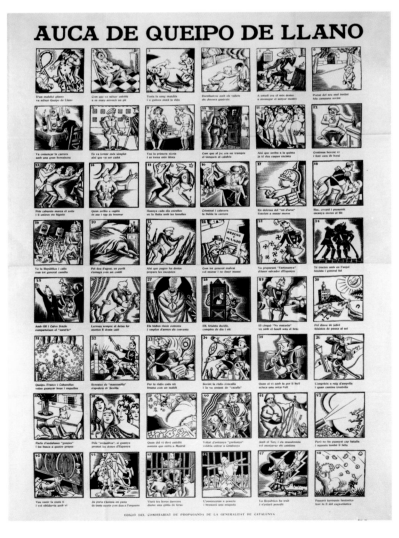

Fig. 3. *The Story of Queipo de Llano,* 1936–39.

Fàbregas's *11 September: Catalans: Catalonia!*, c. 1937 (fig. 4), features a statue of Rafael Casanova, located on Barcelona's ronda de Sant Pere and commemorating the Catalan national holiday, 11 September, date of the 18th-century defeat of Catalan armies supporting Archduke Charles of Austria against the Bourbon King Philip V in the War of Succession. During the civil war, articles appeared on 11 September making parallels between Catalonia's struggle against the centralizing reign of Philip V and its current efforts to defeat Franco's authoritarian nationalist and anti-Catalanist program. While previous national symbols were recontextualized for wartime purposes, Miravitlles and sculptor Miquel Paredes also created a new allegorical image of Catalonia, "El més petit de tots" (The Smallest One), based on a traditional song and designed to both inspire the populace and instill republican and Catalanist values in children.[13] Paredes produced a small sculpture of a marching child clad in the *mono azul* (a one-piece cotton gar-

ment most frequently dyed blue and worn by workers and male and female militia members) and red *barretina* (referencing the hat worn by Catalan peasants and the republican Phrygian cap). This energetic boy gives a clenched-fist salute and holds either a Catalan, republican, CNT–FAI (National Workers Confederation–Iberian Anarchist Federation), or PSUC (Unified Socialist Party of Catalonia) flag.[14] Sold to raise funds for the war, the figurine was reproduced in clay, bronze, and gold, and copies of the last version were given to King George V, Franklin Roosevelt, and others. At least two posters were made promoting this campaign, and the children's book illustrator Lola Anglada created a book based on the character.[15] This figure could be viewed as an updated version of the protagonist of the Catalan anthem "Els segadors" (The Reapers) infused with republican values.

Carles Fontserè, one of Barcelona's most prominent poster artists and a key member of the SDP, has

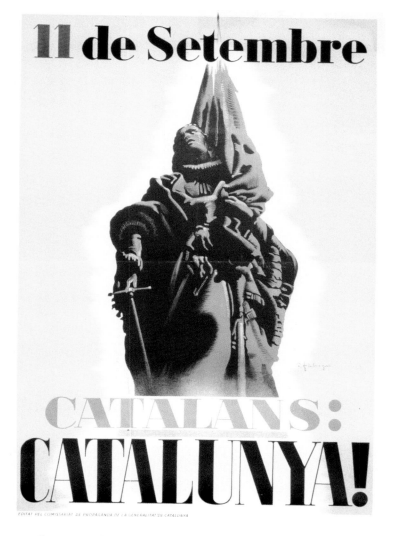

Fig. 4. *11 September: Catalans: Catalonia!*, c. 1937, designed by Ricard Fàbregas.

argued that the appearance of posters on Barcelona's walls within days of the defeat of the uprising there acted as a catalyst by making resistance more tangible and rebutting those skeptics and rebel sympathizers who thought the coup would instantly succeed.[16] The dramatic appearance of large numbers of colorful posters (fig. 5) competing for space on city walls as well as the widely held view that posters contributed to the creation of a "clima psicològic" are noted in numerous press articles. In one of them, published in the Barcelona newspaper *Mirador* in December 1936, Agustí Bartra argued: "The image and phrase impose themselves on us in an obsessive manner. Never had their influence had such an efficient penetration—so much so that it is cruel—until now. Today the walls not only have ears—as the cliché goes—but they have also learned to reason and to scream."[17]

That posters were viewed as a persuasive element is also evident in an anonymous editorial published in March 1937. In it, the writer underscored the importance of posters as a "weapon" that convinces and motivates. According to this writer, a campaign had begun to reduce the "excess of posters, banners, and broadsheets that flood streets and building fronts in Barcelona." He continued: "Posters pass before the somewhat stupefied gaze of Barcelona residents, with the vertiginous speed of a book's pages flapping in the wind, or a deck of cards in the

skillful hands of a con artist. If the normal shelf life of a poster was once 15 days or a month, now it has been reduced to a few minutes."[18] The editorialist concluded by calling on the central republican government and the comissariat to control the number of posters issued as a means to thwart factionalism.[19] Indeed, the republican government against which the right-wing generals rose up in arms was a left-leaning Popular Front coalition, within which disagreements proliferated, festered, and erupted during the course of the war.

This situation notwithstanding, according to Miravitlles, the comissariat produced posters while also acting as a conduit for those generated by various political, labor, governmental, and aid groups, taking care to respect divergent viewpoints.[20] Among the posters produced by the comissariat was *Catalonia Defeated Fascism in 24 Hours,* 1936 (fig. 6), which used photographs to evoke the immediacy of press reports and the widely held belief that such images were irrefutable documentary evidence of actual events. Three key factors behind republican resistance to the rebellion are represented: improvised fighting forces, among them (from top to bottom) Guardias de Asalto (Assault Guards) and citizens behind barricades on carrer Diputació in a widely reproduced image taken by photojournalist Agustí Centelles on 19 July; anarchist forces marching behind their black and red flag; and uniformed

Fig. 5. Posters on a wall in Barcelona, undated, by Kati Horna.

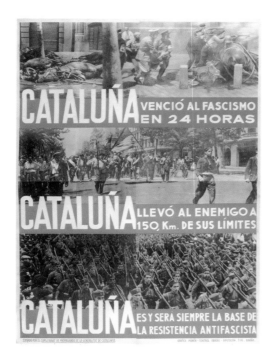
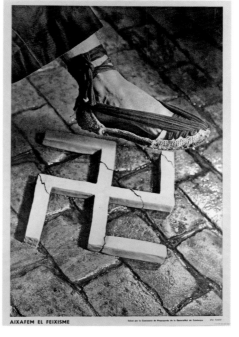

military. The groups portrayed represent spontaneously formed militia units, many organized by labor unions and political parties, as well as military forces that remained loyal to the republic, all mobilized in rapid response to the coup. The poster's tripartite design works to indicate temporal progression, its three vectors reiterate the Generalitat's loyalty to the republic, the strength of its initial response, and its continuing war effort. The use of cropping furthers this sense of dynamism and suggests that the fighting forces depicted are part of a far larger whole.

In Pere Català-Pic's *Let's Crush Fascism,* 1936 (fig. 7), also issued by the comissariat, photography functions in a quite different way. For the first poster issued by the comissariat, Català-Pic created a staged but nonetheless powerful photograph to construct an allegory of Catalonia's victory over fascism.[21] According to Català-Pic's son, the photographer placed a swastika he had made from unbaked clay on the moistened cobblestones of the Rambla and posed the foot of a uniformed Mosso d'Esquadra (Catalan police officer) as if he had just stepped on the object.[22] Català-Pic, the comissariat's Cap de la Secció d'Edicions (Chief of the Publications Section), had written on publicity techniques prior to the war. In an article published in 1937, he argued that propaganda techniques informed by psychology and technology were applicable to advertising as well as politics and had the power to determine the "suc-

cess or failure not only of a trademark, of a manufactured article ... but also of the splendid future, or the downfall of a political movement."[23]

The starkness of the photograph must have stood out from the colorful cacophony of myriad posters for various political factions that covered walls soon after war broke out. Català-Pic employed modernist photographic compositional strategies—cropping, diagonal point of view, and lighting. These modern means were fused with visual elements that referenced both Catalan rural tradition and wartime contemporaneity. The artist selected easily recognizable images: the swastika to indicate the military coup leaders' affinities with fascist ideology, and the quotidian garb of the *miliciano* (militia member) and worker. The hem of a mono azul and the *espardenya* (a handmade shoe worn by rural and urban workers) stand for the strength of the Catalan struggle. Thus Català-Pic met the challenge of translating the complexity of the political situation into a clear message of resistance in which sartorial elements associated with rural labor and local handicraft called to mind populist symbols at the heart of Catalan nationalism—the timeless *pagès* (farmer) tilling the fields. At the same time, these very elements brought to mind the industrial strength of Catalonia, a key element of its nationalist discourse.[24]

An appeal for unity is made to the two constituencies, industrial and rural, that formed the

Fig. 6 (cat. 9:5). *Catalonia Defeated Fascism in 24 Hours,* 1936.
Fig. 7 (cat. 9:12). Pere Català-Pic, *Let's Crush Fascism,* 1936.

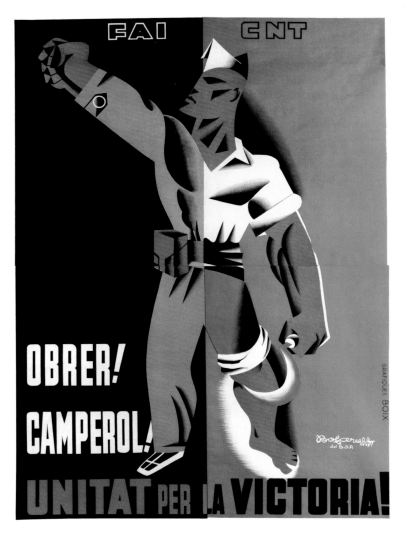

strength of the anarchist trade-union bloc in the poster *FAI CNT. Industrial Worker! Farmworker! Unity for Victory!*, 1936 (fig. 8), by Jacint Bofarull i Forasté.[25] Exhortations to maintain unity are characteristic of a large number of the posters issued by the myriad political parties, union groups, militias, military divisions, government agencies, and cultural organizations active in republican areas and integral to Popular Front discourse. Bofarull dramatically dispenses with perspective, flattening the bifurcated figure—a hybrid rural-industrial worker—against an equally divided composition, comprising black and red areas for the emblematic anarchist colors. These colors, like the figure's clenched-fist salute, were immediately recognizable to viewers, who could identify them with flags, hats, and kerchiefs donned by anarchists. Paradoxically employing division and duality to signify unity, Bofarull created a diagonal axis from the clenched fist to sickle; the figure's head and firmly planted feet create a triangle. In so doing,

Bofarull used elements of abstraction to represent a symbolic notion of unity in struggle. Stark modern typography also acts to convey this idea graphically, creating visual unity, particularly through the use of red letters on the black field, black on the red, and both in the word "la" at the point where the two meet.

A divisive issue, particularly in Catalonia and Aragon where anarchist groups predominated and saw the war as an opportunity to implement libertarian revolution, was the kind of economic and military structures that should prevail in republican Spain. One of the fundamental disagreements was unleashed by the conduct of the war itself; by early 1937 republican authorities began to organize fighting forces under a single military command, disarming the militias that resisted in the interest of coordinating resistance and resources. Many affiliated with anarchist and dissident leftist groups saw a centralized military as antithetical to their

Fig. 8 (cat. 9:8). Jacint Bofarull i Forasté, *FAI CNT. Industrial Worker! Farmworker! Unity for Victory!*, 1936.

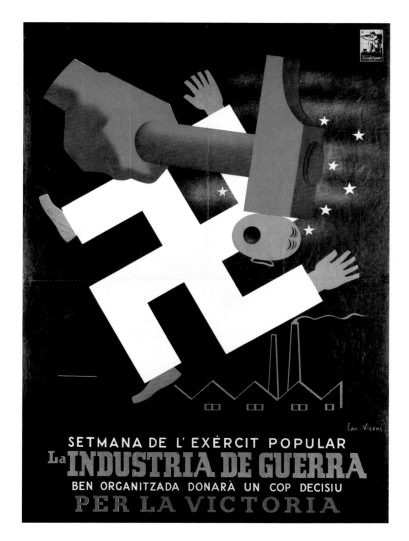

SETMANA DE L' EXÈRCIT POPULAR
La INDUSTRIA DE GUERRA
BEN ORGANITZADA DONARÀ UN COP DECISIU
PER LA VICTORIA

beliefs and contrary to their aim of creating a libertarian collective form of local governance free from hierarchy and "bourgeois" institutions. Likewise, the appropriation of factories and transportation in the interest of collective ownership and distribution of goods created conflicts with both Catalan and republican authorities who wished to centralize control of civilian and military industries.

The 27 February 1937 edition of *La Vanguardia* reproduced posters created as part of the Setmana de L'Exèrcit Popular (Popular Army Week) campaign, for which the SDP was hired to design a new uniform, postcards, pamphlets, and an ephemeral monument erected at the plaça de Catalunya to promote the benefits of military unification.[26] According to Carles Fontserè, the committee that organized this campaign, as well as those for solidarity with Madrid and the Basque region (discussed below), was led by the communists with the collaboration of the comissariat, which commissioned posters executed by the

SDP.[27] Alongside the headings "El arte al servicio de la guerra" (Art in the service of the war) and "Los dibujantes se mobilizan" (Draftsmen mobilize), this campaign was defined as the key to victory, as "Nuestra libertad y nuestra independencia" (Our liberty and independence). Within Catalonia, independence had a dual connotation: the survival of the republic and, with it, Catalonia's government, the Generalitat.

In the poster *Popular Army Week: A Well-Organized War Industry Will Give a Decisive Strike Toward Victory,* c. 1937 (fig. 9), Miralles presents these complex and contested issues in a constructivist-inspired style ideally suited to produce a vivid political allegory with its share of humor. The republic, its Popular Front army, and its unified war industry are conflated as a red arm crushing the enemy with a hammer. Reinforcing this message is a modern factory, rendered through the zigzag outlines of a roof and two smokestacks. The enemy, as in Català-Pic's poster, is rendered as a swastika, an animated cari-

Fig. 9 (cat. 9:13). Nicolau Miralles, *Popular Army Week: A Well-Organized War Industry Will Give a Decisive Strike Toward Victory,* c. 1937.

Madrileños!
Cataluña os ama...

Palabras pronunciadas por el Presi-
dente Companys, en el mítin celebra-
do en la Monumental el 14 de Marzo
de 1937, en ocasión del DIA de MADRID.

EDITAT PEL COMISSARIAT DE PROPAGANDA DE LA GENERALITAT DE CATALUNYA.    GRAF. ULTRA S.A. CORCEGA 220. BARCELONA.

cature of fascism with a head and arms and legs akimbo. Through such allegorical means the diffi-culties inherent in representing both an internal en-emy—Spaniards supporting Franco's forces—and a fractured republic were negotiated.

On 7 November 1936, as the rebel forces launched attacks on Madrid, the republican govern-ment opted to evacuate to Valencia on the south-eastern Mediterranean coast. The besieged capital became a rallying point referenced in many posters and the subject of a propaganda campaign—Ayuda a Madrid (Help Madrid)—with a distinctive Catalan tone that began in March 1937.[28] Such posters worked in tandem with radio and newspaper announce-ments to promote attendance at rallies, their mes-sages reinforced in articles and pamphlets. Such is the case with *Citizens of Madrid! Catalonia Loves You. From President Companys's Speech on the Occasion*

*of the Rally at the Monumental, 14 March 1937, the Day of Madrid,* 1937 (fig. 10), issued by the comissar-iat. In this poster, a dynamic photomontage depicts Companys giving a speech. Many posters featured Francesc Macià, the first leader of the Generalitat under the republic, and Companys, the charismatic president who succeeded him. Coinciding with the Asturias Rebellion of 1934, Companys had declared the existence of a Catalan state and was sentenced to a 30-year jail sentence, commuted after the Popular Front victory of 1936.[29]

Another rally in support of Madrid, also held at the Monumental Bullring, was announced in Henry (Enrique) Ballesteros's poster *For the Liberty of Catalonia: Help Madrid. Sunday the 7th at 10:00 a.m. All Women to the Monumental,* c. 1937 (fig. 11).[30] Ballesteros, head of the SDP, employed stark mod-ern typography and a limited color scheme, creat-

Fig. 10 (cat. 9:6). *Citizens of Madrid! Catalonia Loves You. From President Companys's Speech on the Occasion of the Rally at the Monumental, 14 March 1937, the Day of Madrid,* 1937, photomontage by Agulló.

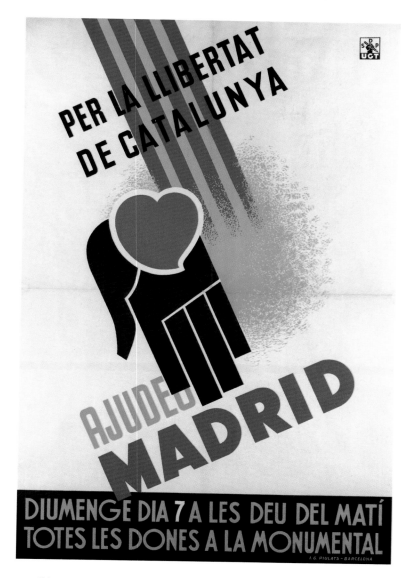

ing a dynamic composition using the red and yellow stripes of the Catalan flag and a heart for mutual love. Both elements were part of a campaign for unity introduced by the comissariat in early 1937, in which citizens were encouraged to don insignia to indicate their support for the war effort (fig. 12).[31] In Ballesteros's poster, the open hand representing aid to the capital joins text and image at key points. The words "liberty" and "Catalonia" are placed directly over the Catalan flag, its red and yellow colors used to designate the words "help" and "Madrid" respectively below. Thus, as we have seen in other posters, rather than appealing solely to loyalty for the republic itself, it was stressed that only a victory of the republican government would guarantee Catalan freedom and self-governance.

Just as Ballesteros's poster appealed to Catalans as Catalans to lend their support to Madrid, other

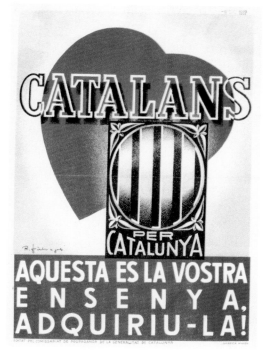

Fig. 11 (cat. 9:11). Henry Ballesteros, *For the Liberty of Catalonia: Help Madrid. Sunday the 7th at 10:00 a.m. All Women to the Monumental*, c. 1937.

Fig. 12. *Catalans: This Is Your Badge, Buy It!*, c. 1937, designed by Ricard Fàbregas.

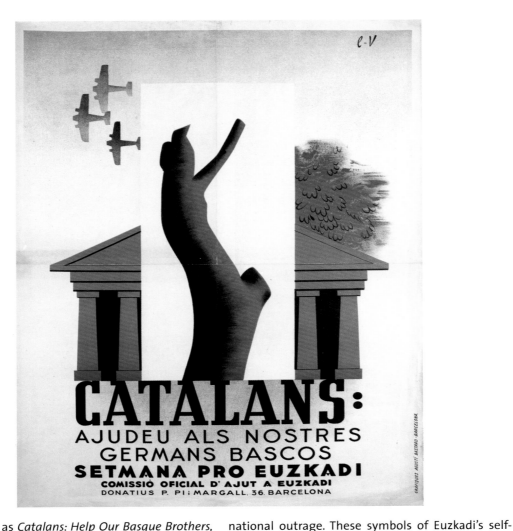

posters such as *Catalans: Help Our Basque Brothers, Pro-Euzkadi Week,* c. 1937 (fig. 13), sought to foster empathy for Euzkadi (the Basque region), and was part of a campaign that culminated in the Setmana Pro Euzkadi, 29 May–6 June 1937. Following a series of losses to the rebels in October 1937, the Basque government established itself in Barcelona and its Delegació General de Euzkadi a Catalunya also issued propaganda posters related to this campaign (fig. 14). In *Catalans: Help Our Basque Brothers,* Nicolau Miralles created a composite image in which the famous tree of Guernica stands in front of the Casa de Juntas (parliament), referring both to the town that had been the capital of Euzkadi and to its history of self-rule. The silhouettes of three bomber planes refer to the brutal German aerial bombardments that devastated the town in April 1937 and elicited inter-

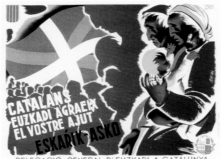

national outrage. These symbols of Euzkadi's self-government, along with the Catalan flag, were also incorporated into a massive ephemeral monument in the plaça de Catalunya, where a rally was held in support of a republican military offensive to defend Euzkadi from rebel advances.[32]

By 15 April 1938, Franco's troops had reached the Mediterranean, splitting the republic in two and isolating Catalonia. Soon after, Dionisio Ridruejo, propaganda chief of Franco's wartime government, began planning the campaign for the triumphal entry to Barcelona, which took place on 26 January 1939. There were disagreements within the rebel camp as to whether or not to employ Catalan for these materials.[33]

Although the injunction against speaking Catalan in public would eventually prevail, and expressions of its culture would even be criminalized,

Fig. 13 (cat. 9:10). Nicolau Miralles, *Catalans: Help Our Basque Brothers, Pro-Euzkadi Week,* c. 1937.

Fig. 14. *Catalans: Euzkadi Appreciates Your Help,* c. 1937, designed by Serra Molist.

some materials were produced addressing the soon-to-be occupied areas in Catalan, such as a broadsheet headed "Ha Llegado España" (Spain Has Arrived—the same slogan used by Catalan artist Josep Morell in a poster designed for the occupation (fig. 15), which graphically conveys the rebels' view that they were literally conquering a territory that had seceded.[34] The self-representation of the new regime as articulated through its propaganda could be summed up thus: the nationalists were the guarantors of Spain's unity, defenders of its traditions, foremost among them its Catholic faith. They were Spain's saviors led by the providential *caudillo* (commander), General Franco, who fulfilled the military's role in preserving the country's greatness. For Franco and his allies, the struggle was an apocalyptic battle to defend Catholic Spain from a republic cast as godless, inhuman, and anti-Spanish. This is clearly the message in the poster *First Crusade: Spain, Spiritual Guide for the World,* c. 1937 (fig. 16), in which the word "crusade" juxtaposed with the number "1" creates a cross whose shadow is cast directly over the peninsula, with the rest of the slogan beneath. In the pastoral letter issued by Cardinal Isidro Gomá and signed by a group of church leaders in July 1937, as well as in countless articles, speeches, and pamphlets, the re-

public was equated with the Soviet Union; the war was depicted as a reprise of the *Reconquista* (the retaking of Spain from the Moors in the Middle Ages), a new battle against atheist communist "infidels," a world conflict in which Spain would take the lead.[35] The anticlerical violence that erupted in republican areas of Spain during the first months of the war was cited as evidence for the need to engage in what was viewed as a religious war.

This view was repeated in nationalist pamphlets, newspapers, postcards, posters, and history books, and from newsreels, posters, films, museums, monuments, and classrooms until the dictator's death in 1975. Among those collaborating in the propaganda campaigns were graphic designers such as Morell, who had shown an interest in modern graphic design. Morell made political posters for republican-era electoral campaigns for the right-wing Catalanist party the Lliga Regionalista and for wartime republican government agencies before working for the new regime.[36] Artists working for Franco had in some cases traveled abroad and also had access to propaganda materials from fascist Italy and Nazi Germany, either provided by those governments or published in periodicals circulating in nationalist areas.[37]

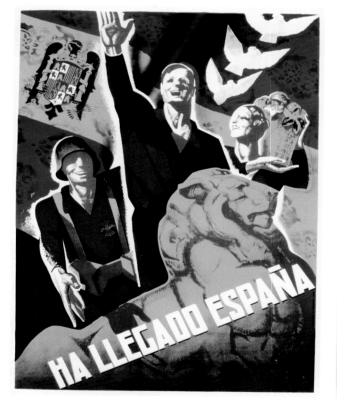

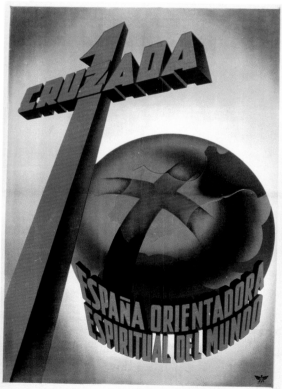

Fig. 15. *Spain Has Arrived*, c. 1939, designed by Josep Morell.

Fig. 16 (cat. 9:14). *First Crusade: Spain, Spiritual Guide for the World,* c. 1937.

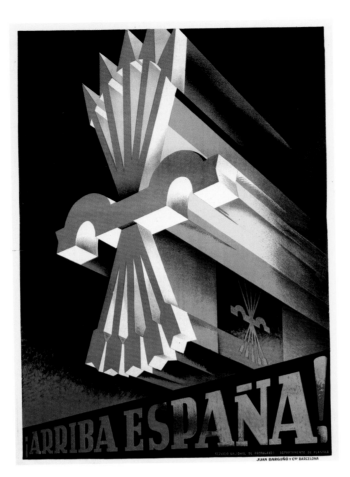

Key to pro-Franco propaganda was the appropriation of past historic events, as well as national, royal, military, and religious symbols to foster parallels among selected traditions from Spain's present and future. As had been the case on the republican side, historical precedents were selectively chosen and interpreted to foster specific interpretations. The poster *Up with Spain!,* 1939 (fig. 17), printed in Barcelona after the occupation, features the *yugo y flechas* (yoke and arrows), a symbol of the union of Aragon and Castile under the Catholic monarchs Isabel and Ferdinand that was the emblem of the Falange Española.[38] Founded by the charismatic poet José Antonio Primo de Rivera in 1933 (son of the former dictator Miguel Primo de Rivera), the Falange combined utopian appeals to nationalism, modernity, and revolution with claims that it would revive Spain's imperial grandeur and traditions. In creating his state party Falange Española Tradicionalista y de las JONS in April 1937, Franco shrewdly appropriated the fallen Primo de Rivera (he died in a republican prison in 1936) as a martyr for his cause, as well as aspects of Falange party imagery and program. In addition to the yoke and arrows, these symbols included the red-and-black banner, the straight-arm open-palm salute, and the slogan "Arriba España" (Up with Spain).[39] In the anonymous poster, the diagonal orientation of the yoke and arrows suggests forward movement. Seen from below and thus monumentalized, the Spanish and Falange party flags emerge like shooting stars from the yoke and arrows. In this way, the poster recalls the Falange (and state party) anthem, "Cara al Sol," whose lyrics make reference to flags carried on a glorious victory march. Ridruejo, who took over Miravitlles's office after the occupation of Barcelona, recalled his awe upon seeing materials produced by the comissariat: "It was clearly obvious that the republicans' propaganda had been far superior to our own."[40]

Tragically, the experience of democracy and freedom to express and develop Catalan culture was crushed along with the republic. With it, the unique fusion of appeals to Catalan national tradition and modern art as well as graphic design that characterized many of the best posters produced during the Spanish civil war came to an end.

Fig. 17 (cat. 9:15). *Up with Spain!,* 1939.

This essay is dedicated to the memory of my grandfather, Vicente Basilio Bellver, who fought to defend the Spanish republic.

1. Mària Campillo, *Escriptors Catalans i Compromís Antifeixista: 1936–1939* (Barcelona: Publicacions de l'Abadia de Montserrat, 1994), 40. The Ministerio de Propaganda was formed on 3 November 1936, when the republican government fled to Valencia; the Junta de Defensa de Madrid, left behind to govern the capital and coordinate its defense, established its own propaganda apparatus. On the Junta de Defensa, see Miguel Angel Gamonal Torres, *Arte y política en la guerra civil española: El caso republicano* (Granada: Diputación Provincial de Granada, 1987), and Gamonal Torres, "La Junta de Defensa de Madrid y el Sindicato de Profesionales de Bellas Artes: Gráfica política y organización artística," in *Los nuevos historiadores ante la guerra civil española* (Granada: Diputación Provincial de Granada, 1990), 356–67.

2. See the interview with Miravitlles, "Jaume Miravitlles. La cultura en guerra," in *La Guerra civil española: Exposición* (Madrid: Ministerio de Cultura/Dirección General del Patirmonio Artístico/Archivos y Museos, 1980), 98. He also succeeded in making the comissariat answer directly to the president in order to avoid potential effects of political infighting.

3. In 1937, the Generalitat's Departament de Cultura and the comissariat co-organized the exhibition *L'Art Catalan du Xe. Au XVe. Siècle*, held at the Jeu de Paume and then extended at the Maisons Lafitte, both in Paris. See *L'art catalan a Paris* (Barcelona: Generalitat de Catalunya/Conselleria de Cultura, 1937). This exhibition as well as others organized by the comissariat in Barcelona is discussed in Basilio, "Reinventing Spain: Images of the Nation in Painting and Propaganda, 1936–1943" (Ph.D. diss., Institute of Fine Arts, New York University, 2002), 94–96, 152–55.

4. Campillo, *Escriptors Catalans i Compromís Antifeixista*, 40–44, 142–53.

5. See Gamonal Torres, *Arte y política en la guerra civil española*; Gamonal Torres, "Arte y propaganda en la Guerra Civil Española," in *Propaganda en guerra* (Salamanca: Consorcio Salamanca, 2002), 71–85; and Basilio, "Re-inventing Spain," chap. 1 and 2.

6. Ricard Martí Morales, *Les tarjetes postals de la Guerra Civil, 1936–1939* (Barcelona: Miquel A. Salvatella, 2000).

7. For an account of the repression of anarchists and Trotskyites within Catalonia, see Pelai Pagès, *La guerra civil espanyola a Catalunya (1936–1939)* (Barcelona: Els llibres de la frontera, 1987).

8. "Renau-Fontserè: Los carteles de la guerra civil. Declaraciones recogidas por María Ruipérez," *Tiempo de Historia* 5, no. 49 (December 1978), 10–25.

9. See Enric Satué, *Los años del diseño. La década republicana. 1931–1939* (Madrid: Turner, 2003), 15–22; "Renau-Fontserè: Los carteles de la guerra civil," 19–22; Steven Heller and Louise Fili, *Deco España: Graphic Design of the Twenties and Thirties* (San Francisco: Chronicle Books, 1997), 1–15.

10. Carles Fontserè, "El Sindicato de Dibujantes Profesionales," in Jaume Miravitlles et al., *Carteles de la República y de la Guerra Civil* (Barcelona: Centre d'Estudis d'Història Contemporània/La Gaya Ciencia, 1978), 353–77.

11. Campillo, *Escriptors Catalans i Compromís Antifeixista*, 181–89, 292–307.

12. See ibid., 144, for a full list of *auques* published by the comissariat.

13. For more details, see Jaume Miravitlles, *Homes i dones de la meva vida. De la sèrie: Gent que he conegut* (Barcelona: Edicions Destino, 1983), 249–52.

14. The Catalan flag was the best-selling version. See ibid., 251.

15. See Basilio, "Re-inventing Spain," 35–37, and Lola Anglada Sarriera, *El més petit de tots* (Barcelona: Comissariat de Propaganda de la Generalitat de Catalunya, 1937).

16. "Renau-Fontserè: Los carteles de la guerra civil," 11–12.

17. Agustí Bartra, "Les parets parlen," *Mirador*, 3 December 1936, 6. All translations by the author, unless noted otherwise.

18. "Editorial. El Sentido de la medida," *La Vanguardia*, 13 March 1937, front page.

19. A subtext here was likely the growing unrest and public dissension within republican ranks in early 1937. See below.

20. Juan M. Soler, "La Comisaria de Propaganda de la Generalidad. El intenso dinamismo de Jaime Miravitlles, al servicio de la causa antifascista," *Mi Revista* (1 May 1938): unpaginated.

21. According to Miravitlles, see ibid.

22. Satué, "El diseño del cartel de guerra en España," in *Carteles de la Guerra, 1936–1939: Colección Fundación Pablo Iglesias* (Madrid: Lunwerg/Fundación Pablo Iglesias, 2004), 46–55.

23. Pere Català-Pic, "The Erection of a New Propaganda," *Nova Ibèria* 1 (January 1937): unpaginated [original in English]. The article was illustrated by several posters, among them Bofarull's, discussed below. For more on Català-Pic, see the essay by Jordana Mendelson in section seven of this catalogue.

24. Enric Ucelay de Cal, *La Catalunya Populista. Imatges cultura i política en l'etapa republicana (1931–1939)* (Barcelona: Edicions de la Magrana, 1982).

25. According to Fontserè, Bofarull, a sympathizer of the PSUC, was part of the SDP until he was expelled in early 1937 following a rift between members of the graphics collective who were part of the PSUC and those who were against Stalin. Following this split, the Célula de Dibujantes del PSUC was formed. Prior to the war, he had contributed satirical illustrations as well as created posters for publicity and sports events. See Fontserè, *Memòries*, 313–27, and Fontserè, "El Sindicato de Dibujantes Profesionales," 371–74.

26. Ballesteros designed the uniform and Miquel Paredes the monumental sculpture of a soldier. See Fontserè, "El Sindicato de Dibujantes Profesionales," 376.

27. According to Fontserè, he did not know whether the direction of these committees originated with the Communist Party of Madrid or the local PSUC. See Fontserè, *Memòries*, 337–38.

28. Fontserè, *Memòries*, 313–14, 337, and Fontserè, "El Sindicato," 376.

29. In the fall of 1934, general strikes were held in many parts of the country. The insurrection in Asturias (a region on the Bay of Biscay, on Spain's northern coast), led by a coalition of socialist and anarchist coal miners, was the most successful; it lasted two weeks before being crushed.

30. See Fontserè, "El Sindicato," 377.

31. This poster was reproduced in the 15 March 1937 issue of *Moments* magazine.

32. Fontserè, "El Sindicato," 376, and "En la Plaza de Cataluña," *La Vanguardia*, 6 June 1937, 2.

33. Dionisio Ridruejo, *Casi unas memorias* (Madrid: Planeta, 1976), 168–71.

34. For more on Franco's propaganda apparatus and on the campaign for the occupation of Catalonia, see Miriam Basilio "Genealogies for a New State: Painting and Propaganda in Franco's Spain, 1936–1940," *Discourse* 24, no. 3 (Fall 2002): 67–94. On the occupation, see *1939: Barcelona Any Zero: Història gràfica de l'ocupació* (Barcelona: Institut de Cultura de Barcelona/Museu d'Història de la Ciutat/Edicions Proa, 1999). For art and propaganda under Franco, see Xavier Barral i Altet, *L'art de la victòria. Belles Arts i Franquisme a Catalunya* (Barcelona: Columna, 1997); Angel Llorente Hernández, *Arte e ideologia en el franquismo, 1936–1951* (Madrid: Visor, 1995); and Basilio, "Re-inventing Spain," chap. 3 and 4.

35. For the religious aspects of Franco's propaganda, see Giuliana di Febo, *La Santa de la Raza: Un Culto Barroco en la España franquista 1937–1962* (Barcelona: Icaria, 1988).

36. Ricard Marti, *Josep Morell* (Barcelona: Ricard Marti, 2003).

37. See Basilio, "Re-inventing Spain," chap. 3.

38. On the Falange, see Stanley G. Payne, *Fascism in Spain: 1923–1977* (Madison: University of Wisconsin Press, 1999).

39. Ibid., 269, 273–309.

40. Ridruejo, *Casi unas memorias*, 167.

# From War to Magic: The Spanish Pavilion, Paris 1937

The Spanish pavilion at the International Exhibition of Art and Technology in Modern Life (Paris, 1937) was a unique and unrepeatable undertaking that was only possible in the climate of passion, intensity, and enthusiasm that all who took part in it developed. It is difficult to imagine how, under the most adverse conditions, an enthusiastic group of men and women were able to carry out a task so emblematic in the history of world's fairs. How could they construct a building in only four months? How could they bring together Josep Lluís Sert, Pablo Picasso, Joan Miró, Julio González, Alberto Sánchez, and Alexander Calder at the same time and place? How was the miracle produced whereby the small pavilion of a country debilitated by war became one of the biggest attractions at the entire fair?

In the midst of the Spanish civil war, the Spanish republican government decided to participate in the exhibition, scheduled to open in Paris in May 1937. This was, without a doubt, an extraordinary decision at a time when the country found itself in such dire straits that everything without immediate usefulness for the prosecution of the war had been rendered superfluous. Nevertheless, it was precisely an intelligent desire for the efficient use of resources that led the government to consider participating in the exhibition, based on the value of the event's enormous potential for propaganda. The supposition was that this opportunity to call attention to Spain within the framework of an international gathering could ease the republican government's difficult negotiations for the vital supply of armaments that the Non-Intervention Pact prevented it from receiving.

In a well-timed move, the government appointed Luis Araquistáin its new ambassador in Paris, with the express objective of obtaining the much-needed weapons. In order to smooth the way for his negotiations, one of the most important things he had to bear in mind was finding the best way to generate positive public opinion of republican Spain outside the country; he immediately realized that the next world's fair would be a perfect showcase for revealing the reality of Spain to the world. It would require giving an impression of normality, government stability, and organizational capacity, making use of the occasion to garner good publicity for the republic's achievements in its few years of existence. It would also warn of the danger to world stability that a potential fascist victory in Spain would entail.

Thus Araquistáin provided the decisive impetus for Spanish participation in the exhibition, with the awareness that if the republican government wanted to be recognized as the only legitimate representative of the country, and as capable of opposing the fascist movement, it needed to win the sympathy of the entire world, make known its strength and the justness of its cause, and gain international confidence. It was therefore most important to show that the majority of the Spanish people, as well as the country's most prestigious intellectuals and artists, recognized and supported the government.

It was from this moment that a feverish level of activity was set in motion. The philosopher José Gaos, who was also rector of the University of Madrid, was chosen to serve as commissioner; he took over the coordination of directives emanating from the president of the republican government, as well as an interministerial committee created especially for the purpose. The building project was entrusted to the Madrid architect Luis Lacasa, who then sought the collaboration of the Catalan architect Josep Lluís Sert. They immediately created a project to design a building for an expository function that would also serve as a vehicle for the propaganda effort. The team around the commissioner was composed of intellectuals of great prestige: the writers Max Aub and José Bergamín were deputy commissioners, and the painter Hernando Viñes acted as secretary. The group was completed by the director general of fine arts, Josep Renau, a well-known poster and photomontage maker; the sculptor Alberto Sánchez; and the filmmaker Luis Buñuel, who contributed the

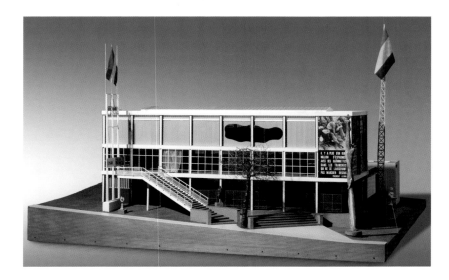

cinematographic material. The committee promptly requested the collaboration—immediately agreed to—of Pablo Picasso, Julio González, Joan Miró, and Alexander Calder. The governments of the Basque provinces and Catalonia also had commissioners, Jose María Uzelai and Ventura Gassol.[1]

Together with many other artists and workers, they began a race against time in which all involved devoted themselves to the task body and soul, and with as much fervor as if they were at the battlefront. On 27 February 1937, the first stone for the Spanish

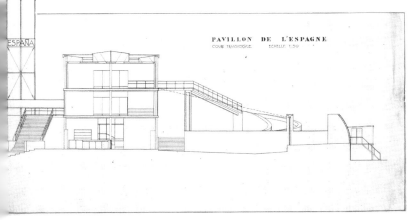

pavilion was laid. The spirit and significance of this event was described in words spoken by Araquistáin himself during the ceremony:

*It seems that some have found it strange that in the midst of a war, the Spanish Republic could find the time and the disposition to be present at this exhibition of Culture and Work. It is precisely this that distinguishes it from the rebellious armed minority that has neither time nor talent for anything but the de-*

*struction of life and human values.*

*For Republican Spain, the war is only an accident, a transitory evil that has been thrust upon it, but which does not in any way keep it from continuing to create material and spiritual works. It is for precisely this that it wishes to live, for which it is fighting: to be free in intellectual creation, social justice, and material prosperity.*

*For this reason, it must triumph. Our pavilion will be the best example of its historic continuity, and the best justification for it. We shall see that the Spanish*

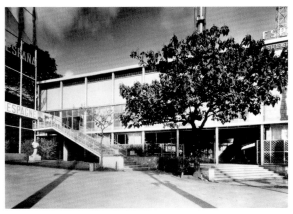

*people must win, because, like Minerva, they possess all weapons: the weapons of Liberty, Culture, and Work.*[2]

In fact, it was with precisely these weapons that those who worked on this undertaking achieved what seemed impossible: the building of one of the most interesting pavilions at the entire exhibition (figs. 1–3)—a small structure, created with great material difficulties in the very limited amount of space

Fig. 1 (cat. 9:16). Josep Lluís Sert and Luis Lacasa, *Pavilion of the Spanish Republic, Paris International Exhibition,* 1937, model made in 1987.
Fig. 2. Pavilion of the Spanish republic (cross-section plan), Paris International Exhibition, 1937, designed by Josep Lluís Sert and Luis Lacasa.
Fig. 3. Pavilion of the Spanish republic (exterior view), Paris International Exhibition, 1937, designed by Josep Lluís Sert and Luis Lacasa.

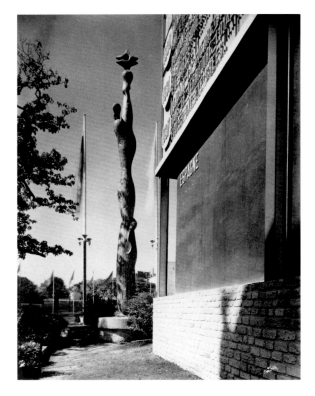

tion with its black, white, gray, and red coloring, the intelligent use of large photomontages on the façade, and the clarion call of Alberto Sánchez's great sculpture *The Spanish People Have a Path That Leads to a Star,* three meters of passion in cement colored with reddish and earth tones (fig. 4).[3]

Perhaps one of the greatest successes in the creation of the pavilion arose from the perfect unity of interest achieved by Lacasa and Sert, two architects who apparently held entirely different conceptions of architecture. Lacasa belonged to the group of protorationalist architects known as the Generación Madrileña del 25 (Madrid Generation of '25). His interest was focused on architecture at the service of society, giving primary attention to the problems of urban planning and multifamily dwellings. He had worked in the Technical Office of the city government in Dresden, and in 1923 spent time at the first Bauhaus school, becoming acquainted with expressionism and rationalism. Nevertheless, he did not incline toward either of these tendencies, accepting only the fundamental principles of rationalism, not its language. His goal was the creation of a nationalist architecture whose identifying characteristics might be clearly and recognizably drawn from traditional Spanish architecture. Thus he based his work on a fusion of rationalist plans and structures employing the most readily available materials, especially those with which architects as well as builders and workers were accustomed—that is, brick, granite, limestone, and the like.

available, but an authentic jewel of rationalist architecture; exceptional content in terms of the visual arts; an excellent exhibition of folk art and folklore that highlighted the wealth and vigor of the Spanish people's age-old culture, which at that moment was threatened; and, finally, complete socioeconomic and cultural information, based on photomontages that showed all of the republic's achievements in the areas of education, health, agriculture, industry, and artistic patrimony. The small Spanish pavilion turned out to be a scintillating advertising poster. Situated in the Jardin du Trocadéro together with the German and Soviet pavilions, it immediately attracted atten-

As for Sert, once his training in Barcelona was completed, he moved to Paris and worked in Le

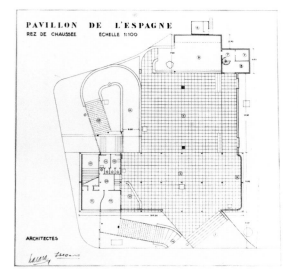

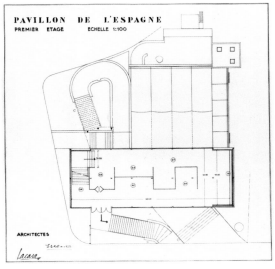

Fig. 4 (cat. 9:17). François Kollar, *Pavilion of the Spanish Republic (Exterior with Alberto Sánchez sculpture), Paris International Exhibition,* 1937.
Fig. 5. Pavilion of the Spanish republic (ground plan, first floor), Paris International Exhibition, 1937, designed by Josep Lluís Sert and Luis Lacasa.
Fig. 6. Pavilion of the Spanish republic (upper level), Paris International Exhibition, 1937, designed by Josep Lluís Sert and Luis Lacasa.

Corbusier's studio from 1929 to 1931. His idea of architecture, therefore, was unrestrained rationalism, and he enthusiastically dedicated himself to the dissemination of this concept upon his return to Barcelona. These efforts could not have occurred at a more opportune moment: The republic had just been established, and the new autonomous government of Catalonia, the Generalitat, welcomed avant-garde currents with interest, supporting the young architects who, led by Sert, formed the group GATEPAC (Association of Spanish Architects and Technicians for Progress in Contemporary Architecture) and started the important magazine *A.C.* in direct connection with the International Congresses of Modern Architecture, CIAM (see fig. 1, p. 400).

When Lacasa received his appointment as architect of the Paris pavilion, he made several designs for a building with a nationalist inspiration, somewhat removed from the languages of the avant-garde. But when he arrived in Paris and contacted Sert, he found that the latter had also made a preliminary plan based on a fully rationalist conception. What might at any other time have developed into an irreconcilable conflict was immediately resolved: Lacasa understood that since they were in France and time was short, Sert's proposal was more suited to the conditions in which the work had to be carried out. The use of brick turned out not to be viable, while Sert's prefabricated materials were easily obtained, which assured rapid construction.

It was clear to Lacasa that in this case the architecture was merely a support for an overarching idea—that is, the "container" had little to offer by itself if it was not simply and solely serving the needs of its contents. Thus the understanding between the two architects was immediate: Sert was master of the rationalist code, the technician who solved all problems and efficiently directed the project; Lacasa was the ideologue, who devoted himself to endowing the architectonic support with its political content. Sert concerned himself with the packaging, Lacasa with its contents.

The building consisted of an open ground floor, with a portico and a large canopied patio, along with two rectangular upper floors (figs. 5 and 6). Its design was adapted to the necessities of the exhibition, featuring a one-way tour route that was predetermined from the start: first, visitors were invited into the ground floor, from which they could enter the third floor by means of a ramp; from there, their path led to the second floor, and farther along, to the exit, by means of an exterior stairway. Thus after encountering the imposing Picasso sculptures *Head of a Woman*, 1931 (Musée Picasso, Antibes), and *Woman with Vase*, 1933 (destroyed), together with *The Montserrat*, 1936–37, by González (see fig. 1, p. 468), and the great totem by Alberto Sánchez, 1937 (see note 3), visitors came into the entrance portico, where they remained trapped in the magnetic field of Picasso's *Guernica*, 1937 (Museo Nacional Centro de Arte Reina Sofía, Madrid), and Calder's *Spanish Mercury From Almadén*, 1937 (fig. 7), through which mercury flowed in homage to the mercury mines of Almadén, an important source of wealth for the republic.[4]

The canopied patio was also at the ground level—an attractive element in and of itself, with a

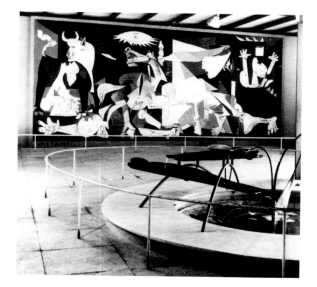

Fig. 7. Picasso's *Guernica* and Calder's *Spanish Mercury From Almadén* installed at the Spanish pavilion, Paris International Exhibition, 1937.

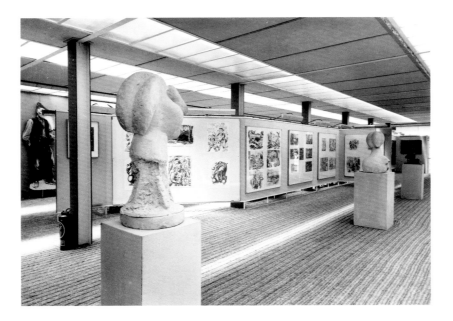

bar serving Spanish products and a stage for performances and film showings. The ramp ascended from the patio and, circling an ellipse, arrived at the third floor, which was divided into two halves. In the folk arts section, samples of crafts and regional Spanish dress were displayed, supported by modern photomontages and an attractive installation made by Alberto Sánchez for the ceramics collection. The visual arts area featured exhibitions of painting and sculpture, where works were rotated in order to show the greatest possible number. The majority of these works were paintings by prestigious artists sent from Spain and alluding to the civil war. There were three other extraordinary Picasso sculptures in the center of the hall, all from 1931: *Head of a Woman* (Musée Picasso, Antibes), *Bust of a Woman (Marie-Thérèse)* (Musée Picasso, Paris), and *Bather*, 1931 (Musée Picasso, Paris) (fig. 8).

Joan Miró's imposing mural *Catalan Peasant in Revolt*, also known as *The Reaper* (fig. 9), presided

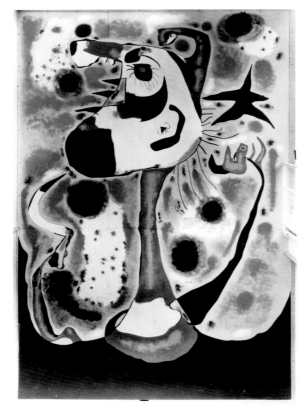

over the descent to the second floor. Occupying the entire wall and the height of both floors, this figure brandished an enormous scythe, pointing the way to the second floor.[5] There expressive and effective photomontages by Josep Renau on education, health, social security, agriculture, defense industries, mercury mining in Almadén, and the safeguarding of the country's artistic patrimony were on view.

General information on the country—its war and peace, its work, its economy, its culture—were all displayed in a comprehensive, highly illustrative

Fig. 8. Exhibition of visual art at the Spanish pavilion, Paris International Exhibition, 1937.
Fig. 9 (cat. 9:22). François Kollar, *"The Reaper" by Joan Miró, Spanish Pavilion*, 1937 (photograph of the mural).
Fig. 10. Catalan culture section in the Spanish pavilion, Paris International Exhibition, 1937.

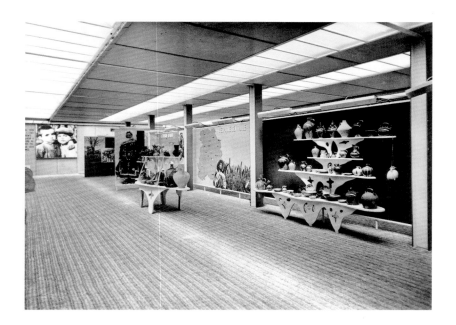

manner, arranged in a minimal but well-conceived space (figs. 10 and 11). The building was a perfect synthesis between rationalism and typical elements of Mediterranean folk architecture. In fact, this adaptation of vernacular architectures to a rationalist structure was one of the most interesting aspects of Le Corbusier's teachings.[6] The pavilion was constructed of materials supplied by new technologies and adaptable to the exigencies of construction speed and lightness. The structure was based on metallic H beams, exactly as supplied by the factory. The exterior wall coverings were made of glass and sheets of corrugated asbestos cement, while the interior wall coverings were Celotex panels assembled with visible screws, and the ceilings were covered with cement tiles—that, on the third floor, alternated with sheets of silvanite to achieve maximum illumination. The vault and elements of the stage were made of reinforced concrete, as were the stairways and the ramp; brick and stone were used only for the foundation and the walls on the ground floor. In addition, all these materials contributed to highlighting another aspect of major importance: color. The walls of the ground floor were whitewashed, except for a small area of ox-blood red. The foundation stones, the Celotex panels, and the asbestos cement were their original gray color, and the metallic beams were painted white, with the laterals in the same ox-blood red. The photomontages contributed their black-and-white tonalities, as did Picasso's *Guernica*. Miró's mural was dominated by the same

colors, and Calder's fountain allowed silver-colored mercury to fall on black-tarred iron supports and make a red disk turn in circles.

As for the echoes of Mediterranean architecture, the axial portion of the pavilion—that is, the large canopied patio—was a typically Hispanic element, accented by the use of terracotta floor tiles and the two large barred windows. The wooden latticework that enclosed the portico gave a hint of Moorish influence on the architecture of southern Spain, as did the use of plant fibers on the floors of the upper stories. Perhaps most ingenious, however, was the solution to the problem of ventilation and insulation from heat. This involved the design of the roof, where a double roof, or parasol, was installed, with a sizable air chamber between the actual roof and the ceiling of the third floor. A system of water sprinklers cooled the air in this space, which entered through louvers placed along the entire length of the tops of the façades; once cooled, the air was moved into the interior of the building by means of electric fans placed in the skylights. This system was invented by Sert, based on ancient formulas found in Moorish architecture and used in some settlements on the coasts of the Levant and the south of Spain.

Lacasa and Sert succeeded in bringing to completion one of the most interesting episodes in the history of Spanish architecture: a building in which avant-garde concepts, tradition, and propaganda were fused in a fully unified composition. At the same time, they were able to offer art of the highest

Fig. 11. Display of regions and cultures of Spain in the Spanish pavilion, Paris International Exhibition, 1937.

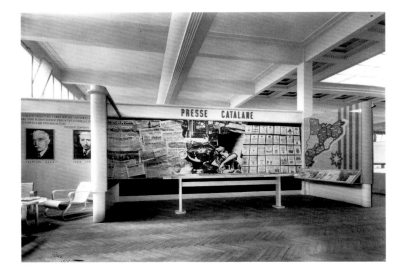

quality and an enormous quantity of information and sensory impressions, as well as a clear message of the need for understanding and aid, without resorting to flashy gimmicks or cries of distress.

The Generalitat made a distinguished contribution to the events that unfolded around the Spanish pavilion. The Catalan government sent its own commissioner, Ventura Gassol, and organized a Catalan committee at the fair; Josep Lluís Sert and Domènec Escorsa i Badia, who worked with him, were members. Antoni Bonet, Sert's assistant, and Josep Torres Clavé, who designed the pavilion's furnishings, were also Catalan architects. The Catalan fabrics stand, located in the International pavilion, and the Catalan press stand, assembled by Sert in the General Press pavilion, were also distinguished (fig. 12). In the latter stand ample space was given to a counter with publications that could be leafed through. There were also several photomontage panels that dis-

played the titles of all the publications produced in Catalonia by the Agrupació Professional de Periodistes (Professional Association of Journalists), a graph of the growth of press runs since 1920, and a map showing the distribution of newspapers published in Barcelona and the rest of Catalonia, as well as the efforts that were made to deliver them to the battlefront. Special editions of periodicals that were already historic—such as the magazines *Quatre Gats*, *Picarol*, and *L'Esquella de la Torratxa*—were exhibited in several display cabinets.

Without question, however, the most outstanding aspect of the Generalitat's involvement centered around the art exhibition directed by Joaquim Folch i Torres—a display Sert helped install—showing the magnificent holdings of the Museu d'Art de Catalunya, Barcelona.[7] This collection, of inestimable value, had been transported from Barcelona to Paris many months earlier to safeguard the Catalan artis-

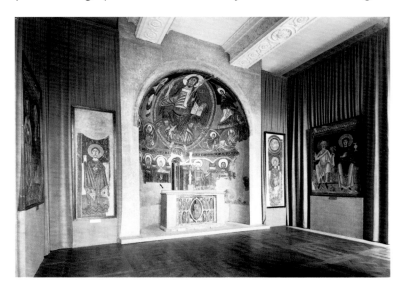

Fig. 12. Catalan press stand in the General Press pavilion, Paris International Exhibition, 1937.
Fig. 13. Medieval Catalan art exhibition, Château de Maisons-Lafitte, during the Paris International Exhibition, 1937.

tic treasury from the ravages of war. With it, an exhibition of far-reaching importance had been held at the Jeu de Paume in April 1937; it was later transferred to the Château de Maisons-Laffite to coincide with the international exhibition. The exhibit, entitled *L'Art Catalan du IXème au XVème siècle* (Catalan Art of the Ninth through Fifteenth Centuries), was extremely rich and spectacular, with large fresco murals, altarpieces, sculptures, codices, and other liturgical treasures. The Ministère de l'Éducation Nationale–Musées Nationaux de France printed the exhibition posters and an important series of publications, among them a folder with loose plates of the best and most representative paintings and a pamphlet, "Le Gouvernement de la Catalogne expose a Paris cinq siècles d'Art Catalan" (The Government of Catalonia Exhibits Five Centuries of Catalan Art in Paris); its cover showed *Saint George and the Princess, 1459–75*, by Jaume Huguet (Museu Nacional d'Art de Catalunya, Barcelona). By way of a catalogue, *L'Art de la Catalogne: De la seconde moitié du neuvième siècle a la fin du quinzième siècle* (Catalan Art from the Ninth to the Fifteenth Centuries) was also published—in French, English, and German—by such reputable publishing houses as Cahiers d'Art of Paris, Anton Schroll & Co. of Vienna, and W. Heinemann of London and Toronto. The catalogue texts were by writers of great prestige: Christian Zervos, Ferran Soldevila, Josep M. Gudiol, and Roland Penrose.

These publications were justified by the quality of the treasures of medieval Catalan art, chosen from among the best works in the Museu d'Art de Catalunya, together with a selection from the Museu Episcopal de Vic, the Museu Diocesà de la Seu d'Urgell, and the Girona Cathedral. Gathered together in the exhibition were the famous Romanesque murals from the apses of the churches of Sant Climent and Santa Maria de Taüll (fig. 13); the *Stoning of St. Stephen* by the Master of Boí; frescoes by the Master of Pedret from the monastery of Sant Pere del Burgal; façade sculptures by the Master of Durro from the church of Sant Quirze i Santa Julita (all now in the collection of the Museu Nacional d'Art de Catalunya); and façade sculptures from the church of San Martí (now in the collection of the Museu Episcopal de Vic). Embroidered tapestries were also exhibited, and among the Romanesque sculptures were several versions of Majesties, Descents, and carvings of the Virgin.

The magic of the Spanish pavilion at the 1937 International Exhibition in Paris, as well as all the events that surrounded this exhilarating chapter in Spanish history, cannot be easily summarized in a few short pages—still less so considering that its history did not come to an end with the closing of the fair.[8] From that moment, the odyssey of the people and works of art that were part of the exhibition began—their exile, disappearance, and long-delayed return to Iberia. A few have returned—including, among others, *Guernica* (but not its creator)—while others were lost forever. Nevertheless, what the little pavilion meant to the Spanish people, and to all those who loved it, will always survive in memories and written recollections.

1. The painter Jose María Uzelai worked in an interesting style of magical realism. In 1936 he was appointed director of fine arts of the Basque government. Ventura Gassol, a politician and writer, was culture counselor for the Generalitat of Catalonia's first government.

2. Excerpt from the speech given by Luis Araquistáin at the ceremony for the laying of the first stone of the Spanish pavilion, 27 February 1937. General Archives of the Administración de Alcalá de Henares, Foreign Section, File 4491.

3. The great cement casting of Sanchez's sculpture *The Spanish People Have a Path That Leads to a Star* disappeared during its transfer to Spain at the end of the fair. Only the original plaster model—now in the Museo Nacional Centro de Arte Reina Sofía in Madrid—has been recovered; since 2001 a replica of the original presides over the museum's entrance.

4. Of Picasso's *Woman with Vase* original plaster (private collection), only the arm holding the vase is preserved. One bronze cast stands on Picasso's grave at the Château de Vauvernagues, France; the second is at the Museo Nacional Centro de Arte Reina Sofía, Madrid. A replica of Calder's *Mercury Fountain* is on display at the Fundació Joan Miró, Barcelona.

5. The magnificent mural, made on six Celotex panels, also disappeared after the exhibition was disassembled. Miró spent many years trying to recover it.

6. The same principle could also be observed in the excellent Japanese pavilion built by Junzo Sakakura, who was also a disciple of Le Corbusier.

7. Joaquim Folch i Torres was a painter, writer, historian, and art critic. Between 1920 and 1939, he was the director of the Museu d'Art de Catalunya and secretary of the Council of Museums. His participation was crucial to the preservation of Catalan Romanesque mural paintings: he directed the delicate work of transferring the frescoes from small churches in the Pyrenees, where they ran a serious risk of pillaging and deterioration, to the Palau Nacional on Montjuïc, which became the Museu Nacional d'Art de Catalunya.

8. An exhaustive description of Spanish participation in the Spanish pavilion may be found in Josefina Alix, *Pabellón Español. Exposición Internacional de París, 1937*, exh. cat. (Madrid: Ministerio de Cultura/Centro de Arte Reina Sofía, 1987), as well as in Catherine Blanton Freedberg, *The Spanish Pavilion at the Paris World's Fair* (New York: Garland, 1986).

Translated by Vajra Kilgour.

# Picasso's Dream and Lie of Franco

CARMEN BELEN LORD

[C]ries of children cries of women cries of birds cries of flowers cries of timbers and of stones
cries of bricks cries of furniture of beds of chairs of curtains of pots of cats and of papers
cries of odors which claw at one another cries of smoke pricking the shoulder of the cries which stew in
the cauldron and of the rain of birds which inundates the sea which gnaws the bone and breaks its teeth
biting the cotton wool which the sun mops up from the plate which the purse and the
pocket hide in the print which the foot leaves in the rock.
—Pablo Picasso, "Dream and Lie of Franco," 1937

Picasso created much of *Dream and Lie of Franco* (two prints and accompanying poem) between 8 and 9 January 1937 (figs. 1 and 2). At almost the same time, he received a commission from the Second Spanish Republic for the centerpiece of its projected pavilion for the Paris International Exhibition, a mural over whose subject and format he would anguish until its resolution in May and June, with the genesis of *Guernica* (see fig. 2, p. 461). The pavilion, designed by Josep Lluís Sert and Luis Lacasa, constituted a crucial propaganda vehicle for the Spanish republic and its effort to generate international support for its government and antifascist military campaign against General Francisco Franco. The Catalan artist Joan Miró, along with his friend, the American sculptor Alexander Calder, were among other prominent artists who contributed their work to the republican cause at the exhibition. After the opening of the Spanish pavilion in July, a month after the official inauguration of the fair, copies of Picasso's *Dream and Lie of Franco*, along with a facsimile of the poem and English and French translations, were sold to visitors for the financial benefit of the republic. Because Picasso's first idea for his large mural for the pavilion had been nonpolitical, the artist initially may have intended to express unconditional solidarity with the republic vis à vis his print *Dream and Lie*.[1] It remains among the most topically political works of Picasso's career, and compelling evidence of his despondency over the war in Spain, as suggested by his vehement reading of the poem for the committee for the Spanish pavilion during their initial meeting regarding his commission.[2]

The two prints of the *Dream and Lie of Franco* were made using a combined etching and sugar-lift aquatint technique. Picasso divided each plate into nine rectangular segments, resulting in 18 separate vignettes, which, for the purpose of the exhibition, were to be sectioned into postcards,[3] although the two prints were ultimately sold uncut, with Picasso's poem and a cover.[4] As suggested by the reversal of the dates written across the upper band of the first print, and upper and lower bands of the second print, the printing process reversed the images and their order as originally conceived by the artist, so that they now read from right to left. As is quickly apparent, they follow neither a chronological nor a narrative progression from frame to frame, but rather juxtapose layered elements in a surrealist manner that intuitively and emotively evokes causes and effects of the Spanish civil war.

The first print features the monstrously deformed armored figure of Franco galloping in manic assault upon the land, wearing a crown, miter, or other ceremonial headgear and variously brandishing swords, spears, and religious banners. Grotesquely mounted upon a horse, a pig, or colossal phallus, Franco's strident figure is easily recognizable by his absurd small mustache and fixed grin, as he attacks a classical bust or bull, prays, or minces across the landscape in *maja* costume. The viciously satirical, cartoon-like renderings of the first print continue in three segments of the second print, two scenes of which intermingle allegorical references to the Minotaur, in continuation of an iconography that deeply concerned Picasso in the years preceding this

work. The remaining vignettes of the second print, completed only on 7 June, reflect a striking change of style and tone, and evoke Franco's civilian victims in a deeply poignant and moving manner. The fear, agony, and death of men, women, children, and animals caught in the path of Franco's campaign is vividly suggested by a lyrical still figure lying in a field, a man and horse intertwined in a peaceful lifeless embrace, as well as women and children under attack. The last four frames link directly to the iconography of *Guernica* in their suggestion of incendiary bombing, burning homes, and mothers with dead children. The distribution of *Dream and Lie of Franco* in 1937, in the charged atmosphere of the Spanish

cause of this awareness he referenced typically Spanish iconography in *Dream and Lie*. In the mounted figure of Franco, Picasso eerily evokes the iconography of traditional Spanish art, such as Diego de Velázquez's royal portraits and the neoclassical public monuments of Madrid. The work is also linked to Francisco Goya's wartime print series, "Disasters of War," with which it shares an austere and gritty topicality expressed in dramatic black and white, as well as pointed allusion to foreign occupation of Spain. In addition to alluding to familiar national fine art, Picasso drew upon Spanish popular art for his *Dream and Lie of Franco,* since he appears also to have

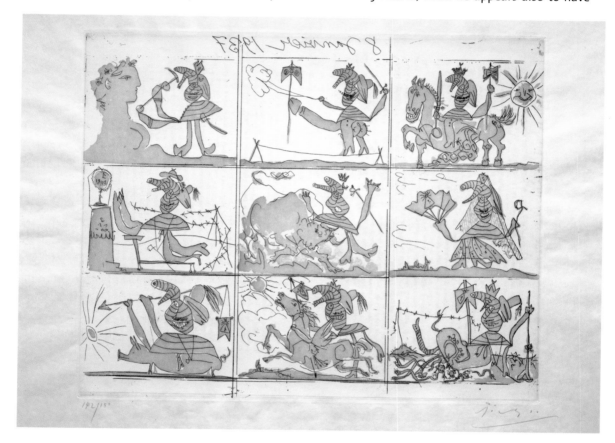

pavilion dominated by Picasso's monumental mural, underscored this complementary relationship between the printed work and painting.

Despite its apparently experimental format and direct reference to unfolding contemporary events, Picasso's *Dream and Lie of Franco* is firmly anchored in Spanish pictorial tradition. As honorary director of the Museo del Prado under the beleaguered republic, Picasso would be especially sensitive to the canon of Spanish art at this time. Perhaps be-

been inspired by traditional prints known as *aucas* or *auques* (Catalan) or *aleluyas* (Castilian). These prints traditionally comprise a sequence of 48 small framed narrative images accompanied by a verse or phrase, which together recount a small history or biography on a single sheet of paper; they evolved from a 17th-century game as well as printed images distributed during religious festivals.[5] Time-honored literary aucas recounting the history of Don Quixote, dressed in battle gear, mounted, and engaged in de-

Fig. 1 (cat. 9:28). Pablo Picasso, *Dream and Lie of Franco,* 1937.

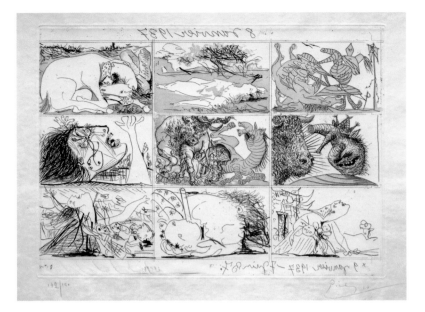

lusional combat, may have been one of the sources that inspired Picasso's use of the format for his savagely critical view of Franco. Prolifically popular in the 19th century, aucas continued in widespread use in Spain in the 20th century. *L'auca del senyor Esteve,* the ironic account of a bourgeois factory owner from birth to death, based upon a book by the Catalan modernista Santiago Rusiñol and illustrated by Ramon Casas, was part of the popular lexicon in Barcelona and would certainly have been familiar to Picasso. Federico García Lorca used an aleluya as a literary source for his sophisticated comedy *Amor de Don Perlimplín con Belisa en su jardín. Aleluya erótica en cuatro versos y un prólogo* (*Love of Don Perlimpín with Belisa in Their Garden. Erotic Aleluya in Four Verses and a Prologue*), which was produced in Madrid in 1933.[6] The auca-like division of images continued in active use during the war in Spain. Josep Obiols's 1937 composition *L'Auca del noi català, antifeixista i humà* (The Auca of the antifascist and humanitarian Catalan boy), for example, was employed as a didactic tool in Catalan schools during the Spanish civil war.

While the auca was traditionally employed to render a complex history more simply, Picasso inverts the popular format in *Dream and Lie* to suggest viscerally multiple faces of the war in Spain. At the same time he subverts the iconography of traditional Spanish art history to expose the presumptuousness of Franco, his duplicity and delusional character, and its calamitous national consequences. In Picasso's two prints, the parallel presentation of multiple concurrent events upon the same flattened pictorial plane results in a deliberate confusion of impressions, suggesting the unrelenting complexity and tension of contemporary history. The cascading, fractured, urgent imagery of Picasso's accompanying poetic prose meditation upon the *Dream and Lie of Franco* interlaces an audial, linguistic orchestration with the printed figures, enhancing their dark tragedy through their combined play upon the multiple senses.[7] In *Dream and Lie of Franco,* Picasso relied upon visual codes that closely referenced Spanish culture to create a powerful representation of fascism in his work, and by contrast, a compelling, deeply felt evocation of authentic enduring Spain.

1. Elizabeth Cowling, *Picasso: Style and Meaning* (New York: Phaidon Press, 2002), 575.

2. On Sert's memory of Picasso's reading and elucidation of the prints for the delegation, see ibid. The composition of the poem coincided with nationalist preparations for the successful siege of Picasso's native Málaga by Italian troops.

3. Herschel B. Chipp, *Picasso's Guernica: History, Transformations, Meanings* (Berkeley: University of California Press, 1988), 66.

4. Roland Penrose, *Picasso: His Life and Work* (New York: Harper & Brothers, 1958), 267.

5. Montserrat Galí Boadella, *Imatges de la memòria: El gravat popular a la Catalunya de la primera meitat del segle XIX* (Barcelona: Alta Fulla Editorial, 1999), 87.

6. See Helen Grant, "Un 'aleluya' erotica de Federico García Lorca y las aleluyas populares del siglo XIX," in *Actas del Primer Congreso Internacional de Hispanistas* (Oxford: Dolphin Book Co., 1964).

7. Picasso's recent poetry was known to the public through André Breton's publication of his 1935–36 work in *Cahiers d'Art* (May 1936). See Marie-Laure Bernadac et al., *The Picasso Museum, Paris. Paintings, Papiers Collés, Picture Reliefs, Sculptures, and Ceramics* (New York: Harry N. Abrams, 1986), 27.

Fig. 2 (cat. 9:29). Pablo Picasso, *Dream and Lie of Franco,* 1937.

# Picasso: Guernica and His Reaction to the Civil War

*MAGDALENA DABROWSKI*

The main feature of the exhibition presented in the Spanish pavilion at the Paris International Exhibition of Art and Technology in Modern Life, inaugurated on 12 July 1937, was a large, somber, monochromatic mural by Pablo Picasso, *Guernica* (figs. 1 and 2). This oversized canvas (measuring 349.3 × 776.6 cm), which commanded the attention of visitors from the moment they entered the space, represented the artist's dramatic response to the civil war devastating his native country.

The republican government in Madrid invited Picasso, in January 1937 (some seven months after the outbreak of the Spanish civil war), to become a major contributor to the exhibition at the pavilion, scheduled to open in June of that year. The intention behind this choice was obvious. Picasso's antiwar and anti-Franco sentiments, as well as his support for the republican cause, were widely known, and in recognition of his artistic achievement as a giant of modernism, the republican government named him, in absentia, director of the Prado Museum. Now, the multinational event presented the war-torn country with an opportunity to gain broader exposure and support for the republican cause and to emphasize national pride with the most advanced art created by the most widely recognized artist—a native Spaniard, even if he was living in Paris. Picasso's presence would clearly focus the world's attention on Spain, and the large mural promised by an artist renowned for his canon-breaking stylistic innovations would attract—even if by controversy—great numbers of the visitors to the fair. Through the architecture of the pavilion and the advanced art exhibited in it, Spain would project an image of progress and of belonging to the intellectual avant-garde. Picasso's participation was therefore strongly advocated by Josep Lluís Sert, one of the architects of the pavilion, and the writer Juan Larrea, then in charge of the Spanish Information Office in Paris.[1]

Placed on the largest wall, Picasso's painting constituted the most shocking and accusatory statement on the reality of war. It was accompanied in the pavilion by Joan Miró's mural *The Reaper* (see fig. 9, p. 454), Alexander Calder's fountain *Spanish Mercury from Almadén* (see fig. 7, p. 453) in the center of the foyer, and an enormous photograph of the Spanish poet Federico García Lorca (who had been executed

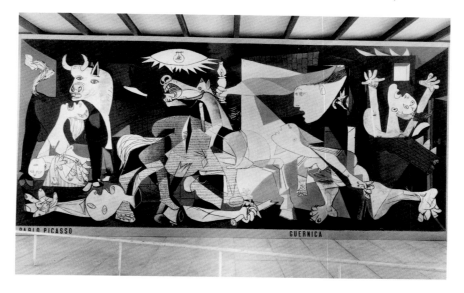

Fig. 1 (cat. 9:18). François Kollar, *Spanish Pavilion, Courtyard with View of "Guernica,"* 1937.
Fig. 2 (cat. 9:19). François Kollar, *"Guernica" Installed at the Pavilion of the Spanish Republic, Paris International Exposition,* 1937.

the previous year by Falangists in Granada) on the opposite wall.

Initially, Picasso intended the work not as a political gesture, but rather as a more neutral and personal depiction of an artist and his model in a studio scene, executed on a mural scale.[2] He rejected that theme after hearing the news of one of the most shattering events of the civil war, the German saturation bombing of the ancient Basque town of Guernica on 26 April 1937. The bombing began on a Monday afternoon, a traditional market day, and lasted three hours, destroying the town and decimating its population. The world was stunned and incensed at the brutality and magnitude of this disastrous event. For the next four days newspapers in Paris, including *L'Humanité* and *Ce Soir,* published accounts of the bombing accompanied by photographs of death and destruction.[3] Picasso registered his outrage and despair in the great mural for the Spanish pavilion, naming it for the devastated town.[4] To this day, this striking composition stands as a powerful, universal symbol of the brutality, horror, and dehumanization of war. The monochromatic palette of grays and whites enhances the impact of the large canvas, and viewers' reactions are triggered by the cumulative effect of the strangely distorted imagery and the mood of tragedy it so dramatically expresses. The symbolism remains as poignant now as it was then, and its universal message retains the same highly expressive power.

Several motifs appear and reappear, in continually changing form, in Picasso's preparatory sketches for *Guernica,* some quick and cursory, others more elaborate and finished. The constants are the horse, the bull, and the woman leaning precariously out of a window holding a candle in her outstretched hand, as if trying to shed light on the ghastly scene below. The motifs were developed in some 67 numbered and dated studies in pencil, pastel, and/or crayon that range from rapid sketches of individual figures to more complex compositions combining several motifs. Most of the drawings were done on paper, the rest on canvas. The final painting—a vast composition almost 26 feet long—was created in just three weeks, between 11 May and 4 June. It was installed in the pavilion in mid June, less than a month before it was officially opened in July.[5]

The completed composition presents a terrifying scene of destruction. The central section depicts a mortally wounded horse straddling a fallen warrior who lies with both arms extended out, holding a broken sword in his right hand. A woman with a candle leans in from the upper right and another, below her, flees the burning city. The entire scene is bathed in an artificial light from a bare light bulb hanging above the horse's head. At left, a woman holding a dead child shrieks in terror near the head of the bull that is trampling the warrior. At right, another frightened woman attempts to escape from a burning house; above her head are flames and a small window. The contorted, tightly packed space accentuates the shocking and morbid aspects of the tragic scene.

The painting's extremely complex iconography has been the subject of innumerable scholarly studies and interpretations. Picasso himself commented on the symbolism of the work, in particular on the meaning of two of the three central motifs: the bull and the horse, in an interview in 1945: "The bull is not fascism, but it is brutality and darkness. . . . The horse represents the people, . . . the Guernica mural is symbolic, . . . allegoric. That's the reason I used the horse, the bull and so on. The mural is for definitive expression and solution of a problem and that is why I used symbolism."[6]

Yet this was not the first time Picasso had used those symbols. In fact, he subsumed into *Guernica* motifs from several of his earlier works, such as his etchings *Minotaure, Minotauromachia,* and *Dream and Lie of Franco,* and his small canvas of the *Crucifixion* (Musée Picasso, Paris), assigning them new meaning by association with this unspeakable calamity. The content of the painting engaged Picasso on several levels: psychological, human, historical, art historical, and religious. His response was felt to an equal degree in personal and specific terms (as a Spaniard, an individual touched directly by the tragedy of the civil war) and in a universal sense (as a human being appalled at the barbarism of the human race). His complicated personal life at that moment contributed an additional layer of sadness.

In creating his apocalyptic image of the horrors of war—the senseless slaughter of the civilian population and the burning of the ancient town—Picasso pre-

sented us with his own, modern version of the biblical theme of the Massacre of the Innocents. He also looked to the pictorial precedents in the art of his compatriot Francisco de Goya, particularly his famous series of etchings "Disasters of War" and his epic historical canvas *Third of May, 1808,* 1814 (Museo del Prado, Madrid), for inspiration and guidance, as it were, in how to depict national tragedy and the cataclysm of war.[7] Additionally, his symbols seem to relate to the entire lineage of historical paintings of disasters such as those by Rubens or Poussin or Theodore Gericault's *Raft of the Medusa,* 1919 (Musée du Louvre, Paris). Stylistically, Picasso's figural style and personal vocabulary of distorted forms recall neoclassical history paintings such as Ingres's *Jupiter and Thetis,* 1811 (Musée Granet, Aix-en-Provence). Yet Picasso's invented imagery of horror and the allegorical import of the symbols he used in *Guernica* appear deliberately to subvert the conceptions and iconography of the Christian, specifically Catholic, faith and traditional Spanish religious painting of earlier centuries, especially works by El Greco. Themes Picasso knew well from his Catholic upbringing (and had even depicted in his youth), such as the Annunciation, Crucifixion, Burial, Lamentation of Christ, and Assumption of the Virgin, or Holy Spirit (represented as a heavenly light or a bird/dove image radiating a spiritual aura from a cloud high in the sky), come into play in the narrative of *Guernica.*[8] The emblems of traditional Christian iconography are inverted and instead embody the powers of evil. Through this conceit the artist emphatically conveyed his personal abhorrence of war, human pain, and death, making his mural a timeless and universal icon of senseless destruction and barbarism.

In its physical format (although the format was in part dictated by the requirements of the interior of the pavilion) and its compositional structure, the painting brings to mind the cornerstone of Christian religious painting: an altarpiece triptych. It has been frequently pointed out that Matthias Grünewald's Isenheim Altarpiece, c. 1515 (Museum Unterlinden, Colmar), was Picasso's reference here. Following that logic, the central "panel" of *Guernica* highlights the expiring horse, the electric light bulb above, and the woman's head; the left "wing" shows the bull claiming the victims of violence below; and the right side presents two stricken female figures.

The evolution of these various motifs can be studied in the numerous preparatory works. The sheet of 8 May (fig. 3) includes one of several studies of the horse that in the final canvas dominates the center of the composition. It also includes an early pencil sketch of the mother with a dead child that, in a modified form, appears in the left section of the composition. The horse, rendered with energetic and decisive pencil strokes, falls to the ground with its head curled down as it gnashes its bared teeth and supports itself on its front legs, anticipating its approaching agony. Remarkably, the movement of its body is suggested by the play of light and shade. In Picasso's sketches over the next three weeks, this symbol of the suffering people of Spain would undergo numerous transformations until it arrived at its final incarnation: the head turned from left to right and raised in a moment of indescribable pain, teeth parted wide and tongue protruding like a dagger. Allegorically, the horse alludes to the crucifixion

Fig. 3 (cat. 9:30). Pablo Picasso, *Horse and Mother with Dead Child (Study for "Guernica"),* 1937.

of the victimized people, whose suffering is compared to that of Christ.

In the upper right section of the same sheet, a mother holds her dead child in a gesture of desperation. The distortions of her body, the fluid lines of which ironically recall some of Picasso's earlier and more peaceful depictions of his mistress (and mother of his first daughter), Marie-Thérèse Walter, enhance the motion of her head, raised to heaven in a scream of pain. The intertwined shapes of mother and child become an expression of unmitigated grief and terror. The strained energy and tension that emanate from the mother's figure endow the small-size drawing with monumental expressive power.

The motif of the young mother with her dead child is the subject of another study, dated 10 May (fig. 4), a spectacular depiction of a desperate figure climbing a ladder in a futile attempt to escape the calamity below. It is executed in pencil and colored crayon on paper, in brilliant magenta and orangey yellow, which contrast dramatically with the whiteness of the bodies and the mother's flowing black robe. The yellow section could suggest the blaze of the burning buildings or it could be the shining sun, only accentuating the drama of the figures. There is a tremendous tension between the gesture of the mother's outstretched arm and her arched neck (reminiscent of Thetis in Ingres's *Jupiter and Thetis*) and the limp body of the child, a heavy but precious burden. The tragedy emanating from the composition is vivid, palpable, and overwhelming.

Even more harrowing is a work drawn and painted on canvas on 22 July, a depiction of a mother and child whose large heads are placed against an empty wall behind them. In Picasso's further contemplation on the theme, the mother's head is shown both in profile and from above, mouth wide open in a scream of pain, tongue protruding like a dagger, a device he used frequently. The two bright dots of color marking the woman's cheeks—in magenta crayon, applied like the rouge women use to emphasize their cheekbones—strengthen the horrific aspect of the image. The blue and green of her hair and the bright orange of her dress clash with the tension of the bodies. The child, only its large head clearly visible, seems almost crushed in the arms of the mother trying to save it.

Fig. 4 (cat. 9:31). Pablo Picasso, *Woman with Dead Child on a Ladder*, 1937.
Fig. 5. *Massacre of the Innocents*, 1611, by Guido Reni.

The mother relives in modern terms the tragedy of her predecessor in a painting by Guido Reni, *Massacre of the Innocents,* 1611 (fig. 5). She suffers the ultimate agony caused by events whose source is out of her control. The evil itself is invisible and anonymous, but its results are havoc and human disaster.

One of Picasso's later studies of the motif of the mother, executed on canvas on 2 July, depicts a woman crying. Here the facial distortions and stylizations are used in a more radical manner. The horse-like open mouth, with large teeth and pointed tongue, is juxtaposed with the strong linear elements of the "tracks" of tears and clownish eyes and eyelashes. The effect is one of horror. The motif of a crying head appeared later in Picasso's work in the so-called postscripts to *Guernica,* painted between 1938 and 1944.

Analyzing the transmutations of Picasso's ideas in his studies for and after *Guernica* allows us to ap-

preciate the enormous power of this awe-inspiring canvas. The gripping imagery, grisaille palette, and distortions of forms and space inspire viewers to decipher for themselves the multivalent symbolism.

The radicalization and heightened emotional expression of Picasso's imagery engendered by the creation of *Guernica* continued in his works of subsequent months. In the dangerously unstable and increasingly threatening political climate, not only in Spain but in Europe in general, and with his personal situation becoming more complicated, his preoccupation with tragedy resurfaced in a series of prints and paintings on the subject of the weeping woman (fig. 6). At that time, two women served as Picasso's models. One, his young mistress Marie-Thérèse Walter—a symbol of serenity, calm, and peace who was being shattered by anxiety both from the war and from her relationship with the artist—became the image

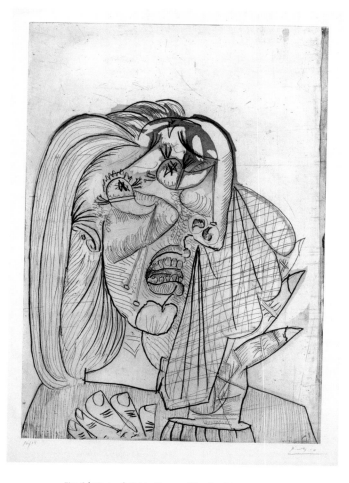

Fig. 6 (cat. 9:32). Pablo Picasso, *Weeping Woman,* 1937.

of screaming mother with child. The other, his more mature new companion the photographer Dora Maar, is portrayed in the numerous so-called post-scripts to *Guernica,* the series of paintings, drawing, and prints entitled "Weeping Woman." Whatever the medium, her stylized, distorted features convey anxiety, emotional distress, and tension. The images are not only depictions of a specific person but universal symbols of a generic grieving woman. Once again, Picasso used his subject to convey his mood and register his protest. The weeping woman symbolizes a terrified Spanish peasant, a lamenting, inconsolable mother overcome by the horrible events she has witnessed. She is an ordinary suffering human being, a paradigmatic victim of the bombing of Guernica and the fatalities of war.

Picasso's most striking and evocative image of a woman crying is the brightly colored *Weeping Woman* of 26 October. It shows a close-up of a woman's head—that of Dora Maar—depicted in brilliant primary colors (yellow, green, red, and blue) that contrast dramatically with the blackness of her hair and dress. To emphasize the woman's unbearable suffering Picasso used cubist distortions of form to define her features. He circled her large dark eyes with black contours and thick straight lashes to convey her distress. With her half-open mouth she bites on a handkerchief (a classic attribute of grief), held in her left hand, as if trying to stifle the sounds of her grief. Her softly combed glossy black hair contrasts jarringly with her contorted face. The painting, full of pathos, emotional anguish, and agony, is the tour-de-force of Picasso's creativity in the immediate post-*Guernica* period.

From November and December 1937, Picasso was haunted by feelings of anxiety and distress and not very prolific. Among the few paintings he executed during that period is a small wood panel of a screaming woman, *Suppliant Woman,* dated 18 December 1937 (fig. 7). The peculiarly squashed full-length figure of a black-clad woman stands in front of a wall or window, her head—covered by a deep magenta mantilla—turned toward heaven, her mouth wide open as if in a prolonged scream, her bizarrely drawn, grotesque hands raised in a gesture of despair. One of her breasts is entirely exposed, as if parts of her dress and white collar had been torn off in a fight or rape. She is grief-stricken, another anonymous yet universal victim of horror and torture, a symbol of an ongoing struggle and a premonition of the terrible events to come, in Europe as much as within Spain: the onset of World War II in September 1939.

This small yet remarkably powerful image creates a closure—both emotionally and artistically—to Picasso's exhausting year of anxiety and preoccupation with the fate of his native land. To quote Gertrude Stein, "It was not the events themselves that were happening in Spain which awoke Picasso but the fact that they were happening in Spain, he had lost Spain and here was Spain not lost, she existed, the existence of Spain awakened Picasso."[9]

The war and Picasso's emotional response to it continued to influence his work until the end of World War II and the liberation of France in 1945, leaving to posterity a number of masterpieces, such as *The Charnel House,* 1944–45 (Museum of Modern Art, New York), that attest to his continuing engagement with the political situation in the world and in Spain. Yet, because of his reaction to the horrors inflicted upon Spain by Franco, explicit in *Guernica* and its numerous postscripts, Picasso would never return.

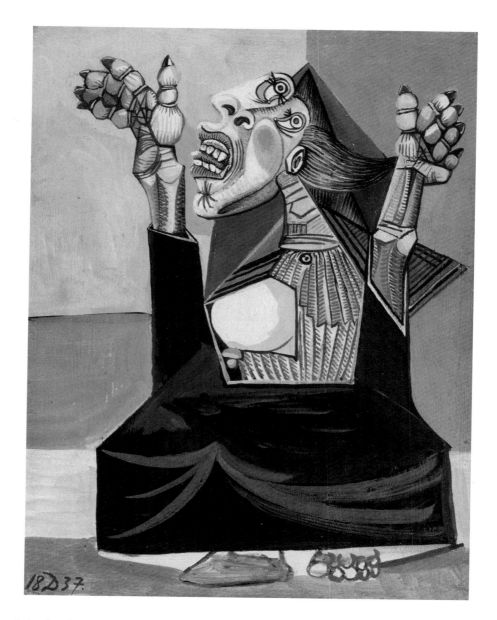

1. See the essay by Josefina Alix in this section of the catalogue.

2. The subject of the artist and his model preoccupied Picasso throughout his lifetime, but he was particularly focused on it while working on his Vollard etchings of the 1930s, and when his model was his mistress Marie-Thérèse Walter, his junior by some 21 years.

3. The history of Guernica is discussed in depth by Juan Larrea and Alfred H. Barr Jr. in *Guernica: Pablo Picasso* (New York: Curt Valentin, 1947); Roland Penrose, *Picasso: His Life and Work* (New York: Shocken, 1962), 268–90; Francisco Calvo Serraller, *El Guernica de Picasso* (Madrid: Museo Nacional Centro de Arte Reina Sofía, 1999); and most recently in *Picasso: War & Peace,* exh. cat. (Barcelona: Museu Picasso, 2004), 13–51.

4. Following its exhibition in Paris, the painting traveled on a lengthy tour of Europe and different venues in the United States. The painting was finally deposited (along with all its studies) on extended loan to the Museum of Modern Art in New York as a result of the efforts of then-director Alfred H. Barr Jr. It remained there until 1981, when according to the artist's wishes (expressed before his death), the painting was returned to Spain, several years after the death of Francisco Franco and once Spain became a democracy again.

5. The creation of *Guernica* (which occurred in Picasso's large, newly rented studio at 7, rue des Grands-Augustins in the Latin Quarter in Paris) was recorded by his companion, photographer Dora Maar, in a series of photographs now preserved in the archives of the Museo Nacional Centro de Arte Reina Sofía in Madrid.

6. Interview with Jerome Seckler, "Picasso Explains," *New Masses* (13 March 1945); also quoted in part in Penrose, *Picasso,* 272 n. 2.

7. In fact, in 1935 the Bibliothèque Nationale in Paris presented an exhibition of Goya's work, which included the complete portfolio of "Disasters of War," which would have given Picasso an additional opportunity to view these prints. An extended discussion of Goya's influence as well as other Christian and secular sources of Picasso's imagery in *Guernica* are discussed in Robert Rosenblum's essay "Picasso's Disasters of War: The Art of Blasphemy," in *Picasso: War & Peace,* 39–53.

8. Rosenblum discusses very convincingly Picasso's sources for his imagery based on examples such as El Greco's *Assumption of the Virgin,* 1577 (Art Institute of Chicago), Goya's *Burial of Christ,* c. 1770–72 (Museo Lazaro Galdiano, Madrid), as well as many other examples of Picasso's "blasphemous" adaptation of traditional religious iconography. See ibid., 42–52.

9. Gertrude Stein, *Picasso* (Paris: Librairie Floury, 1938); also quoted in Judi Freeman, *Picasso and the Weeping Women,* exh. cat. (Los Angeles: Los Angeles County Museum of Art, 1994), 121.

Fig. 7 (cat. 9:37). Pablo Picasso, *Suppliant Woman,* 1937.

# González: Montserrat and the
# Symbolism of the Civil War

*M A G D A L E N A  D A B R O W S K I*

The Spanish pavilion at the International Exhibition of Art and Technology in Modern Life (Paris, 1937) became a symbol of patriotic republican opposition to the nationalist forces of Francisco Franco. When visitors mounted the main steps to the pavilion, and before reaching the point of seeing the emotionally charged mural of *Guernica,* 1937 (see fig. 2, p. 461), they were confronted by a life-size sculpture by Julio González (fig. 1). The naturalistically rendered work depicts the figure of a peasant woman wearing a work dress with a kerchief on her head, holding a sickle in her right hand, and carrying a baby over her left shoulder. Executed in iron, González's favored material, the solid figure stood upright, looking ahead into space, face frozen in her expression of defiance and fear. In posture and attitude, she was the image of human dignity, a symbol of the people of her native Catalan soil. She also represented a mother figure ready to fight to protect her child from danger. In her almost palpable presence and silent if obstinate corporeality, her right foot ready to take a step forward, she embodied the opposition of the Catalan people—as well as the artist himself—to the forces that threatened republican Spain.

The genesis of *The Montserrat* preceded the formal invitation González received from the Spanish republican government, in a letter of 10 April 1937, asking him to present one of his sculptures in the Spanish pavilion at the world's fair in Paris. At that time González was the most distinguished Spanish, or more precisely Catalan, sculptor, even though hehad been living in Paris for many years. He was known for his abstract, open-form welded sculptures composed of linear elements, which were frequently described as drawings in space. A perfect example is his *Head,* 1935 (fig. 2). Executed in iron, the head is defined by a sweeping arc with a few short strands

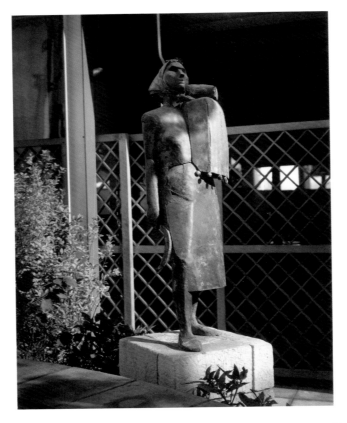

Fig. 1 (cat. 9:21). François Kollar, *"La Montserrat" by Julio González at the Spanish Pavilion, Paris International Exhibition,* 1937.

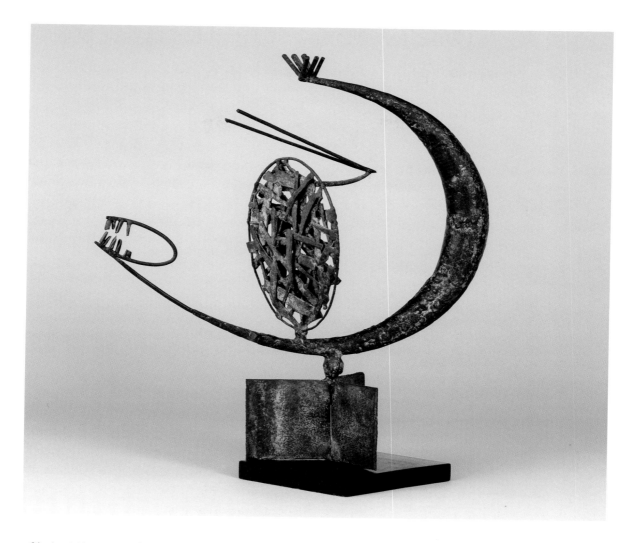

of hair at the top and a jaw-like circular shape with protruding spiky teeth at the bottom. The arc is supported on a small round element at its center of gravity; a large eye, accented with long, straight lashes, is placed near the middle. The overall effect is frightening, inevitably suggesting comparison with the various female heads with open mouths and protruding teeth that appear in some of Picasso's works, in paintings such as the *Large Nude in a Red Armchair,* 1929 (fig. 3), and drawings and sculpture produced from 1929 well into the period of *Guernica* and its postscripts of the early 1940s. But the open form in González's sculpture, devoid of volume yet sweeping through space and encompassing it as a complement of form, creates a

uniquely abstract expression. Small and seemingly delicate, it aggressively interacts with the surrounding space, encroaching invasively into the viewer's space with what feels like anger and belligerence.

During the years 1936–37 González was working on two large sculptures in entirely different styles. One was the realistic depiction of a peasant woman with a child—*The Montserrat*—and the other was the abstract, linear *Woman Combing Her Hair,* 1936 (Museum of Modern Art, New York), which continued his preoccupation with sculptural drawing in space. Both themes appear time and again in the artist's work. Around 1930, for instance, he created a drawing titled *The Montserrat,* a bust-length portrait of a peasant woman in a

Fig. 2 (cat. 9:36). Julio González, *Head,* 1935.
Fig. 3. *Large Nude in a Red Armchair,* 1929, by Pablo Picasso.

kerchief that could have been a project for a small-scale monument. Although throughout his career González was essentially concerned with formal sculptural issues, without any personal emotional engagement, the outbreak of the civil war touched him deeply and released his nostalgia for his Catalan roots. The depiction of the peasant woman and child became the expression of that connection.

The name "Montserrat" is symbolic in several ways. One of the most frequently used Christian names for Spanish women, it is also the name of a large craggy mountain range characterized by its saw-toothed profile ("serra" meaning "saw" in Catalan; the Latin means "serrated") that is a tra-ditional symbol of Catalonia.[1] The subject of maternity, woman and child, was a dominant theme, particularly in decorative arts and sculpture, during the modernista period, the late 19th-century Catalan cultural revival that continued into the early decades of the 20th century. That motif also personified the relationship between Montserrat and Catalonia, expressed in the statue of the Virgin in the Benedictine Monastery of Montserrat. Pope Leo XIII sanctified the connection in 1881, when he named the statue Our Lady of Montserrat, Patron Saint of Catalonia.[2]

González's *Montserrat* embodies all these layers of symbolism. Although the sculpture was executed in 1936–37, he made numerous drawings of a peas-

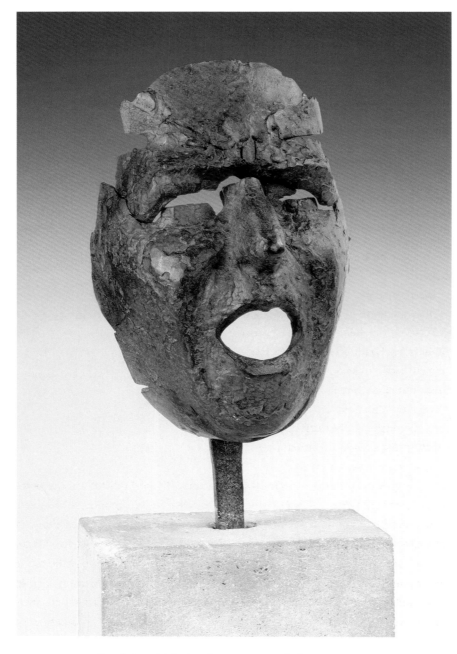

Fig. 4 (cat. 9:35). Julio González, *Screaming Mask of Montserrat*, 1936.

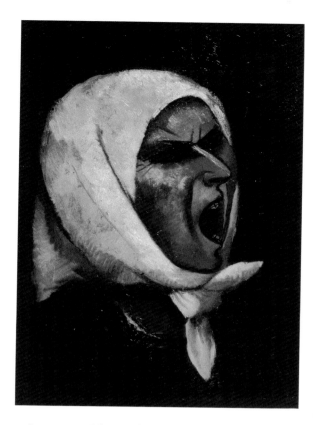

ant woman with an infant on her arm, or simply the woman herself, as early as 1929.[3] The finished sculpture, made of shaped and welded sheets of iron and one of the largest in the artist's oeuvre, exploited his knowledge of the material and its possibilities. Descended from a family of Spanish metalsmiths, González was a master of his craft with an exceptional understanding of the inherent expressive potential of the materials used.

Like *Guernica* in the work of Picasso, *Montserrat* appeared at a juncture in González's life when the political events in his native Spain, and Catalonia in particular, raised his national consciousness. The sculpture stood at the entrance to the pavilion as a symbol of the heroism of the Catalan people, a defiant statement in the face of an unspeakable catastrophe, and an expression of the artist's revulsion and outrage at the brutality and savagery of the civil war.

González's *Mask of Montserrat Screaming* (fig. 4), another iron sculpture of 1936, conveys in a much more haunting and abstract manner the emotional impact of tragedy and the frustration of a human being confronted with cataclysmic events. The ghostly face, with its hollowed eyes and wide-open mouth, inspires fear, awe, and compassion. That powerful expression is heightened by the remarkable textural

quality of the iron skin, resulting from special handling of the material. As Josephine Withers suggests, the mask was probably made directly at the forge (González's frequent practice) by using a torch to melt away and corrode the features of the face, achieving the distinctive surface.[4] The final effect is astonishing: a testament to the artist's inventiveness and craftsmanship, enhanced by his emotional engagement and direct response to the anguish of war.

Before embracing sculpture as his main expressive idiom, González trained as a painter, and he explored that medium to create another memorable image of Montserrat, a small oil (fig. 5). Executed between 1936 and 1939, this evocative portrait seems to be a two-dimensional version of the *Mask of Montserrat Screaming*. The shriek of pain from the frightened peasant's wide-open mouth is almost audible. The monochromatic palette underscores her grim message, and the white kerchief—the only element of light in the dark picture—makes her face stand out even more. She is the face of the scarred

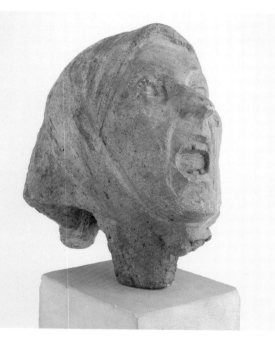

nation and, by implication, the voice of Catalonia. Her powerful image relates to several of González's realistic yet slightly stylized drawings of heads of Montserrat of 1938–42 and to a head created in 1942 (fig. 6) that is a fragment of the monumental sculpture of Montserrat left unfinished in his studio at the time of his death in March 1942. Two upraised arms from this same projected sculpture, already

Fig. 5 (cat. 9:33). Julio González, *Montserrat Screaming, No. 1*, 1936–39.
Fig. 6. *Sculptural Head of La Montserrat*, c. 1942, by Julio González.

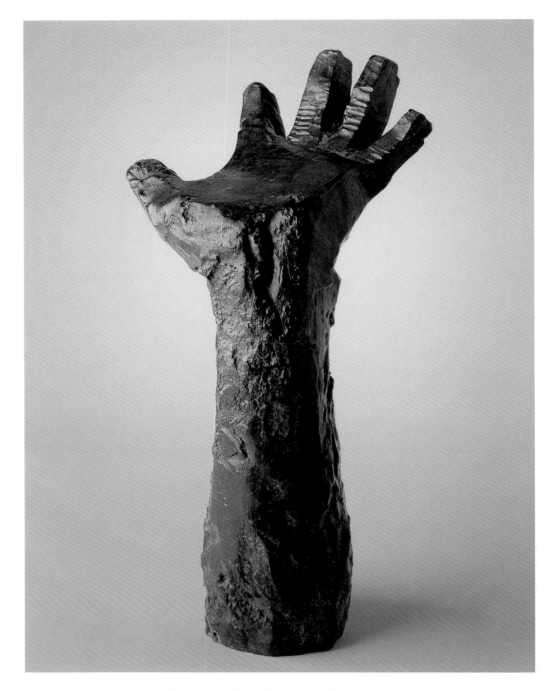

cast in bronze, also remained in the studio. The left arm (fig. 7) is a sturdy peasant's arm, the claw-like fingers of its powerful hand spread out in a self-protective gesture. The same gesture appears in a pencil and india ink drawing González made in 1940. According to the sculptural practice of the time, very large works were created in separate elements and later mounted into a single whole, so these fragments represent a task left unfinished at the artist's death. It was one of González's ambitions to create an oversized version of his 1941–42 *Small Frightened Montserrat* (fig. 8). The small, nearly foot-high figure

was in fact created as a conceptual study in preparation for the large sculpture. One can only imagine the emotional and expressive impact the large version would have had. In the middle of the World War II, this work would have been another of the artist's responses to the trauma of war.

While González had been born in Barcelona and always remained a Catalan at heart, through the years of the civil war and the early years of World War II he lived in Paris. Yet he was—unil the very end—deeply concerned with all aspects of Spanish and Catalan reality. The "Montserrat suite," along

Fig. 7 (cat. 9:38). Julio González, *Raised Left Hand, No. 2.* c. 1942.

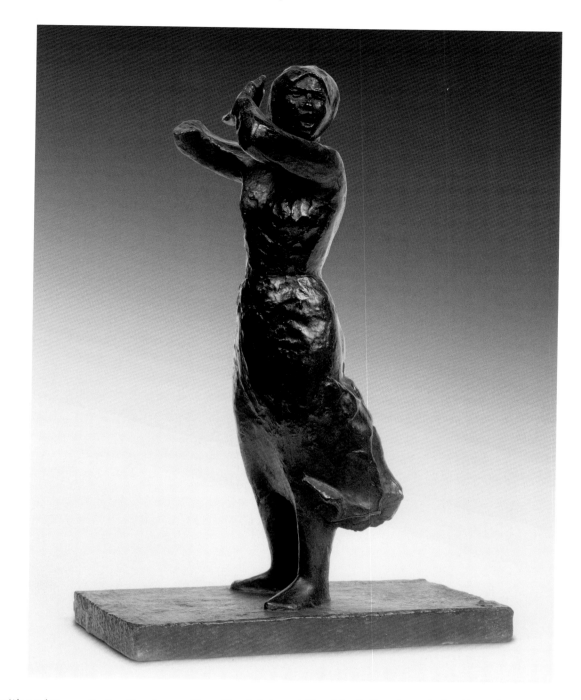

with sculptures *Cactus Man I,* 1939 (González Estate, Paris), and *Cactus Woman (Cactus Man II),* c. 1939–40 (see fig. 6, p. 380), as well as the drawings related to them, constituted his last will and testament conveying to future generations his revulsion and outrage at the bestiality of man. As did his compatriots Picasso, Miró, and Dalí, González registered his personal visual response to the barbarism of world-altering events, and through his own vision transformed his personal emotional responses into universal truth.

1. More elaborate discussion can be found in Josephine Withers, *Julio González: Sculpture in Iron* (New York: New York University Press, 1978), 87–94.

2. To this day, this shrine at the Montserrat Monastery is a pilgrimage destination; see ibid., 90.

3. It should be emphasized, however, that González's drawings were essentially not studies for sculpture but sketches related to the themes of his sculpture. The sculpture itself took shape in the process of its creation. In fact, many drawings were executed after his sculptures, more as exercises on the evolution of form on paper. See Margit Rowell, *Julio González: A Retrospective,* exh. cat. (New York: Solomon R. Guggenheim Museum, 1983), 18–30.

4. Withers, *Julio González,* 87 n. 1.

Fig. 8 (cat. 9:34). Julio González, *Small Frightened Montserrat,* c. 1941–42.

# The Fall of the Republic

*WILLIAM  H.  ROBINSON*

> We are living through a hideous drama that will leave marks in our minds, . . .
> everything happening in Spain is terrifying in a way you could never imagine.
> —Joan Miró, 12 January 1937

Artists responded to the fall of the Second Spanish Republic with works of horrifying violence, anguish, anxiety, and even ironic humor. By the fall of 1938 the signs of impending disaster were all too apparent. A nationalist offensive moving east from Aragon had reached the Mediterranean in April, splitting the republic in two and isolating Catalonia in the northeast. Earlier in the war the republic had relocated the seat of government to Barcelona, which now became the target of an intense bombing campaign by the nationalists. The noose tightened in June when France closed its border with Spain. In September, Great Britain and France began negotiating the Munich accords with Germany and Italy, leading to an agree-ment over the future of Czechoslovakia, but which also had serious consequences for Spain. Afterward, Britain and France were not about to disturb their new marriage of convenience with Adolf Hitler by coming to the aid of the Spanish republic. On 21 September, as General Francisco Franco's nationalist army prepared to invade Catalonia, the republic announced the disbanding and withdrawal of the International Brigades. In December the nationalists launched their expected offensive, and Barcelona fell on 26 January 1939.

Joan Miró responded to these events with brutally violent images expressing feelings of foreboding and defiance. He later described the "cruel and difficult years" of 1936–39 as his period of "savage

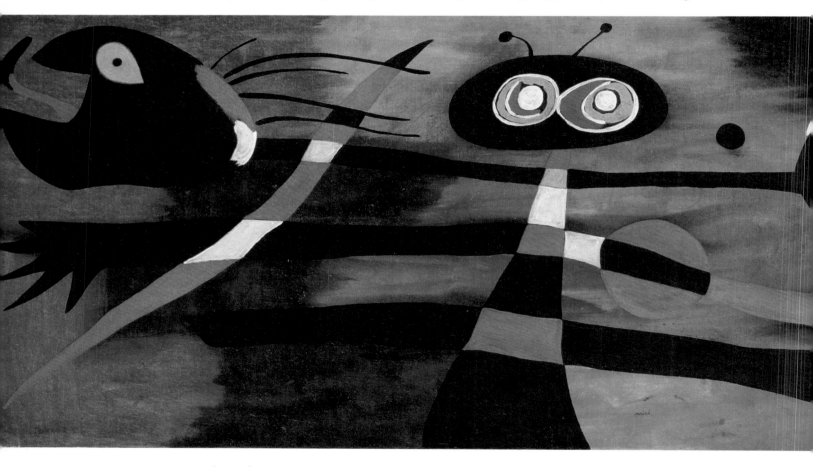

Fig. 1 (cat. 9:39). Joan Miró, *Woman Haunted by the Passage of the Bird–Dragonfly, Omen of Bad News*, 1938.

paintings," when "thinking about death led me to create monsters that both attracted and repelled me."[1] By the autumn of 1938 he was experiencing terrible nightmares, undoubtedly acerbated by worries about his mother, who was living at the family farm in Montroig southwest of Barcelona.[2] The "savage" period reached a peak with Miró's electrifying *Woman Haunted by the Passage of the Bird–Dragonfly, Omen of Bad News* (fig. 1), painted in September 1938. This frightening nocturnal scene depicts a white-headed monster on the right flashing razor-sharp teeth and attacking two figures to the left. One figure flees and cries out with a flaring red tongue, the other turns toward the monster, perhaps to protect its companion. The phrase "Omen of Bad News" in the title, given to the painting by Miró at the time of the Munich conference, according to art historian Jacques Dupin, is commonly interpreted as a premonition of the coming of World War II.[3] However, Miró painted this work nearly a year before the beginning of that war, a conflict that began with the German invasion of Poland in September 1939. In September 1938, by contrast, Miró was more likely concerned about the fate of the Spanish republic.

For years, the republic had sought an alliance with Great Britain and France to counter General Franco's alliance with Germany and Italy. But Britain and France remained hesitant, fearing they might be dragged into a war with Nazi Germany. The signing of the Munich accords in September 1938, prompting Chamberlain's declaration that he had achieved "peace in our time," dashed all hopes of the Western democracies intervening in Spain and rescuing the republic from a grim fate. It is a testament to how powerfully these events affected Miró that, although Pierre Matisse commissioned this painting for the nursery of his children, the artist could not disentangle himself from the menacing, devouring monsters that haunted his imagination.[4] Placing such a disturbing image in a domestic interior has few precedents in the history of art, except perhaps for Francisco Goya hanging the equally terrifying *Saturn Devouring His Sons* in his dining room (now Museo del Prado, Madrid). The association of nocturnal imagery with evil forces or human darkness also recalls Goya's *Third of May, 1808*, 1812 (Prado). At the same time, Miró's merging of terror with childlike innocence presages Picasso's *Night Fishing at*

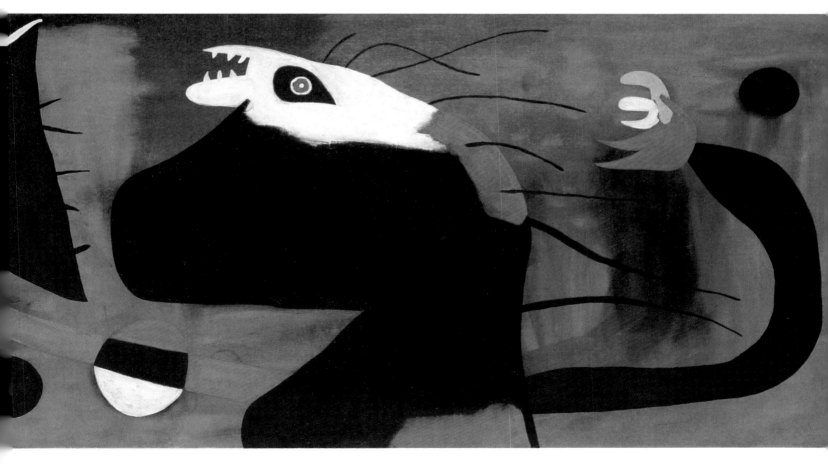

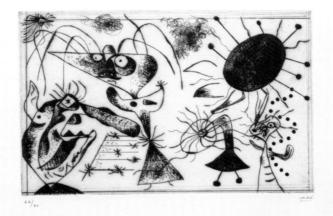

*Antibes* (Museum of Modern Art, New York), painted in August 1939 and interpreted as an image of ritualistic sacrifice informed by the psychological conditions of life just prior to the impending world war.[5] After focusing on avant-garde experimentation in the early 1930s, Miró issued a statement in the spring of 1939 acknowledging that his art could no longer remain disconnected from the pressing political issues of his time: "The outer world, the world of contemporary events, always has an influence on the painter.... If the powers of backwardness known as fascism continue to spread, however, if they push us any further into the dead end of cruelty and incomprehension, that will be the end of all human dignity.... There is no longer an ivory tower. Retreat and isolation are no longer permissible."[6]

Miró's *Black and Red Series,* 1938 (figs. 2a–h), a suite of eight etchings, represents a more intimate response to the unfolding tragedy in Spain.[7] In this series he limited his palette to black and red, the colors of the anarchist flag, set against a white background. The etchings were printed from two separate plates that Miró eventually combined, an idea reportedly recommended by Picasso.[8] As the series progresses, the composition becomes increasingly agitated. The first sheet (fig. 2a) depicts an assemblage of ideographic signs printed only in black and arranged in a vertical format, the orientation confirmed by the artist's signature in the lower right. The second sheet (fig. 2b) is also printed in monochro-

matic black, but the composition shifts to a horizontal format and features four figures arranged across the foreground, a tilled field in the lower left, and an ominous black oval with protruding nodules in the upper right. The largest figure, a defiant woman with a sharply pointed nose, raises her arms to ward off the menacing monster in the lower left, his enormous nose resembling a battering club or nightstick. The defiant woman seems to be protecting the two smaller figures on the right, a girl wearing a dress and a boy in a striped shirt. The creature's physical deformities, suggesting a grotesquely distorted mind, recall Picasso's portrayal of General Franco as a hideous beast in the *Dream and Lie of Franco.* The little girl also appears in Miró's *Au Paradis des fantômes,* an engraving of 1938, where her facial features—two eyes and a mouth inside a tiny head surrounded by a large black oval—are clearly evident.[9] The figure on the extreme right of sheet two in *Black and Red Series* has also been interpreted as a father who is incapable of defending his family.[10]

In the third sheet (fig. 2c), Miró returned to the first image and introduced the color red by printing the plate twice, the second time upside down. The fourth sheet (fig. 2d) combines the vertical and horizontal plates (compare figs. 2a and 2b) by rotating the vertical plate 90 degrees and printing it in red. The menacing black oval in the upper right turns red in the fifth sheet (fig. 2e), then explodes into a ball of flames in sheet seven (fig. 2g). In the final sheet (fig.

Fig. 2a (cat. 9:40a). Joan Miró, *Black and Red Series,* 1938.
Fig. 2b (cat. 9:40b). Joan Miró, *Black and Red Series,* 1938.

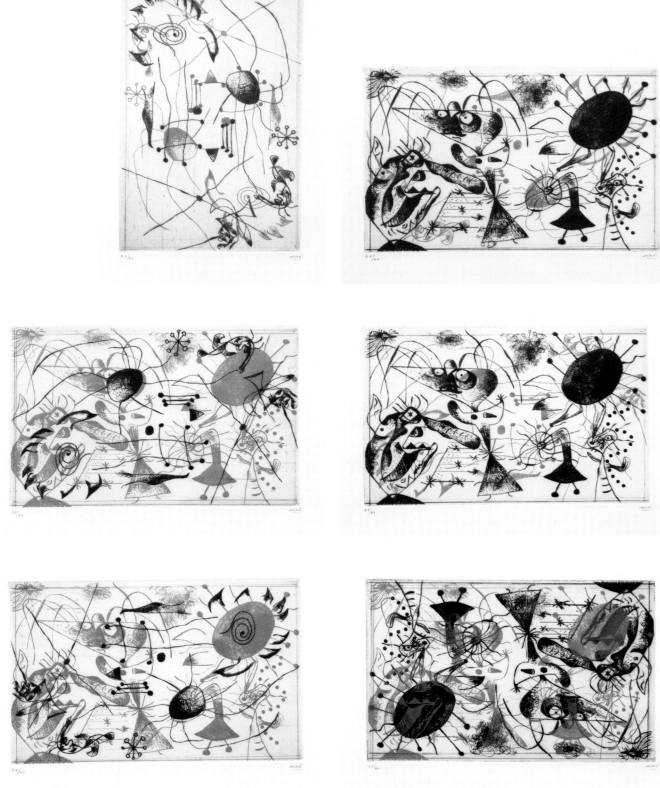

Fig. 2c (cat. 9:40c). Joan Miró, *Black and Red Series*, 1938.

Fig. 2d (cat. 9:40d). Joan Miró, *Black and Red Series*, 1938.

Fig. 2e (cat. 9:40e). Joan Miró, *Black and Red Series*, 1938.

Fig. 2f (cat. 9:40f). Joan Miró, *Black and Red Series*, 1938.

Fig. 2g (cat. 9:40g). Joan Miró, *Black and Red Series*, 1938.

Fig. 2h (cat. 9:40h). Joan Miró, *Black and Red Series*, 1938.

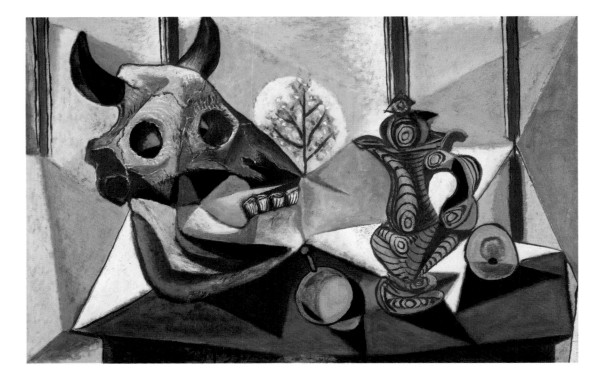

2h), Miró printed the horizontal plate twice (compare fig. 2a), the second time upside down (the orientation again confirmed by the artist's signature in the lower right), so that the figures fall tumultuously from the sky in a vision of apocalyptic destruction.

Picasso reacted to unfolding events in Spain during the winter of 1938–39 by painting a series of still lifes featuring a bull skull, a symbol of death derived from the human skulls of the traditional memento mori theme urging contemplation on the brevity of life. On 29 January 1939, three days after Barcelona surrendered to the nationalists, Picasso painted perhaps the most remarkable work in the series, *Bull Skull, Fruit, and Pitcher* (fig. 3). His substitution of a bull skull for the conventional human skull implies a reference to Spain through associations with that secular ritual Picasso closely associated with his homeland—the bullfight. The painting's agitated forms and emotive colors may also reflect Picasso's mental state following the death of his mother in Barcelona on 13 January. Several aspects of this painting are unique to the series. Rather than a conventional skull, the eviscerated head of a bull is still covered with rotting, yellow flesh. A nail pierces a hotly colored fruit in the lower center,

suggesting intense pain. The agitated and intensely colored pitcher (mostly red, orange, and yellow—colors associated with the Spanish and Catalan flags) suggests the body of a woman, while the white void inside the handle resembles a blank face framed by coifed hair.[11] Moonlight illuminates the distant landscape and enters the room through black bars, casting piercing triangular shadows across the tabletop. Most significantly, a flowering tree grows in the middle of the landscape, its presence highlighted by a beam of moonlight that casts a halo around its exterior. This tree likely refers to the sacred oak of Guernica that had miraculously survived the fire bombing of the Basque city by the German Condor Legion during the nationalist offense of May 1937. That summer, a photomontage at the Spanish pavilion of the Paris world's fair (fig. 4) commented on the bombing with three captions: "Is It a Crime for a People to Defend Its Liberty?" "They Have Destroyed Our People and Our Language," and "The Tree of Guernica, Symbol of Democracy and the Basque People." This photomural offered an insightful complement to Picasso's painting *Guernica* (see fig. 2, p. 461), exhibited in the same pavilion. It seems hardly coincidental that Picasso

Fig. 3 (cat. 9:41). Pablo Picasso, *Bull Skull, Fruit, and Pitcher,* 1939.

Fig. 4. Photomural of the bombing of Guernica and the oak of democracy, by Josep Renau, exhibited at the pavilion of the Second Spanish Republic, Paris International Exhibition, 1937.

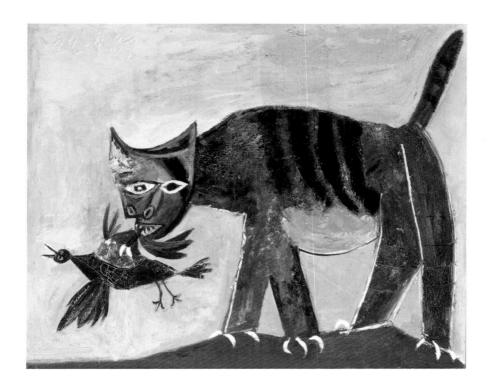

placed a flowering tree in the center of *Bull Skull, Fruit, and Pitcher* so that it appears to sprout from the tip of the decaying skull, suggesting life regenerating from death, and perhaps implying hope for the eventual rebirth of democracy in his homeland.

Picasso tended to avoid using his art to comment on specific political events, preferring instead to make more general statements about the human condition. Several of the most notable exceptions occurred during the Spanish civil war, when he did respond to specific events, although frequently expressing his reactions through a metaphorical language of universal signs and symbols. This may be the case with his frightening image of a cat seizing a bird (fig. 5) painted on 22 April 1939, less than a month after Franco declared the civil war over (1 April). Although this gruesome image may have been inspired by the republic's violent demise, it may also be interpreted more broadly as a metaphor for the strong preying on the weak. Painted after fascist nations had "devoured" Ethiopia, Czechoslovakia, and

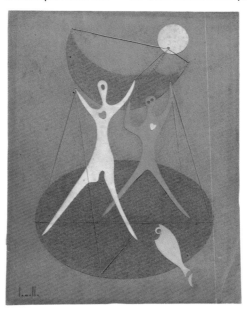

Spain, and at a time of mass executions in Spain and of Nazi persecutions of Jews and dissidents in Germany, *Cat Seizing a Bird* seems to summarize the tragic fate of millions consumed by the irresistible forces of human nature and history.[12]

The fall of Barcelona in January 1939 sent 500,000 refugees, including many prominent artists, fleeing to France. The surrealist Antoni G. Lamolla, a member of the Logicofobista group who had served in the army of the Spanish republic, crossed the border in February and was immediately imprisoned in an internment camp, along with thousands of others. While confined at the camp of Argelès, or shortly thereafter, Lamolla made a small but poignant collage (fig. 6) from razor-blade wrappers, sewing thread, and packaging materials sent by his wife, who had arrived in France before the mass exodus.[13] This modest collage depicts two figures standing in an oval and bound by thread, but who nevertheless raise their arms in a hopeful gesture. Lamolla's predicament did not go unnoticed. Miró

Fig. 5 (cat. 9:42). Pablo Picasso, *Cat Seizing a Bird*, 1939.
Fig. 6. (cat. 9:43). Antoni G. Lamolla, *Untitled*, 1939.

began sending money, Roland Penrose and Christian Zervos offered their support, and Lamolla's wife finally secured his release from the camp.[14] In August 1939 Lamolla established a studio in Dreux, where he managed to survive the Second World War unmolested by the Gestapo.

Artist Antoni Clavé also became a war refugee. After serving on the Aragon front in 1937, he returned to Barcelona and produced theater sets and posters urging support for the Loyalists. After escaping to France with other soldiers of the republican army in January 1939, he was confined at Piras de Mollo and the Harras camp near Perpignan. He obtained his release through the aid of Martin Vivés, an artist from Rousillon, and shortly thereafter exhibited a series of drawings he made in the camp at a pastry shop in Perpignan.

After moving to Paris in April, Clavé made a pair of constructed objects from old or discarded objects, producing a form of antiart that substitutes visual puns and psychic associations for the traditional craft of painting.[15] Clavé recalled that he had first encountered "object-paintings" at the ADLAN exhibition of works by Ramon Marinel·lo, Jaume Sans, and Eudald Serra at the Galeries Catalònia in Barcelona in March 1935.[16] Clavé also noted that he created his constructions of 1939 from an entirely different psychological perspective than one associated with more conventional art: "I was at that moment much freer, not having the intention of making 'a painting' or 'a sculpture.' One has much more freedom when making something only for one's self."[17] He assembled *Man with a Monocle* (fig. 7) and *Telephone* (fig. 8) of 1939 from found objects, including wood, wire, metal fasteners, and a cooking whisk. These parodies of modern mechanization elicit humorous double meanings that lend a strange humanity to the assembled debris. The cooking whisk in *Man with a Monocle* suggests an elongated but empty head punctuated by an aristocratic eyepiece, the wire rods of the whisk perhaps associated with prison bars or a tailor's dummy. The upright spoon in *Telephone* suggests a standing figure, the circular white object on the spoon head a mouth, and the metallic

Fig. 7 (cat. 9:44). Antoni Clavé, *Man with a Monocle*, 1939.

wire a phone cord or perhaps the "motion lines" of a Duchampian figure moving in space. Created after the debacle of the Spanish civil war and on the eve of an even greater conflict, Clavé's "figures" seem to personify the plight of the countless war refugees who were treated as disposal rubbish. Reflecting an attitude of fatalistic humor rather than horror or anguish, these constructions testify to the extraordinary range of thoughts and emotions artists felt at one of the darkest moments in human history.

1. Although Miró identified 1936 as the beginning of his "savage paintings," in fact his images began to show this tendency as early as 1935, perhaps influenced by the violent repressions in Catalonia and Asturias and suggesting premonitions of the coming civil war. See Miró, "Interview with Denys Chevalier" (1962), in *Joan Miró: Selected Writings and Interviews,* ed. Margit Rowell (Boston: G. K. Hall, 1986), 267.

2. Carolyn Lanchner, *Joan Miró* (New York: Museum of Modern Art, 1994), 334.

3. Jacques Dupin and Ariane Lelong-Mainaud, *Joan Miró: Catalogue raisonné: Paintings* (Paris: Daniel Lelong & Successió Miró, 2000), 2: no. 596.

4. Miró signed the painting on the back: "Pour Jacky, Peter et Pauley Matisse."

5. Mark Rosenthal, "Picasso's *Night Fishing at Antibes*: A Meditation on Death," *Art Bulletin* 65 (March 1983), 649–58.

6. Miró statement in *Cahiers d'Art* (April–May 1939), cited in *Miró: Selected Writings,* 166.

7. Jacques Dupin, *Miró engraver* (New York: Rizzoli, 1989), 1: catalogue raisonné nos. 32–39. The series was produced in an edition of 30, engraved in the studio of Louis Marcoussis, and printed at Atelier Lacourière in Paris.

8. Ibid., 1: 12.

9. Ibid., 1: no. 41.

10. Deborah Wye, "Joan Miró *Black and Red Series,*" 1998, www.moma.org/exhibitions/1998/miro/iconography.html.

11. See Jean Sutherland Boggs, *Picasso & Things* (Cleveland: Cleveland Museum of Art, 1992), 259–60.

12. In 1938–39 Picasso also collaborated with Miró, André Masson, Yves Tanguy, Wassily Kandinsky, William Stanley Hayter, and other artists to create two albums of engraving expressing solidarity with the Spanish Second Republic. Miró contributed one etching to each of these albums, *Solidarité,* 1938, and *Fraternity,* 1939 (Dupin, *Miró engraver,* 1: nos. 42 and 43).

13. I would like to thank the artist's daughter, Yolanda García Lamolla, for kindly sharing her knowledge about the history of this collage.

14. Josep Miquel Garcia et al., *El Pintor Lamolla,* exh. cat. (Lleida: Museu d'Art Jaume Morera, 1998), 68–69.

15. I would like to thank Emmanuel Clavé, the artist's grandson, for kindly providing information about the artist and his "constructions." See also Pierre Seghers, *Clavé* (Barcelona: Éditions Poligrafa, 1971), 15–16, 336; Jean-Luc Mercié, *Clavé* (Paris: Seghers, 1980), 11; and Pierre Daix, *Antoni Clavé, Assemblages 1960–1999* (Paris: Ides et Calendes, 2001), 6–8, 257–58.

16. Daix, *Antoni Clavé,* 6.

17. Ibid., translated by the author.

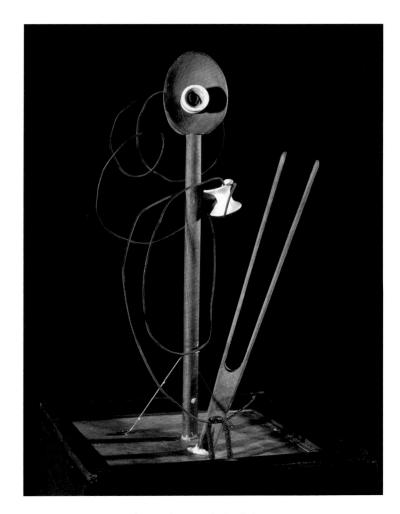

Fig. 8 (cat. 9:45). Antoni Clavé, *Telephone,* 1939.

# Biographies and Checklist

*MARGARET BURGESS*

**Onofre Alsamora** (Barcelona, 1825–1880)

Painter and lithographer. Onofre Alsamora trained at Barcelona's La Llotja. Best known for his scenes of Spain, and specifically his paintings, drawings, and watercolors of Barcelona's monuments, street life, and landscape, Alsamora contributed many lithographs to the volume dedicated to Catalonia in the series *Recuerdos y bellezas de España*.

Cat. 1:2. *Bird's Eye View of Barcelona*, 1860, colored lithograph on paper, 48 x 58 cm. Museu d'Història de la Ciutat de Barcelona. Photo courtesy Museu d'Història de la Ciutat de Barcelona.

**Hermen Anglada-Camarasa** (Barcelona, 1871–Palma de Majorca, 1959)

Painter. Hermenegild Anglada i Camarasa studied at La Llotja in Barcelona where he was taught by Modest Urgell (1839–1919). Influenced by Urgell's involvement with the Quatre Gats, Anglada-Camarasa also participated in the group's artistic activities. In 1894 he moved to Paris to study at the Académie Julian and Académie Colarossi. From 1900 to 1904 he maintained a studio at 9 rue Hégésippe Moreau and developed a style that became increasingly figurative and expressionist, bridging Modernisme and Noucentisme. His iridescent scenes of Parisian nightlife garnered him particular success and inspired many artists, including Wassily Kandinsky (1866–1944) and Pablo Picasso, who arrived in Paris in late 1900. In 1902 Anglada-Camarasa became a member of the Société Nationale des Beaux-Arts and frequently contributed to their exhibitions. Trips to Valencia during this time inspired him to incorporate into his style more folkloric traditions and redirect his subject matter toward capturing peasant life. In 1914 he settled in Majorca. There he focused on highly decorative works of the surrounding landscape. His fame not only reached the major art centers of Spain, but also extended to the rest of the continent, England, and the United States, where his paintings were acclaimed at exhibitions at the Carnegie Institute, Pittsburgh, and major venues. During the Spanish civil war, Anglada-Camarasa returned to Barcelona, where the government granted him special support and he received asylum in the Monastery of Montserrat. After the war he sought refuge in Pougues-les-Eaux, near Nevers, France, returning to Majorca in 1947. Spain's new government awarded him numerous honors before his death.

Cat. 2:12. *Lady in Black, with Flowers*, c. 1899–1900, charcoal, pastel, and oil on paper, 32.8 x 23 cm. Private collection. © 2006 Artists Rights Society (ARS), NY/VEGAP, Madrid.

Cat. 2:13. *The White Ball*, c. 1900, oil on panel, 49 x 75 cm. Private collection, Barcelona, courtesy Artur Ramon Gallery. (New York only.) © 2006 Artists Rights Society (ARS), NY/VEGAP, Madrid.

Cat. 2:14. *Paris at Night*, c. 1900, oil on panel, 22.5 x 35 cm. Masaveu Collection, Oviedo. (Cleveland only.) © 2006 Artists Rights Society (ARS), NY/VEGAP, Madrid. Photo © Gonzalo de la Serna.

Cat. 2:15. *Sketch (Figures)*, c. 1900–1901, oil on panel, 26 x 34 cm. Biblioteca-Museu Víctor Balaguer, Vilanova i la Geltrú. (Cleveland only.) © 2006 Artists Rights Society (ARS), NY/VEGAP, Madrid.

**Josep Aragay** (Barcelona, 1889–Breda, 1973)

Painter, ceramist, and art theorist. A key figure of Noucentisme in Barcelona, Josep Aragay i Blanchart studied at the Acadèmia Galí in 1907–11. After this training he was put in charge of the art direction and publication of the *Almanach dels Noucentistes*. Aragay was also a member of Les Arts i els Artistes. The Galeries Dalmau held the first solo show of his paintings, and the Galeries Laietanes exhibited his ceramics. From 1919 Aragay briefly taught ceramics at the Escola Superior dels Bells Oficis. Later he founded a ceramics workshop and painted murals in Breda, a town north of Barcelona and where a museum devoted to his work is now located.

Cat. 6:2. Title page design for *Almanach dels Noucentistes* (1911) (Barcelona), magazine, 32.5 x 25.2 cm, copy no. 115/150. Biblioteca de Catalunya, Barcelona. Photo courtesy Biblioteca de Catalunya.

Cat. 6:46. *Vase*, Fountain of Santa Anna, 1918, glazed ceramic, 110 x 72 cm. Museu Municipal Josep Aragay, Breda. Photo © Pere Vivas and Jordi Puig, Triangle Postals, Barcelona, 2006.

Cat. 6:47. *Wine*, c. 1930, glazed ceramic, 54 x 17 x 21 cm. Museu Nacional d'Art de Catalunya, Barcelona. Photo © MNAC–Museu Nacional d'Art de Catalunya, 2006, photo Calveras/Mérida/Sagristà.

**Eusebi Arnau** (Barcelona, 1863–1933)

Sculptor and medal maker. One of the leading sculptors of the modernista movement in Catalonia, Eusebi Arnau i Mascort trained at La Llotja in Barcelona and in the architectural workshop of Lluís Domènech i Montaner and Antoni M. Gallissà (1861–1903). Arnau's first major commissions were sculptures and architectural decorative elements for the exteriors of Domènech's and Gallissà's buildings, including Casa Lleó Morera, the Palau de la Música Catalana, and the Fonda España, as well as other major buildings in Barcelona, including Casa Amatller, on which he collaborated with Josep Puig i Cadafalch. Arnau also made outdoor sculptures for the Parc de la Ciutadella as well as commemorative plaques and medals.

Cat. 2:31. *At the Loge*, 1911, marble, 87 x 83 x 48 cm. Lluís Bassat, Barcelona. Photo © Fotografia Gasull.

Cat. 5:35. *Woman with a Camera* or *Nymph Photographer (Model for the Casa Lleó Morera)*, c. 1905, painted plaster, 76.2 x 63.5 x 12.7 cm. Casa-Museu Domènech i Montaner, Canet de Mar. Photo © Pere Vivas and Jordi Puig, Triangle Postals, Barcelona, 2006.

**L'Avenç**

Cat. 1:6. *L'Avenç: Literari, artístic, científic*, no. 4 (30 April 1891) (Barcelona), magazine, 26 x 18 x 3 cm. Biblioteca de Catalunya, Barcelona. Photo courtesy Biblioteca de Catalunya.

**Henry Ballesteros**

Cat. 9:11. *For the Liberty of Catalonia: Help Madrid. Sunday the 7th at 10:00 a.m. All Women to the Monumental*, c. 1937, lithograph, 99 x 68 cm. Biblioteca del Pavelló de la República (Universitat de Barcelona), Fundació Privada Centre d'Estudis d'Història Contemporània–Biblioteca Josep M. Figueras, Barcelona. (Cleveland only.) Photo © Biblioteca del Pavelló de la República.

**Rafael Barradas** (Montevideo, Uruguay, 1890–1929)

Painter. Son of the Spanish artist Antonio Pérez Barradas (1862–1899), Rafael Pérez Barradas actively participated in Montevideo's bohemian artistic life before traveling to Europe. Through his travels to the artistic centers of Europe he became aware of major avant-garde movements, including Futurism. Barradas settled in Barcelona in 1916,

where he was crucial to the promotion of the avant-garde, not only contributingto the art and literature movements, but also developing his own singular style that he termed Vibracionismo—a style inspired in part by the art of the Futurists. Barradas regularly participated in exhibitions at Barcelona's Galeries Dalmau and Galeries Laietanes. He collaborated with Joan Salvat-Papasseit on *Un enemic del Poble* and the periodical *Arc-Voltaic,* and developed an important friendship with Joaquín Torres-García. He also illustrated *Tiempos difíciles (Hard Times)* by Charles Dickens. In 1918 Barradas went to Madrid where he exhibited at the Ateneo, illustrated children's books, and met Gregorio Martínez Serra, director of the Teatro Eslava. Martínez Serra became one of Barradas's great patrons, introducing him to the theater world and granting him numerous commissions for set and costume designs. Toward 1926 Barradas returned to Catalonia and established the Ateneíllo de l'Hospitalet, meetings of modernista artists and writers at his home in l'Hospitalet de Llobregat, near Barcelona. He returned to Montevideo in 1927.

Cat. 7:19. *Barcelona Street at 1 p.m.*, 1918, oil on canvas, 50.7 x 60.5 cm. Colección Arte Contemporáneo–Museo Patio Herreriano, Valladolid.

## Miquel Blay (Olot, 1866–Madrid, 1936)

Sculptor. Renowned for his modernista sculpture, Miquel Blay i Fàbregas's early training was with Josep Berga (1837–1914). From 1880–86 he worked in El Arte Cristiano, a studio and workshop led by the Vayreda brothers, Joaquim (1843–1894) and Marià (1853–1903), in Olot. Later Blay studied at the Académie Julian (Paris) and in Rome. He embarked on his professional career in Paris in 1894, later returning to Barcelona to complete numerous projects and commissions for historic buildings. His sculptures grace the interior and exterior of the Palau de la Música Catalana and the fountain in Barcelona's plaça d'Espanya. Blay taught at the Escuela Superior dels Bellas Artes in Madrid and became director of the Accademia di Belle Arti in Rome in 1925. Often compared to the works of Auguste Rodin (1840–1917), Blay's sculptures are infused with raw emotion; his work has been described as "the sculpture of feeling."

Cat. 2:32. *Daydream,* c. 1905, marble, 50 x 58 x 38 cm. Gothsland Galeria d'Art, Barcelona. Photo © Pere Vivas and Jordi Puig, Triangle Postals, Barcelona, 2006.

## Jacint Bofarull (Barcelona, 1903–1977)

Illustrator, painter, and muralist. Jacint Bofarull i Forasté began his career as a cartoonist for sports magazines such as *El Borinot* and *La Barrila Deportiva.* During the Spanish civil war he established himself as a distinguished poster artist. After the war he was exiled in France, where he continued to work and became known for his comic strip for *L'Indépendant* called "Kim el catalanet" ("Kim, The Little Catalan"). Bofarull moved to Buenos Aires in 1950, returning to Barcelona a decade later, illustrating for local newspapers including *Tele-exprés.*

Cat. 9:8. *FAI CNT. Industrial Worker! Farmworker! Unity for Victory!* 1936, lithograph, 140 x 100 cm. Biblioteca del Pavelló de la República (Universitat de Barcelona), Fundació Privada Centre d'Estudis d'Història Contemporània–Biblioteca Josep M. Figueras, Barcelona. (Cleveland only.) Photo © Biblioteca del Pavelló de la República.

## Antoni Bonet (Barcelona, 1913–1989)

Architect, urban planner, and designer. Antoni Bonet i Castellana received his training in Barcelona at the Escola Superior d'Arquitectura and by working in the studio of Josep Lluís Sert and Josep Torres Clavé (1906–1939). A member of GATCPAC, he worked on urban planning for the city of Barcelona and participated in the design of the Spanish pavilion for the International Exhibition (Paris, 1937). He also trained with Le Corbusier in Paris; many of Bonet's later architectural designs—including four pavilions in Buenos Aires,

where he traveled in 1938—reflect Le Corbusier's influence. Together with the Argentinian designers Jorge Ferrari Hardoy (1914–1977) and Juan Kurchan (1913–1975) whom he had met in Le Corbusier's studio, Bonet founded the Grupo Astral in Buenos Aires. The group collaborated on architectural and urban-design projects as well as furniture design, creating such works as the BKF chair—named after the designers—and reinforcing and reflecting the ideals of GATCPAC. In 1963 Bonet returned to Catalonia and practiced in Barcelona and Girona. His most well-known late-career architectural designs in Barcelona include La Torre Urquinaona, El Plà Montjuïc, and L'Edifici Mediterrani.

Cat. 8:27. Grupo Austral (Antoni Bonet, Jorge Ferrari-Hardoy, Juan Kurchan), *BKF Chair Prototype*, 1938, metal and leather, 91 x 79 x 67 cm. Museu de les Arts Decoratives, Barcelona. Photo © Guillem.

## Lluís Bracons (Manlleu, 1892–Paris, 1961)

Engraver and lacquerer. Lluís Bracons i Sunyer learned the Japanese lacquer technique from Jean Dunand (1877–1942) in Paris. Returning to his native Catalonia, he taught the technique at the Escola Superior dels Bells Oficis. He married Enriqueta Pascual i Benigani (1905–1969), also an artist. He based many of his designs on those of Francesc Galí. In the 1920s he collaborated with Suzanne Duplessis, and together they founded the Bracons-Duplessis workshop for engravers. Many artists, including Salvador Dalí and Antoni Clavé, came to the workshop during their careers.

Cat. 6:63. With Jaume Busquets, *Port de Barcelona*, 1925, lacquered wood, 154 x 154 cm. Artur Ramon Collection, Barcelona. Photo © Ramon Manent.

## Joan Busquets (Barcelona, 1874–1949)

Furniture maker and decorator. Joan Busquets i Jané studied at La Llotja in Barcelona under General Guitart i Lostaló (1859–1926). After his studies Busquets was awarded a *borsa de viatge* to visit the museums of Spain. His first major exhibition was the Third Exposition of Fine and Industrial Arts (Barcelona, 1896), where he received an honorable mention. He became director of the Busquets workshop after his father, Joan Busquets i Cornet (1845–1915), retired. He designed and constructed a stand at the Universal Exposition (Paris, 1900) for Casa Batlló. Throughout the early 1900s, he participated in numerous decorative arts exhibitions in Barcelona, Buenos Aires, Madrid, Mexico, London, and elsewhere, receiving several awards. He also traveled widely, visiting, among other cities, Munich, Paris, and Leipzig. In 1918 he opened the Sala Busquets, a venue for exhibiting artists.

Cat. 5:41. *Sofa*, 1899, mahogany with polychrome pyrography and fabric, 216 x 165 x 70 cm. Private collection, Tarragona. Photo © Pere Vivas and Jordi Puig, Triangle Postals, Barcelona, 2006.

Cat. 5:42. *Mirror*, 1899, mahogany with polychrome pyrography, metal, and glass, 110 x 140 x 13 cm. Private collection, Tarragona. Photo © Pere Vivas and Jordi Puig, Triangle Postals, Barcelona, 2006.

Cat. 5:43. *Folding Screen*, 1899, mahogany with polychrome pyrography and carving, metal, and upholstery, 216 x 160 x 3 cm. Private collection, Tarragona. Photo © Pere Vivas and Jordi Puig, Triangle Postals, Barcelona, 2006.

Cat. 5:44. *Low Chair*, 1899, carved mahogany and upholstery, 73 x 70 x 41 cm. Private collection, Tarragona. Photo © Pere Vivas and Jordi Puig, Triangle Postals, Barcelona, 2006.

Cat. 5:45. *End Table*, 1899, carved mahogany with pyrography and metal, 76 x 74 x 44 cm. Private collection, Tarragona. Photo © Pere Vivas and Jordi Puig, Triangle Postals, Barcelona, 2006.

Cat. 5:46. *High-back Chair*, 1899, carved mahogany with pyrography, 120 x 40 x 45 cm. Private collection, Tarragona. Photo © Pere Vivas and Jordi Puig, Triangle Postals, Barcelona, 2006.

## Gaspar Camps (Igualada, 1874–Barcelona, 1942)

Illustrator, poster designer, and painter. Gaspar Camps i Junyent studied at La Llotja in Barcelona and the Ateneu Igualadí de la Classe Obrera in Igualada. He also studied in Paris from 1892–95 where his teachers were A. W. Bouguereau (1825–1905) and Benjamin Constant, among others. Camps was also influenced by Alphonse Mucha (1860–1939); Camps's work in poster design, in particular, reflects Mucha's style. During his career Camps also made illustrations for *Álbum Salón.*

Cat. 2:24. *Allegory of the Month of January,* illustration for *Album Salón: Primera Ilustración Española en colores* (January 1901), p. 26, magazine, 40 x 30 cm. University of Illinois–Urbana Champaign Library, Urbana. (Cleveland only.)

## Ricard Canals (Barcelona, 1876–1931)

Painter, pastelist, and printmaker. Ricard Canals i Llambí helped establish the liaison between Catalan and French modernista artists of the 1890s and early 1900s. After attending La Llotja with Isidre Nonell, Canals went to Paris in 1896, living in Montmartre for the next 12 years, but remaining

active in the artistic life of Barcelona. Canals probably met Pablo Picasso at the Quatre Gats in Barcelona. Their relationship resumed in Paris, where from 1901 to 1904 Canals occupied a studio at the Bateau-Lavoir, the same building where Picasso lived. Canals reportedly encouraged Picasso to begin making prints in 1904. As an artist Canals was well received in Paris, and the art dealer Paul Durand-Ruel (1831–1922) patronized him. His paintings were accepted for exhibition at the Salon d'Automne as well as at the more conservative National Salons of 1897–1906. In Spain he had painted poor gypsies, bullfights, and popular street life in the realist tradition of Francisco de Goya (1746–1828); in Paris, Canals blended Spanish ideas with the Impressionist and post-Impressionist interest in popular forms of entertainment, such as dance halls and café performances. He also painted many portraits and scenes of working-class life. Canals worked extensively with pastel, often influenced by Edgar Degas (1834–1917) and Pierre-Auguste Renoir (1841–1919). After participating in the National Salon of 1907, Canals returned to Barcelona. His reputation continued to grow during his later years, when his paintings appeared in exhibitions from Belgium to the United States.

Cat. 2:11. *Interior of a Music Hall,* 1900, pastel and charcoal on paper, 43.5 x 53.5 cm. Museu Nacional d'Art de Catalunya, Barcelona. Photo © MNAC–Museu Nacional d'Art de Catalunya, 2006, photo Calveras/Mérida/Sagristà.

## Francesc Canyellas (Barcelona, 1889–1938)

Graphic designer, muralist, and painter. Renowned for the murals embracing noucentista ideals, Francesc Canyellas i Balagueró was also a well-known early 20th-century graphic artist. He trained at La Llotja and became a member of the Cercle Artístic de Sant Lluc. Later he worked in the studio workshop of Manuel Ballarín, where he met Josep Puig i Cadafalch. Puig i Cadafalch invited Canyellas to collaborate with him on numerous projects, and through the architect's workshop, he met Josep Goday (1882–1936). Canyellas and Goday traveled to Italy and were inspired by the Mediterranean landscape and culture. In Barcelona they

became involved in municipal projects for the Comissió de Cultura de l'Ajuntament de Barcelona. Canyellas was appointed draftsman for architectural ornaments and murals throughout Barcelona, including the Palau Nacional de Montjuïc. He also designed a room for the Spanish pavilion at the International Exhibition (Brussels, 1910). He worked on architectural and ornamental designs throughout the 1920s, designing decorative elements for the façade of Joan Prats's shop on Rambla de Catalunya, as well as ceramic plaques for Casa de l'Ardiaca and works for Casa de la Caritat and Casa de la Maternitat. Canyellas complemented such work with landscape painting and graphic art, depicting themes ranging from religion to the seasons to battle during the Spanish civil war. His prints appeared in publications such as *L'Amic de les Arts.* He exhibited in Barcelona at the Sala Parés and the Galeries Syra, as well as in Paris and Amsterdam. Murals for Casa de Correus de Barcelona, the Conselleria de la Rambla de Catalunya, and the Escola de Treball are among Canyellas's most celebrated noucentista works of the late 1920s. He also taught as a professor of design at the Escola Industrial d'Arts i Oficis.

Cat. 6:37. Cover for *D'Ací d'Allà,* no. 6 (June 1921), magazine, 30.5 x 25.4 cm. Mercè Vidal Collection, Esplugues de Llobregat.

## Manuel Capdevila (Barcelona, 1910–2006)

Painter and jewelry designer. Manuel Capdevila i Massana studied with Francesc Galí and entered his father's jewelry workshop. He trained in Paris in 1926 and 1934 and exhibited in Barcelona, Paris, Bilbao, Madrid, and Pittsburgh. His abstract designs in silver and gold garnered him many international awards. His work has been displayed at the Monastery of Montserrat and the Pforzheim Shmuckmuseum. Late in life he became an art professor at the Escola Massana. His son, Joaquim Maria Capdevila i Gaya (b. 1944), also a jewelry maker, runs the family workshop today.

Cat. 9:4a–d. With Ramon Sarsanedas, *Iris, Rhythms, Cetacean,* and *Spain Withdrawn,* 1937, silver, eggshell, and Japanese lacquer, 4.5 x 4.5 x 1 cm (max.) each. Museu Nacional d'Art de Catalunya, Barcelona. Photo © MNAC–Museu Nacional d'Art de Catalunya, 2006, photo Calveras/Mérida/Sagristà.

## Artur Carbonell (Sitges, 1906–1973)

Painter, theater designer, and director. Artur Carbonell i Carbonell was one of the leading members of the surrealist movement in Barcelona. He contributed greatly to *L'Amic de les Arts,* a journalistic lightning rod for the surrealist movement in Catalonia. Carbonell studied with Joaquim Sunyer and exhibited often at the Galeries Dalmau. In the 1930s he exhibited at the Sala Parés and in the epoch-making Exposició Logicofobista organized by ADLAN (Friends of New Art). He also designed stage sets for theaters in Sitges and Barcelona. He became professor at the Institut del Teatre in Barcelona in 1940 and directed theater in the 1930s and 1940s, including plays by Jean Cocteau and Eugene O'Neill.

Cat. 7:45. *Constellation,* 1933, oil on canvas, 50 x 42 cm. Daros Trading S.L., Barcelona.

## Carles Casagemas (Barcelona, 1880–Paris, 1901)

Painter. After serving in the Spanish navy, Carles Casagemas i Coll turned to painting and became an active participant in the artistic activities of the Quatre Gats, where he met Pablo Picasso. Picasso became his close friend; they shared a studio that they decorated. Casagemas accompanied Picasso on his first trip to Paris, where they visited the Universal Exposition (1900) with other Catalan artists including Ramon Pichot. In Paris Casagemas developed an obsession with Germaine Gargallo—later Pichot's wife—but her rejection prompted his severe depression and suicide.

Cat. 3:30. *A Couple,* c. 1899, black ink and colored crayon on paper, 21.5 x 14.5 cm. Artur Ramon Collection, Barcelona. Photo © Fotografia Gasull.

## Enric Casanovas (Barcelona, 1882–1948)

Sculptor. Along with Josep Clarà, Enric Casanovas i Roy was a renowned noucentista sculptor, and his works, with their graceful female figures, are characteristic of the classicizing aesthetic of the time. Casanovas gained his early training in the studio of Josep Llimona in 1896. He also studied at La Llotja, where he achieved recognition and was awarded a travel grant to visit art collections in Europe. He traveled to Paris and other countries in 1900, returning to Barcelona in 1903 and exhibiting at the Quatre Gats. Casanovas participated in the first annual exhibition of Les Arts i els Artistes in 1910. He also traveled to London and Paris in the first decades of the 20th century, where he was inspired by the antiquities of the British Museum and the works of Auguste Rodin. Aristide Maillol (1861–1944) and Pablo Picasso greatly influenced his sculptures during this period. The 1905 exhibition of ancient Iberian sculptures at the Louvre and the numerous Greek and Roman excavations in Catalonia inspired his enthusiasm for Mediterranean classicism. In Barcelona his sculptures garnered awards at numerous exhibitions and positive critical reviews by art critics and theorists including Eugeni d'Ors (1881–1954) and Josep M. Junoy. Casanovas was also a leading member at Barcelona's Escola de Decoració, directed by Joaquín Torres-García. Together with Joaquim Sunyer, Casanovas set up a studio in Majorca for two years, continuing to sculpt using the local stone. During the war he was a supporter of the republic and afterward was exiled in France, living in Avignon, Paris, and Besançon until 1942, when he returned to Spain and was briefly imprisoned.

Cat. 6:12. *Youth and Love*, c. 1914, marble, 66 x 58 x 17 cm. Museu Nacional d'Art de Catalunya, Barcelona. Photo © MNAC–Museu Nacional d'Art de Catalunya, 2006, photo Calveras/Mérida/Sagristà.

Cat. 6:13. *Persuasion*, c. 1913, marble, 28 x 15 x 22 cm. Museu Nacional d'Art de Catalunya, Barcelona. Photo © MNAC–Museu Nacional d'Art de Catalunya, 2006, photo Calveras/Mérida/Sagristà.

## Ramon Casas (Barcelona, 1866–1932)

Painter and poster designer. Ramon Casas i Carbó was one of the leading modernista painters in Barcelona. Casas supposedly began painting at the age of seven and was first apprenticed to Joan Vicens (1830–1886). In 1882 he traveled to Paris to study with Emile-Auguste Carolus-Duran (1837–1917). Casas also frequented the Gervex Academy, where Pierre Puvis de

Chavannes (1824–1898) taught. In Paris he adopted many aspects of Impressionist painting, but his principal subjects were portraits and figural genre scenes. He exhibited at the National Salon and other Parisian venues in addition to sending his works for exhibition in Barcelona. Between 1890 and 1894 he shared a studio in Montmartre with Santiago Rusiñol and Miquel Utrillo. Together they joined the daily artistic life of La Butte, befriending many artists, poets, writers, and musicians, including Erik Satie, and deriving inspiration from the art of J. A. M. Whistler (1834–1903), Henri de Toulouse-Lautrec (1864–1901), and John Singer Sargent (1856–1925). In 1894 Casas returned to Barcelona, helping build the modernista movement in painting with landmark exhibitions in Sitges. In

1897 he helped establish the artists' café and bar the Quatre Gats, along with the art magazine of the same name. He also contributed to the magazines *Pèl & Ploma* and *Forma*. He painted several works documenting historic contemporary events in Barcelona and became especially known for his portraits and posters, which honed a relationship with Pablo Picasso. In February 1900 Picasso exhibited a series of charcoal portraits of fellow artists including Casas—a gesture of both respect for and rivalry toward Casas. During his later years, Casas devoted himself increasingly to portraiture, often commissioned by wealthy clients including Charles Deering—an artist-patron friendship that precipitated many trips to the United States and Europe.

Cat. 2:1. *Santiago Rusiñol*, 1889, oil on canvas, 166 x 96 cm. Private collection. Photo © Fotografia Gasull.

Cat. 2:2. *The Bohemian (Erik Satie in Montmartre or Erik Satie)*, 1891, oil on canvas, 198.9 x 99.7 cm. Northwestern University Library, Evanston, Illinois.

Cat. 2:4. *Dance at the Moulin de la Galette*, c. 1890–91, oil on canvas, 100 x 81.5 cm. Museu Cau Ferrat, Consorci del Patrimoni de Sitges.

Cat. 2:7. *At the Moulin de la Galette (Madeleine or Absinth)*, 1892, oil on canvas, 117 x 90 cm. Museu de Montserrat, Gift of J. Sala Ardiz, Montserrat.

Cat. 2:20. Masthead design for *Pèl & Ploma*, 1899, charcoal, conté pencil, ink on paper, 25.6 x 47.7 cm. Museu Nacional d'Art de Catalunya, Barcelona. Photo © MNAC–Museu Nacional d'Art de Catalunya, 2006, photo Calveras/Mérida/Sagristà.

Cat. 2:21. Cover for *Pèl & Ploma* 1, no. 11 (12 August 1899), magazine, 38 x 55 cm. Jake and Nancy Hamon Arts Library, Southern Methodist University, Dallas. Photo © Tom Jenkins.

Cat. 2:22. Cover for *Pèl & Ploma* 3, no. 16 (June 1901–May 1902), magazine, 20 x 55 cm. Jake and Nancy Hamon Arts Library, Southern Methodist University, Dallas. (Cleveland only.) Photo © Tom Jenkins.

Cat. 3:3. *Ramon Casas and Pere Romeu on a Tandem*, 1897, oil on canvas, 191 x 215 cm. Museu Nacional d'Art de Catalunya, Barcelona. Photo © MNAC–Museu Nacional d'Art de Catalunya, 2006, photo Calveras/Mérida/Sagristà.

Cat. 3:5. *Manolo Hugué*, c. 1897–99, charcoal, pastel, and ink on paper, 62 x 29 cm. Museu Nacional d'Art de Catalunya, Barcelona. Photo © MNAC–Museu Nacional d'Art de Catalunya, 2006, photo Calveras/Mérida/Sagristà.

Cat. 3:6. *Joaquín Torres-García*, 1901, charcoal, 62.5 x 31 cm. Museu Nacional d'Art de Catalunya, Barcelona. Photo © MNAC–Museu Nacional d'Art de Catalunya, 2006, photo Calveras/Mérida/Sagristà.

Cat. 3:7. *Pablo Picasso*, 1900, charcoal and pastel on paper, 77.8 x 47 cm. Museu Nacional d'Art de Catalunya, Barcelona. Photo © MNAC–Museu Nacional d'Art de Catalunya, 2006, photo Calveras/Mérida/Sagristà.

Cat. 3:8. *Pere Romeu*, c. 1897–99, charcoal, pastel, and ink on paper, 62 x 29.5 cm. Museu Nacional d'Art de Catalunya, Barcelona. Photo © MNAC–Museu Nacional d'Art de Catalunya, 2006, photo Calveras/Mérida/Sagristà.

Cat. 3:22. *Quatre Gats*, 1897, chromolithograph, 62 x 37 cm. Alberto Oller y Garriga Collection, Barcelona. Photo courtesy D'Onofrio&Sanjuán.

Cat. 3:24. Cover for *Quatre Gats: publicació artística-literària*, no. 1 (second week of February 1899) (Barcelona), magazine, 39 x 27.6 cm. Universitat de Barcelona, CRAI, Biblioteca de Lletres. Photo © Universitat de Barcelona.

Cat. 3:27. With Miquel Utrillo, *Shadows, Quatre Gats*, 1897, chromolithograph, 66 x 90 cm. Marc Martí Collection, Barcelona.

Cat. 4:1. *Interior in the Open Air*, 1892, oil on canvas, 160.5 x 121 cm. Carmen Thyssen-Bornemisza Collection, Museu Nacional d'Art de Catalunya, Barcelona.

Cat. 4:2. *Elisa Casas,* 1895, oil on canvas, 200 x 100 cm. Josep Codina Collection, Lleida.

Cat. 4:4. *The Garroting,* 1894, oil on canvas, 127 x 166.2 cm. Museo Nacional Cetnro de Arte Reina Sofia, Madrid. Photo © Archivo Fotográfico Museo Nacional Centro de Arte Reina Sofía, Madrid.

See also Picasso, cat. 3:23.

## M. A. Cassanyes (Sitges, 1893–Barcelona, 1956)

Art critic. Magí Albert Cassanyes i Mestre was a contributor to numerous Catalan avant-garde art journals of the early 20th century, such as *L'Amic de les Arts* and *D'Ací d'Allà.* He curated several modernista exhibitions at the Galeries Dalmau, introducing Barcelona artists to the wider European avant-garde.

Cat. 7:43. With J. Viola Gamon (texts), *Catalogue of the Exposició Logicofobista,* Galeria d'Art de la Llibreria Catalònia, Barcelona: ADLAN, May 1936, 30.5 x 25.4 cm. Yolanda Garcia-Lamolla Collection, Lleida. Photo courtesy Arxiu Leandre Cristòfol, Museu d'Art Jaume Morera, Lleida.

## Pere Català-Pic (Valls, 1889–Barcelona, 1971)

Photographer. Inspired by the photography of Man Ray (1890–1976) and by ethnographical images in particular, Pere Català i Pic specialized in highly inventive photography for the advertising world, assisting with numerous campaigns for much of his career. During the 1930s he was in charge of publications for the Generalitat's Comissariat de Propaganda.

Cat. 7:40. *Billy,* 1935–36, bromide print, 29 x 19.5 cm. Museu Nacional d'Art de Catalunya, Barcelona, Dipòsit Fons d'Art de la Generalitat de Catalunya. Photo © MNAC–Museu Nacional d'Art de Catalunya, 2006, photo Calveras/Mérida/Sagristà.

Cat. 7:41. *Desire to Fly,* 1931, bromide print, 27.2 x 37 cm (printed by Pere Català Roca, 1969). IVAM–Instituto Valenciano de Arte Moderno, Generalitat, Valencia.

Cat. 9:12. *Let's Crush Fascism,* 1936, one-ink offset print, 96.5 x 67.7 cm. IVAM–Instituto Valenciano de Arte Moderno, Generalitat, Valencia.

## Ildefons Cerdà (El Cerdà de la Garga, Centelles, 1815–Caldas de Besaya, Santander, 1876)

Engineer, urban planner, theorist, and politician. Ildefons Cerdà i Sunyer's urban plan for Barcelona established the fundamental design that governed the city's expansion in the late 19th century. Extremely active politically, Cerdà translated his progressive opinions into urban plans that were rational and democratic. Based on a grid system, his plan for Barcelona was designed to be egalitarian and facilitate traffic flow in the area later known as the Eixample. Cerdà initially trained as an engineer in Madrid before moving to Barcelona in 1849 as an engineer of the state. Years of experience in government posts in Barcelona and an eagerness to reform the city prompted Cerdà to submit his urban plan to the central government in Madrid; his idea was approved over another entry by Antoni Rovira i Trias (1816–1889). In 1867 Cerdà published *Teoría general de la urbanización,* a seminal text for urban designers. Late in life Cerdà focused his career on the political front, serving, for example, as president of the Barcelona Regional Council. Weakened by the political events of 1874 and the coup d'etat of General Manuel Pavía, Cerdà sought refuge and lived his last years in the town of Santander.

Cat. 1:1. *Plan of the Outskirts of Barcelona and Proposal for the Reform and Expansion of the City by the Highway, Canal, and Port Engineer Ildefons Cerdà,* 1859, lithograph, 77 x 116 cm. Museu d'Història de la Ciutat de Barcelona.

## Josep Clarà (Olot, 1878–Barcelona, 1958)

Sculptor. Inspired by the classicizing art of such sculptors as Aristide Maillol, Emile Bourdelle (1861–1929), and Auguste

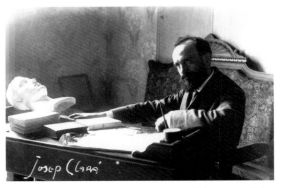

Rodin, Josep Clarà i Ayats created many of the most celebrated sculptures of the Catalan noucentista movement. Eugeni d'Ors, who initiated Noucentisme with *La Veu de Catalunya,* championed Clarà's role in furthering the movement in Barcelona. Clarà studied drawing at the Escola d'Arts i Oficis de la Generalitat in Olot before learning how to sculpt at the École Supérieure des Beaux-Arts in Toulouse. In 1900 he moved to Paris, where he worked in the studio of Louis-Ernest Barrias (1841–1905) and had the opportunity to work in the studio of Rodin. While in Paris Clarà also exhibited at numerous salons, including the Salon de la Société Nationale (1908), where his work received several prizes. He became friends with Isadora Duncan, and his many drawings of her reflect an interest in the dynamism of dance. He traveled to the United States, Greece, and Italy, after which his work took a distinctly classical turn, and his sculptures became influenced by Michelangelo (1475–1564). In the early 1930s Clarà settled permanently in Barcelona and became active in Les Arts i els Artistes. His late subjects were mainly of a religious nature, with a particular emphasis on the Madonna and Child.

Cat. 6:31. *The Goddess,* 1928, marble, 39.5 x 20.4 x 23 cm. Museu Nacional d'Art de Catalunya, Barcelona. Photo © MNAC–Museu Nacional d'Art de Catalunya, 2006, photo Calveras/Mérida/Sagristà.

## Antoni Clavé (Barcelona, 1913–Saint Tropez, 2005)

Painter, sculptor, graphic artist, and stage designer. Antoni Clavé i Sanmartí studied at La Llotja in Barcelona. Originally he worked for an interior decorator; later he also designed posters for Cinematografía Nacional Española and Metro Goldwyn Mayer. During the Spanish civil war, he fought in the republican army and was interned briefly in a refugee camp. He fled to France after the war, arriving in Paris in April 1939. There he focused his artistic energies mainly on works on paper—prints in particular. He also experimented with theater design for operas such as *Carmen* and *The Marriage of Figaro,* and worked on large still lifes, tapestries, and sculptures. Pablo Picasso, Georges Rouault (1871–1958), and Chäim Soutine (1893–1943) influenced Clavé in Paris. By the mid 1950s he had dedicated his career to painting, creating collages, abstract works, and sculptures of found objects.

Cat. 9:9. *Theater from and for the War,* 1938, lithograph, 99 x 69 cm. Biblioteca del Pavelló de la República (Universitat de Barcelona), Fundació Privada Centre d'Estudis d'Història Contemporània–Biblioteca Josep M. Figueras, Barcelona. © 2006, Artists Rights Society (ARS), NY/ADAGP, Paris. Photo © Biblioteca del Pavelló de la República.

Cat. 9:44. *Man with a Monocle,* 1939, metal and wood, 65 x 52 x 9 cm. Private collection. © 2006, Artists Rights Society (ARS), NY/ADAGP, Paris.

Cat. 9:45. *Telephone,* 1939, wood and iron wire, 40 x 22 cm. Private collection. © 2006, Artists Rights Society (ARS), NY/ADAGP, Paris.

## Leandre Cristòfol (Os de Balaguer, 1908–1998)

Painter and sculptor. Known as one of the "Surrealists from Lleida"—along with Antoni G. Lamolla and Manuel Viola (1919–1987)—Leandre Cristòfol i Peralba was one of the most important Spanish Surrealists of the early 20th century

and an innovator in sculpture. Inspired by Marcel Duchamp (1887–1968), Alexander Calder (1898–1976), Francis Picabia, and the art theories of Josep Viola, Cristòfol's creations—with their unique use of such materials as wire and umbrella rods—garnered acclaim and embraced a new era of sculpture. Cristòfol initially trained as a carpenter at the art school in Lleida. Later he studied at the Escola Superior de Belles Arts de Sant Jordi in Barcelona, and participated in art shows in Lleida by 1933. He exhibited in the Exposició Logicofobista and was a member of ADLAN (Friends of New Art). He was also active in the European surrealist movement, exhibiting at the International Exposition of Surrealism in Paris (1938) as well as in Tokyo. The Spanish civil war stymied his career, and he spent a year in concentration camps in France and Morocco. He returned to Barcelona and then to Lleida, where he remained until his death. Throughout the 1970s, 1980s, and 1990s, exhibitions celebrated Cristòfol's art, and a large body of his work was acquired by the Lleida City Council. His last sculptures—innovations in metal—particularly exemplify the spirit of Dada. He was considered one of the "pillars of the Hispanic artistic vanguard."

Cat. 7:46. *Moonlit Night,* 1935, wood and glass, 42 x 32 x 22 cm. Museu d'Art Jaume Morera, Lleida. Photo courtesy Museu d'Art Jaume Morera (Antoni Lonca).

### Salvador Dalí (Figueres, 1904–1989)

Painter, sculptor, filmmaker, writer, and designer. Salvador Dalí i Domènech stretched the boundaries of artistic expression, experimenting with Noucentisme and Cubism, and devising a surrealist "paranoiac-critical" style and flamboyant persona. Dalí's early introduction to painting was through the Pichot family, his father's friends. In Figueres he trained at the municipal school of art. In Madrid he studied at the Real Academia de Bellas Artes de San Fernando—from which he was expelled—and became a member the Generation of '27. He developed close ties with Luís Buñuel (1900–1983), collaborating with him on *Un Chien andalou* and *L'Âge d'or.* In November 1925 he held his first solo exhibition at the Galeries Dalmau, followed by another a year later. He contributed regularly to *L'Amic de les Arts* and, with Sebastià Gasch and Lluís Montanyà, wrote the *Manifest groc* (1928); from then on he was considered the epitome of the surrealist artist, championed by André Breton (1896–1966). His wife, Gala Éluard, became a prominent fixture in his paintings. The couple visited the United States in 1934 and again in the early 1940s and lived there for eight years. During this period Dalí met the Cleveland collectors Reynolds and Eleanor Morse, who became lifelong friends and patrons, and he collaborated on films with directors such as Alfred Hitchcock and Walt Disney. The publication of his autobiography, *The Secret Life of Salvador Dalí* (1942), fed into his widespread critical reception and self-promotion. In 1948 he settled in Portlligat, near Figueres, and entered what he called a "mystic" period, drawing inspiration from fellow Spanish artists such as Francisco de Zurbarán (1598–1664) and Bartolomé Esteban Murillo (1618–1682). To perpetuate his legacy, Dalí founded a museum in Figueres devoted to his art; it opened in 1974, and he was buried there in 1989.

Cat. 6:23. *Cadaqués,* 1923, oil on canvas, 96.5 x 127 cm. Salvador Dalí Museum, St. Petersburg, Florida. (Cleveland only.) © 2005 Salvador Dalí, Gala-Salvador Dalí Foundation/Artists Rights Society (ARS), NY. © 2005 Salvador Dalí Museum, Inc.

Cat. 6:24. *Luis Buñuel,* 1924, oil on canvas, 68.5 x 58.5 cm. Museo Nacional Centro de Arte Reina Sofia, Madrid. (New York only.) © 2006 Salvador Dalí, Gala-Salvador Dalí Foundation/Artists Rights Society (ARS), NY. Photo © Archivo Fotográfico Museo Nacional Centro de Arte Reina Sofía.

Cat. 6:25. *Figure at a Window (Girl at a Window),* 1925, oil on masonite, 105 x 74.5 cm. Museo Nacional Centro de Arte Reina Sofia, Madrid. (New York only.) © 2006 Salvador Dalí, Gala-Salvador Dalí Foundation/Artists Rights Society (ARS), NY. Photo © Archivo Fotográfico Museo Nacional Centro de Arte Reina Sofía.

Cat. 6:26. *Maria Carbona,* 1925, verso: *Still Life (fragment),* 1924, oil on canvas, 52 x 39.2 cm. The Montreal Museum of Fine Arts, Museum of Fine Arts' Volunteer Association Fund. (Cleveland only.) © 2006 Salvador Dalí, Gala-Salvador Dalí Foundation/Artists Rights Society (ARS), NY. Photo © The Montreal Museum of Fine Arts, Christine Guest.

Cat. 7:28. *Bird . . . Fish,* c. 1928, oil and collage of sand and gravel on panel, 61 x 49 cm. The Salvador Dalí Museum, St. Petersburg, Florida. © 2005 Salvador Dalí, Gala-Salvador Dalí Foundation/Artists Rights Society (ARS), NY. © 2005 The Salvador Dalí Museum, Inc.

Cat. 7:30. With Sebastià Gasch and Lluís Montanyà, *Manifest groc (Yellow Manifesto)* (1928). Biblioteca de Catalunya, Barcelona. © 2006 Salvador Dalí, Gala-Salvador Dalí Foundation/Artists Rights Society (ARS), NY. Photo courtesy Biblioteca de Catalunya.

Cat. 7:31. "The Moral Position of Surrealism," *Hèlix,* no. 10 (February 1930) (Vilafranca del Penedès), pp. 4–5, magazine, 30 x 26 x 1 cm. Biblioteca de Catalunya, Barcelona. (Not illustrated.)

Cat. 7:33. *Accommodations of Desire,* 1929, oil on canvas, 22 x 35 cm. The Metropolitan Museum of Art, New York, Jacques and Natasha Gelman Collection, 1998. © 2006 Salvador Dalí, Gala-Salvador Dalí Foundation/Artists Rights Society (ARS), NY. Photo by Malcolm Varon © 1988 The Metropolitan Museum of Art.

Cat. 7:35. *The Dream,* 1931, oil on canvas, 96 x 96 cm. The Cleveland Museum of Art, John L. Severance Fund. © Salvador Dalí, Gala–Salvador Dalí Foundation/Artists Rights Society (ARS), NY.

Cat. 7:37. Text with photographs by Man Ray, "On the Terrifying and Edible Beauty of Architecture in the 'Modern' Style," *Minotaure,* no. 3–4 (12 December 1933) (Paris), pp. 70–71, magazine, 31.7 x 25.4 cm. The Cleveland Museum of Art, Ingalls Library, Gift of Mr. and Mrs. Henry S. Francis. © 2006 Salvador Dalí, Gala-Salvador Dalí Foundation/Artists Rights Society (ARS), NY. © 2006 Man Ray Trust/Artists Rights Society (ARS), NY/ADAGP, Paris.

Cat. 7:38. Text with photographs by Man Ray, "The Phenomenon of Ecstasy," *Minotaure,* no. 3–4 (12 December 1933) (Paris), pp. 76–77, magazine, 31.7 x 25.4 cm. The Metropolitan Museum of Art, New York, Thomas J. Watson Library, purchase Jacob S. Rogers Fund. © 2006 Salvador Dalí, Gala-Salvador Dalí Foundation/Artists Rights Society (ARS), NY. © 2006 Man Ray Trust/Artists Rights Society (ARS), NY/ADAGP, Paris.

Cat. 9:1. *Soft Construction with Boiled Beans (Premonition of Civil War),* 1936, oil on canvas, 100 x 99.8 cm. Philadelphia Museum of Art, The Louise and Walter Arensberg Collection. © 2006 Salvador Dalí, Gala-Salvador Dalí Foundation/Artists Rights Society (ARS), NY. Photo by Graydon Wood, 1995.

See also Miró, cat. 7:29.

### Lluís Domènech i Montaner (Barcelona, 1849–1923)

Architect, historian, and politician. One of the most successful Catalan modernista architects, Lluís Domènech i Montaner designed many of the most beautifully extravagant buildings in Barcelona, including the Palau de la Música Catalana. The son of a bookbinder, Domènech learned early about graphic  arts and design in the spirit of La Renaixença. He graduated from the school of architecture in Madrid in 1873. Later he became professor and director of Barcelona's Escola Superior d'Arquitectura, a position that he held for much of his life. The Universal Exposition (Barcelona, 1888) presented him with several opportunities for innovative architecture;

his designs for the Cafè-Restaurant, among other buildings, catapulted him into the international limelight. Other architectural examples by Domènech include post-1900 buildings such as the Hospital de la Santa Creu i Sant Pau and Casa Lleó Morera, both of which exhibit the architect's signature use of brick, colorful ceramics, and wrought iron. His workshop with Antoni M. Gallissà (1861–1903) became renowned. Domènech was also politically active and an advocate for Catalan autonomy. Early in his career he was a member of the Centre Català and the Lliga de Catalunya. He also wrote many histories of Catalonia and published articles in many of the most popular journals of the day. In recognition of his endeavors for the city of Barcelona, Domènech was elected president of the Ateneu Barcelonès numerous times and was granted awards from Barcelona's Royal Academy of the Natural Sciences and the Arts, among others.

Cat. 1:5. *La Renaixensa: Diari de Catalunya,* 9 May 1881 (Barcelona), masthead designed in 1880, newspaper, 23 x 16 x 6 cm. Biblioteca de Catalunya, Barcelona. Photo courtesy Biblioteca de Catalunya.

Cat. 1:8. *Rooster Greeting the Dawn,* 1892, iron, 76.2 x 60.9 x 50.8 cm. Casa-Museu Domènech i Montaner, Canet de Mar. Photo © Pere Vivas and Jordi Puig, Triangle Postals, Barcelona.

Cat. 5:8. *Project to Reform the Façade of Casa Lleó Morera, Barcelona,* 1903, ink on canvas paper, 91 x 62.5 cm. Ajuntament de Barcelona, Arxiu Municipal Administratiu. Photo © Pep Parer-fotògraf.

Cat. 5:12. *Palau de la Música Catalana, Original Project for the Façades,* c. 1908, blueprint, 101.5 x 69 cm. Arxiu Històric del Col·legi Oficial d'Arquitectes de Catalunya, Barcelona.

Cat. 5:13. After Lluís Domènech i Montaner, *Cross Section Model of Palau de la Música Catalana, 1905–8,* model made by Juan Pablo Marín in 1989–90, plastic fiber and plaster, 120 x 200 x 40 cm. Casa-Museu Domènech i Montaner, Canet de Mar. (Not illustrated.)

Cat. 5:14. *Transparent Yellow Glass Balusters from the Palau de la Música Catalana,* c. 1905, metal, ceramic, and glass, 39.2 x 60.6 x 16.5 cm. Casa-Museu Domènech i Montaner, Canet de Mar. Photo © Pere Vivas and Jordi Puig, Triangle Postals, Barcelona, 2006.

Cat. 5:15. *Ceramic Architectural Ornament with Musical Notes,* c. 1906, ceramic, 50.8 x 76.2 cm. Fundació Orfeó Català–Palau de la Música Catalana, Barcelona. Photo © Pep Parer-fotògraf.

Cat. 5:16. *Floor Tile No. 1019,* 1900, produced by Escofet, Tejera i Cia., hydraulic mosaic, 114.3 x 165.1 cm. Museu Nacional d'Art de Catalunya, Barcelona. Photo © MNAC–Museu Nacional d'Art de Catalunya, 2006, photo Calveras/Mérida/Sagristà.

### Feliu Elias (Barcelona, 1878–1948)

Painter, art critic, caricaturist, and writer. Feliu Elias i Bracons was known not only as the foremost political caricaturist in Catalonia, but also as a precursor to the European and American Neo-Objectivists and as a painter aligned with Neue Sachlichkeit ideals. Elias studied at the Hoyos Painting Academy and the Cercle Artístic de Sant Lluc in Barcelona. In 1910 he traveled to Paris and became aware of French

avant-garde movements, especially the art of Pablo Picasso. He exhibited at the Galeries Dalmau and the Faianç Català (renamed the Galeries Laietanes in 1915) with Les Arts i els Artistes. Although Elias did not officially join the noucentista movement, Barcelona art critics such as Eugeni d'Ors considered Elias's art under that rubric. His caricatures—signed under the pseudonym "Apa"—appeared in journals such as *¡Cu-cut!, La Publicitat,* and *Papitu* (edited by Elias) as well as in Parisian journals such as *Paris-Midi.* A leading political caricaturists, he won the Legion of Honor medal for his book of caricatures, *Kameraden* (1917). As an art critic—signing under the pseudonym "Joan Sacs"—he also contributed to *Vell i Nou* and *Revista Nova.* He published his art theories in *La pintura francesca moderna fins al cubisme,* as well as numerous monographs on his friends and contemporaries, including Xavier Nogués. He taught art history at the Escola Superior dels Bells Oficis. At the end of the 1930s, Elias fled to France but later returned to Barcelona.

Cat. 6:27. *The Gallery,* 1928, oil on wood, 63 x 52 cm. Museu Nacional d'Art de Catalunya, Barcelona. Photo © MNAC–Museu Nacional d'Art de Catalunya, 2006, photo Calveras/Mérida/Sagristà.

### Francesc Elias (Sabadell, 1892–Reus, 1991)

Potter, glass painter, and sketcher. Francesc Elias i Bracons was the brother of the artists Feliu and Lluís (1886–1953) Elias. He studied at Golfe Joan with Charles L'Hospied and at Burjassot with Francesc Quer (1858–1933), working with Quer in Rio de Janeiro in 1911. The next year he established a pottery branch of the Prada workshop of Gustau Violet (1873–1952), followed by pottery factories and workshops in Ernani (1919), Manises (1921), and Cerdanyola (1930)—the latter with Violet. He also set up a workshop of ornamental pottery in Cornellà de Llobregat in 1945, later moving it to Sant Just Desvern. He exhibited his drawings and glass works for the first time in Barcelona in 1917. He cofounded the Evolutionists and contributed to the journal *Un enemic del Poble.* During the 1940s and 1950s, he held exhibitions in Barcelona, Vilafranca del Penedès, Olot, Figueres, Reus, and Montecarlo. Two large stained-glass windows at La Barata, made in collaboration with Josep Obiols, are among his works.

Cat. 6:57. *Covered Jar,* 1932, glazed stoneware, 28.3 x 20.8 cm. Museu de Ceràmica, Barcelona. Photo © Guillem.

### Lambert Escaler (Vilafranca del Penedès, 1874–Barcelona, 1957)

Sculptor, decorative artist, and writer. Best known for his modernista polychromatic terracotta sculptures of women, Lambert Escaler i Milà originally worked as a writer of comedies. He trained in the sculpture studio of Josep Campeny (1858–1922). During his career Escaler also created dioramas and papier-mâché figures.

Cat. 5:18. *Jardinière,* c. 1903, polychrome terracotta, 27 x 40.5 x 27.5 cm. Museu Nacional d'Art de Catalunya, Barcelona. Photo © MNAC–Museu Nacional d'Art de Catalunya, 2006, photo Calveras/Mérida/Sagristà.

### Apel·les Fenosa (Barcelona, 1899–Paris, 1988)

Sculptor. Apel·les Fenosa i Florensa spent much of his early career destitute and poor, suffering from trembling in his left hand. In 1917–18 he attended the Escola d'Arts i Oficis, which offered vocational training in construction, industry, and the graphic arts; his drawing teacher was Francesc Labarta (1883–1963). He gained more practical training at the studio of Enric Casanovas, where he was introduced to Manolo and Antoni Gaudí. Influenced by Labarta, he joined the Evolutionists group in Barcelona that included the sculptor Joan Rebull. Fenosa moved to France to escape military service and worked as a plasterer's assistant in Toulouse, retouching numerous religious sculptures. Determined to become a professional sculptor, he went to Paris, where he visited the Louvre and his compatriot Pere Pruna (1904–1977), who introduced

him to Pablo Picasso. Fenosa stated, "Everything began for me with Picasso when he gave me his encouragement in 1923." Picasso also gave him financial support to get his career started: "If it hadn't been for Picasso, I would never have done anything." Fenosa first exhibited at the Galerie Percier in 1924. He met numerous collectors, including Jacques Guérin and Jean Cocteau. He also befriended the d'Albis family, a relationship that sustained him for the rest of his career. He exhibited at the most important European galleries, including the Galerie Zborowski in Paris and the Sala Parés in Barcelona. Fenosa left Versailles at the onset of World War II, rejoining Coco Chanel—with whom he had a brief affair—Cocteau, and Picasso in Paris. In 1940 he and Picasso sculpted busts of each other—now lost. He married in 1948, and he and his wife, Nicole, visited friends and collectors throughout Spain, England, the Netherlands, Italy, Japan, and Cambodia. The couple settled in El Vendrell, Spain, entertaining collectors, artists, and writers. Late in life Fenosa was the subject of numerous monographs and exhibitions.

Cat. 6:30. *Head of Marthe Morère,* 1927, stone, 42.5 x 22 x 23 cm. Private collection, Paris.© Artists Rights Society (ARS), NY/ADAGP, Paris.

### Esteve Francés (Portbou, 1913–Barcelona, 1976)

Painter. One of the leading painters of the Catalan surrealist movement, Esteve (Esteban) Francés initially studied at La Llotja. He later shared a studio with Remedios Varo and participated in the Exposició Logicofobista of 1936. He fought in the Spanish civil war, after which he sought refuge in France and joined the Parisian surrealist movement. With the approach of the German army on Paris in 1940, Francés fled to Mexico, where he was welcomed by Diego Rivera (1886–1957) and José Clemente Orozco (1883–1949) and where he taught at the Escuela de Bellas Artes. He also participated in the International Exposition of Surrealism (Mexico City, 1940). Francés moved to the United States after World War II, settling in New York. There he was celebrated for his work in costume and theater design for the ballet. He eventually returned to Spain, living first in Majorca and then in Barcelona.

Cat. 7:36. *Surrealist Composition,* 1932, oil on canvas, 58.5 x 72.5 cm. Galería Rafael Pérez Hernando, Madrid.

### Francesc Galí (Barcelona, 1880–1965)

Painter, draftsman, and art educator. An influential art teacher in Barcelona, Francesc d'Assís Galí i Fabra was initially trained in architecture at La Llotja. Inspired by the paintings of Ramon Casas and Santiago Rusiñol and the graphic art of Alexandre de Riquer, Galí developed his own Art Nouveau and modernista style. He became a member of the Cercle Artístic de Sant Lluc and at the age of 26 founded his own school where he encouraged the reading of John Ruskin. His pupils included Josep Aragay, Jaume Mercadé, E. C. Ricart, and Joan Miró. Galí was an influential leader in Noucentisme and designed several covers for *Vell i Nou.* He directed the Escola Superior de Belles Arts until 1924 and was later appointed general director of the fine arts of the Spanish republic. After the Spanish civil war, he lived in exile in London and Hampstead, England.

Cat. 6:34. Cover for *Vell i Nou* 1, no. 1 (15 May 1915) (Barcelona), journal, 30.5 x 25.4 cm. Mercè Vidal Collection, Esplugues de Llobregat.

### Pablo Gargallo (Maella, 1881–Reus, 1934)

Sculptor and designer. Pablo (Pau) Gargallo i Catalán was a transitional figure, his long career overlapping with Catalan Modernisme, Symbolism, Noucentisme, and Cubism. He integrated these diverse styles into his copper and iron constructions. Gargallo initially trained in the workshop of Eusebi Arnau, whose connections with Lluís Domènech i Montaner led to Gargallo's later collaboration with the architect on sculptures for the Palau de la Música Catalana, among other structures. Frequenting the Quatre Gats, Gargallo met Pablo

Picasso, Isidre Nonell, Ricard Canals, and Manolo. He studied at La Llotja and in 1902 won a travel grant to visit Paris, where he saw the sculpture of Auguste Rodin. His first solo exhibition occurred in 1906 at the Sala Parés. In 1907 Gargallo began experimenting with various metals and made his first mask in copper. Between long sojourns in Paris, Gargallo taught as a professor at Barcelona's Escola Superior dels Bells Oficis. He was head of the sculpture department from 1921 to 1923 and branched out into jewelry design. He married Magali Tartanson in 1915, and they moved to Paris in 1924. In 1929 he was commissioned to produce sculptures for the Barcelona International Exposition (1929–30). The Salon d'Automne (1935) held a retrospective of his work, and the city of Zaragosa opened a museum devoted to his art in 1985.

Cat. 3:33. *En Nogueras,* 1900, verso *Young Man with Hat in His Hand,* 1900, charcoal and pastel on Ingres paper, 49.9 x 47.5 cm. Museo Pablo Gargallo, Ayuntamiento de Zaragoza. © Artists Rights Society (ARS), NY/ADAGP, Paris. Photo © Foto-Estudio Guillermo, Pedro Jose Fatás.

Cat. 6:32. *Young Woman's Torso,* 1933, pink marble, 84.5 x 24.3 x 20.5 cm. The Artist's Family. © Artists Rights Society (ARS), NY/ADAGP, Paris.

Cat. 6:36. Front page for *Revista Nova,* no. 45 (31 December 1916) (Barcelona), magazine, 38 x 28 cm. Biblioteca de Catalunya, Barcelona. © Artists Rights Society (ARS), NY/ADAGP, Paris. Photo courtesy Biblioteca de Catalunya.

Cat. 7:5. *Mask with Lock of Hair,* c. 1911 (enlargement of 1907 version), tin and copper, 22.2 x 16.5 x 8.8 cm. Hirshhorn Museum and Sculpture Garden, Smithsonian Institution, The Joseph H. Hirshhorn Bequest, 1981. (Cleveland only.) © Artists Rights Society (ARS), NY/ADAGP, Paris. Photographer: Ricardo Blanc.

Cat. 7:7. *Woman's Torso,* 1915, copper, 29.5 x 17.6 x 11.6 cm. The Artist's Family. © Artists Rights Society (ARS), NY/ADAGP, Paris. Photo (C. F. Walch) © ADAGP.

Cat. 7:54. *Homage to Chagall,* 1933, bronze, 38 x 22 x 21.5 cm. The Artist's Family. (Cleveland only.) © Artists Rights Society (ARS), NY/ADAGP, Paris.

### Antoni Gaudí (Reus, 1852–Barcelona, 1926)

Architect and designer. Considered the "most Catalan of all Catalans" by his contemporaries, Antoni Gaudí i Cornet was one of the most original and inventive architects in the history of art. He trained at the Escola Superior d'Arquitectura in 1873, supplementing his formal education by reading philosophers and art theorists such as John Ruskin. During his early career he worked as a draftsman for several architects, including Joan Martorell (1833–1906) and Francisco de P. del Villar (1828–1901); collaborated with Josep Fontserè i Mestre (1829–1897) on the Parc de la Ciutadella; designed lampposts; and built the factory and two housing units for a planned neighborhood called L'Obrera Mataronense, which reflects his admiration for cooperative ideals. The industrialist Eusebi Güell and his family commissioned Gaudí to design, among other structures, the pavilions at Güell Estate, the Palau Güell, the Colònia Güell Crypt, and Park Güell. Gaudí's other landmark architectural structures in Barcelona include Casa Vicens, Casa Calvet, Casa Batlló, and Casa Milà. Imaginative

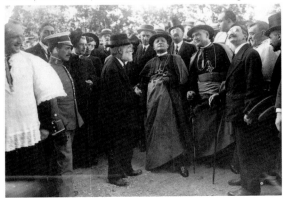

and organic forms inspired by direct observation of nature characterize this period of intense activity. He paid special attention to developing the trades and applied arts by inventing mechanisms, systems, and architectural elements, and by ensuring the strict material execution of projects and the finishing of interiors. The church of La Sagrada Família marked his effort to overcome historical styles and develop his own plasticity and structural forms—the two most basic elements of his style. Gaudí devoted the final years of his life to completing La Sagrada Família, where he achieved a figurative-structural synthesis expressed in the naves of the church and the towers of the Nativity façade. Only a fraction had been built when he was struck and killed by a street tram in 1926.

Cat. 5:47. *Palau Güell, Dressing Table,* c. 1889, made by F. Vidal i Cia., wood, brass, and glass, 120 x 130 x 65 cm. Property of the Güell Family, Barcelona. Photo © Ramon Manent.

Cat. 5:48. *Casa Calvet, Armchair,* c. 1900–1901, made by Taller Casas i Bardés, oak, 101 x 67 x 57 cm. Casa-Museu Gaudí, Park Güell, Junta Constructora del Temple Expiatori de la Sagrada Família, Barcelona.

Cat. 5:49. *Casa Vicens, Fence Fragment,* c. 1883–85, made by Joan Oñó's workshop, wrought and cast iron, 145 x 168 x 15 cm. Casa-Museu Gaudí, Park Güell, Junta Constructora del Temple Expiatori de la Sagrada Família, Barcelona.

Cat. 5:50. *Casa Milà, Hexagonal Paving Tiles,* 1909 (designed for Casa Batlló in 1904), made by E. F. Escofet i Cia., terrazzo, 25 x 28.5 x 2 cm (each), 102.5 x 82 x 6.5 cm (mounted group). Museu Nacional d'Art de Catalunya, Barcelona. Photo © MNAC–Museu Nacional d'Art de Catalunya, 2006, photo Calveras/Mérida/Sagristà.

Cat. 5:51. *Park Güell, Trencadís,* c. 1903, made by Hijo de Jaime Pujol y Bausis factory, Valencia tiles *trencadís* on brick, 54 x 57.5 x 10 cm. Reial Càtedra Gaudí, Barcelona.

Cat. 5:57. *Casa Batlló, Plans for the Façade,* 26 October 1904, ink and pencil on canvas paper, 47.5 x 78 cm. Ajuntament de Barcelona, Arxiu Municipal Administratiu. Photo © Pep Parer-fotògraf.

Cat. 5:60. *Double Folding Screen from Casa Milà,* 1909, oak and frosted glass, 196 x 400 cm. Private collection, courtesy the Allan Stone Gallery, New York.

Cat. 5:61. *Casa Batlló, Two-seat Sofa,* c. 1907, made by Taller Casas i Bardés, ash, 168 x 104 x 75 cm. Casa-Museu Gaudí, Park Güell, Junta Constructora del Temple Expiatori de la Sagrada Família.

Cat. 5:62. With Josep M. Jujol, *Casa Batlló, Door,* c. 1905, made by Taller Casas i Bardés, ash, 230.5 x 135 x 5 cm. Museu Nacional d'Art de Catalunya, Barcelona. Photo © MNAC–Museu Nacional d'Art de Catalunya, 2006, photo Calveras/Mérida/Sagristà.

Cat. 5:66. *Casa Milà, Elevation of the Façade,* 1906, black and red ink on paper, 58.5 x 93 cm. Reial Càtedra Gaudí, Barcelona.

Cat. 5:67. *Casa Milà, Plan for the Third Floor,* 1906, ink on cloth paper, 46 x 84 cm. Ajuntament de Barcelona, Arxiu Municipal Administratiu. Photo © Pep Parer-fotògraf.

Cat. 5:69. *Casa Milà Façade, Window Railing,* c. 1910, iron, 40 x 251 x 4 cm. Fundació Caixa Catalunya, La Pedrera, Barcelona. Photo © Xavier Padrós/Fundació Caixa Catalunya.

Cat. 5:70. *Casa Milà, Knob,* c. 1910, made by Mañach Smelting Works, brass, 4.5 x 5.1 x 4.6 cm. Fundació Caixa Catalunya, La Pedrera, Barcelona. Photo © Xavier Padrós/Fundació Caixa Catalunya.

Cat. 5:71. *Casa Milà, Spyhole Bolt,* c. 1910, made by Mañach Smelting Works, brass, 3.5 x 5 x 1.8 cm. Fundació Caixa Catalunya, La Pedrera, Barcelona. Photo © Xavier Padrós/ Fundació Caixa Catalunya.

Cat. 5:72. *Casa Milà, Knob,* c. 1910, made by Mañach Smelting Works, brass, 6 x 6 x 4.5 cm. Fundació Caixa Catalunya, La Pedrera, Barcelona. Photo © Xavier Padrós/Fundació Caixa Catalunya.

Cat. 5:73. *Casa Milà, Two-piece Door Handle,* c. 1910, brass, 7 x 10.5 x 2.5 cm. and 9 x 11 x 2 cm. Fundació Caixa Catalunya, La Pedrera, Barcelona. Photo ©Xavier Padrós/Fundació Caixa Catalunya.

Cat. 5:86. *Model of Finial for Spires from the Temple of La Sagrada Família,* c. 1920, original fragments with later additions, plaster, 35 x 16 x 9 cm. Museu de la Sagrada Família, Junta Constructora del Temple Expiatori de la Sagrada Família, Barcelona.

Cat. 5:87. *Model of Spires from the Temple of La Sagrada Família,* c. 1910, original fragments with later additions, plaster, 74 x 13 x 13 cm. Museu de la Sagrada Família, Junta Constructora del Temple Expiatori de la Sagrada Família, Barcelona.

Cat. 5:88a–b. *Model of a Column and Capital from the Temple of La Sagrada Família,* c. 1920, plaster, 52 x 8 x 8 cm. Museu de la Sagrada Família, Junta Constructora del Temple Expiatori de la Sagrada Família, Barcelona.

Cat. 5:89. *Model of the Nave Window for the Temple of La Sagrada Família,* 1957, plaster, 172.7 x 74.9 x 36.8 cm. The Museum of Modern Art, New York. (Not illustrated.)

Cat. 5:90. *Cast of Stars and Pigeons Finial Sculpture on the Temple of La Sagrada Família,* 1957, plaster, 45.7 x 208.3 cm. The Museum of Modern Art, New York. (Not illustrated.)

Cat. 5:91. *Model of Column for the Temple of La Sagrada Família,* 1957, plaster, 141.6 x 15.9 cm. The Museum of Modern Art, New York. (Not illustrated.) Digital image © The Museum of Modern Art/licensed by SCALA/Art Resource, NY.

Cat. 5:92. *Colònia Güell Chapel, Sketch of the Interior Nave on an Inverted Photograph of Its Polyfunicular Model,* c. 1910, serigraphy and gouache on photograph, 59.5 x 46 cm. Private collection, Barcelona.

Cat. 5:93. *Colònia Güell Chapel, Sketch of the Elevation of the Main Façade on an Inverted Photograph of Its Polyfunicular Model,* c. 1910, serigraphy and gouache on photograph, 61 x 47.5 cm. Private collection, Barcelona.

See also Mas, cats. 5:52–56, 5:58–59, 5:63–65, 5:83–85.

## Albert Gleizes (Paris, 1881–Avignon, 1953)

Painter, printmaker, and theorist. Albert Léon Gleizes was a founding member of the cubist group Section d'Or in Paris. Gleizes studied at the Collège Chaptal and apprenticed at his father's textile and design firm before serving in the military from 1902–5. He established the Association Ernest Renan in 1905 and the Abbaye de Créteil in 1906. Although he started his art career working in the Impressionist mode, he shifted to experiment with Cubism under the influence of artists whom he met via the Abbaye de Créteil, including Jean Metzinger (1883–1956). Gleizes exhibited with Metzinger and other Cubists at the Salon des Indépandants (1911) and, later, at the 1913 Armory Show in New York. Together Gleizes and Metzinger published the treatise *Du Cubisme* (1912). In 1914 he was conscripted to serve in the French military, after which he traveled to the United States. Gleizes visited Barcelona in 1916, exhibiting at the Galeries Dalmau. He traveled to the United States in 1917 and became extremely spiritual; his art, poetry, and theoretical writing at this time, such as *La Peinture et ses lois* and *Homocentrisme,* were infused with his belief in the strong power of art in society. In the last decades of his life, Gleizes established an artistic and intellectual commune in France.

Cat. 7:8. *Jean Cocteau,* 1916, oil and plaster on canvas, 116 x 80 cm. Cubism Collection, Fundación Telefónica, Madrid. © 2006 Artists Rights Society (ARS), NY/ADAGP, Paris.

## *Glosari*

Cat. 6:1. Eugeni d'Ors (text), *Glosari, 1906: ab les gloses a la conferencia d'Algeciras y les gloses al viure de París* (1907), illustrations by Apa (Feliu Elias), book, 23.2 x 15.5 cm. Biblioteca de Catalunya, Barcelona. Photo courtesy Biblioteca de Catalunya.

## Helios Gómez (Seville, 1905–Barcelona, 1956)

Illustrator and caricaturist. A revolutionary in both his art and social theory, Helios Gómez was an illustrator linked with Barcelona's communist movement during the early 1930s and a leader of the political poster design movement during the Spanish civil war. He trained at the Seville Escuela del Arte y del Diseño Industriales and exhibited early on at the Kursaal in Seville, the Ateneo de Madrid, and the Galeries Dalmau in Barcelona. His involvement with anarchist political groups forced him to leave Spain in 1927. He worked in Paris and Brussels as an illustrator and traveled throughout Europe and the Soviet Union in 1928 before settling in Berlin. At the end of 1930, he returned to Spain where created illustrations for several journals including *L'Opinió*. He became a member of the Federació Comunista Catalano-Balear but was expelled in 1931 and arrested and imprisoned for anarchist activities. Invited to the Soviet Union to attend the International Congress of the Proletarian Artist, Gómez was granted leave to travel to and live in Moscow. Returning to Spain in 1934, he was arrested again as part of an uprising. He fled to Brussels, returned to Barcelona in 1935, and joined the Sindicat de Dibuixants Profesionals. The group spearheaded the poster movement in Barcelona during the civil war. Exiled to France toward the end of the war, he was interned in concentration camps and then deported to Algeria. After 1942 he returned to Barcelona and exhibited surrealist works. He was again arrested and imprisoned until 1954 in the Modelo prison, where he painted a mural for the prison oratory known as Capilla Gitana.

Cat. 9:7. *L'Opinió*, c. 1934, lithograph, 106 x 66 cm. Biblioteca del Pavelló de la República (Universitat de Barcelona), Fundació Privada Centre d'Estudis d'Història Contemporània–Biblioteca Josep M. Figueras, Barcelona. © 2006 Artists Rights Society (ARS), NY/VEGAP, Madrid. Photo © Biblioteca del Pavelló de la República.

## Julio González (Barcelona, 1876–Arcueil, 1942)

Sculptor, painter, and jewelry maker. Considered by David Smith (1906–1965) to be "the father of contemporary sculpture in iron," Julio (Juli) González i Pellicer was one of the foremost sculptors working in iron in the early 20th century. Born to a family of artisans, González had an early familiarity with wrought ironwork. He and his brother, Joan (1868–1908), worked in the family's metalsmith shop and attended classes at La Llotja and the Cercle Artístic de Sant Lluc in Barcelona. They also frequented the Quatre Gats café. Deciding to become a painter after visiting the Museo del Prado in Madrid, Julio moved to Paris with his family in 1900 and associated with his compatriots Pablo Picasso, Manolo, and Pablo Gargallo. His brother's death prompted a profound period of mourning and depression for González. He remained in Paris during World War I; in 1918 he learned the technique of oxyacetelene welding while working at an automobile factory. He taught the techique to Picasso in 1928 and they collaboratively produced a series of welded iron sculptures, including a monument to the poet Guillaume Apollinaire in 1931. In 1934 González was active with the groups Cercle et Carré and Abstraction-Création. His works after 1934 are mainly figurative, including such famous works as *La Montserrat*, which was exhibited at the Spanish pavilion at the Paris International Exhibition (1937). His late sculptures and drawings reflect his anguished reaction to the events surrounding the Spanish civil war and World War II.

Cat. 6:19. *Woman Bathing Her Feet*, 1913, oil on canvas, 110 x 60 cm. Museu Nacional d'Art de Catalunya, Barcelona. © 2006 Artists Rights Society (ARS), NY/ADAGP, Paris. Photo © MNAC–Museu Nacional d'Art de Catalunya, 2006, photo Calveras/Mérida/Sagristà.

Cat. 7:6. *Pensive Face*, 1929, iron mounted on painted wood, 24.5 x 19.7 cm. The Cleveland Museum of Art, Gift of Ralph King. (Cleveland only.) © 2006 Artists Rights Society (ARS), NY/ADAGP, Paris.

Cat. 7:55. *Large Female Torso (Woman's Bust)*, 1935–36, forged iron, 53.5 x 26.5 x 14.5 cm. Museu Nacional d'Art de Catalunya, Barcelona. © 2006 Artists Rights Society (ARS), NY/ADAGP, Paris. Photo © MNAC–Museu Nacional d'Art de Catalunya, 2006, photo Calveras/Mérida/Sagristà.

Cat. 7:56. *Cactus Woman (Cactus Man II)*, c. 1939–40, bronze, 79.3 x 25.6 x 19.2 cm. Museum of Fine Arts, Houston, museum purchase. © 2006 Artists Rights Society (ARS), NY/ADAGP, Paris.

Cat. 9:33. *Montserrat Screaming, No. 1*, 1936–39, oil on canvas, 46 x 33. Museu Nacional d'Art de Catalunya, Barcelona. © 2006 Artists Rights Society (ARS), NY/ADAGP, Paris. Photo © MNAC–Museu Nacional d'Art de Catalunya, 2006, photo Calveras/Mérida/Sagristà.

Cat. 9:34. *Small, Frightened Montserrat*, c. 1941–42, bronze, 31 x 20 x 11 cm. Museu Nacional d'Art de Catalunya, Barcelona. © 2006 Artists Rights Society (ARS), NY/ADAGP, Paris. Photo © MNAC–Museu Nacional d'Art de Catalunya, 2006, photo Calveras/Mérida/Sagristà.

Cat. 9:35. *Screaming Mask of Montserrat*, 1936, iron, 27 x 16 x 22 cm. Musée National d'Art Moderne, Centre Georges Pompidou, Paris. © 2006 Artists Rights Society (ARS), NY/ADAGP, Paris. Photo courtesy CNAC/MNAM/Dist. Réunion des Musées Nationaux/Art Resource, NY, © Bertrand Prévost.

Cat. 9:36. *Head*, 1935, hand-forged iron, 45.1 x 38.7 cm. The Museum of Modern Art, New York, purchase. © 2006 Artists Rights Society (ARS), NY/ADAGP, Paris. Digital image ©The Museum of Modern Art/licensed by SCALA/Art Resource, NY.

Cat. 9:38. *Raised Left Hand No. 2*, c. 1942, bronze, 37 x 20 x 15 cm. IVAM–Instituto Valenciano de Arte Moderno, Generalitat, Valencia. © 2006 Artists Rights Society (ARS), NY/ADAGP, Paris.

See also Kollar, cat. 9:21.

## Xavier Gosé (Alcalá de Henares, 1876–Lleida, 1915)

Printmaker and painter. Active in artistic circles in both Barcelona and Paris, Xavier Gosé i Rovira initially studied at La Llotja in Barcelona in 1894–95 and was taught by Josep Lluís Pellicer (1842–1901). He exhibited at Quatre Gats and contributed to the café's art publication. In 1900 he settled in Paris, where his sketches were published in French and German satirical magazines and journals including *L'Assiette au Beurre* and *Jugend*. Also involved in the world of fashion in Paris, he completed a series of fashion plates and drawings that typified Parisian belle époque taste. He returned to Barcelona, exhibiting at the Sala Parés and the Galeries Dalmau. He became ill soon after and withdrew from public life.

Cat. 3:26. *Throwing the Tackle*, cover for *Quatre Gats: publicació artística-literària*, no. 6 (16 March 1899) (Barcelona), magazine, 30.5 x 25.4 cm. Universitat de Barcelona, CRAI, Biblioteca de Lletres. Photo © Universitat de Barcelona.

Cat. 3:31. *Man on the Beach (Meditation)*, c. 1899, conté crayon and charcoal on paper, 25 x 25 cm. Museu d'Art Jaume Morera, Lleida. Photo courtesy Museu d'Art Jaume Morera (Antoni Loncà).

## Adrià Gual (Barcelona, 1872–1943)

Printmaker, painter, playwright, and teacher. Adrià Gual i Queralt was one of the most well-known theater directors in Barcelona in the early 20th century as well as a graphic artist celebrated for his beautiful posters created at the height of Barcelona's modernista epoch. He studied under Pere Borrell del Caso (1835–1910), who had founded a small academy in Barcelona. Gual was inspired by the art of the Pre-Raphaelites and infused his posters and graphic arts with arabesque lines and melancholic tones. He also trained in his father's lithography workshop before leaving at the turn of the century to work in theater. He became one of the most important directors of the Teatre Íntim, which he ran from 1898. He also directed the Escola Catalana d'Art Dramàtic and later was involved in film production.

Cat. 2:23. Cover for *Joventut: Periódich Catalanista: art, ciència, literatura* (1902) (Barcelona), magazine, 27 x 19 x 5 cm. Biblioteca de Catalunya, Barcelona. Image courtesy Biblioteca de Catalunya.

Cat. 2:25. Illustration for a poem by Pompeu Crehuet in *Garba, Revista setmanal d'Art, Literatura y Actualitats* 1, no. 6 (30 December 1905), 40 x 30 cm. The Metropolitan Museum of Art, New York, Thomas J. Watson Library, Gift of the Friends of the Watson Library. (Cleveland only.)

Cat. 2:27. *Design for Cosmopolis Cycles Poster*, 1898, ink, gouache, and watercolor on paper, 83 x 58 cm. Alberto Oller y Garriga Collection, Barcelona. Photo courtesy D'Onofrio&Sanjuán.

Cat. 2:28. *The Guilty Woman*, 1899, chromolithograph, 69.5 x 100 cm. Arxiu Històric de la Ciutat de Barcelona. Photo © Pep Parer-fotògraf.

Cat. 5:9. *Orfeó Català*, 1904, lithograph, 77 x 111 cm. Museu Nacional d'Art de Catalunya, Barcelona. Photo © MNAC–Museu Nacional d'Art de Catalunya, 2006, photo Calveras/Mérida/Sagristà.

## Alfred Guesdon (Nantes, 1808–1876)

Architect, painter, draftsman, and lithographer. Alfred Guesdon was the artist of a renowned series of lithographs depicting vistas of Spanish cities. French-born, Guesdon first became interested in the Iberian Peninsula while working as a lithographer for the book *España Artística y Monumental*, edited in Paris in 1842–44. At mid century Guesdon began *L'Espagne a vol d'oiseau*, a collection of topographical vistas of Spanish cities including Barcelona. His use of aerial perspective as well as his meticulous renderings of the scenes are especially noteworthy. Historians have suggested that he may have collaborated with the English photographer Charles Clifford (1819–1863), a supposition that reflects the international cross-fertilization of media prevalent at this time.

Cat. 1:3. *Bird's Eye View of Spain, Barcelona*, 1860, colored lithograph (photolithograph), 35.5 x 49 cm. Arxiu Històric de la Ciutat de Barcelona. Photo © Pep Parer-fotògraf.

## Gaspar Homar (Palma de Majorca, 1870–Barcelona, 1955)

Furniture maker, *ensemblier*, and decorator. Gaspar Homar i Mezquida was one of the premier furniture designers of Modernisme in Barcelona. His designs are characterized by floral marquetry motifs (the rose in particular) and whiplashing curves. Homar moved with his family from Majorca to the mainland in 1883, when he and his father began training with the cabinet maker Francesc Vidal (1848–1914) at his workshop in Barcelona, "one of the most prosperous in the Eixample district." There he met Joan and Julio González and Antoni Gaudí. Homar also studied at La Llotja, became a member of the Centre d'Arts Decoratives, and joined the Cercle Artístic de Sant Lluc. After training, Homar worked for Lluís Domènech i Montaner, designing furniture and ensembles for the interiors of the architect's buildings, including the Palau Montaner. He also designed furniture for Casa Amatller by Josep Puig i Cadafalch. In 1907 Homar became the primary decorator of Casa Lleó Morera—one of his most important commissions and modernista interiors—and of the Casa Navàs in Reus, both designed by Domènech. Homar and his father opened the P. Homar e Hijo shop of furniture, antiques, and decorative objects on the carrer Canuda, garnering clients such as Vicenç Bosch. Joan González worked as a cabinet maker with Homar, and Pau Roig (1879–1955) designed fabrics. Homar also collaborated with Alexandre de Riquer, Sebastià Junyent (1865–1908), and Josep Pey (1875–1956). Homar traveled throughout Europe and Africa to keep abreast of stylistic trends and collected a large group of photographs documenting his travels. In the early 1930s Homar's shop suffered from the unrest between the city's employers and labor union activists and was closed.

Cat. 5:33. *Sofa-display Case with "La Sardana" Marquetry Panel*, c. 1903, jacaranda, *limoncillo*, carving and marquetry in jacaranda, *manzonia*, oak, ebony, sycamore, aloe wood, box, cherry and ash from Hungary, with metal and leaded and bevel-edged glass appliqués, 240 x 256.5 x 70 cm. Ajuntament de Badalona, Gift of the Ysamat Bosch Family. Photo © Jordi Domingo.

Cat. 5:34. *Decorative Panel with Figure and Garland of Ribbons and Flowers*, c. 1905, polychrome mosaic with glazed tiles, porcelain, and mother-of-pearl, 86 x 100 x 5 cm. Gaspar Salinas Ramon Collection, Barcelona. Photo © Fotografia Gasull.

Cat. 5:36. *Decorative Design for the Drawing Room at Casa Navàs in Reus*, c. 1905, watercolor on paper, 55.5 x 43.6 cm. Museu Nacional d'Art de Catalunya, Barcelona. Photo © MNAC–Museu Nacional d'Art de Catalunya, 2006, photo Calveras/Mérida/Sagristà.

Cat. 5:37. *Sofa-display Case with Marquetry Panels, Decorative Design for the Drawing Room at Casa Navàs in Reus*, c. 1905, watercolor on paper, 55.5 x 43.6 cm. Museu Nacional d'Art de Catalunya, Barcelona. Photo © MNAC–Museu Nacional d'Art de Catalunya, 2006, photo Calveras/Mérida/Sagristà.

Cat. 5:38. *Project for Headboard with a Representation of the Annunciation*, c. 1905, watercolor on paper, 27.7 x 30.9 cm. Museu Nacional d'Art de Catalunya, Barcelona. Photo © MNAC–Museu Nacional d'Art de Catalunya, 2006, photo Calveras/Mérida/Sagristà.

Cat. 5:39. *Project for Sofa with Mirror in the Back, Including the Upholstery Design*, c. 1905, watercolor on paper, 29.5 x 24.2 cm. Museu Nacional d'Art de Catalunya, Barcelona. Photo © MNAC–Museu Nacional d'Art de Catalunya, 2006, photo Calveras/Mérida/Sagristà.

Cat. 5:40. *Design for a Damask*, c. 1900, watercolor on paper, 28 x 12.4 cm. Museu Nacional d'Art de Catalunya, Barcelona. Photo © MNAC–Museu Nacional d'Art de Catalunya, 2006, photo Calveras/Mérida/Sagristà.

## Josep M. Jujol (Tarragona, 1879–Barcelona, 1949)

Architect, painter, and teacher. Overshadowed by his more well-known colleague and friend Antoni Gaudí, Josep Maria Jujol i Gibert was one of the most creative modernista architects and designers in Barcelona. His work is characterized by exuberant forms, lively color, and innovative use of materials, including recycled objects. Jujol studied architecture at Barcelona's Escola Superior d'Arquitectura when Lluís Domènech i Montaner was the director. Jujol apprenticed with Antoni M. Gallissà in 1901 and later with Josep Font (1859–1922), working with the latter on the Ateneu Barcelonès. Beginning in 1904, Jujol collaborated with Gaudí; their first project together was Casa Batlló, followed by work on Casa Milà, Park Güell, and the cathedral in Majorca. Jujol's first important independent commission was the Teatre Metropol in Tarragona. From then on, Jujol enjoyed a relatively steady steam of commissions and projects throughout Catalonia, including designs for numerous houses, churches, farm buildings, and schools. He often designed the furniture and other decorative elements for his buildings. Late in life he also taught architecture in Barcelona, designed the fountain in the plaça d'Espanya, and served as one of Gaudí's closest collaborators on the Expiatory Temple of the Sagrada Família.

Cat. 5:68. *Elevation of the Interior of the Main Dining Room of Casa Milà, with Cupboard Crowned with the Archangel and the Madonna; Buffet and Piece of Furniture with Shelves*, c. 1909, watercolor and pencil on paper, 54.5 x 184 cm. Arxiu Jujol, Tarragona.

Cat. 5:74. *Botiga Mañach with Drawings in the Margins*, 1910, pencil, watercolor, and ink on greaseproof paper, 42 x 28.5 cm. Arxiu Jujol, Tarragona.

Cat. 5:75. *Chair in the Form of a Bleeding Heart, for the Botiga Mañach*, 1911, wood and twisted iron, 85 x 52 x 69 cm. Private collection, courtesy Allan Stone Gallery, New York.

Cat. 5:76. *Inkwell*, c. 1920–27, bronze, 8 x 15.5 x 15.5 cm. Jujol Family, Tarragona.

Cat. 5:77. *Lamp from Mañach Workshop*, c. 1916, iron and colored glass, 40 x 64 x 190 cm. Ajuntament de Tarragona Teatre Metropol, Tarragona. Photo © Cuixart.com.

Cat 5:78. *Casa Negre, Façade Sketch*, 1914, pencil and watercolor on drawing paper, 42.7 x 58.4 cm. Arxiu Històric del Col·legi d'Arquitectes de Catalunya, Arxiu Jujol, Barcelona.

Cat. 5:79. *Casa Planells, Sketch of the Façade*, 1923, pencil on sulfuric paper, 60.2 x 38.6 cm. Arxiu Històric del Col·legi d'Arquitectes de Catalunya, Arxiu Jujol, Barcelona.

Cat. 5:80. *Seat of Honor in the Church of Sant Feliu Màrtir in Constantí*, 1915, pencil and watercolor on paper, 51 x 66 cm. Arxiu Jujol, Tarragona.

Cat. 5:81. *Hanging Lamp in the Church of the Sagrat Cor in Vistabella*, 1918–23, structure made of cardboard, sheet metal, painted wood, and wire, 114 x 64 cm. Church of the Sagrat Cor, Vistabella. Photo © Pere Vivas and Jordi Puig, Triangle Postals, Barcelona, 2006.

See also Gaudí, cats. 5:60 and 5:62.

### Josep M. Junoy (Barcelona, 1887–1955)

Painter, illustrator, poet, and critic. One of the most prolific satirical illustrators and polemical critics in Barcelona, Josep Maria Junoy i Muns became particularly renowned for his calligrams. He published his early drawings in journals such as *Papitu* and became the director of *La Nova Revista*, cofounded the newspaper *El Matí*, and edited the journal *Troços*. An important commentator and champion of avant-garde artists, Junoy presented the first exhibition of works by Joan Miró at the Galeries Dalmau in 1918. His book of poems and calligrams was published in 1920 with a preface by Guillaume Apollinaire.

Cat. 7:15. *Deltoïdes (a Nijinski)*, poem-illustration in *Troços*, no. 1 (September 1917) (Barcelona), magazine, 28 x 22 cm. Biblioteca de Catalunya, Barcelona. Photo courtesy Biblioteca de Catalunya.

Cat. 7:23. Acrostic (altered by an anonymous person) for *Catalogue of Joan Miró Exhibition*, Galeries Dalmau, Barcelona, 16 February–3 March 1918, 17.5 x 12.3 cm. Fundació Joan Miró, Barcelona.

### François Kollar (Slovakia, 1904–1979)

Cat. 9:17. *Pavilion of the Spanish Republic (Exterior with Alberto Sánchez sculpture), Paris International Exposition*, 1937, photograph, 16.8 x 22.4 cm. Frances Loeb Library, Harvard Design School, Cambridge.

Cat. 9:18. *Spanish Pavilion, Courtyard with View of "Guernica,"* 1937, photograph, 16.5 x 21.6 cm. Frances Loeb Library, Harvard Design School, Cambridge.

Cat. 9:19. François Kollar, *"Guernica" Installed at the Pavilion of the Spanish Republic, Paris International Exposition*, 1937, photograph, 18.4 x 27.3 cm. Frances Loeb Library, Harvard Design School, Cambridge.

Cat. 9:20. *Pavilion of the Spanish Republic, Paris International Exposition, 1937, Stage*, 1937, photograph, 27.4 x 22.3 cm. Frances Loeb Library, Harvard Design School, Cambridge.

Cat. 9:21. *"La Montserrat" by Julio González at the Spanish Pavilion*, 1937, photograph, 22.5 x 24.3 cm. Frances Loeb Library, Harvard Design School, Cambridge.

Cat. 9:22. *"The Reaper" by Joan Miró, Spanish Pavilion*, 1937, photograph, 22.9 x 17.5 cm. Frances Loeb Library, Harvard Design School, Cambridge.

Cat. 9:24. *Manuel Azaña, President of the Spanish Republic, and Dedication to Catalonia*, 1937, photograph, 16 x 22.9 cm. Frances Loeb Library, Harvard Design School, Cambridge. (Not illustrated.)

Cat. 9:25. *The Bombing of Guernica and Pro-Basque (Euzkadi) Displays*, 1937, photograph, 17.1 x 23.1 cm. Frances Loeb Library, Harvard Design School, Cambridge.

Cat. 9:26. *Federico Garcia Lorca, Poet Executed at Granada, Display*, 1937, photograph, 23.2 x 17.5 cm. Frances Loeb Library, Harvard Design School, Cambridge. (Not illustrated.)

Cat. 9:27. Or Daniel Henri, *Woman Speaking from the Top of a Car or Truck*, c. 1937, photograph, 16.5 x 23.2 cm. Frances Loeb Library, Harvard Design School, Cambridge.

### Antoni G. Lamolla (Tarragona, 1910–Dreux, 1981)

Painter and sculptor. Antoni Garcia i Lamolla was a leading member of the Catalan surrealist movement. In the 1930s he exhibited at many important avant-garde venues, including the Exhibition of Iberian Artists (Paris, 1936). He joined ADLAN (Friends of New Art) and exhibited in the Exposició Logicofobista in Barcelona in 1936. He spent most of his life in Lleida, served in the Loyalist army during the civil war, and afterward lived in France.

Cat. 7:49. *Untitled*, 1934, gouache and ink on paper, 34 x 45 cm. Yolanda Garcia-Lamolla Collection, Lleida.

Cat. 7:50. *Diary of a Psychoanalyst*, 1935, gouache and paper on cardboard, 32 x 34.5 cm. Museu d'Art Jaume Morera, Lleida. Photo courtesy Museu d'Art Jaume Morera (Antoni Loncà).

Cat. 9:43. *Untitled*, 1939, paper, string, and cardboard, 30 x 23 cm. Yolanda Garcia-Lamolla Collection, Lleida. (Cleveland only.)

### Le Corbusier (La Chaux-de-Fonds, 1887–Roquebrune-Cap-Martin, 1965)

Architect, painter, urban planner, writer, and theorist. Le Corbusier (Charles-Edouard Jeanneret) was one of the most influential architects of the 20th century and a leader of the avant-garde movement Purism. He studied under Charles L'Eplattenier (1874–1946) at the École d'Art, and he gained experience by working in Paris with Auguste (1874–1954) and Gustave (1876–1952) Perret, and in Berlin with Peter Behrens (1868–1940). He and fellow purist Amédée Ozenfant (1886–1966) published *Aprés le Cubisme* and founded the journal *L'Esprit Nouveau*. Around this time he adopted the pseudonym "Le Corbusier" (derived from the French word *corbeau*, or "raven"). In 1921 he established an architectural studio in Paris with his cousin Pierre Jeanneret (1896–1967), and they designed many private homes, including the Villa Savoye at Poissy, near Versailles, an icon of rationalist design. Travels inspired Le Corbusier to devise various urban plans for dozens of cities and ports, including Geneva, Antwerp, Stockholm, Paris, and Marseilles. He, in turn, inspired the Catalan architectural collective GATCPAC and influenced its urban development plan for Barcelona through his writings, lectures, and guidance; he named the project the Macià Plan after Francesc Macià, then head of the Catalan government. Josep Lluís Sert, one of GATCPAC's founding members, worked in Le Corbusier's Paris studio. During World War II Le Corbusier sought refuge in the Pyrenees, returned to occupied Paris in 1943, and founded the research group ASCORAL (Assembly of Builders for a Renovated Architecture), whose aim was postwar reconstruction. He established the Fondation Le Corbusier in Paris where his impressive collection of notes, drawings, designs, and articles are now housed.

Cat. 8:15. *Barcelona Macià Plan*, 1932, ink and black and colored crayon on paper, 75 x 125 cm. Fondation Le Corbusier, Paris. Foundation Le Corbusier, © Artists Rights Society (ARS), NY/ADAGP, Paris/FLC.

Cat. 8:16. *Barcelona Macià Plan*, 1932, black and colored crayon on paper, 47 x 78 cm. Fondation Le Corbusier, Paris. Foundation Le Corbusier, © Artists Rights Society (ARS), NY/ADAGP, Paris/FLC.

### Le Petit Journal

Cat. 4:18. *Dynamite in Spain,* cover of illustrated supplement to *Le Petit Journal,* no. 157 (25 November 1893) (Barcelona), newspaper, 45 x 31 cm. Borowitz Collection, Kent State University Library, Ohio. Photo Kent State University, Library Special Collections.

### Josep Llimona (Barcelona, 1864–1934)

Sculptor. A key sculptor of Catalan Modernisme, Josep Llimona i Bruguera created graceful works of the female form that express paradigmatic ideals of the time. He received his early training in sculpture at La Llotja in Barcelona, where he studied with Venanci Vallmitjana (c. 1828–1919) and Ramón Martí Alsina (1826–1894) and received the Pensión Fortuny, a

prize offered by the Barcelona City Council in memory of the Catalan painter Marià Fortuny (1838–1874). The award afforded Llimona the opportunity to study in Rome where he was inspired by Italian Renaissance sculpture. Travels to France also introduced him to the art of Auguste Rodin and Constantin Meunier (1831–1905). A spiritual man and devout Catholic, Llimona infused his art with religious motifs. Together with his brother, Joan (1860–1926),

he founded the Cercle Artístic de Sant Lluc in Barcelona. Llimona's sculpture *Grief* won the Prize of Honor at the Fifth International Exposition of Fine Arts (Barcelona, 1907). Many of his sculptures were commissioned for funerary monuments in Barcelona, as he became renowned for the theme of the elegant mourning female figure. Llimona served as president of the Junta de Museus de Barcelona and received the Medal of Honor from the city of Barcelona in 1932 for his achievements.

Cat. 2:33. *Grief,* 1907, marble, 63 x 55 x 68 cm. Private collection, Barcelona. Photo © Fotografia Gasull.

Cat. 5:20. *Exasperation,* 1900, made by Fundición Morales, bronze, 8 x 8 cm. Alberto Oller y Garriga Collection, Barcelona.

### Josep Llorens Artigas (Barcelona, 1892–1980)

Ceramist, art critic, and teacher. The distinguished Catalan ceramist Josep Llorens i Artigas was renowned for his use of beautiful glazes and enamels. He studied at La Llotja, the Cercle Artístic de Sant Lluc, and the Escola Superior dels Bells Oficis and frequented the Acadèmia Galí. He was also an art critic for *La Veu de Catalunya* and contributed articles to other journals and newspapers in Barcelona. He cofounded the Agrupació Courbet in 1918. He went to Paris for further training as a ceramist, settling there in 1924; he became friends with Pablo Gargallo, setting up his studio near him. Llorens Artigas also met Pablo Picasso, Paco Durrio (1868–1940), and Ignacio de Zuloaga (1870–1945), and collaborated with Luís Buñuel, Albert Marquet (1875–1947), and Raoul Dufy (1877–1953), especially. Returning to Barcelona he held a solo show at the Sala Parés, joined the Escola Massana, and taught ceramics. He continued to collaborate with numerous avant-garde artists including Joan Miró and Georges Braque (1882–1963), producing pots and decorative murals. Large murals by Llorens Artigas and Miró are installed at the UNESCO Building in Paris, Harvard University, and the Barcelona airport.

Cat. 6:54. *Clair de Lune Vase,* 1927, stoneware, 25.5 x 12 x 11 cm. Museu de Ceràmica, Barcelona. Photo © Guillem.

Cat. 6:55. *Vase,* 1931, glazed stoneware, 36.5 x 24 cm. Museu de Ceràmica, Barcelona. Photo © Guillem.

Cat. 6:56. *Vase,* 1931, stoneware, h. 26 cm. The Metropolitan Museum of Art, New York, Purchase, Edward C. Moore Jr. Gift.

### Carles Mani (Tarragona, 1866–Barcelona, 1911)

Sculptor. Carles Mani i Roig trained at La Llotja in Barcelona. Early in his career, he was awarded a grant by the Tarragona City Council to study in Paris, where his mentor was Santiago Rusiñol. Upon his return to Spain, Mani collaborated with Antoni Gaudí on sculptures for buildings in Barcelona, including the Sagrada Família and Casa Batlló, and he exhibited at major art shows in Madrid and Barcelona.

Cat. 4:11. *Plaster Study for "The Degenerates,"* c. 1891–1904, plaster, 20.5 x 37 x 22 cm. Museu Nacional d'Art de Catalunya, Barcelona. Photo © MNAC–Museu Nacional d'Art de Catalunya, 2006, photo Calveras/Mérida/Sagristà.

### Manolo (Barcelona, 1872–Caldes de Montbui, 1945)

Sculptor, painter, poet, jewelry designer, and illustrator. Manolo (Manuel Martínez i Hugué) was born the illegitimate son of Benigno Martínez, a Cuban war veteran, and Anna Hugué, a widow. He grew up poor in Barcelona's Gothic quarter and studied briefly at La Llotja before obtaining a job in the foundry of the Barcelona jeweler Lluís Masriera. He met Pablo Picasso, Ramon Casas, Santiago Rusiñol, and other modernista artists at the Quatre Gats, becoming a member of Picasso's intimate circle. In 1901 he joined the Catalan artists in Paris days before Carles Casagemas committed suicide, an event to which Manolo was an eyewitness. He established himself in Montmartre, where he associated with Picasso, Hermen Anglada-Camarasa, Ignacio de Zuloaga, and Josep Dalmau. Manolo's circle of associates soon expanded to include André Salmon, Guillaume Apollinaire, Georges Braque, André Derain (1880–1954), Aristide Maillol, and Paco Durrio (1868–1940). He also designed jewelry and illustrated the poems of Pierre Reverdy. From 1910 to 1927 Manolo was under contract with the dealer Daniel-Henry Kahnweiler and frequently lived in Céret before returning to Barcelona in 1916. After 1910, he worked largely in a classicizing style associated with Noucentisme and Mediterraneanism. After suffering a bout with debilitating arthritis in 1924, he turned more toward painting. He lived and worked in Caldes de Montbui, a spa town in Catalonia, until his death.

Cat. 6:11. *Seated Nude,* 1912 (carved 1913), stone relief on wood base, 44.3 x 24.6 x 4 cm. Hirshhorn Museum and Sculpture Garden, Smithsonian Institution, Gift of Joseph H. Hirshhorn. (Cleveland only.) Photo by Lee Stalsworth.

Cat. 6:29. *Woman's Torso,* 1922, stone relief, 54.5 x 62 x 17 cm. Galerie Louise Leiris, Paris. (Cleveland only.) Photo © Galerie Louise Leiris SAS, Paris.

### Santiago Marco (Tarragona, 1885–Barcelona, 1949)

Decorator and writer. Santiago Marco i Urrútia studied at La Llotja in Barcelona as well as in Mexico with the American glazier Wenwoor. He joined the studio of Francesc Vidal (1848–1914) in Barcelona, branching out on his own in the 1920s. He presided over FAD (Foment de les Arts Decoratives) for many years and participated in several important exhibitions of decorative art in Barcelona, Milan, and Paris. He was integral to the founding of the Escola Massana and was awarded a medal of the Legion of Honor. His published works include *Per la bellesa de la llar humil* (For the beauty of the humble home) and *Per la humanització del moble* (For the humanization of furniture).

Cat. 6:62. *Writing Desk,* 1925, covered *thulis orientalis* root wood, metal, and nacre marquetry with silver handles, 110 x 83 x 42 cm. Montserrat Mainar Collection, Barcelona.

### Ramon Marinel·lo (Terrassa, 1911–Barcelona, 2002)

Sculptor and designer. Ramon Marinel·lo i Capdevila made invaluable contributions to the surrealist and avant-garde movements in Catalonia. He studied law before turning to art. He initially studied at La Llotja with Àngel Ferrant (1891–1961). Marinel·lo also frequented the Cercle Artístic de Sant Lluc and participated in several major avant-garde

exhibitions in Barcelona beginning in the 1930s, including the 1935 ADLAN (Friends of New Art) exhibition and the Exposició Logicofobista (1936). He was active in the surrealist movement until the Spanish civil war. After the war he turned to interior decoration and founded a furniture manufacturing company with his brother. He was a founding member of the Grup Cobalt 49 as well as the Agrupació de Dissenyadors Industrials and received the ADI–FAD Golden Delta award.

Cat. 7:47. *Venus 024*, 1936, collage on paper, 34 x 27 cm. Inés de Rivera Marinel·lo Collection, Barcelona.

### Joan Martí

Cat. 1:4. *Paseo de Gracia*, photograph 12 from *Beautiful Sights in Barcelona: Photographs of the Principal Monuments, Buildings, Streets, Avenues, and All the Best in the Old Capital of the Principality*, Barcelona: Vives and Martí, 1874, 50 positive photographic prints on paper, mounted on sheets bound in an album, 26 x 36 cm. Biblioteca de Catalunya, Barcelona. Photo courtesy Biblioteca de Catalunya.

### Jeroni Martorell (Barcelona, 1877–1951)

Architect. As director of the Servei de Conservació de Monuments, Jeroni Martorell i Terrats was responsible for the restoration of Catalan monuments—including Casa dels Canonges and Casa dels Velers in Barcelona—as well as monasteries, churches, and ancient Roman bridges. He also designed many buildings in Catalonia, such as the Escola Industrial d'Arts i Oficis de Sabadell, and he contributed articles on art theory to the periodicals *Catalunya* and *Vell i Nou*. He wrote reports on architecture and archaeology, including *Inventari gràfic de Catalunya* (1909) and *L'urbanisme en relació als monuments arqueològics* (1935).

Cat. 6:44. *Interior of a Public Library, Calella*, c. 1931, ink on paper, 44 x 53.5 cm. Arxiu Històric del Col·legi d'Arquitectes de Catalunya, Barcelona.

Cat. 6:45. *Project for Unitary Schools, Granollers*, 1918, ink on paper, 50 x 63.5 cm. Arxiu Històric del Col·legi d'Arquitectes de Catalunya, Barcelona.

### Adolf Mas (Solsona, 1861–Barcelona, 1936)

Photographer. Adolf Mas frequented the Quatre Gats and was attracted to Modernisme and Noucentisme. Originally hired by the Mancomunitat de Catalunya and the Institut d'Estudis Catalans to produce a series of photographs of Catalonia, he established the Arxiu Mas (Mas Archive) and continued photographing works of art and architecture—both ancient and modern—throughout Spain. He assembled a vast photographic archive documenting monuments and works of art, many of which no longer exist. He is also known for developing an archival filing system praised for its ease in locating and accessing items. His son Pelagi (1891–1954) assisted him and then continued his work. Their photographic collection is now managed by the Institut Amatller d'Art Hispànic, located in Josep Puig i Cadafalch's Casa Amatller.

Cat. 5:52. With Francesc de Paula Quintana (calligraphy), *Park Güell, Viaduct*, 1910 (photograph) and 1927 (calligraphy), photograph and ink on paper, 50 x 68 cm. Arxiu Històric del Col·legi d'Arquitectes de Catalunya, Barcelona.

Cat. 5:53. With Francesc de Paula Quintana (calligraphy), *Park Güell, Portico*, 1910 (photograph) and 1927 (calligraphy), photograph and ink on paper, 50 x 65 cm. Arxiu Històric del Col·legi d'Arquitectes de Catalunya, Barcelona.

Cat. 5:54. With Francesc de Paula Quintana (calligraphy), *Park Güell, Stairway*, 1910 (photograph) and 1927 (calligraphy), photograph and ink on paper, 50 x 65 cm. Arxiu Històric del Col·legi d'Arquitectes de Catalunya, Barcelona.

Cat. 5:55. With Francesc de Paula Quintana (calligraphy), *Park Güell, Colonnade*, 1910 (photograph) and 1927 (calligraphy), photograph and ink on paper, 69 x 55 cm. Arxiu Històric del Col·legi d'Arquitectes de Catalunya, Barcelona.

Cat. 5:56. With Francesc de Paula Quintana (calligraphy), *Casa Batlló, Façade*, 1910 (photograph) and 1927 (calligraphy), photograph and ink on paper, 65 x 50 cm. Arxiu Històric del Col·legi d'Arquitectes de Catalunya, Barcelona.

Cat. 5:58. With Francesc de Paula Quintana (calligraphy), *Casa Batlló, Staircase and Landing*, 1910 (photograph) and 1927 (calligraphy), photograph and ink on paper, 65 x 50 cm. Arxiu Històric del Col·legi d'Arquitectes de Catalunya, Barcelona.

Cat. 5:59. With Francesc de Paula Quintana (calligraphy), *Casa Batlló, Chimneys*, 1910 (photograph) and 1927 (calligraphy), photograph and ink on paper, 52 x 96 cm. Arxiu Històric del Col·legi d'Arquitectes de Catalunya, Barcelona.

Cat. 5:63. With Francesc de Paula Quintana (calligraphy), *Casa Milà*, 1910 (photograph) and 1927 (calligraphy), photograph and ink on paper, 50 x 64 cm. Arxiu Històric del Col·legi d'Arquitectes de Catalunya, Barcelona.

Cat. 5:64. With Francesc de Paula Quintana (calligraphy), *Casa Milà, Roof and Chimney, Balcony* (inset), 1910 (photograph) and 1927 (calligraphy), photograph and ink on paper, 50 x 68 cm. Arxiu Històric del Col·legi d'Arquitectes de Catalunya, Barcelona.

Cat. 5:65. With Francesc de Paula Quintana (calligraphy), *Casa Milà, Detail of the Façade* (left) *and Main Entrance* (right), 1910 (photograph) and 1927 (calligraphy), photograph and ink on paper, 56 x 72.5 cm. Arxiu Històric del Col·legi d'Arquitectes de Catalunya, Barcelona.

Cat. 5:83. With Francesc de Paula Quintana (calligraphy), *Temple of La Sagrada Família, Apse*, 1910 (photograph) and 1927 (calligraphy), photograph and ink and paper, 64 x 46 cm. Arxiu Històric del Col·legi d'Arquitectes de Catalunya, Barcelona.

Cat. 5:84. With Francesc de Paula Quintana (calligraphy), *Spires from the Apse of the Temple of La Sagrada Família*, 1910 (photograph) and 1927 (calligraphy), photograph and ink on paper, 50 x 65 cm. Arxiu Històric del Col·legi d'Arquitectes de Catalunya, Barcelona.

Cat. 5:85. With Francesc de Paula Quintana (calligraphy), *St. Bernabé Bell Tower of the Temple of La Sagrada Família*, 1910 (photograph) and 1927 (calligraphy), photograph and ink on paper, 70 x 49 cm. Arxiu Històric del Col·legi d'Arquitectes de Catalunya, Barcelona.

See also Masó, cat. 6:41.

### Josep Masana (Granollers, 1894–Barcelona, 1979)

Photographer. Josep Masana i Fargas became an important pictorialist and avant-garde photographer when he settled in Barcelona around 1920. His endeavors in portrait photography and photomontage garnered him commercial attention. His advertising works were published in magazines such as *El Progreso Fotográfico*. Among other achievements Masana founded the Savoy Cinema in Barcelona and was a correspondent for the magazine *Actualidad*.

Cat. 7:42. *Cocaine*, undated, bromide print, 28.7 x 22.5 cm. Museu Nacional d'Art de Catalunya, Barcelona, Dipòsit Família Masana. Photo © MNAC–Museu Nacional d'Art de Catalunya, 2006, photo Calveras/Mérida/Sagristà.

### Rafael Masó (Girona, 1880–1935)

Architect and poet. An acclaimed noucentista architect, Rafael Masó i Valentí was the son of painter and newspaper director Rafael Masó i Pagès. He studied architecture in Barcelona and complemented his studies with forays into poetry, contributing to several publications including *Montserrat, Catalunya,* and *Vida*. His poems were featured in the *Almanach dels Noucentistes*. After completing his studies in Barcelona, Masó returned to Girona, where he collaborated with the athenaeum to compile a compendium of local artists. Influenced by the British architects C. F. A. Voysey (1857–1941) and Charles Rennie Mackintosh (1868–1928), as well as German and Austrian architecture, Masó blended northern

and Catalan elements to develop a singular style paradigmatic of noucentista ideals. He designed such buildings as the Farmàcia Masó, Casa Masó, the Mas El Soler, Casa Salieti, the Edifici Athenea, and Casa Cendra. In the final stages of his life, he was inspired more by traditional and classical styles, and devoted increasing time to archaeology and restoration.

Cat. 6:41. *Desk for Esperança Bru*, 1910, walnut, metal, fabric, and dry flowers, 170.3 x 140.2 x 53 cm. Rosa Masó Bru, Girona. Photograph by Adolf Mas, 1916. Photo © Fundació Amatller, Arixu Mas, Barcelona.

Cat. 6:42. *Design for a Bedroom*, 1910, ink and watercolor on cardboard, 25.5 x 35.5 cm. Joan Tarrús–Josepa Castellà Collection, Barcelona. Photo © Pere Vivas and Jordi Puig, Triangle Postals, Barcelona, 2006.

Cat. 6:43. *Masramon House, Design for the Principal Façade and Perspective*, 1913, pencil and watercolor on paper, 44 x 28 cm. Col·legi d'Arquitectes de Catalunya, Demarcació de Girona, Arxiu Històric, Girona.

## Lluís Masriera (Barcelona, 1872–1958)

Jewelry maker, painter, and stage director. Lluís Masriera i Rosés was one of the premier designers of modernista jewelry of his generation. Emerging from a family of artists and jewelry designers, he studied jewelry design in Geneva, where he learned the styles and techniques of Frank-Édouart Lossier (1852–1925). Masriera began exhibiting his paintings and

modernista jewelry around the turn of the century in Barcelona, Madrid, London, Saragossa, and Paris; his painting *L'ombrel·la japonesa* was particularly celebrated. Masriera's jewelry designs were highly creative, infused with Art Nouveau aesthetics and the style of René Lalique (1860–1945), and resplendent with beautifully wrought floral motifs, birds, nymphs, and winged creatures. His innovations in the technique of translucent enamel were particularly extraordinary and garnered the family firm renown. Masriera was also involved in the theater, founding the Companyia Belluguet, which presented productions of *El retaule de la flor* and *Els vitals de Santa Rita*, as well as works by Miguel de Cervantes and Molière, among others. In 1954 he published *Mis memorias*.

Cat. 5:21. *Pendant with St. George and the Dragon*, c. 1901–2, gold, diamonds, rubies, plique-à-jour translucent enamel, and opaque enamel, 4.5 x 3.6 cm. Museu Nacional d'Art de Catalunya, Barcelona. Photo © MNAC–Museu Nacional de Art de Catalunya, 2006, photo Calveras/Mérida/Sagristà.

Cat. 5:22. *Isolde Pendant*, c. 1910, gold, ivory, enamel, diamonds, sapphires, and pearl, 6.4 x 5.1 cm. The Metropolitan Museum of Art, New York, Gift of Jacqueline Loewe Fowler.

Cat. 5:23. *Pendant with the Bust of a Renaissance Woman*, 1900–1910, gold, diamond, and pearls, h. 6.4 cm, diam. 4.3 cm. Bagués-Masriera, Barcelona.

Cat. 5:24. *Pendant with Airplane over Barcelona*, 1905, gold, diamonds, and plique-à-jour translucent enamel, diam. 3.2 cm. Renée Micoulaud, Barcelona.

Cat. 5:25. *Pendant with Landscape*, c. 1912, yellow gold, diamonds, pearls, rubies, and plique-à-jour translucent enamel, 5 x 3.7 cm. Bagués-Masriera, Barcelona.

Cat. 5:26. *Pendant of a Woman-Fairy*, 1903–6, gold, ivory, diamonds, enamel, and pearls, 7 x 3.7 cm. Bagués-Masriera, Barcelona.

Cat. 5:27. *Pin with the Insect Woman*, c. 1916, gold, diamonds, pearls, rubies, plique-à-jour translucent enamel, and other precious gems, 6.5 x 7 cm. Bagués-Masriera, Barcelona.

Cat. 5:28. *Pendeloques*, no. 12 from *Album of Jewelry Designs*, c. 1905, ink and gouache on paper, 20.3 x 15.2 cm. Bagués-Masriera, Barcelona. (Cleveland only.)

Cat. 6:58. *Necklace*, c. 1909–16. Gold, platinum, ivory, diamonds, and sapphires, 6.9 x 12.5 cm. Bagués-Masriera, Barcelona.

Cat. 6:59. *Bracelet*, c. 1909–16, gold, diamonds, plique-à-jour translucent enamel, and opaque enamel, 4 x 5.5 cm. Bagués-Masriera, Barcelona.

Cat. 6:60. *Pendant with Figure in Motion*, c. 1909–16. Plique-à-jour translucent enamel, diamonds, pearls, and gold, 8.5 x 3.5 cm. Bagués-Masriera, Barcelona.

Cat. 6:61. *Design for Snake Bracelet*, 1925, ink and watercolor on paper, 33.6 x 23.6 cm. Bagués-Masriera, Barcelona.

## Joan Massanet (L'Armentera, 1899–L'Escala, 1969)

Painter. Self-taught, Joan Massanet i Juli originally worked as a pharmacist in Barcelona before becoming a painter. Inspired by the work of Salvador Dalí, Max Ernst (1891–1976), and Giorgio de Chirico (1888–1978), he incorporated elements from each artist's work into his own surrealist style of hyperrealistic dream imagery. Early in his career he exhibited at many of the most important avant-garde venues, including the Galeries Dalmau. In 1936 he participated in the Exposició Logicofobista at the Galeries Catalònia. His first major exhibition, held at Barcelona's Sala Caralt, was followed by numerous other solo and group exhibitions. In the 1950s he founded the Indika group of artists in Girona. Later in life Massanet employed diverse materials in his artwork such as shells, roots, and wood.

Cat. 7:34. *Landscape*, 1929–30, oil on canvas, 61 x 51 cm. Colección Arte Contemporáneo–Museo Patio Herreriano, Valladolid.

## Jaume Mercadé (Valls, 1887–Barcelona, 1967)

Painter and metalworker. Jaume Mercadé i Queralt studied at the Acadèmia Galí in Barcelona before traveling to Paris in 1917. Among his first exhibitions was a solo show at the Galeries Laietanes in Barcelona. Mercadé also traveled to Germany, frequenting museums in Berlin and Munich, where he saw the art of the German Expressionists. Upon returning to Spain, he was appointed professor at the Escola d'Arts i Oficis de la Mancomunitat; he exhibited regularly at the Galeries Laietanes, Galeries Dalmau, and Sala Parés, among other venues in Barcelona and abroad, throughout the 1920s and 1940s. His works were exhibited works at the National Exposition of Fine Arts (Madrid, 1923) and the Carnegie Institute in 1934, and he had a solo show at the Galeries Syra in Barcelona in 1951. He was a member of Les Arts i els Artistes and was influenced by Fauve painting before he turned to classicizing Noucentisme. Eugeni d'Ors and Sebastià Gasch particularly acclaimed his art. Mercadé received numerous medals and awards for his metalwork and paintings.

Cat. 6:64. *Coffee Service*, c. 1925, silver and wood, 19 x 55.8 x 33.6 cm. Jaume Mercadé Gallès Collection, Barcelona. Photo © Pere Vivas and Jordi Puig, Triangle Postals, Barcelona, 2006.

## Margaret Michaelis (Dzieditz, 1902–Melbourne, 1985)

Photographer. An Austrian, Margaret Michaelis (née Gross) spent her most prolific and inspired years in Barcelona. She studied photography in Vienna and trained at the famous Studio d'Ora in the 1920s. In the 1930s she moved to Berlin and met her future husband, the political activist Rudolf Michaelis. Driven from Berlin following Hitler's rise to power, the couple traveled to Spain and settled in Barcelona, where Margaret set up a photography studio. For the next four years, she produced some of her most powerful images. She also became associated with GATCPAC, documenting the group's plans and designs for Barcelona. Later she recorded

the Spanish civil war in photographs that reflect great spontaneity and social engagement. After leaving Barcelona in 1937, Michaelis traveled to Poland and London, eventually settling in Australia and again establishing a photography studio. There she became one of Sydney's most renowned photographers.

Cat. 8:22. *Exterior View of Sert and Torres Clavé's Weekend House at Garraf,* 1934–35, gelatin silver print, 17.5 x 23.5 cm. Arxiu Històric del Col·legi d'Arquitectes de Catalunya, Barcelona.

Cat. 8:23. *Interior View of Sert and Torres Clavé's Weekend House at Garraf,* 1934–35, gelatin silver print, 22.5 x 17 cm. Arxiu Històric del Col·legi d'Arquitectes de Catalunya, Barcelona.

## Ludwig Mies van der Rohe (Aachen, 1886–Chicago, 1969)

Architect, furniture designer, and teacher. Ludwig Mies van der Rohe's rational approach to architectural design influenced generations of architects in the United States and abroad. He initially worked with his father, a stone mason, at building sites in Aachen. Mies had no formal training in architecture, but he did attend Aachen's Domschule and the local trade school. He traveled to Berlin in 1905 to apprentice with Bruno Paul (1874–1968), and one of his first commissions was for Dr. and Mrs. Alois and Sofie Riehl, for whom he built a home (1906–7). He then worked for Peter Behrens before establishing his own architectural office in Berlin in 1912. From 1915 to 1918 Mies served in the Engineers Corps of the German army. After the war he led the Novembergruppe, became vice president of the Deutscher Werkbund, and produced numerous innovative buildings. His German pavilion of 1929 for the Barcelona International Exposition is one of the landmarks of 20th-century design. In 1930 he was appointed director of the Bauhaus, which he ran until the Nazis closed it in 1933. At the end of the 1930s, he moved to Chicago, becoming director of the Armour Institute's architecture department, a position he held for several decades. He embraced American technological advances and designed some of his most inventive high-rise projects over the next 20 years. Mies received many awards throughout his career, including the Presidential Metal of Freedom from the United States in 1963.

Cat. 8:2. *Model for the German Pavilion of the Barcelona International Exposition of 1929,* 1929, acrylic and chrome-plated glass, 29.8 x 68.3 x 98.7 cm. The Museum of Modern Art, New York, Mies van der Rohe Archive, Barcelona Pavilion Replacement Fund. © 2006 Artists Rights Society (ARS), NY/ VG Bild-Kunst, Bonn. Digital image © The Museum of Modern Art/licensed by SCALA/Art Resource, NY.

Cat. 8:3. *Pavilion for Barcelona International Exposition, Plan Drawing, First Preliminary Scheme,* 1929, pencil on tracing paper, 48.4 x 91.4 cm. The Museum of Modern Art, Mies van der Rohe Archive, New York, Gift of the Architect. (Not illustrated.)

Cat. 8:4. *Pavilion for Barcelona International Exposition, Interior Perspective View,* 1929, sketch by Sergius Ruegenberg, crayon and pencil on illustration board, 99 x 130.2 cm. The Museum of Modern Art, New York, Mies van der Rohe Archive, Gift of the Architect. © 2006 Artists Rights Society (ARS), NY/ VG Bild-Kunst, Bonn. Digital image © The Museum of Modern Art/licensed by SCALA/Art Resource, NY.

Cat. 8:5. *Pavilion for the Barcelona International Exposition, Perspective View of the Principal Façade,* 1929, pencil and colored pencil on tracing paper, 20.6 x 26.4 cm. Staatliche Museen zu Berlin, Kunstbibliothek. © 2006 Artists Rights Society (ARS), NY/VG Bild-Kunst, Bonn. Photo © Bildarchiv Preussischer Kulturbesitz, 2006, Kunstbibliothek.

Cat. 8:6. *Pavilion for Barcelona International Exposition, View of the Interior with Table and Stools,* 1929, sketch by Sergius Ruegenberg, pencil on tracing paper, 20.9 x 27.3 cm. Staatliche Museen zu Berlin, Kunstbibliothek. © 2006 Artists Rights Society (ARS), NY/VG Bild-Kunst, Bonn. Photo © Bildarchiv Preussischer Kulturbesitz, 2006, Kunstbibliothek.

Cat. 8:7. *Barcelona Chair,* 1929, chromed steel and leather, 73 x 74 x 76 cm. The Museum of Fine Arts, Houston, Museum purchase with funds provided by J. Brian and Varina Eby, by exchange. © 2006 Artists Rights Society (ARS), NY/VG Bild-Kunst, Bonn.

## Joaquim Mir (Barcelona, 1873–1940)

Painter. Joaquim Mir i Trinxet was one of the most important landscape painters of the Catalan modernista era. He studied with Antoni Caba (1838–1907) at La Llotja, as well as Lluís Graner (1863–1929), and became a member of La Colla del Safrà—along with Isidre Nonell, Ricard Canals, and Adrià Gual. He frequented the Quatre Gats tavern. Toward the

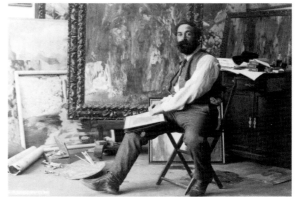

turn of the century, Mir traveled to Majorca where Santiago Rusiñol had settled and where William Degouve de Nuncques (1867–1935) also lived. He exhibited his landscapes from this period at the Sala Parés in Barcelona. A fall into a ravine in Majorca and illness prompted him to return to the mainland, where he recovered at a hospital and finally settled in Vilanova i la Geltrú. During this time he continued to paint, producing many of his most beautiful works and and exhibiting them at venues in Europe and the United States. He also created murals and stained glass for his uncle's home designed by Josep Puig i Cadafalch. He became a founding member of Les Arts i els Artistes and won the Medal of Honor, among other prizes, at the National Exposition of Fine Arts (Madrid, 1930). Financially successful, Mir collected works of art and accumulated a museum-worthy collection of ceramics. At the end of the Spanish civil war, he was briefly imprisoned and his health declined.

Cat. 2:17. *The Rock in the Pond,* c. 1903, oil on canvas, 102 x 128 cm. Museu Nacional d'Art de Catalunya, Barcelona. Photo © MNAC–Museu Nacional d'Art de Catalunya, 2006, photo Calveras/Mérida/Sagristà.

## Nicolau Miralles (Havana, 1911–Barcelona, 1992)

Cat. 9:10. *Catalans: Help Our Basque Brothers, Pro-Euzkadi Week,* c. 1937, lithograph, 100 x 77 cm. Biblioteca del Pavelló de la República (Universitat de Barcelona), Fundació Privada Centre d'Estudis d'Història Contemporània–Biblioteca Josep M. Figueras, Barcelona. (Cleveland only.) Photo © Biblioteca del Pavelló de la República.

Cat. 9:13. *Popular Army Week: A Well-Organized War Industry Will Give a Decisive Strike Toward Victory,* c. 1937, lithograph, 94 x 66 cm. Biblioteca del Pavelló de la República (Universitat de Barcelona), Fundació Privada Centre d'Estudis d'Història Contemporània–Biblioteca Josep M. Figueras, Barcelona. Photo © Biblioteca del Pavelló de la República.

## Joan Miró (Barcelona, 1893–Palma de Majorca, 1983)

Painter, printmaker, sculptor, and ceramist. Acclaimed for his innovative surrealist style that incorporated suggestive and energetic biomorphic forms, Joan Miró i Ferrà was highly influenced by the landscape of Catalonia and the events that unfolded on his native soil. Miró completed formal training at La Llotja, where he studied with Modest Urgell and Francesc Galí. Miró also frequented the Cercle Artístic de Sant Lluc.

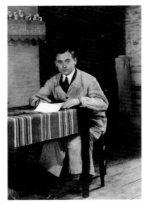

In Barcelona he met Josep Dalmau and Francis Picabia, exhibited at the Galeries Dalmau, and cofounded the Agrupació Courbet. He traveled to Paris where he met Pablo Picasso and Tristan Tzara, then returned to Catalonia and often spent his summers at the family farm in Mont-roig. He soon became friends with André Masson (1896–1987) and the Dadaist poets in Picasso's circle, including Pierre Reverdy, Tzara, and André Breton. Miró began painting in a surrealist manner around 1923–24, and Breton championed him as one of the movement's most important artists. Deeply affected by the Spanish civil war, Miró described the years 1936–39 as his period of "savage paintings." During his later years he spent time in the United States, working on mural commissions at Harvard University, in Cincinnati, and in other cities. He also experimented with ceramics, sculpture, and textiles. The Fundació Joan Miró was established in 1975 in Barcelona under the direction of the artist.

Cat. 7:21. *E. C. Ricart,* 1917, oil and pasted paper on canvas, 81.6 x 65.7 cm. The Museum of Modern Art, New York, Florence May Schoenborn Bequest. © 2006 Sucessió Miró/Artists Rights Society (ARS), NY/ADAGP, Paris. Digital image © The Museum of Modern Art/licensed by SCALA/Art Resource, NY.

Cat. 7:22. Cover for *Arc-Voltaic,* no. 1 (February 1918) (Barcelona), magazine, 30.5 x 25.4 cm. Biblioteca del IVAM–Instituto Valenciano de Arte Moderno, Generalitat, Valencia. © 2006 Sucessió Miró/Artists Rights Society (ARS), NY/ADAGP, Paris.

Cat. 7:24. *Self-Portrait,* 1920, oil on canvas, 73 x 60 cm. Musée National Picasso, Paris. © 2006 Sucessió Miró/Artists Rights Society (ARS), NY/ADAGP, Paris. Photo © Reunion des Musées Nationaux/Art Resources, NY.

Cat. 7:25. *The Farm,* 1921–22, oil on canvas, 123.8 x 141.3 cm. National Gallery of Art, Washington, Gift of Mary Hemingway. © 2006 Sucessió Miró/Artists Rights Society (ARS), NY/ADAGP, Paris. Photo © Board of Trustees, National Gallery of Art.

Cat. 7:26. *The Hunter (Catalan Landscape),* 1923–24, oil on canvas, 64.8 x 100.3 cm. The Museum of Modern Art, New York, purchase. © 2006 Sucessió Miró/Artists Rights Society (ARS), NY/ADAGP, Paris. Digital image © The Museum of Modern Art/licensed by SCALA/Art Resource, NY.

Cat. 7:27. *Woman Strolling on the Rambla of Barcelona,* 1925, oil on canvas, 130 x 97 cm. New Orleans Museum of Art, Bequest of Victor K. Kiam. © 2006 Sucessió Miró/Artists Rights Society (ARS), NY/ADAGP, Paris.

Cat. 7:29. Illustrations for *L'Amic de les Arts,* no. 26 (30 June 1928) (Sitges), pp. 202–3, articles by Salvador Dalí, Sebastià Gasch, and Lluís Montanyà, magazine, 44 x 32 x 1 cm. Biblioteca de Catalunya, Barcelona. © 2006 Salvador Dalí, Gala-Salvador Dalí Foundation/Artists Rights Society (ARS), NY. Photo courtesy Biblioteca de Catalunya.

Cat. 7:48. *Homage to Joan Prats,* 1934, collage, pencil, and charcoal on paper, 63.3 x 47 cm. Fundació Joan Miró, Barcelona, Gift of Joan Prats. © 2006 Sucessió Miró/Artists Rights Society (ARS), NY/ADAGP, Paris.

Cat. 7:51. Cover for *D'Ací d'Allà,* no. 179 (December 1934) (Barcelona), magazine, 33 x 29 cm. Daniel Giralt-Miracle Collection, Barcelona.

Cat. 7:52. *Figures in Front of the Sea,* 1934, pochoir, published in *D'Ací d'Allà,* no. 179 (December 1934) (Barcelona), magazine, 33 x 29 cm. Fundació Joan Miró, Barcelona.

Cat. 7:53. *Nocturne,* 1935, oil on copper, 62.2 x 48.8 cm. The Cleveland Museum of Art, Mr. and Mrs. William H. Marlatt Fund. © 2006 Sucessió Miró/Artists Rights Society (ARS), NY.

Cat. 9:2. *Still Life with Old Shoe,* 1937, oil on canvas, 81.3 x 116.8 cm. The Museum of Modern Art, New York, Gift of James Thrall Soby. © 2006 Sucessió Miró/Artists Rights Society (ARS), NY/ADAGP, Paris. Digital image © The Museum of Modern Art/licensed by SCALA/Art Resource, NY.

Cat. 9:3. *Aidez L'Espagne,* 1937, pochoir, 32.1 x 50.2 cm. The Metropolitan Museum of Art, New York, The Pierre and Maria-Gaetana Matisse Collection, 2002. © 2006 Sucessió Miró/Artists Rights Society (ARS), NY/ADAGP, Paris. Photo © 2005 The Metropolitan Museum of Art.

Cat. 9:39. *Woman Haunted by the Passage of the Bird–Dragonfly, Omen of Bad News,* 1938, oil on canvas, 80 x 315 cm. Toledo Museum of Art, purchased with funds from the Libbey Endowment, Gift of Edward Drummond Libbey. (Cleveland only.) © 2006 Sucessió Miró/Artists Rights Society (ARS), NY/ADAGP, Paris.

Cat. 9:40a–h. *Black and Red Series* (8 plates), 1938, drypoint printed in black and red, 16.8 x 25.8 cm each. The Museum of Modern Art, New York, Purchased with the Frances Keech Fund and funds given. © 2006 Sucessió Miró/Artists Rights Society (ARS), NY/ADAGP, Paris. Digital image © The Museum of Modern Art/licensed by SCALA/Art Resource, NY.

See also Kollar, cat. 9:22.

## Xavier Nogués (Barcelona, 1873–1941)

Painter and graphic artist. Francesc Xavier Nogués i Casas was among the most representative artists of Noucentisme, and he received critical acclaim for his drawings of popular Catalan life and decorative objects. He studied at the academies of Gabriel Martínez i Altés (1858–1940) and Pere Borell del Caso (1835–1910) before leaving Barcelona for Paris in 1901. In Paris, Nogués studied at the Académie Colarossi and Académie Vity. After returning to Barcelona, he became a founding member of Les Arts i els Artistes. He was active in the noucentista movement and was included in the *Almanach dels Noucentistes.* Nogués contributed drawings to various journals and magazines including *Papitu, Vell i Nou, Revista Nova,* and *Cuca Fera,* often using the pseudonym "Babel." Major commissions included the decoration of the cellar of the Galeries Laietanes, which he completed in 1915, as well as ceramic panels for the restaurant Can Culleretes in 1923. He collaborated with ceramists and glass makers, served as an advisor to the Barcelona International Exposition (1929–30), designed sets and costumes for the opera, and illustrated numerous books. During the 1930s he was a professor of engraving at the Escola d'Arts i Oficis de la Generalitat in Olot.

Cat. 6:18. *Coastal Landscape* (fragment of the murals in the cellar of the Galeries Laietanes), 1915, tempera on stucco, 190 x 320 cm. Museu Nacional d'Art de Catalunya, Barcelona. © 2006 Artists Rights Society (ARS), NY/VEGAP, Madrid. Photo © MNAC–Museu Nacional d'Art de Catalunya, 2006, photo Calveras/Mérida/Sagristà.

Cat. 6:48. *Ceramic Panel for Can Culleretes (Picnic),* 1923, painted ceramic, 65.6 x 91.7 cm. Museu de Ceràmica, Barcelona. © 2006 Artists Rights Society (ARS), NY/VEGAP, Madrid. Photo © Guillem.

Cat. 6:49. *Ceramic Panel for Can Culleretes (La Sardana),* 1923, white enamel ceramic painted with oxides, 65.5 x 91.7 cm. Museu de Ceràmica, Barcelona. © 2006 Artists Rights Society (ARS), NY/VEGAP Madrid. Photo © Guillem.

Cat. 6:50. With Ricard Crespo, *Flirt* (glass and plate), 1924, enameled glass, 13.2 x 9 and 2.2 x 14.2 cm. Museu de les Arts Decoratives, Barcelona, Bequest of Santiago Espona. © 2006 Artists Rights Society (ARS), NY/VEGAP, Madrid. Photo © Guillem.

Cat. 6:51. With Ricard Crespo, *Circus Scenes* (glass and plate), 1924, enameled glass, 13.4 x 9.6 and 2.3 x 14.7 cm. Museu de les Arts Decoratives, Barcelona. © 2006 Artists Rights Society (ARS), NY/VEGAP, Madrid. Photo © Guillem.

Cat. 6:52. With Ricard Crespo, *Hunting* (glass and plate), 1924, enameled glass, 13.4 x 9.5 and 2.2 x 14.7 cm. Museu de les Arts Decoratives, Barcelona. © 2006 Artists Rights Society (ARS), NY/VEGAP, Madrid. Photo © Guillem.

Cat. 6:53. With Ricard Crespo, *Fishing* (glass and plate), 1924, enameled glass, 13.3 x 9 and 1.9 x 14.2 cm. Museu de les Arts Decoratives, Barcelona. © 2006 Artists Rights Society (ARS), NY/VEGAP, Madrid. Photo © Guillem.

### Isidre Nonell (Barcelona, 1873–1911)

Painter. Isidre Nonell i Monturiol's expressive *modernista* painting style and themes of social marginalization were seminal influences on the young Pablo Picasso. Nonell studied at La Llotja, formed the artists collective La Colla del Safrà with Joaquim Mir, and frequented the Quatre Gats café, where Picasso discovered Nonell's work. Nonell held his first

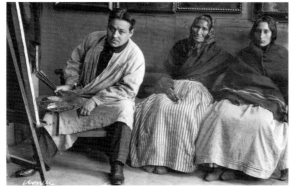

solo show at the café in 1898 and participated in exhibitions at the Sala Parés and the National Exposition (Madrid, 1895). In 1897 he traveled to Paris with Ricard Canals and exhibited at Le Barc de Boutteville with Paul Gauguin (1848–1903) and Henri de Toulouse-Lautrec. Even after returning to Barcelona in 1900 and leaving his Montmartre studio to Picasso, Nonell continued to exhibit at the Parisian Salon des Indépendants and the Salon d'Automne. Nonell's mature paintings focus on the life of the poor, sick, and dispossessed, including gypsies, veterans, and abandoned mothers—subjects that had captivated him in 1897 during a trip to Caldes de Boí. Although admired by other artists, Nonell's melancholic paintings did not find an audience among wealthy patrons. Later his subject matter shifted to more colorful female figures and still lifes. Nonell contributed to *Papitu* and other magazines and journals using the pseudonyms "Noé" and "Josué." A major exhibition of his work was held at the Faiançs Català (later renamed the Galeries Laietanes) in 1910.

Cat. 3:34. *Two Gypsies,* 1902, conté crayon and watercolor on paper, 25 x 29 cm. Artur Ramon Collection, Barcelona. Photo © Fotografia Gasull.

Cat. 4:6. *Cretin of Boí,* 1896–97, mixed media on paper, 30.6 x 22 cm. Museu Nacional d'Art de Catalunya, Barcelona. Photo © MNAC–Museu Nacional d'Art de Catalunya, 2006, photo Calveras/Mérida/Sagristà.

Cat. 4:7. *Repatriate from Cuba on the Wharf,* 1898, ink, watercolor, and varnish on paper, 29.2 x 25.8 cm. Museu Nacional d'Art de Catalunya, Barcelona. Photo © MNAC–Museu Nacional d'Art de Catalunya, 2006, photo Calveras/Mérida/Sagristà. (Cleveland only.)

Cat. 4:8. *Poor People Waiting for Soup,* 1899, oil on canvas, 51 x 65 cm. Museu de Montserrat, Gift of J. Sala Ardiz, Montserrat.

Cat. 4:9. *Blind Beggar,* 1906, conté crayon and watercolor on paper, 48 x 29.8 cm. Plandiura Collection Acquisition, Museu Nacional d'Art de Catalunya, Barcelona. Photo © MNAC–Museu Nacional d'Art de Catalunya, 2006, photo Calveras/Mérida/Sagristà.

Cat. 4:10. *Two Gypsies,* 1903, oil on canvas, 136 x 136 cm. Plandiura Collection Acquisition, Museu Nacional d'Art de Catalunya, Barcelona. Photo © MNAC–Museu Nacional d'Art de Catalunya, 2006, photo Calveras/Mérida/Sagristà.

Cat. 4:15. *Young Gypsy,* 1903, oil on canvas, 81 x 65.5 cm. Museu Nacional d'Art de Catalunya, Barcelona, Jaume Nonell Donation, 1914. Photo © MNAC–Museu Nacional d'Art de Catalunya, 2006, photo Calveras/Mérida/Sagristà.

### Josep Obiols (Sarrià, 1894–Barcelona, 1967)

Painter, muralist, illustrator, and poster designer. Josep Obiols i Palau trained at the Sarrià Escola de Decoració, founded by Joaquín Torres-García. Early in his career Obiols illustrated the *Sil·labari Català,* as well as other books and journals, and designed the poster for the Associació Protectora de l'Ensenyança Catalana. A trip to Italy inspired an interest in murals, and he completed murals in Barcelona for the Palau Nacional de Montjuïc, among other buildings. His paintings were shown at exhibitions in Europe and the United States. He also served as a professor at the Institut Escola. During the Spanish civil war, Obiols designed political posters for the Generalitat. After the war he returned to creating murals and completed projects for the Monastery of Montserrat as well as private chapels.

Cat. 6:35. Cover for *La Revista,* no. 9 (1916) (Barcelona), magazine, 27 x 21 cm. Biblioteca de Catalunya, Barcelona. Photo courtesy Biblioteca de Catalunya.

Cat. 6:38. *Have You Joined the Association to Protect Catalan Education?,* c. 1920, lithograph, 50 x 35 cm. Biblioteca de Catalunya, Barcelona. Photo courtesy Biblioteca de Catalunya.

### Ricard Opisso (Tarragona, 1880–Barcelona, 1966)

Artist and caricaturist. Although lacking formal training, Ricard Opisso i Sala became a valuable member of the group of artists centered around the Quatre Gats in Barcelona. He exhibited there and also contributed to the café's short-lived publication, *Quatre Gats.* His drawings also appeared in journals including *Luz* (in which he published his first work), *Joventut, Pèl & Ploma,* and *¡Cu-Cut!.* Early in his career Opisso worked on the Sagrada Família in the workshop of Antoni Gaudí and was a member of the Cercle Artístic de Sant Lluc. He contributed illustrations to the French journals *Le Rire* and *Fantasio* during his time in Paris. He illustrated children's books and picture cards, and worked on publications such as *L'Esquella de la Torratxa* and *Diario de Barcelona,* which chronicled his involvement in the city's art world. Opisso exhibited at the Sala Parés and the Fifth International Exposition of Fine Arts (Barcelona, 1907).

Cat. 4:5. *Little Ravachol (Montjuïc),* illustration for Raimon Casellas, "En Ravachol petit," *Calendari del ¡Cu-Cut!* (1904) (Barcelona), charcoal and ink on paper, 38.9 x 32.3 cm. Museu Nacional d'Art de Catalunya, Barcelona. (Cleveland only.) © 2006 Artists Rights Society (ARS), NY/VEGAP, Madrid. Photo © MNAC–Museu Nacional d'Art de Catalunya, 2006, photo Calveras/Mérida/Sagristà.

### Orfeó Català

Cat. 5:10. *Orfeó Català. Historial ab motiu del XXV aniversari de sa fundació, 1891–1916* (1916) (Barcelona), cover, magazine, 33.8 x 23 cm. The Cleveland Museum of Art, Ingalls Library, Gift of the Fundació Orfeó Català–Palau de la Música.

Cat. 5:11. *Orfeó Català. Historial ab motiu del XXV aniversari de sa fundació, 1891–1916* (1916) (Barcelona), two-page spread, magazine, 33.8 x 45 cm. The Metropolitan Museum of Art, New York, Department of 19th Century, Modern, and Contemporary Art Archives.

**Francis Picabia** (Paris, 1879–1953)

Painter and writer. Francis Picabia studied at the École des Arts Décoratifs in Paris in 1895–97 and later with Fernand Cormon (1845–1924). During his early years he painted Impressionist landscapes inspired by Alfred Sisley (1839–1899) and exhibited them at the Salon d'Automne and the Salon des Indépendants. Under the influence of Cubism, he experimented with colorful, geometric compositions that Guillaume Apollinaire dubbed Orphism. Picabia was also attracted to Futurism, creating some of the earliest completely abstract paintings. He participated in the Armory Show (New York, 1913). Along with Marcel Duchamp and Man Ray, Picabia initiated the Dada movement in New York. He actively contributed to *291*, the periodical published by Alfred Stieglitz (1864–1946). While living in Barcelona in 1916–17, Picabia published the Dadaist magazine *391*. Later he joined Tristan Tzara in Zurich. In the early 1920s he broke with the Dada movement and began to distance himself from André Breton.

Cat. 7:9. *Marie Laurencin. Four in Hand*, c. 1916–17, india ink, crayon, gouache, and watercolor on board, 56 x 45.5 cm. Musée National d'Art Moderne, Centre Georges Pompidou, Paris. (New York only.) © Artists Rights Society (ARS), NY/ADAGP, Paris. Photo courtesy CNAC/MNAM/Dist. Réunion des Musées Nationaux/Art Resource, NY, © Philippe Migeat.

Cat. 7:10. *Bride*, cover for *391*, no. 1 (25 January 1917) (Barcelona), magazine, 37 x 27 cm. The Museum of Modern Art Library, New York. © 2006 Artists Rights Society (ARS), NY/ADAGP, Paris. Digital image © The Museum of Modern Art/licensed by SCALA/Art Resource, NY.

Cat. 7:11. *Comb*, cover for *391*, no. 2 (10 February 1917) (Barcelona), magazine, 37 x 27 cm. The Museum of Modern Art Library, New York. © 2006 Artists Rights Society (ARS), NY/ADAGP, Paris. Digital image © The Museum of Modern Art/licensed by SCALA/Art Resource, NY.

Cat. 7:12. *Flamenco Dancer*, cover for *391*, no. 3 (1 March 1917) (Barcelona), magazine, 37 x 27.4 cm. The Museum of Modern Art Library, New York. © 2006 Artists Rights Society (ARS), NY/ADAGP, Paris. Digital image © The Museum of Modern Art/licensed by SCALA/Art Resource, NY.

Cat. 7:13. *Wheel*, cover for *391*, no. 4 (15 March 1917) (Barcelona), magazine, 37 x 27 cm. The Museum of Modern Art Library, New York. © 2006 Artists Rights Society (ARS), NY/ADAGP, Paris. Digital image © The Museum of Modern Art/licensed by SCALA/Art Resource, NY.

Cat. 7:14. *Resonator*, 1922, watercolor, gouache, and ink on paper, 72.4 x 53.3 cm. Grey Art Gallery, New York University Art Collection, Donation Frank J. Bradley. © 2006 Artists Rights Society (ARS), NY/ADAGP, Paris. Photo by Sarah Wells.

**Pablo Picasso** (Málaga, 1881–Mougins, 1973)

Painter, sculptor, and ceramist. Pablo Ruiz Picasso studied with his father, an academic painter, before attending the art school in La Coruña and La Llotja in Barcelona. After only a year at Madrid's Real Academia de Bellas Artes de San Fernando, he abandoned his formal studies, returned to Barcelona, and began frequenting the Quatre Gats tavern. He made his first trip to Paris in the fall of 1900. After passing through his Blue and Rose periods (1901–4 and 1904–6), Picasso entered into a period of radical experimentation leading to the invention of Cubism with his collaborator Georges Braque in 1908–9. The Galeries Dalmau, among others in Barcelona, exhibited Picasso's work, which was also featured in the Catalan publications *Joventut, Catalunya Artística,* and *Almanach dels Noucentistes*. In 1917 he collaborated with Jean Cocteau on set designs and costumes for the Ballet Russes's *Parade* and met the ballerina Olga Koklova, whom he married in 1918. Picasso contributed to the first exhibition of surrealist art, held in Paris in 1925, although he never formally joined the movement. Responding to the horrors of the Spanish civil war, he completed the etchings *Dream and Lie of Franco* and created the painting *Guernica* for the Spanish pavilion at the Paris International Exhibition (1937). After Franco's victory in the civil war, Picasso never returned to Spain, but his sister and relatives continued to live in Barcelona.

Cat. 2:9. *Le Moulin de la Galette,* 1900, oil on canvas, 88.2 x 115.5 cm. The Solomon R. Guggenheim Museum, New York. Thannhauser Collection, Gift, Justin K. Thannhauser, 1978. © 2006 Estate of Pablo Picasso/Artists Rights Society (ARS), NY.

Cat. 2:10. *The End of the Act,* c. 1901, pastel on canvas, 72 x 46 cm. Museu Picasso, Barcelona. © 2006 Estate of Pablo Picasso/Artists Rights Society (ARS), NY. Photo © Museu Picasso/AHCB-AF/J. Calafell/R. Feliu.

Cat. 3:2. (Attributed to). *Quatre Gats Mobile,* c. 1899, metal painted on both sides, 35 x 35 cm. Fundació Cultural Privada M. Rocamora, Barcelona. © 2006 Estate of Pablo Picasso/Artists Rights Society (ARS), NY. Photo courtesy D'Onofrio&Sanjuán.

Cat. 3:4. *Interior of the Quatre Gats*, 1899, oil on canvas, 41 x 28 cm. Private collection. © 2006 Estate of Pablo Picasso/Artists Rights Society (ARS), NY. Photo © Museo Picasso, Barcelona/The Bridgeman Art Library.

Cat. 3:9. *Santiago Rusiñol*, 1900, charcoal and watercolor on paper, 33 x 23 cm. El Conventet Collection, Barcelona. © 2006 Estate of Pablo Picasso/Artists Rights Society (ARS), NY. Photo courtesy D'Onofrio&Sanjuán.

Cat. 3:10. *Decadent Poet (Sabartés),* 1900, charcoal and watercolor on paper, 48 x 32 cm. Museu Picasso, Barcelona. © 2006 Estate of Pablo Picasso/Artists Rights Society (ARS), NY. Photo © Museu Picasso–Ramon Muro.

Cat. 3:11. *Self-Portrait,* 1900, pen, ink, watercolor, and chalk on paper, 9.5 x 8.6 cm. The Metropolitan Museum of Art, New York, Gift of Raymonde Paul in memory of her brother, C. Michael Paul. © 2006 Estate of Pablo Picasso/Artists Rights Society (ARS), NY. Photo © 1984 The Metropolitan Museum of Art.

Cat. 3:12. *Ramon Pichot,* 1900, pen, ink, watercolor, and chalk on paper, 9.8 x 8.9 cm. The Metropolitan Museum of Art, New York, Gift of Raymonde Paul in memory of her brother, C. Michael Paul. © 2006 Estate of Pablo Picasso/Artists Rights Society (ARS), NY. Photo © 1984 The Metropolitan Museum of Art.

Cat. 3:13. *Hermen Anglada-Camarasa*, 1900, pen, ink, watercolor, and chalk on paper, 12.1 x 9.8 cm. The Metropolitan Museum of Art, New York, Gift of Raymonde Paul in memory of her brother, C. Michael Paul. © 2006 Estate of Pablo Picasso/Artists Rights Society (ARS), NY. Photo © 1984 The Metropolitan Museum of Art.

Cat. 3:14. *Ramon Casas,* 1900, pen, ink, watercolor, and chalk on paper, 10.8 x 10.2 cm. The Metropolitan Museum of Art, New York, Gift of Raymonde Paul in memory of her brother, C. Michael Paul. © 2006 Estate of Pablo Picasso/Artists Rights Society (ARS), NY. Photo © 1984 The Metropolitan Museum of Art.

Cat. 3:15. *Joaquim Mir,* 1900, pen, ink, watercolor, and chalk on paper, 9.2 x 7.9 cm. The Metropolitan Museum of Art, New York, Gift of Raymonde Paul in memory of her brother, C. Michael Paul. © 2006 Estate of Pablo Picasso/Artists Rights Society (ARS), NY. Photo © 1984 The Metropolitan Museum of Art.

Cat. 3:16. *Santiago Rusiñol,* 1900, pen, ink, watercolor, and chalk on paper, 10.8 x 10.2 cm. The Metropolitan Museum of Art, New York, Gift of Raymonde Paul in memory of her brother, C. Michael Paul. © 2006 Estate of Pablo Picasso/Artists Rights Society (ARS), NY. Photo © 1984 The Metropolitan Museum of Art.

Cat. 3:17. *Pere Romeu Borràs,* 1900, pen, ink, watercolor, and chalk on paper, 7 x 8.6 cm. The Metropolitan Museum of Art, New York, Gift of Raymonde Paul in memory of her brother, C. Michael Paul. © 2006 Estate of Pablo Picasso/Artists Rights Society (ARS), NY. Photo © 1984 The Metropolitan Museum of Art.

Cat. 3:18. *Carles Casagemas*, 1900, pen, ink, watercolor, and chalk on paper, 10.5 x 7.9 cm. The Metropolitan Museum of Art, New York, Gift of Raymonde Paul in memory of her brother, C. Michael Paul. © 2006 Estate of Pablo Picasso/Artists Rights Society (ARS), NY. Photo © 1984 The Metropolitan Museum of Art.

Cat. 3:19. *Frederic Pujulà i Vallès*, 1900, pen, ink, and watercolor on paper, 10.5 x 7.9 cm. The Metropolitan Museum of Art, New York, Gift of Raymonde Paul in memory of her brother, C. Michael Paul. © 2006 Estate of Pablo Picasso/Artists Rights Society (ARS), NY. Photo © 1984 The Metropolitan Museum of Art.

Cat. 3:20. *Benet Soler*, 1900, pen, ink, and watercolor on paper, 10.8 x 8.3 cm. The Metropolitan Museum of Art, New York, Gift of Raymonde Paul in memory of her brother, C. Michael Paul. © 2006 Estate of Pablo Picasso/Artists Rights Society (ARS), NY. Photo © 1984 The Metropolitan Museum of Art.

Cat. 3:21. *Juli Vallmitjana*, 1900, pen, ink, and watercolor on paper, 12.4 x 8.9 cm. The Metropolitan Museum of Art, New York, Gift of Raymonde Paul in memory of her brother, C. Michael Paul. © 2006 Estate of Pablo Picasso/Artists Rights Society (ARS), NY. Photo © 1984 The Metropolitan Museum of Art.

Cat. 3:23. With Ramon Casas, *Quatre Gats Menu, with Pere Romeu Caricatured as a Boer, and Other Sketches*, c. 1900, chromolithograph and pencil on paper, 8.7 x 13.1 cm. Museu Picasso, Barcelona. © 2006 Estate of Pablo Picasso/Artists Rights Society (ARS), NY. Photo © Museu Picasso/AHCB-AF/J. Calafell.

Cat. 3:28. *The Artist's Sister, Lola (Lola in a Spanish Dress)*, c. 1899, oil on canvas, 46.7 x 37.5 cm. The Cleveland Museum of Art, Gift of Mr. and Mrs. David S. Ingalls. © 2006 Estate of Pablo Picasso/Artists Rights Society (ARS), NY.

Cat. 3:32. *Self-Portrait*, 1900, charcoal on paper, 22.5 x 16.5 cm. Museu Picasso, Barcelona. © 2006 Estate of Pablo Picasso/Artists Rights Society (ARS), NY. Photo © Museu Picasso/AHCB-AF/J. Calafell.

Cat. 4:12. *Seated Woman*, 1902, bronze, 14 x 11 x 8 cm. Museu Picasso, Barcelona. © 2006 Estate of Pablo Picasso/Artists Rights Society (ARS), NY. Photo © Museu Picasso, Barcelona–Ramon Muro.

Cat. 4:13. *Woman Ironing*, 1901, oil on canvas, 49.5 x 25.7 cm. The Metropolitan Museum of Art, New York, Alfred Stieglitz Collection. © 2006 Estate of Pablo Picasso/Artists Rights Society (ARS), NY.

Cat. 4:14. *Carlota Valdivia* (later called *La Celestina*), 1903, oil on canvas, 81 x 61 cm. Musée National Picasso, Paris. © 2006 Estate of Pablo Picasso/Artists Rights Society (ARS), NY. Photo © Réunion des Musées Nationaux/Art Resource, NY.

Cat. 4:16. *Blindman's Meal*, 1903, oil on canvas, 95.25 x 65.5 cm. The Metropolitan Museum of Art, New York, Mr. and Mrs. Ira Haupt Gift. © 2006 Estate of Pablo Picasso/Artists Rights Society (ARS), NY. Photo © 1996 The Metropolitan Museum of Art.

Cat. 4:17. *La Vie*, 1903, oil on canvas, 196.5 x 129.5 cm. The Cleveland Museum of Art, Gift of the Hanna Fund. © 2006 Estate of Pablo Picasso/Artists Rights Society (ARS), NY.

Cat. 6:3. *Catalan Landscape (Gósol Landscape)*, 1906, oil on canvas, 69.8 x 99 cm. Private collection. © 2006 Estate of Pablo Picasso/Artists Rights Society (ARS), NY. Photo Christie's Image VII.

Cat. 6:4. *Woman with Loaves*, 1906, oil on canvas, 99.5 x 68.8 cm. Philadelphia Museum of Art, Gift of Charles E. Ingersoll. © 2006 Estate of Pablo Picasso/Artists Rights Society (ARS), NY.

Cat. 6:5. *Head of a Catalan Peasant (Josep Fondevila)*, 1906, oil on canvas, 40.3 x 45.1 cm. The Metropolitan Museum of Art, New York, Gift of Florence M. Schoenborn, 1992. © 2006 Estate of Pablo Picasso/Artists Rights Society (ARS), NY. Photo © 1995 The Metropolitan Museum of Art.

Cat. 6:6. *Head of a Boy*, c. 1906, opaque matte paint, possibly tempera, on board, laid down on wood and cradled, 24.6 x 18.6 cm. The Cleveland Museum of Art, Bequest of Leonard C. Hanna Jr. (Cleveland only.) © 2006 Estate of Pablo Picasso/Artists Rights Society (ARS), NY.

Cat. 6:7. *Nude (Pink)* or *Woman Washing Herself (Study for "The Harem")*, 1906, gouache and watercolor on paper, 63.5 x 48.2 cm. The Cleveland Museum of Art, Hinman B. Hurlbut Collection. (Cleveland only.) © 2006 Estate of Pablo Picasso/Artists Rights Society (ARS), NY.

Cat. 6:8. *The Harem*, 1906, oil on canvas, 154.3 x 110 cm. The Cleveland Museum of Art, Bequest of Leonard C. Hanna Jr. © 2006 Estate of Pablo Picasso/Artists Rights Society (ARS), NY.

Cat. 6:9. *Reclining Nude (Fernande)*, 1906, watercolor and gouache, with pencil and possibly charcoal, on beige modern laid paper, 47.3 x 61.3 cm. The Cleveland Museum of Art, Gift of Mr. and Mrs. Michael Straight. (Cleveland only.) © 2006 Estate of Pablo Picasso/Artists Rights Society (ARS), NY.

Cat. 6:21. *Head of a Woman*, 1921, pastel and charcoal on paper, 64.14 x 49.5 cm. The Metropolitan Museum of Art, New York. (New York only.) © 2006 Estate of Pablo Picasso/Artists Rights Society (ARS), NY.

Cat. 6:22. *Mother and Child*, 1921, pencil on paper, 24.8 x 32.1 cm. The Cleveland Museum of Art, Mr. and Mrs. Lewis B. Williams Collection. (Cleveland only; not illustrated.)

Cat. 7:1. *Manuel Pallarés*, 1909, oil on canvas, 68 x 49.5 cm. The Detroit Institute of Arts, Gift of Anne and Henry Ford II. © 2006 Estate of Pablo Picasso/Artists Rights Society (ARS), NY. Photo © 1984 The Detroit Institute of Arts.

Cat. 7:2. *Houses on the Hill, Horta d'Ebre*, 1909, oil on canvas, 63.5 x 76.2 cm. Nationalgalerie, Museum Berggruen, Staatlich Museen zu Berlin. (New York only.) © 2006 Estate of Pablo Picasso/Artists Rights Society (ARS), NY. Photo courtesy Bilderarchiv Preussischer Kulturbesitz/Art Resource, NY © Jens Ziehe.

Cat. 7:3. *The Factory (The Brick Factory at Tortosa)*, 1909, oil on canvas, 53 x 60 cm. The State Hermitage Museum, St. Petersburg. (Cleveland only.) © 2006 Estate of Pablo Picasso/Artists Rights Society (ARS), NY.

Cat. 7:4. *Still Life with Glass and Lemon*, 1910, oil on canvas, 74 x 101.1 cm. The Cincinnati Art Museum, Bequest of Mary E. Johnston. © 2006 Estate of Pablo Picasso/Artists Rights Society (ARS), NY. Photo Walsh 9/99.

Cat. 9:28. *Dream and Lie of Franco*, 8 January 1937, etching and aquatint, 31.5 x 42.2 cm. The Cleveland Museum of Art, Gift of the Print Club of Cleveland. (Cleveland only.) © 2006 Estate of Pablo Picasso/Artists Rights Society (ARS), NY.

Cat. 9:29. *Dream and Lie of Franco*, 9 January 1937, etching and aquatint, 31.5 x 42.2 cm. The Cleveland Museum of Art, Gift of the Print Club of Cleveland. (Cleveland only.) © 2006 Estate of Pablo Picasso/Artists Rights Society (ARS), NY.

Cat. 9:30. *Horse and Mother with Dead Child (Study for "Guernica")*, 1937, pencil on paper, 23.8 x 72 cm. Museo Nacional Centro de Arte Reina Sofía, Madrid. © 2006 Estate of Pablo Picasso/Artists Rights Society (ARS), NY. Photo © Archivo Fotográfico Museo Nacional Centro de Arte Reina Sofía, Madrid, 2006.

Cat. 9:31. *Woman with Dead Child on a Ladder*, 1937, pencil and colored crayon, 45.5 x 24.3 cm. Museo Nacional Centro de Arte Reina Sofía, Madrid. © 2006 Estate of Pablo Picasso/Artists Rights Society (ARS), NY. Photo © Archivo Fotográfico Museo Nacional Centro de Arte Reina Sofía, Madrid.

Cat. 9:32. *Weeping Woman*, 1937, etching, aquatint, and drypoint, 77 x 56.7 cm (sheet). The Museum of Modern Art, New York. Acquired through the generosity of the Katsko Suzuki Memorial Fund, the Riva Castleman Endowment Fund, David Rockefeller, The Philip and Lynn Staus Foundation Fund, and Agnes Gund and Daniel Shapiro, Linda and Bill Goldstein, Mr.

and Mrs. Herbert D. Schi. (New York only.) © 2006 Estate of Pablo Picasso/Artists Rights Society (ARS), NY. Digital image © The Museum of Modern Art/licensed by SCALA/Art Resource, NY.

Cat. 9:37. *Suppliant Woman*, 1937, gouache and india ink on wood, 24 x 18.5 cm. Musée National Picasso, Paris. © 2006 Estate of Pablo Picasso/Artists Rights Society (ARS), NY. Photo © Réunion des Musées Nationaux/Art Resource, NY. Jean-Gilles Berizzi.

Cat. 9:41. *Bull Skull, Fruit, Pitcher*, 1939, oil on canvas, 65 x 92 cm. The Cleveland Museum of Art, Leonard C. Hanna Jr. Fund. © Estate of Pablo Picasso/Artists Rights Society (ARS), NY.

Cat. 9:42. *Cat Seizing a Bird*, 1939, oil on canvas, 81 x 100 cm. Musée National Picasso, Paris. (Cleveland only.) © 2006 Estate of Pablo Picasso/Artists Rights Society (ARS), NY.

See also Sert, cat. 9:23.

## Ramon Pichot (Barcelona, 1872–Paris, 1925)

Painter, printmaker, and illustrator. The modernista painter Ramon Pichot i Gironès was a close friend of Pablo Picasso. Born into a family of musicians and poets, Pichot studied at La Llotja, joined the artists collective La Colla del Safrà, and frequented the Quatre Gats café. In 1895 he traveled to Paris and in 1898 exhibited at the National Salon. That year he joined Santiago Rusiñol on a trip through Spain, painting the local scenery and exploring the country. He also collaborated with Rusiñol on the play *Fulls de la vida*. Pichot's first solo exhibition was held at the Quatre Gats in 1899. Around 1900 Pichot traveled to Paris and became a member of "la bande à Picasso," a circle of expatriate Spanish artists living in Montmartre. Pichot collaborated with Picasso on decorating the cabaret Zut in Montmartre. He also participated in the celebrated Fauve exhibition at the Salon d'Automne of 1905 and became acquainted with Georges Braque. Although Pichot acquired a permanent residence in Montmartre called La Maison Rose, he returned frequently to Barcelona and participated in local exhibitions at the Galeries Dalmau. Pichot married Germaine Gargallo, the woman whose rejection of Carles Casagemas reportedly led to the latter's suicide. Picasso commemorated Pichot's death with his celebrated painting *The Three Dancers*, 1925 (Tate Gallery, London).

Cat. 3:29. *Granadina*, 1898, charcoal, pastel, and ink on paper, 36 x 32 cm. Private collection, courtesy Artur Ramon Gallery, Barcelona. Photo © Fotografia Gasull.

## Marià Pidelaserra (Barcelona, 1877–1946)

Painter. Marià Pidelaserra i Brias was an important, though underappreciated Catalan landscape artist who experimented with various Impressionist and post-Impressionist techniques. He attended La Llotja and the academy of Gabriel Martínez i Altés (1858–1940) in Barcelona and worked with Adrià Gual in his studio. During a sojourn in Paris, Pidelaserra studied at the Académie Colarossi, gained inspiration from the art of Pierre Puvis de Chavannes, and was particularly impressed by Impressionist and post-Impressionist theories, including Divisionism. He exhibited his paintings at the Sala Parés as well as other venues in Barcelona. He perfected his pointillist style during his time at the hermitage of Sant Segimon del Montseny. Notable exhibitions toward the end of his life include a 1932 installation of his work at the Brooklyn Museum of Art and several shows in Barcelona and throughout Europe.

Cat. 2:16. *Mountains from the Montseny. Calm Day in the Morning*, 1903, oil on canvas, 70.5 x 85.5 cm. Museu Nacional d'Art de Catalunya, Barcelona. Photo © MNAC–Museu Nacional d'Art de Catalunya, 2006, photo Calveras/Mérida/Sagristà.

## Joaquim Pla Janini (Tarragona, 1879–Barcelona, 1970)

Physician and photographer. Joaquim Pla i Janini was one of the foremost masters of the bromide technique, as well as other color processes, used to create his celebrated photographs of Barcelona and the surrounding landscape. Growing up in Manila where his father was a military doctor, Pla Janini followed in the family tradition and studied medicine at La Universidad de Santo Tomás in the Philippines. From a young age he was intrigued by photography, and his first forays in the field apparently began at the age of 14. In 1898, after Spain ceded the Philippines to the United States, the family moved to Barcelona, and Pla Janini continued his medical studies there, earning his degree in 1903 and working as a doctor at the Hospital de la Santa Creu i Sant Pau. During a holiday trip to Camprodon, where he was inspired by the rural landscape, he met Concepció Guarro, who became his wife in 1906. He practiced medicine until 1931—when he retired owing to ill health—while simultaneously pursuing his interests in photography, especially various color processes. He became a member of the Agrupació Fotogràfica de Catalunya in 1924 and later served as its president in 1927–30. In October 1934 *Art de la Llum* devoted a special issue to Pla Janini. His work was represented in numerous exhibitions in Spain; his color photographs of still lifes and landscapes in the pictorialist tradition garnered him numerous prizes. In 1952 he received the Gold Medal at the Salzburg Internationale Photo-Biennale.

Cat. 7:39. *The Fates*, c. 1915–30, bromoil print, triptych, 29 x 41.5, 48.5 x 34.5, and 29 x 41.5 m. Museu Nacional d'Art de Catalunya, Barcelona, Dipòsit Sr. Joaquim Pla Guarro. (Cleveland only.) Photo © MNAC–Museu Nacional d'Art de Catalunya, 2006, photo Calveras/Mérida/Sagristà.

## Àngel Planells (Cadaqués, 1901–Barcelona, 1989)

Painter. Àngel Planells i Cruanyes initially trained as an engraver, and his early style revealed the influence of Feliu Elias and other realist painters. Soon, however, he discovered Surrealism through Salvador Dalí and René Magritte (1898–1967). Planells participated in a 1929 group exhibition at the Galeries Dalmau in Barcelona and thereafter in several individual shows. In 1936 he exhibited with the Associació d'Artistes Independents, in the Exposició Logicofobista, and in the First International Exhibition of Surrealism (London). After the Spanish civil war, he continued to exhibit his surrealist paintings. Later he exhibited repeatedly at the Galeria René Metras, and his art was included in major exhibitions of surrealist art. In 2004–5 a major retrospective of his work toured several museums in Catalonia.

Cat. 7:32. *The Perfect Crime*, 1929, oil on canvas, 41.5 x 41 cm. Private collection. Photo © Fotografia Gasull.

## Josep Puig i Cadafalch (Mataró, 1867–Barcelona, 1956)

Architect, historian, and politician. One of the foremost modernista architects working in Barcelona at the turn of the century, Josep Puig i Cadafalch was celebrated for incorporating diverse styles—such as Northern Gothic, Flemish, and Tyrolean influences—into Catalan architecture. He initially studied architecture and science at the Escola Superior d'Arquitectura, earned his Ph.D. in Madrid, then designed several architectural projects in Mataró (Catalonia), before establishing himself professionally in Barcelona. Among his first works were Casa Martí—which became the Quatre Gats café—and the Macià jewelry store. He designed Casa Amatller, Casa Macaya, Casa Serra, Casa Quadras, and the Casarramona factory, among other projects. He played a key role in designing the plaça de Catalunya. As president and cofounder of the Institut d'Estudis Catalans, Puig directed the restoration of many churches in Barcelona. An archaeologist and architectural historian as well, he was vital to the excavations at the Greco-Roman settlement of Empúries and wrote several books on Gothic and Romanesque architecture, including *L'arquitectura romànica a Catalunya*. He also

contributed articles to *La Veu de Catalunya,* which he co-founded. He lectured widely and taught at Barcelona's Escola d'Arquitectura, as well as at the Sorbonne, Harvard College, and Cornell University. In 1917 he was elected the second president of the Mancomunitat de Catalunya, a post he maintained until the 1923 coup d'état of Miguel Primo de Rivera (1870–1930). At the onset of the Spanish civil war, Puig sought refuge in Paris and then Roussillon, France.

Cat. 3:1. *Casa Martí,* from *L'Oeuvre de Puig Cadafalch, Architecte: 1896–1904* (1904), book, 20 x 24 x 2.5 cm. The Metropolitan Museum of Art, New York, Thomas J. Watson Library, Gift of the Friends of the Watson Library.

Cat. 5:1. Title page of *L'Oeuvre de Puig Cadafalch, Architecte: 1896–1904* (1904), book, 20 x 24 x 2.5 cm. Emory University, Atlanta, Manuscripts, Archives and Rare Book Library.

Cat. 5:2. *Façade of Casa Martí (Quatre Gats), Barcelona,* 1896, ink on canvas paper, 45.5 x 66 cm. Ajuntament de Barcelona, Arxiu Municipal Administratiu. Photo © Pep Parer-fotògraf.

Cat. 5:3. *Façade of Casa Amatller,* 1898, ink on canvas paper, 81 x 59 cm. Ajuntament de Barcelona, Arxiu Municipal Administratiu. Photo © Pep Parer-fotògraf.

Cat. 5:4. *Project for the Main Stairway of Casa Amatller,* 1898–1900, ink and watercolor on paper, 26.2 x 28.5 cm. Institut Amatller d'Art Hispànic, Barcelona.

Cat. 5:5. *Ceiling Lamp from Casa Amatller,* 1898–1900, metal and stained glass, gas lamp adapted for electricity, 146 x 35 cm. Institut Amatller d'Art Hispànic, Barcelona.

Cat. 5:6. Designer, with Taller Homar (probable manufacturer), *Bench from the Entrance Hall of Casa Amatller,* 1900, oak, 112 x 165 x 64 cm. Institut Amatller d'Art Hispànic, Barcelona.

Cat. 5:7. *Casaramona Factory,* c. 1910, model made by Juan Pablo Marín in 1989, wood and metal, 50 x 123.5 x 117 cm. Museu Nacional d'Art de Catalunya, Barcelona. Photo © MNAC–Museu Nacional d'Art de Catalunya, 2006, photo Calveras/Mérida/Sagristà.

Cat. 8:1. *Exposition 1917, Perspective Drawing for the 1917 Universal Exposition of Electrical Industries,* 1915, ink and pencil on canvas paper, 73 x 140 cm. Ajuntament de Barcelona, Arxiu Municipal Administratiu. Photo © Pep Parer-fotògraf.

## Joan Rebull (Reus, 1899–Barcelona, 1981)

Sculptor. Championed by the Catalan art dealer Joan Merli, Joan Rebull i Torroja garnered acclaim during his artistic career for his purity of form and distinguished modeling. He studied at La Llotja in Barcelona and was a member of the Evolutionists. Visiting Paris in 1926–29, he exhibited at the Salon des Indépendants. In 1930 he returned to Spain during the dictatorship of Miguel Primo de Rivera. Rebull became deputy of the Vilanova i la Geltrú parliament in 1931 and later president of the Salon de Montjuïc. He cofounded the Taller-Escola de Pintura i Escultura de Tarragona. In 1933 Madrid's Museo Nacional de Arte Moderno held an exhibition of his works and those of Enric Casanovas. Exiled in 1939, Rebull returned to Paris where he continued to exhibit and collaborate on projects. After 1948 he returned to Barcelona and designed the tomb of the Abat Marcet and the large frieze for the Monastery of Montserrat. By 1962 he had become a professor at the Reial Acadèmia Catalana de Belles Arts de Sant Jordi, Barcelona. Toward the end of his life Rebull was awarded the Gold Medal of the Generalitat of Catalonia.

Cat. 6:28. *Self-Portrait,* 1919, stone, 36 x 25 cm. Cristina Rebull Farré, on deposit at the Museu d'Art i Història de Reus. Photo © Institut Municipal de Museus de Reus.

## Romà Ribera (Barcelona, 1849–1935)

Painter. Romà Ribera i Cirera was a successful painter of Catalan and French bourgeois life. His most celebrated paintings portray women leaving balls and frequenting cafés. He studied at La Llotja and trained with Pere Borrell del Caso. Ribera also studied in Rome and London before establishing himself in Paris. He exhibited at the Paris Universal Exposition (1878), where he received substantial acclaim for his elegant scenes of upper-class social life. After more than a decade in Paris, Ribera returned to Barcelona and exhibited at the Centre d'Aquarel·listes and the Sala Parés. He also served on the jury of numerous art boards.

Cat. 4:3. *Leaving the Ball,* c. 1894, oil on canvas, 113 x 65 cm. Museu Nacional d'Art de Catalunya, Barcelona. Photo © MNAC–Museu Nacional d'Art de Catalunya, 2006, photo Calveras/Mérida/Sagristà.

## E. C. Ricart (Vilanova i la Geltrú, 1893–1960)

Engraver and painter. An innovative artist of the noucentista movement, Enric Cristòfol Ricart i Nin was a leader in woodblock engraving, a founding member of the Agrupació Courbet and Les Arts i els Artistes, and a close friend of Joan Miró. Ricart studied at the Acadèmia Galí and the Escola Superior dels Bells Oficis, where he developed his engraving techniques. He and Miró shared a studio from 1915, and they traveled to Paris together in 1920. Galeries Dalmau held Ricart's first solo show in 1917. Numerous other exhibitions followed at the Sala Parés and other venues in Barcelona and abroad. Ricart illustrated many written works with his engravings, including Santiago Vinardell's *Aleluyas,* William Shakespeare's *Antony and Cleopatra,* and Joan Amades's *Llegendes i tradicions de Montserrat.*

Cat. 7:20. *Joan Miró,* 1916, oil and collage on canvas, 84 x 71 cm. Fundació Joan Miró, Barcelona.

## Alexandre de Riquer (Calaf, 1856–Palma de Majorca, 1920)

Graphic designer, illustrator, painter, and poet. Alexandre de Riquer i Inglada was one of the premier graphic designers in fin-de-siècle Catalonia. He first studied at the École Supérieure des Beaux-Arts in Toulouse in 1873–75. He also attended La Llotja in Barcelona, studying with Antoni Caba (1834–1907). Riquer discovered the art of the British Arts and Crafts movement, the Pre-Raphaelites, Japonisme, American poster and bookplate design, and Art Nouveau on trips to London and Paris. He integrated these styles with his innovative and decorative approach to bookplates and posters, leading the way in these genres in Barcelona and attracting royal patronage and commissions. Riquer showed ingenuity in a number of other artistic endeavors, including decorations for architectural projects, designs for decorative objects, and mural painting. He was one of the founding members of the Cercle Artístic de Sant Lluc. He won numerous awards at major international exhibitions in Barcelona, Chicago, and Madrid. He also distinguished himself as a poet, publishing several collections of sonnets in early 1900, including *Crisantemes,* that exemplify the spirit of Modernisme. He cofounded the journal *Luz* and contributed to *Joventut, La Ilustración Artística,* and *La Ilustració Catalana.* Like his colleague Joaquim Mir, Riquer eventually moved to Majorca and continued to paint and write for the rest of his career.

Cat. 2:19. *Allegory,* cover for *Luz* (3rd week of October 1898), magazine, 37 x 16.5 cm. Biblioteca de l'Ateneu Barcelonès, Barcelona.

Cat. 2:26. *Salon Pedal,* 1897, chromolithograph, 139.5 x 48.5 cm. Museu Nacional d'Art de Catalunya, Barcelona. Photo © MNAC–Museu Nacional d'Art de Catalunya, 2006, photo Calveras/Mérida/Sagristà.

Cat. 5:17. *Screen from Palau Güell*, 1900, stained glass, iron sheet, oil paint, lemon and pine wood, 140 x 50 cm. Palau Güell, Diputació de Barcelona.

### Josep M. Roviralta (Barcelona, 1880–Biarritz, 1960)

Graphic artist and poet. Josep Maria Roviralta cofounded *Luz,* the first modernista magazine in Barcelona, in November 1897 to bring public attention to the art of his colleagues Adrià Gual, Miquel Utrillo, and Santiago Rusiñol, among others. A graphic designer in his own right, Roviralta was also the magazine's principal illustrator, along with Alexandre de Riquer. Roviralta's works were inflected with symbolist themes—often allegorical female figures amid swirling floral elements. Along with Víctor Oliva, Roviralta also directed the production of the programs for the Associació Wagneriana. His poem *Boires Baixes* (1902), illustrated by Lluís Bonnín (1873–1964), was one of the most celebrated literary achievements of the time.

Cat. 2:18. *Harmonies,* cover for *Luz* (2nd week of October 1898), magazine, 37 x 16.5 cm. Biblioteca d'Història de l'Art, Museu Nacional d'Art de Catalunya, Barcelona. Photo © MNAC–Museu Nacional d'Art de Catalunya, 2006, photo Calveras/Mérida/Sagristà.

### G. L. Ruiz

Cat. 1:7. *Universal Exposition in Barcelona 1888*, 1888, chromolithograph and lithograph, 94 x 80 cm. Biblioteca de Catalunya, Barcelona. Photo courtesy Biblioteca de Catalunya.

### Santiago Rusiñol (Barcelona, 1861–Aranjuez, 1931)

Painter and writer. Santiago Rusiñol i Prats and Ramon Casas were among the most important painters in 19th-century Spain, leading the effort to create a modernista art movement. Rusiñol went to Paris in 1887 and joined the bohemian life of Montmartre. He became an important figure among the Spanish artists who frequented the Chat Noir, where he

associated with Casas, Miquel Utrillo, and Manolo, among others. His friends included the painter Suzanne Valadon (1865–1938) and the musician Erik Satie. In Paris, Rusiñol was influenced by Eugène Carrière (1849–1906), Pierre Puvis de Chavannes, and J. A. M. Whistler. From 1890 to 1894 he shared his Montmartre studio with Casas. Together they painted the local cafés and dance halls. In 1891 Rusiñol moved to Sitges and established a house, the Cau Ferrat, which became a gathering place for Catalan Modernistas and the venue for the Festes Modernistes. He was a key figure in founding the artist's café Quatre Gats in 1897. Around the turn of the century, Rusiñol wrote several novels and plays, including *L'auca del senyor Esteve* (1907) and *La mare* (1907). During his later years he devoted himself more to landscape painting, especially, garden scenes.

Cat. 2:3. *Café de Montmartre,* 1890, oil on canvas, 80 x 116 cm. Museo de Montserrat, Gift of J. Sala Ardiz, Montserrat.

Cat. 2:5. *Kitchen at the Moulin de la Galette,* 1890–91, oil on canvas, 97.5 x 131 cm. Museu Nacional d'Art de Catalunya, Barcelona. Photo © MNAC–Museu Nacional d'Art de Catalunya, 2006, photo Calveras/Mérida/Sagristà.

Cat. 2:6. *An Aquarium (Interior of a Café),* 1891, oil on canvas, 100.3 x 81.3 cm. Philadelphia Museum of Art, John G. Johnson Collection. Photo by Graydon Wood.

Cat. 2:8. *Morphine,* 1894, oil on canvas, 87.3 x 115 cm. Museu Cau Ferrat, Consorci del Patrimoni de Sitges. (Cleveland only.)

Cat. 2:29. With Miquel Utrillo, *Pages of Life,* 1898, chromolithograph, 102 x 72 cm. Biblioteca de Catalunya, Barcelona. Photo courtesy Biblioteca de Catalunya.

Cat. 3:25. Cover for *Quatre Gats: publicació artística-literària,* no. 5 (9 March 1899) (Barcelona), magazine, 30.5 x 25.4 cm. Universitat de Barcelona, CRAI, Biblioteca de Lletres. Photo © Universitat de Barcelona.

### Joan Salvat-Papasseit (Barcelona, 1894–1924)

Writer and poet. Editor of the avant-garde magazine *Un enemic del Poble* (1917–19), Joan Salvat i Papasseit was an important poet at the forefront of avant-garde expression in Barcelona. He grew up in a working-class neighborhood in Barcelona, and expressed his radical political views in early writings, *Humo de fábrica* and *Glosas de un socialista.* His first book of poetry, *Poemes en ondes hertzianes* (1919), was strongly influenced by the Futurists and Guillaume Apollinaire. A second book of poems, *L'irradiador del port i les gavines,* was published in 1921. Salvat-Papasseit also wrote one of the best erotic poems in modern European literature, *El poema de la rosa als llavis* (1923). Other writings and manifestos include *Concepte del poeta* (1919), *Contra els poetes amb minúscula* (1920), and *Ossa Menor* (1925). He died of tuberculosis at age 30.

Cat. 7:17. *Columna vertebral: sageta de foc,* poem on front page of *Un enemic del Poble: fulla de subversió espiritual,* no. 9 (December 1917) (Barcelona), magazine, 30.5 x 25.4 cm. Ricard Mas Collection, Barcelona. Photo © Pere Vivas and Jordi Puig, Triangle Postals, Barcelona, 2006.

Cat. 7:18. *L'irradiador del port i les gavines (The Port Light and the Seagulls)* (1921), book of illustrated poems, 19 x 10 cm. Biblioteca de Catalunya, Barcelona. Photo courtesy Biblioteca de Catalunya.

### Antoni Serra (Barcelona, 1869–Cornellà de Llobregat, 1932)

Ceramist and painter. Creator of a dynasty of ceramists and founder of the workshop Ceràmica Serra, Antoni Serra i Fiter was a highly accomplished artist of the modernista movement in Barcelona. Although first active as a painter, by the end of the 19th century he had set up a ceramic workshop in Poblenou. He collaborated with numerous artists and sculptors, including Enric Casanovas, Xavier Nogués, and Pablo Gargallo, to produce distinctive vases and other types of decorated stoneware. He taught at the Escola Superior dels Bells Oficis in 1921 and won numerous awards at exhibitions throughout Europe. He established a family workshop that his sons continued until they, too, set up their own workshops and studios.

Cat. 5:19. *Large Vase,* 1907, porcelain decorated with gold and polychromy, h. 55 cm. Museu de Ceràmica, Barcelona. Photo © Guillem.

### Josep Lluís Sert (Barcelona, 1902–1983)

Architect and urban planner. A Catalan rationalist architect, Josep Lluís Sert i López was a founding member of GATCPAC in Barcelona and later played a leading role in urban planning in the United States. He studied at Barcelona's Escola Superior d'Arquitectura before traveling to Paris to apprentice in the studio of Le Corbusier. After returning to Barcelona, he became one of the main forces behind the establishment of GATCPAC (1930), a collective of socially conscious architects and engineers. He was the principal designer of the Spanish pavilion at the Paris International Exhibition (1937). After the Spanish civil war, Sert fled to the United States, later becoming a citizen. He was active in urban planning for North and South American cities. In 1953 he became dean of the Graduate School of Design at Harvard University and implemented many redesigns of the campus. His other later architectural accomplishments include the Fondation Maeght in France and the Fundació Joan Miró in Barcelona. Before his death Sert received the Gold Medal from the Generalitat, as well as other awards and honorary degrees.

Cat. 8:8. GATCPAC, *A.C. Documentos de Actividad Contemporánea*, no. 1, cover (first quarter 1931) (Barcelona), magazine, 30.5 x 25.4 cm. Arxiu Històric del Col·legi d'Arquitectes de Catalunya, Barcelona.

Cat. 8:9. GATCPAC, *A.C. Documentos de Actividad Contemporánea*, no. 6 (second quarter 1932) (Barcelona), magazine, 30.5 x 25.4 cm. Arxiu Històric del Col·legi d'Arquitectes de Catalunya, Barcelona.

Cat. 8:10. GATCPAC, *A.C. Documentos de Actividad Contemporánea*, no. 25 (1937) (Barcelona), pp. 20–21, magazine, 30.5 x 25.4 cm. Arxiu Històric del Col·legi d'Arquitectes de Catalunya, Barcelona.

Cat. 8:11. *Genara López Apartment Building, Carrer Muntaner, Barcelona, Perspective Drawing*, 1929, photomechanical print on paper, 90.5 x 67.5 cm. Ajuntament de Barcelona, Arxiu Municipal Administratiu. Photo © Pep Parer-fotògraf.

Cat. 8:12. With Joan B. Subirana and Josep Torres Clavé, *Casa Bloc*, 1933, plaster and metal model, designed by Fernando Marzá, architect, made in 1992 by Laura Baringo and Ángel García, 132 x 53 x 19 cm. Taller de Maquetes, Escola Tècnica Superior d'Arquitectura del Vallès (UPC), Sant Cugat del Vallès.

Cat. 8:13. GATCPAC, *A.C. Documentos de Actividad Contemporánea*, no. 11 (third quarter 1933) (Barcelona), magazine, 30.5 x 25.4 cm. Arxiu Històric del Col·legi d'Arquitectes de Catalunya, Barcelona.

Cat. 8:14. GATCPAC, *A.C. Documentos de Actividad Contemporánea*, no. 4 (fourth quarter 1931) (Barcelona), pp. 24–25, magazine, 30.5 x 25.4 cm. Arxiu Històric del Col·legi d'Arquitectes de Catalunya, Barcelona.

Cat. 8:17. GATCPAC, *City of Rest and Vacation and Macià Plan, Photomontages*, c. 1935, four photographs mounted on two boards, 28 x 22.5 cm each board. Arxiu Històric del Col·legi d'Arquitectes de Catalunya, Barcelona.

Cat. 8:18. GATCPAC, *City of Rest and Vacation, Partial Perspective*, 1931–35, blueprint copy on tracing paper, 52.9 x 119.2 cm. Arxiu Històric del Col·legi d'Arquitectes de Catalunya, Barcelona.

Cat. 8:19. GATCPAC, *A.C. Documentos de Actividad Contemporánea*, no. 7 (third quarter, 1932) (Barcelona), pp. 24–25, magazine, 30.5 x 25.4 cm. Arxiu Històric del Col·legi d'Arquitectes de Catalunya, Barcelona.

Cat. 8:20. GATCPAC, *Construction of a Dismountable House*, c. 1932, eight gelatin silver prints, 9.6 x 14.6 cm each. Arxiu Històric del Col·legi d'Arquitectes de Catalunya, Barcelona.

Cat. 8:21. GATCPAC, *Completed Interior of the Dismountable House*, c. 1932, four gelatin silver prints mounted on two boards, 22.5 x 27.9 cm each board. Arxiu Històric del Col·legi d'Arquitectes de Catalunya, Barcelona.

Cat. 8:24. GATCPAC, *A.C. Documentos de Actividad Contemporánea*, no. 19 (1935) (Barcelona), pp. 32–33, magazine, 30.5 x 25.4 cm. Arxiu Històric del Col·legi d'Arquitectes de Catalunya, Barcelona.

Cat. 8:26. With Joan B. Subirana and Josep Torres Clavé, *Dispensari Central Antituberculós*, 1934, model made by Juan Pablo Marín in 1980, plaster, 36 x 63.5 x 18 cm (1/100 scale). Collection Juan Pablo Marín, Barcelona. (Not illustrated.)

Cat. 9:16. With Luis Lacasa, *Pavilion of the Spanish Republic, Paris International Exposition*, 1937, model made in 1987, wood and plastic, 140 x 230.5 x 201 cm. Museo Nacional Centro de Arte Reina Sofía, Madrid. Photo © Archivo Fotográfico Museo Nacional Centro de Arte Reina Sofía, Madrid.

Cat. 9:23. Photographer unknown. *Alberto Sanchez, J. L. Sert, and Pablo Picasso at the Pavilion of the Spanish Republic, Paris International Exposition*, 1937, 22.5 x 24.3 cm. Frances Loeb Library, Harvard Design School, Cambridge. (Not illustrated.)

See also Michaelis, cats. 8:22 and 8:23.

## Joan B. Subirana (Rosario de Santa Fe, 1904–Barcelona, 1979)

Architect. One of the leading members of GATCPAC, Joan Baptista Subirana i Subirana designed many important civic buildings in Barcelona and Madrid, including schools and clinics. He studied math, science, and architecture at schools and universities in Barcelona, Madrid, and Berlin. Among his first architectural projects was a design for housing commissioned by the Valencia City Council. After joining GATCPAC, he worked closely with Josep Lluís Sert and Josep Torres Clavé on projects such as Casa Bloc and the Dispensari Central Antituberculós in Barcelona.

Cat. 8:25. *Central Antituberculosis Clinic, Façade Perspective*, 1934, india ink, pencil, and color pencils on paper, 59.5 x 72 cm. Rosa M. Subirana Collection, Barcelona. Photo © Rocco Ricci.

See also Sert, cats. 8:12 and 8:26.

## Ramon Sunyer (Barcelona, 1889–1963)

Jewelry maker and silversmith. Ramon Sunyer i Clarà was one of the foremost jewelry designers of Noucentisme. He studied with his father, Josep Sunyer i Parera (1850–1919), and at the Acadèmia Galí in Barcelona. Many of his early works were liturgical objects for churches. He exhibited at major international decorative art exhibitions, including the International Exposition of Modern Decorative and Industrial Arts in Paris (1925) and the Sixth Milan Triennal (1936). Sunyer also taught at the Escola d'Arts i Oficis and founded the Amics de l'Art Litúrgic and the Amics de Gaudí. Later in life he led the Cercle Artístic de Sant Lluc.

Cat. 6:65. *Cocktail Shaker Service*, 1928, silver and crystal, 25.4 x 36.8 x 25.4 cm. Joieria Sunyer, Barcelona. © 2006 Artists Rights Society (ARS), NY/VEGAP, Madrid. Photo © Pere Vivas and Jordi Puig, Triangle Postals, Barcelona, 2006.

## Joaquim Sunyer (Sitges, 1874–1956)

Painter, printmaker, and illustrator. Joaquim Sunyer i de Miró was one of the leading painters of Noucentisme. Sunyer first studied with his uncle Joaquim de Miró (1849–1914) and at La Llotja, along with Joaquim Mir and Isidre Nonell. In 1893 Sunyer moved to Paris, where he associated with Théophile-Alexandre Steinlen (1859–1923), Pierre Bonnard (1867–1947), and Adolphe Willette (1857–1926), and exhibited at the Salon d'Automne. During his early years in Paris, Sunyer favored scenes of working-class street life: cafés, dance halls, and other subjects similar to those of Steinlen and the Post-Impressionists. In 1897 he illustrated *Les Soliloques du Pauvres* by Jehan Rictus. Sunyer also associated with Pablo Picasso after the latter's arrival in Montmartre in the fall of 1900. Leaving Paris in 1911, Sunyer settled in Sitges and developed his mature style, which focused on themes of Mediterranean life characteristic of Noucentisme. He also painted in Italy, Majorca, and France, where he joined Aristide Maillol and the artists of Céret. He participated in exhibitions throughout Europe as well as in the United States. During the Spanish

civil war, he traveled to Italy and France, eventually settling in Paris. In the early 1940s Sunyer returned to Spain and contributed to important shows in Barcelona and Madrid until the end of his life.

Cat. 6:10. *Pastoral,* 1910–11, oil on canvas, 106 x 152 cm. Generalitat de Catalunya, Department de Cultura, Barcelona. © 2006 Artists Rights Society (ARS), NY/VEGAP, Madrid.

Cat. 6:17. *The Valley of the Friars,* 1913, oil on canvas, 100 x 120 cm. Joan Tarrús–Josepa Castellà Collection, Barcelona. © 2006 Artists Rights Society (ARS), NY/VEGAP, Madrid. Photo © Pere Vivas and Jordi Puig, Triangle Postals, Barcelona, 2006.

## Josep de Togores (Cerdanyola del Vallès, 1893–Barcelona, 1970)

Painter. Josep de Togores i Llach was an important member of the avant-garde in Barcelona and Paris, and his art reflected the spectrum of modernista styles and movements, from Realism to Surrealism. Stricken with deafness after suffering meningitis during his youth, Togores trained with Joan Llaverias (1865–1938) and Fèlix Mestres (1872–1933) and stud-

ied at the Acadèmia Galí. He exhibited throughout Europe, including the Brussels Universal Exposition (1958) where he won a prize. His early works were influenced by Feliu Elias. A sojourn in Paris allowed him to meet members of the Montmartre artistic avant-garde, including Pablo Picasso, Chäim Soutine, and Amedeo Modigliani, and important dealers such as Daniel-Henry Kahnweiler, with whom he signed a contract. Paul Cézanne (1839–1906) was also an influence, but as Togores's style developed he embraced a wide range of techniques and incorporated many influences, including Cubism, abstraction, Realism, and Surrealism. He returned to Barcelona during World War I and worked in a studio restoring old master paintings. He also joined the Agrupació Courbet. Togores briefly returned to Paris but settled in Barcelona permanently in the early 1930s. He specialized in painting portraits and female figures, and exhibited frequently. He also contributed articles to the magazine *Vell i Nou* and was a member of the Cercle Artístic de Sant Lluc.

Cat. 6:20. *Nudes on the Beach,* 1922, oil on canvas, 89.5 x 116 cm. Museo Nacional Centro de Arte Reina Sofia, Madrid. Photo © Archivo Fotográfico Museo Nacional Centro de Arte Reina Sofía.

## Pere Torné Esquius (Barcelona, 1879–Ile-de-France, 1936)

Painter and draftsman. An unofficial member of the noucentista movement, Pere Torné i Esquius was a renowned illustrator and painter. He studied at La Llotja in Barcelona as well as in Madrid. He exhibited at the Sala Parés to much acclaim and was a member of the Cercle Artístic de Sant Lluc before traveling to Paris in 1905. There he exhibited at the Salon d'Automne and the Salon des Humoristes; his work also appeared in Barcelona's galleries, including the Galeries

Dalmau and the Galeries Laietanes. Although he spent much of his career in France, he continued to celebrate his heritage, contributing to Catalan journals such as *Papitu,* illustrating numerous children's books, and publishing *Els dolços indrets de Catalunya* (1910) in homage to his homeland.

Cat. 6:33. Illustration in *El dolços indrets de Catalunya* (1910), book, 21.2 x 49.5 cm. Biblioteca de l'Escola Tècnica Superior d'Arquitectura del Vallès (UPC), Sant Cugat del Vallès.

## Joaquín Torres-García (Montevideo, 1874–1949)

Painter, sculptor, and writer. A native of Uruguay, Joaquín Torres-García played an influential role in Noucentisme and in avant-garde movements in Barcelona. He moved to that city at an early age and began his artistic studies at La Llotja. He painted with Isidre Nonell, joined the Cercle Artístic de Sant Lluc, and frequented the Quatre Gats. In the early 1900s he worked with Antoni Gaudí on La Sagrada Família and Palma de Majorca's cathedral. Torres-García was also commissioned to paint a series of noucentista murals for the Palace of the Generalitat, on which he worked in 1913–18. He exhibited in many solo and group shows in Barcelona and became an important art writer and teacher. He contributed articles to many Catalan newspapers and journals and published several books of his theories and collected essays. In 1916–17 he became friends with Rafael Pérez Barradas and Joan Miró. Torres-García lived in New York from 1920 to 1922, Italy from 1924 to 1926, and Paris from 1926 to 1932. While in Paris, he associated with important avant-garde artists, including Albert Gleizes, Francis Picabia, and Piet Mondrian (1872–1944). In 1930 he and Michel Seuphor (1901–1999) cofounded Cercle et Carré, devoted to advancing the theories of abstract art. After living in Spain, France, the United States, and Italy, Torres-García returned to Spain in 1932, then left permanently in 1934 for Uruguay, where he established the Asociación de Arte Constructivo, which had important consequences for the development of Latin American art.

Cat. 6:14. *Bather,* 1911, oil on canvas, 51.5 x 40 cm. Cecilia de Torres Collection, New York.

Cat. 6:15. *Project for the Fresco "The Eternal Catalonia,"* 1912, pencil and watercolor on paper, 151 x 96 cm. Generalitat de Catalunya, Departament de Cultura, Barcelona.

Cat. 6:16. *Architectural Composition with Figures,* 1925–26, painted wood, 50 x 52 x 5 cm. Carmen Thyssen-Bornemisza Collection, Museu Nacional d'Art de Catalunya, Barcelona.

Cat. 7:18. *Figure with Landscape of the City,* 1917, oil on cardboard, 70 x 49.5 cm. Private collection.

## Unattributed Posters

Cat. 9:5. *Catalonia Defeated Fascism in 24 Hours,* 1936, photomechanial process, 196 x 137 cm. Jordi Carulla Collection, Barcelona. Photo © Fundació Lluís Carulla.

Cat. 9:6. *Citizens of Madrid! Catalonia Loves You. From President Companys's Speech on the Occasion of the Rally at the Monumental, 14 March 1937, the Day of Madrid,* 1937, photomontage by Agulló, lithograph, 110 x 78 cm. Biblioteca del Pavelló de la República (Universitat de Barcelona). Photo © Biblioteca del Pavelló de la República.

Cat. 9:14. *First Crusade: Spain, Spiritual Guide for the World,* c. 1937, lithograph, 100 x 70 cm. Biblioteca Nacional de España, Madrid. Photo © Laboratorio Fotográfico de la Biblioteca Nacional.

Cat. 9:15. *Up with Spain!,* 1939, lithograph, 117 x 83 cm. Biblioteca del Pavelló de la República (Universitat de Barcelona), Fundació Privada Centre d'Estudis d'Història Contemporània–Biblioteca Josep M. Figueras, Barcelona. Photo © Biblioteca del Pavelló de la República.

## Unattributed Textiles

Cat. 5:29. *Curtain from the Dining Room of Casa Molins*, 1900, probably made by J. Pons Hijo Workshop, velvet made by Sert i Germans, the designer of the print is unknown, velvet carved in a W, hemp pile and cotton backing, yarn-dyed and printed in a single pattern, twill lining, silk warp and cotton weft, cotton and silk *passementerie*, 310 x 170 cm, 6-cm passementerie tassels on three sides. Centre de Documentació i Museu Tèxtil, Terrassa.

Cat. 5:30. *Screen*, 1900–1910, probably made at La España Industrial or Batlló i Cia., four leaves, each measuring 176 x 53 cm, cotton crepe, printed using a three-color fabric printing machine, fabric attached to a structure made of pine. Centre de Documentació i Museu Tèxtil, Terrassa.

Cat. 5:31. *Mauve Silk Dress,* early 1900s, fabric made in Catalonia, body: 45 cm long, neck 31 cm, shoulder 31 cm, chest 90 cm, waist 54 cm, sleeve length 50 cm, skirt: length at the front 99 cm, length at the back 129 cm, waist 59 cm, Jacquard silk woven using 18 cm tie, pattern length 13 cm, silk *voile*, embroidered, silk lining, whale bone stays, fabric density: 84 threads/cm and 30 rows/cm. Centre de Documentació i Museu Tèxtil, Terrassa.

Cat. 5:32. *Carpet*, 1900–1914, made by Sert i Germans, Barcelona, 179.5 x 86.5 cm, 8-cm fringe, wool pile and linen backing, woven on an Axminster automatic loom, single die design, the factory mark 32 Z 2545 appears on the reverse. Centre de Documentació i Museu Tèxtil, Terrassa.

Cat. 6:39. *Curtain*, c. 1900–1910, possibly made at La Indústria Llinera or Bassols, linen and cotton Jacquard, 240 x 141.5 cm. Centre de Documentació i Museu Tèxtil, Terrassa.

Cat. 6:40. *Blue Silk Dress*, 1910–12, satin and silk voile, appliqué embroidery in metal, cotton and silk thread on cotton tulle, imitation metal lace at the collar, appliqué Irish metal crochet work, *passementerie*. Centre de Documentació i Museu Tèxtil, Terrassa.

## Remedios Varo (Anglès, 1908–Mexico City, 1963)

Painter. Remedios Varo Uranga was among the more prominent women artists to contribute to the surrealist movement in Catalonia. Born in the Girona region, she attended the Real Academia de Bellas Artes de San Fernando in Madrid from 1924 to 1930. After visiting Paris in 1931, she moved to Barcelona, where she shared a studio with Esteve Francés and became active in avant-garde circles. In 1935 she began associating with Oscar Domínguez (1906–1957), along with other Surrealists, and participated in the 1936 Exposició Logicofobista organized by ADLAN (Friends of New Art). In 1937 she married the French poet Benjamin Péret and moved to Paris, where she associated with André Breton and participated in surrealist activities. In 1941 she escaped from occupied France by fleeing to Mexico, where she was joined by other refugee Surrealists, including Esteve Francés and Leonora Carrington (b. 1917). After the war, Varo visited Venezuela and Paris, then returned to Mexico, where she married Walter Gruen. Her exhibitions in Mexico City in the 1950s were particularly successful. Among her more celebrated works is a series of notable collages including *Anatomy Lesson*, 1935, and composite images created collaboratively from chance associations, as in *Cadavre exquis,* 1935 (The Museum of Modern Art, New York).

Cat. 7:44. *Anatomy Lesson*, 1935, collage of photographs and pasted papers, 24 x 32 cm. Musée Nacional d'Art Moderne, Centre Pompidou, Paris. © Artists Rights Society (ARS), NY/ADAGP, Paris. Photo courtesy CNAC/MNAM/Dist. Réunion des Musées Nationaux/Art Resource, NY, © Philipe Migeat.

## Carlos Verger (1872–1929)

Cat. 2:30. *Barcelona, City of Winter*, 1909, chromolithograph, 92 x 127 cm. Museu Nacional d'Art de Catalunya, Barcelona. Photo © MNAC–Museu Nacional d'Art de Catalunya, 2006, photo Calveras/Mérida/Sagristà.

## Adolf Zerkowitz (Vienna, 1884–Barcelona, 1972)

Photographer. Adolf Zerkowitz Schlesinger moved with his family to Barcelona in 1914. An innovator in the field of photography, he perfected his techniques in Spain, creating numerous views of Barcelona and other Spanish cities. His innovations in postcard photography, which allowed him to make ten images at a time, revolutionized the field. He captured Barcelona from high perspectives, providing untraditional views of the city. He was a friend of Antoni Gaudí, and his publishing company offered more than 120 different postcards, many of them depicting Gaudí's Sagrada Família. His photographs of Gaudí's most famous buildings were featured in a 1910 exhibition in Paris that also included a model of the Sagrada Família.

Cat. 5:82. With Francesc de Paula Quintana (calligraphy), *Nativity Façade, Temple of the Sagrada Família, 1892–1900,* c. 1927, photograph and ink on paper, 54 x 35 cm. Arxiu Històric del Col·legi d'Arquitectes de Catalunya, Barcelona.

# Bibliography and Research Resources

JORDI FALGÀS AND CARMEN BELEN LORD

This bibliography does not intend to be complete or exhaustive. Readers should refer to the notes in individual essays for additional sources, in particular, articles in magazines and other periodicals, which are not included here. Instead, we have focused on volumes easily available in American libraries and bookstores. We have also emphasized books written or translated to English. Exhibition catalogues published in Catalan or Spanish often include English translations, thus we encourage English readers to refer to them as sources of valuable research in this ever-growing field of scholarship.

## History of Barcelona and Catalonia

Anguera, Pere, ed. *La consolidació del món burgès: 1860–1900. Història, política, societat i cultura dels Països Catalans*, vol. 7. Barcelona: Enciclopèdia Catalana, 2004.

Balcells, Albert. *Cataluña Contemporánea*. 5th ed. 2 vols. Madrid: Siglo XXI, 1984.

___. *Catalan Nationalism: Past and Present*. Ed. Geoffrey J. Walker, trans. Jacqueline Hall with the collaboration of Geoffrey J. Walker. New York: St. Martin's Press, 1996.

___, ed. *Història de Catalunya*. Barcelona: L'Esfera dels llibres, 2004.

Barril, Joan. *Barcelona: The Palimpsest of Barcelona*. Trans. Antonio Funes. Sant Lluís, Menorca: Triangle Postals, 2005.

Boyd, Carolyn P. *Historia Patria: Politics, History, and National Identity in Spain, 1875–1975*. Princeton: Princeton University Press, 1997.

Busquets, Joan. *Barcelona: The Urban Evolution of a Compact City*. Rovereto, Italy: Harvard University Graduate School of Design/Nicolodi, 2005.

Carr, Raymond. *Spain 1808–1939*. Rev. ed. Oxford: Clarendon, 1975.

Casanova, Julián, and Paul Preston. *Anarchism, the Republic, and Civil War in Spain, 1931–1939*. London/New York: Routledge, 2005.

Casassas, Jordi. *Intel·lectuals, professionals i polítics a la Catalunya contemporània (1850–1920)*. Sant Cugat del Vallès: Els Llibres de la Frontera, 1989.

___, ed. *L'època dels nous movements socials: 1900–1930. Història, política, societat i cultura dels Països Catalans*. Vol. 8. Barcelona: Enciclopèdia Catalana, 2005.

Comadira, Narcís. *Catalonia*. Trans. Jacqueline Hall. Barcelona: Generalitat de Catalunya, 2001.

Cubelles, Albert, and Antoni Nicolau, eds. *Abajo las murallas!!! 150 anys de l'enderroc de les muralles de Barcelona*. Exh. cat. Barcelona: Museu d'Història de la Ciutat, 2004.

Esdaile, Charles J. *Spain in the Liberal Age: From Constitution to Civil War, 1808–1939*. Oxford/Malden, Mass.: Blackwell, 2000.

Esenwein, George Richard. *Anarchist Ideology and the Working-Class Movement in Spain, 1868–1898*. Berkeley: University of California Press, 1989.

Fabre, Jaume, and Josep M. Huertas. *Barcelona 1888–1988: la construcció d'una ciutat*. Barcelona: Publicacions de Barcelona, 1988.

___. *Noticiari de Barcelona: de l'Exposició Universal als Jocs Olímpics*. 2d ed. Barcelona: La Campana, 1992.

___. *Burgesa i revolucionària: la Barcelona del segle XX*. Barcelona: Flor del Vent, 2000.

Fradera, Josep M. *La gran transformació: 1790–1860. Història, política, societat i cultura dels Països Catalans*, vol. 6. Barcelona: Enciclopèdia Catalana, 2004.

Fraser, Ronald. *Blood of Spain: An Oral History of the Spanish Civil War*. New York: Pantheon Books, 1979.

Garcia Espuche, Albert, and Anna Garcia Munàrriz. *Barcelona & fotografia*. Exh. cat. Barcelona: Lunwerg, 2005.

Giner, Salvador. *The Social Structure of Catalonia*. Sheffield: Anglo-Catalan Society, 1980.

Hargreaves, John. *Freedom for Catalonia? Catalan Nationalism, Spanish Identity, and the Barcelona Olympic Games*. Cambridge/New York: Cambridge University Press, 2000.

Holguín, Sandie. *Creating Spaniards: Culture and National Identity in Republican Spain*. Madison: University of Wisconsin Press, 2002.

Huertas Claveria, Josep M. *50 Times Barcelona: Visitor's Guide to the City*. Barcelona: Ajuntament de Barcelona, 1998.

___. *La Barcelona desapareguda*. Barcelona: Angle, 2004.

___. *Barcelona, com era, com és*. Barcelona: Ambit, 2005.

Huertas Claveria, Josep M., Jaume Fabre, and Rafael Pradas. *Barcelona: memòria d'un segle*. Barcelona: Ajuntament de Barcelona, 2001.

Hughes, Robert. *Barcelona*. New York: Knopf, 1992.

___. *Barcelona: The Great Enchantress*. Washington: National Geographic, 2004.

Kaplan, Temma. *Red City, Blue Period: Social Movements in Picasso's Barcelona*. Berkeley: University of California Press, 1992.

Litvak, Lily. *España 1900: modernismo, anarquismo y fin de siglo*. Barcelona: Anthropos, 1990.

McDonogh, Gary W, ed. *Conflict in Catalonia: Images of a Urban Society*. Gainesville: University Presses of Florida, University of Florida Press, 1986.

___. *Good Families of Barcelona: A Social History of Power in the Industrial Era*. Princeton: Princeton University Press, 1986.

Orwell, George. *Orwell in Spain: the Full Text of "Homage to Catalonia," with Associated Articles, Reviews and Letters From the Complete Works of George Orwell*. Ed. Peter Davison. London: Penguin, 2001.

Payne, John. *Catalonia: History and Culture*. Nottingham: Five Leaves, 2004.

Payne, Stanley G. *A History of Spain and Portugal*, 2 vols. Madison: University of Wisconsin Press, 1990.

___. *Spain's First Democracy: The Second Republic, 1931–1936*. Madison: University of Wisconsin Press, 1993.

___. *The Collapse of the Spanish Republic, 1933–1936: Origins of the Civil War*. New Haven: Yale University Press, 2006.

Pla, Josep. *La Segunda República Española. Una crónica 1931–1936*. Ed. Xavier Pericay. Barcelona: Destino, 2006.

508

Preston, Paul. *The Spanish Civil War*. London: Harper Perennial, 2006.

Puigjaner, Josep Maria. *Getting to Know Catalonia*. 3rd ed. Barcelona: Generalitat de Catalunya, 1992.

Raguer, Hilari, ed. *De la gran esperança a la gran ensulsiada: 1930–1939. Història, política, societat i cultura dels Països Catalans*, vol. 9. Barcelona: Enciclopèdia Catalana, 2005.

Resina, Joan Ramon, ed. *Iberian Cities*. New York: Routledge, 2001.

Resina, Joan Ramon, and Dieter Ingenschay, eds. *After-Images of the City*. Ithaca: Cornell University Press, 2003.

Romero Salvadó, Francisco J. *Spain, 1914–1918: Between War and Revolution*. London and New York: Routledge, 1999.

——. *Twentieth Century Spain: Politics and Society, 1898–1998*. Basingstoke: Macmillan, 1999.

Sánchez, Alejandro, ed. *Barcelona 1888–1929: Modernidad, ambición y conflictos de una ciudad soñada*. Madrid: Alianza Editorial, 1994.

Sobrequés i Callicó, Jaume, ed. *Història de Barcelona*. Vols. 6–7. Barcelona: Enciclopèdia Catalana, Ajuntament de Barcelona, 1995.

Sobrer, Josep Miquel. *Catalonia, a Self-Portrait*. Bloomington: Indiana University Press, 1992.

Termes, Josep. *De la Revolució de setembre a la fi de la Guerra Civil (1868–1939). Història de Catalunya*, vol. VI. Barcelona: Edicions 62, 1987.

Ullman, Joan Connelly. *The Tragic Week: A Study of Anti-Clericalism in Spain, 1875–1912*. Cambridge: Harvard University Press, 1968.

Vicens Vives, Jaume. *Approaches to the History of Spain*. 2d ed. Berkeley: University of California Press, 1970.

Vicens Vives, Jaume, and Montserrat Llorens. *Industrials i polítics del segle XIX*. 3rd ed. Barcelona: Vicens Vives, 1980.

Vicens Vives, Jaume, and Jordi Nadal. *An Economic History of Spain*. Trans. Frances M. López-Morillas. Princeton: Princeton University Press, 1969.

Vilar, Pierre. *Catalunya dins l'Espanya moderna: recerques sobre els fonaments econòmics de les estructures nacionals*, 3 vols. Trans. Eulàlia Duran de Canher. Barcelona: Curial, Edicions 62, 1979–1991.

Villacorta Baños, Francisco. *Burguesía y cultura: los intelectuales españoles en la sociedad liberal, 1808–1931*. Madrid: Siglo XXI, 1980.

## Modern Art in Barcelona and Catalonia

Ainaud de Lasarte, Joan. *Catalan Painting*, vol. 3. Trans. Michael Heron. Geneva/New York: Skira, Rizzoli, 1990–92.

Aizpúrua, José Manuel, et al. *Les avantguardes fotogràfiques a Espanya: 1925–1945*. Exh. cat. Barcelona: Fundació "la Caixa," 1997.

Alarcó, Paloma, et al. *Picasso to Plensa: A Century of Art from Spain*. Exh. cat. Albuquerque/St. Petersburg, Fl.: Albuquerque Museum/Salvador Dalí Museum, 2005.

Alcolea i Gil, Santiago, ed. *Escultura catalana del segle XIX: del neoclassicisme al realisme*. Exh. cat. Barcelona: Fundació Caixa de Catalunya, 1989.

Alix, Josefina, ed. *Pabellón Español: Exposición Internacional de París, 1937*. Exh. cat. Madrid: Ministerio de Cultura, 1987.

——. *Escultura en España, 1900–1936: un nuevo ideal figurativo*. Exh. cat. Madrid: Fundación Cultural Mapfre Vida, 2001.

*Almanach dels Noucentistes*, facsimile edition. Ed. Francesc Fontbona. Barcelona: José J. de Olañeta, 1980.

*L'avantguarda de l'escultura catalana*. Exh. cat. Barcelona: Generalitat de Catalunya, 1989.

Balsells, David, ed. *Images: Catalan Photography*. Exh. cat. Barcelona: Actar/Generalitat de Catalunya, 1996.

——, ed. *La Guerra Civil espanyola: fotògrafs per a la història*. Exh. cat. Barcelona: Arxiu Nacional de Catalunya/Museu Nacional d'Art de Catalunya, 2001.

Barral i Altet, Xavier, ed. *Art and Architecture of Spain*. Trans. Dominic Currin. Boston: Little, Brown, 1998.

Basilio, Miriam. "Re-inventing Spain: Images of the Nation in Painting and Propaganda, 1936–1943." 2 vols. Ph.D. diss., New York University, Institute of Fine Arts, 2002.

Bassegoda, Bonaventura, ed. *La col·lecció Raimon Casellas: Dibuixos i gravats del Barroc al Modernisme del Museu Nacional d'Art de Catalunya*. Exh. cat. Barcelona: Museu Nacional d'Art de Catalunya, 1992.

Bohigas, Oriol. *Modernidad en la arquitectura de la España republicana*. Barcelona: Tusquets, 1998.

Bohigas, Oriol, Antoni González, and Raquel Lacuesta. *Reseña y catálogo de la arquitectura modernista*. 3rd ed. 2 vols. Barcelona: Lumen, 1983.

Bohigas, Oriol, et al. *El Noucentisme: 1906–1918*. Vol. 7 of *Història de la cultura catalana*. Barcelona: Edicions 62, 1996.

Bohn, Willard. *Marvelous Encounters: Surrealist Responses to Film, Art, Poetry, and Architecture*. Lewisburg, Pa.: Bucknell University Press, 2005.

Bonet, Juan Manuel. *Diccionario de las vanguardias en España (1907–1936)*. Rev. ed. Madrid: Alianza Editorial, 1999.

Bretz, Mary Lee. *Encounters Across Borders: The Changing Visions of Spanish Modernism, 1890–1930*. Lewisburg, Pa./London: Bucknell University Press/Associated University Presses, 2001.

Brihuega, Jaime. *Las vanguardias artísticas en España. 1909–1936*. Madrid: Istmo, 1981.

——. *Manifiestos, proclamas, panfletos y textos doctrinales: las vanguardias artísticas en España, 1910–1931*. 2d ed. Madrid: Cátedra, 1982.

——. *La vanguardia y la República*. Madrid: Cátedra, 1982.

Brihuega, Jaime, and Ramiro Reig. *Els pintors espanyols i el cartelisme sociopolític*. Exh. cat. Valencia: Patronat Martínez Guerricabeitia, 2003.

Cabrera, Asunción, and Almudena Chinarro, eds. *Madrid Barcelona, 1930–1936: la tradición de lo nuevo*. Exh. cat. Barcelona: Fundación "la Caixa," 1997.

Calvo Serraller, Francisco. *Pintores españoles entre dos fines de siglo, 1880–1990: de Eduardo Rosales a Miquel Barceló*. Madrid: Alianza, 1990.

Carbonell Basté, Sílvia, and Josep Casamartina Parassols. *Les fàbriques i els somnis: modernisme tèxtil a Catalunya*. Exh. cat. Terrassa: Centre de Documentació i Museu Tèxtil, 2002.

Carmona, Eugenio, et al. *El Cubismo y sus entornos en las colecciones de Telefónica*. Exh. cat. Madrid: Fundación Telefónica, 2004.

Carulla, Jordi, et al. *Catalunya en 1000 cartells: des dels orígens fins a la Guerra Civil*. Barcelona: Postermil, 1994.

Carulla, Jordi, and Arnau Carulla. *La Guerra Civil en 2000 cartells: República, Guerra Civil, Postguerra*. 2 vols. Barcelona: Postermil, 1997.

——. *El color de la Guerra, The Colour of War: Spanish Civil War, 1936–1939*. Barcelona: Postermil, 2000.

Castellanos, Jordi. *Raimon Casellas i el modernisme*. 2d ed. 2 vols. Barcelona: Curial, 1992.

Cervera, Joseph Phillip. *Modernismo: The Catalan Renaissance of the Arts*. New York: Garland, 1976.

Cirici, Alexandre. *El arte modernista catalán*. Barcelona: Aymá, 1951.

___. *L'art català contemporani*. Barcelona: Edicions 62, 1970.

___. *Barcelona ciutat d'art*. Barcelona: Teide, 1973.

___. *Barcelona Step by Step*. Trans. Bert and Frances Strauss. Barcelona: Teide, 1974.

___. *Ceràmica catalana*. Barcelona: Destino, 1977.

Cirici, Alexandre, and Joaquim Gomis. *1900 in Barcelona: Modern Style, Art Nouveau, Modernismo, Jugendstil*. New York: G. Wittenborn, 1967.

Coll, Isabel. *Diccionario de mujeres pintoras en la España del siglo XIX*. Barcelona: El Centaure Groc, 2001.

Coll, Isabel, Antoni Sella, and Roland Sierra. *L'Escola luminista de Sitges: els precedents del Modernisme*. Exh. cat. Barcelona and Sitges: Diputació de Barcelona, Ajuntament de Sitges, 2002.

Comadira, Narcís. *Forma i prejudici: Papers sobre el Noucentisme*. Barcelona: Empúries, 2006.

Cowling, Elizabeth, and Jennifer Mundy, eds. *On Classic Ground: Picasso, Léger, de Chirico and the New Classicism 1910–1930*. Exh. cat. London: Tate Gallery, 1990.

Dalmases, Núria de, and Daniel Giralt-Mircle. *Argenters i joiers de Catalunya*. Barcelona: Destino, 1985.

*Espanya fi de segle 1898*. Exh. cat. Barcelona: Fundació "la Caixa," 1997.

Flaquer i Revaud, Sílvia, Ma. Teresa Pagès i Gilibets, and Francesc Fontbona. *Inventari d'artistes Catalans que participaren als salons de París fins l'any 1914*. Barcelona: Diputació de Barcelona, Biblioteca de Catalunya, 1986.

Flores, Carlos. *Gaudí, Jujol y el modernismo catalán*. 2 vols. Madrid: Aguilar, 1982.

Fontana, Josep, et al. *Naturalisme, positivisme i catalanisme*. Vol. 5 of *Història de la cultura catalana*. Barcelona: Edicions 62, 1994.

Fontbona, Francesc. *La crisi del modernisme artistic*. Barcelona: Curial, 1975.

___. *El paisatgisme a Catalunya*. Barcelona: Destino, 1979.

___. *Las claves del arte modernista*. 2d ed. Barcelona: Planeta, 1992.

___. *Del neoclassicisme a la Restauració: 1808–1888*. Vol. 6 of *Història de l'art català*. 4th ed. Barcelona: Edicions 62, 1997.

___, ed. *Repertori d'exposicions individuals d'art a Catalunya (fins l'any 1938)*. Barcelona: Institut d'Estudis Catalans, 1999.

___, ed. *El Modernisme*. 5 vols. Barcelona: L'isard, 2002–2004.

Fontbona, Francesc, and Manuel Jorba, eds. *El Romanticisme a Catalunya: 1820–1874*. Barcelona: Generalitat de Catalunya, Pòrtic, 1999.

Fontbona, Francesc, Jordi González, and Sara Puig. *Del modernismo a las vanguardias: dibujos de la colección de la Fundación Francisco Godia*. Barcelona: Fundación "la Caixa," 2003.

Fontbona, Francesc, and Francesc Miralles. *Del modernisme al Noucentisme: 1888–1917*. Vol. 7 of *Història de l'art català*. 2d ed. Barcelona: Edicions 62, 1990.

Fontcuberta, Joan. *Idas & Chaos: Trends in Spanish Photography 1920–1945*, exh. cat. Madrid: Ministerio de Cultura, 1985.

Freixa, Mireia. *El modernismo en España*. Madrid: Cátedra, 1986.

___. *El modernisme a Catalunya*. Barcelona: Barcanova, 1991.

Freixa, Mireia, Laura Mercader, and Joan Molet. *Ruta europea del modernisme*. Barcelona: Mediterrània, 2000.

*Fuera de orden: Mujeres de la vanguardia española*. Exh. cat. Madrid: Fundación Cultural Mapfre Vida, 1999.

Garcia, Josep Miquel. *Els evolucionistes*. Barcelona: Parsifal, 2004.

García de Carpi, Lucía. *La pintura surrealista española: 1924–1936*. Madrid: Istmo, 1986.

García de Carpi, Lucía, and Josefina Alix Trueba, eds. *El surrealismo en España*. Exh. cat. Madrid: Museo Nacional Centro de Arte Reina Sofía, 1994.

García Delgado, José Luis, et al., eds. *Los orígenes culturales de la II República: IX Coloquio de Historia Contemporánea de España*. Madrid: Siglo XXI, 1993.

García Espuche, Albert, ed. *El Modernisme*. Exh. cat. 2 vols. Barcelona: Olimpíada Cultural, Lunwerg, 1990.

___. *El Quadrat d'Or: Centre de la Barcelona modernista*. Barcelona: Ajuntament de Barcelona/Lunwerg, 2002.

García García, Isabel, and Javier Pérez Segura, eds. *Arte y Política en España 1898–1939*. Granada: Junta de Andalucía, Comares, 2002.

Gasch, Sebastià. *Escrits d'art i d'avantguarda (1925–1938)*. Ed. Joan M. Minguet i Batllori. Barcelona: Mall, 1987.

Gausa, Manuel, Marta Cervelló, and Maurici Pla. *Barcelona: A Guide to Its Modern Architecture, 1860–2002*. Barcelona: Actar, 2002.

*La Generación del 14 entre el novecentismo y la vanguardia (1906–1926)*. Exh. cat. Madrid: Fundación Cultural Mapfre Vida, 2002.

Gies, David T., ed. *The Cambridge Companion to Modern Spanish Culture*. New York: Cambridge University Press, 1999.

Giralt, Emili, et al. *Romanticisme i Renaixença: 1800–1860*. Vol. 4 of *Història de la cultura catalana*. Barcelona: Edicions 62, 1995.

Giralt-Miracle, Daniel, ed. *El vitrall modernista*. Exh. cat. Barcelona: Generalitat de Catalunya, 1984.

___, ed. *Avantguardes a Catalunya 1906–1939*. Exh. cat. Barcelona: Fundació Caixa de Catalunya, Olimpíada Cultural, 1992.

Gracia, Ricardo, and Laura Mercader, eds. *Pintors espanyols a París, 1880–1910*. Exh. cat. Barcelona: Fundació "la Caixa," 1999.

Graham, Helen, and Jo Labanyi, eds. *Spanish Cultural Studies. An Introduction: The Struggle for Modernity*. Oxford/New York: Oxford University Press, 1995.

Guigon, Emmanuel, et al. *El surrealismo y la guerra civil española*. Exh. cat. Teruel: Museo de Teruel, 1998.

Harris, Derek, ed. *The Spanish Avant-garde*. Manchester, U.K.,/New York: Manchester University Press, 1995.

Harvard, Robert, ed. *A Companion to Spanish Surrealism*. Woodbridge, Suffolk, U.K./Rochester, N.Y.: Tamesis, 2004.

*Huellas dalinianas*. Exh. cat. Madrid: Sociedad Estatal de Conmemoraciones Culturales, 2004.

Huertas Claveria, Josep M. et al. *Modernisme Route Barcelona*. Barcelona: Ajuntament de Barcelona, 2005.

Jardí, Enric. ___. *Els moviments d'avantguarda a Barcelona*. Barcelona: Cotal, 1983.

___. *Eugeni d'Ors: obra i vida*. Barcelona: Quaderns Crema, 1990.

___. *Història del Cercle Artístic de Sant Lluc*. 2d ed. Barcelona: Destino, 2003.

Jardí, Eulàlia, ed. *Moble català*. Exh. cat. Barcelona: Electa, Generalitat de Catalunya, 1994.

Jiménez Burillo, Pablo, and Lily Litvak, eds. *Luz de gas: la noche y sus fantasmas en la pintura española, 1880–1930*. EExh. cat. Madrid: Fundación Cultural Mapfre Vida, 2005.

Julián, Immaculada. *Les avantguardes pictòriques a Catalunya*. Barcelona: Els Llibres de la Frontera, 1986.

King, S. Carl. *The Photographic Impressionists of Spain: a History of the Aesthetics and Technique of Pictorial Photography*. Lewinston, N.Y.: E. Mellen Press, 1989.

Larson, Susan, and Eva Woods, eds. *Visualizing Spanish Modernity*. Oxford/New York: Berg, 2005.

Léal, Brigitte, and Maria Teresa Ocaña, eds. *Paris Barcelona, 1888–1937*. Exh. cat. Paris/Barcelona: Réunion des Musées Nationaux/Museu Picasso, 2002.

Le Bon, Laurent, ed. *Dada*. Exh. cat. Paris: Éditions du Centre Pompidou, 2005.

Lissorgues, Yvan, ed. *Realismo y naturalismo en España en la segunda mitad del siglo XIX*. Barcelona: Anthropos, 1988.

Litvak, Lily. *El tiempo de los trenes: el paisaje español en el arte y la literatura del realismo, 1849–1918*. Barcelona: Serbal, 1991.

___, ed. *El Modernismo*. 2d ed. Madrid: Taurus, 1991.

___. *Jardines de España: 1870–1936*. Exh. cat. Madrid: Fundación Cultural Mapfre Vida, 1999.

___. *Musa libertaria: arte, literature y vida cultural del anarquismo español, 1880–1913*. Madrid: Fundación de Estudios Libertarios Anselmo Lorenzo, 2001.

López Mondéjar, Publio. *150 Years of Photography in Spain*. Trans. Gerardo Denis. Madrid/Barcelona: Lunwerg, 2000.

Mackay, David. *Modern Architecture in Barcelona, 1854–1939*. New York: Rizzoli, 1989.

Marfany, Joan Lluís. *Aspectes del modernisme*. Barcelona: Curial, 1990.

___, et al. *El Modernisme: 1890–1906*. Vol. 6 of *Història de la cultura catalana*. Barcelona: Edicions 62, 1996.

McCully, Marilyn. *Els Quatre Gats: Art in Barcelona Around 1900*. Exh. cat. Princeton: Art Museum, Princeton University, 1978.

Mendelson, Jordana. *Documenting Spain: Artists, Exhibition Culture, and the Modern Nation, 1929–1939*. University Park: Pennsylvania State University Press, 2005.

Mendoza, Cristina, and Eduardo Mendoza. *Barcelona modernista*. Barcelona: Seix Barral, 2003.

Minguet Batllori, Joan M. *Cinema, modernitat i avantguarda (1920–1936)*. Valencia: 3 i 4, 2000.

Miralles, Francesc. *L'època de les avantguardes: 1917–1970*. Vol. 8 of *Història de l'art català*. 4th ed. Barcelona: Edicions 62, 1996.

Moffitt, John F. *The Arts in Spain*. New York: Thames & Hudson, 1999.

Molas, Joaquim, ed. *La literatura catalana d'avantguarda: 1916–1938*. Barcelona: Antoni Bosch, 1983.

Molas, Joaquim, et al. *Primeres avantguardes: 1918–1930*. Vol. 8 of *Història de la cultura catalana*. Barcelona: Edicions 62, 1997.

Molas, Isidre, et al. *República, autogovern i Guerra: 1931–1939*. Vol. 9 of *Història de la cultura catalana*. Barcelona: Edicions 62, 1998.

Morris, C. B. *Surrealism and Spain, 1920–1936*. Cambridge, U.K.: Cambridge University Press, 1972.

___, ed. *The Surrealist Adventure in Spain*. Ottawa: Dovehouse, 1991.

Naranjo, Juan, et al. *Introducción a la historia de la fotografía en Cataluña*. Exh. cat. Barcelona: Lunwerg/MNAC, 2000.

Obiols, Salvador. *Catalunya en blanc i negre*. Madrid: Espasa-Calpe, 1998.

Pantorba, Bernardino de. *Historia y crítica de las Exposiciones Nacionales de Bellas Artes celebradas en España*. Madrid: Jesus Ramon García-Rama J., 1980.

Peracaula, Lourdes, ed. *La fotografía pictorialista en España, 1900–1936*. Exh. cat. Barcelona: Fundación "la Caixa," 1998.

Peran, Martí, Alícia Suàrez, and Mercè Vidal, eds. *El Noucentisme: un projecte de modernitat*. Exh. cat. Barcelona: Generalitat de Catalunya/Enciclopèdia Catalana/Centre de Cultura Contemporània de Barcelona, 1994.

___, eds. *Noucentisme i ciutat*. Barcelona: Electa/Centre de Cultura Contemporània de Barcelona, 1994.

Permanyer, Lluís. *In Detail: Barcelona Art Nouveau*. Barcelona: Polígrafa, 2004.

Pizza, Antonio, and Josep M. Rovira, eds. *La tradició renovada: Barcelona anys 30*. Barcelona: Col·legi d'Arquitectes de Catalunya, 1999.

___. *G.A.T.C.P.A.C. 1928–1939: Una nova arquitectura per a una nova ciutat/A New Architecture for a New City*. Exh. cat. Barcelona: Museu d'Història de la Ciutat/Col·legi d'Arquitectes de Catalunya, 2006.

Raeburn, Michael, ed. *Homage to Barcelona: The City and its Art, 1888–1936*. Exh. cat. London: Arts Council of Great Britain, 1985.

Reyero, Carlos, and Mireia Freixa. *Pintura y escultura en España, 1800–1910*. Madrid: Cátedra, 1995.

Resina, Joan Ramon, ed. *El aeroplano y la estrella: el movimiento de vanguardia en los Países Catalanes, 1904–1936*. Amsterdam/Atlanta: Rodopi, 1997.

Riquer, Borja de, et al. *Modernismo: Architecture and Design in Catalonia*. New York: Monacelli Press, 2003.

Rosenblum, Robert, MaryAnne Stevens, and Ann Dumas. *1900: Art at the Crossroads*. Exh. cat. New York: Harry N. Abrams, 2000.

Sanjuán, Charo, ed. *Quatre Gats: de Casas a Picasso*. Exh. cat. Barcelona: Bancaja, 2005.

Satué, Enric. *El diseño gráfico en España: historia de una forma comunicativa nueva*. Madrid: Alianza, 1997.

Segel, Harold B. *Turn-of-the-Century Cabaret: Paris, Barcelona, Berlin, Munich, Vienna, Cracow, Moscow, St. Petersburg, Zurich*. New York: Columbia University Press, 1987.

Spiteri, Raymond, and Donald LaCoss, eds. *Surrealism, Politics, and Culture*. Aldershot, Hants, U.K./Burlington, Vt.: Ashgate, 2003.

Stoullig, Claire, ed. *Steinlen y la época de 1900*. Exh. cat. Barcelona: Institut de Cultura, Museu Picasso, 2000.

Termes, Josep, ed. *Carteles de la República y de la Guerra Civil*. Barcelona: Centre d'Estudis d'Història Contemporània, La Gaya ciencia, 1978.

Trenc Ballester, Eliseu. *Les arts gràfiques de l'època modernista a Barcelona*. Barcelona: Gremi d'Indústries Gràfiques, 1977.

Tresserras, Joan Manuel. *D'Ací d'Allà: Aparador de la modernitat (1918–1936)*. Barcelona: Llibres de l'Índex, 1993.

Tusell, Javier, ed. *El modernismo catalán, un entusiasmo*. Exh. cat. Madrid: Fundación Santander Central Hispano, 2000.

Ubero, Lina, and M. Dolors Magallón, eds. *Gaudí / Verdaguer: tradició i modernitat a la Barcelona del canvi de segle, 1878–1912*. Exh. cat. Barcelona: Ajuntament de Barcelona, Triangle Postals, 2002.

Vallcorba, Jaume. *Noucentisme, mediterraneisme i classicisme: apunts per a la història d'una estètica*. Barcelona: Quaderns Crema, 1994.

Vidal, Mercè. *Teoria i crítica del Noucentisme: Joaquim Folch i Torres*. Barcelona: Abadia de Montserrat, 1991.

\_\_. *1912: L'exposició d'art cubista de les Galeries Dalmau*. Barcelona: Universitat de Barcelona, 1996.

Vidal i Oliveras, Jaume. *Josep Dalmau: l'aventura per l'art modern*. Manresa: Fundació Caixa de Manresa/Angle, 1993.

\_\_. *Santiago Segura (1879–1918): una història de promoció cultural*. Sabadell: Museu d'Art de Sabadell, 1999.

## Catalogues and Monographs on Individual Artists

Ades, Dawn, ed. *Dalí*. Exh. cat. New York/Philadelphia: Rizzoli/ Philadelphia Museum of Art, 2004.

Ades, Dawn, et al. *Planells surrealista*. Exh. cat. Blanes: Fundació Àngel Planells/ Museu d'Art de Girona/Obra Social Caja Madrid, 2004.

Aguilera Cerni, Vicente. *Julio, Joan, Roberta González: itinerario de una dinastía*. Barcelona: Polígrafa, 1973.

Ainaud de Lasarte, Joan, ed. *Picasso i Barcelona, 1881–1981*. Exh. cat. Barcelona: Ajuntament de Barcelona, 1981.

Antich, Xavier, et al. *Josep Clarà: la recerca de l'ideal*. Exh. cat. Girona: Fundació Caixa de Girona, 1999.

Badia i Serra, Montserrat, ed. *Joan Rebull*. Exh. cat. Mollet del Vallès: Museu Abelló, 2000.

*Barradas: exposición antológica, 1890–1929*. Exh. cat. Madrid, Barcelona, and Zaragoza: Comunidad de Madrid, Generalitat de Catalunya, Gobierno de Aragón, 1992.

*Barradas/Torres-García*. Exh. cat. Buenos Aires: Cultura de la Nación Argentina, Museo Nacional de Bellas Artes de Buenos Aires, 1995.

Bassegoda Nonell, Joan. *La Pedrera de Gaudí*. 2d ed. Trans. James Eddy. Barcelona: Fundació Caixa de Catalunya, 1989.

\_\_. *Antonio Gaudí: Master Architect*. New York: Abbeville Press, 2000.

\_\_. *Antoni Gaudí*. Barcelona: Edicions 62, 2002.

Bassegoda Nonell, Joan, et al. *Gaudí. Art and Design*. Exh. cat. Barcelona: Fundació Caixa Catalunya, 2002.

Batlle i Jordà, Carles, Isidre Bravo, and Jordi Coca. *Adrià Gual: mitja vida de modernisme*. Barcelona: Diputació de Barcelona, Àmbit, 1992.

Beaumelle, Agnès de la, ed. *Joan Miró, 1917–1934*. Exh. cat. Paris and London: Centre Pompidou, P. Holberton, 2004.

Borràs, Maria Lluïsa. *Picabia*. Trans. Kenneth Lyons. New York: Rizzoli, 1985.

Bravo, Isidre, et al. *Els Masriera: Josep Masriera, 1841–1912, Francesc Masriera, 1842–1902, Lluís Masriera, 1872–1958*. Exh. cat. Barcelona: Museu Nacional d'Art de Catalunya/ Generalitat de Catalunya/Proa, 1996.

Brooke, Peter. *Albert Gleizes: For and Against the Twentieth Century*. New Haven: Yale University Press, 2001.

Brown, Jonathan, ed. *Picasso and the Spanish Tradition*. New Haven: Yale University Press, 1996.

Calvo Serraller, Francisco. *La constelación de Vulcano: Picasso y la escultura de hierro del siglo XX*. Madrid: Tf editores, 2004.

Carbonell, Jordi À. *Manuel Capdevila*. Barcelona: Galaxis, 1993.

Carmona, Eugenio, et al. *Togores: clasicismo y renovación. Obra de 1914 a 1931*. Exh. cat. Madrid/Barcelona: Museo Nacional Centro de Arte Reina Sofía/Museu Nacional d'Art de Catalunya, 1997.

Casamartina, Josep. *L'interior del 1900: Adolf Mas, fotògraf*. Exh. cat. Barcelona: Centre de Documentació i Museu Tèxtil/ Institut Amatller d'Art Hispànic, 2002.

Casamartina, Josep, et al. *Marian Pidelaserra (1877–1946)*. Exh. cat. Barcelona/Madrid: Museu Nacional d'Art de Catalunya/ Fundación Cultural Mapfre Vida, 2002.

Casas, Ramon. *Viatge a París*. Ed. Francesc Fontbona. Barcelona: La Magrana, 1980.

Cela, Ana, and Paloma Castellanos. *Julio González at the IVAM Collection*. Trans. Alison Hughes. Valencia: Generalitat Valenciana, 2001.

*Cerdà, urbs i territori: una visió de futur*. Exh. cat. Madrid: Electa, 1994.

Cirlot, Juan-Eduardo. *Gaudí*. Trans. Steve Cedar. Sant Lluís, Menorca, and Barcelona: Triangle Postals, Ajuntament de Barcelona, 2002.

Coll, Isabel. *S. Rusiñol*. Sabadell: Ausa, 1992.

\_\_. *Ramon Casas, 1866–1932: una vida dedicada al arte, catálogo razonado*. Madrid: De la Cierva, 2002.

Collins, George R., and Juan Bassegoda Nonell. *The Designs and Drawings of Antonio Gaudí*. Princeton: Princeton University Press, 1983.

Comadira, Narcís. *Joaquim Sunyer (A l'entorn del Clot dels Frares)*. Exh. cat. Girona: Ajuntament de Girona, 1990.

Cooper, Douglas, and Gary Tinterow. *The Essential Cubism, 1907–1920: Braque, Picasso & Their Friends*. Exh. cat. London: Tate Gallery, 1983.

Coyle, Laura, William Jeffett, and Joan Punyet-Miró. *The Shape of Color: Joan Miró's Painted Sculpture*. Exh. cat. Washington/ London: Corcoran Gallery of Art/Scala, 2002.

Crippa, Maria Antonietta, et al. *Living Gaudí: The Architect's Complete Vision*. New York: Rizzoli, 2002.

Dalí, Salvador. *Un diari: 1919–1920*. Ed. Fèlix Fanés. Barcelona: Fundació Gala-Salvador Dalí, Edicions 62, 1994.

\_\_. *L'alliberament dels dits: obra catalana completa*. Ed. Fèlix Fanés. Barcelona: Quaderns Crema, 1995.

\_\_. *The Collected Writings of Salvador Dalí*. Ed. Haim N. Finkelstein. Cambridge, U.K./New York: Cambridge University Press, 1998.

Dalí, Salvador, and Federico García Lorca. *Sebastian's Arrows: Letters and Mementos of Salvador Dalí and Federico García Lorca*. Ed. and trans. Christopher Maurer. Chicago: Swan Isle Press, 2004.

Dalisi, Riccardo. *Gaudí: Furniture & Objects*. Trans. Murtha Baca. Woodbury, N.Y.: Barron's, 1980.

Dodds, George. *Building Desire: On the Barcelona Pavilion*. Abingdon, U.K./New York: Routledge, 2005.

Dollens, Dennis, et al. *El universo de Jujol's Universe*. Exh. cat. Barcelona: Ministerio de Fomento/Col·legi d'Arquitectes de Catalunya, 1998.

Domènech i Girbau, Lluís, Lourdes Figueras, and Roser Domènech. *Lluís Domènech i Montaner i el director d'orquestra*. Exh. cat. Barcelona: Fundació Caixa de Barcelona, 1989.

Domènech i Girbau, Lluís, et al. *Domènech i Montaner: año 2000, year 2000*. Exh. cat. Barcelona: Col·legi d'Arquitectes de Catalunya, 2000.

Doñate, Mercè. *Clarà: catàleg del fons d'escultura*. Barcelona: Museu Nacional d'Art de Catalunya, 1997.

\_\_. *Clarà escultor*. Barcelona: Museu Nacional d'Art de Catalunya, 1997.

Doñate, Mercè, ed. *Joan Llimona: 1860–1926, Josep Llimona: 1864–1932*. Exh. cat. Barcelona: Museu Nacional d'Art de Catalunya, 2004.

*Enric Casanovas*. Exh. cat. Barcelona: Ajuntament de Barcelona, 1984.

Falgàs, Jordi. *Dalí: Painter, Paint! An Introduction to the Life and Works of Salvador Dalí*. Barcelona: Escudo de Oro, 2003.

Fanés, Fèlix. *Salvador Dalí: la construcción de la imagen, 1925–1930*. Madrid: Electa, 1999.

Fenosa, Nicole, and Bertrand Tillier, eds. *Apel·les Fenosa: Catalogue raisonnée de l'oeuvre sculpté*. Paris/Barcelona: Flammarion, Polígrafa, 2002.

Figueras, Lourdes. *Lluís Domènech i Montaner*. Barcelona: Santa & Cole/Universitat Politècnica de Catalunya, 1994.

Flores, Carlos and Josep M. Huertas. *La Pedrera: Architecture and History*. Ed. Daniel Giralt-Miracle, trans. Graham Thomson. Barcelona: Caixa Catalunya, 1999.

Fondevila, Mariàngels, ed. *Gaspar Homar, moblista i dissenyador del modernisme*. Exh. cat. Barcelona: Museu Nacional d'Art de Catalunya/Fundació "la Caixa," 1998.

———. *Jujol dissenyador*. Exh. cat. Museu Nacional d'Art de Catalunya/Fundació "la Caixa," 2002.

Fontbona, Francesc. *Gaudí al detall: el geni del modernisme català*. Barcelona: Pòrtic, 2002.

———. *Carles Mani, l'escultor maleït*. Barcelona/Tarragona: Viena/Diputació de Tarragona/Museu d'Art Modern, 2004.

Fontbona, Francesc, and Albert Mercadé. *Jaume Mercadé: pintor i orfebre*. Exh. cat. Girona: Fundació Caixa de Girona, 2005.

Fontbona, Francesc, and Francesc Miralles. *Anglada-Camarasa*. Barcelona: Polígrafa, 1981.

Fontserè, Carles. *Memòries d'un cartellista català (1931–1939)*. Barcelona: Pòrtic, 1995.

*Francis Picabia (1879–1953): Exposició Antològica*. Exh. cat. Barcelona: Ministerio de Cultura/Fundació Caixa de Pensions, 1985.

*Francis Picabia: galerie Dalmau, 1922*. Exh. cat. Paris: Éditions du Centre Pompidou, 1996.

*Francis Picabia, Máquinas y españolas*. Exh. cat. Valencia/Barcelona: IVAM Centre Julio González/Fundació Antoni Tàpies, 1995.

*Francis Picabia: Singulier idéal*. Exh. cat. Paris: Musée d'Art Moderne de la Ville de Paris, 2002.

Freixa, Mireia, and Mercè Vidal, eds. *Gaudí, Jujol i el modernisme al Baix Llobregat*. Barcelona: Mediterrània, 2003.

Galassi, Susan Grace. *Picasso's Variations on the Masters: Confrontations with the Past*. New York: Harry N. Abrams, 1996.

Garcia-Sedas, Pilar. *Joaquim Torres-García: d'una terra, d'un paisatge*. Exh. cat. Girona: Ajuntament de Girona, 1995.

Gibson, Ian. *The Shameful Life of Salvador Dalí*. New York: W. W. Norton, 1997.

Giralt-Miracle, Daniel. *El crit de la terra: Joan Miró i el Camp de Tarragona*. Tarragona: Diputació de Tarragona/Museu d'Art Modern, Columna, 1994.

———, ed. *Gaudí 2002 Miscellany*. Barcelona: Planeta/Ajuntament de Barcelona, 2002.

———, ed. *Gaudí: Exploring Form, Space, Geometry, Structure, and Construction*. Exh. cat. Barcelona: Lunwerg/Ajuntament de Barcelona/Sociedad Estatal para la Acción Cultural Exterior, 2002.

———. *Ramon Casas i el cartell*. Exh. cat. Valencia: Museu Valencià de la Il·lustració i de la Modernitat/Diputació de València/Caja de Ahorros del Mediterráneo, 2005.

Gimferrer, Pere. *The Roots of Miró*. Trans. Elaine Fradley. Barcelona: Polígrafa, 1993.

Güell, Carmen. *Gaudí y el conde de Güell: el artista y el mecenas*. Barcelona: Martínez Roca, 2001.

Guigon, Emmanuel, ed. *Remedios Varo: Arte y literatura*. Exh. cat. Teruel: Museo de Teruel, 1991.

Hine, Hank, William Jeffett, and Kelly Reynolds, eds., *Persistence and Memory: New Critical Perspectives on Dalí at the Centennial*. St. Petersburg, Fl.: Bompiani/Salvador Dalí Museum, 2004.

Jardí, Enric. *Nonell*. 2d ed. Barcelona: Polígrafa, 1985.

———. *Joaquim Mir*. Barcelona: Polígrafa, 1989.

———. *Rafael Barradas a Catalunya i altres artistes que passaren la mar*. Barcelona: Generalitat de Catalunya/Comissió Amèrica i Catalunya, 1992.

*Jaume Mercadé i la joia d'art*. Exh. cat. Tarragona: Caixa Tarragona, 2005.

*Jaume Mercadé: pintor i orfebre*. Exh. cat. Girona: Fundació Caixa de Girona, 2005.

Jeffett, William. *Dalí and Miró circa 1928*. Exh. cat. St. Petersburg, Fl.: Salvador Dalí Museum, 2003.

———, ed. *Dalí: Gradiva*. Exh. cat. Madrid: Fundación Colección Thyssen-Bornemisza/ Fundación Caja Madrid, 2002.

*Joaquim Pla Janini*. Exh. cat. Barcelona: Lunwerg/Fundació "la Caixa," 1995.

*Joan Massanet o el espectro de las cosas*. Exh. cat. Madrid: Aldeasa, 2005.

*Joan Miró, Black and Red Series: A New Acquisition in Context*. Exh. cat. New York: Museum of Modern Art, 1998.

*Joan Rebull, escultor: 1899–1981*. Exh. cat. Barcelona: Fundació "la Caixa," 1999.

*Joan Rebull: años 20 y 30*. Exh. cat. Madrid: Museo Nacional Centro de Arte Reina Sofía, 2003.

*Josep Masana, 1892–1979*. Exh. cat. Barcelona: Generalitat de Catalunya, 1994.

Junoy, Josep Maria. *Obra poètica*. Ed. Jaume Vallcorba Plana. Barcelona: Quaderns Crema, 1984.

Kaplan, Janet A. *Unexpected Journeys: The Art and Life of Remedios Varo*. New York: Abbeville, 1988.

Lahuerta, Juan José. *Casa Batlló, Gaudí*. Trans. Steve Cedar. Barcelona: Triangle Postals, 2001.

———. *Antoni Gaudí 1852–1926: Architecture, Ideology, and Politics*. Milan/London: Electaarchitecture, Phaidon, 2003.

———, ed. *Le Corbusier y España*. Barcelona: Centre de Cultura Contemporània de Barcelona, 1997.

———, ed. *Antoni Gaudí 1852–1926: antología contemporánea*. Madrid: Alianza, 2002.

———, ed. *Universo Gaudí*. Exh. cat. Barcelona: Diputació de Barcelona/Centre de Cultura Contemporània de Barcelona/Museo Nacional Centro de Arte Reina Sofía, 2002.

Laplana, Josep de C. *Santiago Rusiñol: el pintor, l'home*. Barcelona: Abadia de Montserrat, 1995.

Laplana, Josep de C., and Mercedes Palau-Ribes O'Callaghan. *La pintura de Santiago Rusiñol: obra completa*. 3 vols. Barcelona: Mediterrània, 2004.

*Leandre Cristòfol*. Exh. cat. Lleida: Ajuntament de Lleida, 1995.

Lord, Carmen Belen. "Point and counterpoint: Ramon Casas in Paris and Barcelona, 1866–1908." Ph.D. diss., University of Michigan, 1995.

Lubar, Robert S. *Dalí: The Salvador Dalí Museum Collection*. Boston: Bulfinch Press, 2000.

___. "Joan Miró before 'The Farm,' 1915–1922: Catalan Nationalism and the Avant-garde." Ph.D. diss., New York University, Graduate School of Arts and Science, 1988.

*Manolo, esencial: escultura, pintura, dibujo*. Exh. cat. Barcelona: Fundación Francisco Godia, 2003.

Marzà, Fernando, ed. *Le Corbusier i Barcelona*. Exh. cat. Barcelona: Fundació Caixa de Catalunya, 1988.

McCully, Marilyn, ed. *A Picasso Anthology: Documents, Criticism, Reminiscences*. London: Arts Council of Great Britain, 1981.

___. *Julio González: A Retrospective Exhibition*. Exh. cat. Zurich/New York: Art Focus/Dickinson, 2002.

___, ed. *Picasso: The Early Years, 1892–1906*. Exh. cat. Washington: National Gallery of Art, 1997.

Mendelson, Jordana, and Juan José Lahuerta, eds. *Margaret Michaelis: fotografía, vanguardia y política en la Barcelona de la República*. Exh. cat. Valencia/Barcelona: IVAM Centre Julio González/Centre de Cultura Contemporània de Barcelona, 1998.

Mendoza, Cristina. *Ramon Casas: retrats al carbó. Col·lecció del Gabinet de Dibuixos i Gravats del Museu Nacional d'Art de Catalunya*. Exh. cat. Barcelona: Ausa/Museu d'Art Modern del MNAC, 1995.

___, ed. *Torres-García: Pintures de Mon Repòs*. Barcelona: Caixa de Terrassa/Museu Nacional d'Art de Catalunya, 1995.

Mendoza, Cristina, and Mercè Doñate, eds. *Santiago Rusiñol: 1861–1931*. Exh. cat. Barcelona/Madrid: Museu Nacional d'Art de Catalunya/Fundació Cultural Mapfre Vida, 1997.

___. *Joaquim Sunyer: la construcció d'una mirada*. Exh. cat. Barcelona /Madrid: Museu Nacional d'Art de Catalunya/Fundació Cultural Mapfre Vida, 1999.

___. *Isidre Nonell 1872–1911*. Exh. cat. Barcelona/Madrid: Museu Nacional d'Art de Catalunya/Fundació Cultural Mapfre Vida, 2000.

___. *Ramon Casas: el pintor del modernisme*. Exh. cat. Barcelona/Madrid: Museu Nacional d'Art de Catalunya/Fundació Cultural Mapfre Vida, 2001.

Merkert, Jörn. *Julio González*. Milan: Electa, 1987.

Minguet Batllori, Joan M. *Joan Miró: l'artista i el seu entorn cultural (1918–1983)*. Barcelona: Abadia de Montserrat, 2000.

___. *Salvador Dalí, cine y surrealismo(s)*. Barcelona: Parsifal, 2003.

___. *El Manifest Groc: Dalí, Gasch, Montanyà i l'antiart*. Exh. cat. Barcelona: Generalitat de Catalunya/Fundació Joan Miró/Círculo de Lectores, 2004.

___, ed. *Serra: el arte de la cerámica*. Exh. cat. Madrid/Cornellà de Llobregat: Subdirección General de Museos Estatales/Ajuntament de Cornellà de Llobregat, 2005.

Miralles, Francesc. *Llorens Artigas: catálogo de obra*. Barcelona: Polígrafa, 1992.

Miró, Joan. *Joan Miró: Selected Writings and Interviews*. Ed. Margit Rowell, trans. Paul Auster and Patricia Mathews. Boston: G. K. Hall, 1986.

___. *Cartes a J. F. Ràfols: 1917–1958*. Ed. Amadeu Soberanas and Francesc Fontbona. Barcelona: Mediterrània/Biblioteca de Catalunya, 1993.

Nash, Steven A., and Robert Rosenblum, eds. *Picasso and the War Years, 1937–1945*. Exh. cat. New York/San Francisco: Thames & Hudson/Fine Arts Museums of San Francisco, 1998.

Ocaña, Maria Teresa, ed. *Picasso: Landscapes, 1890–1912*. Exh. cat. Trans. Caroline Clancy. Boston: Little, Brown, and Co., 1994.

___, ed. *Picasso and Els 4 Gats: The Early Years in Turn-of-the-Century Barcelona*. Exh. cat. Boston: Little, Brown, and Co., 1995.

___, ed. *Picasso: The Development of a Genius, 1890–1904*. Exh. cat. Trans. Dominic Currin. Barcelona: Lunwerg/Museu Picasso, 1997.

Ocaña, Maria Teresa, and Vincent Pomarède, eds. *Albert Gleizes: le cubisme en majesté*. Exh. cat. Paris/Barcelona/Lyon: Réunion des Musées Nationaux/Museu Picasso/Musée des Beaux-arts, 2001.

Ocaña, Maria Teresa, and Hans Christoph von Travel, eds. *Picasso 1905–1906*. Exh. cat. Barcelona: Electa, 1992.

Ordóñez Fernández, Rafael. *Museo Pablo Gargallo*. Zaragoza: Ayuntamiento de Zaragoza, 2004.

Ordóñez Fernández, Rafael, María Casanova, and Vicky Menor. *Pablo Gargallo*. Exh. cat. Valencia/Biarritz: Institut Valencià d'Art Modern/Ville de Biarritz, 2004.

Ovalle, Ricardo, et al. *Remedios Varo: Catálogo razonado, catalogue raisonné*. México: Era, 1994.

Parcerisas, Pilar, ed. *Miró, Dalmau, Gasch: l'aventura per l'art modern, 1918–1937*. Exh. cat. Barcelona: Generalitat de Catalunya, 1993.

___, ed. *Pere Català i Pic: Fotografia i publicitat*. Exh. cat. Barcelona: Fundació "la Caixa"/Lunwerg, 1998.

Palau i Fabre, Josep. *Picasso in Catalonia*. 2d ed. Trans. Kenneth Lyons. Secaucus, N.J.: Chartwell Books, 1981.

___. *Picasso, the Early Years, 1881–1907*. New York: Rizzoli, 1981.

___. *Picasso Cubism (1907–1917)*. Trans. Susan Branyas, Richard-Lewis Rees, and Patrick Zabalbeascoa. New York: Rizzoli, 1990.

___. *Picasso: From the Ballets to the Drama (1917–1926)*. Trans. Richard-Lewis Rees. Cologne: Könemann, 1999.

___. *Picasso i els seus amics catalans*. Rev. ed. Barcelona: Galàxia Gutenberg/Cercle de Lectors, 2006.

Pereda, Raquel. *Joaquín Torres-García*. Montevideo: Fundación Banco de Boston, 1991.

Permanyer, Lluís. *Clavé escultor*. Barcelona: Polígrafa, 1989.

___. *Josep Puig i Cadafalch*. Trans. Josephine Watson. Barcelona: Polígrafa, 2001.

*El Pintor Lamolla*. Exh. cat. Lleida/Teruel: Patronat Municipal Museu d'Art Jaume Morera/ Museo de Teruel, 1998.

Pizza, Antonio, ed. *J. Ll. Sert y el Mediterráneo–J. Ll. Sert and Mediterranean Culture*. Barcelona: Ministerio de Fomento/Colegio de Arquitectos de Cataluña, 1997.

Quetglas, Josep. *Fear of Glass: Mies van der Rohe's Pavilion in Barcelona*. Basel: Birkhäuser, 2001.

Raeburn, Michael, ed. *Salvador Dalí: The Early Years*. Exh. cat. New York: Thames & Hudson, 1994.

*Rafael Barradas, 1914–1929*. Exh. cat. L'Hospitalet de Llobregat: Centre Cultural Metropolità Tecla Sala, 2004.

Ramon, Artur, and Jaume Vallcorba. *Àlbum Manolo Hugué*. Barcelona: Quaderns Crema, 2005.

Ricart, Enric C. *Enric Cristòfol Ricart: Memòries*. Ed. Ricard Mas Peinado. Barcelona: Parsifal, 1995.

Richard de la Fuente, Véronique. *Picasso à Céret: 1911–1914*. Perpignan: Mare Nostrum, 2002.

Richardson, John, and Marilyn McCully. *A Life of Picasso. Volume I: 1881–1906*. New York: Random House, 1991.

___. *A Life of Picasso. Volume II: 1907–1917*. New York: Random House, 1996.

Rohrer, Judith, and Ignasi de Solà Morales, eds. *J. Puig i Cadafalch: la arquitectura entre la casa y la ciudad*. Exh. cat. Barcelona: Fundación Caja de Pensiones, 1989.

Roig, Sebastià, and Jordi Puig. *Dalí: The Empordà Triangle*. Sant Lluís, Menorca/Figueres: Triangle Postals/Fundació Gala-Salvador Dalí, 2003.

Rovira, Josep M., ed. *Mies van der Rohe Pavilion: Reflections.* Barcelona: Triangle Postals, 2002.

___. *José Luis Sert: 1901–1983.* Milan/London: Electaarchitecture, Phaidon, 2003.

___, ed. *Sert, Half a Century of Architecture 1928–1979.* Exh. cat. Barcelona: Fundació Joan Miró, 2005.

Rubin, William, ed. *Picasso and Portraiture: Representation and Transformation.* Exh. cat. New York: Museum of Modern Art, 1996.

Salvat-Papasseit, Joan. *Selected Poems.* Ed. and trans. Dominic Keown and Tom Owen. Sheffield: Anglo-Catalan Society, 1982.

Socias Palau, Jaume. *Canals.* Madrid: Espasa-Calpe, 1976.

Subirana i Torrent, Rosa M. *El Pavelló Alemany de Barcelona de Mies van der Rohe: 1929–1986.* Barcelona: Fundació Pública del Pavelló Alemany de Barcelona de Mies van der Rohe, 1987.

Sureda Pons, Joan. *Torres García: pasión clásica.* Madrid: Akal, 1998.

Tarrús, Joan, and Narcís Comadira. *Rafael Masó, arquitecte noucentista.* Girona/Barcelona: Col·legi d'Arquitectes de Catalunya/Lunwerg, 1996.

Tinterow, Gary. *Master Drawings by Picasso.* Exh. cat. Cambridge, Mass.: Fogg Art Museum, 1981.

Torres-García, Joaquín. *Escrits sobre art.* Ed. Francesc Fontbona. Barcelona: Edicions 62, 1980.

___. *Historia de mi vida.* Barcelona: Paidós, 1990.

___. *Epistolari català: 1909–1936.* Ed. Pilar Garcia-Sedas. Barcelona: Curial/ Publicacions de l'Abadia de Montserrat, 1997.

Torres-García, Joaquín, and Rafael Barradas. *Joaquín Torres-García y Rafael Barradas: un diálogo escrito, 1918–1928.* Ed. Pilar Garcia-Sedas. Barcelona/Montevideo: Parsifal, Libertad Libros, 2001.

Turner, Elizabeth Hutton, and Oliver Wick, eds. *Calder/Miró.* Exh. cat. Washington: Philip Wilson Publishers/Phillips Collection/Fondation Beyeler, 2004.

Trenc Ballester, Eliseu. *Alexandre de Riquer.* Barcelona: Caixaterrassa/Lunwerg, 2000.

Trenc Ballester, Eliseu, and Alan Yates. *Alexandre de Riquer: 1856–1920: The British Connection in Catalan Modernisme.* Exeter: Anglo-Catalan Society, 1988.

Van Hensbergen, Gijs. *Gaudí.* New York: HarperCollins, 2001.

Varichon, Anne, ed. *Albert Gleizes: catalogue raisonnée.* Vol. 1. Paris: Fondation Albert Gleizes, 1998.

Vélez, Pilar, ed. *Els Masriera: un segle de joieria i orfebreria.* Exh. cat. Girona: Fundació Caixa de Girona, 2004.

Verrié, Frederic Pau, Narcís Comadira, and Pilar Vélez. *Josep Obiols: obra cívica, 1894–1994.* Exh. cat. Barcelona: Generalitat de Catalunya, 1994.

*Visions útils: Pere Català Pic, Josep Sala, fotopublicistes dels anys 30.* Exh. cat. Barcelona: Fundació "la Caixa," 1994.

## The Internet

The Internet currently provides an enormous amount of resources on Barcelona and its visual arts. The following is only a handful of websites that have proven enormously helpful in our research:

*Art Públic, Cultura, Urbanisme.* Catalogue of Architectural Heritage, Catalogue of the sculptures and other works of art in public areas of the city, and Barcelona museums: http://www.bcn.es/

*Arxiu Fotogràfic de l'Arxiu Històric de la Ciutat de Barcelona.* Thousands of photographs from the historical archive of the city: http://www.digitalbank.es/ahc/index.php

*Biblioteca Virtual Joan Lluís Vives.* Facsimile editions of magazines such as *Arc Voltaic, Un enemic del Poble, Vell i Nou, Quatre Gats,* and others: http://www.lluisvives.com/hemeroteca/

*Catàleg Col·lectiu de les Universitats de Catalunya.* The online catalogue of all Catalan universities and many other Catalan archives and libraries: http://www.cbuc.es/ccuc/

*Col·legi d'Arquitectes de Catalunya, Arxiu Històric.* The rich archives of the Catalan architect's association are available at: http://www.coac.net/

The *Hyperencyclopaedia,* taken from the printed version of the Gran Enciclopèdia Catalana and translated into English: http://www.catalanencyclopaedia.com/

*Institut Ramon Llull:* http://www.llull.cat/

*Museu Nacional d'Art de Catalunya:* http://www.mnac.cat/

# Comparative Illustrations

**Foreword**

Fig. 1. Expiatory Temple of La Sagrada Família, construction begun 1882, designed by Antoni Gaudí. Photo © Pere Vivas and Jordi Puig, Triangle Postals, Barcelona, 2006.

Fig. 2. Palau de la Música Catalana, 1905–8, designed by Lluís Domènech i Montaner. Photo © Pere Vivas and Jordi Puig, Triangle Postals, Barcelona, 2006.

**Introduction: Barcelona and Modernity**

Fig. 2. Catalonia showing cities important to this catalogue.

Fig. 3. The autonomous regions of Spain today.

Fig. 4. *The Siege of Barcelona,* 1714, unknown artist. Museu d'Història de la Ciutat de Barcelona. Image courtesy Museu d'Història de la Ciutat de Barcelona.

Fig. 6. Modern Barcelona with the Roman and medieval cities, and the 19th-century expansion.

Fig. 7. Triumphal arch for the Barcelona Universal Exposition, 1888, designed by Josep Vilaseca i Casanovas. Photo © Pere Vivas and Jordi Puig, Triangle Postals, Barcelona, 2006.

Fig. 8. Casa Milà, 1905–10, designed by Antoni Gaudí. Photo © Pere Vivas and Jordi Puig, Triangle Postals, Barcelona, 2006.

Fig. 11. *Serenity,* 1929, by Josep Clarà, in situ in the Parc de Montjuïc, Gardens of Miramar, Barcelona. Photo © Fundació Amatller, Arxiu Mas, Barcelona.

Fig. 12. The plaça d'Espanya, the esplanade, and the National Palace on Montjuïc, Barcelona International Exposition, 1929, photographer unknown. Arxiu Històric de la Ciutat de Barcelona. Image © Arxiu Fotogràfic de l'Arxiu Històric de la Ciutat de Barcelona.

Fig. 15. Disinterred corpses during the Tragic Week, Barcelona, July 1909, photograph by Brangulí. Arxiu Nacional de Catalunya, Sant Cugat del Vallès. Image courtesy Arxiu Nacional de Catalunya.

Fig. 16. General Franco, victory parade in Madrid, May 1939, photographer unknown. AP/Wide World Photos. Photo © AP/ Wide World Photos.

Fig. 17. Fascist salute from children at first communion, Barcelona Cathedral, August 1939, photograph by Brangulí. Arxiu Nacional de Catalunya, Sant Cugat del Vallès. Image courtesy Arxiu Nacional de Catalunya.

Fig. 18. Demonstration for revising the statute of autonomy, Barcelona, February 2006, photograph by Manu Fernández, AP/Wide World Photos. Photo © AP/Wide World Photos.

**1. Rebirth: The Catalan Renaixença**
*The Renaixença in Art*

Fig. 1. *The Origin of the Coat of Arms of the House of Barcelona,* 1843–44, by Claudi Lorenzale i Sugrañes, oil on canvas, 121 x 164 cm. Reial Acadèmia Catalana de Belles Arts de Sant Jordi, Barcelona. Image courtesy Reial Acadèmia Catalana de Belles Arts de Sant Jordi.

Fig. 2. *The Castle, Perpignan,* 1850, by Lluís Rigalt i Farriols, ink and gray wash on paper, 14.5 x 20.3 cm. Reial Acadèmia Catalana de Belles Arts de Sant Jordi, Barcelona. Image courtesy Reial Acadèmia Catalana de Belles Arts de Sant Jordi.

Fig. 4. Aerial view of Barcelona's Eixample and the plaça de Catalunya, 1927, photograph by the Escuela Aeronáutica Naval. Arxiu Històric de la Ciutat de Barcelona. Image © Arxiu Fotogràfic de l'Arxiu Històric de la Ciutat de Barcelona.

Fig. 6. *Antiquaries,* 1863, by Marià Fortuny i Marsal, oil on canvas, 47 x 66.3 cm. Museum of Fine Arts, Boston, S. A. Denio Collection. Photo © 2006, Museum of Fine Arts, Boston.

*Greeting the Dawn*

Fig. 5. *Rooster Greeting the Dawn,* one of the four sculptures in situ atop the Torre de l'Homenatge. Photo © Manolo Laguillo, 2006.

**2. Modernisme: Painting, Sculpture, Graphic Arts**
*The New Art: Modernisme*

Fig. 1. Map of Catalonia with busts of prominent cultural and political figures of the day, c. 1901, unknown artist. Museu d'Història de la Ciutat de Barcelona, Barcelona.

Fig. 2. Interior view of Sala Parés exhibit, c. 1904, photographer unknown. Sala Parés Gallery, Barcelona.

Fig. 3. Raimon Casellas, undated, photograph by Napoleon. Barcelona/Adolf-Ecksteins-Verlag, Berlin-Charlottenburg.

Fig. 4. The living room of Cau Ferrat (Den of Iron) in Sitges. Photo © Pere Vivas and Jordi Puig, Triangle Postals, Barcelona, 2006.

Fig. 5. The original interior of the Quatre Gats café, 1904, photographer unknown. Institut Amatller d'Art Hispanic, Barcelona. Image © Fundació Amatller, Arxiu Mas, Barcelona.

*Casas and Rusiñol*

Fig. 3. *Plein Air,* c. 1890–91, by Ramon Casas, oil on canvas, 51 x 66 cm. Museu Nacional d'Art de Catalunya, Barcelona. Photo © MNAC–Museu Nacional d'Art de Catalunya, 2006, photo Calveras/Mérida/Sagristà.

Fig. 4. *A Summer Cloud,* 1891, by Santiago Rusiñol, oil on canvas, 72 x 87.5 cm. Museu Nacional d'Art de Catalunya, Barcelona. Photo © MNAC–Museu Nacional d'Art de Catalunya, 2006, photo Calveras/Mérida/Sagristà.

Fig. 10. *At the Café (L'Absinthe),* 1876, by Edgar Degas, oil on canvas, 92 x 68 cm. Musée d'Orsay, Paris, legacy of the Count Isaac de Camondo, 1911.

*Modernista Illustrated Magazines*

Fig. 2. *El Gato Negro* 1, no. 1 (15 January 1898), frontispiece by Josep Triadó. Biblioteca de Catalunya, Barcelona. Image courtesy Biblioteca de Catalunya.

Fig. 3. *Hispania,* no. 16 (15 October 1899), cover by Joan Llimona. Biblioteca de Catalunya, Barcelona. Image courtesy Biblioteca de Catalunya.

*Symbolist Sculpture*

Fig. 2. *Monument to Doctor Robert,* conceived by Josep Llimona in 1903, completed in 1910, dismantled in 1940, and rebuilt in its current location in 1985, original architect, Lluís Domenèch i Montaner, reconstruction architect, Josep Miquel Casanovas, sandstone, limestone (parts replaced with artificial stone), and bronze, 12.6 x 9.2 x 11.2 m. Originally located in plaça de la Universitat, currently located in plaça Tetuan (Doctor Robert Gardens), Barcelona. Photo © Ajuntament de Barcelona, CR POLIS-Sector d'Urbanisme.

Fig. 4. *Eve,* 1904, by Enric Clarasó, marble, 132 x 92 x 104.5 cm. Museu Nacional d'Art de Catalunya, Barcelona. Photo © MNAC–Museu Nacional d'Art de Catalunya, 2006, photo Calveras/Mérida/Sagristà.

Fig. 5. *The Wave,* 1905, by Eusebi Arnau, marble, 92 x 150 x 39 cm. Private collection, Barcelona. Photo courtesy the author.

Fig. 7. *Mother's Kiss,* 1896, by Eusebi Arnau, marble, 65 x 82 x 63 cm. Collection "la Caixa," Barcelona.

Fig. 8. *Danaid (The Source),* conceived by Auguste Rodin in 1886, carved before 1902, 36 x 71 x 53 cm. Philadelphia Museum of Art, Gift of Alexandre Harrison to the Pennsylvania Academy of Fine Arts in 1902, and purchased by the Philadelphia Museum of Art with the Annenberg Fund for

major acquisitions and contributions from individual donors, 2003.

### 3. Modernisme: The Quatre Gats
*Quatre Gats and the Origins of Picasso's Career*

Fig. 2. The Quatre Gats tavern (Casa Martí), Barcelona, 1898, designed by Josep Puig i Cadafalch. Photo © Pere Vivas and Jordi Puig, Triangle Postals, Barcelona, 2006.

Fig. 4. Interior of Quatre Gats tavern, 1904, photographer unknown. Fundació Amatller, Arxiu Mas, Barcelona. Image © Fundació Amatller, Arxiu Mas.

Fig. 5. *Pere Romeu*, 1897, by Ramon Casas, oil on canvas, 86 x 67 cm. Private collection, Barcelona. Photo © Fotografia Gasull.

Fig. 7. *Ramon Casas and Pere Romeu in a Car,* 1901, by Ramon Casas, 220 x 315 cm. Private collection, Barcelona. Photo © Fotografia Gasull.

*Picasso's Fellows at the Tavern*

Fig. 3. *Aux aguets,* c. 1891, by Ramon Casas, oil on canvas, 58 x 47.5 cm. Institut Amatller d'Art Hispànic, Barcelona. Image © Fundació Amatller, Arxiu Mas, Barcelona.

Fig. 5. *At the Boqueria's Meat Stands,* 1894, by Isidre Nonell, charcoal on paper, 28.9 x 21.5 cm. Museu Nacional d'Art de Catalunya, Barcelona. Photo © MNAC–Museo Nacional d'Art de Catalunya, 2006, photo Calveras/Mérida/Sagristà.

Fig. 11. *Two Women at a Bar,* 1902, by Pablo Picasso, oil on canvas, 80 x 91.5 cm. Hiroshima Museum of Art, Japan. © 2006 Estate of Pablo Picasso/Artists Rights Society (ARS), NY.

### 4. Modernisme: Art and Society
*Art and Anarchism in the City of Bombs*

Figs. 2, 4, and 6. *Heads of Anarchists* (details), 1894, by Santiago Rusiñol, pencil on paper, 20.5 x 27 cm. Collection: Museu Cau Ferrat, Sitges. © 2006 Artists Rights Society (ARS), NY/VEGAP, Madrid.

Fig. 5. Front page of the Barcelona newspaper *El Liberal,* 5 October 1902, with Pablo Picasso's illustration for the holiday celebrating Our Lady of La Mercè. © 2006 Estate of Pablo Picasso/Artists Rights Society (ARS), NY.

*Bourgeois Life and the Representation of Women*

Fig. 4. *The Child Laborer,* 1882, by Joan Planella, oil on canvas, 182 x 142 cm. Private collection.

*Casas and the Chronicle of Social Life*

Fig. 2. *The Charge,* 1899, by Ramon Casas, oil on canvas, 298 x 470.5 cm. Museo Nacional Centro de Arte Reina Sofía, Madrid, long term loan to Museu Comarcal de la Garrotxa, Olot. Photo © Museo Nacional Centro de Arte Reina Sofía, 2006.

### 5. Modernisme: Architecture and Design
*Architecture and Design of the Modernista Era*

Fig. 1. General plan of the Barcelona Universal Exhibition of 1888. Arxiu Històric de la Ciutat, Barcelona. Photo © Arxiu Fotogràfic de l'Arxiu Històric de la Ciutat de Barcelona.

Fig. 2. Aerial view of Barcelona's Eixample, with La Sagrada Família at the center. Photo © Pere Vivas and Jordi Puig, Triangle Postals, Barcelona, 2006.

Fig. 3. Café-Restaurant, 1888, currently the Museu de Ciències Naturals, designed by Lluis Domènech i Montaner. Photo © Manolo Laguillo, Barcelona.

Fig. 4. Lucien Roisin, postcard showing Casa Amatller, c. 1920–30. Arxiu Històric de la Ciutat, Barcelona. Photo © Arxiu Fotogràfic de l'Arxiu Històric de la Ciutat de Barcelona.

Fig. 5. La Sagrada Família in 1906, photographer unknown. Arxiu Històric de la Ciutat, Barcelona. Photo © Arxiu Fotogràfic de l'Arxiu Històric de la Ciutat de Barcelona.

Fig. 6. *Mosaicos Escofet-Tejera y Ca.,* c. 1902, by Alexandre de Riquer, lithograph, 180 x 103.5 cm. Museu Nacional d'Art de Catalunya, Barcelona. Photo © MNAC–Museo Nacional d'Art de Catalunya, 2006, photo Calveras/Mérida/Sagristà.

Fig. 7. Interior of Domènech's Casa Navàs, Reus, 1901–7. Photo © Duccio Malagamba: fotografía de arquitectura, 2006.

*Puig i Cadafalch*

Fig. 3. *Façade of Casa Martí,* 8 October 1898, by Josep Puig i Cadafalch, ink on linen paper, 81 x 59 cm. Ajuntament de Barcelona, Arxiu Municipal Administratiu. Photo © Gasull Fotografia, Barcelona.

Fig. 4. Façade of Casa Amatller, 1898–1900, designed by Josep Puig i Cadafalch. Photo © Pere Vivas and Jordi Puig, Triangle Postals, Barcelona, 2006.

Fig. 6. *Casa Amatller, Design for the Façade,* 1898–1900, by Josep Puig i Cadafalch, ink and watercolor on Canson paper, 42 x 31 cm. Private collection. Photo © Gasull Fotografia, Barcelona.

Fig. 10. Aerial view of Casaramona Factory, 1903–11, designed by Josep Puig i Cadafalch. Photo © Pere Vivas and Jordi Puig, Triangle Postals, Barcelona, 2006.

*Domènech i Montaner and Architectural Synthesis*

Fig. 1. The auditorium of the Palau de la Música Catalana, 1905–8, designed by Lluís Domènech i Montaner. Photo © Pere Vivas and Jordi Puig, Triangle Postals, Barcelona, 2006.

Fig. 8. The main façade of the Palau de la Música Catalana, 1905–8. Photo © Pere Vivas and Jordi Puig, Triangle Postals, Barcelona, 2006.

Fig. 10. View of the staircase, with transparent yellow glass balusters, Palau de la Música Catalana. Photo © Pere Vivas and Jordi Puig, Triangle Postals, Barcelona, 2006.

*Homar and Busquets*

Fig. 4. *Marquetry Panel with a Lady in a Garden,* c. 1905, by Gaspar Homar, sycamore, majagua, ash, jacaranda, doradillo, and holm oak wood, 156 x 47.5 cm. Museu Nacional d'Art de Catalunya, Barcelona. Photo © MNAC–Museo Nacional d'art de Catalunya, 2006, photo Calveras/Mérida/Sagristà.

*Gaudí*

Fig. 1. Façade of Palau Güell, c. 1889, designed by Antoni Gaudí. Photo © Pere Vivas and Jordi Puig, Triangle Postals, Barcelona, 2006.

Fig. 4. Detail of the dragon stairway at Park Güell, 1900–1914. Photo © Pere Vivas and Jordi Puig, Triangle Postals, Barcelona, 2006.

Fig. 8. Aerial view of Park Güell, 1900–1914. Photo © Pere Vivas and Jordi Puig, Triangle Postals, 2006.

*Casa Milà*

Fig. 3. Wooden trusses arranged for constructing the catenary arches of the attic of Casa Milà, the vertical battens indicate the heights, c. 1909, photograph by the contractor, Josep Bayó. Photo courtesy Arxiu Reial Càtedra Gaudí, Barcelona.

Fig. 4. The ventilation tower on the roof of Casa Milà, taken just as the work was being completed, c. 1910, photograph by the contractor, Josep Bayó. Photo courtesy Arxiu Reial Càtedra Gaudí, Barcelona.

Fig. 6. The roof Casa Milà during construction, 1911, photograph by Josep Bayó. Photo. Photo courtesy Arxiu Reial Càtedra Gaudí, Barcelona.

Fig. 7. The ventilation towers and stairway exits on the roof of Casa Milà. Photo © Pere Vivas and Jordi Puig, Triangle Postals, Barcelona, 2006.

*The Extravagant Jujol*

Fig. 3. The wrought-iron balcony railings, designed by Josep M. Jujol, on the main façade of Gaudí's Casa Milà. Photo © Pere Vivas and Jordi Puig, Triangle Postals, Barcelona, 2006.

Fig. 4. Detail of the Jujol's trencadís on Gaudí's meandering bench in Park Güell square. Photo © Pere Vivas and Jordi Puig, Triangle Postals, Barcelona, 2006.

Fig. 8. The interior of the Botiga Mañach at 57, carrer Ferran, designed by Josep M. Jujol. Arxiu Jujol, Tarragona.

Fig. 10. The crypt of Colònia Güell showing the pews, designed by Antoni Gaudí, c. 1914. Photo © Pere Vivas and Jordi Puig, Triangle Postals, Barcelona, 2006.

Fig. 13. The desk and filing unit for scores for the home of Pere Mañach, c. 1919, designed by Josep M. Jujol, made by the Tallers Comas workshops, lacquered and polychrome pine, silver tanning, metallic saint, relief glass, and metal, 120 x 134 x 31 cm. Gift of Joan Pau Jover to the Generalitat de Catalunya 2006, Museu Nacional d'Art de Catalunya, Barcelona. Photo © MNAC–Museu Nacional d'Art de Catalunya, 2006, photo Calveras/Mérida/Sagristà.

*La Sagrada Família*

Fig. 1. Postcard showing Gaudí's Expiatory Temple of the Sagrada Família, c. 1927. Judith Rohrer collection, Atlanta.

Fig. 5. Jesus in his father's capentry shop, part of the sculptural group on the Nativity façade, La Sagrada Família, c. 1882. Photo © Pere Vivas and Jordi Puig, Triangle Postals, Barcelona, 2006.

Fig. 6. The Temptation of Man from the narthex of the Rosary portal of the Nativity façade, La Sagrada Família, c. 1882. Photo © Pere Vivas and Jordi Puig, Triangle Postals, Barcelona, 2006.

Fig. 7. Joseph guiding the ship of the Church (center left) from the Nativity façade, La Sagrada Família, c. 1882. Photo courtesy of Judith Rohrer.

Fig. 8. "El somni realisat" (The Realized Dream), illustrating Gaudí's vision for La Sagrada Família, *La Veu de Catalunya*, 20 January 1906,

Fig. 10. Gaudí's parish school at La Sagrada Família, c. 1925. Temple Expiatori de la Sagrada Família, Barcelona.

Fig. 11. Model of Gaudí's Colònia Güell chapel, made by Rainer Graefe, Frei Otto, Jos Tomlow, Arnold Walz, and their team. Temple Expiatori de la Sagrada Família, Barcelona.

Fig. 14. Detail of the tower spires from Gaudí's Sagrada Família, c. 1926. Photo © Pere Vivas and Jordi Puig, Triangle Postals, Barcelona, 2006.

Fig. 13. The 1:10 model of the nave of La Sagrada Família in Gaudí's studio, c. 1925. Arxiu del Temple Expiatori de la Sagrada Família, Barcelona. Photo courtesy Judith Rohrer.

Fig. 17. Current construction on nave of La Sagrada Família, 2005. Photo courtesy Judith Rohrer.

**6. Noucentisme and the Classical Revival**
*Catalan Noucentisme*

Fig. 1. The school complex Grup Escolar Ramon Llull, at the junction of carrer Aragó and Avinguda Diagonal in Barcelona, designed by Josep Goday in 1919, with sgraffito decoration by Francesc Canyellas. Photo © Pere Vivas and Jordi Puig, Triangle Postals, Barcelona, 2006.

Fig. 2. *Rain*, 1919, by Rafael Benet, oil on canvas, 80.5 x 95 cm. Museu Nacional d'Art de Catalunya, Barcelona. Photo © MNAC–Museu Nacional d'Art de Catalunya, 2006, photo Calveras/Mérida/Sagristà.

Fig. 3. *The Mediterranean* (also known as *Reclining Bather, Statue for a Shady Garden, The Thought*, and *Latin Thought*), 1909, by Aristide Maillol, bronze (original in plaster), 110 x 117 x 68 cm. Musée Maillol, Paris. © 2006 Artists Rights Society (ARS), NY/ADAGP, Paris.

Fig. 4. *Three Arches with a Pair of Lovers, a Boy Flying a Kite, and a Man Lying Down* (fragment of the murals in the cellar of the Galeries Laietanes), 1915, by Xavier Nogués, tempera on plaster, 154 x 284 cm. Museu Nacional d'Art de Catalunya, Barcelona. © 2006 Artists Rights Society (ARS), NY/VEGAP, Madrid. Photo © MNAC–Museu Nacional d'Art de Catalunya, 2006, photo Calveras/Mérida/Sagristà.

*The Almanach dels Noucentistes*

Fig. 2. Ramon Casas, *Eugeni d'Ors*, c. 1906–7, charcoal and pastel on paper, 56 x 43.8 cm. Museu Nacional d'Art de Catalunya, Barcelona. Photo © MNAC–Museu Nacional d'Art de Catalunya, Barcelona, 2006, photo Calveras/Mérida/Sagristà.

*Picasso in Gósol*

Fig. 1. View of the head of Solidaritat Catalana's demonstration, on 20 May 1906, unknown photographer. The photograph was taken from the top of the Arc de Triomf, looking toward the Parc de la Ciutadella and Domènech's Cafè-Restaurant (above right). Arxiu Històric de la Ciutat, Barcelona. Photo © Arxiu Fotogràfic de l'Arxiu Històric de la Ciutat de Barcelona.

Fig. 5. *The Gósol Madonna*, 12th century, polychromed wood, 77 x 30 cm. Museu Nacional d'Art de Catalunya, Barcelona. Photo © MNAC–Museu Nacional d'Art de Catalunya, 2006, photo Calveras/Mérida/Sagristà.

Fig. 10. *Odalisque with a Slave*, 1839–40, by Jean-Auguste-Dominique Ingres, oil on canvas, 72 x 100.3 cm. Fogg Art Museum, Harvard University Art Museums, Bequest of Grenville L. Winthrop. Photo Kallsen, Katya © 2004 President and Fellows of Harvard College.

Fig. 11. *Christ's Descent into Limbo*, 1516, by Sebastiano Luciani, known as Sebastiano del Piombo, oil on canvas, 226 x 114 cm. Museo del Prado, Madrid. Photo © Museo del Prado, Madrid/ Bridgeman Art Library.

*The Forms of Paradise*

Fig. 2. Joaquín Torres-García, *Philosophy Presented by Pallas on Parnassus*, 1911, by Joaquín Torres-García, oil on canvas, 124 x 385 cm. Institut d'Estudis Catalans Collection, Barcelona. © 2006 Artists Rights Society (ARS), NY/VEGAP, Madrid.

Fig. 4. *Young Women at the Sea Shore*, c. 1879, by Pierre Puvis de Chavannes, oil on canvas, 61 x 47 cm. Musée d'Orsay, Paris. Photo Erich Lessing/Art Resource, NY.

Fig. 8. *Three Nudes in the Wood*, 1913, by Joaquim Sunyer, oil on canvas, 125 x 151 cm. Museu Nacional d'Art de Catalunya, Barcelona. © 2006 Artists Rights Society (ARS), NY/VEGAP, Madrid. Photo © MNAC–Museu Nacional d'Art de Catalunya, 2006, photo Calveras/Mérida/Sagristà.

Fig. 11. *Woman from Fornalutx*, 1916, by Enric Casanovas, stone, 30 x 21 x 28 cm. Museu Nacional d'Art de Catalunya, Barcelona. Photo © MNAC–Museu Nacional d'Art de Catalunya, 2006, photo Calveras/Mérida/Sagristà.

Fig. 13. *La Ben Plantada (The Shapely Woman)*, 1912, by Xavier Nogués, etching and aquatint, 18 x 16 cm. Museu Nacional d'Art de Catalunya, Barcelona. © 2006 Artists Rights Society (ARS), NY/VEGAP, Madrid. Photo © MNAC–Museu Nacional d'Art de Catalunya, 2006, photo Calveras/Mérida/Sagristà.

*Noucentisme and the Revival of Classicism*

Fig. 1. *Olga Kokhlova with Mantilla*, 1917, by Pablo Picasso, oil on canvas, 64 x 53 cm. Christine Ruiz-Picasso Collection, Museo Picasso, Málaga. © 2006 Estate of Pablo Picasso/ Artists Rights Society (ARS), NY.

Fig. 8. *Eugeni d'Ors*, 1928, by Josep de Togores, done for "Coupole et Monarchie," an article published by Ors published in *Les Cahiers d'Occident*, no. 6 (1928).

*The Mediterranean Roots of Noucentista Sculpture*

Fig. 2. *Nude Young Man*, 1917, by Pablo Gargallo, stone. Museu Nacional d'Art de Catalunya, Barcelona. © 2006 Artists Rights Society (ARS), NY/ADAGP, Paris. Photo © MNAC–Museu Nacional d'Art de Catalunya, 2006, photo Calveras/Mérida/ Sagristà.

Fig. 5. *La Baccante*, 1934, by Manolo Hugué (Manuel Martínez i Hugué), bronze, 50 x 80 x 16 cm. Museu Nacional d'Art de Catalunya, Barcelona. Photo © MNAC–Museu Nacional d'Art de Catalunya, 2006, photo Calveras/Mérida/Sagristà.

*Noucentisme between Architecture and the Art of the Object*

Fig. 3. Masramon House, Olot , 1913–14, designed by Rafael Masó, photograph taken in 1916 by Adolf Mas. Photo © Fundació Amatller, Arxiu Mas, Barcelona, 2006.

Fig. 7. Two ceramic plates and a pharmacy bottle, 18th century, Barcelona. Museu de Ceràmica, Barcelona.

Fig. 8. Aragay's panels and vases in situ, Fountain of Santa Anna, 1918 (the vases are replicas from 2002), located at carrer Cucurulla at avinguda Portal de l'Àngel (formerly plaça de Santa Anna), Barcelona. Photo © Pere Vivas and Jordi Puig, Triangle Postals, Barcelona, 2006.

Fig. 16. *Preparatory Drawing for the Glass "Hunting,"* c. 1924, by Xavier Nogués, pencil and watercolor on paper, 12.4 x 28.3 cm. Museu Nacional d'Art de Catalunya, Barcelona. © 2006 Artists Rights Society (ARS), NY/VEGAP, Madrid. Photo © MNAC–Museu Nacional d'Art de Catalunya, 2006, photo Calveras/Mérida/Sagristà.

## 7. The Age of the Avant-Garde
*Avant-Gardes for a New Century*

Fig. 1. Frontispiece of *L'Amour et la mémoire* (1932), photograph of Salvador Dalí by Luis Buñuel. Fundació Gala-Salvador Dalí, Figueres.

Fig. 9. Barcelona artists gather to honor Picasso at the Galeries Laietanes, 1917, photographer unknown. Collection Palau Fabre, Barcelona. Photo © Fundació Amatller, Arxiu Mas, Barcelona.

Fig. 11. The opening of the Picabia exhibition at the Galeries Dalmau, 1922, photographer unknown. Ministerio de Cultura, Fundació Caixa de Pensions.

*Gleizes and Picabia at Galeries Dalmau*

Fig. 3. Double-page advertisement for the Splitdorf-Apelco Single Unit System, published in *Motor Age* (1 July 1915), from which Picabia copied some parts for his *Portrait of Marie Laurencin, Four in Hand.* Jordi Falgàs Collection.

*Art-Evolució and Vibracionismo*

Fig. 2. Drawing published in *Un enemic del Poble,* no. 3 (June 1917), by Joaquín Torres-García, illustrating his text "D'altra òrbita," dated April 1917. Biblioteca de Catalunya, Barcelona. © 2006 Artists Rights Society (ARS), NY/VEGAP, Madrid. Image courtesy Biblioteca de Catalunya.

*Art and Anti-Art*

Fig. 11. *Person Throwing a Stone at a Bird,* 1926, by Joan Miró, oil on canvas, 73.7 x 92.1 cm. The Museum of Modern Art, New York, purchase. © 2006 Successió Miró/Artists Rights Society (ARS), NY/ADAGP, Paris. Digital image © The Museum of Modern Art/licensed by SCALA/Art Resource, NY.

*Miró and ADLAN*

Fig. 3. *Painting,* 1933, by Joan Miró, oil on canvas, 130.5 x 162.9 cm. Wadsworth Atheneum Museum of Art, Hartford, The Ella Sumner and Mary Catlin Sumner Collection Fund. © 2006 Successió Miró/Artists Rights Society (ARS), NY/ADAGP, Paris.

Fig. 4. *Rope and People I,* 27 March 1935, by Joan Miró, oil on cardboard mounted on wood, with coil of rope, 104.8 x 74.6 cm. The Museum of Modern Art, Gift of the Pierre Matisse Gallery, New York. © 2006 Successió Miró/Artists Rights Society (ARS), NY/ADAGP, Paris. Digital image © The Museum of Modern Art/licensed by SCALA/Art Resource, NY.

*Two Sculptors Forged in Barcelona*

Fig. 3. *Large Dancer III (Grand Ballerina),* 1929, by Pablo Gargallo, cut iron, 123 x 70 x 50 cm. Museu Nacional d'Art de Catalunya, Barcelona. © 2006 Artists Rights Society (ARS), NY/ADAGP, Paris. Photo © MNAC–Museu Nacional d'Art de Catalunya, 2006, photo Calveras/Mérida/Sagristà.

Fig. 4. *The Large Trumpet,* 1932–33, by Julio González, forged iron, 48.5 x 26.8 x 14.5 cm. Walter Bechtler Collection, Zollikon, Switzerland. © 2006 Artists Rights Society (ARS), NY/ADAGP, Paris.

## 8. Avant-Gardes: The Rational City
*Revivalism to Rationalism in Architecture and Planning*

Fig. 1. *Plan of the Enlargement of the City of Barcelona,* 1859, by Antoni Rovira i Trias, black and colored ink on paper, 122 x 145 cm. Museu d'Història de la Ciutat de Barcelona. Photo © Museu d'Història de la Ciutat de Barcelona.

Fig. 2. Universitat de Barcelona, 1863–67, Gran Via de les Corts Catalanes, designed by Elies Rogent. Photo © Pere Vivas and Jordi Puig, Triangle Postals, Barcelona, 2006.

Fig. 3. *Plan Showing the Different Construction Zones,* c. 1903, by Léon Jaussely, signed Romulus, lower right, ink and colored pencil on Canson paper, 113.5 x 158.5 cm. Arxiu Històric de la Ciutat, Barcelona. Photo © Arxiu Fotogràfic de l'Arxiu Històric de la Ciutat de Barcelona.

Fig. 4. Commemorative fountain at the plaça d'Espanya for the Barcelona International Exposition, 1928–29, designed by Josep M. Jujol. Photo © Pere Vivas and Jordi Puig, Triangle Postals, Barcelona, 2006.

*The Barcelona Pavilion*

Fig. 1. King Alfonso XIII of Spain leaving the opening ceremonies for the German pavilion, Barcelona International Exhibition, 27 May 1929, photographer unknown. The Museum of Modern Art, New York. © 2006 Artists Rights Society (ARS), NY/VG Bild-Kunst, Bonn.

Fig. 2. German pavilion of the Barcelona International Exhibition, 1929, designed by Ludwig Mies van der Rohe. Photo © Pepo Segura, Fundació Mies van der Rohe, Barcelona.

Fig. 3. German pavilion of the Barcelona International Exposition, 1929, designed by Ludwig Mies van der Rohe. Photo © Pepo Segura, Fundació Mies van der Rohe, Barcelona.

Fig. 4. Interior view of the German pavilion, Barcelona International Exhibition, 1929, designed by Ludwig Mies van der Rohe. Photo © Pere Vivas and Jordi Puig, Triangle Postals, Barcelona, 2006.

Fig. 5. Interior view of the German pavilion, Barcelona International Exhibition, 1929, designed by Ludwig Mies van der Rohe. Photo © Pere Vivas and Jordi Puig, Triangle Postals, Barcelona, 2006.

Fig. 6. German Information Center, Barcelona International Exposition, 1929, photographer unknown. Geheimes Staatsarchiv Preussischer Kulturbesitz, Berlin.

Fig. 7. Barcelona International Exposition at night, 1929, photographer unknown. Bauhaus Archiv, Berlin.

Fig. 8. German pavilion at dusk, Barcelona International Exhibition, 1929, designed by Ludwig Mies van der Rohe. Photo © Pere Vivas and Jordi Puig, Triangle Postals, Barcelona, 2006.

Fig. 14. Georg von Schnitzler, c. 1929, photographer unknown. Photo © HistoCom GmbH, Frankfurt.

*GATCPAC (1930–36)*

Fig. 3. Genara López Apartment Building, carrer Muntaner, Barcelona, project from 1929, construction 1930–31, designed by Josep Lluís Sert with Sixt Illescas. Photo © Pere Vivas and Jordi Puig, Triangle Postals, Barcelona, 2006.

Fig. 21. Dispensari Central Antituberculós, 1934, designed by Josep Lluís Sert, Joan B. Subirana, and Josep Torres Clavé, carrer Torres Amat 8–14, Barcelona. Photo © Pere Vivas and Jordi Puig, Triangle Postals, Barcelona, 2006.

Fig. 22. Dispensari Central Antituberculós, interior view, 1934, designed by Josep Lluís Sert, Joan B. Subirana, and Josep Torres Clavé. Photo © Pere Vivas and Jordi Puig, Triangle Postals, Barcelona, 2006.

Fig. 25. Elementary school in Palau-solità i Plegamans, 1933, designed by Josep Lluís Sert. Arxiu Històric del Col·legi d'Arquitectes de Catalunya, Barcelona.

*Rational or Organic*

Fig. 1. *Table*, c. 1932, designed by Joan B. Subirana, steel and wood. Private collection, Barcelona. Photo by Rocco Ricci.

## 9. Avant-Gardes and Civil War
*Barcelona in the Maelstrom*

Fig. 1. *Montblanc, near Barcelona* (meeting of the International Brigades), 25 October 1938, by Robert Capa, gelatin silver print, 45.7 x 61 cm. Photo © Cornell Capa Photos by Robert Capa/ Magnum Photos.

Fig. 2. The burning of Antoni Gaudí's studio, 1936, photographer unknown. Temple Expiatori de la Sagrada Família, Barcelona.

Fig. 3. *Young Woman from Salamanca and a Militia Woman*, 1937, by Josep Renau, photomontage, 62 x 86 cm. Displayed at the pavilion of the Spanish republic, Paris International Exhibition, 1937. Photo courtesy Josefina Alix Trueba.

Fig. 4. Spain in August 1936.

Fig. 5. Nationalists capture a village near Córdoba, 1936, photographer unknown. AP/Wide World Photos. Photo © AP/Wide World Photos.

Fig. 6. *Bilbao* (citizens facing the alarm of sirens announcing possible bombing), 1937, by Robert Capa, gelatin silver print, 30 x 38.4 cm. Photo © Cornell Capa Photos by Robert Capa/ Magnum Photos.

Fig. 7. Guernica (general view), 26 April 1937, attributed to Azqueta, gelatin silver print, 13 x 18 cm. Biblioteca Nacional, Madrid. Photo © Laboratorio Fotográfico de la Biblioteca Nacional, Madrid.

Fig. 8. Spain in May 1938.

Fig. 9. *Between Argelès-sur-Mer and Le Barcarès, France* (civil war refugees from Catalonia), 1939, by Robert Capa, gelatin silver print. Photo © Cornell Capa Photos by Robert Capa/ Magnum Photos.

*Painting in the Shadow of Death*

Fig. 3. *Weaning of Furniture-Nutrition*, 1934, by Salvador Dalí, oil on canvas, 18 x 24 cm. The Salvador Dalí Museum, St. Petersburg. © 2006 Savador Dalí, Gala-Salvador Dalí Foundation/Artists Rights Society (ARS), NY.

*Miró's Aidez L'Espagne*

Fig. 2. *Preparatory Drawing for "Aidez l'Espagne,"* 1937, by Joan Miró, pencil on paper, 11.5 x 9.5 cm. Fundació Joan Miró, Barcelona. © 2006 Successió Miró/Artists Rights Society (ARS), NY/ADAGP, Paris.

Fig. 3. Miró painting *The Reaper* at the pavilion of the Spanish republic, Paris International Exhibition, 1937, by Pierre Matisse, photograph. The Morgan Library, New York. © 2006 Successió Miró/Artists Rights Society (ARS), NY/ADAGP, Paris. © 2006 Pierre Matisse/Artists Rights Society (ARS), NY.

*Catalans! Catalonia!*

Fig. 3. *The Story of Queipo de Llano*, 1936–39, poster, 122 x 88 cm, published by Comissariat de Propaganda de la Generalitat de Catalunya, Barcelona. Biblioteca del Pavelló de la República, Universitat de Barcelona. Photo © Universitat de Barcelona.

Fig. 4. *11 September: Catalans: Catalunya!*, c. 1937, designed by Ricard Fàbregas, lithograph, 111 x 78 cm, published by Comissariat de Propaganda de la Generalitat de Catalunya, Barcelona. Biblioteca Nacional, Madrid. Photo © Laboratorio Fotográfico de la Biblioteca Nacional.

Fig. 5. Posters on a wall in Barcelona, undated, by Kati Horna. Archivo Histórico Nacional, Sección Guerra Civil, Salamanca.

Fig. 12. *Catalans: This Is Your Badge, Buy It!*, c. 1937, designed by Ricard Fàbregas, lithograph, 111 x 78 cm, published by

Comissariat de Propaganda de la Generalitat de Catalunya, Barcelona. Biblioteca Nacional, Madrid. Photo © Laboratorio Fotográfico de la Biblioteca Nacional.

Fig. 14. *Catalans: Euzkadi Appreciates Your Help*, c. 1937, designed by Serra Molist, lithograph, 50 x 65 cm, published by Delegació General d'Euzkadi a Catalunya, Barcelona. Biblioteca Nacional, Madrid. Photo © Laboratorio Fotográfico de la Biblioteca Nacional.

Fig. 15. *Spain Has Arrived*, c. 1939, designed by Josep Morell, lithograph, 125 x 90 cm, published by Sevicio Nacional de Propaganda, Departamento de Plástica, Barcelona. Biblioteca Nacional, Madrid. Photo © Laboratorio Fotográfico de la Biblioteca Nacional.

*From War to Magic*

Fig. 2. Pavilion of the Spanish republic (cross-section plan), Paris International Exhibition, 1937, designed by Josep Lluís Sert and Luis Lacasa. Photo courtesy the author.

Fig. 3. Pavilion of the Spanish republic (exterior view), Paris International Exhibition, 1937, designed by Josep Lluís Sert and Luis Lacasa. Photo courtesy the author.

Fig. 5. Pavilion of the Spanish republic (ground plan, first floor), Paris International Exhibition, 1937, designed by Josep Lluís Sert and Luis Lacasa. Photo courtesy the author.

Fig. 6. Pavilion of the Spanish republic (upper level), Paris International Exhibition, 1937, designed by Josep Lluís Sert and Luis Lacasa. Photo courtesy the author.

Fig. 7. Picasso's *Guernica* and Calder's *Spanish Mercury from Almadén* installed at the Spanish pavilion, Paris International Exhibition, 1937. Photo courtesy the author. © 2006 Estate of Pablo Picasso/Artists Rights Society (ARS), NY. © 2006 Estate of Alexander Calder/Artists Rights Society (ARS), NY.

Fig. 8. Exhibition of visual art at the Spanish pavilion, Paris International Exhibition, 1937. Photo courtesy the author.

Fig. 10. Catalan culture section in the Spanish pavilion, Paris International Exhibition, 1937. Photo courtesy the author.

Fig. 11. Display of regions and cultures of Spain in the Spanish pavilion, Paris International Exhibition, 1937. Photo courtesy the author.

Fig. 12. Catalan press stand in the Spanish pavilion, Paris International Exhibition, 1937. Photo courtesy the author.

Fig. 13. Medieval Catalan art exhibition, Château de Maisons-Lafitte, during the Paris Internationla Exhibition, 1937. Photo courtesy the author.

*Picasso*

Fig. 4. *Massacre of the Innocents*, 1611, by Guido Reni, oil on canvas, 268 x 170 cm. Pinacoteca Nazionale, Bologna, Alinari/ Bridgeman Art Library.

*González*

Fig. 3. *Large Nude in a Red Armchair*, 1929, by Pablo Picasso, oil on canvas, 195 x 129 cm. Musée Picasso, Paris. © 2006 Estate of Pablo Picasso/Artists Rights Society (ARS), NY. Photo by J. G. Berizzi, Réunion des Musées Nationaux/Art Resource, NY.

Fig. 6. *Sculptural Head of La Montserrat*, c. 1942, by Julio González, plaster, 32 x 20 x 30 cm. IVAM–Institut Valencia d'Art Modern, Generalitat Valencia. © 2006 Artists Rights Society (ARS), NY/ADAGP, Paris.

*The Fall of the Republic*

Fig. 4. Photomural of the bombing of Guernica and the oak of democracy, by Josep Renau, exhibited at the pavilion of the Spanish republic, Paris International Exhibition, 1937. Photo courtesy Josephina Alix.

## Biographies

Photos © Arxiu Fotogràfic de l'Arxiu Històric de la Ciutat de Barcelona.

*Catalan and Spanish Names*

Readers of this catalogue will notice that the spelling of the names of certain artists, and even some of the catalogue essayists, can vary. These apparent inconsistencies occur partly because the use of Catalan, including Catalan names on documents and birth certificates, was declared illegal at various times, mandating the Spanish equivalent. Even when Catalan was not strictly prohibited, artists and publications often opted for Spanish because it is more widely understood. In this catalogue we have used Catalan when appropriate, except for the names of artists who typically used the Spanish version themselves. Of course, most of these artists used Catalan and Spanish alternately, depending upon the situation; thus it is correct to address Julio González as Juli, Pablo Gargallo as Pau, and Joaquín Torres-García as Joaquim. Even Picasso, though born in Spanish-speaking Andalusia, was fluent in Catalan and occasionally signed his letters "Pau" rather than "Pablo."

English-speaking readers should also be aware that Catalan and Spanish names include both their paternal and maternal families. Hence, Antoni Gaudí is formally known as Antoni Gaudí i Cornet ("i" meaning "and" in Catalan). This tradition always places the father's family name first and accepts the deletion of the maternal name. Thus Antoni Gaudí i Cornet is often shortened to Antoni Gaudí; he would be addressed as Senyor/Señor Gaudí (never Senyor Cornet), and alphabetized under "Gaudí." Picasso, who normally would be known as Pablo Ruiz Picasso, is a highly unusual exception. Not only did he adopt his mother's family name, but around 1901 he stopped using the paternal name, "Ruiz," entirely. Rafael Barradas and Antoni G. Lamolla are similar cases. Sometimes the connecting "i" is replaced with a hyphen: "Torres-García" for "Torres i García."

The editors debated over whether to use the native spelling "Catalunya" or the English equivalent "Catalonia." To some the word "Catalonia" expresses, however unintentionally, a paternalistic and neocolonist attitude through which one culture redefines and dominates another by imposing its own language over the original. However, we decided that the familiar English word would facilitate communication, and we note that there is little controversy about Cologne rather than Köln, Germany rather than Deutschland, and Spain rather than España.

*Titles of Works*

Most works of art are titled in English, either following published and accepted translations or translated here for the first time. Exceptions have been made for works of art known by a title in a foreign language (Picasso's *La Vie,* for example). Names of buildings are given in their most familiar form and original language. For example, the house of Manuel Vicens i Montaner is Casa Vicens, the house of Pere and Francesc Martí i Puig is Casa Martí, and the Palace of Catalan Music is the Palau de la Música Catalana. Words associated with well-known locations, such as *carrer* (street), *casa* (house), or *plaça* (square), have not been translated.

Names of museums, institutions, art galleries, and official agencies are given in their original language, unless an English translation is already accepted or may help their identification (Expiatory Temple of the Sagrada Família and Monastery of Santa Maria, for example). Names of exhibitions, on the other hand, have been translated into English to facilitate comprehension, unless they are already well known in their original language.

*Media and Dimensions*

Media and dimensions are included when provided by the lenders. Dimensions appear in centimeters, height preceding width and depth.

*Location of Works*

Current locations of works cited in the text are mentioned when known, although this has not always been possible, especially for owners who wish to remain anonymous.

*Translations*

Unless otherwise noted, the authors translated quotations within their essays. Essays by Alix, Bassegoda Nonell, Carbonell Basté, Carreras, Comadira, Doñate, Fondevila, Fontbona, Freixa, Giralt-Miracle, Mendoza, Ocaña, Quílez i Corella, Rovira, Suàrez, Trenc, Vélez, and Vidal—and all quotations within these essays—were submitted in Catalan or Spanish and have been translated by the Art of Translation, New York, in consultation with the authors and editors.

# Contributors

Josefina Alix is an art historian and freelance curator. She has organized, among other exhibitions, *Pabellón español: Exposición Internacional de París 1937* (1987); *El surrealismo en España* (1994); *Surrealistas en el exilio y los inicios de la Escuela de Nueva York* (1999); and *Un nuevo ideal figurativo. Escultura española 1900–1936* (2002).

Miriam M. Basilio is assistant professor and faculty fellow in the Museum Studies Program at New York University. She was curatorial assistant at the Museum of Modern Art, New York (2001–5), where she co-curated *Tempo* (2002) and *MoMa at El Museo: Latin American and Caribbean Art from the Collection of the Museum of Modern Art* (2004).

Joan Bassegoda Nonell is an architect and curator of the Taller Gaudí–Reial Càtedra Gaudí at the Universitat de Barcelona and Universitat Politècnica de Catalunya, Barcelona. A leading Gaudí scholar, he has written hundreds of books and monographs on Gaudí and Catalan Modernisme over the last four decades, as well as curating many exhibitions in Spain and abroad.

Margaret Burgess is a doctoral candidate in art history at the University of Oxford, England, and formerly a Cleveland Fellow at the Cleveland Museum of Art.

Sílvia Carbonell Basté is head of the Technical Area at the Centre de Documentació i Museu Tèxtil in Terrassa. She is the author of *Les fàbriques i els somnis: modernisme tèxtil a Catalunya* (2002) and other publications including many exhibition catalogues.

Jordi Carreras is an art historian and frequent collaborator with the Museu d'Arts Decoratives de Barcelona. He has taught and published various articles on decorative arts. Among the exhibitions he has curated are *Vidres del 1500 al 2000* (2000) and *Vidre d'artista, Art Nouveau i Art Déco. Col·lecció Salvador Riera* (2004).

Narcís Comadira is a painter, poet, translator, and playwright, as well as a columnist for Barcelona magazines and newspapers, and one of the major scholars of Noucentisme. He has curated several exhibitions and written essays on Joaquín Torres-García, Joaquim Sunyer, Fidel Aguilar, Manolo, and Rafael Masó, among others. His writings on Noucentisme have been collected in *Forma i prejudici: Papers sobre el Noucentisme* (2006).

Magdalena Dabrowski is a special consultant in the department of Nineteenth-Century, Modern, and Contemporary Art at the Metropolitan Museum of Art, and formerly senior curator at the Museum of Modern Art, New York. She has curated exhibitions and published on Wassily Kandisnky, Henri Matisse, Egon Schiele, European Symbolism, and the Russian avant-garde, among other topics.

Mercè Doñate is curator in the department of Modern Art at the Museu Nacional d'Art de Catalunya, Barcelona, and author of many exhibition catalogues, monographs, and essays on modernista Catalan painting and sculpture, most notably by Josep Clarà, Marià Fortuny, Joan Llimona, and Santiago Rusiñol.

Brad Epps is professor of romance languages and literature and chair of Women, Gender, and Sexuality Studies at Harvard University, Cambridge. He is the author of *Significant Violence: Oppression and Resistance in the Narratives of Juan Goytisolo, 1970–1990*, and editor of *Spain Beyond Spain: Modernity, Literary History, and National Identity*, among other publications.

Jordi Falgàs is a Cleveland Fellow in modern art at the Cleveland Museum of Art and formerly assistant executive manager at the Salvador Dalí Foundation (1996–2003). He is the author of *Dalí: painter, paint!* (2003). He has curated exhibitions and published articles on Dalí, Pablo Picasso, and several modern and contemporary Catalan artists.

Mariàngels Fondevila is curator in the department of Modern Art at the Museu Nacional d'Art de Catalunya, Barcelona. She specializes in decorative arts and has curated and written on Art Deco in Catalonia, Josep M. Jujol, and Gaspar Homar.

Francesc Fontbona is director of the Prints and Graphics department at the Biblioteca de Catalunya, Barcelona. He has published extensively on Catalan modernista art, including *La crisi del modernisme artístic* (1975), *El paisatgisme a Catalunya* (1979), and two volumes of the *Història de l'Art Català* (1983–96). He edited the five-volume series *El Modernisme* (2002–4), among many other publications.

Mireia Freixa is professor and chair of the department of Art History at the Universitat de Barcelona. She has written several books on Modernisme (1986, 1991, and 2000) and a monograph on Lluís Muncunill (1996). She has also edited art history manuals (1982, 1990, and 1999).

Daniel Giralt-Miracle is an art critic and freelance curator. He was formerly director of the 2002 Gaudí International Year, the Museu d'Art Contemporani de Barcelona, and the Fundació Caixa de Catalunya. He has curated many exhibitions, including the major exhibition *Avantguardes a Catalunya 1906–1939*.

Jared Goss is associate curator in the department of Nineteenth-Century, Modern, and Contemporary Art at the Metropolitan Museum of Art, New York. Specializing in modern design, he has published and curated exhibitions on Émile-Jacques Ruhlmann and Jean Dunand, among others.

William Jeffett is curator of exhibitions at the Salvador Dalí Museum, St. Petersburg, Florida. He has published many articles on the Catalan avant-garde and curated, among other exhibitions, *The Shape of Color: Joan Miró's Painted Sculpture* (2002), *Dalí and Miró circa 1928* (2003), and *Picasso to Plensa: A Century of Art from Spain* (2005).

Carmen Belen Lord is an independant art historian and specialist in the history of Spanish art. Her research and teaching areas include 19th- to early 20th-century European art, with special expertise in turn-of-the-century Catalan art and culture. She is currently preparing a book on gender representation in Spanish art.

Robert S. Lubar is associate professor at the Institute of Fine Arts, New York University. A noted scholar of modern Spanish art, he has published widely on Pablo Picasso, Joan Miró, and Salvador Dalí.

Jordana Mendelson is associate professor of art history in the School of Art and Design, University of Illinois at Urbana-Champaign. She is the author of *Documenting Spain: Artists, Exhibition Culture, and the Modern Nation 1929–1939* (2005), as well as a contributor to many exhibition catalogues and journals devoted to modern Spanish art.

Cristina Mendoza is chief curator of the department of Modern Art at the Museu Nacional d'Art de Catalunya and former director of the Museu d'Art Modern de Barcelona. She has curated countless exhibitions and written many catalogues devoted to modernista Catalan art. Together with her brother Eduardo, she is the author of *Barcelona modernista* (1989).

Jed Morse is assistant curator at the Nasher Sculpture Center in Dallas. He has curated and written essays for exhibition catalogues, including *Henry Moore: Sculpting the 20th Century* (2001) and *David Smith: Drawing + Sculpting* (2005).

Dietrich Neumann is professor of the history of modern architecture at Brown University, Providence. His books include *Film Architecture: Set Designs from Metropolis to Blade Runner* (1999), *Architecture of the Night: The Illuminated Building* (2002), and a forthcoming biography of Ludwig Mies van der Rohe.

Maria Teresa Ocaña is director of the Museu Nacional d'Art de Catalunya and former director of the Museu Picasso, Barcelona (1983–2006). She has curated many exhibitions and edited and written essays for catalogues devoted to various aspects of Pablo Picasso's life and work, as well as to many other artists of his generation.

Francesc M. Quílez i Corella is curator in the department of Prints and Drawings at the Museu Nacional d'Art de Catalunya, Barcelona. He has curated and published extensively on the collection, including essays on Francesc Fontanals, Francesc and Josep Masriera, Joaquim Mir, Ricard Canals, and Marià Fortuny.

Joan Ramon Resina is professor of romance languages and literature at Stanford University. He has written and edited several books and essays, including *El aeroplano y la estrella: El movimiento vanguardista en los Países Catalanes (1904–1936)* (1997), *Iberian Cities* (2001), and *Casa encantada: lugares de memoria en la España constitucional (1978–2004)* (2005).

William H. Robinson is curator of modern European art at the Cleveland Museum of Art. He has curated numerous exhibitions and published widely, including contributions to *El Modernisme* (2003), *Picasso: The Artist's Studio* (2001), *Diego Rivera: Art & Revolution* (1999), and *Maestros del Impresionismo* (1998).

Judith Rohrer is professor and chair of the department of Art History at Emory University in Atlanta. Specializing in the modernista architecture of Barcelona, she curated *Gaudí in Context. Building in Barcelona, 1873–1926* (1987) and *Josep Puig i Cadafalch: L'arquitectura entre la casa i la ciutat* (1989).

Josep M. Rovira is professor at the School of Architecture, Universitat Politècnica de Catalunya, Barcelona. He is the author of *La arquitectura catalana de la modernidad* (1987), *Leon Battista Alberti* (1988), *Otto Wagner: la arquitectura de nuestro tiempo* (1993), and several monographs and exhibition catalogues on Josep Lluís Sert.

Alícia Suàrez is professor of art history at the Universitat de Barcelona. She has published several books and essays on Catalan modernista art and co-curated *El Noucentisme: Un projecte de modernitat* (1994).

Eliseu Trenc is professor in the department of Spanish at the UFR Lettres & Sciences Humaines de la Université de Reims Champagne-Ardenne, France. A scholar of modernista graphic arts, magazines, and journals, he has also published several books and essays on modernista and avant-garde Catalan art.

Pilar Vélez is director of the Museu Frederic Marès in Barcelona. Specializing in Catalan decorative arts, she has published many monographs and exhibition catalogues on figures such as Josep Obiols, Lluís Bagaria, and Lluís Masriera.

Mercè Vidal is professor of art history at the Universitat de Barcelona. Author of many articles addressing Catalan art and art criticism—in particular Joaquim Folch i Torres, Galeries Dalmau, and Salvador Dalí—she also co-curated *El Noucentisme: Un projecte de modernitat* (1994).

*Barcelona and Modernity: Picasso, Gaudí, Miró, Dalí* was organized by the Cleveland Museum of Art and the Metropolitan Museum of Art, New York, in collaboration with the Museu Nacional d'Art de Catalunya, Barcelona. The Cleveland presentation is sponsored by Baker Hostetler and supported in part through grants from the National Endowment for the Arts and the Getty Research Institute. Additional funding is provided in part by the generous support of the citizens of Cuyahoga County. The Cleveland Museum of Art receives operating support from the Ohio Arts Council.

The Cleveland Museum of Art, 15 October 2006–7 January 2007
The Metropolitan Museum of Art, 7 March–3 June 2007

© The Cleveland Museum of Art 2006. All rights reserved. No part of this publication may be reproduced or transmitted in any form or by any means, electronic or mechanical, including photocopying, recording, or any information storage or retrieval system, without permission in writing from the publisher. The works of art themselves may also be protected by copyright in the United States of America or abroad and may not be reproduced in any form or medium without permission from the copyright holders.

Casebound, Cleveland Museum of Art
ISBN-13: 978-0-940717-87-9
ISBN-10: 0-940717-87-5
Paperback, Cleveland Museum of Art
ISBN-13: 978-0-940717-88-6
ISBN-10: 0-940717-88-3
Casebound, Yale University Press
ISBN-13: 978-0-300-12106-3
ISBN-10: 0-300-12106-7

Library of Congress Control Number: 2006931943

Produced by the Publications department of the Cleveland Museum of Art.
Editing: Barbara J. Bradley, Kathleen Mills, and Jane Takac Panza
Design: Laurence Channing and Carolyn K. Lewis
Production: Charles Szabla
Maps: Carolyn K. Lewis
Scanning: David Brichford
Digital retouching: Ellen Ferar
Rights and permissions: Bridget Weber
Illustration management: Anthony Morris
Translation management: The Art of Translation
Printing: Amilcare Pizzi, Milan

Yale University Press
www.yalebooks.com

# The Cleveland Museum of Art Board of Trustees

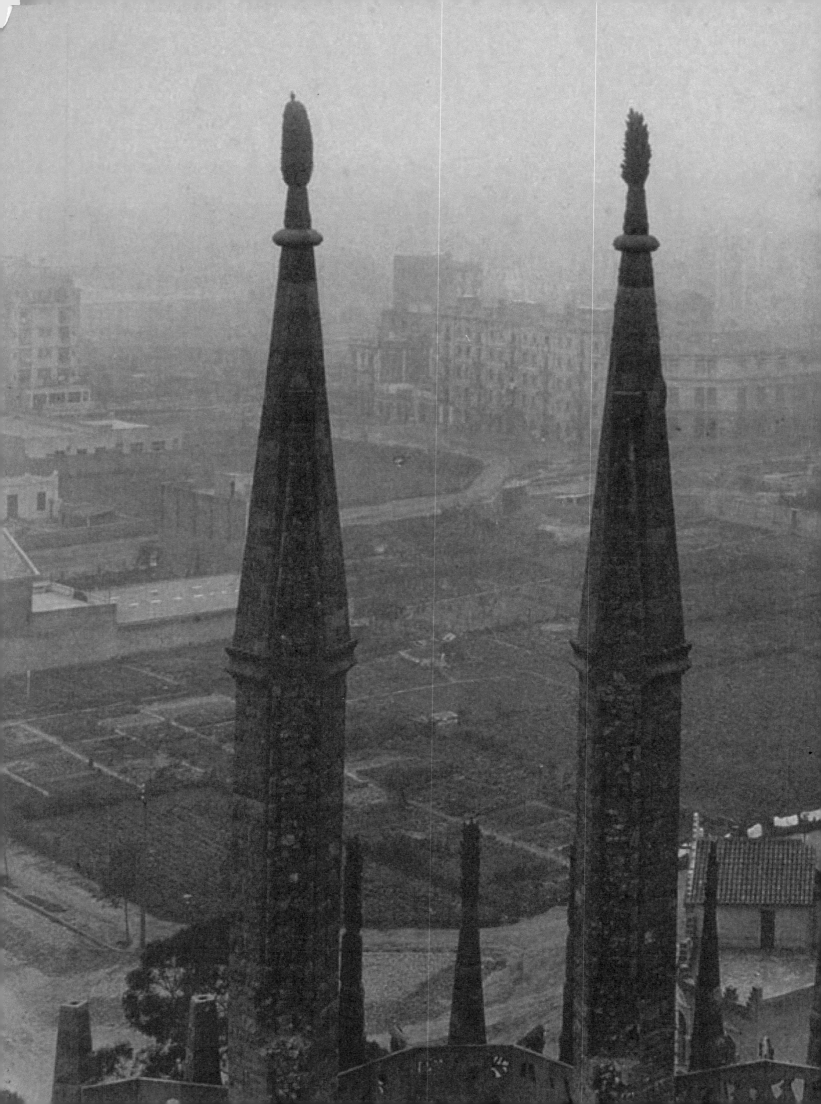